NATIONAL PORTRAIT GALLERY

Early Victorian Portraits

Volume I: Text

RICHARD ORMOND

LONDON: HER MAJESTY'S STATIONERY OFFICE 1973

© *Crown copyright 1973*

SBN 11 290093 3*

Frontispiece: Detail from the portrait of Queen Victoria
by Sir George Hayter, NPG 1250

Endpaper: Engraving of the Chartist Petition, 1842
London Museum

Designed by Alan Stephens

Printed in England for Her Majesty's Stationery Office
by William Clowes & Sons, Ltd.
London, Beccles and Colchester

Colour plates printed by Ben Johnson & Co Ltd, York

CONTENTS

ACKNOWLEDGEMENTS

It would be impossible to list all the numerous people who have contributed to this catalogue. In a sense, my greatest debt is to my colleagues and predecessors who garnered the material on which it is based. Without the reference archive, laboriously built up for over a century, a work of this kind would be impossible. People who have been especially helpful include the late Christine Ginsburg, librarian at the NPG, Major N. P. Dawnay of the Army Museums Ogilby Trust, Sir Oliver Millar, Surveyor of the Queen's Pictures, P. G. W. Annis of the National Maritime Museum, Greenwich and Thomas Pinney of Pomona College, California. Anthony Short was engaged for more than a year in checking and overhauling the typescript, and he was responsible for many useful additions and emendations. Jacqueline Kennish spent nearly as long proof-reading the catalogue, and, without her painstaking effort, the catalogue would be both less accurate and less efficient. The handsome appearance of the catalogue I owe to the designer, Alan Stephens, who has handled a long and difficult text with great ingenuity, and produced a splendid plate volume. Lastly I should like to thank Mrs Underwood, who, for more than four years, wrestled with an ill-written and intractable manuscript to produce an immaculate typescript.

Richard Ormond

INTRODUCTION

The limits of this catalogue are arbitrary from a historical point of view, but they do coincide with the overall plan for cataloguing the portraits in the NPG. Tudor and Jacobean portraits, and those of the seventeenth century, each have a catalogue to themselves; there will be two for the eighteenth century, one for the Regency, two for the Victorians, one for the Edwardians, and at least two for the modern period. The sheer number of portraits and the weight of documentary material precluded any attempt to cover the Victorian period as a whole in a single catalogue. As it is, the present work includes nearly five hundred sitters and over a thousand portraits. Generally speaking, the catalogue includes people born in or around 1800, whose main period of activity falls within the years 1830–60. The title, *Early Victorian*, is not strictly accurate, since the catalogue begins in 1830, not 1837, but the former date seemed to be a more rational dividing point.

There are inevitably a number of inconsistencies and discrepancies. For instance, while most of their contemporaries are catalogued here, Gladstone and Disraeli are excluded because their greatest political triumphs occurred after 1860. Although Tennyson belongs both to this and the later period, 1860–90, the decision to include him here was based partly on a value judgment between the relative quality of his early and late work, partly on his relationship to other poets of the period. Similar considerations determined the inclusion of Robert Browning and the exclusion of Matthew Arnold. Cardinal Newman comes in with the other leaders of the Oxford Movement; Cardinal Manning is consigned to the later period, because his power and influence were at their height after 1860. In all these cases, and many more, arguments for inclusion or exclusion abound, and reflect the narrow limits of the catalogue. The dangers of confusion, however, are lessened to some extent by the existence of the *Concise Catalogue* of the whole collection, which acts as an index to this and the other *catalogues raisonnés*.

No-one could claim that the period after 1830 was an age of great portraiture. Sir Thomas Lawrence was the last of the famous Georgian portraitists and his death in 1830 left a vacuum which remained unfilled. There were certainly a number of artists whose work has been undeservedly ignored, but they were essentially men of the second rank. Sir Francis Grant, F. R. Say, Thomas Phillips, H. W. Pickersgill, Sir Martin Archer Shee, H. P. Briggs, Sir John Watson Gordon, John Partridge, Sir George Hayter, were all capable of surprisingly good work, but their portraits lack the sense of grand design and painterly panache characteristic of their predecessors. In the later part of the period, the portraits of G. F. Watts strike a classic timeless note in contrast to the pedestrian realism practised by most of his contemporaries. In the field of portrait drawing, George Richmond and Samuel Laurence are pre-eminent, both highly accomplished as draughtsmen, and responsible between them for recording many of the leading figures of the age. At a lower aesthetic level, two artists made notable collections of drawings of their famous contemporaries: the dandy, Count D'Orsay, whose profile portraits form an amusing social register of the time; and William Brockedon, who drew many of the great engineers, scientists and inventors of the period. In several instances, no other image of a sitter survives apart from the D'Orsay or Brockedon drawing. Similarly important from a documentary point of view are the two colossal group portraits

by Hayter and Haydon, of the House of Commons and the Anti-Slavery Society Convention, respectively, which record nearly six hundred individuals.

Sculpture in the early Victorian period is of variable quality, but E.H. Baily, J.E. Boehm, William Behnes, J.H. Foley, John Gibson, Matthew Noble and Thomas Woolner, occasionally rise above the general level of mediocrity.

If the period cannot boast a high level of artistic performance, it is extraordinarily rich from an iconographical point of view. The cult of hero worship, and the intense interest in history and biography, finds expression in countless images of famous figures, and images of great diversity. The conventional studio portrait and the commissioned bust are supplemented by the informal sketch, the caricature, the popular woodcut, the death mask and the photograph. The introduction of photography in the 1840s adds a new dimension to portraiture; although it was not possible to catalogue them in detail, photographs are listed in the iconographies of individual sitters and several are reproduced in the plate volume.

The number and variety of images available of the Victorians enables them to be studied in much greater depth and detail than personalities of previous periods. And it is no longer kings and queens and statesmen who hold the stage. Apart from Queen Victoria and Prince Albert, the figures who dominate this catalogue are writers, Browning, Carlyle, Dickens, Thackeray and Tennyson. They are represented in the collection by a variety of images for which there exists a considerable quantity of documentation. In certain instances, it is possible to trace the genesis of a picture almost sitting by sitting, to discover why and for whom it was painted, the comments and attitudes of contemporaries, and its entire subsequent history. The reasons for this are two-fold. In the first place the Victorians were much more self-conscious about the implications of portraiture than earlier generations, much more prone to anecdote and reminiscence, and far more historically orientated. In the second place, vastly more archival material has survived for the nineteenth century than for previous centuries. In many instances, letters from the sitter and artist survive in the NPG's own archive. The published sources for the period are immense, and the volume of unpublished material proportionately greater.

Because of the quantity of images involved, the iconographies of sitters take the form of condensed lists (or, as one colleague unkindly put it, of a telephone directory), but they do establish the type and number of portraits involved, and provide the groundwork for further studies. Interesting recurring patterns are observable, such as the sudden proliferation of sketch statues and monuments by expectant sculptors following the death of a great man, and the corresponding production of posthumous paintings for public institutions. The sociological implications of Victorian portraiture are often quite as interesting as the purely iconographical or aesthetic.

Viewing history in terms of isolated individuals is inevitably lop-sided. The NPG collection cannot, in any sense, claim to be representative. Though essentially historical in composition, it does have some art historical bias, reflected in the fact that there are more portraits of early Victorian artists than any other group (about 18% of the total of some five hundred sitters). Literary figures and statesmen come next (approximately 16% and 11% respectively),

followed by travellers and explorers (10%), naval and military commanders (8%), scientists, engineers and inventors (8%), actors and dramatists (5%), churchmen (3½%), philanthropists (2%), and various smaller groups such as architects, musicians, antiquarians, judges, etc. Commerce, industry and finance are poorly represented, largely because the people who engaged in them rarely achieved individual distinction. The problem here is that the Gallery cannot represent groups or movements, but only outstanding individual figures. Even granting this limitation, the range of people covered by the catalogue is exceptionally wide and constitutes a microcosm of the age as a whole.

STRUCTURE OF THE CATALOGUE ENTRIES

For those represented in the collection by individual portraits, entries are as follows:

Name of sitter, together with date of birth and death.

Concise biographical description. This is intended only as an aide-mémoire. For fuller biographical details, readers are referred to the *Dictionary of National Biography*, and other standard reference works.

Entries on the portraits in the Gallery's collection. In cases where more than one portrait exists for a sitter, entries are arranged firstly in order of medium (oil, water-colour and drawing, miniature and sculpture), and, within these categories, in order of registered number (i.e. the entry for an oil painting automatically precedes that for a drawing or bust; in the case of two oil paintings, that with the lowest registered number is catalogued first). Individual entries are constructed as follows:

(1) Registered number. Each portrait is given a number when it enters the collection, and the series runs consecutively.

(2) Medium (e.g. oil on canvas, pencil on paper).

(3) Size in inches, and size in centimetres. Height precedes width.
Dimensions for painting are usually those of the painted surface.

(4) Artist, and, where possible, date.

(5) Exact transcription of signatures, dates, inscriptions, labels and other identifying marks on the portrait.

(6) Previous collections.

(7) Exhibitions.

(8) Literature.

(9) A full discussion of the portrait's history and origin, where known, related studies, versions, copies, engravings, etc, relevant documents and letters, and other facts and problems associated with it.

(10) Description. As every portrait is reproduced, this takes the form generally of colour notes.

Iconography. A listing and classification of other known images not in the collection, of sitters represented by individual portraits. Details of medium, artist, date, present or last recorded location, exhibitions, related studies, copies, versions and engravings, reproductions in books, etc, are given where known. Where iconographies are small, they are arranged compactly in order of medium, oil paintings, watercolours and drawings, miniatures, busts and statues, prints and photographs. Where iconographies are large, they are arranged chronologically; the dates of group portraits are usually those of the meeting or event depicted, not of the portrait itself. Several portraits not in the collection are reproduced in the plate volume for purposes of comparison.

For sitters represented in the collection by a group portrait, there is a brief entry in the main body of the catalogue, under the name of each individual, and a reference to the relevant group catalogued at the end of the text volume. Collections of portraits by a single artist, acquired as a set, are also discussed at the end of the text volume, after groups. The individual portraits of significant sitters from these collections are included in the main body of the catalogue in the usual way, under the name of the sitter, with an accompanying biographical description and iconography. Unimportant sitters, sitters falling within the limits of other catalogues, and foreigners, are briefly noted by name in the main catalogue, with a reference to the collection as a whole at the end.

ABBREVIATIONS

ILN	*Illustrated London News.*
Irish NPG	Irish National Portrait Gallery; this is part of the National Gallery of Ireland, Dublin.
NPG	National Portrait Gallery, London.
RA	Royal Academy summer exhibition.
RA	Royal Academy or Royal Academician.
Scottish NPG	Scottish National Portrait Gallery, Edinburgh.
SKM, 1868	*Third Exhibition of National Portraits*, South Kensington Museum, 1868.
'SSB'	Scharf's sketchbooks. The notebooks of George Scharf, the first keeper and director of the NPG, containing notes and drawings of portraits.
'TSB'	Trustees sketchbooks. The notebooks of Scharf containing notes and sketches of portraits of particular interest to the gallery.
VE, 1892	*Victorian Exhibition*, New Gallery, London, 1891–2.
Victorian Era Exhibition, 1897	*Victorian Era Exhibition*, Earl's Court, London, 1897.

the Catalogue

ABBOTT *Sir James* (*1807–96*)

General; enlisted in Bengal artillery; engaged in various revenue surveys; served in march to Kandahar, 1838–9; assistant at Herat mission; carried to Russian court Hazrat's offer to free Russian captives, 1839–40; commissioner of Hazara, 1845–53; general, 1877; published poetry and other writings.

4532 Water-colour on paper, 8¼ × 6½ inches (21 × 16·5 cm), by B. BALDWIN, 1841. PLATE 1

Inscribed in ink on an old label (*formerly mounted behind the water-colour*): Painted/by/ B. Baldwin/ London 1841

Collections: By descent to the sitter's son, Raymond Abbott; Miss E. Werge Thomas, presented by her, 1967.

This water-colour shows Abbott in the Afghan costume in which he made his hazardous journey from Herat to Khiva to Russia, bearing the offer of the khan, Hazrat of Khiva, for the release of Russian captives detained in slavery by him. He set out in December 1839, and, after various adventures during which he was wounded, reached Russia in May 1840. He then proceeded to St Petersburg to complete the negotiations, and on his return to England received the thanks of Lord Palmerston, then foreign secretary. The water-colour was evidently painted to commemorate his famous journey. A companion water-colour of an Afghan whom Abbott brought back to Europe with him is still in the collection of Miss Werge Thomas, together with most of Abbott's papers. The water-colour of Abbott has clearly faded; Miss Werge Thomas remembered that the 'Afghan turban had once many colours' (letter of 28 April 1967). She also recalled that Abbott used to stand before the painting, when he was old, and say, 'Is that me?'. B. Baldwin exhibited three portraits at the *RA*, 1842–5, but is otherwise unrecorded. A coloured photograph of Abbott, showing him as a general in the Bengal Artillery, and other photographs of him are owned by Miss Werge Thomas. No other portraits are recorded.

Description: Healthy complexion, brown eyes, dark brown beard. Dressed in a light brown under-garment, blue sash with a bone(?)-handled knife sticking out of it, dark brown over-garment with a fur(?) collar, and a brown and white turban. Pale brownish-grey curtain covering most of background, grey pillar and plinth at left.

À BECKETT *Gilbert Abbott* (*1811–56*)

Comic writer; contributor to *Punch* and the *Illustrated London News*, and for many years leader-writer for the *Times* and *Morning Herald*; author of many plays and humorous works.

1362 Miniature over a photograph, water-colour on paper, 4⅜ × 3¼ inches (11·1 × 8·2 cm), attributed to CHARLES COUZENS, 1855. PLATE 2

Collections: The sitter, presented by his son, Arthur À Beckett, 1904.

Literature: Basil Long, *British Miniaturists* (1929), p 105.

According to Arthur À Beckett (letter of 13 February 1904, NPG archives), the miniature was painted by Couzens in 1855.

Description: Brown eyes, grey hair. Dressed in a white shirt, black neck-tie and black coat. Elbow resting on red table. Greenish background colour.

ICONOGRAPHY The only other recorded likenesses of À Beckett are, a drawing by I. Maguès, exhibited *SKM*, 1868 (595), reproduced M. H. Spielmann, *The History of Punch* (1895), p 272, and a drawing or miniature by F. W., exhibited *RA*, 1846 (1073).

ABERDEEN *George Hamilton Gordon, 4th Earl of (1784–1860)*

Statesman; distinguished antiquarian and connoisseur; foreign secretary, 1841–6; prime minister, 1852–5.

750 Oil on canvas, 45½ × 57 inches (115·6 × 144·8 cm), by JOHN PARTRIDGE, *c* 1847. PLATE 4

Collections: The artist; Partridge Sale, Christie's, 15 June 1874 (lot 62), bought Smith; Henry Willett, presented by him, 1886.

Exhibitions: S K M, 1868 (401).

Literature: Listed in a Partridge MS notebook (NPG archives); R. L. Ormond, 'John Partridge and the Fine Arts Commissioners', *Burlington Magazine*, CIX (1967), 402, reproduced figure 24.

Like Partridge's portraits of Melbourne (NPG 941), Macaulay (NPG 1564) and Palmerston (NPG 1025), this portrait is closely related to the figure of Aberdeen in Partridge's group, 'The Fine Arts Commissioners' (NPG 342 below), and was presumably painted as a finished study for it. Aberdeen is shown in the NPG portrait with a sketch of the Acropolis in his hands, a Greek vase on the table and a model of the Parthenon behind, an expression of his antiquarian interests. He was president of the Society of Antiquaries from 1812–46, and wrote a book on Greek architecture.[1] Partridge painted most of the Fine Arts Commissioners individually between 1844 and 1849, and retained these portraits himself, many of which he exhibited at his own Gallery (copy of catalogue, NPG archives; it does not list Aberdeen's portrait), following his refusal to exhibit at the Royal Academy after 1846. At his death in 1872, his executors attempted to sell these portraits to the original sitters or their descendants, auctioning the remainder in 1874. The Dowager Countess of Aberdeen wrote to Sir John Clarke, one of the executors, on 9 April 1873, thanking him for the offer of her husband's portrait: '*The portrait of Lord Aberdeen does not strike me as at all a good likeness. The eye and expression are not his, but I should like (in case any of my family might wish to save it from being sold away) to ask at what price it is valued, and also the sketches for the pictures of my father and mother, Mr and Mrs Baillie of Mellerstain, called Metterstein in the catalogue.*'[2] In a letter of 17 April 1873, Lady Aberdeen agreed to buy the portraits of her parents (both the kitcat size portraits and the two smaller sketches), but postponed a decision on the portrait of her husband until her son had seen it.[2] As it appeared in the sale, and as Lady Aberdeen only paid £26 12 0 to the executors '*on account of the pictures*' (letter of 8 July 1873), it is clear that the family had decided not to buy the portrait of Lord Aberdeen.

In the past the date 1846 has been given to the portraits of the Commissioners, as well as to the finished picture of the whole group, presumably because this is the date of the meeting depicted. It is clear, however, from contemporary evidence that the big picture was still in progress in 1854. A letter from Lord Aberdeen to Partridge, dated 26 October 1844, informs the artist that he will be pleased to sit for his portrait,[2] and another letter from Lady Aberdeen to Partridge, dated 6 July 1845, states that her husband will call the following day for a sitting.[2] Since Partridge did not apparently start work on the group portrait till 1846, it seems doubtful if the two letters refer to this portrait, which is a study for it. In his MS notebook, Partridge dated this portrait 1847.

Description: Brown eyes, and brown hair with grey streaks. Dressed in a white stock, white shirt, and black suit. Seated in a high backed mahogany chair with red velvet covering. Holding a print with green and brown foreground and blue sky. On the left a table with a red table-cloth, black Greek vase with red figure decoration, quill pen, writing pad, and silver and glass inkstand. Behind on left a stone-coloured model of the Parthenon. On the right, behind, a red dispatch box on a wood and gilt side-table. Background colour very dark brown.

[1] *Inquiry into the principles of beauty in Grecian Architecture* (1822).

[2] This letter, and others mentioned above, are in the NPG archives. The original full-length portraits of Mr and Mrs Baillie, painted in 1828 (see Partridge's MS 'Sitters Book', NPG archives) are in the collection of the Earl of Haddington, and so also are the studies.

793 With Lord Farnborough (left) and Sir Abraham Hume (centre). Pencil and oil on canvas, $21\frac{1}{2} \times 22\frac{3}{4}$ inches ($54\cdot6 \times 57\cdot6$ cm), by PIETER CHRISTOPH WONDER, $c\,1826$. PLATE 5

Inscribed on the painting in pencil above Farnborough's head: Lord Farnborough *above Hume's head:* Abraham Hume *and above Aberdeen's head:* Lord Aberdeen.

Inscribed on old labels on the back of the canvas, corresponding to their relative positions, are the names of the sitters.

Collections: Offered to the NPG by J. S. Coster of Utrecht, 1878; E. Joseph, presented by him, 1888.

This is one of four studies in the NPG for Wonder's group picture of 'Patrons and Lovers of Art' in the collection of Admiral Sir Victor Crutchley. They will be discussed collectively in the forthcoming Catalogue of Portraits, 1790–1830.

Description: Farnborough and Hume grey-haired, in white shirts and stocks, and black suits. Aberdeen brown-haired, in white shirt and stock, grey waistcoat, black coat and light grey trousers. Purple and gilt chair, purple table-cover, red and gilt leather-bound book. Unfinished brown background, with sketchily indicated architecture in pencil. Unfinished chair in pencil at left.

54 See *Groups:* 'The House of Commons, 1833' by Sir G. Hayter, p 526.

342, 3 See *Groups:* 'The Fine Arts Commissioners, 1846' by J. Partridge, p 545.

1125 See *Groups:* 'The Coalition Ministry, 1854' by Sir J. Gilbert, p 550.

2789 See *Groups:* 'Members of the House of Lords, $c\,1835$' attributed to I. R. Cruikshank, p 536.

ICONOGRAPHY This does not include photographs or caricatures. The best source for illustrations of portraits of Aberdeen is Lady F. Balfour, *The Life of George, Fourth Earl of Aberdeen* (1923).

1808 Painting by Sir T. Lawrence. Collection of the Earl of Haddo, Haddo House (plate 3). Exhibited *RA*, 1808 (74). Engraved by C. Turner, published 1809 (example in NPG), engraving reproduced Lady F. Balfour, I, facing 96. A copy by M. Healy is in the Musée de Versailles.

c1812 Bust by J. Bacon. Exhibited *RA*, 1812 (928).

c1814 Bust by J. Nollekens. Exhibited *RA*, 1814 (801).
The same or another bust was in the artist's sale, 1823. A plaster bust by W. Theed the younger of $c\,1865$, showing Aberdeen in the costume of an ambassador as he appeared in $c\,1813$–14, is at the Royal Military Academy, Sandhurst, and may be after the Nollekens. Another cast of the Theed is at Wellington College.

1820 'Trial of Queen Caroline, 1820', water-colour by R. Bowyer, A. Pugin and J. Stephanoff. Houses of Parliament. Engraved by J. G. Murray, published R. Bowyer, 1823 (example in Houses of Parliament).

c1826 Painting by P. C. Wonder (NPG 793 above).

c1830 Painting by Sir T. Lawrence. Collection of Viscount Cowdray, formerly Peel collection. Exhibited *RA*, 1830 (116). Reproduced Lady F. Balfour, I, frontispiece. Engraved by S. Cousins, published Colnaghi, 1831 (example in NPG). Engraved by E. McInnes, published Graves, 1844 (example in British Museum).

1831 Engraving by T. Woolnoth, after A. Wivell, published 1831 (example in NPG), for Jerdan's 'National Portrait Gallery'.

1832 'Society of Antiquaries', engraving by D. Maclise, published *Fraser's Magazine*, V (1832), between 474–5.

1833 'The House of Commons, 1833' by Sir G. Hayter (NPG 54 above).

c1835 'Members of the House of Lords, $c\,1835$' attributed to I. R. Cruikshank (NPG 2789 above).

1837 'Queen Victoria Presiding Over Her First Council, 1837' by Sir D. Wilkie. Royal Collection.

c1839 Painting by Sir M.A.Shee. Scottish NPG (plate 6).
Presumably that exhibited *RA*, 1839 (60). Dated '1830' by F.D.Singh, *Portraits in Norfolk Houses*, I (1927), 343, for reasons which are not given. Aberdeen's age suggests a date nearer 1840.

1840–3 Three paintings by Margaret Carpenter. Listed in her 'Sitters Book' (copy of original MS, NPG archives), pp 29–30 (two of 1840), and p 33 (one of 1843). None has been traced.

1842 'Christening of the Prince of Wales' by Sir G.Hayter. Royal Collection.

1843 'Reception of Queen Victoria and Prince Albert at the Château d'Eu' by E.Lami. Musée de Versailles. Reduced version: Royal Collection.

1843 Lithograph by E.Desmaisons, published A.&C.Baily (example in NPG).

1844 'Queen Victoria Receiving Louis Philippe at Windsor' by F.X.Winterhalter. Royal Collection. A larger version is at Versailles.

1846 'The Fine Arts Commissioners, 1846' by J.Partridge (NPG 342,3 above). Study (NPG 750 above).

1852 Painting by Sir J.Watson Gordon. Collection of the Earl of Haddo, Haddo House.
Exhibited *RA*, 1852 (75). Reproduced Lady F.Balfour, II, frontispiece, when in the Town and Country Hall, Aberdeen. Engraved by E.Burton, published Hill, 1853 (example in British Museum).

1853 'Evening at Balmoral – The Stags Brought Home', water-colour by C.Haag. Royal Collection.
Study of Aberdeen: Royal Collection, exhibited *British Portraits*, RA, 1956–7 (716).

1854 'The Coalition Ministry' by Sir J.Gilbert (NPG 1125 above).

1855 'Queen Victoria Investing Napoleon III with the Order of the Garter' by E.M.Ward. Royal Collection.

c1857 Bust by J.Francis. Exhibited *RA*, 1857 (1348).

1874 Bust by M.Noble. Westminster Abbey.
Reproduced Lady F.Balfour, II, facing 320. Plaster cast: collection of Lord Dudley Gordon. Marble copy of 1964: Houses of Parliament.

Undated Painting called Aberdeen and attributed to J.Hoppner. Edwards Gallery, Edinburgh, 1970.

Undated Miniature by an unknown artist. Formerly in the collection of the Earl of Chesterfield.

Undated Effigy by Sir J.E.Boehm. Great Stanmore Church.
Reproduced Lady F.Balfour, II, facing 320.

Undated Engraving (entitled 'Château d'Eu') by W.Skelton and J.Hopwood (example in NPG).

ABINGDON *Montagu Bertie, 6th Earl of* (*1808–84*)
MP for Oxon.

54 See *Groups:* 'The House of Commons, 1833' by Sir G.Hayter, p 526.

ADAM *Sir Charles* (*1780–1853*)
Admiral, and MP for Clackmannan.

54 See *Groups:* 'The House of Commons, 1833' by Sir G.Hayter, p 526.

ADAM *Professor*
American slavery abolitionist.

599 See *Groups:* 'The Anti-Slavery Society Convention, 1840' by B.R.Haydon, p 538.

ADAMS *Edward Hamlyn* (*1777–1842*)
MP for Carmarthenshire.

54 See *Groups:* 'The House of Commons, 1833' by Sir G.Hayter, p 526.

ADELAIDE *Queen of William IV* (*1792–1849*)

Eldest daughter of George, Duke of Saxe-Coburg Meiningen; married William, Duke of Clarence, 1818; became queen on his accession to the throne, 1830.

1533 Oil on canvas, 36 × 27¾ inches (91·5 × 70·5 cm), by SIR WILLIAM BEECHEY, *c* 1831. PLATE 7

Collections: Messrs Leggatt, purchased from them, 1909.

The early history of this portrait is unknown. It is a version of Beechey's full-length portrait of Queen Adelaide in evening dress at Trinity House, London, exhibited *RA*, 1831 (66). In the NPG version, the Queen is wearing earrings, her pearl tiara appears twice between her ringlets as well as across her forehead, she holds a larger bouquet, and her features differ from those in the Trinity House portrait. Otherwise the two portraits are very similar in pose and treatment, save that the NPG version is half-length, and does not include the pillar or distant view. A full-length replica of the Trinity House portrait was in the Beechey Sale, Christie's, 11 June 1836 (lot 73). The Trinity House portrait was engraved by S. W. Reynolds, published Colnaghi, 1831 (example in NPG). A half-length engraving, also by Reynolds, was published Colnaghi, 1834 (example in NPG). Another engraving by T. Lupton, published W. Sams, 1834 (example in NPG), is based on the Trinity House portrait, but does not include the lace head-dress.

A different portrait-type of Queen Adelaide by Beechey, showing her full-length, seated at a table holding an eye-glass, was in the collection of the Duke of Cambridge (reproduction in British Museum). It was probably the unnamed portrait exhibited *Victorian Era Exhibition*, 1897, 'History Section', p 51 (568), lent by the Duke of Cambridge.

Description: Fresh complexion, blue eyes, brown hair. Dressed in a blue velvet dress with white lace ruff and sleeves, gold chain and locket, and gold and diamond brooch and earrings. Holding a red and white rose. Red curtain behind. Background lower left coloured light brown.

ICONOGRAPHY This does not include popular prints or caricatures (some examples in NPG and British Museum).

c 1821 Miniature by Mrs Green. Exhibited *RA*, 1821 (813).
Engraved by J. S. Agar, published Jennings and Chaplin, 1830, and by F. Engleheart, published Simpkin and Marshall, 1831 (examples in NPG).

c 1825 Lithograph by Grégoire and Deneux, after Z. Belliard, published Rosselin, Paris, *c* 1825 (example with Parker Gallery, London, 1966).

1830 Engraving by J. Porter, after A. M. Huffam, published J. McCormick, 1830 (example in British Museum).

c 1831 Painting by Sir W. Beechey. Trinity House, London.
Exhibited *RA*, 1831 (66). Engraved by S. W. Reynolds, published 1831 (example in NPG). Related version (NPG 1533 above).

c 1831 Painting by F. Flor (in coronation robes). Ex-collection of the Earl of Shrewsbury, Ingestre Hall Sale, H. Spencer and Sons, 21 November 1968 (lot 261), reproduced in catalogue. Another half-length portrait by Flor was formerly at Alton Towers.

c 1832 Painting by H. Dawe. Collection of Lord Hardwicke, Wimpole, 1879.
Engraved by H. Cook, published 1832 (example in NPG), for Jerdan's 'National Portrait Gallery'.

c 1832 Painting by J. Simpson. Brighton Art Gallery.
Commissioned, with a portrait of William IV, by the Brighton Town Council, 1832.

1833 Painting by Sir D. Wilkie (in coronation robes). Formerly Royal Collection(?).

c 1833 Painting by Sir D. Wilkie (on horseback). Scottish NPG (plate 9).
Probably painted at the same time as the state portrait above; see *Wilkie Exhibition*, RA, 1958 (32).

c1833 Drawing by Sir D. Wilkie. Dumfries.

c1833 Water-colour by Sir D. Wilkie (with William IV). Tate Gallery, London.
Exhibited *British Portraits*, RA, 1956–7 (699). This appears to have been a study for a projected double state portrait of William and Adelaide; other related studies are in the Royal Collection (Windsor), Tate Gallery, and formerly collection of J. Woodward.

1833 Engraving by S. W. Reynolds, after A. Grahl, published Ackermann, 1833 (example in British Museum).

1833 Lithograph by R. J. Lane, published 1833 (example in NPG).

c1835–8 Painting by Sir D. Wilkie. Examination Schools, Oxford, presented by Queen Adelaide, 1838.

c1835 Miniature by Sir W. J. Newton. Exhibited *RA*, 1835 (784).

c1836 Miniature by E. Jones. Exhibited *RA*, 1836 (701).

1837 Painting by J. Lucas. Collection of Countess Howe (plate 10).
Exhibited *Kings and Queens of England*, Liverpool, 1953 (43). Reproduced A. Lucas, *John Lucas* (1910), plate XVI. Engraved by J. Thomson, published J. Hogarth, 1845 (example in NPG). Various replicas are recorded.

1837 'Queen Adelaide Receiving Malagissy Ambassadors' by H. Room. Queen's Palace Museum, Madagascar.

c1837 Painting by Sir M. A. Shee. Royal Collection.
Exhibited *RA*, 1837 (68). See O. Millar, *Later Georgian Pictures in the Royal Collection* (1969), I (1085), reproduced II, plate 300. Another version: Goldsmiths Hall, London.

c1837 Miniature by Sir W. J. Newton. Exhibited *RA*, 1837 (862).

1840 'Marriage of Queen Victoria and Prince Albert' by Sir G. Hayter. Royal Collection.
Engraved by C. E. Wagstaff, published H. Graves, 1844 (example in NPG).

1841 'Christening of the Princess Royal' by C. R. Leslie. Royal Collection.

1841 Lithograph by E. Desmaisons, published A. & C. Baily (example in British Museum).

1841 Engraving by H. T. Ryall, after Sir W. C. Ross, published McLean, 1841 (example in NPG).

1844 Drawing by J. Lucas (*inscribed:* 'Queen Adelaide/Drawn by J. Lucas/ at Witley Court March 15th. 1844'). Reproduced A. Lucas, *John Lucas* (1910), plate XVI.

1844 Drawing by J. Lucas (*inscribed:* 'J. Lucas, March 5th, 1844. The Queen Dowager, taken for Sir W. Newton for the picture of the Marriage of Queen Victoria'). British Museum.

1844 Miniature by Sir W. C. Ross. Royal Collection.
Exhibited *Portrait Miniatures*, South Kensington Museum, 1865 (995).

1845 Drawing by G. Richmond. Listed in his 'Account Book' (photostat copy of original MS, NPG archives), p 38, under 1845. Presumably the drawing engraved by J. Thomson, published J. Hogarth, 1845 (example in NPG), for Finden's *Female Aristocracy*. Replica in oils, after the engraved drawing: Guildhall Art Gallery, London.

1849 Painting by F. X. Winterhalter (signed and dated). Collection of George Schäfer, Schweinfurt.
Exhibited *Der Frühe Realismus in Deutschland, 1800–50*, National Museum, Nürnberg, 1967 (287), reproduced in catalogue. Apparently the portrait lithographed by R. J. Lane (similarly signed and dated) (example in NPG). Another unsigned and undated version is in the Royal Collection (plate 8), exhibited *Kings and Queens*, RA, 1953 (269), reproduced in illustrated souvenir. A copy of the type by W. Corden is also in the Royal Collection, exhibited *SKM*, 1868 (328).

1849 Engraving by T. Hodgetts, after R. Rothwell, published 1849 (example in British Museum).

Undated Enamel miniature called Adelaide by J. Lee. Collection of the Earl of Mayo, 1918.
Reproduced *Connoisseur*, L (1918), 33.

Undated Two miniatures by S. Raven and H. Edridge. Exhibited *Royal House of Guelph*, New Gallery, 1891 (989, 1032), lent by J. Whitehead.

Undated Stone medallion by Sir F. Chantrey. Ashmolean Museum, Oxford.

Undated Stone statue by an unknown sculptor. Houses of Parliament.

Undated Bust by G. Boul. Royal Collection, Frogmore.

ADEY *Rev Edward*

Slavery abolitionist.

599 See *Groups:* 'The Anti-Slavery Society Convention, 1840' by B. R. Haydon, p 538.

AGLIONBY *Henry Aglionby (1790–1854)*

MP for Cockermouth.

54 See *Groups:* 'The House of Commons, 1833' by Sir G. Hayter, p 526.

AGNEW *Sir Andrew, Bart (1793–1849)*

MP for Wigtownshire.

54 See *Groups:* 'The House of Commons, 1833' by Sir G. Hayter, p 526.

AIKIN *Arthur (1773–1854)*

Chemist; son of the writer, John Aikin (1747–1822); a pioneer of the Geological Society, 1807; treasurer of the Chemical Society, 1841; published a dictionary and manuals of mineralogy and chemistry, and other works.

2515 (9) Pencil and black chalk, with touches of Chinese white, on brown-tinted paper, $15\frac{1}{2} \times 10\frac{7}{8}$ inches (39·4 × 27·6 cm), by WILLIAM BROCKEDON, 1826. PLATE 11

Dated (lower left): 20 I. 26

Collections: See *Collections:* 'Drawings of Prominent People, 1823–49' by W. Brockedon, p 554.

Accompanied in the Brockedon Album by a letter from the sitter dated 7 January 1834.

ICONOGRAPHY The only other recorded likenesses of Aikin are, an engraving by J. Thomson, after S. Drummond, published J. Asperne, 1819 (example in British Museum), for the *European Magazine*, and a lithograph by S. Holden, after a silhouette by G. Kendrick, listed by F. Johnson, *Catalogue of Engraved Norfolk and Norwich Portraits* (1911), p 2.

AILESBURY *Ernest Augustus Charles Brudenell-Bruce, 3rd Marquess of (1811–86)*

MP for Marlborough.

54 See *Groups:* 'The House of Commons, 1833' by Sir G. Hayter, p 526.

AINSWORTH *William Harrison (1805–82)*

Novelist; began his career as a solicitor; later a publisher; first novel, *Rockwood*, an immediate success, 1834; wrote thirty-nine novels, chiefly historical and romantic; edited or owned several magazines.

3655 Oil on canvas, 36 × 27¾ inches (91·5 × 70·5 cm), by DANIEL MACLISE, *c* 1834. PLATE 12

Collections: The sitter; by descent to his grandson, Captain Swanson, and presented by his wife, Mrs Crocker Fox (who married again), 1949.

Exhibitions: Daniel Maclise, Arts Council at the NPG, 1972 (58).

Literature: S. M. Ellis, *William Harrison Ainsworth and his Friends* (1911), I, 314, II, 226, reproduced as frontispiece (engraved by Edwards); *Connoisseur*, CXXV (May 1950), 121, reproduced.

The head in this portrait is very close to that in Maclise's engraving of Ainsworth, published *Fraser's Magazine*, X (July 1834), facing 48, as no. 50 of his 'Gallery of Illustrious Literary Characters', so it presumably dates from 1834 or earlier. The NPG portrait was engraved by W. C. Edwards for the frontispiece of the fourth edition of Ainsworth's novel, *Rockwood* (1836), and again by S. Freeman, published H. Colburn, 1843 (example in NPG). According to Ellis, Maclise first met Ainsworth in 1827 through Crofton Croker, soon after the painter's arrival in England from Cork. Other paintings and drawings by Maclise are listed below:

1 *1827.* Drawing. Victoria and Albert Museum. Reproduced S. M. Ellis, I, facing 118.
2 *1827.* Drawing. Reproduced S. M. Ellis, I, facing 188, when in the collection of Captain Swanson.
3 *c 1834.* Painting (unfinished). Walker Art Gallery, Liverpool. Presumably the portrait in the Maclise Sale, Christie's, 24 June 1870 (lot 186). Exhibited *Charles Dickens*, Victoria and Albert Museum, 1970 (P1), and *Daniel Maclise*, Arts Council at the NPG, 1972 (57). It is similar in style to the NPG portrait, and shows the sitter at much the same age.
4 *1835.* Drawing of 'The Fraserians'. Victoria and Albert Museum. Published as an engraving in *Fraser's Magazine*, XI (1835), between 2 and 3. Another related drawing is also in the Victoria and Albert Museum.
5 *c 1844.* Painting. Exhibited *RA*, 1844 (9). Engraved by E. Finden, published 1844 (example in NPG), for *Ainsworth's Magazine*. Sotheby's (Belgravia), 20 June 1972 (lot 9).
6 *Undated.* Water-colour. Collection of A. Hallam Murray, 1931.

Description: Florid complexion, red cheeks, blue-green eyes, brown hair. Dressed in a dark green stock, white shirt, brown waistcoat, dark green coat. Background colour brown.

ICONOGRAPHY A painting by H. W. Pickersgill is at Chetham's Hospital and Library, Manchester (now cut down), exhibited *RA*, 1841 (10), reproduced S. M. Ellis, *William Harrison Ainsworth and his Friends*, I, facing 416; a painting called Ainsworth by J. E. Williams of 1862 was in the collection of W. Oraz, 1935; a drawing by Count A. D'Orsay is in the collection of Ray Murphy, ex-Phillipps collection, Sotheby's, 13 February 1950 (lot 215), lithographed by R. J. Lane (example in NPG), presumably the drawing engraved for *Ainsworth's Magazine*, VII (1845), frontispiece; a drawing and a woodcut by G. Cruikshank are in the British Museum; a miniature by S. J. Stump (as a young man) was in the collection of Captain Swanson, reproduced Ellis, I, frontispiece; a miniature by F. Freeman of 1826 (painted at Bath) is reproduced Ellis, I, facing 98; Ainsworth appears in 'Our Library Table', etching by G. Cruikshank, published *Ainsworth's Magazine*, I (1842), 115, 186 and 256, reproduced Ellis, II, facing 16; and in 'Sir Lionel Flamstead and his Friends', etching by G. Cruikshank (example in Victoria and Albert Museum); an engraving by R. J. Lane, after W. Greatbach, was published R. Bentley, 1839 (example in British Museum), reproduced Ellis, I, facing 350. There are a few photographs in the NPG.

ALBERT *Francis Charles Augustus Emmanuel, Prince Consort of England* (*1819–61*)

Second son of Ernest, Duke of Saxe-Coburg-Gotha; married his cousin, Queen Victoria, 1840; played an influential role in public life; noted as a patron of the arts; largely responsible for the Great Exhibition of 1851.

237 Oil on canvas, 95 × 61¾ inches (241·3 × 156·8 cm), by FRANCIS XAVIER WINTERHALTER, 1867, after his portrait of 1859. PLATE 18 & frontispiece to volume 2.

Signed and dated (*bottom left*): Fr Winterhalter/1867

Collections: Commissioned by Queen Victoria, and presented by her, 1867.

This is a full-size replica of Winterhalter's last portrait of Prince Albert, painted in 1859, and now in the Royal Collection; the latter was exhibited *VE*, 1892 (57), reproduced Marquis of Lorne, *VRI: her Life and Empire* (1901), p 121, engraved by S. Bellin and lithographed by J. Vinter (examples in NPG). The Prince Consort is shown in the uniform of the Rifle Brigade, with the star and ribbon of the Garter; behind him are the robes of the Bath, and on the table the chain and star of the same order, with a field-marshal's baton.

Queen Victoria decided to commission the NPG replica after discreet enquiries from the NPG trustees, who were anxious to represent Prince Albert in the collection. In a letter of 6 July 1866, Queen Victoria's private secretary wrote (NPG archives): '*I have received the Queen's Commands to say that Mr Winterhalter has consented to produce a Replica of his last portrait of His Royal Highness*'. He wrote again on 3 April 1867, forwarding the completed replica, '*and I am to signify that Her Majesty has great pleasure in presenting the Institution with a likeness, the accuracy and execution of which have given the Queen much satisfaction.*'

Description: Pale blue(?) eyes, brown hair and whiskers. Dressed in a dark green uniform, with black sword belt, silver decorations, and blue sash. Scarlet and white robes behind. Boule table at right with books and papers. Gilded stool at left with green covering, and a helmet on top. Greenish landscape, blue sky beyond. Floor brownish; background colour greenish-grey.

1199 Plaster cast, painted cream, 29 inches (73·7 cm) high, of a bust by GEORGE GAMMON ADAMS. PLATE 20

Incised on the back: G G. Adams Sc.

Collections: The artist, purchased from his widow, 1899.

Albert is wearing the star and ribbon of the Garter. From the apparent age of the sitter, this bust must have been executed in the last decade of Albert's life, or even posthumously, possibly as one of a popular edition. No marble bust of Albert is known, and besides a medallion exhibited *RA*, 1848 (1315), the NPG bust is Adams' only recorded likeness of the Prince Consort. This bust was purchased at the same time as several other plaster casts of famous 19th century figures, and a marble bust of Sir William Napier (NPG 1197).

1736 Plaster cast, now painted black, 31¼ inches (79·4 cm) high, of a bust by JOHN FRANCIS, 1844. PLATE 16

Incised (*below shoulder*): Albertus Dux Saxonae 1844

Collections: Dr Seymour; Mr Cowland; J. A. Cowland, presented by him, 1914.

Literature: R. Gunnis, *Dictionary of British Sculptors* (1953), p 158.

This cast is closely related to the marble bust of Albert by Francis, now in the Guildhall Art Gallery, which was exhibited *RA*, 1844 (1265). Cowland also owned a plaster bust of Queen Victoria, related to the marble bust by Chantrey in the Royal Collection. Cowland thought that the bust of Albert was also by Chantrey, and wrote on 16 June 1914 (NPG archives):

I understand that my father had them from a Dr Seymour or his widow – that Dr Seymour was a well-known physician in the West End and that Sir Francis Chantrey was a friend or patient of his & gave the busts to him. Sir Francis died in Nov. 1842 [sic]. . . . *An old friend staying with us says he remembers the busts in my father's possession in 1855.*

For other portraits by Francis see iconography below. Plate 16 shows the bust before it was painted black.

342,3 See *Groups:* 'The Fine Arts Commissioners, 1846' by J. Partridge, p 545.

ICONOGRAPHY This does not include photographs (see plates 19, 956) caricatures or most popular prints (several examples in the NPG), nor the smaller items in the Royal Collection. Some group portraits in

which the Prince Consort appears are listed, but only those where his face and figure are recognizable, and of importance. The best sources for illustrations of portraits are the Marquis of Lorne, *VRI: Her Life and Empire* (1901), Sir H. Maxwell, *Sixty Years a Queen* (1897), and H. and A. Gernsheim, *Queen Victoria: A Biography in Word and Picture* (1959), referred to below as Lorne, Maxwell and Gernsheim.

c 1823 Engraving by W. Holl, after Döll (example in NPG), for T. Martin, *The Life of his Royal Highness, the Prince Consort* (1879), I, between 4 and 5.

c 1824 Painting by G. E. van Ebart (with his mother and brother). Royal Collection, Windsor.

1828 Photogravure of a portrait by Schneider, after Eckhardt (example in NPG).

1838 Anonymous engraving, after V. Gortz (example in British Museum), reproduced Gernsheim, p 37.

1839 Drawing by L. von Meyern Hohenberg. Royal Society of Arts, London (plate 13).
Engraved by J. Scott, published T. Boys, 1840 (example in British Museum).

1839 Marble bust by E. Wolff. Royal Collection.

1839 Miniature by Sir W. C. Ross (full-face, in brown coat and blue cravat). Royal Collection, Windsor.
Lithographed by R. J. Lane, published Colnaghi and Puckle, 1840, and engraved by H. T. Ryall, published Colnaghi and Puckle, 1840 (examples in NPG).

1840 'The Marriage of Queen Victoria and Prince Albert' by Sir G. Hayter. Royal Collection.
Reproduced Lorne, p 125 (detail). Engraved by C. E. Wagstaff, published H. Graves, 1844 (example in NPG). Pencil and oil studies in the Royal Collection, and the British Museum.

1840 'The Marriage of Queen Victoria and Prince Albert', miniature by Sir W. J. Newton. Exhibited *RA*, 1844 (771), and *VE*, 1892 (424), lent by Mrs Newton.

1840–5 'Windsor Castle in Modern Times' by Sir E. Landseer. Royal Collection, Windsor.
Landseer Exhibitions, RA, 1874 (173), and 1961 (95). Engraved by T. L. Atkinson, published H. Graves, 1851 (example in NPG). Oil study of Queen Victoria and Prince Albert: Royal Collection, *Landseer Exhibition*, 1961 (61), reproduced in catalogue. A crayon study is also in the Royal Collection, probably that engraved by F. Holl, published 1865 (example in British Museum).

1840 Painting by J. Partridge. Royal Collection, Buckingham Palace (plate 14).
Listed in Partridge's 'Sitters Book' (MS, NPG archives), under 1840. Exhibited *RA*, 1841 (188). Engraved by G. T. Doo, published F. Moon, 1844 (example in NPG). There are several later versions.

1840 Miniature by Sir W. C. Ross (half-length, in profile). Royal Collection, Windsor.
Reproduced Lorne, p 127. Engraved by J. Thomson, by H. T. Ryall, published Colnaghi and Puckle, 1841, and by W. Holl, published Smith, Elder & Co, 1867 (examples in NPG).

1840 Etching by himself (example in Royal Collection, Windsor).

1840 Lithograph by J. Erxleben, after a portrait by F. Hanfstaengl, published Colnaghi and Puckle, 1840 (example in NPG).

1840 Engraving by E. Hacker, after H. E. Dawe, published Dawe, 1840 (example in NPG).

c 1840 Painting by G. Patten. Exhibited *RA*, 1840 (173).
Either the portrait engraved by C. E. Wagstaff, published Hodgson and Graves, 1840, or that etched by C. G. Lewis (examples in NPG).

c 1840 Miniature by J. Haslem. Derby Art Gallery.
Reproduced D. Foskett, *British Portrait Miniatures* (1963), plate 182, facing p 176.

c 1840 Engraving by C. Heath and W. H. Egleton, after W. Drummond, published J. and F. Tallis (example in NPG).

1841 'The Christening of the Princess Royal at Buckingham Palace' by C. R. Leslie. Royal Collection, Buckingham Palace. Reproduced Lorne, p 143. Exhibited *VE*, 1892 (84). Engraved by H. T. Ryall,

published F. Moon, 1849 (example in British Museum). Anonymous lithograph, published A. & C. Baily (example in NPG).

1841 Miniature by Sir W. C. Ross (three-quarter length, in evening dress, with orders). Royal Collection, Windsor. Reproduced D. Foskett, *British Portrait Miniatures* (1963), plate 187, between pp 176–7. Exhibited *RA*, 1841 (826), and *British Portrait Miniatures*, Edinburgh, 1965 (355). Engraved by F. Bacon, published Colnaghi and Puckle, 1841, by W. Holl, published P. Jackson, and by H. T. Ryall, published Colnaghi and Puckle, 1841 (examples in NPG and British Museum).

1841 Drawing by S. Diez. Exhibited *RA*, 1842 (574). Lithographed anonymously, published A. & C. Baily, 1841 (example in NPG). A lithograph of Queen Victoria, identical in style and format (example in NPG), is stated to be by E. Desmaisons after S. Diez.

1841 Marble bust by E. H. Baily. Victoria and Albert Museum.
Possibly the unfinished marble bust exhibited *RA*, 1841 (1217).

1841 Engraving by F. W. Topham, published J. Rogerson, 1841 (example in NPG).

1841 Painting by J. Partridge. Commissioned by the Duchess of Kent. Listed in Partridge's 'Sitters Book' (MS, NPG archives), under 1841. Exhibited *RA*, 1842 (171). Probably the half-length portrait in the Royal Collection, similar to the head in the 1840 portrait (see above), but in a different uniform.

c 1841 Cabinet bust by J. Francis. Exhibited *RA*, 1841 (1287).

c 1841 Medal by B. Wyon (from a model by E. H. Baily). Exhibited *RA*, 1841 (1125).

1842 'The Christening of the Prince of Wales' by Sir G. Hayter. Royal Collection, Buckingham Palace. Reproduced Gernsheim, plate 57. Studies are in the Royal Collection, Windsor.

1842 Painting by F. X. Winterhalter. Royal Collection, Windsor. Engraved by A. Louis, published F. Moon, 1848 (example in NPG). Another version is in the Musée de Versailles et des Trianons, and a copy by R. Rowe is in the Examination Schools, Cambridge.

1842 Painting by Sir E. Landseer (Albert and Queen Victoria as Edward III and Queen Philippa for a *bal costumé*). Royal Collection, Buckingham Palace. Exhibited *Landseer Exhibition*, RA, 1961 (94).

1842 Painting by J. Lucas. Musée de Versailles et des Trianons.
Reproduced A. Lucas, *John Lucas* (1910), plate XXXIV, facing p 41. Engraved by S. Cousins and by S. Bellin (example in NPG). Two versions are in the United Service Club, London, and Dublin Castle; a related portrait was in the collection of the Duke of Gotha.

1842 Engraving by J. Carter, after J. F. Herring, published How and Parsons, 1842 (example in NPG). The original oil by Herring of 1841 is in the Brighouse Art Gallery, Yorkshire.

c 1842 Bust by R. Sievier. Royal Collection.
Exhibited *RA*, 1842 (1268).

1843 'Reception of Queen Victoria at the Château d'Eu' by E. Lami. Musée de Versailles.
Reduced water-colour version: Royal Collection, Windsor.

1843 Painting by F. X. Winterhalter (in Garter Robes). Royal Collection, Buckingham Palace.
Reproduced Lorne, p 121. Engraved by T. Atkinson (example in NPG).

1843 Miniature by R. Thorburn (in armour). Royal Collection, Windsor (plate 15).
Engraved by F. Holl, for T. Martin, *The Life of his Royal Highness, the Prince Consort* (1879), I, frontispiece.

c 1843 Medal (?) by W. Bain. Exhibited *RA*, 1843 (1362).

c 1843 Statue by P. J. Chardini (on horseback). Exhibited *RA*, 1843 (1495).

c 1843 Bust by J. Pitts. Exhibited *RA*, 1843 (1377).
A terra-cotta bust by Pitts is at Hughenden Manor.

1844 Marble bust by J. Francis. Guildhall Museum, London.
Exhibited *RA*, 1844 (1265). Plaster cast (NPG 1736 above).

c 1844 Bust by B. Franceschi. Exhibited *RA*, 1844 (1375).

c 1844 Bust by W. Scoular. Exhibited *RA*, 1844 (1372).

1845 Painting by F. X. Winterhalter (full-length, in military uniform). Royal Collection, Balmoral.
Engraved by W. Skelton and J. Hopwood, published Longman, and Goupil, Paris (example in NPG).

c 1845 Miniature by R. Thorburn. Royal Collection, Windsor.
Exhibited *RA*, 1845 (795). Engraved by J. Brown, published 1848 (example in NPG), for the *Art-Union*.

c 1845 'The Christening of the Prince of Wales', miniature by Sir W. J. Newton.
Exhibited *RA*, 1845 (825).

1846 Painting by F. X. Winterhalter (with the Queen and his children). Royal Collection, Buckingham Palace. Reproduced Maxwell, p 49. Engraved by S. Cousins, published T. Boys (example NPG).

1846 Painting by F. X. Winterhalter (full-length, in court dress). Lady Lever Art Gallery, Port Sunlight.

1846 Statue by J. G. Lough. Royal Exchange, London.
A model for this or the 1847 statue (see below) was at Elswick Hall, Newcastle, listed in the *Catalogue of Lough and Noble Models at Elswick Hall* (*c* 1928), p 25 (66).

1846 Marble statue by E. Wolff. Osborne House, Isle of Wight. Reproduced *Country Life*, CXLVI (1969), 905. Replica (in sandals, in place of bare feet): Royal Collection, Buckingham Palace.

1846 'The Fine Arts Commissioners, 1846' by J. Partridge (NPG 342, 3 above).

c 1846 Painting by Sir F. Grant (in uniform, beside a horse). Christ's Hospital, Horsham (plate 17).
Exhibited *RA*, 1846 (199). Oil sketch: Royal Collection, Windsor.

c 1846 Marble bust by J. Pitts. Exhibited *RA*, 1846 (1425).

1847 Statue by J. G. Lough. Lloyd's, London.

1849 Marble bust by Baron C. Marochetti. Royal Collection, Windsor.
Possibly the bust exhibited *RA*, 1851 (1253).

c 1849 Painting by F. R. Say (in court dress). Examination Schools, Cambridge.
Exhibited *RA*, 1849 (73). Engraved by W. H. Mote, published D. Bogue, 1851 (example in NPG).

1850 'Royal Sports on Hill and Loch, 1850' by Sir E. Landseer. Royal Collection.
Exhibited *RA*, 1854 (63). Engraved by W. H. Simmons, published H. Graves, 1874 (example in British Museum), engraving reproduced Maxwell, p 79. A study, entitled 'Queen Victoria landing at Loch Muich', is in the Royal Collection, exhibited *Landseer Exhibition*, RA, 1961 (16), reproduced in catalogue.

1850 Marble bust by J. Francis (with Queen Victoria). Geological Museum, London.

1851 'The First of May 1851' by F. X. Winterhalter. Royal Collection, Windsor.
Reproduced Gernsheim, plate 103. Engraved by S. Cousins (example in NPG).

1851 'Royal Opening of the Great Exhibition' by H. C. Selous. Victoria and Albert Museum.
Engraving reproduced Maxwell, p 60.

1851 Water-colour by F. X. Winterhalter (Albert and Victoria dressed as Charles II and Catherine of Braganza for a *bal costumé*). Royal Collection, Windsor.

c 1851 Miniature by R. Thorburn (with his brother, the Duke of Saxe-Coburg and Gotha).
Exhibited *RA*, 1851 (987). Enamel copies: Royal Collection, Windsor.

1851 Lithograph from life by C. Baugniet, published Ackermann, 1851 (example in NPG).

1851 Statue by J. Wyatt (on horseback). Formerly Coliseum, Regent's Park.

1851 Marble bust by J. Francis (with Queen Victoria). Mansion House, London.

1851 Lithograph by T.H.Maguire, published G.Ransome, 1851 (example in NPG), for 'Ipswich Museum Portraits'.

1852 Marble bust by J.Francis (with Queen Victoria). Drapers Hall, London.

1853 'Evening at Balmoral', water-colour by C.Haag. Royal Collection, Balmoral. Reproduced Maxwell, p73. Numerous other water-colours of the Royal Family by Haag are in the Royal Collection.

1854 'On the Heights Near Boulogne, 1854' by F.de Prades (signed and dated 1857). Sotheby's, 3 April 1968 (lot 77). Exhibited *RA*, 1857 (1122).

c1854 Model for a marble bust by J.E.Jones. Exhibited *RA*, 1854 (1367).
A marble bust by Jones of 1854 was offered to the NPG in 1964.

1855 Lithograph by R.J.Lane, after F.X.Winterhalter, published J.Mitchell (example in NPG).

1855 'The Queen Investing Napoleon III with the Order of the Garter' by E.M.Ward. Royal Collection. Exhibited *RA*, 1858 (35), and *VE*, 1892 (78). Reproduced Maxwell, p88.

1855 'The Queen Visiting the Tomb of Napoleon I' by E.M.Ward. Royal Collection. Exhibited *RA*, 1858 (254). Reproduced Maxwell, p91.

1855 'Faraday Lecturing at the Royal Institution' by A.Blaikley. Collection of the Faraday Society. Reproduced R.Appleyard, *A Tribute to Michael Faraday* (1931), facing p34. Anonymous lithograph (example in British Museum); a similar lithograph, coloured in oils by the artist, is in the Hunterian Museum, University of Glasgow (plate 324).

1856 Painting by E.Boutibonne and J.F.Herring (on horseback). Royal Collection, Buckingham Palace. Possibly the painting exhibited *RA*, 1857 (24).

c1856 'The Earl of Cardigan Describing the Charge of the Light Brigade to Prince Albert and his Children' by an unknown artist. Brudenell Collection, Deene Park.

c1858 Painting by J.Phillip (in highland dress). Corporation of Aberdeen. Exhibited *RA*, 1858 (78). Engraved by T.O.Barlow, published D.T.White, 1858 (example in NPG). Probably the engraving reproduced Lorne, p265.

1858 'The Marriage of the Princess Royal' by J.Phillip. Royal Collection, Buckingham Palace. Exhibited *RA*, 1860 (58). Reproduced Gernsheim, plate 156. Engraved by A.Blanchard, published Gambart, 1865 (example in British Museum).

1859 Painting by F.X.Winterhalter. Royal Collection, Buckingham Palace. Engraved by S.Bellin and lithographed by J.Vinter (examples in NPG). Replica (NPG 237 above).

1859 Painting by W.Boxall (as Master of Trinity House). Trinity House, London. Exhibited *RA*, 1859 (81).

1859 'Queen Victoria at a Military Review in Aldershot' by G.H.Thomas. Royal Collection. Exhibited *RA*, 1866 (212). Anonymous engraving reproduced Gernsheim, plate 170. Water-colour study: Christie's, 14 November 1967 (lot 166).

1859 Marble bust by M.Noble. City Hall, Manchester. Model exhibited *RA*, 1858 (1162).

1859 Bust by W.Theed. Royal Collection. Exhibited *RA*, 1859 (1231).

1860 Bust by W.Theed. Grocers Company, London.

1860 Marble bust by J.Thomas. Midland Institute, Birmingham. Exhibited *RA*, 1860 (946).

1860 Medallion by Miss S.Durant. Royal Collection, Windsor. Medallions in plaster and in ormolu in NPG.

1861 'The Last Minutes of the Prince Consort' by an unknown artist. Wellcome Institute of the History of

Medicine, London. Lithographed by W. L. Walton (example in Wellcome Institute); a key to the picture, done when it was disposed of by raffle, is in the NPG. A variant version is reproduced R. Awde, *Waiting at Table. Poems and Songs* (1865), frontispiece.

1861 Marble bust by W. Theed. Royal Society of Arts, London.
Probably based on a death-mask by Theed.

c 1862 Painting by J. G. Middleton (as colonel of Hon Artillery Company). Hon Artillery Company.
Exhibited *RA*, 1862 (74).

1862 Marble statue by W. Theed. Osborne House, Isle of Wight.
A marble bust by Theed of 1862 is in the Royal Collection, exhibited *Death and the Victorians*, Brighton Art Gallery, 1970 (addenda), and possibly *RA*, 1862 (992). Another slightly different bust of 1862 by Theed is also in the Royal Collection.

1862 Bust by J. Durham. Guildhall Museum, London (destroyed 1940).
Biscuit porcelain copy, Christie's, 15 June 1961 (lot 20).

c1862 Painting by J. C. Horsley. Royal Society of Arts, London.

1863 Statue by J. E. Thomas. Tenby.

1863 Statues by J. Durham. (1) Albert Hall, London. (2) Guernsey.

1863 Statue by W. Theed (in highland dress). Royal Collection, Balmoral.
Reproduced as a woodcut *ILN*, XLV (1864), 216. Model exhibited *RA*, 1864 (867). A related bronze statuette of 1863 is at Osborne House.

1863 Statue by T. Earle. Licensed Victuallers Asylum, London.
Another statue by Earle of 1864 is apparently in the Old Kent Road, London.

1864 Statue by T. Thornycroft (on horseback). Halifax.
Model exhibited *RA*, 1863 (1011).

1864 Statue by W. Brodie. Perth.

1864 Statue by T. Woolner. University Museum, Oxford.

1864 Effigy by Baron C. Marochetti. Royal Mausoleum, Frogmore.
Reproduced Gernsheim, plate 209.

c1864 Design for a memorial by F. P. Cockerell. Exhibited *RA*, 1864 (796).

1865 Statues by M. Noble. (1) Peel Park, Salford. (2) Manchester. (3) Leeds.
The plaster cast of the Peel Park statue, together with another plaster bust or statue, was formerly at Elswick Hall, Newcastle; see *Catalogue of Lough and Noble Models at Elswick Hall* (*c* 1928), pp 50, 51 (167, 174).

1865 Statue by W. Theed. Coburg.
Statue by W. Blashfield, from Theed's model: Royal Albert Infirmary, Bishop's Waltham.

1865 Statue by J. Durham. Agricultural College, Framlingham.
Model exhibited *RA*, 1865 (897).

1866 Statue by W. Theed (copy of his Coburg statue of 1865). Sydney, Australia.

1866 Bronze statue by T. Thornycroft (on horseback). Liverpool.

1866 Statue by T. Thornycroft. Wolverhampton.

1866 Statue by W. Theed. Surrey County Hospital.

1867 Statue by J. H. Foley. Council House, Birmingham.

1868 Marble statue by W. Theed (with Queen Victoria, as Ancient Saxons). Royal Collection, Windsor.
Reproduced Maxwell, p 120. Plaster cast: Royal Collection, on loan to NPG.

1868 Statue by J. H. Foley. Dublin.

1868 Statue by E.B. Stephens. Art Gallery, Exeter.

c1868 Wax by A. Heness. Exhibited *RA*, 1868 (1061).

1870 Statue by M. Noble. Bombay.
 Reproduced as a woodcut *ILN*, LVII (1870), 552.

c1871 Marble bust (of Albert as a child) by Miss C.A. Fellows. Exhibited *RA*, 1871 (1330).

1874 Statue by J.H. Foley. Cambridge.
 Exhibited *RA*, 1875 (1330). Reproduced as a woodcut *ILN*, LXXII (1878), 52.

1874 Statue by C. Bacon (on horseback). Holborn Circus, London.
 Reproduced as a woodcut *ILN*, LXIV (1874), 37.

1874–6 Statue by J.H. Foley. Albert Memorial, London.
 Reproduced *Architectural Review*, CXXXV (June 1964), 425.

1876 Statue by Sir J. Steell (on horseback). Charlotte Square, Edinburgh.
 Reproduced as a woodcut *ILN*, LXIX (1876), 192.

1877 Marble bust by Sir J. Steell. Royal Collection.

Undated Water-colour by F.X. Winterhalter. Collection of the Earl of Harewood.

Undated Memorial in St George's Chapel, Windsor.

Undated Statue by A. Drury. Victoria and Albert Museum (facade).

Undated Marble bust by J. Adams-Acton. City of Bradford Art Gallery.

Undated Plaster medallion by T. Butler. Royal College of Physicians, London.

Undated Medal by J. Ottley (example in NPG).

Undated Bust by H. Weekes. Collection of Mlle Mathys, Brussels, 1935.

Undated Engraving by H. Robinson, after W. Drummond (example in NPG).

ALDINI *Giovanni* (*1762–1834*)
 Italian experimental philosopher, and author.

2515 (19) See *Collections:* 'Drawings of Prominent People, 1823–49' by W. Brockedon, p 554.

ALEXANDER *George William* (*1802–90*)
 Treasurer of the British and Foreign Anti-Slavery Society.

599 See *Groups:* 'The Anti-Slavery Society Convention, 1840' by B.R. Haydon, p 538.

ALLEN *Joshua William Allen, 6th Viscount* (*1781–1845*)
 Soldier.

4026 (1,2) See *Collections:* 'Drawings of Men About Town, 1832–48' by Count A. D'Orsay, p 557.

ALLEN *Richard* (*1787–1873*)
 Slavery abolitionist.

599 See *Groups:* 'The Anti-Slavery Society Convention, 1840' by B.R. Haydon, p 538.

ALLEN *Stafford* (*1806–89*)
 Slavery abolitionist.

599 See *Groups:* 'The Anti-Slavery Society Convention, 1840' by B.R. Haydon, p 538.

ALLEN *William* (*1770–1843*)
Quaker, scientist, philanthropist and slavery abolitionist.
599 See *Groups:* 'The Anti-Slavery Society Convention, 1840' by B.R.Haydon, p 538.

ALLEN *William* (*1793–1864*)
Naval officer and explorer; took part in Niger expeditions of 1832, and 1841–2; published books of travel.
2515 (68) Black and red chalk, with touches of Chinese white, on green-tinted paper, $13\frac{7}{8} \times 10\frac{3}{8}$ inches ($35\cdot2 \times 26\cdot3$ cm), by WILLIAM BROCKEDON, 1834. PLATE 21

Dated (lower left): 13-6.34

Collections: See *Collections:* 'Drawings of Prominent People, 1823–49' by W. Brockedon, p 554.

Accompanied in the Brockedon Album by a letter postmarked 30 May 1834 from the sitter. The only other recorded portrait of Allen is the drawing by W. Barclay, engraved by G. Cook, published R. Bentley, 1848 (example in NPG), as the frontispiece to Allen's *Narrative of the expedition to the Niger in 1841.*

ANGLESEY *Henry William Paget, 1st Marquess of* (*1768–1854*)
Lord Lieutenant of Ireland.
54 See *Groups:* 'The House of Commons, 1833' by Sir G. Hayter, p 526.
See also forthcoming Catalogue of Portraits, 1790–1830.

ANSON *Sir George* (*1769–1849*)
MP for Lichfield.
54 See *Groups:* 'The House of Commons, 1833' by Sir G. Hayter, p 526.

ANSON *George* (*1797–1857*)
MP for Great Yarmouth.
54 See *Groups:* 'The House of Commons, 1833' by Sir G. Hayter, p 526.
See also forthcoming Catalogue of Portraits, 1790–1830.

ARBUTHNOT *Hugh* (*1780–1868*)
MP for Kincardine.
54 See *Groups:* 'The House of Commons, 1833' by Sir G. Hayter, p 526.

ARGYLL *George Douglas Campbell, 8th Duke of* (*1823–1900*)
Liberal statesman.
1125 See *Groups:* 'The Coalition Ministry, 1854' by Sir J. Gilbert, p 550.
See also forthcoming Catalogue of Portraits, 1860–90.

ARNOLD *Thomas* (*1795–1842*)
Headmaster of Rugby; a moralist, and an important educational theorist; his reforms at Rugby provided a pattern for public schools, and influenced the whole course of 19th century education; author of several widely read pamphlets, sermons and books.
1998 Oil on canvas, 48×39 inches (122×99 cm), by THOMAS PHILLIPS, 1839. PLATE 22

Collections: The sitter; Matthew Arnold; by descent to his daughters, Lady Sandhurst and Mrs Whitridge, and presented by them, 1923.[1]

Exhibitions: RA, 1839 (61); *SKM,* 1868 (511); *VE,* 1892 (221).

Literature: T. Phillips, 'Sitters Book' (copy of original MS, NPG archives), under the year 1839.

This is the only important oil portrait of Arnold in existence. It was engraved by H. Cousins, published J. Ryman, Oxford, 1840 (example in NPG). A half-length copy of the portrait is at Oriel College, Oxford; this copy was engraved by B. Holl, published B. Fellowes, for A. P. Stanley, *The Life and Correspondence of Thomas Arnold* (1844), I, frontispiece. Another copy by T. Aldridge is at Rugby School. The NPG portrait was slightly cut down when it entered the collection (its original measurements were 56 × 44 inches (142·2 × 111·8 cm)). It is mentioned in 'Mrs Arnold's Record' for February 1839, a diary kept by Mrs Arnold for the benefit of her children:

We left Westmoreland, and were for a few days in London, that your Father might sit to Phillips for that admirable portrait which is now in our Rugby dining room, and which will be a precious possession amongst you as long as you live. His longest sitting was on the 8th [of February] which will be a well remembered day by me from the number of friends who found us there, and with them there was so much to say that poor Phillips had to beg for more quiet. Mr Bunsen was there, with Niebuhr's letters in his hand, reading passages with all the earnestness of his earnest nature. Then there was our original friend Crabbe Robinson – and the Stanleys. . . . Phillips was very anxious about his picture, and so impressed with the love of his art and the desire to give and catch real character and not merely a likeness, that I felt to respect him as an artist – besides his being an intelligent and estimable man as far as we saw of him.[2]

Description: Brown eyes and dark brown hair. Dressed in white shirt, white bands, black and red academic robes. Seated in a wooden chair with red covering, holding an open book on his lap. Dark green curtain behind covering most of the background.

168 Marble bust, 30 inches (76·2 cm) high, by WILLIAM BEHNES, 1849. PLATE 23

Incised (underneath shoulder): BEHNES/SCULPT/1849

Collections: James Lee, Bishop of Manchester, presented by him, 1864.

Literature: R. Gunnis, *Dictionary of British Sculptors* (1953), p47.

In a letter from the donor, dated 17 February 1864 (NPG archives), to Earl Stanhope, chairman of the NPG trustees, Bishop Lee thanked him for the honour of accepting the bust, and went on to say that he would send a short account of the bust in a few days. This account was either not sent, or has not survived. The bust was executed posthumously. James Lee had been a master at Rugby under Dr Arnold from 1830 to 1838, and the latter spoke highly of his ability and powers.

ICONOGRAPHY A painting by an unknown artist, and drawings by Lydia Penrose and Jane Arnold, are reproduced N. G. Wymer, *Dr Arnold of Rugby* (1953), facing pp 74, 33 and 161; a miniature by A. Tidey was exhibited *RA,* 1836 (849), listed by Dr S. Tidey, 'List of Miniatures by Alfred Tidey' (typescript, 1924, Victoria and Albert Museum Library), p8, under 1836, where other Arnold family miniatures are also listed; a bust by A. Gilbert and a recumbent effigy by J. Thomas are at Rugby School.

ARUNDELL *Francis Vyvyan Jago* (*1780–1846*)

Antiquary and traveller; chaplain to British factory at Smyrna, 1822–36; journeyed in Asia Minor, 1826–35; published descriptions of his travels and discoveries, 1834; collected antiquities, coins and manuscripts.

[1] There are several letters relating to the portrait and its presentation (NPG archives). It was first offered to the NPG in 1908.

[2] Communicated to the NPG by Mr Humphrey Ward, 1923, from unpublished Arnold family papers.

2515 (36) Black chalk, with touches of Chinese white, on brown-tinted paper, $14\frac{3}{4} \times 10\frac{7}{8}$ inches (37.5×27.6 cm), by WILLIAM BROCKEDON, 1829. PLATE 24

Dated (lower left): 9.6.29

Collections: See *Collections:* 'Drawings of Prominent People, 1823–49' by W. Brockedon, p 554.

Accompanied in the Brockedon Album by a letter from the sitter dated 29 May, and postmarked 1828. This is the only recorded portrait of the sitter.

ASHBURTON *Alexander Baring, 1st Baron (1774–1848)*

Financier, connoisseur, and MP for Essex North.

54 See *Groups:* 'The House of Commons, 1833' by Sir G. Hayter, p 526.

342,3 See *Groups:* 'The Fine Arts Commissioners, 1846' by J. Partridge, p 545.

ASHBURTON *William Bingham Baring, 2nd Baron (1799–1864)*

MP for Winchester.

54 See *Groups:* 'The House of Commons, 1833' by Sir G. Hayter, p 526.

ASHLEY-COOPER *Anthony Henry (1807–58)*

MP for Dorchester.

54 See *Groups:* 'The House of Commons, 1833' by Sir G. Hayter, p 526.

ATKINSON *James (1780–1852)*

Persian scholar and amateur artist; trained as a doctor, he occupied a number of posts in India, and elsewhere in the East; published translations from Persian.

930 Oil on millboard, $9 \times 7\frac{1}{4}$ inches (22.8×18.4 cm), by HIMSELF, *c* 1845. PLATE 25

Collections: Presented by the sitter's son, Canon J. A. Atkinson, 1892.

According to the donor, the portrait was a good likeness of his father. Atkinson is shown in the uniform of a Bengal army surgeon, with a medal for the siege of Ghuznee (1st Afghan war), and the star of the order of the Doranee Empire; this last order was instituted by Shah Shooja of Afghanistan after the 1st Afghan war; Atkinson was permitted to wear the insignia of the third class in 1841 (see *London Gazette*, 17 December 1841). Information on the uniform and orders kindly communicated by Mr Farrington of the India Office Library, London. Canon Atkinson presented several other drawings of Indian officers and officials by his father.

Description: Fresh complexion, dark blue eyes, mainly grey hair and whiskers. Red uniform with gold-braided collar and epaulettes. Dark background colour.

ICONOGRAPHY The only other known portrait of Atkinson is a miniature by Mrs Maria Bellett Browne, a pupil of George Chinnery, painted when he was a young man, which is now in the Scottish NPG, presented by Canon Atkinson, 1893.

ATTWOOD *Thomas (1783–1856)*

Political reformer, and MP for Birmingham.

54 See *Groups:* 'The House of Commons, 1833' by Sir G. Hayter, p 526.

AUSTIN *Sir Horatio Thomas* (*1801–65*)

Admiral and explorer; commanded HMS RESOLUTE in the search for Sir John Franklin, 1850–1.

1218 Oil on canvas, $15\frac{3}{8} \times 12\frac{3}{4}$ inches (39 × 32·5 cm), by STEPHEN PEARCE, 1860. PLATE 26

Collections: See *Collections:* 'Arctic Explorers' by S. Pearce, p 562.

Exhibitions: R A, 1861 (71); *Royal Naval Exhibition*, Chelsea, 1891 (41).

Literature: S. Pearce, *Memories of the Past* (1903), pp 71–2.

Pearce records that he painted Austin in 1860. Austin is wearing the undress uniform of a rear-admiral (1856 pattern), with (from left to right), the order of the Bath (CB), the Naval General Service Medal (1793–1840) with two bars, the Arctic Medal (1818–55), and the Sultan's Medal for Syria (1840). The order round his neck has not been identified.

Description: Healthy complexion, bluish eyes, grey hair and whiskers. Dressed in a dark necktie, white shirt and waistcoat, and a dark blue naval uniform with gold buttons and epaulettes, silver order round his neck with blue and red ribbon, white enamel star, silver and gold medals with multi-coloured ribbons. Background colour dark brownish-grey.

AUSTIN *Sarah* (*1793–1867*)

Translator; *née* Taylor; wife of John Austin (1790–1859), the jurist; translated from German and French and edited several works, chiefly historical.

598 Oil on panel, $7\frac{1}{8} \times 5\frac{5}{8}$ inches (18·1 × 14·3 cm), by LADY ARTHUR RUSSELL, *c* 1867. PLATE 28

Collections: The artist, presented by her, 1879.[1]

In a letter of 12 June 1879 (NPG archives), Lady Arthur Russell offered this portrait to the NPG, stating that it had been painted about twelve years before, and that it was authentic, but not disclosing the fact that she was the artist. On 2 August Scharf replied to her husband, saying that doubt had been cast on the likeness by several of the NPG trustees, and that he must know the name of the artist, adding:

I miss however the grey tint round the mouth, and a piercing look about the eyes when I knew her. Here the person represented appears to be an invalid, & has different colured hair from that which I remember.[1]

On 5 August Lord Arthur Russell replied:

When Lady Arthur gave you her portrait of Mrs Austin she did not tell you that she had painted it as she was very anxious that you should not be in the least fettered in your decision.
The picture was painted from life a short time before Mrs Austin's death when she was very unwell. She was then on a visit to my mother-in-law in the country in France. She then still wore her hair dyed auburn, perhaps you remember her a little later when she showed her grey hair.
The portrait is exceedingly like to my mind, and was thought so by all who saw it at the time & that is the only reason why Lady Arthur thought of offering it to you.
She sincerely hopes you will make no scruple about returning it, if the Trustees feel doubts about accepting it, and she is flattered by your personal opinion of the painting.[1]

Description: Healthy complexion, dark blue eyes, brown hair. Dressed in white/grey head-scarf, dark brown dress. Seated in chair with subdued scarlet covering. Dark brown background.

672 Chalk and pencil on brown, discoloured paper, $20\frac{1}{2} \times 16\frac{3}{8}$ inches (51·5 × 41·6 cm), by JOHN LINNELL, 1834. PLATE 27

[1] Letters from the artist, her husband, the sitter's nephew, Henry Reeve, and G. Scharf, relating to the portrait and its presentation (NPG archives).

Signed and dated (lower left): J. Linnell 1834

Collections: Mrs Austin; by descent to her granddaughter, Mrs Janet Ross, and presented by her, 1883.[1]

In the past this drawing has been dated 1839, due to a misreading of the inscribed date. It is presumably a study for the 1834 oil portrait of Mrs Austin, commissioned from Linnell by Lord Jeffrey, and exhibited *RA*, 1835 (172).[2] Another small oil portrait on panel, painted in 1840,[2] was sold at Sotheby's, 18 October 1950 (lot 152), from the collection of Mrs T. H. Riches. It was exhibited *Exhibition of Works by Old Masters, RA*, 1883 (105), and *VE*, 1892 (130), lent by the Linnell family.

ICONOGRAPHY The only other recorded likeness of Sarah Austin is a painting by H. P. Briggs, exhibited *RA*, 1835 (20), lithographed by W. Taylor, published 1835 (example in NPG).

AVELAND *Gilbert John Heathcote, 1st Baron (1795–1867)*

MP for Lincolnshire.

54 See *Groups:* 'The House of Commons, 1833' by Sir G. Hayter, p 526.

AVERY *John (1807–55)*

Surgeon and inventor; worked with the ambulance service of the Polish Army, early 1830s; invented an apparatus for exploring the passages of the body; developed an operation for cleft palate.

1893 Miniature, water-colour, body colour and varnish on ivory, $8 \times 5\frac{3}{4}$ inches ($20 \cdot 3 \times 14 \cdot 6$ cm), attributed to HENRY COLLEN. PLATE 29

Collections: The sitter; by descent to Macleod Yearsley (a distant cousin), and presented by him, 1921.

Avery is shown in an interior, pointing to his famous apparatus. The traditional attribution to Collen seems valid. This is the only recorded likeness of Avery.

Description: Healthy complexion, blue eyes, dark brown hair and whiskers. Dressed in green stock, white shirt, dark grey coat and waistcoat, gold chain, brown trousers. Metal apparatus on mahogany table with dark leather covering. Leather-bound books in background. Dark red curtain at right.

AYTOUN *William Edmondstoune (1813–65)*

Poet; called to Scottish bar, 1840; joined staff of *Blackwood's Magazine*, 1844; professor of rhetoric and *belles-lettres*, Edinburgh, 1845; published poems and ballads by himself and others.

1544 Plaster cast, painted black, $32\frac{1}{2}$ inches ($82 \cdot 5$ cm) high, of a bust by PATRIC PARK, *c* 1851. PLATE 30

Collections: The sitter; by descent to Andrew Kay, and presented by him, 1909.

Exhibitions: Royal Scottish Academy, 1851 (657), according to F. Rinder, *The Royal Scottish Academy* (1917), p 300.

In a letter of 7 October 1909 (NPG archives), Kay quotes from a letter to himself from Colonel Aytoun, the sitter's son, who says of the NPG bust:

I never saw it, but presume it was a replica of the bust here. This is the original by Patrick [sic] *Park from which the marble busts now in the National Portrait Gallery* [Scottish] *and University here* [Edinburgh] *were copied by Rhind the sculptor.*

[1] Two letters from Mrs Ross about the portrait and its presentation (NPG archives).

[2] See A. T. Story, *The Life of John Linnell* (1891), II, 250. The 1840 portrait is reproduced I, facing 296.

The present location of the bust owned by Colonel Aytoun is not known. The marble copies by John Rhind are still at the University of Edinburgh (presented by the Misses Aytoun, 1887), and the Scottish NPG (presented by the Misses Aytoun, 1890). A plaster bust owned by Blackwood's of Edinburgh was exhibited *Scottish National Portraits*, Edinburgh, 1884 (579), presumably another cast like the NPG bust.

ICONOGRAPHY A water-colour by J. Archer of 1855 is in the Scottish NPG; a miniature by R. Thorburn was in the collection of the Misses Aytoun, exhibited *Scottish National Portraits*, Edinburgh, 1884 (637); a coloured etching by B. Crombie was published 1847, reprinted B. Crombie, *Modern Athenians* (Edinburgh, 1882), plate 38; there is a photograph by T. Rodger of St Andrews (example in NPG), reproduced as a woodcut *ILN*, XLVII (1865), 161.

BABBAGE *Charles (1792–1871)*

Mathematician; invented calculating machine, to which he devoted much of his life and fortune; Lucasian professor of mathematics, Cambridge, 1828–39; principal founder of Statistical Society, 1834; published several influential scientific works.

414 Oil on canvas, 50 × 40 inches (127 × 101·6 cm), by SAMUEL LAURENCE, 1845. PLATE 31

Inscribed on the stretcher: Samuel Laurence/21 Wigmore St/R.A. . . . [*last part indecipherable*]

Collections: Sir Edward Ryan, bequeathed by him, 1876.

Exhibitions: RA, 1845 (227).

Literature: F. Miles, 'Samuel Laurence' (typescript copy, NPG library).

Two undated letters from Babbage to Laurence in the British Museum concern sittings (British Museum, Add MS 37200, f.406–7). The one headed '21 Wigmore St' probably refers to this portrait, as Babbage only moved to this address in c 1844. The letter headed '36 Charlotte St.' probably refers to the portrait of Babbage by Laurence painted in 1837. This was exhibited *RA* 1837 (366), and *VE* 1892 (296), lent by Mrs Isaacs. On entering the collection, the canvas size of the NPG portrait was reduced by folding part of it under the stretcher, so as to reveal only the head and shoulders. This was done at a time when the NPG was very short of space. It led to an exchange of correspondence between Scharf and Colonel Babbage, the sitter's son, who, under the impression that the picture had been cut down, accused the NPG of mutilating his father's portrait, and even threatened to publish the correspondence between himself and Scharf in the *Athenaeum*. The correspondence only ceased when the portrait was restored to something like its original size in January 1882. In one of his letters, Colonel Babbage wrote (NPG archives):

I always considered the portrait of my father very good not only as regards the face but as regards the figure and the attitude of the body. I think an earlier one by the same artist was superior, but this one is very good. The other was taken to S. Australia by my eldest brother and was unfortunately burnt there with his house – this one is the only other Portrait that I know of, at least in oils.

The picture owned by Colonel Babbage's brother must have been a replica of the 1837 portrait, as the original was still in the possession of Mrs Isaacs in 1892 (see above). Its present location is unknown. Sir Edward Ryan was a friend and contemporary of Babbage at Trinity College, Cambridge, and presumably commissioned this portrait from Laurence.

Description: Brown complexion, brown eyes and hair. Dressed in black stock, white shirt and dark brown coat. Elbow leaning on chair covered in black material. Behind at right table covered in plum red velvet cloth, with a folder and a pair of dividers resting on it. Above table on right is a dark green curtain. General background colour reddish-brown.

2515 (33) Black and red chalk on grey-tinted paper, 14¼ × 10½ inches (36·2 × 26·8 cm), by WILLIAM BROCKEDON, 1840. PLATE 32

Dated (lower left): 12.3.40

Collections: See *Collections:* 'Drawings of Prominent People, 1823–49' by W.Brockedon, p 554.

Accompanied in the Brockedon Album by an undated letter from the sitter.

ICONOGRAPHY A miniature by Sir W. J.Newton was exhibited *RA*, 1851 (954), and *VE*, 1892 (588), lent by the Baroness Burdett-Coutts; an engraving by J.Linnell, after a painting by 'MRS', was published Colnaghi, 1833 (example in NPG).

BACK *Sir George* (*1796–1878*)

Admiral and Arctic navigator; served against French during Napoleonic wars; made several voyages of discovery into the Arctic region; published accounts of his voyages.

2515 (46) Black and red chalk, with touches of Chinese white, on green-tinted paper, 14¼ × 10 inches (36 × 25·4 cm), by WILLIAM BROCKEDON, 1833. PLATE 33

Dated (lower left): 10.1.33

Collections: See *Collections:* 'Drawings of Prominent People, 1823–49' by W.Brockedon, p 554.

Accompanied in the Brockedon Album by a letter from the sitter, dated 1 January(?) 1833. Brockedon later made use of this drawing for his painting of Back, now in the Royal Geographical Society, London.

1208 See *Groups:* 'The Arctic Council, 1851' by S.Pearce, p 548.

ICONOGRAPHY A painting by an unknown artist is in the McCord Museum, McGill University, Canada; a portrait by an unknown artist was exhibited *Royal Naval Exhibition*, Chelsea, 1891 (39); a drawing by R.Woodman was exhibited *RA*, 1829 (965), engraved by E.Finden, published J.Murray, 1828 (example in NPG); a woodcut was published *ILN*, LXXIII (1878), 4; a lithograph by W.D[rummond], was published T.McLean (example in British Museum), for 'Athenaeum Portraits'; a photograph by E.Edwards is reproduced L.Reeve, *Men of Eminence*, III (1865), facing 45.

BAILY *Edward Hodges* (*1788–1867*)

Sculptor; gave up commerce and became a pupil of Flaxman, 1807; executed many well-known groups, statues and busts; elected an RA, 1821.

1456 (1) Pencil and black chalk on paper, 4⅝ × 4¾ inches (11·7 × 12 cm), by CHARLES HUTTON LEAR, *c* 1846. PLATE 34

Inscribed (bottom right): Bailey [*sic*]

Collections: See *Collections:* 'Drawings of Artists, *c* 1845' by C.H.Lear, p 561.

Literature: R.L.Ormond, 'Victorian Student's Secret Portraits', *Country Life*, CXLI (February 1967), 288–9, reproduced.

Baily was a visitor at the life school of the Royal Academy, where this drawing was done, in 1846, so it probably dates from that year.

ICONOGRAPHY A painting by himself is in the collection of T.C.Bates; a painting by Sir W.Beechey was exhibited *RA*, 1829 (301), probably the picture etched by Mrs D.Turner (example in NPG); paintings by T.Mogford were exhibited *RA*, 1843 (131), and 1854 (535); paintings by J.Lonsdale and G.Tuson were

exhibited *RA*, 1828 (91), and 1858 (588); paintings (possibly one and the same) by J.E.Williams were exhibited *RA*, 1863 (693), and *SKM*, 1868 (591); a drawing by T.Bridgford was exhibited *RA*, 1843 (1059), engraved by J.Smyth, published 1847 (example in NPG), for the *Art-Union*; a plaster statue by E.G.Papworth junior, executed for Joseph Neeld MP, of Grittleton Hall, was exhibited *RA*, 1856 (1297); busts by E.G.Papworth junior were exhibited *RA*, 1856 (1331), and 1868 (1127); a bust by J.Dinham was exhibited *RA*, 1826 (1092); a bronze medallion by A.B.Wyon was issued by the Art Union (example in NPG); there are several photographs in the NPG; a woodcut was published *ILN*, L (1867), 569.

BAINES *Sir Edward* (*1800–90*)

Journalist, progressive economist, MP, and slavery abolitionist.

599 See *Groups:* 'The Anti-Slavery Society Convention, 1840' by B.R.Haydon, p 538.

BALDWIN *Edward*

Slavery abolitionist.

599 See *Groups:* 'The Anti-Slavery Society Convention, 1840' by B.R.Haydon, p 538.

BALDWIN *Robert* (*1804–58*)

Canadian statesman; called to bar of Upper Canada, 1825; solicitor-general, and later attorney-general, of Upper Canada; responsible for several reforms and parliamentary resolutions.

1721 Oil on paper, $8\frac{1}{2} \times 6\frac{1}{2}$ inches (21·6 × 16·5 cm), by THOMAS WATERMAN WOOD, 1855. PLATE 35

Signed (*lower left*): T.W.Wood *and dated* (*lower right*): Aug. '55.

Collections: A.G.Ross, presented by him, 1913.

The early history of this picture is unknown.

Description: Ruddy complexion, blue eyes, brown hair with grey streaks. Dressed in a white shirt, white stock, with a jewelled pin, black coat and waistcoat.

ICONOGRAPHY A painting by an unknown artist was in Osgoode Hall, Toronto; a photograph of Baldwin in middle age is reproduced J.G.Bourinot, *Canada* (1895), p 365; there is a marble bust of him in the Assembly Chamber, Ottawa; another photograph is reproduced A.Shortt and C.Doughty, *Canada and its Provinces*, IV (1914), facing 414.

BALFE *Michael William* (*1808–70*)

Musical composer and conductor; first appeared in public as a violinist, 1817; produced his first opera at Palermo, 1830; produced a succession of operas in London, including his very successful 'Bohemian Girl', 1843.

1450 Identity doubtful. Oil on canvas, $44 \times 33\frac{3}{4}$ inches (111·8 × 85·7 cm), attributed to RICHARD ROTHWELL. PLATE 37

Collections: Leggatt Brothers, purchased from them, 1906.

Exhibitions: Great Irishmen, Ulster Museum, Belfast, 1965 (9).

Nothing is known of the history of this picture before it entered the NPG. While the features do not disagree with other known portraits of Balfe, there is no conclusive evidence that this portrait represents him. The attribution of the painting to Rothwell is not very convincing. Rothwell's brushwork tends to be looser and more fluent (he was a pupil of Lawrence), and his treatment of subject more generalized.

Description: Light brown complexion, red lips, pale blue eyes. Dressed in dark green stock, pale green stone as a stock-pin, white shirt, dark brown coat, white and black figured waistcoat, gold chain, greenish-yellow trousers. Sitting in mahogany (?) chair with green velvet material. Piano made of lightish brown wood. Background very dark.

ICONOGRAPHY A painting by an unknown artist, and a marble medallion by L. A. Malempré, are in the Irish Academy of Music, exhibited *Dublin Exhibition*, 1872, 'Portraits' (443 and 269); drawings by D. Maclise of *c* 1844 (plate 36), and by J. Wood are in the Irish NPG, the former exhibited *Daniel Maclise*, Arts Council at the NPG, 1972(45); another drawing by Wood was sold Christie's, 5 February 1889 (lot 58), sketch in NPG sale catalogue; a drawing and a miniature, both by unknown artists, were sold at Christie's, 22 February 1889 (lot 1), bought Hodges, and (lot 37), bought by the sitter's son; a marble bust by Sir T. Farrell is in the Irish NPG, reproduced as a woodcut *ILN*, LXXXIII (1878), 513; a bust by J. E. Jones was exhibited *RA*, 1846 (1508) – 'to be executed in marble'; a marble statue by L. A. Malempré is in the Drury Lane Theatre, exhibited *RA*, 1874 (1506), reproduced as a woodcut *ILN*, LXV (1874), 373; a medallion by an unknown artist is in Westminster Abbey, reproduced W. A. Barrett, *Balfe, his Life and Work* (1882), p 292; a memorial window by Ballantine is in St Patrick's Cathedral, Dublin; there are various lithographs and etchings (examples in NPG, Harvard Theatre Collection, and British Museum); an etching by an unknown artist is reproduced T. Russell, *The Proms* (1949), p 16; a lithograph by Prinzhofer was published C. L. Kenney, *A Memoir of W. M. Balfe* (1875), frontispiece; a woodcut was published *ILN*, III (1843), 124; there is a photograph in the NPG, and woodcuts of others.

BANKES *William John* (*c 1784/8–1855*)

Eastern traveller, MP for Dorset.

54 See *Groups:* 'The House of Commons, 1833' by Sir G. Hayter, p 526.

BANNERMAN *Sir Alexander* (*1788–1864*)

MP for Aberdeen.

54 See *Groups:* 'The House of Commons, 1833' by Sir G. Hayter, p 526.

BANNISTER *Saxe* (*1790–1877*)

Miscellaneous writer, lawyer, and slavery abolitionist.

599 See *Groups:* 'The Anti-Slavery Society Convention, 1840' by B. R. Haydon, p 538.

BARHAM *Richard Harris* (*1788–1845*)

Author of the *Ingoldsby Legends*, 1840; cleric and divinity lecturer.

2922 Pencil on paper, 9½ × 7½ inches (24·2 × 19 cm), by RICHARD JAMES LANE, 1842–3. PLATE 38

Inscribed on a label (only the lower part of the inscription is now visible), formerly on the back of the picture: by Lane RA E[sq]

Collections: The sitter; Mrs Bond, his daughter; Mrs M. B. Platt, his granddaughter, presented by her son, Edward Platt, in accordance with his mother's wishes, 1937.

Exhibitions: S KM, 1868 (586).

Literature: R. J. Lane's 'Letter Books' (NPG archives), I, 99; 'Portraits of the Rev Richard Harris Barham' (single printed sheet of portraits belonging to Mrs Bond, *c* 1895, NPG archives); R. H. Barham, *The Ingoldsby Legends*, edited by Mrs Bond (1894), I, reproduced facing XI.

The date of this drawing is given in the list of Barham's portraits (see above). It was engraved by J. Cook, published 1845 (example in NPG), for *Bentley's Miscellany*, also by W.G. Jackman, published Appleton, New York (example in British Museum), and by J. Brown, published Bentley, 1870 (example in NPG), for the annotated edition of Barham's *Legends*. In a letter to Lane of 5 September 1845 (see reference above), M.A. Hughes wrote of the Cook engraving, after the drawing: '*The likeness has drawn many tears from me – I know not what you have done to it but it seems infinitely more like than that I have from R. Barham (which I shall now give to my son:) Yes, there is the kind, cordial, frank expression – there the pleasant smile – there the look I ever had from the dear lost friend, so truly affectionate & true to me and mine.*'

ICONOGRAPHY The following portraits of Barham were owned by his daughter, Mrs Bond, in 1895 (her husband, Dr Bond, sent a single printed sheet with details of the portraits in that year, NPG archives): a painting by an unknown artist of *c* 1790; a painting by an unknown artist of *c* 1794, reproduced R. H. Dalton Barham, *The Life and Letters of the Rev R. H. Barham* (1880), frontispiece; two paintings by unknown artists, of 1822–3 and of 1839, exhibited *VE*, 1892 (236 and 204); the drawing in the NPG (2922 above); a drawing by the Rev D. Barham (the sitter's son) of *c* 1840, engraved by H. Griffiths, 1847 (example in NPG), for *Bentley's Miscellany*, engraving reproduced R. H. Barham, *The Ingoldsby Legends* (annotated edition, 1870), II, frontispiece; another drawing by the Rev D. Barham, reproduced R. H. Barham, *The Ingoldsby Lyrics*, edited by his son (1881), frontispiece; a miniature by an unknown artist of *c* 1794; a silhouette by an unknown artist (as an undergraduate at Oxford) of *c* 1806.

There is a painting by an unknown artist of *c* 1794 in the Royal Museum, Canterbury; a painting by an unknown artist of 1820 is owned by the Corporation of Canterbury; a water-colour by G. Cruikshank (surrounded by some of his characters) was in the collection of Sir Frederick Williams and Sir William Cope, sold Puttick and Simpson, 1892 (?), reproduced R. H. Barham, *The Ingoldsby Legends* (annotated edition, 1870), I, frontispiece, and in subsequent editions; a drawing by C. Martin of 1845 is in the British Museum, published as a woodcut *ILN*, VI (1845), 416, and reproduced as a coloured lithograph C. Martin, *Twelve Victorian Celebrities* (1899), no. 1.

BARING *Sir Francis Thornhill, Baron Northbrook.* See NORTHBROOK

BARING *Henry Bingham* (*1804–69*)

MP for Marlborough.

54 See *Groups:* 'The House of Commons, 1833' by Sir G. Hayter, p 526.

BARNARD *Sir Andrew Francis* (*1773–1855*)

General; served in the Peninsula, 1810–14; wounded at Waterloo; lieutenant-governor of Chelsea Hospital, 1849.

982a Oil on panel, $5\frac{3}{4} \times 4\frac{5}{8}$ inches (14·6 × 11·8 cm), by GEORGE JONES, *c* 1815. PLATE 41

Inscribed, signed and dated in pencil (*bottom left and right*): General/Sir A. Barnard/Waterloo Geo Jones/RA

Collections: The artist, presented by his widow, 1871.

This study is possibly related to Jones' painting of 'Waterloo' in the Royal Hospital, Chelsea; 'Waterloo' was exhibited *RA*, 1822 (313), but the exhibition catalogue omits Barnard from the list of officers. Two other sketches of Seaton and Light (NPG 982 b and c), who were also present at Waterloo, are similar in style, although not of the same date.

Description: Healthy complexion, brown eyes and hair. Dressed in a dark stock, and white collar, with

sketchy indications of a brown and green costume. Background colour, various tones of brown, mauve and grey.

3695 Oil on canvas, 21 × 16⅞ inches (53·3 × 42·9 cm), by WILLIAM SALTER, c 1834–40. PLATE 40

Collections: By descent to W. D. Mackenzie, who also owned the group portrait, and bequeathed by him, 1929.

One of several studies in the NPG for Salter's large picture of the 'Waterloo Banquet at Apsley House', now in the collection of the Duke of Wellington; the group picture was engraved by W. Greatbach, published F. G. Moon, 1846 (example in NPG). The NPG studies will be collectively discussed in the forthcoming Catalogue of Portraits, 1790–1830. Barnard is shown in the uniform of the Rifle Brigade.

Description: Healthy complexion, brown eyes, grey hair. Dressed in a dark greenish-grey uniform, and in a similar cloak trimmed with fur, with a red sash, wearing various orders and medals, holding his sword with one hand, and a black and gold shako in the other. Posed against a very dark landscape, with a glimpse of sea at the left. The sky is very dark grey.

4026 (3) Pencil and black chalk, with faint touches of red on the cheeks, 11¾ × 8½ inches (29·8 × 21·6 cm), by COUNT ALFRED D'ORSAY, 1845. PLATE 39

Signed and dated in pencil (lower right): D'Orsay fecit/1er Aout 1845

Inscribed below in ink, probably the sitter's autograph: A F Barnard

Collections: See *Collections:* 'Men about Town, 1832–48' by Count A. D'Orsay, p 557.

ICONOGRAPHY Barnard appears in the 'Waterloo Heroes Assembled at Apsley House' by J. P. Knight in the collection of the Marquess of Londonderry, exhibited *RA*, 1842 (556), engraved by C. G. Lewis, published H. Graves, 1845 (example in NPG); a painting by an unknown artist was sold at Christie's, 9 April 1937 (lot 64),: a miniature by W. Haines was exhibited *RA*, 1820 (589); another miniature was exhibited *Guelph Exhibition*, New Gallery, 1891 (866), lent by the Earl of Crawford.

BARNES William (1801–86)

The Dorsetshire poet; son of a farmer; schoolmaster, and later a rector; published several books of poems, distinguished by their original use of Dorset dialect.

3332 Oil on canvas, 27 × 20¼ inches (68·6 × 51·5 cm), by GEORGE STUCKEY, c 1870. PLATE 42

Inscribed on the stretcher: Portrait of the Revᵈ· Wᵐ· Barnes/the "Dorset Poet"/by G. Stuckey 23 South Street, Dorchester

Collections: The sitter; by descent to his grandchildren, A. H. Baxter and the Misses G. and E. Baxter, and presented by them, 1947.

Presumably painted in Dorchester, the native town of both artist and sitter. Barnes is holding a copy of his own poems. The date is traditional. According to Mrs Hill of Crewkerne (letters in NPG archives), a descendant of the artist, George Stuckey was born at Thorncombe in Dorset, 1822, the son of Thomas and Mary Stuckey. In 1851 he was admitted to the Royal Academy Schools, recommended by I. M. Leigh. He exhibited one work at the Royal Academy in 1855, 'Portrait of a Gentleman' (55). He died and was buried at Dorchester in 1872. His portraits were almost entirely of local sitters.

Description: Dark complexion, brown eyes, dark grey hair and beard. Dressed in white shirt and dark grey coat. Holding dark leather-bound book (red for title, 'Barnes' Poems'), with red book-mark. Background colour brown.

ICONOGRAPHY A self-portrait, and a water-colour attributed to Barnes himself of *c* 1815, are in the Dorset County Museum, Dorchester, the former exhibited *Painters of Wessex*, Russell-Cotes Museum, Bournemouth, 1962(3); a painting by an unknown artist was exhibited *VE*, 1892 (340), possibly the portrait by Barnes' daughter mentioned in an interview with A. H. Baxter at the NPG, 1946; two drawings by J. Leslie are in the collection of Stuart Leslie (no relation of the artist); a statue by E. R. Mullins is in front of St Peter's Church, Dorchester, reproduced *Country Life*, LXXXIX (1941), 427; a photograph is reproduced J. Forster, *Wessex Worthies* (1920), plate XXVIII, facing p 134; a photograph of a portrait is in the Dorset County Library, Dorchester; a photograph (with friends and relatives) of 1882 is reproduced G. Dugdale, *William Barnes of Dorset* (1953), facing p 80.

BARNETT *Charles James* (*c 1797–1882*)

MP for Maidstone.

54 See *Groups*: 'The House of Commons, 1833' by Sir G. Hayter, p 526.

BARNETT *John* (*1802–90*)

Singer and musical composer; first sang in public at the Lyceum, 1813; continued to sing till 1817; musical director of the Olympic, 1832; published various operas; opened St James's Theatre for English opera, but achieved little success; devoted himself to teaching singing; published *School for the Voice*, 1844.

1587 Oil on canvas, $30\frac{1}{4} \times 24\frac{7}{8}$ inches ($76 \cdot 8 \times 63 \cdot 2$ cm), by CHARLES BAUGNIET, *c* 1839. PLATE 43

Collections: Presented by the sitter's surviving children and R. E. Francillon, 1910.

This portrait was first offered in 1897, but declined at that time owing to the NPG ten-year rule. The name of the artist was provided by one of the sitter's sons, who wrote (letter to Francillon of 24 October 1910, NPG archives): '*Baugniet painted my father in Paris as a young man – so I have always heard him say*'. Baugniet also executed a lithograph of Barnett (dated 1845), showing him as a slightly older man than the NPG picture, but with the same beard, moustache and hairstyle (example in NPG). According to the *Dictionary of National Biography*, this portrait was painted when Barnett was thirty-seven.

Description: Healthy complexion, brown eyes, dark brown hair, moustache and goatee beard. Dressed in a large, dark brown neck-tie, black waistcoat and coat, with a gold watch-chain. Background colour brown.

ICONOGRAPHY A painting by Roger was exhibited *Victorian Era Exhibition*, 1897, 'Music Section' (72), lent by Mrs Barnett; the *Dictionary of National Biography* records a painting by S. Paget in the collection of the sitter's son; a miniature by W. Hudson was exhibited *RA*, 1836 (618).

BARRAS

Prior of the monastery on the Great St. Bernard Pass.

2515 (77) See *Collections*: 'Drawings of Prominent People, 1823–49' by W. Brockedon, p 554.

BARRETT *Edward*

An emancipated slave, and a slavery abolitionist.

599 See *Groups*: 'The Anti-Slavery Society Convention, 1840' by B. R. Haydon, p 538.

BARRETT *Richard*

Slavery abolitionist.

599 See *Groups*: 'The Anti-Slavery Society Convention, 1840' by B.R.Haydon, p 538.

BARRINGTON *George William, 7th Viscount (1824–86)*

Man of affairs.

4026 (4) See *Collections*: 'Drawings of Men About Town, 1832–48' by Count A.D'Orsay, p 557.

BARRON *Sir Henry Winston, Bart (1795–1872)*

MP for Waterford.

54 See *Groups*: 'The House of Commons, 1833' by Sir G.Hayter, p 526.

BARROW *Sir John, Bart (1764–1848)*

Secretary to the Admiralty.

1208 See *Groups*: 'The Arctic Council, 1851' by S.Pearce, p 548.
See also forthcoming Catalogue of Portraits, 1790–1830.

BARROW *John (1808–98)*

Colonel; keeper of the records at the Admiralty; one of the most active promoters of the search for Sir John Franklin.

905 Oil on millboard, $14\frac{7}{8} \times 12\frac{1}{2}$ inches (37·8 × 31·5 cm), by STEPHEN PEARCE, *c* 1850. PLATE 44
Inscribed on a label in the artist's hand, formerly on the back of the picture: John Barrow Esq/F.R.S. F.S.A. FGS. &c./Keeper of the Records of the Admiralty/The original Study painted for/the Historical Picture of the Arctic Council/by Stephen Pearce/1851

Collections: See *Collections:* 'Arctic Explorers' by S.Pearce, p 562.
This is a study for Pearce's 'Arctic Council' (see NPG 1208 below), commissioned by Barrow, as well as an autonomous portrait in its own right; most of the studies were painted in 1850. Only Barrow's head and shoulders appear in the group, but they correspond very closely with the study. In the background of the study are shown copies of books by Sir John Franklin and Sir William Parry; the exact titles are indecipherable.

Description: Healthy complexion, bluish eyes, brown hair and whiskers. Dressed in a dark stock, green stock-pin, white shirt, dark waistcoat. Red curtain behind at left and in centre. Books and bookcase at right dark brown. There is a small paint loss just to the right of the sitter's forehead.

1208 See *Groups*: 'The Arctic Council, 1851' by S.Pearce, p 548.

ICONOGRAPHY The only other recorded portraits of Barrow are, a painting by F.Goodall, exhibited *RA*, 1891 (592), and a marble bust by R.Physick, exhibited *RA*, 1855 (1445).

BARRY *Sir Charles (1795–1860)*

The leading architect of his generation; responsible for the Houses of Parliament (with Pugin), several London club houses and many other private and public buildings.

1272 Oil on canvas, 57 × 44 inches (144·8 × 111·8 cm), by JOHN PRESCOTT KNIGHT, *c* 1851. PLATE 46
Inscribed on a damaged label on the stretcher: Portrait of Charles B[arry]

Collections: The sitter, presented by his son, Bishop A.Barry, 1900.

Exhibitions: R A, 1851 (85); *Barry Exhibition*, Royal Institute of British Architects, 1960.

Literature: Magazine of Art (1901), p415, reproduced; *Country Life*, CXXVIII (1960), reproduced 796; H. Dyson, *John Prescott Knight, R.A.: A Catalogue* (Stafford Historical & Civic Society, 1971), no. 143.

Barry is shown with a pair of compasses in his hand, resting his elbow on some partly unrolled architectural plans, which lie on top of a Gothic cupboard (possibly a sideboard or desk). In the background is a view of part of the New Palace of Westminster under construction, to which the plans presumably refer. This may have been the House of Commons, which was not formally opened until 1852, and only fully completed, after Barry's death, by his son.

Description: Florid complexion, brown eyes, brown hair. Dressed in dark stock, white shirt, black suit and gold watch-chain. Gothic furniture light-brown. Plans in pencil and scarlet wash. Background, including view of the New Palace, dark brown.

342,3 See *Groups:* 'The Fine Arts Commissioners, 1846' by J. Partridge, p 545.

ICONOGRAPHY A painting by L. Dickinson is in the Royal Institute of British Architects; a painting by J. Partridge, a study for the 'Fine Arts Commissioners, 1846' (see NPG 342 above), was sold at Christie's, 15 June 1874 (lot 66); a painting by T. W. Harland was exhibited *R A*, 1840 (613), engraved by the artist (example in NPG), and by A. Nargeot, published Paris, 1855 (example in NPG); a painting by J. Hayter was exhibited *R A*, 1847 (866); a painting by H. W. Pickersgill is in the Houses of Parliament, exhibited *R A*, 1849 (85), possibly the portrait in the Pickersgill Sale, Christie's, 17 July 1875 (lot 314); a copy is in the British Embassy, Constantinople; a painting by W. Bradley was in the collection of the sitter's son, exhibited *S K M*, 1868 (618), and *V E*, 1892 (338), possibly the picture reproduced *Building News* supplement, 5 October 1923; Barry appears in 'The Royal Commissioners for the Great Exhibition' by H. W. Phillips in the Victoria and Albert Museum, exhibited *Victorian Era Exhibition*, 1897, 'History Section' (8); and also in 'The Intellect and Valour of Great Britain,' engraving by C. G. Lewis, after T. J. Barker, published J. G. Browne, Leicester, 1864 (example in NPG); key-plate published Browne, 1863 (example in British Museum); a marble bust by P. Park of 1848 is in the Reform Club, London, reproduced *Country Life*, CVIII (1950), 1499; a bust by W. Behnes was exhibited *R A*, 1849 (1267); a statue by J. H. Foley of 1865 is in the Houses of Parliament (plate 45), reproduced as a woodcut *I L N*, XLVII (1865), 17; a bronze medallion by L. Wiener was issued by the Art Union (example in NPG); a statue by G. Bayes of *c* 1909 is on the facade of the Victoria and Albert Museum.

BASS *Isaac* (*1782–1855*)

Slavery abolitionist.

599 See *Groups:* 'The Anti-Slavery Society Convention, 1840' by B. R. Haydon, p 538.

BATESON *Sir Robert, Bart* (*1782–1863*)

MP for County Londonderry.

54 See *Groups:* 'The House of Commons, 1833' by Sir G. Hayter, p 526.

BATHURST *George Henry Bathurst, 4th Earl* (*1790–1866*)

MP for Cirencester.

54 See *Groups:* 'The House of Commons, 1833' by Sir G. Hayter, p 526.

BAUER *Franz Andreas* (*1758–1840*)

Botanist.

2515 (63) See *Collections:* 'Drawings of Prominent People, 1823–49' by W. Brockedon, p 554.

BAZLEY *Sir Thomas, Bart* (*1797–1885*)

Manufacturer and politician; leading member of the Anti-Corn Law League; MP for Manchester, 1858–80; created a baronet, 1869.

2566 Water-colour and body colour on blue-toned paper, 12 × 7 inches (30·5 × 17·7 cm), by APE (CARLO PELLEGRINI), 1875. PLATE 47

Inscribed on the mount: Sir Thomas Bazley. Bart./August 21, 1875.

Collections: Thomas Bowles; *Vanity Fair* Sale, Christie's, 5 March 1912 (lot 49); Thomas Cubitt, purchased from him, 1933.

This is one of a large collection of original studies for *Vanity Fair*, which were all owned and specially mounted by the first proprietor of the magazine, Thomas Bowles. Those in the NPG will be discussed collectively in the forthcoming Catalogue of Portraits, 1860–90. The water-colour of Bazley was published in *Vanity Fair* as a coloured lithograph, on 21 August 1875, with the title, 'Manchester', and the signature of 'Ape'.

Description: Healthy complexion, white hair and whiskers, black top-hat. Dressed in a black coat, white collar, black morning coat, dark grey trousers, holding a black umbrella.

ICONOGRAPHY A painting by G. Patten, executed for the Chamber of Commerce, Manchester, was exhibited *RA*, 1852 (366); woodcuts, after photographs by Kilburn and by J. & C. Watkins, were published *ILN*, XIX (1851), 508, and XLII (1863), 181, respectively; Bazley appears in the engraving of 'The Anti-Corn Law League' by S. Bellin, after a painting by J. R. Herbert of 1847, published Agnew, 1850 (example in NPG); in 'The Treaty of Commerce, 1862', woodcut by Eastham, published *ILN*, XL (1862), 230–1; and in 'The Eastern Question Conference', woodcut published *ILN*, LXIX (1876), 576–7.

BEAUCHAMP *Henry Beauchamp Lygon, 4th Earl* (*1784–1863*)

MP for Worcestershire West.

54 See *Groups:* 'The House of Commons, 1833' by Sir G. Hayter, p 526.

BEAUFORT *Henry Somerset, 7th Duke of* (*1792–1853*)

Aide-de-camp to the Duke of Wellington in the Peninsula; MP from 1813; a typical tory, and a keen sportsman.

2806 Oil on canvas, 10½ × 8¾ inches (26·7 × 22·3 cm), by HENRY ALKEN, 1845. PLATE 50

Signed and dated (*bottom right*): H. Alken/1845

Collections: F. E. Lepper, purchased from him, 1936.

The early history of this picture is unknown. The evidence that it represents Beaufort is traditional, but there is no reason to doubt it, as it agrees reasonably with other known portraits. Alken was a well-known sporting artist, patronized by Beaufort; he produced several plates of the Beaufort Hunt.

Description: Ruddy complexion, dark eyes, brown hair. Dressed in dark stock, white shirt, dark brown suit, red waistcoat, black shoes and top-hat, and red jewelled stock-pin. Building and pavement light grey. Flowers at right dark green with splashes of red. Background landscape light green and brown, with pale blue, pink, and grey sky.

4026 (5) Pencil and black chalk on blue-tinted paper, 8 × 5⅞ inches (20·2 × 15 cm), by COUNT ALFRED D'ORSAY, 1838. PLATE 51

Signed and dated (*bottom right*): A. D'Orsay/fecit/1838– *Inscribed* (*bottom centre*): Beaufort-

Collections: See *Collections*: 'Drawings of Men About Town, 1832–48' by Count A. D'Orsay, p 557.

There is a lithograph by R. J. Lane, after another portrait of Beaufort by D'Orsay (dated 1840), published J. Mitchell (example in NPG).

999 See *Groups:* 'The House of Lords, 1820' by Sir G. Hayter, in forthcoming Catalogue of Portraits, 1790–1830.

ICONOGRAPHY

c 1812 Water-colour by R. Cosway. Collection of the Duke of Beaufort, Badminton.

c 1812 Water-colour by R. Cosway. Collection of the Duke of Beaufort.
Either a study for, or another version of, the water-colour above.

1817 Coloured etching by R. Dighton (in Hyde Park), published Dighton, 1817 (example in NPG). Reproduced Captain Jesse, *The Life of Beau Brummel* (1886), II, facing 242. Presumably the same etching by Dighton, published T. McLean, 1817 (example in Victoria and Albert Museum, where there is also a reduced version).

1820 'The House of Lords' by Sir G. Hayter (NPG 999 above).

1836 Painting by H. and W. Barraud (with the Beaufort Hunt). Collection of the Hon Mrs Macdonald-Buchanan. Reproduced S. Sitwell, *Conversation Pieces* (1936), plate 124.

c 1837 Painting by W. Gush (in the uniform of the Gloucestershire Yeomanry Cavalry). Exhibited *RA*, 1837 (71). Almost certainly the unattributed portrait in the collection of the Duke of Beaufort, where Beaufort seems to be wearing the uniform of the Gloucestershire Yeomanry. A variant version was in the collection of David Minlore.

1838 Drawing by Count A. D'Orsay (NPG 4026 (5) above).

1839 Painting by Sir E. Landseer (on horseback at the Eglington Tournament). Collection of the Duke of Beaufort. *Landseer Exhibition, RA*, 1961 (96).

1840 Lithograph by R. J. Lane, after Count A. D'Orsay, published J. Mitchell, 1840 (example in NPG).

1840 Marble bust by W. Behnes. Collection of the Duke of Beaufort.
Exhibited *RA*, 1841 (1335).

1841 Drawing by J. Doyle (on horseback). British Museum.

1845 Painting by H. Alken (NPG 2806 above).

c 1847 'Peninsular War Group' by J. P. Knight. Collection of the Marquess of Londonderry.
Exhibited *RA*, 1848 (321). Engraved by F. Bromley, published H. Graves, 1847 (example in NPG).

c 1854 Drawing by J. R. Swinton. Collection of the Duke of Beaufort.
Engraved by G. Zobel, published J. Mitchell, 1854 (example in British Museum).

1854 Marble bust by G. G. Adams. Collection of the Duke of Beaufort.
Either the bust exhibited *RA*, 1855 (1479), or 1856 (1323).

1858 Painting by N. Schiavoni (with his second wife, in a gondola at Venice). Collection of the Duke of Beaufort.

Undated Painting by F. X. Winterhalter (in Garter Robes). Collection of the Duke of Beaufort.
Reproduced O. Sitwell, *Left Hand, Right Hand*, I (1945), 74.

Undated Miniature by F. Rochard. *Exhibition of Portrait Miniatures*, Burlington Fine Arts Club, 1889, case XXX (61).

Undated Lithograph by F. W. Wilkin (example in NPG); lithograph by 'TCW' (example in British Museum).

BEAUFORT *Sir Francis* (*1774–1857*)

Rear-admiral and hydrographer; surveyed several coast-lines; one of the promoters of the search for Sir John Franklin.

918 Oil on millboard, 19⅞ × 16 inches (50·5 × 40·6 cm), by STEPHEN PEARCE, 1850. PLATE 48

Collections: See *Collections:* 'Arctic Explorers' by S. Pearce, p 562.

Exhibitions: R A, 1852 (1294).

This is a study for Pearce's 'Arctic Council' (see NPG 1208 below), as well as an autonomous portrait in its own right. Pose, features and costume are identical with those in the group, except for a differently coloured waistcoat (yellow in the study, dark brown in the group). According to a memorandum by Pearce of *c* 1899 (NPG archives), the study was painted in 1850. Pearce used the NPG study, in conjunction with further sittings, for the three-quarter length portrait of Beaufort of 1855–6 in the National Maritime Museum, Greenwich, exhibited *R A*, 1857 (354), engraved by J. Scott, published H. Graves & Co, 1857 (example in NPG). The latter was commissioned by the subscribers to the Beaufort testimonial, and is mentioned in Pearce's *Memories of the Past* (1903), p 80, reproduced facing p 78, and in a single-sheet pamphlet published by Graves (example in NPG, 'Pearce Documents'). Pearce records painting a replica of the NPG portrait for the sitter's son, in his memorandum of *c* 1899. Besides the group by Pearce, and the drawing by Brockedon (see below), no other portraits of Beaufort are recorded.

Description: Red cheeks, bluish eyes, grey hair. Dressed in a black stock, white shirt, yellow waistcoat and black coat, with a monocle. Inscribing a white map on a brownish-red table. Spectacles and cutting instrument bottom left, with a box of bottles beyond (for inks?). Very dark background colour.

2515 (90) Black and red chalk, with touches of Chinese white, on grey-tinted paper, 14 × 10¼ inches (35·5 × 26·2 cm), by WILLIAM BROCKEDON, 1838. PLATE 49

Dated (lower left): 13.3.38

Collections: See *Collections:* 'Drawings of Prominent People, 1823–49' by W. Brockedon, p 554.

1208 See *Groups:* 'The Arctic Council, 1851' by S. Pearce, p 548.

BEAUMONT *Abraham* (*1782–1848*)

Slavery abolitionist.

599 See *Groups:* 'The Anti-Slavery Society Convention, 1840' by B. R. Haydon, p 538.

BEAUMONT *John* (*1788–1862*)

Slavery abolitionist.

599 See *Groups:* 'The Anti-Slavery Society Convention, 1840' by B. R. Haydon, p 538.

BEAUMONT *Mrs John* (*1790–1853*)

Slavery abolitionist.

599 See *Groups:* 'The Anti-Slavery Society Convention, 1840' by B. R. Haydon, p 538.

BEAUMONT *William* (*1780–1869*)

Slavery abolitionist.

599 See *Groups:* 'The Anti-Slavery Society Convention, 1840' by B. R. Haydon, p 538.

BECHER, *Eliza, Lady Wrixon-*. See WRIXON-BECHER

BECKFORD *Henry*

An emancipated slave from Jamaica, and a slavery abolitionist.

599 See *Groups:* 'The Anti-Slavery Society Convention, 1840' by B.R.Haydon, p 538.

BEDFORD *John Russell, 6th Duke of (1766–1839)*

Lord-Lieutenant of Ireland.

54 See *Groups:* 'The House of Commons, 1833' by Sir G.Hayter, p 526.
See also forthcoming Catalogue of Portraits, 1790–1830.

BEDFORD *Francis Russell, 7th Duke of (1788–1861)*

Statesman.

54 See *Groups:* 'The House of Commons, 1833' by Sir G.Hayter, p 526.

BEDFORD *William Russell, 8th Duke of (1809–72)*

MP for Tavistock.

54 See *Groups:* 'The House of Commons, 1833' by Sir G.Hayter, p 526.

BEDFORD *Paul (1792?–1871)*

Popular comedian; first appeared on stage around 1815; appeared in plays and operas in London, Dublin and the provinces; joined Covent Garden company, 1833; began playing low comedy parts at the Adelphi from 1838, for which he became famous; retired, 1868.

2449 Water-colour and body colour on paper, $12\frac{3}{4} \times 8$ inches (32.4×20.3 cm), by ALFRED BRYAN. PLATE 52

Collections: Claude de Vere, purchased from him, 1936.

Mr de Vere stated that he acquired this water-colour, and the one of William Creswick (NPG 2450), from a stage-hand at the Marylebone Theatre, who had known both actors (letter in NPG archives). Inscribed on a separate piece of paper, mounted below the NPG water-colour is the following autograph: 'Paul Bedford/"I believe you my Boy"'. It does not appear to have any specific connection with the water-colour. There is no doubt, however, that this portrait does represent Bedford.

Description: High colour in cheeks, pale brown eyes, brown hair. Dressed in black stock, white shirt, dark grey suit, fawn overcoat, red carnation, black top-hat. Background colour light blue.

ICONOGRAPHY Two paintings by unknown artists were exhibited *Victorian Era Exhibition*, 1897, 'Music and Drama Section' (128 and 282); a lithograph by R.J.Lane was published J.Mitchell, 1839 (example in NPG); popular prints are listed by L.A.Hall, *Catalogue of Engraved Dramatic Portraits in the Harvard Theatre Collection*, I (1930), 85–6 (various examples in the NPG and British Museum); a photograph is reproduced F.Whyte, *Actors of the Century* (1898), facing p 130, and there is another in the NPG.

BEECHEY *Frederick William (1796–1856)*

Rear-admiral and geographer; son of the artist, Sir William Beechey; surveyed coasts of North Africa and South America; active promoter of the search for Sir John Franklin.

911 Oil on millboard, $15 \times 12\frac{5}{8}$ inches (38.1×32.2 cm), by STEPHEN PEARCE, 1850. PLATE 53

Collections: See *Collections:* 'Arctic Explorers' by S.Pearce, p 562.

Exhibitions: Royal Naval Exhibition, Chelsea, 1891 (38).

Literature: S.Pearce, *Memories of the Past* (1903), p 59.

This is a study for Pearce's group, 'The Arctic Council' (see NPG 1208 below), as well as an autonomous portrait in its own right. The date was provided by the artist in a memorandum of *c* 1899 (NPG archives). In the group, Beechey is shown seated, with his left arm on the table, and his body more in profile than in the NPG study, but features, pose of head, hair, and details of costume are identical. He is wearing the undress uniform (1856 pattern) either of a naval captain with over three years service, or of a commodore (1st or 2nd class), and the Arctic Medal (1818–55). In his memorandum, Pearce records painting another portrait of Beechey in 1858, based on the NPG study, for the Beechey family.

Description: Healthy complexion, blue eyes, auburn hair. Dressed in a dark stock, white shirt, yellow waistcoat, dark blue naval uniform, with gilt buttons and epaulettes, and silver medal with grey ribbon. Background colour dark bluish-grey.

1208 See *Groups:* 'The Arctic Council' by S. Pearce, p 548.

ICONOGRAPHY The only other recorded portraits of Beechey are, a painting by his brother, George Beechey, now in the National Maritime Museum, Greenwich, exhibited *RA*, 1828 (607), and a painting (as a young man) by his father, Sir William Beechey, reproduced *The Times*, 19 January 1937.

BEETON *Isabella Mary* (*1836–65*)

Authoress of the famous *Book of Household Management*, 1859–61; *née* Mayson; married Samuel Beeton, editor and publisher, 1856; contributor to his magazines.

2539 Tinted photograph, $7\frac{1}{4} \times 5\frac{1}{2}$ inches ($18\cdot4 \times 14$ cm) arched top, by MAULL & CO, London. PLATE 54

Collections: The sitter, presented by her son, Sir Mayson Beeton, 1932.

Literature: Daily Mail, 15 April 1936, reproduced.

This is the only known likeness of Mrs Beeton; no other prints from the original negative have survived. The donor thought that the photograph had been tinted by his sister shortly after Mrs Beeton's death.

BELCHER *Sir Edward* (*1799–1877*)

Admiral; surveyed coast-lines in various parts of the world; commanded an expedition in search of Sir John Franklin, 1852; published accounts of voyages, and other works.

1217 Oil on canvas, $15\frac{1}{2} \times 13\frac{1}{8}$ inches ($39\cdot4 \times 33\cdot3$ cm), by STEPHEN PEARCE, *c* 1859. PLATE 55

Apparently signed on the back (*now no longer visible*): Stephen Pearce

Collections: See *Collections:* 'Arctic Explorers' by S. Pearce, p 562.

Exhibitions: RA, 1859 (43); *Royal Naval Exhibition*, Chelsea, 1891 (46).

Belcher is wearing the full-dress uniform (1856 pattern) either of a naval captain with over three years service, or of a commodore (1st or 2nd class), and (from left to right) the China Medal (1842), the order of the Bath (CB), the Naval General Service Medal (1793–1840), with two bars for 'Gaieta 24 July 1815' and 'Algiers', and the Arctic Medal (1818–55). These medals, and Belcher's KCB star and badge, are now in the National Maritime Museum, Greenwich.

Description: Healthy complexion, blue eyes, grey hair and whiskers. Dressed in a dark stock, white shirt, dark blue naval uniform, with gold-braided collar and epaulettes, gilt buttons, silver medals and a white star with multi-coloured ribbons. Background colour dark brown.

ICONOGRAPHY The only other recorded portraits of Belcher are, a photograph by Beard, published as a woodcut *ILN*, XX (1852), 321, and a woodcut published *ILN*, LXX (1877), 300.

BELLOT *Joseph René* (*1826–52*)

French naval lieutenant; lost his life during an expedition in search of Sir John Franklin.

1227 Oil on canvas, 15¼ × 12½ inches (38·6 × 31·9 cm), by STEPHEN PEARCE, 1851. PLATE 56

Collections: See *Collections:* 'Arctic Explorers' by S. Pearce, p 562.

Exhibitions: RA, 1854 (1287); *Royal Naval Exhibition*, Chelsea, 1891 (54).

Literature: S. Pearce, *Memories of the Past* (1903), pp 51, 159–61; single sheet pamphlet published by T. Boys (example in NPG, 'Pearce Documents').

This portrait was painted shortly before Bellot sailed on his last voyage, in search of Franklin, in 1851. It was engraved by J. Scott, published T. Boys, London, and E. Gambart, Paris, 1854 (example in NPG). The engraving was dedicated to Napoleon III, which resulted in an audience for Pearce at the Tuileries on 16 April 1854. The portrait is mentioned in several journals of the day, *Athenaeum*, 15 July 1854, *Morning Herald*, 3 July 1854, and *Daily News*, July 1854. Bellot is wearing the naval uniform of a French lieutenant, the Légion d'Honneur (officer, 4th Class) and the Arctic Medal (1818–55).

Description: Dark brown eyes, hair, and whiskers. Dressed in a dark stock, white shirt, white waistcoat and dark blue naval uniform with gilt buttons and epaulettes, silver medal, and white enamel star, with coloured ribbons. Background colour dark grey.

ICONOGRAPHY The only other recorded portraits of Bellot in England are, a lithograph by L. Maurin (example in NPG), and a photograph by Claudet, reproduced as a woodcut *ILN*, XXIII (1853), 332.

BELZONI *Giovanni Baptista* (*1778–1823*)

Actor, engineer and traveller.

2515 (1) See *Collections:* 'Drawings of Prominent People, 1823–49' by W. Brockedon, p 554.

See also forthcoming Catalogue of Portraits, 1790–1830.

BENNETT *John* (*1773–1852*)

MP for Wiltshire South.

54 See *Groups:* 'The House of Commons, 1833' by Sir G. Hayter, p 526.

BENNETT *George*

Slavery abolitionist.

599 See *Groups:* 'The Anti-Slavery Society Convention, 1840' by B. R. Haydon, p 538.

BENTINCK *Lord George* (*1802–48*)

Statesman; son of the 4th Duke of Portland; keen supporter of horse-racing; MP for King's Lynn, 1826–48; one of the leaders of the tory party, and a passionate protectionist; helped to oust Peel from the party when the Corn Laws were repealed.

1515 Oil on canvas, 50½ × 40 inches (128·3 × 101·6 cm), by SAMUEL LANE, *c* 1836. PLATE 57

Collections: Lady Howard de Walden, the sitter's sister; Charles Ellis, her son; Lady Emlyn; F. C. Bentinck, presented by him, 1908.

Exhibitions: Probably *RA*, 1836 (187).

This is a version after the full-length portrait of Bentinck by Lane of 1834, commissioned by the

Corporation of King's Lynn (Bentinck's constituency), exhibited *RA*, 1834 (262), and *SKM*, 1868 (540), etched and engraved by S.W.Reynolds, published Colnaghi, 1848 and 1849 respectively (examples in NPG). A copy of the NPG portrait by Enrico Belli is in the collection of the Duke of Portland, reproduced C.R.L.Fletcher and E.Walker, *Historical Portraits, 1700–1850* (1919), IV, facing 236.

Description: Healthy complexion, brown eyes, dark brown hair. Dressed in a dark stock, white shirt, black suit, red ribbon round his neck, gold watch-chain, jewelled stock-pin. Beyond the papers under his hand is a silver inkstand with a quill pen. Red curtain top left, red curtain(?) lower right. Rest of background dark brown wall.

134 Marble bust, 31 inches (78·7 cm) high, by THOMAS CAMPBELL, 1848. PLATE 58

Incised (below the shoulder): THOS CAMPBELL SCULP 1848

Collections: The artist; by descent to Thomas Campbell Hogarth, a relative, and purchased from him, 1861.

Campbell also executed a bronze statue of Bentinck in 1848 (erected 1851) for Cavendish Square, London, reproduced as a woodcut *ILN*, XIX (1851), 640, and a marble bust exhibited *RA*, 1857 (1340).

ICONOGRAPHY Two drawings by Count A.D'Orsay, of 1840 and 1848, were sold at Sotheby's, 13 February 1950 (lot 216), bought Colnaghi; the 1840 drawing was lithographed apparently by R.J.Lane, and the 1848 drawing definitely by him, published R.Bentley, 1849 (examples in British Museum); two drawings by J.Doyle and a painting by an unknown artist are at Hughenden Manor; a lithograph, probably after one of these drawings, was published T.McLean, 1848 (example in NPG); other drawings by Doyle are in the British Museum; a drawing by an unknown artist was exhibited *VE*, 1892 (392*); a statue by Sir R.Westmacott of 1835 is at Calcutta; a bust by E.H.Baily of 1842 is in the Russell-Cotes Museum, Bournemouth; a statuette by W.Behnes was exhibited *RA*, 1853 (1339), and a medal by B.Wyon, *RA*, 1854 (1277); an engraving by J.B.Hunt, after a photograph by Claudet, was published 1848 (example in NPG); there is a lithograph by 'C.B.' of 1848, after a daguerreotype, published Claudet (example in NPG); a painting by C.Turner, based on the same photograph, is in the collection of the Duke of Portland.

BERESFORD *Sir John Poo, Bart (1766–1844)*
Admiral, MP for Coleraine.

54 See *Groups:* 'The House of Commons, 1833' by Sir G.Hayter, p 526.

BERKELEY *George Charles Grantley Fitzhardinge (1800–81)*
Writer, sportsman, and MP for Gloucestershire West.

54 See *Groups:* 'The House of Commons, 1833' by Sir G.Hayter, p 526.

BERNAL *Ralph (d 1854)*
Collector and MP for Rochester.

54 See *Groups:* 'The House of Commons, 1833' by Sir G.Hayter, p 526.

BERNAYS *Dr Albert James (1823–92)*
Chemist.

2515 (102) See *Collections:* 'Drawings of Prominent People, 1823–49' by W.Brockedon, p 554.

BESSBOROUGH *John William Ponsonby, 4th Earl of* (*1781–1847*)

Statesman, MP for Nottingham.

54 See *Groups:* 'The House of Commons, 1833' by Sir G. Hayter, p 526.

BESSBOROUGH *John Ponsonby, 5th Earl of* (*1809–80*)

Man of affairs.

4026 (6) See *Collections:* 'Drawings of Men About Town, 1832–48' by Count A. D'Orsay, p 557.

BETHELL *Richard, 1st Baron Westbury.* See WESTBURY

BETHELL *Richard* (*1772–1864*)

MP for Yorkshire, East Riding.

54 See *Groups:* 'The House of Commons, 1833' by Sir G. Hayter, p 526.

BEVAN *Rev William*

Slavery abolitionist.

599 See *Groups:* 'The Anti-Slavery Society Convention, 1840' by B. R. Haydon, p 538.

BICKERSTETH *Henry, Baron Langdale.* See LANGDALE

BIDDER *George Parker* (*1806–78*)

Engineer; exhibited, when very young, as a 'calculating phenomenon'; associated with Robert Stephenson in the London and Birmingham railway; a founder of the Electric Telegraph Company.

2515 (15) Black chalk, with touches of grey wash and Chinese white, on brown-tinted paper, $15\frac{1}{4} \times 11\frac{1}{4}$ inches (38·7 × 28·5 cm), by WILLIAM BROCKEDON, *c* 1825. PLATE 59

Collections: See *Collections:* 'Drawings of Prominent People, 1823–49' by W. Brockedon, p 554.

Accompanied in the Brockedon Album by a letter from the sitter, dated 11 April 1825. There is no connection between letter and drawing, but the date 1825 agrees well with the apparent age of the sitter and his costume.

ICONOGRAPHY The following portraits are in the Institution of Civil Engineers, London: a painting by an unknown artist (as a child); an engraving by J. Lucas, after his painting of 1847, published H. Graves, 1848, reproduced A. Lucas, *John Lucas, RA* (1910), facing p 72 (a replica of the painting was commissioned by Sir Morton Peto); a painting by an unknown artist of *c* 1870; the 'Conference of Engineers at Britannia Bridge' by J. Lucas of 1851, reproduced *Catalogue of Works of Art etc at the Institution of Civil Engineers* (1950), facing p 19; a bust by H. C. Fehr.

A painting by an unknown artist of *c* 1815 was sold at Bonham's, 22 June 1967 (lot 137); a painting by an unknown artist of *c* 1870 was in the collection of H. H. Brown; paintings by R. Carruthers and W. S. Lethbridge were exhibited *RA*, 1818 (3), and 1819 (719), the latter engraved by R. Cooper, published Wetton and Jarvis, 1819 (example in British Museum); a drawing by J. S. Cotman is in the Victoria and Albert Museum, etched by Mrs D. Turner (example in NPG); a marble bust by E. W. Wyon was exhibited *RA*, 1855 (1456); an engraving by S. Freeman, after J. King, was published 1815 (example in NPG); an engraving by H. Meyer, after W. Waite, was published Waite, Abingdon, 1817 (example in NPG); an engraving by J. H. Robinson, after Miss A. Hayter, was published Colnaghi, 1819 (example in NPG).

BINNEY *Thomas* (*1798–1874*)

Nonconformist divine; acquired a high reputation as a preacher; twice elected chairman of the Congregational Union of England and Wales; author of polemical works and verse of a religious character.

2182 Water-colour and body colour on blue-toned paper, $11\frac{3}{4} \times 7\frac{1}{4}$ inches (30·1 × 18·5 cm), by MD C. A. LOYE, 1872. PLATE 60

Signed (lower right): MD. *Inscribed on the mount:* Rev Thomas Binney,/October 12, 1872.

Collections: Thomas Bowles; *Vanity Fair* Sale, Christie's, 5 March 1912 (lot 67); W. H. Fairbairns, presented by him, 1928.

This is one of a large collection of original studies for *Vanity Fair*, which were all owned and specially mounted by the first proprietor of the magazine, Thomas Bowles. Those in the NPG will be discussed collectively in the forthcoming Catalogue of Portraits, 1860–90. The water-colour of Binney was published in *Vanity Fair* as a coloured lithograph, on 12 October 1872, as 'Men of the Day, no. 51', with the title, 'The Head of the Dissenters.'

Description: Sanguine complexion, grey hair. Dressed in white shirt, black clerical costume. Grey pulpit and chair, red cover on reading desk.

599 See *Groups:* 'The Anti-Slavery Society Convention, 1840' by B. R. Haydon, p 538.

ICONOGRAPHY A half-length painting by an unknown artist is at New College, London, and another three-quarter length version of the same type is owned by the Memorial Hall Trust, London; a painting by L. Dickinson also belongs to the Memorial Hall Trust, exhibited *RA*, 1871 (443); busts by C. Summers and P. Slater were exhibited *RA*, 1864 (932), and 1869 (1176); an engraving by W. Holl, after J. R. Wildman, was published Westley and Davis, 1830 (example in NPG); there is a lithograph by C. Baugniet of 1846 (example in NPG); a lithograph by Bell Smith was published J. Palmer, 1846 (example in Memorial Hall Trust collection); there is an engraving by F. Croll (example in NPG), for *Hogg's Instructor*; there is an engraving by J. Cochran, after W. Gush (example in NPG); an engraving by C. H. Jeens was published 1875 (example in British Museum), for Binney's *Weighhouse Chapel Sermons*; there is an engraving by W. H. Egleton, after H. Anelay (example in NPG); a woodcut, after a photograph, was published *ILN*, LXIV (1874), 209; there are various photographs and engravings after photographs in the NPG.

BIRD *Edward Joseph* (*1799–1881*)

Admiral and Arctic explorer.

1208 See *Groups:* 'The Arctic Council, 1851' by S. Pearce, p 548.

BIRNEY *James Gillespie* (*1792–1857*)

American slavery abolitionist.

599 See *Groups:* 'The Anti-Slavery Society Convention, 1840' by B. R. Haydon, p 538.

BIRT *Rev John*

American slavery abolitionist.

599 See *Groups:* 'The Anti-Slavery Society Convention, 1840' by B. R. Haydon, p 538.

BISH *Thomas* (*1780–1843*)

MP for Leominster.

54 See *Groups:* 'The House of Commons, 1833' by Sir G. Hayter, p 526.

BLACKHOUSE *Jonathan*

Slavery abolitionist.

599 See *Groups:* 'The Anti-Slavery Society Convention, 1840' by B.R.Haydon, p 538.

BLACKSTONE *William Seymour* (*1809–81*)

MP for Wallingford.

54 See *Groups:* 'The House of Commons, 1833' by Sir G.Hayter, p 526.

BLAIR *W.T.*

Slavery abolitionist.

599 See *Groups:* 'The Anti-Slavery Society Convention, 1840' by B.R.Haydon, p 538.

BLESSINGTON *Marguerite, Countess of* (*1789–1849*)

Authoress and beauty; *née* Power; married 1st Earl of Blessington, 1818, as her second husband; established, with Count D'Orsay, a famous salon at Gore House; published numerous novels, annuals, and books of reminiscence.

1309 Water-colour on paper, $10\frac{1}{4} \times 8\frac{1}{4}$ inches ($26 \times 21 \cdot 1$ cm), by or after ALFRED EDWARD CHALON, *c* 1834. PLATE 62

Collections: Alfred Jones of Bath, presented by him, 1902.

Exhibitions: Spring Loan Exhibition, Victoria Art Gallery, Bath, 1901 (3); *Charles Dickens*, Victoria and Albert Museum, 1970 (P 15).

On the back of the frame were labels for the Bath exhibition, where the water-colour was attributed to 'A.E.Chalon or Wageman', and a newspaper cutting about the Countess of Blessington, with a woodcut of Gore House. NPG 1309 is identical, except that it is half-length, with the three-quarter length engraving by H.T.Ryall, after A.E.Chalon, published C.Tilt, 1836 (example in British Museum), and also published Fisher, 1844 (example in NPG); the NPG water-colour is clearly not the original, both on the evidence of size and style. The original appears to have been the water-colour by Chalon of 1834 ('in a morning costume') in Lady Blessington's Sale, Phillips, 7–26 May 1849 (lot 602), presumably that exhibited *RA*, 1834 (567); this, or another version, was sold at Christie's, 18 May 1903 (lot 59), bought Leggatt (sketch in NPG sale catalogue). Other water-colours of Lady Blessington by Chalon are as follows:

1 *1837*. In a turban, holding a fan. Christie's, 22 July 1875 (lot 23). Perhaps identical with the water-colour in Lady Blessington's Sale (lot 616), 'in an evening dress'.
2 Lady Blessington's Sale (lot 618). No description.
3 Engraved by J.J.Hinchliff (example in NPG). Seated, in fancy-dress.
4 Engraved by H.Hall, published Bogue, 1845 (example in British Museum), for Heath's 'New Gallery of British Engraving'. Standing, in a bonnet, holding a handkerchief.
5 Exhibited *RA*, 1823 (688).
6 Exhibited *RA*, 1839 (737).

Description: Brown eyes and hair. Wearing a pink dress, white bonnet with blue frills, and a gold and green bracelet. Brown couch visible at left.

1645a Pencil on paper, $7\frac{3}{4} \times 5\frac{5}{8}$ inches ($19 \cdot 7 \times 14 \cdot 2$ cm), by CHARLES MARTIN, 1844. PLATE 61

Inscribed, signed and dated in pencil (*bottom left*): C.M./Gore House./Kensington, May, 1844.

Inscribed by the artist in red crayon on the front of the mount: Gore House. Kensington/May, 1844, *and in pencil in another hand, on the left of the mount:* Charles Martin

Faint pencil inscription along the bottom (possibly an autograph): Lady Blessington
Inscribed on the back of the mount, in the vendor's hand: My father Charles Martin (son of John Martin) drew a large/number of Portraits of distinguished persons of the time for the /"Illustrated London News", in the forties and this is one of them/Thos. C. Martin/I often remember my father/speaking of his visit to Gore House (Albert Hall Mansions on its site)/and the handkerchief Lady B. wore. The late Queen Victoria /always was taken/with a similar/handkerchief/ It was fashionable

Collections: Purchased from the artist's son, Thomas Martin, 1912.

This drawing was published as a contemporary woodcut (example in NPG), for an unidentified newspaper or magazine. It did not appear in the *Illustrated London News*, although Martin published several other portrait drawings there. The NPG drawing was also used for a coloured lithograph in Martin's *Twelve Victorian Celebrities* (1899), no. 3; the lithograph, apparently dated 26 February 1844 (the name of the month is not very clear), has several accessories not shown in the NPG drawing, is more finished, and differs in some other details; the basic pose, however, is the same. Lady Blessington's letter of 14 February 1844, agreeing to sit, is reproduced in facsimile in Martin's book. Several similar drawings by Martin of other 19th century celebrities are in the British Museum, and that of Dickens is in the collection of Mrs Jane Cohen, Boston.

ICONOGRAPHY The following portraits of Lady Blessington were included in her sale, Phillips, 7–26 May 1849 (the only recorded catalogue of the sale is in the Wallace Collection); a painting by Sir T. Lawrence, now in the Wallace Collection (lot 1032), exhibited *RA*, 1822 (80), engraved by J. H. Watt, published 1832 (example in NPG), for the *Amulet*, and by S. Cousins, published Hodgson and Graves, 1837 (example in NPG); a copy is at Hughenden Manor (National Trust), and miniatures after it are in the National Gallery of Ireland, Dublin, the Wallace Collection (by E. Bouchardy), and Lady Blessington's Sale (lot 658); a drawing attributed to Lawrence was exhibited *Amateur Art Exhibition*, London, 1898 (50), lent by Lady Arthur Wellesley; a painting by D'Orsay (contemplating a picture) (lot 1008), possibly that exhibited *RA*, 1844 (205); a painting and a drawing by Sir F. Grant (lots 1218 and 1216); a painting by Valentini (in medieval costume, with Bulwer Lytton and Disraeli) (lot 1063); water-colours by Chalon (lots 602, 616, and 618) (see NPG 1309 above); drawings by Sir E. Landseer (lots 592, 1178 and 1179), the second of these was apparently that engraved by F. C. Lewis, published H. Colburn, 1839 (example in NPG); drawings by D. Maclise (lots 234, 1205, and 1206) (an engraving of Lady Blessington by Maclise was published *Fraser's Magazine*, VII (1833), facing 267, as no. 34 of his 'Gallery of Illustrious Literary Characters'; Lady Blessington also appears in Maclise's engraving of 'Regina's Maids of Honour', published *Fraser's Magazine*, XIII (1836), facing 80, as no. 68 of his 'Gallery'); a life-size drawing by Count A. D'Orsay (lot 621); another drawing by D'Orsay of 1841 was included in a whole lot of drawings (lot 1263), subsequently sold Sotheby's, 13 February 1950 (lot 216), bought Colnaghi, lithographed by R. J. Lane (example in NPG); a miniature by R. Cosway (lot 377) (the same or another miniature by Cosway was exhibited *Pictures from Ulster Houses*, Belfast Museum and Art Gallery, 1961 (181), lent by Edwin Bryson); a miniature by E. T. Parris (lot 610), presumably that engraved by W. Giller, published J. McCormick, 1835 (example in British Museum), and also engraved by J. Thomson, published Longman (example in NPG); an enamel after this miniature (lot 598) (another miniature by J. Haslem, after Parris, was exhibited *RA*, 1836 (909)); a miniature by S. Lane (lot 234), and another by an unknown artist (lot 623); a cameo (lot 689); a marble bust by L. Bartolini (lot 262); busts by and after Count A. D'Orsay (lots 281 and 1472); a bronze medallion by D'Orsay (lot 220), possibly that exhibited *RA*, 1844 (1408); and models of her hands (lots 353 and 570).

Other portraits of Lady Blessington are as follows: a painting by J. Wood, exhibited *RA*, 1838 (7); a posthumous drawing by G. F. Mulvany in the National Gallery of Ireland, Dublin; a drawing by C. Martin of 1844 (NPG 1644 above); drawings by P. H. Stroehling of 1812 and by G. Cattermole in the British Museum; a painting or drawing by H. B. Chalon, exhibited *Victorian Era Exhibition*, 'Historical Section' (201), lent by Sir R. Rawlinson; a marble bust by an unknown artist exhibited *English Decorative Art at Lansdowne House*, 1929 (349), lent by E. Knoblock; a silhouette by Foster of 1829, reproduced E. N. Jackson, *The History of Silhouettes*

(1911), facing p112; an anonymous engraving, after a medallion by H. Weekes, published C. Tilt, 1838 (example in NPG), for Collas and Chorley, *The Authors of England*; an engraving by J. Cochran, after Le Comte, published E. Churton, 1835 (example in NPG), for the *Court Magazine*; a lithograph by R. J. Lane of 1833, after a drawing by Landseer (example in British Museum); an engraving by F. C. Lewis and an anonymous lithograph, both called Lady Blessington (examples in NPG).

BLOMFIELD *Charles James* (*1786–1857*)

Bishop of London, 1828 onwards; instituted a fund for building and endowing churches, 1836; involved in the controversies over the Tractarian movement; edited various Greek texts, including five plays by Aeschylus.

4166 With Cardinal Manning and Sir John Gurney. Pen and ink on paper, $9 \times 7\frac{1}{2}$ inches (22.7×19 cm), by GEORGE RICHMOND, *c*1840–5. PLATE 63

Inscribed below the figures in pencil, in the artist's hand (from left to right): Bⁿ Gurney Bp London. Archdⁿ Manning *and (bottom left):* Fulham Palace

Collections: Mrs John Richmond; E. Kersley; Sir Geoffrey Keynes, presented by him, 1960.

Literature: NPG Annual Report, 1960–1 (1961), p17.

The inscription below Gurney was misread in the *NPG Annual Report* as 'SJⁿ(?)'. Gurney (1768–1845) was a baron of the exchequer, and comparison with other portraits of him establishes the identity beyond question. Manning became Archdeacon of Chichester in 1840, and Gurney died in 1845, so the drawing must have been executed between these two dates. Fulham Palace is the official residence of the Bishop of London. All three men sat to Richmond for formal portraits. Separate entries for Gurney and Manning will be found under their own names elsewhere in the catalogue, which is arranged alphabetically.

ICONOGRAPHY A painting by S. Lane is in the Bishop's House, Chester, exhibited *RA*, 1826 (76), engraved by W. Ward, published C. Stocking, 1827, and engraved anonymously, published B. Wertheim (examples in NPG); another version of this portrait is at Fulham Palace, London; another painting by Lane was exhibited *RA*, 1844 (340); a painting by an unknown artist is in the Bishop's House, Chester; a painting by an unknown artist is recorded in The Athenaeum, Bury St Edmunds, by the Rev E. Farrer, *Portraits in Suffolk Houses (West)* (1908), p51; Blomfield appears in 'Queen Victoria Receiving the Sacrament after her Coronation, 1838', by C. R. Leslie, and in 'The Christening of the Prince of Wales, 1842' by Sir G. Hayter, both in the Royal Collection; paintings by W. Jones and E. U. Eddis were exhibited *RA*, 1829 (288), and 1851 (429); a drawing by G. Richmond is recorded in his 'Account Book' (photostat copy of original MS, NPG archives), p41, under 1846, exhibited *SKM*, 1868 (507), and *VE*, 1892 (383), lent by Sir Arthur Blomfield, engraved by J. Thomson, published J. Hogarth, 1847 (example in British Museum), and by F. Holl (example in NPG); another drawing by Richmond is listed in his 'Account Book', p9, under 1833, probably the drawing in the collection of F. W. Farrer (Richmond's executor), 1896; a water-colour and a bronze bust by Richmond were also in the collection of Farrer, but are not recorded in the 'Account Book'; two drawings by J. Doyle are in the British Museum; miniatures by Sir W. J. Newton, C. Manzini and T. Carrick were exhibited *RA*, 1840 (757), 1842 (810), and 1844 (849); Blomfield appears in 'The Homage', enamel by Sir W. J. Newton, exhibited *RA*, 1841 (839); a statue by G. Richmond is in St Paul's Cathedral, recorded in the artist's 'Account Book', pp69, 73 and 82, under 1859, 1861 and 1867; marble busts by W. Behnes and M. Noble were exhibited *RA*, 1835 (1123), and 1849 (1253); another bust (?) by M. Noble was formerly at Elswick Hall, Newcastle, recorded in *Catalogue of Lough and Noble Models at Elswick Hall* (*c*1928), p47 (162); a bust by H. Weigall was in the Crystal Palace Portrait Gallery, 1854; an engraving by C. S. Taylor, after C. Penny, was published Smith, Elder & Co, 1826 (example in NPG); there is a lithograph by J. W. Templeton, published Colnaghi and Puckle, 1840 (example in NPG); two woodcuts were published *ILN*, VI (1845), 60, and XXIV (1854), 401.

BLOOMFIELD *John Arthur Douglas Bloomfield, 2nd Baron* (*1802–79*)

Diplomatist; envoy extraordinary and minister plenipotentiary at St Petersburg, 1844, at Berlin, 1851, and at Vienna, 1860–71; created a peer, 1871.

1408 Oil on canvas, $29\frac{3}{4} \times 25\frac{1}{8}$ inches ($75\cdot6 \times 63\cdot8$ cm), by SIR THOMAS LAWRENCE, 1819. PLATE 64

Collections: The sitter, bequeathed by his widow, Georgiana, Lady Bloomfield, 1905.

Exhibitions: RA, 1820 (88).

Literature: D.E.Williams, *The Life and Correspondence of Sir Thomas Lawrence* (1831), II, 145; Lord R.Gower, *Sir Thomas Lawrence* (1900), p112; Sir W.Armstrong, *Lawrence* (1913), p115; K.Garlick, *Sir Thomas Lawrence* (1954), p28, and 'Catalogue of the Paintings, Drawings and Pastels of Sir Thomas Lawrence', *Walpole Society*, XXXIX (1962–4), 38.

This portrait is mentioned by Lawrence in a letter of 19 May 1819 to Farington, quoted by Williams (see above). A copy is in a Scottish private collection.

Description: Healthy complexion, brown eyes and hair. Dressed in a white stock, with gold pin, white shirt, dark coat or waistcoat, and loose red coat with fur neck and cuffs. Background colour brown and greenish-grey.

ICONOGRAPHY The only other recorded portraits of Bloomfield are, a painting by E.Hughes, exhibited *RA*, 1879 (318), a painting, probably by Mrs Christina Robertson, of 1848, reproduced *Country Life*, CXVII (1955), 674, and a drawing by F.Sargent, with Messrs Tooth, 1951.

BLORE *Edward* (*1787–1879*)

Architect and artist; son of the topographer, Thomas Blore; helped to illustrate his father's *History of Rutland* and other books; built Sir Walter Scott's house at Abbotsford, *c*1816; architect to William IV and Victoria; published *Monumental Remains of Eminent Persons*, 1824.

3163 Coloured chalk on brown, discoloured paper, $26 \times 21\frac{1}{4}$ inches (66×54 cm), by GEORGE KOBERWEIN, 1868. PLATE 65

Signed and dated (bottom left): G. Koberwein 1868.

Collections: By descent to the sitter's great-granddaughter, Mrs A.H.Walker, and presented by her, 1943.

Description: Florid complexion, blue eyes, greying hair. Dressed in a dark stock, white shirt, dark coat.

ICONOGRAPHY There is a painting attributed to W.Hilton, and a bust by J.Ternouth, exhibited *RA*, 1845 (1449), at the University Press, Cambridge, listed by J.W.Goodison, *Catalogue of Cambridge Portraits* (1955), p179 (329 and 330); a woodcut was published *ILN*, LXXV (1879), 280.

BONE *Robert Trewick* (*1790–1840*)

One of a family of artists; painter of sacred, classic and domestic subjects.

4233 Oil on millboard, $9\frac{3}{4} \times 7\frac{7}{8}$ inches ($24\cdot5 \times 20$ cm), by JOHN PARTRIDGE, 1836. PLATE 66

Inscribed on an early label on the reverse, in the artist's hand: R T Bone / by J Partridge / 1836

Collections: The artist; by descent to his nephew, Sir Bernard Partridge, and bequeathed by his widow, Lady Partridge, 1961.

Exhibitions: Themes and Variations: the Sketching Society: 1799–1851, Victoria and Albert Museum, 1971.

waistcoat and black coat, with gold ring and fob. Seated in a red chair. Reddish-brown book. Background colour light brown.

2515 (56) Black chalk, with touches of Chinese white, on green-tinted paper, $14\frac{5}{8} \times 10\frac{5}{8}$ inches (37·2 × 27 cm), by WILLIAM BROCKEDON, 1831. PLATE 73

Dated (lower left): 13–9. 31

Collections: See *Collections:* 'Drawings of Prominent People, 1823–49' by W. Brockedon, p 554.

Accompanied in the Brockedon Album by a letter from the sitter, dated 6 September 1833.

2550 Pencil on paper, $7\frac{1}{2} \times 9\frac{1}{4}$ inches (19 × 23·5 cm), by an UNKNOWN ARTIST, 1854. PLATE 74

Inscribed in pencil (lower left): March 26th 1854. / Pen: & Ori: steamship "Hindostan" *and in ink, possibly an autograph (bottom centre):* Sir John Bowring

Collections: W. C. Edwards, presented by him, 1932.

In 1854 Bowring was appointed as plenipotentiary to China, and governor, commander-in-chief and vice-admiral of Hong Kong. He was knighted shortly before his departure in February. This drawing was presumably executed on Bowring's sea journey to the Far East.

1082 Bronze medallion, $6\frac{1}{2}$ inches (16·5 cm) diameter, by PIERRE DAVID D'ANGERS, 1832. PLATE 72

Incised (left rim): JOHN BOWRING *and (bottom centre):* P. D. David/1832

Collections: L. Richard; his son-in-law; F. P. Webber; Sir Lionel Cust, presented by him, 1897.

Literature: R. Gunnis, *Dictionary of British Sculptors* (1953), p 121.

According to Webber (letter in NPG archives), this medallion was cast in the Paris foundry of L. Richard. Cust also presented a medallion of Amelia Opie (NPG 1081), and purchased for himself the medallions of Canning, Brunel, Byron, Flaxman, Franklin, Ross, Admiral Smith, Leader and Lord Rivers. Bowring owned the marble bust of Bentham by P. David D'Angers, exhibited R A, 1829 (1189). Another cast of the NPG medallion is in the Musée des Beaux-Arts, Angers.

599 See *Groups:* 'The Anti-Slavery Society Convention, 1840' by B. R. Haydon, p 538.

ICONOGRAPHY

1826 Painting by J. King (NPG 1113 above).

c 1829 Painting by H. W. Pickersgill. Exhibited *R A*, 1829 (477).
Engraved by and published W. Ward, 1832 (example in NPG). Possibly the portrait in the Pickersgill Sale, Christie's, 17 July 1875 (lot 333); see also under 1860 below.

1831 Drawing by W. Brockedon (NPG 2515 (56) above).

1832 Medallion by P. David D'Angers (NPG 1082 above).

1832 'The Reform Banquet, 1832' by B. R. Haydon. Collection of Lady Mary Howick.
Etched by F. Bromley, published J. C. Bromley, 1835 (example in NPG); engraved by and published J. C. Bromley, 1837 (example in British Museum). Haydon records a study of Bowring, drawn in 1833, in his *Diary*, edited W. D. Pope (1963), IV, 108.

c 1835 Bust by E. Ryley. Exhibited *R A*, 1835 (1125).

1837 Drawing by J. Doyle (caricature). British Museum.

1840 Engraving by W. Holl, after B. E. Duppa, published 1840 (example in NPG), for Saunders' 'Political Reformers'.

1840 'The Anti-Slavery Society Convention, 1840' by B. R. Haydon (NPG 599 above).

1842 Woodcut published *I L N*, I (1842), 476.

1844 Engraving by J. Stephenson, after C. A. Du Val, published Ackermann and Agnew, 1844 (example in British Museum).

1844 Drawing by C. Martin. British Museum.
Reproduced as a coloured lithograph C. Martin, *Twelve Victorian Celebrities* (1899), plate IV.

c 1848 Miniature by B. R. Green. Exhibited *RA*, 1848 (1033).
Lithographed by J. H. Lynch, published A. Hall (example in NPG).

1850 'The Anti-Corn Law League', engraving by S. Bellin, after a painting by J. R. Herbert of 1847, published Agnew, 1850 (example in NPG).

1854 Drawing by an unknown artist (NPG 2550 above).

1854 Woodcut, after a photograph by Mayall, published *ILN*, XXIV (1854), 152.

c 1860 Painting by H. W. Pickersgill. Exhibited *RA*, 1860 (11).

1867 Drawing by R. Lehmann. British Museum.

c 1869 Marble bust by E. B. Stephens. Exhibited *RA*, 1869 (1235).

1872 Woodcut published *ILN*, LXI (1872), 541.

c 1874 Bust by W. J. S. Webber. Exhibited *RA*, 1874 (1577).

Undated Painting by W. Tannock. Recorded by G. Scharf, 1876, 'TSB' (NPG archives), XXIV, 68.

Undated Drawing by an unknown artist. Collection of John Keswick.

Undated Anonymous engraving (example in NPG).

Undated Woodcut, after a photograph by Maull and Polyblank, published *ILN*, XXXVII (1860), 506. A painting by a Chinese artist after the same photograph, was offered to the NPG in 1952, by a descendant of Bowring.

BOXALL *Sir William* (*1800–79*)

Portrait painter; studied at RA schools, and in Italy; first exhibited at RA, 1823; elected an RA, 1863; director of the National Gallery, 1865–74; knighted, 1867.

937 Oil on canvas, $27\frac{1}{4} \times 23\frac{5}{8}$ inches (69·2 × 60 cm), by MICHEL ANGELO PITTATORE, 1870. PLATE 76

Collections: Dr Federico Sacchi, first offered by him, 1880, and finally purchased, 1892.

According to a letter from Sir F. W. Burton (3 January 1880, when the portrait was first offered, NPG archives):

The portrait in question was laid in from a large & excellent photograph by Caldesi, which Boxall had had done – but of which the negative was unfortunately broken, so that I believe it yielded but one impression. The painter had sittings from Boxall to complete his portrait. The head only remained unfinished.

According to the donor, who was Boxall's secretary for a time, Pittatore obtained two sittings from the artist in 1870. Pittatore was born at Asti in Piedmont around 1810–20, and came to England in 1862, where he worked for a time as an assistant to R. Lehmann and Boxall, helping to prepare replicas. He painted portraits of several musicians, and also portraits of Mrs R. Sassoon, Sir Moses Montefiore, and the Hon Arthur Kinnaird, the latter exhibited *RA*, 1869 (93). A portrait of Lord Napier of Magdala, painted in one sitting in 1869, was also offered to the NPG by Dr Sacchi, but declined. Pittatore returned to Italy in 1872, where he continued to paint. This information is contained in two letters from the vendor of 19 July 1890 and 19 November 1892 (NPG archives).

Description: Brown eyes, brown hair, grey whiskers. Dressed in a black stock, white shirt, dark brown waistcoat and coat, holding a painting-brush (?). Background colour brown.

ICONOGRAPHY A painting called Boxall by an unknown artist is in the National Gallery; a drawing by Lady Coleridge was exhibited *RA*, 1874 (1217); there are three photographs in the NPG, and a woodcut, after another, was published *ILN*, XLIII (1863), 80.

BOYS *Thomas Shotter* (*1803–74*)

Water-colourist and lithographer; articled to George Cooke, the engraver; studied with Bonington who persuaded him to become a painter; made several continental sketching tours; published his famous 'Picturesque Architecture in Paris, Ghent, Antwerp, Rouen' etc, in 1839, and his 'Views of London', 1843; noted chiefly for his elaborate topographical water-colours.

4820 White ceramic plaque with fired enamel colours, 8 inches (20·2 cm) diameter, by EMILE AUBERT LESSORE, 1856. PLATE 77

Signed (*bottom right*): E Lessore *Inscribed on the back in enamel colour:* T.S.Boys/53./anno 1856

Collections: Purchased from David Collins, 1970.

Lessore exhibited portraits and landscapes at the Salon in Paris from 1831–69. In 1855 he began working for Sèvres as a ceramic painter. He came to England in 1858, and worked for several years with Wedgwood and Minton. The transparent, water-colour effect of NPG 4820 is very characteristic of Lessore's ceramic work, though no other portrait plaques of this kind have as yet been recorded; most of his extant work, on plates and other ceramic wares (a number of examples in the Victoria and Albert Museum, and elsewhere), consists of idealized and decorative figure subjects. However, Lessore evidently had some experience as a conventional portraitist, which would explain the high quality of the NPG plaque as a work of portraiture. He was a great admirer of the English water-colourists (see, for example, his attitude to Cox, *Art Journal* (1876), p203, and consciously modelled his style on theirs. This would explain his connection with Boys, though there is no documentation for it. No other portraits of Boys are recorded. The signature on the plaque is difficult to decipher, but follows a common variant form. The attribution was confirmed by Mrs Helen Lessore, the wife of the artist's grandson.

Description: Healthy complexion, grey hair. Dressed in a white shirt, brown neck-tie and brown coat. Reddish curtain behind at left. Brown and greenish landscape at right, and above a blue and greyish sky. The plaque has one small chip, on the rim at the top.

BRADBURN *George*

American slavery abolitionist.

599 See *Groups:* 'The Anti-Slavery Society Convention, 1840' by B.R.Haydon, p538.

BRADSHAW *George* (*1801–53*)

Originator of railway guides; engraver and printer at Belfast and afterwards at Manchester; first produced, 1839, *Railway Time Tables*, which developed into *Bradshaw's Monthly Railway Guide* (first published, 1841).

2201 Oil on canvas, 36 × 28 inches (91·5 × 71·1 cm), by RICHARD EVANS, 1841. PLATE 78

Collections: The sitter, bequeathed by his son, Christopher Bradshaw, 1928.

The name of the artist and the date were contained in the will of Christopher Bradshaw (relevant extract in letter from his executors of 26 June 1928, NPG archives). On the wall behind the sitter is one of his maps of the railways. This is the only recorded portrait of him.

Description: Fair complexion, grey eyes, brown hair with grey streaks. Dressed in a white stock, white shirt, and very dark grey suit. Seated in an armchair with deep red covering. Map on wall light grey colour. Rest of background dark brown.

BRANDE *William Thomas* (*1788–1866*)

Chemist; FRS, 1809; professor of chemistry, 1812, and later of materia medica, to the Apothecaries' Company; succeeded Davy as professor of chemistry at the Royal Institution, 1813; joint editor of *Quarterly Journal of Science and Art*, 1825; one of secretaries of Royal Society, 1816–26; published numerous scientific works.

4819 Medallion, white plaster figure on black slate(?), $3\frac{3}{4} \times 3\frac{1}{4}$ inches ($9 \cdot 5 \times 8 \cdot 2$ cm) oval, by TROYE, *c* 1820.
PLATE 79

Incised under shoulders of figure on cut-away: Troye fecit:

Inscribed in ink in an old hand, on a label on the back of the frame: This portrait of W. P. Brande – Professor/of Chemistry, Royal Institution, Albemarle/Street, London, & one of the Secretaries/of the Royal Society – was executed/for Mrs Daniell wife of George Daniell/Barrister at law, & mother of Jno. Fredc./ Daniell, Professor of Chemistry, King's/Coll. Lond. & forn [*foreign*] Secy of the Royl. Society/The date of its execution,/ Mr Thos Wilkinson conjectures, may/be in or between the years 1814 & 1820/ The likeness excellent/T Wilkinson
 Below this is a printed cutting from *The Times* of February 1866, mentioning Brande's death.

Collections: Mrs George Daniell; purchased from Daniel Shackleton, 1970.

The identification of this medallion rests on the inscription. This may have been written by a certain Major Thomas Wilkinson of the Indian army, who was a member of the Royal Institution from 1847–1857 (Brande retired from the Royal Institution in 1852). John Frederic Daniell (1790–1845), mentioned in the label, was a distinguished physicist. The identity of the artist is still obscure. Another similarly signed medallion of the Countess of Stamford is in the collection of the Earl of Stamford; the signature has sometimes been read as 'Troyes' (see R. Gunnis, *Dictionary of British Sculptors*, 1953, p 400), but the squiggle after the 'e', which the NPG medallion also has, seems to be merely a flourish. E. J. Pyke (information kindly communicated to compiler) has tentatively suggested that the artist may have been Jean Baptiste Troy (or Troye), who is known to have been in England in the early 19th century. His son, Edward Troye (1808–74), became a successful painter in America; for him and his father, see the *Dictionary of American Biography* and the *New York Historical Society's Dictionary of Artists in America* (1957).

ICONOGRAPHY A painting by H. W. Pickersgill is in the Royal Institution, London, exhibited *RA*, 1830 (353), and *SKM*, 1868 (483); a painting by H. Weigall is in the Society of Apothecaries, London, exhibited *RA*, 1859 (436); a miniature by Sir W. J. Newton was exhibited *RA*, 1851 (1025); there is a lithograph by T. Bridgford, and another by M. Gauci, after L. Wyon (examples in British Museum); an engraving by C. W. Sharpe, after L. Wyon, was published Mackenzie, Glasgow (example in NPG); Brande also appears in a lithograph by Shappen of 'Celebrated English Chemists', after daguerreotypes by Mayall, published 1850 (example in British Museum).

BRAY *Anna Eliza* (*1790–1883*)

Novelist; *née* Kempe; married first the artist, Charles Alfred Stothard (1786–1821), and secondly the Rev Edward Atkyns Bray (1778–1857); published several novels of historical character between 1826 and 1874, besides other writings.

2515 (71) Black and red chalk, with touches of Chinese white, on green-tinted paper, $13\frac{3}{4} \times 10\frac{1}{4}$ inches (34·9 × 26·1 cm), by WILLIAM BROCKEDON, 1834. PLATE 80

Dated (*lower right*): 2.8.34

Collections: See *Collections:* 'Drawings of Prominent People, 1823–49' by W. Brockedon, p 554.

Accompanied in the Brockedon Album by a letter from the sitter, dated 19 July 1834.

ICONOGRAPHY The only other recorded likenesses of Mrs Bray are, two miniatures by W. Patten, exhibited *RA*, 1829 (706), and 1831 (576); one of these was engraved by T. Goodman, anonymously, and by F. C. Lewis (examples in NPG).

BREADALBANE *John Campbell, 2nd Marquess of* (*1796–1862*)

MP for Okehampton, 1820–6, and for Perthshire, 1832; succeeded as marquess, 1834; entertained Queen Victoria at Taymouth, 1842; a strenuous free churchman in the disruption controversy.

2510 Oil on millboard, $13\frac{3}{8} \times 10\frac{3}{8}$ inches (34 × 26·3 cm), by SIR GEORGE HAYTER, 1834. PLATE 81

Inscribed on a piece of paper, originally on the back of the frame, in the artist's hand: The Rt Honble Lord Ormelie. M.P. for Perthshire/Study for my large picture of the/House of Commons. 1833./G. Hayter/1834.

Collections: Hayter Sale, Christie's, 21 April 1871 (lot 496), bought Miller; Queen Mary, presented by her, 1931.

This is a study for Hayter's large picture of 'The House of Commons, 1833' (see NPG 54 below). It was presented at the same time as an oil sketch of Admiral Sir George Elliot (NPG 2511) for the same picture. Both sketches were purchased by Queen Mary from a shop in Harrogate.

Description: Pale blue eyes, brown hair and whiskers. Dressed in a red uniform with black and silver collar, silver epaulettes, holding a white sheet of paper.

54 See *Groups:* 'The House of Commons, 1833' by Sir G. Hayter, p 526.

ICONOGRAPHY A painting by J. M. Barclay was exhibited *RA*, 1850 (311), probably the painting attributed to Barclay in the collection of the Marquess of Breadalbane, Invereil, where there is also a painting by an unknown artist; a painting by Colvin Smith of 1842 is listed in R. C. M. Colvin Smith, *The Life and Works of Colvin Smith, R.S.A.* (1939), p 79 (77); an oil sketch of Breadalbane, with three other peers, by Sir George Harvey is in the Scottish NPG; a bust by B. Thorvaldsen is in the Thorvaldsen Museum, Copenhagen.

BREWSTER *Sir David* (*1781–1868*)

Scientist; editor of *Edinburgh Magazine*, and *Edinburgh Encyclopaedia*; royal medallist for discoveries in relation to polarisation of light; invented kaleidoscope; vice-chancellor of Edinburgh University, 1860; published several works relating chiefly to his optical investigations.

691 Oil on canvas, $50 \times 39\frac{3}{4}$ (127 × 101 cm), by SIR JOHN WATSON GORDON, 1864. PLATE 82

Signed and dated (*lower right*): Sir John Watson Gordon/R.A. & P.R.S.A. Pinxit/1864

Collections: The artist; presented by his brother, Henry Gordon, to the National Gallery, 1865, and subsequently transferred.

Exhibitions: *SKM*, 1868 (484).

Literature: National Gallery, Millbank: Catalogue of the British School (1929), p 141.

This portrait was painted shortly before Gordon's death, and was the last work he completed.

Description: Blue eyes, grey hair. Dressed in a dark green stock, white shirt, dark brown coat and yellow jewelled stock-pin. Seated in a red armchair, holding a pair of spectacles in one hand, and a green object (spectacle case?) in the other. Background colour very dark brown.

ICONOGRAPHY This does not include photographs, of which there are several examples in the NPG, and three photographs in the Scottish NPG by D.O. Hill.

Before 1823	Painting by Sir H. Raeburn. Ex-Raeburn family, Christie's, 16 July 1887 (lot 64). Exhibited *Exhibition of the Works of Sir Henry Raeburn*, Edinburgh, 1876, (168). Engraved by W. Holl, published Fisher, Son & Co, 1832 (example in NPG), for Jerdan's 'National Portrait Gallery'.
1824	Drawing by W. Bewick. Scottish NPG.
1832	Engraving by D. Maclise, published *Fraser's Magazine*, VI (1832), facing 416, as no. 30 in Maclise's 'Gallery of Illustrious Literary Characters'. Pencil study: Victoria and Albert Museum.
1835	'The Fraserians', engraving by D. Maclise, published *Fraser's Magazine*, XI (1835), between 2 and 3. Two pencil studies: Victoria and Albert Museum.
1848	Engraving by F. Croll, published 1848 (example in NPG), for *Hogg's Weekly Instructor*.
1849	Engraving by W.H. Mote (example in NPG), published D. Bogue, for *Year-book of Facts 1849*, frontispiece.
1852	Painting by J. Wilson. University of Glasgow.
c1853	Painting by W.S. Herrick. Exhibited *RA*, 1853 (481).
1857	Drawing by R. Lehmann. British Museum. Probably the portrait exhibited *RA*, 1869 (1135). Reproduced R. Lehmann, *Men and Women of the Century* (1896), no. 9.
1864	Painting by Sir J. Watson Gordon (NPG 691 above).
1864	'The Intellect and Valour of Great Britain', engraving by C.G. Lewis, after T.J. Barker, published J.G. Browne, Leicester, 1864 (example in NPG); key-plate, published Browne, 1863 (example in British Museum).
c1864	Painting by N. Macbeth. Exhibited *RA*, 1864 (459).
c1867	Marble bust (?) by Mrs D.O. Hill. Exhibited *RA*, 1867 (1182).
1868	Woodcut published *ILN*, LII (1868), 189.
c1868	Marble bust by Mrs D.O. Hill (modelled in 1866). Exhibited *RA*, 1868 (1128).
c1869	Painting by N. Macbeth. Royal Society of Edinburgh. Exhibited *RA*, 1869 (222), *Scottish National Portraits*, Edinburgh, 1884 (376), and *VE*, 1892 (93).
1871	Statue by W. Brodie. University of Edinburgh. Reproduced as a woodcut *ILN*, LVIII (1871), 398.
Undated	Painting by Wighton. University of Edinburgh. See D. Talbot Rice and P. McIntyre, *The University Portraits* (1957), pp 21–3.

BRIGHT *John* (*1811–89*)

Prominent radical politician, orator and statesman; with Cobden led the agitation for the repeal of the Corn Laws; active political, social and economic reformer; served in several ministries; one of the most influential and important political figures of the age.

817 Oil on canvas, $50\frac{1}{4} \times 40$ inches ($127 \cdot 6 \times 101 \cdot 6$ cm), by WALTER WILLIAM OULESS, 1879. PLATE 89
Signed and dated (lower left): W.W. Ouless/1879

Collections: Christie's, 4 May 1889 (lot 123), bought Leopold Salomons, and presented by him, 1889.

Literature: The Diaries of John Bright, edited R.A.J.Walling (1930), p448 and n.

Ouless painted another portrait of Bright, also signed and dated 1879, which is now in the Manchester Reform Club. It was exhibited *RA*, 1879 (183), etched by P.Rajon, and engraved by P.Naumann (examples in British Museum). It shows Bright seated in the same chair as in the NPG portrait, but facing the other way, holding a book with both hands on his crossed knees. Sittings for this portrait are recorded in Bright's diary from 13 June 1878 to 3 April 1879, when Bright wrote: '*Jas H. Tuke with me to Mr Ouless, who made a slight alteration in the portrait; but I do not think he has been successful with my likeness*' (Walling, p421). The entry in Bright's diary for 17 August 1879 must refer to the NPG portrait, as the Manchester Reform Club portrait had to be finished for the opening of the Royal Academy in May: '*To Mr Ouless – final sitting. My bro.-in-law Vaughan there. He likes the portrait*' (Walling, p448). Bright's daughter, Priscilla, also approved of the portrait when she went to see it on 1 September (Walling, p448). It is not known who commissioned the NPG portrait. It is significantly close to photographs of Bright by Rupert Potter taken in 1873 (examples in NPG), and a later photograph by Barraud (example in NPG), where the gesture of the hand propping up the head is almost identical, so that it may not have been painted entirely from the life.

Description: Healthy complexion, dark eyes, greyish hair. Dressed in a white shirt, dark stock, black suit, with a gold stock-pin and watch-chain. Seated in a wooden chair. Background colour dark brown.

2322 With W.H.Smith and others. Pencil on paper, $4\frac{3}{8} \times 6\frac{7}{8}$ inches (11 × 17.5 cm), by SYDNEY PRIOR HALL, 1887. PLATE 84

Inscribed in pencil (top left): H of C. *(lower centre):* W.H.Smith. *(centre right):* John Bright *and (bottom right):* – 87

Collections: Presented by the artist's son, Dr H.R.Hall, 1929.

This is one of a series of studies which will be catalogued collectively in the forthcoming Catalogue of Portraits, 1860–90.

3345 Pen and ink on card, $12\frac{1}{2} \times 7\frac{3}{8}$ inches (31.8 × 18.9 cm), by HARRY FURNISS. PLATE 86

Signed (lower right): Hy. F. *Inscribed in ink (top right):* John Bright

Collections: Purchased from the artist's sons, through Theodore Cluse, 1947.

Literature: H.Furniss, 'Private Register' (MS extract, NPG archives), no.2682, entered after October 1917 as unpublished.

This is one of a series of studies which will be collectively discussed in the forthcoming Catalogue of Portraits, 1860–90. Another drawing of Bright by Furniss is reproduced in his *Some Victorian Men* (1924), facing p18.

3808 Pencil on paper, 8 × 5 inches (20.3 × 12.8 cm), by FREDERICK SARGENT. PLATE 87

Autograph in the sitter's hand (lower right): John Bright

Collections: Sir Thomas Thornhill; J.A.Tooth's Galleries, purchased from them, 1951.

Exhibitions: Exhibition of Drawings by Frederick Sargent of Members of the House of Lords, Tooth's Galleries, London, June 1951 (16).

One of a hundred and sixteen drawings acquired by J.A.Tooth, almost all of members of the House of Lords. This drawing of Bright is one of the few exceptions. It is presumably related to one of Sargent's many paintings of the House of Commons.

868 Plaster cast, painted black, 28 inches (71.2 cm) high, of a bust by SIR JOSEPH EDGAR BOEHM, 1881. PLATE 85

Incised on the back below the shoulders: The Rt. Hon. JOHN BRIGHT. May 1881.

Collections: Purchased from the artist's executors, 1891.

Closely related to the marble bust of Bright by Boehm in the collection of the Earl of Rosebery, Dalmeny, exhibited *RA*, 1882 (1677). A terra-cotta version was exhibited *VE*, 1892 (1073), lent by Boehm's executors. Bright records several sittings with Boehm during May 1881 and March 1882 (see *Diaries of John Bright*, edited R.A.J.Walling (1930), pp 463–5, and 476).

ICONOGRAPHY
This does not include caricatures or photographs (see plate 88), of which there are several examples in the NPG.

1843 Painting by C.A.DuVal. Collection of Lord Aberconway, Bodnant (plate 83).
Exhibited *RA*, 1843 (446). Presumably the portrait engraved by S.W.Reynolds, with variations, published Ackermann and Agnew, 1843 (example in NPG).

c1847 Lithograph by G.B.Black (example in NPG). Reproduced J.T.Mills, *John Bright and the Quakers* (1935), II, facing 158.

1847–9 Two paintings by J.P.Knight. Exhibited *RA*, 1847 (181), and 1849 (71).

1847 'The Anti-Corn Law League', engraving by S.Bellin, after a painting by J.R.Herbert of 1847, published Agnew, 1850 (example in NPG).

c1847 Bust by C.A.Rivers. Exhibited *RA*, 1847 (1297).

1858 'Baron Lionel de Rothschild Introduced into the House of Commons, 1858' by H.Barraud. Rothschild Collection.

1860 'The House of Commons, 1860' by J.Phillip. Houses of Parliament.
Engraved by T.O.Barlow, published Agnew & Sons, 1866 (example in NPG).

1860 'Bright Reform Bomb', painting by G.Cruikshank. House of Commons.
Etched key, published W.Tweedie, 1861 (example in House of Commons).

1860 Bust by K.Borycreski. Exhibited *RA*, 1860 (1009).

1861 Engraving by J.H.Baker, after L.Dickinson, published Fairless, Newcastle, 1861 (example in British Museum), engraving exhibited *RA*, 1861 (935).

1862 Painting by B.R.Andrew. Collection of W.J.Lewington, 1930.

1862 'Treaty of Commerce, 1862', woodcut by Eastham, published *ILN*, XL (1862), 230–1.

1865 Three paintings by G.Fagnani. New York Chamber of Commerce; Union League Club, New York; formerly collection of Mrs Bright. Fagnani also painted a joint portrait of Cobden and Bright for the Corporation of Rochdale.

1869 Painting by C.Lucy. Victoria and Albert Museum, London.

c1869 Marble bust by N.N.Burnard. Exhibited *RA*, 1869 (1287).

c1870 Marble bust by J.Adams-Acton. Exhibited *RA*, 1870 (1202).
Either the bust in the National Liberal Club, London, or the bust in the collection of Lady Josephine Chance, 1938 (see under 1889 below).

1874 Painting by L.Dickinson. Reform Club, London.
Exhibited *RA*, 1874 (112). Copy by Hillyard Swinstead: National Liberal Club, London.

c1877 Marble statue(?) by W.Theed. Manchester City Hall.
Exhibited *RA*, 1877 (1417).

1878 Marble bust by G.Burnard. Exhibited *RA*, 1878 (1462).

1879 Painting by W.T.Roden. City Museum and Art Gallery, Birmingham.

1879 Paintings by W.W.Ouless (see NPG 817 above).

1880 Painting by Sir J. E. Millais. Collection of Lord Aberconway, Bodnant.
Exhibited *RA*, 1880 (322), and *VE*, 1892 (136). Engraved by T. O. Barlow, published Agnew, 1882 (example in NPG), engraving exhibited *RA*, 1882 (1284). Copy by R. Fowler: Houses of Parliament. The pose in Millais' portrait is identical to that in a photograph by R. Potter (example in NPG, plate 88); a drawing by T. B. Wirgman, after the photograph, was published *Daily Chronicle*, 27 June 1896.

1881 'The Private View of the Royal Academy' by W. P. Frith. Collection of A. C. R. Pope.
Reproduced *Studio*, CIX (1935), 294.

1882 Painting by F. Holl. City Museum and Art Gallery, Birmingham (on loan from Birmingham Liberal Association). Exhibited *RA*, 1883 (278). Reproduced Sir H. Maxwell, *Sixty Years a Queen* (1897), p 35.

c 1882 Miniature by Mrs S. W. North. Exhibited *RA*, 1882 (1376).

1882 Marble bust by Sir J. E. Boehm. Collection of the Earl of Rosebery, Dalmeny.
Exhibited *RA*, 1882 (1677). Related plaster cast (NPG 868 above). Terra-cotta version exhibited *VE*, 1892 (1073).

1883 Painting by E. Crowe (at the Reform Club). Collection of Mr Lewis, 1932. Exhibited *RA*, 1904 (739). Reproduced Cassell's *Royal Academy Pictures* (1904), p 64.

1884 Drawing by T. B. Wirgman (in his study). Published as a supplement to *The Graphic*, 28 November 1885.

1887 Painting by F. Holl. Reform Club, London.

1887 Drawing by S. P. Hall (NPG 2322 above).

c 1887 Painting by W. B. Morris. Exhibited *RA*, 1887 (367).

c 1889 Marble bust by J. Adams-Acton. Exhibited *RA*, 1889 (2021).
Either the bust in the National Liberal Club, or the bust in the collection of Lady Josephine Chance, 1938 (see under 1870 above).

1891 Bronze statue by Sir W. H. Thornycroft. Rochdale.
Model for this statue exhibited *RA*, 1892 (1868), reproduced Cassell's *Royal Academy Pictures* (1892), p 154. Statue (*in situ*) reproduced J. T. Mills, *John Bright and the Quakers* (1935), II, facing 332. A bronze statuette by Thornycroft of 1891 is in the National Liberal Club, London.

1891 Marble statue by A. B. Joy. Manchester.
Reproduced *Magazine of Art* (1892), p 70. Statue (*in situ*) reproduced J. T. Mills, *John Bright and the Quakers*, II, frontispiece.

c 1892 Marble statue by A. B. Joy. City Museum and Art Gallery, Birmingham.
Reproduced *Diaries of John Bright*, edited R. A. J. Walling (1930), facing p 538. Model for this statue exhibited *RA*, 1893 (1677). A replica of *c* 1902 is in the Houses of Parliament.

1896 Statue by A. Gilbert. National Liberal Club, London.

Undated Painting by Mrs L. Whaite. *London International Exhibition*, 1874 (579).

Undated Drawing by H. Furniss (NPG 3345 above).

Undated Drawing by F. Sargent (NPG 3808 above).

Undated Marble bust by an unknown artist. Lady Lever Art Gallery, Port Sunlight.

Undated Terra-cotta bust by A. Bennet. Gladstone Collection, Hawarden Castle.

Undated Lithograph by W. H. McFarlane; anonymous lithograph; coloured lithograph, published Cassell, Petter, and Galpin; etching by Burton (examples in NPG); etching by C. Laurie (example in British Museum).

BRISTOL *Frederick William Hervey, 2nd Marquess of (1800–64)*

MP for Bury St Edmunds.

54 See *Groups:* 'The House of Commons, 1833' by Sir G. Hayter, p 526.

BRITTON *John (1771–1857)*

Antiquary and topographer; published *Architectural Beauties of Great Britain*, 1805–14, with supplement, 1818–26, and other writings, including an *Autobiography*, 1850; one of the leading figures in the neo-Gothic revival.

667 Oil on canvas, $17\frac{3}{8} \times 14$ inches ($44 \cdot 3 \times 35 \cdot 5$ cm), by JOHN WOOD, 1845. PLATE 90

Signed and dated (bottom centre): John Wood. Pinx. 1845.

Collections: The sitter, presented by his widow, Mrs Helen Britton, 1882.

The picture was engraved by C. E. Wagstaff, published 1847 (example in NPG), for Britton's *Autobiography* (1849), frontispiece. On the table are busts of Shakespeare and the famous antiquarian, William Camden (1551–1623), taken from their funeral monuments (in the engraving the two busts appear in the reverse order). These two busts also appear in the engraving by Thomson after a drawing by Uwins (see iconography below). In 1816, Britton produced an engraving of Shakespeare's bust in Stratford Church with 'Remarks', later republished in his *Autobiography*. The model of a monument on the table also probably has a precise relation to Britton's writings. The plans on which his right hand rests are of Stonehenge; in 1842 he published an essay on Avebury and Stonehenge, also later republished in his *Autobiography*. Similar plans appear in the Uwins drawing. The chair in which Britton sits is reminiscent of A. C. Pugin's designs, and expresses Britton's overwhelming Gothic sympathies. He and Pugin actually collaborated on a number of architectural books.

An earlier painting of Britton by Wood was engraved by J. Thomson, under Britton's direction, and published by H. Fisher, Son & Co, 1828 (example in British Museum). In both this engraving and the NPG painting, Britton looks considerably younger than his age.

Description: Healthy complexion, dark blue eyes, brown hair and whiskers with grey streaks. Dressed in a white shirt, black stock and black suit. Seated in a wooden chair with red velvet covering. Book bottom left with turquoise-coloured marker. Background colour, including books, busts, table, etc, brown. Black inkstand. Background colour behind chair almost black.

2515 (44) Black and red chalk, with touches of Chinese white, on blue-tinted paper, $13\frac{1}{4} \times 9\frac{7}{8}$ inches ($33 \cdot 6 \times 25 \cdot 1$ cm), by WILLIAM BROCKEDON, 1831. PLATE 91

Dated (lower right): 28.12.31

Collections: See *Collections:* 'Drawings of Prominent People, 1823–49' by W. Brockedon, p 554.

Accompanied in the Brockedon Album by a letter from the sitter, dated 6 June 1833.

ICONOGRAPHY Two miniatures by R. W. Satchwell were exhibited *RA*, 1804 (797), and 1805 (542); a miniature by W. Essex was exhibited *RA*, 1854 (662); a bust by W. Scoular was exhibited *RA*, 1819 (1229), engraved by S. Williams, published 1841, with a sonnet by J. Ellis to celebrate Britton's 70th birthday (example in NPG), and anonymously (example in British Museum); an engraving by J. Thomson, after T. Uwins, was published 1820 (example in NPG), for the *European Magazine* (in another version of this engraving (example in NPG), the artists are said to have been Uwins and R. Satchwell); an engraving by J. H. Le Keux, after a photograph by Claudet, was published 1852 (example in British Museum).

BROCK *Rev William (1807–75)*

President of the Baptist Union of Great Britain and Ireland; author of controversial religious works; slavery abolitionist.

599 See *Groups:* 'The Anti-Slavery Society Convention, 1840' by B. R. Haydon, p 538.

BROCKEDON *William* (*1787–1854*)

Painter, author and inventor; exhibited at RA and British Institution, 1812–37; made many journeys to the Alps, and published various books of views and illustrations; took out patents for inventions.

4653 Pencil, coloured chalk and stump on blue/grey tinted paper, $13\frac{1}{2} \times 9\frac{3}{8}$ inches (34·5 × 23·8 cm), by CLARKSON STANFIELD. PLATE 92

Inscribed in pencil (*bottom right*): W.B. Esq^re./ by Stanfield

Collections: A. Yakovleff, purchased from him, 1968.

The identification is supported by comparison with other known portraits of Brockedon. The style of the drawing is not unlike that of Brockedon himself (see his drawings of 'Prominent People', NPG 2515, p 554). An inscription in ink on a separate piece of paper, which came with the drawing, is of doubtful significance: 'Principe del Monte Viso/E.b.v. ? [?]'. There is a Christie's stencil on the back of the drawing relating to their sale on 12 December 1967; the drawing of Brockedon does not, however, appear to have been included in this sale.

ICONOGRAPHY A painting by himself is in the Uffizi Gallery, Florence; a painting by H. W. Phillips, and a miniature by Sir W. J. Newton, were exhibited *RA*, 1848 (289), and 1853 (880), respectively; a drawing by C. Turner was exhibited *RA*, 1833 (486), engraved by the artist, published by him and others, 1835 (example in NPG).

BRODIE *William Bird* (*1780–1863*)

MP for Salisbury.

54 See *Groups:* 'The House of Commons, 1833' by Sir G. Hayter, p 526.

THE BRONTË SISTERS

This group is catalogued here, rather than with the other groups at the end, because of its close relationship with the portrait of Emily (NPG 1724 below).

1725 Oil on canvas, $35\frac{1}{2} \times 29\frac{3}{8}$ inches (90·2 × 74·6 cm), by BRANWELL BRONTË, *c* 1834. PLATES 98–102, 104

Collections: Haworth Parsonage; inherited by the Rev A. B. Nicholls (Charlotte Brontë's husband) on the death of the Rev P. Brontë, 1861; discovered by the second Mrs Nicholls on top of a cupboard, 1914, and purchased from her through Reginald Smith in the same year.

Literature: Mrs Gaskell, *The Life of Charlotte Brontë* (first edition, 1857), edited C. Shorter (1914), pp 135, 619; Mrs E. H. Chadwick, *In the Footsteps of the Brontës* (1914), p 116, reproduced facing p 116; *The Brontës: their Lives, Friendships and Correspondence in Four Volumes* (Shakespeare Head Brontë, 1932), edited T. J. Wise and J. A. Symington, IV, 87; Dr Ingeborg Nixon, 'The Brontë Portraits: Some Old Problems and a New Discovery', *Brontë Society Transactions*, part LXVIII (1958).

The figures in this painting (Anne on the left, Emily in the centre, and Charlotte on the right) are identified by Mrs Gaskell's famous description of it (*Life of Charlotte Brontë*, 1914, p 135):

I have seen an oil painting of his, done I know not when, but probably about this time [1835]. It was a group of his sisters, life size, three-quarters length; not much better than sign painting, as to manipulation; but the likenesses were, I should think, admirable. I could only judge of the fidelity with which the other two were depicted from the striking resemblance which Charlotte, upholding the great frame of canvas, and consequently standing right behind it, bore to her own representation, though it must have been ten years and more since the portraits were taken. The picture was divided, almost in the middle, by a great pillar. On the side of the column which was lighted by the sun stood Charlotte in the womanly dress of that day of

gigot sleeves and large collars. On the deeply shadowed side was Emily, with Anne's gentle face resting on her shoulder. Emily's countenance struck me as full of power; Charlotte's of solicitude; Anne's of tenderness.

In a letter describing her first visit to Haworth in 1853, Mrs Gaskell made one further comment on the portrait (*Life*, 1914, p619):

One day Miss Brontë brought down a rough, common-looking oil painting done by her brother of herself – a little rather prim-looking girl of eighteen – and the two other sisters, girls of sixteen and fourteen, with cropped hair, and sad dreamy-looking eyes.

This would date the portrait to 1834. Until its discovery in 1914 it was thought that the portrait had disappeared or been destroyed. When Clement Shorter visited the Rev Nicholls at his home in Banagher, Ireland, in 1895, he came away with the impression that the NPG fragment, representing Emily (NPG 1724 below), had been cut from the NPG group portrait, the rest of which had been destroyed. Shorter was not aware that both fragment and group portrait were lying upstairs on top of a cupboard, the group portrait having remained there apparently since Nicholls first moved to Ireland in 1861. Nicholls clearly did not want the portrait to become known, and it is surprising that it has survived. His antipathy was apparently shared by Charlotte Brontë, his first wife, who wrote, quite untruthfully, to Mr Williams in 1850 at the time when *Agnes Grey* and *Wuthering Heights* were being republished (*Life*, 1914, p481): '*I grieve to say that I possess no portrait of either of my sisters*'. She did not want Branwell's portraits to be reproduced, though she was prepared to show them to Mrs Gaskell. When the NPG group portrait was discovered, it had been removed from its stretcher, and was folded in four (the fold marks are still clearly visible).[1] Mrs Nicholls wrote about her discovery to Reginald Smith (of Smith, Elder & Co, Charlotte's publishers) in a letter of 12 February 1914 (NPG archives):

I daresay you may wonder how I never said anything of the Portraits but till about six months ago I did not know they were in the House – They must have been put in a wardrobe (top) years ago & servants took down the panel, dusted it & put them back again but about six months ago, I was sitting in the room & my nurse was settling some things for me took down the panel and asked if I knew what was in it. I did not, so was much surprised.

In a conversation at this time with her niece, Miss F. E. Bell, Mrs Nicholls remarked:

"*Your uncle disliked them very much*", *said Aunt Mary*, "*he thought they were very ugly representations of the girls, and I think meant to destroy them, but perhaps shrank from doing so – you see, there is only one other existing portrait of Charlotte, and none at all of Emily and Anne.*"[2]

In 1957, Miss Jean Nixon noticed in the group portrait the outlines of a figure underneath the pillar, (plate 101), which had been painted out. Infra-red photography revealed more clearly the figure of a man, almost certainly Branwell Brontë, who appears second from the right in the two other Brontë group portraits, the destroyed group from which the NPG fragment (NPG 1724 below) comes and the so-called 'Gun Group' (plate 93). He is dressed in a black coat and cravat, and a white shirt, and apparently fits Charlotte's description of her brother, written in the introduction to one of the Angrian stories of 1834: '. . . . *a low slightly-built man attired in a black coat . . . a bush of carroty hair so arranged that at the sides it projected almost like two spread hands. . . . black neckerchief arranged with no great attention to detail.*' It is not known why he painted himself out, unless he felt the composition was too cramped with four figures. There is no evidence for the theory that Branwell painted the portrait of his sisters on top of a canvas, which he had already used for the portrait of a man. The figure of the man is perfectly in scale with the other figures, and forms the logical apex of a triangular composition. The large, blurred pillar, is, as Dr Ingeborg Nixon suggested, of uncertain significance, and this provided her and her sister with the first clue that there might be another figure underneath.

[1] An early daguerreotype of the portrait, taken in Haworth before it was removed to Ireland by the Rev Nicholls, shows it in its original condition. The daguerreotype is reproduced by Mrs Chadwick, facing p116.

[2] *Manchester Guardian*, 17 October 1955. But see the *Sphere*, 14 March 1914, where a letter from a niece of Mrs Nicholls (possibly Miss F. E. Bell) states that Mrs Nicholls had seen the portrait of Emily, but had never seen the NPG group.

Condition: Two main folds across the middle of the canvas from top to bottom and side to side, with extensive losses of paint along them particularly in the centre. Two subsidiary folds across the canvas, one running through the eyes of Emily and Charlotte, the other through their waists and Anne's bust, with further paint losses. Painted extremely thinly, the pencil underdrawing being clearly visible, particularly on the faces. The original thin linen canvas has been laid down on a new canvas; the original stretcher marks and unpainted edge are all visible.

Description: All with brown hair and darkish eyes. Anne (left) in a dark blue dress with wide white collar, Emily (centre) in green dress with wide white collar, Charlotte (right) in brown dress with wide white collar. Reddish table-cloth and books. Pillar yellowish brown. Rest of background almost black.

BRONTË *Anne* (*1820–49*)

Novelist.

1725 See *Groups:* 'The Brontë Sisters, *c*1834' by B.Brontë, above.

BRONTË *Charlotte* (*1816–55*)

One of the remarkable Brontë sisters; a great novelist, whose books, including the well-known *Jane Eyre*, and *Villette*, significantly extended the emotional range of English fiction; married the Rev A.B.Nicholls, 1854.

1452 Coloured chalk on brown, discoloured paper, $23\frac{5}{8} \times 18\frac{3}{4}$ inches (60 × 47·8 cm), by GEORGE RICHMOND, 1850. PLATES 105, 106

Signed and dated (*bottom left*): George Richmond delnt 1850.

Collections: Commissioned by George Smith (Charlotte's publisher), and presented by him to the Rev Patrick Brontë; inherited by the Rev A.B.Nicholls (Charlotte's husband), 1861, and bequeathed by him, 1906 (it entered the collection in 1907).

Exhibitions: SKM, 1868 (569); *VE*, 1892 (369).

Literature: G.Richmond, 'Account Book' (photostat copy of original MS, NPG archives), p52, under 1850; G.Richmond, 'Extracts from Diaries' (photostat copy of original MS, NPG archives), under 13 June 1850; Clement Shorter, *Charlotte Brontë and her Circle* (1896), pp293–4; Mrs Gaskell, *Life of Charlotte Brontë*, edited C.Shorter (1914), pp57 and n, 463–6 and n, 486, 601, and 618; *George Smith: a Memoir* [by S.Lee] *with Some Pages of Autobiography*, edited Mrs G.M.Smith (privately printed London, 1902), pp103–4; A.M.W.Stirling, *The Richmond Papers* (1926), p60; *The Brontës: their Lives, Friendships and Correspondence in Four Volumes* (Shakespeare Head Brontë, 1932) edited T.J.Wise and J.A.Symington, III, 127, 129, 130–1, 168; IV, 47, 86, 88, 253; W.Gérin, *Charlotte Brontë* (1967), pp431 and 441; *Letters of Mrs Gaskell*, edited J.A.V.Chapple and A.Pollard (Manchester, 1966), pp243, 249, 345, 399, 422–3, 425, 446.

 This drawing was executed on one of Charlotte's rare visits to London. George Smith wrote (*Memoir*, pp103–4): '*During Miss Brontë's visit to us in June 1850, I persuaded her to sit to Mr George Richmond for her portrait. This I sent afterwards with an engraving of the portrait of the Duke of Wellington to her father, who was much pleased with them. Mr Richmond mentioned that when she saw the portrait (she was not allowed to see it before it was finished) she burst into tears, exclaiming that it was so like her sister Anne, who had died the year before*'. According to Winifred Gérin (p431), the likeness was to Emily, not to Anne. Mrs Stirling (*Richmond Papers*, p60) had another explanation for the tears: '*Among other tales of his sitters Richmond used to relate one of Charlotte Brontë. When, on June 13, 1850, she arrived to sit for her portrait, he noticed with perplexity that, after she had removed her hat, on the top of her head there reposed a small square of brown merino! Whether it was employed to prop up her hat, or what was its use, he could not imagine, but at last he observed deferentially: "Miss Brontë, you have a little*

pad of brown merino on the top of your head – I wonder if I might ask you to remove it?" To his dismay, Charlotte Brontë, nervous and hypersensitive, burst into tears of confusion'.

On her return to Haworth, Charlotte wrote to George Smith (letter of 27 July 1850, *Letters*, III, 127): '*Papa will write and thank you himself for the portrait when it arrives. As for me, you know, a standing interdict seals my lips it is my intention that the original drawing shall one day return to your hands. As the production of a true artist it will always have a certain worth, independently of subject'*. In the same letter, Charlotte Brontë mentioned a copy (untraced). On 1 August she wrote again, acknowledging the portrait's arrival (*Letters*, III, 130): '*Papa seems much pleased with the portrait, as do the few other persons who have seen it, with one notable exception, viz. our old servant, who tenaciously maintains that it is not like – that it is too old looking doubtless she confuses her recollections of me as I was in childhood with present impressions'*. On the same day, she wrote to Ellen Nussey (*Letters*, III, 129): '*My portrait is come from London Papa thinks the portrait looks older than I do – he says the features are far from flattered, but acknowledges that the expression is wonderfully good and life-like.'*

The Rev P.Brontë wrote a letter of thanks to Smith on 2 August 1850 (*Letters*, III, 130–1): '*The two portraits have, at length safely arrived, and have been as safely hung up, in the best light and most favourable position. Without flattery the artist, in the portrait of my daughter, has fully proved that the fame which he has acquired has been fairly earned. Without ostentatious display, with admirable tact and delicacy, he has produced a correct likeness, and succeeded in a graphic representation of mind as well as matter, and with only black and white has given prominence and seeming life, and speech, and motion. I may be partial, and perhaps somewhat enthusiastic, in this case, but in looking on the picture, which improves upon acquaintance, as all real works of art do, I fancy I see strong indications of the genius of the author of 'Shirley' and 'Jane Eyre'.'*

An unidentified friend wrote to Mrs Gaskell on 3 October 1850 (*Letters*, III, 168) that '*the Richmond, the solitary ornament of the room, looked strangely out of place on the bare walls'*. Mrs Gaskell herself thought the portrait was '*an admirable likeness, though, of course, there is some difference of opinion on the subject; and, as usual, those best acquainted with the original were least satisfied with the resemblance'* (Mrs Gaskell's *Life*, edited Shorter, p 463). The portrait was engraved by J.C.Armytage for the first edition of Mrs Gaskell's *Life* (1857), and was, thereafter, widely reproduced. Until the rediscovery of the Brontë group (NPG 1725 above), it was thought to be the only existing likeness of Charlotte.

Description: Brownish eyes, faint red on the lips and cheeks. In spite of treatment on two or three occasions, damp marks are still visible on the surface of the drawing.

1725 See *Groups:* 'The Brontë Sisters, *c* 1834' by B.Brontë, above.

BRONTË *Emily Jane* (*1818–48*)

One of the remarkable Brontë sisters; her transcendental novel, *Wuthering Heights*, is an outstanding masterpiece.

1724 Oil on canvas, approximately 20¼ × 12¾ inches (51·4 × 32·4 cm) arched top, by BRANWELL BRONTË, *c* 1833. PLATES 97, 103

Collections: Haworth Parsonage; inherited by the Rev A.B.Nicholls (Charlotte Brontë's husband), on the death of the Rev P.Brontë, 1861; possibly the picture given to Martha Brown; discovered by the second Mrs Nicholls on the top of a cupboard in 1914, and purchased from her, through Reginald Smith, in the same year.

Literature: Mrs Gaskell, *The Life of Charlotte Brontë* (first edition, 1857), edited C.K.Shorter (1914), pp 135–6 n; Mrs M.Edgerley, 'Emily Brontë: a National Portrait Vindicated', *Brontë Society Transactions*, part XLII (1932); Dr I.Nixon, 'The Brontë Portraits: Some Old Problems and a New Discovery', *Brontë Society Transactions*, LXVIII (1958); Dame Myra Curtis, 'The "Profile" Portrait', *Brontë Society Transactions*, part LXIX (1959).

This painting, which was discovered at the same time as the famous group portrait of the Brontë Sisters (see NPG 1725 above), is apparently all that remains of a group portrait of the Brontës by Branwell Brontë of which it formed the right-hand part. The shape just visible to the left is almost certainly the shoulder and arm of Branwell Brontë, who also appears second from the right in the two other Brontë groups (NPG 1725, plate 101, where he painted himself out, and the 'Gun Group', plate 93), his head forming the apex of a triangular composition. While the identification of the Brontë sisters in the surviving NPG group is now generally accepted, the identity of the sitter in this fragment is still disputed, and the claims of Emily and Anne have both been pressed.

In an interview in 1895, the Rev Nicholls told Clement Shorter that he had cut out a portrait of Emily, from a group picture, which he then destroyed, and gave the fragment to the Brontës' old servant, Martha Brown, during one of her visits to him in Ireland.[1] Martha Brown is known to have been in possession of this portrait of Emily in 1879, for in that year, Sir William Robertson Nicoll visited her in Haworth and saw it there:

I shall never cease to regret that I did not buy the portrait she had of Emily Brontë, though I got a few other things. I did not buy it because I could not very well afford it, and it has been irrevocably lost. I have made many efforts since, and have been helped by many of Martha Brown's relatives. But that really fine and expressive painting has hopelessly disappeared, and now we have nothing that deserves to be called a likeness of that rarely endowed girl.[2]

If the NPG fragment can be identified as that given to Martha Brown, then its identity as Emily is beyond dispute. Nicoll's description of Martha's portrait as '*that really fine and expressive painting*' certainly fits the NPG fragment, but so far no-one has been able to prove whether or not Martha's picture was ever returned to the Rev Nicholls. One vital piece of evidence has, however, been overlooked. In a letter to Reginald Smith (of Smith, Elder & Co, Charlotte's publishers), written soon after the discovery of the NPG group and fragment, Mrs Nicholls remarked that she had not realized that the Brontë portraits had remained in her husband's possession, but she did imply that she had already seen the fragment: '*the one of Emily I had seen, & remember Mr Nicholls telling me he had cut it out of a painting done by Branwell as he thought it good but the others were bad, & he told Martha to destroy the others*'.[3] The significant fact in this statement is that Mrs Nicholls links the NPG fragment with her husband's statement to Shorter about cutting out the portrait of Emily and giving it to Martha, and hence connects the two as one and the same picture. Other authorities have presumed that Mrs Nicholls identified the fragment as Emily because of its similarity to the portrait reproduced as the frontispiece to the Haworth edition of *Wuthering Heights*.[4] If Mrs Nicholls had already seen the NPG fragment,[5] then the likelihood of its being the Martha Brown picture increases, though how or when Martha Brown's picture was returned to the Rev Nicholls remains a mystery. Sir Robertson Nicoll (see above) mentions searching for the portrait after Martha Brown's death, but is vague about which of her relatives he talked to and when; although he was alive when the fragment entered the NPG in 1914, he did not confirm whether it was the Martha Brown picture or not. If the Martha Brown picture was returned to the Rev Nicholls, his failure to enlighten Shorter in 1895 is not surprising. He did not mention the NPG group, which he had always owned, and he is known to have disliked relic hunters, and the publicity attached to the Brontës. Indeed, he left Shorter with the impression that there had only ever been one group portrait, and that he had cut the fragment for Martha Brown out of this. If the NPG and Martha Brown pictures are, in fact, two separate fragments, as the Rev J.J. Sherrard of

[1] Mrs Gaskell's *Life* (1914), pp135–6 n.

[2] *British Weekly*, XLV (29 October 1908), p101.

[3] Letter of 12 February 1914 (copy of original letter, NPG archives).

[4] The right hand figure of the 'Gun Group' (in profile) was reproduced as the frontispiece to *Wuthering Heights*, having apparently been identified by the Rev Nicholls as Emily (see Mrs Gaskell's *Life* (1914), pp135–6 n). It almost certainly represents Anne.

[5] See the *Sphere*, 14 March 1914, where a letter from a niece of Mrs Nicholls is quoted: '*On examination Mrs Nicholls recognized the portrait of Emily as one which had been cut out of a group by Mr Nicholls, but the second picture, the group of the three sisters, she had never seen till then notwithstanding the many years it must have been in the house*'.

Banagher maintained,[1] then the possibilities multiply. Perhaps the Rev Nicholls did preserve another fragment of the destroyed group (i.e. the NPG fragment represents Anne). Perhaps he cut Martha's portrait of Emily out of yet another lost group (i.e. the 'Gun Group'). None of these alternative suggestions are very convincing.

The identification of the NPG fragment as Emily, whether or not it is the portrait which Martha Brown possessed, is further supported by three separate tracings (Brontë Parsonage Museum, Haworth, plates 94–96) of the Brontë sisters (no tracing of Branwell is known), all apparently done from the destroyed group. The tracing corresponding with the NPG fragment (plate 97) is of the same size, and follows the general outline exactly; it is labelled 'Emily Jane Brontë, 15th year of her age'. The tracing labelled Anne is inscribed '14th year of her age', and Charlotte '18th year of her age'. This would date the portrait to 1833, which agrees with the costume and the apparent age of the sitter. The actual handling of the paint seems more fluent than in the later group, and most authorities prefer to date the fragment to c 1840; there has, however, been no coherent stylistic analysis of Branwell's work, and the evidence of costume and age appear much more significant. The handwriting on the tracings has been identified by Mrs Mabel Edgerley as that of John Greenwood,[2] who had a small bookshop in Haworth, and who supplied all three sisters with notepaper, and knew them well. The tracings descended to his granddaughter, Mrs Judith Moore, along with other Brontë relics, and were in her collection in the 1930s, when they were photographed. Without more corroborative evidence these tracings cannot provide absolute proof of the identity of the sitters in the destroyed group, but being the record of a contemporary witness, they are extremely significant.

The evidence for suggesting that the NPG fragment represents Anne, and not Emily, is almost entirely based on a dubious comparison between the fragment and the so-called 'Gun Group' (plate 93), the third and most puzzling of the Brontë family groups. The original is lost, and all that survives is a photograph of a drawing or engraving, itself probably based on a painting. Ellen Nussey, Charlotte's old friend, who identified the figures in the 'Gun Group', wrote on the back of the print at Haworth: 'Photograph of an oil painting by Branwell Brontë of himself and sisters when quite a boy'. Unless she had muddled the 'Gun Group' with one of the others, Ellen Nussey's evidence supports the idea that there was once a 'Gun Group' painting, although the photograph seems to be of a drawing or engraving, not a painting. The figure in profile on the right of the 'Gun Group' was identified by Ellen Nussey, probably correctly, as Anne, and the taller figure on the left as Emily. There is a superficial resemblance between the NPG fragment and the figure on the right of the 'Gun Group' identified as Anne, and it is on the basis of this that the NPG fragment has been said to represent her. They are both in profile, but their clothes, hairstyles, the relation of their bodies to the table, and the accessories, are all quite different. Those eager to add weight to the theory that the fragment represents Anne are forced to go further for proof, and to compare the other figures in the 'Gun Group' with the tracings of the two lost figures from the destroyed group. Charlotte, apparently wearing the same clothes in both tracing and 'Gun Group', and her pose being similar, is the strongest argument for linking the two groups. The link between Emily in the 'Gun Group' and the so-called tracing of Anne is much more tenuous. If it could be established, then Anne could be identified with the so-called tracing of Emily, and hence with the NPG fragment. Facial likenesses have been listed to support this theory,[3] but evidence of this kind, particularly with crude and derivative images, must remain speculative. In

[1] See *King's County Chronicle*, 12 March 1914, which quotes a letter from Sherrard. Sherrard cannot have seen the fragment which Martha possessed for over twenty years, and it is doubtful if he had studied it very closely.

[2] See Mrs Edgerley's article, *Brontë Society Transactions*, part XLII (1932).

[3] See in particular the article by Dame Myra Curtis, *Brontë Society Transactions*, part LXIX (1959), the most recent defence of Anne as the figure represented in the fragment. This theory was first put forward by Mrs Chadwick in the *Morning Post*, March 1914. In support of Emily, however,

one could cite Charlotte Brontë's comment that G.H. Lewes' face reminded her of Emily (see Winifred Gérin, *Charlotte Brontë* (1967), p431); there is a certain similarity between the fragment and an early drawing of Lewes in the NPG (1373). Also if the profile water-colour of Anne by Charlotte Brontë in the Brontë Parsonage Museum, Haworth, is correctly identified, as seems likely, this would again argue for Emily; the water-colour and fragment show a quite dissimilar cast of features. I am grateful to Winifred Gérin, the recent biographer of Anne and Charlotte Brontë, for these suggestions; she firmly believes that the fragment is Emily.

any case the reason for linking the two groups only rests on their apparent similarity.[1] Branwell Brontë clearly liked painting family groups, and there is no reason why Anne should not have been on the right in one group, and Emily in another, as Charlotte is on the right in the NPG group. It also seems illogical to use the tracings to support one part of the argument, and then to dismiss them as being inaccurately labelled and dated. Once it is denied that the tracings are what they say they are, the reasons for granting them any validity have disappeared.

Condition: Several paint losses, particularly round the edges of the canvas, across the shoulder, and across the nose. Large cracks, particularly wide over the shoulders and dress, due to the use of bitumen

Description: Dark eyes, pale complexion, brown hair. Dressed in a greenish-grey dress with a low-cut neck. Three books on the table, the top one orange. Background colour greyish-brown.

1725 See *Groups:* 'The Brontë Sisters, *c*1834' by B.Brontë, above.

BRONTË ICONOGRAPHY Apart from the Richmond drawing of Charlotte (NPG 1452), the fragment of Emily (NPG 1724), the water-colour of Anne by Charlotte in the Brontë Parsonage Museum, Haworth (almost certainly rightly identified), reproduced W. Gérin, *Anne Brontë* (1959), frontispiece, the so-called 'Gun Group' (see entry for NPG 1724), and the group portrait in the NPG (1725), no other authentic portraits of the Brontë sisters are known. Several portraits have, at one time or another, been wrongly identified as the Brontës, usually on the basis of a supposed similarity with the authentic portraits. The most interesting of them is the water-colour in the NPG (1444), acquired as a portrait of Charlotte in 1906. It is signed and dated 'Paul Héger/1850'; shows the sitter reading a book inscribed 'Shirley/Brontë'; has other inscriptions identifying it on the back; and is said to have been bought originally in Brussels from the Héger family. Soon after its acquisition, a controversy broke out over its authenticity. Dr Paul Héger, the son of Charlotte's teacher, Constantin Héger, denied all knowledge of the water-colour; Charlotte never saw the Hégers again after her departure from Brussels in 1843. The discovery in 1913 of a faint pencil inscription on the back, 'Portrait of Miss Mary Vickers', further confirmed the portrait's dubious status. It seems to have been a genuine portrait of someone else, with false inscriptions added subsequently. The sitter is far too young to represent Charlotte in 1850, and looks quite unlike her.

BROOKE *Sir James* (*1803–68*)

Rajah of Sarawak; after suppressing a rebellion there, invited to assume government, 1841; instituted various reforms and changes; put down piracy; charges of cruelty and illegal conduct brought against him, but could not be proved; one of the more bizarre figures of the early Victorian period.

1559 Oil on canvas, $56\frac{1}{4} \times 43\frac{3}{4}$ inches (142·8 × 111·1 cm), by SIR FRANCIS GRANT, 1847. PLATE 107 & p65

Inscribed in stencil on the stretcher: (904) Sir F. Grant

Collections: Presented to Brooke by the artist; the Rev F.C.Johnson, Brooke's brother-in-law; sold from Johnson's estate, Christie's, 30 June 1877 (lot 142); purchased by Brooke's secretary, Sir Spenser St John, and bequeathed by him, 1910.

Exhibitions: VE, 1892 (82), lent by Baroness Burdett-Coutts (possibly on loan to her from St John).

Literature: Grant's 'Sitters Book' (copy of original MS, NPG archives), under the year 1847; Spenser St John, *Life of Sir James Brooke* (1879), p129, reproduced frontispiece; Sir Henry Keppel, *A Sailor's Life Under Four Sovereigns* (1899), II, 58; J.Steegman, 'Sir Francis Grant, P.R.A.: the Artist in High Society', *Apollo*, LXXIX (1964), reproduced 485.

Brooke, in undress naval uniform, is set against an idealized Eastern landscape, presumably intended to represent Sarawak. The picture was apparently painted as an act of friendship, and given to Brooke by

[1] See Dr Nixon's excellent summary of the evidence for and against Emily and Anne, *Brontë Society Transactions*, part LXVIII (1958). She comes down on the side of Emily.

the artist (Grant's 'Sitters Book' lists no price against the entry for the portrait). The artist's nephew, Charles Grant, was a friend of Brooke (see E. Hahn, *James Brooke of Sarawak* (1953), pp 128–9), and Charles' sister, Annie, eventually married Brooke's nephew, Brooke Johnson (later Brooke Johnson Brooke), the eldest son of the Rev F. C. Johnson (see above). The portrait was painted shortly after Brooke's return to England on 1 October 1847. Henry Keppel (see above) records in his diary for 20 October 1847: '*Accompanied Brooke to Frank Grant's, who was painting his portrait, indeed a striking likeness. Grant the first artist in the country*'. It is not known why the portrait did not pass to Brooke's heir, his younger nephew Charles Johnson Brooke, but to the latter's father, the Rev F. Johnson; there was, however, a good deal of acrimony over the succession (the elder nephew was passed over for the younger), so the portrait may not have been treated as an heirloom, hence its sale. It is not mentioned in Brooke's surviving will in Somerset House. He had originally left all his possessions to Baroness Burdett-Coutts, but later revoked this will; the text of it is given in O. Rutter, *Rajah Brooke and Baroness Burdett Coutts* (1935), pp 156–7.[1]

The portrait was engraved by W. Holl, published J. Murray, 1848 (example in NPG), for Captain R. Mundy's *Narrative of Events in Borneo and Celebes from the Journals of James Brooke*; it was also engraved by G. R. Ward (example in NPG). A copy is owned by the Borneo Company (part of the Inchcape Group), London, and others are recorded.

Description: Healthy complexion, brown eyes, brown hair and whiskers. Dressed in a white shirt, dark blue neckerchief, dark blue jacket with gilt buttons, dark blue belt with brass buckle, white trousers. Holding a white handkerchief, dark blue garment under his left hand. Rock on which his right hand rests greenish-brown. Rock above brown. Landscape at right greenish-grey. Blue and orange sky.

1200 Plaster cast, painted cream, 29½ inches (75 cm) high, of a bust by GEORGE GAMMON ADAMS, 1868. PLATE 108

Incised on the back, below the shoulders: G.G. Adams Sᶜ. 1868

Collections: The artist, purchased from his widow, 1899.

Brooke is shown wearing the star of the Bath. This bust was purchased together with several other plaster casts by Adams, and a marble bust of Napier (NPG 1197).

1426 Marble bust, 27 inches (68·6 cm) high, by THOMAS WOOLNER, 1858. PLATE 109

Incised on the base (right side): T. Woolner. Sᶜ. / London. *and (centre):* Rajah Brooke / 1858

Collections: Mrs Toten Knox, bequeathed by her, 1906.

This is a replica of the marble bust of 1858 commissioned by Sir Thomas Fairbairn, exhibited *R A*, 1859 (1317), and now in the collection of his descendant, J. Brooke Fairbairn. It is not known who commissioned the NPG bust, nor how it entered the collection of the donor. Although both busts are dated 1858, it is clear that the Fairbairn bust, which must be the original, was not finished till 1859 (see below); the inscribed date presumably refers to the year in which Brooke sat. On 2 May 1858, Woolner wrote to Mrs Tennyson (Amy Woolner, *Thomas Woolner: his Life in Letters* (1917), p 148): '*I have been half expecting to do a bust of Sir James Brooke; T. Fairbairn says if he can be induced to sit to me he will have it done in marble*'. During the summer Woolner did execute a bust of Brooke, but in plaster, not marble, for he wrote to Mrs Tennyson on 22 October 1858 (Amy Woolner, p 160): '*A gentleman called who said he thought of having a marble of the Rajah Mrs and Mr Maurice called to see his bust, and my man at the studio had not the sense to put it in a proper light and position to show them*'. It was quite common for sculptors to execute a plaster bust in the hope of attracting a marble commission. It was clear that Brooke could not be persuaded to commission a marble of himself, and it was left to his friend to do so. On 27 March 1859, Woolner wrote yet again to Mrs Tennyson (Amy Woolner,

[1] I would like to record my thanks to W. Craib Lang, who provided invaluable help in establishing the history of the portrait.

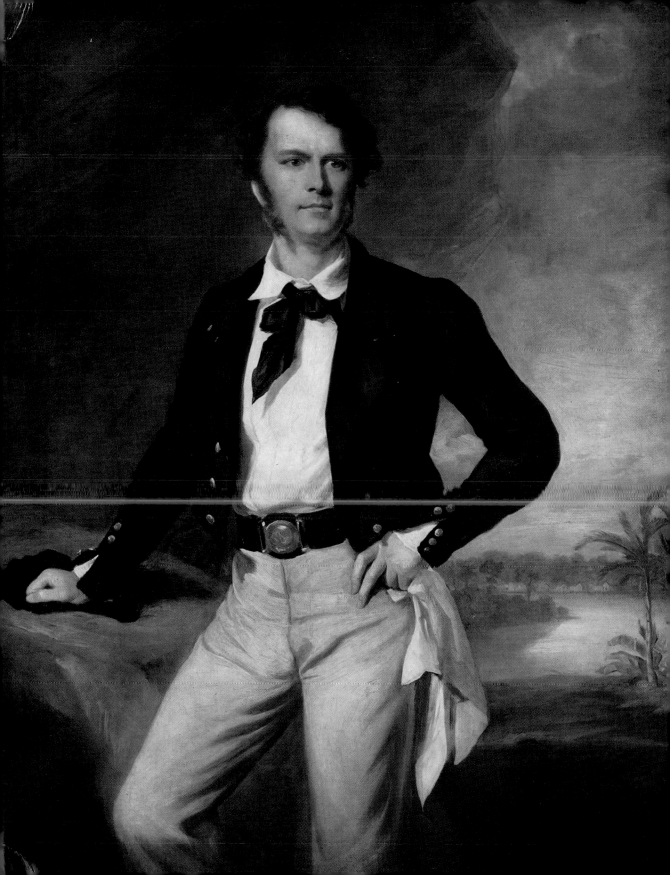

Sir James Brooke by Sir Francis Grant, 1847 NPG 1559

p 168): '*I am working fearfully hard to try and get my Rajah done for the* R.A. *Ex. I do not yet know if Fairbairn will like it sent there.*' That same year Woolner sent a bronze medallion of Fairbairn to the *RA* (1244), as well as the marble bust of the Rajah.

ICONOGRAPHY A painting by J.S.W.Hodges of 1867, exhibited *RA*, 1868 (350), and once owned by Baroness Burdett-Coutts, was sold Christie's, 5 May 1922 (lot 203); a miniature by an unknown artist is reproduced E.Hahn, *James Brooke of Sarawak* (1953), facing p 33; there is an engraving by W.J.Edwards, after a photograph by H.Watkins (example in NPG); an engraving, after a photograph by Maull and Polyblank of 1864, is reproduced G.L.Jacob, *The Rajah of Sarawak* (1876), I, frontispiece; a photograph by Maull and Polyblank is in the NPG; two woodcuts were published *ILN*, XI (1847), 233, and LIII (1868), 17.

BROTHERTON *Joseph* (*1783–1857*)

Reformer and MP for Salford.

54 See *Groups:* 'The House of Commons, 1833' by Sir G.Hayter, p 526.

BROUGHAM AND VAUX *Henry Peter Brougham, 1st Baron* (*1778–1868*)

Lord chancellor.

2772 See catalogue entry under Sir Robert Peel, p 370.
See also forthcoming Catalogue of Portraits, 1790–1830.

BROUGHAM AND VAUX *William Brougham, 2nd Baron* (*1795–1886*)

MP for Southwark.

54 See *Groups:* 'The House of Commons, 1833' by Sir G.Hayter, p 526.

BROUGHTON DE GYFFORD *John Cam Hobhouse, 1st Baron* (*1786–1869*)

Statesman, friend of Byron, and MP for Westminster.

54 See *Groups:* 'The House of Commons, 1833' by Sir G.Hayter, p 526.

BROWN *Robert* (*1773–1858*)

Botanist; naturalist to Captain Flinders' Australasian expedition, 1801–5; famous for his investigation into the impregnation of plants; published several works.

2515 (100) Black and red chalk, heightened with Chinese white, on greenish-grey tinted paper, $15 \times 10\frac{5}{8}$ inches ($38 \times 27 \cdot 1$ cm), by WILLIAM BROCKEDON, 1849. PLATE 110

Signed and dated (lower left): 24.2.49/WB

Collections: See *Collections:* 'Drawings of Prominent People, 1823–49' by W.Brockedon, p 554.

1075 See *Groups:* 'Men of Science, *c* 1808' by J.F.Skill, Sir J.Gilbert, and W. and E.Walker, in forthcoming Catalogue of Portraits, 1790–1830.

ICONOGRAPHY A painting by H.W.Pickersgill is in the Linnean Society, London, exhibited *SKM*, 1868 (516), and *VE*, 1892 (247), engraved by and published C.Fox, 1837 (example in NPG); a replica is in the Scottish NPG; a painting by S.Pearce of 1854 is at Kew Gardens, London, exhibited *RA*, 1855 (405); a bust by P.Slater is in the Linnean Society, London, exhibited *RA*, 1860 (984); a lithograph by T.H.Maguire of 1850 was published G.Ransome, 1852 (example in NPG), for 'Portraits of Honorary Members of the Ipswich Museum'; a woodcut, after a photograph by Maull and Polyblank, was published *ILN*, XXXIII (1858), 29.

BROWNING *Elizabeth Barrett* (*1806–61*)

Poet; noted for her love lyrics; married Robert Browning, 1846, in opposition to her father; resided chiefly in Florence during the later part of her life.

1899 Oil on canvas, 29 × 23 inches (73·7 × 58·4 cm), by MICHELE GORDIGIANI, 1858. PLATE 111

Signed (*bottom right*): M. Gordigiani

Inscribed on a label on the back of the frame in Mrs Eckley's hand: Painted (by Gordigiani/in Florence, the Summer of/1860.) expressly for Sophia May Eckley,/ & pronounced by Robert/Browning to be the best Portrait ever taken of the/Poetess . . who sent it to S.M.E. on her birthday at Lucca

Various notes in pencil on the stretcher in Mrs Eckley's hand: Elizabeth Barrett Browning/(Gordigiani Pinxt Aug 1860 Florence) *and* Belonging Eckley D/ 19th July 1866 *and* 'Incomparable Portrait by far the/best ever taken'/Quoted from letter of Robt Browning/1858 Lucca S. . . . 21

Collections: Commissioned by Mrs Eckley; bequeathed by her to Browning's son; R.B.Browning Sale, Sotheby's, 1 May 1913 (lot 59), bought Mrs Florence Barclay; presented by her husband, Charles Barclay, in accordance with her wishes, 1921.

Exhibitions: VE, 1892 (211).

Literature: Dearest Isa: Robert Browning's Letters to Isa Blagden, edited E.C.McAleer (1951), pp 31, 44, 306–7, 309; *New Letters of Robert Browning,* edited W.C.DeVane and K.L.Knickerbocker (1951), pp 109, 123–4.

This forms a pair with the portrait of Robert Browning (NPG 1898 below), also commissioned by Mrs Eckley. The latter had met the Brownings in Rome in 1858. She helped to introduce Mrs Browning to spiritualism, and became, for a short time, an intimate friend. Relations became strained around 1860, and were not resumed. In later years, Robert Browning heard disquieting rumours that the letters he and his wife had written to Mrs Eckley were being shown to her friends, with a possible view to publication. This breach of confidence did not occur, and the letters, together with the portraits, were bequeathed to Browning's son.

Despite Mrs Eckley's note on the back of this picture, it is clear from contemporary letters, and from an undated memorandum which she wrote (NPG archives), that the portraits were painted in 1858, not 1860. The memorandum reads as follows: '*In case there should be any possibility of mistake hereafter, I do here declare that it is my will that at my decease, the two Portraits of Mr & Mrs Browning which were painted for me in Italy by Gordigiani in the year 1858, & now hanging in the Athenaeum Gallery in Boston shall be given to Robert Barrett Browning as my bequest.*' Mrs Eckley's insistence that she had the best portrait of Mrs Browning (see transcription of label above) was not a simple case of proud possession. Two other friends of Mrs Browning, Miss Heaton and Isa Blagden, were extremely hostile to Mrs Eckley, and did all they could to undermine her influence. Miss Heaton actually commissioned the chalk drawing of Mrs Browning by Field Talfourd (NPG 322 below) to outdo the Gordigiani portrait. Miss Heaton was equally insistent that she had the best portrait. This bitter rivalry did not go unperceived by Mrs Browning. She wrote to her sister that Miss Heaton had made herself very unpopular in Florence by her lack of refinement, and by her '*resolution to "have the only portrait in the world of Mrs Browning" . . . dear Sophie Eckley being really wounded by the slight done to herself and her Gordigiani in Florence*' (McAleer, p 31).

Browning himself was obviously impressed by Gordigiani's portrait. He wrote to Mrs Eckley about it on 19 August 1858, from Le Havre (DeVane and Knickerbocker, p 109):

The portrait is not perfect certainly; the nose seems over long, and there are some other errors in the face; also, the whole figure gives the idea of a larger woman than Ba: but the artist himself was so fully aware that much was yet wanting to the line work, and not a little remaining to be comprised in it, that I wonder he allowed you to come into possession at once; when the accessories (chair and table) are added the main

figure will be reduced to its proper proportion – and at our return, Ba will sit to his heart's content: but I am glad to believe, with you, that something, indeed much has been secured – and most glad as I said, that it gives you the pleasure it should. I know, if we had in this Hâvre, a portrait of you, equally true to our recollections, we should look many a long look at it, and say many a sincere thing.

Dear Mrs Eckley – what you say about its "final destination" is meant as only you mean such kindness – and I shall not be hindering any kindness of yours; only diverting it into its more fitting channel, when I pray you to let it be otherwise than so: without referring to the eventualities which are in the hands of God, let your own dear child keep one day what may remind him of a face he will have forgotten – and let it remain in America. I do not care to write much about this – but let it be so!

In the second paragraph of this letter, Browning was referring to Mrs Eckley's plan, already then in her mind, to leave the portraits to 'Pen' Browning.

When the portrait was finished, Browning became less critical of its faults, and wanted to keep it himself. He wrote to Mrs Eckley on 7 August 1859 (DeVane and Knickerbocker, p123):

I want to ask you a great favour, dear Mrs Eckley: you do not like that portrait of Gordigiani's – that of Ba – I do like it as I like no other: cede it to me, and try once more with some other painter of your choice who may succeed better – I shall be glad indeed. I will also take [the] other, as companion – and sit, myself, if David [Eckley] likes [to] the new painter, whoever he may be, – so shall we all be [satisfied?]. I should really be most grateful to be allowed [to] do this – but I can say no more, as you see.

Mrs Eckley clearly refused to relinquish the portraits. In another letter to her (*c* August 1859) Browning said that he and his wife now agreed to her plan (i.e. of bequeathing the portraits to 'Pen'), and made no further attempt to obtain them. In any case after 1860 Browning ceased to see or write to Mrs Eckley, following the break between her and his wife.

In a letter of 14 February 1911 (NPG archives), Mrs Gordigiani (the artist's widow), wrote to 'Pen' Browning to ask if she could borrow the two portraits for an exhibition in Florence, *Mostra del Ritratto Italiano della Fine del Sec. XVI all'Anno 1861*. In her second letter of 1 March 1911 (NPG archives) she says that the portraits have still not arrived, and wonders if they have been mislaid in transit ('Pen' had evidently agreed to lend them). As the two portraits are not mentioned in the catalogue, they presumably did not arrive in time to be included in the exhibition. Mrs Gordigiani called them the '*deux des plus beaux portraits qu'ai fait mon pauvre mari*'. Gordigiani was a minor provincial artist, who painted several portraits for English patrons.

Description: Pale complexion, dark brown eyes and hair. In a dark dress with white lace cuffs and bib. Brooch at her throat, with a blue stone, on a dark blue velvet ribbon. Chair-back covered in green figured material. Rest of background dark brown.

322 Coloured chalk on brown, discoloured paper, 23¾ × 17⅝ inches (60·3 × 44·7 cm), by FIELD TALFOURD, 1859. PLATES 113, 114

Signed and dated (bottom left): Field Talfourd/Rome. March./1859.

Inscribed on a label, formerly on the back of the drawing: Elizabeth Barrett Browning/Drawn by Field Talfourd-Rome, – 1859./Belonging to, and commissioned by,/Miss Heaton./6. Woodhouse Square./Leeds.

Collections: Presented by Miss Ellen Heaton, 1871.

Exhibitions: SKM, 1868 (600); *Elizabeth Barrett Browning: Centenary Exhibition*, St Marylebone Central Library, London, 1961 (106).

Literature: W. M. Rossetti, 'Portraits of Robert Browning', *Magazine of Art* (1890), p187; *Elizabeth Barrett Browning: Letters to her Sister, 1846–59*, edited L. Huxley (1929), pp306 and 312-13, reproduced facing p306; *Dearest Isa: Robert Browning's Letters to Isa Blagden*, edited E. C. McAleer (1951), p31.

This forms a pair with the drawing of Browning (NPG 1269 below). On 10 February 1859, Mrs Browning wrote to her sister, Henrietta (Huxley, p 306):

Tell him [Storm] *I shall send him a photograph of Mr Talfourd's picture, if it is at all successful, and he is one of the first of the portrait-artists here. He won't let any one see what is done, but seems confident of not missing the mark.*

She wrote again to the same correspondent on 4 March 1859 (Huxley, pp 312–13):

A photograph from Mr Talfourd's portrait of me (which has been greatly admired and considered very like by the Roman world) will be sent to you by an early opportunity. It is too flattering – much idealized, in fact – but there must be a good deal of likeness, or it would not strike so universally. As a work of art, it is certainly most beautiful. Don't let me forget to say that the Prince of Wales told Robert very graciously that he had gone to see it – which he did really – and I was very glad, for the artist's sake.

Miss Heaton commissioned this drawing specifically to rival the portrait of Mrs Browning by Gordigiani (NPG 1899 above), which had been commissioned by Mrs Eckley in 1858. Both ladies cordially disliked one another, and resented each other's friendship with Mrs Browning. Hence the insistence with which each claimed that she had the best portrait. Mrs Browning herself wrote perceptively to her sister, Arabella, later in the year (McAleer, p 31):

It is however all made up to me in the Talfourd portrait – for which Miss Heaton gave the commission. She has made herself so unpopular by her . . . let me whisper to you Arabel . . . by her singular want of refinement & delicacy – & resolution to 'have the only portrait in the world of Mrs Browning' . . . dear Sophie Eckley being really wounded by the slight done to herself and her Gordigiani in Florence.

In a letter to Browning of 18 March 1868 (NPG archives), Miss Heaton wrote that this portrait was 'nearer to a true representation of her than any other You know that I speak of the head in chalk, – for which she so kindly consented to sit, when you were both in Rome in 1859 – to Mr F. Talfourd. – I am glad to know that you approve of this destination for it.' Browning was more cautious, writing to Scharf on 19 March 1868 (NPG archives): 'The portrait is that which I referred to as the best in existence, perhaps'. A copy of the portrait was in the Browning Sale, Sotheby's, 1 May 1913 (lot 5). Four letters from Browning to Miss Heaton, 1868–71, two of them about a photographic reproduction of this portrait, were sold Christie's, 16 July 1969 (lot 112), bought Quaritch.

Description: Faint red in the cheeks, dark blue eyes, dark hair.

ICONOGRAPHY

This does not include photographs. In a letter to the NPG of 28 April 1948, Dr A. J. Armstrong of Baylor University, Texas, enclosed a typed list of portraits of Mrs Browning. The sale of R. B. Browning's pictures was at Sotheby's, 1 May 1913.

As a baby Painting on the lid of a snuff box by an unknown artist. Collection of Mrs V. and Miss M. Altham. Reproduced D. Hewlett, *Elizabeth Barrett Browning* (1953), facing p 32.

1815 Pastel by C. Hayter, Browning Sale, 1913 (lot 10), bought Sabin.
Engraved by G. Cooke for *The Collected Works of Elizabeth Barrett Browning* (1890), I, frontispiece. Almost certainly the picture exhibited *VE*, 1892 (277), lent by R. B. Browning, where it was described as an oil painting by an unknown artist: the sizes were, however, the same as the portrait sold by Sotheby's, and the description in the *VE* catalogue tallies with the engraving.

As a child Engraving by J. Brown, after Mayou, for *The Collected Works of Elizabeth Barrett Browning* (1890), II, frontispiece.

1818 Painting by W. Artaud (with (?) Edward and Henrietta Barrett). Collection of Mrs. V. and Miss M. Altham. Reproduced *Elizabeth Barrett Browning: Letters to her Sister*, edited L. Huxley (1929), frontispiece.

c 1820 Crayon by an unknown artist. Wellesley College Library, Massachusetts. Reproduced D. Hewlett, *Elizabeth Barrett Browning* (1953), facing p 65.

1823 Water-colour by Mrs Barrett (her mother). Collection of Mrs V. and Miss M. Altham (plate 112). Reproduced *E. B. Browning Letters*, edited Huxley, facing p 128.

1828 Painting called Mrs Browning attributed to Sir T. Lawrence. Collection of Charles Avery, New York. See K. Garlick, 'A Catalogue of the Paintings, Drawings and Pastels of Sir Thomas Lawrence', *Walpole Society*, XXXIX (1962–4), 42.

1832 Drawing by Arabella Barrett. Dr Armstrong's list.

1843 Water-colour by Alfred Barrett. Collection of E. R. Moulton-Barrett. Exhibited *Elizabeth Barrett Browning: Centenary Exhibition*, St Marylebone Central Library, London, 1961 (96). Reproduced D. Hewlett, *Elizabeth Barrett Browning* (1953), frontispiece.

1845 Drawing by W. M. Thackeray (with the artist and Mrs Brookfield). Huntington Library, California. Reproduced G. N. Ray, *Letters and Private Papers of W. M. Thackeray* (1945), II, facing 246.

1849 Drawing by L. Dickinson. Dr Armstrong's list.

1853 Painting by T. B. Read. Pennsylvania Historical Society. Reproduced L. Greer, *Browning and America* (University of North Carolina Press, 1952), facing p 48.

1853 Silhouette by J. Turner. Browning Sale, 1913 (lot 1411).

c 1857 Medallion by Marshall Wood. Martin Collection, 1857. Reproduced *The National Magazine* (14 February 1857), p 313.

1858 Painting by M. Gordigiani (NPG 1899 above).

1858 Drawing by Mrs E. F. Fox-Bridell. Sotheby's, 12 March 1951 (lot 242). Reproduced P. Lubbock, *Elizabeth Barrett Browning in her Letters* (1906), frontispiece.

1858 Photograph by Macaire of Le Havre, engraved by T. O. Barlow for the fourth edition of *Aurora Leigh* (1859).

1859 Drawing by F. Talfourd (NPG 322 above).

1859 Drawing by R. Lehmann. British Museum. Exhibited *RA*, 1869 (1135). Reproduced R. Lehmann, *Men and Women of the Century* (1896), no. 11.

1861 Posthumous bust by W. W. Story. Keats and Shelley Memorial Museum, Rome. Reproduced D. Hewlett, *Elizabeth Barrett Browning* (1953), facing p 289.

Undated Painting by H. W. Pickersgill. Exhibited *VE*, 1892 (208), lent by J. Moulton-Barrett.

Undated Drawing by F. Leighton. See *New Letters of Robert Browning*, edited W. C. DeVane and K. L. Knickerbocker (1951), pp 115–6.

Undated Drawing by V. Prinsep, miniature by J. W. Childe, and medallion by M. Smith Dean. Dr Armstrong's list.

Undated Unknown miniature (after 1858 daguerreotype, taken at Le Havre, see above). Collection of Mrs A. C. Whitcombe. Exhibited, *Elizabeth Barrett Browning: Centenary Exhibition*, St Marylebone Central Library, London, 1961 (105).

Undated Silhouette by R. Dighton. Referred to by J. Woodiwiss, *British Silhouettes* (1965), p 71.

BROWNING *Robert* (*1812–89*)

One of the great poets of the 19th century; pre-eminent for his intellectuality, and for his use of dramatic, psychological monologues.

839 Oil on canvas, 37 × 28 inches (94 × 71·1 cm), by RUDOLPH LEHMANN, 1884. PLATE 122

Signed and dated (bottom left): RL (*in monogram*) 1884 *Inscribed on the back of the canvas:* Robert Browning/painted by/Rudolph Lehmann/London 1884

Collections: The artist, presented by him, 1890.

Exhibitions: Summer Exhibition, Grosvenor Gallery, 1885 (10); *Fifth Exhibition*, Royal Society of Portrait Painters, 1895 (83).

Literature: 'Art and Artists', *The Globe* (8 January 1890), p6; W.M.Rossetti, 'Portraits of Robert Browning – III', *Magazine of Art* (1890), pp261–3, reproduced as an engraving, p261; C.L.Hind, 'Portraits of Robert and Elizabeth Browning', *Art Journal* (1890), pp62–3, reproduced p63; R.Lehmann, *An Artist's Reminiscences* (1894), p222; G.E.Wilson, *Robert Browning's Portraits, Photographs and Other Likenesses and their Makers*, edited A.J.Armstrong, *Baylor Bulletin*, XLVI (December 1943), no.4, 139–40.

This is almost identical in pose and format with Lehmann's oil portrait of Browning of 1875 at Baylor University, Texas (purchased from the Lehmann family, 1946), exhibited *RA*, 1875 (90). The latter is reproduced in Lehmann's *Men and Women of the Century* (1896), no.10. According to W.M.Rossetti, both portraits were begun at the same time, the NPG version being finished some years later. Lehmann himself wrote (*Reminiscences*, p222):

I drew him and Mrs Browning in Rome for my Album of Contemporary Celebrities in 1858 [sic][1]*; painted in 1875 the first portrait, in possession of my nephew, R.C.Lehmann; made a second pencil drawing in 1878, now belonging to Mrs Henry Schlesinger; and painted his second portrait, presented by me to the National Portrait Gallery, in 1883* [sic].

It is clear that Lehmann got further sittings from Browning for the NPG portrait in 1884, as it represents the poet as a much older man than the Baylor University version, although both are almost identical in pose, and were presumably started at the same time (i.e. 1875)[2]. Evidence about further sittings is provided by Lewis Hind, who apparently obtained his information from the artist (*Art Journal*, pp62–3):

Browning was an excellent sitter – patient, tractable, and entertaining to a degree. Eight sittings were given for this portrait, and throughout them he talked, always with vivacity, and, apparently never with fatigue. He was no picker of words or subjects, as frank on his own religious beliefs as in a criticism of the last Academy When the eight sittings for the oil painting were finished, and the face, hands, and form had grown upon the canvas, Mr Lehmann sent a messenger to the poet asking for the loan of the clothes in which it had been arranged he should be painted. Directly Browning gathered that his beautiful frock-coat would be fitted upon a model and there painted, he started off post haste to Campden Grove, swung into the studio in a whirl of vigour, and thus unbosomed himself: "Look here! I'd sooner sit for ever than have my frock-coat put on one of those infernal Italian rascals."

Another story connected with these sittings is told by the *Globe* (8 January 1896). Lehmann tried to finish Browning's hands from a model, but '*found that no model's wrist was sufficiently pliable to give the movement he had sketched from the poet's hand. So Browning was summoned again, when he came quite good naturedly as was his wont – although disappointed of his freedom*'.

Description: Healthy complexion, blue (?) eyes, grey hair, moustache and beard. Dressed in a white shirt, dark tie, medium grey suit, gold watch-chain and fob, grey gloves. Background colour dark brown.

1001 Oil on canvas, 26 × 21 inches (66 × 53.3 cm), by GEORGE FREDERICK WATTS, 1866. PLATE 120

Collections: The artist, presented by him, 1895 (see appendix on portraits by G.F.Watts in forthcoming Catalogue of Portraits, 1860–90).

[1] Both the drawing of Browning and of his wife were executed in May 1859, and are in the British Museum. They are reproduced in Lehmann's *Men and Women of the Century* (1896), nos. 10a and 11. When Browning came on the drawing of his wife in the artist's studio after her death, he wept. He much preferred the 1859 drawing of himself to the 1875 oil painting, and did not want the latter to be reproduced in *Men and Women of the Century*. Eventually both were reproduced.

[2] The NPG portrait is also distinguished by the absence of a signet ring on the little finger of the right hand, and the addition of a watch-fob to the chain. Browning's watch and watch-chain are now in the British Museum.

Exhibitions: French Gallery, London, 1866 (222); *London International Exhibition: Fine Arts Department*, 1872 (106); Paris, 1878 (according to Mrs Watts); *Winter Exhibition*, Grosvenor Gallery, 1882, 'Collection of the Works of G.F.Watts' (101); *Worcestershire Exhibition of Fine Arts*, 1882 (139) (typescript copy of catalogue, NPG archives); *Royal Jubilee Exhibition*, Manchester, 1887, 'Fine Arts Section' (504); Whitechapel (St Jude's), 1890 (40); *VE*, 1892 (213).

Literature: Art Journal (1866), p374; *The Athenaeum* (10 November 1866), p613; M.H.Spielmann, 'The Works of G.F.Watts, R.A.', *Pall Mall Gazette* "Extra" no.22 (1886), p29; W.M.Rossetti, 'Portraits of Robert Browning – I and II', *Magazine of Art* (1890), pp246–7, reproduced as an engraving, p188; G.K.Chesterton, 'Literary Portraits of Watts', *Bookman*, XIX (December 1900), 81; G.K.Chesterton, *G.F.Watts* (1904), p77; G.K.Chesterton, *Robert Browning* (1904), p112; 'Catalogue of Works by G.F.Watts', compiled by Mrs M.S.Watts (MS, Watts Gallery, Compton), II, 20; G.E.Wilson, *Robert Browning's Portraits, Photographs and Other Likenesses and their Makers*, edited A.J.Armstrong, *Baylor Bulletin*, XLVI (December 1943), no.4, 99–103; *Dearest Isa: Robert Browning's Letters to Isa Blagden*, edited E.C.McAleer (1951), pp251–2.

The date, 1875, has previously been given to this portrait, probably because in the *VE* catalogue, it was erroneously stated to have been exhibited at the *RA* in that year. There is no evidence that Watts painted Browning more than once, and in any case this portrait is much closer to Browning's portraits of the 1860s than those of the 1870s, when his face had become much more aged. This must be the portrait referred to by the *Athenaeum* in 1866: '*Mr G.F.Watts's portraits of Messrs Robert Browning (222) and Alfred Tennyson (223) are in noble companionship, and are noble works. The former delights us as one of the painter's most nearly perfect pictures. A real work of art, there is in this painting all the higher qualities of portraiture*'. The portrait of Tennyson mentioned in this passage is also in the NPG (1015). Browning wrote to Isa Blagden on 26 November 1866 (McAleer, p251): '*I have just sat to Lawrence* [sic] *for another – and have to repeat the process – which is tiresome in these quick photographing days – but he is a charming person, as indeed is Watts*'. The portrait of Browning by Samuel Laurence is now at Baylor University, Texas (see iconography below).

Description: Healthy complexion, greyish hair and beard. Dressed in a white shirt, black tie, and black coat. Background colour green.

1898 Oil on canvas, $28\frac{1}{2} \times 23\frac{1}{8}$ inches (72·4 × 58·7 cm), by MICHELE GORDIGIANI, 1858. PLATE 118

Signed (bottom left): M. Gordigiani

Collections: Commissioned by Mrs Eckley; bequeathed by her to Browning's son; R.B.Browning Sale, Sotheby's, 1 May 1913 (lot 59), bought Mrs Florence Barclay; presented by her husband, Charles Barclay, in accordance with her wishes, 1921.

Literature: W.M.Rossetti, 'Portraits of Robert Browning – I and II', *Magazine of Art* (1890), pp186–7, 247, reproduced p181; G.E.Wilson, *Robert Browning's Portraits, Photographs and Other Likenesses and their Makers*, edited A.J.Armstrong, *Baylor Bulletin*, XLVI (December 1943), no.4, 65–9; *Dearest Isa: Robert Browning's Letters to Isa Blagden*, edited E.C.McAleer (1951), pp43, 44, 306–7, 309; *New Letters of Robert Browning*, edited W.C.DeVane and K.L.Knickerbocker (1951), pp109, 123.

This forms a pair with the portrait of Elizabeth Barrett Browning (NPG 1899 above, where both portraits are discussed in detail). W.M.Rossetti wrote of it ('Portraits of Browning', p186):

The spacious unwrinkled forehead, in which thought seems to have accumulated and condensed; the watchful eyes, slightly over-drooped by their lids; the half-smiling, half-pondering mouth, – Browning's face was, indeed, seldom without a certain lambency, as of pleasant and kindly thought, which would easily lapse into a smile; the whole set of the visage, which seems to be listening, and preparing to reply – all these points are well given, and realize very satisfactorily the impression which the man produced. The face in this portrait is certainly a highly intellectual one; but I think it is treated with too much morbidezza, so as to lack some of that extreme keeness, which characterized Browning.

Description: Brown eyes, brown hair and beard. Dressed in a white shirt, dark stock, brown suit. His elbow resting on a table or chair-arm, covered with red material with black floral motifs. Rest of background greenish-brown.

1269 Coloured chalk on brown, discoloured paper, $24\frac{7}{8} \times 17\frac{5}{8}$ inches ($63 \cdot 2 \times 44 \cdot 8$ cm), by FIELD TALFOURD, 1859. PLATES 116, 119

Signed and dated (lower right): Field Talfourd/Rome 1859

Inscribed in Browning's hand (bottom left): This portrait was executed at Rome, in 1859,/ as a companion to that of E.B.B. now in the/National Portrait Gallery, by Field Talfourd, – whose/property it remained. I rejoice that it now belongs/to my friend Gosse. Robert Browning,/ Apr.10. '85.

Collections: The artist, sold at his death, 1874; J. Glendinning, purchased from him by Edmund Gosse; purchased from Gosse, 1900.

Exhibitions: Elizabeth Barrett Browning: Centenary Exhibition, St Marylebone Central Public Library, London, 1961 (107).

Literature: W. M. Rossetti, 'Portraits of Browning – I', *Magazine of Art* (1890), p 187, reproduced p 183; G. E. Wilson, *Robert Browning's Portraits, Photographs and Other Likenesses and their Makers,* edited A. J. Armstrong, *Baylor Bulletin,* XLVI (December 1943), no. 4, 56–8; *New Letters of Robert Browning,* edited W. C. De Vane and K. L. Knickerbocker (1951), pp 112–3, 115.

This forms a pair with the portrait of Elizabeth Browning (NPG 322 above). Gosse wrote to W. M. Rossetti at some length about the history of the picture ('Portraits of Browning', p 187):

Of all the portraits of his middle life, that in which Browning took most interest was the crayon drawing, life-size, made in Florence in 1859 by Field Talfourd, the younger brother of the author of 'Ion'. This portrait, which is now in my possession, was lost for nine years, and the history of its vicissitudes is rather curious. It was the pendant to that drawing of Mrs Browning which is the best known of all her heads, and which is now in the National Portrait Gallery. Mr Browning intended to secure it, but his wife's serious illness led his thoughts away from the matter, and, meanwhile, Field Talfourd left Florence. After Mrs Browning's death in 1861, her husband made several efforts to find Talfourd, but in vain. At last, early in 1874, that artist died. The poet did not hear of his death until the contents of the studio were dispersed beyond the hope of being traced. It was not heard of again until, in March, 1885, Mr Hamo Thornycroft, R.A., happened to notice in the back of a shop in Hammersmith a large crayon portrait, which attracted his attention with something vaguely familiar in the face. He pointed it out to me, and I bought it; the only clue to its identity being that the dealer, who had had it for years in his possession, remembered that he had been told that it was 'one of them poets'. Without warning Mr Browning, I dropped in at 19, Warwick Crescent, with the Talfourd drawing under my arm. At the first glimpse of it, the poet shouted out: 'At last! here is the long-lost portrait of me;' and he wrote on the base of it the inscription which is engraved in facsimile *(on page 183). He frequently in later years, referred to his interest in this portrait. In a letter to me, dated February 23rd, 1888, in reference to the illustration of his complete works, he says of the Talfourd picture: 'My sister – a better authority than myself – has always liked it, as resembling its subject when his features had more resemblance to those of his mother than in after-time, when those of his father got the better – or perhaps the worse – of them'.*

There is a photogravure print after the portrait by the Berlin Photographische Gesellschaft (example in NPG).

Description: Light blue eyes, dark hair.

3165 Bronze cast of Browning's right hand clasping that of his wife, approximately $8\frac{1}{4}$ inches (21 cm) long, by HARRIET HOSMER, 1853. PLATE 125

Inscribed on the base of Browning's hand: HANDS OF ROBERT/AND/ Elizabeth Barrett Browning/cast By/ Harriet Hosmer/Rome 1853 *and on the base of Mrs Browning's hand:* Copyright

Collections: W. M. Thackeray (?); Mrs Richard Fuller (his granddaughter), presented by her, 1953.

Exhibitions: Elizabeth Barrett Browning: Centenary Exhibition, St Marylebone Central Public Library, London, 1961 (104).

Literature: Harriet Hosmer: Letters and Memories, edited C. Carr (1913), p 92; N. Hawthorne, *The Marble Faun* (Riverside Edition, Cambridge, USA, 1883), VI, 146; *Dearest Isa: Robert Browning's Letters to Isa Blagden,* edited E. C. McAleer (1951), p 40.

Harriet Hosmer wrote about the hands (Carr, p 92): '*The history of the hands is very brief. In the winter of 1853, my second winter in Rome, I made the acquaintance of Mr and Mrs Browning. I then conceived the idea of casting their hands, and asked Mrs Browning if she would consent. "Yes", she said "provided you will cast them, but I will not sit for the* formatore". *Consequently I did the cast myself*'. Hawthorne's *MarbleFaun* is concerned with American artists in Rome, and it is interesting that he should mention the cast of the hands. Discussing a marble hand by a 16th century sculptor, Miriam remarks: '"*As good as Harriet Hosmer's clasped hands of Browning and his wife, symbolizing the individuality and heroic union of two high, poetic lives!*"'. It is not known how large an edition of casts Harriet Hosmer produced. Cornelia Carr claimed to own the original cast (reproduced Carr, p 92); others are at Baylor and in the collection of the Countess of Iddesleigh. Harriet Hosmer was a close friend of the Brownings, who frequently mention her unconventional behaviour and appearance in their letters of this period.

ICONOGRAPHY

This does not include photographs (see plates 123, 124) or caricatures. The most extensive work on Browning's portraits is G. E. Wilson, *Robert Browning's Portraits, Photographs and Other Likenesses and their Makers,* edited A. J. Armstrong, *Baylor Bulletin,* XLVI, (December 1943), no. 4, which lists over 100 items, and illustrates almost all of them. As no copy of this book is available in England, the following list is included to give some idea of the scope of Browning's iconography. I am indebted to Baylor University, Waco, Texas for sending me a copy of Miss Wilson's book. Other publications dealing with Browning's portraits are, W. M. Rossetti, 'Portraits of Browning – I, II, III', *Magazine of Art* (1890), pp 181–8, 246–52, 261–7; C. L. Hind, 'Portraits of Robert and Elizabeth Browning', *Art Journal* (1890), pp 62–4; Mrs S. Orr, *Life and Letters of Robert Browning* (1908), appendix I, pp 413–7.

1835 Drawing by Beard. Recorded by G. E. Wilson as in the Rischgitz Collection.
Engraved by J. C. Armytage, for Horne's *New Spirit of the Age,* 1844; engraving reproduced G. E. Wilson, p 29.

1837 Drawing by Count Ripert Monclar. Recorded by G. E. Wilson as in the Fitzwilliam Museum, Cambridge (there is no record of it there). In the Browning sale, Sotheby's, 1 May 1913 (lot 7), reproduced in sale catalogue. A copy is at Baylor University, reproduced G. E. Wilson, p 33.

1840 Drawing called Browning by L. Dickinson. Reproduced G. E. Wilson, p 36.

1845 Drawing by E. H. Thompson (posthumous, but made to look as in 1845). Reproduced G. E. Wilson, p 37.

1853 Painting by T. B. Read. Reproduced L. Greer, *Browning and America* (University of North Carolina Press, 1952), frontispiece.

1853 Clasped hands of R. Browning and his wife by H. Hosmer (NPG 3165 above).

1854 Painting by W. Fisher. Wellesley College, Massachusetts.
Reproduced W. M. Rossetti, p 247.

1854 Painting by W. Page. Baylor University, Texas.
Formerly Meynell Collection; see G. E. Wilson, pp 40–4.

c 1854 Medallion by M. Wood. Exhibited *RA,* 1854 (1456).

1855 Drawing by Lady Ritchie (in her journal). Collection of Mrs Richard Fuller, London.
Reproduced G. E. Wilson, p 45.

1855 Water-colour by D. G. Rossetti. Fitzwilliam Museum, Cambridge (plate 115).
Reproduced G. E. Wilson, p 47.

1856 Bronze medallion by T. Woolner. Examples at Baylor University, and City Museum and Art Gallery, Birmingham (plate 117). Baylor version reproduced G. E. Wilson, p 52; Birmingham version reproduced R. L. Ormond, *The Pre-Raphaelites and their Circle*, Birmingham (1965), no. 25. A plaster cast was with J. S. Maas & Co, 1970.

1858 Painting by M. Gordigiani (NPG 1898 above).

1859 Drawing by F. Talfourd (NPG 1269 above).

1859 Drawing by F. Leighton. Reproduced Mrs S. Orr, frontispiece.

1859 Drawing by R. Lehmann. British Museum.
Reproduced G. E. Wilson, p 63.

1861 Bust by W. W. Story. Keats and Shelley Memorial Museum, Rome.
Reproduced G. E. Wilson, p 76. A copy is at Baylor.

1866 Painting by G. F. Watts (NPG 1001 above).

1866 Painting by S. Laurence. Baylor University, Texas.
Exhibited *R A*, 1869 (336). Reproduced G. E. Wilson, p 82.

1868 Woodcut by G. W. H. Ritchie. Reproduced G. E. Wilson, p 84.

1869 Two drawings by W. W. Story (previously attributed to the 9th Earl of Carlisle). Collection of Mrs Nicholson. Reproduced *Browning to his American Friends*, edited G. R. Hudson (1965), between pp 136–7.

1874 Painting by R. B. Browning. St Andrews School, Tennessee.
Reproduced R. Browning, *Centenary Edition of Poems* (1912), V, frontispiece.

1875 Painting by R. Lehmann. Baylor University, Texas (see NPG 839 above).
Reproduced G. E. Wilson, p 104.

1877 Painting by W. Fisher. Baylor University, Texas.
Exhibited *R A*, 1877 (270). Reproduced G. E. Wilson, p 105.

1878 Drawing by R. Lehmann. Collection of Mrs Schlesinger, 1894.

1879 Painting by A. Legros. Victoria and Albert Museum.
Exhibited *Grosvenor Gallery*, 1880 (32). Reproduced W. M. Rossetti, p 252.

1880 Paintings by R. W. Curtis, H. Pennington, J. Story and C. Forbes. Collection of Contessa Rucellai, Florence. The first reproduced E. Dowden, *Robert Browning* (1905), frontispiece, the second G. E. Wilson, p 115.

1881 Painting by R. B. Browning. Collection of Mrs A. Murray, London.
Reproduced G. E. Wilson, p 121.

1881 'The Private View at the Royal Academy' by W. P. Frith. Collection of A. C. R. Pope.
Exhibited *British Portraits*, RA, 1956–7 (447). Reproduced *Studio*, CIX (1935), 294.

1881 Drawing by F. Sandys. Collection of G. L. Craik, 1890.
Exhibited *R A*, 1882 (1263). Reproduced W. M. Rossetti, p 249.

1882 Painting by R. B. Browning. Balliol College, Oxford.
Engraved by P. Naumann, reproduced W. M. Rossetti, p 262.

1882 Painting by R. B. Browning. Sotheby's, 12 March 1951 (241) (plate 121).

1883 Water-colour by Signor Kirchmayer. Collection of Contessa Rucellai.
Reproduced G. E. Wilson, p 134.

1884 Painting by R. Lehmann (NPG 839 above).

1884 Painting by F. Moscheles. Wesleyan University, Ohio.
Reproduced W. M. Rossetti, p 250.

1886 Drawing by J. W. Alexander. Reproduced G. E. Wilson, p 150.

1886 Painting by L. Calkin. Reproduced G. E. Wilson, p 152.

1886 Silhouette by H. Edwin. NPG.
A similar silhouette said to have been done in 1885 is at Baylor University, reproduced G. E. Wilson, p 153.

1886 Bust by R. B. Browning. Browning Hall, Walworth, Connecticut.
Exhibited *VE*, 1892 (1076). Reproduced L. Whiting, *The Brownings: their Life and Art* (1911), facing p 226. Replicas: Balliol College, Oxford; and collection of Dr Knight.

1888 Painting by Sir W. B. Richmond. Collection of Admiral H. W. Richmond.
Reproduced G. E. Wilson, p 164. Photogravure published Berlin Photographische Gesellschaft (example in NPG).

1888 Medallion by G. Natorp. Example in collection of Joan Burke, Isle of Wight.
Type exhibited *RA*, 1888 (1945). Reproduced W. M. Rossetti, p 251.

1889 Painting by R. B. Browning. Baylor University.
Reproduced W. M. Rossetti, p 264.

1889 Painting by R. B. Browning. Trask Collection, Saratoga Springs, NY.

1889 Drawing by Major G. D. Giles. Baylor University.
Reproduced W. M. Rossetti, p 266.

1889 Bust by H. S. Montalba. Oxford University (?).
Exhibited *RA*, 1889 (2152). Reproduced *Art Journal* (1894), p 216.

1898 Engraving by R. Bryden (example in Victoria and Albert Museum, London), reproduced G. E. Wilson, p 194.

1900 Plaque by S. Morse. Collection of Mrs T. B. Stowell, Los Angeles.
Reproduced G. E. Wilson, p 195.

1924 Painting by E. S. Bush. Pasadena Browning Society.
Reproduced G. E. Wilson, p 146.

1931 Medallion by M. Smith Dean. Reproduced G. E. Wilson, p 94.

Undated Terra-cotta bust by unknown sculptor. Collection of J. Scott, 1896

BRUNEL *Isambard Kingdom* (*1806–59*)

Perhaps the greatest Victorian civil engineer; designed Clifton suspension bridge, 1831; designed several outstanding viaducts, bridges and tunnels for the Great Western Railway, 1833–59; designed Great Eastern steamship, 1852–8.

979 Oil on canvas, 36 × 27¾ inches (91·5 × 70·5 cm), by JOHN CALLCOTT HORSLEY, 1857. PLATE 127
Signed and dated (*bottom left*): J.C. Horsley. 1857

Collections: The sitter, presented by his son, Isambard Brunel, 1895.

Exhibitions: RA, 1857 (576); *SKM*, 1868 (491); *Royal Jubilee Exhibition*, Manchester, 1887 (516); *VE*, 1892 (246).

There are four other versions of this portrait:

1 City Art Gallery, Bristol. Commissioned by the South Devon Railway Company, given to the Directors of the Great Western Railway, who presented it to Bristol, 1947. One of the scrolls on the

desk is inscribed 'DEVON/1843'. Reproduced *Catalogue of Oil Paintings in the Bristol Art Gallery* (1957), plate 21.

2 City Art Gallery, Bristol. Presented by W.S.Quantick, 1934. Probably the replica of no.1, commissioned in 1876 by the Directors of the Great Western Railway (which amalgamated with the South Devon Company, 1878), for presentation to their chairman, Sir Daniel Gooch. The scroll is inscribed '[SOUT]H DEVON/1843'. On loan to Swindon station.

3 Collection of Sir Humphrey Brunel Noble. Painted in 1885, and exhibited *Victorian Era Exhibition*, 1897, 'History Section' (9).

4 Institution of Civil Engineers.

The painting of Brunel by Horsley of 1848 is in the Museum of British Transport, exhibited *RA*, 1848 (353), and *Art and the Industrial Revolution*, City Art Gallery, Manchester, 1968 (26); engraved by D.J. Pound, engraving reproduced L.T.C.Rolt, *Isambard Kingdom Brunel* (1957), figure 3. Horsley was Brunel's brother-in-law.

Description: Healthy complexion, brown eyes, brown hair. Dressed in a white shirt, dark stock, black coat. Seated at a wooden table. Silver pencil-holder. Background colour brown.

ICONOGRAPHY Brunel appears in the painting of the 'Conference of Engineers at Britannia Bridge, Clifton' by J.Lucas in the Institution of Civil Engineers, London, reproduced in the catalogue of their collection (1950), facing p19, engraved by J.Scott, published H.Graves, 1858 (example in NPG); a painting by an unknown artist was sold Coe & Sons, 18 January 1967 (lot 830); a drawing by C.Vogel is in the Küpferstichkabinett, Staatliche Kunstsammlungen, Dresden; a marble bust by E.W.Wyon was exhibited *RA*, 1862 (1106); a copy by C.H.Mabey is in the Institution of Civil Engineers; a bronze statue by Baron C.Marochetti is on the Victoria Embankment, London; there is a photograph by R.Howlett of 1852 (examples in NPG (plate 128), and elsewhere), and a woodcut after it was published *Illustrated Times*, 16 January 1858; there is an engraving by D.J.Pound, after a photograph by Mayall (example in NPG, plate 126), and a woodcut after the same photograph was published *ILN*, XXXII (1858), 352; another woodcut was published *ILN*, XXXV (1859), 303; two group photographs are at Brunel University, reproduced *Observer*, 'Magazine Section' (20 September 1970), pp 1 and 14.

BRUNEL *Sir Marc Isambard* (*1769–1849*)

Engineer.

2515 (28) See *Collections:* 'Drawings of Prominent People, 1823–49' by W.Brockedon, p 554.
See also forthcoming Catalogue of Portraits, 1790–1830.

BUCKINGHAM AND CHANDOS *Richard Plantagenet Temple Nugent Brydges Chandos Grenville, 2nd Duke of* (*1797–1861*)

MP for Buckinghamshire

54 See *Groups:* 'The House of Commons, 1833' by Sir G.Hayter, p 526.

BUCKINGHAM *James Silk* (*1786–1855*)

Author and traveller; travelled in the Middle East, India, Europe, and America; journalist and MP; author of an autobiography, travels, and temperance pamphlets.

2368 Oil on canvas, 8 × 6⅞ inches (20·3 × 17·5 cm) painted oval, attributed to MISS CLARA S. LANE, *c* 1850.
PLATE 129

Signed (lower left): C.S.L.

Collections: The sitter, who gave it to Mr Burns; by descent to his grandson, Cecil Burns, and presented by his wife, 1929.

Burns was a close friend of Buckingham, which explains the gift. The painting was previously unattributed, but comparison with the water-colour of E. W. Lane (NPG 3099) by Clara Lane, also signed 'C.S.L.', suggests that it is her work; no other possible artist with the same initials is known. The date is based on costume and the apparent age of the sitter.

Description: Ruddy complexion, dark eyes, grey hair. Dressed in a dark stock, white shirt, red waistcoat and black coat. Background colour brown.

ICONOGRAPHY A painting by H. W. Pickersgill (with his wife, both dressed in oriental costume) was in the collection of Miss Ellen Buckingham Newry, 1916, exhibited *RA*, 1825 (39); a miniature by E. D. Smith (with his son) was exhibited *RA*, 1841 (854); a bust by E. Smith is at Cutler's Hall, Sheffield, possibly the bust reproduced R. E. Turner, *James Silk Buckingham* (1934), located at Cutler's Hall, but said to be by Theed; a bust by W. Theed was exhibited *RA*, 1848 (1458); an etching by W. Brooke was published H. Colburn, for J. S. Buckingham, *Travels in Assyria Media and Persia* (1829), frontispiece; an engraving by G. T. Doo (example in NPG) was published J. S. Buckingham, *Autobiography* (1855), I, frontispiece; an engraving (in Arabian costume) by W. T. Fry was published Longman, Hirst, etc, 1827 (example in NPG).

BUCKLAND *William* (*1784–1856*)

Cleric and geologist; dean of Westminster, 1845–56; president of the Geological Society, 1824 and 1840; wrote several very important geological papers.

1275 Oil on canvas, $29\frac{3}{4} \times 24\frac{5}{8}$ inches ($75 \cdot 5 \times 62 \cdot 5$ cm), by THOMAS PHILLIPS. PLATE 132

Collections: Sir Robert Peel; sale of Peel Heirlooms, Robinson and Fisher, 10 May 1900 (lot 215); bought by Mrs G. C. Bompas, the sitter's daughter, and her husband, and presented by them, 1900.

Literature: Mrs Jameson, 'Collection of Sir Robert Peel', *Private Galleries of Art in London* (1844), p 377 (118); 'Portrait Gallery at Drayton Manor', *Gentleman's Magazine*, XXVII (1847), 291 (34); 'Our National Museums and Galleries: Recent Acquisitions', *Magazine of Art* (1901), p 415, reproduced.

In his 'Sitters Book' (copy of original MS, NPG archives), Phillips lists three portraits of Buckland for the years 1830, 1832 and 1842. They were all exhibited at the *RA*, 1830 (242), 1832 (67) and 1842 (309). The first two are described as half-length, the third as three-quarter length. The 1830 portrait was apparently in the collection of Buckland's friend, Beriah Botfield. A letter from Buckland to Phillips of 27 April 1831 (NPG archives) refers to Botfield's objections to an engraving of the portrait; Buckland recommended Cousins as the engraver. Negotiations were complicated, and it was finally the 1832 portrait which was engraved. The 1832 portrait of Buckland,[1] showing him in academic robes, holding a fossilized skull with his map of Kirkdale Cave on the wall behind, is in the Deanery, Westminster Abbey. It was in the possession of the sitter, and was presented to the Deanery by his grandson, Harold Bompas, 1949; it was exhibited *SKM*, 1868 (480), and engraved by S. Cousins, published Molteno and Graves, 1833 (examples in NPG). In a letter to Phillips of 19 May 1831 (NPG archives), clearly referring to this portrait, Buckland wrote: '*Pray oblige me with one line by the Post of Tomorrow or Saturday to inform me if you wish me to bring up for my first & 2d. sitting my old Friend the Hyaena's head. I take for granted that I must bring my gown.*' Another version of the Westminster portrait, dated 1836, was sold at Sotheby's, 4 October 1944 (lot 99), bought D. Minlore.

The NPG portrait shows Buckland as an older man than the Westminster portrait, but it could not be the 1842 version, which is clearly described as three-quarter length in Phillips 'Sitters Book'; furthermore, in the *RA* catalogue of 1842, it is described as 'The Rev W. Buckland, DD, Professor of Geology in the University of Oxford', which suggests a more formal portrait than the NPG type.

[1] The inscribed date on the picture, '1832', is recorded by G. Scharf, 'SSB' (NPG archives), XC, 8; it was then in the collection of G. C. Bompas, who presented the NPG portrait.

Description: Healthy complexion, blue-grey eyes, brown hair (discoloured grey). Dressed in a white shirt, white stock and black coat. Background colour dark brown, save in bottom left-hand corner, where there is orange and blue evening sky.

2515 (87) Black and red chalk, heightened with Chinese white, on grey-tinted paper, 14 × 10¼ inches (35·4 × 26·1 cm), by WILLIAM BROCKEDON, 1838. PLATE 130

Dated (lower left): 7.2.38

Collections: See *Collections:* 'Drawings of Prominent People, 1823–49' by W. Brockedon, p 554.

Accompanied in the Brockedon Album by a letter from the sitter, dated 11 December 1836.

255 Electro-type bronze cast, 29½ inches (74·9 cm) high, from a plaster bust by HENRY WEEKES, 1858. PLATE 131

Incised (under the shoulder): H. Weekes. R.A. Sᶜ.

Collections: Commissioned from Messrs Elkington & Co by the trustees of the NPG, from the original plaster bust, presented by the artist, 1860.

Buckland is shown with the star of the Bath. This cast was made from a plaster bust, which was either returned to the artist, or has subsequently disappeared. It was common for the trustees of the NPG to commission an electro-type in case of damage to the original. This bust is closely related to the marble bust by Weekes of 1858 in the University Museum, Oxford, exhibited *RA*, 1858 (1306). Another marble bust by Weekes of 1856 is in Westminster Abbey, and one of 1860 is in the Geological Museum, London.

ICONOGRAPHY A painting by T.C. Thompson was in the Deanery, Westminster Abbey (destroyed in the Second World War), exhibited *RA*, 1845 (138), reproduced Mrs E.O. Gordon, *Life and Correspondence of W. Buckland* (1894), frontispiece; a copy by A. Hooker of 1894 is in the University Museum, Oxford; a painting by S. Howell is at Corpus Christi, Oxford, exhibited *RA*, 1829 (101), reproduced Mrs R.L. Poole, *Catalogue of Oxford Portraits*, II (1925), plate XXXII, facing 274; a painting by R. Ansdell of c 1843 is reproduced Mrs E.O. Gordon, facing p 185, together with other sketches and caricatures; a silhouette by A. Edouart of 1828 is in the Woodwardian Museum, Cambridge; there is an engraving by A. Fox, apparently after the Phillips of 1832 (example in NPG); there is a mezzotint called Buckland (if it is rightly named, showing him younger than other recorded portraits) (example in NPG); a lithograph by T.H. Maguire, after a daguerreotype by Claudet, was published G. Ransome, 1852 (example in NPG), for 'Ipswich Museum Portraits'; a woodcut was published *ILN*, VII (1845), 336.

BUCKSTONE *John Baldwin* (1802–79)

Comedian and author; performed at the Surrey Theatre, 1823; wrote numerous farces; his first piece played, 1826; manager of the Haymarket, 1853–76.

2087 Oil on canvas, 17¼ × 13¾ inches (43·8 × 34·9 cm), by DANIEL MACLISE, c 1836. PLATE 133

Collections: John Lane, bequeathed by him, 1925.[1]

Exhibitions: Daniel Maclise, Arts Council at the NPG, 1972 (59).

This portrait is closely related to the engraving of Buckstone by Maclise, published as no. 78 of his 'Portrait Gallery of Illustrious Literary Characters', *Fraser's Magazine*, XIV (December 1836), facing 720. Although the NPG portrait is only three-quarter length and in reverse, and lacks some of the accessories in the engraving, it is almost identical in pose and features. The NPG portrait was probably the model for the engraving, rather than a version after it. It was also engraved by R. Page, published Chapman and Hall (example in NPG). Another portrait of Buckstone attributed to Maclise was sold at

[1] By the terms of his will, the NPG were allowed to select two portraits. They chose this and the portrait of John Palmer (NPG 2086).

Christie's, 22 July 1871 (lot 161), exhibited *VE*, 1892 (291), lent by H.J.Murcott; it was sold again at Sotheby's, 4 November 1964 (lot 166), bought D.R.Fleming. It shows Buckstone as an older man and dates from *c*1840.

Description: Healthy complexion, brown eyes, brown hair. Dressed in a white shirt, dark stock, white waistcoat, black coat, fawn trousers. Seated in a red armchair. Background colour greenish-brown.

3071 Water-colour on paper, $10\frac{1}{4} \times 6\frac{1}{2}$ inches (26×16.8 cm), by ALFRED BRYAN. PLATE 134

Collections: A.Yakovleff, purchased from him, 1939.

The identification and attribution of this portrait seem sound, but there is no information about its provenance.

Description: High-coloured complexion, bluish eyes, dark hair with grey streaks. Dressed in a white shirt, blue and white spotted bow-tie, dark brown coat with velvet collar, light brown trousers, black shoes and top-hat. Background colour light brown and bluish-grey.

ICONOGRAPHY The best source for popular prints of Buckstone is L.A.Hall, *Catalogue of Engraved Dramatic Portraits in the Harvard Theatre Collection*, I (1930), 173–5, which lists 27 items (some examples in NPG and British Museum); a painting by J.P.Knight is in the Garrick Club, London; a painting by E.Chatfield was exhibited *RA*, 1830 (277); a drawing by J.Barrett of 1848 was in the collection of Austin Garland, 1947; miniatures by E.Upton and J.Wyatt were exhibited *RA*, 1839 (1045), and 1873 (1357); there are in the NPG several photographs, and an engraving by D.J.Pound, published 1860, after a photograph by Mayall; a woodcut, after a photograph by W.and D.Downey, was published *ILN*, LXXV (1879), 457.

BULLEY *Thomas*

Slavery abolitionist.

599 See *Groups:* 'The Anti-Slavery Society Convention, 1840' by B.R.Haydon, p538.

BULWER, *Sir Henry, Baron Dalling and Bulwer.* See DALLING

BURDETT *Sir Francis, Bart (1770–1844)*

Parliamentary and prison reformer, MP for Westminster.

54 See *Groups:* 'The House of Commons, 1833' by Sir G.Hayter, p526.

See also forthcoming Catalogue of Portraits, 1790–1830.

BURDETT-COUTTS *Angela Georgina Burdett-Coutts, Baroness (1814–1906)*

One of the most remarkable Victorian philanthropists; heir of Thomas Coutts, the banker; devised innumerable schemes and charities; battled incessantly for social and economic improvements and reforms; on terms of close friendship with many of the great figures of the age.

2057 Miniature, water-colour and body colour on ivory, $16\frac{1}{2} \times 11\frac{1}{2}$ inches (41.9×29.2 cm), by SIR WILLIAM CHARLES ROSS, *c*1847. PLATE 137

Collections: The sitter; W.L.A.B.Burdett-Coutts, bequeathed by him to the National Gallery, 1921, and subsequently transferred.

Exhibitions: RA, 1847 (830); *British Portraits*, RA, 1956–7 (775).

Literature: J.J.Foster, *British Miniature Painters* (1898), p93, reproduced plate LII, facing p110.

Description: Fresh complexion, dark blue eyes, brown hair. Dressed in a light green dress, with white lace collar, cuffs and shawl, heavy gold bracelet, and two black velvet bands on her arms, the one on the left with a ruby stone. Pale blue stone in her necklace. Red carpet with blue pattern on the left.

Gilt table at left, with a blue vase, and red and white chrysanthemums (?), and blue and red tulips. Gilt chair at right with red embossed velvet covering. Wooden library table with silver inkstand. Gilt chair beyond with red velvet covering. Faded red curtain behind at left. Panelling dark brown.

ICONOGRAPHY A copy of a painting by S. J. Stump of 1828 is in the collection of Coutts & Co, London (plate 135), reproduced *Connoisseur*, LXXXIX (1932), 384; a painting by J. R. Swinton is in the Royal Marsden Hospital, exhibited *RA*, 1865 (161), reproduced as a woodcut *ILN*, LIX (1871), 313, and engraved G. Zobel, published J. Hogarth & Sons (example in NPG); a painting of 'A Garden Party Given by Baroness Burdett-Coutts for the International Medical Congress, London, 1881' by A. P. Tilt of 1882 is in the Wellcome Historical Museum, London; a painting by F. de Terry of 1877 was in the collection of Thomas Male, 1920; a painting by E. Long was in the collection of S. Burdett-Coutts, 1934, exhibited *RA*, 1883 (667), and so were two paintings by J. J. Masquerier; Baroness Burdett-Coutts appears in 'The Private View at the Royal Academy, 1881' by W. P. Frith in the collection of A. C. R. Pope, reproduced *Studio*, CIX (1935), 294; a water-colour by T. Chartran is owned by Coutts & Co, London, reproduced *Connoisseur Year Book* (1957), p 23, published as a lithograph in *Vanity Fair*, 3 November 1883, and so is a marble bust by an unknown artist; a miniature by Miss E. Scott was exhibited *RA*, 1842 (603); a bust by G. G. Adams was exhibited *RA*, 1869 (1291); a bust by W. Brodie was in the Gunnis collection, exhibited *RA*, 1874 (1509); another version is owned by Coutts & Co, and a bust attributed to Brodie was in the collection of A. J. Baxter, 1938; there are several engravings and photographs in the NPG (see plate 136); woodcuts were published *ILN*, LIX (1871), 461, and LXI (1872), 77; a lithograph was published in 'Leaders of Society', *Whitehall Review*, 2 September 1880, no. 153.

BURNES *Sir Alexander* (*1805–41*)

Indian political officer; studied native languages; travelled extensively in India, Afghanistan and Persia; killed in the Cabul massacre.

3515 (70) Black and red chalk on green-tinted paper, 14½ × 10½ inches (36·8 × 26·6 cm), by WILLIAM BROCKEDON, 1834. PLATE 138

Dated (lower left): 24.4.34

Collections: See *Collections:* 'Drawings of Prominent People, 1823–49' by W. Brockedon, p 554.

Accompanied in the Brockedon Album by a letter from the sitter, arranging a meeting, dated 23 April 1834.

ICONOGRAPHY The only other recorded portrait of Burnes is an oil painting by D. Maclise (in Bokhara costume), signed and dated 1834, in a private collection, London; it was exhibited *SKM*, 1868 (414), *VE*, 1892 (53), *Irish Portraits*, NPG, 1969 (109), reproduced in catalogue, and *Daniel Maclise*, Arts Council at the NPG, 1972 (56); it was engraved by E. Finden, published John Murray, 1835 (example in NPG), for Burnes, *Travels in Bokhara etc*, engraved anonymously (example in NPG), and lithographed by L. Dickinson, published 1843 (example in NPG), for *Portraits of the Cabul Prisoners*.

BURNET *Rev John*

Slavery abolitionist.

599 See *Groups:* 'The Anti-Slavery Society Convention, 1840' by B. R. Haydon, p 538.

BURNET *John* (*1784–1868*)

Painter and engraver; engraved pictures by David Wilkie; exhibited at the RA, 1808–23, and at the British Institution; pensioned, 1860; wrote treatises on drawing and painting.

935 Oil on canvas, 36 × 27¾ inches (91·5 × 70·5 cm), by WILLIAM SIMSON, 1841. PLATE 139
Signed and dated (bottom right): Wm Simson. 1841
Collections: Bequeathed by Henry Graves, 1892.
Exhibitions: R A, 1841 (567).

Burnet, as a prominent engraver, must have known Graves, one of the leading publishers of engravings in a professional capacity. Graves also bequeathed a portrait of John Boydell (NPG 934), another famous engraver.

Description: Clear, healthy complexion, dark blue eyes, brown hair with grey wisps. Dressed in a white shirt, dark stock, plum red velvet (?) waistcoat, black coat, gold watch-chain and gold chain across his shirt, brown kid (?) gloves. His left arm resting on a brown and red leather-bound book on a brown support. Background colour brown.

ICONOGRAPHY A painting called Burnet by an unknown artist was in the collection of Colonel M.H. Grant, 1952; a water-colour by S.P.Denning is in the Scottish NPG, engraved by C. Fox, published Moon, Boys and Graves, 1827 (example in NPG); a miniature by W.Dance was exhibited *R A,* 1859 (773); a model for a marble bust by J.Fillans was exhibited *R A,* 1840 (1171); a woodcut, after a photograph by J.Watkins, was published *ILN,* LII (1868), 504; another photograph is in the NPG; a woodcut, possibly after a self-portrait, was published *Art Journal* (1850), p277.

BUSHE *John*

4026 (7) See *Collections:* 'Drawings of Men About Town, 1832–48' by Count A.D'Orsay, p557.

BUXTON *Sir Thomas Fowell, Bart* (*1786–1845*)

Influential philanthropist and reformer; MP for Weymouth, 1818–37; advocate of prison reform, and the abolition of slavery and the slave trade; created a baronet, 1840.

3782 Black, white and brown chalk on brown paper, 20⅝ × 16 inches (52·4 × 40·6 cm), by BENJAMIN ROBERT HAYDON, 1840. PLATE 140
Inscribed in black chalk, apparently in the artist's hand (along the bottom): T.Fowell Buxton
Collections: E.Kersley, purchased from him, 1950.
Exhibitions: Victorian Essex, Valence House, Dagenham, 1959 (145).
Literature: The Diary of Benjamin Robert Haydon, edited W.B.Pope (Harvard University Press, Cambridge, Mass, 1963), IV, 661–2.

This is a study for Haydon's 'Anti-Slavery Society Convention, 1840' (NPG 599 below). Haydon records a sitting from Buxton in his diary for 15 August 1840: '*Buxton sat and I never saw such childish vanity & weakness. . . . Buxton's head is a singular expression of tenacity of purpose, and irresolution*' (Pope, IV, 661).

The drawing of Buxton formed part of a collection of nineteen drawings by Haydon for his big group picture, the remaining eighteen being sold at Sotheby's, 11 March 1952 (lot 154). The area of paper not covered by the mount has noticeably darkened.

54 See *Groups:* 'The House of Commons, 1833' by Sir G.Hayter, p526.

599 See *Groups:* 'The Anti-Slavery Society Convention, 1840' by B.R.Haydon, p538.

ICONOGRAPHY A study by Sir G.Hayter, for his 'House of Commons' picture (NPG 54 above), was engraved by J.Brain, published J.Saunders, 1840 (example in NPG), for 'Political Reformers'; a painting by J.Gilbert was exhibited *R A,* 1847 (1013); a painting by H.P.Briggs was exhibited *R A,* 1832 (49), engraved by W.Holl, published Fisher, 1835 (example in NPG); a painting by G.Richmond was exhibited *Local Portraits by*

George Richmond, Castle Museum and Art Gallery, Norwich, 1937 (41), lent by Sir Thomas Buxton, Bart; a water-colour by Richmond from the same collection was also in the exhibition, *Local Portraits by George Richmond*, Castle Museum and Art Gallery, Norwich, 1937 (40), presumably that listed in Richmond's 'Account Book' (photostat copy, NPG archives), p17, under 1836, exhibited *RA*, 1837 (984) *SKM*, 1868 (389), and *VE*, 1892 (398), lent by Lady Buxton, engraved by J.H.Robinson (example in NPG), engraving reproduced A.J.C. Hare, *The Gurneys of Earlham* (1895), II, facing 66; a drawing by Richmond of 1844 was exhibited *SKM*, 1868 (392), lent by Sir Thomas Buxton, possibly the drawing listed in Richmond's 'Account Book', p39, under 1845, of which he executed a small copy in 1846 (see p43); a marble bust by F.Thrupp is in Westminster Abbey, exhibited *RA*, 1848 (1331), the model for which is reproduced as a woodcut *ILN*, x (1847), 253; a marble bust by J.Bell is in Freetown, Sierra Leone, the model for which was exhibited *RA*, 1848 (1392); designs for statues by H.Weekes and W.C.Marshall were exhibited *RA*, 1847 (1329), and 1848 (1348); a marble bust by E.Wolff was exhibited *RA*, 1841 (1257); there is an engraving by J.Thomson, after a drawing by A.Wivell of 1821, published Wivell (example in NPG).

BYNG *Hon Frederick* (*d1871*)

Son of 5th Viscount Torrington, member of Foreign Office.

4026 (8, 9) See *Collections*: 'Drawings of Men About Town, 1832–48' by Count A.D'Orsay, p557.

BYNG *George* (*1764–1847*)

MP for Middlesex.

54 See *Groups*: 'The House of Commons, 1833' by Sir G.Hayter, p526.

BYRON *Anne Isabella, Lady* (*1792–1860*)

Wife of the poet, Lord Byron; slavery abolitionist.

599 See *Groups*: 'The Anti-Slavery Society Convention, 1840' by B.R.Haydon, p538.

CADBURY *Rev Tapper* (*1786–1860*)

Birmingham manufacturer, and slavery abolitionist.

599 See *Groups*: 'The Anti-Slavery Society Convention, 1840' by B.R.Haydon, p538.

CALABRELLA *Baroness de*

Wife of Lady Blessington's first protector.

4026 (19) See *Collections*: 'Drawings of Men about Town, 1832–48' by Count A.D'Orsay, p557.

CALCRAFT *John Hales* (*1796–1880*)

MP for Wareham.

54 See *Groups*: 'The House of Commons, 1833' by Sir G.Hayter, p526.

CAMPBELL, *Sir Colin, 1st Baron Clyde*. See CLYDE

CAMPBELL *John Campbell, 1st Baron* (*1779–1861*)

Lord chancellor; barrister, 1806; MP, 1830; took a leading part in law reform in the Commons; solicitor-general, 1832; attorney-general, 1834–41; created a peer, 1841; lord chancellor, 1859; published several works.

375 Oil on canvas, 48 × 35 inches (121·9 × 88·9 cm), by THOMAS WOOLNOTH, *c*1851. PLATE 142

Collections: Edward Webber, purchased from him, 1873.

Campbell is in court dress. The early provenance of the picture is unknown. It was engraved by W. Walker, and published by him, 1851 (example in NPG).

Description: Healthy complexion, greyish-blue eyes, brown hair. Dressed in a white shirt, with a frill, and frilled cuffs, black court dress, wearing a court sword with a silver hilt. Resting one hand on a white piece of paper (?), on a brown table. Pilaster at left and rest of background various shades of brown.

460 Oil on canvas, $55\frac{1}{2} \times 43\frac{1}{2}$ inches (141 × 110·5 cm), by SIR FRANCIS GRANT, 1850. PLATE 141

Collections: Presented by the Hon Society of Judges and Serjeants-at-law, 1877.

Exhibitions: RA, 1853 (284).

Literature: Grant's 'Sitters Book' (copy of original MS, NPG archives), under 1850; *Connoisseur*, CXXXV (1955), 241, reproduced 237.

This portrait was engraved by T. L. Atkinson, published H. Graves, 1852 (example in the NPG). On the table at right is a copy of Campbell's *Lives of the Lord Chancellors*. An oil study for this portrait is in the Scottish NPG; it was in the artist's sale, Christie's, 28 March 1879 (lot 27), bought by Lord Leighton, and was purchased from the Leighton Sale, Christie's, 14 July 1896 (lot 315).

Description: Healthy complexion, greyish eyes and wig. Dressed in the red and white robes of a judge, with the gold chain of his office as lord chief justice. Seated in a brown wooden chair. Green-covered table at right with a black inkstand and white quill pen, and a brown leather-bound volume. Grey pilaster at right. Rest of background dark brown.

54 See *Groups:* 'The House of Commons, 1833' by Sir G. Hayter, p 526.

ICONOGRAPHY A painting by G. F. Watts is in the House of Lords, exhibited *SKM*, 1868 (469), and a smaller version of 1860 is at the Watts Gallery, Compton, Surrey, exhibited *VE*, 1892 (375); a painting by Sir J. Watson Gordon was exhibited *RA*, 1858 (87); Campbell is represented in 'Queen Victoria's First Council, 1837' by Sir D. Wilkie, in the Royal Collection, Windsor, exhibited *RA*, 1838 (60), engraved by C. Fox, published F. G. Moon (example in British Museum); a marble bust by Sir J. Steell of 1843 is in the Scottish NPG; there is a lithograph by M. Gauci, and one after J. Doyle, published T. McLean, 1839 (examples in NPG); three caricature drawings by Doyle are in the British Museum; there are several woodcuts and photographs in the NPG.

CAMPBELL *Thomas* (*1777–1844*)
Poet.

2515 (93) See *Collections:* 'Drawings of Prominent People, 1823–49' by W. Brockedon, p 554.

4026 (10) See *Collections:* 'Drawings of Men About Town, 1832–48' by Count A. D'Orsay, p 557.

See also forthcoming Catalogue of Portraits, 1790–1830.

CANNING *Charles John Canning, Earl* (*1812–62*)

Governor-general of India; third son of the statesman, George Canning; governor-general of India, 1856–62, during the Mutiny and other troubles; showed great firmness, and instituted several notable reforms.

1057 Chalk on brown, discoloured paper, $24\frac{1}{4} \times 18\frac{7}{8}$ inches (61·6 × 47·9 cm), by GEORGE RICHMOND, 1851. PLATE 143

Signed (bottom left): Geo. Richmond *and inscribed (bottom right):* Lord Canning

Collections: The artist, purchased from his executors, 1896.

Literature: G. Richmond, 'Account Book' (photostat copy, NPG archives), p 54, under 1851.

No price is given against the drawing of Canning in Richmond's 'Account Book', which suggests that it must be the NPG drawing kept by the artist. Another similar drawing (dated 1852) is in the collection of Lord Harewood, reproduced Sir H. Maxwell, *Sixty Years a Queen* (1897), p 99. A third drawing is recorded in the artist's 'Account Book', p 17, under 1836. This could not be either the NPG or Harewood drawings, which show Canning as an older man; also in 1836 Canning was not yet 'Lord Canning', as the NPG drawing is inscribed.

342, 3 See *Groups:* 'The Fine Arts Commissioners, 1846' by J. Partridge, p 545.

ICONOGRAPHY An oil study for Partridge's picture of the 'Fine Arts Commissioners' (see above) was sold at Christie's, 15 June 1874 (lot 87); a painting by C. A. Mornewick is at Government House, Calcutta; a painting by J. R. Dicksee was in the collection of Herbert Dicksee, 1907; a painting by Sir G. Hayter, and a miniature by W. Barclay of 1836, are in the collection of the Earl of Harewood, the former exhibited *SKM*, 1868 (500), the latter *RA*, 1836 (700), and *Exhibition of Victorian Pictures*, City Museum and Art Gallery, Birmingham, 1937 (64), where the artist is erroneously given as 'H. Barclay'; 'Canning's Return Visit to the Maharajah of Kashmir, 1860', water-colour by W. Simpson is in the India Office, London; a statue by J. H. Foley of 1862 is in Westminster Abbey, and another of 1874 (on horseback) is at Calcutta; busts by M. Noble are at: Highcliffe Castle, Hants (1852); collection of Lord Allendale (1860); formerly Elswick Hall, Newcastle, listed in *Catalogue of Lough and Noble Models at Elswick Hall* (c 1928), p 57 (191); formerly Guildhall Art Gallery, London (1862, destroyed 1940), exhibited *RA*, 1864 (1007); a replica of a marble bust by Noble (possibly one of those above) is in the Victoria Memorial Hall, Calcutta; one of these busts is presumably that reproduced E. Barrington, *The Servant of All* (1927), II, facing 184; a marble bust by L. Macdonald was exhibited *RA*, 1842 (1388); a posthumous bust by Miss M. Grant was commissioned by the Raja-i-Rajgân of Kappoortala, exhibited *RA*, 1871 (1257); a plaster bust by an unknown artist is in the Gladstone-Glynne Collection at Hawarden; there are several photographs in the NPG (see plates 144, 145); an engraving, after a photograph by Mayall, was published Virtue (example in NPG); woodcuts after photographs were published *ILN*, XXVII (1855), 649, and XLI (1862), I.

CANOVA *Antonio* (*1757–1822*)
Italian sculptor.

2515 (2) See *Collections:* 'Drawings of Prominent People, 1823–49' by W. Brockedon, p 554.

CANTERBURY *Charles Manners-Sutton, 1st Viscount* (*1780–1845*)
Statesman.

54 See *Groups:* 'The House of Commons, 1833' by Sir G. Hayter, p 526.

4026 (11) See *Collections:* 'Drawings of Men About Town, 1832–48' by Count A. D'Orsay, p 557.

See also forthcoming Catalogue of Portraits, 1790–1830.

CARDIGAN *James Thomas Brudenell, 7th Earl of* (*1797–1868*)
General, MP for Northamptonshire North.

54 See *Groups:* 'The House of Commons, 1833' by Sir G. Hayter, p 526.

CARLILE *Rev James* (*1784–1854*)
Nonconformist divine; educationalist; author of controversial works and pamphlets; and slavery abolitionist.

599 See *Groups:* 'The Anti-Slavery Society Convention, 1840' by B. R. Haydon, p 538.

CARLILE *Richard* (*1790–1843*)

Freethinker and radical; disciple of Thomas Paine; wrote numerous controversial and often seditious tracts and serials; imprisoned on several occasions.

1435 Oil on canvas, $30 \times 24\frac{3}{4}$ inches ($76 \cdot 2 \times 62 \cdot 8$ cm), by an UNKNOWN ARTIST. PLATE 146

Collections: G. J. Holyoake, bequeathed by him, 1906.

The early history of this picture is unknown, but Holyoake was, like Carlile, a vehement free-thinker, and presumably a friend. There is no doubt about the identification.

Description: Healthy complexion, brown eyes, greyish-brown hair. Dressed in a white shirt, black band round his neck with a gold clasp, black coat. Red curtain at right. Background colour dark green and almost black.

ICONOGRAPHY There are three anonymous prints in the British Museum.

CARLISLE *George William Frederick Howard, 7th Earl of* (*1802–64*)

Statesman and author.

54 See *Groups:* 'The House of Commons, 1833' by Sir G. Hayter, p 526.

342, 3 See *Groups:* 'The Fine Arts Commissioners, 1846' by J. Partridge, p 545.

CARLYLE *Jane Baillie Welsh* (*1801–66*)

Wife of Thomas Carlyle; both were embittered by the marriage, although they remained deeply attached; her letters were first published, 1883.

1175 Oil on canvas, $7\frac{7}{8} \times 6$ inches ($20 \times 15 \cdot 1$ cm), by SAMUEL LAURENCE, *c* 1852. PLATE 147

Collections: John Sterling; by descent to Major-General Sterling, and presented by him, 1898.

Literature: F. Miles, 'Samuel Laurence' (typescript copy, NPG library).

The portrait is mounted as a miniature ($2 \times 1\frac{1}{2}$ inches ($5 \cdot 1 \times 3 \cdot 9$ cm)). The mount shows only the head, which is based on a crayon drawing of Mrs Carlyle by Laurence of 1849 at Carlyle's House, London, reproduced *Jane Welsh Carlyle's Letters and Memorials*, edited C. Brown (1903), frontispiece. A replica of this drawing is in the Berg Collection, New York Public Library. According to the donor (memorandum of *c* 1898, NPG archives), the NPG portrait was painted just before the outbreak of the Crimean War. Another oil portrait of Mrs Carlyle, dated 1849, and attributed to Laurence but almost certainly not by him, is also at Carlyle's House, reproduced *New Letters and Memorials of Jane Welsh Carlyle*, edited A. Carlyle (1903), I, facing 258. John Sterling was an old friend of Carlyle.

Description: Sallow complexion, brown eyes and hair, wearing a brown dress with a white collar. Standing in a brownish rocky landscape, against a greenish-grey sky with white clouds. The painting has suffered from bituminous cracking, particularly in the costume, and the lower part of the landscape on the left.

ICONOGRAPHY A painting by S. Gambardella of 1842 was in the collection of Miss Chrystal, 1924, reproduced *Jane Welsh Carlyle: Letters to her Family*, edited L. Huxley (1924), frontispiece; a painting by R. Tait of *c* 1857, with her husband in 5 Cheyne Row, is at Carlyle's House, London (plate 150), reproduced G. Reynolds, *Painters of the Victorian Scene* (1953), facing p 27; two water-colours by K. Hartmann of 1849 and 1850 are at Carlyle's House, the former reproduced *New Letters and Memorials of Jane Welsh Carlyle*, edited A. Carlyle (1903), I, frontispiece; a miniature by K. Macleay of 1826 is in the Scottish NPG, and a copy by Miss L. Monroe is at Carlyle's House, lithographed by T. R. Way, reproduced *New Letters and Memorials*, I, facing 68; a drawing by an unknown artist, executed before 1826, was in the collection of Miss Chrystal, 1924, reproduced

D. A. Wilson, *Carlyle to "The French Revolution"* (1924), facing p 220; a silhouette by an unknown artist, once in the collection of E. Stoddart, is reproduced *Early Letters of Jane Welsh Carlyle*, edited D. G. Ritchie (1889), frontispiece; three photographs by R. Tait of 1856, 1857, and 1862, are reproduced L. and G. Hanson, *Necessary Evil: Life of J. W. Carlyle* (1952), facing pp 440 and 498; two photographs of 1854 and 1862 (now in the Scottish NPG) are reproduced *Jane Welsh Carlyle: a New Selection of her Letters*, edited T. Bliss (1950), plates XI and XIII.

CARLYLE *Thomas* (*1795–1881*)

Essayist and historian; one of the great intellects of the 19th century; his works of history and philosophy exercised a profound influence on the thought and temper of the age.

968 Oil on canvas, 46 × 34¾ inches (116·9 × 88·3 cm), by SIR JOHN EVERETT MILLAIS, 1877. PLATE 163

Collections: Commissioned by J. A. Froude; left unfinished in the possession of the artist; purchased by the Rev R. Cholmondeley; his sale, Christie's, 16 May 1885 (lot 76), bought in; purchased from Cholmondeley, 1894.

Exhibitions: Millais Exhibition, Grosvenor Gallery, 1886 (15).

Literature: J. A. Froude, *Thomas Carlyle: a History of his Life in London, 1834–81* (1884), II, 460–1; J. G. Millais, *Life and Letters of Sir John Everett Millais* (1899), II, 159, reproduced 89; *New Letters of Thomas Carlyle*, edited A. Carlyle (1904), II, 332–3; William Allingham, *Diary*, edited H. Allingham and D. Radford (1907), p 255; I. W. Dyer, *A Bibliography of Thomas Carlyle's Writings and Ana* (1928), section C ('Catalogue of Portraits' by J. A. S. Barrett), p 540, and section D ('Commentary' by J. L. Caw), p 551; D. A. Wilson and D. W. MacArthur, *Carlyle in Old Age* (1934), pp 405–6, 423; D. Piper, *The English Face* (1957), p 290, reproduced plate 127.

William Allingham recorded the following entry in his *Diary* for 11 April 1877: '*Millais is to paint him* [Carlyle]'. On 29 May of the same year, Carlyle wrote to his brother (*New Letters*, II, 332–3):

I confidently meant to have written on Saturday last, but found myself in the hands of Millais, the Painter, and without time for that or any such operation. Millais still keeps hold of me for four days more now, this and Sunday my only holidays from him hitherto, and I see not yet what will be the day of my deliverance. Millais seems to be in a state of almost frenzy about finishing with the extremest perfection his surprising and difficult task; evidently a worthy man. Mary went with me yesterday to see, and had doubts privately as to what the success would be; but indeed it can, with my complete acquiescence, be what it will. For the third and last time I am in the hands of a best Painter in England (Watts, Legros, Millais), and with that I will consider the small quasi-duty of leaving some conceivable likeness of myself as altogether finished.

Froude, who had commissioned the portrait, wrote about its development (Froude, II, 461):

In the second sitting I observed what seemed a miracle. The passionate vehement face of middle life had long disappeared. Something of the Annandale peasant had stolen back over the proud air of conscious intellectual power. The scorn, the fierceness was gone, and tenderness and mild sorrow had passed into its place. And yet under Millais's hands the old Carlyle stood again upon the canvas as I had not seen him for thirty years. The inner secret of the features had been evidently caught. There was a likeness which no sculptor, no photographer, had yet equalled or approached. Afterwards, I knew not how, it seemed to fade away. Millais grew dissatisfied with his work, and, I believe, never completed it.

Millais' failure or refusal to finish the portrait was not entirely due to his own sense of dissatisfaction. Mary Carlyle and a friend, Mrs Anstruther, visited Millais' studio to look at the unfinished portrait. According to Mrs Anstruther (Wilson and MacArthur, p 405):

The picture was in Millais' usual style, – hard, clever, forcible painting. The outline, the features, all correctly given, and with great power of brush. But merely the mask; no soul, no spirit behind. I said it looked modern, and in fact I did not like it.

It was apparently following this particular visit that Millais stopped working on the portrait, refused to show it to anyone else, and talked of starting afresh. A similar story of Millais' refusal to continue with the portrait was told to George Scharf by the Earl of Carlisle, though with no mention of Mrs Anstruther (memorandum by Scharf, 30 November 1894, NPG archives):

A lady, unknown, came with Millais while he was painting Carlyle & looking at the picture said why you have not painted him as a philosopher or sage but as a rough – shire peasant. Millais laid down his palette and never touched the work afterwards.

The portrait remained unfinished (see particularly the hands), and was never offered to Froude. It was bought by an old friend of Millais sometime after 1877. Millais wrote to Scharf on 2 September 1894 (NPG archives), at the time when he was one of the trustees of the NPG: '*I remember painting both the Carlyle, & Collins. The former was done in 3 sittings & I rather think it a goodish portrait.*' Carlyle himself was moderate in his comments on this likeness, compared with the spleen which he vented on his portrait by Watts (NPG 1002 below) (Wilson and MacArthur, p406):

The picture [he said] does not please many, nor, in fact, myself altogether, but it is surely strikingly like in every feature, and the fundamental condition was that Millais should paint what he was able to see.

Ruskin later made similar reservations, only more explicitly. Alfred Lyttleton had remarked how Carlyle's face was '*far finer than his pictures had led me to hope. Pathos was the abiding characteristic*'. Ruskin commented, '*Millais may represent the pathos of a moment, not of a lifetime*' (Wilson and MacArthur, p423). On one of his visits to Millais to sit for his portrait, Carlyle stopped on the staircase, and, looking round the palatial interior, asked: '*Millais, did painting do all that?*' '*Yes, painting did it all.*' '*Well, there must be more fools in this world than I had thought!*' (Wilson and MacArthur, p406).

On 17 July 1914, this portrait was slashed by a militant suffragette, Anne Hunt, as a protest against the re-arrest of Mrs Pankhurst. She received six months imprisonment. The three gashes she inflicted on the portrait, all across the face, are still visible.

Description: Ruddy complexion, brown eyes, grey hair and beard. Dressed in a white shirt, dark stock, black suit. Seated in wooden armchair, holding brown stick. Background colour dark brown.

1002 Oil on canvas, 26 × 21 inches (66 × 53·3 cm), by GEORGE FREDERICK WATTS, 1868–77. PLATES 155, 157

Collections: The artist, presented by him, 1895 (see appendix on portraits by G.F.Watts in forthcoming Catalogue of Portraits, 1860–90).

Exhibitions: Winter Exhibition, Grosvenor Gallery, 1882, 'Collection of the Works of G.F.Watts' (125); *Inaugural Art Exhibition*, City Museum and Art Gallery, Birmingham, 1885–6 (138); *Paintings by G.F.Watts*, Metropolitan Museum of Art, New York, 1885 (99); *Collection of Pictures by G.F.Watts, R.A.*, Museum and Art Gallery, Nottingham, 1886 (13); *Royal Jubilee Exhibition*, Manchester, 1887 (517); *Paintings by G.F.Watts*, Rugby Museum, 1888 (no catalogue); *Paintings by G.F.Watts*, Southwark, 1890 (no catalogue); *VE*, 1892 (212).

Literature: D.Hannay, 'Some Portraits of Carlyle', *Magazine of Art* (1884), p83, reproduced p81; M.H.Spielmann, 'The Works of Mr G.F.Watts, R.A.,' *Pall Mall Gazette* "Extra", no.22 (1886), p30; [Mrs] M.S.Watts, *George Frederic Watts* (1912), I, 249; 'Catalogue of Works by G.F.Watts', compiled by Mrs M.S.Watts (MS, Watts Gallery, Compton), II, 29; D.Wilson and D.W.MacArthur, *Carlyle in Old Age* (1934), p168; I.W.Dyer, *A Bibliography of Thomas Carlyle's Writings and Ana* (1928), section C ('Catalogue of Portraits' by J.A.S.Barrett), p541, and section D ('Commentary' by J.L.Caw), p547.

One of three similar versions, the most important of which was commissioned by John Forster, and is now in the Victoria and Albert Museum (F39), exhibited *Charles Dickens*, Victoria and Albert Museum, 1970 (135). The third version was rescued from destruction by Mrs Watts, and is now in the

Ashmolean Museum, Oxford, bequeathed by Miss K. Lewis (bought by her at the sale following Mrs Watts' death at Limmerslease, April 1939). The NPG portrait is dated 1877 in the various exhibition catalogues in which it appeared (see above), and also by Spielmann (see his letter of 25 June 1927, NPG archives), on the authority of the artist, but it was evidently begun at the same time as the Victoria and Albert Museum version nine years before. Watts frequently worked on his pictures over a period of several years.

Mrs Watts states that her husband began his portraits of Carlyle in 1867, quoting a letter from Carlyle to the artist of 18 June 1867 (M.S.Watts, I, 249–50). This seems to be a mistake or a mis-reading, for Carlyle wrote a letter on 20 May 1868, which contradicts Mrs Watts' evidence: '*On Friday (3 p.m.) I am to give Watts his "first sitting"* '.[1] Forster is known to have commissioned the Victoria and Albert Museum portrait in May 1868,[2] and it seems most unlikely that Watts had begun one of the other two versions a year earlier, particularly as the Forster picture appears to be the prime original. On 20 June 1868, Carlyle again referred to the portrait: '*Watts, too, the Painter, has not quite done with me, I fear; and seems to be making a monster than otherwise. Well, well!*'[3] Carlyle and Watts did not get on well together, the latter '*in vain trying to open the eyes of the great prophet to the value of art outside the historical record in a portrait*' (M.S.Watts, I, 249). Carlyle thought Watts a '*very wearisome, "washed-out", dilettante man, – though an innocent well-intending and ingenious withal*' (Wilson and MacArthur, p 168). Carlyle was an impatient sitter, which acted on the nerves of the artist, and inhibited his powers. When he apologized to Carlyle for making him sit so long, Carlyle doggedly replied (M.S.Watts, II, 232): '*I said I would sit, and so I will do so*'. This was not a sympathetic atmos-phere for Watts, and in self-defence he put curtains round his easel, and refused to show Carlyle what he was doing.[4] By July 1868, Carlyle felt in need of an escape, and he wrote to Watts (M.S.Watts, I, 249):

Unexpectedly I find I have to go to Scotland in about ten days, and continue there I know not how long. If you do want me again, therefore, let it be within that time, fairly within; I am anxious to neglect nothing for perfecting of our mutual enterprise, in which I see in you such excellent desire after excellence, and shall be ready within the prescribed limits and times, any time at a day's notice.

The portrait, however, was not finished before Carlyle's departure. Letters from Watts to Forster during the autumn and winter of 1868–9 plead illness, the weather, and fear of disturbing Carlyle, as the reasons for the delay in finishing the portrait. On 7 June 1869, Watts wrote:

but now the weather is warm I should at once apply for the sittings I have been every day on the point of asking for, but every day hesitating knowing how much Mr Carlyle dislikes the occupation.[2]

Finally in the autumn of 1869, Watts obtained a few more sittings, and delivered the finished portrait to Forster on 7 November 1869. When he asked Carlyle for an opinion on his work, the latter remarked, after deliberation, '*Mon, I would have ye know I am in the hobit of wurin' clean linen!*'[5] His later comments were more violent and bitter. He complained that he had been made to look like 'a mad labourer', and wrote to his brother:

Decidedly the most insufferable picture that has yet been made of me, a delirious-looking mountebank full of violence, awkwardness, atrocity, and stupidity, without recognizable likeness to anything I have ever known in any feature of me. Fuit in fatis. What care I, after all? Forster is much content. The fault of Watts is a passionate pursuit of strength. Never mind, never mind![6]

[1] *New Letters of Thomas Carlyle*, edited A.Carlyle (1904), II, 249 n.
[2] There are eight letters from Watts to Forster relating to this portrait in the Victoria and Albert Museum Library, Forster MSS, F 48, F 65, XL, letters 15–22. Watts' first letter about the commission is dated 7 May 1868.
[3] *New Letters*, II, 249.
[4] See E.R. and J.Pennell, *Life of James McNeill Whistler* (1908 edition), I, 170.
[5] E.R. and J.Pennell, I, 170. A similar story is told by Luke

Ionides, *Memories* (privately printed, Paris, 1925), p 10, who records that Carlyle told Whistler: '*I've been painted by a man of note – Watts, his name – and he painted my shirt-collar as if I'd never had a laundress*'.
[6] J.A.Froude, *Thomas Carlyle* (1884), II, 380. Further com-ments by Carlyle on the portrait are recorded by the artist, Robert Herdman, who painted Carlyle in 1875 (see icono-graphy below); Herdman's unpublished notes are in the collection of Miss Herdman, Edinburgh.

Watts himself regarded all three portraits as failures, but other critics were more favourable. Meredith thought the Forster portrait had the look of Lear encountering the storm on the Cornish coast, and Chesterton wrote:

The uglier Carlyle of Watts has more of the truth about him, the strange combination of a score of sane and healthy visions and views, with something that was not sane, which bloodshot and embittered them all, the great tragedy of the union of a strong countryside mind and body with a disease of the vitals and something like a disease of the spirit. In fact, Watts painted Carlyle 'like a mad labourer', because Carlyle was a mad labourer.[1]

Description: Ruddy complexion, grey hair and beard. Dressed in a white shirt and black coat. Background colour dark muddy brown.

2520 Pen and ink on paper, $6\frac{5}{8} \times 4\frac{3}{8}$ inches ($16\cdot7 \times 11\cdot1$ cm), by CHARLES BELL BIRCH, 1859. PLATE 153
Inscribed (bottom centre): T. Carlyle on a midnight/ramble. Cheyne Walk./C.B.B./1859
Collections: The artist, presented by his nephew, G. von Pirch, 1931.

2794 Pen and ink on paper, $7 \times 4\frac{3}{8}$ inches ($17\cdot8 \times 11\cdot1$ cm), by SIR GEORGE SCHARF, 1874. PLATE 161
Signed, inscribed and dated (bottom right): GS. 16th May. 1874/T. Carlyle. *There are also various colour notes and descriptions of objects in Scharf's hand.*
Collections: Bequeathed by Scharf, together with most of his papers, 1895.

2894 Pen and ink on paper, $4 \times 2\frac{1}{2}$ inches ($10\cdot2 \times 6\cdot3$ cm), by EDWARD MATTHEW WARD. PLATE 154
Inscribed (top left): Carlyle/at British Museum
Collections: Presented by W. Bennett, 1936.
Another sketch of Carlyle by Ward is reproduced Mrs E. M. Ward, *Memories of Ninety Years* (1924), facing p4.

3558 Pen and ink on card, $5\frac{7}{8} \times 8\frac{3}{4}$ inches ($14\cdot9 \times 22\cdot2$ cm), by HARRY FURNISS. PLATE 166
Signed (lower right); Hy.F. *Inscribed in ink (top left):* Carlyle
Collections: Purchased from the artist's sons, through Theodore Cluse, 1948.
This is one of a large collection of Furniss drawings, which will be collectively discussed in the forthcoming Catalogue of Portraits, 1860–90.

658 Terracotta cast of the head, 22 inches ($55\cdot9$ cm) high, from a statue by SIR JOSEPH EDGAR BOEHM of *c* 1875. PLATE 164
Incised (left hand side of base): BOEHM/Fecit
Collections: The artist, presented by him, 1882.
Literature: D. Piper, *The English Face* (1957), pp 289–90, reproduced plate 128.
This bust is closely related to the head of the life-size statue of Carlyle by Boehm. The original plaster model, said to have been executed in January 1875,[2] was formerly in the Royal Scottish Museum, Edinburgh (destroyed *c* 1945), apparently the statue exhibited *RA*, 1875 (1301), engraved by E. Roffe for the *Art Journal* (1878), p148. A marble version was commissioned by the Earl of Rosebery in 1881, exhibited *RA*, 1882 (1672), now in the Scottish NPG (plate 165); a bronze cast of 1883, presumably done from the plaster, is on the Chelsea Embankment, and a copy of 1929 is at Ecclefechan. Boehm also produced an edition of statuettes after the statue (examples in Carlyle's House, London, the Victoria and Albert Museum, Royal Collection, and elsewhere), as well as casts of the head like the NPG bust (other examples in the London Library, formerly collection of J. Ballantyne (said to be dated 1874) and elsewhere). Boehm wrote about the NPG bust in a letter to Scharf of 24 January 1882 (NPG archives):
'The reason why I was so remiss with sending the Carlyle bust is that the mould from which the squeezes for

[1] G. K. Chesterton, *G. F. Watts* (1904), p154.
[2] See J. A. S. Barrett, 'The Principal Portraits and Statues of Thomas Carlyle', section c of I. W. Dyer, *A Bibliography of Thomas Carlyle's Writings and Ana* (1928), p3.

terra cotta copies are to be made was already too blunt as I had a great many busts to do in spite of "The Reminiscences" – and as I wish to give as good an one as possible to your collection I had a new mould made.'

The terracotta bust by Boehm exhibited *RA*, 1881 (1481) must have been of the NPG type, but presumably cast from the earlier mould mentioned by Boehm.

An earlier statuette, showing variations from the statue (for instance, Carlyle is wearing a short and not long coat, and there are differences of detail), was modelled in 1874, possibly as a trial-run for the life-size statue; examples in terracotta and bronze (both dated 1874) are in the Glasgow Museum and Art Gallery, and Carlyle's House, London, respectively, the latter exhibited *Bicentenary Exhibition*, RA, 1968–9 (761). Both are described as 'from life'. Boehm received a series of sittings from Carlyle, almost certainly in 1874. When Carlyle first sat, he briskly informed the sculptor: '*I'll give you twenty-two minutes to make what you can of me*'.[1] When Boehm punctually finished working, Carlyle was so impressed that he gave him another twenty-two minutes, and then allowed him as many sittings as he required. Referring apparently to the 1874 statuette, Carlyle wrote: '*He* [Boehm] *seems to me by far the cleverest Sculptor or Artist I have ever seen He says he will complete the affair in four sittings, but I fear this will hardly be the case*'.[2] According to Wilson and MacArthur,[3] Carlyle sat to Boehm on 25 June 1875, but it is not clear for which portrait; if the plaster statue was the one exhibited *RA*, 1875 (1301), then it must have been finished by May for the opening of the exhibition.

Boehm also modelled a medallion of Carlyle in 1874; the original wax study and casts in plaster and bronze are in Carlyle's House, London; another bronze cast is in the Scottish NPG. This medallion was later adapted as a medal to celebrate Carlyle's eightieth birthday. The original gold medal presented to Carlyle was formerly in the collection of Alexander Carlyle; examples in silver and bronze are in Carlyle's House, London, and elsewhere. A plaster cast of the medallion, together with an interesting letter from Boehm of 1880, about his medallions and statues of Carlyle, was sold at Sotheby's, 2 July 1971 (lot 75).

1241 Plaster cast, painted black, 8½ inches (21·6 cm) diameter, of a medallion by THOMAS WOOLNER, 1855.
PLATE 152

Collections: Sir James Caw, presented by him, 1899.

Literature: Magazine of Art (1900), pp 224–5.

This medallion was specially cast for Sir James Caw to be presented to the NPG. The cast was taken from the medallion in the Scottish NPG, also presented by Sir James Caw, which was one of an original edition of plaster casts. In the past this medallion has erroneously been dated 1851. It is known that Woolner executed a medallion in that year,[4] exhibited *RA*, 1852 (1396), but in 1855 he produced a new version, because he was dissatisfied with his first effort. It is clear that this new medallion was a reworking of the old one, and not based on a new sitting from the life, as Carlyle is still shown without a beard, whereas, by 1854, he had in fact grown one. A bronze cast of the medallion at Carlyle's House, identical with the Scottish NPG plaster cast, is inscribed with the date 1855; so is the medallion reproduced *Magazine of Art* (1900), p 225 (this is not the NPG medallion, although illustrating a discussion about it). Woolner exhibited a bronze medallion *RA*, 1857 (1368), and another medallion or bust *RA*, 1856 (1370). A much cruder medallion of Carlyle by Woolner, an example of which is at the Mary Mellish Archibald Memorial Library, Mount Allison University, New Brunswick, probably represents the 1851 version.[5] A medallion at Carlyle's birthplace, Ecclefechan, Scotland, is said to be the 1851 type.

In 1865 Woolner modelled a plaster bust of Carlyle[6] (examples in the Philosophical Institute,

[1] C. Eaglestone, 'A Memoir of Sir Edgar Boehm', *Blackwood's Magazine*, CXLIX (1891), 348.
[2] See J. A. S. Barrett, p 3.
[3] D. A. Wilson and D. W. MacArthur, *Carlyle in Old Age* (1934), p 354.

[4] See Amy Woolner, *Thomas Woolner: his life in Letters* (1917), p 12.
[5] Presented by Dr J. Clarence Webster, 1948, and said to have come from the family of the sculptor. It was bought in Scotland in 1896.
[6] Amy Woolner, p 262.

Edinburgh, and the Observatory, Maxwelltown), which he executed in marble the following year, presumably that exhibited *RA*, 1868 (1007). This marble bust is now in the University Library, Edinburgh.

1361 Plaster cast, 10¼ inches (26 cm) long, of a death mask by SIR ALFRED GILBERT, 1881. PLATE 168

Collections: The artist; W. E. H. Lecky, presented by his wife, 1904.

Literature: I. McAllister, *Alfred Gilbert* (1929), pp 35–6.

There are other casts of this death mask at Carlyle's House and the Chelsea Public Library, London. Carlyle died on 4 February 1881. Gilbert executed the cast while he was working as an apprentice to Sir J. E. Boehm. He had considerable difficulty with Carlyle's housekeeper before managing to take the cast.

1623 Plaster cast of hands, approximately 10 × 8½ inches (25·4 × 21·6 cm), by MESSRS BRUCCIANI & CO, after SIR JOSEPH EDGAR BOEHM, 1875. PLATE 169

Inscribed on the wrist of the left hand: Brucciani & Co/London

Collections: Messrs Brucciani, presented by them, 1911.

According to a letter written by Edmund Gosse (archives of Carlyle's House, London), Boehm took a cast of Carlyle's hands, while working on his 1875 statue of Carlyle (see NPG 658 above). The hands in this cast and on the statue are identical. The plaster cast of the hands at Carlyle's House (there is also a bronze cast there), given by Lady Gosse, is not signed by Brucciani & Co, and may be Boehm's original cast. Boehm presumably sold his copyright to Brucciani & Co, who produced an edition of casts.

ICONOGRAPHY A fairly full list of Carlyle's portraits is given in I. W. Dyer, *A Bibliography of Thomas Carlyle's Writings and Ana* (1928), section C, prepared by J. A. S. Barrett, and section D, by J. L. Caw, pp 533–53. The iconography below is much fuller, and corrects several inaccuracies, but it does not include photographs or caricatures. There are several photographs in the NPG (see plates 158, 160), in Carlyle's House, London, and in Carlyle's birthplace, Ecclefechan, Scotland.

1833 Engraving published *Fraser's Magazine*, VII (June 1833), facing 706, as no. 37 of Maclise's 'Gallery of Illustrious Literary Characters'. Pencil study of 1832: Victoria and Albert Museum (plate 148).

1834 'The Fraserians' by D. Maclise, engraving published *Fraser's Magazine*, XI (January 1835), between 2 and 3. Two pencil studies: Victoria and Albert Museum.

c 1835 Water-colour by R. Dighton. Carlyle's House, London.

1838 Painting by S. Laurence. Collection of Thomas Carlyle (great-nephew of the sitter).
Exhibited *RA*, 1841 (565). Engraved by J. C. Armytage (example in NPG), for Horne's *A New Spirit of the Age*, 1844.

1838 Drawing by S. Laurence. Carlyle's House, London (plate 149).
Reproduced D. A. Wilson, *Carlyle to 'The French Revolution'* (1927), frontispiece.
Two copies by Caroline Fox: one in the collection of the Fox family; the other sold Laurence Sale, Puttick and Simpson, 12 June 1884 (lot 182), now in the collection of Major Sir Charles Pym.
Another copy, inscribed 'D. Maclise 1825', but clearly not by him, is reproduced *Glasgow Herald*, 5 February 1924, p 9.

c 1838 Drawing by S. Laurence. Berg Collection, New York Public Library.

c 1838 Drawing by S. Laurence. British Museum.

1839 Drawing by Count A. D'Orsay. Sotheby's, 13 February 1950 (lot 216), bought Colnaghi.
Lithographed by R. J. Lane, published J. Mitchell, 1839 (example in NPG), lithograph reproduced D. A. Wilson, *Carlyle on Cromwell and Others* (1925), facing p 64. Copy: Carlyle's House, London.

1841 Drawing by S. Laurence. Carlyle's House, London.
Reproduced *New Letters and Memorials of Jane Welsh Carlyle*, edited A. Carlyle (1903), II, frontispiece.

1842 Painting by S. Gambardella. See *Jane Welsh Carlyle: Letters to her Family*, edited L. Huxley (1924), pp 45, 53 and 85.

1844 Painting by J. Linnell. Scottish NPG (plate 151).
Exhibited *RA*, 1844 (428). Reproduced as an engraving A. T. Story, *Life of John Linnell* (1892), I, 301.

1844 'Dickens Reading *The Chimes* to his Friends', drawing by D. Maclise. Victoria and Albert Museum.
Reproduced D. A. Wilson, *Carlyle on Cromwell and Others* (1925), facing p 272.

c 1848 Bust by H. Weigall. Crystal Palace Collection, 1854.
Exhibited *RA*, 1848 (1437).

1849 Drawing by S. Laurence. Collection of Lord Northampton.
Reproduced J. A. Froude, *Carlyle: his Life in London* (1884), I, frontispiece.

c 1850 Drawing by an unknown artist. Collection of H. P. Rohde.

1851 Medallion by T. Woolner. Example at Mount Allison University, New Brunswick (see NPG 1241 above).

1852–65 'Work' by F. Madox Brown. City Art Gallery, Manchester (plate 156).
Ford Madox Brown Exhibition, Walker Art Gallery, Liverpool, 1964 (25), and elsewhere.
Figure of Carlyle based on a photograph (example in the archives of the City Museum and Art Gallery, Birmingham). Pencil studies of Carlyle and Maurice: City Art Gallery, Manchester. Reduced replica (dated 1863): City Museum and Art Gallery, Birmingham. Carlyle must have been painted into the picture in the later stages of its production, from the evidence of his appearance.

1855 Medallions by T. Woolner (see NPG 1241 above).

1855 Painting by R. S. Tait. Carlyle's House, London.
Exhibited *RA*, 1856 (153).

1857 Drawing by S. W. Rowse. Collection of Charles Norton, Boston, 1883.
Etched by A. S. Solvott for *The Correspondence of Carlyle and Emerson* (1883), II, frontispiece.

1857–8 Painting by R. S. Tait (with his wife at 5 Cheyne Row). Carlyle's House, London (plate 150).
Exhibited *RA*, 1858 (943), as 'A Chelsea Interior'. Reproduced G. Reynolds, *Painters of the Victorian Scene* (1953), facing p 27.

1859 Drawing by H. and W. Greaves. Carlyle's House, London.

1859 Drawing by C. B. Birch (NPG 2520 above).

c 1860 Cameo by F. Anderson. Exhibited *RA*, 1860 (880).

1861 Lithograph by T. R. Way (on horseback), after a photograph, lithograph reproduced *New Letters of Thomas Carlyle*, I, frontispiece.

1865 Plaster busts by T. Woolner. Philosophical Institute, Edinburgh, and Observatory, Maxwelltown.

1866 Marble bust by T. Woolner. University Library, Edinburgh.

1866 Marble bust by Mrs D. O. Hill (modelled in 1866). Exhibited *RA*, 1868 (1131). Possibly the marble bust by Mrs Hill at Carlyle's Birthplace, Ecclefechan.
Another bust, also modelled in 1866, was exhibited *RA*, 1867 (1164).

1868–77 Paintings by G. F. Watts (see NPG 1002 above).

1869 Painting by J. Archer (after a photograph by Elliott and Fry). Carlyle's House, London.
Engraving by J. Brown, after the same photograph, with 1865 autograph (example in NPG).

1869–70 Painting by M. Gordigiani (after a photograph by Mrs Cameron). Collection of Professor Spranger, Florence, 1926. Reproduced *Connoisseur*, LXXVI (1926), 174, where said to be 'from life'.

1870 Drawing by W. Greaves (partly based on a photograph). Scottish NPG.

Other versions: (1) J.S.Maas & Co, 1963 (dated 1871). (2) B.F.Stevens and Brown, 1942. (3) Cecil Higgins Museum, Bedford. (4) Collection of C.J.Sawyer (signed and dated 1872). (5) Sotheby's, 14 December 1966 (lot 195), bought Sawyer. (6) Sotheby's, 30 April 1970 (lot 2), bought Stevens and Brown.

Oil versions: (1) Scottish NPG (dated 1879). (2) Sotheby's, 17 July 1963 (lot 1), bought F.Salmon. (3) Sotheby's, 14 December 1966 (lot 194), bought Sawyer. (4) Collection of Mr Thruston, 1921.

A full-length oil portrait of Carlyle by Greaves, similar in pose to Whistler's portrait of 1873, but the head based on the Scottish NPG drawing of 1870, was sold at Sotheby's, 20 April 1966 (lot 22), bought Woolley. A portrait by Greaves is in Carlyle's Birthplace, Ecclefechan. The figure of Carlyle appears in some of Greaves' topographical drawings of Chelsea; one of these is reproduced T.Pocock, *Chelsea Reach* (1970), facing p65.

1870	Water-colour by 'Ape' (C.Pellegrini). *Vanity Fair* Sale, Christie's, 5 March 1912 (lot 128). Coloured lithograph published *Vanity Fair*, 22 October 1870.
1873	Painting by J.M.Whistler. City Art Gallery, Glasgow (plates 159, 162). Reproduced D.Sutton, *Nocturne: the Art of James McNeill Whistler* (1963), plate v, facing p136. Study for this portrait: Art Institute, Chicago.
1873	Bust by J.D.Crittenden. Edinburgh Public Library. Exhibited *RA*, 1874 (1465).
c1873	Medallion by G.Morgan. Exhibited *RA*, 1873 (1482).
1874	Drawing by Sir G.Scharf (NPG 1794 above).
1874	Statuette by Sir J.E.Boehm. Terra-cotta in Glasgow Museum and Art Gallery, bronze cast in Carlyle's House, London (see NPG 658 above).
1875	Etching by A.Legros (examples in the Scottish NPG and the British Museum).
1875	Water-colour by Mrs H.Allingham (seated in his garden, reading). Reproduced *The Graphic*, XIII (1876), frontispiece. Etched by C.O.Murray, etching exhibited *RA*, 1882 (1294).
1875	Drawing by an unknown artist (signed 'T.H.'). Collection of Sir C.H.Metcalfe, 1929.
1875–81	Plaster and marble statues and busts by Sir J.E.Boehm (see NPG 658 above). Cast of hands (see NPG 1623 above).
1875	Medallions and medals by Sir J.E.Boehm (see NPG 658 above).
1876	Painting by R.Herdman. Scottish NPG. A related drawing of 1875 is in the collection of Mrs Dance.
1876	Etching by A.Legros (example in NPG), reproduced D.Hannay, 'Some Portraits of Carlyle', *Magazine of Art* (1884), p80.
1877	Painting by A.Legros. Scottish NPG.
1877	Painting by Sir J.E.Millais (NPG 968 above).
c1877	Bronze medallion by A.Legros. Examples in Scottish NPG, Kgl Skulpturensammlung, Dresden, and Manchester City Art Gallery.
1878	Water-colour by Mrs H.Allingham (seated in his study). Scottish NPG (plate 167). Between 1875 and 1879, Mrs Allingham painted some thirteen water-colours of Carlyle, mostly of his head alone. Four of these are at Carlyle's House, London. The rest are widely scattered.
1879	Plaster bust by W.Brodie. Scottish NPG.
1879	Marble bust by W.Brodie. University College, Dundee.
1881	Drawing attributed to himself. Sotheby's (printed books), 9 October 1968 (lot 896).
1881	Drawing by an unknown artist. Scottish NPG.
1881	Engraving by Sir H.Herkomer (example in NPG).

1881 Six etchings by H. Helmick (after photographs and sketches), published Etching Society (examples in NPG).

1881 Two drawings by Mrs H. Allingham (after death, 5 February 1881). Carlyle's House, London.

1881 Death mask by Sir A. Gilbert (NPG 1361 above).

1882 Three water-colours by J. Paterson. Scottish NPG.

1883 Water-colour by W. Young. Scottish NPG.

c1883 Medallion by C. Emptmeyer. Exhibited *RA*, 1883 (1656).

1884 Stone medallion by C. F. Voysey. Carlyle's House (exterior), London.
Plaster cast: Carlyle's House.

c1884 Etching by W. Hole, reproduced Hole, *Edinburgh University Portraits*.

1889 Marble bust by D. W. Stevenson. Carlyle's House, London.

c1895 Painting by E. Crowe, based on a drawing of 1879. Exhibited *RA*, 1895 (674).

1895 Stone medallion by F. Thomas. NPG (exterior).
Reproduced *Magazine of Art* (1895), p431.

c1897 Bronze bust by D. McGill. Exhibited *RA*, 1897 (2059).

1904 Plaster bust by J. Tweed. Carlyle's House, London.
Exhibited *14th Annual Exhibition*, Royal Society of Portrait Painters, 1904 (266).

Undated Painting attributed to L. Fildes (bears signature). Collection of Paul Ramey, USA.
Apparently the portrait reproduced D. A. Wilson and D. W. MacArthur, *Carlyle in Old Age* (1934), frontispiece, where it is said to have been painted in Sir H. Herkomer's studio.

Undated Etching by G. Pilotell (example in British Museum).

Undated Lithograph by J. H. Lynch, after a daguerreotype (example in NPG).

Undated Woodcut by M. Jackson, after T. Scott (example in British Museum).

Undated Drawing by E. M. Ward (NPG 2894 above).

Undated Drawing by H. Furniss (NPG 3558 above).

Undated Water-colour by an unknown artist. Scottish NPG.

Undated Two water-colours by unknown artists. Carlyle's Birthplace, Ecclefechan.

Undated Drawing by S. Laurence (reading a book). Formerly collection of H. N. Pym.
Oil version, Laurence sale, Puttick and Simpson, 12 June 1884 (lot 179), bought Smith and Elder.

Undated Drawing by J. Andrews (based on a photograph). Christie's, 22 November 1912 (lot 1).

Undated Various drawings by the 9th Earl of Carlisle: (1) Collection of Lady Anna Macleod.
(2) Collection of Mrs W. Nicholson. (3) Reproduced *Magazine of Art* (1884), p79. (4) Exhibited *Winter Exhibition*, Grosvenor Gallery, 1880 (523). (5) City Museum and Art Gallery, Carlisle (with William Morris), exhibited *George Howard and his Circle*, Carlisle, 1968 (119).

Undated Portrait by J. W. Carmichael. Carlyle's Birthplace, Ecclefechan.

Undated Carlyle Memorial by K. Brown. Kelvingrove Park, Glasgow.
A bust by Dr P. MacGillivray is in the Kelvingrove Art Gallery.

Undated Marble bust by an unknown sculptor. Castle Ashby.

Undated Wallace Monument, Stirling.

Undated Etching by L. Richepin (example in Aberdeen Art Gallery); engraving by F. Croll, after a daguerreotype by Beard (example in NPG); engraving by C. Aikmann (example in Carlyle's Birthplace, Ecclefechan).

CARR *Sir John* (*1772–1832*)
Traveller.

2515 (42) See *Collections:* 'Drawings of Prominent People, 1823–49' by W. Brockedon, p 554.

CARRINGTON *Robert John Smith* (*later Carrington*), *2nd Baron* (*1796–1868*)
MP for Chipping Wycombe.

54 See *Groups:* 'The House of Commons, 1833' by Sir G. Hayter, p 526.

CARTWRIGHT *William Ralph* (*1771–1847*)
MP for Northamptonshire South.

54 See *Groups:* 'The House of Commons, 1833' by Sir G. Hayter, p 526.

CARY *Francis Stephen* (*1800–80*)

Artist and art teacher; took over Sass' well-known Art School in Bloomsbury, 1842; several famous artists received their first training there.

3896 Pencil and chalk on paper, $6\frac{5}{8} \times 5\frac{5}{8}$ inches (16·8 × 14·3 cm), by JAMES HAYLLAR, 1851. PLATE 170

Signed and dated (*lower right*): J. Hayllar/1851 *Inscribed on the back of the original mount:* F.S. Cary – Bloomsbury St Art School

Collections: Purchased from Messrs Tooth & Son, 1953.

This portrait was extracted from an album of drawings by Hayllar, all of which were inscribed with details of the subjects. Another drawing from the same album was similarly signed and dated 1851, and inscribed, 'A pupil at Cary's Art School'. Hayllar was a pupil at this school until about 1851, when he travelled to Italy. No other portraits of Cary are recorded.

CATTERMOLE *George* (*1800–68*)

Prolific painter, water-colourist and illustrator; exhibited at the RA, 1819–27, and at the Water-Colour Society, 1822–50; painted several biblical subjects from 1850.

4579 Pencil and crayon on paper, $15\frac{1}{4} \times 12\frac{3}{8}$ inches (38·6 × 31·5 cm) uneven edges, by an UNKNOWN ARTIST. PLATE 171

Inscribed in pencil (*lower right*): Cattermole at Rouen

Collections: Presented by K. M. Guichard, 1967.

Although the identification is based solely on the inscription, there seems no particular reason to doubt it. The donor also presented a drawing of Horatio Smith (NPG 4578).

ICONOGRAPHY A self-portrait drawing is in the Victoria and Albert Museum, and another of *c* 1820 is in the British Museum.

CAVOUR *Camille, Count* (*1810–61*)
Italian statesman.

2515 (75) See *Collections:* 'Drawings of Prominent People, 1823–49' by W. Brockedon, p 554.

CAYLEY *Edward Stillingfleet* (*1802–62*)
MP for Yorkshire, North Riding.

54 See *Groups:* 'The House of Commons, 1833' by Sir G. Hayter, p 526.

CAYLEY Sir George, Bart (1773–1857)

MP for Scarborough, inventor, and aeronautical pioneer; recognized the basic scientific principles underlying the theory of navigable balloons; published several extremely important and prophetic papers on aeronautical design and theory.

3977 Oil on canvas, 35⅞ × 27⅞ inches (91·2 × 70·8 cm), by HENRY PERRONET BRIGGS, 1840. PLATE 172

Signed and dated (bottom left): H.P. Briggs RA/pinxᵗ 1840 *Inscribed on a label, formerly on the stretcher:* Portrait of Sir George Cayley Bart/H.P. Briggs/33 Bruton Street Berkeley Square

Collections: The sitter; by descent to Sir Kenelm Cayley, Bart, and presented by him, 1956.

Exhibitions: RA, 1841 (394).

In a letter of April 1841 (NPG archives), formerly on the back of the picture, Briggs wrote to Cayley about the RA exhibition: '*I forgot to ask you how you will be described in the catalogue of the Exhibition. The picture looks very well in the frame. It was sent yesterday*'. A copy of the portrait is still with the Cayley family. The plan which Cayley is shown holding presumably relates to one of his inventions.

Description: Dark eyes, grey hair. Dressed in a white shirt, dark stock, red waistcoat, black suit. Seated in a red-covered armchair. Background colour dark brown.

54 See *Groups:* 'The House of Commons, 1833' by Sir G. Hayter, p 526.

ICONOGRAPHY A bust by L. Macdonald is in the collection of Sir Kenelm Cayley; a bust, possibly by Emma Cayley, the sitter's daughter, is in the collection of R.A. Leggard; a bronze cast is in the collection of the Royal Aeronautical Society, and a plaster cast in the collection of Sir Victor Goddard; there is a photograph in the NPG, and a lithograph after a photograph; an engraving by J.J. Penstone, after a photograph by Beard, is reproduced J.E. Hodgson, *History of Aeronautics* (1924), figure 134.

CHADWICK Sir Edwin (1800–90)

Reformer; barrister, 1830; administered poor law; member of sanitary commission, and board of health; published numerous pamphlets, reports and papers.

849 Marble bust, 29¾ inches (75·5 cm) high, by ADAM SALOMON, c 1863. PLATE 173

Collections: The sitter; presented by his widow, Lady Chadwick, 1890.

Exhibitions: RA, 1880 (1561).

In a letter to Scharf, Lady Chadwick wrote (5 November 1890, NPG archives): '*The Likeness was considered good at the time when it was taken now nearly 27 years ago*'. She had, however, forgotten the circumstances of the commission. The delay between the execution of the bust and its first exhibition is difficult to explain, unless Lady Chadwick had misremembered the former date. The apparent age of the sitter is difficult to determine.

ICONOGRAPHY A miniature by Miss M. Gillies was exhibited *RA,* 1848 (849); a terra-cotta bust by G. Tinworth was exhibited *RA,* 1885 (2067); a woodcut was published *ILN,* XII (1848), 39.

CHALON John James (1778–1854)

Landscape and genre painter; born in Geneva; studied art in London, 1796; exhibited 1806–44.

4230 Oil on millboard, 9⅞ × 8 inches (25·1 × 20·1 cm), by JOHN PARTRIDGE, 1836. PLATE 174

Inscribed on an early label on the reverse, in the artist's hand: John James Chalon. RA. 1836/Painter John Partridge

Collections: The artist; by descent to his nephew, Sir Bernard Partridge, and bequeathed by his widow, Lady Partridge, 1961.

Exhibitions: Themes and Variations: the Sketching Society, 1799–1851, Victoria and Albert Museum, 1971.

Literature: Partridge's 'Sitters Book' (NPG archives), p 88 (verso); J. Partridge, two MS notebooks (NPG archives); *NPG Annual Report, 1961–2* (1962), p 3.

One of four similar studies in the NPG for Partridge's group portrait of the 'Sketching Society, 1836', listed in his 'Sitters Book' (NPG archives), p 87 (verso), under 1836, exhibited *RA,* 1838 (408), with the title, 'Sketch of a Sketching Society; the Critical Moment'; it was last recorded in the collection of W. A. Brigg, Kildwick Hall, Keighley, 1913. A related water-colour by Partridge, and a lithograph by J. Hogarth, published 1858, are in the British Museum. The study of Chalon is mentioned in the 'Sitters Book' as '*Small portrait of J J Chalon presented to A.E. Chalon to be returned at his death*'. Three other studies, representing Thomas Uwins (NPG 4231), C. R. Leslie (NPG 4232), and Robert Bone (NPG 4233), are recorded in this catalogue under the names of the individual sitters. A study of another member, J. S. Stump, is listed in the 'Sitters Book', p 88 (verso), as presented to the sitter. Studies of A. E. Chalon, C. Stanfield and Partridge are listed in his MS notebooks (NPG archives). The Sketching Society was founded in 1808 by Francis Stevens and A. E. and J. J. Chalon to study epic and pastoral design: '*The members assemble, at six o'clock, at each other's houses in rotation. All the materials for drawing are prepared by the host of the evening, who is, for that night, President. He gives a subject, from which each makes a design. The sketching concludes at ten o'clock, then there is supper, and after that the drawings are reviewed, and remain the property of him at whose house they are made.*'[1] Partridge's picture shows eleven members of the Society (himself included) grouped around a table, criticizing a drawing on an easel in front of them; Partridge was the president on this particular occasion.

Description: Healthy complexion, greyish eyes, brown hair and whiskers. Dressed in a black neck-tie, white stock, dark greenish-brown coat. Seated in a chair. Red background.

ICONOGRAPHY A painting called a self-portrait was in the collection of Colonel M. H. Grant; a water-colour called Chalon and attributed to C. R. Leslie was in the collection of Mrs Schoen, 1934; a water-colour by J. L. Agassé called Chalon is reproduced *Connoisseur,* XLV (1916), 198.

CHARLEVILLE *Charles William Bury, 2nd Earl of (1801–51)*
MP for Penryn.

54 See *Groups:* 'The House of Commons, 1833' by Sir G. Hayter, p 526.

4026 (12) See *Collections:* 'Drawings of Men About Town, 1832–48' by Count A. D'Orsay, p 557.

CHESHAM *Charles Compton Cavendish, 1st Baron (1793–1863)*
MP for Sussex East.

54 See *Groups:* 'The House of Commons, 1833' by Sir G. Hayter, p 526.

CHESNEY *Francis Rawdon (1789–1872)*
General; explored and surveyed trade routes and rivers in the Middle East, and a projected railway; stationed at Hongkong, 1843–7; general, 1868; published narratives of his surveys.

2659 Oil over a photograph, $8\frac{3}{4} \times 6\frac{7}{8}$ inches (22·2 × 17·5 cm), by an UNKNOWN ARTIST. PLATE 175

[1] *Autobiographical Recollections by the Late Charles Robert Leslie, R.A.,* edited T. Taylor (1860), I, 119. See also Mrs Uwins, *A Memoir of Thomas Uwins, R.A.* (1858), I, 163–207, R. and S. Redgrave, *A Century of Painters of the English School* (1866), I, 485–7, and J. Hamilton, *Victoria and Albert Museum, the Sketching Society* (1971).

Collections: The sitter, by descent to his grandson, R.E.Charlewood, and presented by him, 1934. The photograph over which the artist has painted is the same as that reproduced L.Chesney and J.O'Donnell, *The Life of the late F.R.Chesney* (1885), frontispiece. Charlewood presented another portrait of Chesney to the Royal Artillery Institution, Woolwich, but it has since disappeared, and no details about it have survived.

Description: Dark complexion, blue eyes, greyish hair. Dressed in very dark uniform, with scarlet and gold sash, black hat with white and gold feathers. Wooden sideboard with white marble (blue veins), red book and bronze inkstand. Wall pink/grey. Curtain at right red and grey. Blue sky, pink clouds.

ICONOGRAPHY A portrait by an unknown artist was once in the Royal Artillery Institution, Woolwich; an anonymous engraving was published *Dublin University Magazine*, November 1841, reproduced *Journal of the Society for Army Historical Research*, IX (1930), 246.

CHETWYND *William Fawkener* (*1788–1873*)

MP for Stafford.

54 See *Groups:* 'The House of Commons, 1833' by Sir G.Hayter, p 526

CHILDERS *John Walbanke* (*1789–1886*)

MP for Cambridgeshire.

54 See *Groups:* 'The House of Commons, 1833' by Sir G.Hayter, p 526.

CHINNERY *George* (*1774–1852*)

Portraitist, landscapist and miniature painter; worked in London and Dublin; removed to India, 1802, and practised in Madras and Bengal; left for Macao, 1825, where he spent the rest of his life; an idiosyncratic personality, and an entirely individual artist.

779 Oil on canvas, 28 × 21¼ inches (71·1 × 54 cm), by HIMSELF, *c* 1840. PLATES 177–8

Collections: The artist; Lancelot Dent; by descent to his nephew, John Dent, and presented by him, on his uncle's behalf, 1888.

Exhibitions: RA, 1846 (367); *Chinnery Exhibition*, Tate Gallery, 1932 (11); *Chinnery Exhibition*, National Gallery of Scotland, Edinburgh, and Arts Council, London, 1957 (54); *British Self-Portraits*, Arts Council, London, 1962 (65); *George Chinnery*, City Hall and Art Gallery, Hong Kong, 1965 (52).

Literature: Art-Union (1846), p 180; H. and S.Berry-Hill, *George Chinnery* (1963), pp 37, 55, reproduced plate 2; R.L.Ormond, 'George Chinnery's Image of Himself, II', *Connoisseur*, CLXVII (1968), 160–4, reproduced.

The most famous of all Chinnery's self-portraits. He is shown in his studio in Macao, with a canvas representing an Indian mosque on the easel, and a picture of the Praya Grande, Macao, on the wall behind. A squared-off pen and ink study for the whole composition is in the National Gallery of Ireland, Dublin, and related studies of the head are in the Victoria and Albert Museum (2), and the collection of J.Braga. The NPG portrait was the last painting which Chinnery sent to the RA, where one reviewer, reiterating a perennial criticism of his work, '*wished the extremities had not been so much neglected*' (*Art-Union*, p 180). The portrait was consigned to London through the artist's friend, Lancelot Dent, a well-known merchant. Chinnery wrote to him in a letter of 29 August 1845 (NPG archives):

I have the pleasure to put my own portrait in charge of Mr Duncan, who will kindly deliver it to you. I believe I mentioned to you my particular wish that it should not be engraved during my Life Time – but after my Death I can have no objection – I have put within the Case my written Directions as to its being varnished. I now send a Certificate wh. will save you some trouble I believe at the Custom House in London.

It is not known whether Dent was given the portrait by Chinnery himself, or whether he bought it at the sale of Chinnery's effects in Macao after the latter's death in 1852. It has generally been presumed that this portrait was painted shortly before its first exhibition in 1846. A comparison with other self-portraits suggests that it may date from a few years earlier.

Description: Florid complexion, blue eyes, grey hair. Dressed in a white shirt, white neck-tie, dark grey coat, white trousers, and black shoes. Red curtain at left. Pictures – pale blues, browns and greys. Rest of background and floor greenish-brown. Wooden chair and table with two oriental china tea-cups, a glass bottle, knife and plate. Folder bottom left with red ribbons.

4096 Pencil on paper, $7\frac{3}{4} \times 5\frac{1}{4}$ inches (19.7×13.3 cm), by HIMSELF, 1832. PLATE 176

Inscribed at the top of the drawing are various notes in shorthand, various initials and numbers in longhand (which also appear on the reverse), and the date 1832. This is repeated bottom right. The last line reads: Canton April 10. 1832[1]

Collections: B. Seton, presented by him, 1959.

Literature: R. L. Ormond, 'George Chinnery's Image of Himself, I', *Connoisseur*, CLXVII (1968), 92, reproduced 91.

This drawing was taken out of a scrapbook of Chinnery drawings then in the possession of Mr Seton; this may have been the scrapbook sold Sotheby's, 3 June 1959 (lot 4), bought Appleby.

ICONOGRAPHY Most likenesses of Chinnery are self-portraits, and these are discussed and reproduced in R. L. Ormond, 'George Chinnery's Image of Himself, I and II', *Connoisseur*, CLXVII (1968), 89–93, and 160–4; also reproduced there is a drawing by G. T. Durran, and an engraved caricature by Sir C. D'Oyly; since 1968 several more portraits have come to light; an oil self-portrait in the Scottish NPG; a self-portrait drawing in the collection of Percy Chubb, New Jersey; a self-portrait drawing with the Sporting Gallery, Middleburg, Virginia, 1970; a drawing by Baptista (his pupil) in a scrapbook owned by John Keswick; and three drawings by D'Oyly, said to represent Chinnery, sold Sotheby's, 11 February 1971 (lot 66), bought Frye.

CHORLEY *Henry Fothergill* (*1808–72*)

Critic; clerk in Liverpool; contributed musical criticisms to the *Athenaeum*, and subsequently joined the staff; wrote unsuccessful novels and plays, memoirs on music, a life of Mrs Hemans and an autobiography.

4026 (13) Pencil and black chalk, with touches of red, on paper, $6\frac{3}{8} \times 4\frac{3}{4}$ inches (16.2×12 cm), by COUNT ALFRED D'ORSAY, 1841. PLATE 179

Signed and dated (lower right): d'Orsay/fecit/1841 *Inscribed (bottom centre):* H. Chorley Esq

Collections: See *Collections:* 'Drawings of Men About Town, 1832–48' by Count D'Orsay, p 557.

ICONOGRAPHY The only other recorded portrait of Chorley is a painting by J. Haverty, exhibited *RA*, 1856 (112).

CLANRICARDE *Ulick de Burgh, 1st Marquess of* (*1802–74*)

Statesman.

4026 (14) See *Collections:* 'Drawings of Men About Town, 1832–48' by Count A. D'Orsay, p 557.

[1] The shorthand system used is Gurney's. Thomas Gurney's *Brachygraphy* (1750) contains a reference to 'William Chinnery, Junior, Writing-master and Accomptant, in Gough Square, who, for his own private Use has wrote in this Method the Book of Psalms, and the New Testament'. William Chinnery was the grandfather of George Chinnery. This information was kindly communicated by W. J. Carlton of Andover; see also *Notes and Queries*, CXCIX (May 1954), 214. F. H. Higgenbottam of the Royal Museum, Canterbury, has partly deciphered the shorthand on the NPG drawing which refers to Chinnery's landscapes: 'mine have their perfect effect by being done on a grey stage of this kind. This followed by FGS.'

CLARE *Richard Hobart Fitzgibbon, 3rd Earl of (1793–1864)*

MP for County Limerick.

54 See *Groups:* 'The House of Commons, 1833' by Sir G. Hayter, p 526.

CLARE *Peter (1781–1851)*

Slavery abolitionist.

599 See *Groups:* 'The Anti-Slavery Society Convention, 1840', by B. R. Haydon, p 538.

CLARENDON *George William Frederick Villiers, 4th Earl of (1800–70)*

Statesman.

1125 See *Groups:* 'The Coalition Ministry, 1854' by Sir J. Gilbert, p 550.
See also forthcoming Catalogue of Portraits, 1860–90.

CLARKSON *Mary*

Wife of Thomas Clarkson, junior, and daughter-in-law of Thomas Clarkson (1760–1846).

599 See *Groups:* 'The Anti-Slavery Society Convention, 1840' by B. R. Haydon, p 538.

CLARKSON *Thomas (1760–1846)*

Philanthropist, and a leader of the anti-slavery movement.

599 See *Groups:* 'The Anti-Slavery Society Convention, 1840' by B. R. Haydon, p 538.
See also forthcoming Catalogue of Portraits, 1790–1830.

CLARKSON *Thomas*

Grandson of Thomas Clarkson (1760–1846).

599 See *Groups:* 'The Anti-Slavery Society Convention, 1840' by B. R. Haydon, p 538.

CLAY *Sir William, Bart (1791–1869)*

MP for Tower Hamlets.

54 See *Groups:* 'The House of Commons, 1833' by Sir G. Hayter, p 526.

CLAYTON *Sir William Robert, Bart (1786–1866)*

MP for Great Marlow.

54 See *Groups:* 'The House of Commons, 1833' by Sir G. Hayter, p 526.

CLEASBY *Sir Anthony (1804–79)*

Judge; fellow of Trinity College, Cambridge; barrister; baron of the exchequer, 1868–78; unsuccessful on the bench.

2701 Water-colour and body-colour on blue-toned paper, 12 × 7¼ inches (30.7 × 18.5 cm), by SPY (SIR LESLIE WARD), 1876. PLATE 180

Signed (lower right): Spy *Inscribed on the mount:* The Hon: Sir Anthony Cleasby. February 5, 1876.

Collections: Thomas Bowles: *Vanity Fair* Sale, Christie's, 5 March 1912 (lot 153); Maggs Brothers, purchased from them, 1934.

This is one of a large collection of original studies for *Vanity Fair*, which were owned and specially mounted by the first proprietor of the magazine, Thomas Bowles. They will be discussed collectively

in the forthcoming Catalogue of Portraits, 1860–90. The water-colour of Cleasby was published in *Vanity Fair* as a coloured lithograph, on 5 February 1876, with the title, 'Formerly of the Carlton'.

Description: Healthy complexion, grey wig, white and black judge's robes. Seated on a red bench, before a grey desk.

2897 Water-colour and body colour on blue-toned paper, $12\frac{1}{2} \times 8$ inches ($31\cdot6 \times 20\cdot3$ cm), by SPY (SIR LESLIE WARD), 1876. PLATE 181

 Collections: Viscount Ullswater, presented by him, 1936.

 A study in reverse for NPG 2701 above. The costume is different.

 Description: Healthy complexion, grey wig, black legal costume.

ICONOGRAPHY A painting by G. Richmond is listed in his 'Account Book' (photostat copy, NPG archives), pp 89 and 93, under 1873 and 1876, exhibited *RA*, 1877 (338); a drawing by Richmond is listed p 48, under 1848; a woodcut, after a photograph by J. Watkins, was published *ILN*, LIV (1869), 93; a photograph by Lock and Whitfield is in the NPG.

CLERK *Sir George, Bart* (*1787–1867*) and his family

2772 See *Collections:* 'The Clerk Family, Sir R. Peel, S. Rogers and Others, 1833–57' by Miss J. Wedderburn, p 560.

CLEVELAND *Henry Vane, 2nd Duke of* (*1788–1864*)
 MP for Salop South.

54 See *Groups:* 'The House of Commons, 1833' by Sir G. Hayter, p 526.

CLINT *Alfred* (*1807–83*)

 Etcher and marine painter; son of the painter, George Clint; exhibited, 1828–79, portraits, and later coast views.

4616 Miniature, water-colour and body colour on ivory, $4\frac{5}{8} \times 3\frac{1}{2}$ inches ($11\cdot8 \times 8\cdot8$ cm), attributed to HIMSELF. PLATE 182

 Collections: By descent to the artist's great-nephew, C. R. S. Phillips; purchased from J. S. Maas & Co, 1968.

 The identification was provided by C. R. S. Phillips; there seems no reason to doubt it. No other portraits of Clint are recorded.

 Description: Palish complexion, brown eyes, brown hair and whiskers; dressed in a white necktie, frilled white shirt, black velvet (?) waistcoat and black coat, holding a pair of spectacles; leaning one arm on a maroon chair-arm (?). Most of background covered by a brown curtain of various shades; patch of greenish-grey lower left.

CLIVE *Edward Bolton* (*after 1763–1845*)
 MP for Hereford.

54 See *Groups:* 'The House of Commons, 1833' by Sir G. Hayter, p 526.

CLIVE *Robert Henry* (*1789–1854*)
 MP for Salop South.

54 See *Groups:* 'The House of Commons, 1833' by Sir G. Hayter, p 526.

CLOUGH *Arthur Hugh* (*1819–61*)

Poet; fellow of Oriel College; principal of University Hall, London; travelled widely; one of the most original Victorian poets, whose considerable achievement is now more fully recognized.

3314 Chalk on brown, discoloured paper, 21½ × 17 inches (54·6 × 43·2 cm), by SAMUEL ROWSE, 1860. PLATE 184

Collections: Commissioned by Florence Nightingale, and presented by her to Mrs Clough; by descent to her daughter, Miss B.A. Clough, and presented by her, 1946.

Exhibitions: Cumbrian Characters, Abbot Hall Art Gallery, Kendal, 1968 (69).

Literature: The Poems and Prose Remains of Arthur Hugh Clough, edited by his wife (1869), I, 244–5, reproduced frontispiece; G. Levy, *Arthur Hugh Clough* (1938), pp 181, 227; *The Correspondence of Arthur Hugh Clough*, edited F. L. Mulhauser (1957), II, 576–8, 582, 586; K. Chorley, *Arthur Hugh Clough: an Uncommitted Mind* (1962), pp 64–5.

Rowse was an American artist whom Clough particularly admired. In a letter to Professor Norton of 3 March 1860, Clough wrote (*Poems and Prose Remains*, I, 243): '*Stillman has commenced operations on my face, and returns to the charge on Monday When is Rowse coming over? Will you give him a letter to me? I continue to think his picture of Emerson the best portrait of anyone I know*'. On 1 May Clough wrote to Norton again (*Clough Correspondence*, II, 576): '*As soon as Rowse comes, Stillman gives up his present quarters to him and will come, I believe, into our nearer neighbourhood.*' By 13 July 1860, Rowse had not only arrived, but nearly finished his portrait of Clough (*Clough Correspondence*, II, 577): '*Rowse has done me – (a present from Miss Nightingale to my wife –) very nearly. You will I hope have a photograph, and I hope he won't spoil it before he finishes – He ought to be here at this moment but has not done his sleep yet I suppose.*'

The portrait was completed by 20 July, when Clough wrote to Norton again (*Poems and Prose Remains*, I, 244–5): '*Rowse went off yesterday for Southampton. His picture of Owen is very good, that of me is less successful. He was interrupted in the midst of it, was delayed by sore eyes, and then had to go to Owen; but still it is a very good likeness*'. Rowse had apparently only come over to England on a short summer visit, doing several portraits besides that of Clough. In a letter of 11 October 1860, Clough wrote to Norton (*Clough Correspondence*, II, 578): '*I am glad to hear [of] Rowse's restoration to life and happiness in his native land – I hope however he will someday come over to see us again. The photographs of his picture of me were not done when he came away – I will send you one as soon as opportunity offers.*' Clough distributed photographs of the Rowse drawing to many of his friends. He wrote to Emerson on 4 July 1861 (*Clough Correspondence*, II, 586): '*I send by Miss Hoare four photographs from the drawing which Rowse made of me. Will you keep one and give the others as opportunity offers to Lowell, Norton and Child – I would send one to Rowse, but I am afraid he would think it a failure The likeness itself is to me satisfactory though perhaps not one of Rowse's very best.*' The drawing was engraved by C. H. Jeens for the *Poems and Prose Remains*. A copy by Samuel Laurence is at Oriel College, Oxford, listed by Mrs R. L. Poole, *Catalogue of Oxford Portraits*, II (1925), 97, and another was executed by Harriet Martineau.

1694 Plaster cast, painted cream, 25 inches (63·5 cm) high, of a bust by THOMAS WOOLNER, *c* 1863. PLATE 183

Incised on the front of the base: ARTHUR HUGH CLOUGH

Collections: Purchased from the artist's daughter, Miss Amy Woolner, 1913.

Related to the marble bust by Woolner of 1863 at Rugby School, for which see Amy Woolner, *Thomas Woolner: his Life in Letters* (1917), p 338, and K. Chorley, *Arthur Hugh Clough: an Uncommitted Mind* (1962), p 65.

ICONOGRAPHY A water-colour by an unknown artist is in the collection of Mrs F. M. Clough, Ascot; a drawing by Miss J. H. Bonham Carter was exhibited *SKM*, 1868 (624), reproduced K. Chorley, *Arthur Hugh Clough: an Uncommitted Mind* (1962), frontispiece; a drawing by an unknown artist is in the collection of Miss

K.Duff; a drawing called Clough by an unknown artist is in the National Museum of Wales, Cardiff; a death mask and cast of his hand are at Balliol College, Oxford; a memorial plaque by L.Morris is at Rugby School; a modern bust by F.de Weldon, said to be based on an early etching, is in the City Hall, Charleston, USA.

CLYDE *Sir Colin Campbell, 1st Baron (1792–1863)*

Field-marshal; served in the Peninsula, 1810–13, the West Indies, 1819–26, China, 1842–6, India, 1846–53, and the Crimea, 1854–5; commander-in-chief in India, 1857–60; suppressed the Indian Mutiny; created a peer, 1858, and a field-marshal, 1862.

619 Pen and ink and water-colour on paper, 10 × 5 inches (25·4 × 12·7 cm), by SIR FRANCIS GRANT, *c*1860. PLATE 186

Collections: Viscount Hardinge, presented by him, 1881.

This is a sketch after Grant's painting of Clyde (in the uniform he wore in India[1]), commissioned by Earl Canning, listed in Grant's 'Sitters Book' (copy of original MS, NPG archives), under the year 1860, exhibited *RA*, 1861 (131), and *SKM*, 1868 (454), engraved by S.Cousins, published H.Graves (example in NPG). According to information on the mount, the NPG drawing was executed at Viscount Hardinge's home, South Park, from the artist's recollection of the large picture. The sketch is almost identical with the finished painting except for differences in the pose of the arms. Grant, who was an old friend of the family, gave Hardinge the sketch after finishing it. A copy of the finished painting by F.Graves is at Apsley House, London. A slightly different version, attributed to Grant, was in the collection of J.McClellon, Winnipeg, 1928. Viscount Hardinge was appointed a trustee of the NPG in 1868, and chairman in 1876.

1201 Plaster cast, painted black, 33 inches (83·8 cm) high, of a bust by GEORGE GAMMON ADAMS, 1855. PLATE 185

Incised on the back of the shoulders: Geo. G. Adams S^c 1855

Collections: The artist, purchased from his widow, 1899.

Literature: R.Gunnis, *Dictionary of British Sculptors* (1953), p14.

Probably related to the bust of Clyde by Adams, exhibited *RA*, 1856 (1348). A later plaster bust of Clyde by Adams, dated 1861, is in the Scottish NPG. The NPG bust was purchased at the same time as a number of other plaster casts by Adams, and a marble bust of Sir William Napier (NPG 1197). Clyde is wearing the star of the Bath.

ICONOGRAPHY

1821 Painting by J.W.Pieneman. Wellington Museum, Apsley House, London.
Study for his 'Waterloo' picture: Rijksmuseum, Amsterdam.

1855 Painting by T.Jansen. Collection of J.B.Muir, 1896.

c1855 Bust by G.G.Adams. Exhibited *RA*, 1856 (1348).
Plaster cast (NPG 1201 above).

1856 Woodcut, after a photograph by Mayall, published *ILN*, XXVIII (1856), 9; engraving by D.J.Pound, after same photograph, published 1859 (example in NPG), for Pound's 'Drawing Room Portrait Gallery', (an) engraving by T.W.Hunt, after the same, published J.S.Virtue (example in NPG).

c1856 Painting by H.W.Phillips. Glasgow City Art Gallery (plate 188).
Exhibited *RA*, 1856 (201). Engraved by G.Zobel, published J.Mitchell, 1856 (example in NPG).

[1] Clyde is wearing a non-regulation undress garment, later called a patrol jacket. He is wearing trousers, tucked into his cavalry boots, 'Napoleons', and his head-dress appears to be a low shako, or kepi shape with a white sun-cover, also incorporating a neck-curtain. His sword is a light cavalry sabre of the old pattern. The tent in the background indicates that he was on service. This information was kindly communicated by the National Army Museum, Camberley.

1857 Ebony bust by an unknown artist. Formerly Royal United Service Museum, London.

1857 'Relief of Lucknow' by T. J. Barker, from sketches by E. Lundgren. City Art Gallery, Glasgow. Engraved by C. G. Lewis, published T. Agnew, 1863 (example in NPG, plate 412). Lundgren's sketches were sold Christie's, 16 April 1875; also in the sale were two portraits of Clyde (lots 68 and 108). A water-colour of Clyde and his staff by Lundgren is reproduced *Apollo*, XCII (1970), 143.

1857–8 Photograph by F. Beato (with Sir W. R. Mansfield). National Army Museum (plate 187).

c 1859 Miniature by E. Upton. Exhibited *RA*, 1859 (731).

1860 Painting by Sir F. Grant. Collection of Earl Canning, 1868.
 Sketch of this painting (NPG 619 above).

1861 Plaster bust by G. G. Adams. Scottish NPG.

c 1861 Medal by E. Ortner. Exhibited *RA*, 1861 (1012).

c 1862 Bust by G. E. Ewing. Exhibited *RA*, 1862 (1029).
 Reproduced as a woodcut *ILN*, XLIII (1863), 245.

1864 'The Intellect and Valour of Great Britain', engraving by C. G. Lewis, after T. J. Barker, published J. G. Browne, Leicester, 1864 (example in NPG); key-plate, published Browne, 1863 (example in British Museum).

1866 Marble relief (meeting of Clyde, Havelock and Outram at Lucknow) by M. Noble. Outram Memorial, Westminster Abbey.

c 1868 Bronze statue by J. H. Foley. George's Square, Glasgow.
 Reproduced as a woodcut *ILN*, LIII (1868), 349.

1869 Engraving by C. Tomkins, after C. Mercier, published T. W. Green, 1869 (example in NPG).

Undated Painting by T. J. Barker. Scottish NPG.

Undated Drawing (with Sir Colin Campbell and Sir W. R. Mansfield) by T. B. Wirgman. Exhibited *VE*, 1892 (421a), lent by Miss A. F. Yule (artist's name misprinted I. B. Wiegman).

Undated Lithograph by C. Baugniet (example in British Museum).

Undated Engraving by D. J. Pound, after a photograph by Mayall (example in NPG); engraving by Holl, after another photograph by Mayall (example in NPG).

Undated Drawing by H. H. Crealock. Formerly Royal United Service Museum, London.

Undated Bust by an unknown artist. Formerly India Office, London.

Undated Statue by Baron C. Marochetti. Waterloo Place, London.

Undated Several photographs. NPG.

COBBETT *William* (*1762–1835*)

Writer, agriculturist, and MP for Oldham.

54 See *Groups*: 'The House of Commons, 1833' by Sir G. Hayter, p 526.
 See also forthcoming Catalogue of Portraits, 1790–1830.

COBDEN *Richard* (*1804–65*)

Statesman and radical politician; with Bright, leader of the Anti-Corn Law League; negotiated the commercial treaty with France, 1859–60; a prominent and influential political personality.

201 Oil on canvas, 40¼ × 31¾ inches (102·2 × 80·6 cm), by GIUSEPPE FAGNANI, 1865, after his portrait of 1860–1. PLATE 190
 Collections: Purchased from the artist, 1865.

Literature: Emma Fagnani, *The Art Life of a XIXth Century Portrait Painter Joseph Fagnani* (privately printed, 1930), p119, under 1865.

This is a replica of one of two portraits of Cobden painted by Fagnani in Paris, 1860–1. According to his wife, Emma (letter of 26 July 1885, NPG archives), the '*portrait of Mr Cobden was painted from life, while he was in Paris negotiating the Treaty of Commerce between the two countries in 1860, and the signatures in the picture are fac-similes from the original document.*' The treaty was signed by Baroche and Rouher for the French, and by Lord Cowley and Cobden for the English; the signatures of the last three are visible on the document in the picture (Baroche's is just hidden). In her biography, Emma Fagnani wrote (p53): '*Upon Fagnani's return to Paris, Richard Cobden, who was then negotiating the Treaty of Commerce between England and France, sat to him, and when the picture was finished, declared that he was quite ready to go down to posterity as he was there represented and he should never sit again – Fagnani took two portraits, from life, of the different sides of his face.*' The original of the NPG type was exhibited Salon, 1861, and was subsequently acquired by the New York Chamber of Commerce (see Emma Fagnani, pp65–8). Cobden himself wrote to Fagnani (Emma Fagnani, p54): '*Mr Bright remarked that the mouth and the face generally had too soft an expresion. I can account for it. Madame Fagnani, though she made the time of my sittings much shorter, did not allow my features ever to assume a little sternness.*' According to Emma Fagnani (p119), three replicas of the portrait were painted in 1865: NPG 201; a second for T.B. Potter (reproduced *Daily Chronicle*, 27 June 1896, from a drawing by T.B. Wirgman); and the third for the Union League Club, New York. Fagnani also painted portraits of John Bright for the Union League Club and for the New York Chamber of Commerce, and a joint portrait of Bright and Cobden for the Corporation of Rochdale in 1868. A portrait of Lord Dalling by Fagnani is also in the NPG (852), catalogued here under Dalling.

Description: Brown eyes and hair. Dressed in a white shirt, black stock and suit. Red seals on the document. Background colour almost black.

316 Oil on canvas, $72\frac{1}{4} \times 48$ inches ($183 \cdot 5 \times 121 \cdot 9$ cm), by LOWES DICKINSON, 1870. PLATE 192

Signed and dated (bottom left): LCD (*in monogram*) 1870
Collections: Commissioned from the artist by the Reform Club, and presented by them, 1870.[1]
Exhibitions: RA, 1870 (910).

In 1865 the Reform Club organized a 'Cobden Memorial Fund' among its members in order to purchase a bust of Cobden. The fund was heavily over-subscribed, and, after commissioning a marble bust from Noble (dated 1866), it was decided in 1868 to devote the surplus to a further two portraits of Cobden, one for the Club and one for the NPG. Lowes Dickinson executed both portraits, which were based on photographs, a drawing he had made from the life in 1861,[2] and a miniature by Bean; the latter was exhibited *SKM*, 1868 (461), lent by Mrs Cobden. Bean may be identified with Adolphe Beau, a photograph of Cobden by whom Dickinson is known to have used for his picture (see *RA* catalogue). The pose in Bean's miniature, which must pre-date both of Dickinson's pictures, is identical with that which Dickinson adopted. According to Cobden's family and friends, Dickinson's portraits were extremely like and characteristic.

The NPG and Reform Club versions are very similar.[3] The figure and pose of Cobden are identical, and the box, inscribed 'Cobden', and the papers (including a copy of *The Times*) lying on the ground in the left-hand corner, appear in both. The Reform Club version, which was exhibited *VE*, 1892 (123), is considerably larger (112×56 inches), and has an arched top, in order to fit a special panelled niche in the main hall of the Club. The chests of drawers in both portraits differ, and a curtain in the NPG

[1] A letter of 6 June 1870, from the secretary of the Reform Club, Richard Baxter, explaining the commission, and other letters relating to its presentation (NPG archives).
[2] This drawing is reproduced E.I. Barrington, *The Servant of All* (1927), I, facing 14. A tracing from it by Sir G. Scharf is in the NPG.

[3] Dickinson may possibly have painted an earlier portrait of Cobden, before the NPG and Reform Club versions. In 1865 a Mr Fairless offered a portrait of Cobden by Dickinson to the NPG trustees. It does not seem to have been the 1861 drawing.

version replaces a screen in the other. An engraving by C.H.Jeens (example in NPG),[1] probably after the Reform Club version, shows a table instead of the chest of drawers. The *VE* Catalogue also describes the chest of drawers as a table, presumably because it was too dark to be clearly distinguished.

When this portrait was offered to the trustees of the NPG they were in something of a quandary, as they already had two portraits of Cobden, and did not want a third. They attempted to elicit an opinion from Mrs Cobden as to whether she preferred the Dickinson portrait or the one already in the NPG by Fagnani (NPG 201 above), but she declined to give judgement on this delicate matter.[2] Opinion generally, however, seems to have been in favour of the Dickinson. Baxter, the Reform Club secretary wrote, for instance (letter of 28 June 1870, NPG archives): '*Fagnani's portrait is certainly not a satisfactory one. – I knew Cobden intimately, and I think I never saw a more characteristic likeness of any one than Lowes Dickinson's picture*'. The trustees suggested to the Reform Club that they should take the Fagnani in exchange for the Dickinson, but the Club declined to do this, suggesting the New Town Hall at Rochdale (Cobden's old constituency) as an alternative for the Fagnani. Eventually the trustees decided to keep both portraits. Dickinson himself wrote to Scharf on 27 July 1870 (NPG archives): '*I am very glad your Trustees have accepted the picture – as I took an infinite amount of pains with it. . . . I think I may venture to hope however that if it be determined now to part with one of the three, it will not be with mine.*' A copy of the NPG version by G.Hillyard-Swinstead is owned by the National Liberal Club. An engraving by J.H.Baker, probably after Dickinson's drawing of 1861, was exhibited *RA*, 1862 (920).

Description: Healthy complexion, brown eyes, grey hair and whiskers. Dressed in a white shirt, dark tie, black suit and shoes. Seated in a red covered chair. Wooden chest of drawers at right, with a large blue bound volume on top, two red volumes, and papers. Blue and white papers at left with a wooden box. Blue and red figured carpet. Background colour brown.

219 Marble bust, 27½ inches (69·8 cm) high, by THOMAS WOOLNER, 1866. PLATE 191

Incised (right hand side of bust): T.Woolner, Sc/LONDON 1866, *and (front of base)*: RICHARD COBDEN

Collections: Commissioned by the sitter's widow, Mrs C.A.Cobden, and presented by her, 1868.

Literature: Amy Woolner, *Thomas Woolner: his Life in Letters* (1917), pp262n, 339.

This is a replica. According to Amy Woolner, the original bust, also posthumous, was retained by Mrs Cobden, and is probably the marble of 1866 now in the Brighton Art Gallery (identical with the NPG bust), presented by Henry Willett, 1874. A third version is in Westminster Abbey. The bust, formerly in the collection of the Emperor Napoleon III, may have been a separate type, as it was executed in 1865 (both the Brighton and NPG busts are dated 1866); Woolner records Napoleon's acceptance in a letter to Mrs Tennyson of 27 July 1865. In a letter of 16 July 1866 (NPG archives), Mrs Cobden wrote of the NPG bust: '*considered by me and my family a most excellent likeness of my late Husband.*'

ICONOGRAPHY
This does not include photographs or caricatures, of which there are several examples in the NPG.

1843 Engraving by F.C.Lewis, after C.A.DuVal, published T.Agnew, 1843 (example in NPG, plate 189). Engraving by G.Adcock, after the same, published Fisher, Son & Co (example in NPG), for W.Cooke Taylor's 'National Portrait Gallery'. Engraving, after the same, by J.Stephenson, published Stephenson and Agar, 1847 (example in British Museum).

c1844 Bust by T.Smith. Exhibited *RA*, 1844 (1351).

1846 Bronze statuette after S.Nixon. Marshall Library of Economics, Cambridge.

[1] Reproduced *Cobden's Speeches* (1870), frontispiece. [2] Letter from R.C.Fisher, 23 June 1870, written on behalf of Mrs Cobden (NPG archives).

1850	'The Anti-Corn Law League', engraving by S.Bellin, after a painting by J.R.Herbert of 1847, published Agnew, 1850 (example in NPG).
1851	Woodcut published *ILN*, XIX (1851), 508.
c1853	Painting by G.Patten. Exhibited *RA*, 1853 (66).
1858	'Baron Lionel de Rothschild Introduced into the House of Commons, 1858' by H.Barraud. Rothschild Collection.
1860	'The House of Commons' by J.Phillip. Houses of Parliament. Engraved by T.O.Barlow, published Agnew, 1866 (example in NPG).
1860	Paintings by G.Fagnani (see NPG 201 above).
1861	Drawing by L.Dickinson (see NPG 316 above).
1862	Bronze statue by G.G.Adams. St Peter's Square, Stockport.
1862	'The Treaty of Commerce, 1862', woodcut by Eastham, published *ILN*, XL (1862), 230–1.
1864	'Intellect and Valour of Great Britain', engraving by C.G.Lewis, after T.J.Barker, published J.G.Browne, Leicester (example in NPG); key-plate published Browne, 1863 (example in British Museum).
1865	Porcelain bust after E.W.Wyon. Collection of E.Galinsky.
1865	Marble bust by M.Noble. Dunford Museum, Midhurst.
1865	Woodcut, after a photograph by Downey, published *ILN*, XLVI (1865), 349.
1866	Busts by T.Woolner (see NPG 219 above).
1866	Marble bust by M.Noble. Reform Club, London (see entry for NPG 316 above). Marble copy by E.J.Physick: National Liberal Club. A plaster model for one of Noble's busts or statues was at Elswick Hall, Newcastle, listed in the *Catalogue of Lough and Noble Models at Elswick Hall* (*c*1928), p47 (161).
c1866	Marble busts by Baron C.Marochetti, and N.N.Burnard (unfinished). Exhibited *RA*, 1866 (895 and 906 respectively).
c1866	Bust by A.Mégret. Exhibited *RA*, 1866 (989).
1867	Statue by M.Noble. Peel Park, Salford. Reproduced as a woodcut *ILN*, LI (1867), 648.
c1867	Bronze statue by M.Wood. St Anne's Square, Manchester. Reproduced as a woodcut *ILN*, L (1867), 421.
c1867	Marble bust by J.B.Philip. Exhibited *RA*, 1867 (1037).
c1867	Terra-cotta bust by W.J.Wills. Exhibited *RA*, 1867 (1027).
c1867	Bust by J.Adams. Exhibited *RA*, 1867 (1057).
1868	Painting by C.Lucy. Victoria and Albert Museum, where there is also a replica.
1868	Marble statue by W. and T.Wills. Hampstead Road, Camden Town, London. A model was exhibited *RA*, 1866 (992).
c1868	Bronze bust by J.Adams. Exhibited *RA*, 1868 (1091).
1869	Marble bust by M.Noble. Guildhall Museum, London (destroyed 1940).
c1869	Bust by Miss C.A.Fellowes. Exhibited *RA*, 1869 (1311).
c1869	Medallion by J.S.Wyon. Exhibited *RA*, 1869 (1282).
1870	Paintings by L.Dickinson (see NPG 316 above).
1876	Marble statue by T.Butler. Wool Exchange, Bradford.
Undated	Painting by Miss E.A.Novello. Exhibited *SKM*, 1868 (468).

Undated Miniature by Bean. Exhibited *S K M*, 1868 (461) (see NPG 316 above).

Undated Drawing by L. Fagan. Reproduced L. Fagan, *The Reform Club* (1887), p41.

Undated Drawing by L. Saulini. Küpferstichkabinett, Staatliche, Kunstsammlungen, Dresden.

Undated Bust by E. Papworth. Manchester Reform Club.
Reproduced as a woodcut, *The Globe*, 24 February 1877.

Undated Marble bust by an unknown artist. Gladstone collection, Hawarden Castle.

Undated 'Bois Durci' medallion. Reproduced *Connoisseur*, CIV (1939), 190.

COCKBURN *Sir Alexander James Edmund, Bart* (*1802–80*)

Lord chief justice; barrister, 1829; specialized in election petitions; MP from 1847; attorney-general, 1851–6; lord chief justice, 1859.

933 Oil on canvas, 16½ × 13¾ inches (41·9 × 34·9 cm), by ALEXANDER DAVIS COOPER. PLATE 193

Collections: The artist; Lord Northbourne, presented by him, 1892.

In a letter to the donor of 4 August 1892 (NPG archives), the artist wrote: '*I think that the principal value attached to it is that of its being the only portrait (not photograph) for which he ever sat, he had a great dislike to do so and it was only by the exercise of strong pressure by a much esteemed friend of his that at last he was induced to give me a few sittings at his own house, the picture such as it is was done entirely there and never touched afterwards.*' The date of the portrait is unknown.

Description: Healthy complexion, brownish eyes, grey wig. Dressed in the red and white robes of a judge. Background colour brown.

ICONOGRAPHY A painting by G. F. Watts is at Trinity College, Cambridge, exhibited *VE*, 1892 (113); a copy of 1895 is in the Middle Temple, London, there is a drawing by D. Maclise in the Victoria and Albert Museum, and also a caricature lithograph by Faustin of c 1874; a reproduction of a drawing by F. Lockwood is in the British Museum; a marble bust by J. E. Jones was exhibited *RA*, 1856 (1355); a woodcut was published *ILN*, XVII (1850), 121; a lithograph by 'Ape' (C. Pellegrini) was published *Vanity Fair*, 11 December 1869; an anonymous engraving was published T. Atkinson (example in NPG); there are two anonymous lithographs (examples in NPG, one of 1880); there are various woodcuts and photographs in the NPG.

COCKERELL *Sir Charles, Bart* (*1755–1837*)

MP for Evesham.

54 See *Groups:* 'The House of Commons, 1833' by Sir G. Hayter, p 526.

CODRINGTON *Sir Edward* (*1770–1851*)

Admiral; commanded a ship at Trafalgar; commander-in-chief in the Mediterranean, 1827; destroyed the Turkish fleet at Navarino, 1827; admiral, 1837; retired from active service, 1842.

721 Oil on panel, 21 × 16⅞ inches (53·3 × 42·9 cm), by HENRY PERRONET BRIGGS, 1843. PLATE 194

Inscribed on a label (not in the artist's hand), formerly on the back of the picture: Sir Edward Codrington/ painted by Henry Briggs/June 1843. aged 73

Another label, similarly inscribed but in another hand, and a third label with biographical details of the sitter, were also formerly on the back of the picture.

Collections: The sitter, bequeathed by his daughter, Lady Bourchier, 1884.

Exhibitions: S K M, 1868 (362): *Royal Naval Exhibition*, Chelsea, 1891 (502).

The lower part of the picture is unfinished, particularly the chair, forearm and hand. It was lithographed by R. J. Lane, published 1845 (example in NPG). A copy by G. F. Clarke is in the National Maritime Museum, Greenwich. Lady Bourchier bequeathed a portrait of her husband, Sir Thomas Bourchier (NPG 720), at the same time as this one. An earlier portrait of Codrington by Briggs was exhibited *RA*, 1836 (335).

Description: Ruddy complexion, dark grey eyes, grey hair. Dressed in a white shirt, dark stock, and green/black coat. Seated in a red armchair.

54 See *Groups:* 'The House of Commons, 1833' by Sir G. Hayter, p 526.

ICONOGRAPHY A painting by Sir T. Lawrence of 1826 is in the collection of Colonel G. R. Codrington, Salisbury, exhibited *SKM*, 1868 (333), engraved by J. Cochran, published Fisher, 1830 (example in NPG), for Jerdan's 'National Portrait Gallery', and engraved by C. Turner, published Colnaghi, 1830 (example in British Museum); a painting by H. Patterson is in the Town Hall, Devonport, exhibited *RA*, 1840 (442); two drawings by J. Doyle are in the British Museum, one lithographed, published T. McLean (example in NPG), for Doyle's 'Equestrian Sketches'; there is a drawing by Sir F. Chantrey of 1819 in the Victoria and Albert Museum, which is a study for the bust by Chantrey in the Ashmolean Museum, Oxford, possibly the bust exhibited *RA*, 1819 (1221), lithographed anonymously (example in NPG); an engraving by B. Holl, after Sir G. Hayter's study for NPG 54 above, was published Dowding, 1840 (example in NPG); there are various popular lithographs and engravings in the NPG.

CODRINGTON *Sir William John* (*1804–84*)

General; distinguished himself during the Crimean war at Alma and Inkerman; commander-in-chief at Sebastopol, 1855–6; governor of Gibraltar, 1859–65; general, 1863.

883 (8) With his brother, Edward Codrington (1803–19). Pencil, pen and ink, and grey wash on paper, $6\frac{7}{8} \times 5\frac{1}{8}$ inches (17·5 × 13 cm), by SIR GEORGE HAYTER, *c* 1812. PLATE 195

Inscribed in ink (*bottom left and centre*)*:* Mr Edward and Mr Will^m Codrington

Collections: A. D. Hogarth & Sons, purchased from them, 1891.

Edward is on the left, William on the right. The date is based on the apparent ages of the two boys. This sketch is almost certainly a study for a miniature, whose present location is not known. It is one of several Hayter drawings which will be collectively discussed in the forthcoming Catalogue of Portraits, 1790–1830.

ICONOGRAPHY A painting by Sir W. Boxall was exhibited *VE*, 1892 (153), lent by Major A. E. Codrington; a painting by F. Cruikshank was lithographed by L. Dickinson (example in NPG); there is an anonymous lithograph published Read & Co (hand-coloured example in NPG); at least two photographs were taken in the Crimea by R. Fenton, one reproduced Duke of Argyll, *V.R.I. her Life and Empire* (no date), p 214, another reproduced *Country Life*, LXI (1927), 671; a woodcut, after a photograph by Mayall, was published *ILN*, xxx (1857), 479.

COLBORNE *Nicholas William Ridley-Colborne, 1st Baron* (*1779–1854*)

Statesman and financier.

342, 3 See *Groups:* 'The Fine Arts Commissioners, 1846' by J. Partridge, p 545.

COLBY *Thomas Frederick* (*1784–1852*)

Director of the ordnance survey; attached to ordnance survey of England, 1802; conducted survey of Scotland, 1813–21, and Ireland, 1825–47; director of the survey, 1820.

2515 (82) Black and red chalk, with touches of Chinese white, on grey-tinted paper, $14\frac{1}{8} \times 10\frac{1}{4}$ inches ($36 \times 26 \cdot 1$ cm), by WILLIAM BROCKEDON, 1837. PLATE 196

 Dated (lower right): 27.6.37.

 Collections: See *Collections:* 'Drawings of Prominent People, 1823–49' by W. Brockedon, p 554.

 Accompanied in the Brockedon Album by a letter from the sitter, dated 24 March 1846.

ICONOGRAPHY A monument in St James' Cemetery, Liverpool, is recorded in the *Dictionary of National Biography*, XI (1887), 259, together with a bust by an unknown artist in the Ordnance Map Office, Southampton (destroyed in the Second World War); a drawing, apparently signed 'N. Rattraychatt,' is reproduced Colonel Sir Charles Close, *The Early Years of the Ordnance Survey* (Institute of Royal Engineers, Chatham, reprinted from 'The Royal Engineers Journal') 1926, facing p 98.

COLE *Arthur Henry* (*1780–1844*)

 MP for Enniskillen.

54 See *Groups:* 'The House of Commons, 1833' by Sir G. Hayter, p 526.

COLE *Sir Henry* (*1808–82*)

 Official; played a leading role in the development of the schools of design, and design in general; active promoter of the Great Exhibition of 1851, the South Kensington Museum, and numerous other projects; secretary of the Science and Art Department, 1853–73.

1698 Coloured chalk on brown, discoloured paper, $25 \times 19\frac{1}{2}$ inches ($63 \cdot 5 \times 49 \cdot 5$ cm), by SAMUEL LAURENCE, 1865. PLATE 197

 Signed and dated (bottom left): Samuel Laurence/Delt. 1865

 Collections: The sitter, presented by his son, A. S. Cole, 1913.

 Exhibitions: RA, 1866 (662); *VE*, 1892 (421).

 Literature: F. Miles, 'Samuel Laurence' (typescript copy, NPG library).

 Cole was almost certainly introduced to Laurence by Charles Buller, who was himself drawn by the artist in 1837.

 Description: Healthy complexion, grey eyes, grey hair and beard.

865 Plaster cast, $28\frac{1}{2}$ inches ($72 \cdot 4$ cm) high, of a bust by SIR JOSEPH EDGAR BOEHM, 1875. PLATE 198

 Incised (below the shoulder): Boehm. 1875. Sir Henry Cole C.B.

 Collections: The artist, purchased from his executors, 1891.

 One of an edition of casts presumably related to the marble bust of Cole by Boehm, exhibited *RA*, 1876 (1453). Another plaster bust, identical to the NPG type, is in the Victoria and Albert Museum.

ICONOGRAPHY Cole appears in the painting of 'The Royal Commissioners for the Exhibition of 1851' by H. W. Phillips in the Victoria and Albert Museum, exhibited *Victorian Era Exhibition*, 1897, 'History Section' (8), and in a mosaic in the same museum; a bust by J. Gamble was exhibited *RA*, 1875 (1402); two woodcuts were published *ILN*, XIX (1851), 509, and LXIII (1873), 36; a photograph is in the NPG.

COLERIDGE *Sara* (*1802–52*)

 Author of *Phantasmion*, 1837; daughter of the poet, Samuel Taylor Coleridge; married her cousin, Henry Nelson Coleridge, 1829; annotated and edited her father's writings.

4029 With her cousin, Edith Southey (later Mrs J. W. Warter), on the right. Miniature, water-colour on ivory, $5\frac{5}{8} \times 4$ inches ($14 \cdot 3 \times 10 \cdot 2$ cm), by EDWARD NASH, 1820. PLATE 199

Collections: By descent to Edith Southey's granddaughter, Mrs E. A. Boult, and bequeathed by her, 1957.

Literature: Selections from the Letters of Robert Southey, edited J. W. Warter (1856), III, 212–13; *NPG Annual Report, 1957–8* (1959), p 4.

This miniature was bequeathed together with another of Robert Southey, also by Nash (NPG 4028), which will be catalogued in the forthcoming Catalogue of Portraits, 1790–1830. The name of the artist was not given at the time, and both miniatures were until recently described as by unknown artists. Southey's letter to G. C. Bedford of 6 November 1820 (Warter, III, 212–13), however, undoubtedly refers to them: '*Nash, who is on his way to town, has made an excellent portrait of him* [Cuthbert, Southey's youngest son]; *a tolerable miniature of my poetship; and a double miniature of Sara and Edith which you will be much pleased with.*' I am most grateful to Bertram Davis for pointing out this reference, and for providing corroborative evidence of the authorship of the miniatures. Mr Davis knew Mrs Boult, who was never in any doubt that they were the work of Nash. There are also further references to his own miniature in Southey's correspondence (see, for example, *The Correspondence of Robert Southey with Caroline Bowles*, edited by Edward Dowden (1881), p 151). Nash had travelled with him on the continent and became a close friend, staying several times with the Southeys at Greta Hall, Keswick, between 1815 and 1820.

Description: Sara Coleridge – delicate complexion, blue eyes, brown hair. In a light blue dress with white lace sleeves and neck. Edith Southey – pale complexion, blue eyes, light brown hair. In a green dress with white sleeves, and a white lace neck and gold chain. Red roses in her hair. At left distant view of blue sky. Behind at centre, green wall or pillar. Behind at right red curtain.

ICONOGRAPHY A painting by W. Collins of 1818, in the character of Wordsworth's 'Highland Girl', is in the collection of the Rev G. H. B. Coleridge; a painting by S. Laurence of 1848 is in the collection of the Rev A. D. Coleridge, lithographed by R. J. Lane (example in NPG); a replica is in the collection of W. Coleridge; a painting called Sara Coleridge and attributed to Laurence was sold Christie's, 20 February 1970 (lot 60); a drawing by G. Richmond of 1845 is listed in his 'Account Book' (photostat copy, NPG archives), p 38; a drawing by M. Carpenter is in the British Museum; a miniature by Eliza Jones was exhibited *RA*, 1827 (799).

COLLINSON *Sir Richard* (*1811–83*)

Admiral; engaged in survey work on the South American coast, and the China seas; went in search of Sir John Franklin, 1850–4; admiral and KCB, 1875; wrote geographical papers.

914 Oil on canvas, $15\frac{3}{8} \times 12\frac{7}{8}$ inches (38·9 × 32·6 cm), by STEPHEN PEARCE, after his portrait of 1855.
PLATE 201

Collections: See *Collections:* 'Arctic Explorers' by S. Pearce, p 562.

This is a replica of NPG 1221 below, and was commissioned by Lady Franklin. The only difference between the two portraits is in the arrangement of the medals.

Description: As for NPG 1221.

1221 Oil on canvas, $15\frac{1}{2} \times 13$ inches (39·3 × 33 cm), by STEPHEN PEARCE, 1855. **PLATE 200**

Collections: See *Collections:* 'Arctic Explorers' by S. Pearce, p 562.

Exhibitions: RA, 1856 (22); *Royal Naval Exhibition*, Chelsea, 1891 (42).

Literature: Reproduced as a woodcut *ILN*, XXVI (1855), 472.

Collinson is wearing the full-dress uniform (1846 pattern), either of a naval captain with over three years service, or of a commodore (1st or 2nd class), with (from left to right) the Arctic Medal (1818–55), the Bath (CB), and the China Medal (1842).

Description: Healthy complexion, brown eyes, brown hair and whiskers. Dressed in a dark stock, white shirt, and dark blue uniform, with a silver belt, gold-braided collar and epaulettes, gilt buttons, white enamel star, and silver medals with multi-coloured ribbons. Background colour dark brown.

ICONOGRAPHY The only other recorded likenesses of Collinson are, a photograph by Lock and Whitfield, published *Men of Mark*, II (1877), 12, also published as a woodcut *ILN*, LXXXIII (1883), 309; and a photograph in the Royal Geographical Society, London.

COLONSAY AND ORONSAY *Duncan McNeill, 1st Baron* (*1793–1874*)

Scottish judge; solicitor-general for Scotland, 1834–5, 41–2; MP for Argyllshire, 1843–51; lord advocate, 1842–6; lord justice-general, 1857–67; created a peer, 1867.

2627 Water-colour and body colour on blue-tinted paper, 11 × 6¾ inches (27·8 × 17·2 cm), by SPY (SIR LESLIE WARD), 1873. PLATE 202

Signed (*lower right*): Spy *Inscribed on the mount:* Lord Colonsay./September 13, 1873

Collections: Thomas Bowles; *Vanity Fair* Sale, Christie's, 5 March 1912 (lot 166); Charles Newman, purchased from him, 1933.

This is one of a large collection of original studies for *Vanity Fair*, which were owned and specially mounted by the first proprietor of the magazine, Thomas Bowles. Those in the NPG will be discussed collectively in the forthcoming Catalogue of Portraits, 1860–90. The water-colour of Lord Colonsay was published in *Vanity Fair* as a coloured lithograph, on 13 September 1873, as 'Statesmen, no. 154', with the title, 'Scotch Law'.

Description: White hair and whiskers. Dressed in a black tie, white shirt and dark grey suit. Seated on a red sofa presumably in the House of Lords (a peer's coronet appears in the top right-hand corner), with a black top-hat beside him, stuffed with papers.

ICONOGRAPHY A painting by J. Phillip of 1866, exhibited *R A*, 1866 (93), reproduced A. A. Grainger Stewart, *Portraits in . . . Parliament House, Edinburgh* (1907), no. 12, and a marble bust by Sir J. Steell of 1856, are in the Faculty of Advocates, Edinburgh; a painting by T. Duncan and a plaster bust by Sir J. Steell (related to the marble) are in the Scottish NPG; an etching by B. W. Crombie of 1848 is reprinted in W. S. Douglas, *Crombie's Modern Athenians* (Edinburgh, 1882), plate 39.

COLVER *Rev Nathaniel*

American slavery abolitionist.

599 See *Groups:* 'The Anti-Slavery Society Convention, 1840' by B. R. Haydon, p 538.

CONDER *Josiah* (*1789–1855*)

Bookseller, author of verses, essays and religious tracts, and a slavery abolitionist.

599 See *Groups:* 'The Anti-Slavery Society Convention, 1840' by B. R. Haydon, p 538.

CONOLLY *Arthur* (*1807–42?*)

Traveller; served with the Bengal Cavalry; published, 1834, a description of his overland journey (1829–31) to India; official in Rajpootana, 1834–8; sent to Cabul, 1840, and then to Bokhara; imprisoned and later murdered there.

825 Water-colour on paper, 9½ × 6½ inches (24·1 × 16·5 cm), by JAMES ATKINSON, *c* 1840. PLATE 203

Inscribed in pencil (top right): Carbul [*sic*] July 21/Aug 11 *and (bottom right):* Arthur Conolly –/ subsequently murdered at Bokhara

Collections: The artist, presented by his son, Canon J. A. Atkinson, 1889.

Canon Atkinson presented several portraits by his father to the NPG, including a self-portrait (NPG 930). Besides a miniature by R. Thorburn in the Scottish NPG, this is the only recorded portrait of Conolly. Atkinson was in Cabul from 1838 to 1841, and Conolly was there in 1840; he left in September on a special mission to Central Asia, where he was murdered.

Description: Ruddy complexion, dark eyes, dark brown hair and beard. Dark grey coat.

CONOLLY *Edward Michael* (*1786–1848*)

MP for County Donegal.

54 See *Groups:* 'The House of Commons, 1833' by Sir G. Hayter, p 526.

CONROY *Sir John, Bart* (*1786–1854*)

Served in Royal Artillery; comptroller of household to the Duchess of Kent; unsuccessful in his attempts to control Queen Victoria through her; retired on a pension and created baronet, 1837.

2175 Miniature, water-colour and body colour on ivory, $6 \times 4\frac{1}{2}$ inches ($15 \cdot 2 \times 11 \cdot 4$ cm), by ALFRED TIDEY, 1836. PLATE 204

Inscribed on the original backboard, probably in the artist's hand: Alfred Tidey/88 Charlotte Street/ Fitzroy Sq^re/1836/Sir John Conroy Bt.

Collections: The sitter; by descent to his daughter, Victoire Marie-Louise Conroy, who married Sir Edward Hanmer, 4th Bart, 1842; purchased from the Hanmer family, through Messrs Spink & Son, 1927.

Exhibitions: R A, 1836 (794).

Literature: Dr Stuart Tidey, 'List of Miniatures by Alfred Tidey' (typescript of original MS, 1924, Victoria and Albert Museum Library), p 7, under 1835; D. Foskett, *British Portrait Miniatures* (1963), p 179.

According to Dr Stuart Tidey's list, based on his ancestor's diary, this miniature was begun on 13 August 1835, and finished on 22 February 1836. Conroy is wearing the ribbon and star of the Family Order of the Saxon Duchies, the Saxe-Ernestinische Order.[1] Another miniature of Conroy by Tidey was begun on 11 August 1835, but was apparently never finished, presumably because the artist was dissatisfied with it. It was in the collection of Dr Stuart Tidey's sister-in-law in 1932. In 1835 Tidey painted two other miniatures of Conroy (see Dr Stuart Tidey's List, p 6). One was begun on 9 September 1834 and finished on 27 October of the same year, the other was begun on 17 September 1834, and finished on 22 February 1836, the same date as the NPG miniature.

Description: Healthy complexion, brown hair. Dressed in a white shirt, dark stock, scarlet sash with green edge, black coat, and multi-coloured star. Faded purple curtain behind. Rest of background light brown.

ICONOGRAPHY A painting by H. W. Pickersgill is in the collection of Sir Edward Hanmer, Bart, exhibited R A, 1837 (72), engraved by H. T. Ryall, published F. G. Moon, 1840 (example in NPG); the same or another picture was in the Pickersgill Sale, Christie's, 17 July 1875 (lot 326); an engraving by W. J. Ward, after a painting by W. Fowler, was published Colnaghi and Puckle, 1839 (example in NPG); the original Fowler portrait was offered to the NPG by Mr Hatton, 1860, sketched by Scharf, '*T S B*' (NPG archives), IV, 53.

[1] I am most grateful to Hugh Murray-Baillie for this information.

COOPER *Abraham* (*1787–1868*)

Battle and animal painter; awarded premium for his picture of the 'Battle of Waterloo', 1816; elected RA, 1820; prolific and popular painter of historical and contemporary battles, and animal pieces.

1456 (2) Pencil on paper, heightened with Chinese white, $3\frac{1}{4} \times 3\frac{3}{8}$ inches ($8\cdot1 \times 8\cdot5$ cm), by CHARLES HUTTON LEAR, 1845. PLATE 206

Inscribed (lower right): Nov *and (lower centre):* A Cooper

Collections: See *Collections:* 'Drawings of Artists, *c*1845' by C.H.Lear, p 561.

This drawing was done in the life school of the Royal Academy, where Lear was a student, and was sent, together with others, in an undated letter to his parents (copy, NPG archives): '*No.4 old Abraham Cooper, the animal & battle painter. Very like. He is a most benevolent man & always ready to assist in doing good*'. This drawing was sent with one of Augustus Egg (NPG 1456 (5)), dated '1845'. Cooper was a visitor at the life school in that year.

3182 (1) Pencil on paper, $6\frac{3}{4} \times 4\frac{3}{8}$ inches (17×11 cm), by CHARLES WEST COPE, 1862. PLATE 207

Signed and dated lower left: RA V-/ CWC. [*in monogram*]/1862 – *Inscribed bottom right:* Old Cooper. RA

Collections: See *Collections:* 'Drawings of Artists, *c*1862' by C.W.Cope, p 565.

This drawing, which shows Cooper sketching below the statue of a nude male torso, was executed in the Royal Academy Schools.

3182 (19) With a female model. Pen and ink on paper, $8\frac{1}{4} \times 5\frac{1}{4}$ inches ($21 \times 13\cdot5$ cm), by CHARLES WEST COPE, 1864. PLATE 205

Signed and dated lower right: Dec 1864/ CWC [*in monogram*]/ RA *Inscribed in pencil lower left:* Old Cooper RA

Collections: As for NPG 3182 (1) above.

ICONOGRAPHY A painting by T.Vaughan was exhibited *RA*, 1820 (644); a painting of a 'Mr Cooper' (possibly Abraham) by W.S.Akers was exhibited *RA*, 1821 (671); an oil self-portrait was exhibited *RA*, 1840 (81); two paintings by A.D.Cooper, his son, were exhibited *RA*, 1843 (103), and 1856 (1192), one of them engraved by C.E.Wagstaff (example in NPG); a painting by J.E.Walker was exhibited *RA*, 1863 (600); Cooper appears in his own group portrait, 'The First of October' (with his son; his own portrait by J.Harwood), exhibited *RA*, 1857 (117), as painted for Joseph White of Clonmel; a drawing by T.Bridgford was exhibited *RA*, 1842 (985); an engraving by J.Thomson, after J.Jackson, was published J.Pittmann, 1827 (example in NPG), reproduced *Apollo*, L (1949), 78; an etching by J.H.Robinson, after W.Mulready, was published 1845 (example in NPG), for Pye's *Patronage of British Art*; a woodcut by F.Babbage is reproduced *Apollo*, L (1949), 78; there are several photographs in the NPG.

COOPER *Anthony Ashley, 7th Earl of Shaftesbury.* See SHAFTESBURY

COOPER *Joseph* (*1800–81*)

Slavery abolitionist.

599 See *Groups:* 'The Anti-Slavery Society Convention, 1840' by B.R.Haydon, p 538.

COOPER *Thomas Sidney* (*1803–1902*)

Animal painter; started career as a coach and scene painter; trained in RA schools; ARA, 1845; RA, 1867; renowned for his animal pictures, particularly of cows, which he derived chiefly from Dutch models; occupied a similar position in England to that of Troyon in France.

3236 Oil on canvas, 24 × 20 inches (61 × 50·8 cm), by WALTER SCOTT, 1841. PLATE 208

Collections: Presented by the artist to the sitter; by descent to the sitter's grandson, C.D.Coxon; bequeathed by his wife, Mrs Coxon, to her sister, Mrs F.Powles, and purchased from her, 1945.

Exhibitions: Presumably the portrait exhibited *RA*, 1842 (106).

A detail of this portrait was engraved by G.J.Stodart, published R.Bentley, 1890 (example in NPG), where the date of the original was given as 1841; this was confirmed by the vendor. The picture has suffered severely from bitumen, and is in very poor condition, but the face is relatively untouched.

Description: Healthy complexion, darkish eyes, brown hair. Dressed in a conventional dark suit and neck-tie. Seated in a red-covered chair. Background colour dark brown.

ICONOGRAPHY A painting by W.W.Ouless of 1889 is in the Royal Museum and Art Gallery, Canterbury, exhibited *RA*, 1889 (237); another painting by Ouless of 1891 is in the Aberdeen Art Gallery; a painting by J.P.Knight was exhibited *RA*, 1850 (374); an etching by T.G.Cooper was exhibited *RA*, 1884 (1387); an anonymous woodcut is reproduced *Art Journal* (1849), p337; another woodcut, after a photograph by J. & C.Watkins, was published *ILN*, LI (1867), 5; there are various photographs and reproductions of photographs in the NPG.

COOTE *Sir Charles Henry, Bart* (*1802–64*)

MP for Queen's County.

54 See *Groups:* 'The House of Commons, 1833' by Sir G.Hayter, p526.

COPLEY *John Singleton, the Younger, Baron Lyndhurst.* See LYNDHURST

CORRY *Henry Thomas Lowry* (*1803–73*)

MP for County Tyrone.

54 See *Groups:* 'The House of Commons, 1833' by Sir G.Hayter, p526.

COTTENHAM *Charles Christopher Pepys, 1st Earl of* (*1781–1851*)

Lord chancellor, and MP for Malton.

54 See *Groups:* 'The House of Commons, 1833' by Sir G.Hayter, p526.

COTTESLOE *Thomas Francis Fremantle, 1st Baron* (*1798–1890*)

Statesman; son of vice-admiral Sir Thomas Fremantle (1765–1819); tory MP, 1826–46; served in various administrations; deputy chairman and chairman of the board of customs, 1846–73; raised to peerage, 1874.

3190 Water-colour and body colour on blue-toned paper, 12⅜ × 7⅛ inches (30·8 × 18·2 cm), by SPY (SIR LESLIE WARD), 1876. PLATE 209

Signed (lower right): Spy *Inscribed on the mount:* Lord Cottesloe./July 22, 1876.

Collections: Thomas Bowles; *Vanity Fair* Sale, Christie's, 5 March 1912 (lot 175); A.Yakovleff, purchased from him, 1945.

This is one of a large collection of original studies for *Vanity Fair*, which were owned and specially mounted by the first proprietor of the magazine, Thomas Bowles. Those in the NPG will be discussed collectively in the forthcoming Catalogue of Portraits, 1860–90. The water-colour of Cottesloe was published in *Vanity Fair* as a coloured lithograph, on 22 July 1876, with the title, 'Customs'.

Description: Grey hair. Dressed in a black stock, white shirt, black suit, shoes and top-hat, holding a black cloak (?) over his arm and carrying an umbrella.

54 See *Groups:* 'The House of Commons, 1833' by Sir G. Hayter, p 526.

ICONOGRAPHY A drawing by G. Richmond is listed in his 'Account Book' (photostat copy of original MS, NPG archives), p 76, under 1863, engraved by W. Holl (example in NPG), for the 'Grillion's Club' series; a bust by G. G. Adams was exhibited *RA*, 1878 (1496).

COTTON *Richard Lynch* (*1794–1880*)

Provost of Worcester College, Oxford; fellow of Worcester College, 1816–38; provost, 1839–80; vice-chancellor of Oxford, 1852–7; published sermons.

4541 (9, verso) With various other figures, receiving the Duke of Nemours at Worcester College, Oxford. Pencil, pen and ink on paper, $7 \times 8\frac{7}{8}$ inches (17.9 × 22.4 cm), by MISS CLARA PUSEY, *c* 1856. PLATE 210

Inscribed in ink (top left): The Christ Church Express No 2 *Below are various typewritten notes identifying the subject and the figures, and part of a letter from Clara Pusey in pencil.*

Collections: See Collections: 'Sketches of the Pusey Family and their Friends, *c* 1856' by Miss C. Pusey, p 563.

This drawing is on the back of another drawing which shows an Oxford lunch or dinner party. Both were sent by Clara Pusey to her cousin, Alice Herbert, as part of a running commentary on people and events at Oxford. The letter to Alice, written on both sides of the sheet, is given in full in the discussion of the collection as a whole. The figures represented in this drawing (apart from two sketchy and unidentified figures on the extreme left) are, from left to right, Clara Pusey, the Hon Alan Herbert, Mrs Cotton, Dr Cotton, and the Duke of Nemours.

ICONOGRAPHY A painting by Sir W. Boxall is at Worcester College, Oxford, reproduced Mrs R. Lane Poole, *Catalogue of Oxford Portraits*, III (1925), plate XX, facing 264, engraved by S. Bellin, published J. Wyatt, Oxford, 1858 (example in NPG).

COTTON *Sir Willoughby* (*1783–1860*)

General; served in the Peninsula, 1809–11 and 1813–14; served in Burma, 1825–6; governor of Jamaica, 1829–34; served in the Afghan war, 1838–9; commander-in-chief in Bombay, 1847–50; general, 1854.

824 Water-colour on paper, $9\frac{1}{2} \times 6\frac{1}{2}$ inches (24.1 × 16.5 cm), by JAMES ATKINSON, *c* 1838. PLATE 212

Inscribed in pencil (bottom right): Sir Willoughby Cotton

Collections: The artist, presented by his son, Canon J. A. Atkinson, 1889.

Presented at the same time as several other portraits by Atkinson, including a self-portrait (NPG 930). This drawing was probably executed in Cabul. Cotton was there from 1838–9, and Atkinson from 1838–41.

Description: Dark complexion, greyish hair and beard. Dressed in white shirt, dark stock and pale blue coat.

4026 (15) Pencil and black chalk, with touches of red on cheek and forehead, on paper, 11 × 8 inches (28 × 20.3 cm), by COUNT ALFRED D'ORSAY, 1842. PLATE 211

Signed and dated (lower right): D'Orsay fecit/11 Jany 1842 *Autograph in ink (bottom right):* Willoughby Cotton.

Collections: See *Collections:* 'Drawings of Men About Town, 1832–48' by Count A. D'Orsay, p 557.

Lithographed by R. J. Lane, 1842, published J. Mitchell (example in British Museum).

ICONOGRAPHY There are no other recorded likenesses of Cotton.

COUSINS *Samuel* (*1801–87*)

Mezzotint engraver; one of the leading practitioners of his craft, 1826–83; helped to raise the prestige of his profession; ARA, 1835; first artist to be elected an academician-engraver, 1855; instituted a fund for indigent artists.

1447 Oil on canvas, 36 × 28 inches (91·5 × 71·1 cm), by JAMES LEAKEY, 1843. PLATE 214

Inscribed on the letter (*bottom right*) *which the sitter is holding:* S. Cousins E[sq*r*] RA

Inscribed on a label on the back of the picture (*in the artist's hand*): No. 50/Samuel Cousins Esq*r* R.A./the celebrated engraver. *Inscribed on another label* (*in the donor's hand*): This portrait of/Samuel Cousins/ belongs to/Miss Emily P. Leakey/ 26 East Southernhay/Exeter/Painted by her father James Leakey/. His handwriting is on the wooden frame. *Inscribed on another label* (*in the donor's hand*): There is a small cut on the/lower part of the picture – this/I think was caused by/a nail on a landscape that/ rested against it some years ago

Collections: The artist, presented by his daughter, Miss Emily Leakey, 1906.

The date of this portrait was supplied by Miss Leakey. Both Cousins and the artist were natives of Exeter, which explains their connection.

Description: Dark brown hair, lighter brown side-whiskers, dark blue-green eyes, healthy complexion. Dressed in a black coat, dark grey stock, white shirt, yellow waistcoat. Seated in a mahogany chair with red leather (?) arm-pads and back. Light red curtain behind with gold fringe. Rest of background, including faint suggestion of a pillar, brown/grey.

1751 Pen, wash and body colour on paper, 6⅜ × 5½ inches (16·2 × 14 cm), by FRANK HOLL, 1879. PLATE 213

Collections: E. E. Leggatt, presented by him, 1915.

This is a study for the oil portrait of Cousins by Holl in the Tate Gallery, exhibited *RA*, 1879 (189), and *Annual Exhibition, Royal Society of Portrait Painters*, 1907 (32). It was etched by C. Waltner, published Agnew, 1881 (example in NPG). In the autumn of 1878, Holl's father suggested that his son should paint Cousins, an old friend, in order to establish his ability in portraiture. Holl reluctantly agreed, and managed to persuade Cousins to sit. The finished portrait was widely praised, only Cousins remarking with amusement and some disgust: '*What will all the young ladies say when they see it?*'[1]

In a letter of 28 January 1935 (NPG archives), however, Cousins' nephew, J. H. Cousins, wrote:

*Will you allow me to say, with all respect to Frank Holl, that that drawing was a complete failure to represent the facial appearance of Samuel Cousins, and quite unrecognizable as a portrait of him, and in this opinion all his family agreed. Subsequently however Edwin Long R.A. painted an excellent portrait of Samuel Cousins, which was appreciated by us all, and in his 84*th *year he made an excellent engraving from this portrait* (*without spectacles*) *and distributed Proof Prints amongst his relatives.*

Long's portrait was painted in 1883 (see iconography below). A copy of Holl's portrait was offered to the NPG in 1939 by W. T. Flowers.

3182 (3) See entry under Solomon Hart, p 215.

ICONOGRAPHY Paintings by S. W. Reynolds junior and T. Mogford were exhibited *RA*, 1821 (372), and 1849 (310); a painting by E. Long is in the Tate Gallery, exhibited *RA*, 1883 (470), engraved by S. Cousins, published Fine Art Society, 1884 (example in NPG); a painting by Sir A. S. Cope of 1883 is in the Aberdeen Art

[1] A. M. Reynolds, *The Life and Work of Frank Holl* (1912), p 158. See also pp 157–8 and 159–60.

Gallery; a painting by G.F.Watts was in the collection of Mrs Watts; there are two photographs in the NPG, and another was reproduced *The Times*, 2 March 1932.

COWPER *Hon Charles Spencer* (*1816–79*)

Son of 5th Earl Cowper.

4026 (16) See *Collections*: 'Drawings of Men About Town, 1832–48' by Count A.D'Orsay, p 557.

COX *David* (*1783–1859*)

Landscapist and water-colourist; brought up in Birmingham; began his career as a scene-painter; sketched in Wales, 1805–6; worked intermittently as a drawing-master; made regular summer sketching tours; though underrated in his own day, he has become one of the best-known and best-loved water-colourists of the English school.

1403 Oil on canvas, $30\frac{1}{8} \times 25$ inches ($76 \cdot 5 \times 63 \cdot 5$ cm), by WILLIAM RADCLYFFE, 1830. PLATE 215

Collections: The sitter; by descent to his son, David Cox junior; Shepherd Bros, purchased from them, 1905.

Exhibitions: *Spring Exhibition*, Shepherd Bros, 1905 (90).

Literature: N.Solly, *Memoir of the Life of David Cox* (1875), p 66.

This portrait was painted in Birmingham; Radclyffe was an old friend, who engraved many of Cox's pictures. Solly, who provided the date, wrote:

The costume is very unbecoming, as he has a coat with the very broad stiff collar of that period. . . . The bright grey eyes look out very intelligently from beneath the full and rather bushy eyebrows, and are the most distinguishing feature of the face.

Description: Healthy complexion, brown eyes, and brown hair with grey streaks. Dressed in a black stock, white shirt, yellow waistcoat, and brown coat with brown velvet collar. Seated in a wooden armchair covered with red figured material. Background colour greenish-brown.

1986 Oil on canvas, 24×20 inches ($61 \times 50 \cdot 6$ cm), by SIR WILLIAM BOXALL, 1856. PLATE 218

Collections: The sitter, bequeathed by his son, David Cox junior, with a life interest for his wife and daughters; the portrait entered the collection on the death of Miss Emily Cox, 1923.

Exhibitions: *RA*, 1857 (499); *Dublin Exhibition*, 1872, 'Paintings in Oil' (567).

Literature: N.Solly, *Memoir of the Life of David Cox* (1875), pp 284–5.

Cox travelled to London on 24 May 1856, specially to sit for this portrait. He first went to the artist's studio on 6 June, in company with his granddaughter: '*He appears to have enjoyed the sitting, as he said that Boxall conversed with him very pleasantly all the time*'. A second sitting took place on 12 June. The Boxall portrait was not generally considered so good a likeness as the Watson Gordon picture (see iconography below). Its size was reduced when it entered the collection, because the extremities had become almost invisible.

Description: Healthy complexion, brownish eyes, and grey hair. Dressed in a black stock, white shirt, and dark green or brown coat. Background colour dark brown.

1074 Pencil on paper, $5\frac{1}{4} \times 4$ inches ($13 \cdot 3 \times 10 \cdot 3$ cm), by an UNKNOWN ARTIST, 1855. PLATE 217

Inscribed (*bottom centre*): David Cox 1855

Collections: Henry Bertram, purchased from him, 1896.

According to a letter from the donor (14 October 1896, NPG archives), he showed this drawing to William Linnell, who had known Cox, '*& he at once said it was exactly as he remembered him*'. The head

in this drawing is not dissimilar from the portrait by Watson Gordon, executed the same year (see iconography below), and may be after it.

ICONOGRAPHY A painting by Sir J. Watson Gordon of 1855 is in the City Museum and Art Gallery, Birmingham, exhibited *RA*, 1856 (138), and *SKM*, 1868 (619), reproduced T. Cox, *David Cox* (1947), p 114, and engraved by S. Bellin, published W. Hutton (example in NPG); a study is in the Scottish NPG; a painting called Cox by an unknown artist was in the collection of Colonel M. H. Grant; a painting called Cox by an unknown artist was sold Sotheby's, 12 February 1942 (lot 20); a water-colour by H. Johnson of 1845 (plate 216) is in the collection of Dr W. J. Heely, 1949; a bust by P. Hollins of 1860 is in the City Museum and Art Gallery, Birmingham; there is a bronze medallion by G. Morgan in the NPG; there is a photograph by J. Watkins in the NPG, and another photograph is reproduced N. Solly, *Memoir of the Life of David Cox* (1875), frontispiece.

COX *Rev Francis Augustus* (*1783–1853*)

Baptist preacher; librarian of London University; author and slavery abolitionist.

599 See *Groups*: 'The Anti-Slavery Society Convention, 1840' by B. R. Haydon, p 538.

CRAMER *John Antony* (*1793–1848*)

Cleric and scholar; educated at Christ Church, Oxford, where he became a tutor and rhetoric reader; held other university posts; succeeded Arnold as regius professor of modern history, 1842; dean of Carlisle, 1844; published various historical, classical and geographical works.

2515 (72) Black and red chalk, with touches of Chinese white, on grey-tinted paper, $13\frac{7}{8} \times 10\frac{1}{4}$ inches (35·3 × 26 cm), by WILLIAM BROCKEDON, 1834. PLATE 219

Dated (lower left): 4.10 34

Collections: See *Collections*: 'Drawings of Prominent People, 1823–49' by W. Brockedon, p 554.

Accompanied in the Brockedon Album by a letter from the sitter, dated 3 March.

ICONOGRAPHY This is the only recorded likeness of Cramer except for a miniature by Charlotte Farrier, exhibited *RA*, 1842 (806).

CRANWORTH *Robert Monsey Rolfe, Baron* (*1790–1868*)

Lawyer; barrister, 1816; MP, 1832 onwards; solicitor-general, 1834; vice-chancellor, 1850; raised to peerage, 1850; lord chancellor, 1852–8, and 1865–6.

285 Oil on canvas, $55 \times 43\frac{1}{4}$ inches (139·7 × 109·8 cm), by GEORGE RICHMOND, 1860–2. PLATE 220

Collections: The sitter, bequeathed by him, 1869.

Exhibitions: *RA*, 1862 (242).

Literature: Richmond's 'Account Book' (photostat copy of original MS, NPG archives), pp 71 and 74, under 1860 and 1862.

Cranworth is depicted in his robes as lord chancellor. A study for this painting, dated 1860, is at Lincoln's Inn. In Richmond's 'Account Book' a first payment for this portrait is recorded in 1860, and a second in 1862, so that the portrait may possibly not have been finished till that year. The fact that it was only exhibited at the *RA* in 1862 supports this view. Richmond executed an earlier drawing of Cranworth in 1847 (see iconography below).

Description: Healthy complexion, grey eyes, grey wig. Dressed in a white lace cravat, black and gold-braided robes, black breeches, grey stockings. Green-covered table at left with a white document and a

gold-braided seal-bag with red tassels and a multi-coloured royal coat of arms. Seated on a red velvet-covered armchair. Most of background covered by a red curtain with a small canopy at the top; part of the royal coat of arms is visible on the right. Strip of background on the left dark brown.

1125 See *Groups:* 'The Coalition Ministry, 1854' by Sir J. Gilbert, p 550.

ICONOGRAPHY A drawing is recorded in Richmond's 'Account Book' (photostat of original MS, NPG archives), p 44, under 1847, engraved by F. Holl, published J. Hogarth, 1850, and by W. Holl (examples in NPG); a woodcut by G. C. Leighton, after A. Blaikley (example in NPG), was published *ILN*, XXX (1857), between 126–7; a photograph by Mayall was published *Cassell's Illustrated Family Paper* (October 1858), p 312; a woodcut, after a photograph by W. and D. Downey, was published *ILN*, LIII (1868), 153.

CRAVEN *William, 2nd Earl of (1809–66)*
Lord Lieutenant of Warwickshire.

4026 (17) See *Collections:* 'Drawings of Men About Town, 1832–48' by Count A. D'Orsay, p 557.

CRAVEN *Keppel Richard (1779–1851)*
Traveller.

4026 (18) See *Collections:* 'Drawings of Men About Town, 1832–48' by Count A. D'Orsay, p 557.

CREWDSON *Isaac (1780–1844)*
Quaker, author and slavery abolitionist.

599 See *Groups:* 'The Anti-Slavery Society Convention, 1840' by B. R. Haydon, p 538.

CREWDSON *William Dillworth*
Slavery abolitionist.

599 See *Groups:* 'The Anti-Slavery Society Convention, 1840' by B. R. Haydon, p 538.

CRIPPS *Joseph (1765–1847)*
MP for Cirencester.

54 See *Groups:* 'The House of Commons, 1833' by Sir G. Hayter, p 526.

CRISTALL *Joshua (1767–1847)*
Painter and water-colourist; began career as a china-painter; foundation member of the Water-colour Society, and president of it on its reconstruction, 1821; a prominent figure of the English water-colour school, and an extremely accomplished, though repetitive artist.

1456 (3) Black chalk on brown-tinted paper, heightened with Chinese white, $3\frac{1}{4} \times 3\frac{1}{8}$ inches ($8 \cdot 2 \times 7 \cdot 9$ cm), by CHARLES HUTTON LEAR, 1846. PLATE 221

Inscribed (lower left): J. Cristall/Nov 46

Collections: See *Collections:* 'Drawings of Artists, c 1845' by C. H. Lear, p 561.

ICONOGRAPHY A painting by an unknown artist was recorded by G. Scharf, 'SSB' (NPG archives), XCVI, 51, in the collection of E. J. Tarver, 1878; a drawing by J. Varley is in the Victoria and Albert Museum (Dawson Turner album), and so is a drawing by D. Maclise (Forster Collection); medallion portraits by P. Rouw, and J. Durham, were exhibited *RA*, 1819 (1143), and 1848 (1471); Partridge included Cristall in his 'Sketching Society' of 1836, last recorded in 1913; a related lithograph by J. Hogarth, published 1858, and a related water-colour, are in the British Museum; four studies of J. J. Chalon, T. Uwins, C. R. Leslie and R. T. Bone are in the NPG (NPG 4230–33).

CROKER *Thomas Crofton* (*1798–1854*)

Irish antiquary; clerk at the admiralty in London, 1818–50; edited memoirs and books connected with the legends, topography and archaeology of Ireland.

4555 Oil on millboard, 14 × 10 inches (35·5 × 25·5 cm), by an UNKNOWN ARTIST, *c* 1849. PLATE 222

On the reverse is a Rowney label for the board, a label referring to the Dublin Exhibition, and a small label inscribed: M^r Joly

Collections: Dr Joly (1872); Captain A. W. F. Fuller (1935); David Barclay, purchased from him, 1967.

Exhibitions: Dublin Exhibition, 1872, 'Portraits' (295).

This was offered with a companion portrait of Samuel Lover, with the same provenance, which was not acquired. Both were offered to the NPG by Captain Fuller in 1935, and lent to the Dublin Exhibition by Dr Joly (1819–92), a Dublin barrister, whose large collection of engraved portraits is now in the National Library of Ireland, Dublin. The portrait of Croker was engraved anonymously, published J. McGlashan, 1849 (example in NPG), for the *Dublin University Magazine*. The Irish charter horn depicted on the table was one of his most prized possessions; a woodcut of it by D. Maclise appears in the sale catalogue of his library, Puttick and Simpson, 18–21 December 1854 (lot 335).

Description: Healthy complexion, brownish eyes, brown hair with grey streaks. Dressed in a black neck-tie, white shirt, and black suit and shoes, with a pair of spectacles resting on his stomach, holding a fine brush. Seated in a red chair, with his feet on a red pouffe. Brown wooden table; dun-coloured horn with silver mounts. Light greenish-beige background colour; the figure of a knight in armour shows through faintly in grisaille, top left.

ICONOGRAPHY A painting by S. Pearce was offered to the NPG by the sitter's son, T. F. Dillon Croker, 1870, and again in 1882; it was sketched and recorded by G. Scharf, 'TSB' (NPG archives), XXX, 26; an engraving by D. Maclise (example in NPG) was published *Fraser's Magazine*, III (1831), facing 67, as no. 9 of Maclise's 'Gallery of Illustrious Literary Characters'; a water-colour study for this is in the Castle Museum, Norwich; a pencil study is in the Victoria and Albert Museum, as are two other unrelated drawings by Maclise, one dated 1827, and exhibited *Daniel Maclise*, Arts Council at the NPG, 1972 (6) (Maclise and Croker were close friends); Croker also appears in Maclise's engraving of 'The Antiquaries', published *Fraser's Magazine*, V (1832), between 474–5, in the engraving of 'The Fraserians' by Maclise, published *Fraser's Magazine*, XI (January 1835), between 2–3, for which two drawings are in the Victoria and Albert Museum, and in his painting 'Snap-Apple Night' in the collection of Mrs M. W. Cantor, exhibited *RA*, 1833 (380), and *Bicentenary Exhibition*, RA, 1969 (219); according to the *Gentleman's Magazine*, XLII (1854), 401, an early full-length portrait by Maclise (seated) was then in the collection of Richard Sainthill of Cork; a water-colour by Maclise, possibly that now in the Castle Museum, Norwich (see above), was in the Sir William Drake sale, Christie's, 24 May 1892 (lot 205); an early etching by Maclise was lithographed anonymously, from a unique impression (example in NPG), for a 'Memoir' of Croker (copy in British Museum), reprinted from the *Gentleman's Magazine* (1854), with the addition of the portrait; Croker also appears in the illustration to his article 'Druidical Remains near Lough Gur', published *Gentleman's Magazine*, CIII (1833), 105–12, illustration facing 108; a medallic portrait by W. Wyon is listed by the *Dictionary of National Biography* (no example located).

CROLY *George* (*1780–1860*)

Author and divine; contributor to various magazines, and dramatic critic to the *New Times*; gained reputation as a preacher when rector of St Stephen's, Walbrook, 1835–47; published numerous narrative and romantic poems, novels and sermons.

2515 (31) Black and red chalk, with touches of Chinese white, on green-tinted paper, 14½ × 10¼ inches (36·8 × 26 cm), by WILLIAM BROCKEDON, 1832. PLATE 223

Dated (lower left): 31–8–32

Collections: See *Collections:* 'Drawings of Prominent People, 1823–49' by W. Brockedon, p 554.

Accompanied in the Brockedon Album by a letter from the sitter, dated 12 December, with a postmark for 1829.

ICONOGRAPHY The only other recorded portraits of Croly are, a bust in St Stephen's Church, Walbrook, and two woodcuts published *ILN*, XXIV (1854), 401, after a daguerreotype by Beard, and XXXVII (1860), 531.

CROPPER *John*

Slavery abolitionist.

599 See *Groups:* 'The Anti-Slavery Society Convention, 1840' by B. R. Haydon, p 538.

CROTCH *William* (*1775–1847*)

Composer; child prodigy as an organist; organist at Christ Church, Oxford, and elsewhere, 1790–1807; professor of music at Oxford, 1797–1806; first principal of Royal Academy of Music, 1822–32; composed several works, including oratorios; published various books on musical subjects.

1812 Water-colour on paper, 18 × 14 inches (45·7 × 35·5 cm), by JOHN LINNELL, 1839. PLATE 225

Signed and dated in pencil (lower right): J. Linnell fe[ci]t 1839 *Inscribed in pencil (lower centre):* Dr Crotch

Collections: The artist; purchased from the Linnell sale, Christie's, 15 March 1918 (lot 82).

Exhibitions: RA, 1839 (870).

Included in the same lot in the Linnell sale were several other portraits, among them another of Crotch (NPG 1813 below), which remained in the NPG, and the others were dispersed.

Description: Florid complexion, brown eyes, greyish hair. Dressed in a white neck, dark waistcoat, and grey coat.

1813 Water-colour on paper, 17⅞ × 13¾ inches (45·4 × 34·9 cm), by JOHN LINNELL, c 1839. PLATE 224

Inscribed in pencil (bottom right): Dr Crotch

Collections: As for NPG 1812 above.

Closely related to the water-colour above, except that it is in reverse, and is much less finished.

Description: Florid complexion and brown eyes.

ICONOGRAPHY A painting by J. Sanders was exhibited *RA*, 1779 (289), etched by the artist, published 1778 (example in British Museum); two further paintings by Sanders were exhibited *RA*, 1780 (325), and 1785 (174); a painting called Crotch of c 1784 is in the collection of G. Donworth, Seattle; a painting by Sir W. Beechey is in the Royal Academy of Music, London, exhibited *Victorian Era Exhibition*, 1897, 'Music Section' (45), reproduced W. Roberts, *Sir William Beechey, R.A.* (1907), facing p 76; a painting, possibly by himself, is in the collection of W. B. Stone, reproduced *Country Life*, CIII (1948), 230; a drawing by J. Slater was exhibited *RA*, 1813 (789); a water-colour by T. Uwins of c 1814 is in the British Museum; a drawing by F. W. Wilkin was sold at Christie's, 5 February 1889 (lot 56), bought Brunel; a miniature by an unknown artist was in the collection of T. W. Taphouse, 1904; a plaster bust by J. Fazi is at Christ Church, Oxford; there are three anonymous engravings, one after a silhouette by Mrs Harrington of 1778, and two published by her (examples in British Museum); an engraving by J. Fittler was published Mrs Crotch, 1779 (example in British Museum); an engraving by J. Thomson, after W. Derby, was published 1822 (example in NPG), for the *European Magazine*; an engraving by W. T. Fry was published 1822 (no example located); an anonymous engraving was published April 1779, for the *London Magazine* (variant example in British Museum); a woodcut was published *ILN*, XII (1848), 5.

CRUIKSHANK *George* (*1792–1878*)

Artist and caricaturist; son of the caricaturist, Isaac Cruikshank (1756?–1811?); a popular satirist and caricaturist, with an enormous output; famous for his etchings to Grimm's *Popular Tales*, and his illustrations to Dickens; took up oil-painting in later life and exhibited at the RA; a fervent advocate of temperance.

1385 Oil on canvas, 13 × 10¾ inches (33 × 27·3 cm), by an UNKNOWN ARTIST, 1836. PLATE 226

Collections: Mrs Mary Bell, purchased from her, 1904.

Exhibitions: Charles Dickens, Victoria and Albert Museum, 1970 (c9), reproduced in catalogue.

The early history of this picture is unknown, but it almost certainly represents Cruikshank, in Vandyck costume. The date '1836' was given to the picture when it first arrived in the collection, but the reasons for this are not now known. Possibly there was a label on the back which is now lost, or the vendor may herself have supplied the information. The date would, however, agree with Cruikshank's apparent age in the portrait.

Description: Brown eyes, dark brown hair and beard. Dressed in a brown costume with white lace collar and cuffs, black cloak. Red curtain behind at left. Rest of background muddy brown.

3150 Water-colour on paper, 10 × 8⅝ inches (25·4 × 21·8 cm), by an UNKNOWN ARTIST. PLATE 227

Collections: P. M. Turner, presented by him, 1943.

This water-colour was previously attributed to Cruikshank, and was given to the NPG as a self-portrait. It is, however, clearly based on a photograph by Elliot and Fry, and cannot be accepted on any grounds as the work of Cruikshank. Its early history is unknown.

Description: Ruddy complexion, dark eyes, greyish hair and beard. Dressed in a white shirt, black tie and dark brown coat. Background colour dark reddish-brown with grey streaks.

4259 Seven sheets of paper, three with MS fragments, on which are three sketches of Cruikshank by HIMSELF. PLATE 229

Collections: The sitter; Sir Benjamin Ward Richardson, his executor; by descent to the latter's daughter, Mrs Martin, who gave them to S. Hodgson, and presented by him, 1962.

Literature: NPG Annual Report, 1962–3 (1963), p11.

Two of the sketches are in profile, one in pen-and-ink, the other in pencil, with touches of red; the third sketch is nearly full-face, in pen-and-ink. All three sketches are very small and slight, and they appear on the sheets with MS fragments. These appear to be fragments of letters or drafts of letters, covered with sketches and miscellaneous notes; one is addressed to Horace (?), but tails off, and is left unfinished. Among the other sketches are several profiles of the artist's brother, Isaac Robert Cruikshank, a finished drawing of his sister, Eliza, two smaller sketches of her head, a profile sketch of William Hone, drawings of an owl and a hooded figure, and a sketch of Sir Francis Grant's equestrian portrait of Queen Victoria at Christ's Hospital, Horsham.

1300 Plaster cast, painted black, 30 inches (76·2 cm) high, of a bust by WILLIAM BEHNES, *c*1855. PLATE 228

Incised on the front of the base, in imitation of the sitter's signature: George Cruikshank *and below:* BEHNES

Collections: The original bust (now destroyed) was purchased through A. Clayton, 1901 (see below).

Apparently related to the marble bust by Behnes on Cruikshank's tomb at Kensal Green Cemetery, London, exhibited *RA*, 1855 (1529). The original NPG bust was broken in 1923, and was replaced by a cast from the plaster bust in the British Museum. A similar plaster bust is in the print room of the Victoria and Albert Museum, and another was apparently in the Cruikshank sale, Christie's, 15 May

1878 (lot 169). A marble bust by J. Gawen, possibly that exhibited *RA*, 1868 (1032), with Charles Sawyer, 1938, was apparently based on the Behnes type.

ICONOGRAPHY A painting by H. S. Parkman was exhibited *RA*, 1849 (47); a painting by C. Gow was in the collection of J. Salter, 1926; there are several self-portrait drawings in the British Museum, and another is reproduced *Magazine of Art* (1897), p 266; there are three drawings by G. Scharf of 1875 in 'TSB' (NPG archives), XXI, 68; two miniatures by Mrs Turnbull and W. J. Fleming were exhibited *RA*, 1840 (838), and 1887 (1382); a marble bust by J. Adams-Acton was exhibited *RA*, 1871 (1264); a plaster medallion by G. Halss was in the collection of Mr Holliday, 1931; an engraving by D. Maclise was published *Fraser's Magazine*, VIII (1833), facing 190, as no. 39 of Maclise's 'Gallery of Illustrious Literary Characters'; there is an engraving by C. E. Wagstaff, after F. Stone (example in NPG); there is a lithograph by C. Baugniet, and an etching by F. W. Pailthorpe, published J. F. Dexter, 1883 (examples in British Museum); a woodcut was published *ILN*, LXXII (1878), 153; there are several photographs in the NPG.

CUBBON *Sir Mark* (*1784–1861*)

Commissioner of Mysore; served with the Madras infantry from 1800; inquired into Mysore rebellion, 1831; commissioner of Mysore, 1834–61; lieutenant-general, 1852; died at Suez on his way home.

4250 Water-colour and pencil on paper, $11\frac{1}{4} \times 9\frac{1}{4}$ inches (28·7 × 23·5 cm), by CAPTAIN MARTIN, *c* 1856–61. PLATE 230

Inscribed in pencil (*bottom left and centre*): Lt Genl Sir Mark Cubbon by Capt Martin
Collections: Purchased from Messrs Suckling & Co, 1962.

This portrait was purchased with another of Sir Patrick Grant by the same artist (NPG 4251). They must have been painted in Madras, where both men overlapped for a short period. Grant became commander-in-chief at Madras in 1856, and Cubbon is wearing the star of the Bath awarded him in the same year. Both men left Madras in 1861. The only recorded Captain Martin in Madras at this period was Captain George Matthew Martin of the 42nd Madras Native Infantry, who was a superintendent at Coorg and later at Chettledroog (information from Major Dawnay).

Description: Healthy complexion, brown eyes, brown hair with greyish side-whiskers. Dressed in a black stock, white shirt, red waistcoat and black coat.

ICONOGRAPHY An equestrian statue by an unknown artist is in Bangalore, India, recorded in the *Dictionary of National Biography;* there is an engraving by F. C. Lewis senior, after a portrait by his son of 1845 (example in NPG).

CUBITT *Lewis* (*1799–post 1853*)

Architect; involved in the development schemes of his brothers, Thomas (see below) and William (1791–1863); designed King's Cross Station with his brother, Joseph.

4099 Oil on panel, $24 \times 17\frac{5}{8}$ inches (61 × 44·7 cm), by SIR WILLIAM BOXALL, 1845. PLATE 231

Inscribed on a label on the back of the panel, in an old hand: Mr Lewis Cubitt painted by Boxall / 1845
Collections: Purchased from J. A. Tooth Ltd, 1959.
Exhibitions: Presumably the portrait exhibited *RA*, 1854 (296).
Literature: *NPG Annual Report, 1959–60* (1960), p 7.

Lord Ashcombe, a descendant of the sitter, confirmed the identification (memorandum of an interview, 10 April 1959, NPG archives), and stated that he knew the writing on the label, but did not know which

member of the family had written it (he had seen similar labels of the same type). A comparison with a portrait of Cubitt by an unknown artist at the offices of Holland, Hannen and Cubitt further establishes the identity. No other portraits of Cubitt are known.

Description: Healthy complexion, grey eyes, brown hair. Dressed in a white shirt, black neck-tie and coat. Seated in a red-covered chair. Dark table to left with papers, inkstand and quill pen on it. Background colour various tones of brown and grey.

CUBITT *Thomas* (*1778–1855*)

Builder and developer; brother of Lewis Cubitt (see above); carried out large-scale housing developments in London; built much of Belgravia, and the area around Clapham Park; a liberal patron to churches, schools and charities.

4613 Oil on canvas, $50 \times 39\frac{7}{8}$ inches ($127 \times 101 \cdot 2$ cm), by an UNKNOWN ARTIST. PLATE 232

Collections: By descent through the Cubitt family; presented by Cubitt Estates Ltd, 1968.

Description: Fresh complexion, bluish-grey eyes, grey hair. Dressed in a black stock and neck-tie, white shirt, and black waistcoat and suit, holding a rolled white document in his left hand. Seated in a green-covered armchair. Table at right covered with red cloth, inkpots and a piece of white paper. Most of background covered by deep red curtain. Wall at right various tones of greenish-grey and brown.

ICONOGRAPHY A painting by H.W.Pickersgill (originally full-length, now cut down) is in the collection of the London Master-Builders, exhibited *RA*, 1849 (212), engraved by G.R.Ward (example in NPG); a related miniature and a variant half-length copy are owned by Cubitt Estates Ltd, the latter reproduced *Country Life*, CXLV (1969), 1155; a marble bust by P.Macdowell of 1856 is at Denbies, Dorking, exhibited *RA*, 1856 (1368).

CUMMING-BRUCE *Charles Lennox* (*1790–1875*)

MP for Inverness.

54 See *Groups:* 'The House of Commons, 1833' by Sir G.Hayter, p 526.

CUNNINGHAM *Allan* (*1784–1842*)

Miscellaneous writer; friend of writers and artists; parliamentary reporter, and contributor to magazines; published various important literary, biographical and art historical works.

1823 Oil on canvas, 36×28 inches ($91 \cdot 4 \times 71 \cdot 1$ cm), by HENRY ROOM, *c* 1840. PLATE 233

Inscribed on the back of the canvas: Allan Cunningham/H.Room/del

Collections: Purchased from W.H.Crees & Son of Birmingham, 1918.

This portrait was engraved by J.Thomson, published G.Virtue, 1840 (example in NPG).

Description: Healthy complexion, brown eyes, dark brown hair with grey streaks. Dressed in a dark blue stock, white shirt, dark coat and grey plaid cloak. Background colour brown.

2515 (39) Black and red chalk, with touches of Chinese white, on blue-tinted paper, $13\frac{3}{4} \times 9\frac{1}{2}$ inches ($34 \cdot 9 \times 24 \cdot 1$ cm), by WILLIAM BROCKEDON, 1832. PLATE 234

Dated (lower left): 20–9–32

Collections: See *Collections:* 'Drawings of Prominent People, 1823–49' by W.Brockedon, p 554.

Accompanied in the Brockedon Album by a letter from the sitter, dated 17 September 1832.

ICONOGRAPHY A painting by H.W.Pickersgill is in the Scottish NPG, and so is a drawing by J.Penstone, engraved by the artist, published Cunningham and Mortimer (example in NPG), a marble bust by H.Weekes, exhibited *RA*, 1842 (1396), and a plaster bust by Sir F.Chantrey; a painting by Sir W.Boxall was exhibited *RA*, 1836 (80), and *SKM*, 1868 (300); a painting by F.W.Wilkin was sold at Christie's, 22 July 1871 (lot 65), possibly that lithographed by the artist (example in British Museum); a painting called Cunningham and attributed to Sir D.Wilkie was in the collection of J.J.Bell; a miniature by C.Fox was exhibited *RA*, 1837 (843); two busts by F.W.Smith were exhibited *RA*, 1823 (1060), and 1826 (1042); a marble bust by J.Fillans was exhibited *RA*, 1837 (1255); an engraving by D.Maclise was published *Fraser's Magazine*, VI (1832), facing 249, as no.28 of Maclise's 'Gallery of Illustrious Literary Characters'; a pencil study is in the Victoria and Albert Museum; an engraving by F.Roffe was published J.Limbird, 1822 (example in NPG); an engraving by J.Jenkins, after J.Moore, was published Fisher, 1834 (example in NPG), for Jerdan's 'National Portrait Gallery'; there is an engraving by W.C.Edwards, after W.D.Kennedy (example in NPG).

CUNNINGHAM *Peter* (*1816–69*)

Author and critic; son of Allan Cunningham (see above); chief clerk in the audit office; edited Walpole's letters, 1857, and the works of Drummond of Hawthornden, 1833; compiled a handbook to London, 1849.

1645 Black chalk on brown, discoloured paper, 23¼ × 17 inches (59 × 43·1 cm), by CHARLES MARTIN, *c* 1859. PLATE 235

Collections: Purchased from the artist's son, Thomas Martin, 1912.

Exhibitions: RA, 1859 (829).

Charles Martin was the son of the painter, John Martin. His sister, Zenobia, married Cunningham.

ICONOGRAPHY The only other recorded likeness of Cunningham is a photograph by Cundall, reproduced as a woodcut *ILN*, XXVIII (1856), 205.

CURETON *William* (*1808–64*)

Syriac scholar; chaplain of Christ Church, Oxford; canon of Westminster, 1849–64; discovered the epistles of St Ignatius in manuscript at the British Museum; edited Arabic texts.

3164 Coloured chalk on brown, discoloured paper, 23¾ × 18 inches (60·3 × 45·7 cm), by GEORGE RICHMOND, 1861. PLATE 236

Signed and dated (*bottom right*): Geo.Richmond del^t 1861

Collections: The sitter, presented by his granddaughter, Mrs A.H.Walker, 1943.

Exhibitions: SKM, 1868 (509).

Literature: G.Richmond, 'Account Book' (photostat copy, NPG archives), p73.

Presented at the same time as a drawing of Mrs Walker's great-grandfather, Edward Blore (NPG 3163).

Description: Healthy complexion, dark hair. White stock and shirt.

ICONOGRAPHY The only other recorded likenesses of Cureton are, a bust by G.J.Miller, exhibited *RA*, 1863 (1183), and a daguerreotype by Beard, reproduced as a woodcut *ILN*, XXIV (1854), 400.

CURSETJEE *Manockjee*

Parsee merchant.

2515 (92) See *Collections:* 'Drawings of Prominent People, 1823–49' by W.Brockedon, p554.

DALHOUSIE *Fox Maule Ramsay (Lord Panmure), 11th Earl of (1801–74)*

Statesman; served in the army, 1820–32; MP from 1835 onwards; under-secretary of state, 1835–41; secretary at war, 1846–52, and 1855–8; succeeded to earldom, 1860.

2537 Black and grey wash on paper, $9\frac{3}{8} \times 5\frac{7}{8}$ inches (23·8 × 14·9 cm), by THOMAS DUNCAN, *c* 1838. PLATE 237
Inscribed (bottom of the drawing): This rough sketch is intended as the model/for size, style of vignetting, character & shape of back-/-ground and position on the steel of the/Portrait of the Hon<u>ble</u> Fox Maule.
Collections: Iolo Williams, presented by him, 1932.

The inscription probably refers to the engraving by J. Porter, after a painting by Duncan, published Hodgson and Graves, 1838 (example in NPG). The location of Duncan's original oil portrait is not now known. The NPG water-colour is identical in pose to Porter's engraving though much more sketchy.

ICONOGRAPHY A painting by Colvin Smith of 1861 is in the Church of Scotland Assembly Hall, Edinburgh, probably the picture reproduced *The Panmure Papers*, edited Sir G. Douglas and Sir G. Ramsay (1908), I, frontispiece; paintings by L. Dickinson and J. Phillip were exhibited *RA*, 1848 (803), and 1864 (237); a miniature by Sir W. J. Newton was exhibited *RA*, 1846 (970), and busts by A. Munro and J. Hutchison, *RA*, 1870 (1063), and 1872 (1540); two woodcuts were published *ILN*, XVI (1850), 245, and LXV (1874), 61; there is a photograph by Southwell in the NPG, and an engraving by D. J. Pound, after a photograph by Mayall, was published 1859 (example in NPG), for the 'Drawing Room Portrait Gallery'; there is a lithograph by Posselwhite, after the same photograph, except that it shows the sitter in Masonic dress (example in NPG); there is a lithograph by F. Schenck, after a drawing by W. Crawford of 1845, published Schenck, Edinburgh (example in NPG).

DALHOUSIE *Sir James Andrew Broun Ramsay, 10th Earl and 1st Marquess of (1812–60)*

Governor-general of India; tory MP from 1837; president of the board of trade, 1845; governor-general of India, 1847; played a decisive role in the administrative, political and economic development of India; returned to England, 1856.

188 Oil on canvas, $95\frac{1}{2} \times 59\frac{1}{2}$ inches (242·5 × 151·1 cm), by SIR JOHN WATSON GORDON, 1847. PLATE 240
Signed and dated (bottom left): J. Watson Gordon ARA Pinx 1847
Collections: Presented by the artist's brother, H. G. Watson, 1865.
Exhibitions: RA, 1847 (63).

An oil study for this portrait is in the collection of Captain Colin Broun-Lindsay, Colstoun. The robes on the table appear to be those of the lord clerk register of Scotland. Gordon painted Dalhousie in these robes in another full-length portrait of the same year (see no. 2 below). A copy of NPG 188 by George Sephton of 1905 is in the India Office, London, and a reduced copy by E. Dyer is in the Victoria Memorial Hall, Calcutta. Other paintings of Dalhousie by Gordon are as follows:

1　*c1835.* (Full-length, in the uniform of the Royal Company of Archers). Archers' Hall, Edinburgh. Exhibited *RA*, 1835 (25). Reproduced Ian Hay, *The Royal Company of Archers* (1951), facing p 25. An oil study (plate 238) was sold Lyon and Turnbull, Edinburgh, 17 April 1963 (lot 571). A pencil study is in the Scottish NPG.

2　*1847.* (Full-length, in the robes of the lord clerk register of Scotland). Collection of Captain Colin Broun-Lindsay. Reproduced *Private Letters of the Marquess of Dalhousie*, edited J. G. A. Baird (1910), frontispiece. Exhibited *SKM*, 1868 (465). Similar in pose to NPG 188.

3　*c1858.* (Full-length, seated on a throne). Legislative Council Chamber, Calcutta. Exhibited *RA*, 1858 (125). Engraved by G. Stodart, published J. S. Virtue (example in NPG). Two oil studies are

in the Scottish NPG, and the collection of Captain Colin Broun-Lindsay, Colstoun. A copy by Clark is in the collection of the Earl of Bradford.

4 Two undated paintings were in the Gordon sale, Dowell of Edinburgh, 11 January 1896 (lots 93 and 100).

Description: Brown eyes, brown hair and whiskers. Dressed in a white shirt, dark stock, black coat, grey trousers, holding a black top-hat. Light brown floor. Yellow/gold figured curtain at left. Rest of wall brown. Wooden table at right, with red volume leaning against it, black and gold robes on it, and gilt and glass inkstand. Landscape behind green and bluish-grey. Orange and blue sky.

ICONOGRAPHY The following portraits, besides those by Gordon (for which see NPG 188 above), are in the collection of Captain Colin Broun-Lindsay, Colstoun: 'The Marquess of Dalhousie Entering Cawnpore, 1852', a sepia drawing by G.F.Atkinson, reproduced *Private letters of the Marquess of Dalhousie*, edited J.G.A.Baird (1910), facing p264; a water-colour (visiting Camp Wuzeerabad) of 1851 by an unknown artist; a drawing by G.Richmond of 1844 (plate 239), engraved by H.Robinson, published J.Hogarth, 1845 (example in NPG), engraving reproduced Sir W.Lee Warner, *The Life of the Marquess of Dalhousie* (1904), I, frontispiece; a marble bust by Sir J.Steell of 1847, possibly the bust exhibited *RA*, 1852 (1457).

A marble statue by Sir J.Steell of 1864 is in the Victoria Memorial Hall, Calcutta, reproduced Marquis Curzon, *British Government in India* (1925), II, facing 92; the original plaster cast of this bust is in the Scottish NPG; a marble bust by Steell of 1861 is in the collection of the Marquess of Tweeddale; a statuette by E.W. Wyon, commissioned by the Nepalese Ambassador, Jung Bahadoor, is reproduced as a woodcut *ILN*, XXII (1853), 61.

DALLING AND BULWER *William Henry Lytton Earle Bulwer, Baron (1801–72)*

Diplomatist; better known as Sir Henry Bulwer; published poems, 1822; aided Greeks in struggle for independence; served in army, 1825–9; attaché in various continental cities from 1827; ambassador at Madrid, 1843–8, at Washington, and elsewhere; played an influential role in English foreign affairs; published historical works.

852 Oil on canvas, 30 × 25 inches (76·2 × 63·5 cm), by GIUSEPPE FAGNANI, 1865. PLATE 241

Signed and dated (lower right): Fagnani/1865.

Collections: The artist, presented by his daughter, Emma Fagnani, through Lord Lytton, 1891.

Literature: Emma Fagnani, *The Art Life of a XIXth Century Portrait Painter Joseph Fagnani* (privately printed, 1930), p119, erroneously under 1864.

The picture was first offered to the NPG in 1872 by the artist, and again in 1877 by his daughter. In a letter of 26 January 1891 (NPG archives), Lord Lytton wrote:

If the Committee wishes to have one, it could nowhere obtain a more striking and characteristic likeness of Lord Dalling in his later years. The portrait I am forwarding to you is not only a good one; it is the best I have ever seen, and much better than the two portraits of him by the same hand which I possess myself [one of these is in the collection of David Cobbold, Knebworth].

Mr Fagnani was a young Spanish painter in whom my Uncle (then Sir Henry Bulwer) was much interested when Minister at Madrid. He followed my Uncle to America, where he married an American lady of some fortune; and many years later M and Madame Fagnani settled at Paris where their intimacy with my Uncle was renewed. Many likenesses of my Uncle, both as a young man and as an old one, were taken (in oils, crayon, and water colour) by Mr Fagnani during the course of their long intimacy which must have lasted over forty years. But this portrait was painted not long before my Uncles death when the Artist's powers were at their best; and when, for the reasons I have mentioned, he was better qualified, perhaps, than any other painter however eminent, to produce a characteristic likeness of Lord Dalling.

Description : Pale complexion, blue eyes, grey hair and brown beard. Dressed in a white shirt, dark stock, and dark coat with fur edge on left hand side. Background colour green.

ICONOGRAPHY Two drawings by Count A. D'Orsay, of 1839 and 1845, were sold from the Phillipps Library, Sotheby's, 13 February 1950 (lot 216), bought Colnaghi; the 1845 drawing was sold again, Christie's, 7 December 1967 (lot 64), bought Sawyer; it was lithographed by R. J. Lane in 1845 for the publisher Mitchell; a caricature drawing by J. Doyle is in the British Museum; a water-colour by 'Ape' (C. Pellegrini) was exhibited *Cartoon and Caricature from Hogarth to Hoffnung*, Arts Council, 1962 (84), lent by Draper Hill, lithographed for *Vanity Fair*, 27 August 1870 (no. 95); a lithograph by W. Sharp, after Krieger, was published J. Mitchell (example in NPG); a woodcut was published *ILN*, IX (1846), 245; a woodcut, after a photograph by O. Schoefft of Cairo, was published *Illustrated Review*, IV (1872), 97.

DALTON *John* (*1766–1844*)

Scientist.

2515 (66) See *Collections:* 'Drawings of Prominent People, 1823–49' by W. Brockedon, p 554.
See also forthcoming Catalogue of Portraits, 1790–1830.

DARLING *Grace Horsley* (*1815–42*)

Heroine; daughter of a lighthouse-keeper on the Farne islands; rescued four men and a woman, with her father, from the wreck of the Forfarshire steamship, 1838; her heroic exploit fired the public's imagination, and became one of the potent legends of the Victorian age; died soon afterwards from tuberculosis.

1662 Water-colour and pencil on paper, $12\frac{1}{4} \times 9$ inches (31·1 × 22·9 cm), by HENRY PERLEE PARKER, 1838.
PLATE 244

Signed and dated in pencil (bottom left): From the life Novr 13. HP Parker *Inscribed in ink in Grace Darling's hand (bottom centre):* Grace Horsley Darling *and in pencil in Parker's hand:* autograph

Collections: The artist; Anne Parker (his daughter), purchased from her niece, Mrs Frances Parker Cole, 1912.

Literature: R. Armstrong, *Grace Darling: Maid and Myth* (1965), p 81.

Parker arrived at Longstone Lighthouse in the early part of November 1838, accompanied by the artist, James Carmichael. They had letters of introduction from Albany Hancock, and from David Dunbar, who had already sculpted Grace (NPG 998 below); both letters are quoted in Constance Smedley, *Grace Darling and her Times* (1932), pp 124–5. Carmichael had already executed a pair of imaginary water-colours of the rescue, now in the Grace Darling Museum, Bamburgh (there is a further water-colour by Carmichael there), which were lithographed and sold for a guinea each (reproduced Smedley, facing p 126). He and Parker had decided to collaborate on a picture which would be as accurate and realistic as possible, Parker painting the figures, and Carmichael the seascape. Executed under the direction of Grace and her father, this picture, also in the Grace Darling Museum, is in many ways the most powerful and authentic of all the rescue scenes; it was engraved by D. Lucas (examples in the Grace Darling Museum and the collection of the Marine Society), and is reproduced Smedley, facing p 78. A smaller version by Carmichael alone is also in the Grace Darling Museum. Parker took great pains with the likeness of Grace, writing to Lucas, the engraver, on 26 April 1839 (Smedley, p 129):

There is a compressed expression of the mouth which is very peculiar to Grace Darling. . . . There is also a peculiar character about the lower part of the face and chin. . . . It is somewhat of Bonaparte's character.

Parker executed at least four sketches of Grace Darling herself during his visit to the lighthouse, two

of which are in the NPG, and another two in the Grace Darling Museum, Bamburgh. These last two were presented in 1964 by Dr Kathleen Rutherford, the artist's great-granddaughter (they are part of a set of four by Parker, with Grace Darling's father and mother), and are reproduced by Armstrong, facing pp 104 and 136. One of them is inscribed: '*The original sketch of Grace Horsley Darling for which/she she sat for the likeness. Novr 10. 1838 Longstone Light*[house].' This is very similar in the pose of the head to NPG 1663 below, which was executed at the same sitting. The head in the other sketch in the Grace Darling Museum is similar to NPG 1662, but the clothes are different.[1] In painting Grace for the picture of 'The Rescue', Parker seems to have relied chiefly on his sketch of 10 November in the Grace Darling Museum. It is interesting to note that he owned the cape which Grace Darling had worn during the exploit, and which he used in the 10 November sketch, together with a plaid. A letter from his granddaughter, Amy Nordeley, in 1912 (NPG archives), states that the cape is mounted on paper, with a sepia drawing above it. Both cape and drawing are now in the Grace Darling Museum.

By 24 November 1838, Parker was back in Newcastle-on-Tyne, for on that day he wrote a letter to William Darling (quoted by Smedley, pp 126–7), asking what had happened to a piece of the wreck he had been promised. He also referred to another picture he was painting, apparently that entitled, 'The Darlings Supplying Refreshments to Brooks and the Lifeboat Crew', engraved by C. G. Lewis (example in the Grace Darling Museum). Other correspondence between Parker and William Darling is quoted by Constance Smedley, pp 128–31.

Description: Healthy complexion, brown eyes, brown hair. Blue and brown washes on clothes and background.

1663 Pencil, water-colour and body colour, $9\frac{3}{4} \times 7\frac{7}{8}$ inches (24·8 × 20 cm), by HENRY PERLEE PARKER, 1838. PLATE 242

Inscribed (*bottom of drawing*): This sketch I began from Grace Darling, and thought/it so like that I could not finish it,/at the Longstone Lighthouse Nov. 10. 1838 HP Parker

Collections: As for NPG 1662 above.

Drawn at the same sitting as the more finished water-colour of Grace Darling by Parker in the Grace Darling Museum, Bamburgh, which is reproduced R. Armstrong, *Grace Darling: Maid and Myth* (1965), facing p 136.

Description: Red cheeks, brown eyes, brown hair. White collar.

998 Marble bust, 25 inches (63·5 cm) high, by DAVID DUNBAR, 1838. PLATE 243

Incised on the shoulder and below: GRACE DARLING./BY D. DUNBAR SC.

Collections: Edward Maltby, Bishop of Durham, bequeathed by him to the National Gallery, 1859, and subsequently transferred.

Literature: Catalogue of British School, National Gallery, Millbank (1929), p 107; R. Armstrong, *Grace Darling: Maid and Myth* (1965), pp 81 and 141.

Dunbar was the first artist to arrive in Bamburgh on 6 October 1838 after the rescue. Three weeks later an advertisement in the *Berwick and Kelso Warder* (27 October 1838) read:

Busts of Grace Darling and her Father
Mr Dunbar most respectfully intimates that he has during the present month, modelled Busts of the above Humane Individuals at their residence, Longstone Lighthouse, Fern Islands, and which are about to be published, and which may be seen, at his Rooms in Oxford Street, Newcastle, or in Villers Street, Sunderland. Finished casts one guinea each.

Besides the edition of plaster casts, Dunbar executed three busts of Grace Darling in marble, the NPG

[1] Grace Darling appears to be wearing the camlet cloak given to her at Christmas 1838 by the Duke of Northumberland. This would date the Grace Darling Museum drawing to 1839. The cloak is now in the Grace Darling Museum.

version, presumably commissioned by Maltby from the artist, another version in the Grace Darling Museum, Bamburgh, and a third in the collection of the Royal National LifeBoat Institution. The bust of Grace was praised for the way it expressed her dignity and intellectual beauty. In a letter of 24 October 1838, William Darling wrote:

Sir,

> *We are all very much pleased with the likeness which Mr Dunbar has made of my daughter Grace Horsley, and myself, and we hope he may succeed with his speculation to the full extent of his wishes.*
>
> *Your most obedient servant,*
> *Wm. Darling.*[1]

Dunbar, who had previously executed some memorial busts in Bamburgh Church, almost certainly came to sculpt Grace Darling and her father at the suggestion of Robert Smeddle. Dunbar exhibited medallions of Grace and her father at the *RA*, 1848 (1415 and 1416).

ICONOGRAPHY Following Grace Darling's heroic rescue, a number of artists arrived in Bamburgh to paint the heroine and reconstruct the scene. The demand for popular prints of her legendary exploit was considerable. Constance Smedley, *Grace Darling and her Times* (1932), devotes a chapter to 'Grace Darling and the Artists', and illustrates several portraits and prints. In October 1838, William Darling replied to an artist who had asked for some sittings: '*Please to acquaint your paper that within the last twelve days I and my daughter have sat to no less than seven portrait painters*'. Miss Smedley listed twelve artists in all who were known to have visited the lighthouse, most of them friends of David Dunbar, the first artist on the scene: David Dunbar, Robert Watson, John Reay, Henry Parker, James Carmichael, James Sinclair, Edward Hastings, Mr Andrews, Miss Laidler, Chevalier d'Hardvillier, Thomas Joy and George Harrison. In most cases the artists were employed by newspapers, eager to make the most of Grace Darling's sensational exploit. Grace and her father not only had to sit for their portraits, but to launch the boat, row in it, and answer questions about the rescue. The need for accuracy was strongly felt. In the following list, only portraits of Grace herself are included, not prints and pictures of the rescue.

1838 Busts by D. Dunbar (NPG 998 above).

1838 Water-colours by H. P. Parker (NPG 1662 and 1663 above).

1838 Lithograph by L. Corbaux, after a drawing by E. Hastings, published Ackerman and Dickinson (example in NPG). The same drawing was engraved by W. Collard, published *Grace Darling, the Maid of the Isles* (Newcastle-upon-Tyne, 1839), frontispiece.

1838 Painting by J. Reay. Collection of the artist, 1900.
Lithographed by W. Taylor, printed by J. Reay (example in Grace Darling Museum), lithograph reproduced R. Armstrong, *Grace Darling: Maid and Myth* (1965), frontispiece.

1838 Water-colour by Miss Laidler. Listed by Constance Smedley, pp 121 and 134.

1838 Water-colour by R. Watson. Grace Darling Museum.
This is mounted in a triptych with portraits of Mr and Mrs William Darling.

1838 Lithograph by M. Gauci, after G. Harrison, published Ackermann, 1838 (example in British Museum).

1838 Drawing (?) by Chevalier d'Hardvillier of Edinburgh. Listed by Constance Smedley, p 134.

1838 Painting by MacCulloch (probably Horatio McCulloch). Grace Darling Museum.
Reproduced R. Armstrong facing p 153. See Prince Duleep Singh, *Portraits in Norfolk Houses* (1927), I, 101.

1839 Painting by T. M. Joy. Dundee Art Gallery.
Reproduced *Country Life*, CXXXII (1962), 795. Joy's portrait of W. Darling and his large picture of the rescue (reproduced as above) are also in the Dundee Art Gallery. They were all commissioned by Lord Panmure.

[1] Constance Smedley, *Grace Darling and her Times* (1932), p 122–3.

1843 Engraving by C.Cook, after G.Cook, published J.Rogerson, 1843 (example in British Museum), for the *New Monthly Belle Assemblée*.

1846 Effigy in Bamburgh Cemetery by C.R.Smith (tomb by A.Salvin). Reproduced Constance Smedley, facing p254.

c1848 Medallion by D.Dunbar. Exhibited *RA*, 1848 (1416).

Undated Painting called Grace Darling by J.Phillip. Christie's, 1 June 1867 (lot 354).

Undated Painting called Grace Darling by an unknown artist. Grace Darling Museum.
She appears to be holding the silver watch given to her by the Duke of Northumberland.

DASHWOOD *Sir George Henry, Bart* (*1790–1862*)

MP for Buckinghamshire.

54 See *Groups:* 'The House of Commons, 1833' by Sir G.Hayter, p526.

DAWES *William*

American slavery abolitionist.

599 See *Groups:* 'The Anti-Slavery Society Convention, 1840' by B.R.Haydon, p538.

DEAN *Professor James*

American slavery abolitionist.

599 See *Groups:* 'The Anti-Slavery Society Convention, 1840' by B.R.Haydon, p538.

DE BEGNIS *Claudine* (*1800–53*)

Actress and singer; *née* Ronzi; wife of the singer, Giuseppe de Begnis (1793–1849); appeared frequently on the English stage.

1328 Water-colour on paper, 17¼ × 12 inches (43·8 × 30·5 cm), by ALFRED EDWARD CHALON, *c*1823. PLATE 245

Exhibitions: Deux Artistes Genevois en Angleterre: A. E. et J. J. Chalon, Musée Rath, Geneva, 1971 (18).

Collections: Leggatt Brothers, purchased from them, 1902.

This water-colour represents Claudine de Begnis as Fatima in the opera, 'Pietro L'Eremita'. It was lithographed by Chalon, published J.Dickinson, 1823 (example in British Museum), and by R.J.Lane, published J.Dickinson, 1827 (example in NPG); the latter is listed in Lane's 'Account Book' (MS, NPG archives), I, 12. The sitter was originally thought to be Mme Vestris, and is so described in *The Art Journal*, 1903, p360, where the portrait is reproduced.

Description: Pale complexion, dark brown eyes, brown hair. Dressed in a white dress with gold embroidery and muslin sleeves, a dark blue cloak with ermine edging and gold embroidery, pale blue and gold striped trousers, gold slippers, a white turban with green stripes and a large white feather, and a quantity of jewellery with large red stones. Standing on a red and white tiled stage. Building on left brown and green with red and blue spiral columns. Background buildings white, brown and pale blue. Blue-green trees, and deep blue sky.

ICONOGRAPHY There is a lithograph by N.Blanc (example in British Museum); an anonymous lithograph was published Ainsworth, 1828, and an engraving by P.Legrand, after Colin, was published Legrand, Paris (examples of the last two in the Harvard Theatre Collection).

DE LA BECHE *Sir Henry Thomas* (*1796–1855*)

Geologist; studied geology in England and elsewhere; appointed to carry out a geological survey of England, 1832; president of Geological Society, 1847; published geological works.

2515 (94) Black and red chalk, with touches of Chinese white, on grey-tinted paper, $14\frac{5}{8} \times 10\frac{1}{2}$ inches (37·1 × 26·7 cm), by WILLIAM BROCKEDON, 1842. PLATE 246

Dated (lower left): 22.4.42

Collections: See *Collections:* 'Drawings of Prominent People, 1823–49' by W. Brockedon, p 554.

Accompanied in the Brockedon Album by a letter from the sitter, dated 22 March 1843.

ICONOGRAPHY A painting by H. W. Pickersgill was exhibited *RA*, 1846 (202), possibly the portrait in the Pickersgill sale, Christie's, 17 July 1875 (lot 339); an enamel by H. P. Bone (from life) is in the Geological Museum, London, exhibited *RA* 1847 (678), engraved by and published W. Walker, 1848 (example in NPG); another enamel by Bone (from life) was exhibited *RA*, 1849 (643); a third miniature by Bone was in the collection of R. I. Nicholl, 1958; a bronze bust by E. H. Baily was exhibited *RA*, 1847 (1431), possibly the bust by Baily of 1845 in the Crystal Palace Collection, 1854; a bust by E. G. Papworth is in the Geological Museum, London; a medal by W. Wyon was exhibited *RA*, 1842 (1171); a lithograph by T. H. Maguire was published G. Ransome, 1852 (example in NPG), for 'Portraits of Honorary Members of the Ipswich Museum'; a woodcut of the 'Meeting of the British Association, Southampton' was published *ILN*, IX (1846), 185; a woodcut, after a photograph by Claudet, was published *ILN*, XVIII (1851), 422.

DE LUC (*probably Jean André*) (*1763–1847*)

Swiss geologist, member of the Royal Society.

2515 (78) See *Collections:* 'Drawings of Prominent People, 1823–49' by W. Brockedon, p 554.

DE MAULEY *William Francis Spencer Ponsonby, 1st Baron* (*1787–1855*)

MP for Dorset.

54 See *Groups:* 'The House of Commons, 1833' by Sir G. Hayter, p 526.

DENON *Dominique Vivant, Baron* (*1747–1825*)

French painter, archaeologist and traveller.

2515 (3) See *Collections:* 'Drawings of Prominent People, 1823–49' by W. Brockedon, p 554.

DE QUINCEY *Thomas* (*1785–1859*)

Author of *Confessions of an Opium Eater*; a prominent literary figure in London, and a friend of Coleridge, Wordsworth, Lamb, Southey and others; published his *Confessions*, 1821; author of numerous other works.

189 Oil on canvas, $50\frac{1}{8} \times 39\frac{7}{8}$ inches (127·3 × 101·3 cm), by SIR JOHN WATSON GORDON, *c* 1845. PLATE 249

Collections: The artist, presented by his brother H. G. Watson, 1865.

Exhibitions: RA, 1845 (413); *SKM*, 1868 (622).

An oil study and a half-length replica of this portrait are in the Scottish NPG. A related pencil drawing was in the collection of Mrs Rawnsley of Grasmere in 1955, apparently that now at Dove Cottage.

Description: Sallow complexion, dark grey-green eyes, brown hair. Dressed in a white shirt, dark stock,

black waistcoat and trousers, dark brown coat. Seated in a wooden armchair with green covering.
Wooden table at right with brown leather-bound book and an unidentified red object behind. Background colour brown.

822 Plaster cast, painted black, 26¼ inches (66·7 cm) high, of a bust by SIR JOHN ROBERT STEELL, 1875.
PLATE 248

Incised on the back of the base: Jⁿ STEELL. R.S.A./SCULPTᵗ EDINʳ/1875

Collections: William Bell Scott, presented by him, 1889.

Closely related to the posthumous marble bust of De Quincey by Steell of 1875 in the Scottish NPG,
exhibited *RA*, 1876 (1495). It was apparently executed with the help of a death mask and other
authentic material.[1] A marble replica of 1882 is at Worcester College, Oxford. William Bell Scott was
a friend of Steell, and had met De Quincey. Another plaster cast, identical to the NPG bust, is reproduced *The Bookman*, XXXI (1907), 215.

ICONOGRAPHY A painting by J. Archer is in the City Art Gallery, Manchester; a group drawing by
Archer of 1855, showing De Quincey with his family, was in the collection of Mrs Baird Smith, his granddaughter, reproduced H. A. Eaton, *Thomas De Quincey* (1936), facing p 492; another drawing by Archer, showing
De Quincey alone, but in the same pose as in the group drawing, is at Dove Cottage, Grasmere, reproduced
H. A. L. Rice, *Lake Country Portraits* (1967), facing p 64, exhibited *Cumbrian Characters*, Abbot Hall Art
Gallery, Kendal, 1968 (58), engraved anonymously (example in NPG, plate 247); an early miniature by an unknown
artist was in the collection of Mrs Baird Smith, reproduced *De Quincey Memorials*, edited H. H. Japp (1891), I,
frontispiece; a drawing by T. Hood was sold Christie's, 17 March 1865 (lot 26), sketched by Scharf, 'TSB' (NPG
archives), IX, 32; a bust by J. Cassidy is in the Moss Side Public Library, Glasgow, reproduced *Bookman*, XXXI
(1907), 211; plaster medallions by S. Wood are in the Scottish NPG, Dove Cottage, and formerly collection of
Mrs Baird Smith, the latter reproduced *Bookman*, XXXI (1907), 215; there is a lithograph by F. Schenck of 1845,
after 'WHD' (example in Scottish NPG); there are engravings by F. Croll and by Dawson, after a daguerreotype
by Howie junior (examples in NPG); the same daguerreotype was also engraved for the *Bookman*, XXXI (1907),
211; an engraving by W. H. Mote was published A. and C. Black (example in NPG); there are two photographs at
Dove Cottage, one of these reproduced H. S. Davies, *Thomas De Quincey* (British Council, Writers and their
Work series, 1964), frontispiece.

DERBY *Edward George Geoffrey Smith Stanley, 14th Earl of* (1799–1869)

Prime minister; leader of the tory party after Peel's fall, 1846; prime minister, 1852, 1858–9, and
1866–8; one of the leading political figures of the age; published miscellaneous works, including a
version of the *Iliad*.

1806 Oil on canvas, 56 × 44 inches (142·2 × 111·8 cm), by FREDERICK RICHARD SAY, 1844. PLATE 250

Collections: Sir Robert Peel; sale of Peel Heirlooms, Robinson and Fisher, 6 December 1917 (lot 48),
bought by the grandson of the sitter, the 17th Earl of Derby, and presented by him, 1918.

Apparently commissioned by Peel for his 'Statesmen's Gallery', which contained several other portraits
by Say, including one of the Earl of Ellenborough (NPG 1805).

Description: Blue eyes, brown hair. Dressed in a white shirt, white stock, black suit and waistcoat,
with a gold monocle. Brownish red table-cloth, with a blue dispatch box on it (brass handle, with the
Queen's arms stamped on it). Behind at right a red curtain. Rest of background light brown.

54 See *Groups:* 'The House of Commons, 1833' by Sir G. Hayter, p 526.

2789 See *Groups:* 'Members of the House of Lords, c 1835' attributed to I. R. Cruikshank, p 536.

[1] See J. Caw, *Catalogue of the Scottish National Portrait Gallery* (5th edition, 1899), p 58.

ICONOGRAPHY This does not include photographs, of which there are several examples in the NPG (see plate 253) or caricatures.

As a child Miniature by S. Shelley (with a brother and sister). Collection of the Earl of Derby.

c 1818 Painting by G. H. Harlow. Collection of the Earl of Derby.
Engraved by H. Robinson, published Fisher, Son & Co, 1833 (example in NPG), for Jerdan's 'National Portrait Gallery'. Replica: Eton College (plate 251), reproduced L. Cust, *Eton College Portraits* (1910), plate XXXVII.

1818 Engraving by F. C. Lewis (very close to Harlow's portrait, and probably after it), published Graves and Warmsley, 1842 (example in NPG).

1821–3 'House of Commons, 1821–3', water-colour by A. Pugin, R. Bowyer, J. Stephanoff. Houses of Parliament. Engraved by Scott, published Parkes, 1836 (example in Houses of Parliament).

1833 'The House of Commons, 1833' by Sir G. Hayter (NPG 54 above).

1833 Lithograph by B. R. Haydon, published by him, 1833 (example in British Museum).

c 1835 Drawing called Derby attributed to I. R. Cruikshank (NPG 2789 above).

1839 Painting by H. P. Briggs. Ex-collection of the Earl of Derby, sold Christie's, 8 October 1954 (lot 97). Exhibited *RA*, 1839 (261). Engraved by H. Cousins, published Colnaghi and Puckle, and T. Agnew, 1842 (example in NPG); engraved also by W. H. Mote, published G. Virtue (example in NPG), for 'Portraits of Conservative Statesmen'.

1839 Bust by C. Moore. Commissioned by Lord Skelmersdale. Crystal Palace Portrait Gallery, 1854. Erroneously listed as 1853 by R. Gunnis, *Dictionary of British Sculptors* (1953), p 263. Another bust of Derby by Moore was exhibited *Art Treasures*, Manchester, 1857, 'Sculpture' (127), lent by the artist.

1841 Painting by W. Derby. Collection of the Earl of Derby.

1842 Lithograph by E. Desmaisons, published A. and C. Baily, 1842 (example in NPG, plate 252).

1844 Woodcut published *ILN*, IV (1844), 105.

1844 Painting by F. R. Say (NPG 1806 above).

1848 Parian-ware bust after Count A. D'Orsay. Collection of Roger Fulford.

1851 'The Royal Commissioners for the Exhibition, 1851' by H. W. Phillips. Victoria and Albert Museum. Exhibited *Victorian Era Exhibition*, 1897, 'History Section' (8).

c 1852 Painting by H. C. Selous. Reproduced as a woodcut *ILN*, XX (1852), 169.

1858 Painting by Sir F. Grant. Collection of the Earl of Derby.
Exhibited *RA*, 1859 (236), according to G. Scharf, *Catalogue of the Collection of Pictures at Knowsley Hall* (1875), p 110 (no. 193). Study for this portrait: collection of the Earl of Bradford, Weston Park. Two other portraits after Sir F. Grant are at Hughenden.

1858 Painting by Sir F. Grant (in his robes as chancellor of Oxford University). Examination Schools, Oxford. Exhibited *RA*, 1859 (236), according to Mrs R. L. Poole, *Catalogue of Oxford Portraits* (1912), I, 148–9 (no. 359). In Grant's 'Sitters Book' (copy of original MS, NPG archives), there is only one entry for a portrait of Derby. The RA catalogue gives no indication whether it was this portrait or the one above, in the Earl of Derby's collection, which appeared in the 1859 exhibition. Engraved by F. Bromley, 1860 (no example located).

c 1858 Drawing by A. Blaikley. Reproduced as a woodcut *ILN*, XXXII (1858), 249.

1860 Lithograph by J. Brown, after a photograph by H. Lenthall, published Baily, 1860 (example in NPG).

1864 Drawing by G. Richmond. Collection of the Earl of Derby.

1864 Painting by G. Richmond. Listed in his 'Account Book' (photostat copy, NPG archives), p 78.

1864 'Intellect and Valour of Great Britain', engraving by C.G.Lewis, after T.J.Barker, published J.G.Browne, Leicester, 1864 (example in NPG); key-plate published Browne, 1863 (example in British Museum).

1867 'The Derby Cabinet' by H.Gales. Exhibited *Victorian Era Exhibition*, 1897, 'History Section (49), lent by Baroness Kinloss. Engraved by J.Scott, published Graves, 1870 (example in NPG).

c1868 Statue by W.Theed. St George's Hall, Liverpool.
Exhibited *RA*, 1868 (972). Reproduced as a woodcut *ILN*, LV (1869), 169.

1868 Bust by W.Theed. Collection of the Earl of Derby.

1870 Marble bust by M.Noble. Collection of Mrs M.Kershaw (plate 254).

1871 Painting by L.W.Desanges. Recorded and sketched by G.Scharf, 'TSB' (NPG archives), XXIV, 55.

1871 Bust by H.P.MacCarthy. Merchant Taylors Company, London.

1871 Bust by M.Noble. Guildhall Museum, London (destroyed 1940).

1872 Effigy by M.Noble. Knowsley Church, Lancashire.

1872 Statue by W.Theed. Junior Carlton Club, London.

1872 Marble statue by W.Theed. Hughenden Manor, Buckinghamshire.

1873 Drawing by G.Richmond. Listed in his 'Account Book' (photostat copy, NPG archives), p90.

1873 Statue by M.Noble. Preston.

1874 Statue by M.Noble. Parliament Square, London.
Engraved by W.Roffe, published for the *Art Journal* (1875), p240.
Four bas-reliefs of Derby are on the plinth. The models for the statues and the reliefs were formerly at Elswick Hall, Newcastle, listed in *Catalogue of Lough and Noble Models at Elswick Hall* (c1928), p51 (175), and p60 (205).

1885 Bronze bust by T.Woolner. Sydney, Australia.

1892 Marble bust by F.Gleichen. Houses of Parliament.

Undated Painting by an unknown artist. Collection of Miss Simpkins.

Undated Drawing by Sir G.Hayter. British Museum.

Undated Stone bust by an unknown artist. St Peter's and St James's School, London.

Undated Engraving by F.C.Lewis, after J.Slater (example in British Museum).

Undated Various engravings and lithographs (examples in NPG).

DEVONSHIRE *William Cavendish, 7th Duke of* (*1808–91*)
MP for Derbyshire North.
54 See *Groups*: 'The House of Commons, 1833' by Sir G.Hayter, p526.

D'EYNCOURT *Charles Tennyson* (*1784–1861*)
MP for Lambeth.
54 See *Groups*: 'The House of Commons, 1833' by Sir G.Hayter, p526.

DICK *Quinton* (*1777–1858*)
MP for Maldon.
54 See *Groups*: 'The House of Commons, 1833' by Sir G.Hayter, p526.

DICKENS *Charles John Huffam* (*1812–70*)

One of the great figures of English literature, and the outstanding novelist of his age.

315 Oil on canvas, 37⅛ × 24¾ inches (94·3 × 62·9 cm), by ARY SCHEFFER, 1855–6. PLATE 263

Signed and dated very faintly (*middle left*): Ary Scheffer/1855

Collections: The sitter; purchased from the Dickens Estate, through Messrs Colnaghi, 1870.

Exhibitions: RA, 1856 (62); *Le Livre Anglais: Trésors des Collections Anglaises*, Bibliothèque Nationale, Paris, 1951 (514); *Charles Dickens and his London*, Guildhall Art Gallery, London, May 1962 (36); *Charles Dickens and his London*, South London Art Gallery, December 1963; *The Past We Share*, Southern Methodist University, Texas, 1967 (23); *Charles Dickens*, Victoria and Albert Museum, 1970 (08).

Literature:The Times (5 May 1856), p5; *Athenaeum* (May 1856), p654; J. Forster, *Life of Charles Dickens* (1872–4), III, 103, 123, 125–7; *The Letters of Charles Dickens*, edited by his sister-in-law and eldest daughter (1880–2), I, 413–4, 420, 433–4, II, 149, III, 192; W. P. Frith, *My Autobiography and Reminiscences* (1887), I, 310; F. G. Kitton, 'Charles Dickens and his Less Familiar Portraits', *Magazine of Art* (1888), pp321–2, reproduced p288; F. G. Kitton, *Dickens by Pen and Pencil, and a Supplement to Dickens by Pen and Pencil* (1890–1), catalogue at the end of vol I, IV–V, reproduced I, facing 67 (engraved by R. B. Parkes); *The Letters of Charles Dickens*, edited W. Dexter (Nonesuch Edition, 1938), II, 710, 727, 733, 740, 754, 768–9, III, 241.

Dickens met Ary Scheffer soon after his arrival in Paris in October 1855 on an extended visit. Scheffer introduced him to several distinguished Frenchmen of the day, and insisted on painting his portrait. Sittings began in November, and on the 23rd of that month Dickens wrote to the artist postponing an appointment (*Letters*, Nonesuch edition, II, 710). Shortly afterwards he wrote to Forster in some desperation (*Letters*, II, 710):

You may faintly imagine what I have suffered from sitting to Scheffer every day since I came back. He is a most noble fellow, and I have the greatest pleasure in his society, and have made all sorts of acquaintances at his house; but I can scarcely express how uneasy and unsettled it makes me to sit, sit, sit, with Little Dorritt on my mind, and the Christmas business too – though that is now happily dismissed. On Monday afternoon, and all day on Wednesday, I am going to sit again. And the crowning feature is, that I do not discern the slightest resemblance, either in his portrait or his brother's! They both peg away at me at the same time.

On 10 January of the following year Dickens wrote to Miss Burdett-Coutts telling her that the portrait was finished, though complaining still of a lack of verisimilitude (*Letters*, II, 727). On 19 January, however, he wrote to Wilkie Collins (*Letters*, II, 733): '*I have been sitting to Scheffer to-day – conceive this, if you please, with No.5* [of Little Dorritt] *upon my soul – four hours ! !*' He wrote to Forster the next day (*Letters*, II, 734):

The nightmare portrait is nearly done; and Scheffer promises that an interminable sitting next Saturday, beginning at 10 o'clock in the morning, shall finish it. It is a fine spirited head, painted at his very best, and with a very easy and natural appearance in it. But it does not look to me at all like, nor does it strike me that if I saw it in a gallery I should suppose myself to be the original. It is always possible that I don't know my own face.

This remained Dickens' opinion of the portrait, in spite of further sittings in March (*Letters*, II, 754), caused by Scheffer's own dissatisfaction with the likeness. Before its first exhibition, Dickens wrote to Maclise, on Scheffer's behalf, about the size of frames allowed by the Royal Academy (*Letters*, II, 740), and he was proud of its success there. He wrote to his wife from London (*Letters*, II, 769):

When you see Scheffer, tell him from me that Eastlake, in his speech at the dinner, referred to the portrait as 'a contribution from a distinguished man of genius in France, worthy of himself and of his subject'.

Nevertheless the portrait remains one of the least satisfactory likenesses of Dickens. The novelist told Frith that when Scheffer first met him he exclaimed (Frith, I, 310; the same story is told in *Letters*, III, 241):

'*You are not at all like what I had expected to see you; you are like a Dutch skipper*'. *As for the picture he did of me, I can only say that it is neither like me nor a Dutch skipper.*

A copy of the NPG portrait by Malcolm Stewart was exhibited *Dickens Exhibition*, Memorial Hall, London, March 1903 (350).

Henri Scheffer's portrait, painted at the same time as the NPG portrait, was, according to Forster, '*greatly inferior*'. It was sold at Christie's, 11 July 1863 (lot 104), from the Arnold Scheffer collection, and was erroneously stated to have been exhibited at the Royal Academy. It was bought in, and resold at Christie's, 25 February 1865 (lot 110), bought by the dealer, Flatou.

Description: Ruddy complexion, dark brown eyes, brown hair, beard and moustache. Dressed in a white shirt, black stock, very dark brown coat. Seated in a chair with his elbow resting on a red-covered arm. Background dark brown.

1172 Oil on canvas, $36 \times 28\frac{1}{8}$ inches ($91 \cdot 5 \times 71 \cdot 4$ cm), by DANIEL MACLISE, 1839. PLATES 257–8 & p 141

Signed and dated (bottom right): D. MACLISE PINXIT 1839

Collections: Commissioned by the publishers, Chapman and Hall, to be engraved for the frontispiece of *Nicholas Nickleby;* presented to Dickens either by Chapman and Hall or by Maclise (see below); Dickens Sale, Christie's, 9 July 1870 (lot 40), bought by the Reverend Sir Edward Repps-Jodrell, and bequeathed by him to the National Gallery, 1888; on loan from the National Gallery since 1898, and now on loan from the Tate Gallery.

Exhibitions: RA, 1840 (462); *Charles Dickens*, Victoria and Albert Museum, 1970 (04), reproduced in catalogue; *Daniel Maclise*, Arts Council at the NPG, 1972 (61).

Literature: Fraser's Magazine, XXII (1840), 113; *Athenaeum* (9 May 1840), p 372; W. J. O'Driscoll, *A Memoir of Daniel Maclise, R.A.* (1871), pp 66–7; J. Forster, *The Life of Charles Dickens* (1872–4), I, 156, reproduced as frontispiece (detail only, engraved by R. Graves), and facing 156 (whole composition, engraved by C. H. Jeens); *George Eliot's Life*, edited by J. W. Cross (1885), III, 145; W. P. Frith, *My Autobiography and Reminiscences* (1887), I, 309–10; F. G. Kitton, 'Charles Dickens and his Less Familiar Portraits, I', *The Magazine of Art*, (1888), pp 284–7; *Catalogue of the Pictures in the National Gallery: British and Modern Schools* (1888), p 100 (1250); F. G. Kitton, *Dickens by Pen and Pencil, and Supplement to Dickens by Pen and Pencil* (1890–1), I, 26–8, and catalogue at the end, iv, reproduced I, facing 27 (engraved by E. Roffe), and facing 29 (engraved by R. Graves); *The Diaries of W. C. Macready, 1833–1851*, edited W. Toynbee (1912), II, 25, reproduced I, facing 504 (engraved by Finden); J. Forster, *The Life of Charles Dickens*, edited J. W. T. Ley (1928), I, 127, 129, 212, 290, and 300; *The Letters of Charles Dickens*, edited M. House and G. Storey, I (Pilgrim edition, 1965), 431 n, 558, 577–8, 590, and 599.

Probably painted before 28 June 1839, for on that day Dickens wrote to J. P. Harley (*Letters*, I, 1965, 558): '*Maclise has made another face of me, which all people say is astonishing*'. On the same day, Dickens wrote to Maclise inviting him to come down to Elm Cottage, Petersham, which he had taken for the summer (*Letters*, I, 557). Maclise did visit him there, joining in the garden sports, such as 'bar-leaping, bowling and quoits' with a will (Forster, II, 159–60). A letter from Dickens, probably written in June 1839, to William Finden, the engraver of the portrait, is clear evidence that Finden was in possession of it by the summer (*Letters*, I, 558): '*My mother who is resident in the country and shortly returning to the place from whence she came, is very anxious before she leaves town to see the Portrait of her beloved son.*' Finden's engraving (example in NPG) appeared in the final number of the serialized *Nicholas Nickleby* in October 1839, and was subsequently used as the frontispiece of the first collected edition. An engraving by R. Graves (example in NPG), after this portrait, was exhibited *RA*, 1873 (1251); it was also engraved by C. H. Jeens (example in NPG). According to Forster, the finished portrait was presented to

Dickens by the publishers Chapman and Hall at the Nickleby dinner held in the Albion, Aldersgate Street, on 5 October 1839.[1] The following letters between Maclise and Dickens, if they relate to this picture, as seems probable, make clear that Maclise himself presented Dickens with the portrait, the publishers presumably only having purchased the copyright (O'Driscoll, p 67):

My dear Dickens,

How could you think of sending me a cheque for what was to me a matter of gratification? I am almost inclined to be offended with you. May I not be permitted to give some proof of the value I attach to your friendship? I return the cheque, and regret that you should have thought it necessary to send it to

Yours faithfully,

Daniel Maclise.

Dickens replied to this (O'Driscoll, p 67):

Do not be offended. I quite appreciate the feeling which induced you to return what I sent you: notwithstanding, I must ask you to take it back again. If I could have contemplated for an instant the selfish engrossment of so much of your time and extraordinary powers, I should have had no need (knowing you, I knew that well) to resort to the little device I played off. I will take anything else from you at any time that you will give me, any scrap from your hand; but I entreat you not to disturb this matter. I am willing to be your debtor for anything else in the whole wide range of your art, as you shall very readily find whenever you put me to the proof.

It is unlikely that Maclise did accept the cheque, as he was obsessively scrupulous and proud. J. W. T. Ley in his edition of Forster's *Life* (I, 290) surmised that these letters referred not to the 1839 portrait of Dickens, but to Maclise's picture of a 'Girl at the Waterfall' of 1842 in the Victoria and Albert Museum. The model for this was Georgina Hogarth, and Dickens was so eager to own and pay for the picture, that he bought it through his friend Charles Beard in order to deceive Maclise, who would undoubtedly have given it to him (see *Letters*, Nonesuch edition, 1938, I, 494–5). The letters quoted above do not seem to refer to this incident, as there was no question then of Dickens sending a cheque direct to Maclise. It is much more likely that Dickens, having experienced Maclise's generosity over the question of his own portrait, would on the second occasion, resort to fraud. It seems fairly certain, therefore, that it was Maclise himself who presented the portrait to Dickens, and not Chapman and Hall.

According to all accounts the portrait was astonishingly like, and it remains the most convincing image of the young Dickens, as well as one of Maclise's masterpieces. Thackeray wrote: '*as a likeness perfectly amazing; a looking-glass could not render a better facsimile. Here we have the real identical man Dickens: the artist must have understood the inward Boz as well as the outward before he made this admirable representation of him*' (*Fraser's Magazine*, XXII, 113). George Eliot was less complimentary, referring to that '*keepsakey, impossible face which Maclise gave him*' (*George Eliot*, III, 145).

Maclise was a close friend of Dickens for many years, and, with Forster, they formed an intimate trio. The novelist delighted in his easy and affable society. In 1843 Maclise did a profile drawing of Dickens, his wife and sister-in-law (plate 260), and in 1844 a drawing of Dickens reading *The Chimes* to his friends in Forster's chambers (both in the Victoria and Albert Museum, F76 and F74). He painted Mrs Dickens in 1848 (a pendant to this portrait) exhibited *RA*, 1848 (357), under the erroneous title of 'Mr Charles Dickens' (see Frith, II, 30–1). It was in the Burdett-Coutts sale, Christie's, 5 May 1922 (lot 232), and was last recorded in the collection of Mrs Mills, 1946. In 1842 Maclise did a crayon drawing of four of Dickens' children, as a keepsake, just before the novelist's tour of the United States (collection of Cedric Dickens). Although Maclise and Dickens rarely met in later life, Dickens paid a warm tribute to Maclise's genius, when replying for 'Literature' at the RA dinner of 1870, shortly after Maclise's death and shortly before his own (Forster III, 495–6).

[1] Maclise, Macready, Forster, Stanfield, Wilkie, Cattermole, Hill, Harley, Beard, Jerdan and Browne were present besides the publishers and printers. For Dickens' letters of invitation, see *Dickens Letters*, I, 583–5 and 589–90; see also *Macready's Diary*, II, 25, and Forster, I, 155–6.

Charles Dickens by Daniel Maclise, 1839 NPG 1172

Description: Brown hair, green/brown eyes. Dressed in dark green suit, grey-green stock, brown waistcoat, black shoes. Chair gilt, with red embossed velvet, green curtain, brown-yellow-green carpet, brown wooden panelling.

3445 Pen and ink on card, $10\frac{5}{8} \times 7\frac{3}{4}$ inches (27·1 × 19·7 cm), by HARRY FURNISS. PLATE 268

Signed (bottom right): Hy.F. *Inscribed in ink (along top):* Chap XVII Charles Dickens/ His last Readings

Collections: Purchased from the artist's sons, through Theodore Cluse, 1947.

Literature: H.Furniss, *Some Victorian Men* (1924), reproduced facing p 192, with the title, 'Charles Dickens Reading'.

All six Furniss drawings catalogued here are posthumous; Furniss saw Dickens once, and then only when he was a child. Those drawings reproduced in *Some Victorian Men* were used to illustrate a chapter on 'Charles Dickens – as an Actor', pp 183–200. The NPG drawings are part of a large collection of Furniss drawings which will be collectively discussed in the forthcoming Catalogue of Portraits, 1860–90.

3446 Pen and ink on card, $6\frac{7}{8} \times 5\frac{1}{2}$ inches (17·5 × 14 cm), by HARRY FURNISS. PLATE 266

Signed (lower left): Hy. F. *Inscribed in pencil (along the bottom):* Charles Dickens at the end of [*his life?*] *with the measurements* $6\frac{1}{2}$ *(above) and* $3\frac{1}{2}$ *inch (below) and the number* 8846

Collections: As for NPG 3445 above.

Literature: H. Furniss, *The Two Pins Club* (1925), reproduced facing p 53.

3563 Pen and ink on card, $4\frac{3}{4} \times 7\frac{1}{4}$ inches (12 × 18·4 cm), by HARRY FURNISS. PLATE 269

Signed (bottom right): Hy. F. *Inscribed (along the top):* Boy "Giving [*last part cut off*] Impress (*bottom left*): Bristol Board Windsor & Newton Ld

Collections: Purchased from the artist's sons, through Theodore Cluse, 1948.

3564 Pen and ink on card, $11 \times 4\frac{5}{8}$ inches (28 × 11·7 cm), by HARRY FURNISS. PLATE 270

Collections: As for NPG 3563 above.

Literature: H.Furniss, *Some Victorian Men* (1924), reproduced facing p 188, with the title, 'Charles Dickens at Rehearsal.'

3565 Pen and ink on card, $6\frac{3}{8} \times 6\frac{1}{4}$ inches (16·2 × 16 cm), by HARRY FURNISS. PLATE 271

Signed (bottom left): Hy.F. *Inscribed (top right):* Charles Dickens *and (below):* –$2\frac{1}{2}$–

Collections: As for NPG 3563 above.

3566 Pen and ink on card, $10\frac{5}{8} \times 9\frac{3}{4}$ inches (27 × 24·8 cm), by HARRY FURNISS. PLATE 267

Signed (lower left): Hy.F. *Inscribed (top left):* Charles Dickens exhausted/after his Death of Nancy Reading *and (top right):* Chap XVII

Collections: As for NPG 3563 above.

Exhibitions: Charles Dickens, Victoria and Albert Museum, 1970 (M 35).

Literature: H.Furniss, *Some Victorian Men* (1924), reproduced facing p 194, with the title, 'Charles Dickens Exhausted'.

ICONOGRAPHY The best source for illustrations of Dickens' portraits is F.G.Kitton, *Dickens by Pen and Pencil* (1890–1), which also has a catalogue of portraits at the end of vol I. The following list does not include caricatures or photographs, of which there are examples in the NPG (see plates 259, 264, 265), the Victoria and Albert Museum, and Dickens House.

c 1827 Silhouette called Dickens. Reproduced *Connoisseur*, XXVIII (1910), 309.

1830 Miniature by Janet Barrow. Dickens House, London (plate 255).

Exhibited *Charles Dickens*, Victoria and Albert Museum, 1970 (B6), reproduced in catalogue.
Reproduced Kitton, I, facing 11, engraved by E. Roffe.

1835 Miniature by Miss Rose Drummond. Collection of the Dickens family.
Exhibited *VE*, 1892 (580*). Reproduced Kitton, I, facing 15, engraved by E. Roffe.

1836–7 Drawing by G. Cruikshank. Dickens House, London.
Exhibited *VE*, 1892 (582). Reproduced Kitton, I, facing 17, etched by F. W. Pailthorpe. A drawing by
Cruikshank is in the Victoria and Albert Museum, and others are recorded.

1837 Drawing by S. Laurence. Collection of Major Sir Charles Pym (plate 256).
Exhibited *VE*, 1892 (408), and *Charles Dickens*, Victoria and Albert Museum, 1970 (O2), reproduced in
catalogue. Lithographed by Weld Taylor, 1838.

1837 Etching by 'Phiz' (H. K. Browne), published E. Churton, 1837 (example in British Museum), possibly
the etching by 'Phiz' reproduced Kitton, I, facing 23, together with a drawing by the same artist.

1838 Drawing by S. Laurence. Collection of Lord Glenconner.
Exhibited *RA*, 1838 (858), and *Victorian Era Exhibition*, 1897, 'Historical Section' (239).
Reproduced Kitton, I, frontispiece, engraved by E. Stodart. Lithographed by E. Brown and
anonymously (examples in NPG).

c1838 Drawing by S. Laurence. Mentioned in Kitton, I, catalogue i–ii, and reproduced facing 21.

1839 Painting by D. Maclise (NPG 1172 above).
Copy by C. Fullwood: Garrick Club, and another at Dickens House.

1839 Marble bust by A. Fletcher. Dickens House, London.
Exhibited *RA*, 1839 (1372), and *Charles Dickens*, Victoria and Albert Museum, 1970 (O5).

1840 Water-colour by A. E. Chalon. Exhibited *VE*, 1892 (581), lent by T. W. Coffin.

c1840 Drawing by R. J. Lane. Royal Collection.
Exhibited *RA*, 1843 (1123), *VE*, 1892 (404*), and *Charles Dickens*, Victoria and Albert Museum, 1970
(O3). Reproduced Kitton, I, facing 37, engraved by E. Stodart.

1841 Drawing by Count A. D'Orsay. Sotheby's, 13 February 1950 (lot 210), bought Maggs.
Reproduced Kitton, I, facing 35. Another drawing, dated 1842, was sold in the same sale (lot 209).
One of the drawings was lithographed by R. J. Lane, published J. Mitchell, 1842 (example in British
Museum), listed in Lane's, 'Account Book' (NPG archives), II, 52.

1842 Painting by F. Alexander (executed in Boston). Museum of Fine Arts, Boston (plate 261).
Reproduced Kitton, I, facing 41, engraved by E. Stodart.

1842 Drawings by P. Morand. Exhibited *Dickens Exhibition*, Memorial Hall, London, 1903 (314), lent by
F. T. Sabin. Presumably the two drawings engraved by Dawson Bros, for Kitton, II, postscript.

1842 Drawing by C. Stanfield (with Maclise, Forster, Dickens and the artist in Cornwall). Victoria and
Albert Museum. Reproduced Forster, edited B. W. Matz (memorial edition, 1911), I, facing 288.

1842 Bust by H. Dexter (executed in America). Dickens House, London.
Reproduced Kitton, I, facing 43, engraved by E. Stodart.

1843 Drawing by D. Maclise (with his wife and sister-in-law). Victoria and Albert Museum (plate 260).
Exhibited *Charles Dickens*, Victoria and Albert Museum, 1970 (O7), reproduced in catalogue, and
Daniel Maclise, Arts Council at the NPG, 1972 (44).

c1843 Miniature by Miss M. Gillies. Exhibited *RA*, 1844 (660).
Reproduced as a woodcut *ILN*, II (1843), 239, and Kitton, I, facing 51. Engraved by J. C. Armytage,
published 1844 (example in NPG).

c1843 Bust by P. Park. Exhibited *RA*, 1843 (1510).

1843 Drawing by R. J. Lane. Listed in his 'Account Books' (NPG archives), II, 58.

1844 'Dickens Reading *The Chimes* to his Friends', drawing by D. Maclise. Victoria and Albert Museum.

Reproduced D. A. Wilson, *Carlyle on Cromwell and Others* (1925), facing p 272. Exhibited *Charles Dickens*, Victoria and Albert Museum, 1970 (H 10), reproduced in catalogue.

1844 Drawing by C. Martin. Collection of Mrs Jane Cohen, Boston.
Exhibited *Victorian Era Exhibition*, 1897, 'Historical Section' (271). Reproduced as a lithograph in Martin's *Twelve Victorian Celebrities* (1899), plate 6. An engraving after the drawing (possibly for a contemporary magazine) is reproduced *Bookman* (Dickens number, 1914), p 68.

c 1844 Plaster bust by P. Park. Exhibited *RA*, 1844 (1373).

1845 Drawing by S. Laurence. Christie's, 22 November 1912 (lot 10).

1845 Drawing by D. Maclise (as Bobadil, with Forster as Kitely), on the playbill of *Every Man in His Humour*. Reproduced Forster (memorial edition, 1911), I, facing 394. A sketch by J. Leech is also reproduced.

c 1846 Painting by C. R. Leslie (in the character of Captain Bobadil in 'Every Man in His Humour'). Collection of Mr and Mrs Diehl, Connecticut.
Exhibited *RA*, 1846 (355), and *VE*, 1892 (294). Reproduced Kitton, I, facing 101, engraved by E. Stodart; and lithographed by T. H. Maguire, published J. Mitchell (example in British Museum). A drawing by C. Stanfield, after the painting, is in the Garrick Club, London.

1849 Drawing by G. Sala. Reproduced Kitton, I, facing 57, etched by F. W. Pailthorpe.

1850 Painting by A. Egg (in the character of Sir Charles Coldstream in 'Used Up'). Dickens House, London.
Exhibited *Charles Dickens*, Victoria and Albert Museum, 1970 (G 43), reproduced in catalogue. Reproduced Kitton, I, facing 115, engraved by E. Stodart. A sketch for this was exhibited *VE*, 1892 (576), lent by Charles Dickens. A sketch, possibly the one above, was reproduced *Connoisseur*, IV (1902), frontispiece, as in the collection of J. Grego.

1850 Unfinished painting by Sir W. Boxall. Mentioned in Kitton, I, catalogue, iv.

1854 Painting by E. M. Ward (in his study). Ward sale, Christie's, 29 March 1879 (lot 81), withdrawn. Reproduced Kitton, I, facing 65. In a letter of 2 March 1880 to Scharf (Scharf catalogue of the Ward sale, NPG archives), W. Russell Ward, the artist's son, said that the painting was then owned by his brother.

1855–6 Painting by A. Scheffer (NPG 315 above).

1856 Painting by H. Scheffer (see NPG 315 above).

1858 Lithograph by C. Baugniet, published E. Gambart, 1858 (example in British Museum).

1859 Painting by W. P. Frith (in his study). Victoria and Albert Museum (plate 262).
Exhibited *RA*, 1859 (210), and *Charles Dickens*, Victoria and Albert Museum, 1970 (O 10), reproduced in catalogue. Engraved by T. O. Barlow, published McLean, 1862 (example in NPG), engraving exhibited *RA*, 1862 (935); also engraved by R. Graves, engraving exhibited *RA*, 1873 (1252), and reproduced Kitton, I, facing 147. A study was exhibited *Victorian Era Exhibition*, 1897, 'Historical Section' (241), lent by W. Wright. There is a replica (dated 1886) at Dickens House, exhibited *VE*, 1892 (261), and another (dated 1898) in the Van Sweringen collection, Ohio.

1861 Drawing by R. Lehmann. British Museum.
Exhibited *Charles Dickens*, Victoria and Albert Museum, 1970 (O 9). Reproduced Kitton, I, facing 83, engraved by E. Stodart.

1864 'Intellect and Valour of Great Britain', engraving by C. G. Lewis, after T. J. Barker, published J. G. Browne, Leicester, 1864 (example in NPG); key-plate published Browne, 1863 (example in British Museum).

1869 Drawing by E. Goodwyn Lewis. Sotheby's, 21 July 1943 (lot 13), bought Spencer.
Exhibited *Victorian Era Exhibition*, 1897, 'Historical Section' (238), lent by F. T. Sabin. Coloured reproduction in NPG. Lewis did other drawings of Dickens (reproductions at Dickens House).

1870 Drawing by Sir J. E. Millais (after death). Collection of Mrs Waley, on loan to Dickens House, London. Exhibited *Dickens and his London*, Guildhall Art Gallery, London, 1962 (33), and *Charles Dickens*, Victoria and Albert Museum, 1970 (M39), reproduced in catalogue. Reproduced J. G. Millais, *Life and Letters of Sir J. E. Millais* (1899), II, 31.

1870 Drawing by T. Birch (surrounded by his characters and scenes). Photograph exhibited *Dickens Exhibition*, London, 1903 (347), lent by W. Miller.

1870 Parian ware bust by W. W. Gallimore (examples in Lady Lever Art Gallery, Port Sunlight, and elsewhere).

c1870 Bust by C. Jahn. Exhibited *RA*, 1870 (1129).

c1871 Marble bust by J. Adams-Acton. Exhibited *RA*, 1871 (1261).

c1871 Medal by J. W. Minton. Exhibited *RA*, 1871 (1240).

c1872 Posthumous marble bust by T. Woolner. Exhibited *RA*, 1872 (1560). Reproduced Kitton, I, facing 99, engraved by E. Roffe.

c1905 Marble bust by H. Pegram. Exhibited *RA*, 1905 (1795).

1926 Clay bust by J. T. Tussaud (modelled by J. R. Tussaud, *c*1865). Dickens House, London.

Undated Painting called Dickens by S. Drummond. Dickens House, London. Exhibited *VE*, 1892 (226), lent by Baroness Burdett-Coutts.

Undated Painting by A. Bryant. Portsmouth Corporation.

Undated Sepia drawing attributed to A. Egg, after a photograph by J. Watkins, with features, hair and beard composed of characters from *Barnaby Rudge*. Reproduced *Sixty Four* (catalogue) by Lew Feldman, House of El Dieff, 1964 (14).

Undated Drawings by H. Furniss, (NPG 3445–6 and 3563–6 above).

Undated A painting and a drawing by unknown artists. Christie's, 18 February 1935 (lots 224 and 223).

Undated Miniature by W. S. Barnard. Probably that in collection of Mr Strube, 1930.

Undated Water-colour (with drawings of seventeen characters) by an unknown artist. Sotheby's, 7 March 1918 (lot 361). Possibly the portrait by J. Reading of 1860 in the *Dickens Exhibition*, London, 1903 (321). Painting (as a young man) by an unknown artist: sold as above (lot 364).

Undated Marble bust by G. Fontana. Pennant House, Bebington.

DIGHTON *Richard* (*1795–1880*)

Portraitist and caricaturist; son of the caricaturist Robert Dighton, and brother of the battle-painter Denis Dighton; continued the family style of profile portraits and caricatures, many of which he etched; most of the plates were issued singly, but T. McLean published his 'City Characters', 1824.

1836a Identity doubtful. Pencil and water-colour on paper, $10\frac{7}{8} \times 6\frac{3}{8}$ inches (27·5 × 16·2 cm), attributed to HIMSELF. PLATE 272

Signed (*bottom right*): Dighton

Collections: Purchased from Leggatt Brothers, 1919.

There is no evidence that this water-colour represents Richard Dighton, though it is in his style. Until more evidence comes to light its status must remain dubious. Another so-called self-portrait was sold at Sotheby's, 14–15 November 1932 (lot 323). No other portraits are recorded.

Description: Healthy complexion, brown hair, and sandy whiskers. Dressed in a mauve and blue striped neck-tie, dark blue coat, grey trousers, and black shoes and top-hat. Brown foreground. Background left bare, except for some cross-hatching.

DILLWYN *Lewis Weston* (*1778–1855*)

Naturalist, and MP for Glamorgan.

54 See *Groups:* 'The House of Commons, 1833' by Sir G. Hayter, p 526.

DINEVOR *George Rice Rice-Trevor, 4th Baron* (*1795–1869*)

MP for Carmarthenshire.

54 See *Groups:* 'The House of Commons, 1833' by Sir G. Hayter, p 526.

D'ISRAELI *Isaac* (*1766–1848*)

Author, father of Benjamin Disraeli.

3772 See *Collections:* 'Drawings of Men About Town, 1832–48' by Count A. D'Orsay, p 557.

See also forthcoming Catalogue of Portraits, 1790–1830.

DIVETT *Edward* (*1797–1864*)

MP for Exeter.

54 See *Groups:* 'The House of Commons, 1833' by Sir G. Hayter, p 526.

DOBELL *Sydney Thompson* (*1824–74*)

Poet; lived chiefly in Gloucestershire, but later wintered abroad because of his delicate health; published *The Roman*, 1850, *Balder*, 1853, sonnets on the Crimean war, 1855, and other works; a permanent invalid from 1866.

2060 Mainly brown, grey and white chalk and wash on greenish-grey tinted paper, $16\frac{7}{8} \times 15$ inches (42·9 × 38 cm), by BRITON RIVIERE. PLATE 273

Collections: Presented by the sitter's sister, Mrs Alice Riviere (the wife of the artist), 1924.

According to the donor (letter of October 1924, NPG archives), this drawing was executed by 'my *late husband when a young man. It is undoubtedly the* best *likeness of him that exists*'.

ICONOGRAPHY A drawing or miniature by J. Archer was exhibited *R A*, 1857 (845); an engraving after a portrait by C. M. Dobell of 1865 was published as the frontispiece to the *Life and Letters of Sydney Dobell*, edited 'E J' (1878), I; a woodcut, after a photograph by C. R. Pottinger of Cheltenham, was published *ILN*, LXV (1874), 321.

DODGSON *George Haydock* (*1811–80*)

Water-colour painter; apprentice to the engineer, George Stephenson; published *Illustrations of the Scenery on the Line of the Whitby and Pickering Railway*, 1836; executed architectural drawings, and illustrations to the *Illustrated London News*; in later life, devoted himself to landscape; exhibited a large number of works.

1456 (4) Black chalk on paper, $2\frac{3}{8} \times 2\frac{3}{8}$ inches (6 × 6 cm), by CHARLES HUTTON LEAR, *c* 1845. PLATE 274

Inscribed (*lower right*): Dodgson.

Collections: See *Collections:* 'Drawings of Artists, *c* 1845' by C. H. Lear, p 561.

This is the only recorded portrait of Dodgson, except for a woodcut published *ILN*, C (1892), 592.

DONEGALL *George Hamilton Chichester, 3rd Marquess of (1797–1883)*

MP for County Antrim.

54 See *Groups:* 'The House of Commons, 1833' by Sir G. Hayter, p 526.

DONKIN *Sir Rufane Shaw (1773–1841)*

General, MP for Berwick-upon-Tweed.

54 See *Groups:* 'The House of Commons, 1833' by Sir G. Hayter, p 526.

DORAN *John (1807–78)*

Miscellaneous writer; of Irish origin; employed as a tutor to various aristocrats; contributed essays and translations to various journals; editor of *Church and State Gazette*, 1841; regular contributor to the *Athenaeum*; published a vast number of works devoted to a wide range of literary, historical, theatrical, and anecdotal subjects.

1648 Water-colour and body colour on blue-toned paper, 12 × 6⅞ inches (30·5 × 17·5 cm), by SPY (SIR LESLIE WARD), 1873. PLATE 275

Signed (lower right): Spy *Inscribed on the mount:* Dʳ John Doran, F.S.A./December 6, 1873

Collections: Thomas Bowles; *Vanity Fair* Sale, Christie's, 6 March 1912 (lot 216); Edmund Gosse, an NPG trustee, presented by him, 1912.

This is one of a large collection of original studies for *Vanity Fair*, which were all owned and specially mounted by the first proprietor of the magazine, Thomas Bowles. Those in the NPG will be discussed collectively in the forthcoming Catalogue of Portraits, 1860–90. The water-colour of Doran was published in *Vanity Fair* as a coloured lithograph on 6 December 1873, as 'Men of the Day, no. 72'.

Description: Healthy complexion, grey hair. Dressed in a white bow-tie, white shirt, black coat and shoes.

ICONOGRAPHY There is a lithograph by J. A. Vinter, after a photograph by Dr Diamond (example in British Museum); a woodcut was published *I L N*, LXXII (1878), 133; there is a photograph by Elliott and Fry in the NPG, and others are reproduced Dr Doran, *Annals of the English Stage* (1888), I, frontispiece, and Mrs E. M. Ward, *Memories of Ninety Years*, edited I. G. McAllister (n.d.), facing p 52.

D'ORSAY *Alfred Guillaume Gabriel, Count (1801–52)*

Artist and dandy; with the Countess of Blessington established a fashionable salon and coterie in London; executed portrait drawings (many are in the NPG), busts and oils; one of the most distinguished dandies and social figures of the period.

4540 Black chalk and pencil on paper, with faint red on the lips and cheek, 8¾ × 6½ inches (22 × 16·6 cm), by RICHARD JAMES LANE, 1841. PLATE 276

Signed and dated (bottom right): RJL 1841 –

Collections: David Pratt; purchased by Professor J. H. Plumb, a trustee of the NPG, and presented by him, 1967.

Literature: R. J. Lane, 'Account Books' (NPG archives), II, 51.

This profile drawing was originally thought to be a self-portrait; it is identical in technique with D'Orsay's other profile portraits, of which there are over 60 in the NPG, but Lane himself was responsible for lithographing over 140 of them, and must have been familiar with D'Orsay's style. It would be extremely difficult to execute a profile self-portrait, and in any case Lane's signature is

conclusive. Lane lists the portrait in his 'Account Book' under 6 December 1841: 'Portrait of Ct D'Orsay/from life –/on Paper –'. Two later references in the 'Account Books', II, 51–2, for 15 December 1841 and 12 February 1842, apparently refer to Lane's lithograph of this portrait, which was published J.Mitchell (example in NPG). The NPG drawing was sold with a scrap of autograph: '*My dear Daniell/I send you with pleasure/the profile of your old/friend D'Orsay*'. This may refer to the artist, Daniel Maclise, who was friendly with D'Orsay. The NPG portrait may have been the profile drawing of D'Orsay, sold Christie's, 25 January 1879 (lot 512), of which there is a sketch by G.Scharf in his catalogue of the sale (NPG archives).

 An earlier profile drawing of D'Orsay by Lane, signed and dated 1833, was lithographed by Lane, published J.Mitchell (example in NPG).

ICONOGRAPHY Several portraits of D'Orsay were included in Lady Blessintgon's Sale, Phillips, 7–26 May 1849; the only recorded copy of the catalogue is in the Wallace Collection.

As a youth	Painting by an unknown artist. Lady Blessington's Sale (lot 984).
1823	Painting called D'Orsay by J.Ferneley (on horseback, in Hyde Park). Tooth Galleries, 1936. Reproduced S.Sitwell, *Conversation Pieces* (1936), plate 115.
1828	Painting by J.Stevens. Collection of the Duke of Portland. Possibly the portrait by Stevens in Lady Blessington's Sale (lot 976).
1830	Painting by Sir G.Hayter. Hayter Sale, Christie's, 21 April 1871 (lot 567), bought Lord Carrington.
1833	Lithograph by R.J.Lane, published J.Mitchell (example in NPG).
1833	Plaster statuette by J.P.Dantan. Collection of the Marquess of Londonderry. Exhibited *English Caricature*, Burlington Fine Arts Club, London, 1931–2 (202). See also J.Seligman, *Figures of Fun* (1957), p 141.
1834	Engraving by D.Maclise, published *Fraser's Magazine*, X (December 1834), facing 645, as no. 55 of Maclise's 'Gallery of Illustrious Literary Characters'. Studies for this were sold Christie's, 24 June 1870 (lots 27 and 28). Other drawings of D'Orsay by Maclise were in Lady Blessington's Sale (lots 1204, 1212, 1214 and 1215). One of these (1214), showing D'Orsay painting O'Connell, was apparently in the collection of the Earl of Strafford at Wrotham in 1938.
1836	Painting by Sir F.Grant (on horseback). Lady Blessington's Sale (lot 1048). Exhibited *RA*, 1836 (469). Listed in Grant's 'Sitters Book' (copy of original MS, NPG archives), under the year 1836, where an engraving after the equestrian portrait is also mentioned, presumably the engraving by F.C.Lewis (example in British Museum). The equestrian portrait of D'Orsay by Grant, formerly in the collection of Sir Richard Wallace, exhibited Bethnal Green, 1872 (33), appears to have been an oil sketch, rather than the large picture itself (see L.Binyon, *British Museum Catalogue of Drawings by British Artists*, II (1900), 239, and a letter from Sir James Mann, director of the Wallace Collection, 1949, inserted into the NPG copy of this catalogue). The same or another oil sketch was sold, at Sotheby's, 4 December 1935 (lot 79). A pencil drawing is in the British Museum. Other portraits and sketches by Grant were in Lady Blessington's Sale (lots 617, 1014, 1016 and 1218). A portrait of D'Orsay, 'for a bust', is listed in Grant's 'Sitters Book', under 1848.
c 1838	Drawing by J.Wood. Exhibited *RA*, 1838 (1050).
1839	Painting by Sir G.Hayter. Sold Christie's, 7 December 1928 (lot 94).
1840	Lithograph (with Bulwer-Lytton and Lady Blessington) by Sir E.Landseer (examples in Royal Collection and collection of the Duke of Buccleuch).
1841	Drawing by R.J.Lane (NPG 4540 above).
c 1841	Painting by J.Wood. Offered to the NPG by George Wood, on behalf of the artist's executors, 1870. Exhibited *RA*, 1841 (505). Sketched and recorded by G.Scharf, 1870, 'TSB' (NPG archives), XVII, 81. This, or another version of the portrait, is at Hughenden Manor.

c1841 Water-colour by A. E. Chalon. Exhibited *RA*, 1841 (628).
A drawing by Chalon was exhibited *VE*, 1892 (409).

c1843 Plaster bust by W. Behnes. Exhibited *RA*, 1843 (1519).
Either this, or the one below, is in the Royal Collection. A marble bust by Behnes was in Lady Blessington's Sale (lot 280).

c1847 Bust by W. Behnes. Exhibited *RA*, 1847 (1397).

Undated Painting called D'Orsay by Sir E. Landseer. Formerly in the collection of A. L. Isaacs.
Coloured reproduction in NPG.

Undated Painting by Sir G. Hayter. Hayter Sale, Christie's, 21 April 1871 (lot 574), bought Radclyffe.

Undated Water-colour by Aubry (on horseback). Lady Blessington's Sale (lot 672).
A drawing by Aubry is reproduced M. Sadleir, *Blessington – D'Orsay: a Masquerade* (1933), facing p 48.

Undated Drawing by Wood (possibly J. Wood). Lady Blessington's Sale (lot 670).

Undated Drawing by Sir E. Landseer (boxing with the artist). British Museum.
Exhibited *Landseer Exhibition*, *RA*, 1961 (169). Three drawings by Landseer were in Lady Blessington's Sale (lots 1182, 1187 and 1191).

Undated Three drawings by J. Doyle. British Museum.

Undated Two miniatures by unknown artists. Lady Blessington's Sale (lot 624).

Undated Marble bust by himself. Ilchester Collection (on loan to NPG, 3548, plate 277).
Exhibited *Charles Dickens*, Victoria and Albert Museum, 1970 (P 16). A bronze bust and a statuette by himself were in Lady Blessington's Sale (lots 194 and 196).

Undated Marble bust by L. Bartolini. Lady Blessington's Sale (lot 261).

Undated Anonymous lithograph (example in British Museum).

Undated Two anonymous lithographs (on horseback, the other standing by a horse) (examples in NPG).

Undated Painting attributed to Sir T. Lawrence. Formerly collection of the Countess of Strafford.

DOYLE *Sir Charles Hastings* (*1805–83*)

General; son of lieutenant-general Sir Charles William Doyle (1770–1842); served in the East and West Indies and in Canada; colonel of his regiment, the 87th, 1854; went to the Crimea, but forced to return by ill-health; commanded in Nova Scotia, 1861; lieutenant-governor of the province, 1867–73; general, 1877.

2709 Water-colour and body colour on blue-toned paper, $12 \times 7\frac{1}{8}$ inches (30.4×18.1 cm), by SPY (SIR LESLIE WARD), 1878. PLATE 278

Signed (lower right): Spy *Inscribed on the mount:* Genal Sir Chs Hastings Doyle, K.C.M.G./March 23, 1878.

Collections: Thomas Bowles; *Vanity Fair* Sale, Christie's, 6 March 1912 (lot 221); Maggs Brothers, purchased from them, 1934.

This is one of a large collection of original studies for *Vanity Fair*, which were owned and specially mounted by the first proprietor of the magazine, Thomas Bowles. Those in the NPG will be discussed collectively in the forthcoming Catalogue of Portraits, 1860–90. The water-colour of Doyle was published in *Vanity Fair* as a coloured lithograph, on 23 March 1878, with the title, 'a General'. This is the only recorded portrait of Doyle.

Description: Healthy complexion, black hair and moustache. Dressed in a white shirt, blue neck-tie, mauve waistcoat, brown coat, fawn trousers, black top-hat and shoes, holding a rolled umbrella with a handle in the form of a skull.

DOYLE *John* (*1797–1868*)

Portrait-painter and caricaturist; produced in lithograph, under the signature of 'HB', a celebrated series of satiric portraits of the political celebrities of contemporary England, 1829–51; many of the original drawings are in the British Museum.

2130 Coloured chalk on brown, discoloured paper, $22\frac{5}{8} \times 18$ inches (57·5 × 45·6 cm), by HENRY EDWARD DOYLE. PLATE 279

Signed (*bottom right*): H. Doyle

Collections: Presented by the sitter's grandson, Sir Arthur Conan Doyle, 1926.

Exhibitions: Dublin Exhibition, 1872, 'Portraits' (419).

ICONOGRAPHY A plaster bust by C. Moore is in the Irish NPG, reproduced W. G. Strickland, *Dictionary of Irish Artists* (1913), I, plate XVIII; it is presumably related to the marble bust of Doyle by Moore exhibited *RA*, 1850 (1369).

DRUMMOND *Samuel* (*1765–1844*)

Portrait and historical painter; exhibited at RA from 1791; ARA, 1808; painted chiefly naval scenes, portraits and landscapes; curator of the Royal Academy painting school.

4216 Pen and ink on paper, $5\frac{3}{4} \times 4\frac{3}{4}$ inches (14·6 × 12 cm), by GEORGE HARLOW WHITE, 1842. PLATE 280

Signed and dated (*lower right*): Royl Acad Feb' 28'/1842/G Harlow White. *Inscribed below:* S. Drummond, A.R.A.

Collections: See *Collections:* 'Drawings, *c* 1845' by G. H. White, p 562.

ICONOGRAPHY A self-portrait was exhibited *RA*, 1820 (448), and another, with his wife, was engraved by W. Barnard, published S. Drummond, 1805 (example in British Museum); a painting by T. C. Thompson was exhibited *RA*, 1832 (218); a drawing by J. T. Smith of 1825 is in the British Museum.

DUGDALE *William Stratford* (*1800–71*)

MP for Warwickshire North.

54 See *Groups:* 'The House of Commons, 1833' by Sir G. Hayter, p 526.

DUNCOMBE *Thomas Slingsby* (*1796–1861*)

Radical politician; served in the army till 1819; MP from 1826; an active member of the radical party; defended Lord Durham, 1838; presented Chartist petition, 1842; helped in Prince Louis Napoleon's escape from Ham; worked on behalf of Italian and Hungarian independence.

1651a Pencil, water-colour and body colour on paper, $10\frac{5}{8} \times 8\frac{1}{8}$ inches (27 × 20·7 cm), by JAMES WARREN CHILDE, 1836. PLATE 281

Signed in pencil (*lower right*): J W Childe/135 Strand *Autograph in ink* (*along the bottom*): Thomas Slingsby Duncombe/Nov^r 19^th 1836

Collections: Presented by Lovat Fraser, 1912.

Exhibitions: Possibly the portrait by Childe exhibited *RA*, 1842 (907).

Description: Healthy complexion, brown eyes, black hair and whiskers. Dressed in a dark stock, white shirt, yellow waistcoat, and dark morning coat. Pale brown and blue background.

4026 (20) Pencil and black chalk, with touches of red on cheek and lips, on paper, $11 \times 8\frac{1}{8}$ inches (28 × 20·6 cm), by COUNT ALFRED D'ORSAY, 1839. PLATE 282

Signed and dated (*lower right*): A. D'Orsay/fecit/Oct. 1839./London *Inscribed* (*lower centre*):
T. Duncombe, Esq MP.

Collections: See *Collections:* 'Drawings of Men About Town, 1832–48' by Count A. D'Orsay, p 557.

ICONOGRAPHY A drawing by Wilkins (possibly F. W. Wilkin) of 1824 was in the collection of Thomas H. Duncombe, exhibited *S KM*, 1868 (391); Duncombe is represented in 'The Reform Banquet, 1832' by B. R. Haydon, in the collection of Lady Mary Howick, etched by F. Bromley, published J. C. Bromley, 1835 (example in NPG); a water-colour by Miss M. A. Chalon was exhibited *R A*, 1838 (989); busts by A. Hone and W. Behnes were exhibited *R A*, 1843 (1452), and 1844 (1376); woodcuts were published *I L N*, I (1842), 180, and v (1844), 5; there are various engravings (examples in NPG and British Museum).

DUNDAS *Sir James Whitley Deans* (*1785–1862*)

Admiral, and MP for Greenwich.

54 See *Groups:* 'The House of Commons, 1833' by Sir G. Hayter, p 526.

DUNDAS *Sir Robert Lawrence* (*1780–1844*)

MP for Richmond, Yorkshire.

54 See *Groups:* 'The House of Commons, 1833' by Sir G. Hayter, p 526.

DUNFERMLINE *James Abercromby, 1st Baron* (*1776–1858*)

MP for Edinburgh.

54 See *Groups:* 'The House of Commons, 1833' by Sir G. Hayter, p 526.

DUNLOP *William* (*1792–1848*)

Army surgeon and author; served in Spain, North America and India; assisted in formation of the Canada Company, 1826, and spent the rest of his life in Canada as a pioneer; author of *Sketches of Upper Canada* and numerous other works.

3029 Pencil and water-colour on paper, $8\frac{7}{8} \times 6\frac{7}{8}$ inches (22·5 × 17·5 cm), by DANIEL MACLISE, 1833. PLATE 283

Collections: Presumably Maclise Sale, Christie's, 24 June 1870 (lot 66); Sir William Drake; Drake Sale, Christie's, 24 May 1892 (lot 204); M. H. Spielmann, presented by him, 1939.

Exhibitions: Exhibition of Drawings in Water Colours, Burlington Fine Arts Club, 1880 (93); *British Portraits*, RA, 1956–7 (723); *A Pageant of Canada*, National Gallery of Canada, Ottawa, 1967–8 (146), reproduced catalogue, p 211; *Daniel Maclise*, Arts Council at the NPG, 1972 (47).

This is a finished study for the engraving of Dunlop by Maclise published as no. 35 in his 'Gallery of Illustrious Literary Characters', *Fraser's Magazine*, VII (April 1833), facing 436, with an accompanying character sketch by William Maginn. It was republished in *A Gallery of Illustrious Literary Characters* (*1830–38*), edited W. Bates (1873), facing p 94. The NPG water-colour and the finished engraving are almost identical except that the latter does not include the gun and hunting horn on the left. Maclise's portraits in *Fraser's*, numbering some eighty in all, constituted one of the chief attractions of the magazine in its early days. The collector's mark in the bottom left-hand corner of the NPG water-colour is that of Sir William Drake (Lugt 796). Other Maclise drawings of Jerdan and Praed (NPG 3028 and 3030) were presented at the same time as this one. Dunlop also appears in Maclise's engraving of 'The Fraserians', published *Fraser's Magazine*, XI (January 1835), between 2 and 3, for which there are two pencil studies in the Victoria and Albert Museum. No other portraits of him are recorded.

Description: Brown hair. Grey suit; white shirt.

DURHAM *John George Lambton, 1st Earl of* (*1792–1840*)

Statesman; retired from army, 1811; MP from 1813; lord privy seal, 1830; assisted in preparing first Reform Bill; served as ambassador extraordinary in various European capitals; governor-general of British Provinces in North America, 1838; resigned after criticism, 1838; his report on the affairs of British North America guided the policy of his successors.

2547 Oil on canvas, 36 × 28 inches (91·4 × 71·4 cm), by THOMAS PHILLIPS, after his portrait of 1819. PLATE 285

Collections: By descent to the present Earl of Durham; purchased at the Lambton Castle Sale, Anderson & Garland, 18 April 1932 (lot 52).

Literature: Presumably the portrait listed in Phillips' 'Sitters Book' (copy of original MS, NPG archives), under 1820, 'Mr Lambton 2nd'.

This is a replica of the portrait at Howick (signed and dated 1819), listed in the artist's 'Sitters Book' under 1819, which was originally owned by the 2nd Earl Grey. In a letter of 2 February 1819, Durham wrote to Grey:

Louisa told me that you had expressed a wish for my picture. I have therefore undergone the torture of sitting to Phillips. Yesterday was my last sitting. He has asked my leave to exhibit it, but I demur until you have seen it, as does he, that you may suggest any alterations you think right. He has been told by artists that the picture does him credit, as a painter, independently of any likeness, and he is therefore interested in having your opinion and criticism in time to alter it before it goes.[1]

The Howick portrait was duly exhibited *RA*, 1819 (104), and engraved by S.W.Reynolds (example in NPG). It has been suggested that the NPG portrait might be the work of Lady Grey, wife of the 3rd Earl, who copied several pictures at Howick for Lambton Castle. On stylistic grounds, however, the NPG portrait seems to be entirely the work of Phillips.

Description: Brown eyes and hair. Dressed in a white stock, white shirt, black waistcoat, and black coat, holding a brown leather-bound volume, and wearing a gold ring with a dark jewel. Curtain covering most of background plum red, yellow and grey sky visible lower right. Open book bottom left.

999 See *Groups:* 'The House of Lords, 1820' by Sir G.Hayter, in forthcoming Catalogue of Portraits, 1790–1830.

ICONOGRAPHY This does not include the political caricatures by John Doyle in the British Museum.

1797 Painting by A.Nicodemo, with his family (painted at Naples). Collection of W.H.Lambton, Winslow, 1905. Pastel copy: collection of Lord Liverpool, 1905.

1798 Painting by J.Hoppner, with his family. Lambton Castle Sale, 18 April 1932 (lot 56). Reproduced sale catalogue, facing p21. Pastel copy by Miss L.Lucas: collection of Lord Liverpool, 1905.

1804 Miniature by an unknown artist. Collection of Lord Lambton. Reproduced S.J.Reid, *Life and Letters of the First Earl of Durham* (1906), I, facing 54.

1819–20 Paintings by T.Phillips (NPG 2547 above).

1820 'The House of Lords, 1820' by Sir G.Hayter (NPG 999 above).

c1821 Miniature by Sir W.J.Newton. Exhibited *RA*, 1821 (705).

c1824 Marble bust by W.Behnes. Exhibited *RA*, 1824 (1005).

1828 Miniature by an unknown artist. Collection of S.J.Reid, 1906. Reproduced S.J.Reid, II, facing 32.

[1] S.J.Reid, *Life and Letters of the 1st Earl of Durham* (1906), I, 117; the Howick portrait is reproduced facing 117.

1829 Painting by Sir T. Lawrence. Collection of Lord Lambton (plate 284).
Exhibited *RA*, 1829 (135); *British Institution*, 1830 (51); *SKM*, 1868 (325); *VE*, 1892 (25); *A Pageant of Canada*, National Gallery of Canada, Ottawa, 1967–8 (147), reproduced catalogue, p 213.
Reproduced K. Garlick, *Sir Thomas Lawrence* (1954), plate 94. Engraved by C. Turner, published Colnaghi, 1831 (example in NPG), engraving exhibited *RA*, 1831 (449). Engraved by others (examples in NPG); an engraving by H. Robinson, after a drawing by J. Stewart (example in NPG), is based on the Lawrence.
Copies: Collection of Major J. R. H. Harley; Reform Club; collection of Sir Pryse and Lady Saunders-Pryse (miniature). A portrait, where the head is based on the Lawrence but the costume is different, is in the Public Archives of Canada, Ottawa, ex-collection of the Earl of Durham. Another variant portrait was engraved by H. Cook, published J. Dowding, 1840 (example in NPG), for Saunders' 'Political Reformers'.

1832 'The Reform Bill Receiving the King's Assent, 1832' by S. W. Reynolds. Houses of Parliament. Engraved by W. Walker and S. W. Reynolds junior, published Walker, 1836 (example in NPG). The painting is based on a drawing by J. Doyle, also in the Houses of Parliament.

c1832 'William IV Holding a Council', lithograph by J. Knight (example in British Museum).

1834 Drawing by Count A. D'Orsay. Sotheby's, 2 February 1950 (lot 216), bought Colnaghi. Lithographed by R. J. Lane, published J. Mitchell (example in NPG).

1841 Engraving by C. E. Wagstaff, after G. Dalziel (in masonic dress), published Dalziel, 1841 (example in British Museum).

c1841 Medallion by E. W. Wyon. Exhibited *RA*, 1841 (1128).

Undated Pastel copy of a miniature, and a drawing by the 4th Lord Hawkesbury. Collection of Lord Liverpool, 1905.

Undated Anonymous silhouette (example in NPG).

Undated Engraving by J. Harris (example in British Museum).

DYCE *William* (*1806–64*)

Painter; studied at the RA schools and in Rome; deeply influenced by the German Nazarenes; played an important role in the development of the schools of design; professor of fine arts, King's College, London, 1844; executed frescoes in the Palace of Westminster, 1846 onwards; RA, 1848; one of the most gifted history and subject painters of his time.

3944 (30) Pencil on paper, $9\frac{1}{2} \times 7\frac{1}{4}$ inches (24 × 18·5 cm), by JOHN PARTRIDGE, 1825. PLATE 286

Collections: See *Collections:* 'Artists, 1825' by J. Partridge, p 556.

Exhibitions: William Dyce Centenary Exhibition, Aberdeen Art Gallery, 1964 (94); *The Victorian Vision of Italy*, Leicester Museum and Art Gallery, 1968 (4).

In the Partridge sketch-book, on the blank page immediately preceding this drawing, is inscribed in pencil, 'Dyce'. No other early portraits of Dyce are known, but this drawing agrees well with later portraits of him, and it seems certain that it is correctly identified. Both Partridge and Dyce were in Rome in 1825.

ICONOGRAPHY A painting of 1864 by C. W. Cope is in a private collection (plate 288), exhibited *Dyce Exhibition*, Aberdeen, 1964 (95), and possibly *RA*, 1866 (501); a water-colour by D. Scott of 1832 (plate 287), and a silhouette by A. Edouart, are in the Scottish NPG; a drawing by C. Vogel is in the Küpferstichkabinett, Staatliche Kunstsammlungen, Dresden; a marble bust by E. G. Papworth senior is in the Aberdeen Art Gallery, exhibited *RA*, 1865 (934), and *Dyce Exhibition*, 1964 (96); a bust by L. Macdonald was exhibited *Scottish*

National Portraits, Edinburgh, 1884 (575), lent by Professor C. Fraser; a medallion by G. G. Adams was exhibited *RA*, 1866 (951), and was issued by the Art Union in 1875 (example in NPG); silver impressions of a medal by G. G. Adams were exhibited *RA*, 1867 (1101); there is a memorial brass portrait in St Leonard's Church, Streatham; woodcuts were published *ILN*, XXX (1857), 418, after a photograph by J. Watkins, and XLIV (1864), 224, after a photograph by J. and C. Watkins; two or three photographs by Watkins are in the NPG.

DYER *Joseph Chessborough* (*1780–1871*)

Inventor; born in Connecticut, USA; settled in England, 1811; active in introducing American inventions; took out his first patent for a roving frame used in cotton spinning, 1825; helped to found *North American Review*, and *Manchester Guardian*; engaged in struggle for parliamentary reform; associated with Anti-Corn Law League; published several works.

2515 (55) Black and white chalk on green-tinted paper, $13\frac{3}{4} \times 10\frac{3}{8}$ inches (35×26.4 cm), by WILLIAM BROCKEDON, 1831. PLATE 289

Dated (lower left): 1–9 31

Collections: See Collections: 'Drawings of Prominent People, 1823–49' by W. Brockedon, p 554.

Accompanied in the Brockedon Album by a letter from the sitter, dated 5 January 1824. This is the only recorded portrait of Dyer.

DYKES *Fretchville Lawson Ballantine* (*1800–66*)

MP for Cockermouth.

54 See *Groups:* 'The House of Commons, 1833' by Sir G. Hayter, p 526.

EASTLAKE *Sir Charles Lock* (*1793–1865*)

President of the RA; studied in RA schools, and under Haydon; visited Italy and painted Italian subjects; secretary of Fine Arts Commission; president of RA, 1850; director of National Gallery, 1855; probably the most influential art historian and art administrator of the period.

2477 With heads of G. D. Leslie and John Wood. Pencil on paper, $5\frac{7}{8} \times 3\frac{5}{8}$ inches (14.9×9.1 cm), by CHARLES BELL BIRCH, *c* 1858. PLATE 291

Inscribed in pencil (upper left): G. D. Leslie *and (upper right):* John Wood/Surgeon *and (bottom centre):* Sir C. L. Eastlake

Collections: See Collections: 'Drawings of Royal Academicians, *c* 1858' by C. B. Birch, p 565.

Exhibitions: Sir Charles Eastlake Exhibition, National Gallery, 1965–6 (no catalogue).

2478 Pencil on paper, $2\frac{1}{2} \times 1\frac{7}{8}$ inches (6.3×4.8 cm), by CHARLES BELL BIRCH, 1859. PLATE 293

Inscribed in pencil (on the reverse): Sir C. Eastlake/P.R.A./at R.A. Lecture/1859/CBB

Collections: As for NPG 2477 above.

Exhibitions: As for NPG 2477 above.

2479 Previously called Sir Charles Eastlake; see entry for S. A. Hart, p 215.

2515 (16) Black chalk, with touches of Chinese white, on brown-tinted paper, $15\frac{1}{4} \times 10\frac{7}{8}$ inches (38.9×27.6 cm), by WILLIAM BROCKEDON, 1828. PLATE 294

Dated (bottom left): 30–6–28

Collections: See Collections: 'Drawings of Prominent People, 1823–49' by W. Brockedon, p 554.

Accompanied in the Brockedon Album by an undated letter from the sitter.

3182 (5) See catalogue entry under W. Mulready, p 328.

3182 (12) Pen and ink on paper, $2\frac{7}{8} \times 2\frac{3}{4}$ inches (7·2 × 7 cm), by CHARLES WEST COPE, c 1862. PLATE 292
Inscribed on the page on which the drawing is mounted: Sir C. L. Eastlake
Collections: See *Collections:* 'Drawings of Artists, c 1862' by C. W. Cope, p 565.

3944 (22) Pencil on paper, $9\frac{1}{2} \times 7\frac{1}{4}$ inches (24 × 18·5 cm), by JOHN PARTRIDGE, 1825. PLATE 295
Collections: See *Collections:* 'Artists, 1825' by J. Partridge, p 556.
Exhibitions: British Portraits, RA, 1956–7 (724); *The Victorian Vision of Italy,* Leicester Museum and Art Gallery, 1968 (3).

Comparison with other portraits of Eastlake leaves no doubt that this drawing does represent him. It is almost certain that a water-colour sketch of Rome in the same sketch-book as this drawing is by Eastlake. Both sitter and artist were in Rome at this time.

953 Marble bust, 23 inches (58·4 cm) high, by JOHN GIBSON. PLATE 296
Incised on the side of the base: I GIBSON FECIT/ROMAE
Collections: The sitter, bequeathed by his widow, Lady Eastlake, 1894.
Exhibitions: VE, 1892 (1081); *Sir Charles Eastlake Exhibition,* National Gallery, 1965–6 (no catalogue); *The Victorian Vision of Italy,* Leicester Museum and Art Gallery, 1968 (5).
Literature: Life of John Gibson, RA., edited Lady Eastlake (1870), p 252.

Gibson and Eastlake first met in Rome in 1817 and became close friends. Eastlake was in Rome from 1816–1830, Gibson from 1817 to the end of his life. Lady Eastlake merely lists this bust in her life of Gibson, and does not give a date. From the apparent age of the sitter, it must have been executed on one of Eastlake's later journeys to Rome, probably in the 1840s. What appears to be a copy of this bust, also in marble, is on loan to the Plymouth Art Gallery.

342, 3 See *Groups:* 'The Fine Arts Commissioners, 1846' By J. Partridge, p 545

ICONOGRAPHY

1814 Drawing by J. Hayter. British Museum.
Hayter was only fourteen in 1814, so the drawing may not be his work.

1816 Drawing (with S. Kirkup) by Sir G. Hayter. British Museum.
Another drawing by Hayter in the British Museum presumably dates from this time; see L. Binyon, *Catalogue of Drawings by British Artists,* II (1900), 281 (9a), and 282 (9b).

1825 Drawing by J. Partridge (NPG 3944 (22) above).

1828 Drawing by W. Brockedon (NPG 2515 (16) above).

c 1844 Drawing by T. Bridgford. Royal Hibernian Academy.
Exhibited *RA,* 1844 (800). Engraved by J. Smyth (example in NPG), for the *Art-Union,* and engraved anonymously (example in NPG).

1846 'The Fine Arts Commissioners, 1846' by J. Partridge (NPG 342 above).

1850 Woodcut published *ILN,* XVII (1850), 357.

1851 Painting by D. Huntington. New York Historical Society.
Exhibited *RA,* 1852 (525). Reproduced J. Steegman, *The Consort of Taste* (1950), facing p 200.

c 1857 Painting by J. P. Knight. Royal Academy, London (plate 290).
Exhibited *RA,* 1857 (80), *SKM,* 1868 (621), and *VE,* 1892 (182). Reproduced *Studio,* CIX (1935), 296. Engraved by G. T. Doo, published 1873 (example in NPG), engraving exhibited *RA,* 1873 (1258).

c 1858–9 Drawings by C. B. Birch (NPG 2477–8 above).

1860 Woodcut, after a photograph by J.Watkins, published *ILN*, XXXVI (1860), 449; another woodcut published XXXVIII (1861), 447, after the portrait by Knight.

c1862 Drawings by C.W.Cope (NPG 3182 (5, 12) above).

c1866 Medallion by A.H.Ritchie. Exhibited *Royal Scottish Academy*, 1866 (923).

c1867 Bust by A.H.Ritchie. Exhibited *Royal Scottish Academy*, 1867 (903).

Undated Painting called Eastlake by an unknown artist. Ex-collection of Colonel M.H.Grant.

Undated A drawing by C.Vogel. Küpferstichkabinett, Staatliche Kunstsammlungen, Dresden.

Undated Bust by J.Gibson (NPG 953 above).

Undated Engraving by D.J.Pound, after a photograph by J.Watkins (example in NPG).

Undated Engraving by H.Linton, after a photograph by Mayall (example in NPG).

Undated Photograph by Caldesi, Blandford & Co (example in NPG, plate 297).

 Head and shoulders anonymously lithographed, published *Palgrave Family Memorials*, edited C.J.Palgrave and S.Tucker (privately printed, Norwich, 1878), facing p 114.

EASTLAKE *Elizabeth, Lady* (*1809–93*)

Authoress; travelled in Germany and Russia, and published her experiences, 1841; contributed numerous articles to the *Quarterly*; married Sir Charles Eastlake (see above), 1849; published numerous works, mainly devoted to art historical subjects.

2533 Water-colour on paper, $4\frac{3}{4} \times 4\frac{1}{4}$ inches (12×11 cm), by COKE SMYTH. PLATE 298

Inscribed on the back of the drawing: Lady Eastlake/by Coke Smyth. *Inscribed on the original back mount, in a different hand:* Lady Eastlake/By Coke Smyth

Collections: H.W.Underdon, purchased from him, 1932.

Although the identification is solely based on the inscriptions, there seems no reason to question them. The features are perfectly compatible with known likenesses of Lady Eastlake, although the comparison is not absolutely conclusive.

Description: Brown eyes, and brown hair. Dressed in brown and red, with a pink ribbon and white collar. She is also wearing what appears to be a hair net, secured by pearl-headed pins. Background colour light blue.

ICONOGRAPHY A painting by Sir W.Boxall of *c*1850 is reproduced M.Lutyens, *Millais and the Ruskins* (1967), facing p210; a painting by J.R.Swinton was exhibited *RA*, 1857 (411), and a drawing by the same artist of 1863, *RA*, 1869 (802); a marble bust by W.Theed was exhibited *RA*, 1854 (1497); there is an anonymous engraving in the NPG; a photograph by D.O.Hill (with her mother) (example in NPG) is reproduced H.Schwarz, *David Octavius Hill* (1932), plate 18; a photograph by J.Watkins is reproduced *The Lady's Own Paper*, 9 March 1867, p241; an anonymous photograph is in the NPG (inserted in a copy of *Journals and Correspondence of Lady Eastlake*).

EATON *Joseph* (*1793–1858*)
Slavery abolitionist.

599 See *Groups:* 'The Anti-Slavery Society Convention, 1840' by B.R.Haydon, p538.

EBURY *Robert Grosvenor, 1st Baron* (*1801–93*)
MP for Chester.

54 See *Groups:* 'The House of Commons, 1833' by Sir G.Hayter, p526.

EDWARD VII (*1841–1910*)

4536 'The Four Generations'. See entry under Queen Victoria, p 475.

 See also forthcoming Catalogue of Edwardian Portraits.

EDWARDES *Sir Herbert Benjamin* (*1819–68*)

Indian official; served in Bengal infantry; fought in the Sikh wars; reformed civil administration of Banu, 1847; twice routed rebel Diwán Mulráj, 1848; commissioner of Peshawar, 1853–9; returned to England, 1865.

1391 Oil on canvas, 99 × 63¾ inches (251·5 × 161·9 cm), by HENRY MOSELEY, *c* 1850. PLATE 299

 Inscribed and signed (*bottom right*): GENERAL SIR HERBERT EDWARDES K.C.B. K.C.S.I./Taken in the Afghan dress he wore at Bunnoo in 1848–1849 / H. Moseley pinxit *Inscribed in ink on the back of the stretcher:* Major Herbert Edwardes C.B. H.E. ICS./Painted by Henry Moseley. 52 Upper Charlotte S. Fitzroy Sq<u>re</u>.

 Collections: The sitter, bequeathed by his widow, Lady Edwardes, 1905.

 This portrait must have been painted soon after Edwardes' triumphant return to England from India in January 1850. In 1849, shortly before his return, the Queen had declared him a brevet major and a companion of the Bath, the honours inscribed on the stretcher; the inscription on the painting itself must be later, as Edwardes was not knighted till 1860. A lithograph after this portrait by J.H. Lynch was published H. Squire & Co, 1850 (example in NPG). The town in the background of the picture is unidentified, but may represent Multan, before which Edwardes decisively defeated the rebel Diwán Mulráj in 1848. This portrait was on loan to the India Office, London, for some years in exchange for the marble bust by J.H. Foley (see iconography below). An etching by A. Crowquill, apparently based on the portrait by Moseley, and showing Edwardes in the same costume, was published R. Bentley, 1850 (example in NPG).

 Description: Dark complexion, brown eyes, dark brown hair and beard. Dressed in a red costume, with a green sash round his waist, green trousers, gold-embroidered green cloak, red and gold shoes, red sword scabbard. Orange sky above town. Rest of background dark brown.

ICONOGRAPHY A painting by an anonymous artist is in the Territorial Association Centre, Shrewsbury; a marble monument by W. Theed of 1868 is in Westminster Abbey, reproduced Lady Edwardes, *Memorials of the Life and Letters of Major-General Sir Herbert Edwardes* (1886), II, frontispiece; a bust by J.E. Jones was exhibited *R A*, 1850 (1384); a lithograph by E. Morton, after a miniature by a native artist of 1848, is in the India Office Library, London, and so is a marble bust by J.H. Foley of 1870; there is a lithograph by C. Baugniet, published Gambart, 1858 (example in NPG); various other engravings and lithographs are in the NPG; a photograph by Captain Hutchinson (showing him with Lawrence and Montgomery) was engraved by E. Roffe for Rev J. Cave-Browne, *The Punjab and Delhi in 1857* (1861), I, frontispiece; a photograph by J. Mayall is reproduced G.W. Forrest, *Sepoy Generals* (1901), facing p 178.

EDWARDES

 One of Lord Kensington's sons.

4026 (21) See *Collections:* 'Drawings of Men About Town, 1832–48' by Count A. D'Orsay, p 557.

EGERTON *Francis, 1st Earl of Ellesmere.* See E L L E S M E R E

EGG *Augustus Leopold* (*1816–63*)

 Subject painter; studied at RA schools; painted a large number of genre, literary and subject pictures, including his famous triptych, 'Past and Present' (Tate Gallery); RA, 1860; a popular Victorian artist.

1456 (5) Black chalk on paper, heightened with Chinese white, $2\frac{3}{4} \times 1\frac{3}{4}$ inches ($7 \times 4 \cdot 5$ cm), by CHARLES HUTTON LEAR, 1845. PLATE 300

Inscribed (*lower right*): A. Egg/Nov 45

Collections: See *Collections:* 'Drawings of Artists, *c* 1845' by C.H. Lear, p 561.

This drawing was done in the life school of the Royal Academy, where Lear was a student, and was sent, together with others, in an undated letter to his parents (copy in NPG archives): '*No.3 a very hasty sketch of Egg who came into the school for a few moments & while he stood looking at the figure I made it*'.

ICONOGRAPHY A painting by W.P. Frith was engraved by J. Smyth, published 1847 (example in NPG), for the *Art Union;* a painting by J. Phillip is in the Royal Academy, exhibited *RA*, 1859 (405), *S K M*, 1868 (607), and *British Portraits Exhibition*, RA, 1956–7 (455); it was engraved and published by T.O. Barlow, 1865 (example in British Museum), engraving exhibited *RA*, 1865 (838); a self-portrait of 1858 is in the Hospitalfield Trust, Arbroath, exhibited *British Self-Portraits*, Arts Council, 1962 (80), possibly the self-portrait in the *London International Exhibition*, 1874 (106); a woodcut, after a photograph by J. Watkins, was published *I L N*, xxx (1857), 419; there are also a number of photographs in the NPG (see plate 301).

ELLENBOROUGH *Edward Law, 1st Earl of* (*1790–1871*)

Governor-general of India; eldest son of 1st Baron Ellenborough (1750–1818), the lord chief-justice; tory MP from 1813; lord privy seal, 1828; member of board of control, 1828–30; governor-general of India, 1841; annexed Sind, 1842, and subjugated Gwalior, 1844; recalled, 1844; served in the ministries of Peel and Derby, 1846 and 1858.

1805 Oil on canvas, 56×44 inches ($142 \cdot 2 \times 111 \cdot 8$ cm), by FREDERICK RICHARD SAY, *c* 1845. PLATE 302

Collections: Sir Robert Peel; sale of Peel Heirlooms, Robinson, Fisher and Harding, 6 December 1917 (lot 68), bought H.G. Boston, and presented by him, 1918.

Ellenborough is shown with the star and ribbon of the Bath, awarded him in 1844. On the evidence of costume and the apparent age of the sitter the portrait must date from soon after this. It was apparently commissioned by Peel for his 'Statesmen's Gallery', which included several other portraits by Say, including one of the Earl of Derby (NPG 1806). A copy by Dyer is in the Victoria Memorial Hall, Calcutta, commissioned by Lord Curzon. A miniature copy was sold from the collection of the Earl of Ellenborough, Sotheby's, 11 June 1947 (lot 51).

Description: Healthy complexion, brown eyes and hair. Dressed in a white stock, white shirt, dark morning coat and trousers, with a red ribbon and jewelled star. Background colour brown.

999 See *Groups:* 'The House of Lords, 1820' by Sir G. Hayter, in forthcoming Catalogue of Portraits, 1790–1830.

2789 See *Groups:* 'Drawings of Members of the House of Lords, *c* 1835' attributed to I.R. Cruikshank, p 536.

ICONOGRAPHY A painting by J. Hayes is in Calcutta, recorded by G. Scharf, 'TSB' (NPG archives), XXXVI, 13; a painting attributed to Sir T. Lawrence was in the collection of Sir W.A.C. Law, 1944; a painting by S. Hodges was sold from the Ellenborough Collection, Sotheby's, 11 June 1947 (lot 75), bought Luton; a drawing attributed to Sir T. Lawrence was in the collection of the Earl of Ellenborough, 1946; a drawing by Sir G. Hayter is in the British Museum, and so are five caricature lithographs and four drawings by J. Doyle; woodcuts were published *I L N*, II (1843), 92, and, after a photograph by Maull & Co, LX (1872), 37; there is a photograph by Silvy in the NPG.

ELLENBOROUGH *Jane Elizabeth Law, Countess of (1807–81)*

Famous beauty; *née* Digby; married 1st Earl of Ellenborough (see above), 1824; divorced by him, 1830, on grounds of adultery; became the mistress of Ludwig 1 of Bavaria; married Baron de Venningen, prime minister of Bavaria, 1832; married lastly Sheikh Medj-wal el Mizrab; died of dysentery at Damascus.

883 (10) Pencil and water-colour on paper, 6 × 4½ inches (15·3 × 11·5 cm), by SIR GEORGE HAYTER, *c* 1825.
PLATE 303

Inscribed in pencil (bottom left): Lady Ellenborough

Collections: A. D. Hogarth, purchased from him, 1891.

The date is based on costume and the apparent age of the sitter. It cannot be later than 1830 when Lady Ellenborough divorced her husband. This drawing is one of several studies for miniatures by Hayter, which will be collectively discussed in the forthcoming Catalogue of Portraits, 1790–1830. No finished miniature of Lady Ellenborough is known. Another sketch by Hayter of similar date (NPG 883 (9)) is also inscribed 'Lady Ellenborough', but seems to represent a much older woman, possibly Anne, wife of the 1st Baron Ellenborough.

ICONOGRAPHY A painting called Lady Ellenborough, but probably representing her mother-in-law, Anne, Lady Ellenborough, by Sir T. Lawrence was in the Camille Groult Sale, Galerie Charpentier, Paris, 27 April 1951 (lot 27), etched by C. Waltner, published *Collection de M. John W. Wilson*, 1873; see K. Garlick, *Walpole Society*, XXXIX (1962–4), 74; a painting by J. Stieler is in Schloss Nymphenburg, Munich, commissioned by Ludwig 1 of Bavaria; a miniature by H. Collen was exhibited *R A*, 1829 (936), possibly that engraved by T. Wright (example in NPG); a miniature by R. Cosway was in the collection of J. Lumsden Propert, 1897; there are various lithographs and engravings (examples in NPG, British Museum and Hope Collection, Ashmolean Museum, Oxford).

ELLESMERE *Francis Egerton, 1st Earl of (1800–57)*

Statesman and poet; MP from 1822; early promoter of free trade; secretary at war, 1830; rector of King's College, Aberdeen, 1838; president of the British Association, 1842, and of other learned bodies; published poems, translations, and historical and archaeological works.

2203 Marble bust, 10¾ inches (27·3 cm) high, by MATTHEW NOBLE, *c* 1858. PLATE 304

Incised below the shoulders: EARL OF ELLESMERE. K.C. *and below on the back of the base:* M. NOBLE. S./
LONDON

Collections: The sitter; by descent to his granddaughter, Mrs L. B. Jameson, and presented by her, 1928.

Exhibitions: Probably *R A*, 1858 (1245).

Literature: R. Gunnis, *Dictionary of British Sculptors* (1953), p 275.

It is just possible that this bust is a reduced replica of a larger bust which was exhibited at the *R A*, rather than the original bust itself. Commissioned marble busts were usually life-size. Ellesmere is wearing the star of the Garter.

ICONOGRAPHY

c 1804 Drawing by H. Edridge (with his two sisters, Lady Charlotte and Lady Elizabeth). Formerly collection of the Marquess of Stafford, Trentham Hall.

c 1806 Painting by T. Phillips (with his two sisters). Collection of the Duke of Sutherland.
Exhibited *R A*, 1806 (109).

c1824 Busts by R. W. Sievier. Exhibited *RA*, 1824 (990), and, in marble, 1826 (1059).

c1827 Painting by Sir T. Lawrence. Collection of the Duke of Sutherland.
Exhibited *RA*, 1827 (212). Reproduced *Illustrated Catalogue of Thirty Pictures in the Collection of his Grace the Duke of Sutherland*, Christie's, 1957, p24.

1835 Engraving by D. Maclise, published *Fraser's Magazine*, XII (July 1835), facing 43, as no. 62 of Maclise's 'Gallery of Illustrious Literary Characters'. A drawing for this is in the Victoria and Albert Museum.

1837 Engraving by H. Cousins, after J. Bostock, published T. Agnew, 1837 (example in NPG).

1837 'Return from Hawking' by Sir E. Landseer. Collection of the Earl of Ellesmere.
Exhibited *RA*, 1837 (186). Engraved by S. Cousins, published F. G. Moon, 1840, and etched by C. G. Lewis, published F. G. Moon, 1839 (examples in British Museum).

1852 Drawing by G. Richmond. Exhibited *VE*, 1892 (341), lent by the Countess of Strafford.
Reproduced as a woodcut *Illustrated Times* (cutting in NPG). Lithographed by F. Holl (example in NPG).

1855 'The Queen Investing Napoleon III with the Order of the Garter' by E. M. Ward. Royal Collection.
Exhibited *RA*, 1858 (35). Reproduced Sir H. Maxwell, *Sixty Years a Queen* (1897), p88.

c1856 Painting by E. Long. Collection of the Earl of Ellesmere.
Exhibited *RA*, 1856 (326), and *SKM*, 1868 (376).

c1858 Marble bust by M. Noble (NPG 2203 above).

Undated Painting by Sir G. Hayter. Collection of the Earl of Ellesmere.
Reproduced *Ladies Field*, 5 July 1902. Inscription on the back records that this was done as a copy in Parma in 1826, from the original executed in London (possibly the picture below).

Undated Painting by Sir G. Hayter. Collection of G. Proby, Elton Hall, 1948.

Undated Painting by T. Phillips. Collection of the Duke of Sutherland.

Undated Engraving by J. Stephenson, after O. de Manara (example in NPG).

Undated Drawing by F. W. Wilkin. Collection of the Duke of Sutherland.
Possibly the drawing lithographed by Wilkin (example in British Museum).

Undated Engraving by F. C. Lewis, after J. Slater (example in NPG), for the 'Grillion's Club' series.

Undated Water-colour by D. Dighton. Collection of the Duke of Sutherland.

Undated Miniature by R. Thorburn. Scottish NPG.

ELLICE *Edward* (*1781–1863*)
MP for Coventry.

54 See *Groups:* 'The House of Commons, 1833' by Sir G. Hayter, p526.

ELLIOT *Sir George* (*1784–1863*)
Admiral; second son of the 1st Earl of Minto (1751–1814); present at battles of Cape St Vincent and the Nile; highly esteemed by Nelson; secretary of the admiralty, 1834–5; commander-in-chief at the Cape of Good Hope, 1837–40; commanded in China, 1840; admiral, 1853.

2511 Oil on millboard, $13\frac{3}{8} \times 10\frac{1}{2}$ inches (34 × 26·5 cm), by SIR GEORGE HAYTER, 1834. PLATE 305
Signed and dated (bottom left-hand corner): Sketch George Hayter 1834
Inscribed in the artist's hand in ink, on a label (formerly on the back of the picture): Honble Captⁿ George Elliot. Secretary to/The Admiralty, member for Roxburghshire/Study for my Great Picture of the House of Commons/of 1833/ George Hayter 1834

Collections: The artist; Hayter Sale, Christie's, 21 April 1871 (lot 541), bought Miller; Queen Mary, presented by her, 1931.

This sketch is a study for Hayter's large picture of 'The House of Commons, 1833' (NPG 54 below), and was presented at the same time as another sketch for the same picture of the Marquess of Breadalbane (NPG 2510). Both sketches were purchased by Queen Mary from a shop in Harrogate. No other portraits of Elliot are recorded.

Description: Healthy complexion, brown eyes, brown hair. Dressed in a white shirt, white stock, and dark coat. Background colour light brown.

54 See *Groups:* 'The House of Commons, 1833' by Sir G. Hayter, p 526.

ELLIS *John* (*1789–1862*)

MP; railway chairman, and slavery abolitionist.

599 See *Groups:* 'The Anti-Slavery Society Convention, 1840' by B. R. Haydon, p 538.

ENDERLEY *Charles*

South Sea whaler.

2515 (104) See *Collections:* 'Drawings of Prominent People, 1823–49' by W. Brockedon, p 554.

ENGLEHEART *John Cox Dillman* (*1783–1862*)

Miniature painter; nephew of the miniaturist, George Engleheart (1752–1839); exhibited at RA, 1801–28; retired from profession, 1828, owing to ill-health; chiefly noted for portrait miniatures.

2754 Miniature, water-colour and body colour on ivory, 3⅛ × 2¾ inches (7·9 × 7 cm), by HIMSELF, *c* 1810.
PLATE 306

Inscribed in pencil on the back of the original backboard: JCDE/by/self

Collections: The sitter; by descent to his grandson, Henry Engleheart, and bequeathed by him, 1935.

Literature: G. C. Williamson and H. L. D. Engleheart, *George Engleheart* (1902), p 70, reproduced facing p 66.

The date is based on costume, the apparent age of the sitter, and comparison with other self-portraits. Williamson and Engleheart wrote of this miniature (p 70):

In his portrait of himself the artist is well depicted as a quiet, studious man, not strong in bodily health, refined, cultured and thoughtful, but lacking it is clear, the power of forcefulness, quickness, and nervous tension which characterized his uncle.

Description: Fresh complexion, light brown eyes, white (powdered ?) hair. Wearing a white stock, white shirt, dark-green jacket. Right arm on a red-covered table. Background yellow-brown, darker in top corners.

ICONOGRAPHY A drawing by G. Engleheart (his uncle) of *c* 1796 is in the Engleheart collection, exhibited *British Portrait Miniatures*, Edinburgh, 1965 (253), reproduced Williamson and Engleheart, *George Engleheart* (1902), facing p 64; a miniature by himself of *c* 1810, and a drawing of 1821 are in the Engleheart collection, exhibited *Essex and Suffolk Houses*, the Minories, Colchester, 1964 (50o and 50g), the latter reproduced Williamson and Engleheart, facing p 22; another version of the 1821 drawing is also in the Engleheart collection, as are several other self-portrait miniatures and drawings; a water-colour by himself, with his wife, is in the collection of W. A. Twiston-Davies, listed by J. Steegman, *Survey of Portraits in Welsh Houses*, II (1962), 149 (15).

ENNISKILLEN *William Willoughby Cole, 3rd Earl of* (*1807–86*)

MP for County Fermanagh.

54 See *Groups:* 'The House of Commons, 1833' by Sir G. Hayter, p 526.

ESSEX *Catherine Stephens, Countess of* (*1794–1882*)

Singer and actress; appeared successfully at Covent Garden in 'Artaxerxes', 1813, and remained there till 1822; acted and sang in a variety of classical and contemporary roles; unsurpassed for her rendering of ballads; retired, 1835; married 5th Earl of Essex, 1838.

702 Oil on canvas, $30\frac{1}{4} \times 25\frac{1}{4}$ inches (76·8 × 64·2 cm), by JOHN JACKSON, *c* 1822. PLATE 308

Inscribed on the cover of the sheet of music: Miss Stephens

Collections: The artist; Jackson Sale, Christie's, 16 July 1831 (lot 90), bought Noseda; Robert Vernon, bequeathed by him to the National Gallery, 1847; on loan from the National Gallery since 1883; transferred 1957.

Exhibitions: R A, 1822 (230).

Literature: S. C. Hall, *The Vernon Gallery of British Art*, III (1854), no. 31, under the title of 'The Songstress' (four pages of text), reproduced (engraved by G. Stodart); *Art Journal* (1899), p 68, reproduced.

This portrait may represent Miss Stephens in a particular dramatic or operatic role, but, if so, there is no evidence to suggest what it might be. Jackson painted several theatrical figures including Macready (NPG 1503). Besides the Stodart engraving for the *Vernon Gallery*, this portrait was also lithographed by W. Sharp, published 1832 (example in British Museum), for the *Musical Gem*.

Description: Fair complexion, dark hazel eyes, black hair. Dressed in a dark crimson costume, with muslin sleeves, and a loose ruff of the same material, and a gold sash. Background colour greenish-grey of various tones.

ICONOGRAPHY This does not include popular prints, for which see L. A. Hall, *Catalogue of Dramatic Portraits in the Theatre Collection of the Harvard College Library* (Cambridge, Massachusetts), I (1930), 433–5.

Paintings by G. H. Harlow

c 1813 Collection of J. Bond, 1864. Exhibited *British Institution*, 1864 (157). Sketched by G. Scharf, 'SSB' (NPG archives), LXVIII, 93. Engraved by H. Meyer, published A. Wivell, 1813 (example in British Museum), and by J. Asperne, 1818 (example in NPG), for the *European Magazine*.

c 1816 Petworth House. Sketched by G. Scharf, 'TSB' (NPG archives), VIIa, 5. Engraved by W. Say, published E. Orme, 1816 (example in British Museum).

1817 'Court for the Trial of Queen Catherine' ('Henry VIII'). The original picture appears to be that in the Morrison collection. Exhibited *R A*, 1817 (17). The type was engraved by G. Clint, published W. Cribb, 1819 (example in NPG). A reduced version is in the Royal Shakespeare Memorial Theatre Museum, Stratford-on-Avon, and a copy is in the Garrick Club, London.

1818 Lithograph by R. Cooper, after G. H. Harlow, published W. Cribb, 1818 (example in NPG).

c 1819 (As Diana Vernon in 'Rob Roy MacGregor'). Garrick Club, London. Anonymous engraving, published 1819 (example in Harvard Theatre Collection), for the *British Stage*. Water-colour copy: Garrick Club, London.

Undated (In theatrical costume). Collection of the Hon Lady Shelley-Rolls. See J. Steegman, *Survey of Portraits in Welsh Houses*, II (1962), 135 (28).

Undated (In theatrical costume). Collection of C.H.Waters, 1877.

Sketched by G.Scharf, 'TSB' (NPG archives) XXIII, 40. Possibly a study for the undated picture above. A chalk drawing with the same dimensions ($12\frac{1}{2} \times 9\frac{3}{4}$ inches) was sold at Christie's, 23 March 1877 (lot 79), and may be the same as this painting (Scharf described the original as thinly painted, and it may have been mistaken for a drawing).

Undated Exhibited *Victorian Era Exhibition*, 1897, 'Music Section' (51), lent by T.W.Taphouse.

Undated (Called the Countess of Essex, with a lute). Sedelmeyer Collection, sold Galerie Sedelmeyer, Paris, 16–18 May 1907 (lot 80), reproduced sale catalogue, I, 49.

Undated (Called the Countess of Essex). Anderson Galleries, New York, 4–5 February 1932 (lot 70).

General

1813 Painting by S.de Wilde (as Mandane in 'Artaxerxes'). Garrick Club, London (plate 307).

Engraved by Freeman, published C.Chapple, 1813 (example in Harvard Theatre Collection), for the *Theatrical Inquisitor*.

1814 Engraving by H.R.Cook, published I.H.Payne, 1814 (example in NPG).

c1814–16 Miniatures by S.J.Stump. Exhibited *RA*, 1814 (378), and 1816 (660).

1815 Engraving by Hopwood, after Sir G.Hayter, published J.Bell, 1815 (example in NPG).

1819 Engraving by J.Thomson, published Dean and Munday, 1819 (example in NPG), for the 'Ladies Monthly Museum'.

c1819 Painting by J.Bradley. Exhibited *RA*, 1819 (819).

c1820 Painting by Sir M.A.Shee. Exhibited *RA*, 1820 (24).

c1820 Miniature by Sir W.J.Newton. Collection of Mrs Newton, 1892.

Exhibited *RA*, 1820 (803), and *VE*, 1892 (427). Reproduced *Illustrated Times* (cutting in the NPG).

c1822 Painting by J.Jackson (NPG 702 above).

c1824 Miniature by Miss L.Sharpe. Garrick Club, London.

Possibly the miniature exhibited *RA*, 1824 (736), depicting Miss Stephens in the character of Mistress Ford in 'The Merry Wives of Windsor'.

1825 Engraving by S.W.Reynolds, after H.Fradelle (as Susanna in 'The Marriage of Figaro'), published W.Sams, 1825 (example in British Museum); reproduced H.S.Wyndham, *The Annals of Covent Garden Theatre* (1906), II, facing 2.

c1827 Marble bust by P.Turnerelli. Exhibited *RA*, 1827 (1084).

1831 Water-colour by J.Linnell. Exhibited *VE*, 1892 (414), lent by the Linnell family.

Undated Miss Stephens appears in two groups by Sharp, 'King John', and 'No Song, No Supper'. Christie's, 22 July 1871 (lots 187 and 188).

Undated Engraving by S.Hall, after W.H.Brooke, published W.Pinnock and W.Sams (example in British Museum).

Undated Engraving by H.Robinson, after W.Derby (example in NPG).

Undated Silhouette by an unknown artist. Garrick Club, London.

Undated Paintings called the Countess of Essex and attributed to Sir T.Lawrence. 1. Christie's, 9 April 1895 (lot 286), sketch in NPG sale catalogue. 2. Collection of Sir B.J.Faudel-Phillips, 1927. 3. Collection of W.H.Callander. 4. Harriet Lane Johnson Collection, Smithsonian Institution, Washington. 5. Collection of T.F.Chavasse, 1900, exhibited *Loan Collection of Portraits*, Birmingham, 1900 (1). 6. Fundacion Lazaro Galdiano. Reproduced sale catalogue of Dollfus Collection, Galerie Georges Petit, Paris, 20–1 May 1912, IV, facing 14 (lot 1).

Undated Painting by an unknown artist. Collection of Mrs Spratt, 1932.

ETTY *William* (*1787–1849*)

Painter; studied at RA schools; first exhibited at RA, 1811; travelled on the continent; RA, 1828; famous for his ambitious and exuberant subject paintings, based on historical and mythological themes, where he delighted in the depiction of nude female models.

1368 Oil on millboard, $16\frac{1}{4} \times 12\frac{1}{2}$ inches (41·3 × 31·7 cm), by an UNKNOWN ARTIST, after a photograph by DAVID OCTAVIUS HILL and ROBERT ADAMSON of 1844. PLATE 314

Inscribed on the back in ink in a 19th century hand: Portrait of W. Etty R.A *Also on the back of the portrait is a letter from the artist James Linton to Billington of 17 July 1890, stating that the picture is 'a portrait of "William Etty" by himself & a very beautiful example of his work'.*

Collections: John Billington[1]; Sotheby's, 28 March 1903 (lot 305), bought E. Parsons; purchased from Leggatt Brothers, 1904.

Literature: H. Gernsheim, *Masterpieces of Victorian Photography* (1951), p 11; D. Farr, *William Etty* (1958), p 166; H. Schwarz, 'William Etty's "Self-Portrait" in the London National Portrait Gallery', *Art Quarterly*, XXI (Detroit, 1958), 391–6; *York Art Gallery Catalogue of Paintings, Volume II: English School 1500–1850* (1963), pp 35–6.

This painting is almost identical in size, composition and details, to one in the York Art Gallery, reproduced *York Catalogue* (see above), plate 64, both previously described as self-portraits. They are, however, of poor quality, and their entire dependence on the Hill and Adamson calotype photograph (examples in NPG, British Museum, Scottish NPG and elsewhere, plate 315) suggests the work of a copyist[2]; a variant photograph by Hill and Adamson, evidently done at the same sitting, shows Etty in a slightly different posture, and differs in several slight details. Both photographs are reproduced by Schwarz in the *Art Quarterly* (see above), figures 2–3, who suggests that they were taken in October 1844. The head, from the photograph on which the NPG portrait is based, was etched in reverse by S. J. B. Haydon (example in NPG), and reproduced as a woodcut, also in reverse, *Art Journal* (1849), p 13. Other self-portraits are discussed in the iconography below.

Description: Brown eyes and hair; dressed in a white collar, red stock (?), green neck-tie, dark coat; holding brown brushes and palette with splashes of white, red and blue paint; brown books to left; reddish curtain at left; rest of background brown.

1456 (6) Black chalk, heightened with Chinese white, on greenish-grey toned paper, $6 \times 5\frac{1}{2}$ inches (15·4 × 13·8 cm), by CHARLES HUTTON LEAR, 1845. PLATE 310

Inscribed in chalk (lower left): W Etty/Octr/1845

Collections: See *Collections:* 'Drawings of Artists, *c* 1845' by C. H. Lear, p 561.

Literature: Reproduced D. Farr, *William Etty* (1958), plate 1.

All three drawings of Etty by Lear were executed in the life school of the Royal Academy in 1845; Etty was a visitor in this year. One of them was enclosed by Lear in a letter to his family of 1845 (copy, NPG archives): '*No. 1 is a sketch of Etty and, though I say it, very like*'.

1456 (7) Black chalk, heightened with Chinese white, on brownish toned paper, $6\frac{1}{8} \times 4\frac{3}{8}$ inches (15·6 × 11·1 cm), by CHARLES HUTTON LEAR, 1845. PLATE 311

Inscribed in chalk (lower right): Etty/Etty

[1] There is a letter from Billington of 4 February 1903 offering the portrait to the NPG trustees (NPG archives); he states that he purchased it some twenty-five years earlier, but does not state from what source.

[2] The differences between the paintings and the photograph are negligible, and can almost entirely be accounted for by the differences in technique. Although Farr (see above) includes both the paintings in his catalogue of Etty's work, he expresses doubt about their status. Either the NPG or York version may have been the painting in the William Cox sale, Robinson and Fisher, 14 March 1883 (lot 146); a slight sketch in Scharf's sale catalogue (NPG library) shows what appears to be the same composition. No details of size are, however, given in the catalogue.

Collections: As for 1456 (6) above.

Literature: R.L. Ormond, 'Victorian Student's Secret Portraits', *Country Life*, CXLI (1967), 288, reproduced 289.

1456 (8) Black chalk, heightened with Chinese white, on greenish-grey toned paper, $6\frac{1}{2} \times 5\frac{7}{8}$ inches (16·6 × 15 cm), by CHARLES HUTTON LEAR, 1845. PLATE 312

Inscribed in chalk (*lower right*): Etty

Collections: As for 1456 (6) above.

On the reverse is a fragment of a drawing of a seated female nude.

595 Marble bust, $31\frac{1}{4}$ inches (79·5 cm) high, by MATTHEW NOBLE, 1850. PLATE 313

Incised on the back, below the shoulders: WILLIAM ETTY ESQ R.A *and below, on the socle:* M. NOBLE. SC. 1850./LONDON.

Collections: Purchased at the artist's sale, Christie's, 7 June 1879 (lot 192).

Exhibitions: RA, 1850 (1431), and *Art Treasures Exhibition*, Manchester, 1857 'Sculpture' (152).

This posthumous bust appears to have been based chiefly on photographs (see NPG 1368 above, and iconography below). It is not known why Noble undertook the bust, though he may have done so for speculative reasons. In 1917 the bust suffered some damage while being moved; the end of the nose was broken off, and a crack caused in the lower part of the draperies. What appears to have been a plaster model for the bust was formerly at Elswick Hall, Newcastle, listed in *Catalogue of Lough and Noble Models at Elswick Hall* (*c* 1928), p 69 (242).

ICONOGRAPHY A painting by himself is in the Manchester City Art Gallery (plate 309), exhibited *Etty Retrospective Exhibition*, Society (now Royal) of Arts, 1849 (LXXVII), *Society of Artists*, Birmingham, 1853 (324), and elsewhere, reproduced D. Farr, *William Etty* (1958), plate 20 (most of the self-portraits are discussed by Farr, pp 152–3), engraved and published by C.W. Wass, 1849 (example in British Museum); related versions or copies are in the Fogg Art Museum, Cambridge, Mass; collection of J. Lunn, Bradford; Christie's, 20 February 1959 (lot 160), bought Douglas; Christie's, 21 July 1961 (lot 143), bought Atty; another painting by himself is in the collection of Ir. Thomas H. Etty, Leidschendan; a painting called Etty by himself (with the figures of a man, woman and child, said to be one of the artist's brothers, either Walter or John Etty, and family, in a domestic interior) is in the collection of Mrs Ursula Ali-Khan, a descendant of Walter Etty; the identification of Etty, shown with a sketch-book on the right, is probably correct (the picture, dated by Dennis Farr to *c* 1807–10, is much earlier than other recorded portraits of Etty, but the features agree well with later images of him); a drawing, probably by himself, of *c* 1840 is in the York Art Gallery; a drawing by himself is in the Ashmolean Museum, Oxford, exhibited *British Portraits*, RA, 1956–7 (707), engraved anonymously, published 1834 (example in NPG), for 'Arnold's Magazine of the Fine Arts'; a pencil copy by J.H. Mote (possibly for the engraving) is in the York Art Gallery; a water-colour head and shoulders (similar to that in the Ashmolean drawing) attributed to Etty was sold at Sotheby's, 18 December 1969 (lot 69); a drawing attributed to J. Linnell was in the collection of A.R. Hakoaumoff, 1935, reproduced as a woodcut, *ILN*, VII (1845), 29; a profile drawing by W. Dyce was exhibited *SKM*, 1868 (564), lent by R.E. Smithson; a water-colour by W. Nicholson is in the Royal Scottish Academy, Edinburgh, and a replica is in the Scottish NPG; a drawing by H. Baines of 1847 is in the King's Lynn Museum and Art Gallery, Norfolk; a drawing by W.H. Hunt (sketching in the life school) is reproduced Hunt, *Pre-Raphaelitism and the Pre-Raphaelite Brotherhood* (1905), I, 94; a medal by G.G. Adams, for the Art Union (example in NPG), was exhibited *RA*, 1872 (1464); an etching by W. Gale, was published Day & Son, 1864 (example in NPG); there is a photograph by J. Watkins and a woodcut from an unidentified magazine in the NPG, and various woodcuts and engravings, mainly after known types, in the British Museum; an engraving by C.W. Wass, from a daguerreotype of 1849, was published D. Bogue, for A. Gilchrist, *Life of William Etty, RA.* (1855), I, frontispiece.

ETWALL *Ralph* (*1804–82*)

MP for Andover.

54 See *Groups:* 'The House of Commons, 1833' by Sir G. Hayter, p 526.

EVANS *Sir George de Lacy* (*1787–1870*)

General; served in Peninsula; engaged at Waterloo; MP from 1831; commanded British Legion aiding Christina of Spain against Don Carlos, 1835–7; engaged in the Crimea; general, 1861.

2158 Miniature, water-colour and body colour on ivory, $3\frac{1}{4} \times 2\frac{3}{4}$ inches ($8\cdot3 \times 7$ cm), by an UNKNOWN ARTIST, *c* 1840. PLATE 316

Collections: Presented by Bernald Falk, 1927.

The early history of this miniature is unknown. It probably commemorates Evans' command of the British Auxiliary Legion in Spain, 1835–7. He is apparently dressed in his uniform as colonel of the Legion, with the orders awarded him for his services in Spain: the star and sash of the order of Charles III, and the star of the order of St Ferdinand, awarded him sometime between 1835–40. He is also wearing the star of the Bath (awarded 1838), and another unidentified star. The medals are probably Peninsular and Waterloo ones, rather than Crimean ones; Evans is not wearing the orders of Mejidie or the Légion d'Honneur awarded him in 1856. The date 1840 agrees well with the apparent age of the sitter. The style of the coat is associated with a pre-1840 fashion, but Evans was a Peninsular officer and likely to continue with the styles of his youth. Information on the uniform and orders was kindly communicated by W. Y. Carman of the National Army Museum. The previous attribution of the miniature to Sir W. C. Ross is not very convincing.

Description: Brown eyes, dark brown hair with grey streaks. Dressed in a white collar, red uniform, gold collar and epaulettes, blue sash with a white stripe in the middle. Background colour blue-grey.

ICONOGRAPHY A painting by an unknown artist was in the collection of A. N. Morgan, and another by J. Simpson was exhibited *RA*, 1842 (513); miniatures by E. Upton were exhibited *RA*, 1851 (922), and 1856 (814); there is a bust by an unknown artist in the Brighton Pavilion; a lithograph by J. H. Lynch, after a photograph by R. Fenton of *c* 1855 (possibly that in the Gernsheim collection), was published Colnaghi, 1855 (example in NPG), and exhibited *RA*, 1865 (870); there is a lithograph by M. O'Connor, published Clerk, 1833 (example in NPG), and one by M. Gauci, after A. E. Chalon, published Colnaghi, 1834 (example in British Museum); an engraving by G. Zobel, after a painting by R. Buckner, was published Colnaghi, 1856 (example in NPG), and three woodcuts were published *ILN*, VIII (1846), 128; XXVI (1855), 128; and LVI (1870), 101, the latter after a photograph by E. Edwards, which is reproduced L. Reeve, *Men of Eminence* (1865), III, 79; another photograph by R. Fenton of *c* 1855 is reproduced *Country Life*, LXI (1927), 670.

EVANS *Robert* (*1773–1849*)

Father of George Eliot; estate agent to Francis Newdigate for his estates at Kirk Hallam, Derbyshire, and Arbury, Warwickshire; married, as his second wife, Christiana Pearson, 1813, by whom he had three children, Christiana, Isaac and Mary Ann, the last famous as a novelist under her writing name of George Eliot.

1232a Water-colour on paper, $7\frac{1}{4} \times 5\frac{5}{8}$ inches ($18\cdot5 \times 14\cdot2$ cm), by CAROLINE BRAY, 1841, after a miniature by an UNKNOWN ARTIST. PLATE 317

Collections: The artist, presented by her, 1899.

In a letter to Sir Lionel Cust of 5 July 1899 (NPG archives), Mrs Bray wrote: '*When I copied the miniature of Mr Evans in 1841 which belonged to his daughter, I understood that Carlisle had four or five*

more copies for the different members of the family'. The identity of Carlisle is not known, and neither his copies nor the original miniature are known to have survived. These are the only recorded portraits of Robert Evans. George Eliot met Mrs Bray in 1841, and became an intimate of her family. Her early intellectual development owed much to this friendship.

Description: Ruddy complexion, brown eyes and hair. Seated in a red chair.

EVEREST *Sir George* (*1790–1866*)

Military engineer; surveyed Java, 1813–5; surveyor-general of India; published two accounts of measurements on the Meridional Arc of India; Mount Everest is named after him.

2553 Pencil on blue paper, $9\frac{7}{8} \times 8$ inches (25 × 20·4 cm), attributed to WILLIAM TAYLER, 1843. PLATE 318

Inscribed in pencil (*lower right*): July 30/43 *and below:* Colonel Everest.

Collections: Colonel Bontein; by descent to his son, J.S.Bontein; L.F.Everest, the sitter's son, who married J.S.Bontein's daughter, presented by him, 1932.

The donor wrote about this portrait (letter of 12 July 1932, NPG archives): '*The history of this pencil sketch is peculiar & I think interesting. It was taken on July 30th 1843, by a British Officer of the Army, who was a mutual friend of my father, the late Lord Lawrence (then Governor General of India), and the late Colonel Bontein. It passed into the possession of Col Bontein, who was fond of collecting momentos etc, and afterwards into the possession of his son the late Mr J.S.Bontein, whose daughter I married, & was ultimately handed over to us 40 years ago, or upwards*'. Colonel Bontein was personal assistant to Everest at Dehra Dun from 1838–42[1]; they both had houses at Mussorie in 1843, where this drawing was probably executed. Although Tayler was in the Bengal Civil Service, and not in the army, which contradicts the evidence of the donor, the attribution to him seems plausible. It was first suggested by Percy Macqueen of the Madras Record Office in a letter of 19 January 1933 (NPG archives). Tayler was in India from 1829–43, and did several similar portrait drawings in profile, which are close in style to the NPG drawing.[2]

ICONOGRAPHY There is a painting by Lady Burrard, after a photograph, at the Royal Artillery Institution, Woolwich, and various photographs in the NPG.

EVERSLEY *Charles Shaw-Lefevre, Viscount* (*1794–1888*)

Speaker of the House of Commons.

54 See *Groups:* 'The House of Commons, 1833' by Sir G.Hayter, p 526.

342, 3 See *Groups:* 'The Fine Arts Commissioners, 1846' by J.Partridge, p 545.

EWART *William* (*1798–1869*)

MP for Liverpool.

54 See *Groups:* 'The House of Commons, 1833' by Sir G.Hayter, p 526.

FAIRBANK *William* (*1771–1846*)

Slavery abolitionist.

599 See *Groups:* 'The Anti-Slavery Society Convention, 1840' by B.R.Haydon, p 538.

[1] See Major V.C.P.Hodgson, *List of the Officers of the Bengal Army, 1758–1834* (1927), I, 179.

[2] For illustrations of Tayler's portraits see W.Tayler, *Thirty-Eight Years in India* (1881–2), 2 vols.

FAIRLIE *John*

Married Edmund Power's granddaughter, Louisa Purves.

4026 (22) See *Collections:* 'Drawings of Men About Town, 1832–48' by Count A. D'Orsay, p 557.

FANCOURT *Charles St John* (*1804–75*)

MP for Barnstaple.

54 See *Groups:* 'The House of Commons, 1833' by Sir G. Hayter, p 526.

FARADAY *Michael* (*1791–1867*)

Scientist; assistant to Sir Humphry Davy; liquified chlorine and other gases; announced discovery of benzol, 1825; discovered magneto-electricity, 1831; constructed a 'voltameter'; established diamagnetic repulsion; originated theory of atom as 'centre of force'; one of the most brilliant scientists of his time.

269 Oil on canvas, $35\frac{3}{4} \times 28$ inches (90.8×71 cm), by THOMAS PHILLIPS, 1841–2. PLATES 320, 321

Signed and dated on the front of the trough (bottom left): TP [*in monogram*] 1842

Collections: John Scott Russell,[1] purchased from him through the artist's son, Henry Phillips, 1868.[2]

Exhibitions: RA, 1842 (170).

Literature: T. Phillips 'Sitters Book' (copy of original MS, NPG archives), under 1842; G. Scharf, 'TSB' (NPG archives), XIII, 76.

In a letter of 27 March 1841 from Brighton (NPG archives), Faraday wrote to Phillips:

My dear Sir

I think myself bound to let you know that I shall return to town on Wednesday night & can be with you any time afterwards. I shall be at the Royal Institution on Tuesday for an hour & if I found a message from you saying when you next require me it would enable me to arrange other matters.

 Ever Dear Sir,
 Your faithful
 M. Faraday.

On 24 June 1841, Faraday wrote again (letter in NPG archives): '*I have just received the portrait & note & am very much obliged to you for both of them*'. Phillips presumably worked on the portrait subsequently, hence the inscribed date. In a third letter of 21 or 27 January 1844 (noted by G. Scharf, NPG archives), Faraday wrote to Phillips to say that '*a sharp attack of lumbago, my first, confines me to my room excuse me*'. If this refers to sittings for another portrait, there is no further record of it.

 The trough, brass tube and furnace flames, in the bottom right-hand corner of the NPG picture, presumably relate to Faraday's metallurgical experiments. There is a photogravure reproduction of the portrait, published Photographische Gesellschaft Berlin (example in British Museum).

Description: Healthy complexion, light grey eyes, brown hair with grey streaks. Dressed in a black stock, white shirt and black coat. Light grey-green trough with wood support and brass tube. Bottom right-hand corner orange and red. Rest of background dark greenish-grey.

2515 (24) Black chalk on green-tinted paper, $14\frac{5}{8} \times 10\frac{5}{8}$ inches (37.2×27 cm), by WILLIAM BROCKEDON, 1831. PLATE 319

Dated (lower left): 26.12.31

Collections: See *Collections:* 'Drawings of Prominent People, 1823–49' by W. Brockedon, p 554.

[1] A distinguished inventor and engineer, see *Dictionary of National Biography*.

[2] Five letters from Phillips to Scharf concerning the portrait and its purchase (NPG archives); according to Phillips, who remembered Faraday sitting for it, this portrait was not commissioned, but was given by the artist to Russell, a mutual friend of his and Faraday.

Accompanied in the Brockedon Album by an undated letter from the sitter.

748 Marble bust, 32 inches (81·3 cm) high, by SIR THOMAS BROCK, 1886, after the head of a statue by JOHN HENRY FOLEY, 1877. PLATE 323

Collections: Commissioned and presented by a Committee of Gentlemen, 1886.

Foley's marble statue is in the Royal Institution, London, reproduced as a woodcut *ILN*, LXX (1877), 233. Brock's bust is not an exact replica of the head; he has given Faraday's face a more animated expression, and has altered the folds of the drapery. The bust was commissioned in May 1884, and finished in February 1886. Sir William Frederick Pollock who headed the Committee of Gentlemen (he did not disclose their identity or their motive—presumably admiration of Faraday) wrote (letter of 25 May 1884, NPG archives): '*the bust would represent him at a much later period (he died in 1867) & when the face & head had gained a grander development –Nor is the picture by Phillips, to my thinking, one which did justice to Faraday, even at the time when it was painted*'. An earlier bust by Foley of 1871 is in the Royal Society, London.

ICONOGRAPHY

This does not include photographs, of which there are several examples in the NPG (see plate 322), and woodcuts and reproductions of others. Several are reproduced L. P. Williams, *Michael Faraday* (1965).

1823 Bust by E. H. Baily. Crystal Palace Portrait Gallery, 1854.

c1829 Painting by H. W. Pickersgill. Royal Institution, London.
Exhibited *RA*, 1829 (226), *SKM*, 1868 (487), and *VE*, 1892 (240).
Reproduced R. Appleyard, *A Tribute to Michael Faraday* (1931), frontispiece. Engraved by S. Cousins, published Colnaghi, 1830 (example in British Museum), and engraved by J. Cochran, published Fisher, 1833 (example in NPG), for Jerdan's 'National Portrait Gallery'.

c1830 Bust by E. H. Baily. Exhibited *RA*, 1830 (1244).
Plaster casts: University Museum, Oxford, and The Athenaeum, London; the latter reproduced H. Ward, *History of the Athenaeum, 1824–1925* (1926), facing p26. The type was lithographed by W. Drummond, published McLean, 1835 (example in NPG), for 'Portraits of Members of the Athenaeum'.

1831 Drawing by W. Brockedon (NPG 2515 (24) above).

1836 Engraving by D. Maclise, published *Fraser's Magazine*, XIII (1836), facing 224, as no. 69 of his 'Gallery of Illustrious Literary Characters'. Study: Victoria and Albert Museum (F88), together with another different drawing.

1837 Lithograph by Miss H. S. Turner, after a drawing by E. U. Eddis (example in NPG).

1839 Engraving by C. Turner, published by the artist, 1839 (example in British Museum).

1842 Painting by T. Phillips (NPG 269 above).

1846 Woodcut published *ILN*, IX (1846), 184.

c1846 Medallion by L. Wyon. Exhibited *RA*, 1846 (988).

1851 Lithograph by T. H. Maguire, published G. Ransome, 1851 (example in NPG), for 'Ipswich Museum Portraits'.

1852 Painting by J. Z. Bell. University of Glasgow.

1852 Drawing by G. Richmond. Royal Institution, London.
Exhibited *SKM*, 1868 (534), and *VE*, 1892 (357). Engraved by W. Holl, engraving exhibited *RA*, 1870 (860).

1855 'Michael Faraday Lecturing at the Royal Institution' by A. Blaikley. Collection of the Faraday Society. Reproduced R. Appleyard, *A Tribute to Michael Faraday* (1931), facing p34. Anonymous lithograph

(example in British Museum); a similar lithograph, coloured in oils by the artist, is in the Hunterian Museum, Glasgow (plate 324).

c1855 Pastel by A. Blaikley. Collection of Ernest Blaikley.

c1855(?) Bust by M. Noble. Royal Institution, London. Possibly the bust by Noble exhibited *RA*, 1855 (1510), and *Art Treasures of the United Kingdom*, Manchester, 1857, 'Sculpture' (133), lent by the sitter. A model, possibly for this bust, was formerly at Elswick Hall, Newcastle, listed in *Catalogue of Lough and Noble Models at Elswick Hall* (1928), p64 (223). A small ivory bust by Noble is also in the Royal Institution.

1857 Painting by E. Armitage (with Lord Wrottesley, Mr Grove and Mr Gaissiot). Royal Society, London.

c1860 Engraving by H. Adlard (with Tyndall). Reproduced A. S. Eve and C. H. Creasey, *Life and Work of John Tyndall* (1945), facing p91.

1864 'Intellect and Valour of Great Britain', engraving by C. G. Lewis, after T. J. Barker, published J. G. Browne, Leicester, 1864 (example in NPG); key-plate, published Browne, 1863 (example in British Museum).

1871 Bust by J. H. Foley. Royal Society, London.

1873 Bust by M. Noble. Royal Society, London.
 Reproduced R. Appleyard, *Faraday* (1931), facing p62.

1877 Statue by J. H. Foley. Royal Institution, London.
 Reproduced as a woodcut *ILN*, LXX (1877), 233. Marble copy of the head by Sir T. Brock (NPG 748 above).

c1926 Painting by G. Harcourt. Institution of Electrical Engineers, London.

c1943 Bust by H. E. D. Bate. Exhibited *RA*, 1943 (940).

Undated Painting by A. Blaikley (based on a photograph by Mayall). Royal Society, London.

Undated Painting by H. S. Hyde. Burndy Library, Norwalk, USA.

Undated 'Faraday Lecturing to Victorian Scientists', bronze plaque by W. B. Fagan. Imperial Chemical House, Westminster. Reproduced A. S. Eve and C. H. Creasey, *Tyndall* (1945), facing p116.

Undated Steel plaque by F. J. Halnon. Reproduced Sir R. A. Hadfield, *Faraday and his Metallurgical Researches* (1931), frontispiece.

Undated Various lithographs and engravings (examples in NPG and British Museum).

FARNBOROUGH *Charles Long, 1st Baron* (*1761–1838*)
 Politician and connoisseur.

793 See entry for the Earl of Aberdeen, p3.
 See also forthcoming Catalogue of Portraits, 1790–1830.

FARNHAM *Henry Maxwell, 7th Baron* (*1799–1868*)
 MP for County Cavan.

54 See *Groups*: 'The House of Commons, 1833' by Sir G. Hayter, p526.

FARREN *William* (*1786–1861*)

Actor; first appeared on the stage in Plymouth, and subsequently in Dublin; played Sir Peter Teazle at Covent Garden, 1818; played a great variety of comic roles at Covent Garden, and later at Drury Lane and the Haymarket; manager of the Strand and Olympic theatres, 1850–3; retired, 1855; excelled in character parts, particularly as an old man.

1440 Oil on canvas, 36 × 28¼ inches (91·5 × 71·7 cm), by RICHARD ROTHWELL, *c* 1829(?). PLATE 325

Collections: Oswald Hartley, purchased from him, 1906.

Exhibitions: Royal Hibernian Academy, 1829, according to Strickland.

Literature: W. G. Strickland, *Dictionary of Irish Artists* (1913), II, 307.

Description: Pallid complexion, red lips, light brown eyes, greyish-brown hair. Dressed in a black stock, white shirt, red waistcoat, black coat, and red and gilt fob(?). Seated in a red and gilt armchair. Background colour dark brown.

ICONOGRAPHY This does not include popular prints of Farren in character, for which see L. A. Hall, *Catalogue of Dramatic Portraits in the Theatre Collection of the Harvard College Library* (Cambridge, Mass), II (1931) 9–11 (various examples in NPG and British Museum). For portraits in the Garrick Club see C. K. Adams, *A Catalogue of Pictures in the Garrick Club* (1936).

1818 Painting by G. Clint (as Lord Ogleby in Colman and Garrick's 'The Clandestine Marriage', with Farley and Jones). Garrick Club, London. Exhibited *RA*, 1819 (48).

c 1818 Painting by S. de Wilde (as Lord Ogleby). Victoria and Albert Museum.
Engraved by J. Hopwood junior, published Simpkin and Marshall, 1818 (example in Harvard Theatre Collection), for Oxberry's 'New English Drama'. An engraving by F. Waldeck, after a different portrait by de Wilde of Farren, as Lord Ogleby, was published H. Berthoud junior, 1821 (example in Harvard Theatre Collection). Another version of the painting by S. de Wilde is in the Garrick Club, London.

c 1820 Painting by S. de Wilde (as Lovegold in Fielding's 'The Miser'). Exhibited *RA*, 1820 (876), and *SKM*, 1868 (115), lent by W. C. Cater.

1822 Engraving by C. Picart, after A. Wivell, published Wivell, 1822 (example in NPG).

c 1822 Painting by G. Clint. Garrick Club, London.
Engraved by J. Thomson, published J. Asperne, 1822 (example in NPG), for the *European Magazine*.

c 1822 Painting by S. Drummond. Exhibited *RA*, 1822 (345).

c 1829(?) Painting by R. Rothwell (NPG 1440 above).

c 1841 Cabinet statue by C. A. Rivers (as the Spanish Curate). Exhibited *RA*, 1841 (1263).

c 1842 Bust by J. H. Foley. Exhibited *RA*, 1842 (1395).

c 1845 Miniature by T. Carrick. Garrick Club, London.
Exhibited *RA*, 1845 (775), and *Special Exhibition of Portrait Miniatures*, South Kensington Museum, 1865 (3040). Engraved by H. Robinson, published E. Gambart, 1846 (example in British Museum).

c 1855 Daguerreotype by Mayall, reproduced as a woodcut *ILN*, XXVII (1855), 100.

Undated Painting by G. Clint. Victoria and Albert Museum.
Possibly related to the 1820 portrait by Clint (see above).

Undated Painting(?) called Farren. Christie's, 22 July 1871 (lot 28).

Undated Painting by G. H. Harlow. Memorial Theatre Museum, Stratford-on-Avon, 1896.

Undated Lithograph by J. H. Lynch, published Engelmann & Co (example in British Museum).

Undated Anonymous photograph (example in NPG).

FAZAKERLEY *John Nicholas* (*1787–1852*)
MP for Peterborough.

54 See *Groups:* 'The House of Commons, 1833' by Sir G. Hayter, p 526.

FEILDON *Sir William, Bart* (*1772–1859*)

MP for Blackburn.

54 See *Groups:* 'The House of Commons, 1833' by Sir G. Hayter, p 526.

FELLOWS *Sir Charles* (*1799–1860*)

Traveller and archaeologist; discovered ruins of Xanthus and of Tlos, 1838; published *Journal*, 1839; discovered thirteen ancient cities in Lycia, and published an account of his discoveries, 1841; knighted, 1845.

2515 (97) Black and red chalk, with touches of Chinese white, on greenish-grey tinted paper, $15 \times 10\frac{3}{4}$ inches ($38 \times 27 \cdot 3$ cm), by WILLIAM BROCKEDON, 1845. PLATE 326

Dated (lower left): 16.5.45

Collections: See *Collections:* 'Drawings of Prominent People, 1823–49' by W. Brockedon, p 554.

Accompanied in the Brockedon Album by a letter from the sitter, dated 9 May 1842.

ICONOGRAPHY The only other recorded portrait of Fellows is a painting by H. W. Phillips, exhibited *RA*, 1845 (217).

FENTON *John* (*c 1791–1863*)

MP for Rochdale.

54 See *Groups:* 'The House of Commons, 1833' by Sir G. Hayter, p 526.

FERGUSON *Robert* (*before 1773–1840*)

MP for Kirkcaldy.

54 See *Groups:* 'The House of Commons, 1833' by Sir G. Hayter, p 526.

FERGUSON *Sir Ronald Crauford* (*1773–1841*)

General and MP for Nottingham.

54 See *Groups:* 'The House of Commons, 1833' by Sir G. Hayter, p 526.

316a (48) See *Collections:* 'Drawings by Sir F. Chantrey' in forthcoming Catalogue of Portraits, 1790–1830.

FERGUSSON *Robert Cutlar* (*1768–1838*)

MP for Kirkcudbright.

54 See *Groups:* 'The House of Commons, 1833' by Sir G. Hayter, p 526.

FERNELEY *John* (*1782–1860*)

Animal painter; son of a wheelwright, and apprenticed to his father's trade; studied under Ben Marshall, 1803; pictures of Quorn hunt commissioned by Assheton Smith, 1806 onwards; from this period enjoyed widespread patronage, and became the most popular horse painter of the period; settled at Melton Mowbray, 1814.

2024 Oil on canvas, 30×25 inches ($76 \cdot 2 \times 63 \cdot 5$ cm), by HENRY JOHNSON, 1838. PLATE 327

Inscribed on the back of the canvas: Portrait of John Ferneley Esquire/of Melton Mowbray/painted by/ Henry Johnson – /July 1838.

Collections: Alfred Jones of Bath, presented by him, 1924.

Exhibitions: RA, 1839 (1182); *Leicestershire Hunting Pictures*, City of Leicester Museum and Art Gallery, 1951 (23); *John Ferneley, 1782–1860*, City of Leicester Museum and Art Gallery, 1960 (55).
Literature: Major G. Paget, *The Melton Mowbray of John Ferneley* (1931), reproduced facing p 1.

The early history of this picture after its exhibition at the *RA* is not known. Johnson married Ferneley's daughter, Sarah (1812–1903), in the year in which this portrait was painted.

Description: Healthy complexion, blue-grey eyes, soft brown hair, grey whiskers. Dressed in a black stock, white shirt, dark red waistcoat, black coat. Painting of grey and chestnut stallions fighting in the background. Splashes of white and carmine paint on the palette. Background colour dark brown.

ICONOGRAPHY A painting by himself (indoors, with his family), and a painting by J. Jackson, were sold at Sotheby's, 15 May 1963 (lots 87 and 93); a painting by himself (outdoors, with his family) was in the collection of T. B. Yuille, reproduced W. S. Sparrow, *Book of Sporting Painters* (1931), facing p 164; a painting by himself (with his daughter and others) is reproduced S. Sitwell, *Conversation Pieces* (1936), p 83; a painting by himself (with his favourite mare) is reproduced *Apollo*, XL (1944), 30; a painting by C. L. Ferneley of 1866, then in the collection of Sir Charles Buchanan, is reproduced Major G. Paget, *The Melton Mowbray of John Ferneley* (1931), facing p 102; Ferneley appears in his own painting of 'The Quorn at Quenby' in the collection of Sir R. Bellingham Graham, reproduced W. S. Sparrow, *British Sporting Artists* (1922), facing p 192; an oil study for this picture is in the Leicester Museum and Art Gallery; a terracotta medallion by J. Hancock was exhibited *RA*, 1858 (1269).

FEUILLET DE COUCHE *F. (probably Baron Felix)* (*1798–1887*)

Master of ceremonies to Napoleon III.

2515 (65) See *Collections:* 'Drawings of Prominent People, 1823–49' by W. Brockedon, p 554.

FEVERSHAM *William Duncombe, 2nd Baron* (*1798–1867*)

MP for Yorkshire, North Riding.

54 See *Groups:* 'The House of Commons, 1833' by Sir G. Hayter, p 526.

FIELDEN *John* (*1784–1849*)

Cotton manufacturer, factory reformer, and MP for Oldham.

54 See *Groups:* 'The House of Commons, 1833' by Sir G. Hayter, p 526.

FIELDING *Anthony Vandyke Copley* (*1787–1855*)

Water-colourist; son of the painter, Nathan Fielding (fl 1775–1814); studied under John Varley; began exhibiting at the (now Royal) Society of Painters in Water-Colours, 1810, of which he subsequently became president; became a fashionable drawing-master; best known for his water-colour landscapes and seascapes; a popular and prolific artist.

601 Oil on canvas, 24 × 18¼ inches (61 × 46 cm), by SIR WILLIAM BOXALL, *c* 1843. PLATE 328

Collections: The sitter; by descent to his daughter, Miss Fielding, who returned it to the artist; by descent to his niece, Mrs Longland, and presented by her, 1880.

Exhibitions: RA, 1843 (559).

According to the husband of the donor, the Rev C. P. Longland (letters of 27 January and 4 March 1880, NPG archives), this portrait was given to Fielding in exchange for a picture by him of the Sussex Downs, which was subsequently acquired by the Victoria and Albert Museum (possibly the water-colour, *South Downs, Sussex*). After her father's death in 1855, Miss Fielding gave the portrait back to

Boxall, expressing a hope that it might some day enter a worthy public collection. Boxall himself spoke of it as a portrait that should be offered to the National Portrait Gallery.

Description: Brown eyes, greyish hair. Dressed in a black stock, white shirt, and black suit. Large sea-picture on the right. Seated in a red chair, apparently holding a book containing his own water-colours. Background very dark brown.

ICONOGRAPHY A drawing called Fielding by J.C.Berger is in the Stads Museum, Linköping, Sweden, and a painting called Fielding by an unknown artist is in the collection of Mrs Bohener.

FINCH *George* (*1794–1870*)

MP for Stamford.

54 See *Groups:* 'The House of Commons, 1833' by Sir G.Hayter, p 526.

FITZGERALD *Edward* (*1809–83*)

Poet and translator; friend of Tennyson at Trinity College, Cambridge; lived a retired life in Suffolk; famous for his translation of the *Rubaiyat of Omar Khayyám*, published anonymously, 1859; also translated Sophocles and Calderon.

1342 Miniature, water-colour on ivory, $2\frac{1}{2} \times 2$ inches ($6\cdot5 \times 5$ cm), by EVA, LADY RIVETT-CARNAC, after a photograph of 1873. PLATE 329

Signed (centre right): E.R–C

Collections: Mrs Alice Maud Orr, purchased from her, 1903.

This miniature is based on one of three photographs taken by Cade and Whiten of Ipswich in 1873 (plate 331). FitzGerald wrote about them to Mrs Browne on 17 November 1873:

The Artist always makes three views; but I couldn't face the light of the Machine, so my lovely full face was all blurred: and only a side face, and a looking down one, came out. They are so good-looking (comparatively) that upon my honour I shd never have guessed they were meant for me; and I really do not believe that any one else would.[1]

There is an anonymous engraving after the 'side face' photograph (used by Lady Rivett-Carnac), and another, after the 'looking down one', was published R.Bentley, 1895 (examples in NPG). The latter was also engraved for the *Letters and Literary Remains of Edward FitzGerald*, edited W.A.Wright (1903–7), I, frontispiece. Mrs Orr was the great-granddaughter of George Crabbe the poet, and the niece of the Rev George Crabbe, in whose home FitzGerald died. Lady Rivett-Carnac was the daughter of James Orr, and the wife of Sir George Rivett-Carnac, 6th Bart, whose first wife was Emily, daughter of the Rev George Crabbe[2]. Mrs Orr wrote about the miniature (letter of 9 March 1903, NPG archives):

E.F.G. never had his miniature painted from life – but Mrs Rivett-Carnac had her aunt Miss Mary Crabbe to help her in her work by describing exactly his colouring & expression and I do think it is well done and a perfect likeness.

Miss Mary Crabbe, of Brighton, also provided the photograph from which the miniature is copied.

Description: Blue eyes, greyish hair. Dressed in a white shirt, black stock, brown coat with velvet collar. Background colour greyish-green, heightened with mauve.

ICONOGRAPHY FitzGerald disliked the idea of sitting for portraits which explains why few are recorded; a drawing by J.Spedding, executed when FitzGerald was an undergraduate, is in the Fitzwilliam Museum,

[1] From an unpublished letter in the possession of Peter Kenworthy Browne, quoted in F.Miles, 'Samuel Laurence' (typescript copy, NPG library).

[2] Information provided by Mrs Orr in an interview at the NPG, 2 March 1903. She does not state her exact relationship to Lady Rivett-Carnac or to Miss Mary Crabbe.

Cambridge (plate 330); a similar drawing, apparently by Spedding and probably of FitzGerald, is in the collection of J. H. Spedding; a painting called FitzGerald by T. Churchyard was exhibited *Portraits in Berkshire*, Reading Museum and Art Gallery, 1964 (24).

FLAXMAN *John* (*1755–1826*)

Sculptor and draughtsman.

2515 (32) See *Collections*: 'Drawings of Prominent People, 1823–49' by W. Brockedon, p 554.

See also forthcoming Catalogue of Portraits, 1790–1830.

FLEETWOOD *Sir Peter Hesketh, Bart* (*1801–66*)

Founder of the town of Fleetwood, and MP for Preston.

54 See *Groups*: 'The House of Commons, 1833' by Sir G. Hayter, p 526.

FLEMING *Charles Elphinstone* (*1774–1840*)

MP for Stirlingshire.

54 See *Groups*: 'The House of Commons, 1833' by Sir G. Hayter, p 526.

FOLEY *John Henry* (*1818–74*)

Sculptor; studied in Dublin and at the RA schools, London; ARA, 1849; RA, 1858; executed subject works like 'Innocence' and 'Egeria', large public statues and busts; one of the best known sculptors of the period.

1541 Plaster medallion, clay-coloured, 10½ inches (26·7 cm) diameter, by CHARLES BELL BIRCH, *c* 1876.
PLATE 332

Inscribed on the rim: J. H. FOLEY R. A. *and below the shoulders:* C. B. BIRCH SC.

Collections: The artist, purchased from his nephew, George von Pirch, 1909.

Exhibitions: RA, 1876 (1373); *Irish Exhibition*, London, 1888 (1076a).

A wax relief by Birch, apparently a study for this medallion (6½ × 5 inches, 16·5 × 12·7 cm), is in the Irish NPG, Dublin.

ICONOGRAPHY A painting by T. Mogford is in the Irish NPG, reproduced *Magazine of Art* (1901), p 515; a painting by E. Walker of 1847 is reproduced *Art Journal* (1849), p 49; a painting by an unknown artist, after a photograph, was in the collection of Miss Herrick, 1891, sketched by G. Scharf, 'TSB' (NPG archives), XXXVI, 30; a miniature by W. Egley was exhibited *RA*, 1868 (778); a bust by Sir T. Brock was exhibited *RA*, 1873 (1432), engraved by G. Stodart and reproduced *Art Journal* (1877), p 360; a woodcut, after a photograph by the London Stereoscopic Co, was published *ILN*, LXV (1874), 249, and a woodcut, after a photograph by J. Watkins (example in NPG), was published *ILN*, XXX (1857), 419; a photograph by E. Edwards is reproduced L. Reeve, *Men of Eminence*, I (1863), facing 13.

FOLKES *Sir William John Henry Browne, Bart* (*1786–1860*)

MP for Norfolk West.

54 See *Groups*: 'The House of Commons, 1833' by Sir G. Hayter, p 526.

FOLLETT *Sir William Webb* (*1798–1845*)

Attorney-general; called to the bar, 1824; MP from 1835; solicitor-general under Peel, 1834–5, and 1841; attorney-general, 1844; defended Lord Cardigan in the duel case, and appeared for Norton against Lord Melbourne.

1442 Oil on canvas, $16\frac{7}{8} \times 12\frac{1}{4}$ inches ($42 \cdot 7 \times 31$ cm), by SIR MARTIN ARCHER SHEE, c 1820. PLATE 333

Inscribed on a damaged label formerly on the stretcher: Sir William Follett/the great [*illegible*]/
Councillor of the Crown [?]/bar/Painted by Sir Martin Shee/R.A.

Collections: Purchased at Christie's, 31 May 1906 (lot 144).

The early history of this picture is unknown. The date is based on costume and the apparent age of the
sitter. There seems no reason to doubt that the portrait does represent Follett.

Description: Dark grey eyes, brown hair. Dressed in a white shirt, white stock and brown coat.
Glimpse of green landscape bottom right. Lower portion of sky yellow, upper portion dark blue.

ICONOGRAPHY A painting by F. R. Say is in the Royal Albert Memorial Museum, Exeter, exhibited
RA, 1835 (195), and *SKM*, 1868 (395), engraved by G. R. Ward, published McLean, 1842 (example in NPG);
another version is in the collection of Brigadier W. G. Carr, Ditchingham Hall; a third smaller version was
recorded in the collection of Mrs J. W. Croker, Kensington Palace, 1880, by G. Scharf, 'TSB' (NPG archives),
XXVII, 47; a painting by F. R. Say was sold from the Peel collection, Robinson and Fisher, 6–7 December 1917
(lot 56); it was begun in 1844, but interrupted by Follett's illness, and was never finished (see *Gentleman's
Magazine*, N.S. XXVII, 1847, 291); a painting by C. Stonhouse was exhibited *RA*, 1840 (507); a drawing by
J. Doyle is in the British Museum, lithographed anonymously, published T. McLean, 1845 (example in NPG); a
drawing by F. Stone is in the Scottish NPG; a marble statue by W. Behnes of 1849 is in Westminster Abbey,
exhibited *RA*, 1849 (1204), reproduced as a woodcut *ILN*, XV (1849), 164; a plaster cast is at Haldon Belvedere;
a marble bust by E. B. Stephens is in the Devon and Exeter Institution, exhibited *RA*, 1842 (1327); busts by
W. Behnes and C. A. Rivers were exhibited *RA*, 1843 (1520), and 1845 (1317); an engraving by H. T. Ryall, after
A. E. Chalon, was published Ryall, Fraser and Moon, 1836 (example in NPG), for 'Portraits of Conservative
Statesmen'; a woodcut was published *ILN*, VII (1845), 5.

FORBES *Edward* (*1815–54*)

Naturalist; brother of David Forbes (1828–76), the geologist; collected three thousand plant specimens
on a tour through Austria, 1838; made numerous other naturalist tours; professor of botany at King's
College, London, and lecturer of the Geological Society, 1842; later president of this Society; professor
of natural history at Edinburgh, 1854; published works on geology, botany and palaeontology.

1609 Bronze medal, 2 inches (5 cm) diameter, by LEONARD CHARLES WYON, based on a marble bust by
JOHN LOUGH of 1856. PLATE 334

Inscribed on the rim (*obverse*): EDWARDUS FORBES *and:* J. G. Lough D. L. C. Wyon F.

Inscribed on the reverse: NATURAE/ACER INVESTIGATOR/ET DILIGENS/Nat. MDCCCXV/Ob. MCDCCCLIV

Collections: Miss J. B. Horner, presented by her, 1911.

Another similar medal is in the Scottish NPG. The NPG medal was presented at the same time as a
medal of Henry Hallam by Wyon (NPG 1608). The head of Forbes is based on Lough's marble bust of
1856 in the Geological Museum, London.

ICONOGRAPHY A drawing by T. Faed is in the Scottish NPG, and so is a plaster bust by Sir J. Steell, of
which there is another cast in the Linnean Society, London; an enamel by H. Bone (from life) was exhibited *RA*,
1853 (649); a marble bust by N. N. Burnard is in Douglas, Isle of Man, exhibited *RA*, 1867 (1174); a bust by
J. G. Lough is in the Geological Museum, London, exhibited *RA*, 1856 (1309), and another version is at King's
College, London; a related plaster model was formerly at Elswick Hall, Newcastle, listed in *Catalogue of Lough
and Noble Models at Elswick Hall* (*c* 1928), p33 (101); a bust by E. H. Baily was in the Crystal Palace Portrait
Gallery, 1854; a lithograph by T. H. Maguire was published Ransome, 1852 (example in NPG), for 'Ipswich
Museum Portraits'; there is an anonymous lithograph in the NPG; a woodcut of the 'Meeting of the British Associ-
ation at Southampton' was published *ILN*, IX (1846), 185, and another, after a photograph, XXV (1854), 564.

FORD *Richard* (*1796–1858*)

Critic and traveller; spent several years making riding tours in Spain; contributed to the *Quarterly*, *Edinburgh* and *Westminster* reviews from 1837; published his famous *Handbook for Travellers in Spain*, 1845; published several other works.

1888 Oil on canvas, 12 × 10 inches (30·5 × 25·5 cm), by an UNKNOWN ARTIST, after a portrait by ANTONIO CHATELAIN of 1840. PLATE 335

Inscribed on the back of the canvas: Richard Ford

Collections: John Murray III; by descent to his son, A. Hallam Murray, and purchased from him, 1920.

The original portrait by Chatelain of 1840 is in the collection of Brinsley Ford, exhibited *S K M*, 1868 (426), reproduced *The Letters of Richard Ford*, edited R. E. Prothero (1905), facing p 172. John Murray first published Ford's *Handbook to Spain* in 1845. It was common for the firm to acquire portraits of their more successful authors.

Description: Ruddy complexion, brown eyes, dark brown hair. Dressed in green and brown neckerchief, white shirt and dark brown coat with red stripes on the lapels, and wearing a gold (?) cameo ring. Background colour green.

ICONOGRAPHY The following portraits are in the collection of Brinsley Ford, who has been most helpful in the preparation of this list: a painting by Miss E. Booth (the sitter's aunt) of *c* 1797; a painting by J. Gutierrez of 1831, executed at Seville; a painting by A. Chatelain of 1840; a water-colour by J. Becquer of 1832 (plate 336) (inscribed in Ford's hand, 'Majo Serio – as worn by me at the Feria de Mairena'), reproduced R. Ford, *Handbook for Spain* (1966 edition), I, frontispiece, and *Burlington Magazine*, LXXX (1942), 125; another water-colour by the same artist of 1832 (inscribed in Ford's hand, 'En zamarra the dress in which I rode over Spain'); a third water-colour by Becquer of 1832 (inscribed in Ford's hand, 'El Marsellés'), reproduced R. Ford, *Granada* (Granada, 1955), facing p 129; a drawing by J. F. Lewis of 1833 (inscribed, 'This portrait of me aet. 37, was taken at Seville in 1833 by John F. Lewis. Richard Ford'), reproduced *The Letters of Richard Ford*, edited R. E. Prothero (1905), frontispiece, and *Burlington Magazine*, LXXX (1942), 125; a water-colour by Lewis of 1833 (on a shooting expedition with the artist and others), reproduced Prothero, facing p 108, and *Burlington Magazine*, LXXX (1942), 126; several daguerreotypes. A posthumous painting by J. Phillip is in the collection of Colonel Stirling, Keir.

FORESTER *John George Weld Weld-Forester, 2nd Baron* (*1801–74*)

Peer.

54 See *Groups:* 'The House of Commons, 1833' by Sir G. Hayter, p 526.

FORESTER *George Cecil Weld Weld-Forester, 3rd Baron* (*1807–86*)

General, MP for Wenlock.

54 See *Groups:* 'The House of Commons, 1833' by Sir G. Hayter, p 526.

4026 (24) See *Collections:* 'Drawings of Men About Town, 1832–48' by Count A. D'Orsay, p 557.

FORESTER *Charles* (*1811–52*)

Son of 1st Baron Forester, and brother of John, 2nd Baron, and George, 3rd Baron (see above), soldier.

4026 (25) See *Collections:* 'Drawings of Men About Town, 1832–48' by Count A. D'Orsay, p 557.

FORSTER *Josiah* (*1782–1870*)

Slavery abolitionist.

599 See *Groups:* 'The Anti-Slavery Society Convention, 1840' by B.R.Haydon, p538.

FORSTER *Robert* (*1792–1871*)

Slavery abolitionist.

599 See *Groups:* 'The Anti-Slavery Society Convention, 1840' by B.R.Haydon, p538.

FORSTER *William* (*1784–1854*)

Quaker, philanthropist and slavery abolitionist.

599 See *Groups:* 'The Anti-Slavery Society Convention, 1840' by B.R.Haydon, p538.

FORTESCUE *Hugh Fortescue, 2nd Earl* (*1783–1861*)

MP for Devonshire North.

54 See *Groups:* 'The House of Commons, 1833' by Sir G.Hayter, p526.

FORTIA D'URBAIN *Agricole, Marquis de* (*1756–1843*)

French antiquary and patron of letters.

2515 (49) See *Collections:* 'Drawings of Prominent People, 1823–49' by W.Brockedon, p554.

FOULIS (?)

2515 (52) See *Collections:* 'Drawings of Prominent People, 1823–49' by W.Brockedon, p554.

FOX *Charles Richard* (*1796–1873*)

General, numismatist, and MP for Tavistock.

54 See *Groups:* 'The House of Commons, 1833' by Sir G.Hayter, p526.

FOX *Sackville Walter Lane* (*1800–74*)

MP for Helston.

54 See *Groups:* 'The House of Commons, 1833' by Sir G.Hayter, p526.

FOX *Samuel* (*1781–1868*)

Slavery abolitionist.

599 See *Groups:* 'The Anti-Slavery Society Convention, 1840' by B.R.Haydon, p538.

FOX *William Johnson* (*1786–1864*)

Preacher, politician and author; attained celebrity at South Place Chapel, specially built for him, 1824; co-editor of the *Monthly Repository*; disowned by the unitarians because of his separation from his wife and the independence of his views; continued in vogue as a preacher; contributed to various newspapers; radical MP, 1847–63; published popular lectures.

1374 Oil on canvas, 24⅛ × 20 inches (61·4 × 51 cm), by ELIZA FLORENCE BRIDELL (his daughter), *c*1863.
 PLATE 337
 Signed (bottom right): E.F.Bridell

Collections: The artist, presented by her second husband, George Fox, in accordance with her wishes, 1904.

Exhibitions: RA, 1868 (606).

Eliza Fox first married Frederick Bridell, and then George Fox, her first cousin. According to the donor (letter of 5 May 1904, NPG archives), this portrait was painted after Fox had retired from Parliament, so must date from between 1863 and his death in June 1864. Richard Garnett, who first approached the NPG on the donor's behalf, and who wrote the entry on Fox in the *Dictionary of National Biography*, thought the portrait was an excellent likeness (letter of 23 April 1904, NPG archives). An earlier drawing of her father by Mrs Bridell was engraved by R. Woodman, published C. Fox, 1845 (example in NPG); she also exhibited a drawing of him, *RA*, 1853 (953).

Description: Grey hair, dark brown eyes. Dressed in a dark stock, white shirt, black coat or waistcoat, and loose green over-garment with fur trimming. Background colour dark brown.

ICONOGRAPHY A drawing of Dickens reading *The Chimes* to his friends by D. Maclise of 1844 is in the Victoria and Albert Museum; a drawing by J. Doyle is in the British Museum; a miniature by Miss M. Gillies was exhibited *RA*, 1833 (787); a portrait by J. Lilley and a bust by T. Earle were exhibited *RA*, 1845 (1209), and 1853 (1392); an engraving of the 'Anti-Corn Law League' by S. Bellin, after a painting by J. R. Herbert of 1847, was published Agnew, 1850 (example in NPG); a woodcut was published *ILN*, XII (1848), 298.

FRANKLIN *Jane, Lady* (*1792–1875*)

Née Griffin; married Sir John Franklin (see below), as his second wife, 1828; sent out several ships to search for her husband, and refused for some time to accept evidence of his fate; received founder's medal of the Geographical Society, 1860.

904 Black and grey chalk and stump on paper, 6¼ × 5¼ inches (16 × 13.3 cm) oval, by MISS AMÉLIE ROMILLY, 1816. PLATE 338

Inscribed in Lady Franklin's hand in ink on a label (formerly on the back of the drawing): I bequeath this/ portrait to my/sister Fanny Majendie/and after her death to/Sophia Cracroft./May 17 1853. *Inscribed in ink in another hand (below):* Mary Simpkinson

Collections: Bequeathed by Lady Franklin's niece, Miss Cracroft, 1892.

Literature: The Life, Diaries and Correspondence of Jane Lady Franklin, 1792–1875, edited W. F. Rawnsley (1923), pp 46–7, reproduced frontispiece; F. J. Woodward, *Portrait of Jane: a Life of Lady Franklin* (1951), reproduced frontispiece.

This drawing was executed in Geneva in 1816. Lady Franklin discussed it at length in her 'Geneva Journal', extracts from which are quoted by Rawnsley (see above). Lady Franklin went to Miss Romilly's studio with her sister, Frances (later Mrs Majendie), and both were drawn:

It seems to be her object to seize as much as possible the character and natural expression of the face by making it talk and laugh and to move and be at ease. She talks and laughs incessantly herself. . . . I was drawn with my hair flat, à l'anglaise, perfectly simple, in a plain muslin frock with a low neck and my pelisse thrown back on my shoulders; she arrested me in an attitude I accidentally fell into and said she should choose that We left after two or three hours' interrupted sitting and promised to go again and be finished the following day.

Miss Romilly was helped in her work by her sister, Mrs Dance, who laid in the ground, and worked on the subsidiary parts of the drawing. This portrait was bequeathed at the same time as Lady Franklin's great collection of 'Arctic Explorers' by S. Pearce (see NPG 905–924, p 562), and the portraits of her husband (see below). Mary Simpkinson was another of Lady Franklin's sisters.

ICONOGRAPHY A drawing by J.M.Negelen of Lady Franklin and her daughter was exhibited *RA*, 1837 (753); a drawing by T.B.Wirgman was exhibited *Summer Exhibition*, Royal Society of Portrait Painters, 1896 (242); a bust by Miss M.Grant, probably based on the drawing by Miss Romilly, was exhibited *RA*, 1877 (1409).

FRANKLIN *Sir John* (*1786–1847*)

Arctic explorer; at Trafalgar in the Bellerophon; took part in Arctic expedition, 1818, and commanded his own, 1819–22; commanded a second, equally important expedition, 1825–7; lieutenant-governor of Van Diemen's Land; set out on last Arctic expedition, 1845, and perished with his entire company; one of the great explorers of the age.

903 Oil on canvas, $30\frac{1}{4} \times 20\frac{1}{4}$ inches (76·9 × 56·4 cm), by THOMAS PHILLIPS, 1828. PLATE 339

Signed and dated (*lower right*): TP (*in monogram*) 1828

Collections: Bequeathed by Lady Franklin's niece, Miss Cracroft, 1892.[1]

Exhibitions: VE, 1892 (252).

Literature: Probably listed in Phillips' 'Sitters Book' (copy of original MS, NPG archives), under 1827.

The NPG portrait appears to be a replica of the portrait in the City Museum and Art Gallery, Birmingham,[2] presumably that listed in the artist's 'Sitters Book', under 1824, and exhibited *RA*, 1825 (98). The Birmingham picture was exhibited Birmingham Society of Artists, 1829 (4), acquired by the Society in the same year, and presented by them to the Art Gallery, 1867[3]; the picture was also exhibited *Pageant of Canada*, National Gallery of Canada, Ottawa, 1967–8 (151), reproduced in catalogue. In the *VE* catalogue (see above), the NPG portrait was said to have been painted in 1824, presumably because Miss Cracroft believed it to be the original portrait presented by Franklin to his first wife as a wedding present in 1824, although it is clearly dated '1828'. The Birmingham version is, however, unsigned, and seems to be of inferior quality. It is possible that Phillips became dissatisfied with the original, and repainted the portrait in 1828, giving the new version to Franklin (his first wife was dead by this date), and taking back the old, or he may have retouched the NPG portrait in 1828, and signed and dated it in that year; in this case the Birmingham portrait would be the secondary version.

Another version of the portrait, apparently by Phillips, was in the collection of H.H.Phillips of Birmingham in 1932. Copies are at the National Maritime Museum, Greenwich, the Dudley Art Gallery, the Scott Polar Institute, Cambridge (in water-colour), the Royal Geographical Society, London, and the collection of T.Johns, 1890, recorded by G.Scharf, 'TSB' (NPG archives), XXXV, 64. A portrait called Franklin (apparently wrongly), and attributed to Phillips, is in the National Gallery of Canada. There is an anonymous engraving after the NPG Phillips (example in NPG).

[1] Although the portrait was among the Arctic portraits bequeathed to the NPG by Miss Cracroft, who inherited them from Lady Franklin, Sir John's second wife, it was apparently in her possession only by permission of the legal owners, Eleanor and John Phillip Gell (Eleanor was Franklin's daughter by his first wife, Eleanor Anne, *née* Porden). William Gell, their son and the grandson of Franklin, during an interview at the NPG, 22 January 1932, and in a letter of 1 February 1932 (both NPG archives), explained that the Phillips portrait was painted in 1824 for Mrs Eleanor Anne Franklin, remaining part of her estate, in which Franklin, after her death in 1825, retained only a life interest. When he failed to return from his third Arctic expedition, and was assumed officially dead by the Admiralty, Lady Franklin sponsored search expeditions, largely financed with money from this estate. But, by a Chancery ruling (confirmed later by evidence of Franklin's death), the estate,

including the portrait, passed to Eleanor, now married to the Rev J.P.Gell. She allowed it to remain in Lady Franklin's house, with all the other Arctic portraits (see p 562); it was not returned as agreed, however, when Lady Franklin died in 1875, but was retained by Miss Cracroft. Despite the Rev Gell's request (Eleanor died in 1860) that, by way of compromise, she present it to the NPG, the portrait was not given until 1892, when Miss Cracroft included it as though part of her own bequest. William Gell's account, although probably true, still fails to explain why the NPG portrait is dated '1828'.

[2] See *Catalogue of Paintings*, City Museum and Art Gallery, Birmingham (1961), p 114.

[3] Details of the 1829 Exhibition were kindly supplied by the secretary of the Royal Society of Birmingham Artists, Mr Priddey.

Description: Brownish eyes, brown hair. Dressed in a black stock, white shirt, dark brown (or blue?) coat, possibly naval, with gilt buttons, and epaulettes (?), and a black cloak with a gilt chain. Background colour dark brown.

2515 (81) Black and red chalk, with touches of Chinese white, on grey-tinted paper, $14\frac{1}{8} \times 10\frac{1}{2}$ inches (36×26.5 cm), by WILLIAM BROCKEDON, 1836. PLATE 342

Dated (lower left): 5.5.36

Collections: See *Collections:* 'Drawings of Prominent People, 1823–49' by W. Brockedon, p 554.

Accompanied in the Brockedon Album by a letter from the sitter, dated 14 July 1836.

1230 Bronze cast, $15\frac{7}{8}$ inches (40.4 cm) high, including detachable base, of a bust by ANDREA CARLO LUCCHESI 1898. PLATE 340

Inscribed at the side of the base: A C Lucchesi/98

Collections: Commissioned by the sitter's godson and great-nephew, Willingham Franklin Rawnsley, and presented by him, 1899.

Exhibitions: Twelfth Summer Exhibition, New Gallery, 1899 (478).

Literature: The Life, Diaries and Correspondence of Jane Lady Franklin, 1792–1875, edited W. F. Rawnsley (1923), reproduced facing p 64 (the caption contains further information).

The donor was very dissatisfied with the portraits of Sir John Franklin, particularly that by Phillips (NPG 903 above), which seemed to him to lack the sitter's characteristic energy and determination. In a letter of 29 April 1899 (NPG archives), he wrote:

I accordingly by the aid of a Wax bust in my possession and the Medallion by David & the engraving by Neguelin [sic], *set the Sculptor Lucchesi to work & with the help of those four who are still living who knew Sir John I have got a bust executed in Bronze about $\frac{1}{2}$ lifesize which besides being a bit of very good work is undoubtedly a good likeness.*

The last surviving nephew of Franklin, the Rev Wright, who bore a marked resemblance to his uncle, sat for the last touches to the bust. Other casts are in the Franklin Museum, Hobart, Tasmania, the National Maritime Museum, Greenwich, and the collection of the Rev Edward Alston.

1208 See *Groups:* 'The Arctic Council, 1851' by S. Pearce, p 548 (a portrait of Franklin appears in the background).

ICONOGRAPHY For paintings in the Scott Polar Research Institute, Cambridge, see J. W. Goodison, *Cambridge Portraits* (1955), pp 183–5. A painting by J. Jackson is in the collection of John Murray, London, exhibited *Old Masters Exhibition,* British Institution, 1854 (158), and *SKM,* 1868 (416), engraved by E. Finden, published J. Murray, 1828 (example in NPG); a water-colour by W. Derby is in the National Maritime Museum, Greenwich (plate 341), engraved by J. Thomson, published Fisher, 1830 (example in NPG), for Jerdan's 'National Portrait Gallery'; a drawing by G. Lewis is in the Scott Polar Research Institute, exhibited *RA,* 1823 (520), reproduced Mrs Gell, *John Franklin's Bride* (1930), facing p 88, engraved by F. C. Lewis, published G. Lewis, 1824 (example in British Museum); another similar drawing was in the Bruce Ingram collection; a drawing by J. Negelen was exhibited *RA,* 1837 (961), reproduced H. D. Thrail, *Life of Sir John Franklin, R.N.* (1896), frontispiece (head and shoulders only), engraved and lithographed by various artists (examples in NPG); a copy in oils of the Negelen drawing by S. Pearce is in the Scott Polar Research Institute, possibly the portrait in the background of Pearce's group, the 'Arctic Council' (NPG 1208 above); a miniature by S. Drummond was formerly in the Royal United Service Museum, London; bronze casts of a medallion by David D'Angers of 1829 are in the Musée des Beaux-Arts, Angers, Scott Polar Research Institute, collection of Rev Edward Alston, and exhibited *VE,* 1892 (587), lent by Admiral L. McClintock; casts in plaster and wax are in the Scottish NPG, the Royal Geographical Society, London, and the collection of Adolph Holl, Oslo; a bronze statue by C. Bacon of 1861 is at Spilsby, Lincolnshire, reproduced as a woodcut *ILN,* XXXIX (1861), 338; a statue by M. Noble of 1866

is in Waterloo Place, London, reproduced as a woodcut *ILN*, XLIX (1866), 288; a marble bust by Noble of 1875, forming part of a memorial, is in Westminster Abbey, reproduced *The Life, Diaries and Correspondence of Jane Lady Franklin*, edited W.F.Rawnsley (1923), facing p 192; a plaster model for this was formerly at Elswick Hall, Newcastle, listed in *Catalogue of Lough and Noble Models at Elswick Hall* (*c* 1928), pp 71–2 (257); a statuette by an unspecified artist was exhibited *Royal Naval Exhibition*, Chelsea, 1891 (2863), lent by Henry Willett; a plaster medallion by J.S.Westmacott of 1861 is in the Scott Polar Research Institute; an engraving by W.T.Fry, after a drawing by T.Wageman, was published J.Letts, 1823 (example in NPG), for the *New European Magazine;* woodcuts were published *ILN*, VI (1845), 328, and XIX (1851), 329; there are several other engravings in the NPG; a lithograph by J.S.Templeton is listed by W.G.Strickland, *Dictionary of Irish Artists* (1913), II, 435; a daguerreotype of 1845 (together with others of his officers) was exhibited *Manuscripts and Men*, NPG, 1969 (130), lent by Colonel P.V.W.Gell.

FRASER *James Baillie* (*1783–1856*)

Traveller and writer; with his brother, William Fraser (1784?–1835), explored Nepal; accompanied Dr Jukes to Persia and travelled through Kurdistan to Tabriz, 1821; rode from Semlin to Constantinople, and from there to Teheran, 1833–4; published accounts of his travels and other works.

2515 (48) Black and red chalk, with touches of Chinese white, on green-tinted paper, $13\frac{3}{4} \times 10$ inches ($34 \cdot 8 \times 25 \cdot 5$ cm), by WILLIAM BROCKEDON, 1833. PLATE 343

Dated (*lower left*): 28.10.33

Collections: See *Collections:* 'Drawings of Prominent People, 1823–49' by W.Brockedon, p 554.

Accompanied in the Brockedon Album by a letter from the sitter, dated 29 October 1833.

ICONOGRAPHY The only other recorded portrait of Fraser is a lithograph by W.D[rummond], after a drawing by E.U.Eddis, published McLean (example in NPG), for 'Athenaeum Portraits'.

FREMANTLE *Thomas Francis, 1st Baron Cottesloe.* See COTTESLOE

FRENCH *Fitzstephen* (*1801–73*)

MP for County Roscommon.

54 See *Groups:* 'The House of Commons, 1833' by Sir G.Hayter, p 526.

FROST *William Edward* (*1810–77*)

Painter; RA gold medallist; first exhibited at RA, 1836; painted portraits and subject pictures; noted for his sylvan and bacchanalian subjects, with bevies of nude female figures, in the Etty tradition; RA, 1870.

4303 Water-colour, with touches of Chinese white, on paper, $8\frac{3}{8} \times 6\frac{1}{2}$ inches ($21 \cdot 3 \times 16 \cdot 5$ cm), by HIMSELF, 1839. PLATE 344

Inscribed on an old label, formerly on the back of the water-colour, possibly in the artist's hand: Portrait of the Artist./Sketched in 1839./W.E.Frost. ARA

Collections: Purchased by William Corran in Belfast, *c* 1940; Bonham's, 10 January 1963 (lot 141), bought T.A.G.Pocock, and presented by him, 1963.

Literature: NPG Annual Report, 1963–4 (1964), p 1.

Description: Brown eyes and hair. Dressed in a black stock and neck-tie and blue coat.

ICONOGRAPHY A painting by himself of 1831 was in the possession of Messrs G.J.Nicholson, 1940; a miniature by E.Upton was exhibited *RA*, 1872 (1379); a woodcut, after a painting by himself of *c* 1840, is

reproduced *Art Journal* (1849), p 184; there is an anonymous engraving, after T. Scott (example in British Museum), and two anonymous woodcuts, possibly after photographs (examples in NPG); woodcuts after photographs by J. Watkins were published *ILN*, XXX (1857), 419, and LVIII (1871), 61; two photographs are in the NPG.

FROUDE *Robert* (*1771?–1859*)

Divine, father of J. A., R. H. and W. Froude.

2515 (35) See *Collections:* 'Drawings of Prominent People, 1823–49' by W. Brockedon, p 554.

FULLER *J.*

Traveller and author.

2515 (54) See *Collections:* 'Drawings of Prominent People, 1823–49' by W. Brockedon, p 554.

GALT *John* (*1779–1839*)

Novelist; engaged in commerce; travelled to continent with Byron, 1809, and published an account of his travels; published numerous biographies and novels, and an autobiography.

2515 (37) Black and red chalk, heightened with Chinese white, on green-toned paper, $14\frac{3}{8} \times 10\frac{1}{8}$ inches ($36 \cdot 5 \times 25 \cdot 7$ cm), by WILLIAM BROCKEDON, 1834. PLATE 345

Dated (lower middle): 12.3.34

Collections: See *Collections:* 'Drawings of Prominent People, 1823–49' by W. Brockedon, p 554.

Accompanied in the Brockedon Album by a letter from Galt, dated 15 December 1832.

ICONOGRAPHY A painting by C. Grey is in the Scottish NPG; a drawing by Count A. D'Orsay was sold Sotheby's, 13 February 1950 (lot 216), bought Colnaghi; a miniature by A. Huey was exhibited *RA*, 1814 (409); a bust by J. Henning junior was exhibited Suffolk Street Gallery, London, 1824, see R. Gunnis, *Dictionary of British Sculptors* (1953), p 198; the same or another bust by Henning was exhibited *RA*, 1830 (1184); an engraving by D. Maclise (example in NPG) was published *Fraser's Magazine*, II (1830), facing 555, as no. 7 of Maclise's 'Gallery of Illustrious Literary Characters'; a pencil study for this is in the Victoria and Albert Museum; Galt also appears in Maclise's engraving of the Fraserians, published *Fraser's Magazine*, XI (1835), between 2 and 3; two pencil studies for this are also in the Victoria and Albert Museum; an engraving by T. Woolnoth, after E. Hastings, was published Dean and Munday, 1824 (example in NPG), for the *Ladies Monthly Magazine;* an engraving by R. Graves, after J. Irvine, was published Cochrane and others, 1833 (example in NPG), for Galt's *Autobiography*; there are several anonymous engravings (examples in NPG and British Museum).

GALUSHA *Rev Eton*

American slavery abolitionist.

599 See *Groups:* 'The Anti-Slavery Society Convention, 1840' by B. R. Haydon, p 538.

GARDNER *Alan, 3rd Baron* (*1810–83*)

Held various Court appointments.

4026 (27) See *Collections:* 'Drawings of Men About Town, 1832–48' by Count A. D'Orsay, p 557.

GARNIER *Thomas, the elder* (*1776–1873*)

Of Huguenot origin; fellow of All Souls, Oxford; prebendary of Winchester Cathedral, 1830, and dean, 1840; friend of Palmerston and a staunch whig.

4844 Medallion, white on red wax, $7 \times 6\frac{1}{2}$ inches ($17 \cdot 8 \times 16 \cdot 5$ cm) oval, by RICHARD COCKLE LUCAS, 1850. PLATE 346

Incised (lower left): R C Lucas *and above (along the edge of the rim):* The very Revd T. Garnier/Dean of Winter [*Winchester*]/1850

Collections: Deposited by A.S.Jones, 1944.

Another example of this medallion in the Pyke collection is reproduced *Country Life*, CXXXI (1962), 659.

ICONOGRAPHY A painting by I.F.Bird was exhibited *RA*, 1834 (423), possibly the unattributed painting reproduced A.E.Garnier, *The Garniers of Hampshire* (1900), facing p 42; reproduced in the same book is a drawing by F.W.Wilkin of 1830, and a later unattributed drawing or print, facing pp 38 and 52 respectively; two miniatures by F.Tatham were exhibited *RA*, 1842 (644), and 1854 (994); there are two photographs in the NPG.

GASKELL *Daniell* (*1782–1875*)

MP for Wakefield.

54 See *Groups:* 'The House of Commons, 1833' by Sir G.Hayter, p 526.

GASKELL *Elizabeth Cleghorn* (*1810–65*)

Novelist; *née* Stevenson; married William Gaskell (1805–84), 1832; published *Mary Barton* anonymously, 1848; contributed to *Household Words* from 1850; wrote *Cranford*, 1853, *North and South*, 1855, and a *Life* of Charlotte Brontë, 1857; one of the important novelists of the period.

1720 Coloured chalk on brown, discoloured paper, $24\frac{1}{4} \times 18\frac{3}{4}$ inches ($61 \cdot 6 \times 47 \cdot 7$ cm), by GEORGE RICHMOND, 1851. PLATE 348

Signed and dated (bottom left): George Richmond delt 1851

Collections: The sitter, bequeathed by her daughter, Miss Margaret Gaskell, 1913.

Exhibitions: VE, 1892 (368).

Literature: G.Richmond, 'Account Book' (photostat copy, NPG archives), p 53, under 1851; Richmond, 'Diary' (photostat copy, NPG archives), under 6 February 1851; A.B.Hopkins, *Elizabeth Gaskell: her Life and Work* (1952), pp 92, 115, 349, reproduced facing p 161; *Letters of Mrs Gaskell*, edited J.A.V.Chapple and A.Pollard (Manchester, 1966), pp 158, 179.

This is the most famous and most widely reproduced image of Mrs Gaskell. She sat for it on 6 February 1851 (see reference to Richmond's 'Diary' above), writing on 9 February in a letter apparently to her sister, Marianne (*Letters*, p 158): '*Wednesday I did not go to Richmond, it was too bad a day for him to draw* *Tuesday* [error for Thursday, 6 February] *a long piece of Richmond again. I think it is like me; I hope Papa will think so but I am almost doubtful*'.[1] In a letter of 24 February 1851 to Richmond, Mrs Gaskell wrote (*Letters*, p 179): '*I must plead indisposition as an excuse for not sooner having written to tell you that some time ago my husband placed £31–10s to your account at Masterman's.* . . . *With many pleasant recollections of the time I passed in your studio, believe me to remain Yours very truly E.C. Gaskell*'.[2] The same price is recorded in Richmond's 'Account Book', his normal charge for a portrait drawing. The offer to bequeath the drawing was first made in a letter from Miss Margaret Gaskell of 22 January 1895 (NPG archives), offering the drawing on behalf of herself and her sister, Julia.

ICONOGRAPHY A painting by S.Laurence of *c* 1864 is reproduced A.B.Hopkins, *Elizabeth Gaskell: her Life and Work* (1952), facing p 320; a related drawing by S.Laurence of 1864 is in the collection of Mrs

[1] Published in the *Letters* with the date 13 July 1851. The new date was confirmed by Chapple in a letter of 29 October 1970 (NPG archives).

[2] Published in the *Letters* with the date 24 February (?1852), but the new date confirmed by Chapple (see above).

Trevor Jones, reproduced W. Gérin, *Charlotte Brontë* (1967), facing p 360, where misdated 1854; a second drawing by Laurence is in the collection of Frank Miles; a miniature by W. J. Thomson of Edinburgh of 1832 is in the Library of the University of Manchester, reproduced Hopkins, facing p 48; a plaster bust by D. Dunbar of 1831 was in the City Art Gallery, Manchester (at present untraced), reproduced *Bookman*, XXXVIII (1910), 244, and another cast is on the Mrs Gaskell Memorial Tower at Knutsford; a marble copy by Sir W. H. Thornycroft of 1895 is also in the Library of Manchester University, reproduced Hopkins, facing p 49; a posthumous bronze plaque by Cavaliere A. D'Orsi is on the Mrs Gaskell Memorial Tower, reproduced *Bookman*, XXXVIII (1910), 249; there is a photograph by A. McGlashan of Edinburgh (example in NPG, plate 347).

GASKELL *James Milnes* (*1810–73*)

MP for Wenlock.

54 See *Groups*: 'The House of Commons, 1833' by Sir G. Hayter, p 526.

GEORGE V (*1865–1936*)

4536 'The Four Generations'. See entry under Queen Victoria, p 475.

See also forthcoming Catalogue of Modern Portraits.

GIBSON *John* (*1790–1866*)

Sculptor; of humble parentage; studied under Canova and Thorwaldsen in Rome, where he spent most of his life; became the leading English sculptor of his period, working in an austere neo-classical style; famous for such works as the 'Tinted Venus' and 'Pandora'; also executed statues and busts.

431 Oil on canvas, 36¼ × 28 inches (91.1 × 71.1 cm), by MARGARET SARAH CARPENTER, 1857. PLATE 354

Signed and dated (*bottom left*): Margaret Carpenter./1857.

Collections: William Carpenter, the artist's husband; purchased at the sale of his collection, Christie's, 16 February 1867 (lot 100).

Exhibitions: R A, 1857 (537).

Literature: Mrs Carpenter, 'Sitters Book' (copy of original MS, NPG archives), p 46; G. Scharf, 'TSB' (NPG archives), XI, 40.

Mrs Carpenter lists the portrait under the year 1866, but this clearly refers to its date of sale, as the price entered in the 'Sitters Book', £29–8, is identical with the price paid by the NPG at Christie's.

Description: Brown cyes, brown hair, greyish beard. Dressed in a grey stock, white shirt and grey suit, holding a wooden modelling tool. Seated in wooden armchair with reddish brown covers. Background colour light brown.

1370 Pencil on paper, with slight red tint on the cheeks, 12 × 8½ inches (30·4 × 21·6 cm), formerly attributed to HENRY HOPPNER MEYER, *c* 1860. PLATE 352

Inscribed in pencil (*lower right*): Henry Hoppner Meyer *and* (*bottom centre*): John Gibson R.A.

Collections: B. B. Brook, purchased from him, 1904.

Presented at the same time as a drawing of David Roberts (NPG 1371). They are identical with two drawings in the British Museum (see L. Binyon, *Catalogue of Drawings by British Artists*, III, 1902, 105). Although apparently signed by Meyer, they cannot be by him. The portrait of Gibson represents him as an old man, and cannot possibly be earlier than 1855. Meyer died in 1847, and had ceased to exhibit by 1831.

2515 (96) Black and red chalk, with touches of Chinese white, on greenish-grey tinted paper, $14\frac{3}{4} \times 10\frac{1}{2}$ inches (37·5 × 26·5 cm), by WILLIAM BROCKEDON, 1844. PLATE 350

Dated (lower right): 24.6.44

Collections: See *Collections:* 'Drawings of Prominent People, 1823–49' by W. Brockedon, p 554.

Accompanied in the Brockedon Album by a letter from the sitter, dated 18 June [1844], in which he writes: '*I find that I am engaged every mor.g this week – if you will contract [?] to immortalize me next week name the day & I shall wait upon you*'.

3944 (32) Pencil on paper, $9\frac{3}{8} \times 7\frac{1}{4}$ inches (23·8 × 18·4 cm), by JOHN PARTRIDGE, 1825. PLATE 349

Collections: See *Collections:* 'Artists, 1825' by J. Partridge, p 556.

Comparison with other portraits of Gibson, particularly the Kirkup drawing of 1821 (see iconography below), leaves little doubt that this drawing does represent him. Both artist and sitter were in Rome in 1825.

1795 Marble bust, 17 inches (43·2 cm) high, by WILLIAM THEED, *c* 1868. PLATE 353.

Incised on front of the base: JOHN GIBSON

Collections: Sir Thomas Devitt, Bart, presented by him, 1917.

This is a reduced replica of the marble bust by Theed in the Royal Academy, London, which was exhibited *R A*, 1868 (969). Both were apparently executed as memorial busts after Gibson's death, and are probably a reworking of Theed's original bust of 1852 in Conway parish church, North Wales. Although there is a general similarity between the Royal Academy and Conway busts, there are differences of detail. In the Conway bust Gibson's beard is less pronounced, his hair is shorter, and his nose less straight; there is a wider space between his eye-lids and eye-brows, and his chin has less of a cleft.[1] The 1852 Conway bust, or another version, was in the Crystal Palace Portrait Collection, 1854.

ICONOGRAPHY

c 1819 Bust by Mrs Vose. Exhibited *R A*, 1819 (1190).

c 1821 Lithograph by T. H. Maguire, after a drawing by S. S. Kirkup of 1821 (example in NPG).

1825 Drawing by J. Partridge (NPG 3944 (32) above).

1830 Painting by A. Geddes. Walker Art Gallery, Liverpool.
Probably the portrait exhibited *R A*, 1832 (171); exhibited *The Liverpool Academy*, Walker Art Gallery, Liverpool, 1960 (42). Engraved by S. Bellin (example in British Museum). Replica: ex-collection of Sir Robert Peel; see *Gentleman's Magazine*, NS XXVII (1847), 290.

1831 Lithograph by R. J. Lane (after Gibson ?). Recorded in Lane's 'Account Books' (NPG archives), I, 29.

c 1835 Painting by T. Ellerby. Exhibited *R A*, 1835 (412).

c 1835 Enamel miniature by C. R. Bone. Exhibited *R A*, 1835 (763).

c 1838 Painting by A. Geddes. Exhibited *R A*, 1838 (488).

c 1839 Bust by W. Barton. Exhibited Derby Mechanics' Institute, 1839. See R. Gunnis, *Dictionary of British Sculptors* (1953), p 41.

1843 Drawing by C. Vogel. Küpferstichkabinett, Staatliche Kunstsammlungen, Dresden. Reproduced *Burlington Magazine*, XI (1907), 380.

c 1843 Painting by E. D. Leahy. Exhibited *R A*, 1843 (226).

1844 Drawing by W. Brockedon (NPG 2515 (96) above).

[1] Information kindly communicated by the Rev G. J. Roberts of Conway.

1844	Drawing by C. Martin. Collection of Sir T. Marchant Williams, 1913.
	Newspaper cutting in NPG. Reproduced as a woodcut (in reverse) *ILN*, XI (1847), 261.
c1844	Painting by P. Williams. Academy of St Luke, Rome. Exhibited *RA*, 1844 (372).
	Engraved by C. Wagstaff, published Colnaghi, 1845 (example in NPG). Anonymous engraving (head only, in reverse), published *Art Journal* (1849), p141. A study of 1839, differing in some respects, is reproduced T. Matthews, *John Gibson RA* (1911), facing p122.
1847	Painting by J. Partridge. Partridge Sale, Christie's, 15 June 1874 (lot 67), bought Agnew.
	Exhibited *SKM*, 1868 (589).
1847	Painting by J. Graham-Gilbert. National Gallery of Scotland.
	Exhibited *RA*, 1848 (860), and *Royal Scottish Academy*, 1849 (2). Smaller replica: National Museum of Wales, Cardiff.
c1850	Painting by Sir E. Landseer. Royal Academy, London (plate 351).
	Exhibited *Paintings and Drawings by Sir Edwin Landseer*, RA, 1961 (78). The suggestion that the portrait may have been painted in 1844 is unacceptable on the evidence of the apparent age of the sitter. A replica is in the Walker Art Gallery, Liverpool.
1851	Etching by J. Brown, after a drawing by H. W. Phillips (example in NPG).
c1851	Painting by Sir W. Boxall. Exhibited *RA*, 1851 (180), and possibly *Exhibition of Works by the Old Masters etc*, RA, 1893 (4), lent by Lord Coleridge.
1852	Bust by W. Theed. Parish Church, Conway.
	Exhibited *RA*, 1852 (1473).
1853	Drawing by R. Lehmann. British Museum.
	Reproduced R. Lehmann, *Men and Women of the Century* (1896), p26.
c1855	Drawing by C. Martin. Exhibited *RA*, 1855 (692).
1857	Painting by Mrs M. Carpenter (NPG 232 above).
1857	Woodcut, after a photograph by J. Watkins, published *ILN*, XXX (1857), 418.
c1857	Bronze bust by J. E. Jones. Exhibited *RA*, 1857 (1347).
c1859	Drawing by F. Talfourd. Exhibited *RA*, 1859 (837).
c1859	Engraving by D. J. Pound, after a photograph by Mayall (example in NPG), published Pound's 'Drawing Room Portrait Gallery'.
c1860	Drawing formerly attributed to H. H. Meyer (NPG 1370 above).
c1862	Bust by G. E. Ewing. Exhibited *RA*, 1862 (1007).
1864	Painting by Sir W. Boxall. Royal Academy, London.
	Exhibited *RA*, 1864 (54). Reproduced *Paintings. . . in the Diploma and Gibson Galleries, Royal Academy* (1931), p16.
1864	Anonymous lithograph, after a drawing by C. M. Beresford (example in British Museum).
c1865	Painting by E. Löwenthal. Exhibited *RA*, 1865 (103).
1866	Woodcut, after a photograph by Maull & Co, published *ILN*, XLVIII (1866), 161.
1866	Marble bust by J. Adams. St George's Hall, Liverpool.
	Exhibited *RA*, 1866 (894).
c1866	Busts by Mrs H. E. Cholmeley and H. Bursill. Exhibited *RA*, 1865 (1036), and 1866 (1003).
1868	Bust by W. Theed. Royal Academy, London.
	Exhibited *RA*, 1868 (969). Reduced replica (NPG 1795 above). The head of a statue in Munich is after Theed's bust.
1875	Bronze medallion by J. S. Wyon. Issued by the Art Union of London (example in NPG).

Undated Painting by H.W.Pickersgill. Pickersgill Sale, Christie's, 17 July 1875 (lot 323).

Undated Bust by L.Macdonald. Crystal Palace Portrait Gallery, 1854.

Undated Marble medallion by H.Hosmer. Watertown Free Public Library, Mass. Another medallion is on Gibson's tomb in the Protestant Cemetery at Rome. A third was with Weinreb, 1969.

Undated Anonymous silhouette. Scottish NPG.

Undated Lithographs by T.H.Maguire and J.Jackson, and several photographs (examples in NPG).

GILBERT *Davies* (*1767–1839*)
Scientist.
2515 (88) See *Collections:* 'Drawings of Prominent People, 1823–49' by W.Brockedon, p554.
See also forthcoming Catalogue of Portraits, 1790–1830.

GLADSTONE *Sir Thomas, Bart* (*1804–89*)
MP for Portarlington.
54 See *Groups:* 'The House of Commons, 1833' by Sir G.Hayter, p526.

GLADSTONE *William Ewart* (*1809–98*)
Prime minister.
54 See *Groups:* 'The House of Commons, 1833' by Sir G.Hayter, p526.
1125 See *Groups:* 'The Coalition Ministry, 1854' by Sir J.Gilbert, p550.
See also forthcoming Catalogue of Portraits, 1860–90.

GLYNNE *Sir Stephen Richard, Bart* (*1807–74*)
Antiquary, and MP for Flint.
54 See *Groups:* 'The House of Commons, 1833' by Sir G.Hayter, p526.

GODWIN *Rev B.*
Slavery abolitionist.
599 See *Groups:* 'The Anti-Slavery Society Convention, 1840' by B.R.Haydon, p538.

GODWIN *William* (*1756–1836*)
Philosopher.
2515 (29) See *Collections:* 'Drawings of Prominent People, 1823–49' by W.Brockedon, p554.
See also forthcoming Catalogue of Portraits, 1790–1830.

GOMM *Sir William Maynard* (*1784–1875*)
Field-marshal; at Coruña with Moore; served in the Peninsula, 1810–14; present at Waterloo; major-general, 1837; commander in Jamaica, 1839–42; governor of Mauritius, 1842–9; commander-in-chief in India, 1850–5; field-marshal, 1868; constable of the Tower, 1872–5.

1071 Oil over a photograph stuck on to board, 13 × 10 inches (33·2 × 25·6 cm), by JAMES BOWLES, 1873–4.
PLATE 357

Collections: By descent to Francis Carr-Gomm, and presented by him, 1896.

The head, uniform and medals in this portrait are identical with a photograph by Maull & Co, reproduced as a woodcut *ILN*, LXI (1872), 412. While the uniform, accessories, and background view

of the Tower of London are painted with opaque colours, the face and left hand are slightly tinted in transparent colours, showing what seems to be the original photograph underneath. Gomm is wearing his uniform as constable of the Tower; the sash and star of the Bath; the cross of the order of St Anne of Russia; the gold cross and clasp suspended from his neck, and the medal with six clasps, for services in the Peninsular War; and the Waterloo medal.[1] The name of the artist and the date were provided by the donor who wrote (letter of 17 November 1896, NPG archives): '*We have larger portraits but this is the best portrait we have of him*'.

Description: Brown eyes, grey hair. Dressed in a dark blue uniform with red facings and gilt buttons, wearing a gold sash from right to left, and a crimson one from left to right, various medals and stars with red and crimson ribbons. His sword has a silver hilt and black scabbard. Multi-coloured Dutch rug on table at left, silver keys, and plumed hat. Dark curtain at left and above, with a tassel top right, stone-coloured wall and pillar behind. Tower of London grey, with blue sky above.

3717 Oil on canvas, 21 × 17 inches (53·3 × 43·2 cm), by WILLIAM SALTER, c 1834–40. PLATE 356

Collections: By descent to W.D.Mackenzie, who also owned the group picture, and bequeathed by him, 1929.

This is one of several studies in the NPG for Salter's large picture of the 'Waterloo Banquet at Apsley House', now in the collection of the Duke of Wellington; the group portrait was engraved by W.Greatbach, published F.G.Moon, 1846 (example in NPG). The studies will be discussed collectively in the forthcoming Catalogue of Portraits, 1790–1830. Gomm is shown in the uniform of a major-general.

Description: Healthy complexion, brown eyes and hair. Dressed in a red uniform with gold-braided collar, epaulettes and cuffs, multi-coloured medals and orders, gold sash, brown sword-belt, gilt sword-hilt and tassels, holding a black hat with white feathers. Brown pillar at left, dark brown curtain covering most of background.

2715 Water-colour on blue tinted paper, 10¼ × 6 inches (25·8 × 15·3 cm), by SPY (SIR LESLIE WARD), 1873. PLATE 355

Signed (lower right): Spy *Inscribed on the original mount:* Field marshal Sir William Gomm./August 30, 1873

Collections: T.S.Bowles; *Vanity Fair* sale, Christie's, 6 March 1912 (lot 305); Messrs Maggs, purchased from them, 1934.

This water-colour was published as a coloured lithograph in *Vanity Fair* on 30 August 1873, as no.67 of 'Men of the Day', entitled 'The Constable of the Tower'. The original studies for the *Vanity Fair* cartoons were owned by the first proprietor of the magazine, T.S.Bowles, and specially mounted by him. Those in the NPG will be collectively discussed in the forthcoming Catalogue of Portraits, 1860–90.

Description: Fresh complexion, greyish-blue eyes (?), grey hair. Dressed in a dark stock, white shirt, grey waistcoat, black frock coat, grey trousers, and black shoes with black bows. Background colour greyish-blue.

ICONOGRAPHY A painting by R.McInnes was sold from the Gomm collection, Christie's, 6 March 1914 (lot 14), and a painting by an unknown artist was sold at Christie's, 10 July 1916 (lot 157) – sketches of both in NPG sale catalogues; a drawing by J.R.Swinton was exhibited *RA*, 1869 (794); a miniature by an unknown artist was exhibited *VE*, 1892 (436), lent by Mrs Carr-Gomm; a marble bust of 1843 by Sir J.Steell is at Keble College, Oxford; a statuette by Miss M.Grant was exhibited *RA*, 1875 (1383); there is an engraving by D.C.Swan, after a painting by J.B.Paul (example in United Service Club, London); a woodcut, after a photograph by Maull & Co, was published *ILN*, LXI (1872), 412.

[1] Information kindly communicated by W.Y.Carman of the National Army Museum.

GOODRICKE *Sir Henry James (Harry)* (*d1833*)

Hunting squire.

4026　(29) See *Collections:* 'Drawings of Men About Town, 1832–48' by Count A. D'Orsay, p 557.

GORDON *William* (*1784–1858*)

MP for Aberdeenshire.

54　See *Groups:* 'The House of Commons, 1833' by Sir G. Hayter, p 526.

GORE *Robert* (*1810–54*)

Brother of 4th Earl of Arran, naval captain, politician and diplomat.

4026　(30, 31) See *Collections:* 'Drawings of Men About Town, 1832–48' by Count A. D'Orsay, p 557.

GOSS *Sir John* (*1800–80*)

Musical composer; pupil of Thomas Attwood (1765–1838); organist of St Paul's Cathedral, 1838–72; published *Introduction to Harmony*, 1833, and *Chants, Ancient and Modern*, 1841; knighted, 1872; composed many anthems, orchestral works and glees.

3019　Oil on canvas, $14 \times 11\frac{7}{8}$ inches (35·7 × 30·2 cm), by an UNKNOWN ARTIST, *c* 1835. PLATE 358

Collections: The sitter; by descent to his great-granddaughter, Miss L. E. Speth, and presented by her, 1939.

The date is based on costume, the apparent age of the sitter, and information provided by the donor. A portrait of Goss' daughters by T. M. Joy is signed and dated 1836, and, although an attribution of the NPG portrait to the same artist is tempting, it is not convincing. The portrait of the daughters, together with a portrait of Goss' wife, probably by the same hand as NPG 3019, remained in the collection of Miss Speth. NPG 3019 is the only recorded portrait of Goss.

Description: Brown eyes, dark brown hair. Dressed in a black stock, white shirt, black waistcoat and suit, with a gold watch-chain, and a gold monocle suspended from his neck by a black velvet ribbon. Seated in a red leather armchair. His left elbow resting on a leather-bound book on a small table with a yellow table-cloth trimmed with green, on which also rest some white sheets of music and an inkstand and white quill pen. Curtain behind Goss deep red. Background at right light brown.

GOUGH *Sir Hugh, 1st Viscount* (*1779–1869*)

Field-marshal; served in the Peninsula, 1808–13; major-general, 1830; served in China war, 1841–2; commander-in-chief in India, 1843; commanded British forces during the two Sikh wars, 1845–6, 1848–9; created a viscount, 1849; received freedom of the City of London and a pension; field-marshal, 1862.

805　Pen and ink on paper, $7 \times 5\frac{3}{8}$ inches (17·8 × 13·7 cm), by SIR FRANCIS GRANT, *c* 1853. PLATE 360

Collections: The artist; presented by the 2nd Viscount Hardinge, 1888.

Almost certainly a sketch after, rather than a study for, Grant's full-length oil portrait of Gough, listed in his 'Sitters Book' (copy of original MS, NPG archives), under 1853, exhibited *RA*, 1854 (74), as painted for officers of the Bengal artillery, presumably the portrait owned now by the Royal Artillery, Woolwich, exhibited *Dublin Exhibition*, 1872, 'Portraits' (253), engraved by C. R. Saunders (example in NPG). It shows him in a uniform he wore on his campaigns in India. This or another version is in the United Service Club, London. The NPG drawing follows the finished picture rather than the earlier oil study in the collection of Admiral Barrington Brooke, in which Gough's right arm is shown lower,

holding a white hat. Grant was in the habit of making sketches of his finished portraits from recollection. The drawing of Lord Clyde (NPG 619), which was given to the 2nd Viscount Hardinge by the artist, is another example. Lord Hardinge, chairman for some years of the NPG trustees, and his father were both close friends of Grant.

1202 Plaster cast, painted black, 30¾ inches (78·1 cm) high, of a bust by GEORGE GAMMON ADAMS, 1850.
PLATE 359

Incised on the back of the shoulders: G.G. Adams Sc. 1850

Collections: The artist, purchased from his widow, 1899.

Similar to the 'model for a bust' exhibited *RA*, 1851 (1369), discussed and reproduced as a woodcut *ILN*, XVI (1850), 212:

A fine bust of Viscount Gough has just been modelled by Mr G.G. Adams, 5, Eccleston-street East, Pimlico; and will be executed in marble after it has been exhibited for a short time at Messrs Colnaghi and Co's, Pall-Mall East. The likeness of the veteran hero is remarkably striking.

It is not known if the bust was ever executed in marble; no record of it survives. The NPG bust shows Gough wearing the star of the Bath. It was purchased at the same time as several other plaster busts and a marble bust of Sir William Napier (NPG 1198).

ICONOGRAPHY

1804 Miniature by an unknown artist. Reproduced R.S. Rait, *Life and Campaigns of Hugh First Viscount Gough* (1903), I, facing 24.

1842 Anonymous engraving, after a painting by J.R. Jackson, published Graves and Warmsley, 1842 (example in NPG); the same painting was also engraved by H.B. Hall, published J. Jackson (example in NPG), for Finden's 'Drawing Room Scrap Book'.

1843 Woodcut published *ILN*, II (1843), 117.

c1845 Painting by J. Wheeler (with his staff). Parker Gallery, 1968.

1849 Painting by G. Beechey (commissioned after the battle of Goojerat, 1849, by Colonel Jack). Offered to the NPG by Mary Hay, 1880. Sketched by G. Scharf, 'TSB' (NPG archives), XXVII, 22.

1850 Bust by G.G. Adams (NPG 1202 above).

1850 Anonymous engraving, after a drawing by C. Grey, published J. McGlashan, Dublin (example in NPG).

c1850 Painting by E. Long. Lithographed by J.H. Lynch, published H. Squire, 1850 (example in NPG). Copy by General A.Y. Shortt: East India and Sports Club, London. Anonymous copy: collection of W. Thompson, 1897.

c1850 Model of a bust by E.H. Baily. Exhibited *RA*, 1850 (1441).

1851 Drawing by L. Dickinson. Reproduced R.S. Rait, *Life and Campaigns of Hugh First Viscount Gough* (1903), I, frontispiece.

c1851 Painting by L. Dickinson. Oriental Club, London (plate 361). Exhibited *RA*, 1851 (668). Anonymously engraved (example in NPG), engraving reproduced *History Today*, IX (March 1959), 190. Half-length replica: formerly Defence Service Staff College, India. Copy: Victoria Memorial Hall, Calcutta.

c1851 Painting by J. Harwood. Irish NPG. Exhibited *Royal Hibernian Academy*, 1851, and *Dublin Exhibition*, 1853.

c1852 Painting by H.W. Pickersgill (with his grandson). Exhibited *RA*, 1852 (381).

1853 Painting and drawing by Sir F. Grant (see NPG 805 above).

c 1854 Bust by J. E. Jones. Exhibited *Royal Hibernian Academy*, 1854.
 See W. G. Strickland, *Dictionary of Irish Artists* (1913), I, 559.

c 1857 Bust by J. E. Jones. Exhibited *R A*, 1857 (1328).

1869 Woodcut, after a photograph by Maull & Co, published *ILN*, LIV (1869), 293.

1874–80 Statue by J. H. Foley (on horseback). Phoenix Park, Dublin.

c 1878 Study for the head of an equestrian statue by Sir T. Brock. Exhibited *R A*, 1878 (1535).

Undated Painting by unknown artist. East India and Sports Club, London.

Undated Anonymous bust. India Office, London.

Undated Lithograph by L. Dickinson, after a drawing by C. Grant, published Thacker & Co, Calcutta (example in NPG).

Undated Lithograph by M. and H. Hanhart, engraving by G. J. Stodart, and a photograph (examples in NPG).

GOULBURN *Henry* (*1784–1856*)

Statesman and MP for Cambridge University.

54 See *Groups:* 'The House of Commons, 1833' by Sir G. Hayter, p 526.

GRAHAM *Sir James Robert George, Bart* (*1792–1861*)

Statesman.

54 See *Groups:* 'The House of Commons, 1833' by Sir G. Hayter, p 526.
342, 3 See *Groups:* 'The Fine Arts Commissioners, 1846' by J. Partridge, p 545.
1125 See *Groups:* 'The Coalition Ministry, 1854' by Sir J. Gilbert, p 550.

GRAHAM *Thomas* (*1805–69*)

Chemist; professor of chemistry at Glasgow, 1830–7, and at University College, London, 1837–55; master of the mint, 1855–69; discovered the polybasic character of phosphoric acid; made valuable researches on the compounds of alcohol with salts; introduced the 'Graham tube'; published *Elements of Chemistry*, 1842, and other works.

2164 Oil on canvas, $32 \times 26\frac{5}{8}$ inches ($81 \cdot 3 \times 67 \cdot 5$ cm), by WILHELM TRAUTSCHOLD. PLATE 362

Collections: Walter Krug, purchased from him, 1927.

Literature: Reproduced *Das Neunzehnte Jahrhundert in Bildnissen* (1899, Berlin), III, 247, and *Connoisseur*, LXXX (1928), 259.

The early history of this picture is unknown, but it certainly represents Graham. The name of the artist was supplied by the donor. A reproduction was published by the Berlin Photographische Gesellschaft (example in NPG). Trautschold, who was born and trained in Germany, spent some years in Liverpool, and later in London. He painted a number of English sitters (see for instance his portrait of J. S. Knowles, NPG 2003, also catalogued here).

Description: Healthy complexion, brown eyes, brown hair and whiskers. Dressed in a dark stock and neck-tie, white shirt, bluish-white waistcoat, dark brown coat, fawn trousers. Seated in a chair covered with red material. Curtain at right red and orange, rest of background brown.

ICONOGRAPHY A painting by C. Harding was exhibited *R A*, 1826 (334); a statue by W. Brodie is at Glasgow, reproduced as a woodcut *ILN*, LX (1872), 592; a medallion by J. W. Minton was exhibited *R A*, 1871 (1238–9); there are various engravings by C. Cook and photographs (examples in NPG); a lithograph by W.

Bosley was published Claudet, 1849; an engraving by S. Bellin, and a lithograph by Shappen, after a daguerreotype by Mayall, 1850 (examples in British Museum).

GRANT *Sir Francis* (*1803–78*)

Portrait painter and president of the RA; brother of Sir James Hope Grant (see below); made reputation as a painter of sporting scenes; subsequently established himself as the most fashionable and successful portraitist of the period; president of RA, 1866–78.

1286 Oil on canvas, $29\frac{7}{8} \times 24\frac{7}{8}$ inches (75·8 × 63·1 cm), by HIMSELF, *c*1845. PLATE 366

A label referring to the 1887 exhibition was formerly on the back of the picture.

Collections: The artist; by descent to his son, Colonel Frank Grant, and presented by his sister, Miss Elizabeth Catherine Grant, 1901.

Exhibitions: Royal Jubilee Exhibition, Manchester, 1887 (646); *VE*, 1892 (179).

The date is based on costume, the apparent age of the sitter, and comparison with other self-portraits (see iconography below).

Description: Healthy complexion, greenish-grey eyes, brown hair and whiskers. Dressed in a dark green stock, white shirt, black coat and waistcoat, gold and amber stock-pin, and gold chain. Background colour dark brown.

2521 With Sir Edwin Landseer. Pencil on paper, $7\frac{1}{4} \times 5\frac{7}{8}$ inches (18·5 × 14·9 cm), by CHARLES BELL BIRCH, *c*1870. PLATE 364

Inscribed (bottom left): Sir F. Grant PRA/& Sir E. Landseer R.A. *and (bottom centre):* sketched from life by C.B. Birch ARA

Collections: The artist; by descent to his nephew, George von Pirch, and presented by him, 1931.

If the inscription is contemporary with the drawing, the latter must have been executed between 1866, when Grant became president of the Royal Academy, and 1873, when Landseer died.

1088 Plaster cast, painted cream, $26\frac{1}{2}$ inches (66·7 cm) high, of a bust by MISS MARY GRANT, 1866. PLATE 365

Incised on one side of the base: MARY GRANT./1866 Sc.

Collections: The artist, purchased from her, 1897.

This plaster cast is closely related to the marble bust of Grant by Miss Grant, exhibited *RA*, 1866 (878), and presented by her to the Royal Academy in 1876. Miss Grant was the niece of the sitter. Another smaller bust by Miss Grant is also in the Royal Academy.

ICONOGRAPHY This does not include photographs, of which there are several examples in the NPG; Grant appears in two family group portraits in an album belonging to the 9th/12th Royal Lancers (see iconography of Sir James Hope Grant below).

1822 Painting by Sir J. Watson Gordon (in Elizabethan costume). Collection of the Hon Mrs G. Walsh (his granddaughter), Langham.

1823 Painting by J. Ferneley (with his brothers on horseback). Leicester Museum and Art Gallery.

1825 Painting called Grant by J. Ferneley, the figures attributed to Grant (with Lord Howth, jumping a gate). Collection of Mrs A. Smith, Market Overton. Reproduced Major G. Paget, *The Melton Mowbray of John Ferneley* (1931), facing p24. Another version: Howth Castle.

c1840 Painting by himself. Collection of Mrs Malcolm Patten (his granddaughter), 1937 (plate 363). Reproduced *Apollo*, LXXIX (June 1964), 479.

c1840 Painting by himself. Collection of the Hon Mrs G. Walsh.

c1842 Bust by E. Davis. Exhibited *RA*, 1842 (1330).

1843 Drawing by Count A. D'Orsay. Sotheby's, 13 February 1950 (lot 216), bought Colnaghi.

1845 Woodcut published *ILN*, VI (1845), 292.

c1845 Painting by himself (NPG 1286 above).

c1846 Painting by Sir J. Watson Gordon. Exhibited *RA*, 1846 (253).
Lithographed by T. Fairland (example in NPG; this is inscribed in pencil: 'Francis Grant/to/Count D'Orsay, 1847').

c1846 Miniature by Sir W. C. Ross. Collection of the Hon Mrs G. Walsh.
Drawing after this by Sir F. Grant (dated 1846): Sotheby's, 10 June 1965 (lot 12), bought Agnew.

c1847 Bust by Count A. D'Orsay. Exhibited *RA*, 1847 (1434).

c1847 Plaster statuette by Count A. D'Orsay. Collection of Hon Mrs G. Walsh.

c1850 Painting by J. Ferneley (on Grindal). Collection of Sir R. G. Gilmour, 1931.
Reproduced Major G. Paget, *The Melton Mowbray of John Ferneley* (1931), facing p 51. Probably the picture exhibited *RA*, 1850 (536).

c1850 Painting by J. Ferneley. Collection of Mrs Archibald Smith (his granddaughter), Market Overton.

c1850 Water-colour by an unknown artist (style of Dighton). Collection of the Hon Mrs G. Walsh.

c1855 Engraving by J. Faed. Exhibited *RA*, 1855 (999).

c1865 Painting by himself. Royal Academy, London.
Exhibited *Treasures of the Royal Academy*, RA, 1963 (234). Reproduced *Country Life*, CXXXI (June 1962), 1372. Engraved by G. T. Doo, published 1879 (example in NPG), engraving exhibited *RA*, 1879 (1192).

c1866 Marble bust by Miss M. Grant. Royal Academy, London.
Exhibited *RA*, 1866 (878). Plaster cast (NPG 1088 above). A small marble bust by Miss Grant is also in the Royal Academy.

1866 Woodcut published *ILN*, XLVIII (1866), 232.

c1870 Drawing by C. B. Birch (with Sir E. Landseer) (NPG 2521 above).

1875 Marble bust by H. Weekes. Collection of T. Lewis, 1904.

c1882 Bust by T. G. Stowers. Exhibited *RA*, 1882 (1243).

Undated Painting by J. P. Knight. Scottish NPG.

Undated Drawing by J. R. Swinton. Collection of Mrs Archibald Smith.

Undated Drawing by D. Maclise. Victoria and Albert Museum, London.

Undated Drawing by Sir E. Landseer. Landseer Sale, Christie's, 13 May 1874 (lot 764).

Undated Parian ware bust by J. Noble. Royal Collection.
Exhibited *VE*, 1892 (493).

Undated Drawing called Grant and attributed to him. Küpferstichkabinett, Staatliche Kunstsammlungen, Dresden.

GRANT *Sir James Hope* (*1808–75*)

General; brother of Sir Francis Grant (see above); served with the 9th Lancers, 1826–58; served with Lord Saltoun in first China war, 1840–2; distinguished himself during the Sikh wars and the Indian mutiny; commander-in-chief at Madras, 1862–3; commander of the camp at Aldershot, 1870.

783 Oil on canvas, $84\frac{1}{8} \times 52\frac{3}{4}$ inches (213·6 × 134·2 cm), by SIR FRANCIS GRANT (his brother), *c*1861(?).
PLATE 367

Inscribed on the back of the canvas: Liu^t Gen^l Sir J. Hope Grant GCB/by/Sir Francis Grant PRA

Collections: The artist, purchased from his son, Colonel Frank Grant, 1888.

Exhibitions: Possibly *Royal Scottish Academy*, 1865 (452).

Literature: Grant's 'Sitters Book' (copy of original MS, NPG archives), under the year 1868; F.Rinder and W.D.McKay, *The Royal Scottish Academy, 1826–1916* (1917), p 143.

According to a list of portraits of Grant drawn up by his nephew, Charles Grant (included in an album in the collection of the 9th/12th Royal Lancers), this portrait was painted in the artist's studio. The sword on the wall behind Grant is a Sikh *tulwar*, which he frequently wore. He is shown playing a violincello on which he was a first-rate performer. In 1841 his musical skill helped to secure him a command under Lord Saltoun, an ardent lover of music. A photograph by Rodger of St Andrews, apparently dating from 1861 (example in the album belonging to the 9th Lancers, plate 369), also shows Grant playing a violincello, and is similar in pose to the NPG portrait, though the angle of the head is different. 'A sketch with fiddle', now untraced, was said by Charles Grant to be in a scrapbook at Kilgraston in 1876. The date of the NPG portrait is not certain. Rinder suggests that it was the portrait exhibited at the Royal Scottish Academy in 1865, but there is no conclusive evidence. If the inscription on the back is contemporary with the portrait, it would mean that it must have been painted after March 1866, when the artist was elected president of the Royal Academy, and later knighted. Sir Francis Grant's date in his 'Sitters Book' provides no certain solution, since another portrait of his brother is listed under the year 1868 (now in the United Service Club, see iconography below), although exhibited at the *RA* in 1862. This last portrait was apparently painted on Grant's visit to England in 1861, when the NPG portrait may well have been begun, if not finished; Grant's apparent age and the evidence of other portraits (including the photograph of 1861 discussed above) supports the earlier dating.

Description: Blue eyes, brown hair and whiskers. Dressed in a dark red stock, gold stock-pin, white shirt, dark brown coat, fawn trousers. Seated in a dark gilt chair, covered in dark red or brown material. Sword harness dark red, gilt sword-hilt, dark green scabbard. Floor, curtain at right and background dark brown. Brown violincello; green book on floor.

ICONOGRAPHY The album of photographs in the possession of the 9th/12th Royal Lancers, Market Harborough, was presented to them in 1876 by Charles Grant of Kilgraston, the nephew of Sir James and Sir Francis Grant. The album also contains a list of portraits of Sir James Grant compiled by Charles Grant. Major R.M.Collins of the 9th/12th Royal Lancers very kindly loaned this album to the NPG, and helped to elucidate several points. A copy of Sir Francis Grant's 'Sitters Book' is in the NPG archives.

1828 Painting by Sir F.Grant (on horseback, in uniform of 9th Lancers). Formerly collection of Col Hamilton Grant, Biel. Listed in Grant's 'Sitters Book', under the year 1828.
Photograph of the painting in Lancers' album, where the horse is said to be 'John Gray', belonging to John Grant of Kilgraston (brother of the sitter).

1853 Painting by Sir F.Grant (as Colonel of the 9th Lancers). Scottish NPG.
Exhibited *RA*, 1854 (138), and *Royal Scottish Academy*, 1860 (403). Oil study: Sotheby's, 15 February 1967 (lot 64), misnamed 'Sir Horace Grant', and probably artist's sale, Christie's, 28 March 1879 (lot 62).

1854 Painting by Sir F.Grant (half-length in mess uniform). Collection of Sir David Home (plate 368). Reproduced *Apollo*, LXXIX (1964), 485.

1857 'The Relief of Lucknow' by T.J.Barker, after sketches by E.Lundgren. Corporation of Glasgow. Engraved by C.G.Lewis, published Agnew, 1863 (example in NPG). Lundgren's sketches were sold Christie's, 16 April 1875.

1858 Photograph by Beato (taken in India) (cutting from *Picture Post* in NPG).

1860 Water-colour by Colonel H.H.Crealock. National Army Museum.
Probably the sketch mentioned in Charles Grant's list (no.8), with Colonel Probyn, in China.

1860 Anonymous photograph (as commander-in-chief in China) (example in Lancers' album).

1861 Bust by Miss M. Grant (his niece). Collection of Admiral Barrington Brooke, Biel.

1861 Photograph by Rodger of St Andrews (playing a violincello) (example in Lancers' Album, plate 369)

c1861(?) Painting by Sir F. Grant (NPG 783 above).

c1861 Two photographs (in civilian dress) by Rodger of St Andrews. Listed by Charles Grant.

c1861 Painting by Sir F. Grant (before the Anting Gates of Pekin, with Major Grant and Major Anson). United Service Club, London. Mentioned in Grant's 'Sitter's Book', under the year 1868. Exhibited *RA*, 1862 (208). Engraved by J. Scott, published Graves, 1863 (example in NPG). A letter from Sir Francis Grant to Sir George Scharf of 19 September 1878 (copy, NPG archives) contains information about the portrait.

c1862 Anonymous engraving (on horseback, in winter costume), published J. Hogarth, 1862 (example in the collection of the 9th/12th Royal Lancers).

1864 'Intellect and Valour of Great Britain', engraving by C. G. Lewis, after T. J. Barker, published J. G. Browne, Leicester, 1864 (example in NPG); key-plate, published Browne, 1863 (example in British Museum).

1865 Painting by Sir F. Grant (as commander-in-chief, Madras). Lawrence Asylum, Madras. Exhibited *RA*, 1867 (137). Probably the picture listed in Grant's 'Sitters Book', under the year 1865. Oil-study: collection of Admiral Barrington Brooke, Biel.

1870 Marble bust by Miss M. Grant (his niece). Collection of Admiral Barrington Brooke, Biel. Exhibited *RA*, 1870 (1057).

c1870 Bust by T. Woolner. Exhibited *RA*, 1870 (1115).

c1870 Photograph by Rodger of St Andrews (with his two brothers and sister) (example in Lancers' album).

c1871 Marble bust by T. Woolner. Exhibited *RA*, 1871 (1303).

1873 Two photographs by Hill & Co, Windsor (with his staff on autumn manoeuvres at Aldershot) (examples in Lancers' album, see plate 370).

1873 Photograph by Rodger of St Andrews (playing golf) (example in Lancers' album).

1874 Two photographs by Bassano of London (in general's uniform) (examples in Lancers' album).

1874 Photograph by Rodger of St Andrews (example in Lancers' album).

1875 Two woodcuts published *ILN*, LXVI (1875), 273, and *The Graphic*, 20 March 1875.

1876 Water-colour by Colonel H. H. Crealock (executed at Aldershot). Listed by Charles Grant.

Undated Various sketches (with Colonel Probyn in China, with a fiddle, playing chess, hunting at Dunse Castle, etc). Listed by Charles Grant.

Undated Two statuettes by Count A. D'Orsay. Lady Blessington's Sale, Phillips, 7–26 May 1849 (lots 264 and 267).

Undated Parian ware bust by J. Noble. Royal Collection. Exhibited *VE*, 1892 (482).

Undated Lithograph by Black of Regent Street. Listed by Charles Grant.

Undated Anonymous photograph (example in Lancers' album).

GRANT *Sir John Peter* (*1807–93*)

Indian and colonial governor; son of the chief justice of Calcutta, Sir John Peter Grant (1774–1848); assistant in board of revenue, Calcutta, 1832; secretary to government of Bengal, 1848–52; governor-general of Central Provinces, 1857–9; governor of Jamaica, 1866–73.

1127 Oil on canvas, 26 × 21⅛ inches (66·2 × 53·6 cm), by GEORGE FREDERICK WATTS. PLATE 371

Collections: The artist, presented by him, 1898 (see appendix on portraits by G. F. Watts in forth-coming Catalogue of Portraits, 1860–90).

Exhibitions: Winter Exhibition, Grosvenor Gallery, 1882 (182).

Literature: 'Catalogue of Works by G. F. Watts', compiled by Mrs Watts (MS, Watts Gallery, Compton), II, 59.

This portrait was painted sometime after 1873, as a result of Watts' admiration for Grant's administration in Jamaica.

Description: Dark eyes, grey hair and beard. Dressed in a dark tie, white shirt and dark coat. Seated in a chair. Background colour dark brown.

ICONOGRAPHY No other portraits of Grant are recorded.

GRANT *Sir Patrick (1804–95)*

Field-marshal; served in India with the 11th Bengal native infantry; served in Gwalior campaign, 1843, and in Sikh wars, 1845–6, and 1849; commander-in-chief of Madras army, 1856–61; temporarily commander-in-chief in India, 1857; governor and commander-in-chief of Malta, 1867–72; governor of Chelsea Hospital, 1874–95.

1454 Oil on canvas, 17 × 12⅛ inches (43·3 × 30·8 cm), by E. J. TURNER, after a photograph by MAULL AND FOX, of post-1883. PLATE 372

Collections: The sitter, presented by some members of his family, 1907.

According to Maull and Fox,[1] this painting was finished from life, but, apart from the addition of a cloak, it is hardly distinguishable from the Maull and Fox photograph, the head and shoulders of which was reproduced as a woodcut in an illustrated magazine (cutting in NPG). It is a variant of a similar portrait painted for a member of the family (possibly the earlier portrait attributed to Buckner – see iconography below). Grant is dressed in a field-marshal's uniform of post-1880 (he was promoted in 1883), and is wearing the sash, star and cross of the Bath, and the star of the order of St George and St Michael. The four medals, inaccurately copied from the photograph, are the Sutlej medal, Indian General Service medal (North-West Frontier clasp), Punjab medal and Gwalior star (for Punniar or Maharajpoor).[2]

Description: Dark eyes, grey hair and beard. Dressed in a red uniform, liberally decorated with gold braid, white breeches, black boots, white gloves, and black cloak with crimson lining. Black hat with braid and white feathers. Gilt sword scabbard, white hilt. Red and gold baton. Pillars at right brown. Background landscape green and brown. Sky grey and blue.

4251 Water-colour on paper, 9½ × 7⅛ inches (24·2 × 18·2 cm), by CAPTAIN MARTIN, *c* 1856–61. PLATE 373

Inscribed in pencil (bottom left and centre): Lt Genl Sir Patrick Grant by Capt Martin

Collections: Messrs Suckling & Co, purchased from them, 1962.

See the entry for Sir Mark Cubbon (NPG 4250), where both water-colours are discussed.

Description: Healthy complexion, brown eyes, brown hair and whiskers with grey streaks. Dressed in a dark stock, white shirt, brown waistcoat and coat.

[1] Memorandum of an interview with a member of the firm, 17 January 1907 (NPG archives), who provided the name of the artist; E. J. Turner is not recorded in any of the standard dictionaries of artists.

[2] Information on uniform and decorations kindly communicated by Major N.P. Dawnay.

ICONOGRAPHY A painting by Miss M. Fraser-Tytler (later Mrs G. F. Watts) of 1887 is in the Royal Horse Guards, London, erroneously stated to be by G. F. Watts in the *Dictionary of National Biography*, where another portrait also said to be by Watts is listed as in the possession of the Grant family; a painting attributed to R. Buckner was in the collection of the Countess of Seafield, Castle Grant; a statue or bust by G. Wade is at Royal Hospital, Chelsea; a bust by F. Verheyden was exhibited *RA*, 1897 (1954); there is a photograph in the NPG.

GRANT *Sir Robert* (*1779–1838*)

Statesman, governor of Bombay, and MP for Finsbury.

54 See *Groups*: 'The House of Commons, 1833' by Sir G. Hayter, p 526.

GRANVILLE *Granville George Leveson-Gower, 2nd Earl of* (*1815–91*)

Statesman.

1125 See *Groups*: 'The Coalition Ministry, 1854' by Sir J. Gilbert, p 550.

See also forthcoming Catalogue of Portraits, 1860–90.

GRAVES *Henry* (*1806–92*)

Printseller; brother of the engraver, Robert Graves (1798–1873); sole proprietor of the firm of Henry Graves & Co, 1844; published numerous engravings after Victorian subject paintings and portraits; one of the founders of the *Art Journal* and *Illustrated London News*; a key figure in the print market.

1774b Coloured chalk on paper, 24¼ × 19⅜ inches (61·7 × 49·2 cm), by FREDERICK SANDYS. PLATE 374

Collections: Presented by the sitter's son, Algernon Graves, 1916.

The name of the artist was provided by the donor. It must be an early work by Sandys, reflecting the influence of Richmond. His later crayon drawings are quite different in style.

ICONOGRAPHY A painting by W. M. Tweedie was exhibited *RA*, 1866 (443), engraved by twelve engravers (example in NPG); busts by H. B. Burlowe and C. Bacon were exhibited *RA*, 1831 (1174), and 1866 (999); there is a photograph by H. S. Mendelssohn of Newcastle-on-Tyne in the NPG.

GREEN *Charles* (*1785–1870*)

Aeronaut; made first ascent in a balloon with carburetted hydrogen gas, 1821; constructed great Nassau balloon and made record journey to Weilburg, 1836; made 526 ascents, 1821–52; one of the great aeronautical pioneers of the period.

2557 Oil on panel, 14⅛ × 11⅜ inches (36 × 29 cm), by HILAIRE LEDRU, 1835. PLATE 375

Signed (bottom right): Hilaire Ledru *Inscribed and dated (middle left)*: Charles Green Esq:/1835

Collections: Purchased at Robinson, Fisher and Harding, 1 December 1932 (lot 87).

Description: Grey-green eyes, brown hair. Dressed in a dark stock, white shirt, brown waistcoat, black coat, fawn trousers. Seated in a red-covered armchair. Red curtain behind at right, wall at left green. Brown and white balloon above greenish blue landscape.

4710 See *Groups*: 'A Consultation Previous to an Aerial Voyage to Weilburg, 1836' by J. Hollins, p 537.

ICONOGRAPHY A painting by J. Hollins of 1837 was in the collection of Mrs Robert Hollond, 1880, sketched by G. Scharf, 'TSB' (NPG archives), XXVII, 31, engraved by G. T. Payne, published Hodgson and Graves, 1838 (example in NPG); a lithograph by G. P. Harding was published Harding, 1839 (example in NPG),

reproduced *Connoisseur*, XXVII (1910), 272; a woodcut, after a photograph by Mayall, was published *ILN*, LVI (1870), 401; a daguerreotype by Mayall, showing Green in his balloon, is reproduced as a woodcut *ILN*, XXI (1852), 192.

GREENE *Thomas* (*1794–1872*)

MP for Lancaster.

54 See *Groups*: 'The House of Commons, 1833' by Sir G. Hayter, p 526.

GREVILLE *Charles Cavendish Fulke* (*1794–1865*)

Clerk to the council; manager of the Duke of York's stud, and racing partner of Lord George Bentinck; clerk to council, 1821–59; intimate with statesmen, especially Wellington and Palmerston; his famous *Diary* is a primary source for the politics and personalities of the period.

3773 Red and black chalk and pencil on paper, 11 × 8⅛ inches (27·9 × 20·6 cm), by COUNT ALFRED D'ORSAY, 1840. PLATE 376

Signed and dated in pencil (*lower left*): A. d'Orsay/fecit/24 Mai 1840. *Autograph signature of sitter in ink* (*lower centre*): C. Greville

Collections: See *Collections:* 'Drawings of Men About Town, 1832–48' by Count A. D'Orsay, p 557.

This drawing is one of over fifty profile portraits by D'Orsay in the NPG. It was lithographed by R. J. Lane, published J. Mitchell (example in NPG); the lithograph is mentioned in Lane's 'Account Books' (NPG archives), II, 40, as being completed on 9 July 1840.

ICONOGRAPHY A painting by E. Long was exhibited *RA*, 1856 (476), possibly the unattributed painting in the collection of the Duke of Richmond; a painting called Greville (it seems unlikely that Greville is the young man in this portrait, which appears to date from the 1790s) by J. Hoppner is in the collection of the Duke of Richmond; Greville appears in 'Queen Victoria Presiding at her First Council' by Sir D. Wilkie in the Royal Collection, exhibited *RA*, 1838 (60), engraved by C. Fox, published F. G. Moon, 1839 (example in British Museum); a miniature by R. Cosway is listed by G. C. Williamson, *Richard Cosway, R.A.* (1897), p 119, as then in the collection of the Countess of Strafford; a lithograph by J. Brown, after a photograph by Mayall, is reproduced *British Sports and Sportsmen*, edited by 'The Sportsman' (1908), I, facing 27.

GREVILLE *Sir Charles John* (*1780–1836*)

MP for Warwick.

54 See *Groups*: 'The House of Commons, 1833' by Sir G. Hayter, p 526.

GREVILLE *Robert Kaye* (*1794–1866*)

Botanist, and slavery abolitionist.

599 See *Groups*: 'The Anti-Slavery Society Convention, 1840' by B. R. Haydon, p 538.

GREY *Charles Grey, 2nd Earl* (*1764–1845*)

Prime minister; a supporter of Charles James Fox; one of the managers of Warren Hastings' impeachment, 1787; advocate of reform; foreign secretary, 1806–7; prime minister, 1831–4; successfully carried the great Reform Bill, 1832.

1190 Oil on canvas, 30 × 24¾ inches (76·2 × 63 cm), by an UNKNOWN ARTIST, after a portrait by SIR THOMAS LAWRENCE of *c* 1828. PLATE 381

Collections: Messrs Leggatt, purchased from them, 1899.

Literature: K. Garlick, 'Lawrence Catalogue', *Walpole Society*, XXXIX (1962–4), 95.

This is a copy of the three-quarter length portrait of Grey by Lawrence in the collection of Lady Mary Howick, exhibited *RA*, 1828 (158), and *SKM*, 1868 (310), engraved by S. Cousins, published Colnaghi, 1830 (example in NPG). The NPG portrait is clearly not from Lawrence's hand. Another version of the portrait (similar in size to the original) was sold at Parke-Bernet, New York, 20 May 1960 (228), reproduced in sale catalogue. A copy is in the collection of F. D. Berkeley.

Description: Dark eyes, greyish hair. Dressed in a white stock and shirt and dark coat. Red curtain behind, except lower left and bottom right where greenish-brown.

4137 Oil on canvas, $50\frac{1}{4} \times 39\frac{3}{4}$ inches (127·6 × 101 cm), attributed to THOMAS PHILLIPS, *c* 1820. PLATE 383

Collections: E. Kersley, purchased from him, 1960.

Literature: Possibly the three-quarter length portrait recorded in the artist's 'Sitters Book' (copy of original MS, NPG archives), under 1821.

Phillips painted two almost identical portraits of Grey in 1810–11 (see iconography below), and three portraits are recorded in his 'Sitters Book' (copy of original MS, NPG archives), under the years 1820 and 1821; these almost certainly represent a new portrait-type and are not further versions of the 1810 portrait. The 1820 portrait was a half-length, recorded in the 'Sitters Book' as being that exhibited *RA*, 1820 (51), and commissioned by a Mr Lambton. Under 1821, Phillips records two portraits commissioned by Earl Fitzwilliam – a three-quarter length and a kit-cat. The present Earl Fitzwilliam remembers having only one portrait which he sold around 1950; he described it in a letter of 8 August 1966 (NPG archives) as being almost identical with the head and shoulders of the NPG portrait, and its size as roughly 30 × 24 inches (76·2 × 61 cm). Although not technically large enough for the kit-cat size (36 × 28 inches), the Earl's portrait can be assumed to be the kit-cat recorded by Phillips. The size of the NPG portrait suggests that it could be the three-quarter length portrait also recorded under 1821. The style points almost conclusively to Phillips as the artist (there is no doubt that it represents Grey), and the year 1821 agrees excellently with Grey's costume, his apparent age, and other portraits of known date. There is no other evidence to show how the portrait commissioned for Earl Fitzwilliam could have come into the collection of Mr Kersley, but the NPG portrait is certainly not Mr Lambton's half-length portrait (now unlocated). The NPG portrait shows Grey standing in front of his 'peer's robes', and a volume entitled . . .[?] *of England*.

Description: Dark eyes, brown hair. Dressed in a white stock and shirt, black waistcoat and coat, holding a white piece of paper. Red, ermine and braid robes, and a brown leather-bound book on table behind with multi-coloured cloth. Red-figured material behind at right and in the centre, strips of it at left between brown panels.

316a (59) Pencil on paper, $17 \times 12\frac{1}{4}$ inches (43·3 × 31·3 cm), by SIR FRANCIS CHANTREY, after 1830. PLATE 379

Inscribed in pencil (lower right): Lord Grey

Collections: The artist; George Jones RA (one of Chantrey's executors), presented by his wife, 1871.

There is no record of a bust of Grey by Chantrey to which this 'camera lucida' drawing could relate. The date is based on Grey's apparent age and a comparison with other portraits. The NPG drawing is one of a large collection of Chantrey drawings which will be collectively discussed in the forthcoming Catalogue of Portraits, 1790–1830.

3784 Pencil on paper, $20\frac{7}{8} \times 16\frac{5}{8}$ inches (53·2 × 42·2 cm), by BENJAMIN ROBERT HAYDON, 1834. PLATE 378

Inscribed in pencil (bottom centre): Lord Grey (House of Lords) *and (bottom right):* Jan 11 – 1834

Collections: Presented by A. T. Playfair, 1951.

Literature: Diary of Benjamin Robert Haydon, edited W.B.Pope (Harvard University Press, 1963), IV, 149–51.

This drawing is a study for Haydon's picture of 'The Reform Banquet, 1832', commissioned by Earl Grey for 500 guineas, and now in the collection of his descendant, Lady Mary Howick; it was etched by F.Bromley, published S.C.Bromley, 1835 (example in NPG). Haydon attended the Reform Banquet on 11 July 1832 in a delirium of excitement, and commenced his picture soon afterwards. He received a number of sittings from Grey, writing, for example, on 11 January 1834 (the date of the NPG drawing) (*Diary*, IV, 149):

Lord Grey sat, very pleasantly indeed, and I made in my own opinion and that of Lord Lansdowne, a successful drawing. Sir W.Gordon came in, and suggested one or two things of great use. He said Lord Grey's basis of character was excessive amiability, and it was this which attached others to him. He wished me to soften one or two things, "for instance, the brow", said he; "if a man was dressed it would not be up". Lord Grey smoothed it down. Sir Willoughby little thought what a principle of Art was here concealed! – dressed! Nature dressed!

Haydon found it difficult to reconcile the expectations of Grey and his family with his own desire for truth. Of a sketch made in his diary on 8 April 1833, he wrote (*Diary*, IV, 71, sketch reproduced 72): '*This is really like now, but the family would not be pleased*'. He also had difficulties in selecting a pose for Grey, showing him first in profile, then more three-quarter face, as in the NPG drawing, and finally almost full face. Three similar studies are in the Laing Art Gallery, Newcastle; a drawing of a different type was formerly in the collection of M.Buxton Forman; and several others are in the collection of Earl Spencer, who owns two albums of studies for the group.

On 12 January 1834, Haydon wrote in his diary (*Diary*, IV, 152): '*As soon as I have satisfied them with the likeness in the Picture* [i.e. the group], *I will paint a Portrait of him for myself*'. Haydon records a painting executed in September 1833, apparently that showing Grey in his study now in the Laing Art Gallery (plate 191), the latter was engraved by G.R.Ward, with the title, 'Shall I Resign?', published F.G.Moon, 1836 (example in NPG). Another portrait by Haydon, showing Grey against a landscape, but in a similar pose to that in 'The Reform Banquet', was engraved by H.Cook, published J.Dowding, 1840 (example in NPG), for 'Political Reformers'; this may have been entirely derived from the group by the engraver, and not from another independent painting by Haydon.

54 See *Groups:* 'The House of Commons, 1833' by Sir G.Hayter, p 526.

999 See *Groups:* 'The House of Lords, 1820' by Sir G.Hayter, in forthcoming Catalogue of Portraits, 1790–1830.

ICONOGRAPHY This does not include the pencil caricatures by John Doyle in the British Museum, for which see L.Binyon, *Catalogue of Drawings by British Artists*, II (1900).

1784 Painting by G.Romney. Eton College, Windsor (plate 377).
Reproduced L.Cust, *Eton College Portraits* (1910), plate XI, facing p 22.

1784 Painting by G.Romney. Collection of Lady Mary Howick, Howick.
Reproduced H.Ward and W.Roberts, *Romney* (1904), II, facing 66.

1789 Anonymous engraving, published W.Jones, 1789 (example in NPG).

1793 Painting by Sir T.Lawrence. Collection of Lady Mary Howick.
Exhibited *RA*, 1793 (614), and *SKM*, 1867 (860). Engraved by W.Dickinson, published W.Austin, 1794 (example in British Museum). A copy of this or the 1828 portrait (see below) is at Castle Howard.

1794 Drawing by H.Bone (based on the painting by Lawrence of 1793). NPG (Bone's Drawings, III, 2).
Engraved by Hopwood, published H.Symonds, 1807 (example in NPG).

1795 Anonymous engraving, published B.Crosby, 1795 (example in NPG).

1803 Bust by J. Nollekens. Collection of the Duke of Bedford, Woburn Abbey.

1804 Bust by J. Nollekens. Collection of Major Whitbread, Southill.
Exhibited *RA*, 1804 (947).

1804 Anonymous engraving, published R. Phillips, 1804 (example in NPG), for 'Public Characters'.

1805 Painting by Sir T. Lawrence. Collection of Mr and Mrs Fielding Marshall.
Possibly the painting exhibited *RA*, 1805 (96): see *Walpole Society*, XXXIX (1962–4), 95.

1809 Painting by J. Northcote. Collection of Major Whitbread, Southill.
See Northcote's 'Commonplace Book' (MS, NPG archives), p 30, which also lists a repetition for Grey's friend, Samuel Whitbread, who commissioned the original.

1810 Painting by Sir W. Beechey. Offered to the NPG in 1860 and 1870.
Sketched by G. Scharf, 'TSB' (NPG archives), IV, 30.

1810 Painting by T. Phillips. Collection of Earl Spencer, Althorp.
Listed in Phillips' 'Sitters Book' (copy of original MS, NPG archives), under 1810.
Engraved by C. Turner, published A. Molteno, 1811 (example in NPG).

1811 Painting by T. Phillips (replica of portrait above). Ilchester collection.
Listed in Phillips 'Sitters Book', under 1811. Engraved by R. Hicks, published P. Jackson (example in NPG).

1816 Engraving by S. W. Reynolds, after J. R. Smith, published E. Orme, 1816 (example in British Museum).

1820–1 Paintings by T. Phillips (see NPG 4137 above).

1820 'The House of Lords, 1820' by Sir G. Hayter (NPG 999 above).

1820 'The Trial of Queen Caroline, 1820', water-colour by R. Bowyer, A. Pugin, and J. Stephanoff. Houses of Parliament. Engraved by J. G. Murray, published Bowyer, 1823 (example in British Museum).

c1821 Painting (in peer's robes) by J. Jackson. Collection of the Earl of Jersey.
Probably the portrait exhibited *RA*, 1821 (58).

1823 Anonymous engraving, published 1823 (example in British Museum), for *The Unique*.

c1825 Bust by W. Behnes. Exhibited *RA*, 1825 (1008).
Silver medal after this by W. Bain, exhibited *RA*, 1832 (1055).

c1826 Painting by J. Jackson. Victoria and Albert Museum.
Engraved by W. J. Ward, published W. Ward, 1833 (example in NPG). Probably the portrait exhibited *RA*, 1826 (82).

1827 Marble bust by T. Campbell. Palace of Westminster, London (plate 380).

1828 Painting by Sir T. Lawrence. Collection of Lady Mary Howick.
Exhibited *RA*, 1828 (158), and *VE*, 1892 (4). Reproduced G. M. Trevelyan, *Lord Grey of the Reform Bill* (1920), frontispiece. Engraved by S. Cousins, published Colnaghi, 1830, and by others (examples in NPG). Other versions (see NPG 1190 above).

c1828 Miniature by Sir W. C. Ross. Exhibited *RA*, 1828 (881).

1830 Painting by Sir D. Wilkie. Collection of Captain Leggatt, 1860.
Sketched by G. Scharf, 'TSB' (NPG archives), IV, 13.

After 1830 Drawing by Sir F. Chantrey (NPG 316a (59) above).

1831 Marble bust by T. Campbell. Collection of Lady Mary Howick.
Exhibited *RA*, 1832 (1219). Another bust by Campbell is in the Royal Collection.

1832 'The Reform Bill Receiving the King's Assent' by S. W. Reynolds. Houses of Parliament. Engraved by W. Walker and S. W. Reynolds junior, published Walker, 1836 (example in NPG).
The painting is based on a drawing by J. Doyle, also in the Houses of Parliament.

1832 'The Reform Banquet, 1832' by B.R.Haydon. Collection of Lady Mary Howick. Etched by F. Bromley, published J.C.Bromley, 1835 (example in NPG); engraved and published by J.C.Bromley, 1837 (example in British Museum). For studies and other portraits by Haydon (see NPG 3784 above).

c1832 Bust by J.Francis. Exhibited *RA*, 1832 (1148).

c1832 Marble cabinet statue by J.Francis. Exhibited *RA*, 1832 (1226).

c1832 Lithograph by T.C.Wilson (holding Reform Bill), published S.Gans (example in NPG).

c1832 'William IV Holding a Council', lithograph by J.Knight (example in British Museum).

c1832 Anonymous engraving (holding Reform Bill) (example in NPG).

1833 Painting by F.R.Say. Ex-collections of Sir Robert Peel and the Earl of Rosebery, sold Sotheby's, 12 December 1956 (lot 67), bought Lord Lambton. Exhibited *RA*, 1833 (28). Engraved by W.Say, published Ackermann, 1833 (example in NPG).

1833 'The House of Commons, 1833' by Sir G.Hayter (NPG 54 above).

c1835 Model for a statue by S.Gahagan. Exhibited *RA*, 1835 (1094).

1837 'The First Council of Queen Victoria' by Sir D.Wilkie. Royal Collection. Exhibited *RA*, 1838 (60). Reproduced Sir H.Maxwell, *Sixty Years a Queen* (1897), p5. Engraved by C.Fox, published F.G.Moon, 1839 (example in British Museum).

1837 Marble bust by E.H.Baily. Newcastle-upon-Tyne. *Exhibited RA*, 1837 (1273).

c1837 Painting by J.Ramsay. Literary and Philosophical Society, Newcastle-upon-Tyne. Exhibited *RA*, 1837 (311).

c1837 Monument by J.and B.Green. Exhibited *RA*, 1837 (1152).

c1837 Bust by Sir J.Steell. Exhibited *RA*, 1837 (1264).

1838 Marble statue by T.Campbell. Collection of Lady Mary Howick. Sketch exhibited *RA*, 1831 (1180).

1838 Statue by E.H.Baily. Grey Street, Newcastle-upon-Tyne. A sketch of the statue exhibited *RA*, 1839 (1257). A new head for the statue by R.Hedley was erected, 1948, after destruction of the first by lightning, 1941.

1839 Bust by Sir J.Steell. Council Hall, Edinburgh. Another bust by Steell is in the collection of Lady Mary Howick.

1845 Two woodcuts published *ILN*, VII (1845), 57 and 60.

1853 Bust by C.Moore. Eton College, Windsor.

Undated Painting by H.H.Emmerson. Laing Art Gallery, Newcastle-upon-Tyne.

Undated Painting by J.Lonsdale. Formerly in the collection of Sir Robert Peel. See *Gentleman's Magazine*, XXVII (1847), 290 (9); the writer may have confused this with the 1833 portrait by F.R.Say (see above).

Undated Painting called Grey by J.Northcote. Collection of Major Whitbread.

Undated Miniature by J.Hayter. Collection of L.S.Stroud, 1897.

Undated Bronze bust by an unknown artist. Wellington Museum, Apsley House, London.

Undated Wax cast by an unknown artist. Formerly Holland House, London.

Undated Engravings by H.Cook, and by J.Brown, after R.Scanlan (examples in NPG).

Undated Various lithographs and engravings (examples in NPG and British Museum).

GREY *Sir George, Bart* (*1799–1882*)

Statesman.

1125 See *Groups:* 'The Coalition Ministry, 1854' by Sir J. Gilbert, p 550.

See also forthcoming Catalogue of Portraits, 1860–90.

GREY *Henry George Grey, 3rd Earl* (*1802–94*)

Statesman, MP for Northumberland North.

54 See *Groups:* 'The House of Commons, 1833' by Sir G. Hayter, p 526.

GRIEVE *Thomas* (*1799–1882*), *or William* (*1800–44*)

The two men were brothers, and both made their names as scene-painters; Thomas was chief scenic artist at Covent Garden and later at Drury Lane; he also helped to produce several panoramas; William also worked at Drury Lane and at Her Majesty's; he was particularly noted for moonlight scenes.

4026 (32) Pencil and black chalk on paper, $10\frac{7}{8} \times 8\frac{1}{8}$ inches ($27 \cdot 7 \times 20 \cdot 6$ cm), by COUNT ALFRED D'ORSAY, 1836. PLATE 384

Signed and dated (*lower right*): d'Orsay fecit./1836. London – *Inscribed* (*lower left*): Mr Grieve.

Collections: See *Collections:* 'Drawings of Men About Town, 1832–48' by Count A. D'Orsay, p 557.

It is not certain which brother this drawing represents. The only other recorded portrait of either of them is a water-colour of William in the Garrick Club, London, exhibited *Victorian Era Exhibition*, 1897, 'Music and Drama Section' (604). A comparison between this and the NPG drawing is not conclusive either way.

GRONOW *Rees Howell* (*1794–1865*)

Author and MP for Stafford.

54 See *Groups:* 'The House of Commons, 1833' by Sir G. Hayter, p 526.

GROSVENOR *Rev Cyrus Pitt*

American slavery abolitionist.

599 See *Groups:* 'The Anti-Slavery Society Convention, 1840' by B. R. Haydon, p 538.

GROTE *George* (*1794–1871*)

Historian; banker till 1843; friend of Mill and Bentham; original founder of the first London University, 1828–30; active in reform agitation; MP, 1832–41; president of University College, 1868; famous for his *History of Greece*.

365 Oil on canvas, $35\frac{3}{4} \times 28$ inches ($90 \cdot 8 \times 71 \cdot 1$ cm), by THOMAS STEWARDSON, 1824. PLATE 387

Collections: The sitter, presented by his widow, 1873.

This painting was engraved by J. Brown, published J. Murray, 1873 (example in NPG), for Mrs Grote's *Personal Life of George Grote*. The name of the artist and the date were apparently provided by the donor, probably by word of mouth, as they are not mentioned in any correspondence. Scharf listed them in his first catalogue of the NPG collection (1888). Grote is seen reading a book, the only decipherable word being *Car* at the top of the page; it may possibly be a dictionary.

Description: Healthy complexion, brown eyes, brown hair and whiskers. Dressed in a white stock, white scarf (?), dark green coat with dark velvet collar. Reading book on a red-covered table. Greenish background.

54 See *Groups:* 'The House of Commons, 1833' by Sir G. Hayter, p 526.

ICONOGRAPHY There is a list of oil portraits and busts in M. L. Clarke, *George Grote: a Biography* (1961), pp 187–8.

1805 Miniature by an unknown artist. Collection of Mrs Grote, 1873.
Engraved by J. Brown for A. Bain, *The Minor Works of George Grote* (1873), frontispiece.

1824 Painting by T. Stewardson (NPG 365 above).

1833 'The House of Commons, 1833' by Sir G. Hayter (NPG 54 above).

1834 Water-colour by S. P. Denning. National Provincial Bank, Cornhill, London.
Reproduced M. L. Clarke, facing p 64. Engraved by H. Robinson, published 1840 (example in NPG), for Saunders' 'Political Reformers'. An anonymous engraving after the same water-colour (example in NPG), shows Grote with arms folded.

1838 Anonymous engraving, published J. Thompson, 1838 (example in British Museum), presented to subscribers to *The News*.

1839 Drawing by J. Doyle (caricature, with others). British Museum.
Reproduced M. L. Clarke, facing p 65.

c 1843 Marble bust by W. Behnes. Exhibited *RA*, 1843 (1521).
Probably the bust anonymously engraved (example in NPG).

c 1844 Drawing by L. Dickinson (previously attributed to G. F. Watts). Collection of John Murray (plate 385).
Reproduced M. L. Clarke, facing p 80. Lithographed and published by L. Dickinson, 1844 (example in NPG)

c 1849 Drawing by S. Laurence. Exhibited *RA*, 1849 (863).

1852 Marble bust by W. Behnes. Provost's rooms, University College, London.

1857 Photograph by H. Watkins (example in NPG, plate 386).

1859 Woodcut by F. Staples, after a photograph by H. Watkins, published 1859 (example in NPG), for *The Critic*.

1862 Marble medallion by Miss S. Durant. University College, London.
Exhibited *RA*, 1863 (1135). Reproduced M. L. Clarke, frontispiece.

1870 Painting by Sir J. E. Millais (in robes as vice-chancellor). Senate House, University of London.
Exhibited *RA*, 1871 (165), and *VE*, 1892 (210). Reproduced M. L. Clarke, facing p 160.

1871 Woodcut published *ILN*, LIX (1871), 13.

1872 Marble bust by C. Bacon. Westminster Abbey.
Replica presented to University College, London, 1873; possibly the bust exhibited *RA*, 1873 (1438). The bust in Westminster Abbey was erroneously dated 1855 by R. Gunnis, *Dictionary of British Sculptors* (1953), p 24.

1878 Terra-cotta bust by E. E. Geflowski. University College, London.
Plaster cast offered to the NPG by the artist, 1881, but declined.

Undated Two photographs by Maull & Co, Piccadilly, and by Maull and Polyblank (examples in NPG).

Undated Photograph by Maull & Co, reproduced as a woodcut *Illustrated Review*, II (1871), 33.

Undated Anonymous engraving (after a photograph) reproduced G. Grote, *A History of Greece* (1869), frontispiece, and M. L. Clarke, facing p 161.

GUEST *Sir Josiah John, Bart* (*1785–1852*)

Ironmaster, and MP for Merthyr Tydfil.

54 See *Groups:* 'The House of Commons, 1833' by Sir G. Hayter, p 526.

GUICCIOLI *Teresa, Countess* (*1801–73*)

Byron's mistress.

2515 (61) See *Collections:* 'Drawings of Prominent People, 1823–49' by W. Brockedon, p 554.

GULLY *John* (*1783–1863*)

Prize-fighter, horse-racer, and MP for Pontefract.

54 See *Groups:* 'The House of Commons, 1833' by Sir G. Hayter, p 526.

GURNEY *Sir John* (*1768–1845*)

Judge; barrister, 1793; junior counsel for Hardy, Horne Took, and Thelwall, 1794; defended Crossfield, 1796, and Arthur O'Connor, 1798; procured conviction of two Cato Street conspirators, 1820; baron of the exchequer, 1832–45.

4166 See entry under Blomfield, Charles James, p 41.

ICONOGRAPHY A painting by G. Richmond is listed in the artist's 'Account Book' (photostat copy of original MS, NPG archives), p 36, under 1844, exhibited *RA*, 1845 (1058), engraved by J. Posselwhite (example in NPG); two copies are listed in the 'Account Book', pp 38 and 40, under 1845; a painting by H. P. Briggs was exhibited *RA*, 1840 (38); a miniature by Sir W. J. Newton was exhibited *RA*, 1838 (957); an engraving by W. Holl, after G. H. Harlow, was published R. Cribb, 1821 (example in NPG); an anonymous engraving, and an anonymous lithograph, published W. Cribb, 1819, are in the NPG.

GURNEY *Samuel* (*1786–1856*)

Banker, philanthropist, and slavery abolitionist.

599 See *Groups:* 'The Anti-Slavery Society Convention, 1840' by B. R. Haydon, p 538.

GUTHRIE *George James* (*1785–1856*)

Surgeon; served in the Peninsula, 1808–14; at Waterloo; performed several novel operations; surgeon to Westminster Hospital; professor of anatomy and surgery, 1828–31, and president of College of Surgeons, 1833, 1841, and 1854; published several works on surgery.

932 Miniature, water-colour and body colour on ivory, $3\frac{7}{8} \times 3$ inches ($9\cdot8 \times 7\cdot6$ cm), by REGINALD EASTON. PLATE 388

Collections: The sitter, presented by his daughter, Miss Guthrie, 1892.

The artist's name was provided by Henry Power in a letter of 12 September 1892 (NPG archives).

Description: Healthy complexion, brown eyes, white hair and whiskers. Dressed in a black stock, white shirt, dark-blue waistcoat and coat. Seated in a red chair. Background colour brown.

ICONOGRAPHY A painting by H. Room is in the Royal College of Surgeons, engraved by J. Cochran, published Whittaker, 1839 (example in NPG), for Pettigrew's *Biographical Memoirs of the Most Celebrated Physicians, Surgeons etc*, and engraved and published by W. Walker, 1853 (example in NPG); a posthumous marble bust by E. Davis of 1856 is in the same institution, exhibited *RA*, 1857 (1337), see W. Le Fanu, *A Catalogue of the Portraits in the Royal College of Surgeons of England* (1960), p 30; a drawing by Count

A. D'Orsay of 1840 is in the Royal College of Physicians, lithographed by R. J. Lane (example in NPG); a wood-cut after a photograph by Mayall was published *ILN*, XXVIII (1856), 500.

HALIFAX *Sir Charles Wood, 1st Viscount* (*1800–85*)

Statesman; MP from 1826; served in the administrations of Grey and Melbourne; chancellor of the exchequer, 1846–52; president of the board of control, 1852–5; first lord of the admiralty, 1855–8; secretary of state for India, 1859–66; raised to the peerage, 1866; lord privy seal, 1870–4.

1677 Oil on canvas, $36 \times 27\frac{5}{8}$ inches ($91 \cdot 4 \times 70 \cdot 2$ cm), by ANTHONY DE BRIE, after a portrait by GEORGE RICHMOND of 1873. PLATE 389

Collections: Presented by the sitter's son, the 2nd Viscount Halifax, 1912.

Halifax is shown with the sash and star of the Bath. The original portrait by Richmond is apparently that at Oriel College, Oxford, presented by the 2nd Viscount Halifax, 1924, listed by Mrs R. Lane Poole, *Catalogue of Oxford Portraits*, III (1925), 316, and in Richmond's 'Account Book' (photostat copy of original MS, NPG archives), p 89, under 1873, exhibited *VE*, 1892 (11), and engraved by J. D. Miller (example in NPG), engraving exhibited *RA*, 1886 (1514). Another oil version or copy of this type is in the collection of the present Earl of Halifax, reproduced *Country Life*, CVI (1949), 469. An earlier drawing of Halifax by Richmond, listed in his 'Account Book' pp 69 and 70, under 1861, was engraved by W. Holl (example in NPG), for the 'Grillions Club' series; the head in this drawing is very similar in pose and features to the head in the oil painting, though suggesting a younger man. A second drawing is also listed in the 'Account Book', p 73, under 1861. The NPG copy was evidently executed for the 2nd Viscount Halifax a short time before its presentation (see his letters of 10 and 18 July 1912, NPG archives).

Description: Healthy complexion, greyish eyes, mainly grey hair and whiskers. Dressed in a black neck-tie, white shirt, white waistcoat with a scarlet sash, black coat, silver star, grey trousers. Seated in a gilt and red-covered armchair, holding a brown leather volume. Brown background colour.

54 See *Groups:* 'The House of Commons, 1833' by Sir G. Hayter, p 526.

1125 See *Groups:* 'The Coalition Ministry, 1854' by Sir J. Gilbert, p 550.

ICONOGRAPHY Halifax appears in three group paintings: 'The Reform Banquet, 1832' by B. R. Haydon in the collection of Lady Mary Howick, etched by F. Bromley, published J. C. Bromley, 1835 (example in NPG), engraved and published by J. C. Bromley, 1837 (example in British Museum); 'The House of Commons, 1860' by J. Phillip in the Houses of Parliament, engraved by T. O. Barlow, published Agnew, 1866 (example in NPG); and 'The Marriage of the Prince of Wales, 1863' by W. P. Frith in the Royal Collection, exhibited *RA*, 1865 (52), engraved by W. H. Simmons, published H. Graves, 1870 (example in NPG); Halifax is also represented in 'The Coronation of Queen Victoria', print by G. Baxter, published Baxter, 1841 (example in British Museum); there are several caricature drawings by J. Doyle in the British Museum; a miniature by Sir W. C. Ross was exhibited *VE*, 1892 (530), lent by the 2nd Viscount Halifax; a miniature by E. Tayler was exhibited *RA*, 1875 (1123); an engraving by W. Walker was published Walker, 1856 (example in NPG); a coloured lithograph by Ape (C. Pellegrini) was published *Vanity Fair*, 6 August 1870, as 'Statesmen no. 58'; a woodcut was published *ILN*, XVIII (1851), 153; there are two photographs in the NPG.

HALLAM *Henry* (*1777–1859*)

Historian; barrister; commissioner of stamps; treasurer of the Statistical Society; contributed to *Edinburgh Review*; published *State of Europe during the Middle Ages*, 1818, and a *Constitutional History of England*; father of Tennyson's friend, Arthur Hallam.

2810 Red and black chalk on paper, $8\frac{7}{8} \times 6\frac{3}{4}$ inches (22·6 × 17·1 cm), attributed to GILBERT STUART NEWTON.
PLATE 391

Inscribed in one hand (lower right): Hallam *and in another hand (below):* Author of the/Middle Ages

Collections: M. H. Spielmann, purchased from him, 1936.

Exhibitions: Victorian Era Exhibition, 1897, 'History Section' (199).

This drawing was attributed to Newton by the donor, but his reasons for doing so are not known. There is however little reason to doubt it on grounds of style. It was purchased at the same time as several other portrait drawings from the same collection.

1608 Bronze medal, $2\frac{1}{2}$ inches (6·3 cm) diameter, by LEONARD CHARLES WYON, *c* 1859. PLATE 392

Inscribed on obverse under shoulder of sitter: L. C. WYON F. *Inscribed on reverse:* HENRY/HALLAM./
HISTORIAN./BORN/JULY 9 1777/DIED JAN. 21/1859

Collections: Miss J. B. Horner, presented by her, 1911.

Almost certainly executed as a memorial medal after Hallam's death. It was presented at the same time as a medal of Forbes by Wyon (NPG 1609).

3119 Wax relief, $7\frac{3}{4} \times 5\frac{3}{4}$ inches (19·7 × 14·6 cm) oval, by RICHARD COCKLE LUCAS, 1851. PLATE 390

Incised underneath the shoulder (lower left): R C LUCAS *and (centre left):* Henricus Hallam. F.R.S./1851

Collections: Mrs Malcolm Young; Sotheby's, 13 May 1942 (lot 164), bought by R. Owen, and purchased from him, 1942.

Another version of this wax was in the collection of Sir Henry Lennard in 1929.

342, 3 See *Groups:* 'The Fine Arts Commissioners, 1846' by J. Partridge, p 545.

ICONOGRAPHY

1795 Painting by Sir W. Beechey. Eton College, Windsor.
Reproduced L. Cust, *Eton College Portraits* (1910), plate XXIV, facing p 46.

1828 Drawing by Count A. D'Orsay. Sotheby's, 13 February 1950 (lot 216), bought Colnaghi.

1832 'Society of Antiquaries', engraving by D. Maclise, published *Fraser's Magazine*, V (May 1832), 474–5.

1835 Painting by T. Phillips. Collection of John Murray.
Exhibited *RA*, 1835 (143), and *SKM*, 1868 (493). Listed in Phillips' 'Sitters Book' (copy of original MS, NPG archives), under 1835. Engraved by H. Cousins, published Welch and Gwynne, 1841 (example in NPG), and also etched by Mrs Dawson Turner (where the portrait is said to have been painted in 1834) (example in NPG). Two identical versions: (1) Collection of the Lennard family, exhibited *VE*, 1892 (244); (2) Clevedon Court. A tracing after the portrait by G. P. Harding is in the NPG.

1843 Drawing by G. Richmond. Formerly collection of the Lennard family (plate 393).
Exhibited *SKM*, 1868 (408), and *VE*, 1892 (371). Engraved by W. Holl (example in NPG), where the drawing is erroneously said to have been executed in 1852. In his 'Account Book' (photostat copy, NPG archives), Richmond lists two drawings under the years 1842 and 1844, and mentions touching up the proof, presumably for Holl's engraving, in 1851. The drawing above is, however, clearly dated 1843.

c 1844 Painting by Sir M. A. Shee. Exhibited *RA*, 1844 (314).

1846 'The Fine Arts Commissioners, 1846' by J. Partridge (NPG 342 above).
Study for this: purchased by Lady Lennard (Hallam's daughter) from Partridge's executors, 1873 (relevant correspondence in NPG archives).

c 1847 Painting by H. W. Pickersgill. Exhibited *RA*, 1847 (98).
A drawing by H. W. Pickersgill (inscribed to Miss Hallam) was in the collection of the Lennard family.

1851 Wax medallion by R. C. Lucas (NPG 3119 above).

1858 Painting by E. M. Ward (in his study). Ward Sale, Christie's, 29 March 1879 (lot 84).

c 1859 Medal by L. C. Wyon (NPG 1608 above).

1863 Statue by W. Theed. St Paul's Cathedral, London.
 Marble bust (based on head of this statue) exhibited *R A*, 1863 (1054).

1864 Bust by W. Theed. Royal Collection.
 (Possibly a replica of the bust above.)

1875 Engraving by G. Gabrielli, published Williams and Sons, 1875 (example in NPG).

Undated Drawing attributed to G. S. Newton (NPG 2810 above).

Undated Drawing by L. Fagan, reproduced Fagan, *Life of Sir A. Panizzi* (1880), I, 139.

Undated Lithograph by D. Maclise. Reproduced *The Maclise Portrait Gallery*, edited by W. Bates (1874),
 no. 81, facing p 218 (not originally published in *Fraser's Magazine*).

Undated Bust by Baron C. Marochetti. Exhibited *Art Treasures of the United Kingdom*, Manchester, 1857,
 'Sculpture' (124), lent by the artist.

Undated Terra-cotta statuette by A. Munro. Christ Church, Oxford.
 See Mrs R. L. Poole, *Catalogue of Oxford Portraits*, III (1925), 99.

HALLYBURTON *Lord Douglas Gordon* (*1777–1841*)

MP for Forfar.

54 See *Groups:* 'The House of Commons, 1833' by Sir G. Hayter, p 526.

HAMILTON *Charles*

First suggested the idea of painting the 'House of Commons' group to Hayter.

54 See *Groups:* 'The House of Commons, 1833' by Sir G. Hayter, p 526.

HAMILTON *William Alexander Baillie* (*1803–81*)

Admiral and permanent secretary to the Admiralty.

908 Oil on millboard, $15\frac{1}{4} \times 12\frac{3}{4}$ inches ($38 \cdot 8 \times 32 \cdot 4$ cm), by STEPHEN PEARCE, 1850. PLATE 394

Inscribed in the artist's hand on a damaged label (formerly on the back of the picture): Secretary of
the Admiralty/the original Study, painted for the/Historical Picture of the Arctic Council,/by Stephen
Pearce./1851.

Collections: See *Collections:* 'Arctic Explorers' by S. Pearce, p 562.

This is a study for Pearce's group, 'The Arctic Council' (NPG 1208 below), as well as an autonomous
portrait in its own right. The pose of the head and features are identical in both, but in the group
Hamilton is shown standing, three-quarter length, with his right hand stroking his chin, and his left
hand supporting his right elbow, rather than reading a document as in this study. The document is
entitled, 'From D^r Rae/relative to the Coppermine River/& across to/Victoria Land'; this refers to
John Rae's search for Sir John Franklin between the Mackenzie and Coppermine rivers, 1848–9. In a
'Memorandum' of *c* 1899 (NPG archives), Pearce dated this study to 1850; the date inscribed on the
label presumably refers to the finished group.

Description: Light blue eyes, light brown hair and whiskers. Dressed in a dark grey stock, white shirt,

dark grey waistcoat and coat. Seated in a red-covered armchair, reading a white document. Background colour light greenish-brown.

1208 See *Groups:* 'The Arctic Council' by S. Pearce, p 548.

ICONOGRAPHY No other portraits of Hamilton are recorded.

HAMPTON *Sir John Somerset Pakington, 1st Baron* (*1799–1880*)

Statesman; son of William Russell; took name of Pakington on succeeding to estates of Sir John Pakington, 8th Bart, in 1831; MP from 1837; served in ministries of Lord Derby and Disraeli, 1852, 1858, and 1866–8; indiscreetly revealed the secret history of 1867 reform bill; raised to peerage, 1874.

2628 Water-colour and body colour on green-toned paper, $11\frac{3}{4} \times 7\frac{1}{4}$ inches (29·8 × 18·4 cm), by ATE (ALFRED THOMPSON), 1870. PLATE 395

Inscribed on the mount: Sir John Pakington/February 12, 1870

Collections: Thomas Bowles; *Vanity Fair* Sale, Christie's, 7 March 1912 (lot 584); Charles Newman, purchased from him, 1933.

This is one of a large collection of original studies for *Vanity Fair*, which were all owned and specially mounted by the first proprietor of the magazine, Thomas Bowles. Those in the NPG will be discussed collectively in the forthcoming Catalogue of Portraits, 1860–90. The water-colour of Hampton was published in *Vanity Fair* as a coloured lithograph on 12 February 1870 as 'Statesmen No. 40.', with the title, 'He was Chairman of Quarter Sessions and reconstructed the Navy'. The document sticking out of his trouser pocket is inscribed, 'Use &/Abuse/of/Breech –/Muzzle/Loaders/by J.P.' This document does not appear in the lithograph.

Description: Greyish hair and whiskers. Dressed in a black neck-tie, white shirt, grey waistcoat, black coat, dark grey trousers, and black shoes, holding a pair of glasses and a furled umbrella. Brownish foreground, green background.

ICONOGRAPHY A painting was exhibited *Worcester Exhibition*, 1882, 'Historical Section' (74), lent by the sitter's son; according to a note in G. Scharf's catalogue (NPG library), this was probably by Knight (presumably J.P. Knight); another painting by an unnamed artist was in the same exhibition, 'Historical Section' (28), lent by the County Justices; a description of it in Scharf's catalogue corresponds to the engraving by E. Burton, after a painting by Sir J. Watson Gordon, published J. Keith (example in British Museum); Hampton is represented in 'The House of Commons, 1860' by J. Phillip in the Houses of Parliament, engraved by T.O. Barlow, published Agnew, 1866 (example in NPG); in 'The Derby Cabinet, 1866' by H. Gales, exhibited *Victorian Era Exhibition*, 1897, 'Historical Section' (49), lent by Baroness Kinloss, engraved by J. Scott, published Graves, 1870 (example in NPG); and in 'Baron Rothschild Introduced into the House of Commons, 1858' by H. Barraud, in the Rothschild Collection; a miniature by W. Egley was exhibited *RA*, 1839 (811); a marble bust by Baron C. Marochetti of *c* 1860 is at Haslar Hospital, reproduced as a woodcut *ILN*, XXXVII (1860), 20, and a replica was recorded in the collection of the sitter, 1879, by George Scharf, 'SSB' (NPG archives), XCIX, 48A; there is a caricature drawing by J. Doyle of 1851 in the British Museum, and a caricature lithograph by Faustin (example in NPG), for 'Figaro Cartoon, Men of the Period'; there are various engravings after photographs (examples in in NPG and British Museum); a woodcut was published *ILN*, L (1867), 132, and others, after photographs, XX (1852), 321, and XXXII (1858), 260.

HANMER *Sir John Hanmer, 1st Baron* (*1809–81*)

Poet; succeeded as 3rd Bart, 1828; MP from 1832; raised to peerage, 1872; published several volumes of poetry and other works.

1834n Pencil on paper, $7\frac{5}{8} \times 5$ inches (19·4 × 12·5 cm), by FREDERICK SARGENT. PLATE 396

Signed (lower left): F Sargent *Inscribed (lower right; possibly an autograph):* Hanmer

Collections: A.C.R. Carter, presented by him, 1919.

Presented with other drawings of peers by Sargent, presumably studies for one of his many paintings of the House of Lords. They will be discussed collectively in the forthcoming Catalogue of Portraits, 1860–90.

54 See *Groups:* 'The House of Commons, 1833' by Sir G. Hayter, p 526.

ICONOGRAPHY A painting by an unknown artist is in the collection of Sir Edward Hanmer, Bart; a painting by P. Corbet was exhibited *RA*, 1835 (9); a woodcut was published *ILN*, LXI (1872), 340.

HARCOURT *George Granville* (*1785–1861*)

MP for Oxfordshire.

54 See *Groups:* 'The House of Commons, 1833' by Sir G. Hayter, p 526.

HARDING *James Duffield* (*1798–1863*)

Landscape-artist and lithographer; exhibited with Water-Colour Society from 1818 (member, 1821); unsuccessfully tried oil painting; brought art of lithography to perfection; invented lithotint, and introduced tinted papers for sketches; published various manuals and other works.

1781 Oils on canvas, $29\frac{3}{4} \times 24\frac{7}{8}$ inches (75·6 × 63·2 cm), by HENRY PERRONET BRIGGS, *c* 1840. PLATE 398

Inscribed in ink on a label, part of which is missing, on the back of the stretcher: Portrait of J.D. Harding/ by -[Briggs R.A. –/[por]trait that used to hang /[over the ?] Fireplace in the Studio [at Gor ?]don Square A.R.H.[arding ?]

Collections: The sitter, presented by his grandchildren, J.H. Harding and others, 1916.

Harding lived at 4 Gordon Square during the 1840s. The date of the portrait is based on costume and the apparent age of the sitter.

Description: Healthy complexion, pale grey eyes, reddish-brown hair and side whiskers. Dressed in a dark stock, green cravat, gold pin and chain, white shirt, brown waistcoat and brown coat with a velvet collar. Background colour dark brown.

3125 Pencil and water-colour, with touches of Chinese white, on paper, $15\frac{1}{8} \times 11\frac{1}{8}$ inches (38·4 × 28·2 cm), by LAURENCE THEWENETI, 1825. PLATE 397

Signed in pencil (lower left): L [?] Theweneti

Inscribed in pencil, probably in another hand (bottom left): L. Theweneti *and in a third hand (top left):*

A British Sketcher, year 1825. *Inscribed on the back of the drawing in pencil:* Portrait of James Duffield Harding/by L. Theweneti.

Collections: Messrs Appelby, purchased from them, 1942.

The early history of this drawing is unknown. Laurence Theweneti was one of a family of artists in Bath.

Description: Healthy complexion, greyish-blue eyes, brown hair. Dressed in a dark stock, white shirt, red, blue, yellow and black check waistcoat and morning coat.

ICONOGRAPHY A painting by J.P. Knight is in the Castle Museum, Nottingham; a painting called Harding was in the collection of Colonel M.H. Grant; a drawing by C.K. Childs of *c* 1850 is reproduced as a

woodcut *Art Journal* (1850), p181; there is a lithograph by Laurens of 1860 (example in NPG), and a photograph by Cundall and Downes (example in NPG), the head and shoulders of which is reproduced as a woodcut *ILN*, XLIII (1863), 657; an anonymous photograph is reproduced *Magazine of Art* (1898), p80.

HARDINGE OF LAHORE *Sir Henry Hardinge, 1st Viscount* (*1785–1856*)

Field-marshal; with Moore at Coruña, 1809; fought in Peninsula and Southern France; present at Quatre Bras with Blücher; tory MP from 1820; secretary at war, 1828–30, and 1841–4; governor-general of India, 1844–7; commander-in-chief, 1852–5; field-marshal, 1855.

437 Oil on canvas, $50\frac{1}{8} \times 40$ inches (127·3 × 101·6 cm), by SIR FRANCIS GRANT, after his portrait of 1849. PLATE 399

Collections: The artist, presented by him, 1876.

This picture is a replica of the portrait of 1849 in the collection of Viscount Hardinge, recorded in Grant's 'Sitters Book' (copy of original MS, NPG archives), under the year 1850. The original was engraved by J. Faed, published Colnaghi, 1851 (example in British Museum), and by G. J. Stodart (example in NPG). The idealized Indian landscape behind recalls Hardinge's campaigns in that country. He is wearing the star of the Bath, and the sword which Napoleon wore at Waterloo, presented to him by the Duke of Wellington at the Great Review of the Allied Army in 1816.[1] A study for the 1849 portrait is also in the NPG (508 below). A copy by W. M. Loudan of 1883 is in the East India and Sports Club, London, and a small copy was exhibited *VE*, 1892 (339), lent by the 2nd Viscount Hardinge.

Description: Healthy complexion, blue eyes, grey hair. Dressed in a dark stock, white shirt, black coat, silver star, red and gold-braided sword belt, gilt sword-hilt. Brownish landscape behind. Yellow, brown and greenish sky.

508 Oil on millboard, $10\frac{1}{2} \times 8\frac{1}{2}$ inches (26·7 × 21·6 cm), by SIR FRANCIS GRANT, *c*1849. PLATE 400

Collections: Probably given by the artist to the sitter; 2nd Viscount Hardinge, presented by him, 1878 (at present on loan to the National Army Museum).

This is a study for the 1849 portrait of Hardinge by Grant in the collection of Viscount Hardinge, a replica of which is also in the NPG (NPG 437 above). The study is almost identical in pose and detail with the finished work, except that Hardinge is looking further to the right. The arrangement of the fort and tents in the background differs slightly.

Description: Similar to NPG 437 above.

3721 Oil on canvas, 21 × 17 inches (53·3 × 43·2 cm), by WILLIAM SALTER, *c*1834–40. PLATE 402

Collections: By descent to W. D. Mackenzie, who also owned the group picture, and bequeathed by him, 1929.

This is one of several studies in the NPG for Salter's large picture of the 'Waterloo Banquet at Apsley House', now in the collection of the Duke of Wellington; the group portrait was engraved by W. Greatbach, published F. G. Moon, 1846 (example in NPG). The studies will be collectively discussed in the forthcoming Catalogue of Portraits, 1790–1830. Hardinge is wearing the uniform of a major-general.

Description: Healthy complexion, bluish eyes, greying brown hair. Dressed in a red uniform, with gold-braided collar, epaulettes and cuffs, multi-coloured medals and orders, gilt sword-belt and sword-hilt, black trousers with gold stripe, holding a black hat with gold decorations and white feathers. Background landscape colour, various tones of dark brown and green.

1207a Plaster cast of a medallion, $21\frac{1}{4} \times 18\frac{1}{2}$ inches (54 × 47 cm) oval, by GEORGE GAMMON ADAMS, 1845. PLATE 401

[1] Information given to G. Scharf by the 2nd Viscount Hardinge at South Park, 1885.

Incised (*under the shoulder*): G.G.Adams Sct/1845

Collections: The artist, purchased from his widow, 1899.

Adams exhibited impressions from the unfinished dies of his medallion of Hardinge, *RA*, 1845 (1304); models for both obverse and reverse of the medallion were exhibited the same year (1313). The medal of Hardinge by Adams exhibited *RA*, 1847 (1292) was presumably of a different type, possibly done to commemorate his peerage.

54 See *Groups:* 'The House of Commons, 1833' by Sir G.Hayter, p 526.

ICONOGRAPHY

1818 Miniature by J.B.Couvelet. Collection of Sir Charles Hardinge, 1939.

1836 'The Waterloo Banquet at Apsley House, 1836' by W.Salter. Collection of the Duke of Wellington, Apsley House. Engraved by W.Greatbach, published F.G.Moon, 1846 (example in NPG). Oil study (NPG 3721 above).

c1836 Painting by E.U.Eddis. Collection of Sir Edward Hardinge, 1877.
Reproduction of what appears to be the original (example in NPG). Engraved by C.Turner, published Colnaghi, 1833, and by F.Lightfoot (examples in NPG); engraved by F.Holl (in reverse, if reproduction in NPG represents the original, with other variations), published H.T.Ryall, 1836, and by other publishers (examples in NPG).

c1842 'Waterloo Heroes Assembled at Apsley House, 1842' by J.P.Knight. Collection of the Marquess of Londonderry. Engraved by C.G.Lewis, published H.Graves, 1845 (example in NPG).

1844 Painting by J.Lucas. Victoria Memorial Hall, Calcutta. Formerly collection of Sir Robert Peel, sold Christie's, 6–7 December 1917 (lot 88). Exhibited *RA*, 1845 (235). Reproduced A.Lucas, *John Lucas* (1910), plate XXXIX, facing p 49.

c1845–7 Medallions and medal by G.G.Adams (see NPG 1807a above).

c1846 Miniature by Sir W.C.Ross. Collection of Lord Northbourne, 1923.
Lithographed by E.Dalton, published T.McLean, 1846 (example in NPG), and engraved by G.Cook, published R.Bentley, 1848 (example in NPG). Woodcut (cutting from unidentified magazine, NPG).

1848 Painting by Sir F.Grant (with his staff at Battle of Ferrozerhah). Collection of Viscount Hardinge.
Exhibited *SKM*, 1868 (439). Reproduced Sir H.Maxwell, *Sixty Years a Queen* (1897), p 44. Copy: ex-collection of Lord Northbourne (plate 403), sold Christie's, 3 February 1950 (lot 150), exhibited *VE*, 1892 (314).

1849 Paintings by Sir F.Grant (see NPG 437 and 508 above).

c1853 Bust by J.H.Foley. Exhibited *RA*, 1853 (1396).

c1853 Bronze statue by J.H.Foley (on horseback). Calcutta.
Reproduced *Art Journal* (1853), p 130 (engraved by Dalziel Brothers, after a drawing by J.Clayton), and *Art Journal* (1859), p 36 (engraved by R.A.Artlett, after a drawing by F.Roffe). A drawing of the statue by H.S.Melville was exhibited *RA*, 1859 (1103).

1854 Marble bust by J.H.Foley. Collection of Viscount Hardinge.
Exhibited *RA*, 1854 (1465). Misdated 1852 by R.Gunnis, *Dictionary of British Sculptors* (1953), p 154; see Scharf, 'TSB' (NPG archives), XVII, 30, who records the incised date, 1854, on the bust itself.

1860 Marble bust by J.H.Foley. Royal Collection.
Exhibited *RA*, 1860 (1039). Reproduced as a woodcut *ILN*, XXXVII (1860), 99.

Undated Miniature by an unknown artist. Collection of Viscount Hardinge, 1924.

Undated Painting attributed to Sir D.Macnee. Collection of Sir Charles Hardinge, 1939.

Undated Painting or drawing by the 2nd Viscount Hardinge. United Service Club, London.

Undated Drawing by H. Edridge. Collection of Lord Northbourne, 1892.
Sketched by G. Scharf, 'TSB' (NPG archives), XXXVII, 11; recorded by him at the *VE*, 1892, but not apparently listed in the catalogue.

Undated Anonymous lithograph (style of Doyle), published Dickinson (example in NPG).

Undated Lithograph by G. B. Black, after Balding, and anonymous lithograph, published Dickinson (examples in NPG).

Undated Miniature by J. B. Isabey. Recorded by G. Scharf, 'SSB' (NPG archives), XCV, 46.

Undated Statuette by J. Wyatt (on horseback, with other figures). Bank of Scotland, Edinburgh.

Undated Plaster bust by W. Theed. National Army Museum.

HARDWICKE *Charles Philip Yorke, 4th Earl of* (*1799–1873*)

Admiral, cabinet minister, and MP for Cambridgeshire.

54 See *Groups:* 'The House of Commons, 1833' by Sir G. Hayter, p 526.

HARDY *John* (*1773–1855*)

MP for Bradford.

54 See *Groups:* 'The House of Commons, 1833' by Sir G. Hayter, p 526.

HARLAND *William Charles* (*1804–63*)

MP for Durham.

54 See *Groups:* 'The House of Commons, 1833' by Sir G. Hayter, p 526.

HARRIS *Sir William Cornwallis* (*1807–48*)

Engineer and traveller; served with the Bengal engineers from 1823; went on a hunting expedition in Southern Africa, 1835–7; superintending engineer of the southern provinces of India, 1840; went to Abyssinia in the same year; published account of his travels and books on hunting and African game.

4098 Oil on canvas, $29\frac{7}{8} \times 24\frac{3}{4}$ inches (75·8 × 62·9 cm), attributed to RAMSAY RICHARD REINAGLE, *c* 1823.
PLATE 404

Originally inscribed on the back of the stretcher: Howard 8 [*or possibly* '*d*']

Collections: By descent to the sitter's great-nieces, the Misses Harris, and purchased from them, 1959.

Literature: NPG Annual Report, 1959–60 (1960), pp 6–7.

According to Colonel C. B. Appleby (letter of 29 January 1964, NPG archives), the sitter is probably wearing the uniform of the Bombay Engineers; A. E. Haswell Miller dates the uniform to before *c* 1825. Harris was appointed a 2nd Lieutenant in 1823, and it has been suggested that this portrait is the one by R. R. Reinagle exhibited *RA*, 1823 (311), with the title, 'Portrait of a cadet in the Honourable East India Company's service'. No portraits by Howard are known (he did lithograph Harris' drawings for the latter's *Portraits of Game Animals of Southern Africa*, 1840), and the style of NPG 4098 is quite close to that of Reinagle. There is, however, no supporting evidence for this attribution, and, in the past, Reinagle's 1823 portrait has been traditionally associated with the portrait of Richard Holmes in uniform in the collection of Martin Holmes; the chief objection to this tradition is that no military record for Holmes exists before 1826.

Description: Healthy complexion, greyish eyes, brown hair. Dressed in a red military uniform, with

blue and gold-braided collar and epaulette, gilt buttons, and a brown cloak with a grey fur collar, crimson lining and gilt chain. Brownish landscape at left. Predominantly orange, yellow, and blue-grey sky.

ICONOGRAPHY There is a water-colour by O. Oakley of 1845 in the Africana Museum, Johannesburg, lithographed for the fourth volume of Harris' *Highlands of Ethiopia*.

HARROWBY *Dudley Ryder, 2nd Earl of* (*1798–1882*)

Statesman, MP for Liverpool.

54 See *Groups*: 'The House of Commons, 1833' by Sir G. Hayter, p 526.

HART *Solomon Alexander* (*1806–81*)

Painter; of Jewish origin; student at RA schools; began exhibiting at RA, 1826; ARA, 1835; RA, 1840; visited Italy, 1841; professor of painting at RA, 1854 onwards, and subsequently librarian; noted for his scriptural and historical pictures.

1456 (9) Black chalk on paper, $2\frac{3}{8} \times 2\frac{1}{4}$ inches (6 × 5·7 cm), by CHARLES HUTTON LEAR, 1845. PLATE 407

Inscribed (*bottom right*): S. A. Hart

Collections: See *Collections:* 'Drawings of Artists, *c* 1845' by C. H. Lear, p 561.

This drawing was done in the life school of the Royal Academy, where Lear was a student, and was sent by him to his parents with an undated letter (copy, NPG archives): '*No. 5 Solomon Alexander Hart Esquire Royal Academician – an expression I caught him in when he was making a sketch*'. Other sketches sent with this letter are dated October and November 1845, which dates this one fairly exactly. Hart was a visitor at the life school in 1845.

1476 See entry for D. Maclise, p 295.

2479 Pencil and water-colour on paper, $5\frac{7}{8} \times 3\frac{5}{8}$ inches (14·9 × 9·1 cm), by CHARLES BELL BIRCH, 1853. PLATE 406

Dated (*lower right*): March 1853.

Collections: See *Collections:* 'Drawings of Royal Academicians, *c* 1858' by C. B. Birch, p 565.

Previously this drawing was tentatively identified as a portrait of Sir Charles Eastlake, but the two drawings by Birch which indubitably represent him (NPG 2477 – 8, p 154) are quite dissimilar. NPG 2479 almost certainly represents Hart. There is a drawing of the figure of a young man on the reverse.

3182 (3) With sketches of Samuel Cousins and others. Pencil on paper, 4 × 7 inches (10·3 × 17·9 cm), by CHARLES WEST COPE, *c* 1862. PLATE 405

Inscribed (*upper left*): Hart *and* (*bottom right*): Cousins.

Collections: See *Collections:* 'Drawings of Artists, *c* 1862' by C. W. Cope, p 565.

Besides Hart and Cousins there are faint sketches of figures carrying drawing boards. This drawing was almost certainly done at the Royal Academy Schools.

ICONOGRAPHY An oil self-portrait is in the City Art Gallery, Exeter, and another is in the Royal Academy, exhibited *Anglo-Jewish Historical Exhibition*, Royal Albert Hall, 1887 (1084); there are several photographs by Watkins, Edwards, and others in the NPG, and a woodcut from an unidentified magazine.

HARVEY *Daniel Whittle* (*1786–1863*)

Radical politician, MP for Colchester.

54 See *Groups*: 'The House of Commons, 1833' by Sir G. Hayter, p 526.

HASTINGS *George, 2nd Marquess of* (*1808–44*)

4026 (33) See *Collections:* 'Drawings of Men About Town, 1832–48' by Count A. D'Orsay, p 557.

HASTINGS *Jacob Astley, 16th Baron* (*1797–1859*)

MP for Norfolk West.

54 See *Groups:* 'The House of Commons, 1833' by Sir G. Hayter, p 526.

HATHERTON *Edward John Littleton, 1st Baron* (*1791–1863*)

Politician; MP from 1812; supported Reform Bill; chief secretary to the lord lieutenant of Ireland, 1833; supported Coercion Bill, 1834; resigned office, because of indiscreet communications to O'Connell, 1834; raised to peerage, 1835.

4658 Oil on millboard, 14 × 12 inches (35·5 × 30·5 cm), by SIR GEORGE HAYTER, 1834. PLATE 408
Signed and dated (*bottom right*): George Hayter 1834.

Inscribed in ink on a label on the back, in the artist's hand: John Hatherton Littleton Esq^re M.P./for Staffordshire South/Study for my great picture of The/House of Commons of 1833./George Hayter, 1834

Collections: Purchased at Coe & Sons, 29 January 1969 (lot 990).

This is a study for Hayter's 'House of Commons' group (see NPG 54 below). Its early history is unknown; unlike many of the studies for this picture it does not appear to have been in the Hayter Sale of April 1871. It is also more finished than most other known studies, and was evidently completed as an independent portrait; the upper part of the figure and the features are, however, identical in the study and the finished group.

Description: Healthy complexion, brown eyes and hair. Dressed in a white stock, white shirt, and dark grey coat with a velvet collar, holding a quill pen. Seated in a green and brown high-backed armchair, writing at a table with a yellowish-beige cloth, an inkstand with a stick of red sealing wax, various letters and documents and a red despatch box, inscribed 'W.R.' for William IV. Background colour various shades of grey.

54 See *Groups:* 'The House of Commons, 1833' by Sir G. Hayter, p 526.

ICONOGRAPHY A painting by H. W. Pickersgill was sold from the collection of Lord Hatherton, Christie's, 6 November 1953 (lot 26), exhibited *RA*, 1837 (425); a painting by R. S. Lauder and a statuette by J. Emery were exhibited *RA*, 1839 (1172), and 1865 (988), respectively; a bust by P. Hollins of E. J. Littleton, presumably Baron Hatherton, was exhibited *Birmingham Society of Artists, c* 1827; an engraving by S. Freeman, after an original drawing, was published R. Bentley, 1835 (example in NPG); an engraving by F. C. Lewis, after J. Slater (example in NPG), was published for the 'Grillions Club' series.

HAVELOCK *Sir Henry, Bart* (*1795–1857*)

General; entered army, 1815; went to India, 1823; accompanied Burmese expedition, 1824–6, of which he published a narrative, 1828; served in Afghan and Gwalior campaigns; during Indian mutiny recaptured Cawnpore and relieved Lucknow, 1857.

4835 Pencil and mainly grey wash on paper, 20⅝ × 16⅛ inches (52·4 × 41·2 cm) mounted as an oval, by FREDERICK GOODALL, *c* 1857. PLATE 410

Signed (*lower right*): Fred^k. Goodall. A.R.A. *Inscribed below* (*under the mount*): Goodall A.R.A.
On the backboard is a label for the 1897 exhibition.

Collections: Mrs Howard Williams, who later married G. L. P. Eyre; his sale, 1903; J. N. Joseph, deposited by him, 1934.

Exhibitions: Victorian Era Exhibition, 1897, 'Historical Section' (726).

Literature: The Reminiscences of Frederick Goodall (1902), pp 368–70.

Havelock is shown in military uniform, with the badge and ribbon of the Bath, and various medals (Cabul, 1842, Ghuznee, etc). Goodall records meeting Havelock on several occasions at the home of a mutual friend, Mrs Howard Williams. At the request of Mrs Williams, Goodall drew a portrait of Havelock, after his departure for India, with the aid of photographs and his own recollections of the departed hero: '*About twelve months afterwards, when Lady Havelock had recovered from the first shock of her husband's death, she called upon me at Camden Square, to thank me personally for having painted the portrait. "It is," she said, "the only likeness of him in existence". She had to content herself with a photograph of it, as Mrs Howard Williams could not be persuaded to part with it for any money. When Behnes, the sculptor, received the commission to execute the statue for Trafalgar Square, Lady Havelock begged him to use my portrait for the likeness*' (*Reminiscences,* pp 369–70). Further information about Mrs Williams and the subsequent history of the picture is contained in two letters from her stepson, Layton Eyre, 1934 (NPG archives). For Behnes statue see iconography below. The NPG drawing was engraved by W. H. Mote (example in NPG), for W. Brock, *Biographical Sketch of Havelock* (1858), and by H. Adlard (example in NPG), for J. C. Marsham, *Memoirs of Major-General Sir Henry Havelock, K.C.B.* (1860). The exposed area of the NPG drawing, not covered by the mount, has noticeably darkened.

1204 Plaster cast, painted black, 33 inches (83·9 cm) high, of a bust by GEORGE GAMMON ADAMS, 1858.

PLATE 409

Collections: The artist, purchased from his widow, 1899.

A similar bust, or possibly the same bust, was reproduced as a woodcut *ILN,* XXXII (1858), 508, after a photograph by Lock and Whitfield. An accompanying description (507) stated that: '*The bust has been executed from the best sources; and a few days ago Mr Adams had the honour of submitting it to Her Majesty. It has, we understand, met with the full approbation of Lady Havelock, and of several persons who had been so fortunate as to possess the friendship of the departed hero.*' Havelock is shown wearing the star of the Bath. This bust was purchased at the same time as several other plaster busts by Adams, and a marble bust of Sir William Napier (NPG 1197).

ICONOGRAPHY The only likenesses from the life are Mrs Mannin's water-colour, Lundgren's sketches, and the undated daguerreotype.

1851 Water-colour by Mrs M. Mannin. Collection of the Havelock Estate, on loan to the Yorkshire County Record Office, Northallerton (N. Riding) (plate 411). Reproduced J. C. Pollock, *Way to Glory* (1957), frontispiece. The lithograph by C. J. Baselie, published Colnaghi and M. H. Mason, Brighton, 1857 (example in NPG), shows Havelock in military costume, but is almost certainly based on this water-colour; the head in the woodcut published *ILN,* XXXI (1857), 257, is very similar.

1857 'The Relief of Lucknow' by T. J. Barker, after sketches by E. Lundgren. Corporation of Glasgow. Engraved by C. G. Lewis, published Agnew, 1860 (example in NPG, plate 412). Lundgren's sketches were sold at Christie's, 16 April 1875.

1857 Lithograph by C. Baugniet, published Gambart & Co, 1857 (example in NPG).

c1857 Drawing by F. Goodall (NPG 4835 above).

c1857 Ebony bust by an unknown artist. Formerly Royal United Service Museum, London.

1858 Bust by G. G. Adams (NPG 1204 above).

1858 Bust by W. Behnes. Guildhall Museum, London.
Exhibited *British Empire Exhibition,* Palace of Arts, Wembley, 1925 (N 35), reproduced 'Illustrated Souvenir,' p 76.

c1858 Painting by W. Crabb. Collection of P. French.
Exhibited *SKM*, 1868 (545), and *VE*, 1892 (152). Engraved by J. Sinclair, published H. Graves & Co, and engraved by C. Holl, published J. Virtue, 1858 (examples in NPG).

c 1858 Bust (?) by F. Junck. Exhibited *RA*, 1858 (1206).

1859 Engraving by A. H. Ritchie, published Young & Co, New York, 1859 (example in British Museum), reproduced J. C. Pollock, facing p246.

c1860 Bust by W. Behnes. Exhibited *RA*, 1860 (1072).
Possibly the bust in the Guildhall Museum (see above).

c1860 Sketch for a statue by T. Thornycroft. Exhibited *RA*, 1860 (996).

1861 Bronze statue by W. Behnes. Sunderland.

c1861 Bronze statue by W. Behnes. Trafalgar Square, London.
Reproduced as a woodcut *ILN*, xxxviii (1861), 362.

c1861 Bust by W. Behnes. Exhibited *RA*, 1861 (1045), as presented to Lady Havelock.

1866 Marble relief (meeting Clyde and Outram at Lucknow) by M. Noble. Outram Memorial, Westminster Abbey.

Undated Water-colour by an unknown artist. Victoria Memorial Hall, Calcutta.

Undated Marble bust by M. Noble. Victoria Memorial Hall, Calcutta.
An apparently related model was formerly at Elswick Hall, Newcastle, listed in *Catalogue of Lough and Noble Models at Elswick Hall* (*c*1928), p63 (219).

Undated Anonymous bust. India Office, London.

Undated Anonymous daguerreotype (probably taken in India). On loan to Yorkshire County Record Office, Northallerton.

Undated Anonymous engraving (example in NPG).

HAWES *Sir Benjamin* (*1797–1862*)
Politician, and advocate for the arts.

342,3 See *Groups:* 'The Fine Arts Commissioners, 1846' by J. Partridge, p545.

HAY *Sir Andrew Leith* (*1785–1862*)
Soldier, author, and MP for Elgin and Moray.

54 See *Groups:* 'The House of Commons, 1833' by Sir G. Hayter, p526.

HAY *Sir John, Bart* (*1788–1838*)
MP for Peebleshire.

54 See *Groups:* 'The House of Commons, 1833' by Sir G. Hayter, p526.

HAYES *Sir Edmund Samuel, Bart* (*1806–60*)
MP for County Donegal.

54 See *Groups:* 'The House of Commons, 1833' by Sir G. Hayter, p526.

HAYTER *Sir George* (*1792–1871*)

Portrait and historical painter; son of the miniaturist, Charles Hayter (1761–1835); studied at Rome; established a good portrait practice; painted 'Trial of Lord William Russell' for the Duke of Bedford; portrait and historical painter to Queen Victoria, 1837; knighted, 1842; chiefly remembered for his large group portraits, of which there are two in the NPG, and several in the Royal Collection.

3104 Oil on panel, 20¼ × 20½ inches (51·4 × 52·1 cm), by HIMSELF, 1820. PLATE 421

Signed and dated (top left): Geo Hayter M.A.S.L./Aetat 26 1820/Ipse Pinxit

Collections: Paul Larsen; purchased from him by the National Art Collections Fund, and presented by them, 1941.

Description: Greenish-grey eyes, brown hair. In loose red garment with white collar. Greenish-coloured palette, brushes with traces of red paint. Background colour dark brown.

1103 Sheet of three studies. Pen and ink on brown, discoloured paper, 8¾ × 11⅛ inches (22·1 × 28·2 cm), by HIMSELF, 1843. PLATE 1024

Inscribed on the base of the stand on which Hayter is painting in the left-hand study; GH. painting on the picture/of the House of Commons/of 1833/GH 1843

Collections: Major Harrel, presented by him, 1897.

For Hayter's picture of the 'House of Commons, 1833' see NPG 54 below. A pen drawing of Hayter working on his painting by Sir Edwin Landseer was in the Hayter Sale, Christie's, 20 April 1871 (lot 374).

3082,
3082a A series of seven humorous drawings by HIMSELF, 1821, illustrating his riding accident. Nos. 1–4 (the first sequence) depict the accident, while nos. 5–7 (the second sequence) are concerned with its after-effects. PLATES 414–420

3082 (nos. 1, 2, 4, 5, 6, and 7). *Collections:* Iolo Williams, presented by him, 1940.

3082a (no. 3). *Collections:* John Woodward, presented by him, 1943.

1 Pen and ink on paper, 5¼ × 9⅝ inches (13·4 × 24·4 cm).

Inscribed (top right): No. 1 *and (lower right):* Simply demonstrating how I broke my Collarbone/on the Harrow Road. GH Augst 12.1821.

2 Pencil, pen and ink on paper, 5¼ × 9⅝ inches (13·4 × 24·4 cm).

Inscribed (top left): No 2 *and (bottom centre and right):* My Horse having gone away, two persons come to my assistance/GH.

3 Pen and ink on paper, 5¼ × 9⅝ inches (13·4 × 24·4 cm).

Inscribed (top right): No 3 *and (bottom centre and right):* GH./Mr Tiel kindly lends me his Gig & Man. to go back home.

4 Pen, ink and sepia wash on paper, 5¼ × 9⅝ inches (13·4 × 24·4 cm).

Inscribed (top right): No 4 *and (bottom left and centre):* brought to my own door. My brother helps me out of the Gig. GH.

5 Pen, ink and water-colour on paper, 9½ × 5¼ inches (24·2 × 13·3 cm).

Inscribed (bottom right): GH/bearing with patience/my broken Collarbone/midnight.

6 Pen, ink and water-colour on paper, 9⅝ × 5¼ inches (24·4 × 13·4 cm).

Inscribed (across bottom): Augst 22. 1821. GH 2 o'C a.m. How to enjoy a Broken Collarbone,/providing it is the left one.

7 Pen, ink and water-colour on paper, 10 × 5¼ inches (25·5 × 13·4 cm).

Inscribed (*across bottom*): Advantage of breaking a Collarbone to one/who has not had much time for library study. GH Aug^st 22. 1821./3.0'C A.M.

3182 (6) With a sketch of William Witherington and others. Pencil on paper, 5⅛ × 7⅛ inches (13 × 18 cm), by CHARLES WEST COPE, *c* 1862. PLATE 413

Inscribed (*top right*): With^r RA *and* (*bottom right*): Hayter

Collections: See *Collections:* 'Drawings of Artists, *c* 1862' by C. W. Cope, p 565.

Besides Hayter and Witherington, there are faint sketches of students with drawing-boards. Like Cope's other drawings in the NPG, this was almost certainly executed at the Royal Academy Schools.

54 See *Groups:* 'The House of Commons, 1833' by Sir G. Hayter, p 526.

999 See *Groups:* 'The House of Lords, 1820' by Sir G. Hayter, in forthcoming Catalogue of Portraits, 1790–1830.

ICONOGRAPHY

c 1816 Water-colour by himself (executed in Rome). British Museum.
See *Catalogue of Drawings by British Artists*, II (1900), 283 (6).

1820 Painting by himself (NPG 3104 above).

1820 'The House of Lords, 1820' by himself (NPG 999 above).

1820 Drawing by himself. Christie's, 3 June 1969 (lot 62), bought Agnew.

1821 Series of seven drawings by himself (NPG 3082 and 3082a above).

1822 Painting by himself (executed at Woburn Abbey). Ex-collection of the Duke of Bedford, Christie's, 19 January 1951 (lot 104). Etched by the artist (in reverse) (example in NPG).

c 1823 Painting by J. Hayter (with Sir E. Landseer, C. Hayter, and another unidentified artist). Shipley Art Gallery, Gateshead. Christie's, 9 December 1871 (lot 13).
Sketch in G. Scharf's sale catalogue (NPG archives). Exhibited *RA*, 1823 (23).

1826 Lithograph by R. J. Lane (example in NPG).

1828 Painting by himself. Uffizi Gallery, Florence.

1828 Drawing by himself (teaching his children to swim). Ashmolean Museum, Oxford.
Exhibited *English Drawings and Water-colours*, Colnaghi, 1966 (67).

1833 'The House of Commons, 1833' by himself (NPG 54 above).

1840 'The Marriage of Queen Victoria and Prince Albert' by himself. Royal Collection.
Reproduced Sir H. Maxwell, *Sixty Years a Queen* (1897), p 28.

1843 Sheet of studies by himself (NPG 1103 above).

1843 Drawing by himself. Küpferstichkabinett, Staatliche Kunstsammlungen, Dresden.

c 1862 Drawing by C. W. Cope (NPG 3182 (6) above).

1863 Painting by himself. Sotheby's (Belgravia), 22 February 1972 (lot 16).

Undated Painting called Hayter by himself. Formerly collection of Colonel M. H. Grant.

Undated Caricature by J. Doyle (with Queen Victoria, Prince Albert and Melbourne). British Museum.
See *Catalogue of Drawings by British Artists*, II (1900), 66 (141).

Undated Two drawings by J. Hayter. Sotheby's, 24 July 1969 (lot 66), bought Miss Gray.

Undated Drawings by Sir E. Landseer (working on 'The House of Commons, 1833', etc). Christie's, 20 April 1871 (lots 374 and 376).

HAYWARD *Abraham* (*1801–84*)

Essayist; studied at Inner Temple, 1824; published *Law Magazine*, 1828–44; translated Goethe's *Faust*, 1833; contributed to various quarterlies; published numerous essays and other works.

4072 Water-colour and body colour on blue-toned paper, 12 × 7 inches (30·4 × 17·8 cm), by APE (CARLO PELLEGRINI), 1875. PLATE 422

Signed (*lower right*): Ape. *Inscribed on the mount:* Mr A. Hayward, Q.C./November 27, 1875.

Collections: Thomas Bowles; *Vanity Fair* Sale, Christie's, 6 March 1912 (lot 371); Joseph Hayward (a distant relative of the sitter), presented by him, 1958.

Literature: NPG Annual Report, 1958–9 (1960), p 3.

This is one of a large collection of original studies for *Vanity Fair*, which were all owned and specially mounted by the first proprietor of the magazine, Thomas Bowles. Those in the NPG will be discussed collectively in the forthcoming Catalogue of Portraits, 1860–90. The water-colour of Hayward was published in *Vanity Fair* as a coloured lithograph on 27 November 1875 with the title, 'Anecdotes'.

Description: Greyish hair and whiskers. Dressed in a white shirt, black suit and shoes, and white gloves. Bluish background.

ICONOGRAPHY Hayward appears in 'Lady Waldegrave's Salon at Strawberry Hill, 1865' by L. Desanges, formerly in the collection of the Earl of Waldegrave; a photograph is reproduced H. Ward, *History of the Athenaeum, 1824–1925* (1926), facing p 124.

HEAD *George Head*

Slavery abolitionist.

599 See *Groups*, 'The Anti-Slavery Society Convention, 1840' by B R Haydon, p 538.

HEAPHY *Thomas Frank, the younger* (*1813–73*)

Painter; son of the water-colourist, Thomas Heaphy the elder (1775–1835); exhibited portraits and subject pictures at the RA from 1831; investigated origins of the traditional likeness of Christ, on which subject he published a work.

4016 Water-colour, mixed with varnish, on card, 10 × 9½ inches (25·5 × 24·2 cm), by HIMSELF, *c* 1831.

PLATE 423

Collections: The sitter, presented by his granddaughter, Miss E.D. Morris, 1957.

Literature: NPG Annual Report, 1957–8 (1959), p 1.

According to family tradition (letter from donor of 7 April 1957, NPG archives), this portrait was painted when Heaphy was eighteen, and was the first work he exhibited at the RA; it may therefore be identical with the 'Portrait of a Gentleman' exhibited *RA*, 1831 (530). Heaphy may possibly be represented in a miniature of the family by his father, sold Sotheby's, 11 March 1952 (lot 25). The only other recorded likeness of him is a photograph by Bassano (example in NPG, presented by Miss Morris).

Description: Healthy complexion, brown eyes and hair. Dressed in a dark blue neck-tie, red waistcoat, dark blue coat, fawn trousers. Seated in a red chair, leaning elbow on a table covered in green cloth, with an inkwell and quill pen on it. Most of the background is covered by a red patterned curtain, except for a brown patch top left. The water-colour is in poor condition; the varnish has cracked and partially disintegrated.

HELPS *Sir Arthur* (*1813–75*)

Clerk of the privy council; private secretary to Thomas Spring-Rice (later Lord Monteagle), and later to Lord Morpeth; commissioner of French, Danish and Spanish claims; clerk to the privy council, 1860–75; revised works by Queen Victoria; published history books, biographies and other works.

2027 Coloured chalk on brown, discoloured paper, $23\frac{3}{8} \times 17\frac{3}{4}$ inches ($59\cdot4 \times 45\cdot1$ cm), by GEORGE RICHMOND, 1858. PLATE 424

Signed and dated (*bottom left*): Geo. Richmond deln^t 1858.

Collections: The sitter, bequeathed by his daughter, Miss Alice Helps, 1924.

Exhibitions: V E, 1892 (374).

Literature: G. Richmond, 'Account Book' (photostat copy, NPG archives), p 68.

According to the donor (letter of 11 February 1921, NPG archives) this portrait was executed at the wish of Queen Victoria, who desired that it should eventually be presented to this collection. Edward VII expressed a similar wish.

3083 See *Groups:* 'The Opening of the Royal Albert Infirmary, 1865' by F W, in the forthcoming Catalogue of Portraits, 1860–90.

ICONOGRAPHY A drawing signed R L (possibly for R. Lehmann) of 1857 or 1867 is reproduced *Correspondence of Sir Arthur Helps*, edited E. A. Helps (1917), frontispiece; a bust by M. Wagmüller was exhibited *R A*, 1873 (1417); there is an engraving by C. G. Lewis, after F. Williams (example in British Museum).

HENEAGE *George Fieschi* (*1800–64*)

MP for Lincoln.

54 See *Groups:* 'The House of Commons, 1833' by Sir G. Hayter, p 526.

HENNIKER *John Henniker-Major, 4th Baron* (*1801–70*)

MP for Suffolk East.

54 See *Groups:* 'The House of Commons, 1833' by Sir George Hayter, p 526.

HERBERT OF LEA *Sidney Herbert, 1st Baron* (*1810–61*)

Statesman; son of the 11th Earl of Pembroke; conservative MP from 1832; secretary to board of control, 1834–5, and to the admiralty, 1841–5; war secretary, 1845–6, 1852–5 and 1859–60; primarily responsible for Miss Florence Nightingale going to the Crimea; he remained one of her staunchest friends and allies.

1639 Oil on canvas, $56\frac{1}{4} \times 44$ inches ($143 \times 111\cdot9$ cm), by SIR FRANCIS GRANT, 1847. PLATE 426

Collections: The sitter, presented by his son, the 14th Earl of Pembroke, in accordance with the wishes of his mother, Elizabeth, Lady Herbert of Lea, 1912.

Exhibitions: R A, 1847 (510); *S K M*, 1868 (478); *V E*, 1892 (90).

Literature: Sir F. Grant, 'Sitters Book' (copy of original MS, NPG archives), under 1847.

Despite the fact that Lady Herbert referred to this picture as a replica of the portrait at Wilton (memorandum of October 1896, NPG archives), it is clear that the NPG picture is the original, and that the picture now at Wilton is the replica; this was confirmed by the late Earl of Pembroke. The NPG portrait was engraved by G. R. Ward, published P. and D. Colnaghi, 1847 (example in NPG). A post-

humous portrait of Herbert by Grant is also at Wilton, inherited by Lady Herbert's grandson, Sir Sidney Herbert; correspondence relating to it is in the Wilton archives. In this latter portrait, clothes and setting are different (Herbert is shown in his study, for example), but the head, in pose and features, is almost identical to that in the NPG portrait.

Description: Healthy complexion, bluish eyes, brown hair. Dressed in a black stock, silver stock-pin and watch-chain, white shirt, black velvet (?) coat, black overcoat, and white gloves. Holding black top-hat and cane, standing in bluish and greenish-brown landscape. Sky near horizon orange and yellow, elsewhere bluish-grey.

54 See *Groups:* 'The House of Commons, 1833' by Sir G. Hayter, p526.

1125 See *Groups:* 'The Coalition Ministry, 1854' by Sir J. Gilbert, p550.

ICONOGRAPHY

1833 'The House of Commons, 1833' by Sir G. Hayter (NPG 54 above).

1840 Drawing by G. Richmond. Listed in Richmond's 'Account Book' (photostat copy, NPG archives), p26. A second drawing of Herbert by Richmond is listed in his 'Account Book' under the year 1847, engraved by W. Holl (example in NPG), for the 'Grillions Club' series, and a third drawing under 1852. A drawing by Richmond is reproduced Lord Stanmore, *Lord Herbert of Lea: a Memoir* (1906), I, frontispiece. Drawings of a 'Mr Herbert' are listed for 1842 and 1851.

1844 Woodcut published *ILN*, IV (1844), 136.

1847 Paintings by Sir F. Grant (see NPG 1639 above).

c1850 Miniature by Sir W. C. Ross. Exhibited *RA*, 1850 (880).

1854 'The Coalition Ministry, 1854' by Sir J. Gilbert (NPG 1125 above).

1858 Woodcut, after a photograph by Mayall, published *Cassell's Illustrated Family Paper*, 17 April 1858, p213.

1861 Woodcut published *ILN*, XXXIX (1861), 146.

c1863 Bronze statue by Baron C. Marochetti. Salisbury.
Reproduced as a woodcut *ILN*, XLIII (1863), 104.

c1863 Marble bust by J. B. Philip. Exhibited *RA*, 1863 (1165).

1864 Recumbent marble effigy by J. B. Philip. Wilton Church, Wilts.
Model exhibited *RA*, 1863 (1193).

1865 Bust by J. H. Foley. Harrow School.

1867 Bronze statue by J. H. Foley. Waterloo Place, London.
Reproduced as a woodcut *ILN*, L (1867), 564, and Lord Stanmore, *Lord Herbert*, II, frontispiece.

Undated Painting by an unknown artist. The Admiralty, London.

Undated Drawing by an unknown artist. Oriel College, Oxford.
See Mrs R. L. Poole, *Catalogue of Oxford Portraits*, II (1925), 97 (50).

Undated Bust by L. Macdonald. Crystal Palace Portrait Gallery, 1854.
Probably a plaster cast like the bust in the Gladstone-Glynne Collection, Hawarden Castle.

Undated Photograph by Disderi of Paris (example in NPG, plate 425).

HERBERT *George (1812–38)*

Grandson of 1st Earl of Carnarvon, soldier.

4026 (34) See *Collections:* 'Drawings of Men About Town, 1832–48' by Count A. D'Orsay, p557.

HERBERT *John Rogers* (*1810–90*)

Portrait and historical painter; won his first success with Italian subject pictures, 1834–40; became a Roman Catholic, and from then on devoted himself chiefly to religious works; *R A*, 1846; carried out several frescoes for the Houses of Parliament.

1456 (10) Black chalk on green-tinted paper, heightened with Chinese white, $3\frac{5}{8} \times 2\frac{7}{8}$ inches ($9 \cdot 3 \times 7 \cdot 3$ cm), by CHARLES HUTTON LEAR, *c* 1845. PLATE 427

Inscribed (*bottom right*): Herbert RA

Collections: See *Collections:* 'Drawings of Artists, *c* 1845' by C. H. Lear, p 561.

ICONOGRAPHY The only other recorded portraits of Herbert are a painting by W. V. Herbert, exhibited *R A*, 1881 (920), and a drawing (?) by L. Wyon, exhibited *R A*, 1845 (975).

HERON *Sir Robert, Bart* (*1765–1854*)

MP for Peterborough.

54 See *Groups:* 'The House of Common, 1833' by Sir G. Hayter, p 526.

HERRIES *John Charles* (*1778–1855*)

MP for Harwich.

54 See *Groups:* 'The House of Commons, 1833' by Sir G. Hayter, p 526.

HERSCHEL *Sir John Frederick William, Bart* (*1792–1871*)

Astronomer; son of the astronomer, Sir William Herschel (1738–1822); fellow of St John's College, Cambridge; secretary and later president of the Royal Astronomical Society, 1824–32; discovered and catalogued many double stars and nebulae; described new graphical method of investigating stellar orbits; published several very important and influential books on astronomy; responsible for numerous discoveries and inventions.

1386 Pencil, with touches of colour on the lips and eyes, on paper, 13×10 inches ($33 \times 25 \cdot 4$ cm), by HENRY WILLIAM PICKERSGILL, after his portrait of *c* 1835. PLATE 429

Inscribed in pencil (*bottom left*): Pickersgill *and* (*bottom right*): Sir John Herschel

Collections: Messrs Leggatt and Sons, purchased from them, 1904.

The head in this drawing is identical in detail and size with that in the engraving by W. Ward, published 1835 (example in British Museum), after Pickersgill's portrait of Herschel at St John's College, Cambridge. The drawing was probably executed by Pickersgill to help Ward with his engraving, which explains its tight technique and the faint grid-lines visible across its surface. It is not a preliminary study for the oil portrait. The St John's College portrait was exhibited *VE*, 1892 (239), and was also engraved by J. Cook, published 1845, and by G. Gabrielli, published 1875 (examples in NPG), the latter for the 'Eton Portrait Gallery'.

4148 Silhouette, black and grey wash on discoloured paper, $4 \times 3\frac{1}{2}$ inches ($10 \cdot 2 \times 9$ cm), by an UNKNOWN ARTIST. PLATE 428

Inscribed on a label on the back of the frame: Sir John Herschell

Collections: Captain A. Parker Smith, presented by him, 1960.

Literature: N PG Annual Report, 1960–1 (1961), p 1.

4056 Plaster cast, painted cream, $31\frac{1}{2}$ inches (80 cm) high, of a bust by EDWARD HODGES BAILY, 1850. PLATE 431

Collections: The sitter, by descent to Mrs E. D. Shorland (niece of Sir John Herschel, 3rd Bart); purchased from Sotheby's, 4 March 1958 (lot 466).

Literature: NPG Annual Report, 1958–9 (1960), p7.

This bust is closely related to the marble bust of Herschel by Baily at St John's College, Cambridge (dated 1850), exhibited *RA*, 1850 (1435). The partly visible medal which the sitter is wearing may represent the Copley medal of the Royal Society awarded to him in 1847. An earlier bust of Herschel by Baily, dated 1848, was in the Crystal Palace Portrait Gallery, 1854.

ICONOGRAPHY A painting by C. A. Jensen is in the Royal Society, London; a drawing by G. F. Watts of *c* 1857 is mentioned in [Mrs] M. S. Watts, *George Frederic Watts* (1912), I, 203; photographs of this drawing were sold at Sotheby's, 4 March 1958 (lot 356); a miniature by an unknown artist, after Abbot, was exhibited *Special Exhibition of Portrait Miniatures*, South Kensington Museum, 1865 (728), lent by Sir T. W. Holburne, Bart; a plaster medallion by W. Tassie is in the Scottish NPG; there is an engraving by F. Croll, after a daguerreotype by Mayall (example in NPG), for *Hogg's Instructor;* woodcuts were published *ILN*, VI (1845), 404 (after a drawing by Landells), IX (1846), 184 (with others), and LVIII (1871), 513 (after a photograph by S. Walker); there are at least two photographs by Mrs J. M. Cameron (example of one in NPG, plate 430, reproduced H. Gernsheim, *Julia Margaret Cameron* (1948), plate 51).

HILL *Rowland Hill, 2nd Viscount* (*1800–75*)

MP for Salop North.

54 See *Groups:* 'The House of Commons, 1833' by Sir G. Hayter, p 526.

HILL *Sir Rowland* (*1795–1879*)

Inventor of penny postage; established school on his own plan; invented rotatory printing-press and other machines; submitted a plan for the reform of the post office, 1837; secured adoption of penny postage in budget of 1839; appointed to post office, 1840; dismissed, 1842; chairman of Brighton railway, 1843–6; secretary to post office, 1854–64.

838 Oil on canvas, 49¾ × 40 inches (126·4 × 101·6 cm), by JOHN ALFRED VINTER, after a photograph of *c* 1879. PLATE 432

Signed (bottom right): J. A. VINTER

Inscribed on the back of the canvas, in the artist's hand: Portrait of/Sir Rowland Hill, KCB, LLD, FRS./ (Originator of the Penny Postage)/born at Kidderminster/1795/buried in Westminster/Abbey/1879/ painted by J. A. Vinter/29 Monmouth Road/Bayswater. W.

Collections: Presented by the sitter's son, Pearson Hill, 1890.

This posthumous portrait is identical in pose and composition to the lithograph by Vinter, after a photograph by Maull and Fox, published Vinter, 1879 (example in NPG). In a letter of 13 June 1890 (NPG archives), the donor wrote of the portrait that it '*is not only by far the best of any yet produced, but is an extremely good likeness*'. There are also two letters from the artist (9 and 17 June 1890, NPG archives). The letter on the left of the picture is inscribed 'Sir Rowland Hill', and the date on the calendar is 24 May.

Description: Healthy complexion, brown eyes, grey hair and whiskers. Dressed in a white shirt, black neck-tie, and a black suit. Holding a pair of brown gloves in one hand, and grasping an umbrella in the other. Brown desk on left, with a letter rack and letters with penny black and twopenny red stamps, a white quill pen and a stick of red sealing-wax. Background colour light brown on left, reddish-brown on right.

ICONOGRAPHY A drawing by Miss E. G. Hill of 1877 was exhibited *VE*, 1892 (323), lent by the artist; a water-colour by J. Leech (published as a cartoon in *Punch*, 4 May 1844) is in the Victoria and Albert Museum;

a drawing by G. Richmond of 1834 is recorded in his 'Sitters Book' (photostat copy, NPG archives), p 11; a marble bust by Sir T. Brock is at Kidderminster, exhibited *RA*, 1882 (1546); a marble bust by W. Brodie was exhibited *VE*, 1892 (481), lent by Pearson Hill; a bronze statue by E. O. Ford for the Royal Exchange, was exhibited *RA*, 1882 (1556); the model for another statue by Ford was exhibited 1882 (1660); and a bust by W. D. Keyworth junior (based on a death-mask) was exhibited *RA*, 1880 (1600); a marble statue by P. Hollins was at Birmingham (apparently mislaid, 1940), exhibited *RA*, 1868 (978); a plaster statuette by C. B. Birch was in the collection of his nephew, G. von Pirch, 1924; busts by Miss C. A. Fellowes were exhibited *RA*, 1868 (1118), and 1869 (1315); a statuette by E. R. Mullins was exhibited *RA*, 1879 (1549); a bust or medallion by B. Smith was exhibited *RA*, 1845 (1467); an engraving by W. O. Geller, after A. Wivell junior, was published Wivell, 1848 (example in NPG); an etching by P. Rajon was published Sir R. Hill and G. B. Hill, *The Life of Sir Rowland Hill* (1880), I, frontispiece; a lithograph by W. Taylor was published J. Hogarth (example in NPG); a woodcut was published *ILN*, II (1843), 322, and woodcuts after photographs, XXXVI (1840), 201, XLIV (1864), 496, and LXXV (1879), 220; there are various engravings and woodcuts in the NPG and the British Museum.

HILTON *William* (*1786–1839*)

Historical painter; exhibited at *RA*, from 1803; RA, 1818, and keeper, 1827; chiefly noted for his ambitious history and subject paintings.

1456 (11) Pencil on paper, $3\frac{7}{8} \times 3$ inches (9.8 × 7.6 cm), by CHARLES HUTTON LEAR, *c* 1839. PLATE 433

Inscribed (*bottom centre*): Hilton RA

Collections: See *Collections:* 'Drawings of Artists, *c* 1845' by C. H. Lear, p 561.

This must date from shortly before Hilton's death in 1839.

ICONOGRAPHY There is a self-portrait in the Usher Art Gallery, Lincoln, exhibited *SKM*, 1868 (349); the painting called Hilton by P. de Wint in the Graves Art Gallery, Sheffield, and the two so-called self-portraits sold at Christie's, 12 September 1941 (lots 46 and 47), probably represent the artist's father, himself an artist.

HINTON *Rev John Howard* (*1791–1873*)

Baptist minister, author, and slavery abolitionist.

599 See *Groups:* 'The Anti-Slavery Society Convention, 1840' by B. R. Haydon, p 538.

HOARE *Prince* (*1755–1834*)

Painter and dramatist.

2515 (27) See *Collections:* 'Drawings of Prominent People, 1823–49' by W. Brockedon, p 554.

HOBSON *William Robert* (*1831–80*)

Lieutenant in Royal Navy, 1855; captain, 1866; retired, 1872; chief mate on 'The Fox' in search of Sir John Franklin, and the first to discover evidence of his fate.

910 Oil on canvas, $15\frac{3}{8} \times 12\frac{3}{4}$ inches (39 × 32.5 cm), by STEPHEN PEARCE, *c* 1860. PLATE 434

Apparently signed on the back (*now no longer visible*): Stephen Pearce

Collections: See *Collections:* 'Arctic Explorers' by S. Pearce, p 562.

Exhibitions: *RA*, 1860 (259).

Hobson is wearing the full-dress uniform of a naval commander (1856 pattern), with (from left to right) the Arctic Medal (1818-55), and the Baltic Medal (1854-5).

Description: Healthy complexion, dark grey (?) eyes, dark brown hair and whiskers. Dressed in a dark stock, white shirt, and dark blue naval uniform with gilt buttons and epaulettes, and silver medals.

ICONOGRAPHY The only other recorded likeness of Hobson is a woodcut, after an anonymous photograph, published *ILN*, xxxv (1859), 362.

HODGES *Thomas Law* (*1776–1857*)
MP for Kent, West.

54 See *Groups:* 'The House of Commons, 1833' by Sir G. Hayter, p 526.

HODGSON *Brian Houghton* (*1800–94*)

Indian administrator and orientalist; nominated to Bengal writership, 1816; occupied various administrative posts; came to England, 1843; returned to India in private capacity and continued researches; made a valuable collection of Sanskrit and Tibetan manuscripts; wrote several works.

1707 Oil on canvas, 30 × 25⅛ inches (76·2 × 63·8 cm), by LOUISA STARR-CANZIANI, *c* 1872. PLATE 435

Collections: The sitter, bequeathed by his widow, 1913.

Exhibitions: RA, 1872 (388).

Literature: Reproduced Sir W. W. Hunter, *Life of Brian Houghton Hodgson* (1896), frontispiece.

The sitter is shown in ordinary civil uniform (with a cloak), as worn by officers of the Indian Political Department.

Description: Healthy complexion, greyish eyes, grey hair, moustache and whiskers. Dressed in a dark uniform with gilt buttons, gold-braided collar and cuffs, and a brown cloak with a chain. Background colour dark brown.

ICONOGRAPHY A painting by Mrs M. Carpenter of 1817 is at Haileybury College, exhibited *RA*, 1818 (134), reproduced Sir W. W. Hunter, *Life of Brian Houghton Hodgson* (1896), facing p 23; this was offered to the NPG in 1913, but declined; a painting by C. Alexander is in the Indian Institute, Oxford; a marble bust by T. Thornycroft of 1844 is in the Asiatic Society, Calcutta, reproduced Sir W. W. Hunter, facing p 176, a model for which was exhibited *RA*, 1845 (1392); two photographs of 1871 and 1891 are reproduced Sir W. W. Hunter, facing pp 328 and 333.

HODGSON *Isaac* (*1783–1847*)
Slavery abolitionist.

599 See *Groups:* 'The Anti-Slavery Society Convention, 1840' by B. R. Haydon, p 538.

HOGG *James* (*1770–1835*)
Poet.

2515 (41) See *Collections:* 'Drawings of Prominent People, 1823–49' by W. Brockedon, p 554.
See also forthcoming Catalogue of Portraits, 1790–1830.

HOLDSWORTH *Arthur* (*1780–1860*)
Last governor of Dartmouth.

2515 (80) See *Collections:* 'Drawings of Prominent People, 1823–49' by W. Brockedon, p 554.

HOLL *William, the younger* (*1807–71*)
Engraver; son of William Holl the elder (1771–1838), and brother of Francis Holl (1815–84), both engravers; engraved a vast quantity of Victorian subject pictures, portraits and book illustrations.

2913 Black and white chalk on paper, 8 × 6¾ inches (20·3 × 17 cm), by T. W. HARLAND, 1830. PLATE 436

Signed and dated (lower right): T Harland 1830

Collections: By descent to the sitter's daughter, Mrs E. Holl, and presented by her and her daughter Mrs M. Baker, 1937.

The artist is presumably identical with T. W. Harland who exhibited a number of portrait drawings at the RA, 1832–54, including one in 1846 of H. Holl of the Haymarket Theatre (possibly a relative). Thieme-Becker suggests that T. W. Harland might be identical with John Whitfield Harland who published a *Manual of Shading Instruction* (1870). This seems unlikely, unless the Royal Academy catalogues mispelt Harland's first initial. The initial of the signature of the NPG drawing has sometimes been read as 'J'. No other portraits of Holl are recorded. The donors also presented a portrait of William Holl the elder (NPG 2912), which will be catalogued in the forthcoming Catalogue of Portraits, 1790–1830.

HOLLAND *Henry Richard Vassall Fox, 3rd Baron* (*1773–1840*)
Statesman, patron of arts and letters.

54 See *Groups:* 'The House of Commons, 1833' by Sir G. Hayter, p 526.

See also forthcoming Catalogue of Portraits, 1790–1830.

HOLLAND *Henry Fox, 4th Baron* (*1802–59*)
Diplomat.

4026 (26) See *Collections:* 'Drawings of Men About Town, 1832–48' by Count A. D'Orsay, p 557.

HOLLAND *Sir Henry, Bart* (*1788–1873*)
Physician; visited Iceland and contributed to Sir George Mackenzie's account, 1810; medical attendant to Caroline, Princess of Wales; gave evidence in her favour, 1820; physician-in-ordinary to Prince Albert and Queen Victoria; travelled much on the continent; wrote medical and other works.

1656 Oil on canvas, 30 × 24⅞ inches (76·2 × 63·3 cm), by THOMAS BRIGSTOCKE, c 1860. PLATE 437

Inscribed on a label, formerly on the back of the stretcher, in the artist's hand (referring to the RA exhibition): No 1./"Portrait of Sir Henry Holland/Bart. Phisician [*sic*] in ordinary to her/Majesty the Queen" – Thomas Brigstocke/21 Upper Belgrave Place Pimlico

Collections: Commissioned by Hudson Gurney; purchased from his son, J. H. Gurney, by the sitter's son, Henry, 1st Viscount Knutsford, 1912, and presented by him in the same year.

Exhibitions: RA, 1860 (63).

Literature: Recorded in the collection of J. H. Gurney, 1907, by Prince F. D. Singh, *Portraits in Norfolk Houses*, edited E. Farrer (1927), I, 343.

This was commissioned at the same time as a portrait of Sidney Smith, Holland's father-in-law, which Viscount Knutsford purchased and kept. Gurney and Holland were both well-known travellers, and both were members of the Royal Society. The NPG portrait of Holland was originally three-quarter length. It was cut down on entering the collection; there was originally a globe on the left side, and a table on the right, with a water-colour of a seascape on it.

Description: Healthy complexion, brown eyes, grey hair and whiskers. Dressed in a white shirt, white neck-tie, and black suit. Seated in a green armchair, with wooden arm-ends. Red book at right on edge of brown table. Rest of background brown.

1067 Marble bust, 27¾ inches (70·5 cm) high, by WILLIAM THEED, 1873. PLATE 438

Incised on the back: W. THEED, SC./LONDON. 1873.

Collections: The sitter, presented by his son, Henry, 1st Viscount Knutsford, 1896.

Exhibitions: RA, 1873 (1580).

ICONOGRAPHY A painting by H.W. Phillips was exhibited *RA,* 1857 (636); a drawing by G. Richmond of 1850 is recorded in the artist's 'Account Book' (photostat of original MS, NPG archives), p 51; a marble bust by P. Turnerelli is in the collection of K. Freemantle, Wistow; there is a lithograph by F.W. Wilkin (example in NPG); a woodcut, after a photograph by Mayall, was published *ILN,* LXIII (1873), 421.

HOLLINS *John* (*1798–1855*)

Painter.

4710 See *Groups:* 'A Consultation Previous to an Aerial Voyage to Weilburg, 1836' by himself, p 537.

HOLLOND *Robert* (*1808–77*)

MP, lawyer and aeronaut.

4710 See *Groups:* 'A Consultation Previous to an Aerial Voyage to Weilburg, 1836' by J. Hollins, p 537.

HOLMAN *James* (*1786–1857*)

Blind traveller; served in navy from 1798; became blind at age of twenty-five; travelled unattended in Europe, Siberia, Africa, America and Australasia, from 1812 until his death; published numerous narratives of his travels.

2515 (69) Black and red chalk, with touches of Chinese white, on green-tinted paper, $14\frac{1}{8} \times 10\frac{3}{8}$ inches (35·8 × 26·4 cm), by WILLIAM BROCKEDON, 1834. PLATE 439

Dated (lower left): 14.6.34

Collections: See *Collections:* 'Drawings of Prominent People, 1823–49' by W. Brockedon, p 554.

Accompanied in the Brockedon Album by an undated letter from the sitter.

ICONOGRAPHY A painting by G. Chinnery of 1830 is in the Royal Society, London, exhibited *RA,* 1835 (134), *SKM,* 1868 (413), and *VE,* 1892 (452), reproduced H. and S. Berry-Hill, *George Chinnery* (1963), plate 34; a painting by J.P. Knight was exhibited *RA,* 1847 (72), engraved by J.R. Jackson, published 1847 (example in NPG); a bust by Mary Kipling was exhibited *RA,* 1843 (1181); there is an engraving by R. Cooper, after Fabroni, published J. Holman, *Narrative of a Journey, 1819–21* (1822), frontispiece, and a lithograph by M. Gauci (examples in NPG); an engraving by E. Finden, after T. Wageman (example in NPG), was published J. Holman, *A Voyage Round the World* (1834), frontispiece.

HOOD *Thomas* (*1799–1845*)

Poet; contributed to *London Magazine,* 1821–3, and became a friend of Lamb, Hazlitt and De Quincey; collaborated with J.H. Reynolds in *Odes and Addresses to Great People,* 1825; issued *Whims and Oddities,* 1826–7; editor of the *Gem,* 1829; edited *New Monthly Magazine,* 1841–3; established *Hood's Magazine,* 1844; published numerous works.

855 Oil on millboard, 12 × 9 inches (30·4 × 22·6 cm), by an UNKNOWN ARTIST, *c* 1832–4. PLATE 441

Collections: The sitter, by descent to his son, Thomas Hood, and purchased from his widow, 1891.

Exhibitions: SKM, 1868 (593), as 'by an unknown artist'.

Literature: W.B. Jerrold, *Thomas Hood: His Life and Times* (1907), p 279.

According to Jerrold (see above): '*It was probably during the stay at Wanstead that the portrait of Hood which hangs in the National Portrait Gallery was painted. Mr Longmore remembers the artist visiting Lake House for the purpose and recalls his name as Hilton. The picture has long been 'attributed to Masquerier', but was, there seems little doubt, really the work of William Hilton R.A. . . . There are several slight*

references to Hilton in Hood's writings. At the same time the artist painted the portrait of Jane Hood, and also one of her mother, Mrs Reynolds (now in the possession of Mr Longmore)'. Masquerier was suggested when the portrait entered the collection (see *NPG Annual Report, 1891* (1891), p11), but neither the attribution to Masquerier nor that to Hilton is convincing on stylistic grounds. Apart from William Hilton the elder, no other artist called Hilton appears in any of the standard works of reference. On the other hand, the date given by Jerrold (Hood lived at Lake House, Wanstead, *c*1832–4) accords well with the costume and the appearance of the sitter.

A miniature by F. W. Wilkin after the NPG portrait is in the collection of S. Spinali; the miniature was exhibited *VE*, 1892 (456), lent by Sir Charles Dilke, who had inherited it from his grandfather, the antiquarian Charles Dilke, editor and co-proprietor of the *Athenaeum* with Hood. The elder Dilke often employed Wilkin, particularly as a copyist, but there is no evidence to suggest that the NPG portrait was Wilkin's work; indeed, the two versions are very dissimilar in style. The companion portrait of Mrs Hood mentioned by Jerrold is also in the NPG (856), but is not catalogued as the sitter is not of sufficient importance. There is no further record of the portrait of Mrs Reynolds.

Description: Healthy complexion, brown eyes, brown hair. Dressed in a dark stock, with a red ribbon (?), white shirt, brown waistcoat, and fawn trousers. Sitting in a red and white striped chair. Background colour brown.

ICONOGRAPHY A painting by Thomas Lewis is in the Midland Bank Head Office, London (plate 440), formerly in the collection of Miss Broderip, 1939, when attributed to G. R. Lewis, reproduced J. C. Reid, *Thomas Hood* (1963), facing p72; it was engraved by W. Holl (example in NPG), for *Hood's Own*, by Tomkins, published E. Moxon, for *Works of Thomas Hood* (1862), I, frontispiece; and anonymously (example in NPG); a drawing by D. Maclise (probably rightly named) is in the collection of Professor Batchelor, previously sold Sotheby's, 2 November 1967 (lot 176), bought Sawyer; a bust by E. Davis of 1844 was exhibited *RA*, 1845 (1410), presumably that engraved for *Hood's Own* (February 1845); it was also engraved anonymously for Mrs F. F. Broderip, *Memorials of Thomas Hood* (1869), frontispiece; also engraved by F. Heath and anonymously (examples in NPG), and reproduced as a woodcut *ILN*, VI (1845), 301; a plaster bust by E. Davis of 1867 was in the Royal Society (now untraced, possibly destroyed in the last war); a monument, including a bust, by M. Noble of 1854 is in Kensal Green Cemetery, reproduced Mrs F. F. Broderip, *Memorials of Thomas Hood* (1860), II, frontispiece; there is an engraving by F. Croll, and a woodcut from an unidentified magazine said to be of 1844 (examples in NPG).

HOOK *James Clarke (1819–1907)*

Painter; studied at RA schools; ARA, 1850; RA, 1860; early works chiefly historical; after 1854 painted English coast scenery in a free and robust style; also painted portraits.

1456 (13) Black chalk on brown-tinted paper, heightened with Chinese white, $1\frac{3}{4} \times 2\frac{1}{8}$ inches (4·5 × 5·4 cm), by CHARLES HUTTON LEAR, 1845. PLATE 442

Inscribed (bottom right): Hook

Collections: See *Collections:* 'Drawings of Artists, *c*1845' by C. H. Lear, p561.

This drawing was done in the life school of the Royal Academy, where Lear was a student, and was sent by him to his parents with an undated letter (copy in NPG archives): '*No. 6 is Hook, the student – who I think will get the Gold Medal this year; he is rather clever*'. Other sketches sent with this letter are dated October and November 1845, which dates this one fairly exactly. Hook won the gold medal for painting in 1845 with his 'Finding the Body of Harold'.

4245 See *Groups:* 'The Hanging Committee of the Royal Academy, 1892' by R. Cleaver, in forthcoming Catalogue of Portraits, 1860–90.

ICONOGRAPHY A self-portrait of 1891 is in the Uffizi Gallery, Florence, exhibited *RA*, 1891 (40); another self-portrait of 1895 is in the Aberdeen Art Gallery (plate 443), as is a painting by Sir G. Reid of 1881; a painting by Sir J. E. Millais was exhibited *RA*, 1883 (29), reproduced J. G. Millais, *Life and Letters of Sir John Everett Millais* (1899), II, 157; it was etched by O. Leyde and anonymously engraved (examples in NPG); a painting by R. Hannah was exhibited *RA*, 1859 (636); there is an anonymous engraving in the NPG, and several photographs; other photographs are reproduced *Magazine of Art* (1879), p 12, and *ILN* (as woodcuts), XXX (1857), 419, and XXXVI (1860), 276.

HOOK *Theodore Edward* (*1788–1841*)

Novelist and wit; son of the organist, James Hook (1746–1827); wrote words for his father's comic operas and melodramas; member of the Prince of Wales's set; noted as a practical joker; accountant-general of Mauritius, 1813; dismissed for deficiencies in accounts, 1817; imprisoned for debt, 1823–5; edited *John Bull* and the *New Monthly Magazine;* published numerous novels.

37 Oil on canvas, 29 × 25¼ inches (73·7 × 64·2 cm), by EDEN UPTON EDDIS, *c* 1839. PLATE 446

Collections: Presumably commissioned by the publisher Richard Bentley; purchased from him, 1858.

Exhibitions: SKM, 1868 (295).

This painting was engraved by W. Greatbach, published R. Bentley, 1839 (example in NPG), 1841 (example in British Museum), and 1848 (example in NPG), the latter for R. H. Barham's, *The Life and Remains of Theodore Edward Hook.*

Description: Healthy complexion, brown eyes, brown hair and whiskers. Dressed in a dark green stock, white shirt, brown waistcoat and black coat. Background colour brown.

2515 (101) Black chalk on grey-tinted paper, 14½ × 10¾ inches (37 × 27·4 cm), by WILLIAM BROCKEDON. PLATE 447

Collections: See *Collections:* 'Drawings of Prominent People, 1823–49' by W. Brockedon, p 554. Accompanied in the Brockedon Album by an undated letter from the sitter.

ICONOGRAPHY A drawing by Count A. D'Orsay of 1839 is in the collection of Ray Murphy, ex-Phillipps collection, lithographed by R. J. Lane, published J. Mitchell (example in NPG); a self-portrait drawing of *c* 1831 is in the Denham Album (no. 97) at Yale University Library (plate 445), reproduced R. H. Barham, *The Life and Remains of Theodore Edward Hook* (1849), I, facing 305; two anonymous engravings were published H. Colburn, 1839 and 1841 (examples in NPG); there is an engraving by G. Murray (example in NPG); an engraving by S. Freeman, after Bennett, was published 1807 (example in British Museum), for the *Monthly Mirror* (another example in NPG has an inscription by Hook disclaiming connexions with *John Bull* – dating it to *c* 1820); an engraving by G. Cook, also after Bennett, was published R. Bentley, 1848 (example in NPG); an engraving by D. Maclise (plate 444) was published *Fraser's Magazine*, IX (April 1834), facing 435, as no. 47 of Maclise's 'Gallery of Illustrious Literary Characters', a drawing for which is in the Victoria and Albert Museum; Hook appears in the engraving of 'The Fraserians' by D. Maclise, published *Fraser's Magazine*, XI (January 1835), between 2 and 3, two drawings for which are in the Victoria and Albert Museum; an anonymous engraving of 1808 is reproduced R. H. Barham (1849), I, frontispiece.

HOOKER *Sir William Jackson* (*1785–1865*)

Director of Kew Gardens; formed collection of Norfolk birds; visited Iceland and printed *Recollections*, 1811; regius professor of botany at Glasgow, 1820; director of Kew Gardens, 1841, which he developed into an unrivalled botanical establishment; published a vast number of botanical works.

1673 Plaster cast, painted black, 24¾ inches (62·8 cm) high, of a bust by THOMAS WOOLNER, 1859. PLATE 448

 Incised on the front of the base: SIR WILLIAM HOOKER/1859

 Collections: The artist, purchased from his daughter, Amy Woolner, 1912.

 Related to the marble bust of Hooker by Woolner, in the Royal Botanic Gardens, Kew, exhibited *R A*, 1860 (1075).[1] Another plaster cast is in the Linnean Society, London. The NPG acquired several other plaster busts by Woolner at the same time as this one.

1032 Wedgwood ceramic medallion, white on a blue background, 12¾ × 10⅝ inches (32·4 × 27 cm) oval, from a model by THOMAS WOOLNER, 1866. PLATE 449

 Incised (on the reverse): WEDGWOOD

 Collections: F. T. Palgrave, presented by him, 1896.

 This is identical to the medallion in the centre of Hooker's monument at Kew Church, listed by A. Woolner, *Thomas Woolner: his Life in Letters* (1917), p 339; another version is in the Victoria and Albert Museum. The NPG medallion was acquired by the donor from the artist while he was at work on the monument. The sitter's son, Sir Joseph Dalton Hooker, thought it '*an excellent likeness, the best ever executed of him*' (quoted in a letter of 3 February 1896 from the donor, NPG archives).

ICONOGRAPHY A painting by T. Phillips was recorded in the collection of his son by the *Dictionary of National Biography*, almost certainly the painting listed in Phillips' 'Sitters Book' (copy of original MS, NPG archives), under 1817, with a companion portrait of his wife, both commissioned by his parents-in-law, the Dawson-Turners; an engraving by H. Cook, presumably after the same portrait by Phillips, was published Fisher, 1834 (example in NPG), for Jerdan's 'National Portrait Gallery'; a painting by S. Gambardella is in the Linnean Society, London, exhibited *S K M*, 1868 (464*), and *V E*, 1892 (250), engraved by W. Walker (example in the Royal Botanic Gardens, Kew); a drawing by Sir D. Macnee is in the Royal Botanic Gardens, possibly that reproduced *Country Life*, CXXXVIII (1965), 600; there is an etching by Mrs Dawson Turner, after a drawing by J. S. Cotman of 1813 (example in NPG); a lithograph by T. H. Maguire of 1851 was published G. Ransome (example in NPG), for 'Portraits of the Honorary Members of the Ipswich Museum'; a lithograph by W. Drummond was published T. McLean, 1837 (example in British Museum), for 'Athenaeum Portraits'; there are photographs by Maull and Polyblank and by E. Edwards in the NPG; a woodcut, after a photograph by Edwards, was published *ILN*, XLVII (1865), 193.

HORNE *Richard Henry or Hengist* (*1803–84*)

 Author; served with Mexican navy against Spain; travelled in America and Canada; edited *Monthly Repository*, 1836–7; published various tragedies; corresponded with Mrs Browning; collaborated with her in the *New Spirit of the Age*, 1844; published numerous works.

2168 Oil on panel, 12 × 9½ inches (30·5 × 24·3 cm), by MISS MARGARET GILLIES, *c* 1840. PLATE 450

 Inscribed in ink on a label (formerly on the back): No 1./Portrait of/R. H. Horne Esq^re/by/Miss M. Gillies/6 Southampton Street/London Fitzroy Square

 Collections: The sitter; sold by his executors, Sotheby's, 12 November 1884 (lot 351); purchased by Henry Buxton Forman, and presented by his wife and son, Maurice, 1927.

 In the same sale of 1884 as this portrait was a miniature of Horne by Miss M. Gillies of 1837 (lot 350), presumably the one exhibited *R A*, 1837 (794), and a drawing in profile by the same artist (lot 352). The latter is in the British Museum, and is reproduced E. Gosse, *English Literature: an Illustrated Record*, IV (1903), 196. Another miniature by Miss Gillies was exhibited *R A*, 1846 (843). The drawing

[1] This was commissioned by Sir Joseph Dalton Hooker in April 1859, and there are several letters relating to it in A. Woolner, *Thomas Woolner: his Life in Letters* (1917), pp 169–72, 175, 186, 188, 189n, 190–2. The nose of the bust was broken while it was being placed at the *R A* exhibition.

in the British Museum shows Horne as quite an old man, and does not appear to relate to the NPG portrait or the two miniatures. The date of the NPG portrait is based on the apparent age of the sitter.

Description: Brown eyes, brown hair and whiskers. Dressed in a white collar, and voluminous brown cloak. His hands are resting on the back of a chair covered in red material. Pillar at left and background colour generally dark brown.

2682 Plaster cast, 9 inches (22·9 cm) diameter, of a medallion by CHARLES SUMMERS. PLATE 451

Collections: Presented by Maurice Buxton Forman, 1934.

Inscribed on the back of an early photograph of this plaque (donor's collection), in Horne's hand, was the following note: 'R. H. Horne/From a Medallion/by Charles Summer [*sic*]/(in Australia 1867)/ now in Rome 1877'. Another cast is at Keats House, Hampstead.

ICONOGRAPHY A miniature by Miss E. Drummond was exhibited *RA*, 1827 (594); a daguerreotype by Paine of Islington was anonymously engraved (example in NPG); a woodcut was published *ILN*, LXXXIV (1884), 301.

HORNE *Sir William* (*1774–1860*)
Attorney-general, MP for St Marylebone.

54 See *Groups:* 'The House of Commons, 1833' by Sir G. Hayter, p 526.

HORSLEY *John Callcott* (*1817–1903*)
Painter; son of the musical composer, William Horsley (1774–1858); studied at RA schools; ARA, 1855; RA, 1856; treasurer of RA, 1882–97; chiefly noted for his domestic scenes and portraits.

3182 (2) Pencil on paper, $3\frac{1}{4} \times 1\frac{7}{8}$ inches (8·4 × 4·8 cm), by CHARLES WEST COPE, *c* 1862. PLATE 452

Inscribed (upper left): Horsley

Collections: See *Collections:* 'Drawings of Artists, *c* 1862' by C. W. Cope, p 565.

From his concentrated, downward-looking expression, Horsley is apparently either painting or sketching.

1833 See *Groups:* 'Private View at the Royal Academy, 1888' by H. J. Brooks, in forthcoming Catalogue of Portraits, 1860–90.

4245 See *Groups:* 'The Hanging Committee of the Royal Academy, 1892' by R. Cleaver, in forthcoming Catalogue of Portraits, 1860–90.

ICONOGRAPHY A painting by W. C. Horsley was in the collection of the sitter's widow, exhibited *RA*, 1891 (1126), reproduced J. C. Horsley, *Recollections of a Royal Academician*, edited Mrs E. Helps (1903), frontispiece; another painting by W. C. Horsley is in the collection of the Royal Academy, exhibited *RA*, 1902 (738), reproduced Cassell's *Royal Academy Pictures* (1902), p 21; a painting by himself of 1882 is in the Aberdeen Art Gallery; a miniature by D. Hardy was exhibited *RA*, 1898 (1451); a bust by J. Adams-Acton was exhibited *RA*, 1892 (1941); a woodcut by M. Jackson, after a photograph by J. and C. Watkins, was published *ILN*, XLV (1864), 677; there are three photographs in the NPG, and another is reproduced J. C. Horsley, facing p 310.

HOTHAM *Beaumont Hotham, 3rd Baron* (*1794–1870*)
General, MP for Leominster.

54 See *Groups:* 'The House of Commons, 1833' by Sir G. Hayter, p 526.
See also forthcoming Catalogue of Portraits, 1790–1830.

HOWARD *Philip Henry* (*1801–83*)

MP for Carlisle.

54 See *Groups:* 'The House of Commons, 1833' by Sir G. Hayter, p 526.

HOWLEY *William* (*1766–1848*)

Archbishop of Canterbury.

54 See *Groups:* 'The House of Commons, 1833' by Sir G. Hayter, p 526.

See also forthcoming Catalogue of Portraits, 1790–1830.

HUDSON *Thomas* (*1772–1852*)

MP for Evesham.

54 See *Groups:* 'The House of Commons, 1833' by Sir G. Hayter, p 526.

HUGHES *Edward Hughes Ball* (*d 1863*)

Social celebrity; noted for his reckless expenditure and dissipation; familiarly known as 'Golden Ball'.

4026 (36) Pencil and black chalk, with touches of red on the face, on blue-tinted paper, $7 \times 5\frac{1}{4}$ inches ($17 \cdot 8 \times 13 \cdot 4$ cm), by COUNT ALFRED D'ORSAY, *c* 1848. PLATE 453

Signed (*lower right*)*:* A d'Orsay/fecit *and inscribed* (*bottom centre*)*:* Ball Hughes

Collections: See *Collections:* 'Drawings of Men About Town, 1832–48' by Count A. D'Orsay, p 557.

R. J. Lane in his 'Account Books' (NPG archives), III, 6, records doing a lithograph of Hughes, after D'Orsay, for the publisher Mitchell in 1848 (no example located); this may have been a lithograph after the NPG drawing, since no other is recorded.

ICONOGRAPHY A painting by A. Dedreux was sold in Switzerland in 1949 (coloured reproduction in NPG); a drawing by G. Cruikshank is in the British Museum; two drawings by J. Grego after Dighton or Cruikshank, and the second after a contemporary print, are reproduced *Reminiscences of Captain Gronow* (1889), I, facing 120, and II, facing 92; a caricature etching by R. Dighton was published T. McLean, 1819 (example in NPG).

HUGHES *Seymour Ball*

Son of Edward Ball Hughes (see above).

4026 (35) See *Collections:* 'Drawings of Men About Town, 1832–48' by Count A. D'Orsay, p 557.

HUMBOLDT *Friedrich, Baron* (*1769–1859*)

German naturalist.

2515 (38) See *Collections:* 'Drawings of Prominent People, 1823–49' by W. Brockedon, p 554.

HUME *Sir Abraham, Bart* (*1749–1838*)

Connoisseur.

793 See entry for the 4th Earl of Aberdeen, p 3.

HUME *Joseph* (*1777–1855*)

Radical politician; entered medical service of East India Company, 1797; returned to England, 1807; tory MP, 1812, and subsequently a radical MP; one of the most influential figures in the campaign for political and social reform.

713 Oil on canvas, $61\frac{1}{8} \times 44\frac{3}{4}$ inches ($155\cdot3 \times 113\cdot7$ cm), by JOHN WHITEHEAD WALTON, 1854. PLATE 456

Signed and dated (middle left): J. W. WALTON/1854

Collections: Commissioned by Dr Joseph Glen, the sitter's nephew, and bequeathed by him, 1884.

Exhibitions: RA, 1857 (633).

Literature: G. Scharf, 'TSB' (NPG archives), XXXII, 27–8.

Sittings took place in the artist's studio in 1854, Dr Glen always accompanying his uncle (information contained in a letter of 18 September 1885 from the artist, NPG archives). In 1860, the picture was severely damaged, and Walton repainted most of the figure and background, but not the head. He then signed the picture and dated it to the year of the repainting (information contained in a letter of 14 September 1885 from the artist, NPG archives). In consultation with the NPG, the artist altered the date to '1854' in 1885 to avoid confusion. The face has the look of having been partially painted from a photograph; it is similar to the photograph by Mayall (see iconography below). A reproduction of the painting was published by the Photographische Gesellschaft, Berlin (example in the NPG).

Description: Blue eyes, grey hair and whiskers. Dressed in a dark stock, white shirt, and black suit. Resting his hand on a desk with books and papers. Red curtains at left, rest of background very dark brown.

1098 Coloured chalk on paper, $18\frac{5}{8} \times 14\frac{3}{4}$ inches ($47\cdot4 \times 37\cdot4$ cm), by CHARLES BLAIR LEIGHTON, 1849–50. PLATE 454

Signed (lower left): Blair Leighton

Collections: Edward Hutchins, presented by him, 1897.

The date was provided by the donor (letter of 28 April 1897, NPG archives). A lithograph of this portrait by the artist was published Colnaghi, 1855 (example in British Museum).

Description: Healthy complexion, grey (?) eyes, and grey hair. Dressed in a dark stock, white shirt, and dark coat.

54 See *Groups:* 'The House of Commons, 1833' by Sir G. Hayter, p 526.

ICONOGRAPHY

c1820 Miniature by Sir W. J. Newton. Exhibited *RA,* 1820 (638).
Engraved and published R. Newton, 1821 (example in NPG).

1822 Engraving by T. Wright, after A. Wivell, published Wivell, 1822 (example in NPG).

c1822 Painting by J. Graham. Exhibited *RA,* 1822 (132).
Engraved by T. Hodgetts, published Graham, 1823 (example in NPG).

c1822 Bust by J. Bonomi. New York Historical Society.
Exhibited *RA,* 1822 (1035).

1823 Anonymous engraving, published Smeeton, 1823 (example in British Museum), for *The Unique.*

c1824 Painting by W. Patten junior. Exhibited *RA,* 1824 (353).

1826 Engraving by R. Cooper, after S. C. Smith, published J. Robins (example in NPG).

c1830 Marble bust by A. H. Ritchie. House of Commons Library (plate 455).
Exhibited *RA,* 1830 (1267).

1832 'The Reform Banquet, 1832' by B. R. Haydon. Collection of Lady Mary Howick, Howick. Etched by F. Bromley, published J. C. Bromley, 1835 (example in NPG); engraved and published by J. C. Bromley, 1837 (example in British Museum).

1833 'The House of Commons, 1833' by Sir G. Hayter (NPG 54 above).

1837 Lithograph, 'Political Sketches, no. 490', by J. Doyle (example in NPG); Hume does not appear in the original drawing, see L. Binyon, *Catalogue of British Drawings in the British Museum* (1900), II, 56 (73).

c 1838 Painting by G. P. A. Healy. Exhibited *R A*, 1838 (395).

c 1839 Painting by G. P. A. Healy. Exhibited *R A*, 1839 (117).
Engraved by W. Holl, published J. Saunders, 1840 (example in NPG), for 'Political Reformers'.

c 1846 Bust by W. Behnes. Exhibited *R A*, 1846 (1464).

1849 Painting by G. P. A. Healy. Exhibited *S K M*, 1868 (459), lent by Mrs Hume.
Possibly the painting of 1839 (see above), if misdated in the *S K M* Catalogue.

1849 Two drawings by J. Doyle. British Museum.

1849–50 Drawing by C. B. Leighton (NPG 1098 above).

1854 Painting by J. W. Walton (NPG 713 above).

1854 Painting by J. Lucas. University College, London.
Started in 1851, presented by Hume's colleagues in the House of Commons to Mrs Hume in 1854, and presented by her to University College. Exhibited *R A*, 1856 (249). Reproduced A. Lucas, *John Lucas* (1910), plate XLVIII. Engraved by S. Bellin, published H. Graves, 1854 (example in NPG). Copy by the artist in 1855: collection of Lady Balfour, 1873.

1854 Bust by unknown sculptor. Crystal Palace Collection, 1854.

1855 Lithograph by T. Packer, after a photograph, published Stannard and Dixon, 1855 (example in NPG).

1868 Painting by C. Lucy. Victoria and Albert Museum.

Undated Painting by J. Graham Gilbert. Scottish NPG.

Undated Painting by an unknown artist. Recorded and sketched by G. Scharf, 'T S B' (NPG archives), XXIV, 51.

Undated Engraving by J. Cochran, reproduced L. Fagan, *The Reform Club* (1887), p 30, and an anonymous engraving (examples in the British Museum). A drawing after the Cochran engraving is in the NPG.

Undated Lithograph by G. B. Black, after a photograph by Mayall, published Ackerman, 1854. The same photograph was anonymously etched [?], published Dean and Son, 1855 (example in NPG), and a detail was reproduced as a woodcut *I L N*, XXVI (1855), 196.

HUMPHERY *John* (*1794–1863*)
MP for Southwark.

54 See *Groups*: 'The House of Commons, 1833' by Sir G. Hayter, p 526.

HUNT *William Henry* (*1790–1864*)
Water-colour painter; apprenticed to John Varley; employed by Dr Monro; exhibited at RA from 1807, and at Society of Painters in Water-Colours, of which he became a member; an enormously prolific artist, best known for his figure studies and still-life works.

768 Oil on paper, stuck on card, $5\frac{1}{4} \times 4\frac{1}{4}$ inches (13·5 × 11 cm), by HIMSELF. PLATE 457
Signed (*bottom right*): W Hunt

Collections: The Earl of Leven and Melville, presented by him, 1887.

Exhibitions: Ruskin and his Circle, Arts Council, London, 1964 (251).

There is an extract from an old printed catalogue mounted with this portrait: ' . . . 50 A miniature Portrait of the Artist; *oils, an/admirable likeness* 4 by 5'. This presumably refers to the exhibition or sale where the donor acquired the portrait.

Description: Healthy complexion, brown eyes, grey hair and whiskers. Dressed in a white shirt, dark stock and loose brown coat. Background colour dark brown.

2636 Water-colour on paper, $14\frac{3}{4} \times 11$ inches ($37\cdot4 \times 27\cdot9$ cm), by HIMSELF. PLATE 458

 Collections: H.S.Palmer, RI, bequeathed by him, 1933.

 Literature: Magazine of Art (1898), reproduced p503; *Dictionary of National Biography*, x (1908), 283.

 Description: Healthy complexion, brown eyes, brown hair with grey streaks. Dressed in a dark stock, white shirt and grey coat. Background colour brown.

ICONOGRAPHY There are a great many self-portraits of Hunt, mostly in water-colour; British Museum (2); Victoria and Albert Museum (with daughter and niece); Lady Lever Art Gallery, Port Sunlight, reproduced *Connoisseur*, LXXXVIII (1931), 81; Alpine Club Gallery, 1962 (99); collection of Vokins, 1903; sale of S.Barlow of Middleton, Christie's, 19 June 1875 (lot 42), recorded and sketched by G.Scharf, 1877, 'TSB' (NPG archives), XXIII, 36; collection of M.H.Spielmann, exhibited *British Empire Exhibition*, Wembley Palace of Art, London, 1924 (V125), reproduced 'Illustrated Souvenir', p65; *SKM*, 1868 (585); collection of Colonel M.H.Grant, 1954. A drawing by J.G.P.Fischer is in the British Museum; a bust by A.Munro is in the Royal Society of Painters in Water-Colours, reproduced as a woodcut *ILN*, XLIV (1864), 536; two woodcuts were published in *The Critic*, and *ILN*, 1858 (cuttings in NPG), and another, after a photograph by J. and C.Watkins, was published *ILN*, XLIV (1864), 181; there are two photographs in the NPG.

HYLTON *William George Hylton Jolliffe, 1st Baron* (*1800–76*)

 MP for Petersfield.

54 See *Groups:* 'The House of Commons, 1833' by Sir G.Hayter, p526.

INGHAM *Robert* (*1793–1875*)

 MP for South Shields.

54 See *Groups:* 'The House of Commons, 1833' by Sir G.Hayter, p526.

INGLEFIELD *Sir Edward Augustus* (*1820–94*)

 Admiral; lieutenant, 1842; commander, 1845; went on expedition in search of Sir John Franklin, 1852, of which he published an account; visited Arctic again, 1853 and 1854; served on various stations; second in command in Mediterranean, 1872–5; knighted, 1877; commander-in-chief on North American station, 1878–9; admiral, 1879; retired 1888.

921 Oil on millboard, $15\frac{3}{4} \times 13\frac{1}{4}$ inches ($40 \times 33\cdot7$ cm), by STEPHEN PEARCE, after his portrait of *c*1853.

 PLATE 460

 Inscribed in ink on the back: CAPT INGLEFIELD.R.N./&c. &c. &c.

 Collections: See *Collections:* 'Arctic Explorers' by S.Pearce, p562.

 Exhibitions: Royal Naval Exhibition, Chelsea, 1891 (49).

 This is a replica of NPG 1223 below, and was commissioned by Lady Franklin.

 Description: As for NPG 1223.

1223 Oil on canvas, $15\frac{3}{8} \times 13\frac{1}{4}$ inches ($39\cdot1 \times 33\cdot6$ cm), by STEPHEN PEARCE, *c*1853. PLATE 459

 Signed on the back: Stephen Pearce. *Inscribed in the artist's hand on a damaged label, formerly on the back:* Captain . . .[*damaged*]/F.R.S. F.R.C.S./n – n –/painted by Stephen Pearce/55 Berners Street/Oxford Street.

 Collections: See *Collections:* 'Arctic Explorers' by S.Pearce, p562.

 Exhibitions: RA, 1853 (78).

 Inglefield is wearing the full-dress uniform of a naval commander (1846 pattern), with (from left to

right), the Arctic Medal (1818–55), the Sultan of Turkey's Medal for Syria (1840), and the Naval General Service Medal for Syria (1840).

Description: Healthy complexion, bluish eyes, brown hair and whiskers. Dressed in a dark stock, white shirt, and dark blue naval uniform, with gilt buttons, gold-braided collar and epaulettes, and silver medals with multi-coloured ribbons. Background colour dark grey and white-grey (possibly intended to represent clouds).

2500 Oil on canvas, 38 × 31⅛ inches (96·7 × 79 cm), by the HON JOHN COLLIER, 1897. PLATE 461

Signed (bottom right): John Collier

Collections: Commissioned by the sitter's son, H. B. Inglefield, and bequeathed by him, 1931.

Literature: Hon J. Collier, 'Sitters Book' (photostat copy, NPG archives), p 49, under the year 1897.

This posthumous portrait was painted with the help of two photographs, now in the collection of Lieutenant Commander A. F. Inglefield, who presented examples of each to the NPG. Also in his collection is a letter from Collier to H. B. Inglefield, dated 19 March 1897: '*It has been a very interesting portrait to me to paint and I have liked doing it. I shall be having a photographer here before very long and I will then have it photographed for you. The picture shall be sent to you on Monday the 29th or Tuesday the 30th*'. A platinotype print of it was executed by H. Dixon and Son (example in NPG). Inglefield is wearing an admiral's uniform of the 1856 pattern (apparently amended inaccurately in 1879), with the star and cross of the Bath (KCB), and (from left to right) the Turkish Medal for the Crimea, the Naval General Service Medal with a bar for 'Syria' (1840), the Turkish Order of the Medjidie (4th class), the Arctic Medal (1818–55), the Crimea Medal with a bar for 'Sebastopol', and the Sultan of Turkey's Medal for Syria (1840).

Description: Pale eyes, greyish hair and whiskers. Dressed in a dark blue naval uniform, with gold-braided collar, epaulettes, cuffs, sword-belt, trouser-stripe and sword tassel, gilt buttons, and white, red and silver stars and medals and multi-coloured ribbons, gilt dress sword, black and gold-braided cocked hat and white gloves. Background colour dark brown.

ICONOGRAPHY The only other recorded likenesses of Inglefield are: a painting by Miss E. Mortlock in the collection of Lieutenant Commander A. F. Inglefield; a woodcut, after a photograph by Claudet, published *ILN*, XXIII (1853), 332; and a photograph in the Royal Geographical Society, London.

INGLIS *Sir Robert Harry, Bart (1786–1855)*

Tory politician; private secretary to Lord Sidmouth; MP from 1824; opposed parliamentary reform, Jewish relief, repeal of the corn laws, and the Maynooth grant; commissioner on public records, 1831; privy councillor, 1854; president of the Literary Club; published numerous works.

1062 Black and red chalk, heightened with Chinese white, on brown, discoloured paper, 24⅛ × 18½ inches (61·4 × 47·1 cm), by GEORGE RICHMOND, 1845. PLATE 463

Signed (bottom left): Geo. Richmond. delᵗ. *Inscribed in pencil (bottom right):* Robert Henry Inglis.

Collections: The artist, purchased from his executors, 1896.

Exhibitions: SKM, 1868 (512); *VE*, 1892 (356).

Literature: G. Richmond, 'Account Book' (photo-copy of original MS, NPG archives), p 38, under the year 1845 – 'for self'.

Although the angle of the head is different, Richmond apparently made use of this drawing for his 1854 painting of Inglis in the Examination Schools, Oxford. Inglis was one of Richmond's earliest friends and patrons: '*I owe everything to Sir Robert Inglis, for it was he who put my foot on the first rung*

of the ladder.[1] A drawing of Lady Inglis by Richmond was bequeathed to the NPG by Francis Seymour in 1938, but declined. The NPG bought several of Richmond's portraits from his executors. Other portraits of Inglis by Richmond are listed as follows:

1 *1832*. Drawing or water-colour, listed in 'Account Book', p4.

2 *1834*. Drawing or water-colour, listed in 'Account Book', p12.

3 *1835*. Drawing or water-colour, presented to the sitter, listed in 'Account Book', p16.

4 *1836*. Water-colour, Ashmolean Museum, Oxford.

5 *c1837*. Water-colour, Castle Museum and Art Gallery, Nottingham (plate 462), engraved by J.Jenkins, published R.Ryley, 1837 (example in NPG), for 'Eminent Conservative Statesmen'. Possibly one of the early portraits listed in the 'Account Book' (nos. 1–3).

6 *1854*. Painting, Examination Schools, Oxford, exhibited *RA*, 1855 (159), listed in 'Account Book', p61, engraved by J.Faed, published Colnaghi, 1857 (example in NPG).

7 *1854*. Drawing for Sir T.Acland, listed in 'Account Book', p61.

54 See *Groups:* 'The House of Commons, 1833' by Sir G.Hayter, p526.

342, 3 See *Groups:* 'The Fine Arts Commissioners, 1846' by J.Partridge, p545.

ICONOGRAPHY A painting by Sir M.A.Shee was exhibited *RA*, 1839 (346); an oil study of 1845 for Partridge's 'Fine Arts Commissioners' (see above) was sold at Christie's, 15 June 1874 (lot 72); an oil study for Hayter's 'House of Commons' (see above) was sold at Christie's, 14 June 1968 (lot 115, with a companion study of F.Shaw, dated 1834), bought Agnew, engraved by J.E.Coombs (example in NPG); a painting by H.W.Pickersgill was exhibited *RA*, 1850 (181), possibly the portrait in the Pickersgill sale, Christie's, 17 July 1875 (lot 313); there are several drawings by J.Doyle in the British Museum; a bust by J.K.Wilson was exhibited *RA*, 1838 (1295); there is an engraving by F.C.Lewis, after J.Slater (example in NPG), for the 'Grillion's Club' series; there is an engraving by F.Holl, after C.W.Cope (example in NPG); a woodcut was published *ILN*, I (1842), 240; a woodcut, after a photograph by Beard, was published *ILN*, XXIV (1854), 49.

IRVING *Washington* (*1783–1859*)

American biographer and novelist.

2515 (6) See *Collections:* 'Drawings of Prominent People, 1823–49' by W.Brockedon, p554.

ISAMBERT *M.M.*

French slavery abolitionist.

599 See *Groups:* 'The Anti-Slavery Society Convention, 1840' by B.R.Haydon p538.

JAMES *George Payne Rainsford* (*1799–1860*)

Novelist and historical writer; historiographer royal to William IV; British consul in Massachusetts, 1850–2, and elsewhere; published popular historical works, historical novels and poems.

1259 Oil on board, $8\frac{1}{4} \times 7\frac{1}{8}$ inches (20·8 × 18·2 cm), by STEPHEN PEARCE, 1846. PLATE 464

Inscribed in the artist's hand on a label, formerly on the back of the picture: Painted in 1846, by Stephen Pearce,/when he was Amanuensis to Charles Lever,/(Harry Lorrequer) and Tutor to his Children;/ Charles Lever, & G.P.R. James were then re-/siding at Carlsruhe./Miniature in Oil Colors.

Inscribed on another label, also in the artist's hand, are various biographical details.

[1] A.M.W.Stirling, *The Richmond Papers* (1926), p38. The 'first rung' was a portrait of William Wilberforce in 1832 (for which Inglis made the introduction), engraved by S.Cousins: the engraving became immensely popular.

Collections: The artist, presented by him, 1900.

Literature: Stephen Pearce, *Memories of the Past* (1903), p40.

In a letter of 5 May 1900 (NPG archives), the artist wrote: '*I am glad you like the little portrait of G.P.R.James – I hope you will hang it in a good side light, about 5 feet 4 inches from the floor*'. The artist also told Cust that he had executed an oil portrait of Lever, in 1844, then in the collection of the Rev John Lever, his brother; a chalk drawing of Lever of 1849 is in the National Gallery of Ireland, reproduced S.Pearce, *Memories of the Past*, facing p28.

Description: Healthy complexion, brown eyes, brown hair. Dressed in a white shirt, dark stock, and dark grey coat. Seated in a wooden armchair with dark red covering, and reading a book on a brown wooden table, with a red leather (?) top. On the table are a silver candlestick, a dark wooden (?) ink-stand, and a green leather book. A brown leather book leans against the chair. In the background on the left are bookshelves with brown leather-bound books. At the right there is a thin strip of green, possibly a door or window.

ICONOGRAPHY An anonymous engraving was published H.Colburn, 1839 (example in NPG); an engraving by J.C.Armytage, after F.Cruikshank, was published Parry, Blenkarn Co, 1847 (example in NPG); two engravings of 1831 and 1846, and a photograph of *c*1859, are reproduced *Bookman*, LII (April 1917), 5, 9 and 13.

JAMES *Rev John Angell* (*1785–1859*)

Independent minister, author of religious works, and slavery abolitionist.

599 See *Groups:* 'The Anti-Slavery Society Convention, 1840' by B.R.Haydon, p538.

JAMES *William* (*1791–1861*)

MP for Carlisle.

54 See *Groups:* 'The House of Commons, 1833' by Sir G.Hayter, p526.

JAMES *Rev William*

Slavery abolitionist.

599 See *Groups:* 'The Anti-Slavery Society Convention, 1840' by B.R.Haydon, p538.

JAMES *Sir William Milbourne* (*1807–81*)

Lord justice of appeal.

4710 See *Groups:* 'A Consultation Previous to an Aerial Voyage to Weilburg, 1836' by J.Hollins, p537.

JAMESON *Anna Brownell* (*1794–1860*)

Author; eldest daughter of the miniature-painter, D.B.Murphy; married Robert Jameson (afterwards speaker and attorney-general of Ontario), 1825, but soon separated from him; published numerous works on art, history and other subjects; a keen advocate of women's rights.

689 Marble bust, $23\frac{5}{8}$ inches (60 cm) high, by JOHN GIBSON, 1862. PLATE 465

Incised at the side: J. GIBSON. FECIT. ROMAE.

Incised on the marble pedestal: ANNA JAMESON./1794–1860./A DISTINGUISHED CRITIC,/AND WRITER UPON ART./ENDOWED WITH POETIC GENIUS/AND/A VIGOROUS UNDERSTANDING,/ SHE THREW NEW LIGHT/ON THE CHRISTIAN LEGENDS/WHICH INSPIRED/THE PAINTERS AND SCULPTORS OF THE PAST,/AND AWAKENED/A CLEARER COMPREHENSION/OF TRUTH AND BEAUTY/IN ART/AS WELL AS IN NATURE./IN HER LATER YEARS/ SHE ROUSED PUBLIC ATTENTION/TO THE SUFFERINGS OF EDUCATED WOMEN,/VAINLY ENDEAVOURING TO

EARN/A COMPETENCY,/AND TO THE NECESSITY OF IMPROVING/THEIR CONDITION;/BY REMOVING UNFAIR
OBSTACLES,/AND BY RENDERING/LABOUR AS HONOURABLE AS WEALTH./THIS BUST/IS ERECTED BY THOSE/WHO
ESTEEM/HER GENIUS AND VIRTUE,/AMONG WHOM IS HER FRIEND/THE SCULPTOR,/WHO EXECUTED THE WORK
IN HER HONOUR –/JOHN GIBSON, R.A., OF ROME.

Collections: Commissioned by a body of subscribers, and presented to the South Kensington Museum,
1862; transferred to the NPG, 1883.

Literature: Life of John Gibson, R.A., edited Lady Eastlake (1870), p252; G. MacPherson, *Memoirs of
the Life of Anna Jameson* (1878), p241; T. Mathews, *The Biography of John Gibson, R.A.* (1911), p246.

The idea of commemorating Mrs Jameson by a bust originated with her friend, Miss Susan Horner,
who organized the fund,[1] and wrote to Gibson asking him to accept the commission. He replied on 29
May 1860 from Rome, apologizing for his delay in answering (NPG archives):

*It will give me great pleasure to meet your wishes as well as of those friends of the late Mrs Jameson to erect
a memorial to her memory. It is but rarely I consent to give up my time to a bust, I have charged £150 for a
bust in Mar. but upon this occasion I will execute a bust of Mrs Jameson for the sum of fifty pounds. She
had a friendship for me & had honored me in print.*

*I think the expence of carriage to England would be 5 or 6 pounds. I don't know what would be the cost
of a pedestal to place it upon, that had better be done in London.*

Miss Horner also wrote to Sir Charles Lyell, asking if the bust, when finished, could be put on public
exhibition at the South Kensington Museum, and he replied on 22 June 1860 (NPG archives):

*I have a promise that "the bust of the late Mrs Jameson by Gibson R.A. shall be placed in the corridors to
be appropriated to memorial Sculpture on the grounds of the Royal Commission of 1851 at South Kensington".
also that if the place for it is not finished or ready it shall provisionally be put into the room of sculpture –
The Prince [Albert] wishes in this & other cases that there should be inscribed on the pedestal not only the
name but some statement of the merits of the individual commemorated which he thinks too much neglected
in our public statues, the people requiring instruction.*

Miss Horner accordingly devised an inscription, and sent a printed copy to Gibson,[2] who wrote on 10
August 1860 (NPG archives):

*Your inscription cannot be better. As to the expence of pedestal, cutting letters & putting up I cannot say
but when I return to London Mr Theeds mason will tell us.*

*Mr Theeds's man was to call for the cast of your profile of Mrs Jameson which will be of use to me – I
shall keep it for yr own sake.*

For Miss Horner's medallion of Mrs Jameson see iconography below. On 13 April 1861, Gibson wrote
to Miss Horner about the progress of the bust (NPG archives):

*When yr letter arrived I had not begun to model the bust of Mrs Jameson. As Lady Annabella's departure
was approaching I at once began the work that she might see it. Her Ladyship thought it like. I finished the
model on 9th inst & wrote a note to Mrs Bate the sister of Mrs Jameson, who came & thought it very like
& praised the style & expression. Williams the painter has been & he also said that it is a strong likeness for
he knew her well.*

*Mr Browning the poet has been & remained before the bust for a long time, he gave me praise for the
likeness, the expression & style, he was her intimate friend I like the inscription very much. I am not
able to find fault with it, I feel complimented by the last paragraph.*

*I do not think that the bust can be finished in marble before my departure, for I think of leaving Rome
about the middle of June, when I come to London I shall see you & soon fix the time to model the bust of Sir
Charles Lyell.*

[1] A list of the subscribers is in the NPG.

[2] According to the printed copy, the middle passage of the
inscription was originally more general in its praise: 'HER
LATER YEARS/WERE DEVOTED TO ALLEVIATE/THE SUFFERINGS,/
AND TO IMPROVE THE/SOCIAL CONDITION OF WOMEN,/WHILST
ENABLING THEM BEST/TO FULFIL THEIR VOCATION IN LIFE.'

The bust was finished by the autumn of 1862, and on 9 September Gibson, who was staying in London with the painter, William Boxall, agreed to go with Miss Horner to the South Kensington Museum to help place the bust. It remained there till 1883 when, upon Miss Horner's suggestion, it was transferred to the NPG (relevant correspondence, NPG archives). She had been upset to find the bust in a dark and neglected passage-way near the refreshment room. Miss Horner continued to take an active interest in the bust, complaining to Sir Lionel Cust, director of the NPG, in 1898 that the bust was rather inadequately displayed.

ICONOGRAPHY A miniature by her father, D.B.Murphy, of 1810 was engraved by H.Adlard (example in NPG), for G.MacPherson's *Memoirs of the Life of Anna Jameson* (1878), frontispiece; paintings by J.Hayter and H.P.Briggs were exhibited *RA*, 1833 (148), and 1835 (327), the latter lithographed by R.J.Lane (example in NPG, plate 466); a miniature by T.H.Carrick was exhibited *RA*, 1852 (861); a drawing by C.Vogel, 1839, is in the Küpferstichkabinett, Staatliche Kunstsammlungen, Dresden; a bust by E.G.Papworth junior was exhibited *RA*, 1861 (1082); a medallion by Miss S.Horner was exhibited *VE*, 1892 (1089), lent by Mrs Lyell; an unnamed portrait was in the *Victorian Era Exhibition*, 1897, 'Woman's Work Section', p20 (10), lent by Miss Helen Blackburn; a woodcut, after a photograph by Kilburn, was published *ILN*, XXXVI (1860), 300; there is a photograph by D.O.Hill (example in Scottish NPG, plate 467), reproduced H.Schwarz, *David Octavius Hill* (1932), plate 37; there is a daguerreotype in the British Museum.

JEFFREY *Francis Jeffrey, Lord* (*1773–1850*)

Scottish judge, editor of the *Edinburgh Review*, and MP for Edinburgh.

54 See *Groups*: 'The House of Commons, 1833' by Sir G.Hayter, p526.
See also forthcoming Catalogue of Portraits, 1790–1830.

JERDAN *William* (*1782–1869*)

Journalist; worked on *Aurora*, 1806, and the *Pilot*, 1808; joined *Morning Post*; conducted the *Satirist*, 1807–14; edited the *Sun*, 1813–17; edited *Literary Gazette*, 1817–50; published numerous works, including *The National Portrait Gallery of the Nineteenth Century*.

3028 Pencil and water-colour on paper, $8\frac{3}{4} \times 7\frac{7}{8}$ inches (22·2 × 20 cm), by DANIEL MACLISE, 1830. PLATE 468
Collections: Presumably Maclise Sale, Christie's, 24 June 1870 (lot 66); Sir William Drake; Drake Sale, Christie's, 24 May 1892 (lot 204); M.H.Spielmann, presented by him, 1939.
Exhibitions: Burlington Fine Arts Club, 1880 (94).

This is a finished study for the engraving of Jerdan, which was published as no.1 of Maclise's 'Gallery of Illustrious Literary Characters', *Fraser's Magazine*, I (June 1830), facing 605. Maclise published over eighty caricature drawings, and they constituted one of the chief attractions of the magazine. Other Maclise drawings of Dunlop and Praed (NPG 3029 and 3030) were presented at the same time as this one, with a similar provenance. The collector's mark in the bottom left-hand corner is that of Sir William Drake. Jerdan also appears in Maclise's engraving of 'The Antiquaries', published *Fraser's Magazine*, V (1832), between 474–5.

Description: Dark eyes and black hair. Dressed in a dark stock, white shirt, light brown waistcoat, dark grey coat, fawn trousers and black shoes. Seated in a red-covered chair. Brown case lower right, multi-coloured carpet, brown table. Floor and background colour grey.

ICONOGRAPHY A painting by G.P.A.Healy was exhibited *RA*, 1839 (473); a drawing by Count A.D'Orsay of 1839 was with Colnaghi, 1950, lithographed by R.J.Lane, published J.Mitchell (example in NPG); busts by P.Turnerelli and F.W.Smith were exhibited *RA*, 1825 (1038), and 1828 (1167); an engraving by

H. Robinson, after a portrait by G. H. Harlow of 1815 (example in NPG), was published *The Autobiography of William Jerdan* (1852), I, frontispiece; an engraving by T. Woolnoth, after J. Moore, was published Fisher, Son & Co, 1830 (example in NPG).

JEREMIE *Sir John* (*1795–1841*)

Colonial judge and governor, slavery abolitionist.

599 See *Groups:* 'The Anti-Slavery Society Convention, 1840' by B. R. Haydon, p 538.

JERROLD *Douglas William* (*1803–57*)

Author; appeared on the stage as a child; midshipman, 1813–15; established reputation as a playwright with 'Black-eyed Susan', 1829; contributed to numerous periodicals, including the *Athenaeum* and *Punch*; published *The Story of a Feather*, 1844, and other novels; enjoyed great reputation as a wit.

292 Oil on canvas, 36 × 28 inches (91·5 × 71 cm), by SIR DANIEL MACNEE, 1853. PLATE 471

Signed and dated (bottom right): Daniel Macnee R.S.A./1853.

Collections: W. H. Dixon, FSA, presented by him, 1869.

The donor wrote about this portrait (letter of 28 June 1869, NPG archives): '*Only two portraits were ever painted of the famous wit, – & this is certainly the better. I have the two in my house*'. Another portrait by Macnee was exhibited *RA*, 1852 (609), unless this is the NPG portrait, which was subsequently re-dated.

Description: Blue-grey eyes, brown hair with grey streaks. Dressed in a dark stock, white shirt, green and gold figured waistcoat, silver watch-chain, dark coat and trousers. Seated in a red chair. Green landscape to left. Rest of background brown.

942 Marble bust, 23⅞ inches (60·7 cm) high, by EDWARD HODGES BAILY, 1853. PLATE 469

Incised on the back of the base: E. H. Baily, R.A./Sculp.1853.

Collections: The sitter; by descent to his daughter-in-law, Mrs William Blanchard Jerrold, and presented by her, 1893.

Exhibitions: RA, 1853 (1436); *Art Treasures*, Manchester, 1857, 'Sculpture' (144); *Charles Dickens*, Victoria and Albert Museum, 1970 (P8).

Literature: W. Jerrold, *Douglas Jerrold and 'Punch'* (1910), p 40.

Baily agreed to execute a bust of Jerrold at the latter's 50th birthday party, on 3 January 1853, to commemorate the event. One of those present wrote (W. Jerrold, p 40):

The bust was executed in marble, and is now in the possession of the family, who not only regard it as one of the most poetically conceived works which modern sculpture has produced, but seldom speak of it without calling to mind the interesting occasion which gave rise to it. So admirable is it as a likeness, and so graceful as a composition, that I am constrained to say, in common with others similarly situated, that I was sadly disappointed that Mr Baily was unable to carry out his promise to its full extent.

Baily had promised to give plaster casts of the bust to all present at the birthday party. He did produce a number of casts, one of which is at the *Punch* offices. The NPG bust was engraved by W. H. Mote as the frontispiece of W. B. Jerrold, *The Life and Remains of Douglas Jerrold* (1859). Another, or possibly the same bust, also of marble and dated '1852', was in the Crystal Palace Portrait Gallery, 1854.

ICONOGRAPHY A painting by W. Bewick of 1839 was exhibited *SKM*, 1868 (597), and *VE*, 1892 (102), lent by Mrs Noseda; Jerrold appears in the drawing of 'Dickens reading *The Chimes* to his friends, 1844' by D. Maclise in the Victoria and Albert Museum, reproduced D. A. Wilson, *Carlyle on Cromwell and Others* (1925), facing p 272; a marble bust by E. A. Foley was exhibited *RA*, 1862 (1125); a statuette by E. G. Papworth

senior was exhibited *RA*, 1856 (1287); there is an engraving by T. A. Prior, after a photograph by Beard, and (reversed) by J. Sartain (examples in NPG); an etching by K. Meadows of 1845 is reproduced *Bookman*, LV (February 1919), 159; a woodcut, after a photograph by the London Stereoscopic Co, was published *Illustrated Review*, 15 May 1872, and a woodcut, after a photograph by Dr Diamond, *ILN*, XXX (1857), 598; there are several photographs in the NPG (see plate 470).

JERSEY *George Child-Villiers, 5th Earl of* (*1773–1859*)

Courtier.

54 See *Groups:* 'The House of Commons, 1833' by Sir G. Hayter, p 526.

See also forthcoming Catalogue of Portraits, 1790–1830.

JERSEY *George Augustus Frederick Child-Villiers, 6th Earl of* (*1808–59*)

MP for Honiton.

54 See *Groups:* 'The House of Commons, 1833' by Sir G. Hayter, p 526.

JESSE *Edward* (*1780–1868*)

Writer on natural history; deputy surveyor of royal parks and palaces; published *Gleanings in Natural History* and other works.

2453 Coloured chalk, heightened with Chinese white, on brown-tinted paper, 15 × 11 inches (38·1 × 27·9 cm), by D. MACDONALD, 1844. PLATE 472

Signed and dated (lower left): D Macdonald/1844 *Inscribed (bottom left):* Mr Edward Jesse *and below in another hand:* Writer on Natural History

Collections: Messrs Suckling & Co, purchased from them, 1930.

Nothing is known of the previous history of this drawing. The identification rests on the inscription.

ICONOGRAPHY A bust by an unknown artist is in the Brighton Art Gallery; a model (presumably for a bust or statue) by C. Fines was exhibited *RA*, 1833 (1083); an engraving, probably after a photograph, was published as the frontispiece to 'C.M.', *Letters and Reminiscences of the Rev John Mitford* (1891).

JESSE *John Heneage* (*1815–74*)

Historical writer; son of Edward Jesse (see above); clerk in the admiralty; published numerous historical and other works.

4026 (37) Pencil and black chalk, with faint touch of red on cheek, on paper, 11½ × 9 inches (29·1 × 22·8 cm), by COUNT ALFRED D'ORSAY. PLATE 473

Autograph in ink (lower centre): J. Heneage Jesse

Collections: See *Collections:* 'Drawings of Men About Town, 1832–48' by Count A. D'Orsay, p 557.

ICONOGRAPHY The only other portrait which may represent Jesse is a painting by J. T. Viner, exhibited *RA*, 1833 (415), as 'Mr John Jesse'.

JOCELYN *Robert Jocelyn, Viscount* (*1816–54*)

Soldier and politician.

4026 (38) See *Collections:* 'Drawings of Men About Town, 1832–48' by Count A. D'Orsay, p 557.

JOHNSON *Rev J. H.*

Slavery abolitionist.

599 See *Groups:* 'The Anti-Slavery Society Convention, 1840' by B.R.Haydon, p538.

JOHNSTONE *Sir John Vanden Bempde, Bart (1799–1869)*

MP for Scarborough.

54 See *Groups:* 'The House of Commons, 1833' by Sir G.Hayter, p526.

JONES *George (1786–1869)*

Painter; son of the engraver, John Jones (1745?–97); served in the Peninsula; painted pictures of Waterloo and Vittoria; RA, 1824, librarian, 1834–40, keeper, 1840–50, and acting president, 1845–50; friend of Turner and Chantrey; noted as a painter of battle scenes.

1456 (14) Black chalk on grey-tinted paper, heightened with Chinese white, $4 \times 4\frac{1}{2}$ inches ($10\cdot2 \times 11\cdot4$ cm), by CHARLES HUTTON LEAR, 1845. PLATE 474

Inscribed (bottom right): G Jones./Dec[r] 4/1845

Collections: See *Collections:* 'Drawings of Artists, c1845' by C.H.Lear, p561.

This drawing was done in the life school of the Royal Academy, where Lear was a student, and was sent by him to his parents with an undated letter (copy, NPG archives): '*No.4 is our worthy keeper G.Jones – a very agreeable gentleman*'.

ICONOGRAPHY A drawing by R.Hollingdale was exhibited *RA*, 1870 (833); a water-colour or drawing by A.E.Chalon was exhibited *RA*, 1845 (815); a drawing by A.E.Chalon of 1859 (standing beside his painting of 'Waterloo') was sold at Christie's, 25 November 1969 (lot 192); a marble bust by H.Weekes is in the Royal Academy, London, exhibited *RA*, 1870 (1221); a lithograph by R.J.Lane of 1845, after Count A.D'Orsay, is listed in Lane's 'Account Books' (MS, NPG archives), II, 64, there is an engraving by A.B.Durand, after F.S. Agate (example in NPG); there is a photograph in the NPG.

KAY *William*

Slavery abolitionist.

599 See *Groups:* 'The Anti-Slavery Society Convention, 1840' by B.R.Haydon, p538.

KEAN *Charles John (1811–68)*

Actor; second son of the actor, Edmund Kean; appeared at Drury Lane as Young Norval, 1827; played Shakespearian and other parts; established himself as one of the leading actors of the period.

1249 Oil on canvas, $49\frac{3}{4} \times 39\frac{3}{4}$ inches ($126\cdot3 \times 101$ cm), by SAMUEL JOHN STUMP, c1830. PLATE 479

Apparently signed on the arm of the chair (lower left, now no longer visible): S J Stump

Collections: F.T.Sabin, purchased from him, 1900.

Exhibitions: Possibly the portrait exhibited *RA*, 1831 (701), 'Portrait of Mr Kean, jun.'

This portrait represents Kean as Sir Edward Mortimer in George Colman's 'The Iron Chest', act I, scene III, which he first played at the Haymarket on 12 October 1829.[1] Another painting of Kean by Stump (as Hamlet) was sold at Christie's, 21 November 1952 (lot 157), exhibited *RA*, 1838 (727). Another portrait was exhibited *RA*, 1844 (718), and a miniature is in the Guildhall Art Gallery (plate 475); this last portrait does not apparently show Kean in character.

[1] Information kindly communicated by Raymond Mander, 1954.

Description: Healthy complexion, brown eyes, very dark brown hair. Dressed in a white lace collar, orange-red sash, black and gold over-garment, with lace cuffs and slashed sleeves showing red satin. Green sword belt embellished with red stones, dagger with gilt handle and red sheath. Seated in a red and gilt armchair. Left arm resting on a table with a multi-coloured patterned cloth, silver inkwell, quill pen and white paper. Deep red curtain covers most of background, except for a glimpse of dark grey sky at left.

1307 Coloured chalk on brown, discoloured paper, $26\frac{1}{4} \times 20$ inches ($66 \cdot 7 \times 50 \cdot 8$ cm) oval, by E. GOODWYN LEWIS. PLATE 477

Signed (lower left): E Goodwyn Lewis

Collections: Henry Bussell, purchased from him, 1901.

The vendor wrote (letter of 20 September 1901, NPG archives): '*There are of course many who remember Kean as well as I do and who will tell you what a remarkably life like portrait it is of the man*'. The portrait looks as if it may have been executed from a photograph.

2524 Coloured chalk on paper, $12\frac{1}{4} \times 10\frac{1}{4}$ inches ($31 \cdot 1 \times 26$ cm), attributed to MISS ROSE MYRA DRUMMOND, *c* 1838. PLATE 476

Inscribed on the back: Chas.Kean/on his first appearance/on the stage as Douglas/Drawn by Miss Drummond

Collections: Harley Granville Barker, presented by him, 1932.

In spite of the inscription, this drawing shows Kean as an older man than he was in 1827, when he first played in 'Douglas' as Young Norval (not as Douglas) at Drury Lane, aged sixteen. Providing that the inscription is not wholly erroneous, it is probably the work of one of the Misses Drummond, all five of whom were painters. The head in this drawing is very similar to a painting of Kean as Hamlet in the collection of S. Sandra in 1929, which may be the portrait by Miss R. M. Drummond exhibited *RA* 1838 (299). If this is so, then the NPG drawing would be a study for her 1838 portrait of Kean as Hamlet, which would agree well on grounds of age. This drawing has in the past been taken for the work of Miss Eliza Drummond, but it is not clear why. A water-colour or miniature of Kean as Sir Edward Mortimer by Miss F. Ellen Drummond was exhibited *RA*, 1839 (1025).

Description: Brown eyes, black hair. Background colour bluish-grey.

2772 Pencil and water-colour on paper, $4\frac{1}{8} \times 2\frac{5}{8}$ inches (10.4×6.8 cm), by JEMIMA WEDDERBURN. PLATE 480

Inscribed below the drawing in ink: Kean as Richard the 3d.

Collections: See *Collections:* 'The Clerk Family, Sir R. Peel, S. Rogers and Others, 1833–57' by Miss J. Wedderburn, p 560.

This drawing, like the one below, forms part of an album, and appears on p 33.

2772 Pencil and water-colour, $4\frac{1}{8} \times 5\frac{1}{4}$ inches ($10 \cdot 4 \times 13 \cdot 3$ cm), by JEMIMA WEDDERBURN. PLATE 481

Inscribed below the drawing in ink: "What, does the aspiring blood of Lancaster sink/i' th' ground, I thought it would have mounted"

Collections: As above.

This drawing also represents Kean as Richard III.

Description: In both water-colours, Kean is dressed in a black cap, red and brown garment and brown tights. The other figure in the second drawing is dressed in purple and white.

ICONOGRAPHY Popular prints of Kean are listed in L. A. Hall, *Catalogue of Dramatic Portraits in the Theatre Collection of the Harvard College Library*, II (Cambridge, Mass, 1931), 334–8 (there are some examples

in the British Museum and the NPG, and others are reproduced R.Mander and J.Mitchenson, *A Picture History of the British Theatre* (1957)).

A painting by H.W.Phillips (as Louis XI) is in the Garrick Club, London; a painting, of which the head was painted by E.Opie (as Richard III), was exhibited *SKM*, 1868 (436), and *VE*, 1892 (298), lent by Mrs Logie; a painting by W.Daniels (as Hamlet) is in the Victoria and Albert Museum, exhibited *SKM*, 1868 (568); a painting attributed to W.Mulready (as Hamlet) was in the collection of E.Langston, 1904; a painting called Kean (as Hamlet) by R.Dadd was in the collection of E.Kersley; a painting by Blackie was sold Christie's, 22 July 1871 (lot 141); a painting by H.Phipps (as Richard III) was in the *Dublin Exhibition*, 1872, 'National Portrait Gallery' (230), lent by Mrs Charles Kean; a water-colour by Miss C.S.Lane (as Louis XI) was exhibited *RA*, 1855 (1048), and lithographed by R.J.Lane, published J.Mitchell (example in NPG); a water-colour of *c* 1858 by an unknown artist, possibly L.S.Starkley (with Mrs Kean, as Benedict and Beatrice), is in the Victoria and Albert Museum, as is 'Henry VIII, Princess Theatre, 1855', a water-colour by F.Lloyds in which Kean appears, reproduced Mander and Mitchenson, p103; a water-colour by A.E.Chalon (as Sir Walter Amyott) was exhibited *RA*, 1848 (981), lithographed by R.J.Lane, published J.Mitchell (example in NPG), lithograph exhibited *RA*, 1848 (1090); other water-colours by Chalon were lithographed by E.Morton (as Hamlet), published J.Mitchell, 1838 (example in British Museum), and by R.J.Lane (as Macbeth), published J.Mitchell, 1840 (example in NPG); miniatures by J.W.Childe and by T.Carrick were exhibited *RA*, 1840 (771), and 1842 (870); a drawing by D.Maclise was in the collection of the artist's niece, see W.J.O'Driscoll, *Daniel Maclise* (1871), pp34–5, where a lithograph after the drawing is recorded; a bust by E.G.Papworth junior (as Wolsey) was exhibited *RA*, 1856 (1310); busts by F.B.Tussaud and by T.Butler were exhibited *RA*, 1855 (1471), and 1857 (1313); an engraving by H.Brocas (as Richard III) for the *Dublin Monthly Museum*, 1814, is recorded by W.G.Strickland, *Dictionary of Irish Artists* (1913), I, 90; three lithographs by R.J.Lane (as Hamlet, Shylock, and Richard III) were published J.Mitchell, 1839 (examples in Harvard Theatre Collection); two woodcuts were published *ILN*, xxxv (1859), 131, after a photograph by Mayall, and LII (1868), 117; there are various photographs in the NPG (see plate 478), and one is reproduced J.W.Cole, *The Life and Theatrical Times of Charles Kean* (1860), I, frontispiece.

KEBLE *John* (*1792–1866*)

Divine and poet; fellow and tutor of Oriel College, Oxford, 1811; professor of poetry at Oxford, 1831–41; vicar of Hursley, Hampshire, 1836–66; Keble College was founded in his memory; with his friends John Newman and Edward Pusey, one of the key figures in the Oxford Movement; published numerous works, many of which became popular.

1043 Coloured chalk and stump, heightened with Chinese white, on brown, discoloured paper, $28\frac{1}{4} \times 20\frac{1}{2}$ inches (71·8 × 52·1 cm), by GEORGE RICHMOND, 1863. PLATE 483

Dated (*lower left*): July 24. 1863

Collections: The artist, bequeathed by him, 1896.

Exhibitions: *RA*, 1864 (673); *SKM*, 1868 (510); *VE*, 1892 (382).

Literature: G.Richmond, 'Account Book' (photostat copy, NPG archives), p77, under the year 1863.

In his 'Account Book' Richmond lists this portrait as follows: 'E [*i.e. exhibited*] Rev John Keble – own RA'. It was engraved by W.Holl, published 1864 (example in British Museum), and was bequeathed at the same time as a drawing of Samuel Rogers (NPG 1044). Other portraits of Keble by Richmond are as follows:

1 *1844.* Water-colour, Keble College, Oxford (plate 482), bought Christie's, 11 April 1967 (lot 142), from the collection of Lord Coleridge. Listed in 'Account Book', p35. Engraved by S.Cousins, published for Richmond, 1845 (example in NPG), engraving reproduced G.Battiscombe, *John Keble: A Study in Limitations* (1963), facing p268.

2 *1874*. Marble bust, Keble College. Reproduced Battiscombe, facing p 269. Listed in 'Account Book', p 91. Richmond records that he began work on a bust of Keble in 1872 (presumably the clay model), and on a life-size bust (presumably the marble) in 1873.

3 *1876*. Painting, Keble College, presented by the artist. Listed in 'Account Book', p 93. Exhibited *VE*, 1892 (231). The head is based on the NPG drawing. A replica for Dr Talbot is recorded by Richmond in 1889, and a copy by Miss Donkin is at Oriel College, Oxford. The three portraits at Keble and Oriel (excluding no. 1) are listed by Mrs R. L. Poole, *Catalogue of Oxford Portraits*, II (1925), 98, and III (1925), 283.

ICONOGRAPHY A painting by an unknown artist was in the collection of A. C. Savill, 1922 (tracing in the NPG), apparently based on the photograph reproduced H. R. Haweis, *Poets in the Pulpit* (1880), p 145; a profile drawing by J. Bacon junior of 1851 was in the collection of J. M. Bacon, 1939; there is an anonymous engraving and several photographs in the NPG (see plate 484), and one is reproduced G. Battiscombe, *John Keble* (1963), facing p 284; a woodcut was published *ILN*, XLVIII (1866), 365.

KEEP *Rev John*

American slavery abolitionist.

599 See *Groups*: 'The Anti-Slavery Society Convention, 1840' by B. R. Haydon, p 538.

KELLETT *Sir Henry* (*1806–75*)

Vice-admiral; served in Chinese war, 1840; went in search of Sir John Franklin, 1852; commodore at Jamaica, 1855–9; vice-admiral, 1868; commander-in-chief in China, 1869–71.

915 Oil on canvas, $15\frac{3}{8} \times 12\frac{3}{4}$ inches (39 × 32·3 cm), by STEPHEN PEARCE, after his portrait of 1856.
PLATE 486

Collections: See *Collections*: 'Arctic Explorers' by S. Pearce, p 562.

This is a replica of NPG 1222 below, and was commissioned by Lady Franklin. The only difference between the two portraits is the arrangement of the medals.

Description: As for NPG 1222 below.

1222 Oil on canvas, $15\frac{1}{2} \times 13$ inches (39·4 × 33 cm), by STEPHEN PEARCE, 1856. PLATE 485
Collections: See *Collections*: 'Arctic Explorers' by S. Pearce, p 562.
Exhibitions: *RA*, 1856 (37); *Royal Naval Exhibition*, Chelsea, 1891 (47).
Literature: S. Pearce, *Memories of the Past* (1903), p 60.

Kellett is wearing the full-dress uniform (1856 pattern) either of a naval captain with over three years service, or of a commodore (1st or 2nd class), with (from left to right) the Arctic Medal (1818–55), the Bath (CB) and the China Medal (1842).

Description: Healthy complexion, greyish eyes, grey hair and whiskers. Dressed in a dark stock, white shirt, and dark blue naval uniform with gold-braided collar and epaulettes, gilt buttons, white enamel star and silver medals with multi-coloured ribbons. Background colour brown.

ICONOGRAPHY The only other recorded likeness of Kellett is a woodcut, after a photograph by Kilburn, published *ILN*, XX (1852), 321.

KELLY *Frances Maria* (*1790–1882*)

Actress and singer; niece of the actor, singer and composer, Michael Kelly; friend of the Lambs; first

appeared on stage at the age of seven; played chiefly at Drury Lane; excelled in melodrama; in later life conducted a dramatic school.

1791 Coloured chalk on brown, discoloured paper, 15⅛ × 13 inches (38·5 × 32·9 cm), by THOMAS UWINS, 1822. PLATE 487

Inscribed, signed and dated (bottom left, now almost invisible): Frances Kelly/Thomas Uwins/1822

Collections: Henry Pfungst, presented at his wish, 1917.

ICONOGRAPHY Popular prints of Frances Kelly are listed in L.A.Hall, *Catalogue of Engraved Dramatic Portraits in the Theatre Collection of the Harvard College Library*, II (Cambridge, Mass, 1931), 372–4 (some examples in the NPG and the British Museum); a painting of 1809 by S.de Wilde (as Floretta in 'The Cabinet') is in the Garrick Club, and so is a water-colour by W.Foster of 1811, probably the portrait exhibited *RA*, 1811 (285); a drawing of 1813 by J.Slater is in the Huntington Library, San Marino, reproduced L.E.Holman, *Lamb's 'Barbara S –': the Life of Frances Maria Kelly, Actress* (1935), frontispiece; two engravings by F.W.Wilkin are reproduced L.E.Holman, facing pp 96 and 102; two paintings called 'Miss Kelly' by J.Hayes were exhibited *RA*, 1815 (530), and 1816 (355), and a miniature by Mrs T.J.Barrable, 1858 (642); a woodcut was published *ILN*, VIII (1846), 9.

KEMP *Thomas Read* (*1782–1844*)

Founder of Kemp Town, Brighton, MP for Lewes.

54 See *Groups:* 'The House of Commons, 1833' by Sir G.Hayter, p 526.

KENNEDY *Thomas Francis* (*1788–1879*)

MP for Ayr.

54 See *Groups:* 'The House of Commons, 1833' by Sir G.Hayter, p 526.

KENNEDY *William* (*1813–90*)

Born in Canada; commanded the 'Prince Albert' in the search for Sir John Franklin.

917 Oil on millboard, 15⅜ × 13¼ inches (38·5 × 33·3 cm), by STEPHEN PEARCE, after his portrait of 1853. PLATE 489

Collections: See *Collections:* 'Arctic Explorers' by S.Pearce p 562.

This is a replica of NPG 1225 below, and was commissioned by Lady Franklin.

Description: As for NPG 1225 below.

1225 Oils on canvas, 15¼ × 12¾ inches (38·7 × 32·4 cm), by STEPHEN PEARCE, 1853. PLATE 488

Collections: See *Collections:* 'Arctic Explorers' by S.Pearce, p 562.

Exhibitions: RA, 1854 (1358).

The date was provided by the artist in a memorandum of *c* 1899 (NPG archives). This and NPG 917 above are the only recorded portraits of Kennedy.

Description: Healthy complexion, bluish eyes, brown hair and whiskers. Dressed in a black neck-tie, white shirt, black waistcoat and coat. Background colour dark brown.

KERRISON *Sir Edward, Bart* (*1774–1853*)

General, MP for Eye.

54 See *Groups:* 'The House of Commons, 1833' by Sir G.Hayter, p 526.

See also forthcoming Catalogue of Portraits, 1790–1830.

KERRY *William Thomas Petty-Fitzmaurice, Earl of* (*1811–36*)
> MP for Calne.
54 See *Groups:* 'The House of Commons, 1833' by Sir G. Hayter, p 526.

KETLEY *Rev Joseph*
> Slavery abolitionist.
599 See *Groups:* 'The Anti-Slavery Society Convention, 1840' by B. R. Haydon, p 538.

KING *Edward Bolton* (*1800–78*)
> MP for Warwick.
54 See *Groups:* 'The House of Commons, 1833' by Sir G. Hayter, p 526.

KITCHENER *William* (*1775 ?–1827*)
> Writer on science and music.
2515 (14) See *Collections:* 'Drawings of Prominent People, 1823–49' by W. Brockedon, p 554.

KNATCHBULL *Sir Edward, Bart* (*1781–1849*)
> MP for Kent East.
54 See *Groups:* 'The House of Commons, 1833' by Sir G. Hayter, p 526.

KNIBB *Rev William* (*1803–45*)
> Missionary and slavery abolitionist.
599 See *Groups:* 'The Anti-Slavery Society Convention, 1840' by B. R. Haydon, p 538.

KNIGHT *Miss Ann* (*1792–1868*)
> Slavery abolitionist.
599 See *Groups:* 'The Anti-Slavery Society Convention, 1840' by B. R. Haydon, p 538.

KNIGHT *Charles* (*1791–1873*)
> Author and publisher; worked on various newspapers; produced, with E. H. Locker, the *Plain Englishman*, 1820–2; editor of the *Guardian*; superintended the publications of the Society for the Diffusion of Useful Knowledge; produced *Penny Magazine*, *Penny Cyclopaedia*, *Pictorial Shakespeare*, and numerous other works, many of a popular nature.

393 Marble bust, 25⅝ inches (64·6 cm) high, by JOSEPH DURHAM, 1874. PLATE 490
> *Incised on the front:* CHARLES KNIGHT/1791–1873 *and on the back:* J. DURHAM. ARA/1874
> *Collections:* Commissioned by the grandchildren of the sitter, and presented by them, 1874.

> This is a replica of the marble bust formerly in the collection of the Knight family, exhibited *RA*, 1866 (874).

ICONOGRAPHY A painting by W. Fisk was exhibited *RA*, 1833 (478); a painting by C. H. Kerr, after W. C. Dobson, is owned by the Corporation of London; a miniature by an unknown artist (as a child) is reproduced A. A. Clowes, *Charles Knight: a Sketch* (1892), frontispiece; a miniature by B. R. Green was exhibited *RA*, 1845 (936); a woodcut was published *ILN*, LXII (1873), 265; a woodcut, after a photograph by Edwards and Bult (example in NPG), was published *The Family Friend*, no. 69 (September 1875), 129; a woodcut, after a

photograph by J. Hughes of Ryde, was published *Illustrated Review*, v (January 1873), 57; a photograph is reproduced Clowes, *Charles Knight*, frontispiece.

KNIGHT *Henry Gally* (*1786–1846*)

Author, art historian and connoisseur.

342, 3 See *Groups:* 'The Fine Arts Commissioners, 1846' by J. Partridge, p 545.

KNIGHTLEY *Rainald, 1st Baron* (*1819–95*)

Politician.

4026 (39) See *Collections:* 'Drawings of Men About Town, 1832–48' by Count A. D'Orsay, p 557.

KNOWLES *James Sheridan* (*1784–1862*)

Dramatist; son of the lexicographer, James Knowles; tried the army, medicine, the stage and school-mastering; his tragedy, 'Caius Cracchus', produced at Belfast, 1815; continued to act till 1843; wrote numerous plays and other works.

2003 Oil on canvas, $44\frac{1}{2} \times 34\frac{5}{8}$ inches (113 × 88 cm), by WILHELM TRAUTSCHOLD, *c* 1849. PLATE 491

Collections: Edmund Knowles Muspratt, bequeathed by him, 1923.

Exhibitions: R A, 1849 (53).

The portrait was probably commissioned by the donor's father, James Muspratt, who was a close friend of both Knowles and the artist. The donor, himself the godson of Knowles, also bequeathed a bust of Lord Brougham by J. Adams Acton (NPG 2004). For another portrait by Trautschold see under Thomas Graham in this catalogue (NPG 2164).

Description: Rubicund complexion, bluish-grey eyes, light brown hair. Dressed in a dark stock, white shirt, and black suit. Seated in a red armchair. Background colour dark brown.

ICONOGRAPHY Popular prints of Knowles are listed in L. A. Hall, *Catalogue of Engraved Dramatic Portraits in the Theatre Collection of the Harvard College Library*, II (Cambridge, Mass, 1931), 422–3 (some examples in the NPG and the British Museum); two paintings by Ambrose were sold at Christie's, 22 July 1871 (lots 68 and 75); a painting by W. Bewick of 1837 was with H. Graves & Co, 1880, sketched by G. Scharf, 'TSB' (NPG archives), XXVII, 30; paintings by S. Drummond and J. Stewart were exhibited *R A*, 1834 (293), and 1858 (145); a painting by J. D. Herbert, exhibited *R A*, 1834 (17), and a bust by P. MacDowell, are listed by W. G. Strickland, *Dictionary of Irish Artists* (1913), I, 478, and II, 62; a lithograph by R. J. Lane, after a painting by C. Harding, was published R. Findley, Glasgow, 1826 (example in NPG); an engraving by D. Maclise was published *Fraser's Magazine*, XIV (September 1836), facing 272, as no. 76 of Maclise's 'Gallery of Illustrious Literary Characters'; a drawing by Count A. D'Orsay of 1839 was sold at Sotheby's, 13 February 1950 (lot 216), bought Colnaghi, lithographed by R. J. Lane, published J. Mitchell (example in NPG); marble busts by H. Kachler and P. L. Crowley were exhibited *R A*, 1842 (1370), and 1859 (1363); a bust by C. Tate is listed by R. Gunnis, *Dictionary of British Sculptors* (1953), p 380; a woodcut was published *ILN*, XLI (1862), 677; an unidentified portrait was in the *Dublin Exhibition*, 1872, 'National Portrait Gallery' (288), lent by the Madame Steevens's Hospital; there is a photograph by J. Douglas in the NPG.

LAFAYETTE *Marie Joseph, Marquis de* (*1757–1834*)

French general and statesman.

2515 (57) See *Collections:* 'Drawings of Prominent People, 1823–49' by W. Brockedon, p 554.

LAIRD *John* (*1805–74*)

Shipbuilder; managing director in the firm of William Laird & Son till 1861; constructed one of the first iron vessels, 1829; MP, 1861–74.

2686 Three sketches on notepaper, headed '88 St James's Street, S.W.' Pencil on paper, 6⅞ × 8⅞ inches (17·5 × 22·6 cm), by CHARLES SAMUEL KEENE, *c* 1872. PLATE 492

Inscribed (*top left*): John Laird MP.

Collections: G.S.Bowles, presented by him, 1934.

In a letter of 5 December 1933 (NPG archives), the donor recorded that his father, who wrote the inscription, lived at 88 St James's Street in the early 1870s; from the apparent age of the sitter, the drawing would seem to have been executed around 1872.

ICONOGRAPHY A painting by W.M.Tweedie was exhibited *RA*, 1870 (269); a bust by J.Macbride of 1863 is at Birkenhead Hospital; a bronze statue by A.B.Joy is in Hamilton Square, Birkenhead, reproduced as a woodcut *ILN*, LXXI (1877), 461, a model for which was exhibited *RA*, 1878 (1461); a miniature by Mrs S.W. North was exhibited *RA*, 1880 (1387); a woodcut, after a photograph by J.and C.Watkins, was published *ILN* XXXIX (1861), 74.

LAMBTON, *John George, 1st Earl of Durham.* See DURHAM

LANCE *George* (*1802–64*)

Painter; pupil of B.R.Haydon; exhibited at RA and elsewhere, from 1824; chiefly noted for his still-life pictures.

1713 Pencil and water-colour on paper, 9 × 7¼ inches (22·9 × 18·4 cm), by HIMSELF. PLATE 493

Collections: The artist, presented by his daughter-in-law, Mrs Lance, 1913.

Although this is the only portrait showing Lance with short hair, it undoubtedly represents him. It is very similar to a reproduction, apparently after a self-portrait (example in NPG).

Description: Brown eyes and brown hair, dark green neck-tie.

ICONOGRAPHY The following portraits were in the collection of Miss Ada Lance, 1936: two self-portraits; a painting by G.Clint, exhibited *SKM*, 1868 (562), engraved by J.Smyth (example in NPG), for the *Art Union*, 1847; a miniature by T.Carrick; and a water-colour by A.Stanesby, exhibited *RA*, 1849 (992). An oil self-portrait of *c* 1830 is in the Victoria and Albert Museum; a water-colour self-portrait is in the British Museum; a painting by J.Andrews was exhibited *RA*, 1855 (447), and one by R.Hollingdale, *RA*, 1858 (796); a bust by E.Davis was exhibited *RA*, 1856 (1349); a woodcut was published *ILN*, XXXIX (1861), 647; there are two photographs of Lance in his studio by Maull & Co (example of one in the NPG, and of the other formerly collection of Miss Lance).

LANDER *John* (*1807–39*)

African traveller; brother of Richard Lander (see below), with whom he explored the Niger, 1830–1; published a joint journal, 1832.

2515 (64) Black and red chalk, with touches of Chinese white, on green-tinted paper, 14¼ × 10⅛ inches (36·2 × 25·8 cm), by WILLIAM BROCKEDON, 1834. PLATE 494

Dated (*lower left*): 13.5 34

Collections: See *Collections:* 'Drawings of Prominent People, 1823–49' by W. Brockedon, p 554.

Accompanied in the Brockedon Album by a letter from the sitter, dated 1 May 1834, in which Lander tells Brockedon of the death of his brother, and asks him to keep for the present the drawing of his brother, which Brockedon had promised him (see entry for Richard Lander below). The drawing of John Lander was presumably used for Brockedon's plaster bust of him in the Royal Geographical Society, London.

ICONOGRAPHY The only other recorded portrait of Lander is a bust by Mrs T. Thornycroft, exhibited *RA*, 1840 (1088).

LANDER *Richard Lemon* (*1804–34*)

African traveller; brother of John Lander (see above); accompanied Hugh Clapperton to Western Africa, and published a journal and records of Clapperton's last expedition, 1830; explored Niger, 1830–1, of which he published an account; died on second expedition to the Niger, after a fight with natives.

2442 Oil on canvas, 29½ × 24½ inches (75 × 62·2 cm), by WILLIAM BROCKEDON, *c* 1835. PLATE 496

Inscribed on what appears to be the original frame: RICHARD LANDER Brockeden [*sic*]

Collections: John Murray 1; Murray Sale, Sotheby's, 15 May 1929 (lot 128), bought in; Colonel John Murray, presented by him, 1929.

This posthumous painting shows Lander in his African costume. The head is based on Brockedon's drawing of 1831 (NPG 2515 (47) below), which is the only known likeness of Lander by Brockedon from the life. The painting was engraved by C. Turner, published Colnaghi, 1835 (example in NPG); the only difference between the engraving and painting is in the hair, which was presumably altered by the engraver. Another painting of Lander by Brockedon, showing him in conventional costume, but also based on the NPG drawing, is in the Royal Geographical Society, London, and so is a plaster bust by Brockedon; a marble version of this bust is in the Foreign and Commonwealth Office Library, London. The NPG picture was presented at the same time as a portrait of Dixon Denham (NPG 2441). John Murray 1 was the publisher of Lander's work, and frequently commissioned portraits of his more famous and successful authors.

Description: Healthy complexion, brown eyes and hair. Dressed in a loose, white, collarless shirt, and a dark green African garment with red and greyish stripes. Background colour greyish-green.

2515 (47) Black chalk, with touches of Chinese white, on blue-tinted paper, 14¾ × 10⅝ inches (37·5 × 27·1 cm), by WILLIAM BROCKEDON, 1831. PLATE 495

Dated (lower left): 27.11.31

Collections: See *Collections:* 'Drawings of Prominent People, 1823–49' by W. Brockedon, p 554.

Accompanied in the Brockedon Album by a letter from the sitter, dated 10 October 1832. In a letter of 1 May 1834, John Lander (see entry for him above) wrote to Brockedon from Liverpool:

May I request my dear Sir (if you have not already sent it off) that the sketch of my lamented brother, which you have so kindly promised me, may be left at your house, till you hear from me again. It is now become invaluable to me, & I should be afraid of some accident, were you to send it here by a strange hand. I shall keep it for ever in memory of my dear brother to whom I was tenderly attached & as a proof of your own extreme kindness to him & me.

Presumably John Lander never collected the drawing, unless Brockedon executed a copy for his own album, and returned the original. This drawing was used as a study for paintings and a bust of Lander by Brockedon (see NPG 2442 above).

ICONOGRAPHY A statue by N.N.Burnard of 1852 (based on the bust by Brockedon (see NPG 2442 above), and a sitting from Lander's daughter (see *ILN*, xx (1852), 248) is on top of the Lander column at Truro (now much weathered); an engraving by T.A.Dean, after W.Bagg junior, was published Colburn and Bentley, 1830, for Lander's *Records of Captain Clapperton's Last Expedition to Africa*, frontispiece; an anonymous engraving was published J.Murray, 1832 (example in NPG), for R.and J.Lander, *Journal of an Expedition to Explore the Course and Termination of the Niger*, I, frontispiece.

LANDSEER *Sir Edwin Henry* (*1802–73*)

Animal-painter; youngest son of the artist, John Landseer; entered RA schools, 1816; began to exhibit, 1817; gradually established himself with his animal pictures as the most popular painter of the age; designed the lions for the Nelson monument in Trafalgar Square.

834 Oil on canvas, 45 × 35⅛ inches (114·2 × 89·2 cm), by SIR FRANCIS GRANT, 1852. PLATE 499

Inscribed on a damaged label on the back of the picture: Grant [?] R.A./Sir Edwin Landseer

Collections: Commissioned by William Wells of Redleaf; Wells Sale, Christie's, 10 May 1890 (lot 26); bought Henri, Marquis de Rochefort-Luçay, and presented by him, 1890.

Exhibitions: RA, 1855 (387).

Literature: Sir F.Grant, 'Sitters Book' (copy of original MS, NPG archives), under the year 1852.

Wells had a large collection of Landseer's work, and was a close friend, hence his reason for comissioning this portrait. A preliminary oil sketch, establishing the final composition, is in the Russell-Cotes Art Gallery, Bournemouth: this is probably the sketch once owned by the artist's son, Colonel F.Grant, about which there is correspondence in the NPG archives (it is discussed with NPG 1018 below). Another small oil portrait of Landseer by Grant in the NPG (1018 below), for which there is a pencil study dated 1852 (NPG 436 below), was described by Grant on the back as a study for the Wells portrait. The heads in both are identical (even the curls in the hair are the same), and so is the motif of the dog in the bottom right-hand corner, but pose and accessories are quite different. NPG 1018 is presumably Grant's first idea for the Wells portrait, which he subsequently abandoned, because he or his patron found it unsatisfactory. On the other hand, Grant may only have treated NPG 1018 as a spontaneous study from the life, to obtain a likeness, and worked out the pose independently later on. If this is so, it would throw interesting light on Grant's methods, and suggest that he did not always paint his portraits in comprehensive sittings, but treated head and pose as separate problems. NPG 1018 shows Landseer painting, and is a more appropriate image than the finished portrait, which might be that of a businessman; it is impossible to know why Grant finally adopted such a formal and conventional pose. A life-size unfinished oil portrait of Landseer by Grant, clearly dating from this period, is in the Royal Academy, reproduced *Country Life*, CXXXI (1962), 1373. Although the head differs slightly from those in the portraits already discussed, it is probably another experimental version for the Wells portrait. It shows Landseer in a landscape setting, in hunting clothes, and with a telescope, its case strapped across his back. Another drawing of Landseer, by Grant, is reproduced Mrs E.M.Ward, *Memories of Ninety Years* (n.d.), facing p 4.

Description: Healthy complexion, blue eyes, brown hair with grey streaks. Dressed in a dark stock, with pearl stock-pin, white shirt and black frock coat. Door at left and rest of background brown. Dog grey and brown.

835 Oil on canvas, 31½ × 44½ inches (80 × 113 cm), by JOHN BALLANTYNE, *c* 1865. PLATE 500

Signed (bottom right): John Ballantyne/RSA

Collections: The artist; William Wells, his sale, Christie's, 10 May 1890 (lot 2); bought William Agnew and presented by him, 1890.

Exhibitions: Henry Graves, Pall Mall, 1865; *Landseer Exhibition*, RA, 1961 (92).

Literature: Art Journal (1864), p 122, and (1866), p 29; E. Quayle, *Ballantyne the Brave* (1967), pp 205–12.

Painted while Landseer was working in Baron Marochetti's studio on the clay models for his lions at the base of Nelson's Column in Trafalgar Square. According to Quayle, the portrait of Landseer himself was based on a photograph. The picture was one of a whole series of portraits of artists in their studios by Ballantyne; that of Holman-Hunt is also in the NPG (2555), and four more are in the Scottish NPG. Ballantyne exhibited them as a set in November 1865 under the auspices of H. Graves & Co, intending to have them engraved. As soon as the exhibition opened, Landseer wrote a rude note to Ballantyne demanding that his portrait be withdrawn, since it revealed his designs for the lions in an unfinished state, and he wanted no advance publicity before they were formally unveiled; this did not occur until 1867. Ballantyne replied by pointing out that he had discussed his exhibition with Landseer, who had made no objection at the time (the whole correspondence is quoted in full by Quayle). Ballantyne was forced to withdraw the portrait, which was the central attraction of his exhibition, and the show closed early. Several of the portraits were chromo-lithographed by V. Brooks; that of Landseer by Brooks was published 1867 (example in NPG), and reproduced as a woodcut *ILN*, LXIII (1873), 348. Not until Landseer's lions had been cast and put into position in Trafalgar Square was Ballantyne able to publicize his picture, which had remained in his studio; he apparently sold it direct to William Wells, one of Landseer's most important patrons. He subsequently altered the lions in the painting to conform with the finished casts in Trafalgar Square.

Description: Landseer is shown with grey hair, in a brown coat and grey trousers, sitting on a green stool, with a brown dog at his feet. The lions are white and grey in colour on brown wooden plinths. The floor is light brown and grey in colour. There is a lion's skin, and various tools bottom left. Brown basket, dividers and pail, green steps, and sketch of a lion in grisaille leaning against a brown wooden stand, bottom right. Green curtain in the left background. Red wall right and centre, with an oil painting of a lion. Roof brown, skylights green.

1018 Oil on board, 11⅛ × 10 inches (30·3 × 25·4 cm), by SIR FRANCIS GRANT, *c* 1852. PLATE 501

Inscribed on the back in the artist's hand: The first design for the/original picture in the possession/of W. Wells Esq of Redleaf – /Sir E. Landseer gave one/sitting for this sketch/F. Grant

Inscribed below in the donor's hand: This picture was given to me/by Sir Francis Grant on/July 12 – 1874/R. Quain

Collections: The artist; given to Sir Richard Quain, Bart, and presented by him, 1895.

Exhibitions: Landseer Exhibition, RA, 1961 (153).

Quain was the friend and medical adviser of both artist and sitter. In a letter of 15 October 1896 (NPG archives), Quain wrote:

Sir Edwin Landseer consented at the request of his friend Mr Wells of Redleaf to give Sir Francis Grant a sitting for his portrait. The result was the well known picture of Sir Edwin. Sir Francis made a sketch (about 14 × 8) at the sitting which Sir Edwin gave him – This sketch so pleased Sir Edwin that he painted in it the head & neck of a deer hound. Sir Francis finished the sketch as a painting and gave it to me. The history is written by Sir Francis on the back of the painting.

The original portrait belonging to Mr Wells is now in the NPG (see NPG 834 above, where Grant's portraits of Landseer are discussed in more detail). The heads in both portraits are almost identical, and so is the motif of the dog in the bottom right-hand corner, but they are quite different in pose and accessories. The artist's son, Colonel F. Grant, who owned a study for the Wells portrait, exhibited *VE*, 1892 (39) (probably the oil sketch now in the Russell-Cotes Art Gallery, Bournemouth), which was very close to the finished design, wrote (letter of 26 May 1896, NPG archives): '*It is perfectly evident*

that my father's memory played him false for the moment. No portrait painter would speak of the sketch (given to the NPG by Quain) as the sketch for the Redleaf *portrait except by an oversight'.* Quain could see no reason why his sketch was not the first idea for the Wells portrait, which it probably was, and wrote (letter of 12 May 1896, NPG archives): '*we must regard Sir Francis as knowing something of his own work even more than the Colonel and of telling the truth'.* The NPG drawing (436 below) is closely related to NPG 1018 and was probably done at the same time.

Description: Healthy complexion, blue eyes, brown hair with grey streaks. Dressed in a dark stock, white shirt and grey coat. Easel and background colour brown. Greyish-brown palette with splodges of white, red, and blue paint. Dog grey and brown.

436 Sepia ink on paper, $6 \times 4\frac{3}{8}$ inches ($15 \cdot 2 \times 11 \cdot 1$ cm), by SIR FRANCIS GRANT, *c* 1852. PLATE 498

Signed and dated (bottom left): F Grant fec/1852

Collections: 2nd Viscount Hardinge, presented by him, 1876.

Exhibition: Landseer Exhibition, RA, 1874 (2).

This is closely related to Grant's small portrait in the NPG (1018 above; see also NPG 834), and was probably executed at the same time. It is mounted between two small drawings in pen and wash by Landseer of pheasants and woodcock; they are almost identical with two drawings which Landseer executed at the top of a sportsman's card, together with four other sketches of game, at Woburn Abbey in 1826, reproduced *The Strand Magazine*, I (1891), 335, when they were in the collection of the Duke of Bedford. The woodcock were originally thought to be snipe, but the mistake was pointed out by D.C. Ireland in 1882 and 1891 (letters in NPG archives). Viscount Hardinge was chairman of the NPG trustees. Both he and his father were close friends of Sir Francis Grant.

2521 See entry under Sir Francis Grant, p 193. PLATE 364

4267 Pencil on paper, $7\frac{7}{8} \times 6\frac{1}{8}$ inches ($20 \times 15 \cdot 5$ cm), by HIMSELF, 1818. PLATE 497

Signed and dated (bottom centre): E L 1818 *Inscribed on the back of the drawing in ink:* Edwin Landseer drawn by himself/at our house one evening in 1818 *Inscribed on the old mount:* His own portrait by Himself/Done at Gilstin [*sic*] Park

Collections: Possibly the Plumer family of Gilston Park, Herts; purchased at Sotheby's, 18 April 1962 (lot 52).

Literature: NPG Annual Report, 1962–3 (1963), p7.

ICONOGRAPHY This does not include caricatures or photographs, of which there are several in the NPG; a short list of portraits is included in J.B. Manson, *Sir Edwin Landseer, RA* (1902), p206.

As a boy Miniature called Landseer by G. Clint. Reproduced *Connoisseur*, VIII (1904), 254.

As a boy Painting by himself. Christie's, 8 May 1874 (lot 328), and 13 July 1891 (lot 686).
Sketched by G. Scharf in his 1891 sale catalogue (NPG library). A self-portrait drawing (with Lord Abercorn and W. Wells) was in a scrapbook owned by the Earl of Wemyss.

1813 Drawing by J. Hayter. Collection of the artist, 1874.
Landseer Exhibition, RA, 1874 (144). Date recorded by G. Scharf in his copy of the exhibition catalogue (NPG library). Engraved anonymously (example in British Museum).

c 1815 Painting or drawing by J. Hayter. Exhibited *RA*, 1815 (450).
Exhibited with the title, 'The cricketer: a portrait of Master E. Landseer'.

c 1816 'The Death of Rutland' by C.R. Leslie. Exhibited *RA*, 1816 (518).
Landseer was the model for the young Rutland.

1818 Drawing by himself (NPG 4267 above).

1823 Painting by J. Hayter (with Sir G. Hayter, C. Hayter and another unidentified artist). Shipley Art Gallery, Gateshead. Christie's, 9 December 1871 (lot 13). Sketched by G. Scharf in his sale catalogue (NPG library). Exhibited *RA*, 1823 (23).

1825 Drawing by Sir G. Hayter. British Museum.
There is another undated drawing by Hayter in the British Museum.

1826 Drawing by Sir G. Hayter. Reproduced *Anna Jameson: Letters and Friendships*, edited Miss S. Erskine (1915), facing p 186.

1830 Drawing by E. Duppa. Collection of T. Landseer, 1874.
Engraved by T. Landseer (no example located). Listed by A. Graves, *Catalogue of the Works of the late Sir Edwin Landseer, RA* (1874), p 36.

1834 Drawing by C. Vogel. Küpferstichkabinett, Staatliche Kunstsammlungen, Dresden.

1843 Anonymous lithograph, after a drawing (full-length) by Count A. D'Orsay of 1843, was published J. Mitchell, 1843 (example in NPG). There is a lithograph (half-length), after the same type (example in NPG). This may have been the lithograph, after D'Orsay, listed in R. J. Lane's 'Account Books' (NPG archives), III, 9, under 1848 (Lane did most of the lithographs after D'Orsay). An undated drawing (half-length) is owned by the Department of the Environment. Another was sold at Sotheby's, 13 February 1950 (lot 216), bought Colnaghi.

1852 Paintings by Sir F. Grant (NPG 436, 834, and 1018 above).

c 1865 Painting by J. Ballantyne (NPG 835 above).

c 1865 Painting by himself. Royal Collection; presented by the artist to Edward VII.
Exhibited *RA*, 1865 (152), under the title of 'The Connoisseurs'. Engraved by S. Cousins, published H. Graves & Co, 1867 (example in NPG), and by J. Scott, published Graves, 1881 (example in British Museum); a woodcut, after the painting, was published *ILN*, LXIII (1873), 349.

c 1867 Marble bust by Baron C. Marochetti. Royal Academy, London.
Exhibited *RA*, 1867 (1040).

c 1870 Drawing by C. B. Birch, with Sir F. Grant (NPG 2521 above).

1874 Woodcut (in his studio) published *ILN*, XLV (1874), 264.

1882 Marble medallion by T. Woolner. Landseer Memorial, St Paul's Cathedral.

Undated Painting by J. F. Lewis. Christie's, 26 July 1957 (lot 66), bought Leggatt.

Undated Painting called Landseer by B. R. Haydon. Collection of C. Butting, 1876.
Sketched by Scharf, 'TSB' (NPG archives), XXI, 84.

Undated Water-colour by G. Goursat. Victoria and Albert Museum.

Undated Drawing by himself, boxing with Count D'Orsay. British Museum.
Exhibited *Landseer Exhibition*, RA, 1961 (169).

Undated Drawing by D. Maclise, and another by W. M. Thackeray. Victoria and Albert Museum.

Undated Drawing by Sir F. Grant. Reproduced Mrs E. M. Ward, *Memories of Ninety Years* (no date), facing p 4.

Undated Various prints after photographs (examples in British Museum and NPG).

LANDSEER *Thomas* (*1795–1880*)

Engraver; eldest son of the artist, John Landseer; devoted his life chiefly to engraving and etching the works of his brother, Sir Edwin Landseer (see above); ARA, 1868; published a life of Bewick, 1871.

1120 Coloured chalk and stump, heightened with Chinese white, on buff paper, $13\frac{7}{8} \times 10$ inches (35·2 × 25·5 cm), by his brother, CHARLES LANDSEER. PLATE 502

Signed (bottom right): C.L. A R A *Inscribed below the signature:* X/FS *(the significance of this is not clear).*

Collections: Leggatt Brothers, purchased from them, 1898.

According to Ernest Leggatt and Algernon Graves, who had both known the sitter, this was an excellent portrait of him (letter of 17 March 1898 from the vendors, NPG archives).

ICONOGRAPHY A painting by G. Landseer was exhibited *RA*, 1857 (639), probably the portrait engraved by W. J. Edwards (example in NPG); there is a lithograph by Jessica Landseer of 1858 (example in British Museum); a woodcut, after a photograph by J. Watkins, was published *ILN*, LII (1868), 169; there is a photograph in the NPG, and a woodcut from an unidentified magazine or newspaper.

LANE *Edward William* (*1801–76*)

Arabic scholar; made voyages up the Nile, 1826 and 1827; studied people of Cairo, 1833–5; adopted dress of Egypt; published famous *Account of the Manners and Customs of the Modern Egyptians*, 1836; travelled again in Egypt and published several works; acknowledged as one of the leading Arabic scholars in Europe.

3099 Water-colour on paper, $9\frac{1}{4} \times 7\frac{1}{2}$ inches (23·4 × 19·1 cm), by his niece, CLARA S. LANE, 1850. PLATE 503

Signed and dated twice (bottom centre, one signature directly below the other, and identical in form):
C. S. L. Hastings – 1850

Collections: Appleby brothers, purchased from them, 1941.

Clara Lane also executed a painting of J. S. Buckingham, another Eastern traveller (NPG 2368).

Description: Brown hair and beard. Dressed in a blue patterned dressing-gown. Seated on a sofa covered in blue and white flowered material. Other furniture and books pale brown. Blue and white pot on the bookshelves behind. Background colour bluish-green.

940 Plaster statue, painted cream, $37\frac{1}{2}$ inches (95·3 cm) high, base 22 × $41\frac{3}{4}$ inches (55·9 × 106 cm), by RICHARD JAMES LANE, 1829. PLATE 504

Collections: The artist; by descent to his great-nephew, Stanley Lane Poole, and presented by him, 1893.

Lane is shown seated on a cushion in the 'memlook' dress of an Egyptian gentleman. The donor wrote (letter of 28 March 1893, NPG archives): '*Richard was so much struck by its graceful folds that he determined to attempt a statue of his brother in this costume*'. Sir Frederick Burton wrote (letter of 26 March 1893, NPG archives): '*My old friend Richard Lane, who modelled it soon after his brother returned from Egypt had it in his hall until he died*'. The exact date was provided by the donor. Behind the figure of Lane are a writing case and a box; in his right hand is a cloth, and under his left hand is a small box, apparently containing an inkstand (this is shown in the *ILN* drawing – see below), and a long unidentified object. Although Richard Lane is primarily known as a lithographer,[1] this statue of his brother is not his only work of sculpture. He executed a bust of his brother, dating from about 1833, now in the Bodleian Library, Oxford[2], and other busts of his children and relatives. A woodcut published *ILN*, LXIX (1876), 213, is after a portrait by R. J. Lane of *c* 1835, probably that exhibited *RA*, 1839 (778): the woodcut shows the sitter in Egyptian dress, with the same writing-case and inkstand (open) as on the statue. R. J. Lane also exhibited an unspecified portrait *RA*, 1872 (681), and executed a lithograph (example in British Museum), showing his brother in the dress of a Bedouin Arab. No other portraits of the sitter are known, except a woodcut from an unidentified magazine (cutting in NPG).

[1] A large collection of Lane's lithographs were presented to the NPG by Dr A. Lane Poole, 1956.

[2] See Mrs R. Lane Poole, *Catalogue of Oxford Portraits*, III (1925), 310.

LANGDALE *Henry Bickersteth, Baron* (*1783–1851*)

Master of rolls; studied medicine; fellow of Caius College, Cambridge; called to bar, 1811; KC, 1827; master of rolls, 1836.

1773 Miniature, water-colour on ivory, $4\frac{7}{8} \times 3\frac{7}{8}$ inches (12·3 × 9·9 cm), by HENRY COLLEN, 1829. PLATE 505

Signed and dated (*lower right*): H. Collen. 1829

Inscribed on a label, formerly on the back of the miniature, in the artist's hand: 1829/Painted by H. Collen [*in monogram*]/37 Somerset Street/Portman Square/London –

Collections: The sitter; inherited by A. H. Long as residuary legatee of Lady Langdale's will (see his letter of 11 April 1916, NPG archives), and presented by him, 1916.

Description: Greyish-brown eyes, brown hair. Dressed in a black stock, white and fawn-striped shirt, yellow waistcoat, and dark bluish coat. Seated in a red chair. Dark green curtain at left. Background colour brown.

ICONOGRAPHY The only other recorded portraits of Langdale are: a drawing of 1843 by G. Richmond, exhibited *SKM*, 1868 (565), lent by Lady Langdale, engraved by S. Freeman, published 1852 (example in the British Museum), for *Bentley's Miscellany;* and a lithograph by R. J. Stothard (example in NPG).

LANGTON *William Gore* (*1760–1847*)

MP for Somerset East.

54 See *Groups:* 'The House of Commons, 1833' by Sir G. Hayter, p 526.

LANSDOWNE *Sir Henry Petty-Fitzmaurice, 3rd Marquess of* (*1780–1863*)

Statesman; MP from 1803; chancellor of the exchequer, 1806; succeeded to the title, 1809; supported abolition of slave trade and other liberal measures; served in various whig ministries, 1830–41; president of the council, 1846–52, and in the cabinet, without office, 1852–63.

178 Oil on canvas, $29\frac{7}{8} \times 24\frac{7}{8}$ inches (75·9 × 63·2 cm) painted oval, by HENRY WALTON, *c* 1805. PLATE 507

Collections: Charles Grillion, purchased from him, 1864.

Exhibitions: Paintings by Henry Walton, Castle Museum, Norwich, 1963 (41).

A drawing by Henry Bone after this portrait, 'Bone Drawings' (NPG archives), I, 93, is dated 7 January 1806, so the portrait itself presumably dates from 1805 or earlier. Bone's drawing was presumably a study for one of his enamel miniatures (no examples located). NPG 178 was engraved by C. Turner, published R. Cribb, 1806 (example in NPG), and by J. Hopwood, published 1806 (example in NPG), for the *Universal Magazine*. Grillion (the vendor) was the proprietor of the Clarendon Hotel, and Grillions Club met on his premises. Lansdowne was not a member, and it is not known how Grillion came into possession of the portrait.

Description: Fresh complexion, brown eyes, grey and brown hair. Dressed in a white stock, white shirt, yellow waistcoat, and dark green coat with gilt buttons. Seated in a red chair of which only the back is visible. Background colour dark greenish-brown.

1383 Coloured chalk and stump, heightened with Chinese white, on grey paper, $11\frac{1}{8} \times 8\frac{1}{4}$ inches (28·2 × 21·2 cm), by EDMUND THOMAS PARRIS, 1838. PLATE 508

Signed, inscribed and dated (*bottom left*): The Ms Nob The Marqs of Lansdown [*sic*]/ETP. Grafton St Decr 3 1838 –

Collections: W. Walker, purchased from him, 1904.

This is a study for Parris' painting of the 'Coronation of Queen Victoria', engraved by C.E.Wagstaff and T.Higham, published 1840 (exlampe in British Museum). A study of the Duke of Wellington for the same picture was also offered but declined.

54 See *Groups:* 'The House of Commons, 1833' by Sir G.Hayter, p526.

342, 3 See *Groups* 'The Fine Arts Commissioners, 1846' by J.Partridge, p545.

999 See *Groups:* 'The House of Lords, 1820' by Sir G.Hayter, in forthcoming Catalogue of Portraits, 1790–1830.

1125 See *Groups:* 'The Coalition Ministry, 1854' by Sir J.Gilbert, p550.

ICONOGRAPHY This does not include photographs, of which there are several in the NPG; there is an engraving by D.J.Pound, after a photograph by Mayall (example in the NPG).

c1784 Painting by G.Romney. Collection of the Marquess of Lansdowne, Bowood.
Reproduced *Country Life*, CXVI (1954), 1961.

c1805 Painting by H.Walton (NPG 178 above).

1820 'The House of Lords, 1820' by Sir G.Hayter (NPG 999 above).

1820 'The Trial of Queen Caroline', water-colour by J.Stephanoff, A.Pugin and R.Bowyer. Houses of Parliament. Engraved by J.G.Murray, published R.Bowyer, 1823 (example in NPG).

1821 Water-colour attributed to J.Stephanoff. Victoria and Albert Museum. This is a study for a picture of 'The Coronation of George IV'.

c1827 Painting by Sir T.Lawrence. Collection of the Marquess of Lansdowne, Bowood (plate 506).
Exhibited *British Institution*, 1830 (44), and *SKM*, 1868 (329). Engraved by J.Bromley, published Colnaghi, 1831 (example in NPG), and by H.Cook, published Fisher, 1834 (example in NPG), for Jerdan's 'National Portrait Gallery'. Copies: Bowood, and Ilchester Collection. An engraving by W.H. Egleton, after a drawing by J.Stewart (example in NPG), appears to be based on the Lawrence. A painting attributed to Lawrence was sold Robinson & Fisher, 31 January 1934 (lot 135).

1832 'The Reform Bill receiving the King's Assent, 1832' by S.W.Reynolds. Houses of Parliament. Engraved by W.Walker and S.W.Reynolds junior, published Walker, 1836 (example in NPG).

c1832 'William IV Holding a Council,' lithograph by J.Knight (example in British Museum).

1833 'The House of Commons, 1833' by Sir G.Hayter (NPG 54 above).

1833 'The Reform Banquet, 1833' by B.R.Haydon. Collection of Lady Mary Howick, Howick.
Etched by F.Bromley, published J.C.Bromley, 1835 (example in NPG); engraved and published by J.C.Bromley, 1837 (example in British Museum).

1837 'Queen Victoria Presiding at her First Council, 1837' by Sir D.Wilkie. Royal Collection. Engraved by C.Fox, published F.G.Moon, 1839 (example in British Museum).

1838 'The Coronation of Queen Victoria, 1838' by Sir G.Hayter. Royal Collection. Engraved by H.T.Ryall, published Graves and Warmsley, 1843 (example in NPG).

1838 'Coronation of Queen Victoria, 1838', engraving by C.E.Wagstaff and T.Higham, after E.T.Parris, published 1840 (example in British Museum). Study of Lansdowne (NPG 1383 above).

1840 Engraving by B.Holl, after a drawing by B.R.Haydon, published J.Dowding, 1840 (example in NPG), for 'Political Reformers'.

c1840 Painting by J.Linnell. Linnell Sale, Christie's, 15 March 1918 (lot 33).
Exhibited *VE*, 1892 (12). Either this or another version is in the collection of the Marquess of Lansdowne, and was exhibited *RA*, 1840 (199).

1842 'Christening of the Prince of Wales, 1842' by Sir G. Hayter. Royal Collection.
Reproduced H. and A. Gernsheim, *Queen Victoria: A Biography in Word and Picture* (1959), plate 57.

1846 'The Fine Arts Commissioners, 1846' by J. Partridge (NPG 342 above).
Study of 1847: Christie's, 15 June 1874 (lot 63), exhibited *SKM*, 1868 (396).

c 1847 Coloured lithograph by A. Blaikley, published A. Blaikley, *Pictures of the People from Prince to Peasant* (1847), facing p 23.

1854 'The Coalition Ministry, 1854' by Sir J. Gilbert (NPG 1125 above).

1854 Painting by Sir F. Grant. Collection of the Marquess of Lansdowne (plate 509).
Exhibited *RA*, 1857 (70). Listed in Grant's 'Sitters Book' (copy of original MS, NPG archives), under the year 1854. Engraved by J. R. Jackson, published Printsellers Association, 1857 (example in NPG); engraving exhibited *RA*, 1857 (1193).

1857 'Napoleon III Receiving the Order of the Garter' by E. M. Ward. Royal Collection.
Exhibited *RA*, 1858 (35).

1858 'The Marriage of the Princess Royal' by J. Phillip. Royal Collection.
Exhibited *RA*, 1860 (58). Engraved by A. Blanchard, published E. Gambart, 1865 (example in British Museum).

c 1872 Marble bust by Sir J. E. Boehm. Westminster Abbey.
Model exhibited *RA*, 1872 (1413).

Undated Painting called Lansdowne and attributed to Sir W. Beechey. Simon Sale, New York, 4 April 1929 (lot 80), reproduced sale catalogue, p 39.

Undated Painting by Fabre. Ilchester Collection.

Undated Painting by an unknown artist. Collection of D. E. Bowen, 1945.

Undated Drawing by J. Doyle. British Museum.

Undated Unspecified portrait. India Office, London.

Undated Anonymous lithograph (example in NPG).

LARDNER *Dionysius* (*1793–1859*)

Scientific writer; took holy orders, but devoted himself to literary and scientific work; professor of natural philosophy and astronomy in London University, 1826; published *Cabinet Cyclopaedia* in 133 volumes; lectured in the USA and Cuba, 1840–5; settled in Paris, 1845; wrote various works.

1039 Miniature, oil on wood, $4\frac{3}{4} \times 3\frac{3}{4}$ inches ($12·3 \times 9·5$ cm) oval, by EDITH FORTUNÉE TITA DE LISLE. PLATE 510

Signed (lower left): F. DE LISLE

Collections: Presented by the sitter's son, G. D. Lardner, 1896.

According to a letter from the artist's brother, Gide Lisle (7 March 1926, NPG archives), this posthumous portrait was painted with the aid of an early drawing of Lardner, a photograph, and descriptions of him by friends; the donor sat for the colouring. The artist was trained in the RA schools and later at Julian's atelier in Paris. She painted chiefly oil, pastel and miniature portraits and exhibited at the RA, the Salon, the Pastel Society, and elsewhere (information in the same letter from Gide Lisle).

Description: Fair complexion, blue eyes, brown hair. Dressed in a dark neck-tie, white shirt and waistcoat, black suit. Seated in a grey and red chair at a table, covered with a brown cloth. Background colour brown.

ICONOGRAPHY A painting by J. Ramsay was exhibited *RA*, 1837 (436); a painting called Lardner by an unknown artist was in the collection of Major Seafield Grant, 1926; an engraving by D. Maclise was published *Fraser's Magazine*, V (July 1832), facing 696, as no. 26 of Maclise's 'Gallery of Illustrious Literary Characters'; a

pencil study for this is in the Victoria and Albert Museum; there is an anonymous lithograph, after a drawing by T. Bridgford (example in NPG).

LATROBE *Charles Joseph* (*1801–75*)

Australian governor and traveller; educated for Moravian ministry, but declined to join it; travelled in Switzerland and America; superintendent of the Port Phillip district of New South Wales during the gold fever, 1839; lieutenant governor of Victoria; retired, 1854; published descriptions of his travels.

2515 (45) Black, red and brown chalk on grey-tinted paper, $13\frac{3}{4} \times 10\frac{1}{2}$ inches (35 × 26·7 cm), by WILLIAM BROCKEDON, 1835. PLATE 512

Dated (lower left): 26.3 35

Collections: See *Collections:* 'Drawings of Prominent People, 1823–49' by W. Brockedon, p 554.

Accompanied in the Brockedon Album by a letter from the sitter, dated 7 June 1837.

1672 Bronze cast, 3 inches (7·6 cm) diameter, of a medallion by THOMAS WOOLNER, *c* 1853. PLATE 511

Collections: The artist, purchased from his daughter, Miss Amy Woolner, 1912.

Literature: Amy Woolner, *Thomas Woolner: his Life in Letters* (1917), p 337 n.

This is a reduced version of the portrait medallion of Latrobe executed by Woolner in Australia (a cast of the larger medallion, dated 1853, is owned by B. Venus); Amy Woolner describes the NPG medallion as 'quarter size'. Woolner went to Australia in search of gold in 1852; after his failure at the gold diggings, he resumed his old profession in 1853, and returned to England in 1854. One of the companions with whom he travelled to Australia was a relation of Latrobe, who was responsible for obtaining several commissions for Woolner. A bronze cast of NPG 1672, taken in 1966, is in the University of New South Wales.

ICONOGRAPHY There is a painting by Sir F. Grant in the Town Hall, Melbourne, reproduced Alan Gross, *Charles Joseph La Trobe* (1956), frontispiece.

LAW *Edward, 1st Earl of Ellenborough.* See ELLENBOROUGH

LAWRENCE *Sir Henry Montgomery* (*1806–57*)

Soldier and administrator; brother of Lord Lawrence (see below); joined Bengal artillery, 1822; served in various campaigns in India; resident in Nepal, 1843–6; resident in Lahore, 1847; agent to the governor-general in the Punjab, and later in Rajpootana; chief commissioner in Oudh, 1856; killed while successfully defending Lucknow during the Indian mutiny.

1990 Oil on canvas, $17 \times 12\frac{3}{4}$ inches (43 × 32·4 cm), by an UNKNOWN ARTIST, *c* 1827. PLATE 513

Collections: The sitter, presented by his grandson, Sir Alexander Lawrence, Bart, 1923.

Presented at the same time as the bust by T. Campbell (NPG 1989 below). This portrait has in the past been tentatively attributed to W. H. Brooke, but this attribution does not seem very convincing. According to the donor (letter of 29 May 1923, NPG archives), it was painted when Lawrence was on leave at the age of about twenty-one. A copy was executed for the donor soon after its presentation.

Description: Healthy complexion, blue eyes, brown hair. Dressed in a dark stock, white shirt, and dark grey coat. Background brown.

727 Miniature, water-colour on ivory, $4\frac{1}{4} \times 3\frac{1}{2}$ inches (10·8 × 8·9 cm), by an UNKNOWN ARTIST, *c* 1847. PLATE 514

Collections: Probably given by the sitter to the 1st Viscount Hardinge, and presented by his son, the 2nd Viscount Hardinge, 1884.

This miniature, which appears to be unfinished, is a secondary version of the miniature in the India Office Library, London, exhibited *Great Irishmen*, Ulster Museum, Belfast, 1965 (114a). The latter was formerly in the collection of Sir Herbert Edwardes, engraved by S. Freeman, published R. Bentley, 1851 (example in NPG), for Sir H. B. Edwardes, *A Year on the Punjab Frontier* (1851), I, frontispiece. Lawrence gave Edwardes the India Office Library miniature as a keepsake when they were together in Lahore in 1847, or shortly before Lawrence left for home leave in 1848.[1] Lawrence received his KCB while in England in 1848, and Freeman must have added the star (not drawn in the original) to his engraving of the miniature for Edwardes' book, in order to bring the portrait up to date. According to the engraving, the original was the work of a native artist. A. Constable has suggested that the miniatures may have been the work of Gholam Khan, a Delhi miniaturist, who is said to have painted Lawrence in 1853 (the date may be a mistake), and to have produced several replicas.[2] The NPG miniature is similar in size to that in the India Office Library, and identical in pose and feature (except for the absence of a watch-chain), but it is much lighter in colouring, and much less highly finished. Lawrence was agent for foreign affairs and the Punjab under the 1st Viscount Hardinge's administration. The donor was chairman of the NPG trustees for several years.

Description: Reddish hair and beard (possibly the result of fading, or the unfinished state of the miniature). Dressed in a dark stock, white shirt, light brown waistcoat and dark brown coat. Seated in a chair of which only a fraction of the top-strut is visible. Background colour pale greenish-brown.

1989 Marble bust, 30¾ inches (78·2 cm) high, by THOMAS CAMPBELL, 1849. PLATE 515

Incised on the back of the shoulders: THOS. CAMPBELL SCULP. 1849

Collections: The sitter, presented by his grandson, Sir Alexander Lawrence, Bart, 1923.

Exhibitions: RA, 1849 (1323); probably the bust exhibited *VE*, 1892 (1068), lent by Henry Lawrence.

A replica is in the collection of the donor's son, Sir John Lawrence.

ICONOGRAPHY A painting by J. R. Dicksee is in the National Gallery of Ireland, exhibited *London International Exhibition*, 1872 (459); a copy by Miss M. Saunders is in the Victoria Memorial Hall, Calcutta; a painting by J. H. Millington was exhibited *VE*, 1892 (302), lent by Sir Henry Lawrence; a painting by an unknown artist of *c* 1827 is in the collection of Sir John Lawrence, exhibited *Great Irishmen*, Ulster Museum, Belfast, 1965 (114b); a miniature of *c* 1827 is in the same collection; a painting by H. W. Phillips is in the Lawrence Asylum, India, exhibited *RA*, 1862 (435); another painting by Phillips, presumably a replica, was lent to the *Dublin Exhibition*, 1872, 'Portraits' (257), by Lady Lawrence; a copy of the Phillips by J. E. Breun is in the East India and Sports Club, London; Lawrence appears in the painting of 'A Durbar at Udaipur, 1855' by F. C. Lewis in the India Office Library, London; an untitled portrait was exhibited *Victorian Era Exhibition*, 'Historical Section' (727), lent by Sir Henry Lawrence; a marble statue by J. G. Lough of 1862, with a bas-relief of Lawrence on the plinth, is in St Paul's Cathedral, London; a plaster model for this, together with another model for a bust or statue, was formerly at Elswick Hall, Newcastle, listed in *Catalogue of Lough and Noble Models at Elswick Hall* (*c* 1928), pp 43–4 (149), and p 13 (24); another statue by Lough is at Lahore, and a third on the exterior of the old India Office building; there is also a bust by an unknown artist in the India Office; a medallion by J. H. Foley is in St Paul's Cathedral, Calcutta; there is an anonymous engraving (example in NPG), possibly the engraving by A. N. Sanders, exhibited *RA*, 1867 (939); two lithographs by M. and N. Hanhart are in the India Office Library, and an anonymous one in the Victoria and Albert Museum; there is a photograph, after a miniature or painting by a native artist, in the NPG (A. Constable stated that these photographs were sold

[1] Information kindly communicated by Mrs M. Archer of the India Office Library, letter of 27 June 1967 (NPG archives).
[2] Letter of 23 July 1887 (NPG archives); Constable had met Gholam Khan's grandson, Ismail Khan, himself a miniaturist, from whom he obtained his information about the miniatures of Lawrence.

as souvenirs, letter of 23 July 1887, NPG archives); a miniature by a native artist is in the Art Gallery, Lahore (according to Sir Alexander Lawrence, who owned a copy, letter of 29 May 1923, NPG archives); an engraving by W. J. Edwards, after a photograph, was published J. S. Virtue (example in the NPG); Lawrence appears in 'The Intellect and Valour of Great Britain', engraving by C. G. Lewis, after T. J. Barker, published J. G. Browne, Leicester, 1864 (example in NPG); key-plate, published Browne, 1863 (example in British Museum); a photograph of 1857 by Ahmed Ali Khan (copy in NPG), known as 'Chotay Meah' (see letters from A. Constable, NPG archives), was engraved by H. Adlard as the frontispiece to L. E. Rees' *Narrative of the Siege of Lucknow* (1858); another photograph by Ali Khan shows Lawrence, George Lawrence and Sir Herbert Edwardes (copy in the NPG); a daguerreotype was reproduced *Picture Post*, 3 June 1939; a photograph by Captain Hutchinson (Bengal Engineers), with Edwardes and Montgomery, was engraved by E. Roffe for Rev J. Cave-Browne, *The Punjab and Delhi in 1857* (1861), I, frontispiece.

LAWRENCE *John Laird Mair Lawrence, 1st Baron* (*1811–79*)

Governor-general of India; brother of Sir Henry Lawrence (see above); administrator and magistrate in various northern districts; chief commissioner of the Punjab, 1853–7; capture of Delhi in the mutiny due to his advice and action; at India Office in London, 1859–62; viceroy of India, 1863–9.

1005 Oil on panel, $24\frac{1}{2} \times 19\frac{7}{8}$ inches (62·4 × 50·5 cm), by GEORGE FREDERICK WATTS, 1862. PLATE 518

Signed and dated (*bottom right*): G.F.W./1862

Collections: The artist, presented by him, 1895 (see appendix on portraits by G. F. Watts in forthcoming Catalogue of Portraits, 1860–90).

Exhibitions: Paris, 1878; *Collection of the Works of G. F. Watts*, Grosvenor Gallery, 1882 (59); *Paintings by G. F. Watts*, Metropolitan Museum, New York, 1884–5 (92); *Art Exhibition at the Inauguration of the Museum and Art Gallery*, Birmingham, 1885–6 (158); *Royal Jubilee Exhibition*, Manchester, 1887, 'Fine Art Section' (546); Rugby, 1888; *VE*, 1892 (23); Munich, 1893; Oldham, 1894; *George Frederick Watts*, Arts Council at the Tate Gallery, 1954–5 (33), reproduced in catalogue.

Literature: H. Macmillan, *Life-Work of George Frederick Watts, RA* (1903), p 84; R. E. D. Sketchley, *Watts* (1904), pp 75–8; J. Jessen, *George Frederick Watts* (Berlin, 1901), p 67; J. E. Phythian, *George Frederick Watts* (1906), p 164; 'Catalogue of Works by G. F. Watts', compiled by Mrs M. S. Watts (MS, Watts Gallery, Compton), II, 88.

There are three replicas of this portrait; one in the collection of David Loshak; another in the collection of Mrs M. Chapman, dated 1879, exhibited *The Works of G. F. Watts*, Winter Exhibition, New Gallery, 1896–7; and the third at Calcutta. Watts used the NPG portrait for the face of the Earl of Salisbury in the fresco, 'Justice, a Hemicycle of Lawgivers', in the New Hall of Lincoln's Inn (1853–9). A copy by W. M. Loudan is in the East India and Sports Club, London.

Description: Dark flesh tones, blue (?) eyes, greyish hair and moustache. Dressed in a white shirt and indistinguishable brown coat. Green pillar behind left. Rest of background, dark greyish-blue sky.

2610 Coloured chalk on brown, discoloured paper, $23\frac{1}{4} \times 18\frac{3}{8}$ inches (59·1 × 46·7 cm) mounted as an oval, by E. GOODWYN LEWIS, 1872. PLATE 516

Signed (*lower left*): E. Goodwyn Lewis.

Collections: Commissioned by the sitter's nephew, and presented by his son, Colonel H. Lawrence, 1933.

Exhibitions: Victorian Era Exhibition, 1897, 'History Section' (724).

According to the catalogue of the *Victorian Era Exhibition*, this drawing was executed in 1872 when Lawrence was president of the Megara Commission. This was confirmed in an interview with the

donor (memorandum of 9 March 1933, NPG archives), who stated that the portrait was considered by Lawrence's family to be the best likeness of him.

786 Plaster cast, painted black, 25¾ inches (65·4 cm) high, of a bust by SIR JOSEPH EDGAR BOEHM, c 1882. PLATE 519

Collections: The artist, presented by him, 1885.

Apparently related to the c 1882 statue of Lawrence by Boehm (see iconography below).

2111 Marble bust, 32½ inches (82·5 cm) high, by THOMAS WOOLNER, 1882. PLATE 517

Incised at the side of the base: T WOOLNER SC/LONDON 1882

Collections: Presented by the sitter's son, Sir Herbert Lawrence, 1926.

According to Amy Woolner, *Thomas Woolner: his Life in Letters* (1917), p289, Woolner modelled two busts of Lawrence, shortly after the latter's return from India in 1871. The first of these was classical in style, and was cast in bronze (example in Commonwealth Relations Office, London). The second, more baroque bust was carved in marble for Lawrence's memorial in Westminster Abbey of 1881. The NPG bust is a replica of the latter, commissioned by the donor. Woolner also executed a bronze statue of Lawrence in 1875 (see iconography below).

ICONOGRAPHY This does not include photographs, of which there are several in the NPG (see plate 520), and one in the Victoria and Albert Museum; others are reproduced R.B. Smith, *Life of Lord Lawrence* (1883), I, and II, frontispieces; *ILN* (as woodcuts), XLIII (1863), 637, and LXXV (1879), 17; and the *Journal of Army Research*, IX (1930), 5; an engraving by D.J. Pound, after a photograph by Mayall, was published Pound (example in NPG).

1858 Woodcuts, after a painting by an unknown artist, published *ILN*, XXXIII (1858), 162 and 331.

c 1860 Bust by J. Bailey. Exhibited *RA*, 1860 (1049).

1861 Marble bust by R. Theed. Grocers Company, London. Exhibited *RA*, 1861 (1008)

1862 Painting by G.F. Watts (NPG 1005 above).

1864 'Intellect and Valour of Great Britain', engraving by C.G. Lewis, after T.J. Barker, published J.G. Browne, Leicester, 1864 (example in NPG); key-plate, published Browne, 1863 (example in British Museum).

c 1865 Painting by J.R. Dicksee. Exhibited *RA*, 1865 (342), where it was said to have been painted for the New Institute, Delhi; either this or another version is the painting in the City of London School. Engraved by A.N. Sanders (example in NPG); engraving exhibited *RA*, 1865 (884).

1867 Bust by H. Weekes. St Bartholomew's Hospital, London.

1872 Drawing by E.G. Lewis (NPG 2610 above).

c 1874 Painting by J.E. Williams. Commissioned by subscription for the new School Board offices on the Victoria Embankment, London. Exhibited *RA*, 1874 (21).

1875 Bronze statue by T. Woolner. Government House, Calcutta. Reproduced A. Woolner, *Thomas Woolner: his Life in Letters* (1917), facing p229. Model exhibited *RA*, 1876 (1442).

1876 Painting by V. Prinsep. Government House, Calcutta.

1881 Painting by Hon J. Collier. Collection of Lady M. Lawrence, 1925. Exhibited *British Empire Exhibition*, Wembley Palace of Arts, 1925 (N26), reproduced 'Illustrated Souvenir', p71. Listed in the artist's 'Account Book' (photostat copy, NPG archives), p9. Other portraits by Collier, presumably replicas, are listed under 1911, for the Oriental Club, London, and 1914, for the Memorial Hall, Calcutta.

1881 Busts by T. Woolner (see NPG 2111 above).

c 1882 Bronze statue by Sir J. E. Boehm. Waterloo Place, London.
Exhibited *R A*, 1882 (1566). Bust by Boehm (NPG 786 above). There is also apparently a statue by Boehm at Lahore.

Undated 'Meeting of the First School Board of London' by J. W. Walker. Exhibited *Victorian Era Exhibition*, 1897, 'History Section' (16), lent by J. Macfarlane.

Undated Drawing by A. Helmich (reproduction in British Museum).

Undated Plaster model for a bust or statue by J. G. Lough. Formerly Elswick Hall, Newcastle.
Listed in *Catalogue of Lough and Noble Models at Elswick Hall* (*c* 1928), p 27 (77).

LAWRENCE *Sir Thomas* (*1769–1830*)

Painter.

2515 (21) See *Collections:* 'Drawings of Prominent People, 1823–49' by W. Brockedon, p 554.
See also forthcoming Catalogue of Portraits, 1790–1830.

LAYARD *Sir Austen Henry* (*1817–94*)

Archaeologist.

2515 (103) See *Collections:* 'Drawings of Prominent People, 1823–49' by W. Brockedon, p 554.
See also forthcoming Catalogue of Portraits, 1860–90.

LEATHAM *William* (*1783–1842*)

Slavery abolitionist.

599 See *Groups:* 'The Anti-Slavery Society Convention, 1840' by B. R. Haydon, p 538.

LECESNE *L. C.*

Slavery abolitionist.

599 See *Groups:* 'The Anti-Slavery Society Convention, 1840' by B. R. Haydon, p 538.

LEECH *John* (*1817–64*)

Cartoonist and draughtsman; abandoned medicine for art; published first illustrations, 1835; contributed to *Punch*, 1841–64, and became the leading comic cartoonist of his period; illustrated several books; published sporting sketches.

899 Pencil and water-colour on paper, $13\frac{3}{8} \times 10$ inches ($33 \cdot 9 \times 25 \cdot 4$ cm) framed as an oval, by SIR JOHN EVERETT MILLAIS, 1854. PLATE 524
Signed and dated (lower right): JEM/[*in monogram*] 1854. *Inscribed above monogram in pencil:* J E Millais
Collections: Edwin Lawrence; purchased at Christie's, 6 May 1892 (lot 299).
Exhibitions: R A, 1855 (1098); *Millais Exhibition*, RA, London, and Walker Art Gallery, Liverpool, 1967 (343); *Ben Marshall and John Leech*, Leicester Museum and Art Gallery, 1967 (126).
Literature: W. P. Frith, *John Leech, his Life, and Work* (1891), pp 279–80, reproduced frontispiece; J. G. Millais, *The Life and Letters of Sir John Everett Millais, P.R.A.* (1899), I, reproduced 263, and II, 487; Admiral Sir W. James, *The Order of Release* (1948), pp 240–1.

According to W. P. Frith, this portrait was drawn while Leech and Millais were staying at the Peacock Inn, Baslow, near Chatsworth; Millais was writing letters from there in July 1854. The two men were

intimate friends, and spent several hunting and fishing holidays together. Edwin Lawrence was another friend of Leech (four letters from his son, Basil Lawrence, about the portrait are in the NPG archives). A pencil sketch of Leech by Millais is reproduced J. G. Millais, I, 262.

Description: Fresh complexion, blue eyes, black hair and side-whiskers. Gold (?) stock-pin, white shirt with green dots, and brown coat sketchily indicated.

866 Plaster cast, painted black, 24½ inches (62·2 cm) high, of a bust by SIR JOSEPH EDGAR BOEHM, *c* 1865. PLATE 521

Collections: The artist, purchased from his executors, 1891.

Presumably related to the posthumous bust of Leech by Boehm, exhibited *RA*, 1865 (1025).

ICONOGRAPHY A painting by A. Egg was exhibited *SKM*, 1868 (615), lent by Mrs Leech; a painting by A. H. Tourrier, after a photograph by Silvy (example and related woodcut in NPG), was in the collection of Miss Mary Leech, 1892; a self-portrait water-colour (with his sister) was exhibited *Ben Marshall and John Leech*, Leicester Museum and Art Gallery, 1967 (125), lent by the Fine Art Society, London, and a self-portrait drawing is in the Garrick Club, London; a drawing by R. Doyle is reproduced M. H. Spielmann, *The History of Punch* (1895), p 339; there are two etchings, one by D. Todd (examples in NPG); several photographs are in the NPG (see plates 522, 523), and a woodcut, after one by MacLean, Melhuish and Haes, was published *ILN*, XLV (1864), 508.

LEFROY *Anthony* (*1800–90*)

MP for County Longford.

54 See *Groups:* 'The House of Commons, 1833' by Sir G. Hayter, p 526.

LEFROY *Thomas Langlois* (*1776–1869*)

Irish judge, and MP for Dublin University.

54 See *Groups:* 'The House of Commons, 1833' by Sir G. Hayter, p 526.

LESLIE *Charles Robert* (*1794–1859*)

Painter; son of American parents; student at RA schools; RA 1826; taught briefly in America; published *Memoirs of John Constable*, 1845; professor of painting at RA, 1848–52; published lectures; famous for his genre and literary pictures in a generally comic vein.

2618 Oil on canvas, 29⅞ × 24¾ inches (75·9 × 63 cm), by HIMSELF, 1814. PLATE 525

Signed and dated (top right): C. R. Leslie./1814.

Collections: Painted for the artist's mother, and sent to her in Philadelphia; inherited by the sitter's grandson, Sir Bradford Leslie, 1909, and presented by him, 1933.

Exhibitions: British Self-Portraits, Arts Council, 1962 (77).

Literature: John Constable's Correspondence, III, edited R. B. Becket (Suffolk Records Society, VIII, 1965), 153.

Information about the portrait is contained in the memorandum of an interview with the donor, 31 May 1933 (NPG archives). R. B. Becket rejects it as a self-portrait, arguing that its identity might easily have become confused during the portrait's journey to and from Philadelphia (letter of 25 March 1964, NPG archives): '*It shows rather a chubby young man, whereas C.R.L. is described as gaunt, and had "side-burns" extending below his ear.*' It is true that at first sight the NPG portrait appears to have little resemblance to other portraits of Leslie, but it was painted at least ten years before the two early self-portraits discussed below, when Leslie was only twenty and when one would expect his features to be rounder

and less clearly defined. Chin, nose, eyebrows and hair in the NPG portrait do not contradict Leslie's features in the later portraits; the apparent dissimilarity is due more to a general impression than any precise difference, and this could be accounted for by his youth. In the final analysis, it seems unlikely that family tradition would confuse the portrait of a distinguished ancestor with that of somebody else.

The best-known self-portrait of Leslie is that in the collection of A.R.L.Fletcher (plate 527), exhibited *SKM*, 1868 (347), and *Exhibition of the Works of Old Masters*, RA, 1870 (214), where it is dated 1828, reproduced G.D.Leslie, *The Inner Life of the Royal Academy* (1914), facing p14, where it is dated 1820, and *John Constable's Correspondence*, III (1965), frontispiece; it was engraved by W.Holl, published J.Murray, as the frontispiece to *Autobiographical Recollections . . . by C.R.Leslie*, edited Tom Taylor (1860). 1828 seems a more likely date than 1820. The other self-portrait is in a private collection, exhibited *Washington Irving and his Circle*, Knoedler's, New York, 1947, reproduced *Connoisseur*, CXIX (1947), 114. This is possibly a little later in date than the Fletcher portrait.

Description: Healthy complexion, brown eyes, and brown hair. Dressed in a white stock, a white shirt, and a loose brown overgarment with fur neck and cuffs. The back of a chair is just visible on which Leslie is sitting. Background colour brown.

4232 Oil on millboard, $7\frac{7}{8} \times 10$ inches (20 × 25·3 cm), by JOHN PARTRIDGE, 1836. PLATE 526

Inscribed on an early label on the reverse, in the artist's hand: Charles Robert Leslie RA, 1836./Painter John Partridge

Collections: The artist; by descent to his nephew, Sir Bernard Partridge, and bequeathed by his widow, Lady Partridge, 1961.

Exhibitions: Themes and Variations: the Sketching Society, 1799–1851, Victoria and Albert Museum, 1971.

Literature: J.Partridge, two MS notebooks (NPG archives); *NPG Annual Report, 1961–2* (1962), p4.

One of four similar studies in the NPG for Partridge's group portrait of the 'Sketching Society, 1836', listed in his 'Sitters Book' (NPG archives), p87 (verso), under 1836, exhibited *RA*, 1838 (408), with the title, 'Sketch of a Sketching Society; the Critical Moment'; it was last recorded in the collection of W.A.Brigg, Kildwick Hall, Keighley, 1913. A related water-colour by Partridge, and a photogravure by J.Hogarth, published 1858, are in the British Museum. The other studies, representing J.J.Chalon (NPG 4230), Thomas Uwins (NPG 4231), and Robert Bone (NPG 4233), are included in this catalogue under the names of the individual sitters. A study of another member, J.S.Stump, is listed in Partridge's 'Sitters Book', p88 (verso), as presented to the sitter. Studies of A.E.Chalon, C.Stanfield and Partridge are listed in his MS notebooks (NPG archives). The Sketching Society was founded in 1808 by Francis Stevens and J.J.and A.E.Chalon to study epic and pastoral design: *'The members assemble, at six o'clock, at each other's houses in rotation. All the materials for drawing are prepared by the host of the evening, who is, for that night, President. He gives a subject, from which each makes a design. The sketching concludes at ten o'clock, then there is supper, and after that the drawings are reviewed, and remain the property of him at whose house they are made'.*[1] Partridge's picture shows eleven members of the Society (himself included) grouped around a table, criticizing a drawing on an easel in front of them; Partridge was the president on this particular occasion.

Description: Healthy complexion, dark brown eyes and hair. Dressed in a black neck-tie, white shirt, black coat and waistcoat. Sitting at a table. Red background.

1456 (15) Black chalk heightened with Chinese white, on brown-tinted paper, $3\frac{3}{8} \times 3\frac{3}{8}$ inches (8·6 × 8·6 cm), by CHARLES HUTTON LEAR, 1846. PLATE 528

[1] *Autobiographical Recollections by the Late Charles Robert Leslie, R.A.*, edited by T.Taylor (1860), I, 119. See also Mrs Uwins, *A Memoir of Thomas Uwins, R.A.* (1858), I, 163–207, R. and S.Redgrave, *A Century of Painters of the English School* (1866), I, 485–7, and J.Hamilton, *Victoria and Albert Museum, the Sketching Society* (1971).

Inscribed (bottom right): C.R.Leslie/Nov 46

Collections: See *Collections:* 'Drawings of Artists, *c* 1845' by C.H.Lear, p 561.

Leslie was a visitor at the life school of the Royal Academy in 1846, where this drawing was almost certainly executed.

3182 (4) Pencil on paper, $4\frac{1}{4} \times 3\frac{1}{2}$ inches (10·8 × 8·9 cm), by CHARLES WEST COPE, *c* 1862. PLATE 529

Inscribed (lower right): Leslie Sen[r]

Collections: See *Collections:* 'Drawings of Artists, *c* 1862' by C.W.Cope, p 565.

3182 (5) See entry for William Mulready, p 328.

ICONOGRAPHY A water-colour by A.E.Chalon was exhibited *RA*, 1849 (947), and *VE*, 1892 (318), lent by the Rev B.Gibbons; a medallion by A.B.Wyon was exhibited *RA*, 1868 (1168); wax impressions of a medal by the same artist were exhibited *RA*, 1870 (1225); the finished medal, executed for the Art Union (example in NPG), was exhibited *RA*, 1872 (1494); there are several photographs in the NPG; a woodcut, after one by Mayall, was published *ILN*, XXXIV (1859), 509.

LESLIE *George Dunlop* (*1835–1921*)

Painter; son of C.R.Leslie (see above); studied at RA schools; ARA, 1867; RA, 1876; painted genre and fancy pictures.

2477 See entry for Sir C.L.Eastlake, p 154.

ICONOGRAPHY There is a painting by C.R.Leslie (his father) of 1840 in the Victoria and Albert Museum; an oil self-portrait is in the Aberdeen Art Gallery; a painting by E.Brock was exhibited *RA*, 1910 (267); a drawing or water-colour by P.Leslie was exhibited *RA*, 1917 (807); there are several photographs in the NPG; a woodcut, after a photograph by Fradelle, was published *Magazine of Art* (1880), p 233, and a woodcut *ILN*, LII (1060), 101.

LESTER *Benjamin Lester* (*c 1780–1838*)

MP for Poole.

54 See *Groups:* 'The House of Commons, 1833' by Sir G.Hayter, p 526.

LESTER *Rev C.Edwards*

American slavery abolitionist.

599 See *Groups:* 'The Anti-Slavery Society Convention, 1840' by B.R.Haydon, p 538.

LEWIS *Sir George Cornewall, Bart* (*1806–63*)

Statesman and author; served on commissions of inquiry into Ireland and Malta; poor law commissioner, 1839–47; MP from 1847; editor of the *Edinburgh Review*, 1852–5; chancellor of the exchequer, 1855–8; home secretary, 1859–61; secretary for war, 1861–3; published various works.

1063 Black and white chalk on brown discoloured paper, 23 × 17 inches (58·4 × 43 cm), by GEORGE RICHMOND. PLATE 530

Signed and inscribed (bottom right): R[t]. Hon Cornwal [*sic*] Lewis/G R

Collections: The artist, purchased from his executors, 1896.

This is a sketch rather than a finished drawing, but there is no mention of it or of any finished portraits of Lewis in Richmond's 'Account Book' (photostat copy, NPG archives). It was purchased with several other portrait drawings.

ICONOGRAPHY A painting by H. Weigall is in the National Museum of Wales, exhibited *RA*, 1863 (135), *SKM*, 1868 (444), and *VE*, 1892 (98); see J. Steegman, *Portraits in Welsh Houses*, II (1962), 212 (12); a painting by Sir J. Watson Gordon was in the collection of the Rev J. G. Walker, 1953; Lewis appears in J. Phillip's painting of 'The House of Commons, 1860', in the Houses of Parliament, engraved by T. O. Barlow, published Agnew, 1866 (example in NPG); and in the painting 'Baron de Rothschild Introduced into the House of Commons, 1858' by H. Barraud in the Rothschild collection; a drawing by L. Fagan is reproduced Fagan, *Life of Sir A. Panizzi* (1880), I, 302; a bronze statue by Baron C. Marochetti is at Hereford, reproduced as a woodcut *ILN*, XLV (1864), 269; a bust by H. Weekes is in Westminster Abbey, exhibited *RA*, 1864 (911); a bust by G. J. S. Miller was exhibited *RA*, 1864 (1052); a model for a bust by W. M. Thomas was exhibited *RA*, 1864 (937); there are various photographs in the NPG; woodcuts, after three of them, were published *ILN*, XVI (1850), 388, XXVI (1855), 441, and XLII (1863), 453, and one was engraved by W. Holl as the frontispiece to *Letters of the Right Hon Sir George Cornewall Lewis*, edited Rev Sir G. F. Lewis (1870); there is an engraving by D. J. Pound, after a photograph by J. Watkins, published 1860 (example in NPG), for Pound's 'Drawing Room Portrait Gallery'.

LEWIS *John Frederick* (*1805–76*)

Painter; son of the painter, Frederick Christian Lewis; painted and exhibited animal subjects, 1820–32; visited Spain, 1832–4, and painted Spanish subjects; travelled in the East, 1839, and painted oriental subjects for the rest of his life; his work is characterized by minute detail, firm draughtsmanship and brilliant colour.

1470 Oil on panel, $18 \times 13\frac{7}{8}$ inches (45·7 × 35·2 cm), by SIR WILLIAM BOXALL, 1832. PLATE 531

Collections: The artist; given by him to the sitter's widow, Mrs Lewis, sometime after 1876, and presented in accordance with her wishes, 1907.

In a letter to Thomas Woolner of Tuesday, 23 January (probably 1877, NPG archives: Lewis died in 1876, and Boxall in 1879), Boxall wrote: '*I am laid up with another cold & as you see I can hardly hold my pen. Pray give my most affectionate regards & tell Mrs Lewis that I should not have dared offer so incomplete a thing but for your encouragement. I hope you will find her better – again I beg you will give her my sincere & affect*ᵈ *regards.*' The date of the portrait was provided by Mrs Lewis (letter of 10 March 1905, NPG archives). Although she intended to present the portrait in 1905, she could not bear to part with it, and it only entered the collection in 1907 after her death.

Description: Healthy complexion, brown eyes, brown hair and whiskers. Dressed in a white collar, the rest of the costume is unfinished, green and brown underpainting. Background dark brown.

ICONOGRAPHY A painting by Sir J. Watson Gordon is in the Royal Scottish Academy, Edinburgh, exhibited *RA*, 1854 (295), *Royal Scottish Academy*, 1855 (360), and *Works by Scottish Artists*, Royal Scottish Academy, 1863 (213); a drawing by Sir E. Landseer of 1822 was in the Landseer sale, Christie's, 13 May 1874 (lot 855); there are two photographs in the NPG, and another by J. & C. Watkins was engraved by J. H. and C. G. Lewis (example in NPG); a woodcut after the same photograph was published *ILN*, XLVI (1865), 285; another photograph (in Eastern dress) is owned by Cyril Fry (plate 532).

LEY *John Henry* (*d 1850*)

First clerk of the House of Commons.

54 See *Groups:* 'The House of Commons, 1833' by Sir G. Hayter, p 526.

LEY *William* (*c 1817–47*)

Assistant clerk of the House of Commons.

54 See *Groups:* 'The House of Commons, 1833' by Sir G. Hayter, p 526.

LIDDELL *Henry George* (*1811–98*)

Dean of Christ Church, Oxford; White's professor of moral philosophy at Oxford, 1845; domestic chaplain to Prince Albert, 1846; headmaster of Westminster School, 1846–55; published famous *Greek-English Lexicon*, with Robert Scott, 1843; dean of Christ Church, 1855–91; vice-chancellor, 1870–4.

1871 Marble bust, 27⅝ inches (70·1 cm) high, by HENRY RICHARD HOPE-PINKER, 1888. PLATE 533

Incised on the back of the base: H. RICH^D. PINKER./SCUPT^R. 1888.

Collections: The artist, presented by him, 1920.

Exhibitions: Presumably either *RA*, 1888 (1960), or *RA*, 1898 (1867).

The bust in the *RA* exhibition of 1898 is described in the catalogue as a marble. Pinker may initially have exhibited a plaster bust in 1888, and only executed the marble in 1898, dating it to the year when the original model was executed; on the other hand, the two *RA* busts may represent different types. Another version of the NPG bust is in Westminster Abbey, reproduced *Country Life*, CXXXIX (1966), 778.

ICONOGRAPHY There is a painting by G.F.Watts of 1875 at Christ Church, Oxford, reproduced Mrs R. Lane Poole, *Catalogue of Oxford Portraits*, III (1925), plate X, facing 106; a painting by Sir H.Herkomer of 1891 is in the Ashmolean Museum, Oxford (plate 534), reproduced Rev H.L.Thompson, *Henry George Liddell* (1899), facing p265, exhibited *RA*, 1891 (289); another unfinished version by Herkomer is in the collection of the Liddell family; a drawing by G.Richmond of 1859 is listed in the artist's 'Account Book' (photostat copy, NPG archives), p69, probably the portrait exhibited *RA*, 1865 (692), reproduced A.M.W.Stirling, *Richmond Papers* (1926), facing p186, engraved by W.Holl (example in NPG), engraving exhibited *RA*, 1861 (934); a drawing by Cruikshank of 1839 is reproduced Rev H.L.Thompson, facing p28; a marble bust by E.G.Papworth was exhibited *RA*, 1860 (1019); a statue by an unknown artist is on the Deanery Tower at Christ Church; a medallion by D.G.Lucas was exhibited *RA*, 1859 (1161).

LINNELL *John* (*1792–1882*)

Portrait and landscape painter; studied at RA schools; friend of William Blake and Samuel Palmer; prolific output of portraits and landscapes, which made him famous; ARA, 1821, but withdrew, 1842; declined membership when offered in later life.

1811 Oil on canvas, 35⅞ × 27⅝ inches (91·1 × 70·2 cm), by HIMSELF, *c* 1860. PLATE 536

Inscribed on a label on the reverse: Portrait of John Linnell/painted by himself

Collections: The artist; Linnell Sale, Christie's, 15 March 1918 (lot 27), bought Edward Vicars, and presented by him, 1918.

Exhibitions: Exhibition of Works by the Old Masters &c, RA, 1883 (50); *VE*, 1892 (200).

Literature: A.T.Story, *The Life of John Linnell* (1892), II, reproduced frontispiece; *Magazine of Art* (1892), reproduced p131.

The 1883 RA Catalogue dates this portrait to 1860, and Story, less plausibly, to 1868. Other self-portraits are listed below (most of the dates are approximate):

1 *c1820*. Painting. Collection of Ralph Holland, exhibited *British Self Portraits*, Arts Council, 1962 (76).

2 *c1830*. Drawing. Reproduced Story, I, frontispiece, and *Magazine of Art* (1892), p130.

3 *c1835*. Painting. Collection of Mrs F.Linnell, exhibited *Portraits in Berkshire*, Reading Museum and Art Gallery, 1964 (23).

4 *c1835*. Miniature. Collection of Mrs F. Linnell, exhibited Reading, 1964 (23).

5 *1838* (signed and dated). Painting. Christie's, 17 April 1953 (lot 4) (plate 535); said to have been exhibited at Leeds, 1868, but not apparently in the catalogue of the *National Exhibition of Works of Art*, Leeds, 1868.

Description: Healthy complexion, brownish eyes, grey hair and beard. Dressed in a dark neck-tie, white collar, soft purplish-grey painting-coat. Background colour various tones of green. The canvas in the lower left-hand corner is light brown and orange in colour.

ICONOGRAPHY Linnell appears in the water-colour of 'Students at the British Association, 1807' by A. E. Chalon in the British Museum; a drawing by G. Richmond of 1828 was sold at Christie's, 7 July 1965 (lot 17), bought Agnew; there are several photographs in the NPG, and two woodcuts from unidentified magazines; a portrait called Linnell was formerly in the collection of Colonel M. H. Grant.

LINNELL. One of the sons of the artist, John Linnell (see above).
1456 (16) See *Collections:* 'Drawings of Artists, *c*1845' by C. H. Lear, p 561.

LINNELL. One of the sons of the artist, John Linnell (see above); not apparently the same sitter as NPG 1456 (16) above.
1456 (17) See *Collections:* 'Drawings of Artists, *c*1845' by C. H. Lear, p 561.

L'INSTANT *M*.
Slavery abolitionist from Haiti.
599 See *Groups:* 'The Anti-Slavery Society Convention, 1840' by B. R. Haydon, p 538.

LISGAR *John Young, 1st Baron* (*1807–76*)
Governor-general of New South Wales and Canada, MP for County Cavan.
54 See *Groups:* 'The House of Commons, 1833' by Sir G. Hayter, p 526.

LITTLETON *Edward John, 1st Baron Hatherton.* See HATHERTON

LIVINGSTONE *David* (*1813–73*)
African missionary and explorer; first went to Africa, 1840, and explored the interior; published his travels; made several more expeditions to Africa and became the most famous explorer of the age.

1040 Oil on canvas, 44⅛ × 34 inches (112 × 86·3 cm), by FREDERICK HAVILL. PLATE 542
Inscribed on a label on the back of picture: Portrait of D^r Livingstone/By/Frederick Havill
Collections: John Lillie, presented by him, 1896.

This portrait is almost certainly posthumous, and was presumably painted with the aid of photographs; there is a photograph by Mayall similar in pose and features to the portrait (example in NPG). The sitter's daughter, Mrs Bruce, wrote (letter of 16 May 1896, NPG archives): '*I wonder if the Artist did not paint it from photographs, because I only remember my father sitting to two Artists. The one portrait I have, & the other is at Newstead Abbey*'. Mrs Bruce's portrait was by Craig, and that at Newstead was done by J. B. Harrison (see iconography below). A coloured reproduction of the NPG portrait was published Museum Galleries, 1927 (example in NPG).

Description: Dark complexion, brown eyes, brown hair, moustache and whiskers, with grey streaks. Dressed in a white shirt, black coat, and dark grey trousers. Seated in a red armchair, reading a letter or notebook on his knee. Background colour dark brown.

386 Black chalk on blue-tinted paper, $7\frac{7}{8} \times 6\frac{5}{8}$ inches (19·9 × 16·7 cm), by JOSEPH BONOMI, 1857. PLATE 540

Signed (*bottom right*): Joseph Bonomi/del *Inscribed in pencil, apparently in another hand* (*lower left and centre*): Hartwell July 30 1857

Collections: Presented by William Smith, 1874.

The artist wrote to Scharf about this portrait (letter of 5 May 1874, NPG archives): '*I shall write again respecting the circumstances under which the portrait of Livingstone was made. This is to thank you for your kind letter.*' Unfortunately Bonomi did not write again. However, his friend Mrs Merriman (formerly Mrs Lee of Hartwell), wrote in a letter of 25 April 1874 (NPG archives):

I am sorry to detract from the value of the Portrait of Dr Livingstone which has lately been presented to the National Portrait Gallery but I observe it is said to be an original portrait. *Original it doubtless is, as being the handiwork of my friend Mr Bonomi (who assures me that he has no doubt of its genuineness) but I think it right to state that I am in the possession of the* original *drawing, & that presented by Mr Smith to your Gallery must be one of a few copies which Mr Bonomi remembers to have made when at Hartwell.*

She wrote again in a letter of 1 May 1874 (NPG archives):

Had it not been fixed in a book I should have been pleased to offer to lend it [i.e. her drawing of Livingstone] *to your Gallery for a short time. As far as I can judge from the engraving in the Graphic the copy you possess is a very fair one, but I do not think the likeness has been quite retained.*
The value of mine is enhanced by the autograph of Livingstone which he appended at the time it was drawn. I do not remember how many copies Mr Bonomi made (probably 3 or 4) but they are all likely to have been like your's & not from a different point of view.
Mr Bonomi also made for me a similar profile sketch of Charles Livingstone who accompanied his brother to Hartwell.

The NPG drawing was reproduced as a woodcut in the *Graphic*, IX (1874), 401.

ICONOGRAPHY There is a brief list of Livingstone's portraits in J. L. Caw, *Scottish Portraits* (1903), II, 149–50. There are a few portraits of Livingstone from the life, a great many photographs (examples in the NPG, see plate 541, and elsewhere, many of them reproduced in books on Livingstone), and several posthumous images. In the first category are the miniature by Sarah Newell of 1840 in the London Missionary Society (plate 537) (they also own two interesting early daguerreotypes, plates 538, 539); the painting by A. Craig formerly in the collection of Livingstone's daughter, Mrs Bruce, exhibited *RA*, 1857 (56); the painting by H. W. Phillips in the collection of John Murray, engraved by W. Holl for Livingstone's *Missionary Travels* (1857), frontispiece, and reproduced Caw, II, facing 148; the drawing by E. Grimstone in the Scottish NPG, exhibited *RA*, 1857 (907), of which there is an anonymous lithograph (example in British Museum); the drawing by J. B. Harrison of 1864 executed at Newstead Abbey for Mr Webb, and later in the collection of Lady Chermside, reproduced A. Z. Fraser, *Livingstone and Newstead* (1913), frontispiece; the drawing by J. Bonomi (NPG 386 above); the bust by F. M. Miller, exhibited *RA*, 1857 (1329), and the cabinet bust by the same artist, exhibited *RA*, 1858 (1287); a medallion or cameo by J. Ronca, after Miller, exhibited *RA*, 1867 (1106); the marble bust by Mrs D. O. Hill, executed from sittings in 1865, exhibited *RA*, 1866 (1032), and the statue by her in Edinburgh, a model for which was exhibited *RA*, 1869 (1223), presumably related to the plaster statuette of 1868 in the Scottish NPG; the medal by E. W. Wyon, exhibited *RA*, 1858 (1234).

The posthumous images include the painting by F. Havill (NPG 1040 above); the painting by J. M. Stewart in the Kelvingrove Art Gallery, Glasgow, exhibited *VE*, 1892 (245); a painting by an unknown artist, sold Sotheby's, 22 July 1970 (lot 164), bought Sawyer; the statue by J. Mossman in Glasgow, reproduced as a woodcut *ILN*, LXXI (1877), 605; the statue by Sir W. Reid Dick at Victoria Falls; the bust by W. Brodie, exhibited *RA*, 1878 (1426), possibly the bust listed by R. Gunnis, *Dictionary of British Sculptors* (1953), p63, as in the Livingstone Bruce Collection, 1917; the medal by A. B. Wyon, executed for the Royal Geographical Society, exhibited *RA*, 1875 (1283); the bronze bust by C. d'O. Pilkington Jackson, exhibited *Society of Portrait*

Sculptors, 1953 (106), lent by the Rev J. I. Macnair; and the bronze statue by T. Huxley-Jones, for which the model was exhibited *RA*, 1954 (1206), outside the buildings of the Royal Geographical Society, London; there is also an engraving of the historic meeting between Livingstone and Stanley (example in NPG).

Among the prints and photographs of Livingstone is an engraving by D. J. Pound, after a photograph by Mayall, published 1859 (example in NPG), for Pound's 'Drawing Room Portrait Gallery', and two anonymous engravings (example in NPG); Livingstone appears in 'The Intellect and Valour of Great Britain', engraving by C. G. Lewis, after T. J. Barker, published J. G. Browne, Leicester, 1864 (example in NPG); key-plate, published Browne, 1863, (example in British Museum); woodcuts were published *ILN*, XXIX (1856), 643, after a photograph by Claudet, *ILN*, LXI (1872), 97, *Illustrated Review*, 1871, p 519, after a photograph by the London Stereoscopic Co (example in NPG), *Illustrated Times*, 3 January 1857, and an unidentified magazine (cuttings in NPG).

LOCH *James* (*1780–1855*)

Economist, barrister, and MP for Wick.

54 See *Groups:* 'The House of Commons, 1833' by Sir G. Hayter, p 526.

LOCKE *Wadham* (*1779–1835*)

MP for Devizes.

54 See *Groups:* 'The House of Commons, 1833' by Sir G. Hayter, p 526.

LONDONDERRY *Charles William Stewart, 3rd Marquess of* (*1778–1854*)

Soldier and statesman.

2789 See *Groups:* 'Members of the House of Lords, *c* 1835' attributed to I. R. Cruikshank, p 536.

LONDONDERRY *Frederick William Robert Stewart, 4th Marquess of* (*1805–72*)

MP for County Down.

54 See *Groups:* 'The House of Commons, 1833' by Sir G. Hayter, p 526.

LONG *Edwin Longsden* (*1829–91*)

Painter; accompanied John Phillip to Spain, and painted several Spanish-inspired works; later turned to religious and eastern subjects, like 'Diana and Christ', and 'The Babylonian Marriage Market'; also painter of portraits; RA, 1881.

2474 Pencil on paper, $5\frac{1}{2} \times 3\frac{1}{4}$ inches (14·1 × 8·4 cm), by CHARLES BELL BIRCH, 1858. PLATE 543
 Inscribed in pencil (bottom left): R.A./17 Feb 1858 and (*lower right*): Long
 Collections: See *Collections:* 'Drawings of Royal Academicians, *c* 1858' by C. B. Birch, p 565.

ICONOGRAPHY A drawing by P. Renouard of 1888 was exhibited *Annual Exhibition*, Royal Society of Portrait Painters, 1891 (111), and reproduced R. Quick, 'Life and Works of Edwin Long, R.A.' (Russell-Cotes Art Gallery, Bournemouth, 1931), p 45; another drawing by Renouard of 1888 is reproduced p 43; a marble bust by D. Trentacoste was exhibited *RA*, 1891 (2023); a photograph by P. Calamita is reproduced *Art Journal* (1891), p 222; two woodcuts, after photographs by C. Watkins, were published *ILN*, LXVIII (1876), 436, and *Year-book of Celebrities* (cutting in NPG); a woodcut from an unidentified newspaper of 1876 is in the NPG.

LONG *William* (*fl 1821–55*)

Painter.

1456 (18) See *Collections:* 'Drawings of Artists, *c* 1845' by C. H. Lear, p 561.

LONGLEY *Charles Thomas* (*1794–1868*)

Archbishop of Canterbury; headmaster of Harrow, 1829–36; bishop of Ripon and then of Durham; archbishop of York, 1860–2, and of Canterbury, 1862–8; published sermons and addresses.

1056 Black and white chalk on brown, slightly discoloured paper, 25¼ × 20¼ inches (64 × 51·4 cm), by GEORGE RICHMOND, *c* 1862. PLATE 544

Inscribed in pencil (*lower right*): Sketch for Picture begun as./Archbishop of York *and* (*top right, below mount*): Chalk

Collections: The artist, purchased from his executors, 1896.

This is a sketch for Richmond's oil portrait of Longley of 1862 at Lambeth Palace, listed in Richmond's 'Account Book' (photostat of original MS, NPG archives), pp 75–6, exhibited *R A*, 1863 (61). Richmond executed other versions of this portrait, some with variations, for: Bishopthorpe Palace (1863); Bishop Auckland Palace (1864); Lambeth Palace (1868); Harrow School (1868), exhibited *V E*, 1892 (198); Keble College, Oxford (1875); and Longley's son (1886). Two earlier drawings of Longley by Richmond of 1836 and 1842 (both unlocated) are listed in the 'Account Book', pp 18 and 30.

ICONOGRAPHY A painting by H. P. Briggs is at Christ Church, Oxford, exhibited *R A*, 1838 (8), engraved by G. R. Ward, published Ryman, Oxford, 1839, and by R. Smith, published R. Groombridge (examples in NPG); a painting by Sir F. Grant is at Bishop Mount, Ripon, listed in his 'Sitters Book' (copy of original MS, NPG archives), under the year 1849, engraved by J. Faed, published Colnaghi, 1850 (example in NPG); a miniature by E. Tayler was exhibited *R A*, 1869 (656); a marble bust by E. Davis is at Lambeth Palace, exhibited *R A*, 1844 (1355); there are several photographs in the NPG; there is an engraving by D. J. Pound, after a photograph by Mayall (example in NPG); a woodcut, after one by J. Watkins, was published *I L N*, XXIX (1856), 539, and another, after Mayall, XLI (1862), 380.

LOPES *Sir Ralph, Bart* (*1788–1854*)

MP for Westbury.

54 See *Groups:* 'The House of Commons, 1833' by Sir G. Hayter, p 526.

LOVER *Samuel* (*1797–1868*)

Song-writer, novelist and painter; painted portraits and miniatures in Dublin and London; published ballads, and *Legends and Stories of Ireland*, 1831; founded *Dublin University Magazine* and helped to found *Bentley's Magazine*; wrote plays, poems, parodies and novels.

627 Marble bust, 29¼ inches (74·3 cm) high, by EDWARD ARLINGTON FOLEY, 1839. PLATE 545

Incised on the back of the shoulders: SAMUEL LOVER, *and on the back of the base:* E.A. FOLEY. Sculp./ LONDON.1839.

Collections: The sitter, purchased from the executors of his wife, 1881.

Exhibitions: R A, 1839 (1335).

Literature: G. Scharf, 'TSB' (NPG archives), XXVII, 56 and 69.

This bust was slightly damaged, and its pedestal destroyed, in an accident in 1906. It was on loan to the South Kensington Museum from 1876 till its purchase by the NPG. A bust of Lover's eldest daughter by Foley was exhibited *R A*, 1835 (1104).

ICONOGRAPHY Two paintings by J. Harwood (the one of 1856 reproduced W. G. Strickland, *Dictionary of Irish Artists* (1913), II, plate XXXVIII) are in the Irish NPG, and so is a self-portrait drawing of 1828; a painting called Lover by R. Rothwell was in the collection of Dr W. Hutcheson, 1927; a painting by an unknown artist

was with David Barclay, 1969 (a companion portrait of Crofton Croker by the same artist is in the NPG, 4555), exhibited *Dublin Exhibition*, 1872, 'Portraits' (294), lent by Dr Joly; a painting by himself was sold Sotheby's, 11 January 1967 (lot 58), bought Agnew; a drawing or water-colour by an unknown artist was exhibited *Victorian Era Exhibition*, 'Music Section (Historical)' (111), lent by J. Blockley; there is a lithograph by C. Baugniet of 1844, published Leader and Cock (example in NPG); a woodcut was published *ILN*, IV (1844), 208, and a woodcut, after a photograph by Maull & Co, *ILN*, LIII (1868), 105; another photograph is reproduced Mrs W. Pitt Byrne, *Gossip of the Century* (1899), II, 303.

LOWTHER *Henry Cecil* (*1790–1867*)

MP for Westmorland.

54 See *Groups:* 'The House of Commons, 1833' by Sir G. Hayter, p 526.

LUCAS *David* (*1802–81*)

Engraver; studied under S. W. Reynolds; famous chiefly for his etchings after Constable ('English Landscapes'), and other English painters.

1353 Black chalk on paper, $7\frac{1}{2} \times 6\frac{1}{8}$ inches ($19 \cdot 1 \times 15 \cdot 5$ cm), by THOMAS H. HUNN, 1902. PLATE 547

Signed and dated (*lower right*): T Hunn/1902

Collections: Commissioned by E. E. Leggatt, and presented by him, 1904.

According to the donor, this drawing was based on a photograph of a lost painting of Lucas by his namesake, John Lucas; if this is so, the original portrait is not listed by A. Lucas, *John Lucas* (1910), which catalogues most of his known works. The NPG drawing was engraved as the frontispiece to E. E. Leggatt, *Catalogue of the Work of David Lucas* (1903).

3070 Miniature, water-colour and varnish on ivory, $2\frac{5}{8} \times 1\frac{3}{4}$ inches ($6 \cdot 6 \times 4 \cdot 5$ cm), attributed to ROBERT SATCHWELL, *c* 1820. PLATE 546

Inscribed in ink on the back of the card to which the ivory is stuck: B/S.G. 1820/D.IIr 25.A

Collections: George Lucas, purchased from him, 1898, by the British Museum; transferred from there, 1939.

Literature: F. O'Donoghue, *Catalogue of Engraved British Portraits in the British Museum*, III (1912), 102.

This miniature was apparently attributed to Satchwell by Basil Long. The meaning of the inscription is not clear, but the date 1820 agrees well with the apparent age of the sitter.

Description: Pale complexion, light brown hair. Dressed in a dark stock, white shirt, blue waistcoat and black coat. Background colour brown and green.

ICONOGRAPHY A painting called Lucas and attributed to J. Constable was in a private collection, 1936.

LUCAS *Richard Cockle* (*1800–83*)

Sculptor; exhibited at *RA*, 1829–59; best known for marble, wax and ivory medallions; also produced sketches and etchings; published one or two essays.

1783 Plaster cast, painted black, $25\frac{3}{4}$ inches ($65 \cdot 4$ cm) high, of a bust by HIMSELF, 1868. PLATE 548

Incised on hammer (*see below*): R.C./LUCAS/Scpt/1868

Collections: Christie's, 20 December 1909 (lot 81), purchased by John Lane, and presented by him, 1916.

Depicted in a panel on the front of the base are a hammer and chisel.

ICONOGRAPHY There is an etching by himself (at work on his statue of Isaac Watts, 1858) (example in NPG); the head in this is similar, in pose and features, to the NPG bust; there is another etching by himself, of a different type (example in British Museum); there is also a photograph in the British Museum.

LUCAS *Samuel*

Slavery abolitionist.
599 See *Groups:* 'The Anti-Slavery Society Convention, 1840' by B.R.Haydon, p538.

LUPTON *Thomas Goff (1791–1873)*

Engraver; studied under George Clint; exhibited crayon portraits at *RA*, from 1811; mainly responsible for introduction of steel for mezzotint-engraving; employed by Turner on the 'Liber Studiorum'.

1619 Oil on canvas, 19⅛ × 15⅛ inches (48·5 × 38·4 cm), by GEORGE CLINT. PLATE 549

Collections: The sitter, bequeathed by his son, Thomas Lupton, 1911.

The name of the artist was provided by Thomas Lupton's solicitors in a letter of 25 September 1911 (NPG archives). It is very likely that the portrait was executed during Lupton's apprenticeship to Clint, but the particular significance of his vagabond costume is not known. The portrait was bequeathed together with a plaster bust of Lupton by Scipio Clint, George Clint's son; the latter corresponded very closely with the features in the painting, and was declined. A drawing by N.O.Lupton of 1844, after the bust, is in the British Museum. The only other recorded portrait of Lupton is in George Clint's painting of the last scene of 'A New Way to Pay Old Debts' of 1820, in the Garrick Club, London.

Description: Healthy complexion, hazel eyes, and brown hair. Dressed in a white collar, reddish-brown coat, and yellow hat, with a red bundle over his shoulder, and multi-coloured handkerchief. White sailing-vessels, green sea, and light-coloured sky lower left. Rest of background dark brown.

LUSHINGTON *Stephen (1782–1873)*

Lawyer and reformer; barrister, 1806; MP from 1806; retained as counsel for Queen Caroline before the House of Lords, 1820; judge of high court of admiralty; 1838–67; a noted reformer, and slavery abolitionist.

1646 Oil on canvas, 32¼ × 25½ inches (81·9 × 64·7 cm), by WILLIAM HOLMAN HUNT, 1862. PLATE 550 & page 279

Signed and dated (bottom left): W H H [*in monogram*] 1862

Collections: Commissioned by the sitter's son, Vernon Lushington, and presented by his daughter, Miss Susan Lushington, in accordance with his wishes, 1912.[1]

Exhibitions: RA, 1863 (613); *VE,* 1892 (260).

Literature: W.H.Hunt, *Pre-Raphaelitism and the Pre-Raphaelite Brotherhood* (1905), II, 219–22.

Vernon Lushington was a friend of Holman Hunt and his Pre-Raphaelite colleagues. Hunt went down to the sitter's home at Ockham to paint the portrait, first executing a preliminary drawing (reproduced W.H.Hunt, II, 220): '*the difficulty was that in the mobility of his features it was almost impossible to find any phase between the two extremes that could give the interest of the charming old judge's character*'. Hunt gives a vivid picture of Lushington's character and the progress of the portrait.

Description: Healthy complexion, blue eyes, grey hair and whiskers. Dressed in a dark blue neck-tie, white shirt, check waistcoat and trousers, and dark brown coat. Seated in an armchair with gilt back, and red arms. Reading a brown leather-bound book. Behind is a wooden sideboard, with books on it,

[1] There are three letters from the donor about the portrait (NPG archives). Although she is not accurate in saying that it was the first portrait commission Hunt had received, Lushington obviously wanted to help his struggling friend. Hunt mentions work on the portrait in letters of 20 October 1862 and 25 August 1863 (Bodleian Library, Oxford, MS Don e. 66, ff. 70, 77–8.)

and on the left a predominantly green plate and matching vase with violets and harebells. On the right is a green figured wall-paper, with the edge of a picture frame in the extreme right-hand corner.

1695 (i) With Sir Robert Gifford, Lord Lyndhurst, Lord Truro, Spinetti and others. Pencil, pen and sepia ink and wash on paper, $5\frac{1}{2} \times 8\frac{1}{4}$ inches (14×21 cm), by SIR GEORGE HAYTER, 1820.

Inscribed in ink, in the artist's hand (*bottom left*): 2 and (*bottom right*): House of Lords trial of the Queen/ G H Sept 1820. *Inscribed in pencil, in the artist's hand* (*above the figure on the extreme left*): At first (?), and (*above the second figure on the left*): Door to/Gallery

Collections: Basil Jupp; M.B.Walker, purchased from him, 1913.

This drawing came from a set of extra illustrated RA catalogues formed by Basil Jupp. It is one of several studies in the NPG for Hayter's 'House of Lords' (see NPG 999 below), which will be collectively discussed and reproduced in the forthcoming Catalogue of Portraits, 1790–1830.

599 See *Groups:* 'The Anti-Slavery Society Convention, 1840' by B.R.Haydon, p538.

999 See *Groups:* 'The House of Lords, 1820' by Sir G.Hayter, in forthcoming Catalogue of Portraits, 1790–1830.

ICONOGRAPHY A painting by G.F.Watts of 1867 is in Trinity House, London; two drawings are listed in G.Richmond's 'Account Book' (photostat copy, NPG archives), pp41 and 61, under the years 1846 ('Mr Lushington', presumably Stephen) and 1854; a replica of the latter is listed under the year 1864; a bust by H.B. Burlowe was exhibited *RA*, 1833 (1124); an engraving by T.Wright, after A.Wivell, was published T.Kelly, 1821 (example in NPG); an engraving by W.Holl, after A.Wivell (not the same type as the one above), was published G.Lauford, 1824 (example in NPG); an engraving by W.Walker, after a miniature by Sir W.J. Newton once in the collection of the sitter's family, was published Walker, 1834 (example in NPG); there is a photograph by Maull and Polyblank (example in NPG), and a woodcut, after another, was published *ILN*, LXII (1873), 96.

LYELL *Sir Charles, Bart* (*1797–1875*)

Geologist; son of botanist, Charles Lyell; began continental tours, 1818; secretary of Geological Society, 1823–6, and later president; published influential *Principles of Geology*, 1830–3; professor of geology at King's College, London, 1831–3; published numerous works; created a baronet, 1864.

1387 Oil on canvas, $48\frac{1}{8} \times 35$ inches ($122 \cdot 2 \times 88 \cdot 9$ cm), by LOWES CATO DICKINSON, 1883, after his portrait of *c*1870. PLATE 551

Collections: Commissioned by the sitter's sister-in-law, Mrs Katherine Lyell, and presented by her, 1904.

The original portrait by Dickinson was in the collection of the donor's son, Sir Leonard Lyell, exhibited *RA*, 1870 (109), and *VE*, 1892 (248). There is a copy in Exeter College, Oxford. In a letter of 28 October 1904 (NPG archives), Mrs Lyell wrote of the NPG version: '*I afterwards asked Mr Dickinson if he would make a copy of it, which he kindly did most carefully, and it really is a most exact replica.*'

Description: Healthy complexion, bluish-grey eyes, grey hair and whiskers. Dressed in a cream shirt, dark stock, buff waistcoat, green trousers, dark coat, and grey overcoat or frock coat, with a monocle suspended on a black ribbon. Seated in an armchair, the arms of which are covered in red plush. Background colour dark brown.

1064 Black and white chalk on light grey paper, 17×14 inches ($43 \cdot 2 \times 35 \cdot 5$ cm), by GEORGE RICHMOND. *c*1853. PLATE 552

Inscribed in pencil (*top right*): Sir Charles Lyell

Stephen Lushington by William Holman Hunt, 1862 NPG 1646

Collections: The artist, purchased from his executors, 1896.

This is a study for Richmond's finished portrait drawing in the collection of the Lyell family, which was anonymously lithographed (example in NPG), and engraved by C. Holl as the frontispiece to Mrs Lyell, *Life, Letters and Journals of Sir Charles Lyell* (1881), I; the original drawing is probably that listed in Richmond's 'Account Book' (photostat copy of original MS, NPG archives), p 60, under the year 1853. Another portrait of Lyell by Richmond was begun in 1868 but discontinued. Lady Lyell, the sitter's sister-in-law, who owned the finished drawing, wrote of the NPG's '*wretched likeness*' (letter of 22 October 1904, NPG archives).

ICONOGRAPHY A painting by T. Phillips is listed in his 'Sitters Book' (copy of original MS, NPG archives), under 1816, exhibited *RA*, 1816 (136); also listed by Phillips is a painting of 1819, with Lyell's two brothers, Thomas and Henry, exhibited *RA*, 1819 (163), and a third painting of 1822; two busts by W. Theed (after J. Gibson, according to the *Dictionary of National Biography*) are in Westminster Abbey and the Royal Society, London; there is a painting by an unknown artist in the Geological Society, London; a lithograph by T. H. Maguire was published G. Ransome, 1852 (example in NPG), for 'Portraits of the Honorary Members of the Ipswich Museum'; a lithograph by W. H. Drummond, after J. M. Wright, was published T. McLean (example in British Museum), for 'Athenaeum Portraits'; there is an engraving by C. H. Jeens, another by F. Croll, published for *Hoggs' Instructor* (examples in NPG), and a third by J. Stodart, reproduced Mrs Lyell, *The Life, Letters and Journals of Sir Charles Lyell* (1881), II, frontispiece, and a woodcut published *ILN*, XLVI (1865), 229, all after photographs (some examples of the original photographs are in the NPG); a lithograph by A. Newsam was published J. Mayall, Philadelphia (example in British Museum); there is an anonymous engraving (example in NPG), and a woodcut from an unidentified magazine (cutting in NPG).

LYNDHURST *John Singleton Copley, the younger, Baron* (*1772–1863*)

Lord chancellor; son of the painter, John Singleton Copley; born in Boston, USA; barrister in England, 1804; tory MP from 1818; chief justice of Chester, 1819; solicitor-general, 1819; attorney-general, 1824–6; lord chancellor, 1827–30, 1834–5, and 1841–6; one of the most influential lawyers of the period.

472 Oil on canvas, 93 × 57½ inches (236·2 × 146 cm), by THOMAS PHILLIPS, 1836. PLATE 557

Signed and dated (lower right): T P [*in monogram*] 1836

Collections: Commissioned by the Hon Society of Judges and Serjeants-at-Law, and presented by them, 1877.

Exhibitions: RA, 1836 (72).

Literature: T. Phillips, 'Sitters Book' (copy of original MS, NPG archives), under the year 1836.

An engraving by T. Crawford, after this portrait, was exhibited *RA*, 1933 (1158).

Description: Close inspection of this portrait which is at present on loan to the Law Courts, was impossible. Lyndhurst is shown in the black and gold-braided robes of a lord chancellor. The background colour is reddish-brown.

683 Oil on panel, 24 × 19¾ inches (61·1 × 50·2 cm), by GEORGE FREDERICK WATTS, 1862. PLATE 553

Signed (bottom right): G F Watts

Collections: The artist, presented by him, 1883 (see appendix on portraits by G. F. Watts in forthcoming Catalogue of Portraits, 1860–90).

Exhibitions: SKM, 1868 (451); *Winter Exhibition*, Grosvenor Gallery, 1882, 'Collection of the Works of G. F. Watts' (33); *Watts Exhibition*, Arts Council at the Tate Gallery, 1954–5 (34).

Literature : C. T. Bateman, *G. F. Watts, R.A.* (1901), p 50; H. Macmillan, *The Life-work of George*

Frederick Watts, *R.A.* (1903), p85; 'Catalogue of Works by G.F.Watts', compiled by Mrs M.S.Watts (MS, Watts Gallery, Compton), II, 101.

Painted in 1862, this was the last portrait for which Lyndhurst sat. Watts appears to have retouched it sometime after 1868, as the photograph taken in that year at the *S K M* shows much more sharply defined features. Another version is in the Watts Gallery, and others once belonged to the sitter's family, and to C.H.Rickards; the last was exhibited *Art Exhibition*, Birmingham, 1885–6 (116), and sold at Christie's, 11 February 1911 (lot 129). Lady Lyndhurst complained to the artist that he had made her husband look too old ('Catalogue', II, 101).

Description: Bluish eyes, brown hair. Dressed in red and ermine peer's robes. Background colour dark brown.

2144 Coloured chalk on brown, discoloured paper, $24\frac{5}{8} \times 18\frac{5}{8}$ inches ($62\cdot6 \times 47\cdot4$ cm), by GEORGE RICHMOND, 1851. PLATE 556

Signed (*bottom left*): Geo. Richmond deln[t] *and inscribed and dated* (*bottom right*): Lyndhurst/51

Inscribed on a label, formerly on the back of the drawing: This picture was given to me by Lady Du Cane in Jan[y]./1902 after Lady Lyndhurst's/death. S.C.B. [*Sophia Becket*]. *Inscribed on another label:* This picture was given/me by my mother 27 Dec[r]. 1905/C. Aberdare

Collections: The sitter, bequeathed by his widow, Lady Lyndhurst, with a life interest for her daughter, Lady Du Cane, 1927.[1]

Exhibitions: R A, 1855 (847); *VE*, 1892 (349).

Literature: G.Richmond, 'Account Book' (photostat copy, NPG archives), p54, under 1851.

This drawing was engraved by F.Holl, published J.Murray, 1883, and by W.Holl (examples in NPG). A replica was given to Lady Aberdare by her cousin, Lady Rookwood, in 1927.

4121 Water-colour on paper, $8\frac{3}{4} \times 6\frac{7}{8}$ inches ($22\cdot2 \times 17\cdot5$ cm) cut corners, by F.ROFFE, *c* 1836. PLATE 555

Collections: Messrs F.B.Daniell, presented by them, 1959.

Literature: NPG Annual Report, 1959–60 (1960), p13.

This water-colour was engraved by J.Brown (example in NPG). The pose and head appear to be based on the water-colour by A.E.Chalon (the clothes are different), engraved by R.Artlett, published J. Fraser and H.T.Ryall, 1836 (example in NPG), for 'Eminent Conservative Statesmen'. The costume is based on the full-length water-colour by Chalon (the head is different), lithographed by R.J.Lane, published J.Mitchell, 1836 (example in NPG), probably the portrait exhibited *R A*, 1836 (592).

Description: Dark complexion, brown eyes and hair. Dressed in a dark stock, white shirt and red, yellow and ermine judicial robes. Background colour brown.

1695 (i) With Sir Robert Gifford, Lord Truro, Dr Stephen Lushington and others. Pencil, pen and sepia ink and wash on paper, $5\frac{1}{2} \times 8\frac{1}{4}$ inches (14×21 cm), by SIR GEORGE HAYTER, 1820.

Inscribed in ink in the artist's hand (*bottom left*): 2 *and* (*bottom right*): House of Lords trial of the Queen/ G H Sep[t] 1820 *Inscribed in pencil* (*above the figure on the extreme left*): At first (?), *and* (*above the second figure on the left*): Door to/Gallery

Collections: Basil Jupp; M.B.Walker, purchased from him, 1913.

This drawing came from a set of extra-illustrated RA catalogues formed by Basil Jupp. It is one of several studies in the NPG for Hayter's 'House of Lords, 1820' (see NPG 999 below), which will be collectively discussed and reproduced in the forthcoming Catalogue of Portraits, 1790–1830.

[1] Lady Du Cane, one of Lord Lyndhurst's daughters, was apparently unaware of the clause in her mother's will, when she gave this drawing to her half-sister, Sophia Clarence Becket, in 1902. Lady Aberdare was rather upset when she discovered that she had to give the drawing up on Lady Du Cane's death in 1927.

54	See *Groups:* 'House of Commons, 1833' by Sir G. Hayter, p 526.
342, 3	See *Groups:* 'The Fine Arts Commissioners, 1846' by J. Partridge, p 545.
999	See *Groups:* 'The House of Lords, 1820' by Sir G. Hayter, in forthcoming Catalogue of Portraits, 1790–1830.

ICONOGRAPHY This does not include caricatures or photographs (see plate 554), of which there are several examples in the NPG; for caricatures by J. Doyle, see L. Binyon, *Catalogue of Drawings in the British Museum*, II (1900), 44 onwards.

1776–7	'The Copley Family' by J. S. Copley. National Gallery, Washington. Reproduced J. D. Prown, *John Singleton Copley* (Cambridge, Mass, 1966), II, plate 344. Two studies are reproduced Prown, plates 345 and 346.
1793	'The Red Cross Knight' by J. S. Copley. National Gallery, Washington. Reproduced Prown, II, plate 592. Study: collection of Paul Mellon, reproduced Prown, plate 593.
c 1813	Painting by J. S. Copley. Aberdare Sale, Christie's, 3 June 1932 (lot 83), bought Dunnottar. Reproduced Prown, II, plate 677.
1820	'The House of Lords, 1820' by Sir G. Hayter (NPG 999 above). Study (NPG 1695 (i) above).
c 1820	Drawing by A. Wivell. Collection of the Earl of Crawford and Balcarres. Engraved (in reverse) by T. Wright, published T. Kelly, 1820 (example in NPG).
1827	Anonymous engraving published Knight and Lacy, 1827, and T. North (examples in NPG).
1827	Engraving by T. Woolnoth, after T. Wageman, published Woolnoth, 1827 (example in British Museum).
1828	Engraving by H. Dawe and T. Wright, after A. Wivell, published Martin, 1828, and Sweet, 1837 (examples in British Museum).
1829	Engraving by T. Woolnoth, published C. Sweet, 1829 (example in British Museum), and Fisher & Co, 1830 (example in NPG), for Jerdan's 'National Portrait Gallery'; engraving by G. Stodart, after the same drawing by Woolnoth, published W. Mackenzie (example in NPG).
c 1831	Painting by H. W. Pickersgill. Exhibited *RA*, 1831 (133).
1833	'The House of Commons, 1833' by Sir G. Hayter (NPG 33 above).
1835	Drawing by Count A. D'Orsay. Sotheby's, 13 February 1950 (lot 216), bought Colnaghi. Lithographed by R. J. Lane, published J. Mitchell (example in NPG). Another drawing by D'Orsay was sold Christie's, 6 March 1873 (lot 145). A painting by D'Orsay, aided by Sir E. Landseer, is at Hughenden Manor, and the same or another was in Lady Blessington's Sale, Phillips, 7–26 May 1849 (lot 994); also in this sale were two busts (lots 193 and 1463). A bronze bust of 1846 is in the collection of R. Howard.
1836	Painting by T. Phillips (NPG 472 above).
1836	Engraving by D. Maclise, published *Fraser's Magazine*, XIV (October 1836), facing 457, as no. 77 of Maclise's 'Gallery of Illustrious Literary Characters'. Pencil study, together with another unrelated drawing: Victoria and Albert Museum.
c 1836	Water-colours by A. E. Chalon (see NPG 4121 above).
c 1836	Drawing by F. Roffe (NPG 4121 above).
1837	'The First Council of Queen Victoria' by Sir D. Wilkie. Royal Collection. Exhibited *RA*, 1838 (60). Engraved by C. Fox, published F. G. Moon, 1839 (example in British Museum).

c 1839 Painting by H. W. Pickersgill. Lincoln's Inn, London.
Exhibited *RA*, 1839 (218). Possibly the portrait engraved by G. T. Payne, published T. McLean, 1840 (example in British Museum), and 1841 (example in NPG); the hands and accessories differ, but the pose and features are the same.

1843–4 Two woodcuts, published *ILN*, II (1843), 222, and IV (1844), 105.

1844 Bust by W. Behnes. Trinity College, Cambridge.
A plaster bust by Behnes was exhibited *RA*, 1843 (1523). Another bust by Behnes is in Lincoln's Inn. One of these was probably the bust by Behnes in the Crystal Palace Portrait Collection, 1854.

1845 Engraving by W. Walker, after Sir W. C. Ross, published Walker, 1845 (example in NPG).

1846 'The Fine Arts Commissioners, 1846' by J. Partridge (NPG 342, 3 above).
Oil study, sold Partridge Sale, Christie's, 15 June 1874 (lot 71).

c 1847 Miniature by T. Carrick. Exhibited *RA*, 1847 (785).

c 1847 Coloured lithograph by A. Blaikley, published *Pictures of the People from Prince to Peasant* (1847), facing p 12.

1851 Drawing by G. Richmond (NPG 2144 above).

c 1858 Medallion by R. C. Lucas. Exhibited *RA*, 1858 (1258).
There is a wax example of this medallion in the Bethnal Green Museum.

1859 Woodcut published *ILN*, XXXIV (1859), 261.

1861 Painting by an unidentified artist (signed 'THS'). Collection of J. K. Richardson.

1862 Painting by G. F. Watts (NPG 683 above).

c 1862 Medallion by E. J. Kuntze. Exhibited *RA*, 1862 (1139).

Undated Painting by J. Sant. House of Lords.

Undated Painting attributed to G. Richmond. Christie's, 15 May 1964 (lot 186), bought Graveson.
Probably the picture in the collection of the Earl of Hardwicke, 1879, recorded by G. Scharf, 'TSB' (NPG archives), XXVI, 70.

Undated Painting called Lyndhurst by an unknown artist. Museum of Fine Arts, Boston.

Undated Lithograph by J. Dickinson (example in NPG); another by E. Desmaisons, published A. and C. Baily (example in British Museum).

Undated Engravings by J. Sartain, after G. Harlow, by A. Duncan, and an anonymous engraving (examples in NPG); another by W. D. Taylor, and an anonymous engraving (examples in British Museum).

LYONS *Edmund Lyons, 1st Baron* (*1790–1858*)

Admiral; entered the navy, 1803; served in East Indies, 1810–11, and in the Mediterranean; minister to various European countries; second-in-command of Mediterranean fleet, 1853–5, and commander-in-chief, 1855–8.

685 Oil on canvas, 24 × 19⅞ inches (60·9 × 50·5 cm), by GEORGE FREDERICK WATTS, 1856–7. PLATE 558
Signed (*bottom right*): G. F. Watts

Collections: The artist, presented by him, 1883 (see appendix on portraits by G. F. Watts in forthcoming Catalogue of Portraits, 1860–90).

Literature: 'Catalogue of Works by G. F. Watts', compiled by Mrs M. S. Watts (MS, Watts Gallery, Compton), II, 100; C. T. Bateman, *G. F. Watts, R. A.* (1901), p 51.

This portrait was painted in Constantinople. Watts had accompanied Sir Charles Newton on an archaeological expedition to Halicarnassus, and was sent back by him to Constantinople to obtain some kind of permit from the Sultan. Another three-quarter length portrait of Lyons was painted at much the same time on board Lyons' flagship, now in the collection of the Watts Gallery. A related drawing

is owned by Mrs M. Chapman, Oxford. Watts also painted Stratford de Redcliffe on this same visit to Constantinople (NPG 864).

Description: Healthy complexion, dark-blue eyes, greyish hair. Dressed in a dark green neck-tie, white shirt, and dark coat. Background colour brown and green; a sea-scene is vaguely indicated on the right and left, with a pillar or mast (?) in the centre.

ICONOGRAPHY A painting by L. Dickinson of 1855 is in the collection of the Duke of Norfolk, exhibited *SKM*, 1868 (441), *Royal Naval Exhibition*, Chelsea, 1891 (633), and *VE*, 1892 (138); a copy by W. H. Gadsby is in the United Service Club, London; a painting by Margaret Thomas is at Admiralty House, Portsmouth; there is a reproduction of a drawing by Armitage in the NPG; an enamel miniature is in the collection of the Duke of Norfolk; a marble statue by M. Noble of 1860 is in St Paul's Cathedral, reproduced Captain S. Eardley-Wilmot, *Life of Vice Admiral Lord Lyons* (1898), facing p 418; a model for the statue is reproduced as a woodcut *ILN*, XXXVII (1860), 194; the statue was presumably based on the marble bust by Noble, exhibited *RA*, 1857 (1288); a bust by W. Theed of 1858 is in the National Army Museum; a marble bust called Lyons by an unknown artist is in the collection of W. G. Julian; a marble bust by J. Loft was exhibited *RA*, 1856 (1353); an engraving by G. Zobel, after a painting by R. Buckner, was published Colnaghi, 1856 (example in NPG); a lithograph by J. H. Lynch, after a drawing belonging to Miss Lyons, was published Colnaghi, 1854 (example in NPG); there are two engravings by D. J. Pound, after photographs by Kilburn (examples in NPG), one published 'Drawing Room Portrait Gallery', 1859; an engraving by T. W. Hunt, after a photograph, was published Virtue (example in NPG); a woodcut, after a photograph by Claudet, was published *ILN*, xxv (1854), 21.

LYSTER *John* (*d 1840*)

Soldier.

4026 (40) See *Collections:* 'Drawings of Men About Town, 1832–48' by Count A. D'Orsay, p 557.

LYTTELTON *William Henry Lyttelton, 3rd Baron* (*1782–1837*)

Politician; MP from 1807; son of 1st Baron Lyttelton; succeeded to title, 1828; a prominent whig, a noted Greek scholar and an eloquent orator; lord-lieutenant of Worcestershire, 1833.

883 (15) Pencil and grey wash on paper, $5\frac{1}{8} \times 4\frac{7}{8}$ inches (13 × 10 cm), by SIR GEORGE HAYTER. PLATE 559
Inscribed in ink (bottom left): Rt hon^ble W. H. Littleton [*sic*]
Collections: A. D. Hogarth & Sons, purchased from them, 1891.

This is one of a large number of studies by Hayter, apparently for miniatures, which will be discussed collectively in the forthcoming Catalogue of Portraits, 1790–1830; no finished miniature of Lord Lyttleton by Hayter is known.

ICONOGRAPHY A painting by T. Phillips is mentioned in his 'Sitters Book' (copy of original MS, NPG archives), under the year 1831, and a replica under the year 1837; Henry Bone executed an enamel after Phillips' portrait (one example in the collection of Earl Spencer, Althorp; another in the collection of Isaac Falcke, 1865; a third in the collection of Viscount Cobham), exhibited *RA*, 1844 (994); a drawing by H. Edridge is also in the collection of Earl Spencer; a painting attributed to Sir Thomas Lawrence was at Hagley Hall, Worcs.

LYTTON *Edward George Earle Lytton Bulwer-Lytton, 1st Baron* (*1803–73*)

Novelist; married Rosina Wheeler, 1827, from whom he separated, 1836; wrote for several literary journals; published *Falkland*, 1827, and *Pelham*, 1828, with which he first made his reputation;

published numerous historical and romantic novels, which were extremely popular; MP from 1852; secretary for the colonies, 1858–9.

1277 Oil on canvas, 36 × 28½ inches (91·4 × 72·4 cm), by HENRY WILLIAM PICKERSGILL, c 1831.
PLATE 560

Inscribed on an old label on the back of the stretcher: Lord Litton [*sic*] Bulwer

Collections: Possibly the portrait in the Pickersgill Sale, Christie's, 17 July 1875 (lot 330); Southcott & Co of Bristol, purchased from them, 1900.

Exhibitions: Probably *RA*, 1831 (171).

Although the early history of this portrait was not known or investigated when it was acquired, there seems little reason to doubt that it represents Lytton. Comparison with other early portraits (see iconography below) is not conclusive, but it tends to support the identification. The portrait was accepted as the work of Pickersgill (the name of the artist was supplied by the vendors) until 1909, when an inscription was discovered in the upper right-hand corner. This was read as 'Poole', and the portrait was, therefore, re-attributed to the history painter, P. F. Poole. Poole is not known to have painted portraits, and the style of the painting is strikingly close to the work of Pickersgill. In any case, the inscription, which is very faint, even in an infra-red photograph, does not read 'Poole', and does not appear to be a signature at all. There seems little doubt that this is the Pickersgill portrait exhibited at the *RA*, in 1831, and possibly the one in the Pickersgill Sale. A copy by A. E. Dyer is in the Shire Hall, Hertford.

Description: Bluish-grey eyes, healthy complexion, light brown hair and whiskers. Dressed in a dark stock, white shirt, a waistcoat edged with red, and a dark coat. Seated in a red armchair, his elbow resting on a buff leather-bound book on a table with a red cloth. Background colour brown.

1099 Identity doubtful. Water-colour on paper, 18½ × 13⅜ inches (46·8 × 33·8 cm), attributed to ALFRED EDWARD CHALON. PLATE 561

Collections: G. M. Lane, purchased from him, 1897.

Exhibitions: Amateur Art Exhibition, 105 Piccadilly, 1897 (85).

The early history of this portrait is unknown; the identity and name of the artist were both provided by the vendor. While the features do not absolutely disagree with known portraits of Lytton, the face is broader, and the hair considerably darker, than in most of these, and the general impression is quite different. The attribution to Chalon is not very convincing; an authentic water-colour by him of the same sitter is at Knebworth (see iconography). Lytton's wife, Rosina, was a close friend of Chalon, and her letters to him have been published, *Unpublished Letters of Lady Bulwer Lytton to A. E. Chalon*, edited S. M. Ellis (1914).

Description: The water-colour is partly unfinished, particularly the figure of the sitter and the dog. Dark hair and whiskers. The Vandyck costume is not coloured. Background colour pale browns and blues.

ICONOGRAPHY This does not include photographs, of which there are several examples in the NPG (see plate 561), as well as woodcuts after photographs.

As a child	Anonymous engraving, after a painting, published O. Meredith, *Life, Letters and Literary Remains of Edward Bulwer, Lord Lytton* (1883), I, frontispiece.
As a youth	Painting by T. M. von Holst. Collection of David Cobbold, Knebworth.
1828	Water-colour by A. E. Chalon. Knebworth (plate 563). Engraved by H. Cook, published Longman (example in NPG).

c 1828 Drawing by R. M. Sully. Reproduced Earl of Lytton, *Life of Edward Bulwer, first Lord Lytton* (1913), I, facing 254.

1831 Engraving by J. Thomson, after a drawing by F. R. Say, published Colburn & Bentley, 1831 (example in NPG), for the *New Monthly Magazine*; anonymous engraving, after the same drawing, published Colburn, 1835 (example in NPG).

c 1831 Painting by H. W. Pickersgill (NPG 1277 above).

1832 'The Reform Banquet, 1832' by B. R. Haydon. Collection of Lady Mary Howick, Howick. Etched by F. Bromley, published J. C. Bromley, 1835 (example in NPG); engraved and published J. C. Bromley, 1837 (example in British Museum).

1832 Engraving by D. Maclise, published *Fraser's Magazine*, VI (August 1832), facing 112, as no. 27 of Maclise's 'Gallery of Illustrious Literary Characters'.

1837 Drawing by Count A. D'Orsay. Sotheby's, 13 February 1950 (lot 216), bought Colnaghi. Lithographed by R. J. Lane, published J. Mitchell (example in NPG); reproduced as a woodcut *ILN*, IX (1846), 380.

c 1839 Drawing by J. Doyle (with Disraeli). British Museum. Lithographed by A. Ducôte, published T. McLean, 1839 (example in NPG).

1840 Lithograph (with Count A. D'Orsay and Lady Blessington) by Sir E. Landseer (examples in Royal Collection, and collection of the Duke of Buccleuch).

1848 Drawing by R. J. Lane. Listed in Lane's 'Account Books' (NPG archives), III, 7. Engraved by G. Cook, published R. Bentley, 1848 (example in NPG). Two other drawings are listed by Lane under 1850 and 1851, the latter executed at Knebworth. One of these was engraved by H. Robinson, published Hall and Virtue (example in British Museum).

1849 Bronze bust by C. F. Bacon. Collection of H. G. Daniel, 1938.

1850 Painting by D. Maclise. Knebworth (plate 565). Exhibited *RA*, 1851 (238), *VE*, 1892 (122), and *Daniel Maclise*, Arts Council at the NPG, 1972 (62). Engraved by R. Young (detail), published Chapman & Hall, 1852 (example in NPG). Reproduced as a woodcut (detail) *ILN*, XXIX (1856), 562. Copies: Trinity Hall, Cambridge, and Hughenden Manor. A related pencil drawing is in the Victoria and Albert Museum (Library, sketchbook F48 F59, 61).

1851 Painting by E. M. Ward (in his study). Knebworth (plate 562). Exhibited *British Portraits*, RA, 1956–7 (389). This is one of a series of portraits of writers in their studies, and was purchased at the artist's sale, Christie's, 29 March 1879 (lot 83), where dated 1854 (the picture, however, is signed and dated 1851). Three drawings of Lytton by Ward of 1869 are also at Knebworth, one from life, two from memory; one of these is reproduced Mrs E. M. Ward, *Memories of Ninety Years* (nd), facing p 146.

1858 'Baron de Rothschild introduced into the House of Commons, 1858' by H. Barraud. Rothschild Collection.

1860 'The House of Commons, 1860' by J. Phillip. House of Commons. Engraved T. O. Barlow, published Agnew, 1866 (example in NPG).

1864 'The Intellect and Valour of Great Britain', engraving by C. G. Lewis, after T. J. Barker, published J. G. Browne, Leicester, 1864 (example in NPG); key-plate published Browne, 1864 (example in British Museum).

1870 Caricature by Ape (C. Pellegrini), published *Vanity Fair* (29 October 1870), 'Statesmen', no. 67.

1873 Water-colour by Sir L. Ward and T. Macquoid (standing in the great hall at Knebworth, the figure of Lytton by Ward). Knebworth. See *Art Journal* (1873), p. 88.

1873 Cartoon by F. Waddy, published Waddy's *Men of the Day* (1873), facing p 1.

Undated Painting by an unknown artist (probably after a photograph). Howes Bookshop, 1965.

Undated Painting by Valentini (in mediaeval costume, with Lady Blessington and Disraeli). Lady Blessington's Sale, Phillips, 7–26 May 1849 (lot 1063).

Undated Painting attributed to G. F. Watts. Collection of Miss M. Haythorne, 1952.

Undated Water-colour called Lytton attributed to A. E. Chalon (NPG 1099 above).

Undated Drawing by M. B. Foster. Victoria and Albert Museum.

Undated Parian-ware bust called Lytton by F. Léquine. Knebworth.

Undated Bust by an unknown artist. The Albany, London.

Undated Marble medallion by an unknown artist (inset into a mantlepiece). Knebworth.

Undated Medallion by E. W. Wyon. Exhibited *Society of Artists*, Birmingham, 1838.
Engraved for A. Collas and H. F. Chorley, *Authors of England* (1838), facing p 44.

Undated Plaster cast of his hand. Knebworth.

Undated Engraving by F. C. Lewis, after a bust by H. Burlowe, published Saunders and Otley (example in British Museum).

Undated Anonymous engraving, after a photograph, an engraving by W. Roffe, and another by F. Croll (examples in NPG), the latter for *Hoggs Instructor*.

LYVEDEN *Robert Vernon Smith, 1st Baron (1800–73)*

President of the board of control, and MP for Northampton.

54 See *Groups:* 'The House of Commons, 1833' by Sir G. Hayter, p 526.

MACAULAY *Thomas Babington Macaulay, 1st Baron (1800–59)*

Historian; son of the philanthropist, Zachary Macaulay; barrister, 1826; became a mainstay of the *Edinburgh Review*; MP from 1830; member of the supreme council of India, 1834–8; secretary at war, 1839–41; published first part of famous *History*, 1848; one of the great English intellectual figures of the 19th century.

453 Oil on canvas, $11\frac{3}{4} \times 10$ inches (29·8 × 25·4 cm), by SIR FRANCIS GRANT, 1853. PLATE 567

Inscribed (on the back): The Hon/T. B. Macaulay/by F. Grant/done from life

Collections: The artist; purchased from the Grosvenor Gallery Exhibition of 1877 by Sir William Stirling-Maxwell, Bart, and presented by him, 1877.

Exhibitions: Summer Exhibition, Grosvenor Gallery, 1877 (48); *Centenary Exhibition*, Royal Institute of Chartered Surveyors, 1968.

Literature: Sir F. Grant, 'Sitters Book' (copy of original MS, NPG archives); J. Steegman, 'Sir Francis Grant, P.R.A.: The Artist in High Society', *Apollo*, LXXIX (1964), reproduced 485.

In a letter of 7 May 1877 (NPG archives), Grant wrote: '*The small picture is the original design for the life size head painted for the late Speaker. But I always thought this small picture the best likeness of the two*'. The finished portrait is listed in Grant's 'Sitters Book', under the year 1853, exhibited *RA*, 1854 (69), and *SKM*, 1868 (463), lent by its original owner, the Rt Hon J. E. Denison, later Viscount Ossington. It was engraved by J. Faed (example in NPG). Macaulay records several sittings for the portrait in his 'Journal' (Trinity College, Cambridge) for May and June 1853; he thought the finished work 'excellent'.

Correspondence from the artist, Stirling-Maxwell and others relating to the portrait and its purchase

is in the NPG archives. After buying the portrait, Stirling-Maxwell asked to keep it for a short time in order to have it copied. On his death in January 1878 it was still in his possession, and did not enter the collection until October 1880.

Description: Brown eyes, grey hair. Dressed in a dark stock, white shirt, brown waistcoat and black coat. Seated in a wooden chair. Background colour brown.

1564 Oil on canvas, 37 × 29¼ inches (94 × 74·3 cm), by JOHN PARTRIDGE, *c* 1849–53. PLATE 569

Collections: The artist; Partridge Sale, Christie's, 15 June 1874 (lot 69); Viscountess Knutsford, presented by her husband, Viscount Knutsford, in accordance with her wishes, 1910.

Exhibitions: 'Pictures in Mr Partridge's Gallery', 1851 (copy of catalogue in NPG archives); *VE*, 1892 (209).

Literature: T. Macaulay, *History of England*, edited by C. H. Firth (1913), I, reproduced vii; R. L. Ormond, 'John Partridge and the Fine Arts Commissioners', *Burlington Magazine*, CIX (1967), 401, reproduced 400.

Like Partridge's portraits of Lord Aberdeen (NPG 750), Lord Melbourne (NPG 941), and Lord Palmerston (NPG 1025), this portrait is closely related to the figure of Macaulay in Partridge's group 'The Fine Arts Commissioners' (see NPG 342 below), and was presumably painted as a finished study for it. Macaulay is shown in an interior with three books of Dante's *Divine Comedy* on the table behind him, an indication of his lifelong interest in Dante. He is holding a book of illustrations to the *Divine Comedy* by John Flaxman, the illustration which is visible being that to Canto 21 of *The Inferno*, concerning 'The Bridge' ('e i diaboli si fecer tutti avanti'). Flaxman's designs were first published in Rome by T. Piroli in 1793, but Macaulay is probably holding the first English edition of 1807, also with Piroli's engravings. Partridge painted all the Fine Arts Commissioners individually from 1844 onwards, and retained these portraits himself, many of which he exhibited at his own gallery, following his refusal to exhibit at the Royal Academy after 1846. At his death in 1872, his executors attempted to sell these portraits to the original sitters or their descendants, auctioning the remainder, including this one, at Christie's in 1874. The sizes of the various studies for the finished group do vary. In the case of Lord Melbourne there was both a kitcat size study (ie the size of this portrait), and a larger one (see NPG 941), and the same appears to be true of Lord Palmerston. There is, however, no trace of a larger study of Lord Macaulay.

In the past, the date 1846 has been given to all Partridge's portraits of the Fine Arts Commissioners, and to the finished group, presumably because this was the date of the meeting depicted. It is clear, however, from contemporary evidence that the big picture was still in progress in 1853. A letter from Macaulay to Partridge, dated 21 February 1849 (NPG archives), informs the artist that he will call on Thursday to sit for his portrait, and hopes one sitting will be sufficient. He also mentions the group and another sitting for it in letters of 30 May 1849 (collection of Dr A. N. L. Munby, Cambridge), and 25 April 1853 (on loan to University of Nottingham), and in his 'Journal' for 26 April 1853 (Trinity College, Cambridge); see entry for NPG 342 for more details of these (see below). A copy of NPG 1564 by A. C. Dyer is in the Victoria Memorial Hall, Calcutta.

Description: Fresh complexion, hazel-coloured eyes, dark hair and eyebrows with grey streaks. Dressed in a white collar and dark green coat with black velvet(?) collar. Seated in a chair with red leather covering. On left open book, with gilt and glass inkstand, and a quill pen. Behind two shelves, both with three leather-bound volumes. The rest of the background consists of a deep red curtain.

257 Bronze medallion, 9⅝ inches (24·5 cm) diameter, by BARON CARLO MAROCHETTI, 1848. PLATE 571

Incised (below shoulder): C.M.1848 *and (right hand side):* T. B. Macaulay

Collections: Purchased at the Marochetti Sale, Christie's, 7 May 1868 (lot 98).

Literature: Lord Macaulay, *History of England*, edited C. H. Firth (1913), I, reproduced xi.

A similar bronze medallion was exhibited *VE*, 1892 (1070), lent by Viscountess Knutsford, reproduced the *Bookman*, XLVII (October 1914), 11; another is in the collection of the National Liberal Club; a third is in the Scottish NPG; and a fourth is at Wallington (National Trust), Northumberland, possibly the Knutsford one.

54 See *Groups:* 'The House of Commons, 1833' by Sir G. Hayter, p 526.

342, 3 See *Groups:* 'The Fine Arts Commissioners, 1846' by J. Partridge, p 545.

ICONOGRAPHY This does not include photographs, of which there are several examples in the NPG (see plate 568), or caricatures. Several of the portraits are mentioned by Macaulay in his 'Journal' (Trinity College, Cambridge). I am grateful to Thomas Pinney of Pomona College, California, for his improvements and additions to the list.

1832 'The Reform Banquet, 1832' by B. R. Haydon. Collection of Lady Mary Howick.
Etched by F. Bromley, published J. C. Bromley, 1835 (example in NPG); engraved and published by J. C. Bromley, 1837 (example in British Museum).

1832 'The Reform Bill Receiving the King's Assent' by S. W. Reynolds. Houses of Parliament.
Engraved by W. Walker and S. W. Reynolds junior, published Walker, 1836 (example in NPG).
The painting is based on a drawing by J. Doyle, also in the Houses of Parliament.

1832 Lithograph by Inchbold, after I. Atkinson, published W. Parsons, 1832 (example in Trinity College, Cambridge).

c 1832 Lithograph by L. Haghe, after J. N. Rhodes (example in British Museum). Connected with Macaulay's election in 1832. Another lithograph said to be by Haghe, of apparently similar date, is also in the British Museum.

1833 'The House of Commons, 1833' by Sir G. Hayter (NPG 54 above).
Oil study, Hayter Sale, Christie's, 19–21 April 1871 (lot 533); Macaulay records sitting to Hayter in 1838.

1833 Painting by S. W. Reynolds junior. Collection of Mrs R. Errington.
Engraved by S. W. Reynolds senior, and published by him, 1833 (example in NPG, plate 566).

c 1834 Engraving by T. Illman, said to be after an original drawing of 1834, published Macaulay's *History of England* (1849 edition), I, frontispiece; Macaulay left for India in February 1834, so the date may be inaccurate.

c 1842 Painting called Macaulay and attributed to W. Mulready (in his study, with an unknown man). Collection of S. Wise, 1930. The man identified as Macaulay is reading a volume inscribed 'Lays of Rome', and there is a copy of the *Times* of 1842 on the desk (Macaulay published 'The Lays of Ancient Rome' in 1842); the features, however, do not agree very well with authentic portraits of Macaulay.

1844 Drawing by G. Richmond. Collection of Sir William Dugdale, Bart. Exhibited *VE*, 1892 (365), and *Victorian Era Exhibition*, 1897, 'Historical Section' (241a). Listed in Richmond's 'Sitters Book' (photostat of original MS, NPG archives), p 35, under 1844. Possibly the portrait which Effie Gray (later Mrs Ruskin, secondly Lady Millais) recorded seeing at the house of Sir Robert Inglis, together with one of Hallam, in a letter of 2 December 1848; see Admiral Sir W. James, *The Order of Release* (1947), p 135.

1844–5 Painting by H. Inman. Pennsylvania Academy of Fine Arts, Philadelphia.
Engraved by J. Sartain for Macaulay's *Critical and Miscellaneous Essays* (Modern British Essayists, I, Philadelphia, 1849), frontispiece.

1846 'The Fine Arts Commissioners, 1846' by J. Partridge (NPG 342, 3 above).
Study (NPG 1564 above).

1846 Plaster bust by P. Park. National Trust, Wallington, Northumberland.
Reproduced as a woodcut *ILN*, XVI (1850), 280.

1846 Woodcut published *ILN*, VIII (1846), 348.

1847 Miniature called Macaulay by J. Simpson. Christie's, 15 October 1951 (lot 56).

1847 Drawing by J. Doyle. Reproduced Macaulay, *History of England*, edited by C. H. Firth (1913), I, viii. Two caricature drawings by Doyle are in the British Museum.

1848 Bronze medallion by Baron C. Marochetti (NPG 257 above).

1849 Painting by E. U. Eddis. Apparently the painting engraved by W. Greatbach, published Longman, 1850 (example in NPG), for the first one-volume edition of Macaulay's *Critical and Historical Essays*. Macaulay recorded sittings in his 'Journal', April-May 1849. In February 1850, he mentioned the artist's disappointment with this portrait, and sat for a drawing in March (see below).

1850 Painting by Sir J. Watson Gordon. University of Glasgow. Engraved by J. Faed, published J. Keith, Edinburgh, 1851 (example in British Museum).

1850 Painting by Sir J. Watson Gordon. Scottish NPG. Similar to the painting above, but not a study for it.

1850 Drawing by G. Richmond. Exhibited *SKM*, 1868 (403), lent by Lady Trevelyan. Listed in Richmond's 'Sitters Book' (photostat of original MS, NPG archives), p 50, under 1850.
Engraved by W. Holl, 1861 (according to Richmond's 'Sitters Book') (example in NPG), published 1866 for *The Works of Lord Macaulay*, edited Lady Trevelyan, I, frontispiece. The same or another version was exhibited *VE*, 1892 (366), lent by Viscountess Knutsford.

1850 Drawing by E. U. Eddis. Exhibited *RA*, 1850 (808). A first sitting is recorded by Macaulay in his 'Journal', 1 March 1850; the drawing was finished on 25 March. Engraved by J. Brown, published 1852 (example in NPG), for *Bentley's Miscellany*. A painting, in which the head appears to be based on the drawing, was in the collection of T. N. Longman, 1931, reproduced *Works of Lord Macaulay* (Albany edition, 1898), XII, frontispiece. Either this or another painting by Eddis was in the collection of Dr Nicolls, Hastings, 1938. Further sittings are recorded in the 'Journal' in 1852.

1853 Painting by E. M. Ward (in the sitter's study at the Albany). Ward Sale, Christie's, 29 March 1879 (lot 82), and Hurst Sale, 25 April 1899 (lot 125), bought Agnew (plate 570). Exhibited *SKM*, 1868 (538), and *VE*, 1892 (330). Acquired by NPG, 1972 (NPG 4882), see appendix, 568.

1853 Painting by Sir F. Grant. Formerly collection of Viscount Ossington.
Exhibited *RA*, 1854 (69), and *SKM*, 1868 (463). Study (NPG 453 above).

c 1856 Medallion by D. Hewlett. Exhibited *RA*, 1856 (1276).

1860 Painting by J. B. Brenan (after a photograph by Maull and Polyblank of 1856). Collection of Lady Wise.

1860 Drawing of Macaulay's funeral by Sir G. Scharf. NPG 2689.

1860 Woodcut published *ILN*, XXXVI (1860), 45 (in his library).

c 1863 Sketch for a statue by J. F. Redfern. Exhibited *RA*, 1863 (1098).

1864 'The Intellect and Valour of Great Britain', engraving by C. G. Lewis, after T. J. Barker, published J. G. Browne, Leicester, 1864 (example in NPG); key-plate published Browne, 1863 (example in British Museum).

1866 Marble bust by G. Burnard. Westminster Abbey.
Erroneously listed as by N. N. Burnard, and misdated 1859, in R. Gunnis, *Dictionary of British Sculptors* (1953), p 71.

1868 Marble statue by T. Woolner. Trinity College, Cambridge (plate 572).

1880 Painting by J. Archer (after a photograph by Claudet of *c* 1856). Reform Club, London.

Undated Various lithographs and engravings (examples in NPG and British Museum).

McCLINTOCK *Sir Francis Leopold* *(1819–1907)*

Admiral; entered navy, 1831; served under Sir J.C.Ross, Sir E.Ommaney and others on various Arctic voyages; commanded expedition in search of Franklin, 1857–9; published account of his voyage and fate of Franklin, 1859; commodore in charge at Jamaica, 1865–8; superintendent of Portsmouth dockyard, 1872–7; admiral, 1884.

919 Oil on canvas, $15\frac{1}{2} \times 12\frac{5}{8}$ inches (39·2 × 32·1 cm), by STEPHEN PEARCE, after a portrait of 1856. PLATE 574

Collections: See *Collections:* 'Arctic Explorers' by S.Pearce, p562.

This is a replica of NPG 1226 below, and was commissioned by Lady Franklin.

Description: As for NPG 1226 below.

1211 Oil on canvas, 50 × $40\frac{1}{8}$ inches (127 × 102 cm), by STEPHEN PEARCE, 1859. PLATE 575

Inscribed in ink on a label on the back, in the artist's hand: № 1. CAPTAIN/SIR F. LEOPOLD MᶜCLINTOCK./ R.N: L.L.D: &C. &C. &C. LATE/COMMANDING LADY FRANKLIN'S ARCTIC/DISCOVERY YACHT. "FOX."/PAINTED BY STEPHEN PEARCE/54 Queen Anne Street./Cavendish Square

Collections: See *Collections:* 'Arctic Explorers' by S.Pearce, p562.

Exhibitions: RA, 1860 (242); probably the portrait (or NPG 1226 below) in the *Royal Naval Exhibition*, Chelsea, 1891 (50).

Literature: S.Pearce, *Memories of the Past* (1903), pp67 and 69, reproduced facing p66.

The head in this portrait is apparently based on the smaller study of McClintock by Pearce (NPG 1226 below). McClintock is shown in the costume he wore on his voyage to the Arctic in 1859, against an idealized polar landscape; the ship is presumably the 'Fox'. The overall jumper, overall trousers and hat, as shown in the portrait, are in the National Maritime Museum, Greenwich. The date was provided by the artist in a memorandum of *c*1899 (NPG archives).

Description: Healthy complexion, bluish-grey eyes, brown hair and whiskers. Dressed in a white collar, a natural linen overall jumper and overall trousers ('snow-repellers'), with brown gloves edged with fur, holding a black tarpaulin hat, black leather telescope case, white powder and shot pouch on a brown bandolier, carrying brown double-barrelled shot-gun. Whitish-grey and greyish-blue snowscape. Background colour various tones of orange, grey and brown.

1226 Oil on millboard, $15\frac{1}{8} \times 12\frac{3}{4}$ inches (38·4 × 32·4 cm), by STEPHEN PEARCE, 1856. PLATE 573

Collections: See *Collections:* 'Arctic Explorers', by S.Pearce, p562.

Exhibitions: RA, 1857 (40); possibly the portrait (or NPG 1211 above) in the *Royal Naval Exhibition*, Chelsea, 1891 (50).

The head in this portrait is almost identical with the larger portrait of McClintock (NPG 1211 above), but the pose, costume and setting are entirely different. McClintock is wearing the full-dress uniform of a naval captain (1856 pattern) with less than three years service, and the Arctic Medal (1818–55). Either this portrait, or NPG 919 above, was engraved by H.Davis, published Graves, 1860 (example in British Museum). The date was provided by the artist in a memorandum of *c*1899 (NPG archives).

Description: Healthy complexion, dark bluish(?) eyes, dark brown hair and whiskers. Dressed in a white shirt, and dark blue naval uniform, with gold-braided collar and epaulettes, gilt buttons, and a silver medal with grey ribbon. Background colour dark brown.

ICONOGRAPHY A painting by F.Yates of 1890 is in the collection of John McClintock and Mrs M.McClintock, exhibited *First Annual Exhibition*, Royal Society of Portrait Painters, 1891 (27), and *Great Irishmen*, Ulster Museum, Belfast, 1965 (124); a painting by R.Dowling was exhibited *RA*, 1880 (390); a marble bust by J.R.Kirk is in the Royal Dublin Society, exhibited *Royal Hibernian Academy*, 1862; a woodcut, after a

photograph by Beard, was published *ILN*, xx (1852), 336, and an engraving by D. J. Pound, after a photograph by Cheyne, was published 1861 (example in NPG), for the 'Drawing Room Portrait Gallery'; there are various photographs and engravings in the NPG.

McCLURE *Sir Robert John Le Mesurier* (*1807–73*)

Vice-admiral; entered navy, 1824; made Arctic voyage, 1836–7; commander in search of Franklin, 1850–4; discovered the North-West passage, 1854, but had to abandon his ship; court-martialled, but honourably acquitted; served in China, 1856–61; vice-admiral, 1873.

1210 Oil on canvas, 50⅛ × 40 inches (127·3 × 101·5 cm), by STEPHEN PEARCE, 1855. PLATE 576

Collections: See Collections: 'Arctic Explorers' by S. Pearce, p 562.

Exhibitions: RA, 1855 (236); *Art Treasures of the United Kingdom*, Manchester, 1857, 'Modern Masters' (485); *Royal Naval Exhibition*, Chelsea, 1891 (43); *Pageant of Canada*, National Gallery of Canada, Ottawa, 1967–8 (153), reproduced in catalogue.

Literature: Art Journal (1855), p174; S. Pearce, *Memories of the Past* (1903), pp69–70, reproduced facing p68; single-sheet pamphlet relating to the engraving, published Graves (copy in NPG library).

McClure is shown in the costume he wore on his Arctic expedition, 1850–4, set against an idealized polar landscape. The portrait was engraved by J. Scott, published H. Graves (example in NPG), the engraving dedicated to Queen Victoria; it was also engraved by J. H. Baker, published Longman (example in NPG). This is the only recorded portrait of McClure.

Description: Healthy complexion, blue eyes, brown hair and whiskers. Dressed in a white shirt, dark stock, black and white check scarf, heavy white jacket, with canvas gun-bag and strap, leather gun-straps and gun, leather-covered telescope, dark trousers, and black fur-lined gloves. Greenish-white landscape at left, and seascape at right. Background sky of whitish-grey and dark grey tones.

McCORMICK *Robert* (*1800–90*)

Naval surgeon, explorer and naturalist; entered navy, 1823; served on various stations; went on expedition to Antarctic under Sir J. C. Ross, 1839–43; conducted a search for Franklin, 1852; published an account of his voyages, 1884.

1216 Oil on canvas, 15½ × 12⅞ inches (39·4 × 32·8 cm), by STEPHEN PEARCE, c 1856. PLATE 577

Collections: See Collections: 'Arctic Explorers' by S. Pearce, p 562.

Exhibitions: RA, 1856 (315); *Royal Naval Exhibition*, Chelsea, 1891 (52).

McCormick is shown in the full-dress uniform of a deputy inspector-general of hospitals and fleets (1856 pattern), and the Arctic Medal (1818–55). This is the only recorded portrait of him apart from a lithograph reproduced R. McCormick, *Voyages of Discovery etc* (1884), I, frontispiece.

Description: Dark complexion, dark blue (?) eyes, brown hair. Dressed in a dark stock, white shirt, and dark blue naval uniform, with gold-braided collar and epaulettes, gilt buttons, and a silver medal with a grey ribbon. Background colour dark grey.

McCULLOCH *John Ramsay* (*1789–1864*)

Statistician and political economist; edited *Scotsman*, 1818–20; contributed to *Edinburgh Review*, 1818–37; published *Principles of Political Economy*, 1825; professor of political economy, London University, 1828–32; comptroller of Stationery Office, 1838–64; published several works on statistics and economics.

677 Oil on canvas, 56½ × 44¼ inches (143·5 × 112·4 cm), by SIR DANIEL MACNEE, c 1840. PLATE 578

Collections: Commissioned by Mr Jardine and bequeathed or presented by him to the sitter's widow, Mrs McCulloch; by descent to her daughter, Mrs Margaret Cox, and bequeathed by her, 1883.

Exhibitions: RA, 1840 (385).

According to Mr Reid, the sitter's son-in-law (postscript to a letter from his son, J.R.Reid, 28 April 1883, NPG archives), this portrait was painted for Mr Jardine, a government engineer; it was hanging in the old Stationery Office around 1840, presumably soon after it was painted.

Description: Dark complexion, brown eyes and hair. Dressed in a dark stock, white shirt, black waistcoat and suit. Holding a brown, leather-bound volume of Adam Smith's *Wealth of Nations*, on a red-figured table-cloth, on which are also papers, books and a gilt inkstand. Behind is a greenish globe. Behind the sitter on the left is an armchair covered in red velvet, and a red-figured curtain which covers most of the background. Strip on the right dark brown.

ICONOGRAPHY A painting by B.R.Faulkner is in the Royal Society, London; a drawing by W.Bewick is in the Scottish NPG; a bust by P.Slater was exhibited *RA*, 1855 (1472); there is an anonymous lithograph (example in NPG); a woodcut, after a photograph by J. & C.Watkins, was published *ILN*, XLV (1864), 541.

MACDONELL *Sir James* (*d 1857*)

General; fought in Naples, Sicily, and Egypt, 1804–7; served in the Peninsula, 1812–14; present at Waterloo, 1815; commanded in Canada, 1838–41; general, 1854.

3735 Oil on canvas, $21 \times 16\frac{7}{8}$ inches ($53\cdot3 \times 42\cdot8$ cm), by WILLIAM SALTER, *c* 1834–40. PLATE 580

Collections: By descent to W.D.Mackenzie, who also owned the group portrait, and bequeathed by him, 1929.

This is one of several studies in the NPG for Salter's large picture of the 'Waterloo Banquet at Apsley House', in the collection of the present Duke of Wellington; the group portrait was engraved by W.Greatbach, published F.G.Moon, 1846 (example in NPG). The NPG studies will be collectively discussed in the forthcoming Catalogue of Portraits, 1790–1830. Macdonell is shown in the uniform of a lieutenant-general. According to Miss Reade, the granddaughter of the sitter and the vendor of NPG 2656 below, Macdonell was no longer alive when Salter painted his picture of the banquet, and made use of NPG 2656 which Macdonell's widow lent him (letter of 22 February 1934). This does not tie in with the date of Salter's picture, the date of Macdonell's death, or comparison with the miniature.

Description: Healthy complexion, greyish eyes, sandy hair. Dressed in a red uniform, with gold-braided collar, epaulettes, tassels and cuffs, multi-coloured medals, red and gold sword-belt, sword with gilt handle and tassel, white trousers, holding a black and gold-braided hat with red and white feathers. Background colour various tones of dark green and brown; green seascape lower right.

2656 Miniature, water-colour and body colour on ivory, $6\frac{3}{8} \times 5$ inches ($16\cdot2 \times 12\cdot7$ cm) oval, by an UNKNOWN ARTIST. PLATE 579

Collections: By descent to Miss Julia Reade (granddaughter of the sitter), and purchased from her, 1934.

According to the vendor, this portrait was used by W.Salter for his large painting of 'The Waterloo Banquet, 1836' (see NPG 3735 above), but the comparison between the two is not very close. Macdonell is shown with the star of the Bath and several other medals.

Description: Blue eyes, brown hair. Dressed in a red uniform, with gold-braided epaulettes, neck, cuffs and sword-belt, various medals, dark-blue trousers with gold stripe. Background colour green. There is a crack down the middle of the miniature.

ICONOGRAPHY A painting by F.R.Say is in the Scottish NPG, and another version is in the United

Service Club, London, one of which was exhibited *R A*, 1846 (21), and engraved by and published W. Walker, 1850 (example in British Museum).

McDONNELL *Rev T. M.*

Slavery abolitionist.

599 See *Groups:* 'The Anti-Slavery Society Convention, 1840' by B. R. Haydon, p 538.

MACFARLANE *Charles (d 1858)*

Miscellaneous writer; travelled in Italy, 1816–27, in Turkey, 1827–9; supported himself by literary work; travelled again, 1847–8; poor brother of the Charterhouse, 1857; best known for his *Civil and Military History of England*, 1838–44, and *The Book of Table Talk*, 1836.

2515 (60) Black and red chalk, with touches of Chinese white, on green-tinted paper, $14\frac{1}{2} \times 10\frac{1}{2}$ inches (36.8 × 26.5 cm), by WILLIAM BROCKEDON, 1832. PLATE 581

Dated (left centre): 19.9.32.

Collections: See *Collections:* 'Drawings of Prominent People, 1823–49' by W. Brockedon, p 554.

Accompanied in the Brockedon Album by an undated letter from the sitter. This is the only recorded portrait of Macfarlane.

MACLEOD *Roderick (1768–1853)*

MP for Sutherland.

54 See *Groups:* 'The House of Commons, 1833' by Sir G. Hayter, p 526.

MACLISE *Daniel (1806–70)*

Historical painter; born in Cork; studied at RA schools; established reputation with burlesque, genre and literary pictures; also executed portrait drawings, oils and caricatures; painted frescoes in Houses of Parliament, including his famous 'Meeting of Wellington and Blücher at Waterloo' and the 'Death of Nelson'.

616 Oil on panel, $18 \times 13\frac{7}{8}$ inches (45.7 × 35.2 cm), by EDWARD MATTHEW WARD, 1846. PLATE 584

Signed and dated (bottom right): E M Ward/1846 *Inscribed on the back:* Daniel Maclise Esq RA/EM Ward 1846

Collections: Ward Sale, Christie's, 29 March 1879 (lot 86), purchased by G. Scharf, and presented by him, 1880.

Exhibitions: R A, 1847 (531); *Dublin Exhibition*, 1872, 'Portraits' (241); *Daniel Maclise*, Arts Council at the NPG, 1972 (133).

This portrait was engraved by J. Smyth for the *Art-Union* (1847), facing p 164.

Description: Healthy complexion, brown eyes, brown hair and reddish whiskers. Dressed in a black neck-tie, white shirt, green waistcoat, with a silver watch-chain, dark grey coat, and fawn trousers. Seated in a brown leather-covered armchair. Dark green and gold figured curtain behind at left. Rest of background colour brown.

1456 (19) Black chalk on grey-tinted paper, heightened with Chinese white, $3\frac{1}{8} \times 3\frac{1}{8}$ inches (7.9 × 7.9 cm), by CHARLES HUTTON LEAR, 1845. PLATE 582

Inscribed (bottom left): M^cClise *and (lower right):* Dec^r – 5/1845

Collections: See *Collections:* 'Drawings of Artists, *c* 1845' by C. H. Lear, p 561.

Exhibitions: Daniel Maclise, Arts Council at the NPG, 1972 (134).

Literature: R. L. Ormond, 'Victorian Student's Secret Portraits', *Country Life*, CXLI (February 1967), 288–9, reproduced.

This drawing and the one below were both executed in the life school of the Royal Academy, where Lear was a student, and were sent by him to his family with an undated letter (copy in NPG archives): '*Nos. 1 and 2 are sketches of Maclise*'. Maclise was a visitor at the life school in 1845 and 1846.

1456 (20) Black chalk on grey-tinted paper, heightened with Chinese white, $3\frac{1}{2} \times 3\frac{7}{8}$ inches ($8\cdot9 \times 9\cdot8$ cm), by CHARLES HUTTON LEAR, 1845. PLATE 583

Inscribed (bottom left): M^cClise *and (lower right):* Dec/45

Collections: As for 1456 (19) above.

Exhibitions: As for 1456 (19) above.

2476 With two heads of Solomon Hart, and another of an unidentified man. Pencil on paper, $6\frac{1}{2} \times 3\frac{3}{4}$ inches ($16\cdot5 \times 9\cdot5$ cm), by CHARLES BELL BIRCH, *c*1858. PLATE 585

Inscribed in pencil (top centre): D Maclise R.A. *and (above):* S. Hart R.A.

Collections: See *Collections:* 'Drawings of Royal Academicians, *c*1858' by C. B. Birch, p565.

ICONOGRAPHY This does not include photographs, of which there are several examples in the NPG.

1829 Water-colour by himself. Irish NPG.

Exhibited *Daniel Maclise*, Arts Council at the NPG 1972 (131). Reproduced W. G. Strickland, *Dictionary of Irish Artists* (1913), II, plate XL. Engraved by Millard as the frontispiece to W. J. O'Driscoll, *A Memoir of Daniel Maclise* (1871). Another version is in the Museum of Fine Arts, Boston.

c1830 Painting possibly by himself. Collection of H. R. Taylor, Virginia. Given by Maclise's nieces to W. J. O'Driscoll, the artist's biographer.

c1840 Painting by W. Bewick. Exhibited *RA*, 1840 (456).

c1840 Bust by E. Davis. Exhibited *RA*, 1840 (1077).

1842 Drawing by C. Stanfield (with Forster, Dickens and the artist in Cornwall). Victoria and Albert Museum. Exhibited *Charles Dickens*, Victoria and Albert Museum, 1970 (D9).

1844 Drawing by T. Bridgford. Irish NPG. Exhibited *Royal Hibernian Academy*, 1845. Reproduced Strickland, II, plate XL. Anonymously engraved for the *Dublin University Magazine* (May 1847), facing p594.

1844 Drawing by himself (with others, listening to Dickens reading *The Chimes*). Victoria and Albert Museum. Exhibited *Charles Dickens*, Victoria and Albert Museum, 1970 (H10), reproduced in catalogue.

1845 Two drawings by C. H. Lear (NPG 1456 (19 and 20) above).

1845 Woodcut by C. Martin, published *ILN*, VI (1845), 292.

1846 Painting by E. M. Ward (NPG 616 above).

c1846–9 Drawing by C. W. Cope (painting a fresco in House of Lords). House of Lords.

1857 Lithograph by C. Baugniet, published E. Gambart, 1857 (example in NPG).

1857 Woodcut from an unidentified magazine (cutting in NPG).

c1858 Drawing by C. B. Birch (NPG 2476 above).

c1859 Marble bust, and a replica of the same, by J. Thomas. Irish NPG. One of these exhibited *RA*, 1859 (1293).

1864 'The Intellect and Valour of Great Britain', engraving by C. G. Lewis, after T. J. Barker, published

J.G.Browne, Leicester, 1864 (example in NPG); key-plate published Browne, 1863 (example in British Museum).

c1866 Painting by J.Ballantyne (at work on the 'Death of Nelson' in the House of Lords). Exhibited *RA*, 1866 (414).

1871 Marble bust by E.Davis. Royal Academy. Exhibited *RA*, 1871 (1305), and *Daniel Maclise*, Arts Council at the NPG 1972 (135). Presumably related to the bust of 1840 (see above).

1878 Medal by A.B.Wyon, issued by the Art Union (example in NPG).

Undated Several drawings by himself. Victoria and Albert Museum. One of these is reproduced *Art Journal* (1888), p132.

Undated Drawing by Count A.D'Orsay. Sotheby's, 13 February 1950 (lot 216), bought Colnaghi.

Undated Miniature by an unknown artist. Offered to the Royal Academy by a Mr Rafe, 16 July 1878, but declined (see 'Council Minutes').

Undated Woodcut by M.Jackson, after T.Scott (example in British Museum).

Undated Etching by M.Menpes, and an anonymous woodcut (examples in British Museum).

Undated Lithograph by an unknown artist, published in *A Gallery of Illustrious Literary Characters . . . by the late Daniel Maclise*, edited W.Bates (1873), facing p228.

MACNAGHTEN *Sir William Hay, Bart* (*1793–1841*)

Diplomatist; went to India, 1809; served in various administrative posts; appointed envoy to the Afghan court at Kabul, 1838; nominated governor of Bombay, 1841, but shot by the rebels in Kabul before he could take up his post.

749 Water-colour on paper, $7\frac{1}{4} \times 5\frac{7}{8}$ inches (18·4 × 14·9 cm), by JAMES ATKINSON, 1841. PLATE 586

Inscribed in pencil in the artist's hand, on the original mount: Sir William Hay Macnaghten Bart./ drawn at Jelallabad. Jan^y 13. 1841/and we parted on the 15th alas, for ever;/I, on my return to India, and he to Cabul/to perish by the hand of an assassin/J.A.

Collections: The artist, presented by his son, Canon J.A.Atkinson, 1885.

Several other portraits by Atkinson were presented by his son, including a self-portrait (NPG 930).

Description: Healthy complexion, brown moustache, white side-whiskers, wearing bluish glasses. Dressed in a dark neck-tie, white shirt, black coat and top hat.

ICONOGRAPHY The only other recorded portrait of Macnaghten is a lithograph by L.Dickinson, after a miniature in the possession of the sitter's family, published 1843 (example in NPG), for *Portraits of the Cabul Prisoners*.

MACREADY *William Charles* (*1793–1873*)

Actor; made his first appearance at Birmingham as Romeo, 1810; acted with his father's company in the provinces; first appeared at Covent Garden, 1816; undisputed head of the theatre after his Richard III, 1819, until his retirement, 1851; a great Shakespearian and romantic actor.

1503 Oil on canvas, $36 \times 24\frac{1}{4}$ inches (91·5 × 61·6 cm), by JOHN JACKSON, 1821. PLATE 588

Collections: The sitter, bequeathed by him, 1873, with a life interest for his wife; she presented it in 1908.

Exhibitions: British Institution, 1823 (201); *Shakespeare and the Theatre*, Guildhall Art Gallery, May–June 1964 (3).

Literature: Macready's Reminiscences and Selections from his Diaries, edited Sir Frederick Pollock (1875), I, 229–30; *The Diaries of W. M. Macready, 1833–1851*, edited W. Toynbee (1912), I, 3 n.

This portrait of Macready shows him in the character of Shakespeare's 'Henry IV', in part II, which he played at the Drury Lane Theatre on 25 June 1821, in celebration of the Coronation of George IV. The portrait was originally commissioned by Charles Mathews for his 'Gallery of Theatrical Notables'. Macready wrote of it (*Reminiscences*, p 229):

The picture had made considerable progress, when Fawcett called with me one day to see it. On coming out from Jackson's studio, he exclaimed, 'Why, William, you must not give that picture away – Jackson has never done anything like it!' When I reported this to Jackson, his quiet answer was, "Well: it is very easy to paint another; you would not mind paying for the ground colours being rubbed in by another hand, would you?" My objections were vain to this proposal of my most liberal friend. His pupil made a rough copy of the picture, which Jackson, putting the first draft aside, finished at once. I sent it with a kind note to Mathews, from whom I received this answer:

Dear Macready, – It is not in my power to express satisfactorily to myself my feelings of surprise and pleasure on the receipt of your splendid present, and the gratifying letter that accompanied it The picture is a most beautiful work of art, and a perfect resemblance . . . It was seen by many persons yesterday and universally admired. It is as great an ornament to my gallery as its original is to the profession and sphere he moves in.

The Mathews version is now in the Garrick Club, London; it was lithographed by R. J. Lane, published Ackermann, 1824 (example in British Museum), and engraved by C. H. Jeens for the title-page of *Macready's Reminiscences*, I. According to Macready, the original version was not finished till late in the same year, and he erroneously states that it was then exhibited at the 'British Gallery, Pall Mall': it was not exhibited there until 1823.

Jackson executed a drawing of Macready in the character of Virginius in 1820, engraved by C. Picart, published Colnaghi, 1830, and by C. H. Jeens (examples in NPG), and later a painting of him as Macbeth ('Hark! who lies i' the second chamber!'), formerly in the collection of Major-General C. F. N. Macready, reproduced *Diaries, 1833–1851*, II, facing 224, exhibited *RA*, 1821 (333). Macready became very devoted to the artist, writing that '*as intimacy developed to me more and more the simplicity and benevolence of his nature, my attachment to him kept pace in its growth with my admiration of his genius during his life, and still clings warmly to his memory*' (*Macready's Reminiscences*, I, 213). Macready attended Jackson's funeral on 9 June 1831, and made a donation to his widow.

Description: Dark eyes. Dressed in a dark red and gold under-garment, green and white over-garment and a red head-dress. Background colour very dark brown.

3017 Water-colour on paper, $8\frac{1}{4} \times 6\frac{1}{2}$ inches ($21 \times 16 \cdot 5$ cm), by an UNKNOWN ARTIST, *c*1870. PLATE 592

Collections: Purchased from A. Yakovleff, 1939.

Mounted with this water-colour is the following autograph (fragment of a letter): '*I remain,/Sir,/Your very obedient servant/W. C. Macready,/Tms. Phillips, Esq.*' In the past the 'T' of 'Tms' has been read as a 'J', and the water-colour attributed to John Phillip. It seems more probable that the letter was addressed to the portrait-painter, Thomas Phillips (1770–1845). As the portrait is based on a photograph by H. N. King, taken in Macready's old age, when Phillips was dead, the autograph evidently does not relate to the water-colour.

Description: Blue eyes, grey hair. Dressed in a light stock, white shirt and black coat.

3329 Water-colour on paper, stuck on canvas, $42\frac{1}{2} \times 26\frac{7}{8}$ inches ($108 \times 68 \cdot 2$ cm), attributed to DANIEL MACLISE. PLATE 589

Collections: J. H. Leigh; sold Christie's, 7 July 1916 (lot 141), bought Glassier; Christie's, 22 November 1946 (lot 95), bought Leggatt Brothers, and purchased from them, 1947.

An authentic oil portrait of Macready by Maclise, painted in 1835, is at the Drury Lane Theatre (reproduced *The Diaries of Macready*, I, facing 272). In 1836 Maclise painted Macready as Macbeth, in the scene with the weird sisters, exhibited *RA*, 1836 (22). In 1849 he painted the picture of Macready as Werner, now in the Victoria and Albert Museum, exhibited *RA*, 1851 (644), also *Charles Dickens*, Victoria and Albert Museum, 1970 (G69), reproduced in catalogue, and *Daniel Maclise*, Arts Council at the NPG, 1972 (85). The NPG picture is similar in pose to portraits by Maclise, but the handling seems much too wooden and insensitive to be by his hand. Maclise was a constant visitor at Macready's house, often in company with Charles Dickens and John Forster, and an enthusiastic admirer of him as an actor.

Description: Blue eyes, dark hair (discoloured). Dressed in a dark stock, white shirt, white waistcoat, dark suit (discoloured). Brown covered books on table with red cloth. Floor dark green. Background colour brown.

1504 Marble bust, 32 inches (81·2 cm) high, by WILLIAM BEHNES, 1843–4. PLATE 590

Collections: As for NPG 1503 above.

Exhibitions: RA, 1844 (1308).

Literature: The Diaries of William Charles Macready, 1833–1851, edited W. Toynbee (1912), II, 215, reproduced frontispiece.

Macready records sitting to Behnes on 23 July 1843, but it is not known when the bust was completed. Either this or another version was in the Crystal Palace Portrait Collection, 1854.

ICONOGRAPHY The iconography of Macready consists, to a great extent, of popular engravings of him in various dramatic roles which have already been listed elsewhere, notably in L. A. Hall, *Catalogue of Engraved Dramatic Portraits in the Theatre Collection of the Harvard College Library* (Cambridge, Mass, 1932), III, 129–41 (155 items listed; various examples in NPG), and in the *British Museum Catalogue of Engraved British Portraits*, III (1912), 136–8. The following iconography omits these prints, and also photographs (see plate 591), and engravings after them (examples in NPG and elsewhere).

Paintings by S. De Wilde of 1810 (as Romeo), and undated (as Richard III), were formerly in the collections of Major-General C. F. N. Macready and E. Y. Lownes, reproduced *The Diaries of Macready*, edited W. Toynbee (1912), I, facing viii, and 136, respectively, the former engraved by R. Woodman, published J. Cawthorn, 1810 (coloured example in British Museum); a painting by De Wilde (as Hamlet) was exhibited *RA*, 1812 (355); a painting by G. Clint of 1821 (as Macbeth) is in the Victoria and Albert Museum; a painting by H. P. Briggs of 1844 is in the Garrick Club, London, reproduced *Diaries*, I, frontispiece, exhibited *RA*, 1844 (182); also at the Garrick Club is a painting by J. Boaden (as Orestes in 'The Distressed Mother'), engraved by C. Picart, published Chapple, 1819 (example in NPG), for the 'Theatrical Inquisitor'; a painting by H. Inman of 1827 (as William Tell) was in the Players Club, New York (now untraced), and an oil study for this is in the Metropolitan Museum, New York (plate 587); Macready appears in 'Henry V, Act I, Scene I', a painting attributed to Gilbert, sold Christie's, 11 November 1966 (lot 156), bought Kyrle Fletcher; a painting by W. Bradley was exhibited *Victorian Era Exhibition*, 1897, 'Drama Section' (114), lent by the Brazenose Club, Manchester; a painting by an unknown artist was formerly in the Drury Lane Theatre Collection; a miniature ascribed to G. Engleheart (as Richard III) in the Engleheart Collection is apparently that by J. C. D. Engleheart exhibited *RA*, 1820 (802); there is another miniature by J. C. D. Engleheart (in ordinary dress) in the same collection, presumably that exhibited *RA*, 1824 (738); a miniature by R. Thorburn of 1844 was once in the collection of Major-General Macready, exhibited *VE*, 1892 (429), engraved by Posselwhite, published M. Holloway, 1844 (example in British Museum); a miniature by Miss M. Gillies (as Cardinal Richelieu) was exhibited *RA*, 1839 (918); there is a profile drawing by G. Wightwick of 1869 in the NPG; a drawing by an unknown artist was exhibited *Victorian Era Exhibition*, 1897, 'Drama Section' (91), lent T. H. Wilson, and another drawing was exhibited *Shakespeare, 1564–1964*, Stratford, Connecticut, 1964 (8); a drawing by an unknown artist (as Richard III) was in the Drawing

Shop, New York, 1963 (reproduction in NPG); an unlocated drawing by R. J. Lane (as Ion) is recorded in his 'Account Books' (NPG archives), II, 9, under 1836, lithographed by himself, published J. Mitchell, 1839 (example in NPG), presumably related to the drawing by Lane (with Ellen Tree as 'Clemanthe') exhibited *R A*, 1837 (742); busts by E. Davis and W. F. Spencer were exhibited *R A*, 1840 (1097), and 1868 (1119), respectively; busts either of Macready or of his father William Macready by G. Clarke and P. Hollins were exhibited *R A*, 1825 (987), and 1830 (1204), respectively; an engraving by J. Thomson, after a painting by S. Drummond, was published J. Asperne, 1821 (example in NPG), for the *European Magazine*; there is a lithograph by A. Lemoine, published J. Rigo (example in NPG), and an anonymous engraving (delivering his farewell address, 20 February 1850) (example in British Museum).

MADDEN *Sir Frederic* (*1801–73*)

Antiquary and palaeographer; engaged on catalogue of printed books at the British Museum, 1826–8; keeper of the manuscripts department, 1837–66; the leading palaeographer of his period; published numerous works.

1979 Wax medallion, white on brown wax, $7\frac{1}{4} \times 5\frac{5}{8}$ inches (18·5 × 14·2 cm) oval, by RICHARD COCKLE LUCAS, 1849. PLATE 593

Incised below the shoulder: Sir F Madden R C Lucas S./1849

Collections: Presented by the sitter's grandson, Frederic Madden, 1923.

The companion wax medallion of Lady Madden, the sitter's wife, is in the collection of F. A. V. Madden.

ICONOGRAPHY A painting by an unknown artist is in the British Museum; a lithograph by W. Drummond was published T. McLean, 1837 (example in NPG), for 'Athenaeum Portraits'.

MADDEN *Richard Robert* (*1798–1886*)

Miscellaneous writer; studied medicine; one of the magistrates administering the statute abolishing slavery in Jamaica plantations, 1833–41; special commissioner of West Coast of Africa, 1841–3; correspondent on *Morning Chronicle*, 1843–6; colonial secretary of Western Australia, 1847–50; secretary to loan fund board in Ireland, 1850–80; published numerous works, including *The United Irishmen, their Lives and Times*, 1843–6.

4026 (41) Pencil and black chalk on paper, $6\frac{1}{2} \times 4\frac{3}{4}$ inches (16·5 × 12 cm), by COUNT ALFRED D'ORSAY, 1828. PLATE 594

Dated (lower right): Naples/1er Mars 1828 *Inscribed (bottom centre):* Doctor Madden

Collections: See *Collections:* 'Drawings of Men About Town, 1832–48' by Count A. D'Orsay, p 557.

Another identical drawing of Madden by D'Orsay, similarly signed and dated, is in the Irish NPG, presented by Dr Thomas More Madden, 1900. It was presumably done at the request of the sitter.

599 See *Groups:* 'The Anti-Slavery Society Convention, 1840' by B. R. Haydon, p 538.

ICONOGRAPHY A painting by G. F. Mulvany was exhibited *Royal Hibernian Academy*, 1851, engraved by S. Allen for Madden's *The United Irishmen* (1st series, 2nd edition, 1858), frontispiece; a painting by J. P. Haverty is in the Irish NPG, and so is a silhouette by an unknown artist; a lithograph by R. J. Hamerton (in Turkish costume) was published R. Bentley (example in NPG); an aquatint (in Syrian costume) was published in Madden's *Travels in Turkey, Egypt, Nubia and Palestine in 1824–7* (1829), I, frontispiece; there is an engraving by T. W. Huffam, after a daguerreotype by Claudet (example in NPG).

MADOCKS *John* (*1786–1837*)

MP for Denbigh.

54 See *Groups:* 'The House of Commons, 1833' by Sir G. Hayter, p 526.

MAGUIRE *Rochfort* (*d 1867*)

Naval lieutenant, 1840; captain, 1855; commanded HMS PLOVER in the search for Sir John Franklin, 1852–4.

1214 Oil on canvas, $15\frac{1}{4} \times 12\frac{3}{4}$ inches (38·7 × 32·4 cm), by STEPHEN PEARCE, 1860. PLATE 595

Collections: See *Collections:* 'Arctic Explorers' by S. Pearce, p 562.

Exhibitions: RA, 1862 (604); *Royal Naval Exhibition*, Chelsea, 1891 (53).

Literature: S. Pearce, *Memories of the Past* (1903), p 72.

This is the only recorded portrait of Maguire. He is wearing the undress uniform of a naval commander (1856 pattern), with (from left to right) the Arctic Medal (1818–55), the China Medal (1842 or 1857), and the Naval General Service Medal (1793–1840).

Description: Healthy complexion, dark eyes, brown hair and whiskers. Dressed in a dark neck-tie, white shirt, dark blue waistcoat and naval uniform, with gilt buttons, gold-braided epaulettes, and silver medals with red and grey ribbons. Background colour dark greenish-brown.

MANNING *Henry Edward* (*1808–92*)

Cardinal; leader of the Roman Catholic community in England.

4166 See entry under Blomfield, Charles James, p 41.

 See also forthcoming Catalogue of Portraits, 1860–90.

MANSEL *Henry Longueville* (*1820–71*)

Metaphysician; tutor at St John's College, Oxford, later elected 'professor fellow'; Waynflete professor, moral and metaphysical philosophy, 1855; engaged in several religious and philosophical controversies; dean of St Paul's, 1868–71; published numerous works.

4541 (9, verso) With various other figures at a lunch or dinner party. Pencil and pen and ink on paper, $7 \times 8\frac{7}{8}$ inches (17·9 × 22·4 cm), by MISS CLARA PUSEY, c 1856. PLATE 596

Inscribed in ink (top left and right): The Christ Church Express No 2 Tuesday. *There are several pencil names identifying the figures, and below part of a letter from Clara Pusey.*

Collections: See *Collections:* 'Sketches of the Pusey Family and their Friends, c 1856' by Miss C. Pusey p 563.

This drawing, together with a companion drawing of Dr Cotton receiving the Duke of Nemours at Worcester College on the reverse, was sent by Clara Pusey to her cousin, Alice Herbert, as part of a running commentary on people and events at Oxford. The letter to Alice, on both sides of the sheet, is given at length in the discussion of the collection as a whole. The figures at the table are, from left to right, Mansel, Clara Pusey, Mrs Brine, Mr Starkey, the Hon Alan Herbert, Mr Brine and Mrs Mansel.

ICONOGRAPHY A painting by an unknown artist is at St John's College, Oxford, and so is a marble bust by E. W. Wyon of 1872, exhibited RA, 1873 (1437), for which see Mrs R. L. Poole, *Catalogue of Oxford Portraits*, III (1925), 186; a woodcut by R. Taylor was published ILN, LIX (1871), 128; there is a photograph in the NPG.

MANSFIELD *William David Murray, 4th Earl of* (*1806–98*)

MP for Norwich.

54 See *Groups:* 'The House of Commons, 1833' by Sir G. Hayter, p 526.

MARJORIBANKS *Stewart* (*1774–1863*)
MP for Hythe.

54 See *Groups:* 'The House of Commons, 1833' by Sir G.Hayter, p526.

MARLBOROUGH *George Spencer-Churchill, 6th Duke of* (*1793–1857*)
MP for Woodstock.

54 See *Groups:* 'The House of Commons, 1833' by Sir G.Hayter, p526.

MAROCHETTI *Carlo, Baron* (*1805–67*)
Sculptor; studied at Paris and Rome; baron of Italy; patronised by Carlo Alberto, Louis Philippe and Queen Victoria; chiefly executed monuments, statues and busts.

1038 Bronze statuette, 24⅝ inches (62·5 cm) high, by GABRIELE AMBROSIO, 1888. PLATE 597

Incised on the front of the base: CARLO MAROCHETTI *and on one side:* G Ambrosio. 1888. – TORINO
Collections: Signora Muratori, presented by her, 1896.

The donor was asked to present the statuette by the artist, whom she apparently knew in Florence; she approached the Gallery through her cousin, Mrs Hornsby Drake, the adopted daughter of the famous collector, Sir William Drake. The statuette shows Marochetti seated on a flight of three box steps, holding a chisel and some clay in his hands; behind him on the top step is a partly open manuscript showing a man on horseback, with a modelling tool on top of it; below at the back are some more tools and another roll of paper or clay. Leaning against one side of the steps is a bas relief of a historical episode (possibly the attempted arrest of the five members of Parliament by Charles I), presumably by the sitter. Marochetti is dressed in a shirt and tie, trousers and waistcoat, a loose working robe, and indoor shoes.

ICONOGRAPHY A painting by G.F.Watts was exhibited *VE*, 1890 (278); there is a chromo lithograph by V.Brooks, after a painting (in his studio) by J.Ballantyne (example in NPG); a painting by E.Browning was exhibited *RA*, 1868 (820); there are several photographs in the NPG, and a woodcut, after one by J.Watkins, was published *ILN*, XXXVIII (1861), 178.

MARRIAGE *Joseph* (*1807–84*)
Slavery abolitionist.

599 See *Groups:* 'The Anti-Slavery Society Convention, 1840' by B.R.Haydon, p538.

MARRYAT *Frederick* (*1792–1848*)
Captain RN and novelist; served on various stations during Napoleonic Wars; commanded the Larne in first Burmese war, 1823; commanded successful expedition up Bassein River, 1825; published a series of well-known novels of sea-life, children's books and other works.

1239 Oil on canvas, 30 × 24⅞ inches (76·2 × 63·2 cm), by JOHN SIMPSON, c 1826. PLATE 598

Collections: The sitter; bequeathed by his daughter, Miss Augusta Marryat, 1899.
Exhibitions: *VE*, 1892 (222).

This painting was engraved anonymously, published H.Colburn, 1826 (example in British Museum), and 1835 (example in NPG), and was lithographed (in reverse) by C.Brand (example in NPG).
Description: Healthy complexion, blue-grey eyes, brown hair. Dressed in a dark stock, white shirt, red waistcoat with gilt buttons, dark coat, and travelling cape. Background colours predominantly dark browns and greens.

ICONOGRAPHY A painting by E.Dixon is in the National Maritime Museum, Greenwich, exhibited *RA*, 1839 (453), and *SKM*, 1868 (423), reproduced *Bookman*, LXII (1922), 203; a painting by W.Simson was sold at Christie's, 22 November 1912 (lot 90); a painting by an unknown artist was in the collection of J.S. Adkins, 1889, sketched and recorded by G.Scharf, 'TSB' (NPG archives), XXXV, 33; a drawing of 1827 by W.Behnes was exhibited *VE*, 1892 (406), engraved by H.Cook (example in NPG), and by C.Cook, published R.Bentley, 1851 (example in NPG); another drawing by Behnes was exhibited *VE*, 1892 (565), and was used as the frontispiece to *The Pirate and the Three Cutters*; a drawing of 1841 by Count A.D'Orsay was sold at Sotheby's, 13 February 1950 (lot 215), bought Colnaghi, lithographed by R.J.Lane, published J.Mitchell (example in NPG); a miniature by Sir W.C.Ross was with Charles Woollett & Son, 1956; a miniature called Marryat by A.Buck was sold at Bonham's, 6 June 1957 (lot 45), possibly the miniature recorded by W.G. Strickland, *Dictionary of Irish Artists* (1913), I, 120; a bust by J.E.Carew was exhibited *RA*, 1835 (1112), and *VE*, 1892 (564), lent by Miss Augusta Marryat.

MARSHALL *John* (*1797–1836*)

MP for Leeds.

54 See *Groups:* 'The House of Commons, 1833' by Sir G.Hayter, p 526.

MARTIN *John* (*1789–1854*)

Historical and landscape painter; of humble origin; exhibited at RA, 1812; became famous for his vast and sublime paintings of biblical, religious and literary themes.

958 Oil on panel, $10\frac{1}{2} \times 8\frac{1}{2}$ inches (26.7×21.6 cm), by his nephew, HENRY WARREN, *c* 1839. PLATE 599
Collections: The artist, purchased from his son, Alfred Warren, 1894.
Exhibitions: RA, 1839 (726).

In the background, on the right, is a building with a row of columns seen in steep perspective, with flames apparently raging below, and above are more shadowy buildings; these are suggestive of Martin's own pictures with their incredible architecture and atmosphere of cataclysmic doom. Lying on the ledge in the bottom right-hand corner of the picture is a book of prints, the one open showing a fallen column in the foreground, and classical buildings behind, another reference to Martin's interests. The vendor, in a letter of 28 October 1893 (NPG archives), described the portrait as '*a very faithful portrait of my great uncle*'. It was engraved anonymously, published T.North (example in NPG).

Description: Pink complexion, dark blue eyes, greyish-brown hair, reddish-brown whiskers. Dressed in a white stock, white shirt, black waistcoat and coat. Holding a brown palette with flecks of red, leaning on a brown parapet, with a greyish book on it. Background colour orange and greenish-brown.

2515 (13) Black chalk, with touches of Chinese white, on brown-tinted paper, $15 \times 10\frac{7}{8}$ inches (38.2×27.6 cm), by WILLIAM BROCKEDON, 1826. PLATE 601
Dated (lower left): 9–6. 26
Collections: See *Collections:* 'Drawings of Prominent People, 1823–49' by W.Brockedon, p 554.

Accompanied in the Brockedon Album by a letter from the sitter, dated 8 July 1831.

ICONOGRAPHY A drawing by C.Martin (his son) of 1854 (executed shortly before Martin's death) is in the Laing Art Gallery, Newcastle (plate 600), exhibited *RA*, 1854 (923), *SKM*, 1868 (612), and *John Martin*, Laing Art Gallery, Newcastle, 1970 (107); a drawing by C.R.Leslie of 1822 is in the British Museum; a drawing by C.Vogel is in the Küpferstichkabinett, Staatliche Kunstsammlungen, Dresden; a bust by H.Weekes was exhibited *RA*, 1837 (1275); an engraving by J.Thomson, after W.Derby, was published L.Relfe, 1822 (example in NPG), for the *European Magazine*; an engraving by C.Wagstaff, after T.Wageman, was published 1834

(example in NPG), for *Arnold's Magazine of the Fine Arts;* an engraving by Sear & Co was published Knight and Lacey, 1828 (example in British Museum); examples of the last three prints are in the Laing Art Gallery, exhibited *John Martin*, 1970 (109, 110, 112; also there is a reproduction of a miniature by C.Muss, formerly in the collection of the sitter's grandson, Colonel Bonomi, the reproduction exhibited *John Martin*, 1970 (111).

MARTINEAU *Harriet* (*1802–76*)

Miscellaneous writer; daughter of a Norwich manufacturer, and sister of James Martineau (see below); published novels, philosophical, political, economic and other works, which made her famous; noted for her fiercely independent views.

1085 Oil on canvas, $50\frac{1}{4} \times 40\frac{1}{8}$ inches (127·6 × 101·9 cm), by RICHARD EVANS, 1833–4. PLATE 602

Collections: F.W.Simpson, purchased from him, 1897.

Exhibitions: RA, 1834 (138).

Literature: V.Wheatley, *The Life and Work of Harriet Martineau* (1957), reproduced facing p 48, with a comment by Sir Augustus Callcott, RA, on the portrait: *'What, are your friends about to allow that atrocity to stand there?'*

This portrait appeared on the art market in 1885 from an unknown source (it had not come from the family). According to family letters, it was painted by Evans during 1833 and 1834, *'as a labour of love'*, so it may have been kept by the artist. It was first offered, as a work by Lawrence, to Sir Thomas Martineau, lord mayor of Birmingham, in 1885, by J.Warren of Brixton, who said he had bought it at Foster's saleroom. Offered again in 1886, it was seen by David Martineau, who commented favourably on it, but other members of the family were more critical. It was bought by another dealer, J.R.Thomas, in Puttick and Simpson, in 1890, and was offered to Sir Thomas Martineau again, but declined; it was presumably acquired from Thomas by Simpson.[1]

Description: Healthy complexion, greenish eyes, brown hair. Wearing a black silk dress over a green shirt, white gauze trimming at the neck, secured by a small pearl brooch, and a sable boa. Seated on a small settee covered in red material. The table at the right has a multi-coloured rug on it, and some papers on which the sitter's hand rests. At top right the corner of a large gilt picture-frame can be seen. A large red curtain covers most of the background; on the left is a light-brown panelled door (?).

1796 Coloured chalk on brown, discoloured paper, $24\frac{3}{8} \times 18\frac{5}{8}$ inches (62·6 × 47·3 cm), by GEORGE RICHMOND, 1849. PLATE 603

Signed and dated (*bottom left*): George Richmond delnt 1849.

Collections: The sitter, bequeathed by her niece, Miss Emily Higginson, 1917.

Literature: G.Richmond 'Account Book' (photostat copy, NPG archives), p 50, under 1849; reproduced as a woodcut, *ILN*, LXIX (1876), 61; reproduced V.Wheatley, *The Life and Work of Harriet Martineau* (1957), frontispiece.

This drawing was engraved by F.Holl (example in NPG). E.H.Hodgson gave what he thought was another version of the drawing to a women's institution in the north of England (memorandum of an interview, 19 March 1941, NPG archives). Only one drawing, however, is listed in Richmond's 'Account Book'.

ICONOGRAPHY A painting by S.S.Osgood of 1835 (executed in America) is in the collection of the Rev C.L.Martineau, exhibited *RA*, 1836 (555), and *VE*, 1892 (229); another picture said to be by Charles Osgood is in the Essex Institute, Salem, Mass, reproduced U.Pope-Hennessy, *Three English Women in America* (1929), facing p 282; a statue by Anne Whitney of 1882 (destroyed 1914) is reproduced V.Wheatley, *The Life and Work*

[1] Information from members of the Martineau family, 1897 (NPG archives).

of Harriet Martineau (1957), facing p368; a plaster cast of the head by Anne Whitney is in the collection of Mrs Wilson Payne, reproduced *Art Quarterly*, XXV (1962), 256; a death mask and cast of a hand are in the Armitt Library, Ambleside, reproduced Wheatley, facing p384, the latter exhibited *Cumbrian Characters*, Abbot Hall Art Gallery, Kendal, 1968 (63b); another plaster cast sent to Florence is now unlocated; an engraving by D. Maclise was published *Fraser's Magazine*, VIII (1833), facing 576, as no.42 of Maclise's 'Gallery of Illustrious Literary Characters'; a pencil study for this is in the Victoria and Albert Museum; another drawing by Maclise was in the Drake Sale, Christie's, 24 May 1892 (lot 206); an engraving of *c*1835 is reproduced R.K.Webb, *Harriet Martineau: a Radical Victorian* (1960), frontispiece; an engraving by E.Finden, after a miniature by Miss M.Gillies, was published Colnaghi, 1833 (example in NPG); a similar engraving, after Miss Gillies, by J.C.Armytage was published for Horne's *New Spirit of the Age* (1844); a photograph by M.Bowness of Ambleside is in the NPG (plate 604), reproduced Wheatley, facing p368, and there is woodcut after the same photograph from an unidentified magazine (cutting in NPG); an unspecified portrait was exhibited *Victorian Era Exhibition*, 1897, 'Women's Work Section' (23).

MARTINEAU *James (1805–1900)*

Unitarian divine; apprenticed as engineer; studied divinity, 1822–7; pastor in Liverpool; professor of mental and moral philosophy and political economy at Manchester New College, 1840–57, and later professor of religious philosophy; joint-editor of *Prospective Review*, 1845–54; published numerous religious and philosophical works.

1251 Oil on canvas, $25\frac{7}{8} \times 21$ inches ($65 \cdot 7 \times 53 \cdot 4$ cm), by GEORGE FREDERICK WATTS, after a portrait of 1873. PLATE 605

Collections: The artist, presented by him, 1900 (see appendix on portraits by G.F.Watts in forthcoming Catalogue of Portraits, 1860–90).

Exhibitions: Toynbee Hall, 1888; *Loan Collection of Pictures*, Corporation of London Art Gallery, 1892 (17); Rugby, 1894; Chester, 1895; Southwark, 1895.

Literature: 'Catalogue of Works by G.F.Watts', compiled by Mrs M.S.Watts, (MS, Watts Gallery, Compton), II, 105.

This is a replica of the portrait of Martineau by Watts of 1873 at Manchester College, Oxford, exhibited *RA*, 1874 (51), *Winter Exhibition*, Grosvenor Gallery, 1882 (149), and *Royal Jubilee Exhibition*, Manchester, 1887, 'Fine Art Section' (503), reproduced *The Life and Letters of James Martineau*, edited J.Drummond and C.B.Upton (1902), I, frontispiece, etched by P.Rajon, published Agnew, 1876 (example in NPG). The original portrait was subscribed for by Martineau's old pupils, thirty-seven of whom dined together on 24 June 1874, and formally presented it to Manchester New College. Watts expressed pleasure in painting '*so good and distinguished a man as Mr Martineau*', but would only paint the head, as he considered modern costume '*not only so uninteresting, but so ignoble*' (Drummond and Upton, II, 20). Several of Martineau's friends were disappointed with the portrait, feeling that Watts, who was painting Martineau at a time of ill-health, had misinterpreted his subject: '*We see before us the philosopher and the mystic but not the man of action and the prophet*' (Drummond and Upton, II, 21). Watts frequently painted replicas of his portraits of famous people, with the deliberate intention of presenting them eventually to the nation.

Description: Dark complexion, bluish eyes, brown hair with grey streaks. Dressed in a black neck-tie, white shirt, black coat and waistcoat. Background colour dark reddish-brown.

2348 Pencil on paper, $7\frac{1}{8} \times 4\frac{1}{2}$ inches ($18 \cdot 3 \times 11 \cdot 4$ cm), by SYDNEY PRIOR HALL, 1893. PLATE 608

Inscribed (top left): Martineau *and (lower right):* Martineau/J.M. – 93

Collections: Presented by the artist's son, Dr H.R.Hall, 1929.

A similar but more complete sketch was reproduced *Graphic*, XLVIII (9 December 1893), 711; this was executed at a meeting which Martineau attended to promote a memorial to Dr Jowett, 2 December 1893. The NPG drawing is one of a group of drawings by Hall, which will be collectively discussed in the forthcoming Catalogue of Portraits, 1860–90.

2526 Pencil on paper, 6¾ × 5 inches (17 × 12·8 cm), by CLARA MARTINEAU, 1887. PLATE 607

Dated in pencil (bottom right): Dec 2ⁿᵈ/87 *Inscribed in pencil on the original mounting paper:* By Clara Martineau

Collections: Mrs Helen Allingham (?); presented by her daughter-in-law, Mrs E. C. Allingham, 1932.

Exhibitions: Possibly *R A*, 1900 (1577).

Clara Martineau, the wife of Basil Martineau, was the daughter-in-law of the sitter. The NPG drawing came from an album of sketches, the rest of which were all by Helen Allingham. According to the donor (letter of 29 January 1932, NPG archives), this drawing of Martineau was very similar to the sketches of him by Mrs Allingham (one of these, dated 1891, is at Manchester College, Oxford): 'We possess one of these sketches & we gave one to Miss Worthington of Bowden Cheshire who knew Dr Martineau & who said the likeness was admirable. The sketch by Clara Martineau shows Dr Martineau a trifle heavier looking than he appears in my mother in law's work (my mother in law caught the beautiful delicacy of the face), but the sketches are very similar – & the pose (profile) just about the same'. According to the artist's sister, Mrs Flight (letter of 5 February 1932, NPG archives), Clara Martineau executed several other drawings and paintings of Dr Martineau; a pastel drawing of 1899 and a pencil drawing by Clara, the latter very similar to, and possibly a study for, NPG 2526, and a pastel drawing by Edith Martineau, are in the Doctor William's Library, London, the first reproduced *The Life and Letters of James Martineau*, edited J. Drummond and C. B. Upton (1902), II, frontispiece.

2080 Plaster cast, painted yellow, 14 inches (35·5 cm) high, of a statuette by HENRY RICHARD HOPE-PINKER, 1897. PLATE 606

Incised on the back of the chair: Sketch for the/Dr. Martineau Statue/H R Hope-Pinker Sc/1897

Collections: The artist, presented by him, 1925.

This is a model for the marble statue of Martineau by Hope-Pinker at Manchester College, Oxford, which was exhibited *R A*, 1898 (1932); statue and statuette are almost identical, but there are some differences in the folds of the costume. Similar statuettes are at the Unitarian Headquarters, London, Doctor William's Library, London, and the Unitarian College, Manchester.[1] Hope-Pinker also exhibited a bust of Martineau *R A*, 1897 (2005), and a sketch for a statue, said to have been executed in 1895, at the *Seventeenth Annual Exhibition*, Royal Society of Portrait Painters, 1907 (229); it is just possible that this latter sketch is the NPG statuette, although the dates do not tally.

ICONOGRAPHY There is a painting by C. Agar of 1846 at Manchester College, Oxford, engraved by J. Stephenson, published Stephenson and Agar, Manchester, 1847 (example in NPG), the engraving reproduced A. W. Jackson, *James Martineau* (1900), frontispiece; also at the College are a bust by an unknown artist of *c* 1845, a drawing by Mrs H. Allingham of 1891, and a silhouette of 1813; a painting by A. E. Emslie of 1888 was exhibited *R A*, 1889 (1227), reproduced J. E. Carpenter, *James Martineau* (1905), frontispiece, and the same or a different painting was in the *First Annual Exhibition*, Royal Society of Portrait Painters, 1891 (6); a painting by an unknown artist was reproduced *Christian Life*, 29 April 1905, p 197; Martineau appears in a fresco by E. Armitage at the Doctor William's Library, London, for which there is a pencil study of 1870 in the same collection; a drawing by S. Laurence was sold at Christie's, 22 November 1912 (lot 10), bought W. T. Spencer, sketch in NPG sale catalogue; there is a reproduction of a drawing by T. Wirgman of 1895 in the NPG, from an unidentified magazine; a terra-cotta bust by E. R. Mullins of 1877 is in the Doctor William's Library, London,

[1] Information kindly communicated by the Rev H. L. Short, principal of Manchester College, Oxford, in a letter of 2 April 1968 (NPG archives); he remembers visiting Hope-Pinker's studio, when the sculptor was still alive, and seeing another statuette there.

exhibited *RA*, 1878 (1532), and the same or a different bust was in the *Fifteenth Annual Exhibition*, Royal Society of Portrait Painters, 1905 (273); in the same collection is a bust by P. Pieraccini; a memorial, with a relief bust of Martineau, is at Rochdale; an anonymous lithograph was published Cassell, Petter and Galpin (example in NPG); there is a photograph in the NPG, and several reproductions of others.

MASON *Thomas Monck* (*1803–89*)

Musician, author of operatic works, aeronaut and author of *Aeronautica*.

4710 See *Groups:* 'A Consultation Previous to an Aerial Voyage to Weilburg, 1836' by J. Hollins, p 537.

MATHEW *Theobald* (*1790–1856*)

Apostle of temperance; signed total abstinence pledge, 1838; Roman Catholic priest, 1841; visited principal cities of Ireland advocating abstinence with considerable effect; worked energetically during the Irish famine; preached in USA, 1849; returned to Ireland, 1851.

199 Oil on canvas, 24 × 20 inches (61 × 50·8 cm) painted oval, by EDWARD DANIEL LEAHY, 1846. PLATE 609

Inscribed in white chalk on the back of the canvas: Father Mathew/Painted/from the Life by/E D Leahy 1845 [*sic*]/Exhibited at the/Royal Academy London/1857 [*sic*]

Collections: The artist, purchased from him, 1865.

Exhibitions: RA, 1847 (66).

Literature: G. Scharf, 'TSB' (NPG archives), XVIII, 78; W. G. Strickland, *Dictionary of Irish Artists* (1913), II, 14.

According to a letter of May 1865 from the artist (NPG archives): '*I painted it at his residence in Cork in Jan^y 1846 from the life, it is the original & never has been copied. Exhibited in the Royal Academy in 1847. Price 20 gs.*' The Royal Academy catalogue records that this portrait was '*from the life, while executing a portrait of him for the late Dwarkanauth Tagor*'; the present location of this last portrait is not known.

Description: Bluish eyes, brown hair. Dressed in a white stock, white shirt, dark coat, with a medal suspended from a black ribbon on his chest. Background colour very dark brown.

ICONOGRAPHY A painting by J. P. Haverty (receiving a repentant pledge-breaker), exhibited *RA*, 1844 (521), is in the National Gallery of Ireland, recorded by W. G. Strickland, *Dictionary of Irish Artists* (1913), I, 455; a painting by A. Chisholm is in the collection of the Capuchin Franciscan Friary, Dublin, exhibited *Irish Exhibition*, London, 1888 (1011), and *Great Irishmen*, Ulster Museum, Belfast, 1965 (140), sketched by G. Scharf, 'TSB' (NPG archives), XXXIV, 47; a painting by D. Macdonald, engraved by the artist, published Colnaghi (no example located), is listed by Strickland, II, 57; a painting by S. West was exhibited *RA*, 1847 (497), *SKM*, 1868 (525), and *Dublin Exhibition*, 1872, 'Portraits' (246), lent by J. C. Mathew, and was engraved by W. O. Geller (example in British Museum); a stone statue by Vaughan & Co of Southwark of 1846 is in Cork, reproduced as a woodcut *ILN*, IX (1846), 109; a bronze statue by J. H. Foley of 1863 is also in Cork (Patrick Street), reproduced as a woodcut *ILN*, XLIII (1863), 665; a drawing after this statue by H. S. Melville of 1863 is in the British Museum; a caricature drawing by J. Doyle is also in the British Museum; a statue by Miss M. Redmond is in Dublin, reproduced *Magazine of Art* (1893), p 288; a marble bust by C. Moore was exhibited *RA*, 1842 (1338), probably the bust by Moore exhibited *Royal Hibernian Academy*, 1843; a bust by Moore of 1845 was in the Crystal Palace Portrait Collection, 1854; a bust by J. E. Carew was exhibited Adelaide Gallery, 1844, listed by R. Gunnis, *Dictionary of British Sculptors* (1953), p 80; a marble bust by J. Hogan of 1840 was exhibited *RA*, 1850 (1353); another bust by Hogan was in the collection of H. J. Maguire, Donnybrook, 1913, exhibited *Royal Hibernian Academy*, 1844, listed by Strickland, I, 495, who also records a statue by Hogan in Cork;

Strickland seems to have confused Hogan's 1840 bust with the statue by Vaughan & Co (see above); a lithograph by R.J.Lane, after R.G.A.Levinge, was published 1845 (example in NPG); there is an engraving by J.Kirkwood, after an original portrait by Buck, then in the collection of the Rev D.B.Delany (example in NPG); a coloured lithograph was published W.Spooner, and a different version by J.Pasco (examples in NPG); Father Mathew appears in a lithograph of 'The Illustrious Sons of Ireland', published S.Lipchitz (example in NPG); there is an etching by E.J.Harding and an anonymous lithograph (examples in British Museum); a woodcut was published *ILN*, II (1843), 53; two medals by L.Wyon were exhibited *RA*, 1847 (1290), and 1848 (1314); a medal by W.Woodhouse is listed by Strickland, II, 561.

MATHEWS *Charles James* (*1803–78*)

Actor and dramatist; son of the actor Charles Mathews; practised as an architect; took to the stage, 1835; managed various theatres, including the Olympic and Covent Garden; bankrupt, 1856; continued acting in London and abroad; successful chiefly in comedy and farce; wrote and adapted several light pieces.

1636 Pencil, coloured chalk and wash on discoloured paper, $16\frac{3}{8} \times 11\frac{1}{2}$ inches (41·4 × 29·1 cm), by JOHN FREDERICK LEWIS, 1827. PLATE 610

Signed, but with the rest of the inscription partially cut off at the bottom (bottom right): J.F.Lewis ... [*Venice?*] Dec [?]16 *Inscribed in pencil (bottom right):* Venice/Dec^r 16/1827 *Inscribed on an old label, formerly on the back of the picture:* Portrait of C.J.Mathews/at Venice 1828/By J.F.Lewis. R.A.

Collections: Hughes and Tillmann, purchased from them, 1911.

Description: Mathews is shown with a red fez, and neckerchief, but the rest of his costume is only coloured with touches of blue wash. He is holding a long pipe.

ICONOGRAPHY This does not include caricatures, popular prints, or those showing the sitter in character, for which see L.A.Hall, *Catalogue of Dramatic Portraits in the Theatre Collection of the Harvard College Library,* III (Cambridge, Mass, 1932), 177–81, where over forty items are listed (some examples in British Museum and NPG). In the Garrick Club are 116 water-colours by J.W.Childe, showing Mathews in various roles, 1835–45; also a painting by an unknown artist, after a drawing by S.De Wilde of 1807, showing Mathews as the 'little parson'; a lithograph after the original drawing is reproduced C.Dickens, *Life of Charles James Mathews* (1879), I, facing 12; also in the Garrick is a painting by R.W.Buss (as George Rattleton in 'The Hump-Backed Lover') (plate 611), engraved by G.Adcock, published J.Cumberland, 1836 (example in Harvard collection); a drawing by A.E.Chalon (as Rattleton), possibly the portrait by A.E.Chalon (in character) bequeathed to the NPG, 1930, by E.T.Burr but declined, was lithographed by E.Morton, published J.Mitchell (example in British Museum), and lithographed anonymously, lithograph reproduced C.Dickens, II, facing 76; there is a reproduction of a drawing of 1857 in the NPG by an artist whose signature is too faint to be deciphered; a lithograph after a painting by R.Jones is reproduced C.Dickens, II, frontispiece; there is an engraving by Sands, after the same painting, published Chapman and Hall, 1828 (example in Harvard collection); two portraits were exhibited *Victorian Era Exhibition*, 1897, Drama Section' (278 and 603); a coloured lithograph, after a photograph, was published Cassell, Petter and Galpin; there is a lithograph by W.Clark (with his wife), published F.Glover (example in NPG); a lithograph by R.J.Lane (as himself, and in four characters, all after photographs) was published J.Mitchell, 1861 (example in Harvard collection), reproduced C.Dickens, II, facing 162; a lithograph, after his last photograph, is reproduced C.Dickens, I, frontispiece; several photographs are in the NPG (see plate 612), and a woodcut was published *ILN*, LXXIII (1878), 4.

MATHEWS *Lucia Elizabeth or Elizabetta* (*1797–1856*)

Actress; also known as Madame Vestris; daughter of the engraver, G.S.Bartolozzi; first appeared in Italian opera, 1815; acted frequently in London and the provinces, 1820–31; married C.J.Mathews (see

above), 1835; helped him in his management of Covent Garden and the Lyceum; unrivalled as a stage singer.

2786 Water-colour on paper, 16¾ × 13 inches (42.5 × 33 cm), by SAMUEL LOVER, *c* 1826. PLATE 613

Inscribed on the back: Madame Vestris in the character/of Mrs Ford/, *followed by an illegible signature.*

Inscribed on an old label formerly on the back of the picture: Madam Vestris/By Clint/Engraved. *There is also a damaged cutting from a sale catalogue:* Madame Vestris, full length, an original co/framed; and Mezzo print from the same

Collections: A.W.Holliday, purchased from him, 1935.

This water-colour, showing the sitter in the character of Mistress Ford in the 'Merry Wives of Windsor', was engraved by S.W.Reynolds, as after Lover, published T.C.Smith, 1826 (example in British Museum). The label on the back giving the artist as Clint is, therefore, erroneous.

Description: Fresh complexion, dark eyes and hair. Dressed in a white satin and brown or dark purple dress with lace panels, bodice with pearl border, a long pearl chain and tassel, and a pink bonnet with a pearl border and tassel. Standing in a green and brown garden scene, with red and white flowers and a brown stone pedestal and urn. In the background is a distant view of Windsor Castle and the Thames, with a blue and grey sky above.

ICONOGRAPHY This does not include popular prints, or those which show her in character, for which see L.A.Hall, *Catalogue of Dramatic Portraits in the Theatre Collection of the Harvard College Library*, IV (Cambridge, Mass, 1934), 191–201, where over 130 items are listed (some examples in British Museum and NPG). A painting of 1826 called Mme Vestris and attributed to Sir T.Lawrence is reproduced *Connoisseur*, XLI (1915), 65, possibly the painting sold Christie's, 10 July 1914 (lot 118); there is an engraving by C.W.Marr, apparently after a different portrait by Lawrence (example at Harvard); a painting by F.W.Wilkin was sold Christie's, 22 July 1871 (lot 165); a painting by D.Guest was in the collection of J.R.Thomas; a painting by G.Clint, showing her and others in 'Paul Pry', is in the Victoria and Albert Museum, exhibited *RA*, 1827 (222), engraved by T.Lupton, published Moon, Boys and Graves, 1828 (example in British Museum); a copy of Mme Vestris in Clint's painting by R.W.Buss is in the Garrick Club, London; also in the Garrick Club is a water-colour attributed to Louisa Sharpe, similar to an engraving by J.Cook, after a portrait by Louisa Sharpe of 1828, published R.Bentley, 1847 (example in NPG), and a miniature by J.W.Childe; two paintings by unknown artists were exhibited *Victorian Era Exhibition*, 1897, 'Drama Section' (117), lent by W.H.Vint, and in 'Don Giovanni' (119), lent by J.R.Thomas; a miniature by A.E.Chalon was exhibited *RA*, 1835 (822), *VE*, 1892 (453), and *Victorian Era Exhibition*, 1897, 'Music Section' (112*), lent by Mrs E.M.Ward; two miniatures by S.J.Rochard were exhibited *RA*, 1822 (759), and 1833 (778), and another or possibly one of these in the *Exposition de la Miniature*, Brussels, 1912 (1057), reproduced 'Souvenir', plate XLII (another reproduction in British Museum); a water-colour by H.Singleton (as Zelmira) is in the British Museum; a miniature by G.Brown is in the collection of R.L.B.Powell; an engraving by T.Woolnoth, after T.Wageman, was published Simpkin and Marshall (example in NPG); there is an engraving by T.Woolnoth, after Miss Drummond, published Dean and Munday, 1820 (example in NPG); there is a lithograph by J.H.Lynch, after T.Warrington, an engraving by Alais, after R.E.Drummond, an engraving by J.Cochran and one by T.C.Armytage (examples in NPG); there are also three photographs in the NPG.

MAULE *Fox* (*Lord Panmure*), *11th Earl of Dalhousie.* See DALHOUSIE

MAURICE *Frederick Denison* (*1805–72*)

Writer and divine; founded the 'Apostles Club' at Cambridge; edited various papers; took orders, 1830; involved in many of the religious debates of the period; published numerous articles and other

works; held several academic posts; inaugurated the Working Men's College; one of the most influential thinkers of his time.

354 Oil on canvas, 32 × 26⅜ inches (81·3 × 67 cm), by MISS JANE MARY HAYWARD, 1853–4. PLATE 617

Signed and dated (bottom left, but now no longer visible): J M W [*in monogram*] 1854 *Inscribed faintly on the spine of the book held by Maurice:* H KAINH/ΔIAθHK[H] [*The New Testament*] (*kindly deciphered by Dr. J.Shiel of the University of Sussex*).

Collections: Presented by the artist, 1872.

Exhibitions: R A, 1854 (1127).

The signature and date were recorded by G.Scharf in 1872 (memorandum, NPG archives). In a letter of 12 July 1872 (NPG archives), Miss Hayward wrote to say that she had painted the portrait in 1853; she presumably began the portrait in that year, and signed and dated it in 1854, when it was completed. The copy of the *New Testament* which Maurice is holding may have some reference to his book on *The Unity of the New Testament* published in 1854. The portrait was reduced in size when it entered the collection, by folding more of the canvas around the stretcher. The mark left by an early oval slip frame is still visible on the canvas.

Description: Brownish eyes and hair. Dressed in a white bow-tie, white shirt and black coat. Seated at a table with a greenish cover, holding a red leather-bound book, with papers scattered on the table, and a wooden inlaid inkstand with a white quill pen. Background colour brown.

1042 Oil on canvas, 37 × 33¼ inches (94 × 84·5 cm), by SAMUEL LAURENCE, *c* 1871. PLATE 614

Collections: Bequeathed by the sitter's widow, 1896.

Exhibitions: R A, 1871 (314).

Literature: F.Miles, 'Samuel Laurence' (typescript, NPG library).

A crayon study for this portrait was engraved by C.H.Jeens, published Macmillan, 1883 (example in NPG), for J.F.Maurice, *Life of F.D.Maurice,* I, frontispiece. There is a lithograph by J.H.Lynch, after another crayon drawing by Laurence of *c* 1850, published 1858 (example in Victoria and Albert Museum).

Description: Greyish brown hair. Dressed in a white tie, white shirt, and dark suit. Seated in an armchair reading a brown, leather-bound book. Background colour brown.

1709 Coloured chalk on brown, discoloured paper, 17¾ × 12¾ inches (45·1 × 32·3 cm), by SAMUEL LAURENCE, *c* 1846. PLATE 616

Inscribed (lower right): FD Maurice

Collections: Presented by Sir Michael and Lady Sadler, 1913.

Exhibitions: Probably *R A,* 1846 (1037).

Literature: F.Miles, 'Samuel Laurence' (typescript, NPG library).

Maurice's apparent age in this drawing suggests a date nearer 1840 than 1846, so this may not be the portrait exhibited in 1846. On the other hand, Laurence may not have exhibited the drawing immediately, or he may have made Maurice look younger than he was. An entry in the 'Journal' of Caroline Fox, 18 May 1846, may refer to it: '*Interesting time with Laurence He has much enjoyed F.D.Maurice's sittings lately, and dwelt upon the delicate tenderness of his character*' (*Memories of Old Friends: Being Extracts from the Journals and Letters of Caroline Fox,* edited H.N.Pym (2nd edition, 1883), p253).

1397 Plaster cast of a death mask, in the form of a medallion, painted terra-cotta, 19¼ × 15 inches (48·9 × 38·1 cm) oval, by THOMAS WOOLNER, 1872. PLATE 618

Collections: Presented by Lowes Dickinson, 1905.

Another cast was formerly in the collection of the Misses Stirling, nieces of the sitter. For other portraits of Maurice by Woolner, see iconography below.

ICONOGRAPHY There are two similar paintings by L. Dickinson, one in the collection of the Rev D. B. Maurice, the other at Queen's College, London (1886), exhibited *VE*, 1892 (217); there are three related drawings, all dated 1859, Queen's College, collection of R. L. Ormond, and collection of Mrs G. E. Yates; one of these may have been the drawing exhibited *RA*, 1859 (492); the type was engraved by F. Holl, published Macmillan, 1884, for J. F. Maurice, *Life of F. D. Maurice*, II, frontispiece; a painting by Dickinson for the Working Men's College was exhibited *RA*, 1873 (586); a painting attributed to Sir J. E. Millais is in the collection of Professor Boyland; Maurice appears with Carlyle in F. M. Brown's 'Work' in the City Art Gallery, Manchester (plate 156), where there is also a pencil study for the figure of Maurice; a smaller version of 'Work' is in the City Museum and Art Gallery, Birmingham; a bust by T. Woolner is mentioned by the artist in a letter of 1859, for which see Amy Woolner, *Thomas Woolner: his Life in Letters* (1917), p 162; another bust by Woolner was executed for the Working Women's College in 1861, and replicas are in Westminster Abbey, and the Old Schools, Cambridge (1873), the latter reproduced J. W. Goodison, *Catalogue of Cambridge Portraits* (1955), plate XXIII; a modern bronze plaque by E. and M. Gillick is part of Maurice's memorial at Cambridge, exhibited *RA*, 1937 (1427), reproduced *Royal Academy Illustrated* (1937), p 130; there are two photographs in the NPG (see plate 615), and a reproduction of a third.

MAXFIELD *William* (*1782–1837*)

MP for Great Grimsby.

54 See *Groups*: 'The House of Commons, 1833' by Sir G. Hayter, p 526.

MELBOURNE *William Lamb, 2nd Viscount* (*1779–1848*)

Statesman; barrister, 1804; MP from 1806; Irish secretary under Canning, 1827, and under Wellington, 1828; succeeded to title, 1829; home secretary under Grey, 1830–4; prime minister, 1834 and 1835–41; mentor and adviser to the young Queen Victoria.

941 Oil on canvas, 50 × 40 inches (127 × 101·6 cm), by JOHN PARTRIDGE, 1844. PLATES 626–7 & p 311.

Inscribed on a damaged piece of paper, originally on the stretcher: [*torn*] 1877/Lord Melbourne over chimney piece/Library [*torn*]/Portrait by Partridge I/was glad to obtain the picture/of my old master on the sale/that took place on the Artists/death./A very good likeness C. Howard

Collections: The artist; bought from his executors by the Hon Charles Howard, 1873[1]; presented by his son, the 9th Earl of Carlisle, 1893.

Exhibitions: 'Pictures in Mr Partridge's Gallery', 1851 (copy of catalogue in NPG archives); *SKM*, 1868 (378), where erroneously said to have been lent by Viscountess Palmerston; *VE*, 1892 (2).

Literature: Listed in two Partridge MS notebooks (NPG archives); C. Fletcher and E. Walker, *Historical Portraits, 1700–1850* (1919), IV, reproduced facing 218; R. L. Ormond, 'John Partridge and the Fine Arts Commissioners', *Burlington Magazine*, CIX (1967), 402, reproduced 400.

Behind Melbourne on the right is a leather-bound volume of state papers. Like Partridge's portraits of Lord Aberdeen (NPG 750), Lord Macaulay (NPG 1564), and Lord Palmerston (NPG 1025), this portrait is closely related to the figure of Melbourne in Partridge's group, 'The Fine Arts Commissioners' (NPG 342 below), and was presumably painted as a finished study for it. Partridge painted most of the Commissioners individually between 1844 and 1849, and retained these portraits. After his refusal to

[1] Four letters from Howard to Sir John Clarke, one of Partridge's executors (NPG archives).

2nd Viscount Melbourne by John Partridge, 1844　NPG 941

exhibit any further pictures at the Royal Academy after 1846, he exhibited many of these portraits at his own Gallery. At his death in 1872, his executors attempted to sell them to the original sitters or their descendants, and auctioned the remainder at Christie's, 15 June 1874. In the catalogue of the *SKM* exhibition, the portrait of Lord Melbourne is said to have been lent by Viscountess Palmerston. This appears to have been a printing error. Viscountess Palmerston lent another portrait of Melbourne by Lawrence (315) to the same exhibition, but there is no record of her or her descendants ever having owned a portrait of Melbourne by Partridge. The Partridge portrait in that exhibition (a photograph of it exists) is identical to the NPG portrait and the sizes are similar. Partridge lent several other studies for 'The Fine Arts Commissioners' to the exhibition, and it seems more than likely that it was he who lent the Melbourne. There is no record of Partridge or his executors disposing of any studies for 'The Fine Arts Commissioners' before 1872, nor is there a record of a second study similar to the NPG portrait.

In his two MS notebooks, listing pictures in his possession in 1863 and 1870, Partridge dates this portrait 1844. This apparently contradicts the evidence of a letter written by Melbourne to Partridge, dated 8 November 1848 (NPG archives), in which he agrees to sit for his portrait, but the letter may refer to a sitting for the finished picture of 'The Fine Arts Commissioners', rather than for this study. In any case, the head in the NPG portrait is almost identical with the head of Melbourne in a portrait by Partridge commissioned by Queen Victoria in 1844 (Royal Collection), reproduced Lord D. Cecil, *Lord M.* (1954), facing p 314, although the clothes, pose and accessories are different. This would argue in favour of 1844 rather than 1848 as the date of the NPG portrait. Another version of the Royal Collection portrait type was in the collection of Lord Brocket, ex-collections of Earl Cowper[1] and Lady Desborough, sold Christie's, 16 October 1953 (lot 111). It is listed in Partridge's two MS notebooks and dated 1843.[2] A copy of the NPG portrait by A. Dyer is at Hertford County Hall.

In the past the date 1846 has been given to all Partridge's portraits of 'The Fine Arts Commissioners', and to the finished group, presumably because this was the date of the meeting depicted. It is clear, however, from contemporary documents, that the big picture was still unfinished in 1853.

Although Charles Howard purchased this portrait from Partridge's executors, he declined to buy the portrait of his brother, the 7th Earl of Carlisle, sold Christie's, 15 June 1874 (lot 73), or of his brother-in-law, the 2nd Duke of Sutherland (collection of the present Duke of Sutherland).

Description: Blue eyes, grey hair. Dressed in green stock, white shirt, dark suit with silver fob-chain, and green peer's robes with grey fur. Seated on a red-covered wooden chair with his hand resting on papers on a library table. Red curtain behind at left and centre, brown wooden panelling at right. Holding a pair of gold spectacles.

3050 Oil on panel, $23\frac{1}{2} \times 17\frac{1}{4}$ inches ($59 \cdot 7 \times 43 \cdot 8$ cm), by SIR EDWIN LANDSEER, 1836. PLATE 622

Collections: Landseer Sale, Christie's, 9 May 1874 (lot 247); Earl of Rosebery, purchased at the Rosebery Sale, Christie's, 5 May 1939 (lot 78).

Exhibitions: Paintings and Drawings by Sir Edwin Landseer, RA, 1961 (27).

Probably painted at the same sitting as the similar sketch of Melbourne by Landseer (oval, head only), painted in 1836 at Woburn Abbey for Lady Holland. This is now in the collection of the Earl Mountbatten, Broadlands, exhibited *Landseer Exhibition*, RA, 1874 (442), *Landseer Exhibition*, RA, 1961 (41), and *Reine Victoria Roi Leopold I^{ier} et Leur Temps*, Brussels, 1953 (201), reproduced plate XIX. A version after the NPG portrait is owned by the Marquess of Lothian, Melbourne Hall. A so-called sketch of Melbourne by Landseer was sold at Christie's, 13 December 1961 (lot 145), from the collection of Miss Ruth Mitchell.

[1] Four letters from Earl Cowper to Sir John Clarke concerning the purchase of the portrait from the Partridge estate (NPG archives).

[2] Various portraits of Melbourne, presumably other versions of the Royal Collection type, are listed in Partridge's 'Sitters Book' (NPG archives); under 1844, commissioned by Edward Anson; 1845, by J. Young; and 1848, by the Hon Caroline Norton, and a second by Miss Gayler (?).

Description: Healthy complexion, greyish eyes, dark brown hair with greyish streaks. Dressed in a black neck-tie, white shirt and waistcoat, brown coat, grey trousers. Resting hand on brown covered table, with white papers and a red despatch box (?). Background colour various tones of brown and grey.

316a (87) Full-face and profile views on the same sheet. Pencil on paper, $19\frac{7}{8} \times 27\frac{1}{8}$ inches (50·5 × 68·9 cm), by SIR FRANCIS CHANTREY, 1838. PLATE 625

Inscribed (bottom left): Lord Melbourne 1838

Collections: The artist, presented by the wife of one of his executors, Mrs George Jones, 1871.

These 'camera lucida' drawings apparently relate to the marble bust of Melbourne by Chantrey of 1841, now at Windsor Castle (plate 623). Chantrey executed another bust of Melbourne in 1828 (private collection), and there is an undated plaster bust at the Ashmolean Museum, Oxford. The NPG drawing is one of a group of studies by Chantrey which will be collectively discussed in the forthcoming Catalogue of Portraits, 1790–1830.

3103 Pencil and wash on paper, $14\frac{7}{8} \times 12$ inches (37·9 × 30·6 cm), by SAMUEL DIEZ, 1841. PLATE 624

Signed and dated (centre right): S Diez 1841

Collections: Sotheby's, 27 July 1937 (lot 74); Donald Antiques and Decorations, purchased from them, 1941.

This drawing was lithographed by E. Desmaisons, published A. & C. Baily (example in NPG), with the inscription, 'Windsor Castle, July 1841'. A drawing of the Duke of Sutherland by Diez was offered at the same time, but declined.

4342 Pencil on paper, approximately $13 \times 9\frac{1}{4}$ inches (33 × 23·5 cm) irregular edges, by SIR GEORGE HAYTER, 1837. PLATE 620

Inscribed in ink in the artist's hand (bottom right): The Rt Honble Lord Vist/Melbourne/sketch for my great picture/of the House of Commons/in 1833./Windsor Castle 1837 Sept./G. Hayter

Collections: Purchased from I. Appelby, 1963.

This is a study for Hayter's 'House of Commons' group (NPG 54 below).

54 See *Groups:* 'The House of Commons, 1833' by Sir G. Hayter, p 526.

342, 3 See *Groups:* 'The Fine Arts Commissioners, 1846' by J Partridge, p 545.

999 See *Groups:* 'The House of Lords, 1820' by Sir G. Hayter, in forthcoming Catalogue of Portraits, 1790–1830.

ICONOGRAPHY

1781 Engraving by J. Gillray (example in NPG), reproduced D. Hill, *Mr Gillray: the Caricaturist* (1965), plate 23.

1785 Painting by Sir J. Reynolds (with his two brothers, 'The Lamb Family'). Collection of Viscount Gage. Reproduced E. K. Waterhouse, *Reynolds* (1941), plate 258. Engraved by F. Bartolozzi, published M. Benedetti, 1791, and by S. W. Reynolds, published A. Molteno, 1836 (examples in British Museum).

1785 Miniature (?) by Mrs Cosway (playing with a wolf). Listed *Panshanger Catalogue* (1885), p 303.

1796 Painting by J. Hoppner (in Montem dress). Royal Collection (plate 619). Reproduced Lord D. Cecil, *The Young Melbourne* (1939), facing p 45.

1800 Painting by Sir T. Lawrence. Collection of the Hon Edith Smith. Exhibited *VE*, 1892 (46). Reproduced K. Garlick, *Sir Thomas Lawrence* (1954), plate 53. Copy: Christie's, 12 March 1965 (lot 76), as by T. Phillips.

1805 Painting by Sir T. Lawrence. Collection of the Hon Lady Salmond.
Exhibited *SKM*, 1868 (315). Engraved by S. Freeman, published 1832 (example in NPG), by E. McInnes, published 1839 (example in NPG, plate 621), and by others (examples in NPG).

1820 'The House of Lords, 1820' by Sir G. Hayter (NPG 999 above).

c 1821 'The House of Commons', water-colour by R. Bowyer, A. Pugin and J. Stephanoff. Houses of Parliament. Engraved by J. Scott (example in Houses of Parliament).

1828 Bust by Sir F. Chantrey. Private collection.

c 1831 Painting by J. Jackson. Offered to NPG by A. Smith, 1887.
Sketched by G. Scharf, 'TSB' (NPG archives), XXXII, 65.

1832 'The Reform Banquet, 1832' by B. R. Haydon. Collection of Lady Mary Howick.
Etched by F. Bromley, published J. C. Bromley, 1835 (example in NPG); engraved by and published J. C. Bromley, 1837 (example in British Museum).

1833 'The House of Commons, 1833' by Sir G. Hayter (NPG 54 above).
Oil study of 1838, and a copy: Royal Collection. Pencil study (NPG 4342 above).

1834 Painting by H. W. Pickersgill. Collection of Lady Brocket, 1950.

1834 Miniature by Sir W. C. Ross. Collection of L. H. Luke. Reproduced Lord D. Cecil, *Lord M.* (1954), facing p 112. Another miniature by Ross was reproduced *Connoisseur*, LV (1919), 94, when in the collection of Lionel Grace. One of the two may have been the miniature exhibited *RA*, 1834 (756).

1836 Paintings by Sir E. Landseer (see NPG 3050 above).

c 1836 Bust by J. Francis. Exhibited *RA*, 1836 (1117).
Possibly the bust by Francis of 1836 now in the Museum at Melbourne.

1837 'Party at Ranton Abbey' by Sir F. Grant. National Trust, Shugborough House.
Exhibited *RA*, 1841 (492), and *SKM*, 1868 (449). Engraved by W. H. Simmons.

1837 'Queen Victoria's First Council' by Sir D. Wilkie. Royal Collection, Windsor.
Exhibited *RA*, 1838 (60). Engraved by C. Fox, published F. G. Moon, 1839 (example in British Museum).

c 1837 Colossal marble bust by J. Francis. Exhibited *RA*, 1837 (1289).
A cabinet statue by Francis was exhibited *RA*, 1837 (1254).

1838 'Queen Victoria's Coronation' by Sir G. Hayter. Royal Collection.
Exhibited *VE*, 1892 (6). Engraved by H. T. Ryall, published Graves and Warmsley, 1843 (example in NPG). A study of Melbourne was in the *89th Exhibition of Water-colours and Drawings*, Agnew's, 1962 (189).

1838 Painting by Sir G. Hayter. Formerly collection of Lord Brocket.
Exhibited *RA*, 1838 (220). Engraved by C. Turner, published Colnaghi, 1839 (example in NPG), engraving reproduced H. Dunckley, *Lord M.* (1890), frontispiece. An enamel by H. Bone, after Hayter, was exhibited *RA*, 1840 (892).

1838 'The Queen Receiving the Sacrament after her Coronation' by C. R. Leslie. Royal Collection.
Exhibited *RA*, 1843 (74).

1838 Drawings by Sir F. Chantrey (NPG 316a (87) above).

1838 Bust by R. Moody. Royal Collection.

1838 Marble bust by J. Ternouth. Collection of the Marquess of Lothian.
Another bust by Ternouth was exhibited *RA*, 1837 (1266).

1838 Bust by J. Francis. Royal Collection, Frogmore.

1838 'Homage of the Peers at the Coronation of Queen Victoria', miniature by Sir W. J. Newton. Exhibited *RA*, 1841 (839), and *VE*, 1892 (423), lent by Mrs Newton.

1839	'Queen Victoria Riding at Windsor Castle, 1839' by Sir F. Grant. Royal Collection (plate 947). Exhibited *RA*, 1840 (162), *VE*, 1892 (19), and *Bicentenary Exhibition*, RA, 1968–9 (221). Engraved by J. Thomson. Reproduced Lord D. Cecil, *Lord M.* (1954), facing p 248. A study was in the collection of Lord Strafford.
c 1839	Oil sketch by Sir F. Grant. Exhibited *VE*, 1892 (54), lent by the Hon Evelyn Ashley.
1840	'Marriage of Queen Victoria and Prince Albert, 1840' by Sir G. Hayter. Royal Collection.
1840	Painting by J. Gooch. Collection of Lady Brocket, 1950.
1841	Drawing by S. F. Diez (NPG 3103).
c 1841	Bust by R. Moody. Exhibited *RA*, 1841 (1149).
1841	Bust by Sir F. Chantrey. Royal Collection (plate 623). Another bust by Chantrey is in the Ashmolean Museum, Oxford.
1843	Paintings by J. Partridge (see entry for NPG 941 above).
1846	'The Fine Arts Commissioners, 1846' by J. Partridge (NPG 342 above). Study (NPG 941 above).
Undated	Painting by G. H. Harlow. Irish NPG.
Undated	Painting attributed to Sir T. Lawrence. Christie's, 22 February 1861 (lot 113). Another painting attributed to Lawrence was sold Christie's, 10 July 1914 (lot 102).
Undated	Drawing by Lady Caroline Lamb. In a sketch book formerly at Panshanger House. Reproduced *Country Life*, LXXXV (1939), 174.
Undated	Water-colour by an unknown artist. Formerly at Panshanger House. Reproduced Lord D. Cecil, *The Young Melbourne* (1939), facing p 250.
Undated	Silhouette attributed to F. Atkinson. Reproduced E. N. Jackson, *History of Silhouettes* (1911), plate XXXVII, when in the collection of F. Wellesley.

MELVILL *Sir James Cosmo* (*1792–1861*)

Entered home service of the East India Company, 1808; became financial secretary, 1834, and chief secretary, 1836; after the abolition of the company, 1858, became government director of Indian railways.

4825 Oil on canvas, 49⅞ × 40 inches (126·6 × 101·6 cm), by JOHN JAMES NAPIER, *c* 1858. PLATE 628

Inscribed in ink in the artist's hand on a faded label on the back of the frame, evidently referring to the RA exhibition: No 4/Sir James Melvill K.C.B./late Secretary to the Honorable East India Company/ by John J. Napier

Collections: By descent to the sitter's great great-grandson, Col M. E. Melvill, and presented by him, 1970.

Exhibitions: RA, 1858 (451).

The painting remains at present in an unrestored condition. The document held by the sitter bears a few illegible marks that might be intended for an inscription: 'Mr. . . . [?]/III'. A companion portrait of Melvill's wife was presented at the same time (NPG 4825a), but it is not catalogued here as the sitter is not of sufficient importance. Apart from a painting by E. U. Eddis, exhibited *SKM*, 1868 (448), no other portraits of Melvill are recorded.

Description: Brown eyes, grey hair and whiskers. Dressed in a black neck-tie, white shirt, black waistcoat and suit, holding a white document. Seated in a brown wooden and red-covered armchair. Background colour very dark brown.

MEYRICK *Sir Samuel Rush* (*1783–1848*)

Antiquary; ecclesiastical and admiralty lawyer; adviser on armour to the Tower of London and Windsor Castle; high sheriff of Herefordshire, 1834; wrote a history of Cardiganshire, a history of arms and armour, and other works.

2515 (62) Black and red chalk, with touches of Chinese white, on green-tinted paper, 14 × 10 inches (35·3 × 25·5 cm), by WILLIAM BROCKEDON, *c* 1830. PLATE 629

Dated (lower left): 8th 3.4

Collections: See *Collections:* 'Drawings of Prominent People, 1823–49' by W. Brockedon, p 554.

Accompanied in the Brockedon Album by a letter from the sitter, postmarked 10 May 1830. The date of the drawing is based on costume and the apparent age of the sitter. The inscribed date is confusing, but might be meant for 1834.

ICONOGRAPHY The only other recorded portraits of Meyrick are, a painting by H. P. Briggs, originally at Goodrich Court, exhibited *R A*, 1829 (264), engraved by and published W. Skelton, 1833 (example in NPG), and a miniature called Meyrick by an unknown artist in the collection of Mrs Forestier Walker.

MILDMAY *Paulet St John* (*1791–1845*)

MP for Winchester.

54 See *Groups:* 'The House of Commons, 1833' by Sir G. Hayter, p 526.

MILL *John Stuart* (*1806–73*)

Philosopher; author of 'On Liberty' and numerous other philosophical, economic and political works; probably the most influential English Victorian philosopher.

1009 Oil on canvas, 26 × 21 inches (66 × 53·3 cm), by GEORGE FREDERICK WATTS, after his portrait of 1873. PLATE 631

Collections: The artist, presented by him, 1895 (see appendix on portraits by G. F. Watts in forthcoming Catalogue of Portraits, 1860–90).

Exhibitions: Paintings by G. F. Watts, Metropolitan Museum, New York, 1884–5 (90); *Art Exhibition,* City Museum and Art Gallery, Birmingham, 1885–6 (155); *Collection of Pictures by G. F. Watts,* Museum and Art Gallery, Nottingham Castle, 1886 (20); Toynbee Hall, London, 1892; Southwark, 1894.

Literature: H. S. R. Elliot, *The Letters of John Stuart Mill* (1910), II, reproduced as frontispiece; [Mrs] M. S. Watts, *George Frederic Watts* (1912), I, 273–5; 'Catalogue of Works by G. F. Watts', compiled by Mrs M. S. Watts (MS, Watts Gallery, Compton), II, 108; C. T. Bateman, *G. F. Watts, R. A.* (1901), p 49.

This is a replica of the original portrait commissioned by Sir Charles Dilke, and bequeathed by him to the City of Westminster, who still own it (plate 632). The latter was exhibited *R A*, 1874 (246), *Winter Exhibition,* Grosvenor Gallery, 1882 (130), *Royal Jubilee Exhibition,* Manchester, 1887, 'Fine Art Section' (548), and *VE*, 1892 (227); it was etched by P. Rajon (example in NPG), etching exhibited *R A*, 1875 (1102), and reproduced *Print Collector's Quarterly,* VI, 419. In a letter of 9 March 1873, Mill wrote to Dilke ('Book of MS Letters Relating to the Dilke Portrait', City of Westminster archives):

I hardly know how to answer your very kind and flattering proposal regarding a portrait. I have hitherto disliked having my portrait taken, but I am unwilling to refuse the high compliment paid me by Mr. Watts and yourself; and if sittings can be arranged within the limited time of my stay in London I shall be happy to make an appointment.

Watts recorded one sitting in a letter to Dilke of 16 March 1873 (Westminster archives): '*Mr Mill is to come tomorrow to give me a sitting.*' In her catalogue, Mrs Watts mentions a letter from Mill to Watts promising a sitting on 17 March. According to Mrs Watts, during the sittings Mr and Mrs Fawcett came to see the portrait, and felt that Watts had '*seized that characteristic of Mill which gave the impression of his great refinement and delicacy*'. Watts found Mill a sympathetic sitter '*sensitive to all that was beautiful in form and poetic in thought.*' Mill died on 8 May 1873. On 3 August Watts wrote to Dilke (Westminster archives):

Losing so much time in the Spring by being ill I am a good deal in arrears with my work but I hope to have my copy finished by the middle of the week. Perhaps if not inconvenient you and Lady Dilke would pay my studio a visit about Wednesday afternoon or any other afternoon after 6. You might like to see the picture and the replica together as I am not sure the latter is not the best of the two.

The replica mentioned in this letter is the portrait now in the NPG; Dilke preferred to keep the original, and he was wise to do so, as it is a much stronger and more vital characterization. Watts wrote to Dilke again on 2 September 1873 (Westminster archives):

I regret to say I forgot to make the memorandum on the portrait of Mr Mill to the effect that it was the first painted but that can be done at any time.
I beg to acknowledge your cheque for £315, payment for the portrait...
If you wish to keep the frame its price is 5 gns.

Over the question of an engraver, there was quite a considerable correspondence between Watts and Dilke, before Rajon was selected; the latter wrote to Dilke in French on 4 July 1874 to say that the etching was '*déjà très avancé*' (Westminster archives). Watts thought the finished etching excellent.

Dilke's portrait was the only one done by Watts from the life. When Dilke discovered that Mill's stepdaughter, Helen Taylor, who had urged Mill to sit to Watts, did not possess any portrait of Mill herself, he offered her his own. In a letter of 20 November 1873 to Lady Dilke, she declined the offer (Westminster archives): '*no one has a better right to the portrait of my dear step-father than you and Sir Charles Dilke. . . . It was meant for you; and that, to me gives you a right to it which is sacred.*' She wished to have a replica painted to present to the nation, but discovered that Watts had already painted the NPG portrait for this purpose.

In 1905 a third version of the portrait was lent to the *Watts Memorial Exhibition*, Royal Academy (34), by the executors of the painter, catalogued as if it were the original; it was subsequently exhibited in Edinburgh, and the Royal Hibernian Academy, Dublin, 1906 (32). Dilke at once protested to Mrs Watts, and to several influential people in the art world (his letters to Cust are in the NPG archives). He referred to this version as an indifferent copy, but Mrs Watts was sure that it had been painted by her husband, as it had hung in his gallery at Little Holland House and at Limmerslease. Mrs Watts did, however, agree that this third version was a replica of the NPG replica, and had no status as an original portrait. It is now in the Watts Gallery, Compton, and is much the flattest and weakest of the three versions. Watts often played about with several canvases at the same time, and he often worked on them subsequently. In the case of Carlyle (see NPG 1002), the original is in the Victoria and Albert Museum, a good version in the NPG, and a scrappy, unfinished version in the Ashmolean Museum.
Description: Brown eyes, light brownish-grey hair. Dressed in a dark neck-tie, white shirt and dark coat. Background colour dark brown.

ICONOGRAPHY A drawing by E. Goodwyn Lewis of 1869 is in the collection of Mr and Mrs Graham Hutton; a posthumous bronze medallion by A. Legros is in the Manchester City Art Gallery; a bronze statue by T. Woolner of *c* 1878 is in the Victoria Embankment Gardens, London; an early daguerreotype, and a cameo by, or derived from a work by, Cunningham of Falmouth, are reproduced H. S. R. Elliot, *The Letters of John Stuart Mill* (1910), I, frontispiece, and facing 233; these were once in the collection of Mary Taylor, the daughter of

Mill's stepson, Algernon Taylor, but are now untraced (see *Times Literary Supplement*, 11 November 1949, p 733); there are various photographs taken in the later part of Mill's life (examples in NPG and elsewhere, plate 630); there are over twenty recorded caricatures, in *Punch, Fun, Judy, etc*, including one in the *London Serio-Comic Journal*, 23 November 1868, and another in *Vanity Fair*, 29 March 1873, for which there is a water-colour study of the head in the NPG. I would like to thank Professor F. E. Mineka of Cornell University for his help with the foregoing iconography.

MILLER *Colonel Jonathan*

American slavery abolitionist.

599 See *Groups:* 'The Anti-Slavery Society Convention, 1840' by B. R. Haydon, p 538.

MILLER *William Henry (1789–1848)*

Book collector, MP for Newcastle-under-Lyme.

54 See *Groups:* 'The House of Commons, 1833' by Sir G. Hayter, p 526.

MILLS *John (1789–1871)*

MP for Rochester.

54 See *Groups:* 'The House of Commons, 1833' by Sir G. Hayter, p 526.

MILMAN *Henry Hart (1791–1868)*

Dean of St Paul's; won several prizes at Oxford, including the Newdigate; fellow of Brasenose College; professor of poetry at Oxford, 1821–31; dean of St Paul's, 1849; published poetry, plays, books of history and theology, and other works.

1324 Oil on canvas, $25\frac{1}{2} \times 20\frac{1}{2}$ inches (64·8 × 52 cm), by GEORGE FREDERICK WATTS, *c* 1863. PLATE 633

Collections: The sitter, presented by his three sons, the Rev William, Sir Archibald, and Arthur, 1902 (see appendix on portraits by G. F. Watts in forthcoming Catalogue of Portraits, 1860–90).

Exhibitions: Royal Jubilee Exhibition, Manchester, 1887, 'Fine Art Section' (547).

Literature: 'Catalogue of Works by G. F. Watts', compiled by Mrs M. S. Watts (MS, Watts Gallery, Compton), II, 109.

In a letter of 20 June 1863 (Kensington Central Library archives, kindly communicated by Miss R. J. Ensing), Watts wrote to Mrs Milman:

I perceive that my picture does not please you or the Dean and I despair now of making it do so, regretting for the Dean's sake the trouble he has had. I shall be most happy to keep the picture which I esteem as one of my very best for my own collection, under these circumstances if at all inconvenient to the Dean to come tomorrow I think I can finish without another sitting which however I shall be very glad to have.

The Milmans evidently overcame their objections, since they acquired the portrait. Another version, almost certainly a replica, is in the Royal Academy, presented by the artist, 1876. In a letter of 23 July 1902 (NPG archives), the sitter's son, the Rev William Milman, wrote:

I can throw no light upon the genesis of the Watts Replica of my father's portrait. . . . But when we turn from the unknown to the known I can bear most emphatic testimony to the fact that the Portrait which you received on Monday is 'the Portrait' for which Dean Milman sat exclusively to Mr Watts – I went with my father on two or three occasions when he was sitting to Mr Watts – and that it is the portrait which was sent to the Dean as soon as finished.

Watts frequently executed replicas of the portraits of his more famous sitters. The NPG portrait was engraved for Milman's *History of Latin Christianity* (4th edition, 1883), I, frontispiece.

Description: Brown eyes, grey hair and whiskers. Dressed in a white collar, blue undergarment and black coat. Background colour very dark brown.

ICONOGRAPHY A painting by H.P.Briggs was exhibited *RA*, 1833 (466), and another by H.W.Phillips, *RA*, 1859 (22); a painting by Cruikshank of 1837 is reproduced A.Milman, *Henry Hart Milman* (1900), frontispiece; a drawing by T.Uwins of 1813 is in the British Museum; an engraving by W.Walker, after T.A. Woolnoth, was published W.Walker, 1852 (example in NPG), and a lithograph by J.A.Vinter, after the same picture, was published A.E.Evans, 1854 (example in NPG); two woodcuts were published *ILN*, XV (1849), 336, and XXIV (1854), 400, and another, after a photograph by Mason, LIII (1868), 340; a monument, with a recumbent figure of Milman by F.J.Williamson, is in St Paul's Cathedral (erected 1876; see *Athenaeum*, no.2538 (19 June 1876), 831).

MILNER-GIBSON *Thomas* (*1806–84*)

Statesman; MP from 1837; member of the Anti-Corn Law League; vice-president of board of trade, 1846–8; president of board of trade, 1859–68; promoter of commercial treaty with France.

1930 Water-colour and gum, with touches of Chinese white, on paper, 10 × 8 inches (25·4 × 20·2 cm) cut corners, by CHARLES ALLEN DU VAL, 1843. PLATE 634

Signed and dated (top right): CA Du Val 1843

Collections: By descent to Gery Milner-Gibson-Cullum, and bequeathed by him, 1922.

Exhibitions: VE, 1892 (387).

Literature: Rev E.Farrer, *Portraits in Suffolk Houses* (*West*) (1908), p157.

This portrait was engraved by S.W.Reynolds, published Agnew and others, 1844 (example in NPG). It was copied for the residuary legatee of the donor's estate before entering the collection. Several other portraits were bequeathed by G. Milner-Gibson-Cullum at the same time.

Description: Pinkish cheeks, brown eyes and hair. Dressed in a dark stock, white shirt, light-coloured waistcoat, and dark brown coat. Background colour brown.

ICONOGRAPHY A copy by Miss Collett of a miniature, showing the sitter as a boy, was at Hardwick House, Hawstead, in 1908, recorded by E.Farrer (see reference above), p157; a painting by J.Holmes was exhibited *VE*, 1892 (115), lent by J.Milner-Gibson, presumably the portrait by Holmes engraved by W.Holl, published T.Collins, 1842 (example in NPG); the sitter appears in 'The Anti-Corn Law League', engraving by S. Bellin, after a painting by J.R.Herbert of 1847, published Agnew, 1850 (example in NPG), and in 'The House of Commons, 1860', painting by J.Phillip of 1863 in the House of Commons, engraved by T.O.Barlow, published Agnew, 1866 (example in the NPG); a woodcut was published *ILN*, I (1842), 541, and there are two photographs in the NPG.

MITFORD *Mary Russell* (*1787–1855*)

Novelist and dramatist; published *Miscellaneous Poems*, 1810; wrote for magazines; contributed *Our Village* to *Lady's Magazine*, 1819; published *Rienzi*, *Atherton*, and other works.

404 Oil on millboard, 14 × 12¼ inches (35·5 × 31·1 cm) painted oval, by JOHN LUCAS, *c* 1853, after a portrait by B.R.Haydon of 1824. PLATE 635

Inscribed on a label on the back: Mary Russell Mitford (Authoress)/painted by John Lucas.

Collections: Commissioned by Francis Bennoch; purchased, through Earl Stanhope, Lucas Sale, Christie's, 25 February 1875 (lot 53).

Literature: A. Lucas, *John Lucas* (1910), p 109, where it is inaccurately described as a copy of Lucas' portrait of 1852 (see NPG 4045 below); V. Watson, *Mary Russell Mitford* (1949), p 314.

This portrait is based on the head of B. R. Haydon's portrait of 1824, now in the Reading Museum and Art Gallery. To Miss Mitford, Haydon's portrait *'seemed a strong, unflattered likeness'*, and she commented on another occasion: *'It was so exaggerated, both in size and colour, that none of my friends could endure it.'* She later referred to the painting as *'the cook-maid thing of poor dear Haydon'.*[1] Haydon eventually cut the head out and destroyed the rest of the picture. Francis Bennoch, who owned the Haydon fragment, got Lucas to execute his copy, so as to soften the rumbustious effect of the original. He then had the Lucas engraved by W. Drummond, as the frontispiece to Miss Mitford's *Dramatic Works*, and to vol I of *Atherton* (both of 1854), intending to present the Lucas painting to her as a surprise. Miss Mitford, however, thought that the engraving had been done from the Haydon, and her reactions were so hostile that neither Bennoch nor Lucas dared to tell her of the substitution, let alone present her with the painting; Lucas simply suppressed it. On 11 April 1854, Miss Mitford wrote innocently to the artist: *'Thank you, dearest Mr Lucas, for liking "Atherton". . . . Everybody detests the portrait; William Harness says that it represents a "fierce, dark, strong-minded woman". Mr Hope says that "not only is it utterly unlike the author of 'Atherton' and 'Our Village', but that it was morally impossible that it should have been like her, although it might very possibly be a striking likeness of the author of 'Uncle Tom'".'*[2] Bennoch came into possession of the Haydon portrait in September 1853, so the Lucas must date from the winter of 1853–4.[3]

Description: Dark complexion, bluish eyes, brown hair. Dressed in a white bonnet with a red ribbon, a greyish-brown dress with a white collar, fastened by a gold brooch with a blue stone, and a reddish-brown shawl. Background colour green. Visible across the front of the portrait are pencil grid lines, presumably used by the engraver to transfer the design onto his plate. On the reverse of the portrait is an unfinished oil sketch of a seated man, and a study of a hand.

4045 Coloured chalk on buff (possibly discoloured) paper, $14\frac{7}{8} \times 11\frac{3}{4}$ inches ($37 \cdot 8 \times 29 \cdot 8$ cm), by JOHN LUCAS, 1852. PLATE 637

Inscribed by the artist in chalk (lower left): Drawn at Swallowfield/April 12th 1852/John Lucas *and below in ink:* To Mrs Acton Tindal, with Mr Lucas's respectful Compliments

Collections: Given by the artist to Mrs Acton Tindal; by descent to Clementina Tindal-Carill-Worsley; given by her to Francis Needham, and presented by him, 1963.

Exhibitions: S K M, 1868 (592).

Literature: N P G Annual Report, 1957–8 (1959), p 6.

This is a study for the oil painting by Lucas, which was given by the sitter to her American publisher, J. T. Fields (now in a private collection, U S A). The oil was engraved by S. Freeman, published R. Bentley, 1852 (example in NPG); on the engraving it is stated that the picture was painted on 17 April 1852. It is apparently to this portrait that Miss Mitford referred in a letter said by Harness to date from the spring of 1853, but almost certainly written in the spring of 1852: *'Mr Lucas, an excellent painter of female portraits, and one of the most charming persons in the world, has had the infinite kindness to come down here and paint me. His picture is now in the engraver's hands. As a work of art it is absolutely marvellous – literal, as a likeness, in feature and complexion, but wonderful in the expression – so like, yet so idealized that I think it shows me as I never do look, but yet as, by some strange possibility I may have looked. . . . The present expression – his expression – is thoughtful, happy, tender – as if the mind were*

[1] Letters to Sir William Elford of 21 May 1825 and 16 December 1828, published [Rev W. Harness], *The Life of Mary Russell Mitford*, edited Rev A. G. L'Estrange (1870), II, 205–6, 259–60, and 262, respectively.

[2] Harness, III, 281.

[3] Much of the information for this entry was kindly communicated by Francis Needham (letters and notes in NPG archives).

dwelling in a pleasant frame on some dear friend'.[1] Miss Mitford wrote later to Mrs Acton-Tindal, to whom the NPG drawing is dedicated, on 2 October 1854: '"*Atherton*", *admirably got up, is selling there* [in the USA] *by tens of thousands; and if you see John Lucas, I wish you would tell him, with my love, that the fine picture which I gave to Mr Fields has been engraved there – they tell me admirably – and prefixed to the work*'.[2]

Description: Brownish eyes, greyish hair.

ICONOGRAPHY Harness refers to [Rev W. Harness], *The Life of Mary Russell Mitford*, edited Rev A. G. L'Estrange (1870), 3 vols.

1790 Engraving by J. B. Hunt, after a miniature by J. Plott, published Rogerson and Tuxford, 1852 (example in NPG). See Harness, III, 260.

1823 Engraving by W. Read, after a painting by Miss Drummond, published 1823 (example in NPG), for *La Belle Assemblée*.

1824 Painting by B. R. Haydon. Reading Museum and Art Gallery.
Reproduced *Art Journal* (1866), p 117, and V. Watson, *Mary Russell Mitford* (1949), facing p 177. See Harness, II, 205–6, 259–60, and III, 249–50. Copy by J. Lucas (NPG 404 above); another is in the collection of B. J. Thomason.

1828 Painting by J. Lucas. Destroyed by the artist.
Exhibited *RA*, 1829 (126). Engraved by J. Bromley, published Colnaghi, 1830 (example in British Museum, plate 636); there is a letter of *c* 1830 from Miss Mitford to Lucas about the engraving (NPG archives, artists' autographs). See A. Lucas, *John Lucas* (1910), pp 6–11, and 109; the engraving is reproduced plate IV, facing p 8. See Harness, II, 245, 261–4, and III, 64–5.

1831 Engraving by D. Maclise, published *Fraser's Magazine*, III (May 1831), facing 410, as no. 12 of Maclise's 'Gallery of Illustrious Literary Characters'. A pencil study is in the Victoria and Albert Museum.

1831 Engraving by J. Thomson, after F. R. Say, published Colburn and Bentley, 1831 (example in NPG), for the *New Monthly Magazine*.

1832 Water-colour by A. R. Burt. Folger Shakespeare Library, Washington. Engraved by R. Rolfe (example in NPG), engraving reproduced C. Hill, *Mary Russell Mitford and her Surroundings* (1920), frontispiece.

c 1835 Miniature by Miss E. Jones. Exhibited *RA*, 1835 (705).

1835 Print by G. Baxter, for an illustrated edition of *Our Village* (1835). Reproduced V. Watson, *Mary Russell Mitford* (1949), facing p 80.

1838 Engraving by A. Collas, after a medal by E. W. Wyon, published C. Tilt, 1838 (example in NPG), for A. Collas and H. F. Chorley, *The Authors of England*.

1852 Painting by J. Lucas. Private collection, USA. Engraved by S. Freeman, published R. Bentley, 1852, and engraved anonymously (examples in NPG); woodcut, after Lucas, published *ILN*, XXIV (1859), 369. Study (NPG 4045 above).

c 1853 Painting by J. Lucas, after the 1824 Haydon portrait (NPG 405 above).

Undated Lithograph by I. W. Slater, after J. Slater (example in British Museum).

Undated Engraving by R. Woodman, after Branwhite (example in NPG), and engraving by W. Bond (example in British Museum).

MOFFAT *Robert* (*1795–1883*)

Missionary; sent to Namaqualand by London Missionary Society; played prominent role in converting natives and establishing missions in Africa; translated New Testament into Sechuana; his daughter, Mary, married David Livingstone.

[1] [Rev W. Harness], *The Life of Mary Russell Mitford*, edited Rev A. G. L'Estrange (1870), III, 260–1. This letter could not refer to Lucas' copy after Haydon (NPG 404 above), about which Miss Mitford knew nothing. No other portraits of her by Lucas of this period are recorded.
[2] *Letters of Mary Russell Mitford*, edited H. F. Chorley (second series, 1872), II, 78.

3774 Oil on canvas, 30 × 25 inches (76·2 × 63·5 cm), by WILLIAM SCOTT, 1842. PLATE 638

Inscribed on the reverse: Painted by/W^m. Scott/Dec^r 1842.

Collections: Traditionally said to have descended from the sitter's wife, Mrs Mary Moffat (*née* Smith), to R.M. and R.N. Aldrych-Smith, from whom it was purchased, 1950.

The identification is traditional, but agrees well with authentic portraits of Moffat. The vendors wrote in a letter of 2 February 1950 (NPG archives): *'Very little is known of the history of the portrait except that a certain Alexander Smith was related to Mary Moffat wife of Robert Moffat'.*

Description: Healthy complexion, dark brown eyes and hair. Dressed in a black stock, white shirt, and black coat. Background colour various tones of dark brown and dark green.

ICONOGRAPHY A painting by J.J.Napier was exhibited *RA*, 1873 (510); a miniature by Mrs L.Bolton, after a photograph by Elliott and Fry, was in the collection of Miss Peytouri, exhibited *RA*, 1882 (1416); a lithograph by R.Blind, after a drawing of a miniature of 1815, is reproduced J.S.Moffat, *The Lives of Robert and Mary Moffat* (1885), facing p12, and so is a photograph by Elliott and Fry, frontispiece; there is an engraving by J.Cochran, after H.Room (example in NPG), and a colour print by G.Baxter of 1843 (example in NPG), reproduced C.W.Northcott, *Robert Moffat: Pioneer in Africa* (1961), facing p161; a drawing, 'Visit to Moselekatze' (with Dr A.Smith) by C.Bell of 1835 is in the University of Witwatersrand, reproduced Northcott, facing p160; an engraving of 1843, an engraving of 1819, and a photograph, are reproduced Northcott, frontispiece, facing p30, and facing p177, respectively; two woodcuts were published *ILN*, LX (1872), 452, and LXXII (1878), 148, and another, entitled 'The Eastern Question Conference', LXIX (1876), 576–7.

MOLESWORTH *Sir William, Bart* (*1810–55*)

Politician; utilitarian; founded *London Review*, 1835; gave *Westminster Review* to J.S.Mill; MP from 1832; supported colonial self-government; served in Aberdeen's cabinet, 1853; colonial secretary under Palmerston, 1855; opened Kew Gardens on Sundays; edited Hobbes' complete works.

810 Oil on canvas, 50 × 40 inches (127·1 × 101·6 cm), by SIR JOHN WATSON GORDON, 1854. PLATE 639

Signed and dated (middle right): Sir J^o Watson Gordon/R.A. and P.R.S.A. Pinx^t/1854.

Inscribed on a label, formerly on the back of the stretcher: Portrait of Joseph Robinson/Pease Esq^r. of Hesslewood E.York-/shire. Presented to him by his Friends and Neighbours-/By Sir John Watson Gordon

Collections: The sitter, bequeathed by his widow, 1888.

Exhibitions: RA, 1855 (281); *SKM*, 1868 (541).

The portrait of Pease was exhibited at the RA in the same year as that of Molesworth. Presumably the labels on the back got muddled up. There is no doubt that the NPG portrait represents Molesworth.

Description: Healthy complexion, blue-grey eyes, brown hair. Dressed in a white shirt, black tie, light grey waistcoat with blue checks, silver monocle, gold watch-chain, fawn trousers, dark brown coat, holding a brown wooden walking stick, with gold mount at the top and a horn (?) handle. Seated in a red armchair, with a red and brown patterned table-cloth at right. Background colour, various tones of dark brown and green.

54 See *Groups:* 'The House of Commons, 1833' by Sir G.Hayter, p526.

1125 See *Groups:* 'The Coalition Ministry, 1854' by Sir J.Gilbert, p550.

ICONOGRAPHY The following portraits of Molesworth are reproduced in Mrs Fawcett, *Life of the Rt Hon Sir William Molesworth* (1901); a study for 'The House of Commons, 1833' by Sir G.Hayter (see NPG 54 above), facing p38; a silhouette of 1822, p41; a drawing by R.P.Collier of 1835, facing p239; an engraving

by W. Walker of 1854, published Walker, 1856 (example in NPG), reproduced frontispiece; and a bronze relief by G. Frampton of 1899, formerly in St George's Free Library, Southwark, reproduced facing p 340. A water-colour by A. E. Chalon was exhibited *RA*, 1846 (1047); various caricature drawings by J. Doyle are in the British Museum; a drawing by W. R. Govel of 1846 is in the Rex Nan Kivell collection; a drawing of Molesworth and his friends was reproduced in *The Gentlewoman* (October 1904); a miniature by B. R. Green was exhibited *RA*, 1853 (773), and another by Jacques of 1831 was in the *Special Exhibition of Portrait Miniatures*, South Kensington Museum, 1865 (2207); a marble bust by W. Behnes of 1843 is in the Parliament Buildings, Ottawa, reproduced Mrs Fawcett, facing p 240, and another by the same sculptor of 1842 is in the Reform Club, London; one of the busts was presumably that exhibited *RA*, 1842 (1355); a marble bust by A. Hone was exhibited *RA*, 1837 (1211); a model for a statue by H. H. Armstead was exhibited *RA*, 1874 (1573); an engraving was published *Notices of the Late Sir William Molesworth* (1857), frontispiece, and another of 1854 is reproduced *Selected Speeches of Sir William Molesworth*, edited by H. E. Egerton (1903), frontispiece; an engraving by D. Maclise was published *Fraser's Magazine*, XVII (1838), facing 338, as no. 80 of Maclise's 'Gallery of Illustrious Literary Characters'; there is an anonymous engraving and an anonymous caricature (examples in NPG); woodcuts were published *ILN*, VII (1845), 176, XVIII (1851), 342, after a photograph by Kilburn, and XXVII (1855), 489, after a photograph by B. E. Duppa.

MONTEAGLE *Thomas Spring-Rice*, *1st Baron* (*1790–1866*)

MP for Cambridge.

54 See *Groups*: 'The House of Commons, 1833' by Sir G. Hayter, p 526.

MONTEFIORE *Sir Moses Haim*, *Bart* (*1784–1885*)

Philanthropist; retired from stockbroking with a fortune, 1824; pleaded the cause of oppressed Jews in Turkey, Russia, Morocco and elsewhere; noted for other benevolent actions abroad; visited Jerusalem seven times, and founded a school, a hospital and almshouses there.

2178 Oil on canvas, 23⅞ × 20⅛ inches (60·7 × 51 cm), by HENRY WEIGALL, 1881. PLATE 640

Signed in monogram and dated (*bottom right*): H W/1881.

Collections: The artist; Weigall Sale, Christie's, 6 July 1925 (lot 160), where it was presumably bought in; presented by members of the artist's family, 1928.

Exhibitions: VE, 1892 (304).

A portrait of Montefiore and a copy are listed in Weigall's 'Account Book' (photostat copy, NPG archives), under 1881 (511 and 512). Since both these were paid for, it seems unlikely that either is the NPG picture, which remained with the artist.

Description: Healthy complexion, brown eyes, white beard. Dressed in a white stock, white shirt, light blue waistcoat, dark blue jacket and cap, and a green coat. Background colour brown.

ICONOGRAPHY Various portraits were in the *Anglo-Jewish Historical Exhibition*, Royal Albert Hall, London, 1887 (1047–53a); a painting by S. Hart, for the Congregation of Spanish and Portuguese Jews, was exhibited *RA*, 1848 (99), and another by the same artist, for the Town Hall, Ramsgate (reproduction in NPG), was exhibited *RA*, 1869 (256); a painting by F. Goodall was exhibited *RA*, 1890 (359), and reproduced *Magazine of Art* (1890), p 257; a painting by G. Richmond, for the British and Foreign Life and Fire Assurance Co Ltd, was exhibited *RA*, 1875 (290), listed in the artist's 'Account Book' (photostat of original MS, NPG archives), under the year 1874, where an engraving is mentioned, possibly the engraving by T. L. Atkinson, exhibited *RA*, 1876 (1133); a drawing by L. Sambourne was in the *Victorian Era Exhibition*, 1897, 'Historical Section' (317), lent by H. Hart; a marble bust by H. Weekes was exhibited *RA*, 1877 (1425); a bust by A. Fontana was exhibited *RA*, 1884 (1690); an etching by R. Dighton of 1818 was published T. McLean, 1824 (example in

NPG); there are lithographs by R. Blind (example in NPG), E. Kruger, Lunois and an unknown artist (examples in British Museum); a bronze medal was bequeathed to the NPG by V. Cohen, 1938, but declined; there are several photographs in the NPG, and a woodcut after one was published *ILN*, XLVI (1865), 153.

MOORE *Thomas Edward Laws* (*1819–72*)

Rear-admiral; served on Antarctic expeditions, 1839–43, 1845 and 1848–50; governor of the Falkland Islands, 1855–62.

1215 Oil on canvas, $15\frac{1}{4} \times 12\frac{3}{4}$ inches (38·7 × 32·7 cm), by STEPHEN PEARCE, 1860. PLATE 641
Collections: See *Collections:* 'Arctic Explorers' by S. Pearce, p 562.
Exhibitions: Royal Naval Exhibition, Chelsea, 1891 (53a).
Literature: S. Pearce, *Memories of the Past* (1903), p 72.

Pearce records that Moore and Maguire (see NPG 1214) both sat at the same time, and mentions this in a section dealing with 1860. The portrait of Maguire was exhibited the following year at the *RA*. This is the only recorded portrait of Moore. He is wearing the full-dress uniform (1856 pattern) either of a naval captain with over three years' service, or of a commodore (1st or 2nd class), and the Arctic Medal (1818–55).

Description: Healthy complexion, bluish eyes, brown hair and whiskers. Dressed in a dark blue naval uniform with gold-braided collar and epaulettes, gilt buttons, and a silver medal with a grey ribbon. Background colour dark greenish-grey.

MOORSOM *Constantine Richard* (*1792–1861*)

Vice-admiral, railway chairman, and slavery abolitionist.

599 See *Groups:* 'The Anti-Slavery Society Convention, 1840' by B. R. Haydon, p 538.

MORGAN *Sydney, Lady* (*1783?–1859*)

Novelist; *née* Owenson; published verse and Irish songs; *The Wild Irish Girl* (1806) established her as a novelist; wrote several novels on Irish themes; married Sir T. C. Morgan, 1812; published successful accounts of her travels in France and Italy; first woman to receive a pension, 1837.

1177 Pen and ink on paper, $7\frac{1}{4} \times 9$ inches (18·4 × 23 cm), by WILLIAM BEHNES. PLATE 642
Inscribed in pencil (*top right*): Lady Morgan/by W. Behnes.
Collections: Presented by Francis Draper, 1898.

Although the inscription is apparently later than the drawing, there is no reason to doubt it. The style is too sketchy for a comparison with other portraits to be useful.

ICONOGRAPHY A painting by R. T. Berthon of 1818 is in the National Gallery of Ireland, engraved by J. Thomson, published J. Robins, 1825 (example in NPG), and by J. B. Hunt, published Bentley, 1856 (example in British Museum); a painting by S. Morgan was exhibited *VE*, 1892 (271), lent by Sir Charles Dilke; a painting by S. Gambardella was exhibited *SKM*, 1868 (610), lent by Mrs I. Jones, lithographed by J. H. Lynch, published T. McLean, 1855 (example in NPG), reproduced as a woodcut *ILN*, XXVIII (1856), 73; another portrait by the same artist was offered by him to NPG, 1860, sketched by G. Scharf, 'TSB' (NPG archives), IV, 28; a drawing by C. Martin of 1844 is in the British Museum, reproduced as a coloured lithograph in C. Martin, *Twelve Victorian Celebrities* (1899), no. 8; a drawing by Sir T. Lawrence is in the collection of the Duke of Wellington, engraved (in reverse) by P. Roberts, published D. Mackay (example in NPG); a miniature by S. Lover was exhibited *Exhibition of Portrait Miniatures*, Burlington Fine Arts Club, London, 1889, case V (18), lent by J. Whitehead,

possibly the portrait engraved by R. Cooper, and anonymously, as after S. Lover, published New York (examples in NPG); three miniatures were exhibited *VE*, 1892 (428, 440 and 531); a plaster bust by David D'Angers of 1830 is in the Musée des Beaux-Arts at Angers, the plaster model of which was exhibited *VE*, 1892 (435), lent by Sir Charles Dilke; a bronze medallion by David D'Angers of 1829 is also in the Museum at Angers (based on the same sittings as the bust); a bust by P. Turnerelli was exhibited *RA*, 1831 (1147); a medal by C. Moore, modelled in 1825, was exhibited *RA*, 1834 (966); an engraving by A. Collas, after a medallion by E. W. Wyon, was published A. Collas and H. F. Chorley, *The Authors of England* (1838), facing p 51; an engraving by H. Meyer, after T. Wageman, was published H. Colburn, 1818 (example in NPG), for the *New Monthly Magazine;* an engraving by S. Freeman, after J. Comerford, was published H. Colburn, 1846 (example in NPG), for her *Wild Irish Girl*, frontispiece; an engraving by T. Wright, after a drawing by J. P. Davis, was published Saunders and Otley, 1830 (example in NPG); there is an engraving by J. Godby, after Dighton (example in NPG), and an engraving by H. Meyer, after W. Behnes (example in British Museum); an engraving by D. Maclise (example in NPG) was published *Fraser's Magazine*, XI (May 1835), facing 529, as no. 60 of his 'Gallery of Illustrious Literary Characters'; an anonymous engraving was published Dean and Munday, 1816, for the *Ladies' Monthly Museum;* an anonymous woodcut, after a photograph, was reproduced *Art Journal* (1865), p 217.

MORGAN *Rev Thomas*

Slavery abolitionist.

599 See *Groups:* 'The Anti-Slavery Society Convention, 1840' by B. R. Haydon, p 538.

MORGAN *William*

Slavery abolitionist.

599 See *Groups:* 'The Anti-Slavery Society Convention, 1840' by B. R. Haydon, p 538.

MORLEY *Samuel* (1809–86)

Politician; a leading textile manufacturer; active in dissenting and radical circles; MP, 1865–6, 1868–85; supporter of Gladstone; converted to idea of state education, and to temperance movement; an outstanding philanthropist; built chapels, and granted pensions to his employees.

1303 Plaster cast, 27¾ inches (70·5 cm) high (including base), of a statuette by JAMES HAVARD THOMAS, *c* 1885. PLATE 643

Collections: Francis Draper, presented by him, 1901.

Presumably related to the two statues of Morley by Thomas, one at Bristol (in marble) and the other at Nottingham, and to the bronze bust of 1885 exhibited *Commemorative Exhibition of J. H. Thomas' Work*, Beaux Arts Gallery, London, 1936 (18).

ICONOGRAPHY A painting by H. T. Wells is in the Congregational Memorial Hall, London, exhibited *RA*, 1874 (664); a painting by W. W. Ouless was exhibited *RA*, 1884 (273); busts by H. Wiles (marble), E. Bennett, and W. Merrett were exhibited *RA*, 1867 (1050), 1867 (1148), and 1887 (1814), respectively; there is a woodcut for the *Christian Portrait Gallery*, and a lithographic caricature by 'Pet' (examples in NPG); there are several photographs in the NPG, and one was lithographed in colour for Cassell's *National Portrait Gallery;* a woodcut, after a photograph by Elliott and Fry, was published *ILN*, LVIII (1871), 169; Morley appears in 'The Eastern Question Conference', woodcut published *ILN*, LXIX (1876), 576–7.

MORRIS *Ebenezer Butler* (*fl 1833–63*)

History and portrait painter.

1456 (21) See entry for W. Wyon, p 523.

MORRISON *James* (*1790–1857*)

Merchant and politician; amassed a fortune as a draper; MP from 1830; supported the Reform Bill; endeavoured to improve railway legislation and published pamphlets on the subject.

316a (90) Full-face and profile views on one sheet. Pencil on paper, 19¼ × 25½ inches (49 × 64·7 cm), by SIR FRANCIS CHANTREY, *c* 1842. PLATE 644

Inscribed in pencil, below the profile view (lower right): Morrison

Collections: The artist; presented by the widow of one of his executors, Mrs George Jones, 1871.

These 'camera lucida' drawings are presumably related to the marble bust of Morrison by Chantrey exhibited *RA*, 1842 (1409), of which there is a related plaster bust in the Ashmolean Museum, Oxford. They are part of a large collection of Chantrey drawings which will be discussed in the forthcoming Catalogue of Portraits, 1790–1830. Apart from a marble bust of Morrison by W. Theed, exhibited *RA*, 1849 (1282), there are no other recorded portraits of him.

MORRISON *Rev John*

Slavery abolitionist.

599 See *Groups:* 'The Anti-Slavery Society Convention, 1840' by B. R. Haydon, p 538.

MOSLEY *Sir Oswald, Bart* (*1785–1871*)

MP for Staffordshire North.

54 See *Groups:* 'The House of Commons, 1833' by Sir G. Hayter, p 526.

MOSTYN *Edward Mostyn Lloyd-Mostyn, 2nd Baron* (*1795–1884*)

MP for Flintshire.

54 See *Groups:* 'The House of Commons, 1833' by Sir G. Hayter, p 526.

MOTT *James*

American slavery abolitionist.

599 See *Groups:* 'The Anti-Slavery Society Convention, 1840' by B. R. Haydon, p 538.

MOTT *Mrs Lucretia* (*1793–1880*)

American slavery abolitionist.

599 See *Groups:* 'The Anti-Slavery Society Convention, 1840' by B. R. Haydon, p 538.

MÜLLER *William James* (*1812–45*)

Painter; travelled in Europe, 1833, in Greece and Egypt, 1838, and in Lycia, 1841; studied and worked at Bristol; exhibited mainly landscapes and Eastern subjects at RA, 1833–45, and British Institution, 1840–5; these were widely praised for their originality and vigour of execution.

1304 Miniature, water-colour and gum on ivory, 3⅛ × 2¾ inches (8 × 7 cm), by HIMSELF. PLATE 645

Collections: George Mackey of Birmingham, purchased from him, 1901.

The identification and attribution are traditional, but there is no reason to doubt them. Müller is shown as a very young man, so that a comparison with the later bust or miniature by Branwhite is not very helpful.

Description: Clear complexion, light grey eyes, brown hair. Dressed in a black neck-tie, white shirt, green waistcoat and light grey check jacket. Holding in one hand a palette with blue, green, red, yellow and white paints, and a paint brush in the other. Background colour greenish-brown.

ICONOGRAPHY A miniature by N.Branwhite is in the Tate Gallery; a bust by the same artist of 1845 is in Bristol Cathedral, engraved by C.K.Childs for the *Art Journal* (1850), p344; a painting called Müller (alternatively attributed to Müller or Boxall) was in the collection of F.Brown, 1911.

MULREADY *William* (*1786–1863*)

Painter; entered RA schools, 1808; studied with and taught by John Varley whose sister he married, 1803; illustrated children's books; exhibited at the RA, 1804–62; designed first penny postage envelope, 1840; famous for his genre paintings, and illustrations to *The Vicar of Wakefield*.

1690 Oil on panel, 12¼ × 10 inches (31·1 × 25·4 cm), by JOHN LINNELL, 1833. PLATES 648, 649

Signed and dated (lower left): J.Linnell. Fec.t/1833. *Inscribed (top left):* WM MULREADY Esqr R.A.

Inscribed on a label formerly on the back of the picture: No 4./portrait of Wm Mulready Esqr. R.A./ Painted 1833/By John Linnell/Porchester Terrace/Bayswater

Collections: The artist, sold to Mr Gibbons, 1846; by descent to John Gibbons, and purchased at his sale, Christie's, 29 November 1912 (lot 108).

Exhibitions: RA, 1833 (162); *SKM*, 1868 (551); *VE*, 1892 (174).

Literature: A.T.Story, *Life of John Linnell* (1892), II, 249, where it is erroneously said to have been painted in 1831.

The portrait was engraved by J.Thomson (example in NPG). Another unfinished version (in the same pose and costume, but without the palette) is in the National Gallery of Ireland, exhibited *Great Irishmen*, Ulster Museum, Belfast, 1965 (149).

Description: Healthy complexion, brown eyes, reddish-brown hair and whiskers. Dressed in a white shirt and stock, mottled brown waistcoat, dark brown coat. Holding a brown wooden palette, with splashes of red, brown, yellow, white and black paint, brushes and a mahl stick. Background colour various tones of dark brown and dark green.

4450 Oil on canvas, 8½ × 6⅝ inches (21·6 × 16·8 cm), by HIMSELF, *c*1835. PLATE 647 & p355.

Collections: Mrs Hugh Wyndham, a direct descendant of the artist; Appleby brothers; presented by Arthur Appleby, 1965.

Literature: NPG Annual Report, 1965–6 (1967), p20.

The date is based on the apparent age of the sitter, and a comparison with other portraits of him. Another drawing from the same source, supposed to be a self-portrait, is in the Ashmolean Museum, Oxford. It shows a young man, not dissimilar in features from the drawing of Mulready by his brother of 1829 (see iconography below), but showing no sign of his distinctively shaped lips and cleft chin.

Description: Florid complexion, reddish-brown hair.

1456 (22) Black chalk on paper, 4¼ × 3⅞ inches (10·8 × 9·8 cm), by CHARLES HUTTON LEAR, 1846. PLATE 646

Inscribed in pencil (lower left): March 1846 *and (bottom right):* Mulready

Collections: See *Collections:* 'Drawings of Artists, *c*1845' by C.H.Lear, p561.

Literature: R.L.Ormond, 'Victorian Student's Secret Portraits', *Country Life*, CXLI (1967), 288–9, reproduced 288.

This drawing was executed in the life school of the Royal Academy, where Lear was a student; Mulready was a visitor there in 1845 and 1846. It was sent by Lear with an undated letter to his father (copy in NPG archives):

The heads rise slowly but do not think I am negligent. Whenever I have an opportunity, & these do not occur every day, I take advantage of it as the enclosed will assure you. It is a very lucky hit at our very

great gun Mulready. It will do for a sort of sun around which the lesser planets may cluster. I think myself lucky in getting this, for he is a bird not commonly seen.

2473 Pencil on paper, $4\frac{5}{8} \times 3\frac{3}{8}$ inches ($11\cdot8 \times 8\cdot6$ cm), by CHARLES BELL BIRCH, c 1858. PLATE 650

Inscribed in pencil (bottom centre): Mulready R.A.

Collections: See *Collections:* 'Drawings of Royal Academicians, c 1858' by C. B. Birch, p 565.

3182 (5) Pencil on paper, $6\frac{3}{4} \times 4\frac{1}{4}$ inches ($17\cdot1 \times 10\cdot9$ cm), by CHARLES WEST COPE, c 1862. PLATE 651

Inscribed (centre left): W. My. *and (lower right):* C. Leslie *and (top centre):* $\frac{24}{2}$ width
48

On the reverse is a pencil drawing of Sir Charles Eastlake, inscribed (top centre): Sir C Eastlake *and (centre left):* E.t.c [?]

Collections: See *Collections:* 'Drawings of Artists, c 1862' by C. W. Cope, p 565.

Cope presumably made these sketches at the Royal Academy schools. What Cope's calculation refers to is unknown.

ICONOGRAPHY This does not include photographs, of which there are several examples in the NPG.

1807 'Students at the British Institution', water-colour by A. E. Chalon. British Museum.

1814 'The Refusal' by Sir D. Wilkie (Mulready is portrayed as Duncan Gray). Victoria and Albert Museum. Exhibited *RA*, 1814 (118), reproduced Lord R. Gower, *Wilkie* (1902), facing p 42. Reduced version of 1819: collection of G. Thomson, 1902. An unrelated profile drawing of Mulready by Wilkie is also in the Victoria and Albert Museum.

1829 Drawing by P. Mulready. Probably that exhibited *SKM*, 1868 (552), where it is described as a self-portrait drawing. Engraved by J. H. Robinson for J. Pye, *Patronage of British Art* (1845), p 342.

1830 Bust by C. Moore. Exhibited *RA*, 1831 (1220). Listed by W. G. Strickland, *Dictionary of Irish Artists* (1913), II, 124. Presumably the bust by Moore, dated 1830, in the Crystal Palace Collection, 1854.

1833 Painting by J. Linnell (NPG 1690 above).

c 1835 Painting by himself (NPG 4450 above).

1836 Lithograph by V. Brooks, after a drawing by himself (example in NPG). Reproduced as a woodcut *ILN*, VII (1845), 29.

c 1842 Drawing by T. Bridgford. National Gallery of Ireland. Exhibited *RA*, 1842 (986).

c 1844 Painting by M. Mulready. Exhibited *RA*, 1844 (490).

1844 Drawing by C. Martin. British Museum. Exhibited *Dublin Exhibition*, 1872, 'Portraits' (433). Lithographed anonymously, lithograph reproduced *Fine Arts Quarterly Review*, I, 380.

1846 Drawing by C. H. Lear (NPG 1456 (22) above).

c 1858 Drawing by C. B. Birch (NPG 2473 above).

c 1862 Drawing by C. W. Cope (NPG 3182 (5) above).

1863 Etching by C. W. Cope (example in NPG), exhibited *RA*, 1864 (843).

1863 Woodcut, after a photograph by Cundall and Downes, published *ILN*, XLIII (1863), 93. A painting in the National Gallery of Ireland, formerly called a self-portrait, appears to be after the same photograph.

1866 Marble bust by H. Weekes. Tate Gallery. Exhibited *RA*, 1866 (896).

c 1877 Medal issued by the Art Union (example in NPG); probably the medal-type by G. G. Adams exhibited *RA*, 1877 (1534).

Undated Painting by F. B. Barwell. Victoria and Albert Museum. Exhibited *Dublin Exhibition*, 1872, 'Portraits' (251).

Undated Painting by Sir A. Callcott. Reproduced J. C. Horsley, *Recollections of a Royal Academician* (1903), facing p 18, in whose collection it then was.

Undated Drawing by himself. Reproduced *Art Journal* (1899), p 65.

Undated Anonymous woodcut (example in NPG).

MUNDY *Godfrey Charles* (*d 1860*)

Soldier and author.

4026 (42) See *Collections:* 'Drawings of Men About Town, 1832–48' by Count A. D'Orsay, p 557.

MURCH *Dr*

Slavery abolitionist.

599 See *Groups:* 'The Anti-Slavery Society Convention, 1840' by B. R. Haydon, p 538.

MURCHISON *Sir Roderick Impey, Bart* (*1792–1871*)

Geologist; soldier, 1807–14; made summer tours, 1825–31; named and described Silurian system; president of Geological Society, 1831; travelled extensively throughout Europe and Russia studying geological structures; president of Royal Geographical Society, 1843; internationally honoured for his pioneer work.

906 Oil on canvas, $15\frac{1}{4} \times 12\frac{3}{4}$ inches (38·7 × 32·4 cm), by STEPHEN PEARCE, 1856. PLATE 652

Collections: See *Collections:* 'Arctic Explorers' by S. Pearce, p 562.

Exhibitions: RA, 1857 (51).

Literature: S. Pearce, *Memories of the Past* (1903), pp 56, 64.

Murchison is apparently wearing the star of the Russian order of St Stanislaus. The date of the portrait was provided by the artist in a memorandum of *c* 1899 (NPG archives).

Description: Dark complexion, with high-coloured cheeks, blue (?) eyes, dark brown hair and whiskers. Dressed in a black stock, white shirt, gold monocle, black waistcoat and coat, with a silver star. Background colour brown.

ICONOGRAPHY

1818 Miniature by G. Engleheart. Exhibited *Special Exhibition of Portrait Miniatures*, South Kensington Museum, 1865 (1070).

1823 'The Quorn at Quenby' by J. Ferneley. Collection of Sir Guy Graham. Reproduced W. S. Sparrow, *British Sporting Artists* (1922), facing p 192.

1832 Painting by T. Phillips. Exhibited *RA*, 1832 (457). Listed in Phillips' 'Sitters Book' (copy of original MS, NPG archives), under 1832.

1848 Plaster bust by R. Westmacott. Scottish NPG. Possibly the bust exhibited *RA*, 1848 (1451).

c 1849 Painting by H. W. Pickersgill. Edinburgh University. Exhibited *RA*, 1849 (78). Engraved and published by W. Walker, 1851 (example in NPG). See D. Talbot Rice and P. McIntyre, *The University Portraits* (1957), p 158 (100).

1849 Lithograph by T. H. Maguire, published G. Ransome, 1852 (example in NPG), for 'Portraits of Honorary Members of Ipswich Museum'.

1857 Painting by S. Pearce (NPG 906 above).

1859 Engraving by D. J. Pound, after a photograph by Mayall, published 1859 (example in NPG), for Pound's 'Drawing Room Portrait Gallery'.

1860	Bust(?) by K. Borycreski. Exhibited *RA*, 1860 (1073).
c1861	Bust by E. G. Papworth Senior. Exhibited *RA*, 1861 (1061).
c1863	Photograph by E. Edwards (example in NPG), published L. Reeve, *Men of Eminence*, I (1863), facing 23.
c1866	Marble bust by Mrs D. O. Hill. Exhibited *RA*, 1866 (998).
c1866	Photograph by J. & C. Watkins (example in NPG). Woodcut, after it, published *ILN*, XLVIII (1866), 237.
1868	Caricature drawing by 'Spy' (Sir L. Ward). NPG. (see p 340).
1870	Lithograph caricature by 'Ape' (C. Pellegrini), published *Vanity Fair* (1870), p216.
1871	Bust by H. Weekes. Geological Museum, London. Exhibited *RA*, 1872 (1550). Replica: Royal Geographical Society, London.
1871	Woodcut, after a photograph by Wilson and Beadell, published *ILN*, LIX (1871), 413.
Undated	Painting by Sir E. Landseer. Landseer Sale, Christie's, 9 May 1874 (lot 267). Exhibited *Landseer Exhibition*, RA, London, 1874 (282).
Undated	Various lithographs, engravings and photographs (examples in British Museum and NPG).

MURRAY *Sir John Archibald Murray, Lord* (*1779–1859*)

Scottish judge, MP for Leith.

54 See *Groups:* 'The House of Commons, 1833' by Sir G. Hayter, p 526.

MURRAY *John* (*1778–1843*)

Publisher.

2515 (83) See *Collections:* 'Drawings of Prominent People, 1823–49' by W. Brockedon, p 554.

MURRAY *John* (*1808–92*)

Publisher and patron; son of John Murray (1778–1843); present when Scott acknowledged authorship of the Waverley novels; travelled in Europe, 1829–32; wrote four *Handbooks* and commissioned others; published travel books, and the works of Borrow, Layard, Grote, Darwin, Dr Smiles, and many others.

1885 Oil on canvas, $44\frac{1}{8} \times 34\frac{1}{4}$ inches (112×87 cm), by CHARLES WELLINGTON FURSE, *c*1891. PLATE 653

Once apparently signed, but no signature now visible.

Collections: Presented by the sitter's son, A. H. Hallam-Murray, 1920.

Exhibitions: First Annual Exhibition, Royal Society of Portrait Painters, 1891 (4).

Literature: Illustrated Memoir of Charles Wellington Furse (Burlington Fine Arts Club, 1908), p98, where misdated 1894.

Description: Greyish hair and whiskers, bluish eyes. Dressed in a grey tie, white shirt, grey coat, and brown overcoat and hat. Seated in an armchair, the arms of which are covered in dark red material. Very dark background.

ICONOGRAPHY A painting by Sir G. Reid and a drawing by Pearson are in the collection of John Murray, the former reproduced John Murray IV, *John Murray III* (1919), frontispiece; there is a woodcut, after a photograph by Maull and Fox, from an unidentified magazine (cutting in NPG).

NAPIER *Sir Charles* (*1786–1860*)

Admiral; distinguished himself in naval actions in Mediterranean and West Indies; captain, 1829; commanded Portuguese fleet for Dona Maria, 1833–6; successfully commanded allied forces against

Mohammed Ali, 1839–40; signed an unauthorized convention with him which was afterwards repudiated; MP from 1841; commander of Channel fleet, 1846–9; vice-admiral, 1853; admiral, 1858.

1460 Oil on canvas, 12 × 10 inches (30·5 × 25·4 cm), by E. W. GILL, 1854. PLATE 654

Signed and dated (on the reverse of the canvas): E W Gill/1854

Collections: Purchased from the Scottish Gallery, Edinburgh, 1907.

Literature: H. N. Williams, *Life and Letters of Admiral Sir C. Napier* (1917), facing p 260.

Napier is apparently shown wearing the uniform of an admiral in the Portuguese Navy, with the sword presented to him by the Sultan of Turkey in 1841. The two neck badges are probably the third class of the order of St George (Russia), and the order of the Bath (KCB), although the ribbon of the latter badge is white instead of red. He is apparently wearing two orders on his left breast, one on top of the other. The top one is the order of the Tower and the Sword (Portugal), with a blue sash which Napier wears across his body, and the lower one possibly the order of the Medjidie (Turkey). Owing to insufficient detail and rather smudgy colour, it is difficult to be certain about the orders, and Napier was notorious for wearing them unconventionally. I am indebted to P. G. W. Annis of the National Maritime Museum for his help with the orders and uniform. The NPG portrait was engraved by D. J. Pound (example in NPG).

Description: Healthy complexion, brownish eyes, grey hair. Dressed in a dark neck-tie, white shirt and waistcoat, with red and white ribbons round his neck carrying his orders, a dark blue sash, a dark blue and gilt sword belt, the sword with a white bone(?) handle, and a dark blue scabbard and gilt mount, dark blue naval uniform with gold and silver stars, and gold-braided epaulettes and cuffs. Standing on board ship with one hand resting on a white map on a wooden table. There are various ropes, part of a cannon (bottom left), and a brown wooden gunwale, over which can be seen various ships on a greenish sea. Sky greyish-blue.

ICONOGRAPHY

c1834 Drawing by an unknown artist. Formerly (?) collection of the Countess of Cabo de San Vicente. Lithographed by M. Gauci, published Colnaghi, 1834 (example in Rex Nan Kivell collection, London).

c1835 Painting by J. Simpson. Exhibited *RA*, 1835 (333).
A half-length painting by Simpson was in the collection of the sitter's granddaughter, Mrs Safford, 1901, exhibited *SKM*, 1868 (455), reproduced W. M. Clowes, *The Royal Navy* (1901), VI, facing 417, and apparently H. N. Williams, *Life and Letters of Admiral Sir C. Napier* (1917), frontispiece, engraved by Porter, published Colnaghi, 1841 (example in NPG), and by others (examples in NPG); a miniature by Simpson based on this portrait was engraved by S. Brown, published R. Bentley, 1854 (example in NPG); an engraving by Gibbs, published Rogerson and Tuxford, 1854 (example in NPG), appears to be based on Simpson's half-length portrait, but shows him much older. A three-quarter length version by Simpson in the Scottish NPG (plate 655) is almost identical with the half-length painting, except for its size, and slightly different features (this may have been one of two three-quarter length versions, recorded by G. Scharf in 1862 and 1863, the former sketched by him, 'TSB' (NPG archives), VI, 68). A third portrait, apparently that lithographed by R. J. Hamerton, after Simpson, published H. Colburn, 1837 (example in NPG), is in the Oporto Museum, Portugal; it is similar in style and pose to the two other portraits by Simpson, but differs in details. See also Simpson's 1842 portrait below.

1841 Medal by J. Barber. Scottish NPG.

c1842 Painting by J. Simpson. Exhibited *RA*, 1842 (308).
Possibly the portrait in the Scottish NPG, or that in the collection of Mrs Safford, 1901 (see above).

c1842 Miniature by Miss E. Jones. Exhibited *RA*, 1842 (865).

1843 Woodcut published *ILN*, II (1843), 175.

c 1846 Painting by T.M.Joy. Exhibited *RA*, 1846 (521).

1847 Painting by T.M.Joy. National Maritime Museum, Greenwich.
Engraved by W.Carlos, published A.Meeson, 1847 (example in NPG). Possibly the picture exhibited *RA*, 1854 (387). Another portrait by Joy is in the United Service Club, London.

1850 Painting by T.C.Thompson. Exhibited *Royal Hibernian Academy*, 1850.
See W.G.Strickland, *Dictionary of Irish Artists* (1913), II, 441.

1853 Bust by P.Park, executed for Napoleon III. See R.Gunnis, *Dictionary of British Sculptors* (1953), p291.

1854 Painting by E.W.Gill (NPG 1460 above).

1854 Lithograph by C.Baugniet, published Ackermann, 1854 (example in NPG).
A drawing by L.Fagan, reproduced Fagan, *The Reform Club* (1887), p93, and an anonymous engraving, published Virtue and Co (example in NPG), are both very similar to the lithograph.

1854 Lithograph by Day, published E.Gambart, 1854 (example in NPG).

1854 Lithograph by Skelton, after a drawing by A.H.Taylor, published Skelton, 1854 (example in NPG).

1854 'Les Defenseurs du Droit et de la Liberté de L'Europe', lithograph by M.Alophe, published Goupil (example in NPG).

1854 Woodcut, after a daguerreotype by Mayall, published *ILN*, XXIV (1854), 208.

c 1854 Painting by T.M.Joy. Exhibited *RA*, 1854 (387).
Possibly the portrait of 1847 in the National Maritime Museum, Greenwich (see above), or that in the United Service Club, London.

c 1855 Marble bust by J.Loft. Exhibited *RA*, 1855 (1513).

c 1855 Bust by J.Francis. Exhibited *RA*, 1855 (1443).

1856 Water-colour by B.W.Crombie. Scottish NPG.

1863 Medallion by T.Phyffers. Landport.

1868 Bust in relief by G.G.Adams. St Paul's Cathedral.
Reproduced as a woodcut *ILN*, LIV (1869), 65.

Undated Painting by an unknown artist. Formerly Royal United Service Museum, London.

Undated Painting by an unknown artist. Lever Galleries, London, 1936.

Undated Memorial, with a medallion. Victoria Park, Portsmouth.
Reproduced H.N.Williams, *Life and Letters of Admiral Sir C.Napier* (1917), facing p371. A photograph of Napier is reproduced facing p370.

Undated Plaster medal by J.Henning. Scottish NPG.

Undated Lithograph by M.Alophe, published Goupil & Co; lithograph by A.Laby, published G.Innes; anonymous lithograph; engraving by H.Barnett; engraving by Roffe, after W.Graham, published J.Limbird; engraving by J.V.Barret, published F.P.Davies; anonymous engraving; anonymous woodcut (examples in NPG).

NAPIER *Sir Charles James* (*1782–1853*)

Conqueror of Sind; served with distinction in Napoleonic wars; conquered Sind, 1843; subdued hill tribes, 1844–5; engaged in 1st Sikh war; recalled from England, 1849; suppressed mutinous regiment; resigned, 1850; wrote on military and related subjects.

333 Oil on panel, $11\frac{1}{2} \times 8\frac{3}{4}$ inches (29·2 × 22·2 cm), by GEORGE JONES, 1851. PLATE 659
Signed and dated (lower left): C Napier/June – 51/Geo. Jones

Collections: The artist, presented by his widow, 1871.

Possibly a study for Jones' painting of the 'Battle of Hyderabad', exhibited *RA*, 1854 (13), which shows Napier in a prominent position on the battlefield. Napier also appears in Jones' painting of the 'Battle of Meeanee, 1843' in the Royal Collection, an outline drawing for which was exhibited *RA*, 1849 (938).

Description: Healthy complexion, brown eyes, brown hair with grey streaks, and grey whiskers. Dressed in white shirt and dark brown coat or cloak, with a darker garment underneath, which just shows at the neck. Background colour grey-green.

1369 Oil and pencil on canvas, $21\frac{3}{8} \times 18\frac{5}{8}$ inches ($54 \cdot 3 \times 47 \cdot 3$ cm), by EDWIN WILLIAMS, 1849. PLATE 657

Apparently signed (the signature partially obscured by over-painting) lower right: E Williams [?]

Collections: Messrs Leggatt, purchased from them, 1904.

This painting was engraved by H. Robinson, published A. Whitcombe, Cheltenham, and Colnaghi, 1849 (example in NPG); according to the inscription on the engraving, the original was executed in Cheltenham in March 1849. It is not connected with the 1853 portrait of Napier by Williams (see iconography below).

Description: Brown eyes, greyish hair and whiskers. Dressed in a dark neck-tie, white shirt, yellowish waistcoat and dark brown coat (last two unfinished). Seated at a table, holding a quill pen. Background colour white and yellow (unfinished).

3964 Oil on canvas, $13\frac{7}{8} \times 11\frac{3}{8}$ inches ($35 \cdot 3 \times 28 \cdot 9$ cm), attributed to – SMART. PLATE 656

Collections: Napier family or Pforzer (see below); E. Kersley, purchased from him, 1955.

Literature: L. G. Holland, 'Notebooks' (NPG archives), III, 28; *NPG Annual Report, 1955–6*, p 11.

Holland, an assistant at the NPG, sketched this picture on a loose piece of paper, and wrote underneath: '*by Smart/who exaggerated arm-size/Sir Charles Napier at Oaklands.*' The second phrase is a later addition. Holland inserted the piece of paper into his notebook beside a drawing of another portrait of Napier by Smart (full-length, seated in his tent), which he had seen at the shop of a dealer, Pforzer, 101 London Wall, in November 1889. What appears to be the same portrait by Smart, or possibly another version, was offered to the NPG in the same month by the daughter of Colonel Rathbone, for whom it had been painted. Two versions of the full-length type are in the collections of A. R. Catherall, and Mrs Kennedy, a descendant of the sitter. It is not clear whether Holland saw the NPG portrait at Pforzer's as well, as he gives no location on the separate piece of paper (he might have seen and drawn the NPG portrait elsewhere, and put it beside the other subsequently for the sake of comparison). Holland's inscription is also ambiguous; it might mean that the portrait was painted by Smart at Oaklands, the Napier home, or that Holland had seen the portrait there. The significant gap between 'Napier' and 'at Oaklands' would allow for either interpretation. Holland's note adds weight, however, to the attribution of the portrait to Smart, and is therefore of some importance. There is a lithograph by E. Morton, published Colnaghi, after a third portrait by Smart (example in British Museum), showing Napier standing, and holding a telescope; this was said to be after S. P. Smart (fl. 1774–87), but this is clearly impossible on date. While several 19th century Smarts are recorded, it is not clear which if any of them were responsible for the portraits of Napier.

Description: Healthy complexion, blue eyes, brown hair with streaks of grey. White shirt and trousers, dark blue uniform with brass buttons, gold lanyard, and gold aiguillette, holding a crimson-bound book. Brown furniture, green-topped desk with white papers and a quill pen.

1198 Plaster cast, painted black, $28\frac{1}{2}$ inches ($72 \cdot 4$ cm) high, of a bust by GEORGE GAMMON ADAMS, 1853. PLATE 660

Incised below the shoulders at the back: G G Adams. SC. 1853

Collections: The artist, purchased from his widow, 1899.

The star on Napier's chest is that of the Bath. The NPG bust is presumably related to the marble bust of Napier by Adams of 1853, exhibited *RA*, 1854 (1506), and *Victorian Era Exhibition*, 1897, 'History Section' (783), to the miniature bronze cast of 1853 in the Scottish NPG, and to the colossal bust exhibited *RA*, 1855 (1444). For statues of Napier by Adams, see iconography below; the heads in these statues are based on the NPG type.

ICONOGRAPHY

1798 Engraving by W. H. Egleton, after a miniature of 1798, published J. Murray, 1857 (example in NPG), for General Sir W. Napier, *The Life and Opinions of General James Napier* (1857), I, frontispiece.

c 1821 Miniature by Miss E. Jones. Exhibited *RA*, 1821 (798).
 Other miniatures by the same artist were exhibited *RA*, 1835 (468), 1842 (920), and 1844 (814).

c 1827 Painting by S. Gambardella. Wellington Museum, Apsley House, London.
 Sketched by G. Scharf, 'TSB' (NPG archives), IV, 29.

c 1843–5 Water-colour by an unknown artist. Collection of Captain Colin Broun-Lindsay, Colstoun (PLATE 658).
 Reproduced *Private Letters of the Marquess of Dalhousie*, edited J. G. A. Baird (1910), p 104.

c 1843 Painting by a member of his staff. Formerly Royal United Service Museum, London.

c 1844 Drawing by an unknown artist. Collection of Sir P. Cadell.
 Reproduced R. Lawrence, *Charles Napier, Friend and Fighter* (1952), p 134.

1849 Painting by E. Williams (NPG 1369 above).

1849 Lithograph by R. J. Lane, after a sketch by Count Pierlas of 1848, published Ackermann, 1849 (example in NPG); an engraving by W. H. Egleton, after the same portrait, was published J. Murray, 1857 (example in NPG).

1849 Lithograph by H. B. (John Doyle), published T. McLean, 1849 (example in NPG).
 A study for this is in the British Museum, and so are other drawings of Napier by Doyle.

1849 Drawing by an unknown artist. Collection of Sir P. Cadell.
 Reproduced R. Lawrence, *Charles Napier* (1952), p 185.

1849–53 Two woodcuts, after photographs by Kilburn, published *ILN*, XXIII (1853), 192. An engraving by T. W. Hunt, published Virtue, a lithograph by C. Baugniet, published Hering and Remington, 1849, and an engraving (in reverse, with differences) by T. W. Hunt (examples in NPG), are all after one of the photographs; the other was taken 'as he sat for his bust to Mr Wyon'; there is no further record of this bust.

c 1850 Bust by P. Park. Exhibited *RA*, 1850 (1447).

1851 Painting by G. Jones (NPG 333 above).

c 1852 Painting by H. W. Pickersgill. Exhibited *RA*, 1852 (110).
 Possibly the portrait in the Pickersgill Sale, Christie's, 17 July 1875 (lot 352).

c 1852 Sketch in plaster for a statue by A. Brown. Exhibited *RA*, 1852 (1323).

1853 Bust by P. Park, executed for Napoleon III. See R. Gunnis, *Dictionary of British Sculptors* (1953), p 291.

c 1853 Painting by E. Williams. Exhibited *RA*, 1853 (70), *SKM*, 1868 (543), and *VE*, 1892 (315), lent by Lady McMurdo. Engraved by G. J. Stodart, detail of engraving reproduced R. Lawrence, *Charles Napier* (1952), frontispiece. A copy by General A. Y. Shortt is in the East India and Sports Club.

1853–5 Busts by G. G. Adams (see NPG 1198 above).

c 1855 Sketch for a colossal statue by E. H. Baily. Exhibited *RA*, 1855 (1555).

1856 Bronze statue by G. G. Adams. Trafalgar Square, London.
 Engraved by R. Artlett, published J. S. Virtue, 1858 (example in NPG), for the *Art Journal*.

1860 Marble statue by G. G. Adams. St Paul's Cathedral, London.
Reproduced as a woodcut *ILN*, xxxvi (1860), 72. Misdated 1856 by R. Gunnis, *Dictionary of British Sculptors* (1953), p 14. This and the 1856 statue differ in pose and details (see also NPG 1198 above).

Undated Paintings attributed to Smart (see NPG 3964 above).

Undated Painting by an unknown artist. Collection of Lord Aberdare.
Exhibited *Great Irishmen*, Ulster Museum, 1965 (151).

Undated Water-colour by L. Paget. Exhibited *Victorian Era Exhibition*, 1897, 'Fine Art Section' (662).

Undated Water-colour by Lieutenant Edwards. Reproduced R. Lawrence, *Charles Napier* (1952), facing p 109.

Undated Miniature by J. Holmes. Christie's, 28 October 1970 (lot 52), reproduced in sale catalogue.

Undated Lithograph by C. Grant, after a painting by himself (example in India Office Library).
Reduced version published C. Grant, *Lithographic Sketches of the Public Characters of Calcutta* (Calcutta, *c* 1892), p 106 (copy in NPG library).

NAPIER *Sir William Francis Patrick* (*1785–1860*)

General and historian; served in Peninsula and France, 1808–15; wrote his successful and often translated *History of the Peninsular War*, 1828–40; lieutenant-governor of Guernsey, 1842–7; general, 1859; a keen controversialist and amateur artist; published several works of military history.

1197 Marble bust, 26⅞ inches (68·3 cm) high, by GEORGE GAMMON ADAMS, 1855. PLATE 661
Incised on the front of the base: GEN^L SIR W^M NAPIER *and on the back:* G. G. ADAMS. SC./1855
Collections: The artist, purchased from his widow, 1899.
Exhibitions: Victorian Era Exhibition, 1897, 'History Section' (782).
Literature: 'Catalogue of Medals and Sculpture by Geo. Adams, Acton Green Lodge, Chiswick' (copy in NPG archives).

A plaster cast, related to this bust, is in the Scottish NPG. The type was engraved by W. H. Egleton, published J. Murray, 1857 (example in NPG). Adams executed a statue of Napier in 1863 for St Paul's Cathedral, reproduced as a woodcut *ILN*, xlii (1863), 73, making use of the NPG type for the head. Another marble bust by Adams was exhibited *RA*, 1860 (967). Several plaster casts of busts by Adams were purchased at the same time as this one from the artist's widow.

ICONOGRAPHY There is a painting by himself (in profile) in the collection of his descendant, Mrs M. R. M. Kennedy, engraved by W. H. Egleton (example in NPG); another painting called Napier by an unknown artist (showing the sitter as a young man), possibly also a self-portrait, is in the same collection; a painting by G. Jones was recorded by E. Farrer, *Portraits in Suffolk Houses (West)* (1908), p 25, in the collection of Sir Charles Bunbury; a painting by S. Gambardella of *c* 1845 is in the Wellington Museum, Apsley House, London, sketched by G. Scharf, 'TSB' (NPG archives), IV, 29; a painting by an unknown artist of *c* 1845 is also at Apsley House; Napier appears in 'The Peninsular Heroes' by J. P. Knight, in the collection of the Marquess of Londonderry, exhibited *RA*, 1848 (321), engraved by F. Bromley, published 1847 (example in British Museum); a painting by T. Mogford was exhibited *RA*, 1847 (509); a drawing by G. F. Watts was formerly in the collection of Lord Aberdare (plate 662), exhibited *SKM*, 1868 (548), and *VE*, 1892 (376), anonymously engraved (example in NPG) for *Life of W. F. P. Napier*, edited H. A. Bruce (1864), II, frontispiece; a miniature of 'Major Napier' (possibly this sitter, who became a major in 1813) by A. E. Chalon was exhibited *RA*, 1813 (436); a miniature by R. Smith was exhibited *RA*, 1855 (1062); there is an anonymous engraving, after a miniature by Miss E. Jones (example in NPG), for H. A. Bruce, I, frontispiece, reproduced R. Lawrence, *Charles Napier, Friend and Fighter* (1952), facing p 45; a woodcut, after a photograph by Kilburn, was published *ILN*, xxxvi (1860), 172.

NARES *Sir George Strong* (*1831–1915*)

Vice-admiral; joined search for Franklin, 1852–4; served in Crimean War; surveyed NE coast of Australia, Mediterranean and Gulf of Suez; Antarctic and Arctic voyages, 1872–7; KCB, 1876; board of trade official, 1879–96; conservator of river Mersey, 1896–1910; vice-admiral, 1892.

1212 Oil on canvas, 50 × 40 inches (127 × 101·7 cm), by STEPHEN PEARCE, 1877. PLATE 663

Signed (bottom left): STEPHEN PEARCE pinx[t]

Inscribed on the back of the canvas in the artist's hand: Cap[t.] Sir Geo. S. Nares. RN: KCB: FRS: &c – &c – &c./(in his Arctic dress)/commanding H.M. Ships "Alert" & "Discovery", 1875–76./This expedition reached latitude 83° 20′ 26″ – the high-/est yet attained./Painted by Stephen Pearce. 1877./ 54 Queen Anne Street. Cavendish Square./London.

Inscribed in ink on a label on the back, in the artist's hand: CAPT. SIR GEORGE. S. NARES. RN: KCB. FRS./ Commanding H.M. Arctic Ships "Alert" and/"Discovery" 1875–76./Painted by S. PEARCE/54 Queen Anne Street./Cavendish Square.

Collections: see *Collections:* 'Arctic Explorers' by S. Pearce, p 562.

Exhibitions: RA, 1877 (85); *Royal Naval Exhibition*, Chelsea, 1891 (57).

Literature: S. Pearce, *Memories of the Past* (1903), pp 88–9, reproduced facing p 86.

Nares is shown in the costume which he wore on his Arctic expeditions, against an idealized polar landscape, with one of his ships, the 'Alert', which, in an attempt to reach the North Pole by sea, attained the record latitude recorded by Pearce in his inscription.

Description: Healthy complexion, greyish eyes, brown hair and whiskers. Dressed in a natural linen overall jumper and overall trousers ('snow-repellers'), brown woollen gloves, greyish sealskin mittens suspended from a brown leather strap around his neck, and a thick black sash; holding a staff in one hand and a grey fur hat in the other. Bluish-white snowscape; sky various tones of grey and brown.

ICONOGRAPHY The only other recorded likenesses of Nares are: a photograph by Lock and Whitfield (example in NPG), published *Men of Mark*, III (1878), 3; a woodcut by E. Whymper, published 1876 (example in British Museum), for the 'Leisure Hour'; and three woodcuts published *ILN*, LXVI (1875), 504 (group), 505, and 536 (group).

NASH *Frederick* (*1782–1856*)

Painter; exhibited at RA, 1799–1847, and British Institution, 1812–52; supplied architectural drawings for publications, 1800–10; architectural draughtsman to Society of Antiquaries, 1807; member of Old Water-Colour Society, 1810–12, 1824–56; made several painting tours in Europe; one of the foremost architectural painters of his day.

2688 Water-colour, pencil and chalk, on buff-coloured paper, 10½ × 8⅜ inches (26·8 × 21·4 cm), by JULES NOGUÈS, 1839. PLATE 664

Signed and dated (lower right): J Noguès/1839

Collections: F. T. James, purchased from him, 1934.

The identity of the drawing was provided by the vendor; though it is not proven, there seems no reason to doubt it. A comparison with the drawings listed below is not conclusive, as they both show Nash in profile.

ICONOGRAPHY A profile drawing by W. Henry Hunt was in the collection of Walter Bennett, 1934; a profile drawing by himself was sold from the collection of Lord Nathan, Sotheby's, 10 April 1963 (lot 14), bought Green.

NASMYTH *James* (*1808–90*)

Engineer; constructed six-inch reflecting telescope, 1827; constructed steam-carriage, 1827; invented steam-hammer, 1839 (patented, 1842); invented many machine-tools, including a flexible drill-shaft and hydraulic metal-puncher; he was the first to observe the peculiar mottled appearance of the sun; published an elaborate work on the moon, 1874; one of the most inventive Victorian engineers.

1582 Oil on canvas, 14½ × 12⅛ inches (36·8 × 30·8 cm), by GEORGE BERNARD O'NEILL, 1874. PLATE 665

Inscribed on a damaged label, formerly on the back of the picture: [*Por*]trait of James Nasmyth/[*Inv*]entor of the Steam hammer/. . . . [*missing*] 1874 by G B – O'Neill

Collections: The artist, purchased from him, 1910.

Description: Healthy complexion, greyish eyes, grey hair and whiskers. Dressed in a blue neck-tie, white shirt, grey waistcoat, and dark grey coat. Background colour brown.

ICONOGRAPHY A self-portrait drawing of 1881 is in the Scottish NPG; a drawing by H. Furniss is reproduced Furniss, *Some Victorian Men* (1924), facing p 20; an etching by P. Rajon, after G. Reid, was published *James Nasmyth: an Autobiography*, edited S. Smiles (1883), frontispiece; a photograph by Lock and Whitfield (example in NPG) was published *Men of Mark* (1877), p 18; a photograph by D. O. Hill and R. Adamson of 1843–5 is reproduced H. Schwartz, *David Octavius Hill* (1932), plate 23; there is a woodcut from an unidentified magazine (example in NPG).

NEWARK *Charles Evelyn Pierrepont, Viscount* (*1805–50*)

MP for East Retford.

54 See *Groups:* 'The House of Commons, 1833' by Sir G. Hayter, p 526.

NEWCASTLE *Henry Pelham Fiennes Pelham Clinton, 4th Duke of* (*1785–1851*)

Statesman.

2789 See *Groups:* 'Members of the House of Lords, *c* 1835' attributed to I. R. Cruikshank, p 536.

NEWCASTLE *Henry Pelham Fiennes Pelham-Clinton, 5th Duke of* (*1811–64*)

Statesman; eldest son of 4th Duke; MP from 1832; chief secretary for Ireland, 1846; succeeded to title, 1851; secretary for war and the colonies, 1852–4; secretary for war, 1854–5; colonial secretary, 1859–64.

4576 Oil on canvas, 56 × 43⅞ inches (142·2 × 111·5 cm), by FREDERICK RICHARD SAY, 1848. PLATE 666

Inscribed on the frame, which is almost certainly the original one: THE EARL OF LINCOLN BY SAY 1848

Collections: Dukes of Newcastle, Clumber House; purchased at Christie's, 27 July 1967 (lot 174).

Although this portrait is not included in the *Clumber House Catalogue* (1923), it formed part of the Clumber collection (information from C. G. Stableforth, agent of the Newcastle Estates, in a letter of 19 August 1969, NPG archives). It was presumably commissioned by the sitter, when Earl of Lincoln, or by his father the 4th Duke. Say painted several other prominent statesmen at the time, including Derby and Ellenborough (NPG 1806 and 1805).

Description: Healthy complexion, brown eyes, hair and whiskers. Dressed in a white neck-tie, white shirt, black waistcoat and suit. One hand resting on white papers on top of a variously coloured table-cloth, on the right, with a red leather-bound box full of papers behind. Green drapery at left. Brown and light green pillar on the right. Rest of background various tones of greyish-green.

54 See *Groups:* 'The House of Commons, 1833' by Sir G. Hayter, p 526.

342, 3 See *Groups:* 'The Fine Arts Commissioners, 1846' by J.Partridge, p545.

1125 See *Groups:* 'The Coalition Ministry, 1854' by Sir J.Gilbert, p550.

ICONOGRAPHY The following portraits, either in, or formerly in, the Duke of Newcastle's collection, are listed in the *Clumber House Catalogue* (1923); painting by H.N.O'Neil, now on loan to Keele Hall, Clumber (209); painting by H.W.Phillips, sold Christie's, 4 June 1937 (lot 71), exhibited *R A*, 1863 (471), Clumber (123); drawing by G.Richmond of 1856, now on loan to NPG (NPG 4023), listed in the artist's 'Account Book' (photostat copy, NPG archives), p65, exhibited *V E*, 1892 (344), Clumber (355); painting by G.F.Watts of 1864, sold Christie's, 7 July 1967 (lot 108), and Bonham's, 4 April 1968 (lot 204), exhibited *S K M*, 1868 (452), and *V E*, 1892 (97), Clumber (225); drawing by J.Hayter of 1836 (Clumber 393); various water-colours by J.Simpson of 1855–9, Clumber (394); two marble busts by J.Nollekens and L.Macdonald (Clumber 2512 and 2517).

The 5th Duke of Newcastle appears in 'Lady Waldegrave's Salon at Strawberry Hill, 1865' by L.Desanges, formerly in the collection of the Earl of Waldegrave, who also owned a bust of him by M.Noble, possibly one of the two exhibited *R A*, 1858 (1278), and 1859 (1288); Newcastle also appears in 'On the Heights near Boulogne, 1854' by F.de Prades, sold Sotheby's, 3 April 1968 (lot 77), exhibited *R A*, 1857 (1122); a painting by A.W.Cox is in the Castle Museum and Art Gallery, Nottingham; a drawing by G.Richmond is listed in his 'Account Book' (photostat copy, NPG archives), p29, under 1841, engraved by F.C.Lewis (example in NPG), for the 'Grillions Club' series; two caricature drawings by J.Doyle are in the British Museum; various busts and reliefs are in the Gladstone Collection at Hawarden; busts by P.Park (marble), A.Munro, J.Durham and W.G.Coutts were exhibited *R A*, 1836 (1101), 1864 (907), 1866 (867), and 1867 (1183), respectively; an engraving by G.Zobel, after Sir J.Watson Gordon, was published Colnaghi, 1864 (example in NPG); there is an anonymous lithograph (example in NPG); a woodcut was published *I L N*, VIII (1846), 129, and woodcuts after photographs *I L N*, XXXVII (1860), 575, and XLII (1863), 400, and *Illustrated Times*, 14 February 1857.

NEWMAN *John Henry, Cardinal* (*1801–90*)

One of the great spiritual leaders of the age; the chief founder of the Oxford Movement; converted to Roman Catholicism, 1845; thereafter, through his writings and personal magnetism, exercised a profound influence in spiritual and religious matters.

1022 Oil on canvas, $44 \times 35\frac{1}{4}$ inches ($111 \cdot 8 \times 89 \cdot 5$ cm), by MISS EMMELINE DEANE, 1889. PLATE 672

Signed and dated (*bottom left*): Emmeline Deane/1889/Edgbaston

Collections: Purchased by the sitter for his doctor, George Vernon Blunt, and presented by him, 1896.

Exhibitions: Buck and Reid's Gallery, Bond Street, 1890.

Literature: Two MS memoranda prepared by the artist (NPG archives).

Miss Deane's two memoranda contain her reminiscences of Newman, and information about her four portraits of him (that in the NPG is no.4):

1 Charcoal drawing of 1884 (English College, Rome). The artist's mother, a cousin of Newman, arranged the sittings: '*His face struck me as most impressive – the moulding so decided and the nose so dominant a feature. . . . He sat well, his face full of animation and power*'. The portrait was in the Paris Salon of 1886, and the *International Fine Arts Exhibition*, Rome, 1911, 'British Historical Section', room I (36); it is reproduced W.Ward, *The Life of John Henry Cardinal Newman* (1912), II, frontispiece.

2 Charcoal drawing of 1887 (collection of the artist, 1934, photograph in NPG files). Miss Deane asked Newman to sit for an oil, but he replied: '*It would be a great pleasure and favour to me to be painted by you. But my time is not my own St Bede and St Anselm were each of them finishing a great work, and they had to run a race with time What chance have I of doing my small work, however much I try. And you lightly ask me, my dear child, to give up the long days, which are in fact the only days I have* (copy of a letter, NPG archives). He agreed, however, to sit for a second charcoal

sketch, '*but it wasn't a characteristic study of his expression as he was smiling the whole time as my mother talked to him, and the facial muscles were stiff*'.

3 Oil portrait, 1887–9 (The Oratory, Birmingham, photograph of it in its first stages, NPG files). In the summer of 1887, Father William Neville managed to persuade Newman to sit to Miss Deane for an oil. The portrait started well (Newman remarked, '*she has painted what I feel*'), but the stuffy atmosphere of the room made Newman sleepy and brilliant by turns, and he found it almost impossible to hold the same position for any length of time. Miss Deane subsequently in her studio painted out everything except the face, and repainted the costume and background; she worked on the portrait again in 1889 together with no. 4. It belonged to Newman, and then to Father Neville, who returned it to the artist. It was in the Rome Exhibition of 1911, room I (20).

4 Oil portrait, 1889 (now in the NPG). Dissatisfied with her first oil portrait (no. 3), Miss Deane, late in 1888 or early in 1889 (her two memoranda are contradictory), took a new canvas, drew the figure in, and prepared the ground: '*I settled to paint him in black cassock and rose-coloured cappa magna this time*'. In March 1889 she took her two oils to Birmingham, and on 4 April had a sitting from Newman; afterwards, however, '*the picture seemed to hang fire, and fogs came, and then an east wind set in.*' On 8 April there was a second sitting: '*The Cardinal walked downstairs and sat really well for half an hour and I was able to get some good work done*'. On 10 April Newman came again '*looking very weak and tired*', and again on 17 April, '*a good sitting*'. In between sittings, Miss Deane worked on the costume from a lay figure. She returned to Birmingham in June, and had three final sittings (29 June, 1 and 4 July). On 3 February 1890 Miss Deane repainted the background of the picture in her studio, as it was cold and chalky, and soon afterwards submitted it to the Royal Academy, where it just failed to find a place. Newman paid her a hundred guineas for the painting. A pencil study is reproduced G. H. Harper, *Cardinal Newman and William Froude: a Correspondence* (Baltimore, 1933), frontispiece. Miss Deane executed a miniature copy for Father Neville, which was subsequently given back to her.

Description: Pale complexion, pale grey (?) eyes, grey hair. Dressed in the black and crimson robes of a cardinal, with a crimson skull cap, silver cross hanging from a heavy silver chain, malacca cane with silver handle and crimson tassels, silver ring with a dark stone. Seated in a wooden armchair, only the right arm of which is visible. Very dark background. Cardinal's arms top right.

1065 Coloured chalk on brown, discoloured paper, 16¼ × 13¼ inches (41·3 × 33·6 cm), by GEORGE RICHMOND, 1844. PLATE 669

Collections: The artist, purchased from his executors, 1896.

This is a study for the drawing of 1844 at Oriel College, Oxford (see iconography below). In a letter of 15 July 1896 (NPG archives), one of Richmond's executors, F. W. Farrer, wrote about the NPG drawing, '*which my eldest brother who knew Newman well liked better than the engraved drawing – I mean thought it a better likeness*'.

1668 Plaster cast, painted black, 27⅜ inches (69·5 cm) high, of a bust by THOMAS WOOLNER, 1866. PLATE 670
Incised on the front of the base: JOHN HENRY NEWMAN *and on the side:* T. Woolner Sc/1866
Collections: The artist, purchased from his daughter, Miss Amy Woolner, 1912.

Related to the marble bust by Woolner of 1866 at Keble College, Oxford (see iconography below). There is another plaster cast at Trinity College, Oxford. The NPG bust was purchased with a collection of other plaster busts by Woolner.

ICONOGRAPHY This does not include photographs, of which there are several examples in the NPG (see plate 673); others are reproduced *Bookman*, XXVI (May 1904), 45–57. The portraits at Oxford are listed by Mrs R L. Poole, *Catalogue of Oxford Portraits*, 3 vols (1912–25).

As a child Miniature called Newman by an unknown artist. Collection of the Rev T.D.S.Bayley.

1832 Drawing by Miss M.Giberne, with T.Mozley and R.H.Froude (photograph at Oriel College, Oxford). Miss Giberne also executed a drawing of Newman with his family, reproduced *Art Journal* (1890), p316. Both drawings were once apparently in the collection of the Newman family.

c 1840 Painting by Miss M.Giberne. Reproduced M.Ward, *Young Mr Newman* (1948), frontispiece.

1841 Caricature drawing by J.R.Green (when vicar of St Mary's). Truro Cathedral. Anonymously etched (example in NPG, plate 668). A similar etching is in the British Museum. Related woodcut published *ILN*, v (1844), 45.

c 1841 Marble bust by R.Westmacott. Collection of W.H.Mozley, 1891. Exhibited *RA*, 1841 (1342). Reproduced *Letters and Correspondence of John Henry Newman*, edited A.Mozley (1891), I, frontispiece. Engraved by W.Humphreys, after a drawing of the bust by J.Bridges, published Wyatt and Son, 1844 (example in NPG).

1844 Drawing by G.Richmond. Oriel College, Oxford.
Listed in Richmond's 'Account Book' (photostat copy, NPG archives), p37, under 1844. Exhibited *VE*, 1892 (384). Anonymously engraved with variant collar, published T.McLean, 1856 (example in British Museum). Study (NPG 1065 above).

c 1845 Miniature by Sir W.C.Ross. Christie's, 2 May 1961 (lot 193), bought Francis (ex-collection of Lord Aldenham) (plate 667). Exhibited *VE*, 1892 (455), where it is said to have been painted in 1847, and *International Exhibition*, Brussels, 1912. Engraved by R.Woodman (example in NPG). Water-colour study (dated 1845): Keble College, Oxford, exhibited *VE*, 1892 (363), reproduced Dr Bell, *The English Church* (1942).

1846 Painting by Miss M.Giberne (with Ambrose St John in Rome). Birmingham Oratory.
Reproduced R.Sencourt, *The Life of Newman*, (1948), facing p148.

1850 Lithograph by J.A.Vinter, after a drawing by Miss M.R.Giberne, published Powell & Co, Birmingham, 1850 (example in NPG).

1850 Anonymous caricature engraving (example in NPG).

1851 'Newman Lecturing' by Miss M.Giberne. Birmingham Oratory.
Reproduced L.M.Trevor, *Newman: the Pillar of the Cloud* (1962), facing p307.

1866 Marble bust by T.Woolner. Keble College, Oxford.
Exhibited *RA*, 1867 (1035). Reproduced *Burlington Magazine*, XCV (1953), 243. A letter of 9 June 1866 from Newman to Woolner, arranging a sitting, is quoted by A.Woolner, *Thomas Woolner:His Life in Letters* (1917), p272. Plaster casts: Trinity College, Cambridge, and NPG (see NPG 1668 above).

c 1874 Painting by W.T.Roden. Keble College, Oxford.
Exhibited *RA*, 1874 (143). Reproduced Mrs Poole, *Oxford Portraits*, III, plate XXIII. A replica by Roden of 1879 is in the City Museum and Art Gallery, Birmingham (plate 671), and another version in the Manchester City Art Gallery.

1875 Painting by G.Molinari. Collection of A.Slade, 1939.

c 1875 Drawing by Lady Coleridge. Exhibited *RA*, 1875 (1069).
Probably the drawing reproduced L.M.Trevor, *Newman: Light in Winter* (1962), frontispiece.

1877 Lithograph by 'Spy' (Sir L.Ward), published *Vanity Fair*, 20 January 1877 (example in NPG).

c 1877 Drawing by Lady Coleridge. Exhibited *RA*, 1877 (1266).
Either this or the drawing of *c 1875* was engraved by S.Cousins, published Colnaghi, 1880 (example in NPG).

1879 Lithograph by AS, published *The Whitehall Review*, 10 May 1879.

c 1880 Painting by W.W.Ouless. Oriel College, Oxford.

Exhibited *RA*, 1880 (438). Repainted in 1881. Reproduced L. Bouyer, *Newman: His Life and Spirituality* (1958), frontispiece. Etched by P. Rajon (example in NPG). Another version by Ouless (head and shoulders only) is at the Birmingham Oratory, reproduced *A Tribute to Newman: Essays on Aspects of His Life and Thought*, edited M. Tierney and others (1945), frontispiece. A copy by Mrs B. Johnson is at Trinity College, Oxford.

1881 Painting by Sir J. E. Millais. Collection of the Duke of Norfolk (plate 674).
Exhibited *RA*, 1882 (1514), and *VE*, 1892 (218). Reproduced J. G. Millais, *Life and Letters of Sir John E. Millais* (1899), II, 115. Engraved by T. O. Barlow, published Agnew, 1884 (example in NPG), engraving exhibited *RA*, 1884 (1408). Copy by A. de Brie: Keble College, Oxford.

c1881 Terra-cotta bust by M. Raggi. Exhibited *RA*, 1881 (1483).

c1881 Painting by E. Jennings, after a photograph of 1879. Magdalen College, Oxford.

c1883 Marble bust by F. Verheyden. Exhibited *RA*, 1883 (1526).

1884 Drawing by Miss E. Deane. English College, Rome (see NPG 1022 above).

1885 Drawing by Miss E. Hallé. Royal Collection, Windsor. Exhibited *RA*, 1886 (1505).
A bronze medal by the same artist was exhibited *RA*, 1887 (1921).

c1885 Etching by H. R. Robertson. Exhibited *RA*, 1885 (1597).

1887 Drawing by Miss E. Deane. Formerly collection of the artist (see NPG 1022 above).

1887–9 Painting by Miss E. Deane. The Oratory, Birmingham (see NPG 1022 above).

1889 Painting by Miss E. Deane (see NPG 1022 above).

1892 Bust by Sir T. Farrell. University Chapel, Dublin.
Exhibited *Royal Hibernian Academy*, 1892.

c1892 Statuette by W. Tyler. Exhibited *RA*, 1892 (1931).

1896 Marble statue by L. J. Chavalliaud. Brompton Oratory, London.
Reproduced *Magazine of Art* (1896), p463.

c1912 Statue by H. Pegram. Oriel College, Oxford.
Model exhibited *RA*, 1912 (1782).

c1915 Bronze bust by A. Broadbent (part of a memorial). Trinity College, Oxford.
Exhibited *RA*, 1915 (1848).

Undated Painting by D. Woodlock, possibly after a photograph by Barraud (example in NPG). Collection of E. F. Mahoney, 1912. Exhibited *Franco-British Exhibition*, 1908.

Undated Painting by A. R. Venables. Collection of the Earl of Denbigh, Newnham Paddox, 1907.
Exhibited *Brighton Loan Exhibition*, 1884 (267). Reproduced A. D. Culler, *The Imperial Intellect* (1955), frontispiece.

Undated Design for a Monument by F. Derwent Wood. Victoria and Albert Museum.

Undated Drawing by H. Doyle, and a drawing by R. Doyle. The Oratory, Birmingham.
Both reproduced A. D. Culler, *The Imperial Intellect* (1955), facing p140.

Undated Terra-cotta bust by an unnamed artist. Collection of Miss Draper, 1937.

Undated Engraving by J. Brown. Reproduced *Bookman*, XXVI (1904), 50.

Undated Etching by A. Legros (example in the collection of Cyril Fry).

NEWTON *Ann Mary* (*1832–66*)

Painter; daughter of the painter, Joseph Severn; studied portrait painting under Richmond and Ari Scheffer; exhibited at RA, 1863–5; married Sir C. T. Newton, 1861; thereafter, drew antiquities for his books and lectures; travelled in Greece and Asia Minor.

977 Oil on canvas, 24 × 20½ inches (61 × 52·1 cm), by HERSELF. PLATE 675

Inscribed on a label on the back: Mrs Newton/37 Gower Street

Collections: The sitter, bequeathed by her husband, Sir Charles Newton, KCB, 1895.

Description: Healthy complexion, dark eyes, brown hair, with a red ribbon. Dressed in a blue dress, with a black bead necklace, and a gold bracelet. Holding a brown leather-bound folio of drawings (?), secured with red ribbons. Background colour various tones of green and brown.

ICONOGRAPHY A painting of 'Mrs Charles Newton' by Mrs M. Newton, exhibited *RA*, 1863 (464), probably refers to this sitter; four caricature drawings by herself (with Ruskin and her husband) are reproduced S. Birkenhead, *Illustrious Friends* (1965), facing pp 140 and 141; the NPG self-portrait is reproduced facing p 76.

NICHOLL *John* (*1797–1853*)

MP for Cardiff.

54 See *Groups:* 'The House of Commons, 1833' by Sir G. Hayter, p 526.

NICHOLLS *Sir George* (*1781–1865*)

Poor law reformer and administrator; served in ships of East India Company; became overseer of poor at Southwell, 1821; involved with various banks and canal companies; one of three poor law commissioners, 1834; examined methods of relief in other countries; administered poor law in Ireland, 1838–42; permanent secretary of poor-law board, 1847.

4807 Oil on canvas, 36⅛ × 32 inches (91·9 × 81·5 cm), by RAMSAY RICHARD REINAGLE, 1834. PLATE 676

Inscribed on the back of the canvas, in an old hand: George Nicholls/Poor Law Commissioner/by R.G. [*sic*] Reinagle R.A./Painted 1834 (signed and dated) *Inscribed on a label on the back of the stretcher:* [*L*]eft Hand of Chimney [*pencil*]/Sir George Nicholls K.C.B/B 1781 D 1865/by Reinagle about 1840 [*ink, the last three words crossed out*]

Collections: Possibly the three-quarter length portrait by Reinagle in the collection of Mrs H. G. Nicholls, the sitter's daughter-in-law, recorded by the *Dictionary of National Biography*, XL (1894), 441; the Worsley family (subsequently the Tindal-Carill-Worsley family) of Platt Hall, Manchester, and subsequently of East Carleton Manor, Norfolk; offered to the NPG by the Rev W. C. Hall of Barton Turf, Norwich, as a Reinagle self-portrait, 1946, but declined; purchased at Sotheby's, 29 April 1970 (lot 47), through Leggatt Brothers.

The history of the portrait is recorded in a letter from Hall of 18 July 1946 (NPG archives): '*It came from East Carleton Manor Norfolk with a collection of other portraits some of which are going to the Leicester Art Gallery & the National Portrait Gallery of Scotland. . . . The Collection was formed by the Worsley Family of Platt Hall Manchester. The Worsleys brought them to East Carleton Manor in Norfolk some years ago from whom I obtained the Collection*'. The inscription on the back of the portrait must have been partially or wholly covered up at the time, hence the wrong identification; a photograph of the portrait taken by the NPG in 1946 proves, however, that it is identical with NPG 4807. How the portrait entered the Worsley Collection is unknown, as is their connection with Nicholls. The family is recorded in *Burke's Landed Gentry* (1906 edition) at Platt Hall (the Worsleys had been there since the 17th century), and subsequently at East Carleton Manor, Norfolk (1937 and 1939 editions); the house was sold in 1948. The NPG portrait shows signs of having been cut down at one side and at the top; there is no sign of the signature and date mentioned in the inscription on the back. Whether the NPG portrait is the same as that owned by Mrs H. G. Nicholls remains an open question. There seems no doubt however that the inscription on the back is near-contemporary and authentic, and that the portrait does in fact represent Nicholls.

Description: Healthy complexion, bluish-grey eyes, greyish hair. Dressed in a white shirt, dark stock, dark waistcoat and coat. Seated in a reddish armchair. Red book on a table just visible lower left. Red curtain and grey pillar above. Rest of background brown.

ICONOGRAPHY The *Dictionary of National Biography*, XL (1894), 441, records a drawing by E. U. Eddis of 1839 in the collection of Miss G. E. Nicholls, the daughter of the sitter, and a water-colour by C. Moore in the collection of Miss E. M. G. Wingfield, the granddaughter of the sitter.

NICHOLSON *John* (*1821–57*)

Brigadier-general; served with distinction in Afghanistan, Kashmir and Sind; took part in the second Sikh war; commander of the Punjab movable column during the Indian mutiny; killed while leading the assault on Delhi.

3922 Coloured chalk on brown, discoloured paper, 14 × 10 inches (35·5 × 25·4 cm) mounted as an oval, by WILLIAM CARPENTER, 1854. PLATE 677

Signed and dated in pencil (lower right): W^m Carpenter/Peshawur/1854 *Inscribed in pencil in a later hand (bottom left):* John Nicholson

Collections: Sir Herbert Edwardes; by descent to his great-niece, Mrs R. S. Vandeleur, and purchased from her, 1954.

This drawing was engraved by W. Roffe as the frontispiece to the Rev J. Cave-Browne's *The Punjab and Delhi in 1857* (1861), II. According to the donor (letter of 12 October 1954, NPG archives), '*Nicholson stayed with my great uncle Major General Sir Herbert Edwardes who was commissioner at Peshawur then – for Xmas 53/54 – & I should think that was probably when he had done it – & gave it to him. . . . Nicholson was a great friend of Sir Herbert Edwardes*'. For Edwardes see this catalogue under his name.

Description: Healthy complexion, brown eyes, hair and beard. Dressed in a white shirt and dark coat.

ICONOGRAPHY A posthumous painting by J. R. Dicksee is in the County Museum, Armagh, exhibited *Great Irishmen*, Ulster Museum, Belfast, 1965 (153); another version was formerly in the Delhi Institute, and a copy by C. Vivian is in the East India and Sports Club, London, reproduced L. J. Trotter, *The Life of John Nicholson* (1898), frontispiece; the type was engraved by A. N. Sanders, published H. Graves, 1867 (example in NPG); there has in the past been some confusion as to whether the portrait was the work of J. R. or T. F. Dicksee (prints were variously inscribed with the name of one or the other); in a letter of 25 April 1867 (kindly communicated by Miss E. Werge Thomas, 1955), however, J. R. Dicksee writes to the sitter's mother to say that the portrait of her son is ready, and that the engraver has already seen it; a monument by J. H. Foley of 1862 is in Lisburn Church, Count Wicklow, listed by W. G. Strickland, *Dictionary of Irish Artists* (1913), I, 363, who also records a bust by Foley; a copy of the latter by Sir T. Farrell is in the East India and Sports Club, London; a bas-relief from the monument was engraved by E. Roffe for the *Art Journal* (1865), facing p 124; a bronze statue by Sir T. A. Brock is in the Nicholson Garden at Delhi, the model for which was exhibited *RA*, 1904 (1675); a daguerreotype by Kilburn was in the collection of the sitter's great-nephew, A. A. Maxwell, 1955, reproduced L. J. Trotter, facing p 142, engraved by T. W. Knight (in reverse), published J. S. Virtue (example in NPG); a woodcut after the same daguerreotype, and a woodcut after a photograph, were published *ILN*, XXXI (1857), 564, and 417 respectively.

NOËL *Sir Gerard Noël, Bart* (*1759–1838*)

MP for Rutland.

54 See *Groups:* 'The House of Commons, 1833' by Sir G. Hayter, p 526.

NORFOLK *Henry Charles Howard, 13th Duke of* (*1791–1856*)

Courtier, MP for Sussex West.

54 See *Groups:* 'The House of Commons, 1833' by Sir G. Hayter, p 526.

NORMANBY *Sir Constantine Henry Phipps, 2nd Earl of Mulgrave, and 1st Marquess of* (*1797–1863*)

Statesman and diplomat; MP from 1818; supported parliamentary reform; governor of Jamaica, 1832–4; lord privy seal, 1834; lord lieutenant of Ireland, 1835–9; Marquess, 1838; secretary of war and colonies, 1839; secretary of home office, 1839–41; ambassador at Paris, 1846–52; minister at Florence, 1854–8; author of several novels.

3139 Brown ink on paper, $8\frac{3}{8} \times 5\frac{3}{8}$ inches (21.3×13.7 cm), by DANIEL MACLISE, 1835. PLATE 678

Signed with the artist's pseudonym (*lower left*): Alfred Croquis

Sitter's autograph below: Mulgrave *Inscribed below in pencil in another* (?) *hand:* Author of "Yes & No".

Collections: Possibly included in the artist's sale, Christie's, 24 June 1870; Appleby Brothers, purchased from them, 1943.

This is the finished drawing for the engraving of Normanby by Maclise (they are almost identical; the autograph appears in the engraving, but not the signature), published *Fraser's Magazine*, XII (November 1835), facing 540, as no. 66 of Maclise's 'Gallery of Illustrious Literary Characters'. Another more sketchy pencil study is in the Victoria and Albert Museum. The NPG drawing was sent to the publisher of the magazine, James Fraser, through the post; on the reverse are various postmarks, 'Cork, 23 or 25 Sept. 1835' (twice), and 'A 29 Sept. 1835', and the address of 'James Fraser Esqre/215 Regent Street/London'. Maclise had come originally from Cork, and must have been revisiting the city in 1835; it is not known whether the drawing itself was executed in Cork. Maclise's eighty or so caricatures of contemporary writers in *Fraser's Magazine*, accompanied with word sketches by William Maginn, the editor, were one of the chief attractions of the magazine in its early days. Most of the studies and finished drawings for this series were sold after the artist's death, Christie's, 24 June 1870, in large uncatalogued lots.

ICONOGRAPHY This does not include the caricature drawings by J. Doyle in the British Museum.

c1810 Painting by J. Hoppner. Parke-Bernet Galleries, New York, 20–1 April 1938 (lot 375).
Exhibited *British Institution*, 1817 (123). See W. McKay and W. Roberts, *John Hoppner, RA.* (1909), p 203.

c1813 Painting by J. Jackson. Exhibited *RA*, 1813 (595).
Either this portrait, or that of 1819 (see below), is in the collection of the Duke of Devonshire, Hardwick Hall.

c1819 Painting by J. Jackson. Exhibited *RA*, 1819 (196).

1831 Engraving by J. Thomson, after a drawing by F. R. Say, published Colburn and Bentley, 1831 (example in NPG), for the *New Monthly Magazine*.

c1832 Painting by H. P. Briggs. Exhibited *RA*, 1832 (138).
Engraved by C. Turner, published Colnaghi, 1836 (example in NPG), and by H. Robinson, published Fisher, 1833 (example in NPG), for Jerdan's 'National Portrait Gallery'.

1835 Drawing by D. Maclise (NPG 3139 above).

1838 'Queen Victoria's Coronation' by Sir G. Hayter. Royal Collection.
Engraved by H. T. Ryall, published Graves and Warmsley, 1843 (example in NPG).

c1838 Bust by P. Turnerelli. Exhibited *RA*, 1838 (1363).

1839	Lithograph by R.J.Lane, after a drawing by Count A.D'Orsay. Recorded in Lane's 'Account Books' (NPG archives), II, 33, under 1839 (no example located).
c1839	Painting by N.J.Crowley. Exhibited *RA*, 1839 (508). Engraved by H.Robinson, published Saunders, 1840 (example in NPG), for 'Political Reformers'. Oil sketch, probably a study for this picture: Irish NPG.
1840	Drawing by Count A.D'Orsay. British Embassy, Paris. Lithographed by R.J.Lane, published J.Mitchell (example in NPG).
1842	Drawing by G.F.Watts. Ilchester Collection. Exhibited *British Portraits*, RA, 1956–7 (725).
1844	Woodcut published *ILN*, IV (1844), 101.
Undated	Painting by M.Heuss. Exhibited *VE*, 1892 (27), lent by the Marquess of Normanby. Lithographed by Selb (example in NPG).
Undated	Painting by an unknown artist. Dublin Castle, 1872. Exhibited *Dublin Exhibition*, 1872, 'Portraits' (229).
Undated	Drawing by Sir T.Lawrence. Royal Collection, Windsor.
Undated	Engraving by H.B.Hall, after E.Latilla (example in NPG).
Undated	Lithograph by M.Gauci, after C.Brocky (example in British Museum).

NORTH *Frederick* (*1800–69*)

MP for Hastings.

54 See *Groups:* 'The House of Commons, 1833' by Sir G.Hayter, p526.

NORTHBROOK *Sir Francis Thornhill Baring, Baron* (*1796–1866*)

Statesman; MP from 1826; a lord of the treasury, 1830–4, and joint secretary, 1834, 1835–9; chancellor of the exchequer, 1839–41; first lord of the admiralty, 1849–52; created baron, 1866.

1257 Oil on millboard, 11 × 8¼ inches (28 × 20·9 cm), by SIR GEORGE HAYTER, *c*1833. PLATE 679

Collections: The sitter, presented by his son, the 1st Earl of Northbrook, 1900.

This is a study for Hayter's 'House of Commons' group (see below). Hayter inscribed the name of the sitter and the date on labels on the back of almost all his studies; there are signs that there was once a label on the back of this study, which has been removed. Some of the original studies were sold to the sitters (as this one presumably was), and the rest appeared in Hayter's sale, Christie's, 19 April 1871.

Description: Brown eyes and hair. Dressed in a dark stock, white shirt, fawn waistcoat, brown coat. Background colour brownish-green.

54 See *Groups:* 'The House of Commons, 1833' by Sir G.Hayter, p526.

ICONOGRAPHY A painting of 1809–10 by Sir T.Lawrence (with other members of his family) is in the collection of Lord Northbrook, exhibited *RA*, 1810 (159); an oil study and a pencil drawing are in the same collection; a painting by J.Linnell of 1842 is also owned by Lord Northbrook, exhibited *RA*, 1842 (467), *SKM*, 1868 (453), and *VE*, 1892 (7), for which see A.T.Story, *The Life of John Linnell* (1892), II, 252; a drawing begun by Richmond in 1831, together with a copy, is listed in his 'Account Book' (photostat copy, NPG archives), p81, under 1867; a drawing of 1848 by G.Richmond is reproduced *Journals and Correspondence of Francis Thornhill Baring Lord Northbrook*, edited the Earl of Northbrook, I (1905), frontispiece, listed in Richmond's 'Account Book', p47, engraved by W.Holl (example in NPG), for the 'Grillions Club' series; the same or another drawing was exhibited *VE*, 1892 (350), lent by the Hon Mrs Bonham-Carter, the sitter's daughter; there are several drawings by J.Doyle in the British Museum; two crayon drawings by A.Tidey of 1841 are listed by S.Tidey,

'List of Miniatures by A. Tidey' (typescript, 1924, Victoria and Albert Museum Library), p 11; Northbrook appears in 'The House of Commons, 1860' by J. Phillip, now in the Palace of Westminster, engraved by T. O. Barlow, published Agnew, 1866 (example in NPG); a photograph by Silvy of 1861 is reproduced *Journals*, II (1902), frontispiece.

NORTHCOTE *James* (*1746–1831*)

Painter.

2515 (5) See *Collections:* 'Drawings of Prominent People, 1823–49' by W. Brockedon, p 554.
See also forthcoming Catalogue of Portraits, 1790–1830.

NORTON *Caroline Elizabeth Sarah, later Lady Stirling-Maxwell.* See STIRLING-MAXWELL

NORTON *Hon John T.*

American slavery abolitionist.

599 See *Groups:* 'The Anti-Slavery Society Convention, 1840' by B. R. Haydon, p 538.

O'CONNELL *Daniel* (*1775–1847*)

Irish politician; barrister, 1798; MP from 1828; advocated, and worked tirelessly for, catholic emancipation, extension of suffrage, repeal of the Act of Union, parliamentary reform, and Irish unity; recreated Irish nationalism; lord mayor of Dublin, 1841; called 'The Liberator'.

4582 Oil on millboard, 14 × 12 inches (35·5 × 30·5 cm), by SIR GEORGE HAYTER, 1834. PLATE 683

Inscribed in ink, on a label on the back of the board, in the artist's hand: Daniel O'Connell Esq^re M.P./ for The City of Dublin/Study for my great picture of The/House of Commons of 1833/George Hayter 1834

Collections: Presumably Hayter Sale, Christie's, 21 April 1871 (lot 532); Miss Lorna Kensington; purchased at Sotheby's, 5 October 1967 (lot 337).

This is a study for Hayter's 'House of Commons, 1833' (NPG 54 below). In the finished group O'Connell is shown without a hat, but the profile pose of the head and treatment of the features is very similar in both group and study. In a letter of 4 November 1967 (NPG archives), Miss Kensington stated that the sketch had come from her father, who died in 1931; he might have acquired it from G. H. Hart (?), a bookseller in Bromley, Kent.

Description: Healthy complexion, brown hair. Dressed in a white collar, a black stock, dark unfinished coat and greyish top hat. Brown background colour.

208 Miniature, water-colour and body colour on ivory, 6⅛ × 5¼ inches (15·5 × 13·3 cm) uneven oval, mounted smaller, by BERNARD MULRENIN, 1836. PLATE 681

Signed and dated (lower right): B.M./R.H.A./–36 *Inscribed in pencil on the back:* Mulrenin RHA 1836.

Inscribed on a label, formerly on the back of the miniature: Daniel O'Connell Esq^r. M.P. & – /Bernard Mulrenin R.H.A./Dublin/Painted in/1835 [*sic*]/No. 1.

Inscribed on another label: ON LOAN FROM [*printed*]/Bernard Mulrenin Esq/29th May 18 [*printed*] 65

Collections: The artist, purchased from him, 1866.

Literature: W. G. Strickland, *Dictionary of Irish Artists* (1913), II, 151.

The second label apparently refers to the South Kensington Museum, where the miniature was on

loan, apparently offered for sale. It was not in the Miniature Exhibition of 1865 at South Kensington. In a letter of 14 December 1865 (NPG archives), the artist wrote: '*Mr O'Connell sat to me for the Portrait in question – it is an original picture, and was painted at the request of Mrs O'Connell for the purpose of having several small copies which she presented to the members of his Family; I have just found – rather to my surprise, after such a lapse of time, a note from her on the occasion*'.

Description: Fair complexion, greenish(?) eyes, brown hair. Dressed in a black stock and neck-tie, white shirt, black coat with black buttons and one brass one (upper right). Background colour various tones of brown and greenish-grey.

54 See *Groups:* 'The House of Commons, 1833' by Sir G. Hayter, p 526.

599 See *Groups:* 'The Anti-Slavery Society Convention, 1840' by B. R. Haydon, p 538.

ICONOGRAPHY

This does not include caricatures or popular prints (examples in NPG, Irish NPG, National Library of Ireland, Dublin, and British Museum). Several portraits were in an O'Connell exhibition at the National Gallery of Ireland in 1929; there is no catalogue of this exhibition. 'Strickland' refers to W. G. Strickland, *Dictionary of Irish Artists* (1913), 2 vols.

1800 Miniature by J. Comerford. Strickland, I, 200.

1816 Medal by W. S. Mossop. Strickland, II, 141.

1824 Drawing by J. Comerford. Strickland, I, 200.
 Engraved by T. Heaphy, published J. Molteno, 1825 (example in Irish NPG).

1825 Engraving by R. Cooper, after a drawing by S. C. Smith, published J. Robins, 1825 (example in NPG).

1825 Anonymous lithograph, published N. Chater & Co, 1825 (example in NPG).

c 1828 Bust by P. Turnerelli. Exhibited *RA*, 1828 (1153).
 Ten thousand casts of this bust were said to have been sold, see R. Gunnis, *Dictionary of British Sculptors* (1953), p 402.

c 1830 Medallic portrait by C. Moore (modelled from memory, 1825). Exhibited *RA*, 1830 (1096).

1832 'The Reform Banquet, 1832' by B. R. Haydon. Collection of Lady Mary Howick.
 Etched by F. Bromley, published J. C. Bromley, 1835 (example in NPG); engraved by and published J. C. Bromley, 1837 (example in British Museum).

c 1832 Doulton Reform Flask. Royal Doulton Potteries.
 Reproduced *Country Life*, CVII (1950), 226.

1833 'The House of Commons, 1833' by Sir G. Hayter (NPG 54 above).
 Study (NPG 4582 above).

1834 Engraving by D. Maclise, with R. L. Shiel (example in NPG), published *Fraser's Magazine*, IX (1834), facing 300, as no. 46 of Maclise's 'Gallery of Illustrious Literary Characters'. Pen and ink study: Victoria and Albert Museum, exhibited *Daniel Maclise*, Arts Council at the NPG, 1972 (51).

1834 Two bronze statuettes by J. P. Dantan (one with Cobbett). Musée Carnavalet, Paris.
 Listed by J. Seligman, *Figures of Fun* (1957), pp 140–1.

1835 Silhouette by A. Edouart. Reproduced E. N. Jackson, *History of Silhouettes* (1911), plate XXXVII.
 Two other anonymous silhouettes, one of 1829 (reproductions in NPG).

1836 Miniature by B. Mulrenin (NPG 208 above).

c 1837 Bust by C. Moore. Exhibited *RA*, 1837 (1241).

c 1838 Painting by Sir D. Wilkie. National Bank of Ireland, on loan to Williams & Glyn's Bank, London (plate 680). Exhibited *RA*, 1838 (200); *British Institution*, 1842 (122); *SKM*, 1868 (432); *Dublin Exhibition*, 1872, 'Portraits' (225); *VE*, 1892 (144); *Wilkie Exhibition*, RA, 1958 (49). Reproduced R. Dunlop, *Daniel O'Connell* (1900), frontispiece.

1840 'The Anti-Slavery Society Convention, 1840' by B. R. Haydon (NPG 599 above).

1841 Painting by C. A. Du Val. Collection of J. J. Hickey, sold Robinson & Fisher, 2 June 1927 (lot 191). Exhibited *Irish Exhibition*, London, 1888 (1009). Sketched by G. Scharf, 'TSB' (NPG archives), XXXIV, 48. Engraved by S. W. Reynolds, published Agnew, and Ackermann, 1844 (example in NPG); engraved (bust only) by Bosselmann, published Payne (example in NPG).

1843 Miniature marble bust by J. E. Jones. Irish NPG (plate 682). Exhibited *RA*, 1844 (1380). Engraved anonymously (example in NPG). Possibly the bust in the Crystal Palace Portrait Collection, 1854.

1843 Painting by C. Grey. Strickland, I, 412. Exhibited *Royal Hibernian Academy*, 1843. Engraved by and published J. Peterkin, 1845 (example in Irish NPG).

1844 Miniature by T. Carrick. Colnaghi, 1939, from the Pretyman family. Exhibited *RA*, 1844 (817). Engraved by W. Holl, published Fisher & Co, 1844 (example in NPG), for W. Cooke Taylor's 'National Portrait Gallery'; woodcut after Carrick by H. Uhlrich from an unidentified magazine (cutting in NPG). Head and shoulders version: collection of Mrs Mountford.

1844 Painting by H. O'Neil, with his fellow prisoners. Strickland, II, 198.

1844 Painting by N. J. Crowley, during his imprisonment. Collection of Sir John Gray, 1913. Exhibited *RA*, 1845 (82); *Dublin Exhibition*, 1872, 'Portraits' (236). Lithographed anonymously (example in National Library of Ireland). Strickland, I, 237, who lists another painting by Crowley in the collection of Major Maher of Ballinkeele, 1913.

c 1844 Water-colour by H. Newton. Irish NPG. Reproduced Marquess of Lorne, *V.R.I: Her Life and Empire* (1901), p 14. Lithographed by Maclure and Macdonald, published A. Lesage, Dublin, 1844 (example in National Library of Ireland). Another water-colour by Newton was in the collection of Major E. M. Conolly, Castletown, 1937.

1846 Colossal marble statue by J. Hogan. City Hall, Dublin. Reproduced as a woodcut *ILN*, IX (1846), 288. Plaster cast: Limerick.

1847 Wax mask, from a death cast taken at Genoa. Irish NPG.

c 1847 Painting by Sir T. A. Jones, executed for the Royal Irish Yacht Club. Strickland, I, 564. Exhibited *Royal Hibernian Academy*, 1873.

c 1850 Bust by J. Hogan. Exhibited *RA*, 1850 (1357).

1865 Statue by J. Cahill. Ennis, Ireland. Model exhibited *Royal Hibernian Academy*, 1864. Strickland, I, 148. Another statue by Cahill, exhibited *Royal Hibernian Academy*, 1878, was sent to America.

1866 Statue by J. H. Foley (finished by T. Brock after Foley's death). Sackville Street, Dublin.

1871 Painting by S. C. Smith. City Hall, Dublin, destroyed by fire, 1908. Exhibited *Royal Hibernian Academy*, 1872, and *Irish Exhibition*, London, 1888 (978). Sketched by G. Scharf, 'TSB' (NPG archives), XXXIV, 38. Replaced after 1911 with a painting after the original by S. C. Smith junior. Another painting by S. C. Smith senior is owned by the Corporation of Waterford.

Undated Painting by G. F. Mulvany. Irish NPG (plate 684). Reproduced M. Tierney, *Daniel O'Connell* (1949), frontispiece.

Undated Painting by an unknown artist. Collection of Mrs D. O'Connell, *c* 1924 (reproduction in NPG).

Undated Drawing or painting by T. Bridgford. Strickland, I, 87. Lithograph of O'Connell and fellow prisoners, published S. J. Machen, Dublin, *c* 1844, recorded by Strickland (no examples located).

Undated Drawing of D'Orsay painting O'Connell by D. Maclise. Lady Blessington's Sale, Phillips, 7–26 May

1849 (lot 1214). Another drawing by Maclise showing O'Connell addressing an audience was in the same sale (lot 1213).

Undated Drawing by J. Doyle. Irish NPG.

Other drawings by Doyle are in the British Museum; one of 1837 is reproduced Sir H. Maxwell, *Sixty Years a Queen* (1897), p 20; another (with R. Shiel and J. Lawless) was exhibited *Dublin Exhibition*, 1872, 'Portraits' (420).

Undated Two miniatures by unknown artists. Formerly in the collection of the O'Connell family. Reproduced A. Houston, *Daniel O'Connell: his Early Life and Journal* (1906), frontispiece, and D. Gwynn, *Daniel O'Connell: the Irish Liberator* (1929), facing p 62.

Undated Bust by Count A. D'Orsay. Lady Blessington Sale, Phillips, 7–26 May 1849 (lot 1475). In the same sale were statuettes, one in bronze, and designs for a statue (lots 200, 279, 1152 and 1153).

Undated Three medals by J. Jones. Strickland, I, 557.

One of these was a reduced copy of the medal by Mossop of 1816 (see above).

Various dates Paintings by J. P. Haverty: 1. Reform Club, London (painted 1823–30). Reproduced M. MacDonagh, *The Life of Daniel O'Connell* (1903), frontispiece. Engraved by W. Ward, published J. Haverty, 1836 (example in Irish NPG). 2. 'Reading his Election Address to P. V. Fitzpatrick and F. W. Conway,' *c* 1828. Irish NPG. Reproduced R. Dunlop, *Daniel O'Connell* (1900), facing p 200. Exhibited *Royal Hibernian Academy*, 1847, and *Dublin Exhibition*, 1872, 'Portraits' (286). 3. Town Hall, Limerick. 4. Collection of T. O'Brien, Limerick, 1913. Listed by Strickland, I, 455. There is also a lithograph by Haverty (with T. Steele and O'Gorman Mahon) presumably of 1828.

Various dates Medals by J. and by W. Woodhouse, of 1828 and 1841 after Turnerelli; of 1864; and of 1866 and 1875 after Foley. Strickland, II, 555 and 561.

O'CONNOR *Dennis* (*The O'Connor Don*) (*1794–1847*)

MP for County Roscommon.

54 See *Groups*: 'The House of Commons, 1833' by Sir G. Hayter, p 526.

O'FERRALL *Richard More* (*1797–1880*)

Governor of Malta, MP for County Kildare.

54 See *Groups*: 'The House of Commons, 1833' by Sir G. Hayter, p 526.

OMMANEY *Sir Erasmus* (*1814–1904*)

Admiral; first discovered evidence of Franklin's death; captain, 1846; administered Irish relief, 1847–8; Arctic expedition in search of Franklin, 1850–1; knighted, 1877; served in Russian War and West Indies; admiral, 1877; KCB, 1902.

1219 Oil on canvas, $15\frac{3}{8} \times 12\frac{3}{4}$ inches (39 × 32·5 cm), by STEPHEN PEARCE, 1861. PLATE 685

Collections: See *Collections*: 'Arctic Explorers' by S. Pearce, p|562.

Exhibitions: R A, 1861 (69); *Royal Naval Exhibition*, Chelsea, 1891 (44).

Literature: S. Pearce, *Memories of the Past* (1903), p 72.

This is the only recorded portrait of Ommaney. He is wearing the undress uniform (1856 pattern) either of a naval captain with over three years' service or of a commodore (1st or 2nd class), the cross of the order of the Redeemer (Greece), either the 4th or 5th class (knight), or the 2nd class (grand commander), to which he was later promoted, the Baltic Medal (1854–5), the Arctic Medal (1818–55), and the Naval General Service Medal (1793–1840).

Description: Healthy complexion, bluish eyes, brown hair and whiskers. Dressed in a dark tie, white shirt and waistcoat, and dark blue naval uniform, with gold-braided epaulettes, gilt buttons, silver stars and a white cross with white and blue ribbons. Background colour greenish-brown.

O'NEILL *Eliza, Lady Wrixon-Becher.* See WRIXON-BECHER

OPIE *Mrs Amelia* (*1769–1853*)

Wife of the painter, John Opie; novelist and poet; philanthropist and slavery abolitionist.

599 See *Groups:* 'The Anti-Slavery Society Convention, 1840' by B.R.Haydon, p538.
See also forthcoming Catalogue of Portraits, 1790–1830.

ORANMORE AND BROWNE *Dominick Browne, 1st Baron* (*1787–1860*)

MP for County Mayo.

54 See *Groups:* 'The House of Commons, 1833' by Sir G.Hayter, p526.

OSBORN *Sherard* (*1822–75*)

Rear-admiral; served in East Indies, 1838–9, and in China, 1840–3; went on two Arctic expeditions in search of Franklin, 1850–1, 1852–4; managing director of Telegraph Construction Co, 1867–73; rear-admiral, 1873; wrote for *Blackwood's Magazine;* published works on naval subjects.

916 Oil on canvas, $15\frac{1}{2} \times 13$ inches ($39 \cdot 3 \times 33$ cm), by STEPHEN PEARCE, after a portrait of 1857–. PLATE 687
Collections: See *Collections:* 'Arctic Explorers' by S.Pearce, p562.
This is a replica of NPG 1224 below, and was commissioned by Lady Franklin.
Description: As for NPG 1224.

1224 Oil on canvas, $15\frac{1}{2} \times 12\frac{7}{8}$ inches ($39 \cdot 3 \times 32 \cdot 8$ cm), by STEPHEN PEARCE, 1857. PLATE 686
Collections: See *Collections:* 'Arctic Explorers' by S.Pearce, p562.
Exhibitions: RA, 1857 (491); *Royal Naval Exhibition*, Chelsea, 1891 (51).
Literature: S.Pearce, *Memories of the Past* (1903), p60.

This portrait was engraved by H.Davis, published H.Graves, 1861 (example in NPG). Osborn is wearing the full-dress uniform of a naval captain with less than three years service (1856 pattern), and (top to bottom, left to right), the Bath (CB), the Légion d'Honneur (officer, 4th class), the order of the Medjidie (Ottoman Empire), the Arctic medal (1818–55), the China medal (1842 or 57), and the Crimean medal (1854–6). The date of the portrait was provided by the artist in a memorandum of *c* 1899 (NPG archives), where the name of the engraver is given as J.Scott, presumably an error.

Description: Healthy complexion, dark eyes, dark brown hair and whiskers. Dressed in a dark stock, white shirt, dark blue naval uniform, with gold-braided collar and epaulettes, gilt buttons, white and silver medals and stars with multi-coloured ribbons. Background colour dark grey.

ICONOGRAPHY The only other recorded likenesses of Osborn are: a photograph by Beard, reproduced as a woodcut, *ILN*, XX (1852), 336; a woodcut (probably after a photograph) published *ILN*, LXVI (1875), 489; and another woodcut, probably after a photograph, from an unidentified magazine (cutting in NPG).

OSSINGTON *John Evelyn Denison, 1st Viscount* (*1800–73*)

Speaker of the House of Commons, MP for Nottinghamshire, South.

54 See *Groups:* 'The House of Commons, 1833' by Sir G.Hayter, p526.

OSWALD *Richard Alexander* (*1771–1841*)

MP for Ayrshire.

54 See *Groups:* 'The House of Commons, 1833' by Sir G. Hayter, p 526.

OUTRAM *Sir James, Bart* (*1803–63*)

Lieutenant-general; joined Indian army, 1819; from 1825–60 served almost continuously as Indian soldier and administrator; became famous for the defence of Haidarabad, 1843, his victory over the Persians, 1857, and the defence and relief of Lucknow, 1857; received baronetcy, pension, and freedom of London, 1858; published works on military subjects.

661 Oil on canvas, $27\frac{3}{4} \times 19\frac{7}{8}$ inches (70·6 × 50·5 cm), by THOMAS BRIGSTOCKE, *c* 1863. PLATE 689

Collections: The artist; sold Messrs Foster, 3 May 1882 (lot 113), bought Colnaghi, and purchased from them, 1882.

Exhibitions: SKM, 1868 (445).

Literature: G. Scharf, 'TSB' (NPG archives), XXX, 13.

This is a study for the painting of Outram by Brigstocke in the Oriental Club, London, exhibited *RA*, 1863 (346), of which there is a lithograph by R. J. Lane of 1863 (example in NPG); another version was in the collection of Henry Havelock Allan, 1909. A photograph of the NPG painting taken at the 1868 exhibition (example in NPG) shows that Brigstocke subsequently cut it down in size, softened the features, and washed out the details of costume and medals, which had previously been roughly indicated in chalk; there are still enough identical details to identify the NPG portrait as the one exhibited by Brigstocke.

Description: Healthy complexion, brown eyes, dark brown hair and beard. The red of the uniform indicated on the shoulders, the rest of the canvas below white and unfinished. Background colour dark blue-grey.

ICONOGRAPHY Outram appears in 'The Relief of Lucknow' by T. J. Barker, after sketches by E. Lundgren, in the collection of the Corporation of Glasgow, engraved by C. G. Lewis, published T. Agnew, 1863 (example in NPG, plate 412); Lundgren's sketches were sold Christie's, 16 April 1875, including a separate painting of Outram (lot 109); a painting by F. W. Lock was exhibited *RA*, 1861 (817); a painting by an unknown artist is in the United Service Club, London, possibly the portrait exhibited *VE*, 1892 (99); a painting by an unknown artist is in the Scottish NPG, possibly the painting by A. Buxton (recorded in the *Dictionary of National Biography* as commissioned by Sir J. Fayrer), of which a copy by J. E. Breun is in the East India and Sports Club, London; a drawing by J. B. Robinson is reproduced in his *Derbyshire Gatherings* (1864), p 17; a portrait by General A. Y. Shortt is in the East India and Sports Club, London; a marble bust by M. Noble of 1866 (part of a monument, with a relief sculpture showing the meeting of Outram, Clyde and Havelock at Lucknow) is in Westminster Abbey, reproduced as a woodcut *ILN*, XLVIII (1866), 652, and General Sir F. J. Goldsmid, *James Outram: a Biography* (1880), II, facing 386; another bust by Noble was exhibited *RA*, 1864 (1010), possibly the small bronze bust exhibited *VE*, 1892 (1074), lent by Sir F. B. Outram; a bronze statue by the same sculptor is in the Victoria Embankment Gardens, London, reproduced as a woodcut *ILN*, LIX (1871), 537; a marble bust by J. H. Foley is in the Victoria Memorial Hall, Calcutta, exhibited *RA*, 1861 (1053), and an equestrian statue by him of 1873 is also in Calcutta, reproduced as a woodcut *ILN*, LXIII (1873), 113, and LXV (1874), 20, engraved by W. Roffe, published Virtue for the *Art Journal* (1875), facing p 22, and Goldsmid, II, frontispiece; a coloured engraving of 'The Durbar of the Rajah of Travancore: Reception of General Outram and Staff' was published J. S. Virtue (example in NPG); a lithograph by C. Baugniet was published E. Gambart and Colnaghi, 1858 (example in NPG); there are several photographs and engravings of photographs in the NPG, and in the National Army Museum (see plate 688), and others are reproduced Goldsmid, I, frontispiece; L. J. Trotter, *The Bayard*

of India (1903), frontispiece; *History Today*, IX (April 1959), 235; a photograph by Kilburn in the NPG was reproduced *Picture Post* (3 June 1939).

OWEN *Hugh* (*1784–1861*)

Soldier; served in Peninsula; with Portuguese army from 1810; published *Civil War in Portugal*.

975 Miniature, water-colour on ivory, $2\frac{5}{8} \times 2\frac{1}{8}$ inches (6·6 × 5·3 cm) oval, attributed to ANDREW ROBERTSON, 1808. PLATE 690

Collections: The sitter, presented by his son, Hugh Owen, 1895.

The name of the artist and the date were provided by the donor in a letter of 3 December 1894 (NPG archives). The attribution was queried by the artist's daughter, Emily Robertson, in a letter of 14 August 1896, and by Basil Long in a letter of 15 March 1928 (both letters in NPG archives). To the former, Hugh Owen replied (letter of 19 January 1897, NPG archives): '*but I miss a strip of paper which ought to have answered Mr Robertson's daughter's objection. It was a thin narrow strip apparently cut from an exhibition catalogue. I cannot remember the exact words but I think they were – portrait of an officer of 16th Lt dragoons – Andrew Robertson*'. When the miniature was accepted by the NPG, the original locket in which it arrived was returned to the donor; it was in this locket that Owen failed to find the cutting from the catalogue. Owen is wearing the uniform of the 16th Light Dragoons, in which, in 1808, he was a lieutenant.

Description: Healthy complexion, blue eyes, brown hair. Dressed in a black stock, white collar, dark uniform with a red collar, grey frogging, and a grey belt. Background colour almost black.

ICONOGRAPHY The only other recorded portrait of Owen is a painting by an unknown artist in the collection of Alan Wylde.

OWEN *Sir Richard* (*1804–92*)

Naturalist; conservator, Hunterian Museum, 1827–56; first Hunterian professor of comparative anatomy, 1836–56; recognized as the first naturalist of his day; superintendent of natural history collection of the British Museum, 1856–83; author of numerous works; received international honours.

938 Oil on canvas, $56\frac{1}{4} \times 44$ inches (142·9 × 111·9 cm), by HENRY WILLIAM PICKERSGILL, *c*1845. PLATE 691

Collections: The sitter, presented by his daughter-in-law, Mrs Emily Owen, in accordance with his wishes, 1893.

Exhibitions: Possibly *R A*, 1845 (206); *Royal Jubilee Exhibition*, Manchester, 1887 (489).

Literature: L. G. Holland, 'Sketchbooks' (NPG archives), III, 21.

This portrait was first offered to the NPG in 1889, but only entered the collection on the death of the sitter. At the time it was first offered, Davies Sherborn wrote (letter of 5 November 1889, NPG archives): '*the portrait represents the Professor speaking upon the "Pearly Nautilus" – one of his most famous works & one he published about 1832*'. He is wearing the robes of a professor. A photogravure of this picture was published Photographische Gesellschaft, Berlin (example in NPG). Another version, almost identical in pose and features, but showing Owen holding a large bone, was in the collection of G. F. Boston, 1948; it came from the collection of Sir Robert Peel, and was in the sale of Peel heirlooms, Robinson, Fisher and Harding, 6–7 December 1917 (lot 59). There are two further half-length paintings by Pickersgill, one in St Bartholomew's Hospital, engraved by W. Walker, 1852 (example in NPG), and the other, showing him in academic robes, reproduced Rev R. Owen, *The Life of Richard Owen* (1895), I, frontispiece; a water-colour, apparently based on this portrait, and attributed to

W. Etty, is in the Royal College of Surgeons (see iconography below). The St Bartholomew's Hospital portrait may have been that exhibited *RA*, 1856 (93).

Description: Healthy complexion, brown eyes and hair. Dressed in a dark stock and neck-tie, white shirt, black waistcoat, black coat and trousers, and black and scarlet academic robes. Holding a white nautilus shell with brown markings. On the left is a table with a green cloth, and in a glass jar what appear to be the innards of the shell. Background colour greenish-brown.

2515 (98) Black and red chalk, with touches of Chinese white, on greenish-grey tinted paper, $14\frac{3}{4} \times 10\frac{3}{8}$ inches (37·5 × 26·7 cm), by WILLIAM BROCKEDON, 1847. PLATE 693

Dated (lower right): 28.5 47

Collections: See *Collections:* 'Drawings of Prominent People, 1823–49' by W. Brockedon, p 554.

Accompanied in the Brockedon Album by a letter from the sitter dated 16 October.

ICONOGRAPHY A painting by W. Holman Hunt of 1881 is in the British Museum of Natural History (plate 694), exhibited *Summer Exhibition*, Grosvenor Gallery, 1881 (44), reproduced W. H. Hunt, *Pre-Raphaelitism and the Pre-Raphaelite Brotherhood* (1905), II, facing 96; a painting by W. H. Gilbert (as an old man) is in the Lancaster Museum and Art Gallery (Storey Institute); a painting by H. J. Thaddeus (as an old man) is in the Town Hall, Lancaster; two paintings by unknown artists (one as a young man) are in the Lancaster Museum and Art Gallery; a painting by an unknown artist is in a private collection, exhibited *Cumbrian Characters*, Abbot Hall Art Gallery, Kendal, 1968 (65); paintings by J. G. Middleton and G. T. Doo were exhibited *RA*, 1838 (69), and 1855 (399); a pastel by C. Hopley is in the Royal College of Surgeons, exhibited *RA*, 1869 (902), and so is a water-colour of 1848 attributed to W. Etty (see entry for NPG 938 above), reproduced W. Le Fanu, *A Catalogue of the Portraits in the Royal College of Surgeons of England* (1960), plate 44; a water-colour by E. Griset of *c* 1873 is in the Victoria and Albert Museum; a drawing by R. Lehmann of 1890 is in the British Museum, reproduced R. Lehmann, *Men and Women of the Century* (1896), no. 57; a drawing by L. Sambourne (with Professor Huxley) was exhibited *Victorian Era Exhibition*, 1897, 'Historical Section' (316); a caricature by F. Waddy was published in his *Cartoon Portraits and Biographical Sketches of the Men of the Day* (1873), p 36; a lithograph by T. H. Maguire of 1850 was published G. Ransome, 1852 (example in NPG), for 'Ipswich Museum Portraits'; a woodcut 'The Meeting of the British Association' was published *ILN*, IX (1846), 184; a marble bust by E. H. Baily, formerly in the Royal College of Surgeons, was destroyed in 1941, exhibited *RA*, 1846 (1516), reproduced Sir A. Keith, *Illustrated Guide to the Museum of the Royal College of Surgeons* (1910), p 69; a plaster bust by W. H. Thornycroft of 1880 is in the Royal College of Surgeons, reproduced *Annals of the Royal College of Surgeons of England*, I (1947), 112, presumably related to the marble bust exhibited *RA*, 1881 (1487); a bronze bust by A. Gilbert of 1895 is also in the Royal College of Surgeons, exhibited *RA*, 1896 (1885), reproduced W. Le Fanu, plate 33, and another cast is in the British Museum of Natural History; a marble bust by C. Summers was exhibited *RA*, 1871 (1186), and a bust by M. Wagmuller, *RA*, 1872 (1545); a bronze statue by Sir T. Brock is in the British Museum of Natural History, model exhibited *RA*, 1895 (1622), reproduced Cassell's *Royal Academy Pictures* (1895), p 129; a stone bust by an unknown artist (inscription indecipherable) is in the Lancaster Museum and Art Gallery (Storey Institute); there is an engraving by H. T. J. Thaddeus of 1889 (unrelated to the painting by Thaddeus listed above) (example in NPG); a cutting, from an unidentified magazine, referring to this engraving, and reproducing a sketch of 1891 by Thaddeus of Owen signing the proofs, is in the Wellcome Historical Museum, London; there is an engraving by C. H. Jeens, after a photograph, and one by D. J. Pound, after a photograph by J. Watkins (examples in NPG); there are several photographs of Owen in the NPG (see plate 692), and others are reproduced *ILN*, LX (1872), 117, as a woodcut, *Das Neunzehnte Jahrhundert in Bildnissen* (Berlin, 1901), V, 554, and Rev R. Owen, I, facing 319, II, frontispiece, and facing 232.

PAGET *Sir Arthur* (*1771–1840*)

Diplomat.

4026 (43) See *Collections:* 'Drawings of Men About Town, 1832–48' by Count A. D'Orsay, p 557.

PAGET *Frederick (1807–66)*

MP for Beaumaris.

54 See *Groups:* 'The House of Commons, 1833' by Sir G. Hayter, p526.

PAKINGTON *Sir John Somerset, 1st Baron Hampton.* See HAMPTON

PALGRAVE *Sir Francis (1788–1861)*

Historian; articled clerk, 1803–22; changed his name from Cohen on becoming Christian, 1823; barrister, 1827; wrote for the 'Review', 1814-21, and after, on literary, aesthetic and antiquarian subjects; edited for Record Commission; knighted, 1832; deputy-keeper of HM records, 1838-61; specialized in mediaeval history and greatly stimulated its critical study.

2069 Plaster cast, painted white, $10\frac{7}{8}$ inches (27·6 cm) diameter, of a medallion by THOMAS WOOLNER, 1861. PLATE 695

Incised below the shoulders: T. WOOLNER SC. *and below this on the rim:* SIR FRANCIS PALGRAVE./1861

Collections: The sitter, presented by his granddaughters, the Misses Palgrave, 1924.

Literature: Amy Woolner, *Thomas Woolner: his Life in Letters* (1917), p338.

Either this or another cast was exhibited *RA*, 1861 (996).

ICONOGRAPHY A drawing by G. Richmond of 1844 is listed in Richmond's 'Account Book' (photostat copy, NPG archives), p36, exhibited *SKM*, 1868 (503), and *VE*, 1892 (373), lent by R. H. Inglis Palgrave; there is an etching by Mrs D. Turner, after a drawing by T. Phillips of 1823 (example in NPG), published *Palgrave Family Memorials*, edited C. J. Palmer and S. Tucker (Norwich, 1878), facing p108.

PALMER *Robert (1793–1872)*

MP for Berkshire.

54 See *Groups:* 'The House of Commons, 1833' by Sir G. Hayter, p526.

PALMER *Samuel (1805–81)*

Painter and etcher; exhibited at RA and elsewhere from 1819; profoundly influenced by Blake; studied with John Linnell, later his father-in-law; endowed his early landscapes with a visionary quality that was only fully appreciated later.

2154 Pencil, and pen and ink, heightened with Chinese white, on brown paper, $9\frac{3}{8} \times 8$ inches (23·7 × 20·3 cm), by GEORGE RICHMOND, *c* 1829. PLATE 698 & see opposite

Inscribed in pencil (lower right): Samuel Palmer/by/George Richmond RA

Inscribed in ink on the paper covering the back-board: Samuel Palmer RWCS/by George Richmond/RA/ belonging to F & E Redgrave/27 Hyde Park Gate SW7

Collections: The Misses F. M. and E. Redgrave, presented by them, 1927.

Exhibitions: Palmer Exhibition, Victoria and Albert Museum, 1926 (5); *Samuel Palmer*, Graves Art Gallery, Sheffield, 1961 (2).

The position of the head in this drawing is very close to that in the miniature of Palmer by Richmond (see NPG 2223 below), and may possibly have been a study for it; the hair, however, is different. Another drawing of 1830, showing Palmer with long hair and glasses, looking down, is in the collection of Mrs Miriam Hartley, and was exhibited *Samuel Palmer and his Circle*, Arts Council, 1957 (133), reproduced

DETAILS

Top: Samuel Palmer NPG 2223 *Bottom left to right*: Thomas Peacock NPG 1432, William Mulready NPG 4450,
Richard Redgrave NPG 2464

catalogue, plate 1; this is also said to be a study for the NPG miniature, although later in date. Other drawings of Palmer by Richmond are as follows:

1 *1825*. (Caricature). Victoria and Albert Museum. *Palmer Exhibition*, Victoria and Albert Museum, 1926 (4).

2 *1828*. (Assuming a character). Ex-collection of Kerrison Preston. *Palmer Exhibition*, 1926 (6); *Palmer Exhibition*, Arts Council, 1957 (126); *Exhibition of English Drawings and Water-colours*, Colnaghi, 1966 (17), reproduced catalogue, plate IX.

3 *1830*. Collection of Mrs F.L.Griggs. *Samuel Palmer Exhibition*, Graves Art Gallery, Sheffield, 1961 (3).

4 *Undated*. Victoria and Albert Museum. *Palmer Exhibition*, 1926 (3).

5 *Undated*. *Palmer Exhibition:* 1926 (7), lent by A.H.Palmer; possibly by J.Linnell.

6 *Undated*. Victoria and Albert Museum. Formerly in the collection of Sir Frank Short.

2155 Pencil on brown-toned paper, $6\frac{1}{2} \times 4\frac{7}{8}$ inches (16·6 × 12·5 cm), by CHARLES WEST COPE. PLATE 700

Inscribed in pencil (bottom left): S. Palmer R W S *and (bottom right):* by C.W.Cope RA

Collections: The Misses F.M.and E.Redgrave, presented by them, 1927.

Exhibitions: Palmer Exhibition, Victoria and Albert Museum, 1926 (10).

The donors were almost certainly descendants of either Richard or Samuel Redgrave, both of whom were friendly with Palmer. Cope executed other drawings of artists, also in the NPG (see NPG 3182, 'Drawings of Artists, *c*1862' p565).

2223 Miniature, water-colour and body-colour on ivory, $3\frac{1}{4} \times 2\frac{3}{4}$ inches (8·3 × 7 cm), by GEORGE RICHMOND, 1829. PLATE 697

Inscribed in ink on the card on which the miniature is mounted, apparently in the artist's hand: Sam[l]. Palmer Esq. (Painter)/Painted by Geo Richmond in Half Moon St in Nov[r]/1829/Exhibited at R[L] Ac[y]. 1830

Incised on the copper back of the frame, apparently in the artist's hand: Sam[L] Palmer E/1829/Painted by/ exhibited 1830/Geo Richmond/in 1829/TKR GR/1874

Collections: The artist; by descent to his grandson, Dr R.T.Richmond, and purchased from him, 1928.

Exhibitions: RA, 1830 (668); *Special Exhibition of Portrait Miniatures*, South Kensington Museum, 1865 (2408); *Samuel Palmer*, Graves Art Gallery, Sheffield, 1961 (1).

Literature: G.Grigson, *Samuel Palmer – The Visionary Years* (1947), pp98, 149 and 205, reproduced plate 4.

Palmer's expression and long hair recall Durer's self-portrait as Christ, possibly intentionally. Other drawings of Palmer by Richmond, some of them possibly studies for this miniature, are discussed above (NPG 2154).

Description: Fresh complexion, brown eyes, hair and beard. Dressed in a white shirt, yellow under-garment and red over-garment with grey fur collar. Green landscape and blue sky behind; orange-tipped foliage bottom left and top right. The colours are very clear and bright.

ICONOGRAPHY A self-portrait drawing of 1824–8 is in the Ashmolean Museum, Oxford (plate 696), possibly the drawing by Palmer exhibited *RA*, 1824 (706), with the title 'Study of a Head'; the Ashmolean portrait was exhibited *British Portraits*, RA, 1956–7 (705), reproduced G.Grigson, *Samuel Palmer – The Visionary Years* (1947), plate 24; another self-portrait drawing of 1828 is in the collection of Anthony Richmond, exhibited *Samuel Palmer and his Circle*, Arts Council, 1957 (125); a drawing of 1868 by A.H.Palmer is reproduced A.H.Palmer, *The Life and Letters of Samuel Palmer* (1892), frontispiece; a drawing of 1819 by H.Walter

was in the *Palmer Exhibition*, Victoria and Albert Museum, 1926 (2), possibly the drawing in the Cotswold Gallery, 1936; another later drawing by the same artist is in the British Museum; a drawing by J. Linnell is in the collection of the Misses Joan and Barbara Ivimy, exhibited Arts Council, 1957 (115); this is a study for Linnell's painting of 'The Road to Emmaus' of 1834-5 in the collection of Mrs R. Lambe, on loan to the Ashmolean Museum, Oxford, which also has a sketch for the painting; a caricature of Palmer and Calvert by Linnell was in the *Palmer Exhibition*, 1926 (8), lent by A. H. Palmer; a painting called Palmer by Linnell was reproduced *Magazine of Art* (1892), p 133; a drawing of 1856 by Sir W. B. Richmond was in the *Palmer Exhibition*, 1926 (9), lent by A. H. Palmer; in a letter of 5 February 1881 to W. Abercrombie (collection of Sir Geoffrey Keynes, photo-copy NPG archives), Palmer stated that he had sat to two photographers, Cundall, and Fradelle & Marshall; there is an example of the former in the NPG, and a woodcut after it (plate 699).

PALMERSTON *Henry John Temple, 3rd Viscount* (1784-1865)

Statesman; MP from 1807; supported parliamentary reform; secretary-at-war, 1809-28; foreign secretary, 1830-41, and 1846-51; home secretary, 1853-5; prime minister, 1855-8, 1859-65; his vigorous policy of intervention made him one of the most powerful figures in European politics.

1025 Oil on canvas, 37 × 29 inches (94 × 73.7 cm), by JOHN PARTRIDGE, 1844-5. PLATES 704, 706

Collections: The artist; purchased from his executors by W. Cowper Temple[1]; Evelyn Ashley, presented by him, 1896.

Exhibitions: 'Pictures in Mr Partridge's Gallery, 1851' (copy of catalogue, NPG archives); *VE*, 1892 (41).
Literature: Listed in two Partridge MS notebooks (NPG archives); R. L. Ormond, 'John Partridge and the Fine Arts Commissioners', *Burlington Magazine*, CIX (1967), 402, reproduced 400.

Like Partridge's portraits of Aberdeen (NPG 750), Macaulay (NPG 1564), and Melbourne (NPG 941), this portrait is closely related to the figure of Palmerston in Partridge's group, 'The Fine Arts Commissioners, 1846' (see NPG 342 below), and was presumably painted as a finished study for it. Palmerston is wearing the ribbon of the Bath. Partridge painted most of the Commissioners individually between 1844 and 1849, and retained these portraits. After his refusal in 1846 to exhibit any further pictures at the Royal Academy, he exhibited many of these portraits at his own gallery. At his death in 1872, his executors attempted to sell them to the original sitters or their descendants, and auctioned the remainder at Christie's, 15 June 1874. W. Cowper Temple, later Lord Mount Temple, was the second son of Palmerston's wife by her first marriage to Earl Cowper. He died without heirs in 1888.

In the past, the date 1846 has been given to all Partridge's portraits of the Commissioners, and to the finished group, presumably because this was the date of the meeting depicted. It is clear, however, from contemporary evidence that the big picture was still in progress in 1853. Palmerston was one of the first to be painted; a letter from Lady Palmerston (NPG archives), dated Tuesday, 26 March (if the day and date are correct, the year must be 1844), informs Partridge that her husband will sit on the following day. In Partridge's two notebooks, listing pictures in his possession in 1863 and 1870, the NPG portrait is dated 1845. A copy by A. Dyer is at Hertford County Hall. Another oil study of Palmerston for 'The Fine Arts Commissioners' was also owned by Partridge, described in his two MS notebooks as a large half-length, and dated 1846.

Partridge painted another portrait of Palmerston in 1849, listed in his 'Sitters Book' (NPG archives), under 1849. This was a full-length painting, commissioned by members of the House of Commons, and presented by them to Lady Palmerston after the debate on the Greek Question, 25 June 1850. It passed by descent from Evelyn Ashley to Lady Mountbatten, and is now on loan to the Department of the Environment from Earl Mountbatten. Sometime after 1868 Partridge repainted the head of

[1] Letter from W. Cowper Temple of 17 November 1873, asking his solicitor the address of the solicitors dealing with Partridge's estate, so that he can settle the bill for this portrait (NPG archives).

Palmerston on a new piece of canvas, which was then inserted into the original canvas. The painting was exhibited *S K M*, 1868 (456), and engraved by S. Cousins (example in NPG), engraving reproduced P. Guedalla, *Palmerston* (1926), facing p 306. A letter from Palmerston to Partridge of 7 February 1850 (NPG archives) informs him how to get to the Visitors Gallery of the House of Commons.

Description: Dark complexion, green-blue eyes, brown hair. Dressed in a green stock, white shirt, red sash of the Bath, black coat. Seated in a library chair with green leather (?) covering. Behind at left a dark red curtain, behind at right brown panelling.

751 Water-colour on paper, $10\frac{1}{4} \times 8\frac{1}{2}$ inches (26×21.6 cm), by THOMAS HEAPHY, 1802. PLATE 703

Signed and dated (bottom right): T. Heaphy/1802

Inscribed on the back of the original frame: drawn by T. Heaphy/Portrait painter to the Princess of Wales/July, 1802/Presented to Lord Pelham by/Lord Palmerston July 10, 1802

Collections: Thomas Pelham, 2nd Earl of Chichester; presented by his grandson, the 4th Earl of Chichester, 1886.

Exhibitions: Works of Art and Industry, Brighton, 1867, 'Water-colours and Drawings' (33).

Lord Pelham was Palmerston's guardian. Other water-colours by Heaphy are as follows:

1 Collection of Mrs Baumer. Similar to the NPG type.

2 With his younger brother, William. Exhibited *R A*, 1803 (616).

3 Signed and dated 1804. Collection of Lord Faringdon.

4 Signed. Collection of Mrs Baumer. Similar to no. 3.

5 Signed and dated 1806. Collection of Earl Mountbatten. Reproduced P. Guedalla, *Palmerston* (1926), facing p 52.

Description: Healthy complexion, pale eyes, light brown hair. Dressed in a white stock, white shirt, brown coat with black velvet collar, and grey breeches. Landscape painted in grey washes.

1206 Plaster cast, painted black, 30 inches (76.2 cm) high, of a bust by GEORGE GAMMON ADAMS, *c* 1867. PLATE 710

Collections: The artist, purchased from his widow, 1899.

Presumably related to the bust of Palmerston by Adams exhibited *R A*, 1867 (1134). Palmerston is wearing the star of the Order of the Garter.

2226 Wax relief, $7\frac{1}{4} \times 5\frac{1}{4}$ inches (18.4×13.3 cm), by RICHARD COCKLE LUCAS, 1856. PLATE 708

Incised (left hand side): Palmerston 1856

Collections: W. Boswell & Son, purchased from them, 1928.

Another version of this wax is in the collection of Lord Faringdon, and a third was offered to the NPG in 1943. Lucas modelled an earlier series of wax reliefs of Palmerston in 1851, the type exhibited *R A*, 1851 (1386); examples of this are in the Victoria and Albert Museum (Gunnis Bequest), Brooks's Club, London, and the Pyke Collection, the latter reproduced *Country Life*, CXXXI (1962), 659.

4508 Wedgwood parian-ware bust, $17\frac{1}{2}$ inches (44.5 cm) high, from a model by EDWARD WILLIAM WYON, *c* 1865. PLATE 709

Incised on the back, below the shoulders: Rt HON VISCOUNT PALMERSTON K.G./E.W. WYON Sc.

Collections: Purchased from Mrs Margaret Harwood, 1967.

One of a fairly large edition of commemorative parian-ware busts. According to W. A. Billington of the Wedgwood Museum (letter of 14 February 1967, NPG archives), Wyon's model was certainly finished by the early part of 1866.

54	See *Groups:* 'The House of Commons, 1833' by Sir G. Hayter, p 526.
342,3	See *Groups:* 'The Fine Arts Commissioners, 1846' by J. Partridge, p 545.
1125	See *Groups:* 'The Coalition Ministry, 1854' by Sir J. Gilbert, p 550.

ICONOGRAPHY This does not include photographs (various examples in the NPG), or political caricatures (for caricatures by J. Doyle, see L. Binyon, *Catalogue of Drawings in the British Museum* (1900), II).

1788 Miniature by L. Read. Collection of Mrs Baumer.

1794 Painting by an unknown artist (with his sister, painted at Munich). Collection of Earl Mountbatten, Broadlands. Reproduced P. Guedalla, *Palmerston* (1926), facing p 36.

1802–6 Water-colours by T. Heaphy (see NPG 751 above).

1806 Drawing by H. Edridge. Collection of Mrs Baumer.

c 1820 Painting by Sir T. Lawrence (unfinished). Earl Mountbatten, Broadlands (plate 701). Reproduced Guedalla, facing p 102.

1829 Painting by J. Lucas. Exhibited *RA*, 1829 (60). Engraved by H. Cook, published Fisher, 1833 (example in NPG), for Jerdan's 'National Portrait Gallery'.

1830 Marble bust and plaster cast by R. C. Lucas. Earl Mountbatten, Broadlands.

1833 'The House of Commons, 1833' by Sir G. Hayter (NPG 54 above). Study of Palmerston: Earl Mountbatten, Broadlands, reproduced Guadella, facing p 178.

c 1835 Miniature by R. Stothard. Exhibited *RA*, 1835 (765).

1837 'Queen Victoria's First Council' by Sir D. Wilkie. Royal Collection, Windsor. Exhibited *RA*, 1838 (60). Engraved by C. Fox, published F. G. Moon, 1839 (example in British Museum).

1838 Miniature by Sir W. C. Ross. Earl Mountbatten, Broadlands (plate 702). Exhibited *RA*, 1838 (864); lithographed by J. S. Templeton, published T. McLean, 1840 (example in NPG). Another version of this was offered to the NPG, 1955. Copy by the Duke of Casarano: Ilchester Collection.

1841 Lithograph by J. Doyle (on horseback), published T. McLean, 1841 (example in NPG, plate 705). Reproduced Guedalla, facing p 236.

c 1841 'The Homage', miniature by Sir W. J. Newton. Exhibited *RA*, 1841 (839).

1844 Marble bust by T. Sharp. Earl Mountbatten, Broadlands. Exhibited *RA*, 1844 (1314).

1846 'The Fine Arts Commissioners, 1846' by J. Partridge (NPG 342 above). Study (NPG 1025 above).

1846 Bust by C. Moore. Crystal Palace Portrait Collection, 1854. Possibly the bust by Moore exhibited *RA*, 1848 (1436), and possibly that exhibited *Royal Hibernian Academy*, 1853.

1850 Painting by J. Partridge. Earl Mountbatten, on loan to the Department of the Environment. Exhibited *SKM*, 1868 (456).

1851 Marble bust by E. B. Stephens. Avenue Palmerston, Ciudad Rodrigo, presented by Lady Mountbatten. Presumably the bust exhibited *RA*, 1851 (1329).

1851 Wax relief by R. C. Lucas (see NPG 2226 above).

c 1851 Marble bust by R. C. Lucas. Exhibited *RA*, 1851 (1373).

1854 'The Coalition Ministry' by Sir J. Gilbert (NPG 1125 above).

1855 Engraving by F. Holl, after a drawing by G. Richmond of 1852, published Colnaghi, 1855 (example in NPG). The original drawing is possibly that in the collection of Mrs Baumer.

c1855 Painting by F. Cruikshank (speaking in the House of Commons). Earl Mountbatten, Broadlands, on loan to the Department of the Environment. Engraved G. Zobel, published Brooker, 1861 (example in British Museum). Oil study: Earl Mountbatten, on loan to the NPG (3953) (plate 707); copy of this study Rosebery Sale, Christie's, 5 May 1939 (lot 35).

1856 Wax relief by R. C. Lucas (NPG 2226 above).

1858 'The Marriage of the Princess Royal' by J. Phillip. Royal Collection.

c1859 Marble statuette by R. C. Lucas. Exhibited *RA*, 1859 (1240).

1860 'The House of Commons in 1860' by J. Phillip. Houses of Parliament.
Exhibited *VE*, 1892 (142). Engraved by T. O. Barlow, published Agnew, 1866 (example in NPG).

1860 'Bright Reform Bomb, 1860' by G. Cruikshank. Houses of Parliament.
Etched key, published W. Tweedie, 1861 (example in Houses of Parliament).

1860 Marble bust by M. Noble. Reform Club, London.
Probably the bust exhibited *RA*, 1861 (1024). Other versions: House of Commons, and Trinity House, London. A plaster model by Noble, apparently related to this type, was at Elswick Hall, Newcastle, listed in *Catalogue of Lough and Noble Models at Elswick Hall* (*c*1928), p54 (179).

c1861 Bust by J. E. Jones. Exhibited *RA*, 1861 (1094).

1862 Painting by Sir F. Grant. Foreign Office, London.
Reproduced W. B. Pemberton, *Lord Palmerston* (1954), facing p228. Engraved by F. Holland and G. Zobel, published H. Graves & Co, 1865 (example in NPG).

1863 Painting by E. B. Morris (as Lord Warden of the Cinque Ports). Town Hall, Dover.
Exhibited *RA*, 1863 (612). Possibly related to the engraving by F. Bacon, after a portrait by Morris, published Morris, 1864 (example in British Museum). Head and shoulders version (oval): Earl Mountbatten, Broadlands.

c1863 Painting by W. T. Roden. Town Hall, Tiverton. Exhibited *RA*, 1863 (330).

1863 'Marriage of the Prince of Wales' by W. P. Frith. Royal Collection, Windsor.
Exhibited *RA*, 1865 (52). Engraved by W. H. Simmons, published H. Graves, 1870 (example in NPG).

c1864 Marble bust by E. G. Papworth junior. Exhibited *RA*, 1864 (913).

1865 Painting by H. Barraud (on horseback, in front of the House of Commons). Earl Mountbatten, Broadlands. Reproduced Guedalla, facing p452.

1865 Caricature bronze statuette by Depinez (with Napoleon III). Foreign Office, on loan from Earl Mountbatten.

1865 Death-mask by R. Jackson. Example formerly in Hutton collection.
Reproduced L. Hutton, *Portraits in Plaster* (1894), p175.

1865 Statue (in garter robes) by R. Jackson (based on a death-mask). Westminster Abbey.
Reproduced as a woodcut *ILN*, LVII (1870), 76.

1865 Painting by M. Claxton (after a photograph). Offered to NPG, 1870.

1865 Lithograph by J. A. Vinter, after G. H. Thomas, published Day & Son, 1865 (example in NPG).

1866 Painting by J. Lucas (as Master of Trinity House). Trinity House, London.
Three studies of Lord Palmerston were sold at the Lucas Sale, Christie's, 25 February 1875. One of these was a half-length copy of the 1829 portrait (probably lot 15), and another was a bust-size oval copy of the same (lot 19). They were finished in 1868 (see A. Lucas, *John Lucas* (1910), p110). The last study (probably lot 30) relates to the 1866 portrait, and is now at Broadlands. The Trinity House portrait has in the past been attributed erroneously to H. W. Pickersgill.

1867 Bust by J. Edwards. Tiverton Town Hall.

1867 Bronze statue by M. Noble. Romsey, Hants.
Reproduced as a woodcut *ILN*, LIII (1868), 81.

c1867 Bust by G. G. Adams. Exhibited *RA*, 1867 (1134).

c1867 Bust by J. Durham. Guildhall Museum, London (destroyed 1940).
Exhibited *RA*, 1867 (1058).

c1867 Bronze statuette by N. Roskell. Exhibited *RA*, 1867 (1116).

c1867 Model for a recumbent statue by T. Sharp. Exhibited *RA*, 1867 (1090).

1868 Marble statue by T. Sharp. Palmerston Park, Southampton.
Exhibited *RA*, 1868 (1002).

1870 Bust by R. Jackson. Harrow School.

c1872 Marble bust by E. B. Stephens. Exhibited *RA*, 1872 (1537).

c1874 Painting by Sir F. Grant. Exhibited *RA*, 1874 (115).

1876 Bronze statue by T. Woolner. Parliament Square, London.

Undated Painting by H. W. Pickersgill. Offered to NPG, 1937.

Undated Painting by L. C. Dickinson (after a photograph). Reform Club, London.

Undated Painting by an unknown artist. St John's College, Cambridge.

Undated Painting by an unknown artist (with members of his cabinet). Christie's, 6 March 1970 (lot 140), bought Steel.

Undated Painting called Palmerston attributed to F. X. Winterhalter. Collection of G. F. C. Hauswald, 1948.

Undated Painting called Palmerston attributed to J. Linnell. Collection of E. Dexter, *c* 1900.

Undated Drawing by W. Walker. NPG, reference collection.

Undated Drawing by G. Koberwein. Collection of Mrs Baumer.

Undated Drawing called Palmerston attributed to G. Richmond. Collection of Lord Faringdon.

Undated Miniature by W. Essex (based on a photograph of Palmerston in old age). Christie's, 15 October 1963 (lot 81), bought Singer.

Undated Statue (in garter robes) by an unknown artist. Earl Mountbatten, Broadlands.
Possibly related to the statue by R. Jackson of 1865 (see above).

Undated Bois durci medallion. Reproduced *Connoisseur*, CIV (1939), 190.

Undated Anonymous lithograph (example in NPG).

PANIZZI *Sir Anthony* (*1797–1879*)

Keeper of printed books, British Museum; left Italy, 1822; professor of Italian, University College, 1828; edited Boiardo and Ariosto; assistant librarian, British Museum, 1831; keeper, 1837–66; conceived idea of reading-room and full catalogues; secured important accessions; active on behalf of Italian patriots.

1010 Oil on canvas, $29\frac{3}{4} \times 29\frac{5}{8}$ inches (75·5 × 75·3 cm), by GEORGE FREDERICK WATTS, *c* 1847. PLATE 711

Collections: The artist, presented by him, 1895 (see appendix on portraits by G. F. Watts in forthcoming Catalogue of Portraits, 1860–90).

Exhibitions: Winter Exhibition, Grosvenor Gallery, 1882, 'Collection of the Work of G. F. Watts' (16); *Art Exhibition*, City Museum and Art Gallery, Birmingham, 1885–6 (117); *Collection of Pictures by G. F. Watts*, Museum and Art Gallery, Nottingham, 1886 (48); *VE*, 1892 (233); *George Frederick Watts*, Arts Council touring exhibition, 1955 (5), reproduced in catalogue, plate VIb.

Literature: [Mrs] M. S. Watts, *George Frederic Watts* (1912), I, 66, 100–1; J. E. Phythian, *George*

Frederick Watts (New York, 1906), p169; C.T.Bateman, *G.F.Watts, RA* (1901), p48; R.Muther, *Geschichte der Englischen Malerei* (1903), p268, reproduced p269; Earl of Ilchester, *Chronicles of Holland House* (1937), pp373–4; E.R.Dibdin, *George Frederick Watts* (1923), pp32 and 34; 'Catalogue of Works by G.F.Watts', compiled by Mrs M.S.Watts (MS, Watts Gallery, Compton), II, 122.

This is an unfinished version of the portrait in the Ilchester Collection, exhibited *Watts Exhibition*, Arts Council (London only), 1955 (12). The latter was apparently executed at the British Museum between 16 October and 7 November 1847, and shows Panizzi in a characteristic attitude, transcribing notes from an early printed book. In an undated letter, Panizzi wrote to Haywood:

I dined at Holland House on Saturday last, and Watts (the painter) came after dinner. There is at Holland House a famous portrait of Baretti by Sir Joshua Reynolds. Lord and Lady Holland and some of the guests having prepared all this without my knowledge beforehand, surrounded me after dinner, made me look at Baretti's portrait, and then said there should be a pendant to it, and that my portrait, taken by Watts, should be the thing. It was no use saying more than I did – which was not a little to decline the honour. The thing was a foregone conclusion; and so, before Watts goes to Italy, which he is going to do almost immediately, he is going to paint me.[1]

Another quite different portrait of Panizzi was presented to the sitter by the officers of the British Museum on his retirement in July 1866, and subsequently returned by him to the Museum; it was exhibited *RA*, 1868 (685), engraved by J.Outrim, published J.Noseda (example in British Museum); Outrim's engraving was exhibited *RA*, 1874 (1276).

Description: Healthy complexion, brown eyes, brown hair with grey streaks. Dressed in a white shirt, black neck-tie, dark green waistcoat, and dark reddish-brown coat. Seated at a table covered in a dark green cloth. The book Panizzi is reading is white, and it rests on another reddish-brown, leather-bound volume. The piece of paper on which he is writing, with a white quill pen, is white and it rests on a pinkish blotter. In the immediate foreground is a dark green sheet of paper, apparently an official British Museum form on which is printed, '[PRIV]ATE AND CONFIDENTIAL/ . . . PRINTED BOOKS/ . . . [BRIT]ISH MUSEUM.' At the top of this paper is part of a hand-written note, which appears to read: 'A Panizzi/British Museum/Complimentary'. In the background of the portrait are shelves with large books, reddish-brown in colour; on the left the grid pattern of a wire-fronted bookcase is vaguely indicated.

2736 Pencil, water-colour and gouache, on blue-toned paper, $11\frac{7}{8} \times 6\frac{7}{8}$ inches (30·1 × 17·4 cm), by APE (CARLO PELLEGRINI), 1874. PLATE 713

Signed (lower right): Ape *Inscribed on the mount:* Sir Anthony Panizzi, K.C.B./January 17, 1874.

Collections: Thomas Bowles; *Vanity Fair* Sale, Christie's, 7 March 1912 (lot 587); Messrs Maggs, purchased from them, 1934.

This is one of a large collection of original studies for *Vanity Fair*, which were all owned and specially mounted by the first proprietor of the magazine, Thomas Bowles. Those in the NPG will be discussed collectively in the forthcoming Catalogue of Portraits, 1860–90. The water-colour of Panizzi was published as a coloured lithograph on 17 January 1874, as no.LXXVII of 'Men of the Day', with the title, 'Books'.

Description: Healthy complexion, grey hair and white beard. Dressed in a dark grey suit and waistcoat. Holding a reddish book on a table, with a walking stick. Colour of floor reddish-brown, and of background blue.

[1] L.Fagan, *The Life of Sir Anthony Panizzi* (1880), I, 324; Fagan dates this letter 1850. The Earl of Ilchester, *Chronicles of Holland House* (1937), p374n (the Ilchester version is reproduced facing p374), on the evidence of the Holland House Dinner Books, dates the dinner to 16 October 1847.

The terminal date of 7 November 1847 is given in the Arts Council catalogue (London), p27. M.S.Watts, I, 100, provides the information that the portrait was painted in the British Museum.

2187 Wax medallion, white on brown wax, $6\frac{3}{4} \times 5\frac{1}{8}$ inches ($17\cdot2 \times 13$ cm) oval, by RICHARD COCKLE LUCAS, 1850. PLATE 712

Inscribed along bottom of rim: R C Lucas Sculpt/1850 *and along right-hand side of rim:* Antonio Panizzi Esq/British Museum –

Collections: Purchased at Sotheby's, 16 February 1928 (lot 12).

This was purchased with a wax medallion of Thomas Winter Jones by Lucas, which is now in the British Museum. Other versions of the Panizzi wax are in the British Museum, and the collection of Mrs Betty St John, 1949.

ICONOGRAPHY A marble bust is in the British Museum Reading Room; various photographs and woodcuts are in the NPG and British Museum; an etching by L. Fagan of *c* 1866, exhibited *RA*, 1878 (1202), is reproduced L. Fagan, *The Life of Sir Anthony Panizzi* (1880), I, frontispiece; a woodcut, apparently after a photograph, is reproduced Fagan, II, 309; another woodcut was published *ILN*, LXXIV (1879), 369; a photograph by E. Edwards is reproduced L. Reeve, *Men of Eminence*, II (1864), 17.

PANMURE *Fox Maule, 2nd Baron (11th Earl of Dalhousie)*. See DALHOUSIE

PAPWORTH *John, afterwards John Buonarotti* (*1775–1847*)

Architect, designer, and landscape-gardener; exhibited at RA, 1794–1841; designed St Bride's Avenue and other important works; founder-member of Associated Artists in Water-Colour, and of Institute of British Architects; published numerous volumes on all aspects of his work.

2515 (53) Black chalk, with touches of Chinese white, on green-tinted paper, $14\frac{1}{8} \times 10\frac{3}{8}$ inches ($36 \times 26\cdot3$ cm), by WILLIAM BROCKEDON. PLATE 714

Collections: See *Collections:* 'Drawings of Prominent People, 1823–49' by W. Brockedon, p 554.

Accompanied in the Brockedon Album by a letter from the sitter, dated 6 August 1829.

ICONOGRAPHY The only other recorded portraits of Papworth are a bust by his brother, T. Papworth, exhibited *RA*, 1807 (1015), and an engraving by J. Green, after W. Say (example in British Museum).

PARKE *Sir James, 1st Baron Wensleydale*. See WENSLEYDALE

PARRY *Sir William Edward* (*1790–1855*)

Rear-admiral; commanded three Arctic expeditions in search of North-West passage; attempted to reach North Pole and attained latitude 82° 45'; hydrographer to the admiralty, 1825–9; knighted, 1829; rear-admiral, 1852; lieutenant-governor of Greenwich Hospital, 1853; published accounts of his expeditions.

912 Oil on millboard, $15\frac{1}{8} \times 12\frac{3}{4}$ inches ($38\cdot4 \times 32\cdot4$ cm), by STEPHEN PEARCE, 1850. PLATE 715

Inscribed in the artist's hand on a label on the back of the picture: Sir Wm. Edward Parry. Kt./L.L.D F.R.S. L & E./The original Study painted for the/Historical Picture of the Arctic Council,/by Stephen Pearce./1851.

Collections: See *Collections:* 'Arctic Explorers' by S. Pearce, p 562.

Literature: S. Pearce, *Memories of the Past* (1903), p 53.

This is a study for Pearce's group, 'The Arctic Council' (NPG 1208 below), as well as an autonomous portrait in its own right. It was apparently once dated 1850 on the back, which is probably the date

when Pearce began work on the group. In the group, Parry is shown three-quarter length pointing at a chart held by Sir George Back, but his costume, pose, and features are identical with this study. He is wearing the undress uniform either of a captain with over three years service or of a commodore (first or second class). The date, '1850', was also given by the artist in a memorandum of *c* 1899 (NPG archives); the date '1851' in the inscription presumably refers to the group.

Description: Healthy complexion, blue eyes, white hair. Dressed in a black stock, white shirt, white waistcoat with gold chain, dark blue naval uniform with gold-braided epaulettes. Red curtain at left. Rest of background greenish-brown.

1208 See *Groups:* 'The Arctic Council' by S. Pearce, p 548.

ICONOGRAPHY

c 1818 Painting by R. Field. Collection of J. W. Nutting, 1848.
See H. Piers, 'Artists in Nova Scotia', *Collections of the Nova Scotia Historical Society*, XVIII (1914), 116.

1819 Painting by Sir W. Beechey. National Maritime Museum, Greenwich.
Reproduced Ann Parry, *Parry of the Arctic* (1963), facing p 32.

1820 Painting by S. Drummond. Formerly Royal United Service Museum, London. Another version is in the collection of P. E. Parry. One of these exhibited *RA*, 1821 (174), and reproduced A. G. Garnier, *The Garniers of Hampshire* (1900), facing p 46. The type was engraved anonymously (example in British Museum), and engraved by J. Thomson (half-length only), published 1821 (example in NPG), for the *European Magazine*, and engraved by others (examples in NPG); an engraving by C. Heath, after W. H. Brooke, published Sherwood & Co, 1823 (example in NPG), is also apparently after the Drummond.

c 1820 Painting by J. Jackson. Sotheby's, 15 May 1929 (lot 126), ex-collection Lt-Col John Murray.
Exhibited *British Institution*, 1854 (162).

c 1820 Plaster bust attributed to L. Gahagan. Collection of Sir Sidney Parry, 1926.

1823 Lithograph by F. Pistrucci, published Noseda, 1823 (example in British Museum).

1823 Anonymous engraving, published G. Smeeton, 1823 (example in NPG), for *The Unique*.

1827 Painting by T. Phillips. Collection of J. H. Bingham.
Exhibited *RA*, 1827 (310). Listed in Phillips' 'Sitters Book' (copy of original MS, NPG archives), under the year 1827. Reproduced Ann Parry, *Parry of the Arctic* (1963), facing p 64.

1827 Engraving by S. W. Reynolds, after W. Haines, published Haines, 1827 (example in British Museum).

c 1827 Miniature by Sir W. J. Newton. Exhibited *RA*, 1827 (794).

1831 Anonymous engraving, published W. Wright, 1831 (example in NPG).

1838 Painting by C. Skottowe. National Maritime Museum, Greenwich.
Exhibited *RA*, 1838 (209). Reproduced W. L. Clowes, *Royal Navy* (1901), VI, 512. Engraved by S. Bellin, published Colnaghi, 1839 (example in British Museum).

1841 Drawing by G. Richmond. Listed in Richmond's 'Account Book' (photostat copy, NPG archives), p 28.
Reproduced Ann Parry, *Parry of the Arctic* (1963), facing p 176. Engraved by H. Adlard (where the original is erroneously dated to 1842), published Longman & Co (example in NPG).

1851 'The Arctic Council' by S. Pearce (NPG 1208 above).
Study (NPG 912 above).

Undated Painting by Hayter (presumably Sir G. Hayter). Collection of Mrs Honor Barnes.
Exhibited *SKM*, 1868 (422), and *Victorian Era Exhibition*, 1897, 'Historical Section' (41).

Undated Lithograph by H. Perry (example in British Museum). Anonymous engraving, published Jaques and Wright (example in NPG).

365

PATON *Mary Ann, Mrs Wood.* See WOOD

PAYNE *George* (1803–78)

Race-horse owner; inherited three large fortunes which were spent on racing and inveterate gambling; sheriff of Northamptonshire, 1826; master of hounds.

2957 With Admiral Rous (on the right). Oil on board, 14¾ × 11½ inches (37·5 × 29·3 cm), by G. THOMPSON. PLATE 716

Inscribed on a label, originally on the back of the portrait: Admiral Rous,/ – and – /George Paine [*sic*],/ Original Oil Painting from/Life. By: – G. Thompson./Nottingham.

Collections: Leggatt Brothers, purchased from them, 1938.

There are several water-colours of Rous and Payne, together and separate, by members of the Dighton family, which are strikingly similar to this painting: Victoria and Albert Museum; Jockey Club; collection of the Earl FitzWilliam; collection of Mrs Billson, 1938; Sotheby's, 14–15 November 1932 (lots 307 and 317); Bonham's, 10 April 1959 (lot 252); possibly *Victorian Era Exhibition*, 1897, 'Historical Section', 'sports sub-section' (147). It has been suggested that the NPG portrait is based on them, rather than vice-versa. The woodcut published *ILN*, v (1844), 72, also appears to be after Dighton.

Description: Payne; healthy complexion, brown hair and whiskers, dressed in a dark check cravat, white shirt, black suit, brown gloves, and black top-hat. Rous; healthy complexion, brown hair, grey whiskers, dressed in a blue-spotted cravat, white shirt, greenish-grey waistcoat, black coat, fawn trousers and black top-hat. Background colour light brownish-grey.

4732 Water-colour on blue-toned paper, 12⅛ × 7 inches (30·6 × 18 cm), by APE (CARLO PELLEGRINI), 1875. PLATE 717

Signed (lower right): Ape *Inscribed on the mount which is original:* Mr George Payne./September 18 1875.

Collections: Thomas Bowles; *Vanity Fair* Sale, Christie's, 7 March 1912 (lot 595); purchased at Christie's, 10 February 1970 (lot 5).

This is one of a large collection of original *Vanity Fair* cartoons which were owned and specially mounted by the first proprietor of the magazine, Thomas Bowles. Those in the NPG will be discussed as a group in the forthcoming Catalogue of Portraits, 1860–90. The water-colour of Payne was published as a coloured lithograph in *Vanity Fair* on 18 September 1875, with the title, 'GP'.

Description: Healthy complexion, dark brown hair and whiskers with grey streaks. Dressed in a blue and white cross-striped neck-tie, white shirt, black frock-coat, grey trousers, black shoes and top-hat, holding a pair of black binoculars.

ICONOGRAPHY A lithograph by T. C. Wilson, after a drawing, was published 1841 (example in British Museum), for Wildrake's *Cracks of the Day;* an engraving by T. Brown, after a photograph by Kilburn, was published *British Sports and Sportsmen*, edited 'The Sportsman' (1908), I, facing 63; there is an anonymous engraving, possibly after a painting (example in NPG); an unspecified portrait was exhibited *Victorian Era Exhibition*, 1897, 'Sporting Section' (160), lent by Messrs H. Graves.

PEACOCK *Thomas Love* (1785–1866)

Novelist, poet, and official of the East India Company; a close friend of Shelley; published satirical novels interspersed with lyrics, which enjoyed a wide vogue.

1432 Oil on millboard, $6\frac{1}{2} \times 5\frac{1}{2}$ inches ($16 \cdot 5 \times 14$ cm), by HENRY WALLIS, 1858. PLATE 718 & p 355

Dated (bottom right): 24.1.1858 *Inscribed on the back of the original backboard:* THOMAS LOVE PEACOCK/ HENRY WALLIS/1858 *Also on the back is the 1868 exhibition label.*

Collections: The artist, purchased from him, 1906.

Exhibitions: S K M, 1868 (623).

Literature: The Works of Thomas Love Peacock, edited H. F. B. Brett-Smith and C. E. Jones (Halliford edition, 1924–34), I, CLXXXIX – CXC.

The artist wrote about the portrait in two letters (17 March and 7 April 1906, NPG archives): '*The portrait was painted by me on the 24th of Jany: 1858, Mr Peacock being in his 73rd year. He told me that it was the first time he had sat for his portrait: he was never painted again . . . I had hoped to have painted a picture of T. L. Peacock that wd have been more than a study, however the opportunity never occurred.*' The sitter's granddaughter, Edith Nicolls, did not like this portrait, claiming that it gave him a high colour, which he never possessed as an old man, and an expression which none of his friends would have recognized; she particularly requested that no reproduction of it should appear in the Halliford edition of his works. Her dislike of the portrait probably reflected her dislike of the artist, who had run off with Peacock's daughter, Mary, while she was still married to George Meredith.

A comparison between the portrait, and a photograph of it taken in 1868 (example in NPG), shows that Wallis made some subsequent alterations to the sketch; he also cut it down in size (it was originally oval), and replaced the first inscribed date with that now visible. Richard Garnett, one of the NPG trustees at the time, first suggested that Wallis should be approached to see if he would sell the portrait.

Description: Bluish eyes, grey hair, rubicund complexion. Dressed in a white shirt, dark neck-tie, and brown coat. Background unfinished.

3994 Miniature, water-colour on ivory, $3 \times 2\frac{3}{8}$ inches ($7 \cdot 6 \times 6$ cm) oval, by ROGER JEAN, *c* 1805. PLATE 719

Signed (lower right): R Jean *There is an obliterated inscription on the back of the card backboard.*

Collections: The sitter (?); by descent to his granddaughter, Edith Nicolls (Mrs Clarke); Mrs K. Hall Thorpe (her daughter), till 1956; Miss E. B. Clarke (Mrs Thorpe's sister); Miss Mary Stickland, from whom it was purchased, 1956.

Literature: C. Van Doren, *The Life of Thomas Love Peacock* (1911), reproduced facing p 28; *The Works of Thomas Love Peacock,* edited H. F. B. Brett-Smith and C. E. Jones (Halliford edition, 1924–34), I, XXX, reproduced frontispiece; *NPG Annual Report 1956–7* (1958), p 8.

This was purchased at the same time as a miniature of Peacock's mother, Sarah (reproduced Halliford edition, IV, frontispiece), and another of a man in 18th century naval uniform, possibly representing Peacock's father, Samuel, or his grandfather, Thomas; all three miniatures are mounted together. Miss Stickland also owned a miniature of Peacock's daughter, Margaret (reproduced Halliford edition, X, frontispiece), who died as a child. Although the identification of the NPG miniature of Peacock is only based on tradition, there seems little reason to doubt it. The date is based on costume and the apparent age of the sitter.

Description: Greyish eyes, sandy hair. Dressed in a white stock, white shirt, and dark blue or black coat. Background colour greenish-grey.

ICONOGRAPHY The only other known likeness of Peacock is a photograph by Maull & Co of 1857 (example formerly owned by Edith Nicolls), reproduced *Works of Thomas Love Peacock,* edited H. Cole (1875), I, frontispiece, and Halliford edition, II, frontispiece.

PEARSALL *Robert Lucas de* (*1795–1856*)

Musical composer; spent the later part of his life on Lake Constance; chiefly known for his composition of madrigals.

1785 Oil on canvas, 20⅞ × 16¾ inches (53 × 42·5 cm) oval, by his daughter, MRS PHILIPPA SWINNERTON HUGHES, after her portrait of 1849. PLATE 720

Collections: The artist, presented, in accordance with her wishes, by W. B. Squire, 1917.

This picture was painted from the artist's recollection of her portrait of 1849 now in the Benedictine Abbey of Einsiedeln in Switzerland. According to Hubert Hunt (letter of 21 August 1927, NPG archives), an authority on Pearsall, Mrs Hughes brought out this portrait in 1916 (it had previously been hidden away), and put it up in her room: '*She told me that she had tried to reproduce from memory a portrait she had painted from life, but that she* could not catch the right expression'. In comparison with the original, the NPG portrait is weak and unconvincing.

Another painting of Pearsall of 1856 by his daughter, showing him bearded, and wearing the order of St John of Jerusalem, was exhibited *Victorian Era Exhibition*, 1897, 'Music and Drama Section', subdivision 'Music – Oil Paintings' (8). It was offered by the artist to the NPG in 1912, but declined. According to W. B. Squire (letter of 15 March 1917, NPG archives): '*The picture she had evidently repainted & quite spoiled*'. A drawing of Pearsall by Mrs Hughes, also showing him bearded, and possibly connected with this portrait, was in the collection of the Ladies Frances and Blanche Stanhope, 1937.

Description: Ruddy complexion, pale brown eyes, grey side-whiskers. Dressed in a white collar, dark stock, dark coat, and red skull-cap with a tassel. Very dark grey background.

ICONOGRAPHY According to Hubert Hunt (letter of 30 April 1937, NPG archives), the only other known portraits of Pearsall were, a water-colour by an unknown artist in the Bristol Art Gallery (showing him as a boy); a drawing by an unknown artist of c 1810, then in the collection of the Ladies Frances and Blanche Stanhope; and a photograph taken after death.

PEASE *Miss Elizabeth*

Slavery abolitionist.

599 See *Groups:* 'The Anti-Slavery Society Convention, 1840' by B. R. Haydon, p 538.

PEASE *Joseph* (*1772–1846*)

A founder of the Peace Society; pamphleteer for the Anti-Slavery Society.

599 See *Groups:* 'The Anti-Slavery Society Convention, 1840' by B. R. Haydon, p 538.

PEASE *Joseph* (*1799–1872*)

Nephew of Joseph Pease (see above); quaker, philanthropist; industrialist; MP for County Durham South.

54 See *Groups:* 'The House of Commons, 1833' by Sir G. Hayter, p 526.

PEEK *Richard*

Slavery abolitionist.

599 See *Groups:* 'The Anti-Slavery Society Convention, 1840' by B. R. Haydon, p 538.

PEEL *Sir Robert, Bart* (*1788–1850*)

Statesman; leader of the tory party; prime minister, 1834–5, 1839, and 1841–6; one of the most important and influential statesmen of his age.

772 Oil on panel, 17⅞ × 14⅞ inches (45·5 × 37·7 cm), by JOHN LINNELL, 1838. PLATE 725

Indistinctly signed and dated (middle right): [*J.LIN*?]NELL. F.1838.

Inscribed on a label, formerly on the back of the picture: No2/Portrait of/the Rᵗ. Honᵇˡ. Sir Robert Peel Bart. M.P./John Linnell/Bayswater. 1838

Collections: Commissioned by Thomas Norris[1]; Norris Sale, Christie's, 9 May 1873 (lot 30), bought Viscount Cardwell[2]; purchased at the Cardwell Sale, Christie's, 9 May 1887 (lot 201), through Agnew's.

Exhibitions: RA, 1838 (175).

Literature: A. T. Story, *Life of John Linnell* (1892), II, 251, where the date is given as 1837; G. Scharf, 'TSB' (NPG archives), XV, 8.

This portrait was engraved by the artist, published T. Boys, 1838 (example in NPG), and B. Moss, 1850 (example in British Museum). An almost identical water-colour version of the NPG portrait (head and shoulders only) was sold Christie's, 8 June 1962 (lot 11), bought Tillotson. An oil version of the NPG painting (the head and costume are almost identical, but the pose is slightly different), signed and dated 1840, is in the collection of the Hon Robert Peel, exhibited *Jubilee Exhibition*, Manchester, 1887 (767), sold Christie's, 10 April 1897 (lot 142), and 26 February 1937 (lot 119). A second version of the 1840 portrait is owned by Earl Peel.

There are two other separate portrait types of Peel by Linnell. One was in the Linnell Sale, Christie's, 15 March 1918 (lot 45) (sketch of it in NPG sale catalogue), which shows Peel looking out, with one hand on his breast, and the other resting on books. The other type was offered to the NPG by Messrs Radclyffe in 1869, but declined; there is a sketch and a full description of it by G. Scharf, 'TSB' (NPG archives), XV, 8 and 24, and it was engraved by J. Scott, published T. Boys, 1840 (example in NPG). Scharf went to interview the aged Linnell in connection with this last portrait. According to Linnell the painting was based on a drawing from the life, and was commissioned by a publisher (presumably Boys or Radclyffe). The drawing mentioned by Linnell may have been the one in the Linnell Sale, Christie's, 15 March 1918 (lot 81); this lot also included a drawing by Linnell after Lawrence's portrait of Peel (see NPG sale catalogue). In the interview with Scharf, Linnell also stated that Peel had expressly sat to him for the NPG portrait, which was then owned by Norris: '*He spoke of Sir Robert as a kind friend and a generous Patron of his, and so he seems invariably to have proved to all rising and deserving artists*'.[3]

A painting of Peel's cousin, Robert Peel, by Linnell was exhibited *RA*, 1839 (498), engraved by J. Linnell, published Welch and Gwynne, 1841 (example in NPG). Linnell also painted Peel's daughter in 1838.

Description: Healthy complexion, bluish eyes, auburn hair. Dressed in a black stock, white collar, white waistcoat with a silver watch-chain, black coat, and dark grey trousers. Seated in a gilded armchair with a red-covered back, holding a white document, leaning his elbow on a table with a reddish-brown cloth, and an open book (very sketchily indicated). There is a pillar on the upper right-hand side of the picture. Background colour various shades of brown and green.

795 With David Wilkie (centre), and Lord Egremont (right). Oil on canvas, 21⅝ × 19 inches (54·9 × 48·3 cm), by PIETER CHRISTOPH WONDER, *c* 1826. PLATE 722

[1] Norris was a partner of Peel's father; he himself was painted twice by Linnell in 1836 and 1837.

[2] Cardwell was one of Peel's executors.

[3] Copy of letter of 17 February 1869 from Scharf to Earl Stanhope (NPG archives); see also 'TSB', XV, 8.

Inscribed in pencil above Peel: Sir/Robert Peel *above Wilkie:* Sir/Mr/D Wilkie (Peintre) *and above Egremont:* Lord Egremont

Collections: Offered to the NPG by J.S.Coster of Utrecht, 1878; E.Joseph, presented by him, 1888.

This is one of four oil studies in the NPG for Wonder's large picture, 'Patrons and Lovers of Art', in the collection of Admiral Sir Victor Crutchley, exhibited *British Institution*, 1831 (345); the large group was commissioned by the noted connoisseur and patron, Sir John Murray, who was responsible for Wonder's stay in England from 1824 till 1831. The studies will be discussed collectively in the forthcoming Catalogue of Portraits, 1790–1830.

Description: Peel in white shirt, black frock-coat, trousers and shoes; Wilkie in white shirt, green frock-coat and trousers; Egremont, seated in a reddish-brown chair, in white stock, white shirt, white waistcoat, dark blue coat, fawn trousers, white gaiters, and dark brown shoes, holding dark brown hat, and lighter brown gloves. Unfinished background colour light yellow.

870 Identity doubtful. Oil on canvas, 20 × 15 inches (50·8 × 38·1 cm), by an UNKNOWN ARTIST. PLATE 723

Inscribed on a label, formerly on the back of the picture: Bought at Vokins for 25 £. by Romney/Formerly in the possession of Daniel Lyon.

Collections: Daniel Lyon (Lysons?); Vokins; Mathew James Higgins by 1856[1]; H.V.Higgins (his son), purchased from him, 1891.

The identity of this picture rests on a tenuous tradition going back to the mid-19th century. There are no other early portraits of Peel with which to compare it, and the early history of the picture remains obscure. The portrait attributed to Lawrence, exhibited *SKM*, 1868 (386), purporting to represent the young Peel, is of equally doubtful authenticity.

Description: Healthy complexion, bluish eyes, light brown hair. Dressed in a white shirt, and dark brown coat. Background colour dark brown.

3796 Oil on canvas, 94¼ × 57⅞ inches (240·7 × 147 cm), by HENRY WILLIAM PICKERSGILL. PLATE 724

A label on the back of stretcher identifies the portrait as the property of H.Graves of Pall Mall.

Collections: The artist; Pickersgill sale, Christie's, 17 July 1875 (lot 355), bought Graves; 2nd Earl Iveagh, presented by him, 1951.

Exhibitions: Royal Jubilee Exhibition, Manchester, 1887 (520).

Literature: MS catalogue of Lord Iveagh's collection (Kenwood), where the picture is said to have been purchased from Graves.

Another signed version of this portrait, showing Peel in a similar pose but in different clothes and with different accessories, is owned by the Department of the Environment (Home Office). The latter was engraved by G.R.Ward, published Hering and Remington, 1851 (example in British Museum). A copy is at Scotland Yard. Peel's son told Lord Iveagh that he considered the NPG portrait to be the best likeness of his father that he had ever seen (letter from Lord Iveagh, 8 December 1950, NPG archives).

Description: Healthy complexion, greyish eyes, sandy hair. Dressed in a white and gold striped neck-tie and stock, white shirt, white waistcoat with gold watch-chain, dark brown coat and grey trousers, black shoes, holding a white document. Standing beside a table with a deep red cloth fringed in gold, on which is a dark green dispatch box, with papers inside. The carpet is red, and there is a yellow satin curtain on the right. Rest of background dark brown.

316a (99) Profile and full-face views on the same sheet. Pencil on paper, 18⅞ × 27⅝ inches (48 × 70·2 cm), by SIR FRANCIS CHANTREY, *c* 1833. PLATE 726

[1] See *Dictionary of National Biography* for Lysons and M.J.Higgins; information about the Higgins provenance is given in a letter from Mary Higgins of 14 June 1891 (NPG archives).

Inscribed in pencil, under the full-face view: Sir Robert Peel Bart.

Collections: The artist, presented by the widow of one of his executors, Mrs George Jones, 1871.

These 'camera lucida' drawings are related to the marble bust of Peel by Chantrey of 1833, which was included in the Peel Sale, Robinson, Fisher and Harding, 6–7 December 1917 (lot 189), reproduced sale catalogue, facing p 18; this is probably the bust listed in Chantrey's 'Ledger' (MS, Royal Academy), p 230, as commissioned by Aberdeen in 1830, and delivered to Aberdeen in 1834 (price, 150 guineas). Another marble version of 1835 is in the Royal Collection, listed in the 'Ledger', p 264, as begun and finished in 1835. The NPG drawings are part of a collection of studies by Chantrey, which will be collectively discussed in the forthcoming Catalogue of Portraits, 1790–1830.

2378 Pencil on paper, $6\frac{3}{4} \times 4\frac{3}{8}$ inches ($17 \cdot 2 \times 11$ cm), by SYDNEY PRIOR HALL. PLATE 727

Inscribed in pencil (middle left), with a line from Peel's mouth: My son Sir. *Inscribed below:* From Cartoon in Punch/A Chip of the Old Block./which M^r. Gladstone thought though a/Caricature conveyed the best impression/of Peel.

Inscribed in ink on the reverse: This M^r. Gladstone considered to be/the best portrait of Peel. A cari-/cature in Punch (copy by S.P.H.).

Collections: Presented by the artist's son, Dr H. R. Hall, 1930.

Efforts to locate the original published cartoon in *Punch* have not been successful. This drawing is one of a number of drawings by Hall which will be collectively discussed in the forthcoming Catalogue of Portraits, 1860–90.

2772 With Lord Brougham and others. Pencil and water-colour on paper, $4\frac{5}{8} \times 6$ inches ($11 \cdot 9 \times 15 \cdot 1$ cm), by JEMIMA WEDDERBURN, 1844. PLATE 728

Dated (bottom right): March 9^th 1844. *Inscribed below the drawing in ink:* Sir Robert Peel shewing his pictures. Whitehall Gardens *Inscribed below this in pencil in another hand:* Lord Brougham Maria Clerk Sir George Clerk, Sir Robert Peel, Isabella Clerk J.B James Clerk

Collections: See *Collections:* 'The Clerk Family, Sir R. Peel, S. Rogers and others, 1833–57' by Miss J. Wedderburn, p 560.

This drawing forms part of an album, and appears on p 28 above a drawing showing a breakfast party at the house of Samuel Rogers. It is reproduced T. Lever, *The Life and Times of Sir Robert Peel* (1942), facing p 232.

Description: Men and women in black dresses and suits. Red carpet, red and white striped sofa, yellowish wall and gilt picture frames.

596 Marble bust, $30\frac{7}{8}$ inches ($78 \cdot 4$ cm) high, by MATTHEW NOBLE, 1851. PLATE 729

Incised on the back below the shoulders: PEEL. *Incised on the back of the base:* M. NOBLE. SC./LONDON./ 1851.

Collections: Noble Sale, Christie's, 7 June 1879 (lot 189), bought W. Boore, and purchased from him 1879.

Exhibitions: Art Treasures of the United Kingdom, Manchester, 1857, 'Sculpture' (129).

The head in this bust is similar to the life-size Noble bust of 1850 in the collection of Earl Peel, apparently bt. in at the Peel sale, Robinson, Fisher and Harding, 6–7 December 1917 (lot 192), exhibited *R A*, 1851 (1379). Another marble version is in the Houses of Parliament (dated 1851), and two identical cabinet versions are in the collection of Earl Peel (dated 1850), and the NPG (dated 1851, NPG 596a below). All four of the last-mentioned busts show Peel in conventional costume, whereas NPG 596 shows him with a bare neck, and loose drapery across his shoulders. Noble did several statues

of Peel (see iconography below), in which he made use of the same head as represented in the four marble busts; it seems unlikely that Noble ever received a sitting from the life. A plaster model possibly related to these busts was at Elswick Hall, Newcastle, listed in *Catalogue of Lough and Noble Models at Elswick Hall* (*c* 1928), p 66 (234).

596a Marble bust, 16¾ inches (42·5 cm) high, by MATTHEW NOBLE, 1851. PLATE 730
Incised on the back of the shoulders: Peel *and below:* M. Noble SC/London/1851
Collections: Unknown.

This bust was discovered in the NPG bust store with no indication of its source or origin. It is a reduced replica of Noble's bust of 1850 in the collection of Earl Peel (see NPG 596 above); another version of the same size as NPG 596a is also owned by Earl Peel (dated 1850). The tip of the nose in the NPG bust is damaged.

54 See *Groups:* 'The House of Commons, 1833' by Sir G. Hayter, p 526.
342,3 See *Groups:* 'The Fine Arts Commissioners, 1846' by J. Partridge, p 545.
2789 See *Groups:* 'Members of the House of Lords, *c* 1835' attributed to I. R. Cruikshank, p 536.

ICONOGRAPHY This does not include caricatures, or popular prints (examples in British Museum and NPG).

As a youth Paintings called Peel, by an unknown artist (NPG 870 above), and attributed to Sir T. Lawrence, exhibited *SKM*, 1868 (386). Two miniatures by unknown artists were exhibited *Portrait Miniatures*, South Kensington Museum, 1865 (2220 and 2814).

c 1820 Painting by an unknown artist. Collection of Earl Peel.

1826 Painting by Sir T. Lawrence. Collection of Earl Peel (plate 721).
Exhibited *RA*, 1826 (101), and *VE*, 1892 (20). Reproduced K. Garlick, *Sir Thomas Lawrence* (1954), plate 115. Engraved by C. Turner, published Colnaghi, 1828 (example in NPG); engraved by numerous other artists (examples in NPG and British Museum). There are several versions and copies of this painting.

c 1826 Painting by P. C. Wonder (see NPG 795 above).

1829 Anonymous etching, possibly after A. Buck, published 1829 (example in NPG).

1833 'The House of Commons, 1833' by Sir G. Hayter (NPG 54 above).
Study of Peel: Hayter Sale, Christie's, 21 April 1871 (lot 477).

1833 Marble bust by Sir F. Chantrey. Collection of Earl Peel, bt. in at Robinson, Harding and Fisher, 6–7 December 1917 (lot 189), reproduced sale catalogue, facing p 18. Another marble version, dated 1835, is in the Royal Collection. Working drawing (NPG 316a above). Engraving by A. R. Freebairn, after a gem by J. S. De Veaux, after Chantrey's bust (example in British Museum). A marble copy of the 1835 bust by J. Adams-Acton is in the National Liberal Club, London, and another by R. Glassby of 1896 in the Royal Collection.

c 1836 Painting by J. Wood (executed for celebration dinner at Tamworth, 1835). Exhibited *RA*, 1836 (307). Engraved by W. Ward, published Graves & Co, 1836 (example in NPG).

1837 'The Queen's First Council' by Sir D. Wilkie. Royal Collection.
Exhibited *RA*, 1838 (60). Engraved by C. Fox, published F. G. Moon, 1839 (example in British Museum).

1837 Bronze medal by J. Ottley. Scottish NPG.

1838 Paintings by J. Linnell (see NPG 772 above).

1838 Lithograph by G. Yvedon (example in NPG).

c 1840 Bust by A. Bienaimé. Formerly collection of W. Ketton-Cremer, Norfolk.

1841 Engraving by F. Bromley, after J. D. Francis, published Welch and Gwynne, 1841 (example in NPG).

c1841 Medallic portrait by T. R. Pinches, from a model by H. Weekes. Exhibited *RA*, 1841 (1117).

1842 'The Christening of the Prince of Wales' by Sir G. Hayter. Royal Collection.

1842 Anonymous engraving, after J. D. Francis (not the same picture as the one listed above), published Welch and Gwynne, 1842 (example in NPG).

1843 Woodcut published *ILN*, II (1843), 73.

1844 'Queen Victoria Receiving Louis Philippe at Windsor Castle, 1844' by F. X. Winterhalter. Musée de Versailles. Lithographed anonymously, published Goupil and Vibert (example in British Museum). Smaller version: Royal Collection. Oil study: collection of Jean Schmit, Paris, 1939. Oil study of Peel and Wellington: Royal Collection (plate 731), reproduced *Sir Robert Peel from his Private Papers*, edited C. S. Parker, II (1899), frontispiece, engraved by J. Faed (example in NPG). A separate painting of Peel by Winterhalter is in the Royal Collection, reproduced T. Lever, *The Life and Times of Sir Robert Peel* (1942), frontispiece.

1844 Water-colour by Miss J. Wedderburn (NPG 2772 above).

1844 Woodcut published *ILN*, IV (1844), 105.

c1844 Model by R. Moody. Exhibited *RA*, 1844 (1251).

1845 Painting by G. Fagnani. See Emma Fagnani, *The Art Life of a XIXth Century Portrait Painter Joseph Fagnani* (privately printed, 1930), pp 21 and 115.

1846 'The Fine Arts Commissioners, 1846' by J. Partridge (NPG 342, 3 above).

1846 Drawing by an unknown artist (in the House of Commons), reproduced as a woodcut *ILN*, VIII (1846), 65.

c1846-7 Busts by W. Graham. Exhibited *RA*, 1846 (1505), and 1847 (1379).

1850 Bust by R. Physick. Merchant Taylors Company.

1850 Lithograph by J. Doyle, published T. McLean, 1850 (hand-coloured example in NPG).

1850 Woodcuts published *ILN*, XVII (1850), 1 (on horseback), and 37.

1851 Bronze statue by E. H. Baily. Bury, Lancashire.
Reproduced as a woodcut *ILN*, XIX (1851), 601.

1851 Marble busts by M. Noble (see NPG 596 above).

1851 Statue or bust by J. P. Papera, bronze bust by L. Gardie, and wax statuette by H. Ross. Great Exhibition 1851. See R. Gunnis, *Dictionary of British Sculptors* (1953), pp 289, 162, and 325 respectively.

c1851 Sketch by M. Noble. Exhibited *RA*, 1851 (1349).

c1851 Statuette by J. E. Thomas. Exhibited *RA*, 1851 (1304).

c1851 Bust by W. Gray. Exhibited *RA*, 1851 (1295).

1852 Statue by A. H. Ritchie. Montrose.

1852-4 Marble statue by M. Noble. St George's Hall, Liverpool.
Reproduced as a woodcut *ILN*, XXV (1854), 513. Statuette exhibited *RA*, 1852 (1347).

1852 Bronze statue by M. Noble. Peel Park, Salford.
Reproduced as a woodcut *ILN*, XX (1852), 389. Noble executed another statue at Tamworth, Staffordshire. The model for the Peel Park statue was at Elswick Hall, Newcastle, listed in *Catalogue of Lough and Noble Models at Elswick Hall* (c 1928), p 59 (197).

1852 Statue by J. Gibson. Westminster Abbey.
Marble bust, identical to the head of the statue, exhibited *Art Treasures of the United Kingdom*, Manchester, 1857, 'Sculpture' (130), lent by H. Cardwell (reproduction in NPG).

1852	Bronze statue by W. Behnes. Leeds. Sketched by G. Scharf, 'SSB' (NPG archives), LXXXI, 64A. Model exhibited *RA*, 1851 (1293).
1852	Statue by T. Duckett. Preston. Reproduced as a woodcut *ILN*, XX (1852), 448.
c1852	Statuette by A. Johnson. Exhibited *RA*, 1852 (1363).
c1852	Design for a statue by H. Weekes. Exhibited *RA*, 1852 (1350).
1853	Bronze statue by W. C. Marshall. Manchester. Model exhibited *RA*, 1853 (1463).
1853	Statue by J. G. Mossman. Glasgow.
1853	Bust by W. Anderson. Memorial at Forfar.
1853	Marble bust by J. Francis. Frank Partridge, London, 1938.
1854	Colossal marble bust by A. Munro. Public Baths, Oldham. Exhibited *RA*, 1854 (1390). Reproduced as a woodcut *ILN*, XXV (1854), 165.
1855	Two statues by W. Behnes. Bradford, and Police College, Hendon, London. The latter (originally at Cheapside, London) is reproduced as a woodcut *ILN*, XXVII (1855), 44.
1855	Statue by P. Hollins. Calthorpe Park, Birmingham.
c1856	Statuette by E. G. Papworth. Exhibited *RA*, 1856 (1290).
c1865	Marble bust by A. Bromley. Exhibited *RA*, 1865 (942).
1872–3	Marble statue by W. Theed. Huddersfield. Reproduced as a woodcut, *ILN*, LXII (1873), 561.
1876–7	Bronze statue by M. Noble. Parliament Square. This replaced an earlier statue by Baron Marochetti; see *The Times*, 11 December 1876.
Undated	Painting by Sir D. Wilkie (oil sketch, standing by a horse). Collection of D. Geider, 1969. Presumably a study for a large equestrian portrait never carried out.
Undated	Paintings by H. W. Pickersgill (see NPG 3796 above).
Undated	Painting by an unknown artist. Collection of Edgar Newgass, 1956.
Undated	Painting by an unknown artist. Robinson and Foster, 1 August 1940 (lot 134).
Undated	Painting called Peel by an unknown artist. Puttick and Simpson, 15 July 1885 (lot 292). Sketched by G. Scharf, 'TSB' (NPG archives), XXXIII, 15.
Undated	Drawing by S. P. Hall (NPG 2378 above).
Undated	Drawing (unfinished) by an unknown artist. Collection of the Duke of Newcastle.
Undated	Lithograph, after a silhouette by J. Bouvier, published W. Spooner (example in NPG).
Undated	Miniature by Sir W. C. Ross. Reproduced *The Private Letters of Sir Robert Peel*, edited G. Peel (1920), p10.
Undated	Miniature by R. Thorburn, and another by A. E. Chalon. Recorded in the *Dictionary of National Biography*.
Undated	Bronze bust by J. E. Jones. City Museum and Art Gallery, Birmingham.
Undated	Plaster bust by Sir J. Steell. Scottish NPG.
Undated	Marble bust by an unknown artist. Brighton Pavilion.
Undated	Bust by an unknown artist. National Liberal Club, London.
Undated	Various lithographs and engravings (examples in NPG and British Museum).
Undated	Painting by R. R. Scanlan. Department of the Environment.

PELHAM–CLINTON *Henry Pelham Fiennes, 5th Duke of Newcastle.* See NEWCASTLE

PENDARVES *Edward William Wynne* (*1775–1853*)

MP for Cornwall West.

54 See *Groups:* 'The House of Commons, 1833' by Sir G. Hayter, p 526.

PENNY *William* (*1809–92*)

Whaling officer; commanded the 'Lady Franklin' in the search for Sir John Franklin.

1209 Oil on canvas, $50\frac{1}{8} \times 39\frac{3}{8}$ inches (127·3 × 100 cm), by STEPHEN PEARCE, 1853. PLATE 732

Signed and dated (bottom right): STEPHEN PEARCE. 1853

Inscribed on a damaged label in the artist's hand on the back of the stretcher: . . . commander of the vessels "The [*Lady*]/Franklin" and "The Sophia" employed/on the search for Sir John Franklin/Stephen Pearce. 25 Queen Anne Street. *Various other labels on the back relating to exhibitions and the engraving by J. Scott (see below).*

Collections: See *Collections:* 'Arctic Explorers' by S. Pearce, p 562.

Exhibitions: RA, 1853 (423); *Art Treasures of the United Kingdom*, Manchester, 1857, 'Modern Masters' (484); *Royal Naval Exhibition*, Chelsea, 1891 (45); *Pageant of Canada Exhibition*, National Gallery of Canada, Ottawa, 1967–8 (154), reproduced catalogue, p 225.

Literature: S. Pearce, *Memories of the Past* (1903), reproduced facing p 58; single-sheet pamphlet relating to the engraving, published H. Graves & Co (example in NPG, 'Pearce Documents').

Penny is shown in the sealskin costume he wore on his Polar expeditions, against an idealized Arctic landscape. The flag on the left is inscribed: 'GOD AIDING [US TO ?] DO OUR DUTY.' The portrait was engraved by J. Scott, published H. Graves & Co, 1863 (example in NPG). It is mentioned briefly in several contemporary newspapers and journals, including the *Art Journal, Morning Herald* and *Britannia*. This is the only recorded portrait of Penny.

Description: Healthy complexion, brown eyes, dark brown hair and whiskers with grey streaks. Dressed in a white shirt and brown and grey sealskin jacket, with canvas pocket and red, blue and white border, sealskin trousers and cap. Multi-coloured flag at left. Landscape at right white and greenish-grey. Background colour dark bluish-grey.

PERCEVAL *Alexander* (*1787–1858*)

Serjeant-at-arms of the House of Lords, MP for County Sligo.

54 See *Groups:* 'The House of Commons, 1833' by Sir G. Hayter, p 526.

PERING *Richard* (*1767–1858*)

Inventor.

2515 (17) See *Collections:* 'Drawings of Prominent People, 1823–49' by W. Brockedon, p 554.

PERKINS *Jacob* (*1766–1849*)

American inventor.

2515 (7) See *Collections:* 'Drawings of Prominent People, 1823–49' by W. Brockedon, p 554.

PERRY *Sir Thomas Erskine* (*1806–82*)

Indian judge; son of the radical journalist, James Perry; judge of the supreme court of Bombay, 1840, and later chief justice; retired, 1852; member of the Council of India, 1859–82; published legal works and books on Indian subjects.

1817 Black, red and white chalk on brown, discoloured paper, $10\frac{1}{4} \times 12\frac{1}{4}$ inches (26×31 cm), by JOHN LINNELL. PLATE 733

Inscribed in pencil (top left): Sir Erskine Perry *and (top right):* Sir [?] Perry/25 Chester Street/G.P.

Collections: The artist; purchased at the Linnell Sale, Christie's, 15 March 1918 (lot 82).

This drawing was bought in a lot which included several other Linnell water-colours and drawings; thirteen of these were retained by the Gallery, and the rest, of unknown or unimportant sitters, dispersed. A water-colour by Linnell of Lady Perry of 1841 is listed by A. T. Story, *Life of John Linnel* (1892), II, 258.

ICONOGRAPHY The NPG drawing is the only certain portrait of Perry; a painting by P. Simpson of a 'Thomas Perry' was exhibited *RA*, 1825 (415), and a miniature by J. C. D. Engleheart of a 'T. Perry' was exhibited *RA*, 1824 (754).

PETTY-FITZMAURICE *Sir Henry, 3rd Marquess of Lansdowne.* See LANSDOWNE

PHELPS *Samuel* (*1804–78*)

Actor; first appeared on stage, 1826; appeared as Shylock at the Haymarket, 1837; produced Shakespeare at Sadler's Wells for nearly twenty years; afterwards acted, chiefly at Drury Lane; excelled in characters of rugged strength.

3015 Brown and grisaille wash on blue-toned paper, $21\frac{1}{2} \times 14\frac{1}{2}$ inches ($54 \cdot 7 \times 36 \cdot 8$ cm), by ALFRED BRYAN. PLATE 735

Collections: Suckling & Co; H. Arthurton, purchased from him, 1939.

This was offered with thirteen other drawings by Bryan of various people, most of them apparently connected with the stage; few of the others could be identified, and only the drawings of Phelps and Swinburne (NPG 3016) were purchased. There are, however, several other works by Bryan in the collection, acquired at different times from other sources; he specialized in caricatures of theatrical personalities. Another caricature of Phelps by him (in character) was published as a woodcut in an unidentified magazine (cutting in NPG).

3503 Pen and ink on paper, $5\frac{1}{2} \times 4\frac{7}{8}$ inches ($13 \cdot 8 \times 12 \cdot 3$ cm) uneven edges, by HARRY FURNISS. PLATE 734

Inscribed in blue crayon (bottom right): $-1\frac{1}{2}-$ *and on the back in pencil:* Phelps

Collections: The artist; purchased from his sons, through Theodore Cluse, 1947.

Literature: Reproduced Furniss, *Confessions of a Caricaturist* (1902), I, 24, with the title, 'Phelps, the first actor I saw'.

This and NPG 3596 below form part of a large collection of Furniss drawings in the NPG, which will be discussed collectively in the forthcoming Catalogue of Portraits, 1860–90. A third drawing of Phelps by Furniss is reproduced in his *Some Victorian Men* (1924), facing p 148; it shows Phelps making his farewell appearance on the stage, as Brutus.

3596 Pen and ink on card, $9\frac{1}{4} \times 3\frac{1}{8}$ inches ($23 \cdot 4 \times 7 \cdot 8$ cm), by HARRY FURNISS. PLATE 736

Signed in ink (lower right): Hy.F. *Inscribed below in pencil:* Phelps

Collections: The artist; purchased from his sons, through Theodore Cluse, 1948 (see NPG 3503 above).

ICONOGRAPHY Popular prints are listed in L. A. Hall, *Catalogue of Dramatic Portraits in the Theatre Collection of the Harvard College Library*, III (Cambridge, Mass, 1932), 328–30 (some examples in NPG and British Museum); a painting by Sir J. Forbes-Robertson of 1878 is in the Garrick Club, London (as Cardinal

Wolsey), reproduced W. M. Phelps and Sir J. Forbes-Robertson, *Life and Life-Work of Phelps* (1886), frontispiece, etched by C. P. Slocombe, published Fine Art Society, 1879 (example in NPG); a painting by R. Waller is also in the Garrick Club; a painting by an unknown artist (as Brutus), said to be in the collection of Phelps' daughter, was lithographed anonymously for *Life and Life-Work*, facing p 210; a painting by N. J. Crowley (as Hamlet) is in the Shakespeare Memorial Theatre Gallery, Stratford-on-Avon; a water-colour by Crowley of 1852 (almost certainly representing Phelps) was in the collection of C. Staal; a painting by A. Elmore (as Coriolanus) was in the collection of John Quinn of Liverpool, 1912; the *Dictionary of National Biography* records a miniature of Phelps by Sir W. C. Ross, commissioned by Queen Victoria; various unspecified portraits were lent to the *Victorian Era Exhibition*, 1897, 'Drama Section' (18, 86, and 278); there are several photographs, and woodcuts and engravings after photographs, in the NPG; others are reproduced in books on the theatre, like F. Whyte, *Actors of the Century* (1898), facing p 4 and 132; woodcuts (in character) were published *ILN*, LVIII (1871), 120, LXIV (1874), 561, LXVI (1875), 48, and (after a photograph), LXXIII (1878), 465.

PHILIPS *Sir George, Bart* (*1766–1847*)

MP for Warwickshire South.

54 See *Groups*: 'The House of Commons, 1833' by Sir G. Hayter, p 526.

PHILLIP *John* (*1817–67*)

Subject and portrait painter; exhibited at RA from 1838, chiefly portraits and Scottish subjects; after a visit to Seville, 1851, concentrated on Spanish subjects, for which he became famous.

3335 Oil on canvas, 20½ × 22½ inches (52 × 57·2 cm), attributed to HIMSELF. PLATE 737

Collections: J. B. Davenport; by descent to Major J. C. Davenport; Russell Baldwin & Bright of Leominster; Leger Galleries, purchased from them, 1947.

According to information supplied by the vendor (letter of 13 February 1947, NPG archives), John Phillip used to stay with J. B. Davenport (1799–1862) of Foxley, Herefordshire[1], the ancestor of Major Davenport. The painting is very close to Phillip's work in style, and the features of the sitter accord well with other early authentic self-portraits, though the comparison is not absolutely conclusive. Major Davenport apparently owned other paintings by Phillip.

Description: Fresh complexion, dark brown hair. Dressed in a dark stock and waistcoat, dark brown velvet coat and light grey trousers. Seated in a dark green and brown chair, holding a light brown palette, with splashes of red, white and brown paint, and looking at a white canvas, on which is a rough design, apparently of two figures. Beyond the canvas, which has no visible signs of support (an easel is indicated in pencil), is a brown and pink table. A dark red curtain is on the right. The rest of the background is brown.

2446 Water-colour, gouache, varnish, and oil, on paper, 18 × 14½ inches (45·6 × 36·8 cm) painted oval, attributed to SIR DANIEL MACNEE. PLATE 738

Inscribed on a label, formerly on the back of the painting, are some notes from the National Portrait Gallery Illustrated Guide, referring to pictures by Phillip and Macnee, probably by the donor.

Collections: H. Campbell Johnston, presented by him, 1929.

The attribution was supplied by the donor, and is questionable. The identification is certainly right.

Description: Grisaille sketch, mainly in blacks, greys and whites. Brown eyes, white hair and beard. Dressed in a white shirt, black neck-tie, black waistcoat, jacket and skull-cap.

[1] See *Burke's Landed Gentry* (1937), pp 571–2.

ICONOGRAPHY An oil self-portrait of 1840 is in the Aberdeen Art Gallery, and so is a painting by Phillip of himself and his wife; three other oil self-portraits are in the National Gallery of Scotland, the Scottish NPG, and the Glasgow Art Gallery, the last exhibited *John Phillip R.A.*, Aberdeen Art Gallery, 1967 (10), reproduced plate 1; a drawing by R. Dadd as 'Glorious Jock' is in the British Museum, previously thought to be a self-portrait, and as such exhibited Aberdeen, 1967 (addenda), and *Royal Academy Draughtsmen*, British Museum, 1969 (29); another drawing by Dadd is in the collection of Capt. R. H. Dadd; a painting by H. O'Neil was exhibited *RA*, 1858 (424), and *SKM*, 1868 (599); a painting by E. Long was in the collection of Mrs Long, 1904; a painting by J. Ballantyne (showing Phillip in his studio) is in the Scottish NPG, exhibited *RA*, 1867 (487), and there is a chromo-lithograph of it by V. Brooks (example in the NPG); a painting by J. A. Houston is in the Royal Scottish Academy, and so is a painting by an unknown artist, apparently signed, 'B. N. D.'; a small painting by C. E. Cundall is in the Garrick Club, London, possibly identical with, or related to, the miniature by E. C. Cundell [*sic*], exhibited *VE*, 1892 (431); a drawing by C. Gow was in the collection of Mrs A. Dalziel, 1939; a marble bust by W. Brodie is in the Aberdeen Art Gallery, exhibited *RA*, 1868 (971); a plaster bust by J. Hutchison is in the Scottish NPG, presumably related to the bust exhibited *RA*, 1861 (1067); a bust by J. Thomas was exhibited *RA*, 1860 (1021); there are various woodcuts and engravings in the British Museum, and several photographs in the NPG; others are reproduced as woodcuts *ILN*, xxxv (1859), 543, and L (1867), 285, and Mrs E. M. Ward, *Memories of Ninety Years* (n.d.), facing p 280.

PHILLIPPS *Sir Thomas, Bart* (*1792–1872*)

Antiquary and bibliophile; amassed a huge and highly important collection of books and manuscripts (now dispersed); printed genealogies, registers and catalogues on his own private press.

3094 Two profile views on the same sheet. Water-colour on paper, $9\frac{1}{2} \times 13\frac{3}{8}$ inches (24·1 × 33·9 cm), by SIR HENRY DRYDEN, 1853. PLATES 739, 740

Inscribed in ink on the reverse: Sir T. Phillipps B^t / Middle hill Co Wor / H D Aug 1853

Collections: The artist; purchased from his daughter, Alice Marcon, 1948.

Dryden was a close friend of the sitter. The profiles are slightly dissimilar, but must have been done at much the same time.

Description: Figure on the left, grey hair, white shirt and stock, pink waistcoat, dark blue coat; figure on the right, grey hair, white shirt, light blue coat. Both backgrounds grey.

ICONOGRAPHY A painting by T. Phillips was in the collection of Alan Fenwick, recorded by J. P. Neale, *Views of the Seats of Noblemen and Gentlemen in the United Kingdom*, IX (1826), no. 47, p 4, at Middle Hill, the sitter's early home, and by the *Dictionary of National Biography*, at Thirlestane House; a portrait was in the *Worcestershire Exhibition*, Worcester, 1882, 'Historical Section' (132), lent by C. Phillips; in a note by Scharf in his copy of the catalogue (NPG library), this is described as a miniature.

PHILLIPS *Henry* (*1801–76*)

Musician; appeared as a singing boy at the Haymarket and Drury Lane; subsequently made his name as a bass singer; retired, 1863.

1962f Pencil, pen and ink on paper, $9 \times 6\frac{1}{8}$ inches (22·7 × 15·6 cm), by ALFRED EDWARD CHALON, 1828. PLATE 741

Inscribed in ink (top left): Pirate of Genoa (*bottom left*): Phillips/1828 and (*bottom right*): Cap^n. Tornado

Collections: Purchased from Miss Florence A. Blake, 1922.

The drawing is one of a collection of drawings of opera singers and others by Chalon, which will be collectively discussed in the forthcoming Catalogue of Portraits, 1790–1830.

ICONOGRAPHY Popular prints of Phillips are listed in L. A. Hall, *Catalogue of Dramatic Portraits in the Theatre Collection of the Harvard College Library*, III (Cambridge, Mass, 1932), 333–4 (some examples in NPG and British Museum); a painting by J. W. Wright (as Uberto d'Ardinghelli, in the opera 'The Free-Booters') was exhibited *RA*, 1828 (363), engraved by and published C. Turner, 1829 (example in British Museum); another painting by J. W. Wright (with his wife) was exhibited *RA*, 1830 (567); a painting by J. P. Knight was exhibited *RA*, 1841 (471), engraved by H. E. Dawe; a painting by G. Clint was sold Christie's 22 July 1871 (lot 164); a painting by J. Ramsay was exhibited *RA*, 1834 (178); miniatures by Mrs Turnbull, and J. W. Childe, were exhibited *RA*, 1830 (658), and 1833 (651); a bust by C. Tate is listed by R. Gunnis, *Dictionary of British Sculptors* (1953), p 380; there is a lithograph by C. Baugniet of 1846 (example in British Museum).

PHILLIPS *Molesworth* (*1755–1832*)

Soldier, accompanied Captain Cook on his last voyage.

2515 (4) See *Collections:* 'Drawings of Prominent People, 1823–49' by W. Brockedon, p 554.
See also forthcoming Catalogue of Portraits, 1790–1830.

PHILLIPS *Thomas* (*1770–1845*)

Painter.

2515 (70) See *Collections:* 'Drawings of Prominent People, 1823–49' by W. Brockedon, p 554.
See also forthcoming Catalogue of Portraits, 1790–1830.

PHILLIPS *Wendell* (*1811–84*)

Prominent American slavery abolitionist.

599 See *Groups:* 'The Anti-Slavery Society Convention, 1840' by B. R. Haydon, p 538.

PHIPPS *Sir Constantine Henry, 2nd Earl of Mulgrave and 1st Marquess of Normanby.* See NORMANBY

PHIPPS *Hon Edmund* (*1760–1837*)

Son of 1st Baron Mulgrave, general.

4026 (44) See *Collections:* 'Drawings of Men About Town, 1832–48' by Count A. D'Orsay, p 557.

PHIPPS *Edmund* (*1808–57*)

Author; son of the 1st Earl of Mulgrave; barrister; published several financial pamphlets and other works.

4026 (45) Pencil and black chalk on paper, $11\frac{1}{2} \times 9$ inches (29·2 × 22·8 cm), by COUNT ALFRED D'ORSAY, 1848.
PLATE 742

Signed and dated (lower right): d'Orsay fecit/6 Mars. 1848. *Autograph in ink (lower centre):* Edmund Phipps –

Collections: See *Collections:* 'Drawings of Men About Town, 1832–48' by Count A. D'Orsay, p 557.

There is a lithograph after this drawing by R. J. Lane, published J. Mitchell, 1848 (example in NPG); it is listed in Lane's 'Account Books' (MS, NPG archives), III, 6.

ICONOGRAPHY The only other recorded portrait of Phipps is a miniature by Miss M. A. Knight, exhibited *RA*, 1812 (652).

PHIPPS *Maria-Louisa* (*d 1888*)

Née Campbell; wife of Hon Charles F. Norton, and secondly of Hon Edmund Phipps (1808–57) (see above).

1916 See *Groups:* 'Samuel Rogers, Mrs Norton (Lady Stirling-Maxwell) and Mrs Phipps, *c* 1845' by F. Stone, p 545.

PICKERING *Ferdinand* (*1811–c 1882*)

Artist.

3182 (15, 16) See *Collections:* 'Drawings of Artists, *c* 1862' by C. W. Cope, p 565.

PICKERSGILL *Henry William* (*1782–1875*)

Painter; first exhibited at the RA, 1806; devoted himself primarily to portrait painting, and established a large and successful practice.

1456 (23) Black chalk on brown-tinted paper, with touches of Chinese white, $3\frac{3}{8} \times 3$ inches (8·5 × 7·5 cm), by CHARLES HUTTON LEAR, 1848. PLATE 745

Inscribed (lower left): Pickersgill *and (lower right):* Nov 48

Collections: See *Collections:* 'Drawings of Artists, *c* 1845' by C. H. Lear, p 561.

3097 (1) With a faint pencil sketch of an eye and nose. Pen and ink on paper, $9 \times 7\frac{1}{4}$ inches (22·9 × 18·5 cm), by SIR EDWIN LANDSEER. PLATE 744

Inscribed in ink (top centre): Pickersgill presented at Court/by Sir Edwin Landseer

Collections: Purchased from Appleby Brothers, 1940.

This is one of a collection of caricatures by Landseer which will be collectively discussed in the forthcoming Catalogue of Portraits, 1790–1830.

3182 (9) With two sketches of William Witherington. Pencil on paper, $4\frac{1}{4} \times 3\frac{3}{8}$ inches (11 × 8·6 cm), by CHARLES WEST COPE, *c* 1862. PLATE 743

Inscribed (top left): Witherington *and (lower left):* Pick^ll.

Collections: See *Collections:* 'Drawings of Artists, *c* 1862' by C. W. Cope, p 565.

On comparison with other portraits, it is clear that this drawing represents H. W. and not F. R. Pickersgill. Both Witherington and H. W. Pickersgill were uncles of the younger Pickersgill, and appear in the drawing to be men of the same age.

ICONOGRAPHY A self-portrait was exhibited *RA*, 1808 (616); there is a drawing by C. Vogel in the Küpferstichkabinett, Staatliche Kunstsammlungen, Dresden, 1834; there are a number of photographs in the NPG, and a woodcut after one by Watkins was published *ILN*, LXVI (1875), 456.

PINCHES *Thomas*

Slavery abolitionist.

599 See *Groups:* 'The Anti-Slavery Society Convention, 1840' by B. R. Haydon, p 538.

PINNEY *William* (*1806–98*)

MP for Lyme Regis.

54 See *Groups:* 'The House of Commons, 1833' by Sir G. Hayter, p 526.

PLUMPTRE *John Pemberton* (*1791–1864*)

MP for Kent East.

54 See *Groups:* 'The House of Commons, 1833' by Sir G. Hayter, p 526.

POLLOCK *Sir George, Bart* (*1786–1872*)

Field-marshal; served in Burma and India; recaptured Kabul, 1842; returned to England, 1846; became senior government director of the East India Company; field-marshal, 1870.

2459 Pencil on greyish-green toned paper, $9\frac{7}{8} \times 8\frac{1}{2}$ inches (25 × 21·6 cm) mounted as an oval, by COLONEL LIONEL GRIMSTON FAWKES, 1872. PLATE 748

Signed (*lower centre*): LGF *Inscribed in pencil* (*lower left*): Sketch from life/April 1872 – *and autographed* (*lower right*): Geo Pollock

Collections: The artist, presented by him, 1930.

In a letter of 22 January 1930 (NPG archives), the artist wrote about the portrait, '*which I took from life in April 1872 when he was 86 years old. I spent 2 days with him at his house on Clapham Common when I was a young just-joined Subaltern in the R-A. & he was the father of the Regt. He died soon after & I was at his funeral in Westminster Abbey*'. He also recorded that Pollock had autographed the drawing.

364 Marble bust, $26\frac{3}{4}$ inches (68 cm) high, by JOSEPH DURHAM, 1870. PLATES 746, 747

Incised on the front of the base: F M. Sir GEORGE/POLLOCK *and on the back:* J. DURHAM. A.R.A./1870

Collections: The sitter, presented by the executors of his widow, Lady Pollock, in accordance with her wishes, 1873.

ICONOGRAPHY A painting by S. Lane is in the Oriental Club, London, exhibited *RA*, 1848 (371); a painting by Sir F. Grant is in the India Office, London, listed by the artist in his 'Sitters Book' (copy of original MS, NPG archives), under 1856, exhibited *RA*, 1857 (220), *VE*, 1892 (151), and *Victorian Era Exhibition*, 1897, 'Historical Section' (746), engraved by J. J. Chant, published H. Graves, 1857 (example in NPG); a copy is in the East India and Sports Club, London; an oil sketch was in the artist's sale, Christie's, 28 March 1879 (lot 29); a painting by H. Valda of *c* 1867 is in the Royal Artillery Institution, Woolwich; paintings by Beechey and J. W. Walton were exhibited *RA*, 1846 (546), and 1854 (549); paintings by unknown artists were in the collections of Alfred Jones of Bath, *c* 1920, and Dr Nash, 1959; a water-colour by Miss Beadell of 1870 is in the Victoria Memorial Hall, Calcutta; a marble bust by H. Weekes is in the Merchant Taylors Company, exhibited *RA*, 1874 (1455); busts by P. Ball and J. Durham were exhibited *RA*, 1869 (1294), and 1871 (1270); a lithograph by G. H. Ford, apparently based on the Lane painting, was published Smith, Elder & Co, and Colnaghi, 1850 (example in NPG); a woodcut was published *ILN*, I (1842), 356; a photograph by Maull & Co is reproduced C. R. Low, *The Life and Correspondence of Field Marshal Sir George Pollock* (1873), frontispiece; a photograph by J. Watkins is reproduced as a woodcut *ILN*, LIX (1871), 441.

POLLOCK *Sir Jonathan Frederick, Bart* (*1783–1870*)

Judge: barrister, 1809; tory MP from 1831; attorney-general, 1834–5, and 1841–4; chief baron of the exchequer, 1844–66.

758 Oil on canvas, $54\frac{3}{4} \times 43\frac{1}{2}$ inches (139 × 110·5 cm), by SAMUEL LAURENCE, *c* 1842. PLATE 749

Collections: The sitter, presented by his son, Sir Frederick Pollock, Bart, 1887.

Exhibitions: RA, 1842 (217).

Literature: F. Miles, 'Samuel Laurence' (typescript copy, NPG library).

Pollock was one of Laurence's most constant friends and patrons. Two studies for this portrait are

in the collection of Miss Armide Oppé. A copy is owned by Mrs R. C. D'Oyly Mann. Another oil portrait of Pollock by Laurence was exhibited *RA*, 1847 (168), and a drawing of 1863 is in the NPG (732 below).

Description: Sallowish complexion, greyish eyes, grey wig. Dressed in the red and ermine robes of a judge, with his (?) gold chain of office, holding open a brown leather-bound volume on his knee. Resting the other hand on the red judicial bench on which he is seated. Almost all the background covered by a dark reddish-brown curtain. Lighter brown patch of wall top right-hand corner.

732 Black and white chalk on brown, discoloured paper, $21\frac{1}{8} \times 14\frac{3}{4}$ inches (53·7 × 37·5 cm), by SAMUEL LAURENCE, 1863. PLATE 750

Signed and dated (bottom centre): Samuel Laurence / Delt. 1863

Collections: Commissioned by W. M. Thackeray in 1862, and presented by his daughter, Mrs (later Lady) Ritchie, 1885.

Exhibitions: RA, 1863 (768).

Literature: The Times, 22 January 1864; Sir J. Pollock, *Time's Chariot* (1950), p 23; F. Miles, 'Samuel Laurence' (typescript copy, NPG library).

The story of this drawing is told by Thackeray in *The Times*: '*The Chief Baron was dining with me the other day and we laid our heads together to make a little plan for a painter-friend of ours to take each of our heads off; so, Mr Painter, execute thine office on that dear old Chief Baron whenever thou canst catch him; or me at thy leisure*'. The drawing of Thackeray by Laurence, which was given to Pollock, was in the collection of Lady Ritchie (see entry for Thackeray, NPG 725). According to Lady Ritchie (letter of 27 June 1884, NPG archives), Thackeray and Pollock exchanged portraits '*out of friendship for one another and for the painter too*'. The present Sir John Pollock owns a drawing of Pollock by Thackeray.

54 See *Groups:* 'The House of Commons, 1833' by Sir G. Hayter, p 526.

ICONOGRAPHY A painting by Sir F. Grant is owned by the Corporation of Huntingdon, listed in the artist's 'Sitters Book' (copy of original MS, NPG archives), under 1848, exhibited *RA*, 1849 (140), reproduced *Connoisseur*, CXXXV (1955), 239, engraved by S. W. Reynolds junior, published Colnaghi, 1850 (example in British Museum); a painting by T. Phillips is listed in his 'Sitters Book' (copy of original MS, NPG archives), under 1834, exhibited *RA*, 1834 (61), engraved by H. Robinson, published R. Ryley, J. Fraser, and F. G. Moon, 1838 (example in NPG), for 'Portraits of Conservative Statesmen'; paintings by Miss Mary Maskall, W. Long, and W. W. Ouless were exhibited *RA*, 1829 (125), 1834 (220), and 1873 (93); a miniature by Miss Maskall was exhibited *RA*, 1812 (608), and a miniature by an unknown artist was exhibited *VE*, 1892 (440*), lent by Lady Pollock; busts by W. Behnes of 1842 and by T. Woolner of c 1870 are in the Inner Temple, London, the former probably the bust exhibited *RA*, 1844 (1384); a bust by J. Durham was exhibited *RA*, 1848 (1399); a caricature lithograph by 'ATE' (A. Thompson) was published *Vanity Fair*, 2 April 1870; a woodcut was published *ILN*, I (1842), 304; a photograph by J. & C. Watkins is in the NPG, and another is reproduced as a woodcut *ILN*, XLIX (1866), 424.

POMFRET Thomas William Fermor, 4th Earl of (*1770–1833*)

General.

1695 (J) See entry under William IV, p 509.

POOLE John (*1786?–1872*)

Dramatist and author of miscellaneous works; wrote popular comedies and farces for the London theatre; in later life obtained a pension through Charles Dickens.

3807 Oil on canvas, 30 × 25 inches (76·2 × 63·5 cm) painted oval, by HENRY WILLIAM PICKERSGILL, *c* 1826.
PLATE 752

Inscribed on a label, formerly on the stretcher: John Poole Esq^r/ H W. Pickersgill/ R A *Also on the stretcher was a visiting card for the dealers,* J. and W. Vokins.

Collections: The artist; Pickersgill Sale, Christie's, 16–17 July 1875 (lot 337), presumably bought Vokins; collection of Sir Henry Irving; Irving Sale, Christie's, 16 December 1905 (lot 139); purchased at Christie's, 5 October 1951 (lot 122).

Exhibitions: RA, 1826 (337).

This portrait was engraved by G. Clint, published T. Lupton, 1827 (example in British Museum); it was also engraved by J. Thomson, published Colburn and Bentley, 1831 (example in NPG), for the *New Monthly Magazine.*

Description: Healthy complexion, dark greyish eyes, brown hair. Dressed in a white stock, white shirt, black waistcoat, with gold watch-chain, and black coat. Background curtain colour rich red and brown.

2515 (25) Black and red chalk on green-tinted paper, 14⅞ × 10⅝ inches (37·8 × 27·1 cm), by WILLIAM BROCKEDON, 1830. PLATE 751

Dated (lower left): 18–11–30

Collections: See *Collections:* 'Drawings of Prominent People, 1823–49' by W. Brockedon, p 554.

Accompanied in the Brockedon Album by an undated letter from the sitter.

ICONOGRAPHY A drawing by J. Hollins of 1821 was in the collection of G. B. Mountford, 1935; there is an engraving called Poole (example in NPG).

POOLE *Paul Falconer* (*1807–79*)

Historical painter; largely self-taught; first exhibited at RA, 1830; chiefly painted poetic and ambitious historical pictures; elected an RA, 1861.

2532 Oil on canvas, 24 × 20 inches (61 × 50·8 cm), by FRANK HOLL, 1879. PLATE 753

Signed and dated (lower right): Portrait of P. F. Poole R A/ 2 hours sketch. /F.H. 1879

Collections: The artist, presented by his sister-in-law, Mrs Ellen Holl, and her daughter, Mrs Constance Baker, 1932.

Presented at the same time as drawings of Francis and Frank Holl (NPG 2530 and 2531).

Description: Bluish(?) eyes, brown hair, grey beard. Background colour dark green; unfinished areas of canvas white.

ICONOGRAPHY There is a photograph in the NPG, and two anonymous woodcuts, almost certainly after photographs; a woodcut was published *ILN*, XXXVIII (1861), 175.

PORTMAN *Edward Berkeley Portman, 1st Viscount* (*1799–1888*)
MP for St Marylebone.

54 See *Groups:* 'The House of Commons, 1833' by Sir G. Hayter, p 526.

POST *Jacob* (*1774–1855*)
Quaker and slavery abolitionist.

599 See *Groups:* 'The Anti-Slavery Society Convention, 1840' by B. R. Haydon, p 538.

POTTER *Richard* (*1778–1842*)

MP for Wigan.

54 See *Groups:* 'The House of Commons, 1833' by Sir G. Hayter, p 526.

POULTER *John Sayer* (*d 1847*)

MP for Shaftesbury.

54 See *Groups:* 'The House of Commons, 1833' by Sir G. Hayter, p 526.

POWELL *John Allan*

Solicitor, law agent for the 1st Earl of Blessington.

4026 (46) See *Collections:* 'Drawings of Men About Town, 1832–48' by Count A. D'Orsay, p 557.

POWERSCOURT *Richard Wingfield, 6th Viscount* (*1815–44*)

4026 (47) See *Collections:* 'Drawings of Men About Town, 1832–48' by Count A. D'Orsay, p 557.

POWIS *Edward Herbert, 2nd Earl of* (*1785–1848*)

MP for Ludlow.

54 See *Groups:* 'The House of Commons, 1833' by Sir G. Hayter, p 526.

POYNTZ *William Stephen* (*c 1769–1840*)

MP for Ashburton.

54 See *Groups:* 'The House of Commons, 1833' by Sir G. Hayter, p 526.

PRAED *Winthrop Mackworth* (*1802–39*)

Poet; barrister, 1829; MP from 1830; secretary to the board of control under Peel, 1834; published poems and prose essays.

3030 Pencil and water-colour on paper, $11\frac{3}{4} \times 9$ inches (29·8 × 23 cm), by DANIEL MACLISE. PLATE 754
Collections: Sir William Drake; Drake Sale, Christie's, 24 May 1892 (lot 204); M. H. Spielmann, presented by him, 1939.
Exhibitions: British Portraits, RA, 1956–7 (729); *Daniel Maclise*, Arts Council at the NPG, 1972 (41).

This portrait was probably bought at the artist's sale, Christie's, 24 June 1870, where many of Maclise's drawings and water-colours were sold in large uncatalogued lots. It has the same provenance as two other Maclise water-colours of Jerdan and Dunlop, presented at the same time (NPG 3028 and 3029). The collector's stamp in the bottom right hand corner is that of Sir William Drake (Lugt 736).

Description: Brown and reddish-brown wash, black stock.

ICONOGRAPHY According to a note by A. H. M. Praed, 1923 (NPG archives), there were two paintings of Praed by A. Mayer, one in the collection of Sir George Young of Formosa, the other owned by Sir Hedworth Meux; the former was exhibited *SKM*, 1868 (371), and was lithographed by M. Gauci (example in NPG), and by W. Drummond, published T. McLean, 1837 (example in NPG), for 'Athenaeum Portraits'; Drummond's lithograph is reproduced *Selections from the Works of William Mackworth Praed*, edited Sir G. Young (1866), frontispiece; Praed appears in the 'Billiard Room Group' by H. N. O'Neil in the Garrick Club, London; a painting by H. N. O'Neil was exhibited *RA*, 1868 (448); a marble bust by C. Smith was exhibited *RA*, 1841 (1313), possibly the marble bust in the collection of Mrs Praed, see *Poems of William Mackworth Praed*, with a memoir by Rev D. Coleridge (4th edition, *c* 1882), pl xi; an anonymous engraving (as a young man) is reproduced *Poems* (*c* 1882), frontispiece; a medallion by R. Smith is on Praed's tomb in Kensal Green Cemetery, London.

PRESCOD *Samuel J.*

Slavery abolitionist from Barbados.

599 See *Groups:* 'The Anti-Slavery Society Convention, 1840' by B.R.Haydon, p538.

PRICE *Dr Thomas*

Slavery abolitionist.

599 See *Groups:* 'The Anti-Slavery Society Convention, 1840' by B.R.Haydon, p538.

PRICE *William Lake* (*1810–after 1896*)

Water-colour painter; pupil of A.C.Pugin, and De Wint; exhibited at the Old Water-Colour Society, to which he was elected an associate, 1837; made several continental sketching trips; also painted in oil, and exhibited pictures at the RA; also executed portrait photographs.

2538 Coloured chalk on greyish paper, 6½ × 7⅞ inches (16·5 × 19·9 cm), by ALFRED EDWARD CHALON, *c* 1844. PLATE 755

Inscribed (top right): Mr Lake Price *and across the bottom:* Studies for the picture of John Knox reproving the Ladies/A.E.Chalon

Collections: Iolo Williams, presented by him, 1932.

This is a study for Chalon's 'John Knox Reproving the Ladies of Queen Mary's Court', exhibited *RA*, 1844 (73), engraved by W.T.Roden, published J.Hogarth, 1851 (example in Witt Library, London); Price is one of the young gallants on the left of the picture. No other portraits of him are recorded.

PRIDEAUX *Walter* (*1806–89*)

Chairman of the Assam Tea Co, lawyer and poet.

4710 See *Groups:* 'A Consultation Previous to an Aerial Voyage to Weilburg, 1836' by J.Hollins, p537.

PRINCE *Dr G.K.*

Slavery abolitionist.

599 See *Groups:* 'The Anti-Slavery Society Convention, 1840' by B.R.Haydon, p538.

PRIOR *Sir James* (*1790?–1869*)

Author of miscellaneous works; entered the navy as a surgeon, and wrote accounts of his voyages; deputy-inspector of hospitals, 1843; published biographies of Burke and Goldsmith.

2515 (43) Black and red chalk, with touches of Chinese white, on green-tinted paper, 13½ × 9½ inches (34 × 24·2 cm), by WILLIAM BROCKEDON, 1832. PLATE 756

Dated (lower left): 12.3.32

Collections: See *Collections:* 'Drawings of Prominent People, 1823–49' by W.Brockedon, p554.

Accompanied in the Brockedon Album by a letter from the sitter, dated 7 September 1832.

ICONOGRAPHY A painting by R.Rothwell was exhibited *RA*, 1854 (597); a portrait by an unknown artist was in the *Dublin Exhibition*, 1872, 'Portraits' (444), lent W.Smith; a marble bust by W.Pepper was exhibited *RA*, 1862 (1101); there is an engraving by Mrs D.Turner, after a drawing by E.U.Eddis of 1832 (example in NPG); a lithograph by W.Drummond, after E.U.Eddis (not the same portrait as that listed above), was published McLean, 1835 (example in NPG), for 'Members of the Athenaeum'.

PROCTER *Adelaide Ann* (*1825–64*)

Poetess; eldest child of Bryan Waller Procter (see below); took great interest in social questions affecting women; collected poems, published 1858; many of her hymns are still in use.

789 Oil on canvas, 37½ × 31 inches (95·3 × 78·7 cm) painted oval, by EMMA GAGGIOTTI RICHARDS. PLATE 757

Signed (lower right): E.G.R.

Collections: Bryan Procter, the sitter's father, bequeathed by his widow, Mrs Anne Procter, 1888.

Exhibitions: SKM, 1868 (605).

A woodcut by C.D.Mitton, after the painting, was published 1882 (example in NPG), for *Legends and Lyrics: a book of Verses by Adelaide Procter* (1882 edition). The NPG picture was bequeathed at the same time as the portrait of Bryan Procter (see NPG 788 below).

Description: Pale complexion, greenish eyes, brown hair. Dressed in a black costume, trimmed with red, and with red tassels, wearing various gold rings. Background colour brown.

ICONOGRAPHY There is a photograph in the NPG, and an engraving was published in Adelaide Procter's *Legends and Lyrics* (1866 edition), frontispiece.

PROCTER *Bryan Waller* (*1787–1874*)

Poet; practised as a solicitor in London; intimate with Leigh Hunt, Charles Lamb and Charles Dickens; barrister, and a metropolitan commissioner in lunacy; published plays, poems, songs and other works, several under the pseudonym, Barry Cornwall.

2515 (23) Black and red chalk, with touches of Chinese white, on blue-tinted paper, 14½ × 10⅝ inches (36·3 × 27 cm), by WILLIAM BROCKEDON, 1830. PLATE 759

Dated (lower right): 2,11,30

Collections: See Collections: 'Drawings of Prominent People, 1823–49' by W.Brockedon, p554.

Accompanied in the Brockedon Album by an undated letter from the sitter.

4026 (48) Pencil and black chalk, with traces of red on the cheek, on paper, 11⅛ × 8⅛ inches (28·2 × 20·5 cm), by COUNT ALFRED D'ORSAY, 1841. PLATE 760

Signed and dated (lower right): d'Orsay fecit/1841 *Autograph in ink (below):* B W Procter *and inscribed in pencil (below):* Barry Cornwall

Collections: See Collections: 'Drawings of Men About Town, 1832–48' by Count A.D'Orsay, p557.

788 Marble bust, 28½ inches (72·4 cm) high, by JOHN HENRY FOLEY. PLATE 758

Incised on the front of the base: BARRY CORNWALL

Collections: The sitter, bequeathed by his widow, Mrs Anne Procter, 1888.

Bequeathed at the same time as the portrait of Adelaide Procter (see NPG 789 above). Procter's bust may have some connection with his monument by J.H.Foley, listed by W.G.Strickland, *Dictionary of Irish Artists* (1913), I, 363.

ICONOGRAPHY A drawing by C.Martin of 1844 is in the British Museum, reproduced as a coloured lithograph in C.Martin, *Twelve Victorian Celebrities* (1899), no.9; a drawing by R.Lehmann of 1869 is in the British Museum, reproduced R.Lehmann, *Men and Women of the Century* (1896), facing p61; a drawing by H.Bone of 1810, after Sir M.A.Shee, is in the NPG ('Bone's Drawings', III, 15); a bust by J.E.Jones was exhibited *RA,* 1851 (1363); Procter appears (as Barry Cornwall), in 'The Fraserians', an engraving by D.Maclise, published *Fraser's Magazine,* XI (January 1835), between 2 and 3; two pencil studies for this are in the Victoria and Albert Museum; an engraving by B.Holl, after A.Wivell, was published Cramer, Addison and

Beale, 1832 (example in the Harvard Theatre Collection, where there is also an anonymous engraving); there is an anonymous woodcut (example in NPG), and an anonymous engraving is reproduced *The Diaries of William Charles Macready*, edited W. Toynbee (1912), I, facing 86; a photograph by H. Watkins is reproduced as a woodcut *ILN*, LXV (1874), 353.

PROUT *Samuel (1783–1852)*

Water-colour painter; famous for his views of continental cities, and studies of architecture.

1618 Oil on canvas, 30 × 25⅛ inches (76·2 × 63·8 cm) painted oval, by JOHN JACKSON, 1823. PLATE 761

Inscribed on the back of the canvas: S. Prout by Jackson RA./1823

Inscribed on a label on the back of the canvas, in the donor's hand: Portrait of Samuel Prout/by Jackson R.A./Bequeathed to/The National Portrait Gallery/London/By his son SG. Prout/in 1908

Collections: The sitter, bequeathed by his son, Samuel Gillespie Prout, 1911.

Description: Healthy complexion, bluish-grey eyes, brown hair. Dressed in a white stock, white shirt, white waistcoat, and black coat. Background colour very dark brown.

1245 Grisaille pastel, with touches of Chinese white, 13⅜ × 10⅞ inches (34 × 27·6 cm), by CHARLES TURNER, c 1836. PLATE 762

Collections: The artist; purchased from his grandson, Mr Savory of Brighton, by F. W. Simpson; purchased from him, 1899.

Exhibitions: Presumably *RA*, 1836 (580).

Literature: Reproduced *Magazine of Art* (1900), p 225, and *Connoisseur*, CXVIII (1946), 112.

Prout is leaning on a leather-bound volume inscribed, 'S Prout / Works / Vol / D'. The name of the artist, and the provenance of the drawing were provided by the vendor (letter of 18 August 1899, NPG archives).

2515 (12) Coloured chalk, with touches of Chinese white, on green-tinted paper, 15 × 11 inches (37·9 × 28·3 cm), by WILLIAM BROCKEDON, 1826. PLATE 763

Dated (bottom left): 10. 7–26

Collections: See *Collections:* 'Drawings of Prominent People, 1823–49' by W. Brockedon, p 554.

Accompanied in the Brockedon Album by an undated letter from the sitter.

ICONOGRAPHY A so-called self-portrait was in the collection of Colonel M. H. Grant; a sketch, presumably in oil, by W. Brockedon was exhibited *RA*, 1812 (139); a painting attributed to J. Opie is listed by A. Earland, *John Opie and his Circle* (1911), p 309; a water-colour by an unknown artist was in the collection of Mrs E. K. Driver, 1957; a drawing by H. Edridge was in the collection of John Montagu, 1936; a drawing or miniature by C. Forster was exhibited *RA*, 1838 (939); a miniature by J. P. Fischer of 1835 was exhibited *RA*, 1837 (777), and *Royal House of Guelph*, New Gallery, London, 1891 (1071), recorded and sketched by G. Scharf, 1877, 'TSB' (NPG archives), XXIII, 34; a miniature by R. Satchwell was exhibited *RA*, 1808 (793); a miniature by an unknown artist is in the Royal Collection, Windsor; an anonymous woodcut, after Sir W. C. Ross, was published *Art Journal* (1849), p 76; an anonymous engraving was published *Magazine of Art* (1898), p 588.

PUGIN *Augustus Welby Northmore (1812–52)*

Architect, designer and ecclesiologist; son of the architect and artist, A. C. Pugin; the most influential, and one of the most distinguished 19th century neo-Gothic architects; published several highly important and didactic books on architectural theory and design.

1404 Oil on canvas, 24⅛ × 20 inches (61·3 × 50·8 cm), by an UNKNOWN ARTIST, *c* 1840. PLATE 764

Inscribed along the top: AUGUSTUS: WE[LBY NORTHMO]RE: PUGIN: R.I.P. *and below this, on the left-hand side:* Nat 1812/Obit 1852 *Painted on the right-hand side is Pugin's crest, with the motto,* 'en avant'.

Collections: Mr Pitman of Pitman & Sons (ecclesiastical decorators); J.N.Brown, 1881; Shepherd's Gallery, purchased from them, 1905.

Literature: G. Scharf, 'TSB' (NPG archives), XXVII, 67; R.E.Dell, 'A Portrait of Augustus Welby Pugin', *Burlington Magazine*, VII (1905), 331–2, reproduced 333.

This picture was first offered to the NPG by Brown in 1881 but declined. According to Clement Pitman (memorandum of an interview, 1 March 1937, NPG archives), the lettering and coat of arms on the portrait were painted by his father, soon after he bought the painting, though from what source and at what date are not known. This evidence supports Dell's conjecture that the portrait was not posthumous (he thought the likeness too striking), though the inscription might suggest it. According to Dell, the portrait was unknown to Pugin's widow, whom Pugin had married in 1849. The date is based on the apparent age of the sitter. When it first entered the collection, the picture was attributed to G.Richmond, but it is quite unlike his work in style, and it is not recorded in his 'Sitters Book'. George Mackay in a letter of 25 February 1907 (NPG archives), suggested that it might have been the work of his father, Father Edward Mackay, a pupil of H.P.Briggs, and an intimate friend of Pugin. Mackay became professor of painting at Oscott College, and painted many prominent Catholics.

Description: Light brown eyes, brown hair. Dressed in a white collar, and black costume. Background colour reddish-brown.

ICONOGRAPHY A painting by J.R.Herbert is in the Royal Institute of British Architects (plate 765), exhibited *RA*, 1845 (423), *SKM*, 1868 (588), and *VE*, 1892 (177), etched and engraved by the artist (example in NPG), and lithographed by J.H.Lynch, published C.Dolman, 1853 (example in British Museum), for the *Metropolitan and Provincial Catholic Almanac*; a copy by F.Hill is also in the Royal Institute of British Architects; a painting by A.J.Oliver was exhibited *RA*, 1819 (346), and *International Exhibition*, London, 1874 (189), lent by E.W.Pugin; a painting by W.D.M.Measor was exhibited *RA*, 1862 (606); a lithograph by J.Lynch, after a drawing by J.Nash, is reproduced B.Ferrey, *Recollections of A.N.W.Pugin and A.Pugin* (1861), frontispiece; Pugin's monument, with an effigy, is in St Augustine's, Ramsgate, reproduced *Architectural Review*, CIII (1948), 165.

PURVES J. Home

Soldier, nephew of the Countess of Blessington.

4026 (49) See *Collections:* 'Drawings of Men About Town, 1832–48' by Count A.D'Orsay, p 557.

PUSEY Edward Bouverie (1800–82)

Regius professor of Hebrew at Oxford, and canon of Christ Church; with Keble and Newman, one of the leaders of the Oxford movement; unlike Newman, remained a staunch Anglican; concerned with ineffectual schemes for church union in his later years.

1059 Black and white chalk on bluish-grey toned paper, 28¼ × 22 inches (71·7 × 56 cm), by GEORGE RICHMOND, *c* 1890. PLATE 766

Inscribed by the artist, on a piece of headed notepaper ('20, York Street,/Portman Square. W.'), *attached to the back-board:* George Richmond R.A/Study for the Picture of Dʳ. Pusey now at Christ Church/ Oxford/(Posthumous)/ Loan by G.Richmond

Collections: The artist, purchased from his executors, 1896.

Exhibitions: VE, 1892 (381).

This is a study for the picture of Pusey by Richmond of 1890 at Christ Church, listed by Mrs R. Lane Poole, *Catalogue of Oxford Portraits*, III (1925), 101–2, and in the artist's 'Account Book' (photostat copy, NPG archives), p 104. Richmond also executed a marble bust of Pusey in 1883 (based on a death-mask taken by Dr Acland, and various prints and sketches), now at Pusey House, Oxford, exhibited *RA*, 1884 (1787), listed in the 'Account Book', pp 98–9; a study for this bust is also at Pusey House, and a plaster cast is at Keble College, Oxford, listed by Mrs Poole, III, 285. The marble is shown in a photograph of Richmond in his studio of 1883 (example in NPG).

Henry Clarke, in a letter of 2 February 1923 (NPG archives), claimed to possess an earlier painting of Pusey by Richmond, which he had bought in Oxford in 1883–4. According to Clarke, a committee was formed during Pusey's lifetime in order to commission a portrait, which they wanted to present to him. Pusey refused to sit, and the project fell through. Richmond, hearing of it, however, came down to Oxford and surreptitiously sketched Pusey in the cathedral, hoping to win the commission. The committee reprimanded Richmond, who disposed of the portrait privately, and it came into Clarke's possession; a similar account was published in the *Manchester Guardian*, 17 October 1924. The story sounds improbable, for Richmond was an established artist, who had no need to obtain commissions in this underhand way. He would hardly have been asked to paint Pusey in 1890, if he had caused trouble on an earlier occasion.

2594 Water-colour and body colour on blue-toned paper, 12 × 7 inches (30·5 × 17·8 cm), by APE (CARLO PELLEGRINI), 1875. PLATE 767

Signed in pencil (bottom right): Ape *Inscribed on the mount:* Rev. E. B. Pusey, D.D./January 2, 1875

Collections: Thomas Bowles; *Vanity Fair* Sale, Christie's, 7 March 1912 (lot 632); Thomas Cubitt, purchased from him, 1933.

This is one of a large collection of original studies for *Vanity Fair*, which were all owned and specially mounted by the first proprietor of the magazine, Thomas Bowles. Those in the NPG will be discussed collectively in the forthcoming Catalogue of Portraits, 1860–90. The water-colour of Pusey was published in *Vanity Fair* as a coloured lithograph on 2 January 1875, as no. 95 of 'Men of the Day', with the title, 'High Church'.

Description: Grey hair and beard, black eyebrows and skull-cap. Dressed in a black suit and shoes and a black gown.

4541 (4, recto) With his family and others at breakfast. Pencil, pen and ink on paper, $7\frac{1}{8} \times 8\frac{7}{8}$ inches (18·1 × 22·6 cm), by MISS CLARA PUSEY, 1856. PLATE 770

Inscribed in ink (top left): No 1 Christ Church express *and dated in pencil (lower right):* 13th September/ 1856. *Below is part of a letter from Clara Pusey, and pasted onto the drawing are type-written labels identifying the figures.*

Collections: See *Collections:* 'Sketches of the Pusey Family and their Friends, *c* 1856' by Miss C. Pusey, p 563.

This drawing of the Puseys at breakfast, and a companion one of the Herberts on the reverse, was sent by Clara Pusey to Alice Herbert, as an amusing commentary on the friendship between themselves and their families. The inscription is given at length in the discussion of the collection as a whole. The figures at the table are, from left to right, a servant, the Rev J. Brine, Alice Herbert, Clara Pusey, Edith Pusey, Robinson, Mrs Brine, Sidney Pusey and Dr Edward Pusey.

4541 (7, recto) Two separate drawings, pencil and pen and ink on paper, $2\frac{3}{8} \times 1\frac{1}{2}$ inches (6 × 3·7 cm), and $4 \times 1\frac{3}{4}$ inches (9·8 × 4·5 cm), respectively, by MISS CLARA PUSEY, *c* 1856. PLATES 768, 769

Collections: As for 4541 (4, recto) above.

The second of these two drawings by Pusey's niece shows him preaching, and the first officiating at a service. Another drawing of Pusey's head by Clara Pusey is at Pusey House, Oxford.

4541 (9, recto) See entry for Bishop Samuel Wilberforce, p 505.

ICONOGRAPHY A painting by Miss R. Corder is at Pusey House, Oxford, reproduced H. P. Liddon, *The Life of Edward Bouverie Pusey* (1893–7), I, frontispiece; copies are at Christ Church and Keble College, Oxford; a painting by an unknown artist is at Christ Church, and so is a drawing by an unknown artist (showing him as an undergraduate); a drawing by the Rev E. Kilvert is reproduced Liddon, II, frontispiece; a drawing by A. Macdonald (after death) was engraved by G. J. Stodart for Liddon, IV, frontispiece; there are several engravings and photographs in the NPG, and one was published as a woodcut *ILN*, II (1843), 410; a drawing or engraving by an unknown artist is reproduced *Architectural Review*, XCVIII (1945), 150.

PYE *John* (*1782–1874*)

Landscape engraver; engraved several plates after J. M. W. Turner, who approved of his work; introduced several technical developments; one of the most influential engravers of his period.

2190 Plaster cast, painted bronze, 28⅛ inches (71·4 cm) high, of a bust by H. B. BURLOWE, 1831. PLATE 771
Incised on the back of the shoulders: JOHN PYE./HB [*in monogram*] Burlowe/Sculptor./1831.
Collections: The sitter; by descent to his great-niece, Miss Edith Walker and presented by her executors, 1928.

ICONOGRAPHY An engraving by J. H. Robinson, after W. Mulready, was published J. Pye, *Patronage of British Art* (1845), p 362; there are several photographs in the NPG, and another is reproduced as a woodcut *ILN*, LXIV (1874), 185.

RAE *John* (*1813–93*)

Arctic explorer; a surgeon in the Hudson's Bay Company; took part in the expeditions searching for Sir John Franklin; discovered evidence of his fate from the natives on the west coast of Boothia, and obtained the government reward of £10,000.

1213 Oil on millboard, 15⅛ × 13¼ inches (38·4 × 33·6 cm), by STEPHEN PEARCE, c 1853. PLATE 772
Collections: See *Collections:* 'Arctic Explorers' by S. Pearce, p 562.
Exhibitions: RA, 1853 (598); *Royal Naval Exhibition*, Chelsea, 1891 (56).

This portrait was engraved by J. Scott, published Graves & Co, 1858 (example in NPG), the engraving exhibited *RA*, 1858 (1133). There is a replica in the Scottish NPG (no. 1488), commissioned by the sitter, and presented by his descendant, Dr J. H. Tallant.

Description: Healthy complexion, brown eyes, brown hair and beard. Dressed in a dark stock, white shirt, and brown cape or cloak lined with white fur. The red and blue fringe beyond the fur-lining is probably decorative, but might just possibly be some kind of academic hood. The background colour is predominantly light grey.

ICONOGRAPHY A painting by an unknown artist is in the Stromness Town Hall, Orkney; a bust by G. Maccallum was exhibited *RA*, 1866 (1044); a daguerreotype by Beard is reproduced as a woodcut *ILN*, XXV (1854), 421; there is a photograph by E. Dallas of Edinburgh (example in NPG); a woodcut (probably after a photograph) was published *The Graphic*, XLVIII (1893), 130; there is a reproduction of a photograph from an unidentified magazine (cutting in NPG).

RAMSAY *Fox Maule (Lord Panmure), 11th Earl of Dalhousie.* See DALHOUSIE

RAMSAY *Sir James Andrew Broun, 1st Marquess of Dalhousie.* See DALHOUSIE

RAMSBOTTOM *John* (*d 1845*)
MP for Windsor.
54 See *Groups:* 'The House of Commons, 1833' by Sir G. Hayter, p 526.

RAMSDEN *John Charles* (*1788–1837*)
MP for Malton.
54 See *Groups:* 'The House of Commons, 1833' by Sir G. Hayter, p 526.

RASSAM *Christian*
Nestorian christian; British vice-consul at Mosul, 1839–79.
2515 (89) See *Collections:* 'Drawings of Prominent People, 1823–49' by W. Brockedon, p 554.

RATHBONE *Richard*
Slavery abolitionist.
599 See *Groups:* 'The Anti-Slavery Society Convention, 1840' by B. R. Haydon, p 538.

RAWSON *Mrs*
Slavery abolitionist.
599 See *Groups:* 'The Anti-Slavery Society Convention, 1840' by B. R. Haydon, p 538.

REDGRAVE *Richard* (*1804–88*)

Subject and landscape painter; painted chiefly genre and subject pictures, and landscapes; closely connected with the government schools of design; surveyor of the Crown pictures; with his brother, Samuel Redgrave, wrote an important history of English painting, and a dictionary of artists.

2464 Oil on canvas, 7 × 6 inches (17·9 × 15·2 cm), by HIMSELF. PLATE 773 & 355
Collections: The sitter; by descent to his son (?), Gilbert Redgrave, and presented by him, 1930.
Literature: Reproduced as a woodcut *Art Journal* (1850), p 48.

This was presented at the same time as a woodcut of Samuel Redgrave.

Description: Healthy complexion, dark greyish eyes, brown hair. Dressed in a dark stock, white shirt, and black, medieval-looking cape. Red background.

4486 Brown wash on paper, $5\frac{7}{8} × 4\frac{1}{2}$ inches (14·9 × 11·5 cm), by SIR FRANCIS GRANT, 1872. PLATE 774
Inscribed in the artist's hand, along the bottom of the drawing: Richard Redgrave Esq RA FG[t] 1872
Collections: John Woodward; J. S. Maas & Co, purchased from them, 1966.
Literature: NPG Annual Report, 1966–7 (1967), p 28.

Redgrave was on the RA hanging committee in 1872, during the presidency of Grant, and it was probably at the RA that this drawing was executed.

ICONOGRAPHY A self-portrait, showing Redgrave as a young man, was in the collection of John Oram, 1903; a painting by A. S. Cope is in the Aberdeen Art Gallery, exhibited *RA*, 1880 (324); a miniature by Mrs

North was exhibited *RA*, 1872 (1333); a terra-cotta bust by R.A.Ledward was exhibited *RA*, 1882 (1632); there are several photographs in the NPG, and two are reproduced as woodcuts *ILN*, XVIII (1851), 219, and *Magazine of Art* (1892), p27.

REEVES *John Sims* (*1818–1900*)

Singer; first public appearance, 1839; studied in Paris and Milan; first appearance in oratorio, 1848; thereafter ranked as the premier English tenor; professor of singing at the Guildhall School of Music.

2764 Oil on canvas, $94\frac{1}{2} \times 58\frac{1}{4}$ inches (240 × 148 cm), by ALESSANDRO OSSANI, 1863. PLATE 776

Signed and dated (bottom right): A. Ossani 1863 *Inscribed in ink on a printed Roberson label on the back of the stretcher:* Sig Ossani/Sims Reeves Esq/99. . . . *[illegible]* Terrace [?] *The canvas was supplied by Charles Roberson of 99 Long Acre, but this is not the address on the label.*

Collections: The sitter, purchased from his daughter-in-law, Mrs Herbert Sims Reeves, 1935.

Exhibitions: Victorian Era Exhibition, 1897, 'Music and Drama Section, Music Historical Sub-Division' (54).

Literature: Reproduced C.E.Pearce, *Sims Reeves* (1924), facing p174.

This portrait shows Reeves in the title-role of the opera 'Fra Diavolo, ou l'Hôtellerie de Terraciné' by Auber and Scribe (libretto). He first played the part early in 1852 at Drury Lane, with instantaneous success. He revived the opera on several occasions, and always spoke of it as one of his favourite parts. '"*It is musical*", *he once said*, "*so full of point, so interesting; it always gives you something to think about*"' (Pearce, p167). Reeves was also responsible for changing the finale of the opera. Instead of 'Fra Diavolo' being limply led away by his captors, Reeves substituted an escape for the romantic robber, a leap from a precipice, recapture, and eventual death while seizing a member of his band whom he believed had betrayed him (see Pearce, p174). This was generally admitted at the time to be a vast improvement. The NPG portrait has suffered from bituminous cracking and various damages, and is at present in an uncleaned and unrestored state.

Description: Dark complexion, greyish-brown eyes, dark brown hair and moustache. Dressed in a white shirt, with a gold chain and locket around his neck, dark green coat and breeches with a red border and red ribbons at the knees, a red cloak, a multi-coloured, fringed sash, a gold ring with a green stone, white stockings, and brown sandals. Holding a dark green hat with a red feather and a peacock feather and green and red ribbons. Leaning on a brown wood and steel flint-lock gun. Standing in a predominantly brown and green landscape. Pale greyish-blue sky.

1962 (g) Pencil and water-colour on paper, $8\frac{1}{8} \times 5\frac{7}{8}$ inches (20·6 × 14·8 cm), by ALFRED EDWARD CHALON. PLATE 775

Collections: Purchased from Mrs Florence A.Blake, 1922.

Description: Dark eyes, brown hair. Dressed in a purple neck-tie, white shirt, black coat with red rose in his left buttonhole, and bluish-grey trousers. Background brown colour washes.

This is one of a small collection of water-colours of opera singers and others by Chalon, which will be collectively discussed in the forthcoming Catalogue of Portraits, 1790–1830.

ICONOGRAPHY Popular prints are listed in L.A.Hall, *Catalogue of Dramatic Portraits in the Theatre Collection of the Harvard College Library*, III (Cambridge, Mass, 1932), 400–1 (some examples in NPG and British Museum); a lithograph by C.Baugniet of 1850, an engraving by A.Crowquill, two photographs (of 1858 and 68), and a drawing of Reeves and his musical companions in 1892 by L.Calkin for the *Sphere*, are reproduced C.E.Pearce, *Sims Reeves* (1924), frontispiece, and facing pp142, 204, 252 and 294; a water-colour by Spy (Sir

L.Ward) was in the *Victorian Era Exhibition*, 1897, 'Drama and Music Section, Historical Sub-Division' (159), reproduced as a coloured lithograph in *Vanity Fair*, 10 May 1890; a bronze bust by E.W.Wyon is in the collection of E.F.Croft-Murray; there are two caricature lithographs in the NPG, one for the *Hornet* of 1871; there are also several photographs in the NPG; woodcuts after photographs were published *ILN*, XXXI (1857), 128, XCVIII (1891), 633, and CIII (1893), 344.

REID *Sir John Rae, Bart* (*1791–1867*)

MP for Dover.

54 See *Groups:* 'The House of Commons, 1833' by Sir G.Hayter, p526.

REINAGLE *Ramsay Richard* (*1775–1862*)

Portrait, landscape and animal painter; son of the artist, Philip Reinagle; RA, 1823; compelled to resign after exhibiting the work of another painter as his own, 1848.

3025 Identity doubtful. Coloured chalk on grey-toned paper, $5\frac{1}{8} \times 4\frac{1}{8}$ inches (13·1 × 10·4 cm), attributed to HIMSELF. PLATE 777

Collections: M.H.Spielmann, presented by him, 1939.

This was presented together with several other drawings of artists. The basis of the identification, which was supplied by the donor, is unknown.

ICONOGRAPHY A painting by P.Reinagle (the sitter's father), previously attributed to the Rev M.W. Peters (with his two sisters, all as children), is in the Bearsted Collection, Upton House (National Trust), exhibited *RA*, 1788 (181), and *Bicentenary Exhibition*, RA, 1968–9 (24); two paintings called Reinagle by himself were in the collection of the Rev W.C.Hall, 1946; one of these is the painting now identified as Sir George Nicholls by Reinagle (NPG 4807); Reinagle appears in a water-colour of 'Students at the British Institution, 1807' by A.E.Chalon in the British Museum, where there is also a self-portrait drawing; a death-mask is in the Bodleian Library, Oxford, reproduced *Connoisseur*, CXXII (1948), 23.

RENNIE *George* (*1791–1866*)

Civil engineer; eldest son of the engineer John Rennie (1761–1821); entered into partnership with his brother, Sir John Rennie (1794–1874); had a considerable business as a railway engineer; also superintended the mechanical business of the firm.

3683 Miniature, water-colour on ivory, $4\frac{3}{4} \times 3\frac{1}{2}$ inches (12·2 × 8·7 cm), by JOHN LINNELL, 1824. PLATE 778
Signed (middle left): I.L.F./1824

Inscribed in pencil on the back of the card on which the miniature is mounted: Portrait of/George Rennie Esqʳ/Painted from the Life by/John Linnell/Septᵗ 1824 –/London/No 6 Cirencester Place/Fitzroy Sqʳ
Also in the miniature case, at the back, was one of Rennie's visiting cards, inscribed: portrait [*ink*] Mᴿ RENNIE, [*printed*]/by Linnell, [*ink*]/39, Wilton Crescent, Belgrave Square. [*printed*]

Collections: Apparently the miniature listed by Story (see below), as in the collection of the Misses A. and E.Rennie, 1892; Ewart Wheeler, purchased from him, 1949.

Literature: A.T.Story, *Life of John Linnell* (1892), II, 255; D.Foskett, *British Portrait Miniatures* (1963), p176, reproduced facing.

This superb miniature by Linnell is the only recorded portrait of Rennie. The town in the background has not been identified. Linnell was living at 6 Cirencester Place in 1824.

Description: Fresh complexion, blue eyes, light brown hair. Dressed in a white shirt and stock, light

yellowish waistcoat and brown coat; behind is a view of a light bluish river and grey bridge, and a brown building with green bushes in the foreground and a grey church tower beyond on the left. Blue sky.

REYNOLDS *Joseph* (*1769–1859*)

Slavery abolitionist.

599 See *Groups:* 'The Anti-Slavery Society Convention, 1840' by B.R.Haydon, p538.

RICHARDS *Sir George Henry* (*1820–96*)

Admiral and hydrographer to the Admiralty; commanded the 'Assistance' in search of Sir John Franklin, 1852; fellow of the Royal Society.

923 Oil on canvas, $15\frac{1}{4} \times 12\frac{3}{4}$ inches (38.7×32.4 cm), by STEPHEN PEARCE, 1865. PLATE 779

Apparently signed on the back (now no longer visible): Stephen Pearce

Collections: See *Collections:* 'Arctic Explorers' by S.Pearce, p562.

Exhibitions: RA, 1866 (577); *Royal Naval Exhibition*, Chelsea, 1891 (48).

Richards is wearing the full-dress uniform (1864 pattern) either of a naval captain with over three years service or of a commodore (1st or 2nd class), the Arctic Medal (1818–55), and the China Medal (1842 or 57). The date of the portrait was provided by the artist in a memorandum of *c* 1899 (NPG archives).

Description: Blue(?) eyes, brown hair and whiskers. Dressed in a dark stock, white shirt, dark blue naval uniform with gold-braided collar and epaulettes, gilt buttons, and two silver stars, one with grey ribbon (left), the other crimson with yellow edges. Background colour greenish-brown.

ICONOGRAPHY The only other recorded likenesses of Richards are, a painting by F.G.Cotman exhibited *RA*, 1883 (1484), and photographs by Beard and by Vandyk, reproduced as woodcuts *ILN*, xx (1852), 336, and cix (1896), 709.

RICHARDSON *Sir John* (*1787–1865*)

Arctic explorer and naturalist; accompanied Franklin on two Arctic expeditions, 1819 and 1825; inspector of hospitals, 1840; conducted a search for Franklin, 1847; published books on polar exploration, and other works.

909 Oil on millboard, $14\frac{7}{8} \times 12\frac{1}{2}$ inches (37.8×32 cm), by STEPHEN PEARCE, 1850. PLATE 781

Apparently signed and dated on the back (now no longer visible): Stephen Pearce 1850 (*the date subsequently amended to 1851*).

Collections: See *Collections:* 'Arctic Explorers' by S.Pearce, p562.

Exhibitions: Royal Naval Exhibition, Chelsea, 1891 (32).

Literature: S.Pearce, *Memories of the Past* (1903), pp53–5.

This is a study for Pearce's group of the 'Arctic Council, 1851' (see NPG 1208 below), as well as an autonomous portrait in its own right. In the finished group, Richardson is shown three-quarter length pointing at charts on the table, but his pose is identical with that in this study. He is wearing the undress naval uniform (1856 pattern) of a staff surgeon (i.e. a surgeon with over twenty years service). In a memorandum of *c* 1899 (NPG archives), Pearce records painting the NPG study in 1850. The date on the back of the portrait was originally recorded as 1850, but was later amended to 1851 for reasons unknown. Most of the studies for the 'Arctic Council' were executed in 1850.

Description: Healthy complexion, blue eyes, light brown hair. Dressed in a black stock, white shirt and dark blue naval uniform with gold-braided epaulettes. Background colour darkish brown.

888 Plaster cast, 8 inches (20·3 cm) diameter, of a medallion by BERNHARD SMITH, 1842. PLATE 780

Incised (round left rim): JOHN RICHARDSON M.D.

Collections: Sir Joseph Dalton Hooker, presented by him, 1892.

Exhibitions: Cumbrian Characters, Abbot Hall Art Gallery, Kendal, 1968 (60).

Another cast of this medallion is in the Scott Polar Research Institute, Cambridge, signed and dated '1842'; it is listed by J. W. Goodison, *Catalogue of Cambridge Portraits* (1955), p 185 (344); a third also dated 1842 is in the collection of the Rev Edward Alston. A related marble medallion of 1844 is in the Linnean Society, London. The type was exhibited *RA*, 1844 (1346). The NPG medallion was presented at the same time as a companion medallion of Sir James Ross by Smith (NPG 887). Hooker thought they were both done in 1844, presumably the date when he purchased them, and described them as *'first-rate likenesses'* (letter of 25 January 1892, NPG archives).

1208 See *Groups:* 'The Arctic Council, 1851' by S. Pearce, p 548.

ICONOGRAPHY The only other recorded portraits of Richardson are: a painting by T. Phillips at the Royal Naval Hospital, Gosport, Hants, exhibited *RA*, 1829 (64), engraved by E. Finden, published J. Murray, 1828 (example in NPG); a painting by an unknown artist, in an Arctic landscape (reproduction in the NPG); and an engraving by H. Adlard, reproduced Rev J. McIlraith, *The Life of Sir John Richardson* (1969), frontispiece.

RICHARDSON *Robert* (*1779–1847*)

Physician and traveller; accompanied the 2nd Earl of Belmore and party on a tour of Europe and the Middle East; claims to have been the first Christian traveller admitted to Solomon's mosque; published *Travels,* 1822.

2515 (26) Black and red chalk on brown-tinted paper, $15\frac{1}{8} \times 10\frac{7}{8}$ inches (38·4 × 27·7 cm), by WILLIAM BROCKEDON, 1826. PLATE 782

Dated (bottom left): 2.6.26

Collections: See *Collections:* 'Drawings of Prominent People, 1823–49' by W. Brockedon, p 554.

Accompanied in the Brockedon Album by an undated letter from the sitter. This is the only recorded portrait of Richardson.

RICHMOND AND LENNOX *Charles Gordon Lennox, 5th Duke of* (*1791–1860*)

Statesman.

54 See *Groups:* 'The House of Commons, 1833' by Sir G. Hayter, p 526.

See also forthcoming Catalogue of Portraits, 1790–1830.

RICHMOND *George* (*1809–96*)

Portraitist and subject painter; son of the artist Thomas Richmond; inspired by William Blake; friend of Samuel Palmer and John Linnell; established a large and very successful practice as a portrait water-colourist and draughtsman; later painted in oil; portrayed many of his famous contemporaries.

2509 Oil on millboard, $13\frac{7}{8} \times 10\frac{3}{4}$ inches (35·3 × 27·4 cm), by HIMSELF, 1853. PLATE 783

Inscribed on the backboard in pencil: Portrait of one of my best/Friends (GR) by Himself/ 1853/Feby 1st. 1855

Collections: The sitter; presented by his daughter-in-law, Mrs Walter Richmond, in accordance with the wishes of her husband, 1931.

Exhibitions: Ruskin and his Circle, Arts Council, London, 1964 (231).

Literature: Possibly the portrait listed in Richmond's 'Account Book' (photostat copy, NPG archives), p68, under 1858 ('*My own head small size*').

The board on which this portrait is painted has the label of Paulmier, Versailles, so it may possibly have been painted in France. Other self-portraits are recorded as follows:

1. *1830.* Miniature. Collection of the Richmond family, exhibited *Special Exhibition of Portrait Miniatures,* South Kensington Museum, 1865 (1042), reproduced A. M. W. Stirling, *The Richmond Papers* (1926), facing p34.

2. *c1830.* Drawing. Collection of Sir Geoffrey Keynes (plate 784).

3. *1840.* Painting. Collection of Kerrison Preston, exhibited *British Self-Portraits,* Arts Council, 1962 (79).

4. *c1840.* Painting. Collection of Miss A. E. Kennedy, 1939.

5. *c1840.* Drawing. Ashmolean Museum, Oxford.

6. *c1850.* Painting. Sold Christie's, 16 July 1965 (lot 25), bought Buxton.

7. *1854.* Painting (in a black Renaissance cap). City Museum and Art Gallery, Birmingham, listed in Richmond's 'Account Book' (photostat copy, NPG archives), p61, under 1854, and p82, under 1867.

8. *1858.* Painting. Listed in 'Account Book', p68, under 1858. Possibly the NPG picture.

9. *1860.* Painting. Sold Christie's, 19 November 1965 (lot 7), bought Bernard, listed in 'Account Book', p71, under 1860.

10. *1863.* Painting. Collection of the Richmond family, listed in 'Account Book', p76, under 1863, engraved by W. Holl (example in NPG), for the 'Grillions Club' series.

11. *1867.* Painting (in DCL cap and gown). Formerly Painter-Stainers Company, London, presented by the artist, 1887 (destroyed by fire, 1941), listed in 'Account Book', pp81–2, under 1867. I am grateful to Mrs M. Lake of the Painter-Stainers Company, who provided a pre-war photograph of the Livery Hall, in which the portrait of Richmond is just visible.

12. *1868.* Painting (in DCL cap and gown). Uffizi Gallery, Florence. Very similar to no. 11, and probably derived from it, but in reverse.

Description: Healthy complexion, brownish eyes and hair. Dressed in a dark stock, white collar, and dark coat. Background colour dark green and brown.

2157 Plaster cast, painted cream, 26 inches (66 cm) high, of a bust by J. DENHAM, *c* 1834. PLATE 785
Incised marks on the back of the shoulders, possibly intended to read: Richmond
Collections: The sitter; presented by his daughter, Lady Kennedy, 1927.

According to the donor (letter of 24 March 1927, NPG archives), this bust was executed when Richmond was about twenty-five. The artist was apparently a friend.

2157a Electro-type in bronze, 25¾ inches (65·4 cm) high, of NPG 2157 above.
Collections: Commissioned by the trustees of the NPG, in case of damage to the original plaster.

1833 See *Groups:* 'Private View at the Royal Academy, 1888' by H. J. Brooks, in forthcoming Catalogue of Portraits, 1860–90.

ICONOGRAPHY A painting by W.E.Miller was in the collection of the artist, 1930, exhibited *Fifth Summer Exhibition*, New Gallery, 1892 (7); a drawing by S.Palmer of 1827, showing Richmond engraving 'The Shepherd' (presumably 'Abel the Shepherd' by Richmond, exhibited *RA*, 1825 (333)), was in the collection of Mrs W.Richmond, 1947, reproduced G.Grigson, *Samuel Palmer – the Visionary Years* (1947), plate 23; a drawing called Richmond (probably correctly) by S.Palmer of 1827 was sold Sotheby's, 4 April 1968 (lot 86), reproduced in catalogue; a drawing by Sir W.B.Richmond is reproduced A.M.W.Stirling, *The Richmond Papers* (1926), p371; a drawing called Richmond (probably correctly) is in the NPG reference files; there is an engraving by Stephenson and Royston, after a portrait by W.Lovatt of 1842 (example in NPG); there are several photographs in the NPG; two are reproduced A.M.W.Stirling facing pp72 and 402; and two as woodcuts in *ILN*, XLIX (1866), 216, and *Magazine of Art* (1896), p296.

RICKMAN *John* (*1771–1840*)

Statistician, assistant clerk of the House of Commons.

54 See *Groups:* 'The House of Commons, 1833' by Sir G.Hayter, p526.

RIPON *Frederick John Robinson, 1st Earl of* (*1782–1859*)

Prime minister, 1827–8.

54 See *Groups:* 'The House of Commons, 1833' by Sir G.Hayter, p526.

RIPPON *Cuthbert*

MP for Gateshead.

54 See *Groups:* 'The House of Commons, 1833' by Sir G.Hayter, p526.

ROBERTS *Sir Abraham* (*1784–1873*)

General; served in India and Afghanistan for much of his career; general, 1864; father of the 1st Earl Roberts.

3928 Oil on canvas, stuck on to board, 30 × 24½ inches (76·2 × 62·2 cm), by an UNKNOWN ARTIST. PLATE 786
Inscribed in ink on the back of the stretcher: General Sir Abraham Roberts – G.C.B. 1784–1873
Collections: The sitter; by descent to his widow, Lady Roberts, and presented by her executor, General Sir Ewan Miller, 1955.

This was presented at the same time as the portrait of Earl Roberts by J.S.Sargent (NPG 3927). It is the only recorded portrait of Sir Abraham Roberts.

Description: Healthy complexion, grey eyes, grey hair and whiskers. Dressed in a white collar, dark blue uniform with gold-braided epaulettes, with a crimson sash and a crimson and gold-striped sash, a dark green and red ribbon supporting the medal at his neck, and other multi-coloured orders and medals. Background colour dark brown.

ROBERTS *David* (*1796–1864*)

Painter; began his career as a scene-painter to a travelling company; established his reputation with pictures of ruins, architecture, landscapes, and scenes in Europe and the Middle East; published several series of lithographs; a popular and prolific artist.

1371 Coloured chalk on brown, discoloured paper, 14 × 9⅛ inches (35·6 × 23·2 cm), by an UNKNOWN ARTIST.
PLATE 787

Inscribed in pencil (*lower right*): Henry Hoppner Meyer *and below:* David Roberts

Collections: B.B.Brook; purchased from him, 1904.

Literature: Reproduced *Connoisseur*, CXXII (1948), 22.

Presented at the same time as a drawing of John Gibson (NPG 1370). They are identical with two drawings in the British Museum, for which see L.Binyon, *Catalogue of Drawings by British Artists*, III (1902), 105. Although apparently signed by H.H.Meyer, they cannot be by him; the drawing of Gibson represents him as an old man and cannot be earlier than 1855; Meyer died in 1847, and had ceased to exhibit by 1834.

3182 (7) Pencil on paper, $4\frac{1}{2} \times 3\frac{1}{2}$ inches ($11 \cdot 4 \times 8 \cdot 8$ cm), by CHARLES WEST COPE, *c* 1862. PLATE 788

Inscribed (*lower right*): Dd. Roberts/RA

Collections: See *Collections:* 'Drawings of Artists, *c* 1862' by C.W.Cope, p 565.

ICONOGRAPHY A painting by Sir D.Macnee is in the Royal Scottish Academy, and so is a painting by Sir J.Watson Gordon, exhibited *Royal Scottish Academy*, 1855 (468); an oil-sketch by Sir E.Landseer was in the Landseer Sale, Christie's, 9 May 1874 (lot 268), exhibited *Landseer Exhibition*, RA, 1874 (302); a painting by himself (in oriental costume) was in the collection of his granddaughter, Mrs Stanton, 1955; a painting by R.S. Lauder (in Eastern dress) was exhibited *RA*, 1840 (169), and *International Exhibition*, London, 1874 (174); a painting by J.J.Napier was exhibited *RA*, 1861 (560), and *VE*, 1892 (172); a painting by J.Simpson was exhibited *SKM*, 1868 (608), and *International Exhibition*, London, 1874 (69); a self-portrait drawing is in the Newport Museum and Art Gallery, Monmouthshire, exhibited *David Roberts and Clarkson Stanfield Exhibition*, Guildhall Art Gallery, London, 1967 (102); a drawing by Clarkson Stanfield is in the Royal Academy, exhibited Guildhall, London, 1967 (100); a drawing by T.Bridgford is in the Royal Hibernian Academy, Dublin, exhibited *RA*, 1843 (1069); a bronze medallion by G.Morgan was issued by the Art Union, 1875 (examples in NPG and Scottish NPG), a model and example of which were exhibited *RA*, 1873 (1476), and 1874 (1470); there is a lithograph by C.Baugniet of 1844 (example in NPG), a smaller version of which was published Day and Son, 1855 (example in NPG), a woodcut was published *ILN*, XXX (1857), 418; there are several photographs in the NPG; a photograph by D.O.Hill is in the British Museum; there is an engraving by D.Pound after a photograph by J. Watkins (example in NPG), and another photograph by Watkins is reproduced as a woodcut *ILN*, XLV (1864), 580.

ROBINSON *George Richard* (*1781–1850*)

MP for Worcester.

54 See *Groups:* 'The House of Commons, 1833' by Sir G.Hayter, p 526.

ROBSON *Thomas Frederick* (*1822?–64*)

Actor; his real name 'Thomas Robson Brownhill'; established a reputation in burlesque and farce, and in some serious parts.

1877 Coloured chalk on brown, discoloured paper, $14\frac{3}{8} \times 10\frac{3}{4}$ inches ($36 \cdot 6 \times 27 \cdot 3$ cm) mounted as a smaller oval, by ARTHUR MILES, 1861. PLATE 789

Signed and dated (*lower right*): Arthur Miles 11th March 1861

Collections: Purchased from Mrs F.Robson, 1920.

Exhibitions: Victorian Era Exhibition, 1897, 'Music and Drama Section' (595).

ICONOGRAPHY Popular prints are listed in L.A.Hall, *Catalogue of Dramatic Portraits in the Theatre Collection of the Harvard College Library*, III (Cambridge, Mass, 1932), 431–3; two portraits, one a water-colour, were in the *Victorian Era Exhibition*, 1897, 'Music and Drama Section' (99 and 585); there are photographs in the NPG and the Garrick Club, London, and others are reproduced *ILN*, XLV (1864), 208 (as a woodcut), and F.Whyte, *Actors of the Century* (1898), facing p 140.

ROCHE *William* (*1775–1850*)

MP for Limerick.

54 See *Groups:* 'The House of Commons, 1833' by Sir G. Hayter, p 526.

ROEBUCK *John Arthur* (*1801–79*)

Politician; barrister, 1831; MP from 1832; disciple of Bentham; advocated advanced and radical policies; defended his status as an 'independent member'; in later life became increasingly conservative.

1777 Oil on canvas, 30 × 24¾ inches (76·2 × 62·9 cm), by an UNKNOWN ARTIST. PLATE 790

Collections: The sitter; presented by him to Dr Black; Dr Campbell; by descent to Mr Rayner; F. H. Clarke, purchased from him, 1916.

The identification and provenance were provided by the vendor in a letter of 17 June 1916 (NPG archives); on comparison with other portraits of Roebuck, NPG 1777 appears to be rightly named. It was said to have been painted by G. F. Watts, a very dubious attribution. A portrait of Jeremy Bentham, with the same provenance, and also said to be by Watts, was offered at the same time, but declined.

Description: Pink complexion, light brown eyes and hair. Dressed in a green (?) neck-tie, white stock and shirt, yellow-brown waistcoat, and brown coat with darker brown velvet collar. Seated in a reddish chair. Background colour brown.

2695 Water-colour and coloured chalk on blue-toned paper, 11¾ × 7 inches (29·9 × 17·8 cm), by APE (CARLO PELLEGRINI), 1874. PLATE 791

Signed (*lower right*): Ape *Inscribed on the mount:* Mʳ. J. A. Roebuck, M.P./April 11, 1874.

Collections: Thomas Bowles; *Vanity Fair* Sale, Christie's, 8 March 1912 (lot 657); W. R. Cryer, purchased from him, 1934.

This is one of a large collection of original studies for *Vanity Fair*, which were all owned and specially mounted by the first proprietor of the magazine, Thomas Bowles. The studies in the NPG will be discussed collectively in the forthcoming Catalogue of Portraits, 1860–90. The water-colour of Roebuck was published as a coloured lithograph in *Vanity Fair* on 11 April 1874, as 'Statesmen', no. 167, with the title 'tear em'.

Description: Greyish-white hair. Dressed in a black neck-tie, white shirt, black coat, trousers and shoes.

54 See *Groups:* 'The House of Commons, 1833' by Sir G. Hayter, p 526.

ICONOGRAPHY A painting by H. W. Pickersgill is in the National Gallery of Canada, Ottawa, exhibited *RA*, 1860 (152), and *VE*, 1892 (268); a painting by R. Smith is owned by the Corporation of Sheffield; a marble bust by T. Smith is in the Mappin Art Gallery, Sheffield, and a painting by G. F. Watts was formerly there (destroyed Second World War), engraved by H. Robinson, as after J. Watts, published J. Saunders, 1840 (example in NPG); a painting by J. Green is in the Guildhall, Bath, exhibited *RA*, 1833 (377); ten caricature drawings by J. Doyle are in the British Museum; busts by E. G. Papworth junior and T. W. Rowe were exhibited *RA*, 1859 (1359), and 1874 (1623); there is a lithograph cartoon by 'Faustin' (example in NPG); woodcuts were published *ILN*, I (1842), 224, X (1847), 324, LXXV (1879), 549 (after a picture by Wyllie), and *The Graphic*, IX (1874), 384; there are four photographs in the NPG, and another is reproduced as a woodcut *ILN*, XXVI (1855), 480; there is an engraving by D. J. Pound, after a photograph by Mayall (example in NPG); a woodcut was published in an unidentified newspaper or magazine (cutting in NPG).

ROGERS *Samuel* (*1763–1855*)

Poet, banker and connoisseur.

342,3 See *Groups:* 'The Fine Arts Commissioners, 1846' by J. Partridge, p 545.

1916 See *Groups*: 'Samuel Rogers, Mrs Norton (Lady Stirling-Maxwell) and Mrs Phipps, *c* 1845' by F. Stone, p 545.

2772 See *Collections*: 'The Clerk Family and Others' by Miss J. Wedderburn, p 560.

See also forthcoming Catalogue of Portraits, 1790–1830.

ROGET *Peter Mark* (*1779–1869*)

Physician and savant; influential in medical research, physiology, sanitation, mechanics, calculation, language and many other fields; published numerous papers and books, including *Thesaurus of English Words and Phrases* in 1852.

2515 (79) Black and red chalk on green-tinted paper, $14\frac{1}{4} \times 10\frac{1}{2}$ inches (36·2 × 26·6 cm), by WILLIAM BROCKEDON, 1835. PLATE 792

Dated (lower left): 27.11.35

Collections: See *Collections*: 'Drawings of Prominent People, 1823–49' by W. Brockedon, p 554.

Accompanied in the Brockedon Album by a letter from the sitter, dated 15 November 1852.

ICONOGRAPHY The only other recorded portraits of Roget are: a drawing by E. U. Eddis (listed as unlocated in *Catalogue of Portraits. Royal College of Physicians* (1926), p 59), engraved by J. Cochran, published Whittaker & Co, 1839 (example in NPG), for Pettigrew's *Memoirs of Physicians, Surgeons, etc*, and lithographed by W. D[rummond], published T. McLean (example in NPG), for 'Athenaeum Portraits'; and a photograph by E. Edwards of Baker St (example in NPG).

ROLFE, *Robert Monsey, Baron Cranworth*. See CRANWORTH

ROMER *Isabella Frances* (*d 1852*)

Writer of miscellaneous works; married Major Hamerton, 1818, but separated from him in 1827, and resumed her maiden name; published books on mesmerism, travel and biography.

4026 (50) Pencil and black chalk, with touches of red, on paper, $12 \times 8\frac{7}{8}$ inches (30·5 × 22·6 cm), by COUNT ALFRED D'ORSAY, 1847. PLATE 793

Signed and dated (lower right): d'Orsay fecit/8 July 1847 *Autograph in ink (below)*: Isabella F Romer

Collections: See *Collections*: 'Drawings of Men About Town, 1832–48' by Count A. D'Orsay, p 557.

This drawing was lithographed by R. J. Lane (example formerly in Lichfield Collection), listed in Lane's 'Account Books' (MS, NPG archives), III, 3, as completed on 17 July 1847.

ICONOGRAPHY The only other recorded portrait of Miss Romer is a painting by Sir F. Grant, engraved by J. Brown, published R. Bentley, 1848 (example in NPG).

RONALDS *Sir Francis* (*1788–1873*)

Electrician and meteorologist; invented a telegraphic instrument and a perspective tracing instrument; honorary director of the Meteorological Observatory, Kew, 1843–52; devised a system of automatic registration for meteorological instruments by means of photography; knighted, 1871; left a large library devoted to electrical subjects.

1095 Oil on canvas, $24\frac{1}{4} \times 20$ inches (61·6 × 50·8 cm), by his nephew, HUGH CARTER, *c* 1870. PLATE 794

Signed in monogram (bottom right): HC

Inscribed on a damaged label on the back of the stretcher: [*Sir Francis Ronald?*] Esq. FR[*S*]/by Hugh Carter/46 Bedford Gardens Campden Hill *Inscribed on a label formerly on the back of the frame:* Sir Francis Ronald/FRS./by Hugh Carter R.I.

Collections: The artist; presented by him, 1897.

Literature: Reproduced as a woodcut *ILN*, LVI (1870), 464.

The artist apparently made a copy of this portrait for himself, shortly before presenting the original (see letters from him, NPG archives). A coat of arms is faintly visible in the top left-hand corner. This or another version was recorded in the collection of the artist's sister, Mrs Samuel Carter (*Dictionary of National Biography*).

Description: Brownish eyes, grey hair. Dressed in a black neck-tie, white shirt, and black waistcoat and coat. Background colour very dark brown.

1075, See *Groups:* 'Men of Science, *c* 1808' by J. F. Skill, Sir J. Gilbert, and W. and E. Walker, in the
75a forthcoming Catalogue of Portraits, 1790–1830.

ICONOGRAPHY A marble bust by E. Davis is in the Royal Society, London, exhibited *RA*, 1871 (1259); another marble bust by Davis of 1876 is in the Institution of Electrical Engineers, London; the portrait of Ronalds in 'Men of Science' (see above) was apparently based on a photograph (no example located).

ROSS *Sir James Clark* (*1800–62*)

Rear-admiral and explorer; entered navy, 1812; accompanied Sir William Parry on various voyages of exploration in the 1820s; discovered magnetic pole on expedition with Felix Booth, 1831; commanded expedition for geographical discovery in the Antarctic, 1839-43; led expedition in search of Sir John Franklin, 1848-9.

913 Oil on millboard, $15\frac{1}{8} \times 12\frac{3}{4}$ inches (38·4 × 32·3 cm), by STEPHEN PEARCE, 1850. PLATE 797
 Collections: See *Collections:* 'Arctic Explorers, 1851' by S. Pearce, p 562.

 Literature: S. Pearce, *Memories of the Past* (1903), pp 55–6.

 This is a study for Pearce's group of the 'Arctic Council, 1851' (NPG 1208 below), as well as an autonomous portrait in its own right. The pose, features and costume are the same in both. The date of the NPG study was provided by the artist in a memorandum of *c* 1899 (NPG archives). Pearce also made use of this study, supplemented by further sittings, for his three-quarter length portrait of Ross of 1870 at the National Maritime Museum, Greenwich, exhibited *RA*, 1871 (26), and *Royal Naval Exhibition*, Chelsea, 1891 (33), reproduced Pearce, *Memories of the Past*, facing p 54, engraved by A. Scott, published Graves (example in NPG).

 Description: Healthy complexion, brown eyes, grey hair. Dressed in a black stock, white shirt, yellow waistcoat, black coat. A blue handkerchief (?) with white spots appears from under the coat on the right side at the bottom. Background colour light greenish-brown.

2515 (99) Black and red chalk, with touches of Chinese white, on greenish-grey tinted paper, $14\frac{5}{8} \times 10\frac{3}{8}$ inches (37·1 × 26·5 cm), by WILLIAM BROCKEDON, 1848. PLATE 796
 Dated (*lower left*): 14.3.48
 Collections: See *Collections:* 'Drawings of Prominent People, 1823–49' by W. Brockedon, p 554.

887 Plaster cast, 8 inches (20·3 cm) diameter, of a medallion by BERNHARD SMITH, 1843. PLATE 795
 Incised (*round left rim*): CAPT. JAMES CLARKE ROSS RN
 Collections: Sir Joseph Dalton Hooker, presented by him, 1892.

Other casts of this medallion are in the Scott Polar Research Institute, Cambridge, signed and dated '1843', listed by J. W. Goodison, *Catalogue of Cambridge Portraits* (1955), pp 185–6 (345), and in the Royal Geographical Society, London. A related marble medallion of 1844 is in the Linnean Society, London. The type was exhibited *RA*, 1844 (1344). Bernhard Smith's brother was a lieutenant on one of the ships of Ross' expedition to the Antarctic (information in a letter from the donor of 2 March 1892, NPG archives). The NPG medallion was presented at the same time as a companion medallion of Sir John Richardson (NPG 888). Hooker thought they were both done in 1844, presumably the date when he purchased them; he described them as '*first-rate likenesses*' (letter of 25 January 1892, NPG archives).

1208 See *Groups:* 'The Arctic Council, 1851' by S. Pearce, p 548.

ICONOGRAPHY A painting by H. W. Pickersgill is in the National Maritime Museum, Greenwich, exhibited *RA*, 1848 (366), engraved by A. Fox, published T. Fielder, 1850 (example in NPG); also in the Maritime Museum is a painting by J. R. Wildman of 1833–4, engraved by R. M. Hodgetts, published Colnaghi, 1835, and by H. Cook, published Colnaghi, 1840 (examples in NPG), and a painting by an unknown artist; the latter is possibly the picture owned by Mr Chatto, 1913, or a version after it; a painting by an unknown artist of 1833 is in the Royal Geographical Society, London, exhibited *Royal Naval Exhibition*, Chelsea, 1891 (34); in the same collection there is a water-colour by an unknown artist, a reproduction of a drawing by an unknown artist, and an engraving by F. Holl of 1860, after a drawing by G. Richmond of 1849 (drawing not recorded in Richmond's 'Account Book'); there is a lithograph by J. Negelen (example in NPG), and a lithograph by T. H. Maguire of 1851 (example in NPG), published G. Ransome, 1852, for 'Ipswich Museum Portraits'; a photograph is in the NPG; a woodcut was published *ILN*, III (1843), 268.

ROSS *Sir John* (*1777–1856*)

Arctic explorer; went in search of North-West Passage, 1818, and 1829–33; published accounts of voyages, gold medallist of geographical societies of London and Paris, 1834; consul at Stockholm, 1839–46; went on expedition in search of Sir John Franklin, 1850.

314 Oil on canvas, 52 × 43¾ inches (132·1 × 111·1 cm), by JAMES GREEN, 1833. PLATE 798

Collections: The artist; purchased from his son, B. R. Green, 1870.

Exhibitions: RA, 1834 (330).

According to the vendor (letter of 13 July 1870, NPG archives), this portrait was painted immediately on Ross' return from his last expedition; this must refer to Ross' expedition of 1829–33 in search of the North-West Passage, and not to his later expedition in search of Franklin, 1850–1. Ross returned to England from the Arctic in October 1833. He is shown in the full dress naval uniform of a commander of the period, 1833–43; the cuff is not quite correct, but follows a fairly common variant form. The cap is apparently unofficial. Ross is wearing the class badge of the Swedish order of the Sword, awarded him for his service in the Baltic.[1]

Description: Healthy complexion, blue eyes, sandy hair. Dressed in a black stock, white shirt, and dark blue naval uniform, with red and gold-braided collar, epaulettes and cuffs, a white and gold order suspended from a blue and yellow silk ribbon, a blue and gilt sword belt, in which is tucked a fur cap (?), and a large fur skin draped over one shoulder and around the back of his body. He is holding in one hand a brown glove, and a blue cap with a red lining and a gilt band and tassel, and in the other a brown wooden spear tipped with steel. He is leaning on the brown wooden prow of a rowing boat, secured by a rope. He is shown against a white Arctic landscape.

[1] Information on uniform and the order kindly communicated by P. G. W. Annis of the National Maritime Museum, Greenwich.

ICONOGRAPHY There are several versions of the same portrait-type by B.R. Faulkner; the first of these appears to have been the three-quarter length painting offered to the NPG by P.H. Simpson, 1874, probably the portrait engraved by R. Hart, published Captain J. Ross, 1834 (example in NPG), for his *Appendix to the Narrative of a Second Voyage in Search of a North-West Passage*, II (1835), frontispiece (the engraving shows a three-quarter length pose), and possibly the portrait owned by the sitter, the head of which was lithographed by R. J. Lane, published J. Dickinson, 1834 (example in NPG); a second half-length version by Faulkner is in the Scottish NPG, recorded and sketched by G. Scharf, 1874, 'TSB' (NPG archives), XIX, 53; a third half-length version, wrongly attributed to Sir W. Beechey, was in the collection of Major A.S. Grant, apparently the portrait sold at Christie's, 24 June 1960 (lot 110), bought Frost and Reed; a different portrait-type by Faulkner was exhibited *SKM*, 1868 (419), and possibly *RA*, 1834 (261); the *SKM* portrait shows Ross with the order of the Bath, awarded him in 1834; Faulkner exhibited another painting *RA*, 1829 (87), probably one of the versions already listed.

A painting and a water-colour by unknown artists are in the Royal Geographical Society, London, the former exhibited *Royal Naval Exhibition*, Chelsea, 1891 (30); a painting by an unknown artist of *c* 1833 is in the National Maritime Museum, Greenwich; a painting by an unknown artist was in the collection of Charles Dawson, 1896; a painting by Lambert was in the collection of Mrs Lambert, 1870, sketched by G. Scharf, 'TSB' (NPG archives), XV, 82; a painting by an unidentified artist (signed 'TRW') was sold Christie's, 9 December 1876 (lot 27), sketch in Scharf's NPG sale catalogue; a painting by J. Hayter was exhibited *RA*, 1834 (306), probably the painting recorded and sketched by G. Scharf, 1868, 'TSB' (NPG archives), XI, 41; a painting by J. Brassington was exhibited *RA*, 1836 (35); miniatures by Mrs Hamilton and H. Hervé were exhibited *RA*, 1834 (822), and 1843 (721); there is a bronze medallion by David d'Angers of 1836 (example in Musée des Beaux-Arts, Angers); there is an engraving by W. Watkins, after T. H. Shepherd, published J. Saunders, 1835 (example in NPG), and a lithograph by H. Gouldsmith, published Gouldsmith, 1833 (example in NPG); an engraving by D. Maclise (example in NPG) was published *Fraser's Magazine*, IX (1834), facing 64, as no. 44 of Maclise's 'Gallery of Illustrious Literary Characters'; there are several popular engravings and lithographs in the NPG; a photograph is reproduced as a woodcut *ILN*, XXIX (1856), 275.

ROSS *Sir William Charles* (*1794–1860*)

Miniature-painter; studied at RA schools; assistant to the miniaturist Andrew Robertson; established a large and extremely successful practice; painted members of the royal family and leading aristocratic families.

1946 Miniature, water-colour on ivory, $5 \times 3\frac{7}{8}$ inches (12·6 × 9·8 cm), by HUGH ROSS, *c* 1843. PLATE 799

Inscribed on a damaged label, formerly on the back of the picture: Portrait [*Damaged*] te/Sir W[*illiam*] Charles Ross RA/Painted by his Brother Hugh Ross/Lent for Exhibition/by Hugh Ross Esqʳ/38 Fitzroy Square/W *Inscribed on another label:* Specimens of the late Hugh/Ross from Mrs H Ross/Strand Cottage/Strand on the Green/Chiswick Middl[*esex*]

Collections: Baroness Burdett-Coutts; purchased from the Burdett-Coutts Sale, Christie's, 11 May 1922 (lot 395).

Exhibitions: RA, 1843 (839).

Literature: J. J. Foster, *British Miniature Painters* (1898), p 93, reproduced plate L*; reproduced *Connoisseur*, CXXII (1948), 21.

It is not clear to what exhibitions the labels refer; the sitter moved to 38 Fitzroy Square in 1845.

Description: Healthy complexion, brown eyes, greyish hair and whiskers. Dressed in a white stock and neck-tie, white shirt, with green and pearl (?) buttons, blue waistcoat, black coat, and dark over-garment. Background colour brown.

ICONOGRAPHY A painting by T.H.Illidge was exhibited *RA*, 1846 (93) and *SKM*, 1868 (561), reproduced *Art Journal* (1849), p48; a painting by Mrs J.M.Rogers was exhibited *RA*, 1856 (365); a drawing by himself was in the collection of D.Guérault, 1922 (tracing of drawing in NPG); a drawing by Count A.D'Orsay was sold at Sotheby's, 13 February 1950 (lot 216), bought Colnaghi; a miniature by himself is in the Victoria and Albert Museum, reproduced G.C.Williamson, *The History of Portrait Miniatures* (1904), II, plate LXXVII; another, or possibly the same miniature, was in the *Exhibition of Portrait Miniatures*, Burlington Fine Arts Club, 1889, case X (52), lent by J.Whitehead; a miniature by Mrs Dalton is in the Royal Collection; a miniature by W.Ross (his father), with his brother and sisters, was exhibited *RA*, 1809 (690); a miniature by Miss M.Ross was exhibited *RA*, 1834 (830); busts by F.W.Smith, E.W.Wyon, and P.Park were exhibited *RA*, 1824 (1035), 1840 (1123), and 1844 (1352); woodcuts, after photographs by J.Watkins, were published *ILN*, XXX (1857), 418, and XXXVI (1860), 113.

ROSSLYN *James St Clair Erskine, 2nd Earl of* (1762–1837)

General and statesman.

54 See *Groups:* 'The House of Commons, 1833' by Sir G.Hayter, p526.

599 See *Groups:* 'The House of Lords, 1820' by Sir G.Hayter in forthcoming Catalogue of Portraits, 1790–1830.

ROTHSCHILD *Lionel Nathan de* (1808–79)

Banker; educated at Göttingen; succeeded to the chief management of the Rothschild banking-house in England, 1836; involved in many national and private financial transactions; elected MP, 1847, but not allowed to sit owing to his refusal as a Jew to take the oath; re-elected repeatedly and finally allowed to sit, 1858; interested in several philanthropic movements.

3838 Oil on canvas, 19¾ × 15 inches (50·2 × 38·1 cm), by MORITZ DANIEL OPPENHEIM, 1835. PLATE 800

Signed and dated (bottom right): M Oppenheim/1835

Inscribed on a label on the back of the stretcher: Prof. Moritz Oppenheim, 1800–1882/Portrait of Lionel Nathan Rothschild,/painted 1836

Collections: The artist; by descent to his grandson, Alfred Oppenheim, and purchased from him, 1952.

Exhibitions: Exhibition of Anglo-Jewish Art and History, Victoria and Albert Museum, 1956 (473).

According to the vendor (letter of 4 July 1952, NPG archives), this portrait was probably painted in the autumn of 1835, when the young Rothschild was staying with his uncle in Frankfurt. The visit resulted in Rothschild's engagement to his cousin, Charlotte Rothschild. Oppenheim was a prominent Frankfurt artist.

Description: Healthy complexion, dark eyes, dark brown hair. Dressed in a black stock and neck-tie, white shirt, black waistcoat, coat and trousers. Seated in a wooden arm-chair, covered in red material, holding a blue handkerchief on his knee. Blue sky, and brown and green landscape on the left, purple curtain on the right, with a grey wall in the bottom right-hand corner.

ICONOGRAPHY A painting by Sir F.Grant (hunting with his three brothers) is in the Rothschild Collection, Ascott, listed in Grant's 'Sitters Book' (copy of original MS, NPG archives), under 1841, reproduced *Country Life*, CVIII (1950), 827; a group painting of 'Baron Lionel de Rothschild Introduced into the House of Commons, 1858' by H.Barraud is in the Rothschild collection; a water-colour by his wife of *c*1835 was in the collection of Emma, Lady Rothschild, 1935; a marble bust by R.C.Belt was exhibited *RA*, 1880 (1531); a lithograph by W.Richardson was published Hartwig (example in NPG); woodcuts were published *ILN*, XI (1847), 65 and 76, and a photograph by Barraud and Jerrard is reproduced as a woodcut *ILN*, LXXIV (1879), 565; a lithograph, after a photograph by O.Rejlander, was published 1877 (example in NPG), for Cassell's 'National Portrait Gallery'.

ROTHWELL *Richard* (*1800–68*)

Painter; trained in Dublin, where he worked for a time; member of the Royal Hibernian Academy, 1826; subsequently moved to London, where he was assistant to Sir Thomas Lawrence; exhibited at RA from 1830, chiefly portraits and fancy pictures, for which he was noted.

3182 (8) Pen and ink and black chalk on paper, $3\frac{1}{2} \times 3\frac{3}{8}$ inches (8·7 × 8·4 cm), by CHARLES WEST COPE, *c* 1862. PLATE 801

Inscribed (*bottom left*)*:* Rothwell

Collections: See *Collections:* 'Drawings of Artists, *c* 1862' by C. W. Cope, p 565.

ICONOGRAPHY There are self-portraits in the National Gallery of Ireland, Dublin, and the Ulster Museum, Belfast; six more are listed by W. G. Strickland, *Dictionary of Irish Artists* (1913), II, 307; a self-portrait, not apparently recorded by Strickland, was in the Chicago Institute of Arts, 1901, on loan from Mrs M. Macabe; a miniature by Mrs M. B. Green was exhibited *R A*, 1833 (772), and a bust by E. Richardson, *R A*, 1847 (1432).

ROUS *Henry John* (*1795–1877*)

Admiral and sportsman; entered navy, 1808; captain, 1825; retired, 1835; devoted himself to horse-racing; steward of Jockey Club; tory MP, 1841; admiral, 1863.

2957 See entry for George Payne, p 365, and plate 716.

ICONOGRAPHY A painting by H. Weigall is in the Jockey Club, London, exhibited *R A*, 1866 (161), and so is a marble bust by M. Raggi, exhibited *R A*, 1878 (1427); a water-colour by an unknown artist was exhibited *Victorian Era Exhibition*, 1897, 'Historical Section, sports sub-section' (147); a drawing by Count A. D'Orsay of 1842 is owned by the Department of the Environment, lithographed by R. J. Lane, published J. Mitchell (example in NPG); a marble bust by R. C. Belt was exhibited *R A*, 1878 (1442), and a terra-cotta statuette by M. Raggi, *R A*, 1878 (1502); a caricature lithograph by 'A T E' (A. Thompson) was published *Vanity Fair*, 7 May 1870; an engraving by J. Brown was published Baily Bros, 1860 (example in NPG), reproduced *British Sports and Sportsmen* (1908), I, facing 31; a woodcut (example in NPG) was published *Illustrated Sporting News*, 23 June 1866; a lithograph was published 1877 (example in NPG), for Cassell's 'National Portrait Gallery'; a woodcut was published *ILN*, LXX (1877), 613.

RUSSELL *Lord Charles James Fox* (*1807–94*)

M P for Bedfordshire.

54 See *Groups:* 'The House of Commons, 1833' by Sir G. Hayter, p 526.

RUSSELL *Lord John Russell, 1st Earl* (*1792–1878*)

Statesman; son of the 6th Duke of Bedford; whig MP from 1813; strenuous advocate of reform; member of the cabinet from 1832; prime minister, 1846-52, and 1865-6; one of the most influential statesmen of his period.

895 Oil on canvas, $17\frac{3}{4} \times 15$ inches (45·1 × 38·2 cm), by GEORGE FREDERICK WATTS, *c* 1851. PLATE 805

Collections: The artist, presented by him, 1892 (see appendix on portraits by G. F. Watts in forthcoming Catalogue of Portraits, 1860–90).

Exhibitions: V E, 1892 (286).

Literature: [Mrs] M. S. Watts, *George Frederic Watts* (1912), I, 113–14; 'Catalogue of Works by G. F. Watts', compiled by Mrs M. S. Watts (MS, Watts Gallery, Compton), II, 138.

Although Russell appears older in this oil sketch than in the drawing (NPG 2635 below), it must date from the same period; Mrs Watts mentions it as one of her husband's first portraits of his famous contemporaries in a section of her biography dealing with 1851. In her catalogue she records that sittings took place at Holland House. In a letter of 14 February 1892 (NPG archives), Watts himself wrote: '*I think it was like*'.

Description: Brown hair and whiskers with greyish wisps. Dressed in a dark neck-tie, white collar, dark coat, holding a white piece of paper. Background colour brown. The hand is unfinished.

1121 Oil on canvas, 79¼ × 44 inches (201·3 × 111·9 cm), by SIR FRANCIS GRANT, 1853. PLATE 808, 809
Inscribed in ink, on a damaged label on the back of the stretcher (referring to the RA exhibition of 1854): No. 1/Portrait of the/John Russell/Francis Gra[*nt*]/No 27 Sussex-p[*lace*]/Regents-[*park*]/ Lo[*ndon*]. . . . *Also on the back is the VE exhibition label.*

Collections: By descent to the 11th Duke of Bedford, and presented by him, 1898.

Exhibitions: RA, 1854 (193); *Art Treasures of the United Kingdom*, Manchester, 1857, 'Modern Masters' (580); *VE*, 1892 (119).

Literature: Sir F. Grant, 'Sitters Book' (copy of original MS, NPG archives), under 1853; [D. Colnaghi and A. McKay], *Catalogue of Pictures, Miniatures, Drawings, and Busts at Woburn Abbey* (1868), p ccxxii; G. Scharf, *Catalogue of the Collection of Pictures at Woburn Abbey* (1877), p 167 (1889 and 1890 editions), p 179; A. M. Tavistock and E. M. S. Russell, *Biographical Catalogue of the Pictures at Woburn Abbey* (1890), I, 81–2.

Russell is holding a paper inscribed, 'REFORM-BILL/1854'; the leather-bound book on the table is inscribed, 'STATE/PAPERS/1853', and one of the books on the chair, 'REPORT–RAMSGATE/H.C./1850'. No price is listed against the portrait in Grant's 'Sitters Book', so he may possibly have presented it to the sitter or his family. The portrait was engraved by J. Faed (erroneously inscribed 'Fade' on the print), published H. Graves, 1854 (example in NPG). A small oil study was in the collection of the Earl of Strafford, Wrotham. Another version, or possibly the same picture, was recorded in the collection of Lord Russell, Lord Stairs, 1875, by G. Scharf, 'SSB' (NPG archives), XCII, 75.

Description: Sallow complexion, dark grey(?) eyes, brown hair. Dressed in a black stock and neck-tie, fastened by a gold and amber(?) pin, white shirt, black waistcoat, with a gold watch-chain, black trousers and coat. Standing in front of a red-covered table, with a brown book and white papers on the right. A black dispatch box and two green and blue books are on the gilt and red-covered chair on the right. Two white documents are on the floor. Background colour dark brown and sage.

2635 Coloured chalk on buff-coloured paper, 24 × 20 inches (61 × 50·8 cm), by GEORGE FREDERICK WATTS, c 1852. PLATE 806
Signed (lower right): G. F. Watts

Collections: The sitter, bequeathed by his daughter, Lady Agatha Russell, 1933 (see appendix on portraits by G. F. Watts in forthcoming Catalogue of Portraits, 1860–90).

Exhibitions: Presumably the drawing exhibited *RA*, 1852 (1001).

678 Marble bust, 27½ inches (69·8 cm) high, by JOHN FRANCIS, 1832. PLATE 803
Incised on the back, below the shoulders: LORD JOHN RUSSELL. 1832

Collections: By descent to the 9th Duke of Bedford, and presented by him, 1883.

Exhibitions: RA, 1833 (1150).

Other busts of Russell by Francis are listed in the iconography below.

4291 Terra-cotta head, painted brown, 2½ inches (6·3 cm) high, by SIR JOSEPH EDGAR BOEHM, c 1880. PLATE 807

Inscribed in ink on a label, formerly on the base of the bust: Lord John Russell/Earl Russell 1792–1878 Prime Minister/Terra Cotta sketch by/Sir Edgar Boehm for/Statue in Westminster/given Lady Arthur Russell/by Alfred Gilbert who/was Boehm's legatee/1892

Collections: The artist; Alfred Gilbert; Lady Arthur Russell, presented by her daughter, Miss Flora Russell, 1962.

Literature: NPG Annual Report, 1962–3 (1963), p4.

This is a preliminary study of Russell's head for the full-length marble statue in the Palace of Westminster, the model for which was exhibited *RA*, 1880 (1590), reproduced *Magazine of Art* (1880), p336. A related marble bust is in Westminster Abbey. The donor commissioned three plaster casts of the NPG head.

54 See *Groups:* 'The House of Commons, 1833' by Sir G. Hayter, p526.

342, 3 See *Groups:* 'The Fine Arts Commissioners, 1846' by J. Partridge, p545.

999 See *Groups:* 'The House of Lords, 1820' by Sir G. Hayter, in forthcoming Catalogue of Portraits, 1790–1830.

1125 See *Groups:* 'The Coalition Ministry, 1854' by Sir J. Gilbert, p550.

ICONOGRAPHY This does not include caricatures, popular prints, or photographs, of which there are several examples in the NPG; caricature drawings by J. Doyle are in the British Museum.

As a boy Painting by Sir W. Beechey. Collection of the Duke of Bedford.

1804 'Woburn Sheepshearing' by G. Garrard. Collection of the Duke of Bedford.
Engraved J. C. Stadler, and T. Morris, published Garrard, 1811 (example in British Museum).

c1815 Painting by Sir G. Hayter (in Van Dyck costume). Ilchester Collection. Another version is at Longleat (plate 802), attributed to Sanders by G. Scharf, 'SSB' (NPG archives), LXV, 60.

1820 'The House of Lords, 1820' by Sir G. Hayter (NPG 999 above).

c1820 'The House of Commons', water-colour by R. Bowyer, A. Pugin, and J. Stephanoff. Houses of Parliament. Engraved by J. Scott (example in Houses of Parliament).

1831 Engraving by D. Maclise (example in NPG), published *Fraser's Magazine*, IV (1831), facing 65, as no. 15 of Maclise's 'Gallery of Illustrious Literary Characters'. Pencil study: Victoria and Albert Museum (plate 804).

c1831 Drawing by J. Slater. Exhibited *RA*, 1831 (603).
Lithographed by F. C. Lewis, published W. B. Cocke, 1825 (example in NPG), for the 'Grillions Club' series.

1832 Painting by Sir G. Hayter. Collection of the Duke of Bedford.
Exhibited *RA*, 1832 (401). Engraved by J. Bromley, published Colnaghi, 1836 (example in NPG). Small version: collection of the Earl of Bradford, recorded by Mary Boyle, *Biographical Catalogue of the Portraits at Weston, the Seat of the Earl of Bradford* (1888), p211. Oil study: Hayter Sale, Christie's, 21 April 1871 (lot 662). A copy by a pupil, presumably after this portrait, was in the same sale (lot 555).

1832 Bust by J. Francis (NPG 678 above).

c1832 'William IV Holding a Council', lithograph by J. Knight (example in British Museum).

c1832 Lithograph by T. C. Wilson, published S. Gans (example in NPG).

1832 'The Reform Banquet, 1832' by B. R. Haydon. Collection of Lady Mary Howick.
Etched by F. Bromley, published J. C. Bromley, 1835 (example in NPG). Lithograph by B. R. Haydon, after his original study of Russell, published T. McLean, 1833 (example in NPG).

1833 'The House of Commons, 1833' by Sir G. Hayter (NPG 54 above). Oil study: Hayter Sale, Christie's, 21 April 1871 (lot 513).

c1836 Statue by J. Francis. Exhibited *RA*, 1836 (1098).

1837 'The First Council of Queen Victoria, 1837' by Sir D. Wilkie. Royal Collection. Exhibited *RA*, 1838 (60). Engraved by C. Fox, published F. G. Moon, 1839 (example in British Museum).

1838 Bust by J. Francis. Royal Collection.

c1839 Marble bust by P. Hollins. Exhibited *RA*, 1839 (1384). Engraved by W. Holl, after a drawing by H. Room, published J. Saunders (example in NPG), for 'Political Reformers'.

1841 'Coronation of Queen Victoria', print by G. Baxter, published Baxter, 1841 (example in British Museum).

c1841 Bust by J. Ternouth. Exhibited *RA*, 1841 (1318).

1842 Lithograph by E. Desmaisons, published A. H. and C. E. Baily, 1842 (example in NPG).

c1842 Miniature by T. Carrick. Colnaghi's, 1939, from the Pretyman family. Exhibited *RA*, 1842 (840). Reproduced as a woodcut *ILN*, XXVI (1855), 393. Engraved by S. Bellin, published G. Routledge, 1844, by W. Holl, and (bust only) anonymously (examples in NPG). Enamel copy by H. Bone exhibited *RA*, 1844 (995), possibly the enamel type at Althorp. According to a memorandum (NPG archives), the Pretyman miniature was dated 1843; this may be a mistake or the miniature may have been a later version of the original.

c1843 Bust by R. Westmacott. Collection of the Duke of Bedford. Exhibited *RA*, 1843 (1530).

1843–4 Woodcuts published *ILN*, II (1843), 73, and IV (1844), 101.

1846 'The Fine Arts Commissioners, 1846' by J. Partridge (NPG 342, 3 above). Oil study: Partridge Sale, Christie's, 15 June 1874 (lot 70).

1847 Coloured lithograph by A. Blaikley, published Blaikley, *Pictures of the People from Prince to Peasant* (1847), facing p25.

1847 Woodcut published *ILN*, XI (1847), 65.

1847 Anonymous lithograph (equestrian), published T. McLean, 1847 (example in NPG).

c1848 Marble bust by J. Francis. Exhibited *RA*, 1848 (1405).

1851 'The Royal Commissioners for the Great Exhibition, 1851' by H. W. Phillips. Victoria and Albert Museum. Exhibited *Victorian Era Exhibition*, 1897, 'Historical Section' (8).

1851 Woodcut published *ILN*, XVIII (1851), 137.

c1851–2 Painting and drawing by G. F. Watts (NPG 895, and 2635 above).

1853 Painting by Sir F. Grant (NPG 1121 above).

1854 'The Coalition Ministry, 1854' by Sir J. Gilbert (NPG 1125 above).

c1854 Bust by unknown artist. Crystal Palace Portrait Collection, 1854.

1855 Painting by L. Dickinson (retouched from life, 1867). Collection of E. Kersley, 1944.

1858 'The Marriage of the Princess Royal, 1858' by J. Phillip. Royal Collection. Engraved by A. Blanchard, published E. Gambart, 1865 (example in British Museum).

1858 'Baron Lionel de Rothschild Introduced into the House of Commons, 1858' by H. Barraud. Rothschild Collection.

c1858 Marble bust by Baron C. Marochetti. Exhibited *RA*, 1858 (1311). Possibly the bust now in the collection of Mrs Gilbert Russell.

1860 'The House of Commons, 1860' by J.Phillip. Houses of Parliament.
Engraved by T.O.Barlow, published T.Agnew, 1866 (example in NPG).

1864 'Queen Victoria presenting a copy of the Bible to an Indian', engraving by W.H.Simmons, after T.J.Barker, published R.Turner, 1864 (example in British Museum). A related oil sketch is in the Hermitage, Leningrad.

1864 'The Intellect and Valour of Great Britain', engraving by C.G.Lewis, after T.J.Barker, published J.G.Browne, Leicester, 1864 (example in NPG); keyplate, published Browne, 1863 (example in British Museum).

1865 'Lady Waldegrave's Drawing-Room, Strawberry Hill' by L.Desanges. Collection of the Earl of Waldegrave.

c1867 Marble bust by C.B.Birch. Guildhall Art Gallery (destroyed 1940).
Exhibited *RA*, 1867 (1161). Plaster cast: collection of G.von Pirch (the artist's nephew), 1924.

1869 Caricature lithograph by 'Ape' (C.Pellegrini), published *Vanity Fair*, 5 June 1869.
The original water-colour is owned by Anthony Russell.

c1871 Painting by J.Sant. Exhibited *RA*, 1871 (364).

1878 Woodcut published *ILN*, LXXII (1878), 517.

c1879 Etching by L.Lowenstam after a photograph (example in NPG). Exhibited *RA*, 1879 (1275).

1880 Statue by Sir J.E.Boehm. Palace of Westminster. Related marble bust, Westminster Abbey.
Study (see NPG 4291 above).

c1880 Terra-cotta bust by J.Adams-Acton. Exhibited *RA*, 1880 (1639).

1883 Bronze bust by T.Woolner. Sydney, Australia.
Another cast was offered to the NPG by the bronze founder, 1893.

c1893 Painting by J.R.Dicksee. Exhibited *RA*, 1893 (1375).

Undated Painting by J.Archer (after a photograph). Reform Club, London.

Undated Drawing by A.Wivell. Collection of the Earl of Crawford and Balcarres.

Undated Drawing apparently by J.Luntley. Collection of W.G.Jones, 1928.

Undated Small bust by an unknown artist. Collection of the Earl of Liverpool, 1905.

RUSSELL *Charles* (*1786–1856*)
MP for Reading.

54 See *Groups:* 'The House of Commons, 1833' by Sir G.Hayter, p526.

RUSSELL *William Congreve* (*1778–1850*)
MP for Worcestershire East.

54 See *Groups:* 'The House of Commons, 1833' by Sir G.Hayter, p526.

SABINE *Sir Edward* (*1788–1883*)

General; joined army, 1803; astronomer to various Arctic expeditions; made voyages to conduct experiments in magnetic inclination; appointed a scientific adviser to the admiralty, 1828; assisted in magnetic survey of British islands; general secretary of British Association; treasurer and later president of the Royal Society; repeated magnetic survey, 1861; general, 1870; member of various learned societies.

907 Oil on millboard, $14\frac{7}{8} \times 12\frac{5}{8}$ inches (37·8 × 32 cm), by STEPHEN PEARCE, 1850. PLATE 810
Inscribed on the back of the picture in the artist's hand: The original study,/for the Historical Picture of the Arctic Council/of/Col. Sabine, R.A. &c – &c – &c/by Stephen Pearce.

Collections: See *Collections:* 'Arctic Explorers' by S. Pearce, p 562.

Exhibitions: Royal Naval Exhibition, Chelsea, 1891 (37).

Literature: S. Pearce, *Memories of the Past* (1903), pp 57–8.

This is a study for Pearce's group of the 'Arctic Council' (see NPG 1208 below), as well as an autonomous portrait in its own right. The pose and features are identical in both, except that Sabine is shown wearing uniform in the group. The date of the NPG portrait was provided by the artist in a memorandum of *c* 1899 (NPG archives). Pearce also painted a three-quarter length portrait of Sabine in 1855, based on the NPG study and further sittings, which is now in the Royal Society, London, engraved by J. Scott, published H. Graves, 1859 (example in NPG). In his memorandum Pearce records painting a replica of this last portrait for Lady Sabine; he also records a fourth unidentified portrait of Sabine (*Memories*, p 58).

Description: Healthy complexion, bluish eyes, grey hair and whiskers. Dressed in a black stock, white shirt and brown coat. Background colour brown. There are several paint losses in the bottom left-hand corner.

1208 See *Groups:* 'The Arctic Council' by S. Pearce, p 548.

ICONOGRAPHY A painting by G. F. Watts is owned by the Royal Artillery, London, exhibited *RA*, 1875 (188), and *VE*, 1892 (29); a painting by D. Y. Blakiston was exhibited *RA*, 1854 (182); a bust by J. Durham is in the Royal Society, London, probably that exhibited *RA*, 1860 (1060); a bust by Miss L. Pasley was exhibited *RA*, 1880 (1628); a lithograph by T. H. Maguire was published G. Ransome, 1852 (example in NPG), for 'Portraits of Honorary Members of Ipswich Museum'; woodcuts were published *ILN*, IX (1846), 184, LV (1869), 353 (after a photograph), and LXXXIII (1883), 13; there is a photograph by W. Walker in the NPG.

SAMS *Joseph (1784–1860)*
Slavery abolitionist.

599 See *Groups:* 'The Anti-Slavery Society Convention, 1840' by B. R. Haydon, p 538.

SANDYS *Arthur Moyses William Hill, 2nd Baron (1792–1860)*
MP for County Down.

54 See *Groups:* 'The House of Commons, 1833' by Sir G. Hayter, p 526.

SANDYS *Arthur Marcus Cecil Hill, 3rd Baron (1798–1863)*
MP for Newry.

54 See *Groups:* 'The House of Commons, 1833' by Sir G. Hayter, p 526.

SANFORD *Edward Ayshford (1794–1871)*
MP for Somerset West.

54 See *Groups:* 'The House of Commons, 1833' by Sir G. Hayter, p 526.

SASS *Henry (1788–1844)*
Painter; exhibited at RA from 1807; travelled in Italy, 1815–7, and published an account of his journey; opened a drawing school in Bloomsbury, London, which he conducted till 1842; several famous artists received their first training there.

1456 (24) Pencil on paper, 2 × 2¼ inches (5 × 5·6 cm), by CHARLES HUTTON LEAR, *c* 1839. PLATE 811

Inscribed (lower right): H Sass Esq^r

Collections: See *Collections:* 'Drawings of Artists, *c* 1845' by C.H.Lear, p 561.

This drawing must have been executed shortly before Lear left Sass' academy in 1839. Lear entered the Royal Academy schools on 21 December 1839, recommended by Sass.

ICONOGRAPHY Two paintings by himself were exhibited *RA*, 1813 (24), and 1824 (276); another called Sass was in the collection of C.Rich, 1938; a drawing by D.Maclise was in the Drake Sale, Christie's, 24 May 1892 (lot 209), exhibited *Burlington Fine Arts Club Exhibition*, 1880 (87), sold again Sotheby's, 16 July 1970 (lot 128), bought Agnew; a miniature by Sir W.J.Newton was exhibited *RA*, 1808 (758); busts by W.Scoular and W.G.Nicholl were exhibited *RA*, 1819 (1217), and 1822 (1012); an engraving by E.Stalker was published by the artist, 1822 (example in NPG).

SAYERS *Tom* (*1826–65*)

Pugilist; bricklayer in Brighton and later in London; began pugilistic career, 1849, when he beat Crouch; won champion's belt, 1857; his last fight, 1860.

2465 Plaster cast, painted cream, 11⅞ inches (30·3 cm) high, including base, of a statuette by A. BEZZI. PLATE 812

Incised on the front: TOM SAYERS *and on the side:* A.Bezzi

Collections: Charles Whibley, presented by his wife, in accordance with his wishes, 1930.

This is presumably one of a popular edition of casts; the left arm has been broken off at some time and repaired.

2465a Bronze electrotype of NPG 2465 above (but without the base), 11⅛ inches (28·3 cm) high, by MORRIS SINGER & CO.

Collections: Commissioned by the trustees of the NPG in case of damage to the original plaster.

ICONOGRAPHY A painting called Sayers was sold at Sotheby's, 15 June 1960 (lot 109), bought Frost and Reed; a photograph of an oil painting, formerly in the possession of the sitter, is in the Brighton Art Gallery; a bronze bust was in the collection of H.J.Preston, Royal Albion Hotel, Brighton, 1931, purchased from Douglas Holman, an old friend of Sayers, who owned a water-colour of this bust; a bust was in the *Victorian Era Exhibition*, 1897, 'Historical Section, sports sub-section' (636), and so was a coloured engraving (619); there is a lithograph of 1860 by R.Childs (example in British Museum); a photograph was published G.Newbold, 1860 (example in Victoria and Albert Museum), engraved for *Tom Sayers* (1866), frontispiece (this anonymously published biography was by H.D.Miles).

SCALES *Rev Thomas*

Slavery abolitionist.

599 See *Groups:* 'The Anti-Slavery Society Convention, 1840' by B.R.Haydon, p 538.

SCARLETT *Sir James Yorke* (*1799–1871*)

General; entered army, 1818; tory MP for Guildford, 1836–41; commanded 5th Dragoon Guards, 1840–54; in command of the heavy brigade in the Crimea, and led their famous charge at Balaclava; later commanded the entire British cavalry there.

807 Plaster cast, painted black, 29½ inches (75 cm) high, of a bust by MATTHEW NOBLE, *c* 1873. PLATE 813

Incised on the back of the shoulders: GEN^L SIR JAM^S YORKE SCARLETT K.C.B. K.G.

Collections: The artist, presented by his widow, 1888.

Accepted with a bust of the Duchess of Sutherland (NPG 808), both busts described as original plaster models by the donor (letter of 19 July 1888, NPG archives). A marble version of the NPG type is in the collection of Mrs M. Kershaw, and another dated 1873 is in the Townley Hall Art Gallery, Burnley; one of the two presumably that exhibited *RA*, 1875 (1394).

ICONOGRAPHY A painting by Sir F. Grant was commissioned by the 5th Dragoon Guards, exhibited *RA*, 1857 (452), engraved by F. Bromley (no example located), the engraving exhibited *RA*, 1859 (1192); another (equestrian) painting by Sir F. Grant is listed in his 'Sitters Book' (copy of original MS, NPG archives), under 1870, exhibited *RA*, 1871 (157), and *VE*, 1892 (127), lent by Lord Abinger; a drawing by an unknown artist is in the NPG reference files; a woodcut was published *Illustrated Times*, 16 December 1871, p 377; a drawing by E. Goodwyn Lewis, another by E. Havell and two photographs, are in the Townley Hall Art Gallery, Burnley.

SCHOMBURGK *Sir Robert Hermann* (*1804–65*)

Traveller; educated in Germany; explored British Guiana, 1831–5, and was later government commissioner for surveying and making boundaries there, establishing the 'Schomburgk line'; British consul at San Domingo, and later at Bangkok, 1857–64; published descriptions of British Guiana and the Barbados.

2515 (91) Black and red chalk, with touches of Chinese white, on grey-tinted paper, $14\frac{5}{8} \times 10\frac{3}{4}$ inches (37 × 27·2 cm), by WILLIAM BROCKEDON, 1840. PLATE 814

Dated (lower left): 2.6.40 *Inscribed on the left and at the top are two series of numbers,* '*1–11*', *and* '*1–13*' (*their significance is not clear*).

Collections: See *Collections:* 'Drawings of Prominent People, 1823–49' by W. Brockedon, p 554.

Accompanied in the Brockedon Album by a letter from the sitter, dated 1 June 1840.

ICONOGRAPHY The only other recorded portrait of Schomburgk is a drawing by E. U. Eddis, lithographed by M. Gauci, published P. Gauci, 1840 (example in British Museum).

SCOBLE *John*

Slavery abolitionist.

599 See *Groups:* 'The Anti-Slavery Society Convention, 1840' by B. R. Haydon, p 538.

SCOTT *Sir Edward Dolman, Bart* (*1793–1851*)

MP for Lichfield.

54 See *Groups:* 'The House of Commons, 1833' by Sir G. Hayter, p 526.

SCOTT *Sir George Gilbert* (*1811–78*)

Architect; pupil of Robert Smirke; designed and restored a large number of cathedrals and churches; designed the Foreign Office, St Pancras Station and the Albert Memorial; one of the most influential and prolific neo-Gothic architects of the period.

1061 Coloured chalk on brown, discoloured paper, $18\frac{1}{2} \times 12\frac{1}{2}$ inches (47 × 31·8 cm), by GEORGE RICHMOND, 1877. PLATE 816

Signed and dated (top right): Sir Gilbert Scott. RA./June 27. 1877./Geo Richmond

Inscribed on the left: Nose *and upper left:* Eyes.

Collections: The artist, purchased from his executors, 1896.

This is a study for the oil painting in the Royal Institute of British Architects, listed in Richmond's 'Account Book' (photostat copy, NPG archives), p94, under 1877, exhibited *RA*, 1878 (460), and *VE*, 1892 (196), etched by A.L.Merritt, published 1879 (example in British Museum). A smaller variant version, said to have been painted around 1870, is in the Royal Academy, presented by the artist, 1886. There is a reference in Richmond's 'Account Book', p86, to a portrait begun in 1870, possibly a reference to one of the oils. The NPG drawing was purchased with several other Richmond items. It was apparently engraved for Scott's *Personal and Professional Recollections*, edited G.G.Scott (1879), frontispiece.

2475 Pencil on paper, $4\frac{5}{8} \times 3\frac{1}{2}$ inches (11·7 × 8·9 cm), by CHARLES BELL BIRCH, 1859. PLATE 815

Inscribed in pencil (bottom centre): Sir Gilbert Scott R.A./Lecturing at the R.A. 1859

Collections: See *Collections:* 'Drawings of Royal Academicians, c 1858' by C.B.Birch, p 565.

ICONOGRAPHY A medallion by G.G.Adams (example in NPG), and a silver impression of a medal, both commissioned by the Art Union of London, were exhibited *RA*, 1884 (1853), and 1885 (2123); a woodcut was published *ILN*, XXXVIII (1861), 175; there are several photographs in the NPG, and woodcuts after others were published *ILN*, LXI (1872), 109, and LXXII (1878), 341.

SCOTT *James Winter* (*1799–1873*)
MP for Hampshire North.

54 See *Groups:* 'The House of Commons, 1833' by Sir G.Hayter, p 526.

SCOTT *Sir Walter* (*1771–1832*)
Novelist and poet.

2515 (30) See *Collections:* 'Drawings of Prominent People, 1823–49' by W.Brockedon, p 554.

See also forthcoming Catalogue of Portraits, 1790–1830.

SEAFIELD *Francis William Ogilvy-Grant, 6th Earl of* (*1778–1853*)
MP for Elgin and Nairn.

54 See *Groups:* 'The House of Commons, 1833' by Sir G.Hayter, p 526.

SEATON *Sir John Colborne, 1st Baron* (*1778–1863*)
Field-marshal; served with Sir John Moore in the Peninsula; fought at Waterloo; lieutenant-governor of Guernsey, 1825, and of Upper Canada, 1830; crushed Canadian revolt, 1838; governor of the Ionian Islands, and later commander of the forces in Ireland; field-marshal, 1860.

982b Oil on millboard, 11 × 9 inches (28 × 22·8 cm), by GEORGE JONES, 1860–3. PLATE 817

Signed (middle right): Geo Jones RA *and inscribed in the artist's hand (top left and lower left, twice)* Field Marshal/Lord Seaton

Collections: The artist, presented by his widow, 1871.

Exhibitions: Pageant of Canada, National Gallery of Canada, Ottawa, 1967–8 (259), reproduced catalogue, p291.

This sketch was executed at some time between 1860, when Seaton was created field-marshal, and his death in 1863; his apparent age agrees with these dates.

Description: Grey hair, white collar, black neck-cloth. Faint brown around head, rest of picture unfinished grey underpainting.

1205 Plaster cast, painted black, 32 inches (81·3 cm) high, of a bust by GEORGE GAMMON ADAMS, 1863. PLATE 818

Incised on the front of the base: SEATON *and on the back of the shoulders:* G.G.Adams S^c 1863.

Collections: The artist, purchased from his widow, 1899.

Exhibitions: Probably *Victorian Era Exhibition*, 1897, 'Historical Section' (784).

This cast is directly related to the marble bust of Seaton by Adams of 1863 in the United Service Club, London, exhibited *RA*, 1864 (1005), reproduced as a woodcut *ILN*, XLIV (1864), 96, with an accompanying commentary: '*we think this the best bust we have seen from this hand, and the more creditable to him as a posthumous work*'. In 1866 Adams executed a bronze statue of Seaton at Mount Wise, Devonport, reproduced as a woodcut *ILN*, XLIX (1866), 584, a model for which was exhibited *RA*, 1867 (1013). The NPG bust was purchased at the same time as several other works by Adams.

ICONOGRAPHY A painting by J.W.Pieneman of 1821 is in the Wellington Museum at Apsley House, London, exhibited *SKM*, 1868 (201), *VE*, 1892 (91), with an erroneous attribution to H.W.Pickersgill, and *Pageant of Canada*, National Gallery of Canada, Ottawa, 1967–8 (258), reproduced in catalogue; a painting by W.Fisher of 1862 is in the United Service Club, London, exhibited *RA*, 1862 (290), engraved by J.Scott (example in NPG), engraving exhibited *RA*, 1864 (832); a painting and a bust by unknown artists are in the Regimental Museum of the Oxford and Berkshire Light Infantry, Oxford; Seaton appears in the painting by F.de Prades, 'On the Heights Near Boulogne, 1854', sold Sotheby's, 3 April 1968 (lot 77), exhibited *RA*, 1857 (1122); a drawing by G.Richmond is listed in his 'Account Book' (photostat copy, NPG archives), p52, under 1850, presumably the portrait by G.Richmond engraved by W.J.Edwards, published H.Graves, 1855, and also anonymously engraved, published R.Bentley, 1866 (examples in NPG); woodcuts were published *ILN*, XXIII (1853), 5, and XLII (1863), 472 (after a photograph).

SEBRIGHT *Sir John Saunders, Bart* (*1767–1846*)

Agriculturist, MP for Hertfordshire.

54 See *Groups:* 'The House of Commons, 1833' by Sir G.Hayter, p526.

SEDGWICK *Adam* (*1785–1873*)

Geologist; Woodwardian professor of geology at Cambridge, 1818; president of the Geological Society, 1831; member of learned societies; published several works on geological and other subjects; helped to increase the university geological collection.

4502 Silhouette, black paper laid down on card, 11 × 7¼ inches (28 × 18·4 cm), by AUGUSTE EDOUART, 1828. PLATE 819

Signed and dated in ink (*bottom left*): Aug^t Edouart fecit 1828

Inscribed in pencil in Dr W.T.Bayne's hand (*bottom centre and right*): Adam Sedgwick. Professor of Geology. Cambridge

Collections: Given by the sitter to George Pryme, professor of political economy at Cambridge; by descent to his grandson, Dr. W.T.Bayne; by descent to the latter's grandson, R.L.Bayne-Powell, and sold by him, Sotheby's, 25 July 1966 (lot 27), from where purchased by the gallery.[1]

Literature:NPG Annual Report, 1966–7 (1967), pp33–4.

A similar but not identical silhouette (unsigned) is in the Sedgwick Museum, Cambridge, reproduced

[1] Information on provenance kindly communicated by last owner, 1971.

J. W. Clark and T. M. Hughes, *The Life and Letters of Adam Sedgwick* (1890), I, 310.[1] They wrote of it (309): '*It gives a good general notion of his dress and figure* [in his office of senior proctor at Cambridge], *as he may have stood, watch in hand to announce to those who were being examined, that the clock was about to strike, and that they must fold up their papers*'. A third signed version of the silhouette is in the collection of Major W. Sedgwick Rough.

1669 Plaster cast, painted black, 26 inches (66 cm) high, of a bust by THOMAS WOOLNER, *c* 1860. PLATE 820
Incised on the front of the base: PROFESSOR SEDGWICK
Collections: The artist, purchased from his daughter, Miss Amy Woolner, 1912.

This bust corresponds almost exactly to the marble bust of Sedgwick of 1860 in Trinity College, Cambridge, reproduced Amy Woolner, *Thomas Woolner: his Life in Letters* (1917), facing p 77, except that the relief (in the case of the NPG bust, a fish) and the inscription along the base differ. Another plaster cast is in the Department of Geology, Cambridge, listed by J. W. Goodison, *Catalogue of Cambridge Portraits* (1955), p 145. There are several references to Sedgwick sitting for his bust, and a letter from him, in Amy Woolner, pp 182, 186–8, 202–4. Woolner himself wrote that '*it has rarely been my lot to contemplate so magnificent a head as his*'. The NPG bust of Sedgwick was purchased together with other plaster busts by Woolner.

ICONOGRAPHY The following portraits are in the Department of Geology, Cambridge, listed by J. W. Goodison, *Catalogue of Cambridge Portraits* (1955), pp 144–7; a painting by T. Phillips, listed in Phillips' 'Sitters Book' (copy of original MS, NPG archives), under 1832, exhibited *RA*, 1832 (202), reproduced Goodison, plate XIX, engraved by S. Cousins, published Molteno and Graves, 1833 (example in NPG); a painting by S. Laurence of *c* 1844 (see below), reproduced Goodison, plate XVIII; a painting by R. B. Farren of 1870; a drawing (as a young man) by H. W. Jukes; a drawing by L. Dickinson of 1867, reproduced J. W. Clark and T. M. Hughes, *The Life and Letters of Adam Sedgwick* (1890), II, frontispiece, probably the portrait exhibited *RA*, 1873 (1322); a plaster bust by H. Weekes of 1846, directly related to the marble bust in the Geological Society, London (see below); a plaster bust by T. Woolner (see NPG 1669 above); a bronze statue by E. Onslow Ford of 1901.

A drawing by S. Laurence of 1844, was owned by Mrs Richard Sedgwick, 1890, exhibited *RA*, 1845 (966), lithographed by J. H. Lynch, published R. Roe (example in NPG); it was used as a study for the painting in the Department of Geology (see above), and for another version of this painting from Laurence's collection, sold Puttick and Simpson, 12 June 1884 (lot 172), Christie's, 22 November 1912 (lot 26), and Robinson, Fisher and Co, 29 June 1916 (lot 190), exhibited *VE*, 1892 (235); a painting by Sir W. Boxall of 1851 is at Trinity College, Cambridge, and so is a bust by T. Woolner of 1860, of which there are related plaster casts in the NPG (1669 above), and the Department of Geology (see above); a marble bust by H. Weekes of 1846 is in the Geological Society, London, exhibited *RA*, 1846 (1517), of which there is a plaster cast in the Department of Geology (see above); a bust by an unknown artist of 1846, possibly another cast of Weekes' bust, is in Kendal Museum, exhibited *Cumbrian Characters*, Abbot Hall Art Gallery, Kendal, 1968 (59); a lithograph by T. H. Maguire of 1850 was published Ransome, 1854 (example in NPG), for 'Portraits of Honorary Members of the Ipswich Museum'; a woodcut was published *ILN*, LXII (1873), 133.

SEVERN *Anne Mary, later Mrs Newton.* See NEWTON

SEVERN *Joseph* (*1793–1879*)

Painter; studied at RA schools; accompanied Keats to Italy, and attended him at his death, 1821; practised at Rome, painting landscapes and subject pictures; in England, 1841–60; British consul at Rome, 1860–72.

[1] According to Clark and Hughes, 309n, this was presented to the Registry of the University by the Rev J. Romilly, and was subsequently transferred to the Sedgwick Museum. The *Cambridge Chronicle* of 29 February 1828 wrote: '*Monsieur Edouart, whose arrival was announced last week, has already met with a considerable patronage from the gentlemen of the University.*' I would like to thank the staff of the Sedgwick Museum for their help.

3091 Pencil on paper, 10 × 7 inches (25·3 × 17·7 cm), by HIMSELF, c 1820. PLATE 821

Inscribed on the mount in pencil: Pencil portrait of Joseph Severn the friend of Keats./belonging to Arthur Severn of Brantwood, Coniston./1912. *Inscribed on the back of the drawing in pencil:* Joseph Severn – Rome/aged 25 –

Collections: By descent to Arthur Severn; presumably Henry Buxton Forman, presented by his son, Maurice Buxton Forman, 1940.

Literature: Reproduced *John Keats and his Family: a Series of Portraits*, printed for M. Buxton Forman (Edinburgh, 1933); and *Poetical and Other Writings of John Keats*, edited H. Buxton Forman, revised by M. Buxton Forman (Hampstead Edition, 1938–9), VIII, facing 134.

The donor stated that this drawing had belonged to Arthur Severn (memorandum of an interview, 15 October 1940, NPG archives), but did not indicate whether it was acquired by himself or his father; Henry Buxton Forman wrote and edited several works on Keats and Shelley. A drawing almost identical to NPG 3091 is in Keats House, London, and a photographic reproduction of this is in the Keats-Shelley Memorial Museum, Rome; the latter is described as an original drawing, but investigation by the present compiler proved that it was a photograph. The Keats House and NPG drawings must have been executed soon after Severn's arrival in Rome with the moribund Keats in 1820; he was twenty-seven at the time, and not twenty-five as stated in the inscription.

3944 (18) Possibly Joseph Severn. Pencil on paper, 9½ × 7¼ inches (24 × 18·5 cm), by JOHN PARTRIDGE, 1825. PLATE 822

Signed and dated (lower right): J. Partridge/Nov 1825/Rome.
Inscribed in pencil on the reverse: Mrs Westmacott.
Collections: See *Collections:* 'Artists, 1825' by J. Partridge, p 556.

Although the features are not dissimilar from those in authentic portraits of Severn, the face as a whole is too thin to be confidently identified as his. Mrs Westmacott's name appears on the back of another drawing in the Partridge sketch-book.

3944 (20) Probably Joseph Severn. Pencil on paper, 9½ × 7¼ inches (24 × 18·5 cm), by JOHN PARTRIDGE, 1825. PLATE 823

Collections: As for NPG 3944 (18) above.

This drawing agrees much better than the drawing above with authentic portraits of Severn, particularly the Kirkup (see iconography below).

As the Partridge sketch-book contains two drawings by Severn, it seems probable that Partridge did in fact take his likeness. Partridge's style is more mannered than is at first apparent, which makes the problem of identification in this instance extremely difficult.

ICONOGRAPHY A painting by himself of 1876 is reproduced S. Birkenhead, *Illustrious Friends* (1965), facing p 205, and *Keats-Shelley Memorial Bulletin*, XXI (1970), facing 40; a drawing by S. Kirkup of 1822 is reproduced C. W. Sharp, *Life and Letters of Joseph Severn* (1892), frontispiece, and S. Birkenhead, frontispiece; an engraving, after a portrait of c 1820 (probably a miniature), is reproduced C. W. Sharpe, facing p 248; there is a reproduction (apparently from a book) after a miniature of similar date (example in NPG); a detail from a group photograph of c 1872 is reproduced *John Keats: Letters of Joseph Severn to H. Buxton Forman* (privately printed, Oxford, 1933), frontispiece.

SEYMOUR *Henry* (*c 1776–1843*)

Serjeant-at-arms.

54 See *Groups:* 'The House of Commons, 1833' by Sir G. Hayter, p 526.

SHAFTESBURY *Anthony Ashley Cooper, 7th Earl of (1801–85)*

Philanthropist and reformer; MP from 1826; throughout a long life, fought strenuously for factory, housing, educational, sanitary and lunacy reform; more than any other single individual highlighted the sufferings of the poor and under-privileged, and helped to implement the concept of social welfare.

1012 Oil on panel, 23⅞ × 19¾ inches (60·6 × 50·2 cm), by GEORGE FREDERICK WATTS. PLATE 824

Collections: The artist, presented by him, 1895 (see appendix on portraits by G. F. Watts in forthcoming Catalogue of Portraits, 1860–90).

Exhibitions: Winter Exhibition, Grosvenor Gallery, 1882 (23); *Art Exhibition at the Inauguration of the Museum and Art Gallery*, Birmingham, 1885–6 (154); *Royal Jubilee Exhibition*, Manchester, 1887, 'Fine Art Section' (502); Toynbee Hall, 1889; Manchester, 1890; Cardiff, 1894; Winchester School, 1894.

Literature: 'Catalogue of Works by G. F. Watts', compiled by Mrs M. S. Watts (MS, Watts Gallery, Compton), II, 143.

The British Museum have a photograph of a unique impression of a related etching by Watts.

Description: Dark flesh tones, brown eyes and reddish-brown hair. Dressed in a black neck-tie, white shirt, and black coat. Background colour dark brown.

1728 Oil on canvas, 50 × 40 inches (127 × 101·6 cm), by the HON JOHN COLLIER, 1877. PLATE 828

Inscribed on a label, formerly on the back of the frame: No 2/The Earl of Shaftesbury/K.G./by John Collier/6 William Street/Lowndes Square/London S.W

Collections: James Wilkes, presented by him to the Commission in Lunacy; on the abolition of the commission, the portrait was presented to the NPG in accordance with the wishes of James Wilkes, 1914.[1]

Exhibitions: R A, 1878 (445).

Literature: Hon J. Collier, 'Sitters Book' (photostat copy of original MS, NPG archives), p I, under 1877.

In a minute of 14 October 1878 (copy, NPG archives), the Board of the Lunacy Commission tendered their thanks to Mr Wilkes for securing '*a worthy representation of Lord Shaftesbury as an ornament for their Board Room, where from the first he has constantly presided over the deliberations of a body called into existence mainly by his exertions*'. In a second minute of 6 November 1878 (copy, NPG archives), a letter from Shaftesbury of 31 October 1878 was communicated, in which he thanked the Board for '*a copy of the Minute passed on October 14 in reference to a Portrait of myself that has been hung on the walls of our Board Room*'.

Description: Pale complexion, dark greyish-blue (?) eyes, brown hair with grey streaks. Dressed in a black neck-tie, white shirt and black suit. Resting one arm on a standing desk covered with papers, a quill pen and an envelope; two brown leather-bound books are visible below the desk. Rest of background dark brown (there is a vague suggestion of a patterned wall-paper).

1834cc Pencil on paper, 8 × 5⅛ inches (20·3 × 13 cm), by FREDERICK SARGENT. PLATE 825

Signed (lower left): F Sargent *Inscribed below, possibly an autograph:* Shaftesbury

Collections: A. C. R. Carter, presented by him, 1919.

Presented with thirty-three other drawings of peers by Sargent, presumably studies for one of his many paintings of the House of Lords. These studies will be discussed as a group in the forthcoming Catalogue of Portraits, 1860–90.

862 Plaster bust, painted black, 27¼ inches (69·2 cm) high, of a bust by SIR JOSEPH EDGAR BOEHM, 1875. PLATE 827

[1] Copy of Wilkes' deed of gift, NPG archives.

Incised on the side of the shoulders: Boehm 75 *and on the side of the base:* BOEHM.

Collections: The artist, purchased from his executors, 1891.

This is presumably related to the terra-cotta bust by Boehm exhibited *RA*, 1876 (1364). The NPG bust was one of several by Boehm purchased at the same time.

54 See *Groups:* 'The House of Commons, 1833' by Sir G. Hayter, p 526.

ICONOGRAPHY A painting attributed to Sir F. Grant is in the collection of the Department of the Environment (not recorded in Grant's 'Sitters Book'); a painting by T. Rodwell is in the collection of Earl Mountbatten; a painting by F. Havill was sketched and recorded by G. Scharf, 1888, 'TSB', xxxv, 3; a painting by Sir J. E. Millais of 1877 is owned by the British and Foreign Bible Society, London, exhibited *RA*, 1878 (242), *Winter Exhibition*, Grosvenor Gallery, 1886 (72), *VE*, 1892 (129), and *Old Masters*, RA, 1898 (64), reproduced J. G. Millais, *Life and Letters of Sir J. E. Millais* (1899), II, 85, engraved by R. Josey, published H. Graves, 1878 (example in NPG); a painting called Shaftesbury by an unknown artist was in the collection of Hugh Cameron, Boston, USA, 1958; a painting by M. Stewart was exhibited *Victorian Era Exhibition*, 1897, 'Historical Section' (5), lent by the French Reformed Evangelical Church, Bayswater; a painting by an unknown artist was at Crichel, Dorset, 1938; a drawing by G. Richmond is recorded in his 'Account Book' (photostat copy of original MS, NPG archives), p 72, under 1861, probably the drawing exhibited *RA*, 1863 (798), engraved by H. Robinson, published J. Hogarth (example in NPG); caricature drawings by J. Doyle are in the British Museum; a miniature by Mrs J. Robertson was exhibited *RA*, 1831 (817); marble and plaster busts by W. Merrett were in the Guildhall Art Gallery, London (the marble destroyed 1940); busts by J. Adams-Acton and R. C. Belt were exhibited *RA*, 1886 (1868), and 1884 (1708); a marble bust by M. Noble of 1859 is in the church at Wimborne St Giles, Dorset, presumably the bust exhibited *RA*, 1859 (1327), reproduced as a woodcut *ILN*, xxxv (1859), 178, which was presented to Lady Shaftesbury; an engraving by W. J. Edwards, after F. Sandys, was published H. Graves, 1855 (example in NPG); an engraving by H. Robinson, after Sir W. C. Ross, was published G. Virtue (example in NPG); there is an engraving by F. C. Lewis, after J. Slater (example in NPG), for the 'Grillions Club' series; woodcuts were published *ILN*, I (1842), 173, and IV (1844), 197; a caricature by Ape (C. Pellegrini) was published *Vanity Fair*, 13 November 1869, 'Statesmen, no. 35'; there are several photographs (see plate 826), reproductions of photographs, popular engravings and lithographs in the NPG.

SHARPE *Matthew* (*d 1845*)

MP for Dumfries.

54 See *Groups:* 'The House of Commons, 1833' by Sir G. Hayter, p 526.

SHARPE *Samuel* (*1799–1881*)

Egyptologist; banker; published works on Egyptian history and hieroglyphics; worked on various revised texts of the New Testament; wrote a Hebrew history and grammar; president of the British and Foreign Unitarian Association, and of Manchester College (now at Oxford); liberal benefactor of University College, London.

1476 Oil on canvas, 23¾ × 20 inches (60·4 × 50·8 cm), by his daughter, MISS MATILDA SHARPE, 1868. PLATE 829

Signed and dated on the back of the canvas: Samuel Sharpe/His Daughter/Matilda Sharpe/Pingebat/ 1868 *Inscribed on the front of the canvas in white (top left-hand corner):* Samuel/Sharpe/1868

Collections: The artist, presented by her and her sister, Miss Emily Sharpe, 1907.

Exhibitions: Channing School, Highgate, London, 1960.

This is the only recorded portrait of Sharpe. It was presented with a portrait of Joseph Bonomi (NPG 1477).

Description: Healthy complexion, grey hair and whiskers (eyes not visible). Dressed in a black stock, white shirt, black coat and waistcoat. Reading a dark-covered book, the pages with red edges. Seated in a red chair (the back just visible on the left). Two small standing Egyptian statuettes on a table at the right. Background colour green.

SHAW *Sir Frederick, Bart* (*1799–1876*)

MP for Dublin University.

54 See *Groups:* 'The House of Commons, 1833' by Sir G. Hayter, p 526.

SHAW-LEFEVRE *Sir John George* (*1797–1879*)

Public official; fellow of Trinity College, Cambridge, 1819; barrister, 1825; under-secretary at colonial office, 1833; helped to found colony of Australia, 1834; vice-chancellor of London University, 1842–62; deputy-clerk and later clerk of the parliaments from 1848; involved in numerous other public duties.

2741 Water-colour on paper, heightened with Chinese white, $11\frac{3}{4} \times 7\frac{3}{8}$ inches (30 × 18·9 cm), by APE (CARLO PELLEGRINI), 1871. PLATE 830

Signed in pencil (bottom right): Ape *Inscribed on the mount, which is the original:* Sir J. C. Lefevre, K.C.B./July 1st, 1871.

Collections: Thomas Bowles; *Vanity Fair* Sale, Christie's, 8 March 1912 (lot 701); Maggs Brothers, purchased from them, 1934.

This is one of a large collection of original cartoons for *Vanity Fair*, which were owned and specially mounted by the first proprietor of the magazine, Thomas Bowles. Those in the NPG will be collectively discussed in the forthcoming Catalogue of Portraits, 1860–90. The water-colour of Shaw-Lefevre was published in *Vanity Fair* as a coloured lithograph (in reverse) on 1 July 1871, as 'Men of the Day, No. 27', with the title, 'La Reyne le veult'.

Description: Brown hair and whiskers, grey wig. Dressed in a white collar and black legal robes; back or side of a red bench in foreground.

ICONOGRAPHY A painting by Sir J. Watson Gordon is in the Scottish NPG, exhibited *RA*, 1860 (3); another painting by the same artist was exhibited *RA*, 1849 (179); a drawing by G. Richmond was exhibited *VE*, 1892 (346), lent by Sir W. Farrer, listed in Richmond's 'Account Book' (photostat copy, NPG archives), p 69, under 1861, as (erroneously) for the 'Grillions Club' series (Shaw-Lefevre was a member, but his portrait was not apparently engraved for the series), and p 97, under 1881, as sold to Farrer; Shaw-Lefevre appears in two group photographs in the NPG; there is also a woodcut from an unidentified magazine in the NPG.

SHEE *Sir Martin Archer* (*1769–1850*)

Portrait painter and president of the RA; educated in Dublin; RA, 1800; a founder of the British Institution, 1807; president of the Royal Academy, 1830–50; established a large and successful portrait practice; published poems, two novels and a play.

1093 Oil on canvas, 30 × $24\frac{3}{4}$ inches (76·2 × 62·8 cm), by HIMSELF, 1794. PLATE 832

According to a note in the NPG files, inscribed on the back (inscription no longer visible), presumably on the stretcher or canvas (relined): Sir Martin Archer Shee P.R.A. Ipse Pinxit 1794. Age 25

Collections: The sitter; by descent to his son, Major Martin Archer Shee; purchased at Christie's, 8 May 1897 (lot 59).

Exhibitions: RA, 1795 (135); *VE*, 1892 (190).

Literature: W. G. Strickland, *Dictionary of Irish Artists* (1913), II, 335, reproduced plate LVI, facing 346.

Strickland erroneously lists the NPG portrait, and that previously owned by Major Archer Shee, as two separate pictures. Other self-portraits are listed below:

1 Painting. Exhibited *RA*, 1798 (68).
2 Painting, with E. Ellis. Exhibited *RA*, 1816 (77). Probably the painting sold Sotheby's, 15 January 1958 (lot 123), where the figure with Shee is called Andrew Vesian.
3 Painting (at a young age). *Dublin Exhibition*, 1872, 'Portraits' (404), lent by Lord James Butler.
4 Engraving by J. Thomson, after a drawing (?) by Shee, published Sherwood and Co, 1824 (example in NPG), for the *European Magazine*. Reproduced W. Sandby, *History of the Royal Academy of Arts* (1862), II, 73.

Description: Healthy complexion, brown eyes, grey wig. Dressed in a white shirt, white stock, dark green waistcoat and coat. Deep red curtain covering most of background, except for a glimpse of green and orange sky bottom right.

3153 Black chalk and water-colour on paper, $9\frac{5}{8} \times 8\frac{1}{4}$ inches (24·4 × 21 cm), by JOHN JACKSON, *c* 1815.
PLATE 831

Collections: Mrs M. F. Warner; sold Sotheby's, 2 June 1943 (lot 10), bought Arthur Spencer of the Siddons Gallery, and purchased from him, 1943.

Exhibitions: Presumably *RA*, 1815 (607).

Literature: Connoisseur, CXIX (1947), 33.

This drawing was engraved by W. T. Fry, published Cadell and Davies, 1817 (example in NPG), for 'Contemporary Portraits'. It was purchased with several other portrait drawings of artists by Jackson, also part of the 'Contemporary Portraits' series.

Description: Healthy complexion, brownish eyes, grey hair. Dressed in a white shirt and stock, and a grey coat.

ICONOGRAPHY A drawing by T. Bridgford of *c* 1841 is in the Irish NPG, reproduced as a woodcut *Art Journal* (1849), p 12, engraved by H. Griffiths, published J. McGlashan, Dublin, 1846 (example in NPG), for the *Dublin University Magazine*; a drawing by C. Vogel is in the Küpferstichkabinett, Staatliche Kunstsammlungen, Dresden; an anonymous etching was published 1834 (example in NPG), for Arnold's *Magazine of the Fine Arts*.

SHEIL *Richard Lalor* (*1791–1851*)
Dramatist, author, and MP for County Tipperary.
54 See *Groups:* 'The House of Commons, 1833' by Sir G. Hayter, p 526.

SHIELD *William* (*1748–1829*)
Composer.
2515 (11) See *Collections:* 'Drawings of Prominent People, 1823–49' by W. Brockedon, p 554.
See also forthcoming Catalogue of Portraits, 1790–1830.

SINCLAIR *Sir George, Bart* (*1790–1868*)
Author, MP for Caithness.
54 See *Groups:* 'The House of Commons, 1833' by Sir G. Hayter, p 526.

SMEAL *William* (*1792–1877*)

Slavery abolitionist.

599 See *Groups:* 'The Anti-Slavery Society Convention, 1840' by B.R.Haydon, p538.

SMITH *Benjamin Leigh* (*1828–1913*)

Made several expeditions to the Arctic; published accounts of his travels.

924 Oil on millboard, 15 × 12¼ inches (38·1 × 31·2 cm), by STEPHEN PEARCE, 1886. PLATE 833
Inscribed on the back of the picture, in the artist's hand: B.Leigh Smith./painted by Stephen Pearce. 1886
Collections: See *Collections:* 'Arctic Explorers' by S.Pearce, p562.
Literature: S.Pearce, *Memories of the Past* (1903), p97.

A replica is at Jesus College, Cambridge. No other portraits of Smith are recorded. On the wall behind him is a map of Alexandra Land, entitled, 'Discoveries in the "Eira" 1880–2 by B.Leigh Smith'.

Description: Healthy complexion, greyish eyes, grey hair and beard. Dressed in a green stock, white shirt, dark grey waistcoat and coat, gold watch-chain. Seated in a red chair. Colour of map brownish-white. Rest of background brown and dark brown.

SMITH *Charles Hamilton* (*1776–1859*)

Soldier and writer on natural history; served in English army, 1797–1820; wrote several military and natural history books.

2515 (22) Pencil and black and red chalk, with touches of Chinese white, on brown-tinted paper,
14 × 10⅝ inches (35·5 × 26·9 cm), by WILLIAM BROCKEDON, 1830. PLATE 834
Dated (lower left): 16.8.30
Collections: See *Collections:* 'Drawings of Prominent People, 1823–49' by W.Brockedon, p554.

Accompanied in the Brockedon Album by a letter from the sitter, dated 5 February 1831.

ICONOGRAPHY A painting by E.Opie was last recorded in the collection of Mrs Rendel (*Dictionary of National Biography*), exhibited *RA*, 1840 (223), and *SKM*, 1868 (127), engraved by J.Scott, published E.Fry, Plymouth, 1841 (example in NPG); a bust by F.A.Legé, exhibited *RA*, 1822 (1021), may represent Smith; two miniatures of 'C.H.Smith' by Mrs C.H.Smith were exhibited *RA*, 1836 (760), and 1850 (950), but almost certainly do not portray this sitter.

SMITH *Edward*

Slavery abolitionist.

599 See *Groups:* 'The Anti-Slavery Society Convention, 1840' by B.R.Haydon, p538.

SMITH *Sir Harry George Wakelyn, Bart* (*1787–1860*)

Colonial soldier and governor; served in Napoleonic wars; in the Kaffir war, 1835–6; adjutant-general in India, 1840; fought in Gwalior campaign; defeated the Sikhs at Aliwal; created baronet and major-general, 1846; governor of the Cape of Good Hope, 1847; suppressed Boers, 1848, and Kaffirs, 1850–2; prevented convicts being landed; lieutenant-general, 1854; four towns in South Africa named in his honour.

1945 Miniature, water-colour and body colour on ivory, 6¼ × 4⅞ inches (16 × 12·3 cm), by an UNKNOWN ARTIST, *c* 1846. PLATE 835
Collections: C.Eskell van Noorden, 1903, when offered to NPG; Baroness Burdett-Coutts, purchased at her sale, Christie's, 9–11 May 1922 (lot 388).

Smith is shown in the uniform of a major-general, with the Peninsula Medal (twelve bars), the Waterloo Medal, the Maharajpore (Gwalior) Star, the Sutlej Medal (three bars), and the ribbon, badge, and star of the Bath. Smith was created a major-general in 1846, and awarded the Bath in that year, so the miniature was probably painted soon afterwards, and before he departed for South Africa in 1847. The previous attribution to Sir W. C. Ross is clearly erroneous. The head bears some resemblance to the miniature by W. Melville of 1842 (see iconography below). Baroness Burdett-Coutts also owned a drawing of Smith by an unknown artist, exhibited *VE*, 1892 (334), possibly the drawing by Isabey recorded in her collection by the *Dictionary of National Biography*.

Description: Healthy complexion, grey eyes, brown hair with grey streaks. Dressed in a red uniform, gold-braided collar, cuffs and epaulettes, and gilt buttons, wearing multi-coloured decorations and medals, a red sash, a red and gilt sword-belt, and black trousers, holding a black hat with red and white feathers. Colour of curtain at right dark green; rest of background light green.

1255 Plaster cast, painted bronze, $29\frac{3}{4}$ inches (75·6 cm) high, of a bust by GEORGE GAMMON ADAMS, *c*1849. PLATE 836

Collections: The artist, purchased from his widow, 1900.

This cast is related to the marble bust of Smith by Adams in St Mary's Church, Whittlesea. The latter, although not erected as a memorial until 1862, may have been one of the two marble busts by Adams exhibited *RA*, 1848 (1373), and 1849 (1285). According to R. Gunnis, *Dictionary of British Sculptors* (1953), p14, a bust of Smith by Adams of 1849 was in the United Service Club, London, but there is no trace of it there now. Mrs Adams wrote about the NPG cast in a letter of 9 April 1900 (NPG archives): '*My price for it would be 2 guineas as it would have to be recast owing to damp, it is a handsome bust; I fancy he must have been well known to Mr Adams as he has also done his portrait in wax.*' The location of the wax portrait is not known, but Mrs Adams lent a second plaster bust to the Army and Navy Exhibition, Westminster Aquarium, 1900. The NPG bust was coloured by the Victoria and Albert Museum in 1922. Smith is shown wearing the star of the Bath. Several other busts by Adams were purchased at the same time.

ICONOGRAPHY The *Dictionary of National Biography* lists one painting in Government House, Cape Town, another in the possession of the Rifle Brigade, another, apparently by Isabey, in the possession of Mrs Waddelow of Whittlesea, and four in private possession (possibly some of those listed below); also listed is 'The Triumphal Reception of the Sikh Guns', engraving by C. Grant and F. C. Lewis, after W. Taylor (no example located), in which Smith figures prominently; a painting by P. Levin of 1856 was in the collection of Mrs Lambert, reproduced *The Autobiography of Lieut-General Sir Harry Smith* (1902), edited G. C. Moore Smith, II, frontispiece; a painting by W. Melville of 1842 (with a companion portrait of his wife) was in the collection of Mrs T. E. Dean, 1933; a painting by H. Moseley of 1847 was exhibited *RA*, 1852 (1083), lithographed by T. Fairbank (example in India Office Library); a painting by an unknown artist of *c*1815 is reproduced Moore Smith, I, frontispiece; a woodcut after a painting was published *ILN*, VIII (1846), 241; a miniature by T. J. Gullick was exhibited *RA*, 1853 (674); a bust by P. Park was reproduced as a woodcut *ILN*, XI (1847), 165, described as being sent to Glasgow; a bust by J. Edwards was exhibited *RA*, 1850 (1446); a second bust by P. Park of 1848 is listed by R. Gunnis, *Dictionary of British Sculptors* (1953), p291; a bust called Smith by an unknown artist is in the National Army Museum; there is an anonymous engraving, after T. Chadwell (example in NPG); there are several other engravings and lithographs, some after photographs (examples in NPG).

SMITH *John* (*1766–1833*)

Draughtsman and antiquary.

2515 (34) See *Collections:* 'Drawings of Prominent People, 1823–49' by W. Brockedon, p554.

SMITH *Thomas Southwood* (*1788–1861*)

Public health reformer; unitarian minister at Edinburgh; graduated MD, 1816; helped to found *Westminster Review*, 1824, Society for Useful Knowledge, Penny Cyclopaedia, and public health societies; hospital doctor from 1824; his influential reports on epidemics and insanitary conditions greatly advanced the cause of public health; built model housing units.

339 Marble bust, 26 inches (66 cm) high, by JOEL T. HART, 1856. PLATE 837
Incised on the front of the base: SOUTHWOOD SMITH *and on the back:* J. T. HART./Sculpt./1856.
Collections: Commissioned by a committee of noblemen and gentlemen, and presented by them, 1872.
Exhibitions: RA, 1858 (1310).

A meeting to consider how best to acknowledge Smith's achievement was held at the residence of the Earl of Shaftesbury on 7 May 1856. An elaborate, hand-written address (NPG 339a), commemorating the occasion, is headed, 'Recognition of the Public Services of Dr Southwood Smith'. It continues: '*It was Resolved that this meeting deeply impressed with the untiring and successful labours of Dr Southwood Smith in the cause of Social Amelioration, and specially recognizing the value of those labours in the great cause of Sanitary Improvement, are anxious to tender him some mark of their personal esteem. That accordingly a Bust of Dr Southwood Smith be executed in Marble and Presented to some suitable Institution as an enduring Memorial of his eminent services in the promotion of the Public Health.*' The long list of subscribers includes Palmerston, the Earl of Carlisle, the Marquess of Normanby, the Duke of Buccleuch, the Duke of Newcastle, the Earl of Shaftesbury, the bishop of London, Lord Brougham, Charles Dickens, Rowland Hill, Monckton Milnes, and the artist. The bust was first offered to the NPG in 1862 (see letters from the hon secretary of the committee, R. D. Grainger, NPG archives), but, owing to the ten-year rule, it was not formally accepted until 1872. Hart also executed a marble medallion for Smith's tomb in the Protestant Cemetery at Florence; this is based on the NPG bust. Hart lived chiefly at Florence from 1849 onwards.

ICONOGRAPHY A bust by an unknown sculptor, apparently based in part on the NPG bust, is in the Highgate Literary and Scientific Institute, London; a miniature by Miss M. Gillies was exhibited *RA*, 1835 (725), apparently the miniature engraved by J. Saddler (no example located), engraving exhibited *RA*, 1868 (917), and by J. C. Armytage, published Smith, Elder & Co (example in NPG), for R. Horne's *A New Spirit of the Age* (1844).

SMITH *William* (*1808–76*)

Dealer in prints; sold important collections of engravings to the British Museum; retired, 1848; helped in management of the Art Union; a founder and trustee of the NPG, and its deputy chairman, 1858; FSA, 1852; presented his collection to the Victoria and Albert Museum.

1692 Oil on canvas, 30 × 25 inches (76 × 63·6 cm), by MARGARET SARAH CARPENTER, 1856. PLATE 838
Signed and dated (lower right): Margaret Carpenter/1856.

Collections: Bequeathed by George Smith, the brother of the sitter, 1886, with a life interest for his wife and three daughters; the portrait was handed over by the two surviving daughters, Mrs Henderson and Mrs York, 1913.

This portrait was etched by the artist's husband, W. Carpenter, 1858 (in reverse, with variations, mostly in the costume and chair) (example in NPG); there is also a second slightly different etching by him (example in British Museum).

Description: Healthy complexion, brown eyes, grey hair and whiskers. Dressed in a black neck-tie, white shirt, and black waistcoat with gold watch-chain, and black coat. Seated in an orange-covered

arm-chair (back and arm just visible). Background colour various shades of brown and reddish-brown.

ICONOGRAPHY The only other recorded portraits of Smith are two photographs in the NPG.

SMITH *William Henry* (*1825–91*)

Newsagent and statesman.

2322 See entry for John Bright, p53.

See also forthcoming Catalogue of Portraits, 1860–90.

SMYTH *William Henry* (*1788–1865*)

Admiral and scientific writer; in active naval service, *c*1804–24; charted Mediterranean coasts, 1815–24; FRS, 1826; founder-member of Royal Geographical Society and president, 1849–50; built an observatory; contributed many papers to the Royal Astronomical Society, and was president, 1845–6; contributed papers to numerous societies; published scientific and naval works; admiral, 1863.

2515 (85) Black and red chalk, with touches of Chinese white, on grey tinted paper, $14 \times 10\frac{1}{8}$ inches ($35 \cdot 5 \times 25 \cdot 7$ cm), by WILLIAM BROCKEDON, 1838. PLATE 839

Dated (lower left): 17.1.38

Collections: See *Collections:* 'Drawings of Prominent People, 1823–49' by W.Brockedon, p554.

Accompanied in the Brockedon Album by a letter from the sitter, dated 23 April 1839. An anonymous lithograph after the drawing (in reverse) was published Day and Haghe (example in NPG).

ICONOGRAPHY The only other recorded portraits of Smyth are: a plaster bust by an unknown artist formerly in the Royal United Service Museum, London; a painting by E.U.Eddis of *c*1861, reproduced as a woodcut *ILN*, XLVII (1865), 317; and a lithograph by N.Ploszcznski of 1864, after a drawing by C.Gow (example in the Rex Nan Kivell collection, London).

SOANE *Sir John* (*1753–1837*)

Architect.

2515 (76) See *Collections:* 'Drawings of Prominent People, 1823–49' by W.Brockedon, p554.

See also forthcoming Catalogue of Portraits, 1790–1830.

SOMERS *John Somers Cocks, 2nd Earl* (*1788–1852*)

MP for Reigate.

54 See *Groups:* 'The House of Commons, 1833' by Sir G.Hayter, p526.

SOMERSET *Lord Granville Charles Henry* (*1792–1848*)

Chancellor of the duchy of Lancaster, MP for Monmouthshire.

54 See *Groups:* 'The House of Commons, 1833' by Sir G.Hayter, p526.

SOMERSET *Jane Georgiana, Duchess of* (*1809–84*)

Wife of 12th Duke; sister of Caroline Norton (Lady Stirling-Maxwell).

3791 See entry under Lady Stirling-Maxwell, p432.

SOMERVILLE *Mary (1780–1872)*

Scientific writer; *née* Fairfax; introduced by her second husband to a brilliant intellectual circle; won fame with a work on Laplace, 1831; excelled in broad syntheses of existing scientific knowledge, particularly in *The Connexion of the Physical Sciences*, 1834.

690 Coloured chalk on brown paper, $27\frac{1}{4} \times 23\frac{7}{8}$ inches (69·2 × 60·6 cm) rough and unequal oval, by JAMES RANNIE SWINTON, 1848. PLATE 840

Signed and dated (lower left): James R Swinton/7ᵗʰ March 1848

Collections: The sitter, bequeathed by her daughter, Miss Martha Somerville, 1879 (owing to a misunderstanding the portrait did not enter the collection until 1883).

The NPG drawing was engraved by F. Holl, published J. Murray, 1848 (example in NPG), for Mary Somerville's *Physical Geography*, I, frontispiece; it was also engraved by F. Croll (example in NPG), for the portrait gallery of 'Hogg's Weekly Instructor', and a woodcut after it was published *ILN*, LXI (1872), 573. The original elaborate frame of the drawing was carved by the donor. An earlier three-quarter length painting of Mary Somerville by Swinton, executed in Rome in 1844, was exhibited *VE*, 1892 (159), lent by Sir William Ramsay-Fairfax, and probably *Victorian Era Exhibition*, 1897, 'Women's Work Section, Historical Division' (15).

Description: Healthy complexion, brown eyes, grey-black hair.

316a (114–15) Profile and full-face views on the same sheet. Pencil on paper, $19\frac{1}{8} \times 25\frac{5}{8}$ inches (48·4 × 65·2 cm), by SIR FRANCIS CHANTREY, 1832. PLATE 841

Inscribed under the profile view in pencil: Mary Somerville/14 Augt 1832 *and under the full-face view:* Mʳˢ Somerville 14 Aug 1832

Collections: The artist, presented by the widow of one of his executors, Mrs George Jones, 1871.

These 'camera lucida' drawings are related to the marble bust in the Royal Society, London, exhibited *RA*, 1837 (1272), and *British Portraits*, RA, 1956–7 (697); the inscribed date, '1840', was apparently added later. A related plaster bust is in the Ashmolean Museum, Oxford, and two more are at Somerville College, Oxford. A copy is in the Royal Institution, London. The drawings of Mary Somerville are part of a large collection of Chantrey studies which will be discussed as a group in the forthcoming Catalogue of Portraits, 1790–1830.

ICONOGRAPHY A painting by T. Phillips is in the Scottish NPG (plate 842), purchased from the Murray Collection, Sotheby's, 15 May 1929 (lot 130), listed in Phillips' 'Sitters Book' (copy of original MS, NPG archives), under 1834, exhibited *RA*, 1834 (66), lithographed in reverse by Miss H. S. Turner (example in NPG); a painting by J. Jackson is at Somerville College, Oxford, and so is a painting by an unknown artist, presented by Colonel J. Ramsay-Fairfax; the donor described it as a self-portrait, but it appears too fluent and sophisticated to be the work of an amateur; a drawing by S. Laurence is at Girton College, Cambridge, purchased at the Laurence sale, Puttick and Simpson, 12 June 1884 (lot 219), presumably related to the painting exhibited *RA*, 1836 (413); a drawing by C. Vogel is in the Küpferstichkabinett, Staatliche Kunstsammlungen, Dresden; a water-colour by Mrs Heming (*née* Lowry) of 1818 was recorded and sketched in the collection of W. J. Lowry, 1877, by G. Scharf, 'TSB' (NPG archives), XXIII, 39; a miniature by Miss E. Jones was exhibited *RA*, 1837 (876); an unnamed portrait was lent to the *Victorian Era Exhibition*, 1897, 'Women's Work Section' (1), by Miss Helen Blackburn; a marble bust by L. Macdonald was owned by Sir H. W. Ramsay-Fairfax-Lucy, exhibited *RA*, 1846 (1460), reproduced *Personal Recollections of Mary Somerville*, edited Martha Somerville (1877), frontispiece, engraved by E. Finden (example in British Museum); bronze casts of a medallion by L. Macdonald of 1844 are at Somerville College, Oxford, and formerly collection of Mrs Henry Lyell, 1913; a reduced plaster version is in the Scottish NPG; a bronze medallion by David D'Angers is in the Musèe des Beaux Arts, Angers; a plaster medallion by R. Macpherson is in the Scottish NPG, and a medallion by an unknown artist is at Somerville College.

SOUL *Joseph*

Slavery abolitionist.

599 See *Groups:* 'The Anti-Slavery Society Convention, 1840' by B. R. Haydon, p 538.

SPALDING *Jack*

Ex-Lancer, gambler at Crockford's.

4026 (51) See *Collections:* 'Drawings of Men About Town, 1832–48' by Count A. D'Orsay, p 557.

SPEDDING *James* (*1808–81*)

Editor of Francis Bacon; one of the Cambridge 'Apostles'; remained a close friend of Tennyson, Fitzgerald and others; wrote on Shakespeare; his editions of Bacon's *Works* (1857–9) and *Life and Letters* (1861–74) were the result of thirty years of scholarship.

2059 Red and black chalk on grey-toned paper, 19¼ × 12⅝ inches (49 × 32·1 cm), by GEORGE FREDERICK WATTS, *c* 1853. PLATE 843

Inscribed on a label formerly on the back of the backboard: To our executors/After our death we have/ promised that this drawing/by Watts of James Spedding/shall be given to the National Portrait/ Gallery – S F and Isabel Spedding

Collections: The artist; Mrs Charles Cameron; Sir Henry Taylor; the Misses Sarah and Isabel Spedding (the sitter's nieces), presented by Isabel Spedding, 1924 (see appendix on portraits by G. F. Watts in forthcoming Catalogue of Portraits, 1860–90).

Exhibitions: V E, 1892 (392); *Cumbrian Characters*, Abbot Hall Art Gallery, Kendal, 1968 (66).

Literature: [Mrs] M. O. Watts, *George Frederic Watts* (1912), I, 114.

In a letter of 15 July 1908 (NPG archives), Miss Sarah Spedding wrote:

This *one is merely a head – face ¾ profile – it is an admirable likeness and a singularly fine drawing – and its history is as follows. Mr Watts begged my uncle to let him 'have his head or face' for one of the philoso- phers in the large fresco in Lincolns Inn Hall – where the result can be seen. The drawing which he made as a study for the picture he gave to the late Mrs Charles Hoy Cameron – a common friend – she left it to Sir Henry Taylor expressing a wish that after his death it should be ours. He sent it to me himself not long be- fore his death.*

This letter was prompted by the offer to the NPG of a drawing of Spedding by Watts from the collec- tion of Mrs Catherine Donne; this drawing turned out to be a reproduction of NPG 2059, and is now in the NPG archives. In a second letter of 5 August 1908 (NPG archives), Miss Sarah Spedding promised to leave her drawing to the NPG. The Lincolns Inn fresco was begun in 1853 and completed in 1859.

ICONOGRAPHY A painting by S. Laurence of *c* 1840 is mentioned in a letter (Trinity College library) from Spedding to John Allen of 24 August 1840; another version was given by the artist to Edward Fitzgerald, sold Christie's, 8 December 1883 (lot 17); a painting by S. Laurence of 1859 is in the collection of J. H. F. Spedding, presumably that exhibited *R A*, 1860 (123), together with three other portraits by Laurence; a posthumous painting by S. Laurence of 1881–2 is at Trinity College, Cambridge (chapel), and so is a marble medallion by T. Woolner of 1882, exhibited *R A*, 1882 (1637); several paintings of a 'Mr Spedding' were in the Laurence Sale, Puttick and Simpson, 12 June 1884 (lots 154 and 161); a drawing by S. Laurence is in the collection of Miss Armide Oppé; a drawing by himself of 1834 was in the collection of the Master of Trinity College, 1908; a woodcut was published *ILN*, LXXVIII (1881), 281.

426

SPEKE *John Hanning* (*1827–64*)

African explorer; army officer in India, 1844–54; explored Somaliland and central Africa, with Sir Richard Burton, discovering Lake Tanganyika, and, independently, Victoria Nyanza; with J.A.Grant, proved the latter to be the source of the Nile; Speke and Grant were the first to cross equatorial Africa.

1739 Plaster cast, painted black, 32½ inches (82·5 cm) high, of a bust by LOUIS GARDIE, 1864. PLATE 844

Incised on the front of the base: JOHN HANNING SPEKE/BORN 1827. DIED 1864./ "HONOR EST A NILO"
Incised on the back of the shoulders: L Gardie Sculp. 1864 Bath *and below, on the back of the base:* John Hanning/Speke/Born 1827 Died. 1864.

Collections: Mr King (a solicitor in Bath); purchased at his sale by Alfred Jones, and presented by him, 1914.

According to the donor, in a letter of 26 September 1914 (NPG archives), Gardie was working in Bath, *c* 1860–70, but he did not know for whom the bust of Speke was executed. Another bust of Speke by Gardie, dated 1865, is in the Royal Geographical Society, London.

ICONOGRAPHY A painting by W.Waterhouse was exhibited *SKM*, 1868 (547), and *VE*, 1892 (86), lent by W.Speke; a painting by H.W.Phillips, with Captain J.A.Grant and a native, was in the collection of Speke's brother-in-law, Sir John Dorrington, exhibited *RA*, 1864 (324); a copy, representing Speke only, is in the collection of Lord and Lady Milford; a bust by E.G.Papworth senior is in Shire Hall, Taunton, exhibited *RA*, 1865 (1038); a bust by S.C.Pieroni is in the Royal Albert Memorial Museum, Exeter; a monument is in Kensington Gardens, London; several photographs and popular woodcuts and engravings are in the NPG, and a photograph by Williams is reproduced as a woodcut *ILN*, XLIII (1863), 17.

SPENCER *John Charles Spencer, 3rd Earl* (*1782–1845*)
Statesman.
54 See *Groups:* 'The House of Commons, 1833' by Sir G.Hayter, p 526.
See also forthcoming Catalogue of Portraits, 1790–1830.

SPENCER *Frederick Spencer, 4th Earl* (*1798–1857*)
MP for Midhurst.
54 See *Groups:* 'The House of Commons, 1833' by Sir G.Hayter, p 526.

STACEY *George* (*1787–1857*)
Slavery abolitionist.
599 See *Groups:* 'The Anti-Slavery Society Convention, 1840' by B.R.Haydon, p 538.

STAIR *John Hamilton Macgill Dalrymple, 8th Earl of* (*1771–1853*)
General, MP for Edinburgh.
54 See *Groups:* 'The House of Commons, 1833' by Sir G.Hayter, p 526.

STANDISH *Charles* (*1790–1863*)
Politician and sportsman.
4026 (52) See *Collections:* 'Drawings of Men About Town, 1832–48' by Count A.D'Orsay, p 557.

STANFIELD *Clarkson* (*1793–1867*)

Painter; left the navy, 1818; became a scene-painter; worked at Drury Lane; founder member of Society of British Artists; exhibited landscapes and seascapes regularly at RA and elsewhere, 1820–67; elected RA, 1835; called 'the English Vandevelde'.

2637 Oil on canvas, 30⅛ × 25 inches (76·5 × 63·5 cm), attributed to JOHN SIMPSON, *c* 1829. PLATE 845

Collections: By descent to the sitter's granddaughter, Mrs Harriet Bicknell, and presented by her, 1933.

A portrait of Stanfield by Simpson, signed and dated 1829, and close in style, treatment and date to the NPG portrait, was recorded by J. S. Steegman in the collection of another descendant of Stanfield (memorandum of 26 September 1933, NPG archives); he does not, however, give the name of the owner. The 1829 Simpson portrait was exhibited *R A*, 1829 (359), *S K M*, 1868 (601), and *V E*, 1892 (194); it was engraved by W. Say, published B. Tiffin, 1834 (example in British Museum).

Description: Healthy complexion, greenish brown (?) eyes, brown hair and whiskers. Dressed in a dark stock, white collar, and black coat. Background colour very dark brown.

2515 (40) Black and red chalk, with touches of Chinese white, on green-tinted paper, 14¾ × 10⅝ inches (37·5 × 27 cm), by WILLIAM BROCKEDON, 1833. PLATE 846

Dated (lower left): 12.11.33

Collections: See *Collections:* 'Drawings of Prominent People, 1823–49' by W. Brockedon, p 554.

Accompanied in the Brockedon Album by an undated letter from the sitter.

ICONOGRAPHY A painting by Sir D. Macnee is in the Royal Scottish Academy, exhibited *R A*, 1859 (113); another painting by Macnee was recorded in the collection of Robert Napier by J. C. Robinson, *West Shandon Catalogue* (1865), p 61; a painting called Stanfield by an unknown artist is in the Sunderland Art Gallery; a painting called Stanfield was with Spink and Son, reproduced *Country Life*, CXXXVI (1964), 397; Stanfield appears in 'The Sketching Society, 1836' by J. Partridge, which was in the collection of W. A. Brigg of Kildwick Hall, Keighley, 1913, exhibited *R A*, 1838 (408); a related water-colour and a lithograph by J. Hogarth of 1858 are in the British Museum; a water-colour by A. E. Chalon was exhibited *R A*, 1849 (934), and *V E*, 1892 (319); a drawing by himself of 1842, with Maclise, Dickens and Forster in Cornwall, is in the Victoria and Albert Museum; a drawing by D. Maclise was exhibited *S K M*, 1868 (572); a drawing by D. Roberts is in the Royal Academy, exhibited *David Roberts and Clarkson Stanfield Exhibition*, Guildhall Art Gallery, London, 1967 (101), reproduced in catalogue; a bust by G. Clarke of Birmingham is listed R. Gunnis, *Dictionary of British Sculptors* (1953), p 103; there is a lithograph by E. U. Eddis (example in British Museum); an anonymous woodcut was published *ILN*, XXXV (1859), 511, and a woodcut, after a photograph by Watkins, L (1867), 545; a woodcut, after a photograph by Maull and Polyblank, was published *Cassell's Illustrated Family Paper*, 4 June 1859, p 8, and another was published in an unidentified magazine (cutting in NPG); two photographs are in the NPG.

STANHOPE *Philip Henry Stanhope, 4th Earl* (*1781–1855*)

Man of affairs.

2789 See *Groups:* 'Members of the House of Lords, *c* 1835' attributed to I. R. Cruikshank, p 536.

STANHOPE *Philip Henry, 5th Earl* (*1805–75*)

Historian; MP from 1830; under-secretary for foreign affairs, 1834–5; FSA, 1841, and president from 1846; secured extension of copyright, and foundation of the NPG; first chairman of NPG trustees from 1857; lord rector of Aberdeen, 1858; a founder of the Historical Manuscripts Commission; a prolific historian, working chiefly on the 18th century.

4336 Oil on millboard, 13¾ × 11¾ inches (35 × 29·9 cm), by SIR GEORGE HAYTER, 1834. PLATE 847

Signed and dated (bottom right): Sketch 1834/George Hayter

Inscribed on a label on the back of the board: Lord Viscount Mahon, M.P./for Hertford/Study for my great picture of The/House of Commons of 1833/George Hayter 1834.

Collections: The sitter; by descent to his great-granddaughter, Miss Cicely Stanhope, and presented, in accordance with her wishes, 1963.

Literature: Sketched by G. Scharf at Chevening, 1876, 'SSB' (NPG archives), XCIII, 72; *List of Portraits at Chevening* (1931), p 12; *NPG Annual Report, 1963–4* (1964), pp 3–4.

This is a study for Hayter's 'House of Commons, 1833' (see below). The study was engraved by J. W. Cook (example in NPG).

Description: Fresh complexion, light grey eyes, brown hair and whiskers. Dressed in a dark grey stock, white shirt and waistcoat, grey coat. Rest of background light stippled brown.

499 Marble bust, 29½ inches (75 cm) high, by HENRY HUGH ARMSTEAD, after a bust by LAWRENCE MACDONALD of 1854. PLATE 849

Collections: Commissioned and presented by the sitter's son, the 6th Earl Stanhope, 1878.

The original bust by Macdonald is at Chevening, the home of the Stanhopes; it was sketched by G. Scharf, 'SSB' (NPG archives), XCIII, 83, and is reproduced H. Ward, *History of the Athenaeum* (1926), facing p 74. Another undated bust of Stanhope by Macdonald is also at Chevening, for which see R. Gunnis, *Dictionary of British Sculptors* (1953), p 249. Armstead executed a medallion of Stanhope for the Home Office building (see his letter to Scharf of 6 February 1875, NPG archives).

955 Plaster cast, painted white, with touches of ochre, 10¼ inches (26 cm) diameter, of a medallion by FREDERICK THOMAS, *c* 1894. PLATE 850

Collections: Sir George Scharf, presented by him, 1894.

This is a reduced cast of the stone medallion on the exterior of the NPG building; the original full-scale plaster model for this was in the NPG, reproduced *Magazine of Art* (1895), p 431. In connection with the large medallion, the sitter's son, the 6th Earl Stanhope, wrote to George Scharf (letter of 12 March 1894, NPG archives): '*I am sorry to find that I have no large sized Photographs of my Father here, though there are a few at Chevening. If you will therefore kindly send me a Postcard of Mr Thomas' Jun^r. direction, I will send him a Photograph, on the first opportunity . . . I should be glad to have a good medallion of my Father at the New Nat. Portrait Gallery'.*

54 See *Groups:* 'The House of Commons, 1833' by Sir G. Hayter, p 526.

342,3 See *Groups:* 'The Fine Arts Commissioners, 1846' by J. Partridge, p 545.

ICONOGRAPHY The following portraits are at Chevening: a painting by J. Lucas of 1837, reproduced A. Lucas, *John Lucas* (1910), plate XXI (where a replica for Sir E. Kerrison is also mentioned), engraved by W. and F. Holl, published R. Ryley, J. Fraser, and F. G. Moon, 1839 (example in NPG), for Virtue's 'Portraits of Conservative Statesmen'; a painting by L. Dickinson, presumably a replica of the portrait owned by Countess Beauchamp (see below); a painting by W. W. Ouless of 1875, exhibited *RA*, 1876 (430); a painting by Miss Donkin after E. M. Ward's portrait of 1854 (see below); a water-colour by an unknown artist (with his brother George), sketched by G. Scharf, 'SSB' (NPG archives), XCIII, 72; a water-colour by W. Haines (in coronation robes), also listed by Scharf, engraved by S. W. Reynolds (example at Chevening); a bust by L. Macdonald of 1854, of which there is a copy in the NPG (499 above).

A painting by an unknown artist was in the collection of the Hon Mrs Douglas Hamilton, Norfolk, 1933; a painting by J. Partridge of 1845, a study for the 'Fine Arts Commissioners' (see NPG 342 above), is in the Society

of Antiquaries, London (plate 848), reproduced *Burlington Magazine*, CIX (1967), 403; a painting by L. Dickinson was in the possession of the sitter's daughter, Countess Beauchamp, listed, together with a marble bas-relief, in the *Madresfield Court Catalogue* (1909), pp 26 and 40, and in Scharf's catalogue of the same collection (1878), p 24 (the artist given as J. L. Dickenson in both, but as L. Dickinson on the engraving, which must be right, as there are no other portraitists of the name), engraved anonymously, published J. Murray, 1873 (example in NPG); there is a replica(?) at Chevening, listed in Canon Scott Robertson, *Chevening Church and Chevening House* (1891), p 22, and *List of Portraits, Etc at Chevening* (1931), p 39 (as by 'Dickenson' in both), the dates of the various Chevening and Madresfield catalogues proving that there are two versions, and not one; a painting by E. M. Ward of 1854 (in his study) is at Hughenden Manor, and a copy by Miss Donkin of 1879 is at Chevening (see above); a painting by W. Yellowlees was exhibited *RA*, 1829 (405); two drawings by J. Doyle, and a drawing by G. Scharf of 1873 or 1876, are in the British Museum; a drawing called Stanhope by an unknown artist is in the collection of the Countess of Longford; there is an engraving by F. C. Lewis, after J. Slater (example in NPG), for the 'Grillions Club' series; there are several photographs in the NPG (see plate 851), and one is reproduced as a woodcut *ILN*, XXXII (1858), 401; a woodcut was published *ILN*, LXVIII (1876), 61.

STANHOPE *Hon Lincoln* (*1781–1840*)

Soldier, son of the 3rd Earl of Harrington.

4026 (53) See *Collections:* 'Drawings of Men About Town, 1832–48' by Count A. D'Orsay, p 557.

STANLEY *Edward George Geoffrey Smith, 14th Earl of Derby*. See DERBY

STANLEY *Edward John Stanley, 2nd Baron* (*1802–69*)

Statesman, MP for Cheshire North.

54 See *Groups:* 'The House of Commons, 1833' by Sir G. Hayter, p 526.

STANTON *Henry B.*

Slavery abolitionist.

599 See *Groups:* 'The Anti-Slavery Society Convention, 1840' by B. R. Haydon, p 538.

STARK *James* (*1794–1859*)

Landscape painter; student of John Crome; elected to Norwich Society of Artists, 1812; exhibited at the RA and elsewhere, 1811–59; completed his *Scenery of the Rivers of Norfolk*, 1840.

1562 Water-colour and black chalk on paper, $10\frac{1}{2} \times 8\frac{1}{4}$ inches (26·7 × 21 cm), by HORACE BEEVOR LOVE, 1830. PLATE 852

Signed and dated (lower right): H B Love Jany/1830

Inscribed on a label, formerly on the back of the picture: James Stark/by/H B Love

Collections: The sitter; by descent to his daughter-in-law, Mrs R. Isabella Stark, and purchased from her, 1910.

Literature: Reproduced *Art Journal* (1850), p 182, as an anonymous woodcut (head only).

Inscribed in pencil at the top of the rolled sheet of paper which Stark is holding, 'Scenery of the/ Yare & Waveney' (both rivers in Norfolk). This is presumably a reference to the *Scenery of the Rivers of Norfolk*, engraved from Stark's pictures by Edward Goodall, William Miller and others, with a text by J. W. Robberds (1827–34). A portrait of Stark's friend, J. C. Cotman, by Love is also in the NPG (1372).

Description: Fresh complexion, brown eyes and hair. Dressed in a white shirt, black stock and jacket.

ICONOGRAPHY A painting called Stark by himself was in the collection of Colonel M.H.Grant; a drawing and a lithograph by unknown artists are in the British Museum; a bust by J.Heffernan was exhibited *RA*, 1818 (1048).

STAUNTON *Sir George Thomas, Bart* (*1781–1859*)

Writer on China, MP for Hampshire South.

54 See *Groups:* 'The House of Commons, 1833' by Sir G.Hayter, p 526.

STAVELEY *Thomas Kitchingman* (*1791–1860*)

MP for Ripon.

54 See *Groups:* 'The House of Commons, 1833' by Sir G.Hayter, p 526.

STEANE *Rev Edward*

Slavery abolitionist.

599 See *Groups:* 'The Anti-Slavery Society Convention, 1840' by B.R.Haydon, p 538.

STEER *John* (*1780–1856*)

Slavery abolitionist.

599 See *Groups:* 'The Anti-Slavery Society Convention, 1840' by B.R.Haydon, p 538.

STEPHEN *Sir James* (*1789–1859*)

Colonial under-secretary; barrister, 1811; counsel to colonial office, 1813; accepted permanent post, 1825; prepared anti-slavery bill, 1833; wrote for *Edinburgh Review* from 1838; resigned office, appointed KCB and privy councillor, 1847; professor of modern history, Cambridge, 1849–59; published essays and lectures.

1029 Marble bust, $29\frac{1}{8}$ inches (74 cm) high, by BARON CARLO MAROCHETTI, 1858. PLATES 853, 854

Collections: By descent to the sitter's grandson, Sir Herbert Stephen, and presented by him, 1896.
Exhibitions: *RA*, 1859 (1349).

In a letter of 17 August 1858 (copy of the original communicated by the donor, NPG archives), the sitter wrote to Sir Henry Taylor:

I have just been released from attendance on the Baron Marochetti, who undertook to exhibit me in marble. He began his work by assuring me that he never flattered, and he has certainly ended it by being as good as his word. Now, to pay a man more than could maintain a hard-working curate a whole year for twelve hours' work in moulding one's visage, and to get no flattery after all, is really to burn one of Mr Ruskin's 'Lamps of Truth' at a very high cost.

ICONOGRAPHY Two drawings were mentioned by Sir Herbert Stephen, the donor of the NPG bust, in a letter of 24 January 1896 (NPG archives); a plaster bust by A.Munro is in the Colonial Office library, presumably related to the marble by Munro exhibited *RA*, 1866 (993).

STEPHENS *Catherine, Countess of Essex*. See ESSEX

STERRY *Henry* (*1803–69*)

Slavery abolitionist.

599 See *Groups:* 'The Anti-Slavery Society Convention, 1840' by B.R.Haydon, p 538.

STERRY *Richard* (*1785–1865*)

Slavery abolitionist.

599 See *Groups:* 'The Anti-Slavery Society Convention, 1840' by B.R.Haydon, p538.

STEUART *Robert* (*c1806–42*)

MP for Haddington.

54 See *Groups:* 'The House of Commons, 1833' by Sir G.Hayter, p526.

STEVENS *Alfred* (*1818–75*)

Sculptor and designer; studied in Italy, 1833–42; taught design in London, 1845–7; chief designer at Hoole & Co, Sheffield; executed Wellington monument at St Paul's; entrusted with interior design of several houses; one of the most important and ambitious artists of the period.

1526 Pencil on paper, $11\frac{3}{8} \times 9$ inches ($29 \times 22 \cdot 8$ cm), by HIMSELF, *c*1835–40. PLATE 857

Collections: James Gamble, purchased from him, 1908.

Exhibitions: Painters of Wessex, Bournemouth, 1962 (68).

Literature: D.S.MacColl, 'Portraits by Alfred Stevens', *Burlington Magazine*, XIV (1909), 266, reproduced 267.

Gamble had been a student of Stevens, and had a large collection of his work. Both he and MacColl thought the drawing must have been executed during Stevens' student years in Rome (see letter from vendor, 1 December 1908, NPG archives). There is, however, no conclusive proof that it represents Stevens. On the reverse of the NPG drawing is a figure sketch, probably a study for the 'Brazen Serpent'.

1413 Plaster cast, painted white, $14\frac{3}{4} \times 12$ inches ($37 \cdot 4 \times 30 \cdot 4$ cm) oval, of a death-mask by REUBEN TOWNROE, 1875. PLATE 856

Incised on the back, in monogram: R T

Collections: Purchased from the artist, 1905.

Literature: Reproduced K.R.Towndrow, *Alfred Stevens* (1939), facing p258.

In a letter of 1905 (NPG archives), the artist wrote: '*I made this cast shortly after his death, at that time I was his pupil & assistant*'.

ICONOGRAPHY An oil self-portrait painting of 1832, two self-portrait drawings, a silverpoint drawing by A.Legros (posthumous, partly based on a photograph, reproduced K.R.Towndrow, *Alfred Stevens* (1939), facing p44), and a bronze bust by E.Lanteri, (of which there is a plaster cast in the City Art Gallery, Manchester), are in the Tate Gallery; a painting attributed to himself (similar to the photograph of *c*1867, see below) was in the collection of Professor Morris Moore, 1923; a painting by G.C.Eaton (in his house at 9 Eton Villas, Hampstead) was in the collection of F.R.Eaton, reproduced Towndrow, facing p214; a bust by W.Ellis of *c*1876 is in the Mappin Art Gallery, Sheffield; a marble medallion by F.Wood is reproduced *Magazine of Art* (1893), p286, where it is said to have been presented to Blandford; there is a photograph of *c*1867 (example in NPG (plate 855), another reproduced Towndrow, frontispiece), and another by W.S.Bird is reproduced *Magazine of Art* (1892), p303.

STEVENSON *Joseph* (*1806–95*)

Historian and archivist; in MS department, British Museum, 1831; on Record Commission from 1834; Anglican priest, and keeper of records at Durham, 1841; a founder-editor of the Rolls series; a catholic, 1863, priest, 1872, and Jesuit, 1885; catalogued in Vatican archives; edited numerous texts and wrote biographies.

982 Plaster cast, painted white, $5\frac{1}{2}$ inches (14 cm) diameter, of a medallion, by CHARLES MATTHEW.
PLATE 858

Incised (left): JOS/EPH S/TEVE/NSON./S.J.

Inscribed in ink on the back of the medallion: Everard Green Esq/Rouge Dragon [*College of Heralds*],
With kindest regards/from/J M Gray/June 1893./Medallion of Father Joseph Stevenson S.J./Modelled
by Chas Matthew/Edinburgh

Collections: J.M.Gray; Everard Green, presented by him, 1895.

A wax and a bronze medallion by the same artist, both of 1889, are in the Scottish NPG, the former
bequeathed by J.M.Gray. These are the only recorded likenesses of the sitter.

STEWART *Alexander* (*1830–72*)

Whaling officer; commanded the 'Sophia', 1850–1, sent out by Lady Franklin in the search for her
husband; commanded the 'SS COLUMBIAN' during the Crimean War.

1220 Oil on canvas, $15 \times 12\frac{3}{4}$ inches ($38 \cdot 1 \times 32 \cdot 4$ cm), by STEPHEN PEARCE, *c* 1854. PLATE 859

Collections: See *Collections:* 'Arctic Explorers' by S.Pearce, p 562.
Exhibitions: R A, 1854 (525).

This is the only recorded portrait of Stewart. He is dressed as an officer of the merchant navy.
Description: Healthy complexion, dark eyes, brown hair. Dressed in a dark neck-tie, white shirt, dark
blue coat, with gilt buttons. Background colour dark grey.

STIRLING-MAXWELL *Caroline Elizabeth Sarah, Lady* (*Caroline Norton*) (*1808–77*)

Poetess, society wit and beauty; published Byronic poetry from 1829; married, 1827, Hon G.C.Norton,
who unsuccessfully sued Melbourne for crim. con., 1836; published social poetry, novels, criticism, and
influential pamphlets on women's rights; married Sir W.M.Stirling-Maxwell (see below), 1877.

3791 With her sister, Jane, Duchess of Somerset (standing). Oil on canvas, $84 \times 58\frac{5}{8}$ inches ($213 \cdot 3 \times 149$ cm),
by an UNKNOWN ARTIST[1]. PLATES 860, 862

Collections: Purchased from Knight, Frank and Rutley, by Lady Wavertree, a descendant of the sitter,
and presented by her, 1951.

The identification of the sitters is traditional. The features of the two women agree fairly well with
authentic likenesses of them, but not conclusively so. In a letter of 21 February 1951 (NPG archives),
Francis Howard wrote: '*I bought it for her* [Lady Wavertree] *many years ago at Knight Frank and
Rutleys if I remember rightly.*' The portrait was said to be by Sir Francis Grant, but it is not listed in
his comprehensive 'Sitters Book' (copy of original MS, NPG archives), and it does not correspond with
his work in colour or style. No convincing alternative attribution has been suggested.
Description: Lady Stirling-Maxwell (on the left): healthy complexion, greyish eyes, brown hair.
Dressed in a greyish-brown costume, with gold necklace, and red patterned shawl, holding a guitar,
with a blue ribbon tied at the top. Duchess of Somerset: healthy complexion, brown eyes and hair.
Dressed in a yellow costume, white stockings and black shoes, holding a bunch of multi-coloured
flowers. Brown and white spaniel. Various black and red volumes lying on multi-coloured marble floor.
Brown pillar at left. Dark grey water-barrel (?) at right. Brown and green landscape. Blue sky behind.

[1] At the time of going to press, it was found that this picture was painted by Andrew Geddes, but the identity of the sitters is doubtful.
 See appendix.

729 Plaster cast, painted dark bronze, 21⅝ inches (55 cm) high, of a bust by FRANCIS JOHN WILLIAMSON, 1873. PLATE 864

Incised on the back of the socle: F.J. WILLIAMSON. Sc./ESHER./1873.

Collections: The artist, presented by him, 1884.

Exhibitions: Possibly *RA*, 1873 (1421).

A companion to the bust of her husband (see NPG 728 below, where both busts are discussed). A bronze version, similarly signed and dated, is in Pollok House, Glasgow.

1916 See *Groups:* 'Samuel Rogers, Mrs Norton (Lady Stirling-Maxwell) and Mrs Phipps, *c* 1845' by F. Stone, p 545 (detail, plate 863).

ICONOGRAPHY A painting by W. Etty is at Pollok House, Glasgow (plate 861), exhibited *VE*, 1892 (283), reproduced D. Farr, *William Etty* (1958), plate 90; another painting by Etty, with her two sisters (?), is in the City Art Gallery, Manchester, reproduced Farr, plate 93; a painting by G. F. Watts is in the National Gallery of Ireland, Dublin, and so is a drawing by J. Hayter, engraved by J. Thomson, published H. Colburn, 1833 (example in NPG), for the 'Court Journal'; there are two similar drawings, one in the collection of Lord Grantley, 1954, the other engraved by G. J. Stodart, published R. Bentley, 1886 (example in NPG); a painting by Sir G. Hayter is at Chatsworth, reproduced *Connoisseur*, IX (1904), 149, engraved by J. Cochran, published 1836 (example in NPG), for 'Churton's Portrait and Landscape Gallery', and lithographed anonymously (example in British Museum); a painting by J. R. Swinton (with Lady Dufferin and the Duchess of Somerset) was exhibited *RA*, 1852 (35), and *VE*, 1892 (17), lent by the Marquess of Dufferin and Ava; a drawing by Swinton, possibly related to the oil, is in the collection of Brigadier Swinton; paintings by E. T. Parris and Miss E. G. Richards, were exhibited *RA*, 1833 (350), and 1852 (545); a painting called Lady Stirling-Maxwell, and attributed to Sir M. A. Shee, was at the Sedelmeyer Gallery, Paris, 1896 (95), reproduced sale catalogue, facing p 122; a drawing by B. R. Haydon is reproduced in his *Diaries*, edited W. B. Pope (1963), IV, 97, possibly the drawing he later pawned (see IV, 236); Haydon also portrayed Lady Stirling-Maxwell as 'Cassandra Prophesying the Death of Hector', a painting recorded in the collection of the Duke of Sutherland, 1844; a drawing by Sir E. Landseer is in the Nottingham College of Art, exhibited *Arts and Antiques in Nottinghamshire*, Castle Museum, Nottingham, 1937 (557), possibly the drawing engraved by F. C. Lewis, published H. Colburn, 1840 (example in NPG); a water-colour by Mrs Ferguson of Raith of 1862 is in the Scottish NPG; a caricature drawing by herself was in the collection of Mrs Hodges, 1930; a miniature by J. West was exhibited *RA*, 1856 (975); busts by P. Hollins and T. Butler are listed by R. Gunnis, *Dictionary of British Sculptors* (1953), pp 205 and 74, the latter (a marble) exhibited *RA*, 1844 (1354); a marble bust by Lord Gifford (as a young woman) is at Pollok House, Glasgow; a wax medallion by R. C. Lucas is reproduced *Connoisseur*, XXVI (1910), 142, when in the collection of L. Harcourt; an engraving by D. Maclise (example in NPG) was published *Fraser's Magazine*, III (1831), facing 222, as no. 10 of Maclise's 'Gallery of Illustrious Literary Characters'; a pencil study is in the Victoria and Albert Museum; Lady Stirling-Maxwell was the model for 'Justice' in Maclise's fresco of that title in the House of Lords; a related oil study of 'Caroline Norton as Erin' is in the collection of the Hon. Desmond Guinness, exhibited *Daniel Maclise*, Arts Council at the NPG, 1972 (96); an engraving by H. Robinson, after T. Carrick, was published P. Jackson (example in NPG); there is an engraving by J. C. Bromley, after E. T. Parris, and a lithograph by I. W. Slater, after a drawing by J. Slater, published J. Slater, 1829 (examples in British Museum); a woodcut was published *ILN*, LXX (1877), 613; there is another woodcut and a photograph in the NPG.

STIRLING-MAXWELL *Sir William, Bart (1818–78)*

Historian, connoisseur, and collector; published the first scholarly work on Spanish painters, 1834; and a biography of Charles V; remodelled his estates, and developed 'Keir strain' in cattle and horses; MP from 1852; active in social and literary circles; rector of St Andrews, 1862; chancellor of Glasgow, 1876; bibliographer; his *Don John of Austria* published posthumously, 1883.

728 Plaster cast, painted dark bronze, 22⅝ inches (57·1 cm) high, of a bust by FRANCIS JOHN WILLIAMSON, 1873. PLATE 865

Incised on the back of the socle: F.J. WILLIAMSON. Sc./ESHER./1873.

Collections: The artist, presented by him, 1884.

Exhibitions: Possibly *RA*, 1873 (1439).

This is a companion to the bust of Lady Stirling-Maxwell (NPG 729 above). In a letter of 1 August 1884 (NPG archives), the artist wrote that the NPG busts were executed '*as studies for their busts during life*'. In a second letter of 13 December 1884 (NPG archives), he wrote: '*They were modelled at Keir about 1876 or 1877 [sic] and Sir William commissioned me to execute them in marble, but he unfortunately died before they were both completed. When Sir William's bust was finished it was purchased by the late Mr William Stirling Crawford, and is now I believe in the possession of the Dowager Duchess of Montrose. The marble bust of Mrs Norton I never carried out, but the finished model is in my studio*'. A bronze version of the NPG type, with broader shoulders and a cloak, is in the Scottish NPG.

ICONOGRAPHY The following portraits are listed by J.L.Caw, *Scottish Portraits* (1903), II, 152: a painting by W.Douglas (as a child) at Pollok House, Glasgow; a painting of 1839 by J.G.Gilbert at Keir; and a drawing by G.Richmond at Keir, reproduced Caw, II, facing 151. A woodcut was published *ILN*, LIX (1871), 512.

STODDART *Charles* (*1806–42*)

Soldier and diplomat; army captain on half pay, 1834; military secretary in Persia; presented British ultimatum to Mahomed Shah, 1838; envoy to Bokhara, but imprisoned by the Ameer; communicated Ameer's desire for alliance to Palmerston, 1841; he and Arthur Conolly beheaded by Ameer, 1842.

2515 (74) Black and red chalk on grey-tinted paper, 14⅜ × 10½ inches (36·5 × 26·7 cm), by WILLIAM BROCKEDON, 1835. PLATE 866

Dated (lower left): 1.5.35

Collections: See *Collections:* 'Drawings of Prominent People, 1823–49' by W.Brockedon, p554.

Accompanied in the Brockedon Album by a letter from the sitter, dated 10 July 1825 (or possibly 1835).

ICONOGRAPHY No other portraits of Stoddart are recorded; a miniature by an unknown artist called Stoddart (NPG 931) probably represents Major Stephen Stoddart, father of Charles Stoddart.

STOVEL *Rev Charles*
Slavery abolitionist.

599 See *Groups:* 'The Anti-Slavery Society Convention, 1840' by B.R.Haydon, p538.

STRAFFORD *John Byng, 1st Earl of* (*1772–1860*)
Field-marshal, MP for Poole.

54 See *Groups:* 'The House of Commons, 1833' by Sir G.Hayter, p526.

See also forthcoming Catalogue of Portraits, 1790–1830.

STRAFFORD *George Stevens Byng, 2nd Earl of* (*1806–86*)
MP for Chatham.

54 See *Groups:* 'The House of Commons, 1833' by Sir G.Hayter, p526.

STRATFORD DE REDCLIFFE *Stratford Canning, 1st Viscount* (*1786–1880*)

Ambassador; most of his career spent as ambassador in Constantinople advancing British interests in the Levant, first against Napoleon, later against the Czar; on diplomatic missions to Switzerland, 1814–20, America and Portugal; MP from 1828; played a key role in diplomatic events in Constantinople leading to the outbreak of the Crimean war; resigned his post, 1858.

684 Oil on panel, 24 × 20 inches (61 × 50·7 cm), by GEORGE FREDERICK WATTS, 1856–7. PLATE 869

Signed (*bottom right*): G.F.Watts *Inscribed on a label, formerly on the back of the stretcher:* G.F.Watts. Little Holland House/No 3. Portrait of the late/Lord Stratford de Redcliffe

Collections: The artist, presented by him, 1883 (see appendix on portraits by G.F.Watts in forthcoming Catalogue of Portraits, 1860–90).

Exhibitions: Winter Exhibition, Grosvenor Gallery, 1882 (197).

Literature: [Mrs] M.S.Watts, *George Frederic Watts* (1912), I, 165; 'Catalogue of Works by G.F. Watts', compiled by Mrs M.S.Watts (MS, Watts Gallery, Compton), II, 150.

Painted in Constantinople during the winter of 1856–7. Watts accompanied Sir Charles Newton on an archaeological expedition to Halicarnassus, and was sent back by him to Constantinople to obtain some kind of permit from the Sultan. During this same visit Watts painted Admiral Lyons (NPG 685). In her biography, Mrs Watts wrote:

Lord Stratford consented to sit for two portraits: one of these now in the National Portrait Gallery was unfinished and was completed many years later. When speaking generally of the confidences made to him by his sitters, Signor used to say that Lord Stratford was the most indiscreet of them all. Perhaps he knew best the loyalty of his painter.

The second Watts portrait, showing the sitter in ordinary dress, is reproduced in Mrs Watts' catalogue; the head is almost identical to that in the NPG portrait.

Description. Healthy complexion, pale blue eyes, white hair. Dressed in a brown stock, white shirt, and white ermine peer's robes. Background colour red.

1513 Coloured chalk on brown, discoloured paper, 24¼ × 18⅞ inches (61·7 × 47·8 cm), by GEORGE RICHMOND, 1853. PLATE 870

Signed and dated (*bottom right*): Geo. Richmond deln.^t 1853

Collections: The sitter, bequeathed by his daughter, the Hon Louisa Canning, 1908.

Literature: G.Richmond, 'Account Book' (photostat copy of original MS, NPG archives), p 59, under 1853.

This drawing was engraved anonymously, possibly by F.Holl (example in NPG), and by G.Stodart, for S.Lane-Poole, *The Life of Stratford Canning* (1888), II, frontispiece; a copy of the drawing (possibly a reproduction of some kind, but apparently signed and dated 1859) was in the collection of Paul Fatio, Rome, 1933.

791 Plaster cast, painted black, 25 inches (63·5 cm) high, of a bust by SIR JOSEPH EDGAR BOEHM, 1864. PLATES 867, 868

Incised on the front of the base: VISCOUNT STRATFORD OF REDCLIFFE K C G B *and on the side:* J.E. Boehm fect./1864

Collections: Miss Mary Anne Talbot, presented by her executors, 1888.

Exhibitions: Winter Exhibition, Grosvenor Gallery, 1881 (370).

Related to the marble bust in the British Embassy at Istanbul, presumably the marble bust exhibited *RA*, 1865 (953). A plaster bust by Boehm, presumably another cast, was in the collection of R.Mills, 1891.

ICONOGRAPHY A painting by Sir H. Herkomer of 1879 is at King's College, Cambridge, exhibited *Summer Exhibition*, Grosvenor Gallery, 1880 (140), and *VE*, 1892 (141); a painting by H. R. Graves is at Eton College, exhibited *RA*, 1863 (214); a drawing by R. Lehmann of 1859 is in the British Museum, reproduced R. Lehmann, *Men and Women of the Century* (1896), p71, exhibited *RA*, 1869 (1135); a miniature (with two ladies) by A. Robertson was exhibited *RA*, 1819 (881), presumably the miniature, said to be of 1816, engraved by G. J. Stodart (example in NPG), for S. Lane-Poole, *The Life of Stratford Canning* (1888), I, frontispiece; there is an engraving by F. C. Lewis, after J. Slater (example in NPG), for the 'Grillions Club' series; an entry of 1828 in R. J. Lane's 'Account Books' (NPG archives), I, 15, referring to his lithograph after J. Slater, is presumably the lithograph after the same drawing as that engraved by Lewis (example in British Museum, where the lithograph is said to be anonymous); there is an anonymous engraving, a photograph by G. Glanville (plate 871), and an anonymous woodcut after a photograph (examples in NPG).

STRATHNAIRN *Hugh Henry Rose, Baron (1801–85)*

Field-marshal; major, 1826; served in Syria, 1840–8; in the Crimea; major-general, 1854; won several battles during the Indian Mutiny campaigns; commander-in-chief in India, 1860; commander of forces in Ireland, 1865–70; created baron, and GCSI, 1866; colonel, Royal Horse Guards, 1869; field-marshal, 1877.

1331 Plaster cast, painted dark bronze, 24⅞ inches (63·2 cm) high, of a bust by EDWARD ONSLOW FORD, *c* 1895. PLATE 872

Collections: Purchased from the artist's son, W. Onslow Ford, 1902.

This is a sketch for the head of Ford's bronze equestrian statue of Strathnairn at Albert Gate, Knightsbridge, reproduced *Magazine of Art* (1895), p439, and *Art Journal* (1898), p296. It was purchased with busts of Millais and Huxley by the same sculptor (NPG 1329, 1330).

ICONOGRAPHY A painting by an unknown artist, after a photograph by Bassano, is in the United Service Club, London; a caricature lithograph by Ape (C. Pellegrini) was published *Vanity Fair*, 20 August 1870.

STRICKLAND *Agnes (1796–1874)*

Historian; published verse and stories from history; wrote, with her sister Elizabeth, the popular and well-documented *Lives of the Queens of England* (1840–8); other series of royal biographies followed, and a novel; granted civil list pension, 1870.

403 Oil on canvas, 36¼ × 28¼ inches (92 × 71·7 cm), by JOHN HAYES, 1846. PLATE 873

Inscribed in ink in the artist's hand on a damaged label on the back of the stretcher, referring to its exhibition at the RA: *[illegible, presumably title]*/by John Hayes/at Frith Street Soho Sq^re

Inscribed in pencil on the same label in another and later hand: 28 Great Russell Street/Bedford Square

Collections: The sitter, bequeathed by her, 1875.

Exhibitions: RA, 1847 (535).

The portrait was engraved by F. C. Lewis, published H. Colburn, 1848 (example in British Museum), for Agnes Strickland's *Lives of the Queens of England*; on the engraving it is stated that the portrait was painted in June 1846. Agnes Strickland's sister, Mrs Gwillym, wrote of the portrait:

'*It is so dearly valued by all her family as an exact resemblance of her thirty years ago*' (letter of 2 October 1874, NPG archives). Hayes' address given in the 1847 RA catalogue was Frith Street, Soho.

Description: Healthy complexion, brown eyes, black hair. Dressed in a black or dark blue velvet dress, over a white undergarment, showing at the sleeves and neck. Pearl brooches at the sleeves, and a pearl

bracelet. Holding a rolled piece of paper, with gold and coloured letters, and an elaborate illuminated border, possibly some kind of testimonial. Red curtain at right, and a grey, stone pillar. Suggestion of landscape at left, with an orange streak above. Rest of sky various tones of blue and grey.

2923 Coloured chalk on grey paper, 10 × 8 inches (25·5 × 20·5 cm), by CHARLES L. GOW, 1846. PLATE 874
Signed and dated (lower right): C L Gow/1846 *Inscribed in pencil (top right):* 2A
Collections: Wilfrid Partington, presented by him, 1937.

This drawing had been inserted in a book (title not recorded), from which it was removed at the time of its accession. Two other drawings of Miss Strickland by Gow, part of a collection of over a hundred portrait drawings by the same artist, were recorded in the collection of James Dalziel, 1939 (he presented one to Dame Una Pope-Hennessy). Dalziel was the son of a Scottish landscape painter of the same name, who had been a life-long friend of Gow.

ICONOGRAPHY A painting by A. Hervieu, and a water-colour by A. E. Chalon were exhibited *RA*, 1840 (286), and 1853 (930); there are two photographs in the NPG, and another is reproduced as a woodcut *ILN*, LXV (1874), 113; an engraving is published J. M. Strickland, *Life of Agnes Strickland* (1887), frontispiece, and a bust by Bailey (presumably E. H. Baily) is mentioned, pp 179–80.

STRICKLAND *(later Cholmley) Sir George, Bart (1782–1874)*
MP for Yorkshire, West Riding.
54 See *Groups:* 'The House of Commons, 1833' by Sir G. Hayter, p 526.

STUART *Lord Dudley Coutts (1803–54)*
Advocate of the independence of Poland, MP for Arundel.
54 See *Groups:* 'The House of Commons, 1833' by Sir G. Hayter, p 526.

STUART *Charles (1810–92)*
MP for Bute.
54 See *Groups:* 'The House of Commons, 1833' by Sir G. Hayter, p 526.

STUART *Captain Charles*
Slavery abolitionist from Jamaica.
599 See *Groups:* 'The Anti-Slavery Society Convention, 1840' by B. R. Haydon, p 538.

STURGE *John*
Slavery abolitionist.
599 See *Groups:* 'The Anti-Slavery Society Convention, 1840' by B. R. Haydon, p 538.

STURGE *Joseph (1793–1859)*
Quaker, philanthropist and prominent slavery abolitionist.
599 See *Groups:* 'The Anti-Slavery Society Convention, 1840' by B. R. Haydon, p 538.

STURT *Charles (1795–1869)*
Australian explorer; served in army during Napoleonic wars; military secretary to governor, New South Wales, 1827; explored the largest Australian river-system (Murray–Darling), and made

several expeditions into central Australia; commissioner of lands, 1839–42; registrar-general, 1842–9; colonial secretary, 1849–51; retired to England and published accounts of his journeys.

3302 Oil on canvas, 55¾ × 43¾ inches (141·5 × 111 cm), by JOHN MICHAEL CROSSLAND, c 1853. PLATE 875

Inscribed on the spine of the top book in the pile of three, to the left of the sitter: EXPED[*ITION*]/[*presumably INTO*]/SOUTHERN/AUSTRALIA *and on the spine of the lowest book:* SOUTH AUSTR[*ALIAN*]/LEGISLATIVE AND/. . . [*illegible, presumably* EXECUTIVE]/COUNCIL PAP[*ERS*]/1853

Collections: The sitter, presented by his grandson, Geoffrey C. N. Sturt, 1946.

Literature: Mrs Napier G. Sturt, *Life of Charles Sturt* (1899), p 384.

This is a replica of the three-quarter length portrait in the Art Gallery of South Australia, Adelaide. The top book in the pile of three in the Adelaide portrait is inscribed: 'EXPEDI[*TION*]/INTO/SOUTHE[*RN*]/ AUSTRA[*LIA*]/CAP STURT/VOL II/'; this is a copy of Sturt's famous travel book, published in 1834. The lowest book is inscribed: 'SOUTH AUSTRA[*LIAN*]/LEGISLAT[*IVE COUNCIL*?]/VOTES OF PRO[*CEEDURE*?]/C[*?*]/ 1852;' this must have been a volume containing 'Votes and Procedures and Council Papers of the Legislative Council of South Australia'.[1]

A half-length version of the portrait is also in the Art Gallery of South Australia, reproduced Mrs Napier Sturt, frontispiece, and a copy was presented to Sturt's daughter. Mrs Sturt gives the date of the half-length portrait as c 1849, but it almost certainly post-dates the larger version, which cannot be earlier than 1852.

Description: Healthy complexion, blue eyes, light brown hair. Dressed in a black stock and neck-tie, white shirt, yellow waistcoat, dark green jacket and trousers. Standing in front of a green armchair on the right, leaning his hand on a red-covered table, with green, red and blue books, and a large piece of white paper. Background colour, various shades of brown.

ICONOGRAPHY Mrs Napier G. Sturt, *Life of Charles Sturt* (1899), p 384, lists a drawing by G. Kober-wein of 1868, reproduced facing p 360, in the collection of Geoffrey C. N. Sturt, 1946, exhibited *R A*, 1868 (756), and two busts by C. Summers, one in the Art Gallery of South Australia, Adelaide, the other in the collection of Mr Habey Knight; a statue by Captain A. Jones of 1916 is in Adelaide, reproduced Jones, *Memoirs of a Soldier Artist* (1933), facing p 104.

SUMNER *John Bird* (*1780–1862*)

Archbishop of Canterbury; canon of Durham, 1820; published widely read theological works, 1815–29; bishop of Chester, 1828–48; founded many churches and schools; archbishop of Canterbury, 1848; involved in controversy over baptism, 1847–51; opposed removal of Jewish disabilities; respected for his moderate attitudes.

397 Oil on canvas, 32 × 25⅞ inches (81·3 × 65·7 cm), by MARGARET SARAH CARPENTER, c 1852. PLATE 879

Collections: By descent to Dr Ronald Carter, whose wife was the great-granddaughter of the sitter, and presented by him, 1956.

Literature: NPG Annual Report, 1955–6 (1956), p 7.

The pose of the head in this portrait is very similar to the 1839 portrait-type by Mrs Carpenter, but it shows Sumner as an older man, with greyer hair. The 1839 portrait is listed in the artist's 'Account Book' (copy of original MS, NPG archives), pp 26 and 28, under 1838 and 1839, exhibited *R A*, 1839 (1176), engraved by S. Cousins, published J. Seacome, Chester, and Ackermann, 1840 (example in NPG). There are three identical three-quarter length versions of the type, and it is not clear whether no. 1 or 2 is the original:

[1] I am most grateful to R. G. Appleyard of the Art Gallery of South Australia for providing transcripts of these inscriptions.

1 Bishop's House, Chester. Probably the portrait offered to the NPG, 1880, sketched by Scharf, 'TSB' (NPG archives), XXVII, 65, who records that it was signed and dated '1834' (the '4' presumably being a misreading for '9'). No signature or date are now visible on the picture, but it has been cut down and is in poor condition.

2 University College, Durham.

3 Lambeth Palace, London. Signed and dated '1842'. Presumably the portrait exhibited *SKM*, 1868 (380), lent by the Rev J.H.R.Sumner.

A different three-quarter length portrait-type, showing Sumner as an older man, was engraved by J.R.Jackson (example in British Museum). It was probably this portrait which was exhibited *RA*, 1852 (317).

Description: Healthy complexion, brown eyes, grey hair. Dressed in a high white collar, dark green clerical under-garment and black coat. Background colour dark brown.

2467 Coloured chalk on brown, discoloured paper, 24 × 18½ inches (61 × 46·8 cm), by GEORGE RICHMOND, 1849. PLATE 878

Collections: The sitter, bequeathed by his granddaughter, Miss Elizabeth Sumner, 1930.

Literature: G.Richmond, 'Account Book' (photostat of original MS, NPG archives), p49, under 1849.

This drawing was engraved by F.Holl, published J.Hogarth, 1849 (example in NPG). Another Richmond drawing of 1835 was in the collection of the sitter's great-great-nephew, Major R.Gibson, 1931. Two other drawings are listed in Richmond's 'Account Book', p8, under 1833, and p11, under 1834; one of the two was exhibited *RA*, 1834 (560).

1207 Plaster cast, painted cream, 17¾ inches (45·2 cm) high, of a bust by GEORGE GAMMON ADAMS, 1863. PLATES 876, 877

Incised on the back, below the shoulders: G.G.Adams. 1863.

Collections: The artist, purchased from his widow, 1899

Presumably related to the posthumous marble bust of Sumner exhibited *RA*, 1864 (1057). Several other plaster casts by Adams and a marble bust of Sir William Napier (NPG 1197) were purchased from Mrs Adams.

ICONOGRAPHY A painting by E.U.Eddis is at Lambeth Palace, exhibited *RA*, 1851 (7), reproduced *Portraits of the Archbishops of Canterbury*, edited G.M.Bevan (1908), facing p25; another painting by Eddis of 1853 is at King's College, Cambridge, exhibited *VE*, 1892 (43), and *Victorian Era Exhibition*, 1897, 'Historical Section' (44); a painting by an unknown artist is at Lambeth Palace, possibly the painting by H.W.Pickersgill, exhibited *RA*, 1854 (64); another or possibly the same portrait by Pickersgill was in the artist's sale, Christie's, 17 July 1875 (lot 350); a painting by D.Huntington was exhibited *RA*, 1853 (277); Sumner officiates in 'The Marriage of the Princess Royal' by J.Phillip in the Royal Collection; a marble statue by H.Weekes is in Canterbury Cathedral, exhibited *RA*, 1869 (1192), and a view of his monument there by Miss L.Rayner was exhibited *RA*, 1858 (995); a marble bust by A.Gatley was exhibited *RA*, 1848 (1397); two anonymous engravings are reproduced W.H.Wilkins, *Our King and Queen* (c1901), I, 106–7; a woodcut was published *ILN*, XII (1848), 295; there are several photographs, and prints after photographs, in the NPG, and others are reproduced as woodcuts *ILN*, XXIV (1854), 400, and XLI (1862), 301.

SUSSEX *Augustus Frederick, Duke of* (*1773–1843*)

Son of George III.

4026 (54) See *Collections:* 'Drawings of Men About Town, 1832–48' by Count A.D'Orsay, p557.

See also forthcoming Catalogue of Portraits, 1790–1830.

SUTHERLAND *George Granville Leveson-Gower, 1st Duke of (1758–1833)*

Statesman and magnate.

1695 J See entry under William IV, p 509.

See also forthcoming Catalogue of Portraits, 1790–1830.

SUTHERLAND *George Granville Sutherland-Leveson-Gower, 2nd Duke of (1786–1861)*

Statesman and connoisseur.

342, 3 See *Groups:* 'The Fine Arts Commissioners, 1846' by J. Partridge, p 545.

999 See *Groups:* 'The House of Lords, 1820' by Sir G. Hayter, in forthcoming Catalogue of Portraits, 1790–1830.

SUTHERLAND *Harriet Elizabeth Georgiana Leveson-Gower, Duchess of (1806–86)*

A close and influential friend of Queen Victoria; daughter of 6th Earl of Carlisle; married 2nd Duke of Sutherland, 1823; mistress of the robes under whig administrations, 1837–61.

808 Plaster cast, painted cream, 27¼ inches (69·2 cm) high, of a bust by MATTHEW NOBLE, 1869. PLATE 880

Incised on the back, below the shoulders: HARRIET DUCHESS OF SUTHERLAND *and on the back of the socle:* M NOBLE SCᵀ./1869

Collections: The artist, presented by his widow, 1888.

Presumably related to the marble bust exhibited *RA*, 1870 (1172), which is probably the bust of 1870 now at Castle Howard. Noble also executed a statue of the Duchess for Dunrobin Castle (1869), and a recumbent effigy for the chapel at Trentham (1868), the latter reproduced *Art Journal* (1875), p 183. A plaster model related to one of these was at Elswick Hall, Newcastle, listed in *Catalogue of Lough and Noble Models at Elswick Hall* (*c* 1928), p 57 (185). The NPG bust was presented at the same time as a bust of Sir James Scarlett (NPG 807), both of which were described as original models of busts (letter from the donor of 19 July 1888, NPG archives). The Duchess of Sutherland is shown wearing the badge of the order of Victoria and Albert. The monogram 'HS' beneath a ducal coronet is modelled in relief on the front of the base.

ICONOGRAPHY The following portraits are in the collection of the Duke of Sutherland: a painting by F. X. Winterhalter of 1849, reproduced *The Early Victorian Period*, Connoisseur Period Guide (1958), plate 36 (an enamel, after the Winterhalter, by Marie Pauline Laurent was exhibited *RA*, 1852 (642)); a painting by Sir T. Lawrence of 1827, with her daughter, exhibited *RA*, 1828 (114), reproduced *Illustrated Catalogue of Thirty Pictures in the Collection of His Grace the Duke of Sutherland*, Christie's (1957), p 18, engraved by E. Finden, 1831, by S. Cousins (retouched by Lawrence), and by others (examples in NPG); a painting by R. Buckner, exhibited *RA*, 1847 (36), and *VE*, 1892 (77); and a water-colour by A. E. Chalon, exhibited *RA*, 1838 (744), engraved by H. Robinson, published Longman, 1839 (example in NPG), for 'Heath's Book of Beauty'.

A painting by G. Sayer is at Hardwick Hall; the Duchess of Sutherland appears in the 'Coronation of Queen Victoria', a print by G. Baxter, published 1841 (example in British Museum); in 'Queen Victoria Receiving the Sacrament after her Coronation' by C. R. Leslie of the same year; in the 'Marriage of Queen Victoria and Prince Albert' by Sir G. Hayter of 1840; in the 'Christening of the Princess Royal' by C. R. Leslie of 1841; and in the 'Marriage of the Prince of Wales', by W. P. Frith of 1863; the last four pictures are in the Royal Collection; a profile drawing by J. Jackson of 1821 is at Castle Howard, lithographed by R. J. Lane, published J. Dickinson, 1829 (example in NPG); Lane records a profile drawing of 1836–7, executed for a medal and commissioned by the Duke of Sutherland, in his 'Account Books' (NPG archives), II, 11, and v, 8; a drawing by G. Richmond of

1846 is recorded in his 'Account Book' (photostat copy of original MS, NPG archives), p 41; a miniature by Sir W. C. Ross of *c* 1860 is in the Wallace Collection, reproduced *Catalogue of Miniatures* (1935), plate 38; and another, 'The Homage', by Sir W. J. Newton was exhibited *RA*, 1841 (839); a bust by an unknown artist is at Hawarden Castle, and another by E. W. Wyon, based on the Winterhalter portrait and sittings from life in 1852, was exhibited *RA*, 1853 (1458); a medal by W. Bain is in the Scottish NPG; there is an engraving by W. H. Mote, after a drawing by J. Hayter (example in NPG), for 'Portraits and Memoirs', and an anonymous lithograph (example in NPG).

SWAIN *Charles* (*1801–74*)

Poet; worked as a dyer, 1816–30, and then as an engraver; wrote several volumes of poetry and popular songs ('I cannot mind my wheel, mother'); honorary professor at Manchester Royal Institution; received civil list pension, 1856.

4014 Oil on panel, $12\frac{7}{8} \times 9\frac{5}{8}$ inches (32·8 × 24·3 cm), by WILLIAM BRADLEY, *c* 1833. PLATE 881

Inscribed on a label, formerly on the back of the picture: Portrait in oil of Charles Swain/1801–1874/the Man[r]. Poet, painted by W[m] Bradley,/1801–1857/Man[r]. Artist. This painting/was bought by me through Thos Agnew/& Sons from T. E. W. Mellor Esq, Withington,/Boyne Park, Tunbridge Wells, who had/ it from his father who was a friend/& patron of Bradley's, & lived in Man[r]./I knew Chas Swain, & this portrait/is a particularly good likeness./Francis Nicholson,/The Knoll,/Windermere./May 1912.

Collections: T. E. W. Mellor; Francis Nicholson; Major M. W. Spencer, purchased from him, 1957.

Literature: NPG Annual Report, 1957–8 (1959), pp 6–7.

There are several other portraits of Swain by Bradley, none of them identical, but all similar, and, on the evidence of costume, of the same date. The only dated portrait is 6a in the list below. Another was exhibited *RA*, 1837 (172). Recorded portraits, beside that in the NPG, are as follows:

1 Finished oil painting. Salford Art Gallery, presented by William Townsend, 1854.

2 Finished oil painting. City Art Gallery, Manchester, presented by Mrs Clara Swain Dickins, 1888.

3 Finished oil painting. Collection of G. P. Earwaker, 1958; collection of his step-daughter, Mrs J. E. Joscelyne. This is not certainly by Bradley, but is close in style to nos. 1 and 2.

4 Painting. Exhibited *Royal Jubilee Exhibition*, Manchester, 1887 (642), lent by R. Leake, MP (possibly no. 2).

5 Oil sketch. Central Library, Manchester, presented by Mrs J. Prince Lee, 1871. Inscribed, 'Mr Charles Swain the Poet [?] Sketched from the life. W[m] Bradley.'

6 Drawing. City Art Gallery, Manchester, bequeathed by H. W. Winterbottom, 1936.

6a Drawing (signed and dated 1833). Collection of K. Jordan. Almost identical with no. 6.

7 Miniature. City Art Gallery, Manchester, from the estate of the sitter's nephew. Engraved by Freeman for Swain's *Dramatic Chapters* (1847), frontispiece.

8 Engraving, almost certainly after an oil portrait. Central Library, Manchester.

Nos. 1–3 show an almost full-face pose. Nos. 5–8 and NPG 4014 show Swain looking up to the right. No. 5 may be the original for this type, but it does not exactly correspond to the other versions. The costume in all the portraits is approximately the same, except in the drawings, where Swain is shown in an open-neck shirt.

Description: Dark complexion, brown eyes and hair. Dressed in a dark neck-tie, white collar, and brown coat. Background colour greenish-brown.

ICONOGRAPHY The only other recorded portraits of Swain are, a marble bust by E. G. Papworth in the City Art Gallery, Manchester, a woodcut by F. J. Smyth (example in British Museum), and a woodcut, after a photograph by B. W. Bentley, published *Transactions of the Manchester Literary Club*, I (1874–5), facing 96.

SWAN *Rev Thomas*

Slavery abolitionist.

599 See *Groups:* 'The Anti-Slavery Society Convention, 1840' by B. R. Haydon, p 538.

SYDENHAM *Charles Edward Poulett Thomson, 1st Baron (1799–1841)*

Governor-general of Canada, MP for Manchester.

54 See *Groups:* 'The House of Commons, 1833' by Sir G. Hayter, p 526.

SYKES *Sir Tatton, Bart (1772–1863)*

Landed gentleman; began to breed sheep, and to develop a stud of race-horses, from 1803, holding annual sales; improved his estates; MFH for forty years; frequently raced his own horses.

3102 Oil on millboard, $4\frac{3}{4} \times 3\frac{3}{4}$ inches (12 × 9·5 cm) painted oval, by an UNKNOWN ARTIST. PLATE 882

Inscribed on the back of the board, twice, in pencil: Sir Tatton Sykes Bart

Collections: Leggatt Brothers, purchased from them, 1941.

Attached to the back of the portrait was a document of remission, dated 1878, granting John Melloy a free pardon. Its significance is not clear. Comparison with other portraits of Sykes confirms the identification of the NPG picture.

Description: Healthy complexion, brown eyes, greyish hair. Dressed in a white cravat, a black coat and top-hat. Background colour yellow with superimposed tones of grey.

ICONOGRAPHY A painting by Sir F. Grant (equestrian) is in the collection of Sir Richard Sykes, listed in the artist's 'Sitters Book' (copy of original MS, NPG archives), under 1847, exhibited *RA*, 1848 (441), and *British Portraits*, RA, 1956–7 (370), reproduced *Country Life*, CVI (1949), 1144, and CXIV (1953), 781, engraved by G. R. Ward (example in NPG); a painting by Sir T. Lawrence of *c* 1806 is in the same collection (with his brother Sir Mark Masterman Sykes, and the latter's wife, Henrietta), reproduced K. Garlick, *Sir Thomas Lawrence* (1954), plate 68; a painting by H. Hall is in the Mellon collection, exhibited *Painting in England 1700–1850: Collection of Mr and Mrs Paul Mellon*, Virginia Museum of Fine Arts, Richmond, 1963 (369), reproduced catalogue, p 192; two paintings by unknown artists were recorded in the collections of H. S. Constable and Lord Middleton by Lord Hawkesbury, 'East Riding Portraits', *Transactions of the East Riding Antiquarian Society*, X (1903), pp 57 (16), and 66 (5); a painting by an unknown artist was exhibited *The English, 1700–1942*, Harrogate Art Gallery, 1943, lent by Mrs Guy Gilby; an anonymous painting was sold Christie's, 23 May 1969 (lot 183), bought Perman; a posthumous marble bust by H. Weekes was exhibited *RA*, 1865 (938); an engraving by J. Brown was published 1861 (example in British Museum), for 'Baily's Magazine'; a photograph by J. Eastman of Manchester is reproduced as a woodcut (in reverse) *ILN*, XLII (1863), 413, and engraved by D. J. Pound (example in NPG), for the 'Drawing Room Portrait Gallery'; an unnamed portrait was exhibited *Victorian Era Exhibition*, 1897, 'Historical Section, Sports Sub-section' (159).

TAGLIONI *Marie (1809–84)*

The foremost ballerina of the century, and a major figure in the development of ballet as a separate art-form; her chief roles were in 'La Sylphide' (1832), and 'Pas de Quatre' (1845); retired, 1847.

1962 (L) Water-colour on paper, $11\frac{3}{4} \times 9\frac{1}{8}$ inches (29·8 × 23·2 cm) bottom two corners cut, by ALFRED EDWARD CHALON, *c* 1831. PLATE 883

Inscribed in ink (bottom left): Taglioni

Collections: Purchased from Mrs Florence Blake, 1922.

This water-colour shows Taglioni performing the Tyrolienne dance in Rossini's 'Guillaume Tell'; she danced this in 1830, and again at the King's Theatre, Haymarket, April–July 1831 (information kindly provided by C. R. Williams). A lithograph by R. J. Lane, after another water-colour by Chalon, published 1831 (example in NPG), shows her in the same costume. Other water-colours of Taglioni by Chalon are in the Victoria and Albert Museum, and five were sold Christie's, 20 January 1970 (lot 46), bought Fine Art Society. Some of these and a great number of other Chalon water-colours were lithographed by Lane and other artists (examples in NPG and Victoria and Albert Museum), and two were exhibited *R A*, 1832 (519), and 1851 (1139). Several of the Lane lithographs are recorded in his 'Account Books' (NPG archives). The NPG water-colour forms part of a small collection of water-colours by Chalon of theatrical personalities, which will be collectively discussed in the forthcoming Catalogue of Portraits, 1790–1830.

Description: In a white, red and black costume, with red bows, blue and white stockings and brown shoes.

ICONOGRAPHY Fifty-seven popular prints are listed in L. A. Hall, *Catalogue of Dramatic Portraits in the Theatre Collection of the Harvard College Library*, IV (Cambridge, Mass, 1934), 121–4 (some examples in NPG and Victoria and Albert Museum); a few are reproduced A. Levinson, *Marie Taglioni* (Paris, 1929); a painting by G. Lepaulle of *c* 1835 (with her brother, Paul, in the costumes for 'La Sylphide') is in the Louvre, and another version was reproduced *Connoisseur*, CLXV (1970), adverts, p 52; also reproduced in the *Connoisseur* was a lithograph and Meissen figure (p 53); a drawing by D. Maclise was in the artist's sale, Christie's, 24 June 1870 (lot 33); woodcuts were published *ILN*, VII (1845), 8, and x (1847), 244.

TALBOT DE MALAHIDE *James Talbot, 4th Baron (1805–83)*

MP for Athlone; lord-in-waiting to Queen Victoria, 1863–66; president of the Archaeological Society, 1863–83.

1834 Pencil on paper, $7\frac{7}{8} \times 4\frac{7}{8}$ inches (20·1 × 12·5 cm), by FREDERICK SARGENT. PLATE 884

Inscribed in pencil (lower left; possibly an autograph): Talbot de Malahide

Collections: A. C. R. Carter, presented by him, 1919.

Presented with other drawings of peers by Sargent, presumably studies for one of his many paintings of the House of Lords. They will be discussed collectively in the forthcoming Catalogue of Portraits, 1860–90.

54 See *Groups*: 'The House of Commons, 1833' by Sir G. Hayter, p 526.

ICONOGRAPHY An oil sketch for Hayter's 'House of Commons' group (see NPG 54 above) is in the collection of Lord Talbot de Malahide; a photograph by Lock and Whitfield was published *Men of Mark*, 1876.

TALBOT *Christopher Rice Mansel (1803–90)*

MP for Glamorgan.

54 See *Groups*: 'The House of Commons, 1833' by Sir G. Hayter, p 526.

4026 (55) See *Collections*: 'Drawings of Men About Town, 1832–48' by Count A. D'Orsay, p 557.

TALFOURD *Sir Thomas Noon* (*1795–1854*)

Judge, critic and poet; his reviews led to friendship with Lamb, Wordsworth and Coleridge; law reporter on *The Times;* serjeant, 1833, and justice of the common pleas, 1849; MP from 1835; published poetry, and drama, notably the tragedy *Ion* (1835).

417 Oil on canvas, 55½ × 43½ inches (141 × 110·5 cm), by HENRY WILLIAM PICKERSGILL. PLATE 885

Collections: Pickersgill Sale, Christie's, 17 July 1875 (lot 309), bought G. J. Shaw-Lefevre, and purchased from him, 1876.

A different portrait by Pickersgill, showing Talfourd in ordinary costume, is in the Middle Temple, possibly the portrait exhibited *RA*, 1851 (128), described by the *Art Journal* (1851), p 155, as a half-length, standing figure. This or another portrait was in the same sale as the NPG portrait (lot 310), and so were six letters from Talfourd to the artist (lot 82g).

Description: Close inspection of this portrait, which is at present on loan to the Law Courts, was impossible. Talfourd is shown in a wig and the red and white robes of a judge, holding a white piece of paper and a quill pen. He is seated in a red-covered armchair, against which a brown leather-bound book is leaning. Background colour dark brown.

ICONOGRAPHY A painting by J. Lucas was in the collection of the Rev Talfourd Major, 1910, exhibited *SKM*, 1868 (616), reproduced A. Lucas, *John Lucas* (1910), plate LII, facing p 75, engraved by S. Freeman, published H. Colburn, 1837, for the *New Monthly Magazine*, by W. O. Burgess, published Welch and Gwynne, 1840, and by J. C. Armytage, published Smith, Elder & Co (examples in NPG and British Museum), the last for R. Horne, *A New Spirit of the Age* (1844); a smaller version of the Lucas painting is in the Garrick Club, London; a painting by an unknown artist is in the Law Library of Harvard University; a drawing by Field Talfourd was in the collection of Miss E. L. Johnston, Boston, 1912; a miniature by Miss Eliza Jones was exhibited *RA*, 1837 (926); a bust by J. G. Lough of 1855 is in the Crown Court, Stafford; an engraving by D. Maclise (example in NPG) was published *Fraser's Magazine*, XIV (1836), facing 68, as no. 74 of Maclise's 'Gallery of Illustrious Literary Characters'; a pencil study for this is in the Victoria and Albert Museum, and so is another unrelated drawing; an engraving by W. Holl, after K. Meadows, was published J. Saunders, 1840 (example in NPG), for 'Political Reformers'; there is an engraving by E. Roffe, after B. R. Haydon (example in NPG); two woodcuts were published *ILN*, I (1842), 432, and XV (1849), 52.

TANKERVILLE *Charles Bennet* (*Lord Ossulston*), *6th Earl of* (*1810–99*)
Man of affairs.

4026 (56) See *Collections:* 'Drawings of Men About Town, 1832–48' by Count A. D'Orsay, p 557.

TATTERSALL *Richard* (*the younger ?*) (*1785–1859*)
Horse auctioneer.

4026 (57) See *Collections:* 'Drawings of Men About Town, 1832–48' by Count A. D'Orsay, p 557.

TATUM *William* (*1783–1862*)
Slavery abolitionist.

599 See *Groups:* 'The Anti-Slavery Society Convention, 1840' by B. R. Haydon, p 538.

TAUNTON *Henry Labouchere, 1st Baron* (*1798–1869*)
Statesman.

54 See *Groups:* 'The House of Commons, 1833' by Sir G. Hayter, p 526.

TAYLOR *Edward* (*1784–1863*)

Musician; sheriff of Norwich, 1819; conducted in festivals; Gresham professor of music from 1837; lectured widely and wrote on music; translated and adapted works by Spohr (his friend), Haydn, and also wrote words for Mozart's 'Requiem Mass'.

4217 Pencil on paper, 4¾ × 3⅜ inches (12 × 8·7 cm), by GEORGE HARLOW WHITE, 1845. PLATE 886

Inscribed in pencil (bottom part of the sheet): Edward Taylor/Professor of Music, Gresham College/Geo Harlow White Nov 24 1845

Collections: See *Collections:* 'Drawings, c 1845' by G. H. White, p 562.

ICONOGRAPHY The only other recorded portrait of Taylor is a painting by R. S. Tait, engraved by H. E. Dawe, published C. Muskett, Norwich (example in British Museum).

TAYLOR *Sir Henry* (*1800–86*)

Civil servant and author; held posts in the treasury, 1817–20, and the colonial office, 1824–72; active in literary and philosophical circles; his published works include reviews, essays and plays, the most successful being 'Philip Van Artevelde'.

1014 Oil on canvas, 24 × 20 inches (61 × 50·8 cm), by GEORGE FREDERICK WATTS. PLATE 888

Collections: The artist, presented by him, 1895 (see appendix on portraits by G. F. Watts in forthcoming Catalogue of Portraits, 1860–90).

Exhibitions: Winter Exhibition, Grosvenor Gallery, 1882 (91); Glasgow, 1888; *VE,* 1892 (205); Rugby, 1894; *Fourth Annual Exhibition,* Royal Society of Portrait Painters, 1894 (110).

Literature: 'Catalogue of Works by G. F. Watts', compiled by Mrs M. S. Watts (MS, Watts Gallery, Compton), II, 155.

In her catalogue Mrs Watts dates the portrait 1868–70, but the Grosvenor Gallery catalogue gives it as 1882, presumably on the authority of the artist. On the grounds of age, the latter date is more probable. An unfinished replica (or possibly a preliminary study) is in the Watts Gallery at Compton. Another full-length portrait of Taylor by Watts was exhibited *RA,* 1852 (480); for a review see *Art Journal* (1852), p 173. A drawing possibly related to it, showing Taylor without a beard, was exhibited *VE,* 1892 (364), lent by H. H. Cameron, sketched by L. G. Holland, 'Notebooks' (NPG archives), II, 26; this was presumably the drawing exhibited *RA,* 1851 (1144). Taylor was an old friend of the artist and a frequent guest at Little Holland House.

Description: Bluish eyes, grey hair and beard. Dressed in a brown robe. Background composed of a green and brown floral pattern, possibly a tapestry.

2619 Marble bust, 27½ inches (69·8 cm) high, by LAWRENCE MACDONALD, 1843. PLATE 887

Incised on the back, below the shoulders: L. MACDONALD. FECIT. ROMA. 1843.

Collections: The sitter, presented by his granddaughter, Lady Trowbridge, 1933.

Exhibitions: RA, 1845 (1383); possibly the bust in the 'Crystal Palace Portrait Gallery', 1854 (419*).

ICONOGRAPHY A drawing by S. Laurence was exhibited *RA,* 1852 (846); a bust by A. Munro was exhibited *RA,* 1864 (996); a medal by Elinor Hallé was exhibited *Victorian Era Exhibition,* 1897, 'Women's Work Section – Applied Art' (143), and a medallic portrait by E. W. Wyon, *RA,* 1841 (1127); there is a photograph by O. Rejlander, and two by Margaret Cameron, in the NPG; others are reproduced H. Gernsheim, *Julia Margaret Cameron* (1952), plates 30, 45 and 48; a woodcut was published *The Graphic,* XXXIII (1886), 581.

TAYLOR *Rev Henry*

Slavery abolitionist.

599 See *Groups:* 'The Anti-Slavery Society Convention, 1840' by B.R.Haydon, p 538.

TAYLOR *Isaac* (*1787–1865*)

Artist, author and inventor; trained as an engraver; translated the classics; published theological and philosophical works, including *The Natural History of Enthusiasm*, 1830; later wrote devotional and biographical works; invented a beer tap and a machine for engraving on copper.

884 Coloured chalk on buff paper, $21\frac{5}{8} \times 16\frac{5}{8}$ inches ($55 \times 42 \cdot 3$ cm), by his nephew, JOSIAH GILBERT, after a drawing of 1862. PLATE 889

Signed and dated (*lower right*): J.Gilbert (copy)/1862

Collections: The artist, presented by him, 1892.

The original drawing by Gilbert of 1862 was commissioned by a Mr Johnstone, and the NPG replica was executed around 1890. In a letter of 9 January 1892 (NPG archives), the artist wrote: '*In saying that the drawing did not quite equal the original in "go" I did not mean as to likeness, which I think is very successful in rendering the sort of far-away contemplative look of Isaac Taylor which was characteristic of him*'. In a later letter Gilbert gave details of his career. An earlier drawing by him of Taylor, signed and dated 1854, was exhibited *S K M*, 1868 (504), lent by the sitter.

Description: Healthy complexion, greyish eyes and hair. Dressed in a black neck-tie, white shirt and black coat.

ICONOGRAPHY A painting by F.P.Freyburg of 1890 was exhibited *VE*, 1892 (310), lent by Henry Taylor; this was presumably the portrait listed in his collection by the *Dictionary of National Biography*; a medallion by W.D.Keyworth was exhibited *RA*, 1865 (1010); a woodcut was published *ILN*, XLVII (1865), 136.

TAYLOR *Michael Angelo* (*1757–1834*)

MP for Sudbury.

54 See *Groups:* 'The House of Commons, 1833' by Sir G.Hayter, p 526.

TAYLOR *William*

Slavery abolitionist.

599 See *Groups:* 'The Anti-Slavery Society Convention, 1840' by B.R.Haydon, p 538.

TELFORD *Thomas* (*1757–1834*)

Engineer.

2515 (67) See *Collections:* 'Drawings of Prominent People, 1823–49' by W.Brockedon, p 554.
See also forthcoming Catalogue of Portraits, 1790–1830.

TEMPLE *Henry John, 3rd Viscount Palmerston. See* PALMERSTON

TENNYSON *Alfred Tennyson, 1st Baron* (*1809–92*)

Poet laureate; 'In Memoriam' and the Arthurian poems caught the national imagination; the lyricism and psychological intensity of his early work was later modified into a more public poetry; wrote literary dramas; the only author raised to the peerage for literature.

1015 Oil on canvas, 24⅛ × 20¼ inches (61·3 × 51·4 cm), by GEORGE FREDERICK WATTS, *c*1863–64. PLATE 900

Collections: Presented by the artist, 1895 (see appendix on the portraits by G.F.Watts, in forthcoming Catalogue of Portraits, 1860–90).

Exhibitions: French Gallery, London, 1866 (223); *Winter Exhibition*, Grosvenor Gallery, 1882, 'Collection of Works by G.F.Watts' (112); *Worcestershire Exhibition*, Worcester, 1882, 'Fine Art Section' (137); *Royal Jubilee Exhibition*, Manchester, 1887 (257); Gravesend, 1894; Hammersmith, 1894.

Literature: Art Journal (1866), p374; *Athenaeum*, no.2037 (10 November 1866), 613; *Magazine of Art* (1893), p100, reproduced p96; R.G.D.Sketchley, *Watts* (1904), pp79–80, 89, 184; (Mrs) M.S.Watts, *George Frederic Watts* (1912), II, 167n, 192; 'Catalogue of Works by G.F.Watts', compiled by Mrs M.S.Watts (MS, Watts Gallery, Compton), II, 158; R.Chapman, *The Laurel and the Thorn* (1945), reproduced plate 16; 'Watts Exhibition' catalogue, Arts Council, 1954, p30.

This is a variant version of the portrait painted for Sir William Bowman (see no.3 in list below), which was begun in 1863, and finished in 1864. In November 1863, Bowman wrote to Watts (M.S. Watts, I, 218): '*I am delighted to hear you propose soon to finish for me the head of the great poet. The sooner the better. The only thing I would have wished otherwise in the head of the great artist* [Watts' portrait of himself, commissioned by Bowman, and now in the Tate Gallery], *is that in size and handling it does not (but perhaps my impression is wrong) match the other for I would fain have painter and painted, a pair of nobles answering one to the other on my walls*'. According to Mrs Watts (M.S.Watts, II, 167n), the Bowman and NPG portraits were begun at the same time (they are almost identical in pose, features and composition). In her MS Catalogue, she states that the NPG picture remained unfinished for some time, and that it was '*worked upon from time to time*'.

Watts was a passionate admirer of Tennyson and his work. In his portraits of the poet, he sought to embody '*the shape and colour of a mind and life*', and nowhere more prophetically than in the NPG painting. The flat frontal composition, the simplicity of the costume, the decorative use of bay leaves and sky, and the emphasis on the brooding features, produce an arresting and idealized characterization. Tennyson himself wrote a short poem on Watts, quoted in H.Tennyson, *Tennyson and his Friends* (1911), p173.

Lists of Watts' portraits of Tennyson will be found in M.S.Watts, *George Frederic Watts* (1912), II, 167n, her very important MS Catalogue (Watts Gallery, Compton), II, 157–8 (with illustrations), H.Tennyson, *Alfred Lord Tennyson: a Memoir* (1897), II, 431, and the 'Watts Exhibition' catalogue, Arts Council, 1954–5, pp29–30. The following list is based on these, with emendations, corrections and additions:

1 *1857*. Half-length painting (profile). National Gallery of Victoria, Melbourne (plate 897). In her MS Catalogue, Mrs Watts dates this work 1856–8, but in her biography, 1857 (M.S.Watts, I, 170).

2 *1858–9* (Signed, and dated 1859). Half-length painting (popularly called 'the great moonlight portrait'). Collection of the Hon Mrs Hervey-Bathurst, Eastnor Castle. Exhibited Colnaghi, 1860 (see *Art Journal* (1860), p126); *Winter Exhibition*, Grosvenor Gallery, 1882 (95); *Watts Exhibition*, RA, 1905 (189); *Watts Exhibition*, Arts Council at the Tate Gallery, 1954–5 (25); and elsewhere. Engraved by J.Stephenson, published Colnaghi, 1862 (example in NPG), by the same artist for the *Art Journal* (1874), facing p27, by G.J.Stodart (example in British Museum), for Tennyson's 'Death of Œnone', by W.B.Gardner for the *Magazine of Art* (1893), p41, and by Sir F.Short, published R.Dunthorne, 1903 (example in Usher Art Gallery, Lincoln); Short's engraving was exhibited *RA*, 1904 (1311), and reproduced *Connoisseur*, XXXVI (1913), 129. Tennyson mentions sittings for this work in his Letter Diary for March 1859, see H.Tennyson, *Materials for a Life of A.T.* (*c*1895), II, 214. Sittings in the summer of 1858 are mentioned by H.Tennyson, *Alfred Lord Tennyson: a Memoir* (1897), I, 428. It was while this portrait was being painted that Tennyson is

said to have asked Watts what was in his mind when he painted a portrait, and to have embodied the reply in his poem, 'Lancelot and Elaine'. There are several recorded copies of this portrait.

3 *1863–4* (Signed, and dated 1864). Half-length painting (full-face, against bay leaves). Collection of Lord Lambton, Fenton House, Northumberland. Ex-collection of Sir William Bowman; Christie's, 8 June 1917 (lot 127), and again, 1 June 1956 (lot 153); Captain Spencer-Churchill; his sale, Christie's, 25 June 1965 (lot 100), bought Bush, reproduced in sale catalogue. Exhibited *National Exhibition of Works of Art*, Leeds, 1868 (1357), *Watts Exhibition*, RA, 1905 (67), and elsewhere. In his Letter Diary for 3 July 1863, Tennyson wrote (*Materials for a Life of A.T.*, II, 379): '*Watts is working away at me*'. This portrait was subsequently finished for Bowman, but it did not begin as a commission. For Bowman's letter to Watts, see M.S.Watts, I, 217–8.

4 *1863–4* (and later). NPG 1015 (see above).

5 *1890.* (Signed, and dated 1890). Half-length painting (in Oxford DCL gown). Trinity College, Cambridge, presented by the artist (plate 902). Exhibited *Watts Exhibition*, RA, 1905 (200). Reproduced *Connoisseur*, CXLIV (1959), 11. In his Journal for 26 May 1890, Hallam Tennyson wrote (*Materials for a Life of A.T.*, IV, 256): '*G.F.Watts left to-day* [from Farringford] *having done a fine portrait of A.T.*'. For a long and interesting description of the visit and sittings, see M.S.Watts, II, 158–67. A preliminary drawing for the portrait (signed, and dated 1890) is in the Usher Art Gallery, Lincoln, reproduced *Tennyson Collection* (Lincoln, 1963), frontispiece.

6 *1890.* Half-length painting (in peer's robes). Art Gallery of South Australia, Adelaide. Reproduced A.Waugh, *Alfred Lord Tennyson* (1892), frontispiece. Painted at the same time as no. 5, and almost identical in pose, features and general composition.

7 *1898–1905.* Bronze statue. Lincoln. See M.S.Watts, II, 283–4, and 305–6. A photograph of Watts at work on the statue is reproduced M.S.Watts, II, facing 305; other similar photographs are in the Central Library, Lincoln, and the Watts Gallery, Compton. The original plaster model is also at Compton, as are innumerable smaller sketches and models.

Mrs Watts (M.S.Watts, II, 167n) mentions another portrait of Tennyson done at the time when Watts was painting Mrs Tennyson and her sons (i.e. *c* 1865). This seems to be a mistake. She does not mention this portrait in her much fuller MS Catalogue, and it is not listed elsewhere.

Description: Dark complexion, brown hair and beard. Dressed in a white collar and dark, undefined costume. Dark green bay-leaves behind the head. Deep blue sky, with white clouds, and orange streaks lower right.

2460 Oil on canvas, $26\frac{3}{4} \times 22\frac{3}{4}$ ($68 \times 57 \cdot 8$ cm), by SAMUEL LAURENCE, *c* 1840. PLATES 890, 893

Inscribed in pencil on the back of the stretcher: Given by Edward Fitzgerald to Emily Tennyson/Alfred Tennyson/by Samuel Laurence/Very fine

Inscribed in ink on a label, formerly on the back of the picture: This Portrait of Alfred Tennyson belongs to/his Wife Mrs A Tennyson

Collections: Commissioned by Edward Fitzgerald, and given by him to Lady Tennyson, sometime after 1867; accepted by the National Gallery as a bequest from Hallam, Lord Tennyson, 1930; on loan from the National Gallery since 1930, and subsequently transferrred.

Exhibitions: Tennyson Centenary Exhibition, Fine Art Society, London, 1909 (40); *Tennyson Exhibition*, Usher Art Gallery, Lincoln, 1959.

Literature: R.H.Horne, *A New Spirit of the Age* (1844), II, frontispiece, engraved by J.C.Armytage; Caroline Fox, *Memories of Old Friends*, edited H.N.Pym (1882), I, 53–4; *Magazine of Art* (1893), p42, reproduced p37; H.Tennyson, *Alfred Lord Tennyson: a Memoir*, I, reproduced frontispiece; *Letters and Literary Remains of Edward Fitzgerald*, edited W.A.Wright (1903–7), I, 195–6, 278–9, II, 286, IV,

218 and 317; F.M.Brookfield, *The Cambridge "Apostles"* (1906), reproduced facing p308 (after the Lynch lithograph); H.I.Fausset, *Tennyson* (1923), p116, reproduced frontispiece (after the lithograph); H.Nicolson, *Tennyson* (1923), pp6 and 138; F.Miles, 'Samuel Laurence' (typescript, NPG library). Fitzgerald and Tennyson first met as undergraduates at Trinity College, Cambridge, and remained lifelong friends. Fitzgerald commissioned Laurence, another close friend, to paint Tennyson around 1840, but his preference for lodgings prevented him from taking possession of it until 1867. In May 1844, he wrote to Laurence (Wright, I, 195): '*I long for my old Alfred portrait here sometimes, but you had better keep it for the present*'. He wrote again shortly afterwards, when Laurence was apparently contemplating another portrait (Wright, I, 196): '*I hear Alfred Tennyson is in very good looks: mind and paint him quickly when he comes to town; looking full at you*'. In the same year, the NPG portrait was engraved by J.C.Armytage (example in NPG), for Horne's *A New Spirit of the Age* (1844), and lithographed by J.H.Lynch, published Roe, Cambridge, *c*1849 (example in NPG). Fitzgerald wrote two letters about the lithograph in 1849, the first to Laurence (Wright, I, 278): '*Roe promised me six copies of his Tennyson. Do you know anything of them?*' The second reference occurs in a letter to J.Allen (Wright, I, 279): '*A lithograph has been made from Laurence's portrait of him; my portrait: and six copies are given to me. I reserve one for you*'.

The portrait itself was seen by Caroline Fox on 17 May 1846 (*Memories of Old Friends*, II, 53–4): '*To Samuel Laurence's studio to be drawn. Admirable portraits in his rooms of Hare, Tennyson, Carlyle, Aubrey de Vere and others*'. In 1867, Fitzgerald finally took possession of the portrait, and soon afterwards gave it to Mrs Tennyson. He wrote to Wright in May 1881 (Wright, IV, 218): '*I know of no other portrait of A.T. by S.L. except that which I bought of him some forty years ago, and gave to Mrs T. as being one that she might be glad of – young and beardless. It was the only one of A.T. that I ever cared to have; though it failed (as Laurence and most other Painters do fail) in the mouth, which A.T. said was 'blubber-lipt'*.' In the last letter he ever wrote, Fitzgerald explained to Laurence why he had given away the portraits of Allen and Tennyson (Wright, IV, 317): '*Your drawing of Allen always seemed to me excellent, for which reason it was that I thought his wife should have it, as being the Record of her husband in his younger days. So of the portraits of Tennyson which I gave his Wife. Not that I did not value them myself, but because I did value them, as the most agreeable Portraits I knew of the two men; and, for that very reason, presented them to those whom they were naturally dearer to than even to myself. I have never liked any Portrait of Tennyson since he grew a Beard*'.

The Laurence portrait, with its romantic and evocative mood, remains the most famous and the most reproduced image of the young and beardless Tennyson. It was one of the few portraits which Tennyson himself liked, and of which his family approved. Hallam, Lord Tennyson wrote in a letter of 25 November 1892 (NPG archives), when he was offering the copy of the Woolner bust (NPG 947 below): '*There is the young portrait without moustache or beard which is the finest save Watts – From this I could not part as it was given us by Edward Fitzgerald – but they might copy this*.'

Another portrait of Tennyson by Laurence was included in his sale, Puttick and Simpson, 12 June 1884 (lot 181). It is not known whether this was a version of the NPG picture, or a separate portrait altogether.

Description: Sallow complexion, brown eyes and hair. Dressed in a dark stock, white collar, and unfinished brown coat. Background colour, brown.

970 Black chalk on brown, discoloured paper, 24⅝ × 19¾ inches (62·5 × 50·2 cm), by M.ARNAULT, after a photograph by JOHN MAYALL of 1864. PLATE 903

Collections: Presented by Emily, Lady Tennyson, 1894.

Literature: Reproduced *Das Neunzehnte Jahrhundert* (Berlin, 1899), II, no.135.

The donor's son, Hallam, Lord Tennyson, wrote on her behalf in a letter of 27 November 1894 (NPG archives): '*imperfect as the portrait is artistically, she hopes that, being a good likeness, the Directors*

of the National Portrait Gallery will keep it until they get a better work of art'. Lord Tennyson subsequently wrote (letter of 17 December 1894, NPG archives), to say that he knew nothing about the artist, '*but the picture was considered a good likeness of my father I believe by more than one expert*'. There is an anonymous etching after Arnault's portrait (example in British Museum). Other portraits based on the same Mayall photograph include the painting by E.G. Girardot, and the drawing by L. Dickinson (see iconography below); the photograph was Tennyson's favourite.

3940 Pencil on paper, $7\frac{3}{4} \times 5\frac{1}{2}$ inches (19.7 × 13.9 cm), attributed to JAMES SPEDDING, *c* 1831. PLATE 891
Inscribed in pencil (upper right): A Tennyson/aet 22 circa
Collections: Purchased at Sotheby's, 22 June 1955 (lot 515).
Literature: NPG Annual Report, 1955–6 (1956), p8.

This drawing was found inserted into an edition of Tennyson's *Works* (6 vols, 1872–3). The attribution to Spedding, who was at Cambridge with Tennyson, seems convincing; Spedding executed a similar informal drawing of Tennyson reading in 1835, reproduced H.T. Tennyson, *Alfred Lord Tennyson: a Memoir* (1897), I, facing 147 (see also Spedding's drawing of Edward Fitzgerald, reproduced plate 330). Sir Harold Nicolson wrote of the NPG drawing (letter of 6 September 1955): '*It is a remarkable drawing and must, I think, have been done on the boat when he was returning from his strange expedition to Spain. It is illustrative of the strange, untidy gawky creature he was when he first went to Cambridge, and is more important from the documentary point of view than the finished studio portraits.*'

4343 Water-colour on paper, $12\frac{7}{8} \times 9\frac{1}{2}$ inches (32.8 × 24.2 cm), by WILLIAM HENRY MARGETSON, 1891, after a photograph by BARRAUD of 1882. PLATE 909
Collections: Presented by the Rev J.B. Hodgson, 1963.
Literature: NPG Annual Report, 1963–4 (1964), p16.

This grisaille water-colour was executed for the magazine, *Black and White*, 15 August 1891, p230, as no. 7 of a series called 'The Men of the Hour'. It is very close to, and almost certainly based on, a photograph by Barraud of 1882 (example in NPG). The Rev Hodgson inherited the portrait from his father.
Description: The colour scheme of this water-colour is restricted to whites, greys and blacks. Tennyson is shown in a black neck-tie, white shirt, black waistcoat, coat, cloak and hat.

947 Marble bust, $28\frac{1}{2}$ inches (72.4 cm) high, by MISS MARY GRANT, 1893, after a bust by THOMAS WOOLNER of 1856–7. PLATE 896
Incised on the front of the base: TENNYSON *and on one side:* T WOOLNER S C./LONDON/1857/COPIED BY MISS GRANT, 1893
Collections: Commissioned by Hallam, Lord Tennyson, the sitter's son, and presented by him, 1893.

This replica of Woolner's bust was carved from a plaster cast belonging to the donor. The original marble bust by Woolner (dated 1857) is now at Trinity College, Cambridge, exhibited *Art Treasures Exhibition*, Manchester, 1857, 'Sculpture' (145), and *British Portraits*, RA, 1957 (452); it was anonymously engraved (example in NPG), and reproduced as a woodcut, with a long description, *ILN*, XXXI (1857), 520. There are several related plaster casts, and two marble replicas were carved for Charles Buxton (1861), now in the Museum and Art Gallery, Ipswich, and for Charles Jenner, now in Westminster Abbey.

Woolner began work on his first bust of Tennyson in 1856. On 6 January he wrote to Mrs Tennyson (Amy Woolner, *Thomas Woolner: his Life in Letters* (1917), p109): '*I feel certain he* [Tennyson] *anticipates the operation with shoulder-shrugging horror and I feel sorry to torture him, but as it is a duty I owe myself and country I nerve myself to disregard the fact: I owe it to myself, because in all probability I shall never have another head to equal his so long as I live, therefore ought to make the most*

of it I hope to lure him into complacency by doing such a likeness of you as will please him, and reward your trouble in sitting by doing his bust in a way that will satisfy you; such are my purposes and wiles. Moxon [the publisher] *told me if business went satisfactorily with him this spring he would give me a commission to do it in marble.*' Woolner executed a medallion of Mrs Tennyson in 1859. In March 1856, he sent his assistant to Farringford to take a mould of Tennyson's forehead and nose (see Amy Woolner, pp 110–11). By April 1856 a cast of the original clay model of Tennyson's bust was finished, Woolner writing to Mrs Tennyson (Amy Woolner, pp 111–12): '*Moxon has not been to see the bust tho' I expect him every day; all who have admire it very much; some say it is by far the finest thing I have done and everybody who knows the original says the likeness is as striking as possible*'. Woolner also finished his revised medallion of Tennyson at this time (see NPG 3847 below).

In November 1856, Mrs Tennyson wrote to Woolner to say that she and her husband were delighted with the '*delicate yet lofty beauty of the medallion and with the grandeur of the bust*' (Amy Woolner, p 123). Although he did not receive a commission, Woolner executed the bust in marble during the winter of 1856–7. He told Mrs Tennyson that the bust was finished in a letter of 8 March 1857 (Amy Woolner, p 130). Although Woolner produced an edition of plaster casts, he found it difficult to attract purchasers for the marble itself; after lengthy negotiations it was acquired by Trinity College in 1859 (see Amy Woolner pp 144–5, 151–3, 173–82).

Hallam, Lord Tennyson commissioned the NPG bust because he regarded the original as one of the most satisfactory likenesses of his father; much more so than Woolner's bust of 1873, which was also on offer to the gallery from Woolner's daughter (see NPG 1667 below). Lord Tennyson wrote about this last bust (letter of 26 September 1893, NPG archives): '*It is a fine bust and an original although not nearly so fine to our mind as the beardless bust nor did my father like it half as much.*' Miss Grant finished her copy in October 1893, writing to Scharf (letter of 6 October 1893, NPG archives): '*The bust is all right & quite finished now.*' On the following day, Lord Tennyson wrote to Scharf (letter NPG archives): '*One or two points I suggested to Miss Grant as being unlike the original. The carver promised to attend to them – but Miss Grant was quite positive that the copy was a faithful copy – before my suggestions (and that her carver was the best in London). The nose for example was not refined enough in my opinion but I faced the wrath of Miss Grant as I pointed this out. (She was inclined to be wrathful.) However Miss Grant's copy is very fine; and we must be thankful for having obtained such a fine copy – I naturally desire it to be perfect. Perhaps if you saw anything that differed in the cast & the copy, you would not mind telling her so, or better, the carver.*'

Lord Tennyson, however, changed his opinion when the copy was privately criticized by Frederic Stephens, art critic of the *Athenaeum*. He offered to withdraw the copy, and give to the NPG in return Woolner's cast which had belonged to his father (letter of 4 November 1893, NPG archives): '*The cast (tho' not so durable) is of course finer than the copy – as the master hand has worked upon it: & the trustees acceptance of it will get you & me out of much obloquy.*' He later wrote to say that Mrs Woolner would offer a cast in place of the bust. Scharf, however, insisted that the original offer must be considered first; Lord Leighton, one of the trustees, wrote to him at this time (letter of 6 December 1893, NPG archives): '*I saw the bust today; it is not a masterpiece of carving – but entre nous, I don't much like the original – you have taken paintings at least as bad & it is therefore perhaps best to accept it and not snub Hallam Tennyson, who offers it.*' The trustees subsequently inspected the bust at an official meeting, and unanimously decided to accept it. Lord Tennyson replied (letter of 9 December 1893, NPG archives): '*We are extremely glad that you all think the bust worthy*'. Frederic Stephens, who had criticized the copy, subsequently made efforts to acquire the original 1873 marble bust for the gallery, but without success (see his two letters to Scharf of 17 December 1893 and 19 July 1894, NPG archives).

Woolner modelled several busts and medallions of Tennyson, and became an intimate friend of the Tennyson family; his extensive correspondence with Mrs Tennyson is quoted at length on both sides in Amy Woolner, *Thomas Woolner: his Life in Letters* (1917). Included below is a short list of Woolner's portraits of the poet:

1850–1. Medallion. A bronze cast of this is apparently in the Usher Art Gallery, Lincoln (see NPG 3847 below).

1856. Medallion (a re-working of the 1851 medallion). Several extant casts (see NPG 3847 below).

1856–7. Marble bust. Trinity College, Cambridge (for a discussion of this, related replicas and casts, and the NPG copy, see above).

1864. Alto-relievo medallion. Type exhibited *RA*, 1867 (1091), anonymously engraved, published F. Moxon, 1866 (example in NPG). A cast is in the Usher Art Gallery, Lincoln, where there is also a marble version dated 1866; another cast is reproduced *Magazine of Art* (1893), p97. See Amy Woolner, p339.

1873. Marble bust. Art Gallery of South Australia, Adelaide (for related cast and a full discussion, see NPG 1667 below).

1874. Draped plaster bust. Listed by Amy Woolner, p341.

1178 Plaster cast, painted black, 35 inches (88·9 cm) high, of a bust by FRANCIS JOHN WILLIAMSON, 1893. PLATES 907, 908

Incised below the shoulders: TENNYSON *and on the back of the socle:* F.J. WILLIAMSON SC/ESHER. 1893.
Collections: Presented by the artist, 1898.

This is related to the original marble bust of Tennyson by Williamson of 1893 in the Guildhall Art Gallery, exhibited *RA*, 1894 (1778), reproduced Cassell's *Royal Academy Pictures* (1894), p30, of which there is a replica at Windsor Castle. Another plaster cast is in the Usher Art Gallery, Lincoln.

1667 Plaster cast, painted black, 28¼ inches (71·6 cm) high, of a bust by THOMAS WOOLNER, 1873. PLATE 906

Incised on one side of the base: A. TENNYSON *and on the other:* T WOOLNER SC / 1873
Collections: Purchased from the artist's daughter, Miss Amy Woolner, 1912.

This plaster bust is one of a fairly large edition of casts from Woolner's original bust of 1873. The marble is in the Art Gallery of South Australia, Adelaide, exhibited *RA*, 1876 (1424), reproduced *Magazine of Art* (1893), p98; this was at one time offered to the NPG (see NPG 947 above). A marble version of 1876 is in the Usher Art Gallery, Lincoln, possibly the bust in the *Tennyson Centenary Exhibition*, Fine Art Society, London, 1909 (76), lent by Mrs Woolner. A similar plaster cast, described as the original model, is in the Lincoln Central Library, and a bronze cast is in St Margaret's Church at Somersby. Hallam Tennyson, *Alfred Lord Tennyson: a Memoir* (1897), II, 152, records that his father was daily in Woolner's studio in the early part of November 1873 for sittings for the new bust. Amy Woolner, *Thomas Woolner: his Life in Letters* (1917), pp305–6, called it 'the greatest bust of the Sculptor, a majestic and idealistic representation of the Poet Laureate'. Tennyson himself, however, much preferred the earlier, beardless bust of 1856–7 (see NPG 947 above). A photograph of Woolner at work on the marble bust is reproduced Amy Woolner, facing p325. For a list of other medallions and busts of Tennyson by Woolner, see NPG 947 above.

3847 Plaster cast, 10¼ inches (26 cm) diameter, of a medallion by THOMAS WOOLNER, 1856. PLATE 895

Incised below the head: T. WOOLNER. Sc./1856.
Collections: Mrs Charles Orme (*née* Patmore); Miss Sybil Bastian; purchased at Sotheby's, 22 December 1952 (lot 175).

In 1850–1, Woolner modelled his first medallion of Tennyson. He wrote to Mrs Tennyson in January 1851 (Amy Woolner, *Thomas Woolner: his Life in Letters* (1917), p11): '*You quite mistake in supposing that I have gone to any expense and trouble on your account for I have been gratifying my own feelings of admiration entirely in whatever I have done with regard to the medallion, and I am wholly indebted to your gracious kindness in permitting me to visit you at Coniston and doing so. Tell Mr Tennyson that I sent a*

cast to Mrs Fletcher as he desired – pray remember me in the kindest way to the divine man.' The bronze medallion in the Usher Art Gallery, Lincoln, which differs in details from the NPG type and is in reverse, appears to be a version of the 1850–1 medallion.

Woolner was dissatisfied with this first medallion, and on his return to England from Australia determined to do another. On 25 December 1854, he wrote to Mrs Tennyson (Amy Woolner, p 105): '*I have been thinking of the medallion and have concluded it will be better to make another entirely of a smaller size Tell Mr Tennyson it will not require a great deal of time as I am so well acquainted with his features now, and he need not anticipate it as an extraordinarily formidable task.*' The new medallion was finished in 1856, presumably after fresh sittings, though the type does not differ radically from the bronze medallion in the Usher Art Gallery (probably one of the 1850–1 type). According to Hallam Tennyson, *Alfred Lord Tennyson: a Memoir* (1897), I, 383, the new medallion was executed in March 1856. In July Woolner wrote to Mrs Tennyson (Amy Woolner, p 115): '*I was at the Browning's last night; I took them a cast of Mr Ten.'s med: they were immensely pleased – meant to have it framed and carry it about with them wherever they went. Browning said no likeness could possibly be better. I have improved it since you saw the photograph – it was upon your hint that it "looked scornful tho' very grand". I watched his face and now have put a slight touch of sweetness which I think is of golden value, and now I consider it the* very best *med: I have done. I have a cast for you when you please to claim it.*' Most of Tennyson's friends liked the medallion, Spedding writing to Woolner in September 1856 (Amy Woolner, p 117): '*Your medallion of the Laureate is magnificent, and puts all competitors out of the field.*' Mrs Tennyson wrote on 11 November (Amy Woolner, pp 122–3): '*Dr and Mrs Mann are here and are delighted as well as A. and myself with the delicate yet lofty beauty of the medallion and with the grandeur of the bust.*' The type was exhibited (in bronze) *R A*, 1857 (1370), and engraved as the frontispiece to the first illustrated edition of Tennyson's *Poems* (Moxon, 1857); for Woolner's letter to Mrs Tennyson about the engraving see Amy Woolner, p 121 and n. Woolner evidently produced quite a large edition of bronze and plaster casts from his medallion, and other examples, besides that in the NPG, are recorded; one is in the Gladstone-Glynne collection; others are reproduced *Magazine of Art* (1893), p 38, and in Amy Woolner, facing p 42.

Included in the same lot as the NPG medallion of Tennyson was a drawing of Woolner by D. G. Rossetti (NPG 3848), and a medallion of Helen Orme by Woolner; according to a label on the back, the former was presented to Mrs Charles Orme, apparently by Woolner himself, around 1860. Woolner also executed a medallion of Mrs Tennyson (see Amy Woolner, pp 112–4).

ICONOGRAPHY The largest collection of portraits and photographs is at Lincoln, divided between the Tennyson Research Centre at the Central Reference Library, and the Tennyson Room at the Usher Art Gallery. These are referred to below as Lincoln Central Library and Usher Art Gallery, respectively. The numbers in brackets after the items in the Usher Art Gallery refer to the catalogue of the *Tennyson Collection: Usher Art Gallery, Lincoln* (Lincoln, 1963). The *Tennyson Memorial Exhibition* was held at the Fine Art Society, London, 1909. A series of articles on Tennyson's portraits by Theodore Watts was published in the *Magazine of Art* (1893), pp 37–43, 96–101, 177–8 (references given below).

1824 Silhouette called Tennyson by an unknown artist. Usher Art Gallery (169), on loan from the Hon Mrs A. Tennyson.

1830 Drawing by J. Harden (with Hallam, John Harden, and Mrs Harden, on board the 'Leeds' from Bordeaux to Dublin). Collection of A. S. Clay. Exhibited *Tennyson Memorial Exhibition*, 1909 (14). Reproduced H. Tennyson, *Tennyson & His Friends* (1911), facing p 441. A photograph is in the Usher Art Gallery (345). Another similar drawing is also in the collection of A. S. Clay.

c 1831 Drawing attributed to J. Spedding (NPG 3940 above).

1835 Drawing by J. Spedding (at Mirehouse). Reproduced H. Tennyson, *Alfred Lord Tennyson: a Memoir* (1897), I, facing 146. A photograph is in the Usher Art Gallery (166).

1835 Drawing by E. Fitzgerald (at Mirehouse). Reproduced H. Tennyson, I, facing 153. A similar drawing is in the collection of J. Spedding, Mirehouse.

c1837–40 Miniature by Miss A. Dixon. Two versions: 1. Collection of Lord Brownlow, given by the artist to Lady Marian Alford, wife of Viscount Alford, eldest son of the 1st Earl Brownlow. 2. Collection of Mrs Rachel Bigg and her brothers (plate 892), exhibited *Special Exhibition of Portrait Miniatures*, South Kensington Museum, 1865 (2926), lent by J. L. Fytche, reproduced Sir C. Tennyson, *Alfred Tennyson* (1949), facing p81. The pose and the unfinished treatment of the coat are very similar to the Laurence portrait of *c*1840 (see below), and may partly be based on it. Miss Dixon lived at Horncastle, and it has been suggested that she may have painted Tennyson before he left Lincolnshire.

c1840 Painting by S. Laurence (NPG 2460 above).

c1840 Drawing called Tennyson by his sister-in-law, Mrs Agnes Weld, said to be after an early daguerreotype. Lincoln Central Library. Exhibited *Tennyson Memorial Exhibition*, 1909 (19). Engraved by E. J. Stodart, as after a daguerreotype of 1838 (this is impossible, since Daguerre had not yet published his invention) (example in NPG), for H. Tennyson, *Alfred Lord Tennyson: a Memoir* (1897), I, facing 166. The features are quite unlike those in other early recorded portraits of Tennyson.

c1840 Anonymous etching, apparently based on the Laurence portrait (example in NPG).

c1850 Three drawings by R. Doyle. British Museum.
One is reproduced *Magazine of Art* (1893), p39.

1851 Bronze medallion by T. Woolner. Usher Art Gallery (164, where it is erroneously said to be one of the 1856 medallions; see NPG 3847 above).

1855 Drawing by D. G. Rossetti (reading 'Maud' at Browning's house, 27 September 1855).
Collection of Mrs Donald Hyde, USA (from Browning's collection) (plate 894). Exhibited *VE*, 1892 (395). Reproduced in the catalogue of the Browning Sale, Sotheby's, 1–8 May 1913, facing p6. Two other versions are in the City Museum and Art Gallery, Birmingham, and formerly collection of W. M. Rossetti; the former is widely reproduced, the latter in *Pre-Raphaelite Letters and Diaries*, edited W. M. Rossetti (1900), facing p233.

1856 Medallion by T. Woolner (see NPG 3847 above).

c1856 Photograph by Mayall. Engraved by H. Linton, after a drawing by E. Morin (examples in British Museum and Usher Art Gallery), for the *National Magazine*, November 1856. Engraved anonymously in reverse (example in NPG).

1856–7 Busts by T. Woolner (see NPG 947 above).

1857 Painting by G. F. Watts. National Gallery of Victoria, Melbourne (see list at the end of the entry for NPG 1015 above) (plate 897).

1857 Photograph by L. Carroll (several examples extant). Reproduced S. D. Collingwood, *The Life and Letters of Lewis Carroll* (1898), facing p71. Carroll also did a photograph of Tennyson and his family at the same time. For a third photograph previously attributed to Carroll, see the photograph by Cundall and Downes of 1861 below.

c1857 Marble bust by W. Brodie. Exhibited *RA*, 1857 (1354).

c1857 Photograph by O. Rejlander (with his wife and sons at Farringford) (example in Usher Art Gallery, 208). Reproduced *Magazine of Art* (1893), p40.

1859 Painting by G. F. Watts. Collection of Mrs Hervey-Bathurst, Eastnor Castle (see list at the end of the entry for NPG 1015 above).

1859 Photograph by O. Rejlander (full-length, in his cloak) (example in Usher Art Gallery, 201).
Engraved by E. J. Stodart (example in NPG), for H. Tennyson, *Alfred Lord Tennyson: a Memoir*

(1897), I, facing 438. Other similar photographs, apparently by Rejlander, are in the Usher Art Gallery (202, 209).

c1860 Cameo by F. Anderson. Exhibited *RA*, 1860 (880).

1861 Two similar photographs by Cundall and Downes (three-quarter and half-length, wearing a hat) (examples in NPG). The half-length is reproduced *Magazine of Art* (1893), p178, as by an unknown photographer. A third photograph (example in NPG, plate 901), reproduced H. Gernsheim, *Lewis Carroll – Photographer* (1949), plate 8, as by Carroll, is also certainly by Cundall and Downes (the costume, apart from the absence of a hat, is very similar to that in the two photographs of 1861). The attribution to Cundall was first suggested by W. D. Paden, *Times Literary Supplement* (30 June 1950), p412.

1863 Lithograph by M. Julien, after a photograph by O. Rejlander, published H. Graves and V. Delarue, 1863 (example in NPG).

1863–4 Paintings by G. F. Watts (see NPG 1015 above).

1864 Medallion by T. Woolner. Examples in bronze and marble, Usher Art Gallery (178–9; see list at the end of the entry for NPG 947 above).

1864 Photograph by J. Mayall (examples in Lincoln Central Library), published 'Mayall's New Series of Photographic Portraits'. Engraved by W. H. Mote (example in NPG). This was Tennyson's favourite photograph.

c1864 Painting by E. G. Girardot, based on the Mayall photograph above. Usher Art Gallery (180). Reproduced *Magazine of Art* (1893), facing p42.

c1864 Drawing by L. Dickinson, based on the Mayall photograph above. Offered to NPG by Colnaghi, 1894 (reproduction in NPG). Another version, inscribed to Lady Tennyson and dated 1892, is in the Usher Art Gallery (186).

c1864 Drawing by M. Arnault, based on the Mayall photograph above (NPG 970 above).

c1864 Profile photograph by Elliott and Fry (examples in NPG).

c1864 Various photographs by W. Jeffrey (examples in NPG and Lincoln Central Library). One of these reproduced as a woodcut by M. Jackson *ILN*, XLIV (1864), 165.

c1864 Woodcut, after a drawing by Sir J. Gilbert, of Tennyson meeting Garibaldi, published *ILN*, XLIV (1864), 381.

c1864 Various photographs by the London Stereoscopic Company (examples in NPG). One of them lithographed (example in NPG), for 'Cassell's Modern Portrait Gallery'.

1865 Photograph by Mrs J. M. Cameron (examples in NPG (plate 898), Usher Art Gallery, and elsewhere). Nicknamed by Tennyson 'The Dirty Monk'. Reproduced H. Gernsheim, *Julia Margaret Cameron* (1948), plate 22, *Magazine of Art* (1893), p43, and elsewhere.

1867 Photograph by Mrs J. M. Cameron (looking to right) (dated examples in Lincoln Central Library). Reproduced *Alfred, Lord Tennyson and his Friends* (1893), plate 4, where the date given is 1866.

c1867 Photograph by Mrs J. M. Cameron (full-face). Reproduced H. Gernsheim, *Julia Margaret Cameron* (1948), plate 7.

1869 Photograph by Mrs J. M. Cameron (looking to right) (example in NPG, plate 899). Reproduced H. Gernsheim, *Julia Margaret Cameron* (1948), plate 52.

c1869 Photograph by Mrs J. M. Cameron (looking down, blurred) (example in Lincoln Central Library).

c1869 Cameo by J. Ronca. Exhibited *RA*, 1869 (1072).

1871 Coloured lithograph by 'Ape' (C. Pellegrini), published *Vanity Fair*, 22 July 1871. A pencil study is in the collection of Sir Charles Tennyson.

1871 Photograph by B. Scott & Son of Carlisle (with the family of Charles Howard at Naworth Castle) (example in Usher Art Gallery, 200).

c1871 Engraving after a photograph by Mrs J. M. Cameron of 1871 (reading) (example in NPG); engraving reproduced *Magazine of Art* (1893), p97.

c1872 Medallion by C. Jahn. Exhibited *RA*, 1872 (1493).

1873 Busts by T. Woolner (see NPG 1667 above).

c1873 Two drawings by the 9th Earl of Carlisle (on the same sheet of paper). Collection of Lord Henley (plate 905). Exhibited *George Howard and his Circle*, City Art Gallery, Carlisle, 1968 (123).

c1873 Caricature by F. Waddy, reproduced in his *Cartoon Portraits* (1873), facing p78.

1874 Engraving of a sketch by C. Holden, after a photograph by Downey. Usher Art Gallery (111).

c1875 Various photographs by Mayall (examples in NPG). One engraved anonymously, published W. Mackenzie (example in NPG); another published *Men of Mark* (1883).

c1875 Photograph by Elliott and Fry (full-face, in a hat) (example in NPG).

1876 Marble bust by J. D. Crittenden. Exhibited *RA*, 1876 (1485).

1879 Water-colour by Sir H. Herkomer. Lady Lever Art Gallery, Port Sunlight.
Exhibited *Summer Exhibition*, Grosvenor Gallery, London, 1879 (49), and *Tennyson Centenary Exhibition*, 1909 (63). Photogravure (example in NPG). A related chalk drawing of 1879 is in the Usher Art Gallery (187), and a related etching of 1879 was published Goupil, 1879 (example in NPG), exhibited Grosvenor Gallery, 1879 (275), reproduced *Magazine of Art* (1893), p178. The pose and features of all three portraits are similar, but there are differences in costume.

1880 Drawing by Mrs H. Allingham. *Tennyson Centenary Exhibition*, 1909 (112). Another sketch by Mrs Allingham of 1880 was in the same exhibition (136).

c1880 Etching by P. Rajon (example in Museum of Fine Arts, Boston). Reproduced *Print-Collector's Quarterly*, VI (*c*1916), 429, and *Magazine of Art* (1893), p100.

1881 Painting by Sir J. E. Millais. Lady Lever Art Gallery, Port Sunlight.
Exhibited Fine Art Society, London, 1881, *Millais Exhibition*, Walker Art Gallery, Liverpool, and Royal Academy, London, 1967 (101), and elsewhere. See R. R. Tatlock, *English Paintings In the Lady Lever Art Gallery* (1928), p103. Engraved by T. O. Barlow, published Fine Art Society, 1882 (example in NPG), engraving exhibited *RA*, 1882 (1289); photogravure detail of the head (example in NPG, plate 904).

1882 Photograph by Barraud (in a hat) (example in NPG). Another photograph by Barraud of roughly the same date (example in NPG), was published in *Men and Women of the Day* (1888); a water-colour by W. H. Margetson, based on this photograph, is in the NPG (4343 above). There is a later photograph by Barraud (without a hat) (reproduction in NPG), lithographed by J. A. Vinter (example in Lincoln Central Library); the drawing by R. Lehmann of 1890 (see below) is based on it.

c1882 Medallion by A. Legros. Bronze cast in City Art Gallery, Manchester; plaster cast in Usher Art Gallery (171, as by an unknown artist). The type was exhibited *RA*, 1882 (1606). Other examples are reproduced *Magazine of Art* (1893), p98, and *Connoisseur*, XX (1910), 275. Legros also executed a lithograph of Tennyson (example with Craddock & Barnard, London, 1970).

1883 Woodcut cartoon by Sir J. Tenniel, published *Punch*, LXXXV (22 September 1883), 139.

1884 Drawing by F. Sandys. Collection of Harold Macmillan.
Exhibited *Tennyson Centenary Exhibition*, 1909 (85). Reproduced *Apollo*, LXXXV (1967), 45. Lithograph, Usher Art Gallery (188).

c1884 Bronze medal by J. W. Minton (example in Usher Art Gallery, 173). Type exhibted *RA*, 1884 (1854).

c1884 Etching by A. Forestier, after a photograph by Elliott and Fry (example recorded by G. Scharf, 'SSB' (NPG archives), CXIII, 30). Reproduced as a woodcut in the supplement to *ILN*, 19 January 1884.

1885 Etching by S. Hollyer, after C. Roberts (in his study at Aldworth) (example in Usher Art Gallery, 192).

1885 Woodcut cartoon by L. Sambourne, published *Punch*, LXXXVIII (27 June 1885), 302.

1888 Photograph by H. H. H. Cameron (full-face, in a hat) (example in Lincoln Central Library). Reproduced *Alfred, Lord Tennyson and his Friends* (1893), plate 5, and apparently *ILN*, CI (1892), 473. Another late photograph by Cameron and Smith (wearing a skull-cap) is reproduced as a woodcut *ILN*, CI (1892), 483.

c 1889 Drawing by R. Cleaver (from memory, with his nurse on Freshwater Downs, after his illness of 1888–9) (reproduction in Usher Art Gallery, 185).

1890 Painting by G. F. Watts (in academic gown). Trinity College, Cambridge (plate 902). Variant version (in peer's robes): Art Gallery of South Australia, Adelaide (see list at the end of the entry for NPG 1015 above, for both).

1890 Water-colour or drawing by Mrs H. Allingham (in his study). *Tennyson Centenary Exhibition*, 1909 (136), lent by the artist. Presumably the portrait of 1890 of which there is an engraving in the Lincoln Central Library.

1890 Drawing by R. Lehmann (based on a photograph by Barraud). British Museum. Reproduced R. Lehmann, *Men and Women of the Century* (1896), no. 73, and *Magazine of Art* (1893), p 101.

1890 Engraving by W. B. Gardner, after a photograph by Mrs Cameron (example in NPG), published as a supplement to *Black and White*, 26 December 1891. A bronze medal, apparently after the same photograph, is in the Usher Art Gallery (170).

1891 Water-colour by W. H. Margetson (based on a photograph by Barraud) (NPG 4343 above).

1891 Woodcut cartoon by Sir J. Tenniel, published *Punch*, CI (15 August 1891), 79.

1892 Drawing by L. G. Holland (walking in Parliament Square, 22 July 1892). L. G. Holland, 'Sketchbooks' (NPG archives), VIII, 54.

1892 Engraving by M. Klinkicht (reproduction in Usher Art Gallery, 193).

1892 Woodcut of Tennyson on his deathbed, from the *ILN* (reproduction in the Usher Art Gallery, 383).

c 1892 Drawing or woodcut by W. B. Gardner. Exhibited *RA*, 1892 (1592). Possibly the woodcut exhibited *Victorian Era Exhibition*, 1897, 'Fine Art Section' (1227), lent by the artist (see also NPG 1015 above).

c 1892 Photograph by H. H. H. Cameron (profile; the last photograph taken of the poet) (reproduction in NPG). Reproduced *ILN*, CI (1892), 489.

1893 Busts by F. J. Williamson (see NPG 1178 above).

1893 Marble bust by Miss M. Grant, after a bust by Woolner (NPG 947 above).

c 1893 Miniature by Miss E. Webling. Exhibited *RA*, 1893 (1334).

c 1893 Marble bust by J. T. Tussaud. Exhibited *RA*, 1893 (1705).

c 1894 Bust by J. Whitehead. Exhibited *RA*, 1894 (1741).

c 1898–1905 Bronze statue by G. F. Watts. Lincoln (see list at end of entry for NPG 1015 above).

c 1898 Statuette by F. Mowbray Taubman. Exhibited Royal Society of Portrait Painters, 1898 (192).

c 1899 Bust by H. Montford. Exhibited *RA*, 1899 (1954).

1901 Drawing by Alice Hambridge. *Tennyson Centenary Exhibition*, 1909 (91), lent by Lord Tennyson.

c 1910 Marble statue by W. H. Thornycroft. Trinity College, Cambridge. Model exhibited *RA*, 1910 (1909), reproduced Cassell's *Royal Academy Pictures* (1910), p 130.

Undated Drawing by J. W. Wilson (in the House of Lords), reproduced as a woodcut, *ILN*, CI (1892), 478.

Undated Bronze cast of Tennyson's left hand. Usher Art Gallery (172).

Undated Photograph of Tennyson, possibly by Mrs J. M. Cameron (with Hallam and Lionel) (example in Usher Art Gallery, 210), reproduced H. Tennyson, *Tennyson and his Friends* (1911), facing p188.

Undated Various anonymous photographs (examples in NPG, and at Lincoln), and an anonymous engraving after one of them (example in NPG). Other photographs are reproduced as woodcuts *ILN*, CI (1892), 488 (with Hallam and Lady Tennyson), and 487.

THACKERAY *William Makepeace* (*1811–63*)

Novelist; contributed to a variety of newspapers and journals, including *Punch*, with his own illustrations, and lectured extensively; achieved fame with *Vanity Fair* 1847–8; his status as a major novelist confirmed by *Pendennis*, *The Newcomes*, and other works.

725 Oil on canvas, 29¾ × 24¾ inches (75·5 × 63 cm), by SAMUEL LAURENCE, *c* 1864. PLATE 916

Collections: The artist; Laurence Sale, Puttick and Simpson, 12 June 1884 (lot 158), bought Colnaghi, and purchased from them, 1884.

Literature: F. G. Kitton, 'The Portraits of Thackeray', *Magazine of Art* (1891), p291, reproduced as an engraving; General J. G. Wilson, *Thackeray in the United States* (1904), I, reproduced frontispiece; F. Miles, 'Samuel Laurence' (typescript copy, NPG library).

This unfinished painting is one of several versions, most of them posthumous, showing Thackeray in profile reading a paper. In the case of famous sitters, Laurence was frequently able to obtain several commissions for replicas. The original crayon drawing of Thackeray by Laurence (signed, and dated 1862), from which this portrait and the other versions are derived, is in the collection of Mrs Ritchie, London, exhibited *SKM*, 1868 (603). It was given by Thackeray to his great friend, Sir Frederick Pollock, in exchange for a portrait of Pollock by Laurence (now in the NPG, 732). Thackeray wrote: '*The Chief Baron was dining with me the other day and we laid our heads together to make a little plan for a painter friend of ours to take each of our heads off*' (*The Times*, 22 January 1864). According to Lady Ritchie, Thackeray's daughter, they exchanged portraits '*out of friendship for each other & for the painter too*' (letter of 27 June 1884, NPG archives). Pollock later presented the drawing of Thackeray to Lady Ritchie, in exchange for a crayon replica, executed *c* 1863–4; the latter was exhibited *VE*, 1892 (418). Other replicas are listed below:

1 Crayon copy, commissioned by Anthony Trollope, 1864. Collection of Professor G. N. Ray. Reproduced G. N. Ray, *Thackeray: The Age of Wisdom* (1958), plate XXI.

2 Crayon copy. Collection of Major Lambert, sold Anderson Galleries, New York, 26 February 1914 (lot 560).

3 Crayon copy (1862). Collection of F. Hyde, 1937.

4 Crayon copy (1864). Collection of K. Tite, 1968, apparently the drawing (signed, and dated 1864), sold Christie's, 25 November 1969 (lot 199), bought Sawyer.

5 Oil copy, commissioned by George Smith, 1862. Collection of Colonel and Mrs T. R. Badger.

6 Oil copy, commissioned by Edward Fitzgerald, 1864. Christie's, 8 December 1883 (lot 16).

7 Oil copy. Collection of W. Crewsdon, 1948. Exhibited *Japan-British Exhibition*, London, 1910, 'British Section of Fine Arts' (63).

8 Oil copy (unfinished). Collection of Mrs W. Bevan, 1892. Exhibited *VE*, 1892 (206).

9 Oil study. Puttick and Simpson, 12 June 1884 (lot 158), bought Colnaghi, together with NPG 725. Possibly one of the versions listed above.

Thackeray was a close friend of Laurence for many years, and helped to secure him patrons. They probably met through Edward Fitzgerald in the early 1840s, but only became intimate after George Smith the publisher had commissioned a drawing of Thackeray from Laurence in 1852. In 1853 Thackeray wrote to Bancroft (*Thackeray Papers*, III, 317): '*I think Lawrence* [sic] *is the best drawer of heads since Van Dyke*'. In a humorous letter to Laurence of the same year (*Thackeray Papers*, III, 89), Thackeray wrote: '*I hereby appoint Samivel Laurence Esquire, my Portrait-painter in Ordinary, and forbid all Hartists to attempt to paint my Mug save and excepting the said Samivel & the undersigned Thackeray*'. The 1852 drawing, in the collection of Mrs Dickinson (a descendant of Smith) (plate 913), is the best and most famous of all Laurence's portraits of Thackeray. It was exhibited *RA*, 1864 (679), engraved by F. Holl, published 1853 (example in NPG), and by G. Kruell (reproduction in NPG), and etched anonymously (example in NPG); it was also reproduced in woodcut form in many contemporary journals (some cuttings in NPG). As in the case of the 1862 drawing, there are a number of replicas:

1 Collection of Lord Northampton.

2 Berg Collection, New York Public Library, reproduced J. W. Dodds, *Thackeray: A Critical Portrait* (1941), frontispiece.

3 Formerly collection of Major Lambert, sold Anderson Galleries, New York, 26 February 1914 (lot 561), reproduced L. Melville, *W. M. Thackeray* (1910), II, facing 8.

4 Formerly collection of Mrs Clive Bell (now destroyed).

5 Formerly collection of F. T. Sabin, exhibited *Thackeray Exhibition*, Old Charterhouse, London, 1911 (47); in the catalogue it is said to be dated 1842, presumably in a misreading or misprint for 1852.

6 Puttick and Simpson, 12 June 1884 (lot 195), bought in; possibly one of the versions above.

7 British Museum (signed and dated 1848). This drawing is evidently after the 1852 drawing.

8 Collection of R. Metzdorf, USA, from the Whitelaw Reid collection. Apparently the drawing (signed, and dated 1849) in the collection of D. E. Grant, 1938, also said to be from Whitelaw Reid (the sizes are the same). The authenticity of this drawing is questioned by Miles.

A different oil portrait, showing Thackeray almost full-length, with his hands in his pockets, is in the Reform Club, London, commissioned in 1881; it was in the *Thackeray Exhibition*, 1911 (77), where it is erroneously dated 1864 in the catalogue, and is reproduced L. Melville, *W. M. Thackeray* (1910), II, facing 40. Another version of this type and a study were in the Laurence Sale, Puttick and Simpson, 12 June 1884 (lot 159), bought in.

Description: Brown eyes, grey hair, white shirt and dark stock. Holding a light yellow piece of paper. Background colour brown and reddish brown. Foreground unfinished.

4210 Oil on canvas, 24 × 20 inches (61 × 50·8 cm) painted oval, by FRANK STONE, *c* 1839. PLATE 912 & p 461

Collections: The artist; given by him to Thackeray; by descent to the latter's granddaughter, Mrs Richard Thackeray Fuller, and bequeathed by her, 1961.

Exhibitions: VE, 1892 (262); *Thackeray Centenary Exhibition*, Prince's Gallery, Piccadilly, May 1911; *Thackeray Exhibition*, Old Charterhouse, London, 1911 (3); *Charles Dickens*, Victoria and Albert Museum, 1970 (P5).

Literature: F. G. Kitton, 'The Portraits of Thackeray', *Magazine of Art* (1891), p290; A. T. (Lady) Ritchie, *Chapters from Some Memoirs* (1894), pp91–2; General J. G. Wilson, *Thackeray in the United States* (1904), I, reproduced facing 81; possibly the portrait mentioned in a letter from Mrs Thackeray of 3 July 1839 in G. N. Ray, *The Letters and Private Papers of W. M. Thackeray* (1945–6), I, 388; G. N. Ray, *Thackeray: the Uses of Adversity* (1955), reproduced frontispiece.

Thackeray's daughter, Lady Ritchie, remembered visiting Stone's studio in Tavistock Square with her father, when the two men talked about their early days. Stone brought out the unfinished NPG portrait,

which he had painted several years earlier over a sketch of a lady with a guitar (her red dress is still visible), and gave it to Thackeray: '*a cheerful, florid picture of my father, as I for one had never seen him, with thick black hair and a young ruddy face*' (Lady Ritchie, p92). Kitton and Wilson both date the portrait to 1836, but if Mrs Thackeray's letter of 3 July 1839 to Mrs Carmichael refers to the NPG picture, then it must have been painted in 1839: '*Stone is doing a portrait of W. they say it is excellent so I hope he intends to do whats handsome by me and give it to me*' (*Thackeray Papers*, I, 388). As Stone and Thackeray were friendly for several years, it is possible that Stone painted more than one portrait, and that Mrs Thackeray's letter refers to another. In spite of Lady Ritchie's favourable comments quoted above, Kitton states that she did not consider the NPG portrait a satisfactory likeness. Thackeray first met Stone at Maclise's studio, and often used to visit his '*irregular ménage* [Stone openly lived with his mistress, by whom he had several children, and only married her late in life] *and go walking with him in Kensington Gardens*' (*Uses of Adversity*, p169). Stone's private life provided Thackeray with the plot for his 'A Shabby Genteel Story', first published in *Fraser's Magazine* (May–October 1840).

Description: Unfinished. Florid complexion, dark brown hair, brown eyes. Dressed in a white collar and dark stock. Patches of vivid green and red, lower left. Background dark brown.

3925 Pen and ink and wash on paper, $4\frac{5}{8} \times 3\frac{7}{8}$ inches ($11 \cdot 7 \times 9 \cdot 8$), by SIR EDWIN LANDSEER, 1857. PLATE 915

Inscribed on the back of the original backboard: Mr Thackeray sketched at/South Bank by Sir Edwin Landseer/in 1857/F.G. [*Francis Grant*]

Collections: Sir Francis Grant; by descent to his granddaughter, the Hon Mrs Walsh; sold Christie's, 28 January 1955 (lot 4), bought Colnaghi, and purchased from them, 1955.

Exhibitions: Landseer Exhibition, RA, 1961 (100).

4209 Pencil on brown, discoloured paper, $8 \times 5\frac{1}{4}$ inches ($20 \cdot 3 \times 13 \cdot 3$ cm), by DANIEL MACLISE, *c* 1840. PLATE 914

Collections: The sitter; by descent to his granddaughter, Mrs Richard Thackeray Fuller, and bequeathed by her, 1961.

Exhibitions: Thackeray Centenary Exhibition, Prince's Gallery, Piccadilly, May 1911.

Literature: W.M. Thackeray, *The Orphan of Pimlico*, reproduced frontispiece, after a copy by Thackeray.

The copy by Thackeray for the *Orphan of Pimlico* is in the Harvard University Library. Maclise drew Thackeray on several occasions (see iconography below), and was friendly with him for a number of years; both men contributed to *Fraser's Magazine*.

495 Plaster cast, painted cream, 33 inches ($83 \cdot 8$ cm) high, from a bust by JOSEPH DURHAM, 1864. PLATE 918

Incised on the back: J. Durham Sc/1864

Collection: H. Graves & Co, presented by them, 1878.

Literature: F.G. Kitton, 'The Portraits of Thackeray', *Magazine of Art* (1891), p293, reproduced p295.

Closely related to the marble bust of Thackeray by Durham at the Garrick Club, London, which is also dated 1864.

495a Terra-cotta cast of NPG 495 above, painted black, 30 inches ($76 \cdot 3$ cm) high, by SIR JOSEPH EDGAR BOEHM.

Incised on the back: J. Durham Fect/1864

Collections: Commissioned by the trustees of the NPG in case of damage to the original.

The difference in size between 495 and 495a is due to the shrinkage of the terra-cotta during baking.

620 Plaster cast, painted black, 20 inches ($50 \cdot 8$ cm) high, by SIR JOSEPH EDGAR BOEHM, after a plaster bust by J.S. DEVILLE of 1824–5. PLATE 910

William Makepeace Thackeray by Frank Stone, *c*1839 NPG 4210

Collections: Sir Leslie Stephen, presented by him, 1881.

Literature: F.G.Kitton, 'The Portraits of Thackeray', *Magazine of Art* (1891), p289, reproduced.

Deville was an Italian sculptor, who had perfected a process for taking moulds of faces from the life, with the help of straws to prevent suffocation. He took a mould of Thackeray's features at the home of Thackeray's mother in Devonshire, which he then modelled into a bust. This was apparently very accurate as a likeness. Lady Ritchie, who owned the original bust, exhibited *VE*, 1892 (1084), where attributed to 'Delisle', reproduced G.N.Ray, *Thackeray: The Uses of Adversity* (1955), plate III, allowed Boehm to make two casts from it, and presented one to Leslie Stephen, and the other to Lady Airlie (information in letters from Lady Ritchie and Leslie Stephen, NPG archives). She later sent another cast to Major Lambert, sold Anderson Galleries, New York, 26 February 1914 (lot 571), and allowed a marble copy to be made from this under the direction of E.Onslow Ford, sold Anderson Galleries (lot 570); the latter is possibly the marble bust after Deville now in the collection of E.Steese, New York. The original Deville cast is now owned by Mrs J.E.Martineau.

In return for having these busts made, Major Lambert agreed to pay for alterations to Baron Marochetti's unsatisfactory bust of Thackeray in Westminster Abbey of *c*1866 (see iconography below). These alterations were carried out under the supervision of Onslow Ford, who arranged for H.Wernher to execute a copy of the restored Marochetti bust for Major Lambert, sold Anderson Galleries (lot 572).

620a Bronze electrotype of NPG 620 above, 20 inches (50·8 cm) high, by ELKINGTON & CO, 1881.

Collections: Commissioned by the NPG trustees, in case of damage to the original.

738 Marble bust, 17¼ inches (43·8 cm) high, by NEVILL NORTHEY BURNARD, *c*1867. PLATE 919

Collections: Sir Theodore Martin, presented by him, 1885.

Literature: F.G.Kitton, 'The Portraits of Thackeray', *Magazine of Art* (1891), p293, reproduced p295; L.Melville, *W.M.Thackeray* (1910), reproduced II, facing 59.

Presumably a replica of the bust exhibited *RA*, 1867 (1163), which was commissioned by the Plymouth Public Library; see R.Gunnis, *Dictionary of British Sculptors* (1953), p71. There is now no trace of the original bust, nor any records relating to it: both the City of Plymouth Public Library and the Plymouth Proprietary Library were blitzed during the Second World War.

1282 Plaster cast, painted cream, 21 inches (53·3 cm) high, of a statuette by SIR JOSEPH EDGAR BOEHM, 1864. PLATE 917

Incised on the front of the base: THACKERAY *at the side* J.E. BOEHM fec/1864 *and on the back* Copy

Collections: Mrs Wylie, presented by her in memory of her husband, Charles John Wylie, 1900.

Literature: F.G.Kitton, 'The Portraits of Thackeray', *Magazine of Art* (1891), pp292–3, reproduced p293; G.N.Ray, *Thackeray: The Age of Wisdom* (1958), reproduced plate XI, between pp144–5.

According to Kitton, who interviewed the sculptor shortly before his death, Boehm began modelling a statuette of Thackeray in wax during the course of two half-hour sittings which Thackeray gave him in Paris in 1860. On his return to England, however, Thackeray refused to give Boehm any further sittings, because he thought the rough nature of Boehm's model indicated its probable failure. On the novelist's death, Boehm was reminded of the unfinished statuette, and on the advice of Millais quickly finished it. He then produced seventy casts from the original stauette, some in plaster and some in bronze, which were sold in less than three weeks. The type was exhibited *RA*, 1864 (959). Other known casts are as follows: the Athenaeum, London; the Garrick Club, London; *VE*, 1892 (1085), lent by Lady Ritchie; collection of Miss Fraser, 1926; formerly collection of Anthony Trollope; Charles Sawyer Ltd, 1938 (catalogue 147, no.351): this was the statuette given by Lady Ritchie to Arthur Clough, as a wedding present; formerly collection of Major Lambert (bronze and plaster casts), sold

Anderson Galleries, New York, 26 February 1914 (lots 575 and 576); *Thackeray Exhibition*, the Old Charterhouse, London, 1911 (67), lent Messrs E. Parsons & Co.

A large drawing by Boehm, in the collection of Sir Arthur Elton, corresponds with the front view of the statuette. A label on the back describes it as a 'cartoon' by Boehm for a statue of Thackeray, but there is not sufficient evidence to decide whether it is Boehm's original cartoon for a much larger statue (the sizes of cartoon and statuette do not correspond), which he never executed, or a copy after the statuette. It is quite possible that Boehm hoped to stimulate a commission for a life-size statue with the production and sale of the statuettes.

1501 Plaster cast of face, 13 inches (33 cm) high, and right hand, 7⅝ inches (19·3 cm) long, taken after death by MESSRS BRUCCIANI & CO, 1863. PLATE 921

Incised on base of face cast: D. Brucciani & Cᵒ Lᵗᵈ London *and on hand cast:* D. Brucciani & Co.

Collections: Messrs Brucciani & Co, presented by them, 1908.

Thackeray died during the night of 23/24 December 1863, and the death mask was made the following morning at the request of the surgeon, Sir Henry Thompson. There is a discussion of the death mask in L. Hutton, *Portraits in Plaster* (New York, 1894), pp 86, 91–92, 95, where another example is reproduced, p 89. Another cast of the hand is reproduced G. N. Ray, *The Letters and Private Papers of W. M. Thackeray* (1945–6), IV, facing 296, and a fourth cast was in the collection of Major Lambert, sold Anderson Galleries, New York, 26 February 1914 (lot 574).

ICONOGRAPHY This does not include photographs (see plate 920), caricatures or most of the self-portraits by Thackeray himself. The best sources for illustrations of Thackeray's portraits are, F. G. Kitton, 'The Portraits of Thackeray', *Magazine of Art* (July 1891), pp 289–95, and L. Melville, *W. M. Thackeray* (1910). The Thackeray Collection formed by Major Lambert was sold at the Anderson Galleries, New York, 25–7 February 1914.

1814 Drawing by G. Chinnery (with his parents). Harris Museum and Art Gallery, Preston.
Exhibited *VE*, 1892 (401). Reproduced H. and S. Berry-Hill, *George Chinnery, 1774–1852* (1963), plate 25.

c 1824–5 Busts by and after J. S. Deville (see NPG 620 above).

1829 Drawing by J. Spedding. Collection of Mr Ball.
Reproduced G. N. Ray, *Thackeray Letters*, I, facing 74. A drawing by Spedding of 1831 in the same collection is reproduced Ray, I, facing 150.

1830 Water-colour by Mrs Musgrave. Exhibited *Thackeray Exhibition*, the Old Charterhouse, London, 1911 (35), lent by C. P. Johnson.

1832 Drawing by D. Maclise. Garrick Club, London (plate 911).
Reproduced G. N. Ray, *Thackeray Letters*, I, facing 238. Exhibited *Daniel Maclise*, Arts Council at the NPG, 1972 (37).

1833 Drawing by D. Maclise. Garrick Club.
Reproduced Kitton, p 290.

1834 Drawing by himself. The Athenaeum, London.
Reproduced G. N. Ray, *Thackeray: The Uses of Adversity* (1955), plate VII.

1835 Water-colour by W. D'Egville. Collection of F. Sabin, 1911.

1835 Drawing by D. Maclise. Collection of Major Lambert, sold Anderson Galleries, 1914 (lot 565).
Reproduced Melville, I, frontispiece.

1835 'The Fraserians', engraving by D. Maclise, published *Fraser's Magazine*, XI (January 1835), between 2 and 3. Two related drawings are in the Victoria and Albert Museum.

c 1835 Miniature by an unknown artist. Pierpont Morgan Library, New York.
Copy exhibited *Thackeray Exhibition*, the Old Charterhouse, London, 1911 (40).

1839 Painting by F. Stone (NPG 4210 above).

c1840 Drawing by D. Maclise (NPG 4209 above).

c1842 Painting by L. Poyet (executed in France). Exhibited *Thackeray Exhibition*, the Old Charterhouse, London, 1911 (46), lent Messrs Pearson & Co. Reproduced H. Ward, *History of The Athenaeum, 1824–1925* (1926), facing p152.

1845 Drawing by E. Crowe. Collection of Major Lambert, sold Anderson Galleries, 1914 (lot 555). Reproduced General J. G. Wilson, *Thackeray in the United States* (1904), I, facing 328.

1848 Drawing by Count A. D'Orsay. Collection of Major Lambert, sold Anderson Galleries, 1914 (lot 556). Reproduced G. N. Ray, *Thackeray Papers*, II, facing 386, and elsewhere. Another drawing by D'Orsay also of 1848, is in the collection of Mrs Norman Butler, London. A copy of the head in the Lambert drawing, apparently by Thackeray himself, was sold Christie's, 9 March 1956 (lot 110).

1848 Water-colour by R. Doyle. Scottish NPG.
Other sketches of Thackeray by Doyle are in the British Museum. Six sketches of Thackeray are reproduced *Early Writings of William Makepeace Thackeray*, edited C. P. Johnson (1888), pp 16, 27, 34, 47, 58, and facing p61.

1849 Water-colour by E. D. Smith. *Thackeray Exhibition*, the Old Charterhouse, London, 1911 (50), lent by W. J. Williams. Reproduced *The Sphere*, 8 July 1911.

1850 Water-colour by W. Drummond. Collection of Major Lambert, sold Anderson Galleries, 1914 (lot 557). Reproduced L. Melville, I, facing 308.

c1850 Water-colour attributed to D. Dighton (on horseback). Collection of Major Lambert, sold Anderson Galleries, 1914 (lot 558). Reproduced Melville, I, facing 160. Dighton died in 1827.

1852 Drawings by S. Laurence (see NPG 725 above) (plate 913).

1853 Drawing by C. Martin. British Museum.
Reproduced as a coloured lithograph in C. Martin, *Twelve Victorian Celebrities* (1899), plate XI.

1854 Painting by E. M. Ward (in his study). Formerly collection of Major Lambert, now destroyed. Reproduced Kitton, p292. Exhibited *RA*, 1864 (404), where dated 1844 (a misprint?), *SKM*, 1868 (531), *Royal Jubilee Exhibition*, Manchester, 1887 (797), and *VE*, 1892 (325), lent by Richard Hurst. Date, '1854', and inscription on back, recorded by Scharf, 'SSB' (NPG archives), XCIX, 22. Sold Ward Sale, Christie's, 29 March 1879 (lot 85), and Hurst Sale, Christie's, 25 April 1899 (lot 126), bought Gribble.

1855 Painting by J. Lambdin (executed in USA). Collection of Major Lambert, sold Anderson Galleries, 1914 (lot 554), reproduced sale catalogue, facing p90.

1857 Drawing by Sir H. Thompson. Collection of Major Lambert, sold Anderson Galleries, 1914 (lot 567).

1857 Water-colour attributed to D. Maclise. Collection of Major Lambert, sold Anderson Galleries, 1914 (lot 564). Reproduced Melville, II, frontispiece.

1857 Drawing by Sir E. Landseer (NPG 3925 above).

1857 Drawing by an unknown artist. *Thackeray Exhibition*, the Old Charterhouse, 1911 (61), lent by W. T. Spencer.

1859 Water-colour by S. Lover. *Thackeray Exhibition*, Grolier Club, New York, 1912 (144).

1860 Drawing by C. S. Keene. Collection of the Ritchie family.

c1860 Painting attributed to F. Leighton. Sold Anderson Galleries, New York, 7 February 1922 (lot 248).

1861 Drawing by F. Walker (at a play). Collection of Mrs Ritchie.
Reproduced *The Cornhill*, February 1861, and elsewhere.

1863　　Drawing by E. Goodwyn Lewis. Kensington Public Library.
　　　　　Reproduced Melville, II, facing 16.

1863　　Death mask by Brucciani & Co (NPG 1501 above).

1864　　Drawing by Sir J. E. Millais, from memory. Collection of the Ritchie family.
　　　　　Exhibited *V E*, 1892 (502), and *Thackeray Exhibition*, Old Charterhouse, London, 1911 (5). Reproduced
　　　　　E. Gosse, *English Literature: Illustrated Record*, IV (1903), 277.

1864　　Bust by J. Durham (NPG 495 above).

1864　　Painting by Sir J. Gilbert. Garrick Club, London.
　　　　　Reproduced Kitton, p 194. Reproduced as a lithograph in *A Gallery of Illustrious Literary Characters*,
　　　　　edited by W. Bates (1873), facing p 222.

1864　　Statuette by Sir J. Boehm (NPG 1282 above).

1864　　Woodcut published *ILN*, XLIV (1864), 33.

c1864　 Bust by J. Williamson. Exhibited *R A*, 1864 (968).

c1866　 Bust by Baron C. Marochetti (later altered by E. Onslow Ford). Poets Corner, Westminster Abbey.
　　　　　Reproduced as a woodcut, before alteration, *ILN*, XLVIII (1866), 401, and, after alteration, J. G. Wilson,
　　　　　Thackeray in the United States (1904), II, facing 114. A plaster cast of the original bust, and a marble
　　　　　copy by H. Wernher of the altered bust were in the collection of Major Lambert, sold Anderson
　　　　　Galleries, 1914 (lots 572 and 573; the latter was sold again, Anderson Galleries, 6–7 February 1922
　　　　　(lot 247), reproduced sale catalogue, frontispiece).

c1867　 Bust by N. N. Burnard (NPG 738 above).

1896　　Bronze plaque by R. B. Goddard. Collection of Major Lambert, sold Anderson Galleries, 1914 (lot 562).

1900　　Painting by W. Lockhart Bogle. Trinity College, Cambridge.

1911　　Marble bust by L. Jennings. Thackeray Memorial, Calcutta.
　　　　　Model exhibited *Thackeray Exhibition*, the Old Charterhouse, London, 1911 (81), and *R A*, 1911
　　　　　(1834).

1911　　Bronze bas-relief by Margaret Parsons. Exhibited *Thackeray Exhibition*, 1911 (80), lent by the artist.

Undated　Painting attributed to D. Maclise. Collection of S. Causley.
　　　　　Exhibited *Thackeray Exhibition*, the Old Charterhouse, London, 1911 (36).

Undated　Painting attributed to D. Maclise (after a photograph). Offered to NPG, 1948. Either this or the photo-
　　　　　graph was etched anonymously (example in NPG).

Undated　Water-colour by himself (lecturing). Henry E. Huntington Library, USA.

Undated　Marble bust by an unknown artist. Collection of W. McCullough-Torrens, 1866.

Undated　Drawing by H. Furniss. Reproduced Furniss, *The Two Pins Club* (1925), p 54.

THOMASON *Sir Edward* (*1769–1849*)

　　　　　Manufacturer of buttons, medals, and plate; patented numerous inventions; liberally honoured by the
　　　　　European sovereigns for his biblical medals presented to them, and for his work in trade relations;
　　　　　knighted, 1832.

2515　　(73) Black and red chalk, with touches of Chinese white, on grey-tinted paper, $13\frac{3}{4} \times 9\frac{7}{8}$ inches
　　　　　($34\cdot9 \times 25\cdot1$ cm), by WILLIAM BROCKEDON, 1834. PLATE 922
　　　　　Dated (*lower right*): 1.10.34
　　　　　Collections: See *Collections:* 'Drawings of Prominent People, 1823–49' by W. Brockedon, p 554.

Accompanied in the Brockedon Album by an invitation from the sitter, on his factory notepaper, dated 10 September 1830.

ICONOGRAPHY The only other recorded portraits of Thomason are, a painting by an unknown artist in the City Museum and Art Gallery, Birmingham, an engraving by C.E.Wagstaff (example in NPG), and an engraving by S.Freeman for Thomason's *Memoirs During Half a Century* (1845), frontispiece.

THOMPSON George (1804–78)

Orator and organizer of the anti-slavery movement; involved in anti-slavery agitation in America; escaped to England, 1835; MP, 1847–52; involved in reform movement and Anti-Corn Law League.

3523 Pen and ink on paper, $11\frac{5}{8} \times 8\frac{3}{8}$ inches (29·5 × 21·3 cm), by HARRY FURNISS. PLATE 923

Signed (bottom right): Hy. F.

Inscribed along the top in ink: George Thompson. The last of the Great Victorian/public orators *and below in pencil:* Chap II

Collections: The artist, purchased from his sons, through Theodore Cluse, 1947.

Literature: Reproduced H.Furniss, *Some Victorian Men* (1924), p16; H.Furniss, 'Register of Drawings' (MS, NPG archives), entered after October 1917 as unpublished.

Part of a huge collection of drawings by Furniss, which will be discussed collectively in the forthcoming Catalogue of Portraits, 1860–90.

599 See *Groups:* 'The Anti-Slavery Society Convention, 1840' by B.R.Haydon, p538.

ICONOGRAPHY A painting by G.Evans was exhibited *RA*, 1842 (284), engraved by C.Turner, published G.Evans, 1842 (example in NPG); a bust by S.J.B.Haydon was exhibited *RA*, 1847 (1375); a woodcut, after a photograph by C.Braithwaite of Leeds, was published *ILN*, LXXIII (1878), 377.

THOMPSON William Hepworth (1810–86)

Classical scholar, specializing in Plato, whose works he edited; fellow (1834) and tutor (1844) of Trinity College, Cambridge; regius professor of Greek, 1853; Master of Trinity, 1866–86; vice-chancellor, 1867–8.

1743 Coloured chalk on brown, discoloured paper, $20 \times 14\frac{1}{4}$ inches (50·8 × 36·2 cm), by SAMUEL LAURENCE, 1841. PLATE 924

Signed and dated (lower left): S. Laurence 1841

Collections: Miss S.F.Spedding, purchased from her, 1914.

Literature: C.B.Johnson, *William Bodham Donne and his Friends* (1905), p70; F.Miles, 'Samuel Laurence' (typescript copy, NPG library).

In a letter of 22 February 1842, Donne wrote to Blakesley (Johnson, p.70): '*Laurence has a masterly pencil and time will doubtless soften the asperity of his style which gives, at least to the two drawings I have seen, more of melancholy than I hope either Thompson or Trench exhibit in their daily countenances*'. The drawings of Thompson and Trench (NPG 1685) were part of a whole series of drawings of the Cambridge 'Apostles' executed by Laurence at this time. The drawing of Thompson was lithographed by Weld Taylor, according to Miles (no example located). Laurence also executed a painting of Thompson in 1869, now at Trinity College, Cambridge, exhibited *RA*, 1869 (72), and *Summer Exhibition*, Grosvenor Gallery, 1879 (203), and a second version for Thompson himself. In a letter of 1869 to Thompson

(Trinity College Library, quoted by Miles), Laurence refers briefly to the NPG drawing: '*The* same side *of the face I drew years ago. Your face is more influenced by the light and shade cast upon it than most I have looked at*'.

ICONOGRAPHY A painting by Sir H. Herkomer of 1881 is at Trinity College, Cambridge, exhibited *RA*, 1882 (251), reproduced A. L. Baldry, *Herkomer* (1901), facing p 36, engraved by the artist (example in NPG).

TOOKE *William* (*1777–1863*)

President of the Society of Arts, MP for Truro.

54 See *Groups:* 'The House of Commons, 1833' by Sir G. Hayter, p 526.

TREDGOLD *J. Harfield*

Slavery abolitionist.

599 See *Groups:* 'The Anti-Slavery Society Convention, 1840' by B. R. Haydon, p 538.

TREDGOLD *Mrs*

Slavery abolitionist.

599 See *Groups:* 'The Anti-Slavery Society Convention, 1840' by B. R. Haydon, p 538.

TRENCH *Richard Chenevix* (*1807–86*)

Archbishop of Dublin; special preacher, 1843, and Hulsean lecturer, 1845–6, at Cambridge; rector of Itchenstoke, 1844; professor of divinity, King's College, London, 1846–58; dean of Westminster, 1856; Archbishop of Dublin, 1863; opposed disestablishment of Irish Church; published poetry, and works on history, literature, divinity and philology.

1683 Coloured chalk on brown, discoloured paper, $18\frac{7}{8}$ × $13\frac{7}{8}$ inches (48 × 35·2 cm), by SAMUEL LAURENCE, *c* 1841. PLATE 926

Collections: Fanny Kemble; H. N. Pym; Pym Sale, Christie's, 22 November 1912 (lot 9), bought E. E. Leggatt, and presented by him, 1912.

Exhibitions: VE, 1892 (403).

Literature: Fanny Kemble, *Further Records* (1890), I, 274; H. N. Pym, *A Tour Round My Bookshelves* (1891), p 58; C. B. Johnson, *William Bodham Donne and his Friends* (1905), p 70; F. M. Brookfield, *The Cambridge 'Apostles'* (1906), reproduced facing p 332; F. Miles, 'Samuel Laurence' (typescript copy, NPG library).

This drawing was anonymously lithographed (example in NPG). In a letter of 22 February 1842, W. B. Donne wrote to thank J. W. Blakesley for sending him one of the lithographs (Johnson, p 70): '*Laurence has a masterly pencil and time will doubtless soften the asperity of his style which gives, at least to the two drawings I have seen, more of melancholy than I hope either Thompson or Trench exhibit in their daily countenances*'. The drawings of Trench and Thompson (NPG 1743) were part of a series of drawings of the Cambridge 'Apostles' executed by Laurence at this time. Brookfield wrote to Laurence in 1849 (Miles): '*It wd., after all, be difficult to do better than you have done of Venables, Trench, Morris – many more – which are to my mind better things than I have seen from any other hand*'. Fanny Kemble commented: '*It is a matter of regret to me that the two likenesses of the Archbishop of Dublin, in his lately published memoirs, should give so unfavourable an idea of his very fine and noble countenance. I have myself a head of him, by Samuel Lawrence* [sic], *which does far more justice to his refined and sweetly serious face – the very face of a poet*'. Another similar drawing of Trench by Laurence, signed and dated 1841, is in the collection of Lt Commander Chenevix-Trench, the great-grandson of the sitter.

ICONOGRAPHY A painting by G. Richmond was sold from the Wilberforce collection, Christie's, 14 July 1939 (lot 22), listed in the artist's 'Account Book' (photostat of original MS, NPG archives), p 68, under 1858, exhibited *RA*, 1859 (510), reproduced *Richard Chenevix Trench Archbishop: Letters and Memorials*, edited Maria Trench (1888), I, frontispiece; it was presented to Samuel Wilberforce, Bishop of Oxford, in 1861, and so inscribed on the picture, as a marriage fee for marrying Richmond's eldest daughter; it was engraved by J. R. Jackson, published Colnaghi and Scott, 1863 (example in NPG), but with a different ecclesiastical medal (Trench was translated from the Deanery of Westminster to the Archbishopric of Dublin in 1863); an early proof of the engraving, before lettering (example in NPG), shows the same medal as in the painting; two related drawings by G. Richmond, both signed and dated 1859, are in the See House (plate 925), and the Synod Hall, Dublin, the former reproduced T. R. F. Cooke-Trench, *A Memoir of the Trench Family* (privately printed, 1897), facing p 120, and J. Bromley, *The Man of Ten Talents* (1959), frontispiece, exhibited *Church Disestablishment*, National Gallery of Ireland, Dublin, 1970 (109); one of these is probably the drawing listed in Richmond's 'Account Book', p 68, under 1858.

There is a reproduction of a painting by F. Holl in the NPG; a painting by Sir T. A. Jones is in the collection of the Archbishop of Dublin, exhibited *Royal Hibernian Academy*, 1874, and *Irish Exhibition*, London, 1888 (992), sketched by G. Scharf, 'TSB' (NPG archives), XXXIV, 40; a painting by an unknown artist is in the Deanery, Westminster Abbey; a drawing by T. Bridgford is at Alexandra College, Dublin, exhibited *Royal Hibernian Academy*, 1873; a bust by J. Watkins was exhibited *RA*, 1868 (1000); there are several engravings, woodcuts and photographs in the NPG.

TROLLOPE *Frances* (*1780–1863*)

> Novelist; *née* Milton; married Thomas Anthony Trollope, 1809; wrote a vast number of novels, and also works of travel and observation, notably *Domestic Manners of the Americans*, 1831–2; mother of the novelist Anthony Trollope.

3906 Oil on canvas stuck on board, 6 × 5 inches (15·1 × 12·6 cm), by AUGUSTE HERVIEU, *c* 1832. PLATE 927

Collections: The sitter; by descent to her great-granddaughter, Miss Muriel Rose Trollope, and bequeathed by her, 1954.

Exhibitions: SKM, 1868 (596); *VE*, 1892 (445).

Literature: T. A. Trollope, *What I Remember* (1887), II, 334–5; F. E. Trollope, *Frances Trollope: Her Life and Literary Work* (1895), I, 161, 178, reproduced frontispiece.

A water-colour copy of the NPG portrait by Miss Lucy Adams is in the British Museum, engraved by W. Holl, published Fisher, 1845 (example in NPG), for Cooke-Taylor's 'National Portrait Gallery'. An engraving by J. Brown, clearly derived from the NPG portrait, but differing in details, was published H. Colburn, 1839 (example in NPG), for the *New Monthly Magazine*. According to F. E. Trollope, the NPG picture was not the portrait of Mrs Trollope by Hervieu exhibited *RA*, 1833 (361). The latter was a life-size, three-quarter length painting, engraved by W. Greatbach (example in the NPG), as the frontispiece to Mrs Trollope's *Domestic Manners of the Americans* (1839 edition). The engraving shows that the large portrait was quite different in type from the NPG picture. It belonged to T. A. Trollope, but was lost by him while moving from Florence to London. Mrs Trollope sent a portrait of herself by Hervieu to the Princesse de Metternich, probably a copy or version of one of the two types already discussed. The recipient's letter of thanks is quoted by T. A. Trollope: '*Je remercie M. Hervieu de l'avoir fait aussi ressemblant. Et je vous assure, chère Madame Trollope, que rien ne pouvait me toucher aussi vivement et me faire autant de plaisir que ce souvenir venant de vous*'. Two portrait miniatures by Hervieu, both dated 1832 (which is probably the date of the NPG portrait of Mrs Trollope), representing two of her sons, probably Thomas Adolphus and Anthony, were purchased from the executors of Miss Muriel Rose Trollope by the NPG, 1954. Their identity has not been finally established. Hervieu was a close

friend of the Trollope family. He accompanied Mrs Trollope to America and illustrated her *Domestic Manners of the Americans* (first edition, 1832), and several of her later novels. His relations with her are discussed by J. F. McDermott, 'Auguste Hervieu in America', *Gazette des Beaux-Arts*, LI (1958), 169–90.

Description: Healthy complexion, light brown/grey (?) eyes, brown hair. Dressed in a brown costume with a white lace bib, kerchief, and cap, tied at the neck by a blue ribbon. Two blue bows in her hair under the cap, and a blue bracelet; seated on a plum-red sofa, with a small partly open box just visible on the left, probably a work-box (this part of the composition is not clear). Background colour brown.

ICONOGRAPHY There are various woodcuts and engravings in the NPG.

TRURO *Thomas Wilde, Baron* (*1782–1855*)

Lord chancellor; attorney, 1805; called to the bar, 1817; defended Queen Caroline, 1820, with distinction; king's serjeant, 1827; MP from 1831; solicitor-general, 1834; attorney-general, 1841 and 1846; chief justice of the common pleas, 1846–50; privy councillor, 1846; lord chancellor, 1850–2; initiated various chancery reforms.

483 Oil on canvas, 55 × 43 inches (139·7 × 109·2 cm), by THOMAS YOUNGMAN GOODERSON, after a portrait by SIR FRANCIS GRANT of 1850. PLATE 929

Signed (bottom left): T. Y. Gooderson/After F. Grant R.A.

Collections: Presented by the Hon Society of Judges and Serjeants-at-Law, 1877.

This is a copy of the original painting by Grant at St Paul's School, listed in the artist's 'Sitters Book' (copy of original MS, NPG archives), under 1850, exhibited *RA*, 1851 (421), *SKM*, 1868 (473), and *VE*, 1892 (92), engraved by G. Zobel, published J. Mitchell, 1851 (example in NPG). Another copy by Gooderson is in the House of Lords, and an anonymous copy was in the collection of C. R. Schonmeyr, 1961. The NPG portrait was one of several presented by the same society in 1877. It represents Truro in the year in which he became lord chancellor, with the lord chancellor's mace and seal bag on the table behind (he is not, however, dressed in his robes of office).

Description: Close inspection of this portrait, which is at present on loan to the Law Courts, was impossible. Truro is dressed in black legal robes, holding a white paper inscribed 'A Bill'. Table at right with mace and seal bag. Grey pilaster behind at right. A brown curtain covers most of the rest of the background.

1695 (i) With Sir Robert Gifford, Lord Lyndhurst, Dr Stephen Lushington, Spinetti and others. Pencil, pen and sepia ink and wash on paper, 5½ × 8¼ inches (14 × 21 cm), by SIR GEORGE HAYTER, 1820.

Inscribed in ink, in the artist's hand (bottom left): 2 *and (bottom right):* House of Lords trial of the Queen/G H Sept 1820

Inscribed in pencil, in the artist's hand (above the figure on the extreme left): At first (?) *and (above the second figure on the left):* Door to/Gallery

Collections: Basil Jupp; M. B. Walker, purchased from him, 1913.

This drawing, like 1695 (o) below, came from a set of extra illustrated RA catalogues formed by Basil Jupp. It is one of several studies in the NPG for Hayter's 'House of Lords, 1820' (see NPG 999 below), which will be collectively discussed and reproduced in the forthcoming Catalogue of Portraits, 1790–1830.

1695 (o) With a second slight profile just visible to the right. Pencil, pen and sepia ink and wash on paper, heightened with Chinese white, 5⅜ × 4⅜ inches (13.7 × 11·1 cm), by SIR GEORGE HAYTER, 1820. PLATE 928

Inscribed in ink, in the artist's hand (middle right): Mr Councellor Wilde (*visible below this inscription is the word 'Wilde' in pencil*) *and* (*bottom right*): 21 [*or* 27, *cut off*] *and in pencil* (*middle bottom*): Paper

Collections: As for 1695 (i) above.

999 See *Groups:* 'The House of Lords, 1820' by Sir G. Hayter, in forthcoming Catalogue of Portraits, 1790–1830.

ICONOGRAPHY A painting by H. W. Pickersgill was in the collection of the Incorporated Law Society, exhibited *RA*, 1852 (61); a miniature by Sir W. C. Ross was exhibited *RA*, 1849 (751); a marble bust by H. Weekes is in the Houses of Parliament, and another bust by Weekes is in the Middle Temple; one of these was probably the marble bust by Weekes exhibited *RA*, 1856 (1361); a medallic portrait by E. W. Wyon was exhibited *RA*, 1833 (1206); an engraving by T. Wright, after A. Wivell, was published T. Kelly, 1821 (example in NPG); there is a woodcut by H. Linton, after Thomas (example in NPG), for the 'Illustrated Exhibitor and Magazine of Art'; a woodcut was published *ILN*, XVII (1850), 69.

TUCKETT *Henry*

Slavery abolitionist.

599 See *Groups:* 'The Anti-Slavery Society Convention, 1840' by B. R. Haydon, p 538.

TUPPER *Martin Farquar (1810–89)*

Writer; barrister, 1835; published his famous poem, *Proverbial Philosophy*, which had world-wide success, 1838; published numerous other works, including an *Autobiography*; ingenious inventor.

4381 Water-colour on paper, 13½ × 9¾ inches (34·4 × 24·9 cm), by FRANÇOIS THÉODORE ROCHARD, 1846.
PLATE 930

Signed and dated in pencil (bottom left): F Rochard 1846 *Inscribed in ink on the back:* Martin F. Tupper/ Author of "Proverbial Philosophy"/ Court Poet to Victoria/Given to W. W. G. Stables/by Mrs C. Tupper/who left Auckland Road, (12)/Upper Norwood/on the outbreak of the 2nd German/war. Oct. 1939.

Collections: By descent to Mrs C. Tupper; W. W. G. Stables; purchased at Christie's, 16 June 1964 (lot 32).

Literature: NPG Annual Report, 1964–5 (1966), pp 35–6.

This portrait was engraved by H. B. Hall for the 1853 edition of Tupper's *Proverbial Philosophy*, and by C. W. Sharpe (example in NPG), for the 1854 and 1866 editions. The *Dictionary of National Biography* also records that it was engraved by J. H. Baker for *Proverbial Philosophy*, but this seems to be a mistake. For another engraving by Baker see iconography below.

Description: Healthy complexion, brown eyes, brown hair and whiskers. Dressed in a white shirt, brown neck-tie, light grey waistcoat, grey frock-coat and trousers, and greyish-brown overcoat, holding a black top-hat. Stone-coloured plinth and balustrade behind, pale blue sky, and a suggestion of a light greyish-green bush or tree middle right.

ICONOGRAPHY A painting by A. W. Devis (with his brother, Daniel, as children, now said to be cut down) was in the collection of A. K. Schneider, New York, exhibited *British Institution*, 1848 (117), reproduced S. H. Pavière, *The Devis Family of Painters* (1950), plate 43; a photograph of what appears to be a variant version (showing only Martin) is in the NPG archives; a marble bust by W. Behnes was exhibited *RA*, 1835 (1088), lithographed by J. H. Lynch (example in NPG); there is an engraving by W. Walker after a portrait by H. W. Pickersgill, an engraving by J. H. Baker possibly after a photograph, a woodcut from an unidentified magazine after a photograph by Elliott and Fry, and an engraving by D. J. Pound for his 'Drawing Room Portrait Gallery' after a

photograph by Mayall (examples in NPG); there are several photographs in the NPG, and there is a woodcut from the *ILN* in the British Museum, presumably the woodcut, after a photograph, published *ILN*, xcv (1889), 718.

TURNBULL *David*

Slavery abolitionist.

599 See *Groups*: 'The Anti-Slavery Society Convention, 1840' by B.R.Haydon, p538.

TURNER *Charles* (*1774–1857*)

Engraver, chiefly in mezzotint, both of portraits and scenes; executed plates for J.M.W.Turner's 'Liber Studiorum', 1807–9, and his 'Rivers of England'; engraver to George III, 1812; ARA, 1828.

1317 Coloured chalk on canvas, 30 × 24⅞ inches (76·2 × 63·2 cm), by HIMSELF, 1850. PLATE 931

Signed and dated (bottom right): C Turner/1850

Inscribed in ink on a label, formerly on the back of the picture, referring to the RA exhibition of 1856: Nº 2/Portrait of an Engraver/By/C.Turner. A.E./Warren Street Fitzroy Square/150

Collections: The sitter; by descent to his daughter, Mrs Wilmot; sold after her death in Hastings; I.Adams; R.Beverley Homewood; Frederick Simpson, purchased from him, 1902.[1]

Exhibitions: *RA*, 1856 (619), with the title, 'Portrait of an engraver'.

Literature: *Magazine of Art* (1902), p471, reproduced.

This was purchased with a drawing of the 3rd Earl Spencer by Turner (NPG 1318), but drawings of Sir Francis Chantrey and Lord George Bentinck by the same artist were declined. The head is very similar to that in a painting of Turner, probably also by himself, which was offered to the NPG in 1901 by G.Becker, recorded as in the collection of H.Krinsley, New York, 1959. It shows Turner seated at a table, working on his engraving of Sir Robert Peel after Lawrence, which further confirms the identity.

Description: Brown eyes, greyish hair. Dressed in a dark stock and neck-tie, white shirt, light waistcoat, and dark coat. Background grey. The portrait is predominantly in grisaille.

2515 (59) Coloured chalk on green-toned paper, 14 × 10½ inches (35·6 × 26·5 cm), by WILLIAM BROCKEDON, 1832. PLATE 932

Dated (lower right): 9.9.32

Collections: See *Collections*: 'Drawings of Prominent People, 1823–49' by W.Brockedon, p554.

Accompanied in the Brockedon Album by a letter from Turner, dated 12 October.

ICONOGRAPHY A painting by an unknown artist was in the collection of Walter Bennett, 1934; a painting by J.Boaden was exhibited *RA*, 1830 (443); a painting by J.Lonsdale was in the collection of J.S. Savery of Clapham, 1907, engraved by C.Turner (example in NPG), the engraving reproduced A.Whitman, *Charles Turner* (1907), frontispiece.

TURNER *James Mallord William* (*1775–1851*)

Painter.

1456 (25) See *Collections*: 'Drawings of Artists, *c* 1845' by C.H.Lear, p561.

See also forthcoming Catalogue of Portraits, 1790–1830.

[1] History of the portrait from the vendor in a letter of 7 March 1902 (NPG archives); he enclosed visiting cards from Adams and Homewood (both dealers), and a letter to Adams from the auctioneers, J.& A.Bray of Hastings, of 6 March 1902, who had sold Mrs Wilmot's effects, confirming the provenance.

TURPIN DE CRISSÉ *Launcelot, Count* (*1781–1852*)

French painter.

2515 (50) See *Collections:* 'Drawings of Prominent People, 1823–49' by W. Brockedon, p 554.

TYNTE *Charles John Kemeys* (*1800–82*)

MP for Somerset West.

54 See *Groups:* 'The House of Commons, 1833' by Sir G. Hayter, p 526.

TYRELL *Sir John Tyssen, Bart* (*1795–1877*)

MP for Essex North.

54 See *Groups:* 'The House of Commons, 1833' by Sir G. Hayter, p 526.

TYTLER *Patrick Fraser* (*1791–1849*)

Historian; practised as barrister, 1813–32; king's counsel in exchequer, 1816–30; formed Bannatyne Club with Scott; his history of Scotland published 1828–43; published several other historical and biographical works; advocated calendars of state papers.

226 Oil on canvas, $36 \times 29\frac{1}{8}$ inches ($91 \cdot 5 \times 74$ cm), by MARGARET SARAH CARPENTER, c 1845. PLATE 933

Inscribed (*top left*): Patrick Fraser Tytler

Collections: The artist, purchased from her, 1867.

Exhibitions: RA, 1845 (79).

This portrait is not listed in Margaret Carpenter's 'Sitters Book' (copy of original MS, NPG archives), presumably because it was not sold. In a letter of 26 December 1870 (NPG archives), J. Gibson Craig, a friend of the sitter, referred to the portrait as the '*most absurd caricature & has not the smallest resemblance. Tytler was a little man with rather a broad face & never had any pretention to dandyism*'. Gibson Craig owned the small painting by Sir J. Watson Gordon, now in the Scottish NPG (see iconography below).

Description: Healthy complexion, blue eyes, light sandy hair. Dressed in a white shirt, cravat and black neck-tie, grey waistcoat, black coat and grey trousers. Seated in an armchair, the back and arms of which are covered in a green figured material. Holding a light brown leather-bound volume, held open at a page of illustration. Background colour various shades of brown.

ICONOGRAPHY A painting by Sir J. Watson Gordon is in the Scottish NPG, exhibited *SKM*, 1868 (496), and *Scottish National Portraits*, Edinburgh, 1884 (289), reproduced J. L. Caw, *Scottish Portraits* (1903), II, facing 117; a study for this portrait, or possibly a reduced replica, is also in the Scottish NPG, and another version was exhibited *VE*, 1892 (242), lent by J. S. Fraser Tytler (in the catalogue this portrait was said to be the one exhibited *SKM*, 1868 (see above), which was lent by George Young; Young still owned it, however, in 1903); another painting by Sir J. Watson Gordon, showing Tytler as an older man, was in the Fraser Tytler collection, 1961; a lithograph by R. J. Lane (example in NPG) is listed in his 'Account Book' (NPG archives), III, 22, under 1851; a lithograph by W. Drummond was published T. McLean, 1836 (example in British Museum), for 'Athenaeum Portraits.'

UWINS *Thomas* (*1782–1857*)

Painter; illustrated mainly English authors, including Scott; professional miniature painter from 1799; exhibited at Old Water-Colour Society, 1809–18, and at RA, 1799–1808, and after 1830; RA, 1838; keeper of the National Gallery, 1847–55.

4231 Oil on millboard, $9\frac{7}{8} \times 7\frac{7}{8}$ inches ($25 \cdot 1 \times 20$ cm), by JOHN PARTRIDGE, 1836. PLATE 935

Inscribed on an early label on the reverse, in the artist's hand: Thomas Uwins RA. 1836./Painter John Partridge

Collections: The artist; by descent to his nephew, Sir Bernard Partridge, and bequeathed by his widow, Lady Partridge, 1961.

Exhibitions: Themes and Variations: the Sketching Society, 1799–1851, Victoria and Albert Museum, 1971.

Literature: J. Partridge, two MS notebooks (NPG archives); *NPG Annual Report, 1961–2* (1962), p 3.

One of four similar studies in the NPG for Partridge's group portrait of the 'Sketching Society, 1836', listed in his 'Sitters Book' (NPG archives), p 87 (verso), under 1836, exhibited *RA*, 1838 (408), with the title, 'Sketch of a Sketching Society; the Critical Moment'; it was last recorded in the collection of W. A. Brigg, Kildwick Hall, Keighley, 1913. A lithograph and related water-colour, the former published J. Hogarth, 1858, are in the British Museum. Full entries for the other studies, representing J. J. Chalon (NPG 4230), C. R. Leslie (NPG 4232), and Robert Bone (NPG 4233), will be found in this catalogue under the names of the individual sitters. A study of another member, J. S. Stump, is listed in Partridge's 'Sitters Book', p 88v, as presented to the sitter. Studies of A. E. Chalon, C. Stanfield and Partridge are listed in his MS notebooks (NPG archives). The Sketching Society was founded in 1808 by Francis Stevens and A. E. and J. J. Chalon to study epic and pastoral design: *'The members assemble, at six o'clock, at each other's houses in rotation. All the materials for drawing are prepared by the host of the evening, who is, for that night, President. He gives a subject, from which each makes a design. The sketching concludes at ten o'clock, then there is supper, and after that the drawings are reviewed, and remain the property of him at whose house they are made'.*[1] Partridge's picture shows eleven members of the Society (himself included) grouped around a table, criticizing a drawing on an easel in front of them; Partridge was the president on this particular occasion. Uwins was one of the new members elected when the Society was reconstituted in 1829.

Description: Healthy complexion, bluish (?) eyes, grey hair. Dressed in a black neck-tie, white shirt and black coat. Sitting in a chair, resting his hand on a table. Background colour red.

1456 (12) Black chalk on grey-tinted paper, heightened with Chinese white, $2\frac{3}{4} \times 3$ inches ($7 \times 7 \cdot 7$ cm), by CHARLES HUTTON LEAR, 1845. PLATE 936

Inscribed (bottom left): Uwins/Dec 45

Collections: See *Collections:* 'Drawings of Artists, *c* 1845' by C. H. Lear, p 561.

A letter from Lear to his family about Uwins was in the collection of his executor, John Elliott, in 1907. Uwins was an official visitor to the life school of the Royal Academy, where this drawing was done, in 1845 and 1846.

3944 (14) Pencil on paper, $9\frac{1}{2} \times 7\frac{1}{4}$ inches ($24 \times 18 \cdot 5$ cm), by JOHN PARTRIDGE, 1825. PLATE 934

Signed and dated (bottom right): J. Partridge/Octr 1825/Naples.

Collections: See *Collections:* 'Artists, 1825' by J. Partridge, p 556.

Comparison with other portraits of Uwins leaves no doubt that this drawing does represent him.

4218 Pencil on paper, $3\frac{1}{4} \times 2\frac{1}{4}$ inches ($8 \cdot 4 \times 5 \cdot 8$ cm), by GEORGE HARLOW WHITE, *c* 1845. PLATE 937

Inscribed in pencil (bottom): Thomas Uwins. R.A.

Collections: See *Collections:* 'Drawings, *c* 1845' by G. H. White, p 562.

[1] *Autobiographical Recollections by the Late Charles Robert Leslie, R.A.*, edited by T. Taylor (1860), I, 119. See also Mrs Uwins, *A Memoir of Thomas Uwins, R.A.* (1858), I, 163–207, R. and S. Redgrave, *A Century of Painters of the English School* (1866), I, 485–7, and J. Hamilton, *Victoria and Albert Museum, the Sketching Society* (1971).

ICONOGRAPHY A painting by T.H.Illidge was exhibited *SKM*, 1868 (602), lent by Mrs E.Way, engraved by J.Smyth, published 1847 (example in NPG), for the *Art-Union*; a drawing by T.Bridgford was exhibited *RA*, 1844 (755); a painting called Uwins was in the collection of Colonel M.H.Grant, 1954; a medallion or bust by L.Wyon was exhibited *RA*, 1844 (1019).

VERNER *Sir William, Bart* (*1782–1871*)

MP for County Armagh.

54 See *Groups:* 'The House of Commons, 1833' by Sir G.Hayter, p526.

VERNEY *Sir Harry, Bart* (*1801–94*)

Soldier, traveller, and MP for Buckingham.

54 See *Groups:* 'The House of Commons, 1833' by Sir G.Hayter, p526.

VERNON *George John Venables-Vernon* (*later Warren*), *5th Baron* (*1803–66*)

Author, MP for Derbyshire South.

54 See *Groups:* 'The House of Commons, 1833' by Sir G.Hayter, p526.

VERULAM *James Walter Grimston, 2nd Earl of* (*1809–95*)

MP for Hertfordshire.

54 See *Groups:* 'The House of Commons, 1833' by Sir G.Hayter, p526.

VESTRIS *Lucia Elizabeth, later Mrs C.J.Mathews.* See MATHEWS

VICTORIA *Queen* (*1819–1901*)

Daughter of the Duke of Kent, and granddaughter of George III; succeeded to the throne, 1837; married Prince Albert of Saxe-Coburg Gotha, 1840; influenced to a considerable extent the foreign and home policies of successive governments, and the attitudes and manners of her people; her reign, the longest in British history, saw the consolidation of the Empire, the expansion of industry and commerce, numerous reforms, and the beginnings of state education and social welfare.

1250 Oil on canvas, $112\frac{1}{2} \times 70\frac{1}{2}$ inches (285·8 × 179 cm), by SIR GEORGE HAYTER, 1863, after his portrait of 1838. PLATES 941, 942 & frontispiece

Signed and dated (*bottom left*): Hayter, Eques, & K.S.L./London 1863.

Collections: Purchased from the artist's executors by HM Queen Victoria, 1871, and presented by her, 1900.

Literature: Documents in the Royal Archives, Windsor, relating to its purchase, PP Vic 8580, 8701, and 12400, and to its presentation, PP Vic 3643.

After failing to acquire the 1840 portrait of Queen Victoria by Wilkie (see iconography below) in 1899, the NPG trustees made representations to the Queen, who not only presented NPG 1250, but gave permission for a copy to be made of her portrait by Von Angeli (NPG 1252 below). NPG 1250 is a replica of the full-length, life-size state portrait in the Royal Collection at Holyrood House. The latter, also purchased by Queen Victoria from Hayter's executors in 1871, is described in all the documents relating to its purchase as the original version (see references to papers in the Royal Archives above).

Hayter's son stated that it had been retained by his father so that he could make copies for presentation and state purposes; several of these copies are still in English embassies abroad, another was given by Queen Victoria to the Crown Princess of Russia, and there is one in the Liverpool Town Hall. Until the discovery of the papers in the Royal Archives, it had always been assumed that the original version was Hayter's small full-length portrait in the Royal Collection, Windsor (46 × 34 inches), listed by C. H. Collins Baker, *Catalogue of the Principal Pictures in the Royal Collection at Windsor Castle* (1937), p 152, exhibited *VE*, 1892 (135). This is mentioned in Queen Victoria's 'Diary' for 18 August 1838 (Royal Archives, Windsor): '*The small one he has done for me, of myself in the Dalmatic Robes, is finished; it is excessively like and beautifully painted*'. The Windsor version may have been the modello for the Holyrood portrait, or simply a reduced replica. Sittings for the large portrait are recorded in Queen Victoria's 'Diary' for 17, 20, 25 and 30 July, and 2, 4, 6, 7, 9, 13, 14 and 17 August 1838. The setting appears to have been imaginary; Queen Victoria is shown wearing the same costume as in Hayter's group picture of the coronation, and in his painting of her taking the coronation oath (see iconography below). There are several related studies by Hayter in the Royal Library, Windsor, and another was with Leggatt Brothers, 1944. An engraving by H. T. Ryall, after the portrait, is reproduced *Connoisseur Year Book* (1953), p 32. NPG 1250 is more colourful and more broadly painted than the Holyrood portrait, and it differs in certain small details, but is identical in pose and composition. Other paintings of Queen Victoria by Hayter are listed in the iconography below.

Description: Healthy complexion, greyish-blue eyes, brown hair. Dressed in the royal crown, a white dress, and the heavy red and gold Dalmatic robes, holding the sceptre, and resting her feet on a gilded foot-rest. Seated on a gilded throne underneath a red canopy, with a fringe of tassels of gold, and a subdued red background with the royal arms. Floor in the foreground greenish-grey.

1252 Oil on canvas, 46½ × 36 inches (118·2 × 91·4 cm), by BERTHA MÜLLER, 1900, after a portrait by HEINRICH VON ANGELI of 1899. PLATE 962

Signed (top left): Bertha Müller/nach H. v. Angeli

Collections: Commissioned by the NPG trustees, 1899, and delivered, 1900.

Commissioned after the failure of the NPG to acquire the 1840 portrait of Queen Victoria by Wilkie (see iconography below). Permission for the copy to be done was given by the Queen, who also presented a portrait of herself by Hayter (NPG 1250 above). The original portrait by Von Angeli is in the Royal Collection, Windsor, exhibited *Pageant of Canada*, National Gallery of Canada, Ottawa, 1967 (253), reproduced in catalogue, listed by C. H. Collins Baker, *Catalogue of the Principal Pictures in the Royal Collection at Windsor Castle* (1937), p 4. The NPG copy was executed in Von Angeli's studio in Vienna under the supervision of the artist; a letter from him of 12 October 1899 (NPG archives), gives details of Bertha Müller's qualifications and the price of the copy. A second letter of 19 April 1900 (NPG archives) states that the copy was entirely her own work. Another copy by Bertha Müller is in the Royal Collection, exhibited *Kings and Queens*, RA, 1953 (272).

Description: Healthy complexion, greyish eyes and hair. Dressed in black, with a white lace bonnet, the blue sash of the Garter, a silver bracelet on one hand, gold and silver bracelets on the other, a pearl necklace and earrings. Seated in a red armchair, with her elbow resting on a mauve table cloth, with a fan and white and yellow roses on it. Rest of background greyish-brown.

4536 'The Four Generations' (Queen Victoria with the Prince of Wales, later Edward VII, the Duke of York, later George V, and Prince Edward, late Duke of Windsor). Oil on canvas, 21 × 28 inches (53·4 × 71·1 cm), by SIR WILLIAM QUILLER ORCHARDSON, c 1897. PLATE 965

Collections: Possibly artist's sale, Waring & Gillow, 24–27 May 1910 (lot 740); Mrs C. Frank, purchased from her, 1967.

Exhibitions: Possibly *Winter Exhibition*, RA, 1911 (148), lent by A. S. Cope, RA.

Literature: Orchardson Exhibition catalogue, Scottish Arts Council, 1972 (68).

This is a study for the large painting at Carlton House Terrace, London, originally commissioned by the Royal Agricultural Society in 1897, exhibited *RA*, 1900 (143), as 'Windsor Castle, 1899: portraits'.[1] Another more finished oil study is in the Russell-Cotes Museum, Bournemouth, exhibited *Pageant of Canada*, Ottawa, 1967 (254), *Decade: 1890–1900*, Arts Council, 1967 (6), and *Sir William Quiller Orchardson, RA*, Scottish Arts Council, 1972 (68), reproduced in all three catalogues. There are five preliminary pencil studies of the heads at Windsor, two exhibited *Orchardson*, Scottish Arts Council, 1972 (66–7). The sizes of the picture in the artist's sale and the 1911 RA exhibition correspond to those of the NPG, except that they suggest an upright picture (possibly a mistake).

Description: Mainly in brown monochrome, with traces of colour; the red flowers held by the Duke of Windsor, and his blue sash.

316a (125) Pencil on paper, 20 × 16¼ inches (50·8 × 41·4 cm), by SIR FRANCIS CHANTREY, *c* 1839. PLATE 944

Inscribed in pencil (bottom right): Victoria

Collections: The artist, presented by the widow of one of his executors, Mrs George Jones, 1871.

This profile drawing, and the full-face drawing below (126), executed by means of a 'camera lucida', are related to the marble bust of 1839 in the Royal Collection, of which a replica is in the NPG (NPG 1716 below). The drawings are two of a collection of studies by Chantrey, which will be collectively discussed in the forthcoming Catalogue of Portraits, 1790–1830.

316a (126). Pencil on paper, 19½ × 17¼ inches (49·5 × 43·5 cm), by SIR FRANCIS CHANTREY, *c* 1839. PLATE 943

Collections: As for NPG 316a (125) above.

708 Water-colour on paper, 57⅜ × 38½ inches (145·8 × 97·8 cm), by LADY JULIA ABERCROMBY, 1883, after a portrait by HEINRICH VON ANGELI of 1875. PLATE 961

Signed and dated (lower right): J G A [*in monogram*]/after/V. Angeli, /1883.

Collections: Presented by the artist, 1883.

This copy of the portrait by Von Angeli in the Royal Collection was painted with the idea of presentation to the NPG. It was approved by the Queen, who also liked the few slight alterations from the original. The artist, who had received lessons from Mrs Clarendon Smith of the Institute of Water-colours (information about Lady Abercromby's career in her letter of 22 November 1883, NPG archives), was one of Queen Victoria's Ladies of the Bedchamber. Queen Victoria is shown wearing the order of the Garter and the order of Victoria and Albert.

Description: Healthy complexion, greyish eyes, brown hair. Dressed in black, with a white lace neck, white cuffs, bonnet, and handkerchief, the blue sash and star of the Garter, the white ribbon and medal of the order of Victoria and Albert, a pearl bracelet with an inset medallion of Prince Albert, a small silver brooch, and a pearl necklace. Blue and orange sky, and brown and green landscape at left. Grey pillar and wall behind. The royal arms top right.

1297 Pen and ink and water-colour on paper, 9⅛ × 6 inches (23·3 × 15·1 cm), by SIR DAVID WILKIE, *c* 1840. PLATE 949

Collections: Dr David Laing; Lord Ronald Gower, presented by him, 1901.

This is a study for Wilkie's state portrait of 1840 in the Lady Lever Art Gallery, Port Sunlight, from the collection of the Marquess of Normanby.[2] Queen Victoria disliked the large portrait intensely and

[1] See H. O. Gray, *The Life of Sir William Quiller Orchardson* (*c* 1910), pp 16, 283–7, 337; the picture is reproduced facing p 286.

[2] This was offered to the NPG in 1899, but declined on the advice of the Queen.

refused to accept it for the Royal Collection.[1] A related oil sketch was sold Christie's, 2 May 1952 (lot 184), and three drawings, one dated 15 October 1838, were sold at Sotheby's, 12 February 1964 (lot 117). On the back of the original card, on which the NPG water-colour is mounted, is a cutting from a bookseller's catalogue where the name of Dr Laing is given as a previous owner.

Description: Dressed in a red robe, red curtain at right. Blue sky. Grey and brown washes for architecture, with touches of orange on floor.

2954 Pencil and water-colour on paper, with touches of body colour, $12\frac{3}{8} \times 7\frac{7}{8}$ inches (31·5 × 20 cm), by GEORGE HOUSMAN THOMAS, *c* 1863. PLATE 957

Collections: Purchased from A. Yakovleff, 1938.

This is a study for Thomas' painting of 'The Marriage of the Prince of Wales, 1863' in the Royal Collection (see iconography below).

Description: Dressed in a white veil, black dress, with white cuffs, the blue sash and star of the order of the Garter, and the badge of the order of Victoria and Albert; holding a white prayer book. Blue curtain in front of the box with gilt fringe and border. Rest of box brown.

4042 Pencil on brown paper, $14\frac{3}{4} \times 9\frac{7}{8}$ inches (37·5 × 25·1 cm), by ADOLPHE DE BATHE. PLATE 958

Inscribed in pencil (lower right): H.M. Queen Victoria/Sketched from life for Miniature/by Adolphe de Bathe

Collections: Purchased from the artist's widow, Mrs A. de Bathe, 1956.

Purchased together with a drawing of Princess Ena. The location of Bathe's original miniature is not known. On the evidence of the sitter's age, the drawing appears to date from the late 1880s or early 1890s.

4108 Water-colour and body colour on card, $13\frac{3}{4} \times 10\frac{1}{2}$ inches (35 × 26·5 cm) painted oval, by AARON EDWIN PENLEY, *c* 1840. PLATE 959

Signed in pencil (lower right): A. Penley.

Inscribed on a label, formerly on the back of the picture: Queen Victoria, by Aaron Penley: *c* 1840./ Painted from sittings, and bought by the Queen. On/the artist's marriage to Caroline Turner the portrait was/presented to him by the Queen, framed as it is. Caroline/Turner was sister of my great-grandmother Charlotte Amelia,/Mrs Chambers. Her son Claude Penley married my/great-aunt Eliza Steegman, and from him my father/acquired the portrait./John Steegman, 1935.

Inscribed in ink on the original backboard, in an old hand:77.... [*other letters or numbers not legible*]/Her Majesty the Queen/Painted in 1840/by/[*Aar*]on Penley

Collections: As on the label above, presented by J. Steegman, 1959.

Literature: J. Steegman, 'Aaron Penley: A Forgotten Water-Colourist', *Apollo*, LXVII (1958), 14, reproduced 15, with the date 1841; *NPG Annual Report, 1959–60* (1960), p1.

The technique is that of a miniaturist. The bust on the pedestal represents Prince Albert. A letter from the donor of 27 January 1959 (NPG archives) confirms the history of the miniature.

Description: Fresh complexion, blue eyes, brown hair. Dressed in a black dress with a white lace neck, white handkerchief, pearl and gold bracelets. Leaning on a grey pedestal, with a grey bust on it, and a red pot. Behind at left a gilt and red plush chair with the monogram 'VR' in gold. Red curtain behind with a gold border. Small area of background at left greyish-green.

2088 Miniature, water-colour on ivory, $3\frac{1}{4} \times 4$ inches (8·2 × 10·2 cm) oval, by MISS MARY HELEN CARLISLE. PLATE 960

Collections: Presented by the artist's sister, Miss Sybil Carlisle, 1925.

[1] See A. Cunningham, *Life of Sir David Wilkie* (1843), III, 531, where payment of £200 by the Lord Chamberlain is recorded under 1840.

In a letter of 5 July 1925 (NPG archives), the donor sent details of her sister's life and career. The original miniature, of which the NPG miniature is a version, was purchased by Edward VII (memorandum from the donor, NPG archives).

Description: Healthy complexion. Dressed in a black costume and white bonnet. Background colour various tones of mauve, blue, grey, orange, etc.

858 Plaster cast, painted a terra-cotta colour, 34 inches (86·4 cm) high, after a model by SIR JOSEPH EDGAR BOEHM, *c* 1887. PLATE 959

Collections: The artist, purchased from his executors, 1891.

This over life-size bust is related to the head of Queen Victoria's bronze statue in front of Windsor Castle; this shows her full-length, standing, and is reproduced R.R.Holmes, 'The Queen's Pictures', Jubilee Number of the *Magazine of Art* (1887), p45. Queen Victoria herself gave permission for the bust to be placed in the collection (letter of 19 March 1891, from her secretary, Sir Henry Ponsonby, NPG archives).

 A marble statue by Boehm of 1871, showing Queen Victoria seated with a dog, is also at Windsor Castle, reproduced *The Portfolio* (1885), facing p234. There is a related statuette, showing some variations, of 1869 (examples in bronze, Royal Collection, and collection of Professor W.E.Fredeman); the type was exhibited in terra-cotta *RA*, 1870 (1125). A bust related to the 1871 statue is in the Royal Geographical Society, London, and another is at Waddesdon Manor. A version or model of one of the statues was exhibited *VE*, 1892 (1061), lent by the artist's executors. Boehm also executed a marble bust of Queen Victoria for her eldest daughter, Victoria, later Empress of Germany, the model for which was exhibited *Summer Exhibition*, Grosvenor Gallery, 1884 (415). Another marble bust by Boehm was exhibited *RA*, 1874 (1534).

1716 Marble bust, 27¾ inches (70·5 cm) high, by SIR FRANCIS CHANTREY, 1841. PLATES 945, 946

Incised on the front of the socle: THE QUEEN *and on the back:* SIR FRANCIS CHANTREY,/SCULPTOR,/1841.

Collections: Presented by the sitter to Sir Robert Peel, 1846; offered for sale by the Peel Trustees, Robinson, Fisher & Co, 19 November 1913 (lot 94), bought in; purchased immediately after the sale from the Peel Trustees, with the aid of a contribution from G.Harland Peck, 1913.

This is a replica of the marble bust by Chantrey of 1839 in the Royal Collection, the latter exhibited *RA*, 1840 (1070), engraved anonymously, published 1849 (example in NPG), for the *Art Union*. There are slight differences in the tiara, but the two busts are otherwise identical. For Chantrey's original pencil studies see NPG 316a (125 and 126) above. According to the 1913 sale catalogue, the NPG bust was given to Peel after the Queen's visit to Drayton Manor in 1846. Chantrey's original plaster model is in the Ashmolean Museum, Oxford, and casts were owned by J.H.Cowland and Sir Thomas Brock. A reduced ivory copy by B.Cheverton of 1842 is in the Victoria and Albert Museum, reproduced in their booklet *Kings and Queens* (1937), p45. A bronze copy by T.Thornycroft was issued by the Art Union in 1848, one example reproduced *Country Life*, CXLV (1969), 1494.

ICONOGRAPHY Queen Victoria is probably the most painted and photographed personality in history. Her long reign and the growth of illustrated newspapers and magazines resulted in a flood of popular images, besides a vast number of state and family portraits. No attempt has ever been made to systematize her iconography, or to catalogue the main portrait types. The following iconography cannot pretend to be complete even in this respect, but it is more extensive than any previous listing. Most previous studies have been picture books, reproducing paintings and prints without any documentation or critical appraisal. The largest and most useful are R.R.Holmes, 'The Queen's Pictures', Jubilee Number of the *Magazine of Art* (1887), Sir Herbert Maxwell, *Sixty Years a Queen* (1897), Justin McCarthy, *Early Portraits of Queen Victoria* (1897), the Marquess of Lorne, *V.R.I.: Her Life and Empire* (1901), and H. and A.Gernsheim, *Queen Victoria: a Biography in Word and Picture* (1959); these appear in the text below with the abbreviations 'Holmes', 'Maxwell', 'McCarthy', 'Lorne'

and 'Gernsheim'. Some of the earlier pictures have been catalogued by O. Millar, *The Later Georgian Pictures in the Collection of HM the Queen* (1969), 2 vols, who appears as 'Millar'. The date given to groups is usually that of the event depicted, not the date of the finished picture. The following iconography does not include popular prints, sketches (many of these are in the Royal Souvenir Albums at Windsor), unimportant groups, caricatures or photographs (see plates 952, 956, 964), and only a selection of the huge number of statues which were erected indiscriminately throughout the Empire. There are usually several versions and copies of most portrait types, and these have not generally been listed.

As Princess

1819 Miniature by J. P. Fischer. Royal Collection, Windsor.
Three related water-colours and drawings are also in the Royal Collection, and another was exhibited *VE*, 1892 (390), lent by the Rev B. Gibbons.

1821 Painting by Sir W. Beechey (with her mother). Royal Collection, Buckingham Palace.
Reproduced Maxwell, p4, and Millar, plate 170 (671). Exhibited *RA*, 1822 (66), and *VE*, 1892 (1).
Engraved by and published W. Skelton, 1823 (example in British Museum).

1821 Bust by P. Turnerelli. Exhibited *RA*, 1823 (1072).
Engraved by J. Thomson, from a drawing by W. Wivell, published executors of J. Asperne, 1821 (example in NPG), for the *European Magazine*.

c 1822 Miniature by A. Stewart. Numerous versions are in the Royal Collection, Windsor, and elsewhere.

1823 Water-colour by S. P. Denning. Dulwich College Picture Gallery (plate 938).
Reproduced Lorne, facing p1.

1824 Painting by W. Fowler. Collection of Sir E. Hanmer, Flints.
Engraved by W. Ward, published Fowler, 1825 (example in NPG). Engraved by and published C. Turner, with variations, 1825 (example in British Museum).

c 1826 Miniature by A. Stewart. Numerous versions are in the Royal Collection, Windsor, variously dated.
One version reproduced D. Foskett, *British Portrait Miniatures* (1963), facing p156, another version engraved by T. Woolnoth, published 1832 (example in NPG), for Jerdan's *National Portrait Gallery*.

1827 Painting by W. Fowler. Royal Collection, Windsor.
Reproduced Maxwell, p7. Engraved by R. Golding, published Colnaghi, 1830 (example in NPG).
Other versions: 1. Christie's, 24 March 1950 (lot 163). 2. Collection of the Duke of Bedford.

1828 Drawing by S. Catterson Smith. Royal Collection, Windsor.
Engraved by T. Wright, published Colnaghi, 1829 (example in NPG); engraving by Dean reproduced McCarthy, plate 3.

1829 Drawing by R. J. Lane. Royal Collection, Windsor.
Lithographed by the artist, published J. Dickinson, 1829 (example in NPG); lithograph reproduced McCarthy, plate 3. The drawing is listed in Lane's 'Account Books' (NPG archives), I, 55, under 1829, as presented to the sitter. There are numerous later drawings and lithographs of Queen Victoria by Lane (several examples in NPG); four of 1837–8 are reproduced McCarthy, plates 5, 6, 7, and 12. Three drawings by Lane were exhibited *RA*, 1838 (589, 590, and 1042).

1829 Marble bust by W. Behnes. Royal Collection, Buckingham Palace.
Reproduced Maxwell, p7. Exhibited *RA*, 1829 (1216), and *Bicentenary Exhibition*, RA, 1968–9 (233).
Engraved by J. Thomson, after a drawing of the bust by H. Corbould (example in NPG), for the *Juvenile Forget Me Not*. A second version in marble of 1828 (possibly the original) is in the collection of HM the Queen Mother; a third version in plaster is at Bethnal Green Museum, possibly that exhibited *RA*, 1828 (1188); and a fourth in marble was with the Fine Art Society, London, 1968.

1830 Painting by R. Westall. Royal Collection, Buckingham Palace (plate 939).
Reproduced Maxwell, p4, and Millar, plate 302 (1170). Exhibited *RA*, 1830 (64), *VE*, 1892 (14), and

Royal Children, Queen's Gallery, Buckingham Palace, 1963 (91). Engraved by E. Finden, published Hodgson, Boys and Graves, 1834 (example in NPG). Three related studies, two dated 1829, are also in the Royal Collection, listed by A. P. Oppé, *English Drawings at Windsor Castle* (1950), p 100. A miniature version was exhibited *VE*, 1892 (470), lent by the Hon A. Bourke.

1830 Drawing by J. Hayter. Royal Collection, Windsor. Reproduced Lorne, p 2.

c 1831 Painting by Sir D. Wilkie (with her mother and attendants). Collection of HM the Queen Mother, Clarence House. Reproduced Millar, plate 278 (1187). Exhibited *Wilkie Exhibition*, RA, 1958 (50), reproduced 'Illustrated Souvenir', plate 20. Three pencil studies, one of which is dated 1831, are in the same collection.

1832 Painting by A. Dubois Drahonet. Royal Collection, Windsor. Exhibited *VE*, 1892 (5).

1833 Painting by Sir G. Hayter. Formerly Royal Collection of Belgium (destroyed by fire).
Exhibited *RA*, 1833 (17), painted for Leopold 1 of Belgium. Engraved by J. Bromley, published Colnaghi, 1834 (example in British Museum). An oil study of 1832 and a copy are in the Royal Collection, Windsor, the former exhibited *VE*, 1892 (13), and *Royal Children*, Queen's Gallery, Buckingham Palace, 1963 (53). Two pencil studies are also at Windsor. A copy was sold from the collection of HRH the Princess Royal, Christie's, 17 June 1966 (lot 105), bought Howton.

1834 Drawing by Sir G. Hayter (with her mother). Royal Collection, Windsor.
Reproduced Lorne, p 61. Exhibited *Kings and Queens Exhibition*, RA, 1953 (273). Lithographed by R. J. Lane, published J. Dickinson (example in NPG).

1834 Drawing by C. Vogel, Küpferstichkabinett, Staatliche Kunstsammlungen, Dresden.

c 1836 Painting by an unknown artist. Collection of Princess Iris Galitzine.
Reproduced *Country Life*, CXXXII (1962), 1219.

c 1837 Miniature by H. Collen. Royal Collection, Windsor.
Engraved by and published T. Woolnoth, 1837 (example in NPG); engraving reproduced Lorne, p 62. Collen exhibited miniatures of Queen Victoria at the *RA*, 1836 (660), 1837 (830), and, in imitation of cameo, 1849 (846).

As Queen

1837 Painting by Sir G. Hayter (seated, in robes of state). Guildhall Art Gallery, London.
Reproduced Lorne, p 105. Exhibited *RA*, 1838 (61). Engraved by H. Cousins, published Colnaghi, 1839 (example in NPG). Queen Victoria records fourteen sittings in her diary (Royal Archives), October–December 1837. Replica (head only): Royal Collection, Buckingham Palace.

1837 Painting by E. T. Parris (at Drury Lane Theatre). The original version is possibly that formerly in the collection of Queen Mary, exhibited *Queen Mary's Art Treasures*, Victoria and Albert Museum, 1954, p 13 of the guide. The type was engraved by C. E. Wagstaff, published Hodgson and Graves, 1838 (example in NPG); engraving reproduced McCarthy, plate 13. Other versions: 1. Christie's, 31 October 1947 (lot 120), wrongly attributed to G. A. Aglio. 2. Collection of J. D. Maillé.

1837 'The Queen Presiding Over her First Council, 1837' by Sir D. Wilkie. Royal Collection, Windsor.
Reproduced Gernsheim, p 29, and Millar, plate 279 (1188). Exhibited *RA*, 1838 (60), *VE* 1892 (18), and *Wilkie Exhibition*, RA, 1958 (37). Engraved by C. Fox (example in British Museum). Many studies for this picture survive (see Millar).

1837 'Queen Victoria's Progress to the Guildhall' by J. H. Nixon. Corporation of London.

1837 Miniature by Sir W. C. Ross (full-face, head and shoulders). Royal Collection, Windsor.
Reproduced *Apollo*, LXXVI (1962), 451, where the date given is 1838. Possibly the miniature exhibited *RA*, 1838 (901).

1837 Drawing by Louisa Costello. Royal Collection, Windsor.
Reproduced Gernsheim, p28; engraved by S.Freeman, published H.Colburn, 1837 (example in NPG).

1838 'The Coronation of Queen Victoria' by Sir G.Hayter. Royal Collection, Buckingham Palace.
Reproduced Gernsheim, p35. Engraved by H.T.Ryall, published Graves and Warmsley, 1843
(example in NPG). Many studies survive, in the Royal Collection, Windsor, and the British Museum;
see also *Facsimiles of Sketches by George Hayter at the Coronation of H.M.Queen Victoria*, published
C.Van Noorden, London (copy in NPG library).

1838 Painting by Sir G.Hayter (seated, in her coronation robes) (see NPG 1250 above).

1838 Painting by Sir G.Hayter (standing, taking the coronation oath). Queen's University, Belfast.
Engraved by W.H.Egleton, published 1851; engraving reproduced Lorne, p91. Pencil study
reproduced Lorne, p90.

1838 'Queen Victoria Receiving the Sacrament at her Coronation' by C.R.Leslie. Royal Collection,
Windsor. Reproduced Gernsheim, p35. Exhibited *RA*, 1843 (74), *VE*, 1892 (35), and *Pageant of
Canada*, National Gallery of Canada, Ottawa, 1967–8 (251), reproduced in catalogue. Engraved by
S.Cousins, published F.G.Moon, 1843 (example in British Museum). Oil study of Queen Victoria:
Victoria and Albert Museum.

1838 'Coronation of Queen Victoria' by J.Martin. Tate Gallery.

1838 Painting by T.Sully (three-quarter length). Wallace Collection.
Reproduced *Wallace Collection Catalogue of Pictures and Drawings* (1968), p312. Probably the portrait
exhibited *RA*, 1840 (483). Engraved by C.E.Wagstaff, published Hodgson and Graves, 1840 (example
in NPG). A full-length version of 1839 is owned by the St George's Society of Philadelphia, who were
responsible for sending Sully to England to paint the Queen. A head and shoulders oil study from life
of 1837 is in the Metropolitan Museum, New York.

1838 Painting by E.H.Corbould (equestrian). Collection of R.Gordon, Peru, 1938.

1838 'Homage of the Peers at the Coronation of Queen Victoria', miniature by Sir W.J.Newton.
Exhibited *RA*, 1841 (839), and *VE*, 1892 (423), lent by Mrs Newton. Water-colour study of Queen
Victoria: British Museum.

1838 Miniature by J.MacCarthy. Exhibited *VE*, 1892 (434), lent by Rev F.R.Ellis.

1838 Water-colour by A.E.Chalon (in robes of state). Royal Collection of Belgium.
Exhibited *RA*, 1838 (733), and *The Lions and the Unicorn*, NPG, 1966. Engraved by S.Cousins,
published F.G.Moon, 1838 (example in British Museum). Other versions exist, and the head was used
for several early stamps, including the penny black.

1838 Water-colour by A.E.Chalon (seated on a terrace at Windsor Castle). Scottish NPG (plate 940).
Lithographed by R.J.Lane, published T.Boys, 1838 (example in NPG); lithograph reproduced Lorne,
p110.

1838 Marble bust by H.Weekes. Collection of the Marquess of Normanby.
Reproduced Lorne, p136.

1838 Plaster bust by Sir J.Steell. Scottish NPG.
Presumably that exhibited *RA*, 1839 (1332).

c1838 Painting by A.Aglio. House of Lords.
Engraved (with variations) by J.Scott, published T.Boys, 1838 (example in British Museum);
engraving reproduced McCarthy, plate 10.

c1838 Drawing by J.D.Francis. Sold Sotheby's, 3 June 1964 (lot 59), bought Mrs Hanley.
Engraved by F.C.Lewis, published J.Dickinson, 1838 (according to McCarthy) (example in NPG);
engraving reproduced McCarthy, plate 8.

1839–40 Painting by Sir F. Grant (on horseback, with Lord Melbourne and others). Royal Collection, Windsor (plate 947). Listed in Grant's 'Sitters Book' (copy of original MS, NPG archives), under 1840. Reproduced Maxwell, p 18. Exhibited *RA*, 1840 (162), and *VE*, 1892 (19). Engraved by J. Thomson, published T. McLean, 1841 (example in NPG). A study is in the collection of the Earl of Strafford. A related drawing of Queen Victoria of 1842 is in the Royal Collection, Windsor, reproduced *Country Life*, CXI (1952), 232.

1839 'Queen Victoria and her Suite' (on horseback) by R. B. Davis. Collection of the Marquess of Anglesey. Exhibited *RA*, 1841 (510). An engraving is reproduced Lorne, p 133.

1839 Painting by Sir E. Landseer. Royal Collection, Windsor (plate 948).
Exhibited *Kings and Queens Exhibition*, RA, 1953 (270), reproduced 'Illustrated Souvenir', p 81. Engraved by W. H. Simmons, published Graves, 1877 (example in British Museum). Lithographed by F. Hanfstaengl (example in NPG); lithograph reproduced McCarthy, plate 9.

1839 Marble bust by Sir F. Chantrey. Royal Collection, Windsor.
Replica and preliminary drawings (NPG 1716 and 316a above).

1839 Engraving by S. W. Reynolds (with King Leopold of Belgium, the Duke of Wellington, and others, on horseback), after Reynolds and F. Taylor, published T. Boys, 1839 (example in NPG). A related watercolour, erroneously attributed to G. Cattermole, was sold at Christie's, 19 February 1960 (lot 23).

c 1839 *Various related equestrian paintings by Sir E. Landseer*

1 'Reviewing Troops with the Duke of Wellington' (small, sketchy and unfinished). Christie's, 22 July 1966 (lot 92). Exhibited *Landseer Exhibition*, RA, 1874 (244), *Landseer Exhibition*, RA, 1961 (23), reproduced in catalogue, and *Bicentenary Exhibition*, RA, 1968 (230).

2 With a hound (large, sketchy and unfinished). Collection of HM the Queen Mother. Reproduced *Art Journal* (1875), p 3. Half-length detail engraved by J. Scott, published H. Graves, 1882 (example in NPG).

3 With dogs and a cavalry escort, in front of Windsor Castle (small, sketchy and unfinished). Royal Collection. Exhibited *Landseer Exhibition*, RA, 1961 (24).

4 With dogs in Windsor Home Park (large, finished). Fairhaven Collection, on loan at Ashridge House. Exhibited *RA*, 1873 (256), where said to be 'not from life', and *Landseer Exhibition*, RA, 1961 (82), reproduced in catalogue. Engraved by T. Landseer, published Agnew, 1877 (example in British Museum).

5 With dogs, attendants and a dead stag, in Windsor Home Park (small, finished). Wolverhampton Art Gallery. Exhibited *British Empire Exhibition*, Wembley, 1925 (W 39), reproduced 'Illustrated Souvenir', p 7. Engraved by T. L. Atkinson, published H. Graves, 1868 (example in British Museum); engraving reproduced Lorne, p 145.

All five pictures show Queen Victoria as a young woman, but their exact relationship to one another is not clear. Nos. 1–3 are apparently contemporary, nos. 4–5 worked up later. The pose of the figure is similar in nos. 1–4, but there are differences in details of the costume and headgear. Nos. 1–4 also show the same white horse, its foreleg raised in nos. 2–4, its head bent in nos. 2–3. The horse in no. 5 is a chestnut, but its pose is similar to nos. 2–4. The same hound appears in nos. 2–4, and the same dog in nos. 3–4.

1840 'Marriage of Queen Victoria and Prince Albert' by Sir G. Hayter. Royal Collection, Buckingham Palace. Reproduced Gernsheim, p 67. Exhibited *VE*, 1892 (24). Engraved by C. E. Wagstaff, published Graves, 1844 (example in NPG). Studies for the group are in the Royal Collection, Windsor, and the British Museum.

1840 'Marriage of Queen Victoria and Prince Albert', miniature by Sir W. J. Newton. Exhibited *RA*, 1844 (771), and *VE*, 1892 (424), lent by Mrs Newton.

1840 Painting by Sir D. Wilkie. Lady Lever Art Gallery, Port Sunlight.
Exhibited *RA*, 1840 (62). Water-colour study (NPG 1297 above). The original portrait was offered to the NPG by the Marquess of Normanby in 1899, but declined at the instigation of the Queen. A half-length seated portrait of Victoria by Wilkie, said to date from 1839, is in the Glasgow Art Gallery, exhibited *VE*, 1892 (26).

1840 Painting by J. Partridge. Royal Collection, Buckingham Palace.
Recorded in the artist's 'Sitters Book' (NPG archives), under 1840. Reproduced L. Cust, *Paintings at Buckingham Palace and Windsor Castle* (1905), I, plate 1. Exhibited *RA*, 1841 (61). Engraved by J. H. Robinson, published F. G. Moon, 1845 (example in British Museum); engraving reproduced Lorne, p 175.

1840 Painting by F. X. Winterhalter (half-length, in her bridal veil). Royal Collection, Windsor.

1840 'Queen Victoria Entering Holyrood Palace' by Sir D. Wilkie. Maas Gallery, London, 1963.

1840 Marble bust by J. Francis. Reform Club.
Exhibited *RA*, 1840 (1138).

c 1840 Painting by an unknown artist. Government House, Mauritius.

c 1840 Painting by W. Fowler. Royal Collection.
Engraved by B. P. Gibbon, published Welch and Gwynne, 1840 (example in British Museum); engraving reproduced Lorne, p 117. Another version: collection of the Duke of Bedford. A portrait by Fowler of 1838, possibly another version, was exhibited *Victorian Era Exhibition*, 1897, 'Historical Section' (656), lent by General Sir Lynedoch Gardiner. Three miniatures by W. Essex, after Fowler's portraits of 1824, 1827 and *c* 1840 were exhibited *RA*, 1858 (618).

c 1840 Miniature by Sir W. C. Ross (whole length, in state chair). Formerly Royal Collection, Windsor.
Engraved by F. Bacon, published Colnaghi and Puckle, 1841 (example in NPG).
Identical to the painting by H. L. Smith of 1840 in Fishmongers Hall, reproduced J. W. Touse, *A Short Account of Portraits etc. In the Possession of the Company* (1907), facing p 13, which is presumably after the miniature.

c 1840 Miniature by Sir W. C. Ross (three-quarter face). Royal Collection, Windsor.
Lithographed by R. J. Lane, published Colnaghi and Puckle, 1840 (example in NPG). Engraved by H. T. Ryall, published Colnaghi and Puckle, 1840 (example in NPG); engraving reproduced McCarthy, plate 15.

c 1840 Water-colour by A. E. Penley (NPG 4108 above).

1841 'Christening of the Princess Royal' by C. R. Leslie. Royal Collection, Buckingham Palace.
Reproduced Gernsheim, p 70. Exhibited *VE*, 1892 (84). Engraved by H. T. Ryall, published F. G. Moon, 1849 (example in NPG).

1841 Painting by J. Partridge. Commissioned by the Duchess of Kent.
Listed in the artist's 'Sitters Book' (NPG archives), under 1841. Probably the half-length portrait in the Royal Collection, similar to the head in the 1840 portrait (see above).

1841 Drawing by S. Diez. Exhibited *RA*, 1842 (572).
Lithographed by E. Desmaisons, published Baily, 1841 (example in NPG); lithograph reproduced Lorne, p 132.

1841 Miniature by Sir W. C. Ross (in profile). Royal Collection, Windsor.
Reproduced Holmes, p 15. Possibly the miniature exhibited *RA*, 1842 (847). Engraved by H. T. Ryall, published Colnaghi and Puckle, 1842 (example in NPG).

1841 Marble bust by Sir F. Chantrey (see NPG 1716 above).

c 1841 Statue by J. Bell. Exhibited *RA*, 1841 (1242), and possibly that in the Great Exhibition, 1851.

1842 'The Christening of the Prince of Wales' by Sir G. Hayter. Royal Collection, Buckingham Palace. Reproduced Gernsheim, p73. Exhibited *VE*, 1892 (94). Engraved by W. Greatbach (no example located). Studies are in the Royal Collection, Windsor.

1842 'The Christening of the Prince of Wales', water-colour by L. Haghe. Royal Collection, Buckingham Palace. A large study is also in the Royal Collection.

1842 'The Christening of the Prince of Wales', miniature by Sir W. J. Newton. Exhibited *VE*, 1892 (422), lent by Mrs Newton.

1842 Painting by J. Partridge. Presumably Versailles (painted for Louis Philippe). Listed in the artist's 'Account Book' (NPG archives), under 1842, together with a miniature. Exhibited *RA*, 1842 (63). Engraved by Tavernier, published Colnaghi, 1844 (example in British Museum).

1842 Painting by Sir M. A. Shee. Royal Academy. Exhibited *RA*, 1843 (136), and *British Portraits*, RA, 1956–7 (526).

1842 Painting by F. X. Winterhalter (three-quarter length, figure in profile). Royal Collection, Windsor. Exhibited *SKM*, 1868 (384). Engraved by F. Forster, published F. G. Moon, 1847 (example in British Museum). The most reproduced and popular early image of Queen Victoria. There are innumerable versions and copies; most of these appear to be based on the picture in the collection of the Earl of Hardwicke, which, unlike the Royal picture, shows Victoria wearing the Garter. The Hardwicke version was exhibited *Pageant of Canada*, National Gallery of Canada, Ottawa, 1967–8 (252), reproduced in catalogue.

1842 'Windsor Castle in Modern Times' by Sir E. Landseer (Queen Victoria, Prince Albert and the Princess Royal). Royal Collection, Windsor. Exhibited *Landseer Exhibition*, RA, 1874 (173), and *Landseer Exhibition*, RA, 1961 (95). Engraved by T. L. Atkinson, published H. Graves, 1861 (example in NPG); engraving reproduced Maxwell, p40. Oil study of Queen Victoria and Prince Albert of 1839 in Royal Collection, Windsor, exhibited *Landseer Exhibition*, 1961 (61), reproduced in catalogue. Water-colour study in collection of Earl of Harewood.

1842 Painting by Sir F. Grant (with the Prince of Wales and the Princess Royal). Royal Collection, Buckingham Palace (plate 951). Listed in the artist's 'Sitters Book' (copy of original MS, NPG archives), under 1842. Given to Prince Albert by Queen Victoria, Christmas 1842.

1842 Painting by Sir E. Landseer (with the Prince of Wales and the Princess Royal). Royal Collection. Exhibited *Royal Children*, Queen's Gallery, Buckingham Palace, 1963 (43), together with a chalk study (42), possibly that exhibited *Landseer Exhibition*, RA, 1874 (387). The painting was engraved by S. Cousins, published H. Graves, 1844 (example in NPG); engraving reproduced McCarthy, plate 18.

1842 Painting by Sir E. Landseer (with Prince Albert, dressed as Queen Philippa and Edward III for a *bal costumé*). Royal Collection, Buckingham Palace. Exhibited *Landseer Exhibition*, RA, 1874 (211), and *Landseer Exhibition*, RA, 1961 (94). Reproduced J. Harris, G. de Bellaigue and O. Millar, *Buckingham Palace* (1968), p306.

1842 Painting by F. Newhenham. Formerly Junior United Service Club, London; presented to HMS VINCENT, 1959. Exhibited *RA*, 1844 (67).

c 1842 Marble bust by J. Francis. Guildhall Art Gallery, London. Possibly the bust exhibited *RA*, 1842 (1267). A cabinet bust by Francis was exhibited *RA*, 1841 (1289).

1843 'Reception of Queen Victoria and Prince Albert by Louis Philippe' by E. Lami. Musée de Versailles. Reduced water-colour version: Royal Collection, Windsor.

1843 'Louis Philippe and Family and Queen Victoria and Prince Albert at the Château d'Eu' by F. X. Winterhalter. *Winterhalter Loan Exhibition*, Knoedler, 1936 (20), lent by Mrs Derek FitzGerald.

1843 'Reception of Queen Victoria and Prince Albert by Louis Philippe at the Château d'Eu' by F. X. Winterhalter. Musée de Versailles. Oil study: collection of Jean Schmit, Paris, 1939.

1843 Painting by Sir F. Grant. United Service Club, London.
Listed in the artist's 'Sitters Book' (copy of original MS, NPG archives), under 1843. Exhibited *RA*, 1843 (15).

1843 Painting by F. X. Winterhalter (standing, in garter robes). Royal Collection, Windsor.
Reproduced Maxwell, p 93. Engraved by T. L. Atkinson, published F. G. Moon, 1847 (example in British Museum).

1843 Painting by F. X. Winterhalter (half-length, with loose, flowing hair). Royal Collection, Windsor (plate 953).

1843 Lithograph by E. Dalton, after Sir W. C. Ross (seated, reading), published S. and J. Fuller, 1843 (example in NPG); reproduced Lorne, p 236.

1843 Marble bust by J. Flatters. Victoria and Albert Museum.
Exhibited *The Romantic Movement*, Arts Council at the Tate Gallery, 1959 (980).

c 1843 'Queen Victoria Landing at the Chain Pier, Brighton' by R. H. Nibbs. Corporation of Brighton.
Exhibited *Victorian Era Exhibition*, 1897, 'Historical Section' (36).

c 1843 Equestrian statuette by P. J. Chardini. Exhibited *RA*, 1843 (1486).

1844 'Reception of Louis Philippe at Windsor' by F. X. Winterhalter. Musée de Versailles.
Smaller version: Royal Collection, Windsor, reproduced Maxwell, p 41, exhibited *VE*, 1892 (76). An oil study of the head of Queen Victoria, and a version of her and the children derived from the composition, are also in the Royal Collection.

1844 Miniature by R. Thorburn. Royal Collection, Windsor.
Exhibited *Portrait Miniatures*, South Kensington Museum, 1865 (990), and *British Portrait Miniatures*, Arts Council, Edinburgh, 1965 (364). Engraved by H. Robinson, published 1847 (example in NPG), for the *Art-Union*. Dated 1841 by some authorities.

1844 Statue by Sir J. Steell. Royal Institution, Edinburgh.

c 1844 Marble statue by J. Gibson. Royal Collection, Osborne House. Reproduced *Country Life*, CXLVI (1969), 905. Replica in marble of *c* 1849: Royal Collection, Buckingham Palace. One of the two versions was engraved by T. W. Hunt, published 1849 (example in NPG), for the *Art Journal*.

1845 Painting by F. X. Winterhalter (full-length, standing, window to left). Royal Collection, Balmoral.
Engraved by Hopwood, published Goupil (example in NPG).

1845 Painting by Sir F. Grant (on horseback). Christ's Hospital, Horsham.
Exhibited *RA*, 1846 (66). Oil sketch: Royal Collection, reproduced *Apollo*, LXXIX (1964), 482, exhibited *Animal Painting*, Queen's Gallery, Buckingham Palace, 1966–7 (36). See also Grant's equestrian portrait of 1850 (listed below).

1845 Painting by Sir E. Landseer (dressed as Catherine the Great for a *bal costumé*). Royal Collection.
Exhibited *Landseer Exhibition*, RA, 1874 (226).

1845 'Queen Victoria opening Parliament, 1845' by A. Blaikley. House of Lords.
Exhibited *RA*, 1845 (1136); figure of Victoria lithographed by and published Blaikley (example in NPG), for *Pictures of the People, from Prince to Peasant* (1847).

1845 Statue by J. Thomas. Lincoln's Inn Library, London.
Other statues by Thomas are at the Palace of Westminster.

1845 Marble statue by J. G. Lough. Royal Exchange, London.
Exhibited *RA*, 1845 (1330). A plaster model was at Elswick Hall, Newcastle, listed in the *Catalogue of Lough and Noble Models at Elswick Hall* (*c* 1928), p 45 (155).

1846 Painting by F. X. Winterhalter (with her family). Royal Collection, Buckingham Palace. Reproduced Maxwell, p 49, and J. Harris, G. de Bellaigue and O. Millar, *Buckingham Palace* (1968), p 310.

Exhibited *Kings and Queens Exhibition*, RA, 1953 (271). Engraved by S. Cousins, published F. G. Moon, 1850 (example in NPG), engraving exhibited *RA*, 1850 (1096). Oil study: exhibited *Winterhalter Loan Exhibition*, Knoedler, 1936 (26), lent by Princess Helena. Pencil study or copy: Sotheby's, 4 April 1968 (lot 119). Copy by E. Belli: Royal Collection, Osborne House, exhibited *VE*, 1892 (45).

1846 Painting by Count A. D'Orsay. Department of the Environment (old War Office building). The type engraved by H. Lemon, published H. Bridges, Sheffield, 1849 (example in NPG); engraving reproduced Lorne, p 211. Another version is in the British Embassy in Tunis. Copies are recorded.

1846 Painting by F. X. Winterhalter (with the Prince of Wales). Royal Collection, Kensington Palace (plate 954); purchased at Christie's, 7 July 1939 (lot 102).

1846 Engraving by J. Posselwhite, after H. E. Dawe (in the Royal Closet at St George's Chapel), published S. Rogerson, 1846 (example in NPG), for the *Liverpool Mercury*.

1847 'The Queen Sketching at Loch Laggan with the Prince of Wales and the Princess Royal' by Sir E. Landseer. Royal Collection. Exhibited *Landseer Exhibition*, RA, 1961 (13), reproduced in catalogue. Engraved by J. T. Willmore, published H. Graves, 1858 (example in NPG); engraving exhibited *RA*, 1859 (1209), and reproduced Lorne, p 261.

1847 Painting by H. J. Stewart (landing at Dumbarton). Dumbarton County Council. Exhibited *Scottish Groups and Conversation Pieces*, Arts Council at the Scottish NPG, 1956 (27).

1847 Water-colour by F. X. Winterhalter (holding a fan). Formerly collection of Queen Mary. Lithographed by T. Fairland (example in NPG).

1847 Miniature by Sir W. C. Ross. Trinity College, Cambridge.

1847 Miniature by R. Thorburn (with Prince Alfred and Princess Helena). Formerly Royal Collection. Exhibited *RA*, 1848 (835). Detail of Queen Victoria and Princess Helena engraved by F. Holl as the frontispiece to Sir T. Martin, *Life of the Prince Consort*, II (1877). A copy is in the Royal Collection. A painting by Thorburn of Queen Victoria with the Prince of Wales is reproduced Lorne, p 202.

c 1848 Marble bust by J. Gibson. Corporation of Liverpool. Exhibited *RA*, 1848 (1317), and *British Portraits*, RA, 1956–7 (527). A plaster cast is in the Royal Academy.

1849 Painting by S. Catterson Smith. Formerly at Mansion House, Dublin. Sketched by G. Scharf, 'TSB' (NPG archives), XXXIV, 40. Exhibited Royal Hibernian Academy, 1858, and *Irish Exhibition*, London, 1888 (982). Engraved by G. S. Sanders, published T. Cranfield, Dublin, 1857 (example in British Museum).

1849 Drawing by H. J. Stewart (with Prince Albert and their children). Scottish NPG.

1850 Painting by F. X. Winterhalter (with Prince Arthur). Royal Collection, Buckingham Palace (plate 955). Exhibited *Royal Children*, Queen's Gallery, Buckingham Palace, 1963 (52). Engraved by G. Zobel, published Colnaghi, 1852 (example in NPG); engraving reproduced McCarthy, plate 20.

1850 Painting by Sir F. Grant (on horseback). Army and Navy Club. Listed in the artist's 'Sitters Book' (copy of original MS, NPG archives), under 1850, where it is said to have been based on eight sittings given in 1845. It shows Queen Victoria in the same dress as the 1845 equestrian portrait at Christ's Hospital, Horsham (listed above), and is obviously connected with it, possibly representing a first idea. It was specially finished for the Army and Navy Club.

1850 'Royal Sports on Hill and Loch' by Sir E. Landseer. Royal Collection. Exhibited *RA*, 1854 (63). Engraved by W. H. Simmons, published H. Graves, 1874 (example in British Museum); engraving reproduced Maxwell, p 79. Oil study: Royal Collection, exhibited *Landseer Exhibition*, RA, 1961 (16), reproduced in catalogue.

1850-5 Marble statue by J. Gibson. Houses of Parliament.

1850 Marble bust by J. Francis (with Prince Albert). Geological Museum.
Other versions: Mansion House, and Drapers Hall, London.

1851 'The Opening of the Crystal Palace' by H. C. Selous. Victoria and Albert Museum. Reproduced Gernsheim, p 97.

1851 'May the First, 1851' by F. X. Winterhalter (Queen Victoria, Prince Albert, Prince Arthur and the Duke of Wellington). Royal Collection, Windsor. Reproduced Maxwell, p 59. Exhibited *King's Pictures*, RA, 1946–7 (56). Engraved by S. Cousins, published Colnaghi, 1852 (example in NPG). Copy by F. R. Say: Royal Collection, exhibited *VE*, 1892 (75).

1851 Water-colour by F. X. Winterhalter (Victoria and Albert dressed as Catherine of Braganza and Charles II for a *bal costumé*). Royal Collection, Windsor.

1851 Marble bust by R. Physick. Royal Herbert Hospital, Woolwich.

1851 Statue by A. H. Ritchie. Holyrood Palace.

1852 Painting by F. X. Winterhalter (with the Duchess of Nemours). Royal Collection, Buckingham Palace. Reproduced J. Harris, G. de Bellaigue and O. Millar, *Buckingham Palace* (1968), p 309.

1853 Water-colour by E. Lami. Victoria and Albert Museum.

1853 Bronze statuette by T. Thornycroft. Royal Collection, Buckingham Palace. Related to the 1860 statue at Liverpool, see below. The original model was commissioned by the Art Union, and exhibited *RA*, 1854 (1417). Another cast was sold Sotheby's, 6 March 1969 (lot 69).
Thornycroft exhibited an equestrian statue of Queen Victoria at the Great Exhibition, 1851.

1854 Statue by M. Noble. Manchester.

1854 Bust by J. E. Jones. National Gallery of Ireland, Dublin.

1855 'Queen Victoria Visiting the Tomb of Napoleon I' by E. M. Ward. Royal Collection. Reproduced Maxwell, p 91. Exhibited *RA*, 1858 (251), and *VE*, 1892 (16).

1855 'Queen Victoria's First Visit to Wounded Crimean Soldiers' by J. Barrett. Private collection, Wales. Engraved by T. O. Barlow (no example located). Reduced replica: Royal Collection.

1855 'Queen Victoria Investing Napoleon III with the Order of the Garter at Windsor Castle' by E. M. Ward. Royal Collection. Reproduced Maxwell, p 88. Exhibited *RA*, 1858 (35), and *VE*, 1892 (78).

1855 'Queen Victoria Decorating Crimean War Heroes' by G. H. Thomas. Royal Collection, Buckingham Palace. Exhibited *VE*, 1892 (150).

1855 Water-colour by F. X. Winterhalter. Royal Collection, Windsor. Reproduced Lorne, p 230, and Gernsheim, p 110. Lithographed by R. J. Lane, 1855 (example in NPG).

1855 Marble bust by Baron C. Marochetti. Collection of Major David Gordon. Exhibited *RA*, 1856 (1221).

1856 Painting by E. Boutibonne and J. F. Herring (on horseback). Royal Collection, Buckingham Palace. Presumably the painting exhibited *RA*, 1857 (15).

1856 Painting by F. X. Winterhalter (half-length in red). Royal Collection, Buckingham Palace.

1856 Marble bust by J. Durham. Formerly Guildhall Art Gallery (destroyed 1940). Exhibited *RA*, 1856 (1222). Engraved by R. Artlett, published 1857 (example in NPG), for the *Art Journal*. Another version in marble: Royal College of Music. Biscuit porcelain copy of 1855 sold Christie's, 15 June 1961 (lot 20). A plaster cast of 1855 was in the Royal Albert Memorial Museum, Exeter (presumably destroyed).

1856 Marble bust by M. Noble. Houses of Parliament. A colossal marble bust of 1856 is in the City Hall, Manchester. Other busts by Noble are in the India

Office, London, the Institution of Civil Engineers, and Trinity House, London. A Parian-ware bust is in the Bristol Art Gallery. A plaster model, possibly for one of the 1856–7 busts, was at Elswick Hall, Newcastle, listed in *Catalogue of Lough and Noble Models at Elswick Hall* (*c* 1928), pp 49–50 (166).

1857 Marble busts by M. Noble. Royal Collection, and collection of the Earl of Ellesmere. One of the versions exhibited *RA*, 1857 (1207). Another version of 1859 was with Ted's Antiques, 1970.

1857 Marble statue by M. Noble. Peel Park, Salford.

1858 'The Marriage of the Princess Royal' by J. Phillip. Royal Collection, Buckingham Palace. Reproduced Gernsheim, p 121. Exhibited *RA*, 1860 (58), and *VE*, 1892 (58). Engraved by A. Blanchard, published E. Gambart, 1865 (example in British Museum).

c 1858 'The Royal Family' by J. Archer. Sotheby's, 29 October 1941 (lot 104).

1859 Painting by F. X. Winterhalter (seated, in robes of state). Royal Collection, Buckingham Palace. Reproduced Maxwell, frontispiece. Exhibited *VE*, 1892 (36), and *The King's Pictures*, RA, 1947 (486). Engraved by W. H. Simmons (no example located). Another version: collection of S. H. Scher.

1859 'Queen Victoria and Prince Albert at a Military Review in Aldershot' by G. H. Thomas. Royal Collection. Reproduced Maxwell, p 116. Exhibited *RA*, 1866 (212), and *VE*, 1892 (62). Water-colour study: Christie's, 14 November 1967 (lot 166), bought Spink.

1860 Bronze statue by T. Thornycroft (on horseback). Liverpool.

1860 Marble bust by W. Theed. Grocers Hall, London.
Exhibited *RA*, 1861 (978).

1861 Bust by T. Earle. Royal Collection, Buckingham Palace.
Exhibited *RA*, 1864 (866).

c 1861 'The Last Moments of the Prince Consort' by an unknown artist. Wellcome Institute of the History of Medicine. Lithographed by W. L. Walton, printed by C. J. Culliford (example in Wellcome Institute); a key, done when the painting was first disposed of by raffle, is in the NPG. A variant version is reproduced R. Awde, *Waiting at Table. Poems and Songs* (1865), frontispiece.

1862 'The Marriage of Princess Alice to Prince Louis of Hesse' by G. H. Thomas. Royal Collection. Reproduced Maxwell, p 122. Exhibited *VE*, 1892 (106).

1863 'The Marriage of the Prince of Wales' by W. P. Frith. Royal Collection, Windsor. Reproduced Lorne, p 297. Exhibited *RA*, 1865 (52), and *VE*, 1892 (114). Engraved by W. H. Simmons, published H. Graves, 1870 (example in NPG).

1863 'The Marriage of the Prince of Wales' by G. H. Thomas. Royal Collection, Buckingham Palace. Reproduced Holmes, p 29. Water-colour study of Queen Victoria (see NPG 2954 above).

1863 Drawing by Sir N. Paton. Royal Collection, Windsor.
Study for the unfinished picture of the 'Royal Family Mourning Prince Albert' at Kew Palace.

1864 'Queen Victoria Presenting a Bible to an Indian', engraving by W. H. Simmons, after T. J. Barker, published R. Turner, 1864 (example in British Museum). A related oil sketch is in the Hermitage, Leningrad.

1864 Bronze bust by W. Theed. Royal Collection, Buckingham Palace.

1864 Painting by A. Graefle. Royal Collection, Osborne House.
Engraved by W. Holl, published J. Mitchell, 1864 (example in NPG).

1865 Painting by J. C. Horsley (with her children, and made to look as in *c* 1850). Royal Society of Arts, London.

1865 Marble statue by A. Brodie. Aberdeen.

1866 'The Marriage of Princess Helena' by C. Magnussen. Royal Collection, Buckingham Palace. Reproduced Holmes, p 31. Exhibited *VE*, 1892 (145).

1866 Painting by Sir E. Landseer (on horseback, with John Brown and two of her daughters). Royal Collection, Buckingham Palace. Exhibited *R A*, 1867 (72), and *British Portraits*, RA, 1956–7 (376). Engraved by J. Stephenson, published H. Graves, 1871 (example in British Museum); engraving reproduced Maxwell, p 127. Chalk study of Queen Victoria: Royal Collection, Windsor, exhibited *Landseer Exhibition*, RA, 1874 (48). Pastel version of whole composition: Royal Collection, Balmoral.

1866 Statue by J. Durham. Public Record Office, London.

1866 Marble medallion by Miss S. D. Durant. Royal Collection, Windsor.
 Exhibited *R A*, 1866 (875). Two small ormolu medallions by Miss Durant are in the NPG (2023a).

1866 Statue by T. Earle. Hull.

1867 'Queen Victoria investing the Sultan of Turkey with the Order of the Garter' by G. H. Thomas. Exhibited *R A*, 1868 (399), and *Royal Naval Exhibition*, Chelsea, 1891 (1608), lent by the proprietors of the *Graphic*. Reproduced Holmes, p 32. Replica (unfinished) and an undated drawing by Thomas: collection of the Earl of Bradford.

1867 Marble bust by A. and W. Brodie. Royal Collection, Balmoral.
 Exhibited *R A*, 1868 (929). Replica: Scottish NPG. Bronze version exhibited *Victorian Era Exhibition*, 1897, 'Historical Section' (535), lent by T. Craig Brown.

1868 Marble statue by W. Theed (with Prince Albert, both dressed as Anglo-Saxons). Royal Collection, Windsor. Reproduced Maxwell, p 120. Exhibited *R A*, 1868 (926). Plaster cast: Royal Collection (on loan to the NPG).

c 1868 Marble effigy by Baron C. Marochetti. Royal Mausoleum, Frogmore.
 Reproduced Gernsheim, p 255.

1871 Marble statue (seated) by Sir J. E. Boehm. Royal Collection, Windsor (see NPG 858 above).

1871 Engraving by S. Cousins, after L. Dickinson, published 1871 (example in NPG); engraving exhibited *R A*, 1871 (841).

c 1871 Marble bust by Miss M. Grant. Executed for the Raja-i-Rajgan of Kappoortala.
 Exhibited *R A*, 1871 (1273).

1872 Statue by M. Noble. Bombay.
 Plaster model of head and shoulders: Foreign and Commonwealth Office. A plaster model of the whole statue was at Elswick Hall, Newcastle, listed in *Catalogue of Lough and Noble Models at Elswick Hall* (*c* 1928), p 72 (261).

1872 Marble bust by Miss S. D. Durant. Inner Temple, London.
 Exhibited *R A*, 1872 (1517).

c 1872 Painting by J. Sant (with three of her grandchildren). Royal Collection.
 Exhibited *R A*, 1872 (259). Engraved by T. O. Barlow, published E. S. Palmer, 1876 (example in British Museum), engraving exhibited *R A*, 1876 (1129), and reproduced W. H. Wilkins, *Our King and Queen* (*c* 1901), II, 519. Another painting of Queen Victoria by Sant is at Trinity House, Hull, and a painting attributed to him is in the Royal Collection.

1874 'The Marriage of the Duke of Edinburgh' by N. Chevalier. Royal Collection, Buckingham Palace. Reproduced Holmes, p 37. Exhibited *VE*, 1892 (79).

1874 Marble statue by M. Noble. St Thomas' Hospital, London.
 Exhibited *R A*, 1874 (1495). Engraved by H. Balding, published 1878 (example in NPG), for the *Art Journal*. Another marble statue by Noble is in Leeds Town Hall.

c 1874 Marble bust by Sir J. E. Boehm. Exhibited *R A*, 1874 (1534) (see NPG 858 above).

1875 Painting by H. von Angeli. Royal Collection.
 Water-colour copy by Lady Abercromby (see NPG 708 above).

1875 Statue by H. Weekes. Calcutta.
Model exhibited *RA*, 1869 (1218).

1875 Marble statue by M. Marshall Wood. Formerly Parliament House, Toronto (destroyed by fire, 1883).
Exhibited *RA*, 1875 (1321). A bronze statue by Wood, reproduced *Art Journal* (1883), p 29, was
destroyed by fire at the Garden Palace, Sydney, 1882.

1875 Marble bust by H. S. H. Count Gleichen. Walker Art Gallery, Liverpool.
Exhibited *RA*, 1876 (1509), and *Kings and Queens of England*, Walker Art Gallery, 1953 (45).

1876 Bronze statue by C. B. Birch. Victoria Embankment, London.

1876 Marble bust by Princess Louise. Royal Academy.
Exhibited *Kings and Queens of England*, RA, 1953 (275). A bust by Princess Louise was exhibited *RA*,
1869 (1142). A drawing of 1881 by the same artist is in the Royal Collection, Windsor, and several
undated drawings are recorded.

1877 Painting by H. von Angeli. Sold from the collection of Princess Beatrice, Christie's,
5 May 1950 (lot 73).

1879 'The Marriage of the Duke of Connaught' by S. P. Hall. Royal Collection, Buckingham Palace.
Reproduced Holmes, p 40. Exhibited *VE*, 1892 (100).

1880 'Princess Victoria Receiving the News of her Accession' by H. T. Wells. Tate Gallery.

c 1880 Statue by Sir J. E. Boehm. Temple Bar Memorial, London.

1882 'The Marriage of the Duke of Albany' by Sir J. D. Linton. Royal Collection, Buckingham Palace.
Reproduced Holmes, p 41. Exhibited *VE*, 1892 (126).

1883 Marble statue by T. Woolner. Council House, Birmingham.
Exhibited *RA*, 1883 (1541).

1885 'The Marriage of Princess Beatrice and Prince Maurice of Battenberg' by R. C. Woodville. Royal
Collection, Buckingham Palace. Reproduced Holmes, p 44. Exhibited *VE*, 1892 (107).

1885 Painting by H. von Angeli. Royal Collection, Windsor.
Reproduced Maxwell, p 167. Exhibited *VE*, 1892 (133). Coloured reproduction issued by the *ILN*
(example in NPG).

1887 'The Royal Family at the Time of the Jubilee' by L. Tuxen. Royal Collection, Buckingham Palace.
Reproduced Gernsheim, p 204. Exhibited *VE*, 1892 (70).

1887 'Queen Victoria's Jubilee Garden Party' by F. Sargent. Collection of M. Bernard.

1887 Painting by S. C. Smith junior. Royal College of Surgeons, Dublin.
Exhibited *Royal Hibernian Academy*, 1889.

1887 Painting by G. Schmitt. Stuttgart.

1887 Marble statue by F. J. Williamson. Royal Collection, Balmoral.
A bust by Williamson was exhibited *RA*, 1887 (1842); a photograph of this or another bust by Williamson is in the NPG reference files.

1887 Bronze statue by Sir J. E. Boehm. In front of Windsor Castle.
Related plaster bust (see NPG 858 above).

1887 Statue by Sir A. Gilbert. Winchester.
Reproduced I. McAllister, *Alfred Gilbert* (1929), facing p 80. Model exhibited *RA*, 1888 (1940).
Replica: Newcastle-upon-Tyne, reproduced *Magazine of Art* (1903), p 545.

c 1887 Jubilee Memorials by M. Raggi. 1. Hong Kong. 2. Kimberley. 3. Toronto.

c 1887 Statue by H. S. H. Count Gleichen (standing before throne). Royal Holloway College.
Reproduced *Art Journal* (1887), p 161 (or possibly the model).

1888 'Queen Victoria's Visit to the Glasgow Exhibition of 1888' by Sir J. Lavery. Corporation of Glasgow.

Reproduced, together with a study of Queen Victoria's head, Sir J. Lavery, *The Life of a Painter* (1940), plate 7. An oil sketch for the composition is in the Aberdeen Art Gallery.

1888 Painting by H. Grant. Corporation of Devizes.

c 1889 Statue by C. B. Birch. Udaipur, India.
Reproduced *ILN*, xcv (1889), 827.

1891 'Baptism of Prince Maurice of Battenburg' by G. O. Reid. Royal Collection, Buckingham Palace. Exhibited *Royal Scottish Academy*, 1893 (230), with the title, 'First Baptism for 300 Years of a Royal Prince in Scotland'. Studies of Queen Victoria: 1. Royal Scottish Academy. 2. Scottish NPG.

1893 'Marriage of George V and Queen Mary' by L. Tuxen. Royal Collection, Buckingham Palace.

1893 Painting by H. von Angeli. Royal Collection, Buckingham Palace. Apparently the portrait reproduced Maxwell, p 177. Another similar portrait is at Osborne House.

1893 Marble statue by Princess Louise (in coronation robes, and made to look as in *c* 1838). Kensington Gardens. Reproduced Lorne, p 364.

1894 Painting by L. Tuxen. Kunsthistorisk Pladearkiv, Copenhagen.
Reproduced V. Poulsen, *Dänische Maler* (Die Blauen Bücher series, Germany, 1961), p 65.

1896 'Marriage of Princess Maud and Prince Charles of Denmark' by L. Tuxen. Royal Collection, Buckingham Palace.

1896 Statue by F. J. Williamson. Collection of R. G. Cooke, Athelhampton, Dorchester. Other versions: 1. Rangoon, reproduced *Magazine of Art* (1896), p 79. 2. Londonderry, reproduced *Magazine of Art* (1901), p 254. 3. King Williamstown, South Africa. 4. Auckland, New Zealand. A marble statuette by Williamson was exhibited *RA*, 1892 (1904).

1896 Statue by Sir W. H. Thornycroft. Royal Exchange, London.
Reproduced *Magazine of Art* (1896), p 421. Marble version of 1899 in Durban, reproduced *Magazine of Art* (1899), p 239.

c 1896 Miniature by Mrs Corbould-Ellis. Corporation of London.

1897 'The Four Generations' by Sir W. Q. Orchardson (see NPG 4536 above).

1897 Marble bust by E. O. Ford (connected with the memorial of 1901, see below). Royal Collection, Windsor. Reproduced Cassell's *Royal Academy Pictures* (1899), p 193. Exhibited *RA*, 1899 (2053). Another related marble bust was sold at Christie's, 15 June 1961 (lot 22).

1897 Marble bust by W. B. Rhind. Scottish Conservative Club, Edinburgh.
Reproduced *Magazine of Art* (1898), p 576.

c 1897 Painting by J. H. Bentley. Guildhall, Lincoln.

c 1897 Marble statue by Sir T. Brock. In front of new extension to NPG, Carlton House Terrace. Originally commissioned by members of the Constitutional Club to celebrate the Diamond Jubilee.

1899 Painting by H. von Angeli. Royal Collection.
Copy by B. Müller (see NPG 1252 above).

1899 Painting by B. Constant. Royal Collection, Windsor.
Reproduced C. H. Collins-Baker, *Catalogue of the Principal Pictures in the Royal Collection at Windsor Castle* (1934), plate 3. Exhibited *RA*, 1901 (149).

1899 Marble bust by E. O. Ford. Corporation of London, Mansion House (plate 963).
Exhibited *British Portraits*, RA, 1956–7 (532). Related to the bust of 1897 and the statue of 1901 by Ford.

c 1899 Woodcut by Sir W. Nicholson (example in NPG).

1900 Statue by E. R. Mullins. Port Elizabeth, South Africa.

c 1900 Statue by J. W. Rollins. Victoria Hospital, Belfast.

1901 Painting by S. J. Solomon (unfinished). Reproduced Supplement to the *Sphere*, 26 January 1901.

1901 Water-colour by Sir H. Herkomer (on her death-bed). Royal Collection, Osborne.

1901 Bronze statue (on marble memorial) by E. O. Ford. Manchester.
Exhibited *RA*, 1901 (1711). Reproduced *Art Journal* (1901), p 176. For related busts, see under 1897 and 1899 above.

1901 Bronze statue by G. Frampton. Victoria Memorial Hall, Calcutta (together with the model). Other statues by Frampton are at Leeds, Newcastle and Winnipeg.

1901 Memorial by Princess Louise. Manchester Cathedral.
Reproduced *Magazine of Art* (1902), p 335.

1901 Statue by Sir T. Brock. Hove.
Reproduced *Magazine of Art* (1901), p 384. Another statue by Brock is in the Victoria Memorial Hall, Calcutta, reproduced Marquis Curzon, *British Government in India* (1925), I, facing 192.

1901 Marble bust by Sir T. Brock, Christ Church, Oxford.
Exhibited *RA*, 1901 (1820). Reproduced Cassell's *Royal Academy Pictures* (1901), p 135.

1901 Statue by an unknown artist. Weymouth.

c 1902 Memorial by F. L. Jenkins. Liverpool.
Designs reproduced *Magazine of Art* (1902), pp 298–9.

c 1902 Statue by A. Toft. Leamington.
Reproduced *Magazine of Art* (1902), p 240. Other statues by Toft are at Nottingham and South Shields.

1903 Statue by A. Drury. Guildhall Square, Portsmouth.
Another statue by Drury is on the façade of the Victoria and Albert Museum.

1904 Bust by H. L. Florence. Victoria Monument, Kensington High Street, London.

c 1907 Bronze statue by H. Hampton. Lancaster.

c 1911 'The Victoria Memorial' by Sir T. Brock and Sir A. Webb. The Mall, London.
Sketch model reproduced *Magazine of Art* (1902), p 140.

Undated Painting by F. X. Winterhalter (with a wreath of corn in her hair). Royal Collection, Sandringham.

Undated Painting attributed to F. X. Winterhalter. Collection of Earl Beauchamp.
Possibly the painting reproduced Lorne, p 312.

Undated Painting by W. and H. Barraud (riding, with the Duchess of Kent). Exhibited *Lansdowne House Exhibition*, 1929 (367), lent by Mrs F. Menzies.

Undated Painting by L. Casabianca. Corporation of London.

Undated Painting by G. P. Green. Guildhall, Hull.

Undated Painting by H. Weigall. Burghley House, Northamptonshire.

Undated Painting by Sir J. J. Shannon. Scottish NPG.

Undated Painting by A. Melville. Sotheby's, 13 July 1966 (lot 262), bought Caldwell.

Undated Pastel by F. Rochard. Collection of Earl Beauchamp.

Undated Drawing by A. de Bathe (see NPG 4042 above).

Undated Miniature by Miss M. H. Carlisle (see NPG 2088 above).

Undated Marble statue by C. Nicoli. Brighton.
A marble bust by the same artist is in the Museum and Art Gallery, Bristol.

Undated Terra-cotta bust by J. Broad. Doulton Museum. Reproduced *Country Life*, CXXVI (1959), 905.

Undated Marble bust by J. Adams-Acton. City Art Gallery, Bradford.

Undated Marble bust by Sir A. Gilbert. Royal Courts of Justice, on loan from the Army and Navy Club.

Undated Statue by Sir T. Farrell. Guildhall, Londonderry.

Undated Statue by G. Simonds. Town Hall, Reading.

Undated Two statues by J. Adams-Acton. Kingston and the Bahamas.
Listed in the *Dictionary of National Biography*; a gilt plaster model for a colossal statue was offered to the NPG by Miss D. Adams-Acton, 1913.

Undated Statue by Baron C. Marochetti. Glasgow.

Undated Statues or memorials recorded by A. Kuhn, 'Dictionary of English Sculptors: 19th–20th century' (typescript, 1967, Victoria and Albert Museum; the locations of several dated items already listed were provided by Kuhn): by J. Hughes (Dublin); by J. Hutchinson; by J. Tweed (Aden); by A. Turner (Sheffield, Delhi, North Shields); by G. Wade (Ceylon); by Sir B. Mackennal (Lahore, Blackburn).

VIGORS *Nicholas Aylward* (*1785–1840*)

Zoologist, MP for Carlow.

54 See *Groups:* 'The House of Commons, 1833' by Sir G. Hayter, p 526.

VILLIERS *Hon Augustus* (*1810–47*)

Soldier, son of the 5th Earl of Jersey.

4026 (58) See *Collections:* 'Drawings of Men About Town, 1832–48' by Count A. D'Orsay, p 557.

VIVIAN *Richard Hussey Vivian, 1st Baron* (*1775–1842*)

General, MP for Truro.

54 See *Groups:* 'The House of Commons, 1833' by Sir G. Hayter, p 526.

See also forthcoming Catalogue of Portraits, 1790–1830.

VIVIAN *George* (*1798–1873*)

Connoisseur.

342, 3 See *Groups:* 'The Fine Arts Commissioners, 1846' by J. Partridge, p 545.

VIVIAN *John Henry* (*1785–1855*)

MP for Swansea.

54 See *Groups:* 'The House of Commons, 1833' by Sir G. Hayter, p 526.

WAGHORN *Thomas* (*1800–50*)

Served in the navy, 1812–17, and as pilot in Bengal marine service, 1819–24; commanded a sloop in the Burmese war, 1824–5; advocated the overland route from Cairo to Suez on the Indian trade-route; demonstrated its feasibility, 1829; organized transport service for it; published pamphlets on the subject; lieutenant RN, 1842; developed a shipping firm.

974 Oil on canvas, 30 × 25 inches (76·2 × 63·5 cm), by SIR GEORGE HAYTER. PLATE 966

Collections: The sitter; Mr Wheatley, bequeathed by his widow, Mary V. Wheatley, 1895.

According to the executors of the donor, Mr Wheatley had been employed by Waghorn as a young man and had succeeded to his business. The portrait was lithographed by Standidge & Co, published Leggatt, Hayward and Leggatt, *c* 1847 (example in NPG), where the artist was said to be Hayter. This was confirmed in the donor's will.

Description: Healthy complexion, greyish eyes, brown hair. Dressed in a black stock, white waistcoat with gilt buttons and a black coat. Background colour brown.

ICONOGRAPHY A statue by H.H.Armstead is at Chatham, the plaster model for which was exhibited *RA*, 1889 (2032), and *Royal Naval Exhibition*, Chelsea, 1891 (2850); a colossal bronze bust by an unnamed artist was at the entrance to the Suez Canal, reproduced as a woodcut *ILN*, LXI (1872), 384; a lithograph by Day and Haghe, after a painting by C.Baxter, was published H.Leggatt, 1837 (example in NPG); there is an anonymous lithograph (example in NPG), and a woodcut was published *ILN*, VII (1845), 292.

WAKEFIELD *Edward Gibbon* (*1796–1862*)

Colonial statesman; diplomatic official, 1814–6, 1820–6; imprisoned, 1826–9, for abducting an heiress; wrote influentially on penal reform, and later on colonial economics and administration; promoted foundation of South Australia and New Zealand colonies; worked tirelessly as adviser in Canada, and in London for the New Zealand Company.

1561 Miniature, water-colour and body colour on ivory, $3\frac{3}{8} \times 2\frac{3}{4}$ inches (8·5 × 7 cm), by an UNKNOWN ARTIST, *c* 1820. PLATE 967

Collections: Mrs J.Storr, presented by her, 1910.

The donor also owned a bust of Wakefield, reproduced A.J.Harrop, *The Amazing Career of Edward Gibbon Wakefield* (1928), frontispiece, perhaps the bust by Park (see iconography below). Mrs Storr's relationship to the sitter is not known, but there is no reason to doubt the identification (comparison with later portraits is almost conclusive). The date is based on costume and the apparent age of the sitter.

Description: Healthy complexion, brown eyes, brown hair and whiskers. Dressed in a white stock, white shirt, yellow waistcoat and blue coat. Background colour greenish-grey.

ICONOGRAPHY A painting by E.J.Collins of 1850 (the dogs by R.Ansdell) is in the Christ Church Museum, New Zealand, reproduced I.O'Connor, *Edward Gibbon Wakefield* (1928), facing p254; a marble bust by J.Durham of 1875 is in the Foreign and Commonwealth Office, exhibited *RA*, 1876 (1374), reproduced O'Connor, facing p262; a bust by P.Park was exhibited *RA*, 1840 (1166); an engraving by B.Holl, after a drawing by A.Wivell of 1823, was published Colnaghi, 1826 (example in Mitchell Library, Sydney), reproduced E.Wakefield, *New Zealand after Fifty Years* (1889), frontispiece; a daguerreotype, of which there is a large reproduction in the NPG, is reproduced R.Garnett, *Edward Gibbon Wakefield* (1898), frontispiece.

WALKER *David* (*1837–1917*)

Surgeon and naturalist; accompanied the 'Fox' in the search for Sir John Franklin; died in North America.

922 Oil on canvas, $15\frac{1}{2} \times 12\frac{7}{8}$ inches (39·4 × 32·7 cm), by STEPHEN PEARCE, 1860. PLATE 968

Inscribed on a label, formerly on the back of the picture: Dᵣ WALKER. M.D./SURGEON AND NATURALIST OF LADY FRANKLIN'S/ARCTIC YACHT "FOX"./Painted by S.Pearce./[*label damaged, 18?*]3 54 Queen Anne Street/Cavendish Square

Collections: See *Collections:* 'Arctic Explorers' by S.Pearce, p562.

Exhibitions: RA, 1860 (261).

Literature: S.Pearce, *Memories of the Past* (1903), p69.

This is the only recorded portrait of Walker. He is wearing the Arctic Medal (1818–55).

Description: Healthy complexion, dark eyes, brown hair and beard. Dressed in a dark stock, white shirt, with two yellow buttons set with red stones, dark waistcoat and coat, with silver watch-chain, and a silver medal with a grey ribbon. Background colour dark brown.

WALL *Charles Baring* (*1795–1853*)

MP for Guildford.

54 See *Groups:* 'The House of Commons, 1833' by Sir G. Hayter, p 526.

WALTER *John* (*1776–1847*)

Proprietor of *The Times*, MP for Berkshire.

54 See *Groups:* 'The House of Commons, 1833' by Sir G. Hayter, p 526.

WARBURTON *Henry* (*1785–1858*)

Philosophical radical, MP for Bridport.

54 See *Groups:* 'The House of Commons, 1833' by Sir G. Hayter, p 526.

WARD *Edward Matthew* (*1816–79*)

Painter.

3182 (10) See *Collections:* 'Drawings of Artists, *c* 1862' by C. W. Cope, p 565.

See also forthcoming Catalogue of Portraits, 1860–90.

WARD *Sir Henry George* (*1797–1860*)

Colonial governor, MP for St Albans.

54 See *Groups:* 'The House of Commons, 1833' by Sir G. Hayter, p 526.

WARREN *Samuel* (*1807–77*)

Lawyer and novelist; entered Inner Temple, 1828; special pleader, 1831–7; barrister, 1837; QC, 1851; recorder of Hull, 1852–74; master in lunacy, 1859–77; author of several legal text books, political tracts, and successful novels.

1441 Oil on canvas, 36 × 27⅞ inches (91·5 × 70·8 cm), attributed to JOHN LINNELL, *c* 1835–40. PLATE 969
Collections: John Blackwood, purchased from his daughter, Mary Blackwood Porter, 1906.

This portrait was offered with another of Sir Edward Hamley (now Staff College, Camberley); both men were close friends of John Blackwood the publisher. According to the vendor, the portrait of Warren was commissioned direct from the artist, but neither she nor her cousin, William Blackwood, who also vouched for its authenticity (their letters in NPG archives), could remember his name. There was at the time a suggestion that Henry Weigall might have been the artist, as he had exhibited a portrait of Warren *RA*, 1851 (894). In a letter of 19 June 1906 (NPG archives), however, Weigall wrote to say that he thought that his portrait was probably a miniature; this is confirmed by Weigall's 'Account Book' (photostat copy, NPG archives), where a miniature of Warren is listed under 16 May 1850 (28), commissioned by Mr Blackwood. At some time subsequently, and for reasons unknown, Milner, then director of the NPG, ascribed the portrait to Linnell. The attribution is plausible, though Linnell generally worked on a smaller scale, but it has yet to be proved. The date of the portrait is based on costume.

Description: Healthy complexion, brown eyes and hair. Dressed in a dark stock and neck-tie, white shirt, grey waistcoat, and black suit, with a gold monocle suspended round his neck from a black ribbon. Holding a white book, and leaning on an unidentified green object. Red and gold patterned curtain behind at left. Rest of background dark brown.

ICONOGRAPHY A painting by Sir J. Watson Gordon is in the collection of Messrs Blackwood and Sons, Edinburgh, exhibited *RA*, 1856 (424), *Royal Scottish Academy*, 1857 (350), and *VE*, 1892 (303); a painting by N. J. Crowley, exhibited *Royal Hibernian Academy*, 1837, is listed by W. G. Strickland, *Dictionary of Irish Artists* (1913), I, 238; a water-colour attributed to the sitter's nephew, Edward Warren, was in the collection of Miss E. Ashton Jonson, 1916; busts by H. Weigall senior and T. Earle, and a medallion by M. Wood, were exhibited *RA*, 1849 (1271), 1856 (1322), and 1857 (1302); various woodcuts, photographs and reproductions of photographs are in the NPG, and others were published *ILN*, XII (1848), 323, XXIX (1856), 598, and LXXI (1877), 137.

WATERTON *Charles* (*1782–1865*)

Naturalist; educated at Stonyhurst; made various naturalist expeditions to Guiana and elsewhere; published successful account of his journeys, 1825; converted Walton Hall, Yorkshire, into a wild-life sanctuary and natural history museum; prepared specimens by his own method.

2014 Oil on canvas, $24\frac{1}{8} \times 20\frac{1}{4}$ inches ($61 \cdot 3 \times 51 \cdot 4$ cm), by CHARLES WILSON PEALE, 1824. PLATE 970

Inscribed on the back of the original canvas (*now covered by relining*)*:* Painted from the life,/in the year 1824 in/Philadelphia U.S. by/Charles Wilson Peale Esq[r]/of/Philadelphia

Collections: Purchased from the Waterton estate by Bromhead Cutts & Co, through the Public Trustee, and purchased from them, 1924.

Exhibitions: Charles Waterton, Wakefield City Museum, 1951 (46).

Literature: C. C. Sellers, *Charles Wilson Peale* (Philadelphia, 1947), II, 369–71, reproduced facing 370; C. C. Sellers, 'Portraits and Miniatures by Charles Wilson Peale', *Transactions of the American Philosophical Society*, n.s. XLVIII, part I (Philadelphia, 1952), 244 (no. 960), reproduced plate 350.

Waterton visited Philadelphia on his return journey from South America, attracted by the growing fame of Peale's Museum, founded by C. W. Peale, who was a naturalist as well as an artist. He was discovered in the museum by Titian Peale, the artist's son, complaining about his inability to get a good cup of tea anywhere in America. Titian Peale took him home, to the best tea he had yet tasted abroad, and he at once became a friend of the elder Peale and his whole family. At this first meeting, which must have occurred early in June 1824, Waterton launched into a description of his own method of preserving specimens, exhibiting a cat and a South American bird (presumably those depicted in the portrait) as examples of his work. He offered to instruct Titian Peale in his method, an offer which was gratefully accepted. The two men travelled in New Jersey collecting birds and animals, while the elder Peale went south to Maryland. Sellers suggests that the portrait was painted on the latter's return to Philadelphia later in the summer, as a thank-you present to Waterton, who refused any recompense for instructing Titian. In his MS autobiography (quoted by Sellers, 1952, 244), Peale wrote that the portrait, '*although done in a short time is an acknowledged likeness*', It was apparently exhibited at the Museum soon after it was painted. The bird, a Guiana Red Cotinga of the Amazon-Guiana region[1], and the cat, were portrayed as examples of Waterton's method, which enabled him to preserve animals without using conventional methods of stuffing. Peale had developed his own method along the same lines. The book shown in the portrait is inscribed 'WATERTON'S/METHOD/P[eale]Museum'; no work of this title was ever published by Waterton, but he appended a section to his *Wanderings in South America &c* (1825), entitled 'original instructions for the perfect preservation of birds, etc, for cabinets of natural history'; these instructions were also quoted in Titian Peale's *Circular of the Philosophical Museum &c* (Philadelphia, 1831). The subsequent history of the portrait is not clear. Sellers identifies it with the portrait of Waterton included in the sale of items from Peale's Museum,

[1] Kindly identified by the staff of the British Museum of Natural History. Sellers erroneously describes the bird as a Virginia Cardinal.

Thomas & Sons, Philadelphia, 1854, which was bought by George Ord for $12. He does not explain how it then entered Waterton's collection, or the collection of his descendants. It seems more probable that the NPG portrait was given by Peale to Waterton at the time, and brought home by him. If this is so, the portrait sold in 1854 would be another version, painted by Peale for himself. The NPG portrait was engraved by H. Adlard as the frontispiece to Waterton's *Essays on Natural History* (3rd series, 1857). A brief description of Peale and the Peale Museum is included in Waterton's *Wanderings*, p 301.

Description: Healthy complexion, greyish eyes, brown hair. Dressed in a black stock, white shirt, yellow waistcoat, and black coat with gilt buttons. Holding a red and black bird. Tabby-coloured cat's head and brown leather-bound volume on table. Background colour, various tones of brown and green.

1621 Pen and ink on paper, $3\frac{1}{8} \times 3\frac{7}{8}$ inches (8×9.8 cm), by PERCY HETHERINGTON FITZGERALD, 1860. PLATE 971

Inscribed in ink (top left): SO – (?)

Inscribed on a sheet of brown paper, formerly used as a backing for the drawing: Charles Waterton/ Naturalist – Bird stuffer/Traveller, & eccentric/ From a sketch made in 1860/at Walton Hall. Yorkshire/ by Percy FitzGerald MA. FSA

Collections: The artist, presented by him, 1911.

The date of the drawing was confirmed in a letter from the artist (NPG archives). There is a line of writing just visible at the bottom of the drawing, which has been cut off.

ICONOGRAPHY A bust by H. Ross was exhibited *RA*, 1866 (1048); a posthumous bust by W. Hawkins of 1865 is in the Linnean Society, London; according to Mrs W. Pitt Byrne this bust was based on a death-mask and a drawing by herself, the latter reproduced in her *Gossip of the Century* (1899), IV, 83; a woodcut was published *ILN*, V (1844), 124.

WATKINS *John Lloyd Vaughan* (1802–67)
MP for Brecon.

54 See *Groups:* 'The House of Commons, 1833' by Sir G. Hayter, p 526.

WATSON *Richard* (1800–52)
MP for Canterbury.

54 See *Groups:* 'The House of Commons, 1833' by Sir G. Hayter, p 526.

WATTS *Alaric Alexander* (1797–1864)

Journalist and poet; successful editor of various journals; bankrupt, 1850, but pensioned, 1854; published verse miscellanies and his own poetry; initiated and edited a publication, 'Men of the Time', 1856.

2515 (51) Black chalk, with touches of Chinese white, on brown-tinted paper, $14\frac{7}{8} \times 11\frac{1}{8}$ inches (37.8×28.2 cm), by WILLIAM BROCKEDON, 1825. PLATE 972

Dated (bottom left): Novr 1825

Collections: See *Collections:* 'Drawings of Prominent People, 1823–49' by W. Brockedon, p 554.

ICONOGRAPHY A bust by C. Bacon was exhibited *RA*, 1847 (1421); an engraving by D. Maclise (example in NPG) was published *Fraser's Magazine*, XI (June 1835), facing 652, as no. 61 of Maclise's 'Gallery of Illustrious Literary Characters'; there is a photograph by J. and C. Watkins in the NPG, and a woodcut after another was published *ILN*, XLIV (1864), 449.

WAYLETT *Harriet* (*1798–1851*)

Actress and singer; *née* Cooke; married first Waylett, an actor, and secondly G. A. Lee, a musician; performed at various provincial and London theatres, 1816–49; manageress of the Strand Theatre, 1834; her soubrette parts and her singing won her wide popularity.

3097 (9) Pen and ink on paper, $6\frac{1}{8} \times 4\frac{1}{2}$ inches (15·5 × 11·4 cm), by SIR EDWIN LANDSEER. PLATE 973

Inscribed in pencil (along the top): Mrs Waylett as 'a Butterfly' *and in ink (along the bottom):* Mrs Waylett, as the 'Butterfly'./by Sir Edwin Landseer.

Collections: Appleby Brothers, purchased from them, 1940.

This is part of a small collection of caricatures by Landseer, which will be discussed as a group in the forthcoming Catalogue of Portraits, 1790–1830.

ICONOGRAPHY A painting by R. Rothwell is listed in W. G. Strickland, *Dictionary of Irish Artists* (1913), II, 309; a miniature by J. W. Childe was exhibited *RA*, 1834 (738); sixteen popular prints are listed in L. A. Hall, *Catalogue of Dramatic Portraits in the Theatre Collection of the Harvard College Library*, IV (Cambridge, Mass, 1934), 240–1 (some examples in NPG and British Museum).

WEBB *Philip Barker* (*1793–1854*)

Botanist; studied geology under Dean Buckland; travelled in Italy, Greece and the Troad, 1817–18, rediscovering the Scamander and Simois; collected natural history specimens in many parts of Europe and elsewhere; published many works; his collections are housed in the Botanical Institute at Florence.

4327 Oil on canvas, $15 \times 10\frac{1}{2}$ inches (38 × 26·6 cm), by LALOGERO DI BERNARDIS, 1820. PLATE 974

Signed and dated (along the edge of the daïs on which Webb sits, lower left and centre): LALOGERO DI BERNARDIS 1820

Inscribed in faded ink on an old label on the back of the stretcher (much of it indecipherable even with the aid of ultra-violet rays and infra-red photography, and apparently cut off on the right hand side): Description of the portrait [*of*] Philip Barker Webb Esq^r in the/Turkish Costume in [?] . . . [?] of Suliman Effendi . . . [?]/ . [?]/ [?] right side above his head is the [?]/ [?] of the [?] Sultan Mahmoud [?]/ [?] Webb Barker [?] Turk/ [?] 19th 1820

Collections: An unlocated Puttick and Simpson sale, bought by a Mr Longden (?); Edwin Savage Ltd; Basil Ward, purchased from him, 1963.

Literature: NPG Annual Report, 1963–4 (1964), p 9.

Webb is shown in a typical Turkish interior, wearing the garment of a çelebi or effendi, with a characteristic felt hat and turban. Inscribed in gold to the left of his head is the imperial monogram or tugra of Sultan Mahmud II (1785–1839, ruled 1808–39), and on the right in Turkish (or possibly Persian, as it uses the letter 'P'), 'Philip Webb'. From the evidence of the script, the artist would appear to be Levantine, but nothing is known of him (information on the costume and inscriptions kindly communicated by G. M. Meredith-Owens of the British Museum).

Description: Healthy complexion, brown eyes and moustache. Dressed in predominantly red and scarlet garments of various tones, ornamented with gold and black designs and borders, yellow socks, black hat and white turban, with a silver-hilted sword. Holding a string of pearls in one hand, and a long brown pipe in the other. Seated on blue cushions with gold borders. Multi-coloured rug in fore-

ground with a pair of Turkish shoes on the left. Grey wall behind decorated with red and green floral swags. Blue sky visible through window.

ICONOGRAPHY A painting called Webb by an unknown artist was with Appleby Brothers, 1947; a painting by Martini, after a portrait by Roemer of 1847, and a marble bust by E. Lusini of 1874, are in the Botanical Institute, Florence.

WEBB *Richard D.*

Slavery abolitionist.

599 See *Groups:* 'The Anti-Slavery Society Convention, 1840' by B.R. Haydon, p538.

WEBSTER *Thomas* (*1800–86*)

Painter and etcher; chorister of St George's Chapel, Windsor; student at RA schools, 1821; exhibited at RA and elsewhere, 1823–79; contributed to Etching Club volumes; RA, 1846; famous for his domestic, school, and village scenes.

2879 Pencil on paper, $4\frac{7}{8} \times 3\frac{3}{8}$ inches (12·3 × 8·6 cm), by EDWARD MATTHEW WARD, 1862. PLATE 975

Inscribed in pencil in the artist's hand (*bottom left*): T Webster RA/Sketched at Council/July/62

Collections: W. Bennett, presented by him, 1936.

The inscription must refer to the Royal Academy Council. This was one of several portrait drawings by Ward owned by the donor. He presented or sold to the NPG several other portrait drawings at the same time, but no others by Ward.

ICONOGRAPHY A painting by himself was with Leger Galleries, 1943, presumably the self-portrait exhibited *RA*, 1878 (259); a painting by J. C. Horsley is in the Aberdeen Art Gallery, a miniature by W. W. Scott was exhibited *RA*, 1853 (835), and busts by J. Durham and J. A. Raemackers, *RA*, 1878 (1456), and 1879 (1584); there are several photographs, and woodcuts after photographs, in the NPG.

WELLINGTON *Arthur Wellesley, 1st Duke of* (*1769–1852*)

Prime minister and field-marshal.

54 See *Groups:* 'The House of Commons, 1833' by Sir G. Hayter, p526.

2789 See *Groups:* 'The Members of the House of Lords, *c*1835' attributed to I.R. Cruikshank, p536.
See also forthcoming Catalogue of Portraits, 1790–1830.

WENSLEYDALE *Sir James Parke, 1st Baron* (*1782–1868*)

Judge; barrister, 1813; raised to the king's bench and knighted, 1828; transferred to court of exchequer 1834; raised to peerage, 1856; resigned over Procedure Acts, 1855, but continued actively as privy councillor and in the Lords.

1695 (H) With Sir Christopher Robinson and Dr Adams on either side of him. Pen and ink and wash on brown paper, $7\frac{7}{8} \times 10\frac{3}{4}$ inches (20 × 27·4 cm), by SIR GEORGE HAYTER, 1820. PLATE 976

Signed and dated: G Hayter/for the Trial/ of the Queen/1820.

Collections: M. B. Walker, purchased from him, 1913.

This is a study for Hayter's group portrait of 'The House of Lords, 1820' (see NPG 999 below).

Other studies and the group itself will be discussed at length in the forthcoming Catalogue of Portraits, 1790–1830.

2028 Pencil on blue-toned paper, $8\frac{7}{8} \times 6\frac{3}{4}$ inches ($22 \cdot 5 \times 17 \cdot 2$ cm), by his grandson, the 9TH EARL OF CARLISLE, c 1863. PLATE 977

Collections: Presented by the sitter's grandson, Viscount Ullswater, 1924.

In a letter of 20 April 1924 (NPG archives), the donor wrote: '*The drawing was made about the year 1863 and as I can testify, who knew him well, is an admirable likeness*'. Another water-colour by the same artist of 1865 was in the collection of James Lowther (see iconography below for other portraits owned by him). A bronze medallion by the 9th Earl is in the collection of Lord Henley, exhibited *George Howard and his Circle*, City Art Gallery, Carlisle, 1968 (127).

999 See *Groups:* 'The House of Lords, 1820' by Sir G. Hayter, in forthcoming Catalogue of Portraits, 1790–1830.

ICONOGRAPHY A painting by T. Phillips is in the Inner Temple, listed in the artist's 'Sitters Book' (copy of original MS, NPG archives), under 1838, exhibited *RA*, 1838 (468), engraved and published by W. Walker, 1847 (example in NPG); this portrait and another by an unknown artist of 1803 were at one time in the collection of James Lowther; a copy by Phillips of his 1838 portrait for Magdalen Hospital is listed in his 'Sitters Book', under 1840; a painting by G. F. Watts is at Castle Howard, exhibited *Winter Exhibition*, Grosvenor Gallery, 1882 (133), and *VE*, 1892 (30); a painting by R. Rothwell was exhibited *RA*, 1832 (414); a drawing by G. Richmond of 1847 was exhibited *VE*, 1892 (342), lent by the Earl of Carlisle, listed in the artist's 'Account Book' (photostat of original MS, NPG archives), p 44, under 1847; a miniature by A. Plimer, as a boy, is reproduced G. C. Williamson, *Andrew and Nathaniel Plimer* (1903), facing p 44; an engraving by T. Wright, after A. Wivell, was published T. Kelly, 1821 (example in NPG); a woodcut, after a pen-and-ink sketch, was published *ILN*, XXIX (1856), 100; a photograph by Walker & Sons is in the NPG, and a woodcut after another was published *ILN*, LII (1868), 265.

WENTWORTH *William Charles* (*1793–1872*)

'The Australian patriot'; official in New South Wales, 1811; educated at Cambridge, 1816; barrister, 1822; returned to Sydney; thereafter played a key role in Australian political life; promoter of the idea of colonial self-government.

1671 Bronze cast, 3 inches (7·6 cm) diameter, of a medallion by THOMAS WOOLNER, c 1854. PLATE 978
Incised on the rim: W.C.WENTWORTH
Collections: Purchased from the artist's daughter, Miss Amy Woolner, 1912.

This is a reduced cast of Woolner's medallion of Wentworth, executed in Australia in 1854. Woolner wrote home on 19 March 1854 (Amy Woolner, *Thomas Woolner: his Life in Letters* (1917), p 73): '*You will have seen by the newspapers I sent how highly a medallion of Wentworth I did is spoken of. There has been the greatest praise bestowed upon it but as was the case in England with me the matter seems to end there*'. Woolner had hoped to obtain the commission for a projected statue of Wentworth, but his efforts in Australia and later in England proved unsuccessful. Bronze casts of the larger medallion are in the following collections: Sydney University, reproduced *Connoisseur Year Book* (1957), p 51, possibly that formerly in the collection of F. Wentworth; B. Venus; Miss Anne White. Another is reproduced Amy Woolner, facing p 35. The type was exhibited *RA*, 1856 (1282).

ICONOGRAPHY The only other recorded portraits of Wentworth are, a painting by an unspecified artist in the Parliament building, Sydney, a statue by Pietro Tenerani of Rome of 1861 at Sydney University, and a woodcut published *ILN*, LX (1872), 400.

WEST *Benjamin* (*1738–1820*)

Painter.

1456 (26) See *Collections:* 'Drawings of Artists, *c* 1845' by C. H. Lear, p 561.

See also forthcoming Catalogue of Portraits, 1790–1830.

WESTBURY *Richard Bethell, 1st Baron* (*1800–73*)

Lord chancellor; barrister, 1823; practised in equity courts; QC, 1840; MP from 1851; vice-chancellor of the Duchy of Lancaster, 1851; attorney-general, 1856; carried through several important legal reforms; lord chancellor and raised to peerage, 1861.

1941 Oil on canvas, $24\frac{3}{8} \times 19\frac{5}{8}$ inches (62×49.9 cm), by MICHELE GORDIGIANI. PLATE 979

Collections: The artist, purchased from his son, Edouardo Gordigiani, 1922.

Literature: The Times, 31 May 1922.

A second very similar portrait of Westbury by the same artist was acquired by the Privy Council Office from the same source; it shows the sitter three-quarter face, but in the same costume, and was obviously executed at the same date. No details concerning the history of the portraits was offered by the vendor, who was not even certain of their identity. Comparison with other portraits of Westbury is, however, conclusive. They were probably executed sometime after 1865 in Italy. Westbury had a villa there where he spent some of his last years. The canvas of the NPG portrait was, however, supplied by W. Eatwell of Baker Street.

Description: The portrait is partially unfinished. Ruddy complexion, bluish-green eyes, grey hair. Dressed in a white neck-tie, shirt, and waistcoat. Dark coat. Background greenish-brown.

ICONOGRAPHY A painting by Sir F. Grant is in the Middle Temple, listed in the artist's 'Sitters Book' (copy of original MS, NPG archives), under 1862, exhibited *RA*, 1863 (147), and *VE*, 1892 (95); a miniature by Mrs F. Dixon was exhibited *RA*, 1862 (727); a marble bust by J. Bailey of 1852 is at Wadham College, Oxford, exhibited *RA*, 1853 (1363); a marble bust by T. Earle was exhibited *RA*, 1845 (1418); an engraving by G. J. Stodart, after a miniature by an unknown artist of *c* 1825, was published R. Bentley, 1887 (example in NPG), for T. A. Nash, *The Life of Richard Lord Westbury* (1888), I, frontispiece; a caricature lithograph by 'Ape' (C. Pellegrini) was published *Vanity Fair,* 15 May 1869, with the title, 'An Eminent Christian Man'; there are various photographs, and engravings and woodcuts after photographs, in the NPG, and others were published T. A. Nash (1888), II, frontispiece, *ILN*, XVIII (1851), 314, XXXIX (1861), 13, and LXIII (1873), 105.

WESTMACOTT *Sir Richard* (*1775–1856*)

Sculptor.

1456 (27) See *Collections:* 'Drawings of Artists, *c* 1845' by C. H. Lear, p 561.

2515 (95) See *Collections:* 'Drawings of Prominent People, 1823–49' by W. Brockedon, p 554.

See also forthcoming Catalogue of Portraits, 1790–1830.

WESTMACOTT *Richard* (*1799–1872*)

Sculptor; son of the sculptor, Sir Richard Westmacott (see above); student at RA schools, 1818; studied in Italy, 1820–6; exhibited at RA, 1827–55; RA, 1849; professor of sculpture, 1857–67; wrote several works and lectured on art; executed imaginative subjects, busts, and monuments.

3944 (4) Pencil on paper, $9\frac{1}{2} \times 7\frac{1}{4}$ inches (24×18.5 cm), by JOHN PARTRIDGE, 1825. PLATE 980

Signed and dated (*lower right*)*:* J.Partridge/– Novr 1825 –/Rome –

Collections: See *Collections:* 'Artists, 1825' by J.Partridge, p556.

In the Partridge sketch-book, this drawing precedes what is almost certainly a drawing by Westmacott after one of his statues. The features agree well with a later photograph of Westmacott (see below), and the sculpting chisel he is holding seems conclusive. Besides Gibson, also drawn in the sketch-book (p32), Westmacott was the only other young English sculptor of any note in Rome at this time.

4026 (59) Pencil and black chalk, with touches of red on the face, on paper, 6¾ × 5 inches (17 × 12·7 cm), by COUNT ALFRED D'ORSAY, 1831. PLATE 981

Signed and dated (*lower right*)*:* D'Orsay/fecit/1831 *Inscribed* (*bottom centre*)*:* R.Westmacott-Junior

Collections: See *Collections:* 'Drawings of Men About Town, 1832–48' by Count A.D'Orsay, p557.

ICONOGRAPHY A painting by A.Baccani was exhibited *RA*, 1865 (113); a drawing of Richard Westmacott or his father by C.Vogel is in the Küpferstichkabinett, Staatliche Kunstsammlungen, Dresden; there is a photograph by J.Watkins (example in NPG); a woodcut, probably after a photograph, was published *ILN*, LX (1872), 457.

WEYLAND *Richard* (*1780–1864*)

MP for Oxfordshire.

54 See *Groups:* 'The House of Commons, 1833' by Sir G.Hayter, p526.

WHARNCLIFFE *James Archibald Stuart-Wortley-Mackenzie, 1st Baron* (*1776–1845*)

Statesman.

2789 See *Groups:* 'Members of the House of Lords, *c*1835' attributed to I.R.Cruikshank, p536.

WHEATSTONE *Sir Charles* (*1802–75*)

Scientist and inventor; professor of experimental physics, King's College, London, 1834; FRS, 1836; with Sir W.F.Cooke, the first to use the electric telegraph for communication; prolific in inventions and developments, mainly in electro-magnetic physics.

726 Black and white chalk on brown, discoloured paper, 28⅜ × 20½ inches (72 × 52·1 cm), by SAMUEL LAURENCE, 1868. PLATE 983

Inscribed in pencil (*lower left*)*:* 2½ Thursday *and in faint chalk* (*bottom centre*)*:* Sir Charles Wheatstone.

Collections: Purchased at the artist's sale, Puttick and Simpson, 12 June 1884 (lot 192), through Messrs Colnaghi.

Literature: Reproduced *Das Neunzehnte Jahrhundert in Bildnissen* (Berlin, 1899), II, 199; F.Miles 'Samuel Laurence' (typescript, NPG library).

A letter from Wheatstone to Laurence of 18 April 1868, referring to a sitting, is in the collection of W.B.Laurence. A bronze relief, based on the NPG drawing, is on the outer wall of St Michael's Church, Gloucester. NPG 726 was purchased at the same time as an oil painting of Thackeray by Laurence (NPG 725).

2515 (84) Black and red chalk, with touches of Chinese white, on grey-tinted paper, 14¼ × 10⅛ inches (36 × 25·7 cm), by WILLIAM BROCKEDON, 1837. PLATE 982

Dated (*lower left*)*:* 20.11.37

Collections: See *Collections:* 'Drawings of Prominent People, 1823–49' by W.Brockedon, p554.

Accompanied in the Brockedon Album by a letter from the sitter, dated 19 November 1834.

ICONOGRAPHY A painting by C. Martin is in the Royal Society, exhibited *RA*, 1870 (428); a marble bust by W. G. Brooker was exhibited *RA*, 1878 (1444); there are various photographs, and woodcuts and engravings after photographs, in the NPG, and others were published *ILN*, IX (1846), 184, LII (1868), 145, and LXVII (1875), 461.

WHEELER Samuel (1776–1858)

Slavery abolitionist.

599 See *Groups:* 'The Anti-Slavery Society Convention, 1840' by B. R. Haydon, p 538.

WHEWELL William (1794–1866)

Master of Trinity College, Cambridge; fellow of Trinity, 1817; professor of mineralogy, 1828–32; president of Geological Society, 1837–9; master of Trinity, 1841–66; vice-chancellor, 1843 and 1856; instrumental in introducing science and mathematics to Cambridge; published many works.

1390 Plaster cast, painted cream, 28⅜ inches (72 cm) high, of a bust by EDWARD HODGES BAILY, 1851. PLATE 984

Incised on the back: E.H. BAILY R.A./Sculp 1851

Collections: Purchased from Miss Emily Chinenson, 1904.

Related to the marble bust of Whewell by Baily of 1851 at Trinity College, Cambridge, which was exhibited *RA*, 1852 (1440). The vendor wrote (letter of 18 June 1904, NPG archives) that the NPG bust '*was done on the* sly *for my husband, who was then a* rich *undergraduate & being a great admirer of Dr Whewell, he coaxed the man to sell him this cast*'. Another plaster cast is in the Department of Geology, Cambridge, catalogued by J. W. Goodison, *Catalogue of Cambridge Portraits* (1955), p 147. A bust by Baily, said to be of 1850, was in the Crystal Palace Portrait Collection, 1854.

ICONOGRAPHY Two paintings by Margaret Carpenter are listed in her 'Sitters Book' (NPG archives), pp 33 and 35, under 1843 and 1844, one of which was exhibited *RA*, 1844 (19); a study for this was exhibited *RA*, 1866 (659), presumably the portrait listed in her 'Sitters Book', p 45; a finished sketch for a portrait by Mrs Carpenter was sold Christie's, 16 February 1867 (lot 88); a painting by S. Laurence of 1845 is at Trinity College, Cambridge, exhibited *RA*, 1847 (410), and *SKM*, 1868 (485), engraved by and published W. Walker, 1853 (example in British Museum); a painting by J. Lonsdale of 1825 is also at Trinity, and a marble statue by T. Woolner of 1872 is in the chapel, exhibited *RA*, 1873 (1516); a painting called Whewell and attributed to W. Etty was in the collection of H. von Gundherr, 1938; there is an engraving by W. Holl, after a drawing by A. de Solomé (example in NPG); a lithograph by W. Drummond, after E. U. Eddis, was published T. McLean, 1835 (example in NPG), for 'Athenaeum Portraits'; there is a lithograph by Miss H. S. Turner after the same type, in reverse (example in NPG); there is a photograph by L. Reeve in the NPG; two woodcuts were published *ILN*, IX (1846), 184, and XLVIII (1866), 293.

WHITE Edward

Connoisseur and friend of Charles Lamb.

3182 (11) See *Collections:* 'Drawings of Artists, c 1862' by C. W. Cope, p 565.

WHITE Henry (1790–1876)

Lawyer.

2515 (58) See *Collections:* 'Drawings of Prominent People, 1823–49' by W. Brockedon, p 554.

WHITE *Luke* (*d 1854*)

MP for County Longford.

54 See *Groups:* 'The House of Commons, 1833' by Sir G. Hayter, p 526.

WHITE *Samuel* (*d 1854*)

MP for County Leitrim.

54 See *Groups:* 'The House of Commons, 1833' by Sir G. Hayter, p 526.

WHITEHORNE *James*

Slavery abolitionist.

599 See *Groups:* 'The Anti-Slavery Society Convention, 1840' by B. R. Haydon, p 538.

WIFFEN *Jeremiah Holmes* (*1792–1836*)

Poet and translator; quaker; opened school at Woburn, 1811; librarian at Woburn Abbey, 1821; published his own and his brother's poetry; published translations, including the work of Tasso, and other works.

2515 (18) Black chalk, with touches of Chinese white, on grey-tinted paper, $13\frac{3}{4} \times 10\frac{1}{8}$ inches ($35 \times 25 \cdot 8$ cm), by WILLIAM BROCKEDON, 1830. PLATE 985

Dated (*lower right*): 29.1.30

Collections: See *Collections:* 'Drawings of Prominent People, 1823–49' by W. Brockedon, p 554.

Accompanied in the Brockedon Album by a letter from the sitter, dated 1 February 1830.

ICONOGRAPHY A drawing by Sir G. Hayter of 1824 is in the British Museum, reproduced Mary Wiffen and S. R. Pattison, *The Brothers Wiffen* (1880), frontispiece, lithographed by R. J. Lane (example in NPG); a drawing or lithograph by Lane is listed in his 'Account Books' (NPG archives), II, 6, under 1836, for the Duchess of Bedford; an engraving by J. Thomson, after A. Wivell, was published H. Fisher, 1824 (example in NPG).

WIGNEY *Isaac Newton* (*c 1795–1844*)

MP for Brighton.

54 See *Groups:* 'The House of Commons, 1833' by Sir G. Hayter, p 526.

WILBERFORCE *Samuel* (*1805–73*)

Bishop; son of the famous William Wilberforce; rector, 1830–40; dean of Westminster, 1845; bishop of Oxford, 1845–69, and of Winchester, 1869–73; an important and influential church leader.

1054 Oil on paper, $17\frac{1}{2} \times 13\frac{1}{8}$ inches ($44 \cdot 4 \times 33 \cdot 2$ cm), by GEORGE RICHMOND, *c* 1864. PLATE 989

Collections: Purchased from the artist's executors, 1896.

This is a study for the three-quarter length portrait of Wilberforce owned by the Bishop of Oxford, listed in Richmond's 'Account Book' (photostat of original MS, NPG archives), p 78, as begun in 1864, and p 79, as finished in 1865[1]. The latter was exhibited *R A*, 1865 (61), engraved by S. Bellin (example

[1] An anecdote about Wilberforce's impatience at Richmond's delay in finishing the portrait is related in A. M. W. Stirling, *The Richmond Papers* (1926), pp 51–2. See also R. G. Wilberforce, *Life of the Right Reverend Samuel Wilberforce, D.D.* (1880–2), III, 76.

in NPG), and recorded and sketched in the Bishop of Oxford's Palace at Cuddesdon in 1866 by G. Scharf, 'SSB' (NPG archives), LXXVI, 25. Other portraits of Wilberforce by Richmond are as follows:

1 *1834*. Water-colour or drawing. Listed in Richmond's 'Account Book', p11, as engraved. Presumably the early looking portrait engraved by R. Woodman, published Hayward and Moore (example in NPG).

2 *1843*. Drawing. Collection of Mrs Arnold Reckitt. Listed in Richmond's 'Account Book', p34, under 1843. Exhibited *East Yorkshire Portraits*, Ferens Art Gallery, Hull, 1959 (47). Engraved by H. Robinson, published J. Hogarth, 1845 (example in NPG).

3 *c1851*. Drawing. Exhibited *VE*, 1892 (379), lent by the Rev Canon Wilberforce. Engraved by W. Holl (example in NPG), for the 'Grillions Club' series, engraving exhibited *RA*, 1860 (924). In the exhibition catalogue the drawing was said to be signed and dated 1850 or 1851. Wilberforce did not become a member of Grillions Club until 1851.

4 *1868*. Painting. Royal Academy, diploma work. Listed in Richmond's 'Account Book', p82, under 1868. Exhibited *RA*, 1868 (59). Two other versions of this type, identical to the Royal Academy portrait except that they show the sitter's hand resting on an open and not a closed book, are in the Westminster Abbey Deanery, and formerly in the collection of Miss Susan and Dr Octavia Wilberforce. The former was presented to the Deanery by the sitter's son, Archdeacon Wilberforce. The latter was sold at Christie's, 14 July 1939 (lot 21), presumably the portrait exhibited *VE*, 1892 (197), lent by Reginald Wilberforce. One of the two is listed in Richmond's 'Account Book', p82, under 1868, and was engraved by J. R. Jackson, published J. Mitchell, 1871 (example in NPG), engraving exhibited *RA*, 1872 (1299).

Description: Fresh complexion, dark eyes, brown hair. Dressed in white, red and black clerical and academic robes, holding a black mortar-board, with a blue ribbon at his neck supporting an episcopal medal (?). Holding the finial of a chair. Green curtain covers most of the background.

1993 Water-colour and body colour on green-toned paper, $12 \times 7\frac{1}{8}$ inches (30.5×18.2 cm), by APE (CARLO PELLEGRINI), 1869. PLATE 988

Signed (lower right): Ape

Collections: Charles Newman, purchased from him, 1923.

This is one of a large collection of original water-colour portraits for *Vanity Fair* in the NPG, which will be discussed collectively in the forthcoming Catalogue of Portraits, 1860–90. The water-colour of Wilberforce was published as a coloured lithograph (in reverse) in *Vanity Fair*, 24 July 1869, as 'Statesmen, No. 25/"Not a brawler".'

Description: Brown hair, blue eyes. Dressed in black and white clerical robes, with a blue ribbon round his neck.

4541 (9, recto) With Edward Pusey (1800–82) and others. Pen-and-ink on paper, $6\frac{3}{8} \times 8\frac{3}{4}$ inches (16.2×22.2 cm), by MISS CLARA PUSEY, *c*1856. PLATE 986

Inscribed in ink (top left): The Cadogan Express *and (bottom right):* coming out of Cathedral *and (bottom left):* Dearest Alice/How can I thank you & Jamie [*inscription here cut off*]

Collections: See *Collections:* 'Sketches of the Pusey Family and their Friends, *c*1856' by Miss C. Pusey, p563.

This drawing of various figures emerging from the cathedral at Christ Church, Oxford, was sent by Clara Pusey to her cousin, Alice Herbert. The only identifiable figures are Bishop Wilberforce in the doorway, and Edward Pusey on the right.

4541 (11, recto) Pencil and water-colour on paper, $6\frac{3}{8} \times 5\frac{1}{4}$ inches ($16\cdot3 \times 13\cdot3$ cm) uneven edges, by MISS CLARA PUSEY, *c* 1856. PLATE 987

Collections: As for NPG 4541 (9, recto) above.

This water-colour shows Wilberforce preaching, presumably in the cathedral at Christ Church.

Description: Blue eyes and dark hair; dressed in black and white clerical robes, with a blue ribbon round his neck supporting his episcopal medal; pulpit red and brown; greyish wash background.

ICONOGRAPHY A painting by F. R. Say is at Lambeth Palace, exhibited *RA*, 1846 (252), engraved by T. L. Atkinson, published T. Ryman, Oxford, 1849 (example in NPG); a painting by W. M. Tweedie was sold at Christie's, 10 June 1882 (lot 169), offered to the NPG, 1883, but declined, exhibited *RA*, 1863 (461), and *Victorian Era Exhibition*, 1897, 'Historical Section' (55), lent by F. Ryman Hall, sketched and recorded by G. Scharf, 1883, 'TSB' (NPG archives), XXX, 33; a painting by an unknown artist is at Oriel College, Oxford; Wilberforce appears in the painting of 'Napoleon III Receiving the Order of the Garter, 1855' by E. M. Ward in the Royal Collection, exhibited *RA*, 1858 (35); a water-colour by Dighton was sold at Sotheby's, 14 November 1932 (lot 315); a miniature or drawing by T. F. Heaphy was exhibited *RA*, 1848 (1066); a miniature by Sir W. J. Newton was sold at Christie's, 23 June 1890 (lot 171), pencil sketch in NPG sale catalogue; a wooden bust by an unknown artist of 1876 is at Christ Church, Oxford; a bust by T. W. Rowe was exhibited *RA*, 1874 (1622); a woodcut was published *ILN*, VII (1845), 336; there are several photographs, and woodcuts and engravings after photographs, in the NPG; others are reproduced R. G. Wilberforce, *Life of the Right Reverend Samuel Wilberforce, D.D.*, II (1881), frontispiece, and R. G. Wilberforce, *Bishop Wilberforce* (1905), frontispiece.

WILBRAHAM *George* (*1779–1852*)

MP for Cheshire South.

54 See *Groups:* 'The House of Commons, 1833' by Sir G. Hayter, p 526.

WILDE *Thomas, Baron Truro.* See TRURO

WILKINSON *Sir John Gardner* (*1797–1875*)

Explorer and Egyptologist; resided in Egypt, 1821–33, exploring and excavating; completed *Survey of Thebes*, 1830; his *Survey of Egypt*, 1835, became a standard work; knighted, 1839; account of his travels in Balkans published 1848; wrote on English antiquities, and aesthetics.

2515 (86) Black and red chalk on grey-tinted paper, $14\frac{1}{4} \times 10\frac{3}{8}$ inches ($36 \times 26\cdot4$ cm), by WILLIAM BROCKEDON, 1838. PLATE 990

Dated (lower left): 26.1.38

Collections: See *Collections:* 'Drawings of Prominent People, 1823–49' by W. Brockedon, p 554.

4026 (28) Pencil and black chalk, with faint touches of red on cheek and eyebrow, $11\frac{1}{8} \times 8\frac{1}{8}$ inches, ($28\cdot2 \times 20\cdot6$ cm), by COUNT ALFRED D'ORSAY, 1839. PLATE 991

Signed and dated (lower right): A. D'orsay/fecit/1st Decb 1839 *Autograph in ink (lower centre):* J. Gardner Wilkinson

Collections: See *Collections:* 'Drawings of Men About Town, 1832–48' by Count A. D'Orsay, p 557.

ICONOGRAPHY A painting by H. W. Phillips was exhibited *RA*, 1842 (138); possibly the painting attributed to Phillips, and said to be of 1844, at Calke Abbey, Derby, 1925 (reproduction in NPG); a drawing by J. F. Lewis was sold Sotheby's, 18 December 1963 (lot 170), bought Colnaghi; a photograph by E. Edwards is reproduced L. Reeve, *Men of Eminence*, I (1863), 73, and *ILN* (as a woodcut, detail only), LXVII (1875), 500.

WILLIAM IV (1765–1837)

Third son of George III; entered the navy, 1779; Duke of Clarence, 1789; lived with Mrs Jordan, c 1791–1811; married Adelaide of Saxe-Coburg Meiningen, 1818; succeeded to the throne, 1830; generally popular.

2199 Oil on canvas, 87 × 59 inches (221 × 149·8 cm), by SIR MARTIN ARCHER SHEE, c 1800. PLATE 997

Inscribed on a label, formerly on the back of the stretcher, below a cutting from Christie's catalogue of 18 March 1921: The above portrait was purchased at the Sale by the/late Wm. Lawson Peacock and is this day purchased from/his Exers. by Lieut. Col. Archer Shee M.P., D.S.O. and sent to/Ashurst Lodge Sunningdale – Ascot. June 7. 1922

Collections: Purchased by Hugo Wemyss from John Taylor, c 1900; Christie's, 18 March 1921 (lot 57), bought Peacock; sold to Colonel Archer Shee, 1922; purchased at Christie's, 29 June 1928 (lot 127), with the aid of a contribution from the National Art Collections Fund.

Literature: Possibly the portrait sketched and recorded by G. Scharf at Kensington Palace, 1881, 'SSB' (NPG archives), CXIV, 39.

Scharf's pencil drawing of the portrait at Kensington Palace is identical in pose and composition with the NPG portrait, which is possibly the same picture. There is no record of such a portrait still in the Royal Collection, so it may possibly have belonged personally to some member of the Royal Family and subsequently have been sold. According to Hugo Wemyss (letter of 18 October 1932, NPG archives) the NPG portrait was bought by him at a sale conducted by John Taylor, a furniture remover, in a room not normally used as a saleroom in Sloane Street around 1900, where it was catalogued as a portrait of an unknown gentleman in naval uniform.

The attribution to Shee was first suggested by Colin Agnew, on stylistic grounds, and is certainly right (Scharf listed the Kensington Palace portrait as 'apparently by Hoppner'). The head is almost identical with that in Shee's full-length portrait of William in the Walker Art Gallery, Liverpool, except that the features of the NPG picture suggest a slightly younger man; the Liverpool portrait was exhibited R.A. 1800 (12), engraved by and published J. Ward (example in NPG). Both portraits were presumably based on the same sitting from life, and show the sitter in a similar pose, though with a different setting and accessories. The costume in both is the full-dress uniform of an admiral, of the period 1795–1812, with the addition of peer's robes in the Liverpool version; William was appointed an admiral on 14 April 1799 (information from P. G. W. Annis of the National Maritime Museum, Greenwich). The two portraits may have been commissioned to celebrate this event. Another portrait of William IV by Shee was exhibited *R A*, 1801 (158).

Description: Light greenish-blue eyes, healthy complexion, grey (powdered?) hair. Dressed in a white stock, dark blue gold-braided naval uniform, with a white waistcoat and breeches, and black shoes with silver buckles, wearing the star, blue sash and garter of the order of the Garter, holding a cocked hat and sword in one hand, and a brass telescope in the other. A large mainly red flag draped over a cannon on the right, with four cannon balls below. Predominantly dark greyish sky, bluish-grey sea, and mainly brown rocky foreground.

3767 Oil on canvas, 24 × 20 inches (61 × 50·8 cm), by WILLIAM SALTER, c 1834–40. PLATE 1001

Collections: By descent to W. D. Mackenzie, who also owned the group portrait, and bequeathed by him, 1929.

One of several studies in the NPG for Salter's large picture of the 'Waterloo Banquet at Apsley House', now in the collection of the Duke of Wellington; the group was engraved by W. Greatbach, published F. G. Moon, 1876 (example in NPG). The NPG studies will be collectively discussed in the forthcoming Catalogue of Portraits, 1790–1830. William IV is shown in the uniform of a general, with the star and ribbon of the Bath.

Description: Fresh complexion, dark eyes, grey hair. Dressed in a red uniform, with black and gold-braided collar, cuffs and epaulettes, black trousers with a gold stripe, gold sash round his waist, red sword-belt with gold and red tassel, bone-hilted sword with gilt scabbard, crimson ribbon, silver star, gold medal with red and green ribbon, holding a cocked hat with white and red feathers. Background colour greenish-grey.

316a (141) Pencil on paper, 17⅛ × 13⅛ inches (43·5 × 33·3 cm), by SIR FRANCIS CHANTREY, 1837. PLATE 1002

Inscribed in pencil (lower right): Tracing from the Tracings/given to Lady Mary Fox and/Mademoiselle D'Este, August 1837/FC.

Collections: The artist, presented by the widow of one of his executors, Mrs George Jones, 1871.

This profile drawing is almost identical to NPG 316a (142) below, except that it is slightly larger, and is clearly derived from it. Both drawings are part of a collection of studies by Chantrey, which will be collectively discussed in the forthcoming Catalogue of Portraits, 1790–1830.

316a (142) Pencil on paper, 17⅛ × 13⅛ inches (43·5 × 33·3 cm), by SIR FRANCIS CHANTREY, 1830. PLATE 1002

Inscribed in pencil (lower right): Drawn from King William IIII./with a Camera Lucida,/ten days after he ascended the Throne/by F. Chantrey *and middle left, referring to two alternative lines defining the shape of the nose:* inner line/the true one

Collections: As for NPG 316a (141) above.

This 'camera lucida' drawing is related to the marble bust of 1831 in the collection of Lord de L'Isle and Dudley (for this and several later replicas, see iconography below). NPG 316a (141) above is a related copy of this drawing.

1163 Water-colour on paper, 11¼ × 9 inches (28·5 × 22·8 cm), by an UNKNOWN ARTIST, after a portrait by HENRY DAWE of *c* 1830. PLATE 1005

Collections: A. Leonard Nicholson, purchased from him, 1898.

This is similar in pose and features, though different in accessories, to the half-length engraving by J. Cochran, after a painting by Dawe then owned by Queen Adelaide, published Fisher, 1831 (example in NPG), for Jerdan's 'National Portrait Gallery'. A three-quarter length version of this type, possibly the same picture, was engraved by Dawe, published Colnaghi, 1830 (example in British Museum). A similar three-quarter length painting is in the collection of Earl Spencer, and another, wrongly attributed to Lawrence, was in the Duke of Cambridge's sale, Christie's, 11 June 1904 (lot 97). A related miniature by C. Jagger, then owned by the Countess of Erroll, was engraved and published by H. Dawe, 1827 (example in NPG), and another similar miniature, presumably by or after Jagger, is owned by the Duke of Richmond.

Description: The water-colour is very faded. Brownish eyes, greyish hair. Dressed in a white shirt and stock, blue sash and silver star of the order of the Garter, and green coat. Seated in a reddish chair, holding red leather book. Background colour grey and green.

1632 Pencil on paper, 12¼ × 8 inches (31·1 × 20·4 cm), attributed to SIR GEORGE HAYTER, *c* 1825–8. PLATE 1000

Inscribed on the original mount in pencil: From the Henriks Sale Nov 24 1909/remounted Aug 1910

Collections: Henriks Sale; Mrs M. E. Sadleir, presented by her, 1911.

William IV is wearing the uniform of an ordinary army general of the *c* 1825–8 pattern, with the star of the Garter. He is presumably represented as a general of Marines. Faint grid-lines are visible across the whole of the drawing. The attribution to Hayter is traditional. The drawing is not related to Hayter's group of the 'House of Lords, 1820' (see NPG 999 and 1659 (J) below).

1695 (J) With the Duke of Sutherland, Lord Pomfret and others unidentified. Pen and ink and wash on brown, slightly discoloured paper, $5\frac{3}{8} \times 8\frac{1}{8}$ inches ($13 \cdot 5 \times 20 \cdot 7$ cm), by SIR GEORGE HAYTER, 1820.
PLATE 995

Signed and dated (bottom right): House of Lords/no 9. GH Oct 1820 *and inscribed with the names of the sitters.*

Collections: M. B. Walker, purchased from him, 1913.

One of a collection of studies for Hayter's 'House of Lords, 1820' (see below), which will be discussed collectively in the forthcoming Catalogue of Portraits, 1790–1830.

4703 Water-colour on card, $8\frac{1}{8} \times 6$ inches ($20 \cdot 7 \times 15 \cdot 1$ cm), by REGINALD EASTON. PLATE 1006

Signed (lower right): R. Easton *Inscribed on the back of the original backboard in ink, in an old hand:* King William IV *Also on the backboard are two old labels for the framers, John Lane of 22 Albert Terrace, and for William Biggs of 31 Conduit Street.*

Collections: Hugo Cragoe, purchased from him, 1970.

William is shown wearing the star, badge and sash of the Garter, and an unidentified order around his neck. From the evidence of the sitter's age and a comparison with other portraits of him, this water-colour must date from the very end of William's life. Another almost identical version is in the Royal Library at Windsor.

Description: Healthy complexion, bluish-grey eyes, grey hair. Dressed in a white stock, white shirt and waistcoat, with a red ribbon and white and gold order at his neck, and a blue sash and grey and silver star, and a greyish-blue coat. Seated in a red and gilt chair. Salmon-pink curtain and grey pillar covering most of background; glimpses of blue sky top left and right.

2920 Red wax medallion, $2\frac{3}{8} \times 2\frac{1}{8}$ inches ($6 \times 5 \cdot 2$ cm) oval, by JOHN DE VEAUX. PLATE 999

Embossed (lower left): De Veaux. Sct.

Collections: R. M. Holland Martin, presented by him, 1937.

This is similar to an engraving by Freebairn, after a medal by W. Wyon, itself based on a bust by Chantrey, published R. Jennings (example in NPG). An intaglio gem of William IV by De Veaux, then in the collection of the Duke of Sussex, was exhibited *RA*, 1832 (1084).

999 See *Groups:* 'The House of Lords, 1820' by Sir G. Hayter, in forthcoming Catalogue of Portraits, 1790–1830.

ICONOGRAPHY This is a selective iconography, and only includes the more important portrait types. Popular prints and caricatures are excluded (examples in NPG and British Museum). 'Millar' refers to Oliver Millar, *The Later Georgian Pictures in the Collection of H. M. The Queen* (1969), 2 vols, and 'Oppé' to A. P. Oppé, *English Drawings . . . In the Collection of H. M. The King at Windsor Castle* (1950).

c1767 Painting by A. Ramsay. Royal Collection.
Millar (999), reproduced. This picture was previously called the Duke of Kent by Zoffany. Related studies for the composition are in the National Gallery of Scotland, Edinburgh.

1770 'George III, Queen Charlotte and their Six Eldest Children' by J. Zoffany. Royal Collection.
Millar (1201), reproduced. Engraved by R. Earlom, published R. Sayer, 1771 (example in British Museum). An oil sketch is also in the Royal Collection, Millar (1202), reproduced. Another version, possibly a copy, was in the McAlpin Hotel, New York, 1920.

1770 Engraving by Johnson, published R. Marshall, 1770 (example in British Museum).

c1770 Painting by J. Zoffany (with Princess Charlotte). Royal Collection.
Millar (1204), reproduced.

c1772 'The Establishment of the Academy of Arts' by G.Manini. Exhibited *Free Society of Artists*, 1772 (113).

c1773 'Queen Charlotte with Members of her Family' by J.Zoffany. Royal Collection. Millar (1207), reproduced. Exhibited *RA*, 1773 (320).

1778 Painting by Sir B.West (with his brother, the Duke of Kent). Royal Collection (plate 992). Millar (1144), reproduced. Exhibited *RA*, 1780 (7). A detail of William IV was engraved and published by V.Green, 1780 (example in NPG).

1779 'Queen Charlotte' (with her family in the background) by Sir B.West. Royal Collection. Millar (1139), reproduced. A variant version of 1782 is also in the Royal Collection, Millar (1140).

c1780 Engraving by J.Collyer, after T.Stothard (as a midshipman of the 'Prince George') (example in NPG), for Harvey's *Naval History*.

c1780 Engraving by F.Bartolozzi and P.Sandby, after Sir B.West (as a midshipman of the 'Prince George') (example in British Museum). The same picture was lithographed by W.Day, published Ackermann, 1832 (example in NPG).

1781 Anonymous engraving, published 1781 (example in NPG), for the *London Magazine*.

c1781 Painting by T.Gainsborough. Collection of Mrs Etienne Boegner, USA. From the collection of the Duke of Cambridge. Engraved by G.Dupont (example in British Museum). A secondary version of 1782 is in the Royal Collection (plate 993), exhibited *RA*, 1783 (134), listed by Millar (781), where both portraits are reproduced.

1783 Anonymous engraving, published J.Walker, 1783 (example in NPG).

1785 Drawing called William IV by J.Downman. Royal Collection. Oppé, p44 (190).

c1785 Drawing by O.Humphry. Reproduced G.C.Williamson, *Life and Works of Ozias Humphry* (1918), facing p42, when in the Turner collection.

1787 'The Royal Family, 1787', engraving by J.Murphy, after T.Stothard, published J.Jeffryes, 1794 (example in NPG).

1787 Wedgwood medallion by J.Lochee. Wedgwood Museum, Barlaston. Exhibited *Wedgwood*, Kenwood, 1954 (154). Two Wedgwood medallions by J.Flaxman are reproduced M.Jonas, *Notes of an Art Collector* (1908), p4.

1788 Anonymous engraving, published R.Morison, Perth, 1788 (example in NPG).

1788 Engraving by E.Scott, after a drawing by Sir T.Lawrence, itself based on a bust by J.Lochee, published Scott, 1788 (example in NPG). A model by J.Lochee, presumably for a bust, was exhibited *RA*, 1786 (302).

1790 Engraving by I.Salliar, after R.Cosway, published Cosway, 1790 (example in British Museum).

c1790 Miniature by P.Jean. Exhibited *RA*, 1790 (326).

1791 Miniature by R.Cosway. Royal Collection (plate 994). Exhibited *Royal House of Guelph*, New Gallery, 1891 (362), and *Kings and Queens*, RA, 1953 (267), reproduced 'Illustrated Souvenir', p76. Another version of the same type, except that the sitter is in Garter robes, is in the Walters Art Gallery, Baltimore, probably the miniature formerly in the collection of the Duke of Cambridge, reproduced G.C.Williamson, *Richard Cosway, R.A.* (1897), facing p1, sold Christie's, 10 June 1904 (lot 321). There are two versions of an earlier miniature type by Cosway: 1. Collection of Viscount Hood (mounted in a gold snuff-box), exhibited *Royal Gifts*, Christie's, 1961–2 (28). 2. Reproduced G.C.Williamson, *Catalogue of Miniatures of the Duke of Cumberland* (1914), plate XX. There is an engraving by E.Scriven, after a different miniature by Cosway (example in NPG). Two miniatures by Cosway were exhibited *Royal House of Guelph*, New Gallery, 1891 (373),

lent by the then Prince of Wales, and (414), lent by the Earl of Portarlington; another was exhibited *Royal Naval Exhibition*, 1891 (1861), lent by the Duke of Edinburgh; another (as a midshipman) was in the Duke of Cambridge's Sale, Christie's, 10 June 1904 (lot 318); another is listed by Williamson, *Richard Cosway, R.A.* (1897), p 109, as then in the collection of the Hon William Fielding. A drawing attributed to Cosway is in the Royal Collection, listed by Oppé, p 37 (153).

c 1791 Painting by J. Hoppner. Royal Collection (the picture was in the Carlton House fire, and is in very poor condition). Millar (835). Engraved by E. Hodges, published W. Dickinson, 1792 (example in British Museum). Presumably the portrait exhibited *R A*, 1791 (98); another portrait by Hoppner was exhibited *R A*, 1792 (195). A half-length copy is at Clarence House.

1792 Engraving by C. Warren, after R. Corbould, published C. Cooke, 1792 (example in NPG).

1793 Painting by Sir T. Lawrence. Collection of Lord de L'Isle and Dudley.
Exhibited *R A*, 1793 (63), and *Royal House of Guelph*, New Gallery, 1891 (87). A replica is at Upton House (National Trust), exhibited *Kings and Queens*, RA, 1953 (265), reproduced 'Illustrated Souvenir'; another version is in the collection of Major Goff, reproduced *Country Life*, XCIII (1943), 74.

1793 'Introduction of the Duchess of York to the Royal Family', engraving by J. Murphy, after R. Livesay, published E. Walker, 1793 (example in British Museum).

1794 Engraving by C. Knight, after J. Hoppner, published 1794 (example in British Museum).

1795 Caricature etching by J. Gillray (entitled 'Naval Eloquence'), published H. Humphrey, 1795 (example in NPG).

c 1796 Painting by J. Hoppner. Exhibited *R A*, 1796 (173).

c 1797 Miniature by R. Bowyer. Exhibited *R A*, 1797 (1043).

1800 Engraving by J. Chapman, published 1800 (example in NPG).

c 1800 Paintings by Sir M. A. Shee (see NPG 2199 above).

c 1800 Miniature by H. Hone. Christie's, 29 November 1966 (lot 23).
Reproduced in the sale catalogue, where it is wrongly identified as George IV.

c 1800 Miniature called William IV by A. Robertson. Collection of J. B. Roberts.

1804 'Woburn Sheepshearing' by G. Garrard. Collection of the Duke of Bedford, Woburn.
Engraved by J. C. Stadler and T. Morris, published G. Garrard, 1811 (example in British Museum).

1806 Engraving by T. Cheesman, after Sir W. Beechey, published E. Harding, 1806 (example in NPG), for 'Portraits of the Whole of the Royal Family'.

1809 Miniature by R. Cosway. Royal Collection.
Sketched by G. Scharf, 'T S B Windsor' (NPG archives), III, 28.

c 1809 Drawing by H. Edridge. Exhibited *R A*, 1809 (491).

c 1810 Miniature by A. Robertson. Reproduced *Letters and Papers of Andrew Robertson*, edited Emily Robertson (c 1898), facing p 176. Possibly the miniature by Robertson exhibited *Exhibition of Portrait Miniatures*, Burlington Fine Arts Club, 1889, p 36 (49), and *Royal House of Guelph*, New Gallery, 1891 (991), lent by Jeffery Whitehead.

c 1813 Drawing by H. Edridge. Exhibited *R A*, 1813 (606).

1818 Two miniatures by P. Fischer. Royal Collection.

1819 Miniature by S. T. Roche. Duke of Cambridge's Sale, Christie's, 13 June 1904 (lot 442).

1820 'House of Lords, 1820' by Sir G. Hayter (NPG 999 above).
Study (NPG 1695J above).

1821 'Banquet at the Coronation of George IV' by G. Jones. Royal Collection.
Millar (867), reproduced. Exhibited *British Institution*, 1823 (42).

1821 Engraving by W. Skelton, published Skelton, 1821 (example in British Museum).

c1825–8 Drawing attributed to Sir G. Hayter (NPG 1632 above).

1827 Miniature by J. Holmes (?). Collection of Mrs Hore-Ruthven.
Recorded by J. Steegman, *Portraits in Welsh Houses* (1962), II, 11. Possibly the portrait lithographed by Holmes, published Colnaghi and Holmes (example in British Museum).

1827 Plaster medallion by J. Henning. Scottish NPG.

1827 Engraving by W. Ward junior, after A. Wivell, published W. Sams, 1827 (example in NPG). Engraved again by W. Holl, published W. Sams, 1829 (example in NPG). There is a lithograph by M. Gauci, and an anonymous engraving, published W. Sams, after a similar type, save that the sitter is in civil not naval uniform (examples in NPG).

1827 Engraving by S. Freeman, after W. M. Craig, published E. Orme, 1827 (example in British Museum).

1827 Anonymous lithograph, published 1827 (example in NPG), for subscribers to the *Weekly Times*.

c1827 Painting by Sir T. Lawrence. Royal Collection.
Millar (877), reproduced. Exhibited *RA*, 1829 (57). Engraved by T. Hodgetts, published Colnaghi, 1831 (example in NPG). A half-length version of 1830 (showing the sitter in masonic robes) is in the collection of the Prince of Wales Masonic Lodge. A chalk study is in the collection of the Duke of Richmond (plate 996), reproduced Millar, presumably the drawing in the Lawrence Sale, Christie's, 19 June 1830 (lot 406), lithographed by F. C. Lewis, published Colnaghi, 1831, and anonymously engraved, published Colburn and Bentley, 1831 (examples in NPG). Related drawing: Sotheby's, 12 February 1964 (lot 120), as by Wilkie, bought Folio Society. An enamel after Lawrence by J. Lee was exhibited *RA*, 1832 (487).

1829 Lithograph by A. Dubois Drahonet (drawn from life, at Dieppe, 1829), published Paris (example in NPG).

1830 Engraving by W. Say, after M. W. Sharp, published W. Sams, 1830 (example in British Museum).

1830 Engraving by D. Lucas, after R. Bowyer, published Bowyer, 1830 (example in British Museum).

1830 Engraving by W. Nicholas, after A. M. Huffam, published S. Hollyer, 1830 (example in British Museum).

c1830 Paintings by H. Dawe (see NPG 1163 above).

c1830 Painting by A. Morton. Exhibited *RA*, 1830 (182).
Presumably the portrait engraved by S. W. Reynolds, published Colnaghi, 1832 (example in British Museum). There are several other variant versions of this type, including one at the National Maritime Museum, Greenwich, and another at London University. According to Colonel C. Field, *Britain's Sea-Soldiers* (1924), I, 274, William IV presented five full-length portraits of himself by Morton to each of five divisions of the Royal Marines, in 1831. A lithograph by R. J. Lane, after a drawing by Morton, then owned by Viscountess Falkland, was published J. Dickinson, 1831 (example in NPG). An enamel miniature by H. Bone, after Morton, was exhibited *RA*, 1831 (464).

1831 'The Opening of London Bridge, 1831' by G. Jones. Exhibited *RA*, 1832 (180).
Key reproduced A. T. Bolton, *The Portrait of Sir John Soane* (1927), facing p 474.

1831 Coronation medal by W. Wyon. Reproduced *Connoisseur*, III (1903), 174.

1831 'Coronation of William IV' by R. B. Davis. Royal Collection.
Millar (728).

1831 Marble bust by Sir F. Chantrey. Collection of Lord de L'Isle and Dudley.
Possibly the bust exhibited *RA*, 1831 (1190), listed in Chantrey's 'Ledger' (MS, Royal Academy), p 226. Related drawings, one of 1830 (NPG 316a (141,2) above).

1831 Statue by W. M. Gardner. Cheltenham.

1831 Miniature bronze bust by S. Parker. Scottish NPG.

1831 Engraving by B. Holl, after A. Wivell, published T. Kelly, 1831 (example in NPG).

c 1831 Painting by Sir W. Beechey. Trinity House, London.
Exhibited *R A*, 1831 (65). Other portraits by or attributed to Beechey are owned by the Admiralty, the Houses of Parliament and the Novia Scotia Legislative Library. A full-length painting (in robes) was in the Beechey Sale, Christie's, 11 June 1836 (lot 72). Another was exhibited *Royal Naval Exhibition*, Chelsea, 1891 (379), lent by the Baroness Burdett-Coutts. Beechey exhibited portraits of William IV *R A*, 1832 (197), and 1833 (71). A miniature by Bone, after Beechey, was exhibited *R A*, 1833 (497), and another of 1831 exhibited *Royal House of Guelph*, New Gallery, 1891 (990), lent by J. Whitehead.

1832 Painting by J. Simpson. Brighton Art Gallery.
Exhibited *R A*, 1833 (317).

1832–4 Painting by S. Lane. Houses of Parliament.

1832 'Signing of the Reform Bill', marble relief by Sir F. Chantrey. Collection of the Earl of Leicester, Holkham.

1832 Bust by Sir F. Chantrey. Commissioned by the Goldsmiths Company. Listed in Chantrey's 'Ledger' (MS, Royal Academy), p 229. Another bust by Chantrey of the same year, commissioned by the King and given to the Earl of Munster, is listed p 232.

1832 Painting by Sir D. Wilkie (in garter robes). Royal Collection (Waterloo Chamber, Windsor).
Millar (1185), reproduced. Exhibited *R A*, 1832 (71). According to C. H. Collins Baker, *Catalogue of the Principal Pictures in the Royal Collection at Windsor Castle* (1937), p 312, another version was presented to the Scottish Hospital, 1833. A three-quarter length replica is in the Toledo Museum of Art, and a head and shoulders replica in the City Museum and Art Gallery, Birmingham (a signature and date, '1838', on the latter picture may not be genuine). There is a version of 1835 in the Examination Schools, Oxford. A copy was in the Ormond collection (art market, 1954). Studies are in the Royal Collection, exhibited *Wilkie Exhibition*, RA, 1958 (86); collection of Brinsley Ford; and formerly collection of John Woodward. A related unfinished oil sketch is in the collection of Lord de L'Isle and Dudley, exhibited *Old Masters*, British Institution, 1842 (71). A water-colour by Wilkie in the Tate Gallery, and a sketch in the Royal Collection, both showing William IV in garter robes (the former, with Queen Adelaide), may represent a project for a double state portrait. A painting by Wilkie was exhibited *R A*, 1837 (67). For other portraits see 1833 and *c* 1833 below.

1832 Two busts by J. Francis. Freemasons Hall, and the Mansion House, London.
One of these was exhibited *R A*, 1832 (1150).

c 1832 'William IV Holding a Council', lithograph by J. Knight, published Knight (example in British Museum).

c 1832 Bust by J. C. F. Rossi and two models for statues. Exhibited *R A*, 1832 (1174).

1833 Painting by Sir D. Wilkie (in the uniform of the Grenadier Guards). Wellington Museum, Apsley House, London (plates 1003, 1004). Exhibited *R A*, 1833 (140), and *Wilkie Exhibition*, RA, 1958 (35).

1833 Painting by Sir M. A. Shee. Royal Collection.
Millar (1084), reproduced. Exhibited *R A*, 1834 (67) and *S K M*, 1868 (320). A replica of this portrait is in the Royal Academy, exhibited *R A*, 1835 (63), and *British Portraits*, RA, 1956–7 (524). One of the two versions was engraved by C. Turner, published Colnaghi, 1836 (example in British Museum); a half-length detail of the portrait was also engraved by Turner, published Colnaghi, 1836 (example in NPG). A copy of the Royal Academy portrait is in the Royal Collection, Millar (1089). Another portrait of William IV by Shee was exhibited *R A*, 1838 (121).

1833 Water-colour by Sir D. Wilkie (seated, in uniform). Collection of Mrs T. G. Winter. Exhibited *Wilkie Exhibition*, RA, 1958 (85).

c 1833 Painting by Sir D. Wilkie (in civil costume). Scottish NPG.
The head is similar to that in the Apsley House portrait. Another similar portrait is at Slane Castle; see Millar (1185).

1834 Bust by Sir F. Chantrey. Commissioned by Lord Holland.
Listed in the artist's 'Ledger' (MS, Royal Academy), p241.

1834 Marble bust by S. Joseph. Collection of Lord de L'Isle and Dudley.
Presumably the bust exhibited *R A*, 1835 (1052).

1834 Plaster statuette by J. P. Dantan. Musée Carnavalet, Paris.
Reproduced J. Seligman, *Figures of Fun* (1957), plate 11.

c 1834 Painting by J. Simpson. United Service Club, London.
Exhibited *R A*, 1834 (284). Another painting by Simpson is in the National Gallery of Ireland, Dublin.

1835 Miniature by an unknown artist. Recorded in the collection of R. Harvey Mason, Nector Hall, 1908, by Prince F. D. Singh, *Portraits in Norfolk Houses* (1927), II, 95.

1835 Marble bust by Sir F. Chantrey. Greenwich Palace Chapel.

1835 Marble bust by S. Joseph. United Service Club, London.

1836 Engraving by R. Woodman, after K. Meadows, published Lamb and Son, 1836 (example in British Museum).

c 1836 Painting by J. H. Carter (with Sir Charles Morgan, in Windsor Park). Collection of Mrs D. L. Corkery, Southerndown. Recorded by J. Steegman, *Portraits in Welsh Houses* (1962), II, 101.
Lithographed by M. Gauci (example in British Museum). Several other versions of the picture exist.

c 1836 Miniature by Sir W. J. Newton. Exhibited *R A*, 1836 (788).
Possibly the miniature exhibited *Royal House of Guelph*, New Gallery, 1891 (1884), lent by the Earl of Mayo.

1837 Miniature by Sir W. J. Newton. Duke of Cambridge's Sale, Christie's, 10 June 1904 (lot 291).

1837 Marble bust by Sir F. Chantrey. Royal Collection (formerly at Kew Palace) (plate 998).
Listed in Chantrey's 'Ledger' (MS, Royal Academy), p276. Other busts by Chantrey are at Eton College (1836); Royal Collection (1837); formerly Herrenhausen, Hanover (1837); the Royal Academy (1841), exhibited *British Portraits*, RA, 1956–7 (522); the Ashmolean Museum, Oxford (plaster model); the Admiralty (1841), exhibited *Royal Naval Exhibition*, Chelsea, 1891 (2839); and collection of Mrs E. Trench, 1944. Related drawings (NPG 316, 141,2 above).

1837 Engraving by W. Skelton, published W. Deeley, 1837 (example in NPG).

c 1837 Miniature by an unknown artist (said to be the last portrait of William IV from life).
Collection of Lord de L'Isle and Dudley. Reproduced *Connoisseur*, XVI (1906), 24.

c 1837 Statue by an unknown artist. Göttingen, Germany.
Reproduced *Liverpool Libraries, Museums and Arts Committee Bulletin*, IV (1954), 18.

1844 Granite statue by S. Nixon. Greenwich.
Study for head exhibited *R A*, 1843 (1415).

c 1844 Statue by C. B. Robinson. Exhibited Westminster Hall, 1844.
See R. Gunnis, *Dictionary of British Sculptors* (1953), p324.

1867 Statue by W. Theed. Sessions House, Old Bailey, London.

Undated Painting by an unknown artist. Deal Borough.

Undated Painting attributed to Sir G. Hayter. Walker Art Gallery, Liverpool.
See *Liverpool Libraries, Museums and Arts Committee Bulletin*, IV (1954), 17–20, reproduced on the cover.

Undated Painting attributed to Sir G. Hayter. The Admiralty, Sheerness.

Undated Painting by an unknown artist. Collection of the Earl of Denbigh, Newnham Paddox, 1907.

Undated 'The Waterloo Banquet' by W. Salter. Collection of the Duke of Wellington, Apsley House. Engraved by W. Greatbach, published F. G. Moon, 1846 (example in NPG). Study (NPG 3767 above).

Undated Water-colour by R. Dighton. Sotheby's, 14–15 July 1932 (lot 306).

Undated Drawing by H. D. Hamilton. Royal Collection.
Oppé (286).

Undated Miniature attributed to E. Miles. Victoria and Albert Museum.

Undated Miniatures by R. Easton, J. Meyer and an unknown artist. Royal Collection.
The miniature by Meyer was exhibited *Royal House of Guelph*, New Gallery, 1891 (360). Another version of the Easton is in the NPG (see 4703 above).

Undated Two miniatures by unknown artists (as a boy, one showing him as a sailor). Duke of Cambridge's Sale, Christie's, 13 June 1904 (lots 457 and 465a). One of them possibly the miniature exhibited *Royal House of Guelph*, New Gallery, 1891 (387).

Undated Miniature by Mary, wife of 7th Earl of Denbigh. Collection of the Earl of Denbigh, Newnham Paddox, 1907.

Undated Miniature by an unknown artist. Exhibited *Royal Naval Exhibition*, Chelsea, 1891 (1860), lent by G. H. Rudd.

Undated Miniature by an unknown artist. Exhibited *Portrait Miniatures*, South Kensington Museum, 1865 (2224), lent by J. Brett.

Undated Miniature by Hamburger. Collection of the Queen of Holland, 1924.

Undated Miniature by an unknown artist. White's Club, London.
Exhibited *Victorian Era Exhibition*, 1897, 'Historical Section' (640).

Undated 'George III with his Sons and Sons-in-law', silhouette by F. Atkinson. Wellesley Sale, Christie's, 19 June 1917 (lot 133). Reproduced *One Hundred Silhouette Portraits Selected from the Collection of Francis Wellesley* (1912), plate I.

Undated Silhouette by Watkin. Wellesley Sale (lot 132). Reproduced Wellesley, plate VIII.
Other silhouettes by Watkin are in the Victoria and Albert Museum, and the Royal Collection, the latter reproduced *Connoisseur*, XC (1932), 292.

Undated Engraving of silhouette by I. Bruce (example in NPG).

Undated Statue by L. Gahagan. Sold from Chandos House, Bath, 1840.
See R. Gunnis, *Dictionary of British Sculptors* (1953), p 161.

Undated Plaster bust by an unknown artist. Formerly Royal United Service Museum.

Undated Wax medallion by J. de Veaux (see NPG 2920 above).

Undated Wax medallion by I. Gosset (as a young man). Collection of Miss Gosset, 1922.

WILLIAMS *F.*

Doorkeeper of the House of Commons.

54 See *Groups:* 'The House of Commons, 1833' by Sir G. Hayter, p 526.

WILLIAMS-BULKELEY *Sir Richard Bulkeley, Bart (1801–75)*

MP for Anglesey.

54 See *Groups:* 'The House of Commons, 1833' by Sir G. Hayter, p 526.

WILLIAMSON *Sir Hedworth, Bart* (*1797–1861*)

MP for County Durham North.

54 See *Groups:* 'The House of Commons, 1833' by Sir G. Hayter, p 526.

WILLOUGHBY DE ERESBY *Peter Robert Drummond-Willoughby, 22nd Baron* (*1782–1865*)

Joint hereditary lord great chamberlain.

342, 3 See *Groups:* 'The Fine Arts Commissioners, 1846' by J. Partridge, p 545.

WILLSHIRE *Sir Thomas, Bart* (*1789–1862*)

General; served in South America, Portugal, the Netherlands, and India; commander of Bombay infantry, 1839; commandant at Chatham, 1841–6; general and GCB, 1861.

2008 Miniature, water-colour and body colour on ivory, $3\frac{1}{4} \times 2\frac{1}{2}$ inches ($8\cdot1 \times 6\cdot3$ cm) oval, by an UNKNOWN ARTIST. PLATE 1007

Collections: Percy Webster, purchased from him, 1923.

The early history of this miniature is unknown, but it appears to be correctly identified. Willshire is dressed in military uniform, and he is shown wearing the Peninsular Medal, the ribbon, badge and star of the order of the Bath, and the ribbon and star of the order of the Doranee Empire (1st Class).

Description: Healthy complexion, brown eyes, grey hair. Dressed in a white shirt, black stock, and a red uniform, with a black collar, a crimson ribbon round his neck, and a crimson and green ribbon across his chest, with variously coloured medals and orders. Background colour bluish-grey.

ICONOGRAPHY A painting by T. Heaphy was exhibited *VE*, 1892 (288), lent by Lady Willshire, and a miniature by an unknown artist was formerly in the Royal United Service Museum.

WILMOT *Sir John Eardley Eardley, Bart* (*1783–1847*)

Slavery abolitionist.

599 See *Groups:* 'The Anti-Slavery Society Convention, 1840' by B. R. Haydon, p 538.

WILSON *Horace Hayman* (*1786–1860*)

Orientalist; assistant-surgeon to East India Co; learnt Hindustani; assay master at Calcutta mint, 1816; studied Sanskrit, and Indian drama; professor of Sanskrit, Oxford, 1832; librarian to East India Co, 1836; director of Royal Asiatic Society, London, 1837–60; published Indian texts, and a Sanskrit–English dictionary.

2748 Oil on canvas, 30×25 inches ($76\cdot2 \times 63\cdot5$ cm), by an UNKNOWN ARTIST. PLATE 1010

Collections: The sitter, bequeathed by his grandson, Alexander Hayman Wilson, 1934.

This portrait was formerly attributed to George Chinnery, whose name was mentioned in the will of Alexander Wilson. Both artist and sitter were in Calcutta for several years at the same period. While the style of the portrait is vaguely Chinneryesque, the attribution, on purely stylistic grounds, is not very convincing.

Description: Healthy complexion, brown eyes and hair. Dressed in a white stock and shirt, and a black coat, holding a newspaper, and resting one arm on a green table (it is a seated pose). Most of background covered by a red curtain. Sliver of brown wall at left.

316a (143) Profile and full-face views on the same sheet. Pencil on paper, $18\frac{3}{4} \times 25\frac{5}{8}$ inches ($47 \cdot 5 \times 65 \cdot 1$ cm), by SIR FRANCIS CHANTREY, *c* 1837. PLATE 1009

Inscribed in pencil (bottom centre): Professor Horace Hayman Wilson/St Giles's/Oxford

Collections: The artist, presented by the widow of one of his executors, Mrs George Jones, 1871.

These 'camera lucida' drawings are related to the marble bust of Wilson in the Asiatic Society, Calcutta, exhibited *RA*, 1837 (1286). There is a related cast in the Ashmolean Museum, Oxford, and a further bust by or after Chantrey on the façade of the India Office building, London. The NPG drawings are part of a collection of studies by Chantrey in the NPG, which will be collectively discussed in the forthcoming Catalogue of Portraits, 1790–1830.

826 Water-colour on paper, $5\frac{1}{2} \times 4\frac{3}{8}$ inches ($13 \cdot 9 \times 11 \cdot 3$ cm), by JAMES ATKINSON, 1821. PLATE 1008

Inscribed in pencil, presumably in the artist's hand (top right): Gardens Oct 4.1821 *and (bottom right):* H H Wilson

Collections: The artist, presented by his son, Canon J. A. Atkinson, 1889.

This drawing was executed in Calcutta, where Wilson was assay master at the Mint, and Atkinson his assistant. Several other portraits by Atkinson were presented by his son, including a self-portrait (NPG 930).

Description: Healthy complexion, brown eyes and hair. Dressed in a white shirt and neck-tie, and a dark coat.

ICONOGRAPHY A painting by Sir G. Hayter was in the collection of Maurice Beaufoy, the sitter's great-grandson, 1934; a painting by R. Tait was exhibited *SKM*, 1868 (554), lent by the artist; a painting by J. Goodrich was exhibited *RA*, 1842 (463); a painting by R. Home is in the Asiatic Society, Calcutta, listed in C. R. Wilson, *A Descriptive Catalogue of the Asiatic Society of Bengal* (Calcutta, 1897), pp 30–1; a painting by Sir J. Watson Gordon was in the Royal Asiatic Society, London (destroyed before 1943, owing to its poor condition), engraved by and published W Walker, 1851 (example in NPG); a water colour by an unknown artist of 1808 is in the Victoria Memorial Hall, Calcutta.

WILSON *James* (*1805–60*)

Politician and political economist; developed successful business manufacturing hats; established the *Economist*, 1843; MP from 1847; held various government posts; introduced paper currency and direct taxation, and reformed system of public accounting.

2189 Oil on canvas, $50\frac{1}{8} \times 40$ inches ($127 \cdot 3 \times 101 \cdot 6$ cm), by SIR JOHN WATSON GORDON, 1858. PLATE 1011

Signed and dated (bottom left): Sir John Watson Gordon/RA & PRSA pinxit/1858

Collections: The sitter's wife; Mrs Bagehot; presented by Mrs Russell Barrington, the sitter's daughter, 1928.

Exhibitions: *RA*, 1859 (194); *SKM*, 1868 (544).

Literature: Dictionary of National Biography, LXII (1900), 102; Emilie I. [Mrs Russell] Barrington, *The Servant of All* (1927), II, 12–13, 123, reproduced facing 12.

This portrait was presented to Mrs Wilson by the Royal Scottish Academy in recognition of the services her husband had rendered to them in 1858, when he was financial secretary to the Treasury. He secured the land on which the Academy is now built. The Academy also presented Mrs Wilson with a replica of Sir J. Steell's marble bust of Wilson in the Scottish NPG (see iconography below). In a letter of 17 May 1859, Watson Gordon wrote (*Servant of All*, II, 12–13): '*Nothing can exceed the satisfaction I feel at the kindly manner in which you express your approbation of the Portrait of Mr Wilson. Indeed it is most gratifying considering the great obligations we all feel ourselves under to the original*'. Wilson himself

records sitting to Watson Gordon and Steell in a letter of 20 December 1858 (*Servant of All*, II, 123). The NPG portrait was engraved by F. Stacpoole, published H. Graves, 1860 (example in NPG). A copy of the portrait was given by Wilson's children to the gallery of local worthies in Hawick town hall.

Description: Healthy complexion, dark eyes, brown hair. Dressed in a white shirt, black neck-tie and suit, with a gold-mounted monocle suspended on a black cord from his neck. Seated in a red armchair. Background colour various tones of brown and green.

ICONOGRAPHY A marble statue by Sir J. Steell of 1865 is in the Dalhousie Institute, Calcutta, reproduced as a woodcut *ILN*, XLVII (1865), 428, and E. I. Barrington, *The Servant of All* (1927), II, facing 315; a marble bust by Steell of 1859 is in the Scottish NPG, and a replica was presented to the sitter's wife; a related plaster cast, also of 1859, is in the Museum at Hawick; Wilson appears in the engraving of the 'Meeting of the Council of the Anti-Corn Law League' by S. Bellin, after a painting by J. R. Herbert of 1847, published Agnew, Manchester, 1850 (example in NPG); a caricature drawing by R. Doyle is in the British Museum; a woodcut, after a daguerreotype by Beard, was published *ILN*, XI (1847), 369; there is an engraving by D. J. Pound, after a photograph by Davy of Plymouth (example in NPG), for the 'Drawing Room Portrait Gallery'; a photograph is reproduced *The Servant of All*, I, frontispiece.

WILSON *William*

Slavery abolitionist.

599 See *Groups:* 'The Anti-Slavery Society Convention, 1840' by B. R. Haydon, p 538.

WINCHILSEA *George, 11th Earl of* (*1815–87*)

4026 (60) See *Collections:* 'Drawings of Men About Town, 1832–48' by Count A. D'Orsay, p 557.

WINDSOR *Prince Edward Albert Christian George Andrew Patrick David, Duke of* (*1894–1972*)

4536 'The Four Generations', see entry under Queen Victoria, p 475.

WINMARLEIGH *John Wilson Patten, 1st Baron* (*1802–92*)

MP for Lancashire North.

54 See *Groups:* 'The House of Commons, 1833' by Sir G. Hayter, p 526.

WISEMAN *Nicholas Patrick Stephen, Cardinal* (*1802–65*)

Leader of the Roman Catholic church in England; ordained, 1825; rector of English College at Rome, 1828–40; held various papal appointments in England; exerted strong influence on the Oxford Movement; archbishop of Westminster and cardinal, 1850; helped to allay Protestant fears; widely respected; published numerous works; Westminster Cathedral built in his memory.

2074 Black and white chalk on brown, discoloured paper, mounted over canvas on a stretcher, $21\frac{3}{4} \times 16\frac{1}{2}$ inches (55.2 × 42 cm), attributed to HENRY EDWARD DOYLE. PLATE 1014

Inscribed on an old-looking label, formerly on the back of the frame: Cardinal Wiseman/By/Richard Doyle

Collections: Presented by Cardinal Bourne, Archbishop of Westminster, 1924.

This drawing is not unlike H. E. Doyle's style (it is quite untypical of Richard Doyle's work), and the label may well have confused the two artists. There are old damage marks on the drawing, on the right cuff, on the mitre at the right, and the scoured lines lower left and centre. For another drawing

by H.E.Doyle see NPG 4237 below, and for one attributed to R.Doyle see NPG 4619 below. A water-colour by H.E.Doyle of 1858 is in the Irish NPG, possibly that exhibited *RA*, 1858 (794), and *Dublin Exhibition*, 1872, 'Portraits' (425), lent by the artist. Two drawings said to be by Richard Doyle are in a scrapbook owned by the Earl of Wemyss.

4237 Coloured chalk on brown, slightly discoloured paper, $18\frac{3}{8} \times 12\frac{5}{8}$ inches (46·6 × 32·1 cm), by HENRY EDWARD DOYLE. PLATE 1012

Signed and dated (lower right): H E [*in monogram*] Doyle
Collections: E.Kersley, purchased from him, 1961.

This is not apparently related to the other drawing attributed to Doyle in the NPG (see 2074 above).

4619 Pen and ink on paper, $10\frac{5}{8} \times 7\frac{1}{2}$ inches (26·9 × 19 cm), attributed to RICHARD DOYLE. PLATE 1013

Inscribed in pencil along the bottom: Cardinal Wiseman/by R.Doyle
Collections: Mrs Mavis Strange, purchased from her, 1968.

This drawing certainly represents Wiseman, but there is nothing to support the attribution; the inscription looks considerably later than the drawing. For portraits by or attributed to Henry Doyle see NPG 2074 and 4237 above.

ICONOGRAPHY A painting by J.R.Herbert is at St Mary's College, Oscott, exhibited *RA*, 1842 (530), and *VE*, 1892 (207), engraved and published by G.R.Ward, 1855 (example in NPG), engraving exhibited *RA*, 1855 (1027); a miniature after it is reproduced W.Ward, *Life and Times of Cardinal Wiseman* (1897), II, frontispiece; paintings by T.Furse of *c* 1840 and by an unknown artist are in the English College at Rome; a painting by T.Brigstocke was exhibited *RA*, 1851 (463), and *SKM*, 1868 (526), lent from St Cuthbert's College, Ushaw; a painting is reproduced D.Gwynn, *Cardinal Wiseman* (1929), facing p44; a painting by J.P.Haverty was exhibited *Dublin Exhibition*, 1872, 'Portraits' (284); miniatures by F.Rochard and Miss Raimbach were exhibited *RA*, 1837 (586), and 1852 (826), the former probably the one, then in the collection of Cardinal Vaughan, reproduced W.Ward, I, frontispiece; a miniature by an unknown artist was exhibited *VE*, 1892 (442), lent by Cardinal Manning; busts by C.Moore were exhibited *RA*, 1851 (1321), 1853 (1358), Crystal Palace Portrait Gallery, 1854, and Leeds, 1853; a bust by S.Clint was exhibited Liverpool Academy, 1837; a bust by J.Currie was exhibited *RA*, 1865 (1027); a monument by E.W.Pugin is in Westminster Cathedral; a sketch design by C.A. Buckler for a monument is in the collection of the Royal Institute of British Architects, exhibited *Death and the Victorians*, Brighton Art Gallery, 1970 (48), reproduced in catalogue; an engraving by G.S.Shury, from an original picture, was published 1850 (example in NPG); a lithograph by G.E.Madeley, after M.R.Giberne (1846), was published Hering and Remington, 1846 (example in NPG); there is an anonymous engraving, after a full-length portrait said to be by Grant, presumably Sir F.Grant (example in NPG); a woodcut, after a portrait by Moira and Haig, was published *ILN*, XLVI (1865), 189, and another woodcut was published *ILN*, XVII (1850), 341; there are various photographs, and engravings after photographs, in the NPG; others are reproduced W.Ward, II, facing p254, and D.Gwynn, frontispiece and facing p268.

WITHERINGTON *William Frederick* (*1785–1865*)

Landscape painter; left business for art; student at RA schools; exhibited at British Institution, 1808–43, and at RA, 1811–63; RA, 1840; painted a few literary subjects, but mainly landscapes and views.

3182 (6) See entry under Sir George Hayter, p220.
3182 (9) See entry under H.W.Pickersgill, p379.

ICONOGRAPHY The only other recorded likeness of Witherington occurs in a group portrait by J.E. Williams (with F.R.Pickersgill and P.Macdowell), in the collection of Mr Arthurton, 1936, exhibited *RA*, 1864 (317).

WOLLASTON *William Hyde* (*1766–1828*)

Scientist.

2515 (10) See *Collections:* 'Drawings of Prominent People, 1823–49' by W. Brockedon, p 554.
See also forthcoming Catalogue of Portraits, 1790–1830.

WOMBWELL *Sir George, Bart* (*1792–1855*)

4026 (61) See *Collections:* 'Drawings of Men About Town, 1832–48' by Count A. D'Orsay, p 557.

WOOD *John* (*1825–91*)

Surgeon; MB, London, 1848; surgeon at King's College Hospital, London; professor of surgery there, 1871; joint-lecturer with Lister on clinical surgery, 1877; vice-president of the Royal College of Surgeons, 1885; Hunterian professor, 1884–5; published various works on surgery.

2477 See entry under Sir Charles Eastlake, p 154.

ICONOGRAPHY Wood appears in two group portraits by H. J. Brooks at the Royal College of Surgeons, 'The Council of 1884–5' and 'The Court of Examiners', for which see W. Le Fanu, *Catalogue of Portraits &c in the Royal College of Surgeons* (1960), pp 64–5 (201, 204); the former is reproduced in F. G. Hallett's *Catalogue* (1930), facing p 13.

WOOD *Mary Ann* (*1802–64*)

Opera-singer; *née* Paton; performed as a child; at Bath, 1820; at the Haymarket and Covent Garden, from 1822; established reputation with parts in 'The Barber of Seville' and 'The Beggar's Opera'; married Lord Lennox, 1824; divorced him, and married the tenor, Joseph Wood, 1831; unrivalled as a singer, after her performance in Weber's 'Der Freischütz', 1824, and 'Oberon', 1826.

1351 Oil on millboard, 24 × 19⅞ inches (60·8 × 50·5 cm) oval, by THOMAS SULLY, 1836. PLATE 1015
There is a Rowney label on the back of the board.
Collections: Presented by Robert Wood, 1903.
Literature: C. H. Hart, *A Register of Portraits Painted by Thomas Sully* (Philadelphia, 1909), p 183 (1900); E. Biddle and M. Fielding, *The Life and Works of Thomas Sully* (Philadelphia, 1921), p 323 (2001).
This painting was begun in Philadelphia on 11 March 1836, and finished on 5 August. It is a study for the large painting of Mary Ann Wood in the Royal College of Music, London, representing her as Amina in the last scene of the opera 'La Sonnambula' (Biddle and Fielding, 2000); this also dates from 1836, and was presented by Robert Wood, the sitter's son. It has recently been restored. Sully painted other portraits of Mary Ann Wood, including one for his own collection (head, 1836, Biddle and Fielding, 1999), and a copy of a portrait by his son-in-law, John Neagle (head and shoulders, 1836, Biddle and Fielding, 2002). The original Neagle, showing Mary Ann Wood as Amina, was with Hirschl and Adler, 1971, and a replica of 1848 is in the Pennsylvania Academy of the Fine Arts, Philadelphia; Sully's copy was in the collection of W. McHale, Cleveland, 1921.
Description: Clear complexion, grey eyes, dark brown hair. The hands are unfinished. Background colour brown and greenish-brown.

ICONOGRAPHY Popular prints are listed in L. A. Hall, *Catalogue of Dramatic Portraits in the Theatre Collection of the Harvard College Library*, IV (Cambridge, Mass, 1934), 288–92 (some examples in NPG and British Museum); according to Robert Wood (letter of 19 October 1903, NPG archives), a drawing by Sir T.

Lawrence was burnt in a fire at the artist's studio, and an unspecified portrait by Sir W. J. Newton was at Berkeley Castle in 1873; two miniatures by Newton were exhibited *RA*, 1814 (414), and 1823 (722), the latter engraved by R. Newton, published Hurst and Robinson, 1823 (example in British Museum); a miniature by J. W. Childe, and a painting by S. Chinn are in the Guildhall Art Gallery, London; a water-colour by J. Stewart, as Susanna in the 'Marriage of Figaro', is in the Garrick Club, London; a drawing by T. Wageman was exhibited *RA*, 1828 (531), and engraved by T. Woolnoth (example in NPG); a water-colour by A. E. Chalon was sold at Coe's, 16 February 1966 (lot 811); a caricature by Chalon was in the *British Theatrical Loan Exhibition*, Dudley House, London, 1933 (330), reproduced in catalogue; a painting by F. J. Meyer, as Rebecca in the 'Maid of Judah', was exhibited *RA*, 1829 (398); a painting by Le Chevalier Viennot was exhibited *RA*, 1826 (704); a drawing or miniature by Miss E. Sharpe, as Aymante in the opera 'My Native Land', was exhibited *RA*, 1824 (717); a bust by W. Scoular was exhibited *RA*, 1825 (1056); there are two photographs in the NPG.

WOOD *Thomas* (*1777–1860*)

MP for Breconshire.

54 See *Groups:* 'The House of Commons, 1833' by Sir G. Hayter, p 526.

WOODWARK *Rev John*

Slavery abolitionist.

599 See *Groups:* 'The Anti-Slavery Society Convention, 1840' by B. R. Haydon, p 538.

WRIGHT *Thomas* (*1789–1875*)

Prison philanthropist; apprentice in iron-foundry, becoming foreman; deacon of Grosvenor Street chapel, Manchester, 1825–75; became concerned with rehabilitation of prisoners; visited Salford prison, and condemned men elsewhere, from 1838; refused post as HMI of prisons; accepted a public fund and worked full-time in prisons, and for poor and delinquent children, from 1852.

1016 Coloured chalk on brown discoloured paper, 24 × 20 inches (61 × 50·8 cm), by GEORGE FREDERICK WATTS, *c* 1850–1. PLATE 1016

Inscribed on a label on the back in the artist's hand (*referring to the R A exhibition*)*:* No 3. Thomas Wright/of Manchester/G. F. Watts/30 Charles Street/Berkeley Square

Collections: The artist, presented by him, 1895 (see appendix on portraits by G. F. Watts in forthcoming Catalogue of Portraits, 1860–90).

Exhibitions: RA, 1851 (1167); *Winter Exhibition*, Grosvenor Gallery, 1880 (390).

Literature: [Mrs] M. S. Watts, *George Frederic Watts* (1912), I, 130–1.

This drawing was used by Watts for the head of the 'Good Samaritan' in his second version of the picture of this title (Watts Gallery, Compton). The first version, which is similar in composition, but shows a different model, is in the City Art Gallery, Manchester, exhibited *RA*, 1850 (408), presented by the artist to Manchester in the same year as a token of his admiration for Wright.[1] Sometime after the presentation, Wright visited the artist's studio, '*bringing Mr Watts a thank-offering of six pocket-handkerchiefs. He also gave him the great pleasure of hearing that the presentation of that picture, having called attention to his* [Wright's] *work, had been already of great service to him. Seeing that the head of Wright was remarkable in its refined and spiritual beauty, he asked if it was possible for him to give a sitting of an hour or so; with the result that a drawing in black and red chalk – now in its place in the National Portrait Gallery – was made in the Charles Street studio, and there Wright is niched amongst men who have made their mark*' (M. S. Watts, I, 130–1).

[1] Both pictures of the 'Good Samaritan' are listed in Mrs Watts, 'Catalogue of Paintings by G. F. Watts' (MS, Watts Gallery), I, 65; the Watts Gallery picture is dated 1849–1904.

ICONOGRAPHY A painting by Sir J. Watson Gordon of 1853 is in the boardroom, HM Prison, Manchester; a painting of Wright 'Visiting a Condemned Prisoner' by Major C. Mercier is in the Guildhall Art Gallery, London; another painting of Wright by Mercier was in the Museum and Art Gallery, Salford (now destroyed); there are various woodcuts, after photographs, in the NPG, and another was published *ILN*, LXVI (1875), 456.

WRIXON-BECHER *Eliza, Lady (1791–1872)*

Actress; *née* O'Neill; appeared at Drogheda, Belfast, and Dublin; at Covent Garden, 1814, winning fame as Juliet; played comedy roles, but considered the pre-eminent tragic actress of her time; married W. Wrixon-Becher (knighted, 1831) in 1819 and retired to Ireland; praised by Macready and Hazlitt.

445 Oil on canvas, 30 × 25 inches (76·3 × 63·5 cm), by JOHN JAMES MASQUERIER, *c* 1815. PLATE 1017

Collections: Lord Egremont; by descent to his grandson, the Hon Percy Wyndham, and presented by him, 1877.

According to the donor (letter of 7 August 1876, NPG archives), this picture formed part of Lord Egremont's collection at East Lodge, Brighton. It, or a variant, was engraved by W. Say, published D. Cox, 1815 (example in NPG); the engraving shows slight differences in the stole and the position of one arm. Another portrait of the same sitter by Masquerier was in the Burdett-Coutts sale, Christie's, 4 May 1922 (lot 55).

Description: Healthy complexion, greyish eyes, brown hair. Dressed in a red costume with a narrow lace border at the neck, and a white fur stole. Seated on a brown settee. Background very dark brown.

ICONOGRAPHY A painting by T. C. Thompson is in the National Gallery of Ireland, and so is a miniature by Sir W. J. Newton, exhibited *RA*, 1826 (618), possibly the miniature sold Christie's, 23 June 1890 (lot 143); a painting by G. F. Joseph, showing her as the tragic muse, is in the Garrick Club, London, exhibited *RA*, 1815 (39); a painting by Bell of Dublin, and a group painting of 'King John' by Sharp, were sold at Christie's, 22 July 1871 (lots 129 and 187, respectively); a painting by G. Dawe, as Juliet, was exhibited *RA*, 1816 (199), engraved by G. Maile, published Dawe, 1815, and by H. Dawe, published Dean (examples in British Museum); there is an engraving by F. C. Lewis, after a vignette drawing of the Dawe type (example in NPG); a painting by J. S. W. Hodges was in the Burdett-Coutts Sale, Christie's, 5 May 1922 (lot 210), exhibited *Irish Exhibition*, London, 1888 (1105), where it was sketched and recorded by G. Scharf 'TSB' (NPG archives), XXXIV, 42 and 48; a painting by J. Kennerley was exhibited *RA*, 1817 (526); a drawing called Lady Wrixon-Becher by Sir T. Lawrence is in the Victoria and Albert Museum, and another, attributed to Lawrence or G. H. Harlow, is in the Royal Collection, Windsor; a drawing by J. Downman of 1812 was in the collection of R. Blumenthal, 1928; miniatures by T. Farrer and Miss Drummond were exhibited *RA*, 1816 (469 and 578, respectively); a miniature called Lady Wrixon-Becher by A. Plimer was sold at Sotheby's, 11 November 1947 (lot 71), reproduced sale catalogue; an impression from an intaglio gem by D. Crisp was exhibited *RA*, 1816 (887); an engraving by H. Meyer, after A. W. Devis, as Belvidira in Otway's 'Venice Preserved', was published J. Bell, 1816 (example in NPG), and a drawing for or after the engraving is in the NPG; an engraving by Blood, after S. Drummond, was published 1814 (example in NPG), for the *European Magazine;* an engraving by T. Woolnoth, after T. Wageman, was published Simpkin and Marshall, 1818 (example in NPG); there is an engraving by J. S. Agar, after R. Cosway (example in British Museum); other popular prints are listed in L. A. Hall, *Catalogue of Dramatic Portraits in the Theatre Collection of the Harvard College Library*, IV (Cambridge, Mass, 1934), 300–3 (some examples in NPG and British Museum).

WROTTESLEY *John Wrottesley, 1st Baron (1771–1841)*

MP for Staffordshire South.

54 See *Groups:* 'The House of Commons, 1833' by Sir G. Hayter, p 526.

WYNN *Charles Watkin Williams* (*1775–1850*)

MP for Montgomeryshire.

54 See *Groups:* 'The House of Commons, 1833' by Sir G. Hayter, p 526.

WYON *William* (*1795–1851*)

Chief engraver at the Royal Mint; won gold medal of Society of Arts, 1813, for Ceres medal; second engraver at the Mint; employed in George III recoinage, 1816–25; prepared William IV coins from 1830; the first medallist RA, 1838; a prolific workman.

1456 (21) With head of E. B. Morris. Black chalk on grey-tinted paper, heightened with Chinese white, $3\frac{1}{4} \times 5\frac{1}{8}$ inches (8·3 × 13 cm), by CHARLES HUTTON LEAR, *c* 1845. PLATE 1019

Inscribed (*bottom left*): Morris *and* (*lower right*): Wyon

Collections: See *Collections:* 'Drawings of Artists, *c* 1845' by C. H. Lear, p 561.

Literature: R. L. Ormond, 'Victorian Student's Secret Portraits', *Country Life*, CXLI (February 1967), 288–9, reproduced.

This drawing was done in the life school of the Royal Academy, where Lear was a student, and was sent by him with an undated letter to his mother (copy in NPG archives, communicated by donor):

Enclosed he [his father] *will find one or two more. The bald head to the right is Wyon of the Mint who executes the dies for the coin of the realm. The other curious head is E. B. Morris. He got the gold medal some years ago, since when he has failed in various attempts to paint historical pictures, and is, as you will read in his face, a disappointed man. I dare say he is talented but some dark spirit has led him into the wrong path & he is far away from where he ought to be. His brow & eye tell you how deeply conscious he is of the fact He is a long gaunt unearthly looking creature clad entirely in rusty black Contrast these two heads, the sensual contentedness of the one, the dark anxious mental agony of the other.*

Morris won the Royal Academy Gold Medal for painting in 1837 with his 'Horatius Returning from his Victory over the Curiatii'.

2515 (8) Pencil and black chalk, with touches of Chinese white, on brown-tinted paper, $15\frac{1}{4} \times 11$ inches, (38·9 × 27·8 cm), by WILLIAM BROCKEDON, 1825. PLATE 1018

Dated (*bottom left*): Dec^r 25 1825

Collections: See *Collections:* 'Drawings of Prominent People, 1823–49' by W. Brockedon, p 554.

Accompanied in the Brockedon Album by an undated letter from the sitter.

ICONOGRAPHY There is a portrait medallion by L. C. Wyon in the NPG, executed for the Art Union, and another version is reproduced *Spink and Son's Monthly Numismatic Circular* (January–February 1915), p 8; a drawing by C. Vogel is in the Küpferstichkabinett, Staatliche Kunstsammlungen, Dresden; an engraving by W. D[rummond], after a drawing by E. U. Eddis, was published McLean, 1835 (example in NPG), for 'Athenaeum Portraits'; an engraving by J. Kirkwood, after a drawing by L. C. Wyon of 1842 (example in NPG), was published in Sainthill's *Olla Podrida*.

WYSE *Sir Thomas* (*1791–1862*)

Politician, diplomatist, and author.

342, 3 See *Groups:* 'The Fine Arts Commissioners, 1846' by J. Partridge, p 545.

YOUNG *Sir Allen William* (*1827?–1915*)

Served in the 'Fox' in the search for Sir John Franklin, and later commanded the 'Pandora' in the Arctic regions.

920 Oil on canvas, $15\frac{1}{2} \times 13$ inches (39·4 × 33 cm), by STEPHEN PEARCE, 1876. PLATE 1020

Signed and dated (*lower left, written sideways*): Stephen Pearce pinx/1876

Collections: See *Collections:* 'Arctic Explorers' by S. Pearce, p 562.

Exhibitions: Royal Naval Exhibition, Chelsea, 1891 (55).

Literature: S. Pearce, *Memories of the Past* (1903), p 88.

This is the only recorded portrait of Young.

Description: Blue eyes, sandy hair and beard. Dressed in a dark stock, silver stock-pin, white shirt, dark coat. Background colour brown (lower left) and green.

YOUNG *George Frederick* (*1791–1870*)

MP for Tynemouth.

54 See *Groups:* 'The House of Commons, 1833' by Sir G. Hayter, p 526.

Groups

THE HOUSE OF COMMONS, 1833

Hayter's picture represents the moving of the address to the Crown on 5 February 1833, at the opening of the first Reformed Parliament in the House of Commons (St Stephen's Chapel, destroyed by fire, 1834). The figure actually speaking on the left is the 2nd Marquess of Breadalbane. The picture includes nearly four hundred identifiable figures, mainly MPs, but with a smattering of important whig and tory peers, and a few outsiders.

54 Oil on canvas, $118\frac{1}{4} \times 196$ inches ($300 \cdot 3 \times 497 \cdot 8$ cm), by SIR GEORGE HAYTER, 1833–43. PLATES 1021–1031

Signed and dated (*lower right, on the folder beside the artist*): George Hayter Eques/pingebat/1833. 1843.

Collections: Purchased by the Government and presented by them, 1858.

Exhibitions: Egyptian Hall, Piccadilly, London, 1843; *British Institution*, 1848 (416).

Literature: Sir G. Hayter, 'A Descriptive Catalogue of the Great Historical Picture of the Interior of the British House of Commons', 1843; *The Times*, 29 June 1837, 4 April 1843, and 11 August 1858; *Art-Union* (1843), p 122, and (1848), p 81; *Art Journal* (1859), p 289, and (1860), p 318; *Athenaeum*, no. 806 (1843), 340–1; *The Diary of Benjamin Robert Haydon*, edited W. B. Pope (Cambridge, Mass, 1963), V, 259–60; for MS references, see text below.

Unlike his earlier group portrait of the 'House of Lords, 1820' (NPG 999, depicting the trial of Queen Caroline), Hayter did not receive an official commission to paint the House of Commons in 1833. He was, however, an ardent supporter of the reform movement, and many of his most devoted patrons were prominent whig aristocrats and politicians. In his preface to the 1843 Catalogue, Hayter acknowledged the help and kindness of, among others, the Duke of Bedford, Earl Spencer, Lord John Russell, the Duke of Wellington, the Earl of Aberdeen, Sir Robert Peel, Lord Lyndhurst, Sir Robert Inglis, Joseph Hume, and Charles Hamilton, '*who exerted his utmost influence to induce him to commence so arduous a task*'. In a letter to Gladstone of 8 March 1854 (British Museum, Add MS, 44378, f 85), Hayter wrote:

Early in the year 1833, I was induced by my Friends to undertake the arduous task of painting the above subject. I was assisted, and encouraged, by the most distinguished personages in both Houses, first in obtaining the necessary sittings from every person represented, and by my being at all times admitted to the House, to study the habits and manners of the members, previously to their coming to my studio to sit, I was enabled to perform a work of truth, and secondly by a firm belief on the part of those who sat, that it would certainly be purchased by the nation. – But, Sir, such an undertaking, produced with the care which I bestowed on every part of it, could not be performed in a short time: and unfortunately for me, as concerned my probable pecuniary reward, the great party of Reformers were no longer in the majority in 1843 when my picture was finished. I could not cherish a hope that the government of that day would willingly purchase the representation, which I had laboured to make as truthful as possible, placing O'Connell, Cobbett, Gully, &c. &c. &c. in the midst of the high conservative members. – Sir Robert Peel, however, with the love of art, and enlightened feelings he professed, did not shrink from sitting, even when engaged by Mr Croker, not to do so; but assisted me by inducing others to follow his example, amongst whom the present Chancellor of the Exchequer will be found, without which my picture must have been a one sided failure. I may however state, that having relinquished the lucrative profession of general portrait painting, to achieve an unique production, as to the number of portraits contained in one picture, I was left without the anticipated reward. – Still, Sir I was to be consoled, by having persons of all ranks, who saw it, declare that it was a wonderful production, which must eventually become national property. – I have been induced to wait patiently.

The history of Hayter's picture can be divided into two parts: the first, covering the actual painting of the group, and the second, the artist's laborious efforts to sell it. When he first undertook the work in 1833, Hayter evidently hoped that it would not only be a profitable undertaking but one which would increase his reputation and fame. Like many artists before him, he saw that interest in a documentary

record of a contemporary event was bound to be very considerable. Such a painting, combining history painting, portraiture and contemporary reportage, would have an immediate appeal, as works of pure art frequently did not. In his introduction to the 1843 exhibition catalogue, Hayter wrote of the excitement aroused by the Reform Bill, and of the significance of the meeting of the first Reformed House of Commons:

The event was one to be perpetuated, and it may be assumed that painting can represent the scene to posterity better than poetry or prose: by these the mind may be made acquainted with the results attendant on the meeting; but the public, it is hoped, will appreciate the labour of an artist to transmit to posterity, by truth of delineation, that evidence of the actual occurrence, and of its details, which must belong to the features, dress, or habits of our present day, and which do not come within the province of an author.

Hayter went on to state that no previous painter had ever painted a picture containing nearly 400 portraits, in which every person had sat to the artist. He wrote also of the difficulties he had encountered:

The etiquette and the architectural monotony of form in the House imposed limits not to be transgressed in the composition, if the true scene were to be represented. Expression is little to be looked for on such occasions, and, therefore, there are but few attempts made to represent strong feeling The light governing the Picture, as it does, from the further end and two sides of the House, rendered it necessary to treat the whole in a manner unusual in great compositions, where the masses of light are arranged at the discretion of the painter. The colour of European costume cannot be considered favourable to an artist; the colours worn are nearly the same, and, from the material of which they are composed, are less calculated to reflect light than silks and satins. These were some of the unyielding materials for such a work.

Many of Hayter's studies of individual heads survive (they are listed with the names of the sitters below), but relatively few general compositional studies, or figure studies. Those recorded are as follows: a small oil sketch for the whole composition (14 × 22 inches (35·5 × 55·8 cm)), now in the Houses of Parliament (plate 1023), possibly that in the Hayter Sale, Christie's, 21 April 1871 (lot 615), listed by R.J.B. Walker, 'Catalogue of Paintings, Drawings, Sculpture and Engravings in the Palace of Westminster' (Ministry of Public Building and Works, 1962), IV, 120; a perspective drawing (NPG 3073 below); several pencil studies in the Hayter Sale (lot 350). It is clear that Hayter made numerous visits to the House of Commons, and he must have produced a large number of sketches, as he did in the case of the 'House of Lords, 1820' (NPG 999), but few appear to have survived.

The large painting evidently took Hayter considerably longer than he had originally envisaged. He must have realized the dangers of delay. Most of his studies of individual heads which survive date from 1833–5, which suggests that he hoped to finished the big picture itself within a reasonable space of time. A report in *The Times*, clearly prompted by, and possibly dictated by, the artist, confirms this (29 June 1837):

Mr Hayter's picture of the moving the address to his late Majesty William IV, in the House of Commons, in the year 1833, is in rapid progress towards its completion. There is every prospect that by the commencement of next year it will be finished As an historical picture this work has the highest claims to encomium. The story is well told, and the characteristics of many of the members are depicted with a fidelity which at once illustrates the subject It is desirable that those gentlemen who have promised the artist to sit, in order that he may lose no time in finishing his arduous task, will not delay to redeem their promises, and it is to be hoped that Mr Hayter will receive the reward he so justly deserves for his perseverance, intense labour, and great professional merit, in bringing this gigantic work to perfection.

In the same year, Queen Victoria visited Hayter's studio, and recorded what she saw in her diary (Royal Archives, Windsor, 8 May 1837):

We went to Mr George Hayter's and saw all his fine pictures. His large picture of the Reform House of Commons, full of portraits is splendid, it is an immense work and will only be finished next year. The studies

of the different members for which they sat, and which are then copied into the larger picture, are beautiful, so highly finished and so like. Hayter is out and out the best portrait-painter in my opinion.

Queen Victoria's comment has some bearing on Hayter's delay in finishing the 'House of Commons' group. She appointed him 'portrait and history painter to the Queen' on her accession, and commissioned several individual and group portraits in the years immediately following, which kept him busy.

The NPG picture was not finally finished until 1843. A drawing showing Hayter at work on the picture, dated 1843, is in the NPG (1103, catalogued under Hayter), and another by Landseer was in the Hayter Sale (lot 374). The picture was exhibited at the Egyptian Gallery in Piccadilly, together with other large works by Hayter, from April to August 1843, and was moderately well received. *The Times* reviewer wrote (4 April 1843):

The greatest praise that can be bestowed upon this picture is to say that it professes to represent with fidelity a great historical event, and that it fulfills every proposition which it makes.

Similar comments were voiced in the *Art-Union* and the *Athenaeum*, the reviewer of the latter journal writing at some length (no. 806, April 1843, 340–1):

The management of the light seems, to us, excellent; and this, too, it will be recollected, is arbitrary: then the mathematical angularity of a composition in which four rows of heads necessarily form a prominent object, is happily varied. Sir E. Codrington's hand on the pillar, the eager attitude of O'Connell Lord John Russell leaning forward are all accidents at once conducive to truthful and to pictorial effect The likenesses are, for the most part, good. It is true that Sir George Hayter sees his sitters through some medium which sharpens their features, a certain pinched thinness of face being as characteristic of his portraits, as a squareness of contour is of those by Leslie; but it would be hard to name the artist who would have been, on the whole, more faithful, or so spirited: – while the industry with which the work has been wrought up and finished, is creditable to its painter.

The most hostile criticism of the picture came from the bitterly jealous Haydon, whose own group portrait of the 'Anti-Slavery Society Convention, 1840' (NPG 599 below), had received relatively little publicity (*Diary of Benjamin Robert Haydon*, V (1963), 259–60, for 5 April 1843):

Went to see Hayter's Picture. The Time is fast coming when we shall get sick of these bastard 'High Art Works'. Brougham came in with me, & as he looked at the Picture he said, 'The most striking thing in it is Burdett's breeches. It is outrageously ridiculous to make the door Keeper of the House the most prominent head in it.' This was spitish but true Hayter has acted like a sensible Man who Knows the world. He has made every body pay 10.10 & gave them their sketch. I sketched every body & made them pay nothing Hayter has received 4000.

The last part of Haydon's statement is evidently untrue. Although Hayter may have sold some of the sketches at the time, a large number appeared in his sale, and, unlike the 'Anti-Slavery Society Convention', the big picture itself was not commissioned. Nor was Hayter able to find a publisher for an engraving of the picture, as he must have hoped to do; such engravings were often extremely profitable.

The problem of disposing of the 'House of Commons' group was to occupy Hayter for thirteen years. Interest in the Reform Bill had lapsed, and the sheer size of the picture precluded its purchase by private individuals. Hayter had really missed his market, and his influential friends, who might have helped him in the years immediately following the passage of the Reform Bill, were unwilling to do so eleven years later. In a typical letter of solicitation and self-pity, Hayter wrote to Peel on 1 December 1845 (British Museum, Add MS, 40580, f129):

Pray let me hope you will pardon my intruding this letter on your attention, as it is only by your decision that any success can result from the application which I desire to make to the Trustees of the National Gallery The picture, which occupied me the greatest portion of ten years, is essentially a national document: and I trust that it will not be improper to say that the kind opinion which you did me the honor

to express, when you favored me by sitting for it, ever remained on my mind as one of the greatest rewards for my labour and led me to hope that at a future period you might not oppose it becoming the property of the National Gallery I take the liberty of enclosing the accompanying catalogue, the perusal of which may recall the picture and aid me in pleading for that kind interest from you, Sir, which is indispensable to the attainment of this high object of my ambition.

There are several earlier letters from Hayter to Peel on the subject of his picture, including one of 8 July 1844 asking for a new sitting, as the artist was dissatisfied with the existing likeness (British Museum Add MS, 40548, f136; see also 40526, f438).

In 1848, Hayter exhibited the picture at the British Institution. He had written to the Duke of Sutherland on 22 October 1847 (Sutherland Papers, Staffordshire County Record Office, 10699. D593/P/22/1/17(dd)):

I had the honor to receive Your Grace's most kind reply to my application for your powerful aid to assist me in obtaining permission to exhibit my great picture of the First reformed parliament at the British Gallery for sale, next year I humbly beg Your Grace to do me the honor to accept my most sincere thanks.

In spite of his renewed efforts, Hayter was still unable to find a buyer, and he received some hostile criticism from the *Art-Union* (1848, p81):

It is understood that none but unexhibited pictures are admitted, but we nevertheless find, occupying an entire end of the rooms, a large and well known, because well exhibited, picture by Sir George Hayter. This, to say the least, is an unaccountable infraction of the rules of the Institution.

Hayter's final hopes of selling the picture centred on the Government. He wrote letters to Lord John Russell, to Gladstone, and probably to other prominent statesmen, attempting to enlist their support. A letter of 6 March 1850 to Lord John Russell is a characteristic example (British Museum, Add MS, 38080, f92):

From what has been said to me by those members, whom I have seen, I think I may venture to report favourable progress, concerning my great picture. Lord Ellesmere, Mr Edd. Ellice, Mr Sydney Herbert, Adml. R. Gordon, Mr Labouchere, Mr Macaulay, Mr Greene, and others, all treat the subject as certain in its result: and most kindly offer me every assistance, but it becomes evident, that although Mr Hume [?] will willingly bring the subject before the House, if your Lordship thinks proper; still the government only has the power to propose the purchase. It certainly exhibits a singular case, for your Lordship knows that his Grace the Duke of Bedford, would have bought it, if there had been any possibility of placing it in Woburn Abbey Another person, as I stated last year, would have given me 5000, gs. for it, if the law would have permitted him to dispose of it by raffle These are almost *sufficient proofs that the picture is appreciated as valuable, and, as historical, highly interesting!*

The portrait was put on exhibition for a time in the tea-room of the Houses of Parliament, but there was little enthusiasm for it. On 19 January 1854, Hayter wrote to Russell again (British Museum, Add MS, 38080, f98):

I have improved the effect of it very much, *by taking away the real curtains and draperies, in which it has hitherto been seen; and have finished the picture, according to my first intention by painting the curtains; and putting it into a proper gilt frame. Upon the subject of sending it to public auction, with a reserve price, – I am lead to believe that, should it not be sold, at that time; that after my death it would stand a much worse chance of being well sold, from having been so placed unsuccessfully.*
Perhaps your Lordship, could name one, or two members of parliament, who would take the necessary interest in it, and who would, if they once took it in hand, easily awaken the subject in the minds of others, so as to effect its purchase Perhaps it would answer to invite all the Lords, and Commons, for a certain number of days, to come here to see it, placing an open book to be signed, by all those who consider that it ought to be purchased?

Hayter's subsequent letter to Gladstone on the same subject has already been quoted.

In 1858, Hayter's efforts were finally rewarded. The Tory Government agreed to buy the picture on the recommendation of a special committee composed of Lord John Russell, Lord Elcho and Mr Cunningham. *The Times* wrote (11 August 1858):

This picture undoubtedly affords one of the greatest and most important collective series of portraits in existence, and it is to be hoped will soon be deposited in some place where the public will have the opportunity of referring to it.

Later the same year the picture was presented to the NPG by the Government, Disraeli's secretary, Ralph Earle, writing to Earl Stanhope, chairman of the NPG trustees (copy of a letter, 24 July 1858, NPG archives):

The Chancellor of the Exchequer being prevented by pressing occupations, from writing to your Lordship, with his own hand has desired me to state, for the information of the Trustees of the National Portrait Gallery, that had he been able to assist at the meeting today, he would then have announced his intention of offering to add the picture, which has just been purchased by the Government, from Sir George Hayter, to the National Portrait Gallery.

Palmerston wrote to Queen Victoria on 3 August 1859 (Royal Archives, RA. A27/98), referring to the discussions of estimates in the House of Commons:

The next was on the vote of Two Thousand Pounds engaged by the late Government to be paid to Sir George Hayter for his Picture of the first reformed House of Commons, an indifferent work of art, and a Collection of bad Likenesses but the money had been actually paid by the late Government, and the vote was required to Sanction the Payment which ought not to have been made until after the vote had been obtained – on Division the numbers were equal, 82 for the vote and 82 against it. – The casting vote was with the Chairman Mr Massey and he gave his vote in accordance with the general Rule, that in such cases the Speaker or Chairman should vote in such a manner as to give the House a further opportunity of Considering the matter. Mr Massey therefore voted with the ayes, for the Grant, because in that way he afforded the House another opportunity of considering the matter on the Report of the Resolution, whereas if he had voted with the noes, there would have been at once an end of the Proposal It is remarkable that while the present Government were supporting votes prepared by their Predecessors Two of which namely that to Sir George Hayter and that to Mr Barber they would not themselves have originated, most of the Supporters of the late Government present in the House voted against these proposed Grants.

For a further discussion of the matter in the House of Commons, see *Art Journal* (1859), p289.

In 1867 Hayter, who had heard that his picture was not in good condition, wrote a letter of complaint to the NPG (29 April 1867, NPG archives):

It is now reported as suffering seriously from damp, and the colouring changed and fading. – The total ruin of this, my greatest labour, will thus be totally ruined, and my future reputation thereby deteriorated! May I request you to do me the kindness, to take such measures as you know to be efficient, for correcting this unforseen event.

Hayter's information proved to be incorrect, and the condition of the picture, then and now, remains sound.

The following alphabetical list, largely the work of Mrs Kay, and based on that in Hayter's 1843 catalogue, includes every known sitter in the picture. An asterisk beside the name of the sitter denotes that other portraits of him are included in this catalogue, which is arranged alphabetically, with (except in the case of other groups) an accompanying iconography. Other sitters are briefly listed in the main body of the catalogue, and referred to this entry.

The constituency, and the number in brackets referring to the key, are given after each name. The key itself is reproduced with the big picture. Studies are listed below each name, with the date, if recorded, and the present location, if known; almost all are on millboard, approximately 14 × 12 inches

(35·5 × 30·5 cm). The majority were in the Hayter Sale, Christie's, 19–21 April 1871. The following people are represented in the picture:

Abercromby, James. See Dunfermline.
*Aberdeen, George Hamilton Gordon, 4th Earl of (1784–1860). (316).
Abingdon, Montagu Bertie, 6th Earl of (Lord Norreys) (1808–84). Oxfordshire (236).
Adam, Admiral Sir Charles (1780–1853). Clackmannan (361).
Adams, Edward Hamlyn (1777–1842). Carmarthenshire (362).
Aglionby, Henry Aglionby (1790–1854). Cockermouth (281).
Agnew, Sir Andrew, Bart (1793–1849). Wigtownshire (287).
Ailesbury, Ernest Augustus Charles Brudenell-Bruce, 3rd Marquess of (Lord Ernest Bruce) (1811–86). Marlborough (209).
 Study, 1834, collection of Lady Berwick, Attingham.
Althorp, Viscount. See Spencer.
Anglesey, Henry William Paget, 2nd Earl of Uxbridge, and 1st Marquess of (1768–1854). (2). Lord lieutenant of Ireland.
Anson, Sir George (1769–1849). Lichfield (70).
Anson, George (1797–1857). Great Yarmouth (75).
 Study, Hayter Sale (lot 538).
Apsley, Viscount. See Bathurst.
Arbuthnot, Hugh (1780–1868). Kincardine (331).
 Copy by pupil of study (with Hay and Gordon), Hayter Sale (lot 564).
Ashburton, Alexander Baring, 1st Baron (1774–1848). Essex North (253).
 Study, Hayter Sale (lot 507).
Ashburton, William Bingham Baring, 2nd Baron (1799–1864). Winchester (202).
 Study, Hayter Sale (lot 529).
Ashley, Lord. See Shaftesbury.
Ashley-Cooper, Anthony Henry (1807–58). Dorchester (173).
 Study, Christie's, 30 March 1972 (lot 93); presumably Hayter Sale (lot 470).
Astley, Sir Jacob. See Hastings.
Attwood, Thomas (1783–1856). Birmingham (296).
 Study, Hayter Sale (lot 461).
Aveland, Gilbert John Heathcote, 1st Baron (1795–1867). Lincolnshire (330).

Bankes, William John (c 1784–1855). Dorset (190).
 Study, Hayter Sale (lot 535).
Bannerman, Sir Alexander (1788–1864). Aberdeen (82).
 Copies by pupils of studies, Hayter Sale (lots 546 and 558).
Baring, Alexander. See Ashburton.
Baring, Francis Thornhill. See Northbrook.
Baring, Henry Bingham (1804–69). Marlborough (204).
 Study, Hayter Sale (lot 527).
Baring, William Bingham. See Ashburton.
Barnett, Charles James (c 1797–1882). Maidstone (30).
 Copy by pupil of study, Hayter Sale (lot 558).
Barron, Sir Henry Winston, Bart (1795–1872). Waterford (28).
 Study, 1835, Sabin Galleries, 1970.
Bateson, Sir Robert, Bart (1782–1863). County Londonderry (260).
Bathurst, George Henry Bathurst, 4th Earl (Viscount Apsley) (1790–1866). Cirencester (178).
 Study, Hayter Sale (lot 529).
Beauchamp, Henry Beauchamp Lygon, 4th Earl (1784–1863). Worcestershire West (292).
 Study, collection of Earl Beauchamp, 1909.
Bedford, Francis Russell, 7th Duke of (Marquess of Tavistock) (1788–1861). (4).
Bedford, John Russell, 6th Duke of (1766–1839). (7).
Bedford, William Russell, 8th Duke of (Lord Russell) (1809–72). Tavistock (60).
 Study, collection of Duke of Bedford (previously called Lord John Russell). Copy by pupil, Hayter Sale (lot 549).
Belfast, Earl of. See Donegall.
Benett, John (1773–1852). Wiltshire, South (73).
Beresford, Sir John Poo, Bart (1766–1844). Coleraine (308).
 Study, Hayter Sale (lot 493).

Berkeley, George Charles Grantley FitzHardinge (1800–81). Gloucestershire, West (13).
Bernal, Ralph (d 1854). Rochester (120).
 Study, Hayter Sale (lot 482).
Bessborough, John William Ponsonby, 4th Earl of (Viscount Duncannon) (1781–1847). Nottingham (155).
Bethell, Richard (1772–1864). Yorkshire, East Riding (286).
Bish, Thomas (1780–1843). Leominster (272).
Blackstone, William Seymour (1809–81). Wallingford (211).
 Study, Hayter Sale (lot 497).
Blandford, Marquess of. See Marlborough.
*Breadalbane, John Campbell, 2nd Marquess of (Earl of Ormelie) (1796–1862). Perthshire (136).
 Study, 1834, NPG 2510 (this is catalogued elsewhere under Breadalbane.)
Bristol, Frederick William Hervey, 2nd Marquess of (Earl Jermyn) (1800–64). Bury St Edmunds (170).
 Study, 1837, National Trust, Ickworth.
Brodie, William Bird (1780–1863). Salisbury (110).
Brotherton, Joseph (1783–1857). Salford (295).
 Study, Hayter Sale (lot 498).
Brougham and Vaux, William Brougham, 2nd Baron (1795–1886). Southwark (123).
 Study, Hayter Sale (lot 539).
Brougham de Gyfford, John Cam Hobhouse, 1st Baron (1786–1869). Westminster (150).
 Copy by pupil of study, Hayter Sale (lot 545).
Browne, Dominick. See Oranmore and Browne.
Bruce, Lord Ernest. See Ailesbury.
Brudenell, Lord. See Cardigan.
Buckingham and Chandos, Richard Plantagenet Temple Nugent Brydges Chandos Grenville, 2nd Duke of (Marquess of Chandos) (1797–1861). Buckinghamshire (168).
Burdett, Sir Francis, Bart (1770–1844). Westminster (99).
*Buxton, Sir Thomas Fowell, Bart (1786–1845). Weymouth (88).
 Study engraved by J. Brain, published J. Saunders, 1840 (example in NPG), for 'Political Reformers'.
Byng, George (1764–1847). Middlesex (86).
 Study engraved by W. Holl, published J. Saunders, 1840 (example in NPG), for 'Political Reformers'.
Byng, George Stevens. See Strafford.
Byng, Sir John. See Strafford.

Calcraft, John Hales (1796–1880). Wareham (206).
*Campbell, John Campbell, 1st Baron (1779–1861). Dudley (95). Solicitor-general.
 Study, Hayter Sale (lot 468); copy by pupil (lot 554).
Canterbury, Charles Manners-Sutton, 1st Viscount (1780–1845). Cambridge University (156). Speaker of the House.
 Study, collection of Lord Hastings.
Cardigan, James Thomas Brudenell, 7th Earl of (Lord Brudenell) (1797–1868). Northamptonshire, North (262).
 Study, Hayter Sale (lot 473); copy by pupil (lot 553).
Carlisle, George William Frederick Howard, 7th Earl of (Viscount Morpeth) (1802–64). Yorkshire, West Riding (66).
 Study, 1835, offered to NPG, 1899, but declined. A similar but differently posed portrait, formerly in the sitter's collection, was engraved by H. Cook, published J. Dowding, 1840 (example in NPG), for 'Political Reformers'.
Carrington, Robert John Smith (later Carrington), 2nd Baron (1796–1868). Chipping Wycombe (118).
Cartwright, William Ralph (1771–1847). Northamptonshire, South (301).
 Study, collection of Miss Elizabeth Cartwright.
Castlereagh, Viscount. See Londonderry.
Cavendish, Lord. See Devonshire.
Cavendish, Charles Compton. See Chesham.
Cayley, Edward Stillingfleet (1802–62). Yorkshire, North Riding (319).
*Cayley, Sir George, Bart (1773–1857). Scarborough (320).

Chandos, Marquess of. See Buckingham and Chandos.
Charleville, Charles William Bury, 2nd Earl of (Lord Tulla-
more) (1801–51). Penryn (309).
Chesham, Charles Compton Cavendish, 1st Baron (1793–1863).
Sussex, East (108).
Chetwynd, William Fawkener (1788–1873). Stafford (74).
Study, Hayter Sale (lot 499).
Childers, John Walbanke (1789–1886). Cambridgeshire (27).
Copy by pupil of study, Hayter Sale (lot 545).
Clare, Richard Hobart FitzGibbon, 3rd Earl of (1793–1864).
County Limerick (297).
Study, Hayter Sale (lot 531).
Clay, Sir William, Bart (1791–1869). Tower Hamlets (245).
Clayton, Colonel Sir William Robert, Bart (1786–1866). Great
Marlow (69).
Copy by pupil of study, Hayter Sale (lot 554).
Cleveland, Henry Vane, 2nd Duke of (Earl of Darlington)
(1788–1864). Salop, South (266).
Study, 1834, collection of Lord Barnard, Raby Castle.
Clive, Viscount. See Powis.
Clive, Edward Bolton (after 1763–1845). Hereford (77).
Study, collection of Lady Mary Clive.
Clive, Robert Henry (1789–1854). Salop, South (182).
Cobbett, William (1762–1835). Oldham (256).
Cockerell, Sir Charles, Bart (1755–1837). Evesham (356).
*Codrington, Sir Edward (1770–1851). Devonport (23).
Study, Hayter Sale (lot 464), presumably that engraved by
B. Holl, published Dowding (example in NPG), for 'Political
Reformers'.
Cole, Viscount. See Enniskillen.
Cole, Arthur Henry (1780–1844). Enniskillen (210).
Study, formerly collection of Captain Berkeley Williams.
Copies, Hayter Sale (lots 560 and 561).
Conolly, Edmund Michael (1786–1848). County Donegal (224).
Study, Hayter Sale (lot 475).
Coote, Sir Charles Henry, Bart (1802–64). Queen's County (360).
Study, Hayter Sale (lot 471).
Corry, Henry Thomas Lowry (1803–73). County Tyrone (214).
Study, Hayter Sale (lot 518).
Cottenham, Charles Christopher Pepys, 1st Earl of
(1781–1851). Malton (22).
Study, Hayter Sale (lot 542).
*Cottesloe, Thomas Francis Fremantle, 1st Baron (1798–1890).
Buckingham (203).
Study, Hayter Sale (lot 542).
Cripps, Joseph (1765–1847). Cirencester (185).
Cumming-Bruce, Charles Lennox (1790–1875). Inverness (322).

Dalrymple, Sir John Hamilton Macgill, Bart. See Stair.
Darlington, Earl of. See Cleveland.
Dashwood, Sir George Henry, Bart (1790–1862). Bucking-
hamshire (51).
De Mauley, William Francis Spencer Ponsonby, 1st Baron
(1787–1855). Dorset (33).
Denison, John Evelyn. See Ossington.
*Derby, Edward George Geoffrey Smith Stanley, 14th Earl
of (1799–1869). Lancashire, North (147).
Devonshire, William Cavendish, 7th Duke of (1808–91).
Derbyshire, North (32).
D'Eyncourt, Charles Tennyson (1784–1861). Lambeth (76).
Study, Hayter Sale (lot 536).
Dick, Quintin (1777–1858). Maldon (238).
Dillwyn, Lewis Weston (1778–1855). Glamorgan (127).
Copy by pupil of study, Hayter Sale (lot 548).
Dinevor, George Rice Rice-Trevor, 4th Baron (1795–1869).
Carmarthenshire (208).
Study, 1835, National Museum of Wales, Cardiff.
Divett, Edward (1797–1864). Exeter (46).
Donegall, George Hamilton Chichester, 3rd Marquess of (Earl
of Belfast) (1797–1883). County Antrim (129).
Donkin, Sir Rufane Shaw (1773–1841). Berwick-upon-Tweed
(58).
Dugdale, William Stratford (1800–71). Warwickshire, North
(298).
Study, Hayter Sale (lot 501). Copy by pupil (lot 557).

Duncannon, Viscount. See Bessborough.
Duncombe, William. See Feversham.
Dundas, Sir James Whitley Deans (1785–1862). Greenwich
(36).
Dundas, Sir Robert Lawrence (1780–1844). Richmond, York-
shire (121).
Dunfermline, James Abercromby, 1st Baron (1776–1858).
Edinburgh (83).
Study, Hayter Sale (lot 495).
Dykes, Fretchville Lawson Ballantine (1800–66). Cocker-
mouth (44).

Eastnor, Viscount. See Somers.
Ebrington, Viscount. See Fortescue.
Ebury, Robert Grosvenor, 1st Baron (1801–93). Chester (141).
Ellice, Edward (1781–1863). Coventry (92).
*Elliot, Sir George (1784–1863). Roxburghshire (137).
Study, 1834, NPG 2511 (this is catalogued elsewhere under
Elliot). Presumably Hayter Sale (lot 541).
Enniskillen, William Willoughby Cole, 3rd Earl of (Viscount
Cole) (1807–86). County Fermanagh (261).
Etwall, Ralph (1804–82). Andover (49).
Study, Hayter Sale (lot 489).
*Eversley, Charles Shaw-Lefevre, 1st Viscount (1794–1888).
Hampshire, North (100).
Ewart, William (1798–1869). Liverpool (244).

Fancourt, Charles St John (1804–75). Barnstaple (300).
Farnham, Henry Maxwell, 7th Baron (1799–1868). County
Cavan (171).
Fazakerley, John Nicholas (1787–1852). Peterborough (109).
Study, Hayter Sale (lot 514).
Feildon, Sir William, Bart (1772–1859). Blackburn (53).
Fenton, John (c 1791–1863). Rochdale (359).
Study, Hayter Sale (lot 538).
Ferguson, Robert (before 1773–1840). Kirkcaldy (68).
Ferguson, Sir Ronald Craufurd (1773–1841). Nottingham
(162).
Fergusson, Robert Cutlar (1768–1838). Kirkcudbright (96).
Study, Hayter Sale (lot 503); copy by pupil (lot 547).
Feversham, William Duncombe, 2nd Baron (1798–1867).
Yorkshire, North Riding (195).
Study, Hayter Sale (lot 541).
Fielden, John (1784–1849). Oldham (200).
Copy by pupil of study, Hayter Sale (lot 557).
Finch, George (1794–1870). Stamford (263).
FitzGibbon, Richard Hobart. See Clare.
Fleetwood, Sir Peter Hesketh, Bart (1801–66). Preston (25).
Study, 1834, collection of T. K. Parr, 1939; presumably
Hayter Sale (lot 491).
Fleming, Charles Elphinstone (1774–1840). Stirlingshire (54).
Copy by pupil of study, Hayter Sale (lot 560).
Folkes, Sir William John Henry Browne, Bart (1786–1860).
Norfolk, West (29).
Study, 1834, collection of Sir William Folkes, Hillington
Hall, 1909.
Forester, George Cecil Weld Weld-Forester, 3rd Baron
(1807–86). Wenlock (291).
Study, Hayter Sale (lot 511).
Forester, John George Weld Weld-Forester, 2nd Baron
(1801–74). (87).
Fortescue, Hugh Fortescue, 2nd Earl (Viscount Ebrington)
(1783–1861). Devonshire, North (138).
Study engraved by W. Holl, published J. Saunders, 1840
(example in NPG), for 'Political Reformers'.
Fox, Charles Richard (1796–1873). Tavistock (72).
Study, Hayter Sale (lot 512).
Fox, Sackville Walter Lane (1800–74). Helston (299).
Fremantle, Thomas Francis. See Cottesloe.
French, Fitzstephen (1801–73). County Roscommon (284).
Study, Sabin Galleries, 1970.

Gaskell, Daniel (1782–1875). Wakefield (325).
Study, collection of Gaskell family, 1932.
Gaskell, James Milnes (1810–73). Wenlock (227).
Copy by pupil of study, Hayter Sale (lot 544).

Gladstone, Sir Thomas, Bart (1804–89). Portarlington (229).
Copy by pupil of study, Hayter Sale (lot 550).
*Gladstone, William Ewart (1809–98). Newark-upon-Trent (228).
Glynne, Sir Stephen Richard, Bart (1807–74). Flint (106).
Study, Gladstone collection, Hawarden Castle.
Goderich, Viscount. See Ripon.
Gordon, William (1784–1858). Aberdeenshire (326).
Copy by pupil of study (with Arbuthnott and Hay), Hayter Sale (lot 564).
Goulburn, Henry (1784–1856). Cambridge University (250).
Study, 1834, collection of Major-General E.H. Goulburn.
*Graham, Sir James Robert George, Bart (1792–1861). Cumberland, East (146).
Study, Hayter Sale (lot 478).
Grant, Francis William Ogilvy. See Seafield.
Grant, Sir Robert (1779–1838). Finsbury (153).
Study, Hayter Sale (lot 465).
Greene, Thomas (1794–1872). Lancaster (186).
Greville, Sir Charles John (1780–1836). Warwick (302).
Study, 1836, collection of the Earl of Warwick.
*Grey, Charles Grey, 2nd Earl (1764–1845). Prime Minister (9).
Study, Hayter Sale (lot 524).
Grey, Henry George Grey, 3rd Earl (Viscount Howick). (1802–94). Northumberland, North (132).
Grimston, Viscount. See Verulam.
Gronow, Rees Howell (1794–1865). Stafford (340).
Study, Hayter Sale (lot 543).
Grosvenor, Lord Robert. See Ebury.
*Grote, George (1794–1871). City of London (216).
Study, Hayter Sale (lot 479).
Guest, Sir Josiah John, Bart (1785–1852). Merthyr Tydfil (285).
Gully, John (1783–1863). Pontefract (282).
Study, Hayter Sale (lot 519).

*Halifax, Charles Wood, 1st Viscount (1800–85). Halifax (97).
Copy by pupil of study, Hayter Sale (lot 550).
Hallyburton, Lord Douglas Gordon (1777–1841). Forfarshire (31).
Study, Hayter Sale (lot 539).
Hamilton, Charles. Not a member: the picture was painted at his suggestion (374).
*Hanmer, John Hanmer, 1st Baron (1809–81). Shrewsbury (226).
Harcourt, George Granville (1785–1861). Oxfordshire (17).
*Hardinge, Henry Hardinge, 1st Viscount (1785–1856). Launceston (157).
Hardwicke, Charles Philip Yorke, 4th Earl of (1799–1873). Cambridgeshire (288).
Hardy, John (1773–1855). Bradford (234).
Copy by pupil of study, Hayter Sale (lot 561).
Harland, William Charles (1804–63). Durham (318).
Study, Hayter Sale (lot 466).
Harrowby, Dudley Ryder, 2nd Earl of (Viscount Sandon) (1798–1882). Liverpool (11).
Harvey, Daniel Whittle (1786–1863). Colchester (221).
Study, Hayter Sale (lot 467).
Hastings, Jacob Astley, 16th Baron (1797–1859). Norfolk, West (373).
*Hatherton, Edward John Littleton, 1st Baron (1791–1863). Staffordshire, South (134).
Study, 1834, NPG 4658 (this is catalogued elsewhere under Hatherton).
Hay, Sir Andrew Leith (1785–1862). Elgin and Moray (140).
Study, 1833, National Trust, Leith Hall, Aberdeenshire.
Hay, Sir John, Bart (1788–1838). Peeblesshire (327).
Copy by pupil of study (with Arbuthnot and Gordon), Hayter Sale (lot 564).
Hayes, Sir Edmund Samuel, Bart (1806–60). County Donegal (207).
*Hayter, Sir George (1792–1871). The painter of the picture (375).
Heathcote, Gilbert John. See Aveland.
Heneage, George Fieschi (1800–64). Lincoln (119).

Henniker, John Henniker-Major, 4th Baron (1801–70). Suffolk, East (194).
*Herbert, Sidney Herbert, 1st Baron (1810–61). Wiltshire, South (180).
Heron, Sir Robert, Bart (1765–1854). Peterborough (161).
Herries, John Charles (1778–1855). Harwich (252).
Hill, Lord Arthur Marcus Cecil. See Sandys.
Hill, Lord Arthur Moyses William. See Sandys.
Hill, Rowland Hill, 2nd Viscount (1800–75). Salop, North (290).
Study, Hayter Sale (lot 500).
Hobhouse, John Cam. See Broughton de Gyfford.
Hodges, Thomas Law (1776–1857). Kent, West (56).
Holland, Henry Richard Vassall Fox, 3rd Baron (1773–1840). (6).
Study, Hayter Sale (lot 492).
Horne, Sir William (1774–1860). St Marylebone (152).
Study, Hayter Sale (lot 506).
Hotham, Beaumont Hotham, 3rd Baron (1794–1870). Leominster (192).
Howard, Philip Henry (1801–83). Carlisle (52).
Study, 1835, collection of Howard family, Corby Castle.
Howick, Viscount. See Grey.
Howley, William (1766–1848). Archbishop of Canterbury (311).
Hudson, Thomas (1772–1852). Evesham (240).
Study, Hayter Sale (lot 510); copy by pupil (lot 562).
*Hume, Joseph (1777–1855). Middlesex (218).
Study, Hayter Sale (lot 502).
Humphery, John (1794–1863). Southwark (143).
Study, Hayter Sale (lot 483).
Hylton, William George Hylton Jolliffe, 1st Baron (1800–76). Petersfield (183).
Study, Hayter Sale (lot 494).

Ingham, Robert (1793–1875). South Shields (329).
Study, 1838, Bonham's, 30 April 1970 (lot 214), and again 30 July 1970 (lot 217).
Inglis, Sir Robert Harry, Bart (1786–1855). Oxford University (258).
Study, Agnew, 1968; presumably Hayter Sale (lot 481); engraved by J.E. Coombs (example in British Museum).

James, William (1791–1861). Carlisle (280).
Study, 1838, collection of Selwyn Powell.
Jeffrey, Francis Jeffrey, Lord (1773–1850). Edinburgh (85).
Study, Hayter Sale (lot 522); engraved by J.E. Coombs and by Sartain (examples in NPG).
Jermyn, Earl. See Bristol.
Jersey, George Child-Villiers, 5th Earl of (1773–1859). (312).
Jersey, George Augustus Frederick Child-Villiers, 6th Earl of (Viscount Villiers) (1808–59). Honiton (188).
Johnstone, Sir John Vanden Bempde, Bart (1799–1869). Scarborough (67).
Jolliffe, William George Hylton. See Hylton.

Kemp, Thomas Read (1782–1844). Lewes (220).
Kennedy, Thomas Francis (1788–1879). Ayr (154).
Study, Scottish NPG; presumably Hayter Sale (lot 487); copy by pupil (lot 546).
Kerrison, Sir Edward, Bart (1774–1853). Eye (225).
Kerry, William Thomas Petty-Fitzmaurice, Earl of (1811–36). Calne (63).
Study, collection of the Earl of Powis; copy by pupil, Hayter Sale (lot 552).
King, Edward Bolton (1800–78). Warwick (333).
Knatchbull, Sir Edward, Bart (1781–1849). Kent, East (259).
Copy by pupil of study, Hayter Sale (lot 553).

Labouchere, Henry. See Taunton.
Langton, William Gore (1760–1847). Somerset, East (91).
*Lansdowne, Henry Petty-Fitzmaurice, 3rd Marquess of (1780–1863). (3).
Lefroy, Anthony (1800–90). County Longford (177).
Lefroy, Thomas Langlois (1776–1869). Dublin University (255).
Study, engraved by H. Robinson (example in British Museum).

Lester, Benjamin Lester (c1780–1838). Poole (89).

Ley, John Henry (d1850). First clerk of the House (158).
Study, Hayter Sale (lot 517).

Ley, William (c1817–47). Assistant clerk of the House (160).

Lincoln, Earl of. See Newcastle.

Lisgar, John Young, 1st Baron (1807–76). County Cavan (179).

Littleton, Edward John. See Hatherton.

Loch, James (1780–1855). Wick (372).

Locke, Wadham (1779–1835). Devizes (116).
Study, engraved by J.E.Coombs (example in British Museum).

Londonderry, Frederick William Robert Stewart, 4th Marquess of (Viscount Castlereagh) (1805–72). County Down (165).

Lopes, Sir Ralph, Bart (1788–1854). Westbury (364).

Lowther, Henry Cecil (1790–1867). Westmorland (196).
Study, Hayter Sale (lot 490).

Lygon, Henry Beauchamp. See Beauchamp.

*Lyndhurst, John Singleton Copley, Baron (1772–1863). (315).

Lyveden, Robert Vernon Smith, 1st Baron (1800–73). Northampton (142).

*Macaulay, Thomas Babington Macaulay, 1st Baron (1800–59). Leeds (10).
Study, Hayter Sale (lot 533).

Macleod, Roderick (1768–1853). Sutherland (43).
Study, Hayter Sale (lot 509).

Madocks, John (1786–1837). Denbigh (114).
Copy of study, 1841, collection of Mrs S.C.F.Lousada-Lloyd, Corwen.

Mahon, Viscount. See Stanhope.

Manners-Sutton, Charles. See Canterbury.

Mansfield, William David Murray, 4th Earl of (Viscount Stormont) (1806–98). Norwich (248).
Study, Hayter Sale (lot 476).

Marjoribanks, Stewart (1774–1863). Hythe (41).

Marlborough, George Spencer-Churchill, 6th Duke of (Marquess of Blandford) (1793–1857). Woodstock (237).
Study, Hayter Sale (lot 531); copy by pupil (lot 559).

Marshall, John (1797–1836). Leeds (131).

Maxfield, William (1782–1837). Great Grimsby (242).
Study, Hayter Sale (lot 485).

Maxwell, Henry. See Farnham.

*Melbourne, William Lamb, 2nd Viscount (1779–1848). (8).
Study, 1838, Royal Collection, and also a copy; copies by pupils, Hayter Sale (lots 544 and 559); pencil study for figure, 1837, NPG 4342 (this is catalogued elsewhere under Melbourne).

Mildmay, Paulet St John (1791–1845). Winchester (101).
Study, collection of Sir Gerald Mildmay, 1931.

Miller, William Henry (1789–1848). Newcastle-under-Lyme (293).
Study, Hayter Sale (lot 526).

Mills, John (1789–1871). Rochester (21).

*Molesworth, Sir William, Bart (1810–55). Cornwall, East (199).
Study, reproduced Mrs Fawcett, *Life of the Rt Hon Sir William Molesworth* (1901), facing p38.

Monteagle, Thomas Spring-Rice, 1st Baron (1790–1866). Cambridge (151).
Study, Hayter Sale (lot 530).

Morpeth, Viscount. See Carlisle.

Mosley, Sir Oswald, Bart (1785–1871). Staffordshire, North (57).

Mostyn, Edward Mostyn Lloyd-Mostyn, 2nd Baron (1795–1884). Flintshire (113).

Murray, Sir John Archibald Murray, Lord (1779–1859). Leith (94).

Newark, Charles Evelyn Pierrepont, Viscount (1805–50). East Retford (125).

*Newcastle, Henry Pelham Pelham-Clinton, 5th Duke of (Earl of Lincoln) (1811–64). Nottinghamshire, South (304).
Study, Hayter Sale (lot 530).

Nicholl, John (1797–1853). Cardiff (169).
Study, 1833, collection of R.I.Nicholl, Bridgend.

Noël, Sir Gerald Noël, Bart (1759–1838). Rutland (368).
Study, Hayter Sale (lot 521); copy by pupil (lot 552).

Norfolk, Henry Charles Howard, 13th Duke of (Earl of Surrey) (1791–1856). Sussex, West (90).

Norreys, Lord. See Abingdon.

North, Frederick (1800–69). Hastings (342).

*Northbrook, Francis Thornhill Baring, 1st Baron (1796–1866). Portsmouth (128).
Study, NPG 1257 (this is catalogued elsewhere under Northbrook).

*O'Connell, Daniel (1775–1847). Dublin (257).
Study, 1834, NPG 4582 (this is catalogued elsewhere under O'Connell).

O'Connor, Dennis (The O'Connor Don) (1794–1847). County Roscommon (275).

O'Ferrall, Richard More (1797–1880). County Kildare (50).
Study, Hayter Sale (lot 472).

Oranmore and Browne, Dominick Browne, 1st Baron (1787–1860). County Mayo (84).

Ormelie, Earl of. See Breadalbane.

Ossington, John Evelyn Denison, 1st Viscount (1800–73). Nottinghamshire, South (12).
Study, Hayter Sale (lot 469).

Oswald, Richard Alexander (1771–1841). Ayrshire (283).

Paget, Frederick (1807–66). Beaumaris (354).
Study, Hayter Sale (lot 535).

Palmer, Robert (1793–1872). Berkshire (232).

*Palmerston, Henry John Temple, 3rd Viscount (1784–1865). Hampshire, South (144).
Study, collection of Earl Mountbatten, Broadlands.

Patten, John Wilson. See Winmarleigh.

Pease, Joseph (1799–1872). County Durham, South (243).

*Peel, Sir Robert, Bart (1788–1850). Tamworth (249).
Study, Hayter Sale (lot 477).

Pendarves, Edward William Wynne (1775–1853). Cornwall, West (112).

Pepys, Charles Christopher. See Cottenham.

Perceval, Alexander (1787–1858). County Sligo (213).
Study, Hayter Sale (lot 484).

Philips, Sir George, Bart (1766–1847). Warwickshire, South (135).
Study, Hayter Sale (lot 515).

Pinney, William (1806–98). Lyme Regis (107).

Plumptre, John Pemberton (1791–1864). Kent, East (15).

*Pollock, Sir Jonathan Frederick, Bart (1783–1870). Huntingdon (294).
Study, Hayter Sale (lot 508).

Ponsonby, William Francis Spencer. See De Mauley.

Portman, Edward Berkeley Portman, 1st Viscount (1799–1888). St Marylebone (370).

Potter, Richard (1778–1842). Wigan (241).
Study, Hayter Sale (lot 505).

Poulter, John Sayer (d1847). Shaftesbury (80).
Study, 1834, collection of Paul Rich, 1972.

Powis, Edward Herbert, 2nd Earl of (Viscount Clive) (1785–1848). Ludlow (246).
Study, collection of the Earl of Powis.

Poyntz, William Stephen (c1769–1840). Ashburton (71).

Ramsbottom, John (d1845). Windsor (26).

Ramsden, John Charles (1788–1837). Malton (122).

Reid, Sir John Rae, Bart (1791–1867). Dover (230).

Rice-Trevor, George Rice. See Dinevor.

Richmond and Lennox, Charles Gordon Lennox, 5th Duke of (1791–1860). (1).
Study, Hayter Sale (lot 540).

Rickman, John (1771–1840). Assistant clerk of the House. (159).

Ripon, Frederick John Robinson, 1st Earl of (Viscount Goderich) (1782–1859). (5).

Rippon, Cuthbert. Gateshead (274).

Robinson, George Richard (1781–1850). Worcester (233).

Roche, William (1775–1850). Limerick (271).
Study, Hayter Sale (lot 525).

*Roebuck, John Arthur (1801–79). Bath (215).

Rosslyn, James St Clair Erskine, 2nd Earl of (1762–1837). (310).

Russell, Charles (1786–1856). Reading (187).

Russell, Lord Charles James Fox (1807–94). Bedfordshire (61).

*Russell, John, 1st Earl (Lord John Russell) (1792–1878). Devonshire, South (149).
 Copies of studies by pupils, Hayter Sale (lots 549, 555 and 556).

Russell, Lord. See Bedford.

Russell, William Congreve (1778–1850). Worcestershire, East (130).
 Study, Hayter Sale (lot 536).

Sandon, Viscount. See Harrowby.

Sandys, Arthur Moyses William Hill, 2nd Baron (Lord Arthur Hill) (1792–1860). County Down (355).
 Study, Hayter Sale (lot 533).

Sandys, Arthur Marcus Cecil Hill, 3rd Baron (Lord Arthur Marcus Cecil Hill) (1798–1863). Newry (62).
 Study, Hayter Sale (lot 520); copy by pupil (lot 556).

Sanford, Edward Ayshford (1794–1871). Somerset, West (105).

Scott, Sir Edward Dolman, Bart (1793–1851). Lichfield (34).

Scott, James Winter (1799–1873). Hampshire, North (358).

Seafield, Francis William Ogilvy-Grant, 6th Earl of (1778–1853). Elgin and Nairn (323).

Sebright, Sir John Saunders, Bart (1767–1846). Hertfordshire (357).
 Study, Hayter Sale (lot 534).

Seymour, Henry (c 1776–1843). Serjeant-at-arms (167).

*Shaftesbury, Anthony Ashley-Cooper, 7th Earl of (Lord Ashley) (1801–85). Dorset (307).
 Study, Hayter Sale (lot 504).

Sharpe, Matthew (d 1845). Dumfries (24).

Shaw, Sir Frederick, Bart (1799–1876). Dublin University (212).
 Study, 1834, Agnew, 1968; presumably Hayter Sale (lot 480).

Shaw-Lefevre, Charles. See Eversley.

Sheil, Richard Lalor (1791–1851). County Tipperary (239).

Sinclair, Sir George, Bart (1790–1868). Caithness (16).
 Study, Hayter Sale (lot 528).

Smith, Robert John. See Carrington.

Smith, Robert Vernon. See Lyveden.

Somers, John Somers Cocks, 2nd Earl (Viscount Eastnor) (1788–1852). Reigate (289).
 Study, Hayter Sale (lot 523).

Somerset, Lord Granville Charles Henry (1792–1848). Monmouthshire (251).

Spencer, Frederick Spencer, 4th Earl (1798–1857). Midhurst (64).

Spencer, John Charles Spencer, 3rd Earl (Viscount Althorp) (1782–1845). Northamptonshire, South (148).
 Study engraved by E. Scriven, published J. Saunders, 1840 (example in NPG), for 'Political Reformers'.

Spring-Rice, Thomas. See Monteagle.

Stair, John Hamilton Macgill Dalrymple, 8th Earl of (1771–1853). Edinburgh (40).
 Study, 1834, collection of the Earl of Stair; copy by pupil, Hayter Sale (lot 551).

*Stanhope, Philip Henry Stanhope, 5th Earl (Viscount Mahon) (1805–75). Hertford (235).
 Study, 1834, NPG 4436 (this is catalogued elsewhere under Stanhope); presumably Hayter Sale (lot 540).

Stanley, Edward George Geoffrey Smith. See Derby.

Stanley, Edward John Stanley, 2nd Baron (1802–69). Cheshire, North (65).
 Study, 1834, sold Sotheby's, 4 November 1964 (lot 129).

Staunton, Sir George Thomas, Bart (1781–1859). Hampshire, South (111).
 Study, said to be dated 1847, sold Puttick and Simpson, 15 February 1928 (lot 130).

Staveley, Thomas Kitchingman (1791–1860). Ripon (45).

Steuart, Robert (c 1806–42). Haddington (55).
 Study, Hayter Sale (lot 474).

Stormont, Viscount. See Mansfield.

Strafford, George Stevens Byng, 2nd Earl of (1806–86). Chatham (117).
 Study, Hayter Sale (lot 537).

Strafford, John Byng, 1st Earl of (1772–1860). Poole (37).
 Copy by pupil of study, Hayter Sale (lot 547).

Strickland (later Cholmley), Sir George, Bart (1782–1874). Yorkshire, West Riding (163).

Stuart, Charles (1810–92). Bute (193).

Stuart, Lord Dudley Coutts (1803–54). Arundel (78).

Surrey, Earl of. See Norfolk.

Sydenham, Charles Edward Poulett Thomson, 1st Baron (1799–1841). Manchester (145).
 Study engraved by W. H. Mote, published J. Saunders, 1840 (example in NPG), for 'Political Reformers'.

Talbot, Christopher Rice Mansel (1803–90). Glamorgan (126).
 Study, 1834, collection of C. M. Campbell, Penrice Castle, Glamorgan.

*Talbot de Malahide, James Talbot, 4th Baron (1805–83). Athlone (279).
 Study, 1833, collection of Lord Talbot de Malahide; presumably Hayter Sale (lot 488).
 Copy by pupil (lot 551).

Taunton, Henry Labouchere, 1st Baron (1789–1869). Taunton (139).

Tavistock, Marquess of. See Bedford.

Taylor, Michael Angelo (1757–1834). Sudbury (219).
 Study, Hayter Sale (lot 516); copy by pupil (lot 562).

Tennyson, Charles. See D'Eyncourt.

Thomson, Charles Edward Poulett. See Sydenham.

Tooke, William (1777–1863). Truro (103).

Tullamore, Lord. See Charleville.

Tynte, Charles John Kemeys (1800–82). Somerset, West (18).
 Study, Hayter Sale (lot 486).

Tyrell, Sir John Tyssen, Bart (1795–1877). Essex, North (189).
 Study, Hayter Sale (lot 534).

Venables-Vernon, George John. See Vernon.

Verner, Sir William, Bart (1782–1871). County Armagh (222).

Verney, Sir Harry, Bart (1801–94). Buckingham (14).

Vernon, George John Venables Vernon (later Warren), 7th Baron (1803–66). Derbyshire, South (81).
 Copy of study by pupil, Hayter Sale (lot 563).

Verulam, James Walter Grimston, 2nd Earl of (Viscount Grimston) (1809–95). Hertfordshire (303).
 Study, collection of Earl of Verulam, Gorhambury.

Vigors, Nicholas Aylward (1785–1840). Carlow (273).

Villiers, Viscount. See Jersey.

Vivian, John Henry (1785–1855). Swansea (42).

Vivian, Richard Hussey Vivian, 1st Baron (1775–1842). Truro (59).

Wall, Charles Baring (1795–1853). Guildford (205).

Walter, John (1776–1847). Berkshire (39).
 Study, Hayter Sale (lot 532).

Warburton, Henry (1785–1858). Bridport (217).
 Study engraved by W. H. Mote, published J. Saunders, 1840 (example in NPG), for 'Political Reformers'.

Ward, Sir Henry George (1797–1860). St Albans (104).
 Study, Hayter Sale (lot 537).

Watkins, John Lloyd Vaughan (1802–65). Brecon (93).
 Study, Hayter Sale (lot 543); copy by pupil (lot 548).

Watson, Richard (1800–52). Canterbury (38).
 Copy of study by pupil, Hayter Sale (lot 563).

Weld-Forester, George Cecil Weld. See Forester.

Wellington, Arthur Wellesley, 1st Duke of (1769–1852). (317).
 Two studies, both of 1839, collections of the Duke of Wellington and the Earl of Sandwich; see Lord G. Wellesley and J. Steegman, *The Iconography of the First Duke of Wellington* (1935), p 18, where the latter is reproduced, plate 35.

Weyland, Richard (1780–1864). Oxfordshire (35).

White, Luke (d 1854). County Longford (19).

White, Samuel (d 1854). County Leitrim (20).

Wigney, Isaac Newton (c 1795–1844). Brighton (48).

Wilbraham, George (1779–1852). Cheshire, South (79).

William, F. Doorkeeper (267).

Williams-Bulkeley, Sir Richard Bulkeley, Bart (1801–75). Anglesey (115).

Williamson, Sir Hedworth, Bart (1797–1861). County Durham, North (124).

Winmarleigh, John Wilson Patten, 1st Baron (1802–92). Lancashire, North (191).

Wood, Charles. See Halifax.

Wood, Thomas (1777–1860). Breconshire (223).

Wrottesley, John Wrottesley, 1st Baron (1771–1841). Staffordshire, South (133).

Wynn, Charles Watkin Williams (1775–1850). Montgomeryshire (247).

Yorke, Charles Philip. See Hardwicke.

Young, George Frederick (1791–1870). Tynemouth (335).

Young, John. See Lisgar.

Description: General diffused golden light, walls deep reddish-brown. Black pillars with gilded capitals supporting gallery. Brass chandeliers. Light brown floor and ceiling. Green curtain at either side framing picture. Foreground dark brown. Most of the figures in dark suits, with white shirts, dark neck-ties and multi-coloured waistcoats (Breadalbane in red uniform on the left is an exception). The general effect of the painting is relatively subdued.

1103 Sheet of three studies, showing Hayter at work on the 'House of Commons' group, 1843. See entry under Hayter, p 219. PLATE 1024

3073 Pencil on paper, $12\frac{5}{8} \times 17\frac{3}{4}$ inches (32×45.2 cm), by SIR GEORGE HAYTER. PLATE 1022

Inscribed in pencil (bottom left): sketch of the Interior of the House of Commons/for Sir G. Hayter's picture. *Above are various numbers.*

Collections: Presented by P. C. I. B. McNalty, 1939.

This perspective drawing tallies fairly closely with the composition of Hayter's 'House of Commons' group, and there seems little doubt that it is a preliminary study for the picture.

THE BRONTË SISTERS, *c* 1835

1725 See entry under Brontë, p 57.

MEMBERS OF THE HOUSE OF LORDS, *c* 1835

2789 Pencil and sepia wash on paper, $8\frac{3}{4} \times 7\frac{3}{8}$ inches (22.3×18.7 cm), attributed to ISAAC ROBERT CRUIKSHANK, *c* 1835. PLATE 1032

Collections: Presented by Godfrey Brennan, 1935.

Although there is nothing to prove that this sheet of heads is by Cruikshank, it is close to his work in style; the two domestic scenes in water-colour on the reverse are even more typical. These studies are not known to relate to any finished drawing or print, though they may have been executed with a finished design in mind. The date is based on costume and the apparent age of the sitters. The various people represented are briefly noted in the main body of the catalogue, which is arranged alphabetically, and are then referred here; an asterisk denotes that there are other portraits of the sitter in the NPG. The following numbers represent the sitters in order from left to right, top to bottom:

1 LONDONDERRY, Charles William Vane-Stewart, 3rd Marquess of (1778–1854). Soldier and statesman. Full-length figure, gesticulating.

2 LONDONDERRY, Charles William Vane-Stewart, 3rd Marquess of (1778–1854). Head only, inscribed above, 'Londonderry'.

3 STANHOPE, Philip Henry Stanhope, 4th Earl (1781–1855). Man of affairs. Head only, inscribed above, 'Stanhope'.

4 NEWCASTLE, Henry Pelham Fiennes Pelham-Clinton, 4th Duke of (1785–1851). Statesman. Head only, inscribed above, 'Newcastle'.

5 Unidentified seated figure, possibly the Duke of Newcastle (see no. 4 above).

*6 ABERDEEN, George Hamilton Gordon, 4th Earl of (1784–1860). Prime minister. Head only, inscribed above, 'Aberdeen'.

7 WHARNCLIFFE, James Archibald Stuart-Wortley-Mackenzie, 1st Baron (1776–1845). Statesman. Head only, inscribed above, 'Wharncliffe'.

8 Unidentified seated figure, possibly the Duke of Wellington (see no. 11 below).

*9 ELLENBOROUGH, Edward Law, 1st Earl of (1790–1871). Governor-general of India. Head only, inscribed above, 'Ellenborough'.

*10 Said by G.M.Trevelyan to be DERBY, Edward George Geoffrey Smith Stanley, 14th Earl of (1799–1869). Prime minister. Possibly the Earl of Ellenborough (see no.9 above). Full-length standing figure.

*11 WELLINGTON, Arthur Wellesley, 1st Duke of (1769–1852). Field-marshal and prime minister. Head only.

*12 PEEL, Sir Robert, Bart (1788–1850). Prime minister. Head only.

13 Unidentified standing figure. Possibly Peel.

A CONSULTATION PREVIOUS TO THE AERIAL VOYAGE TO WEILBURG, 1836

On 7–8 November 1836, Thomas Green, the celebrated balloonist, Thomas Monck Mason, the author of *Aeronautica*, and Robert Hollond, the lawyer and MP, made an important voyage from London to Weilburg in the well-known Vauxhall balloon, lent for the occasion by the proprietors, Gye and Hughes; the distance of about four hundred and eighty miles took eighteen hours, a record not beaten for a voyage from England till 1907. The voyage was made at the expense of Hollond who was passionately interested in ballooning (he made his first ascent in 1830 with Green's son). It was undertaken mainly in order to test a more elaborate form of guide-rope invented by Green. Provided with numerous scientific instruments, lavish supplies of food and wine, and parachutes for dropping communications and fireworks in case of a landing in the dark, the ascent was made from Vauxhall Gardens at about 1.30 pm on 7 November 1836. The English coastline was reached about 4.30 pm, and the crossing of the channel took place in darkness (the first crossing by Englishmen at night). From Calais, the balloon passed over Ypres, Lille, Brussels, Namur, Liège and Spa, crossing the Rhine about 6 am. A safe landing was made in a field in the valley of Elbern, about eight miles from Weilburg in Nassau, at 7.30 am. The balloonists were entertained in Weilburg in honour of their adventure, and the balloon itself was ceremoniously re-christened 'The Great Balloon of Nassau'. In England, news of the record aerial flight caught the public imagination, and it was hailed as a great achievement of aerial navigation. The voyage is described in detail by Thomas Monck Mason, *Account of the Late Aeronautical Expedition from London to Weilburg* (1836), and in his *Aeronautica* (1838), pp29–98 (with accompanying illustrations). Hollond's original log of the voyage was in a catalogue issued by T.Thorp of Guildford (no.326, 1919, item 4), apparently bought at the sale of Mrs Hollond's effects, Wonham House, Bampton, Devon, in December 1916. See also J.E.Hodgson, *The History of Aeronautics in Great Britain* (1924), pp250–4.

4710 Oil on canvas, 58 × 81½ inches (147·5 × 206·4 cm), by JOHN HOLLINS, *c*1836–8. PLATE 1033

Collections: Commissioned by Robert Hollond; by descent to E.R.Hollond; sold by his executors, Christie's, 6 March 1970 (lot 71), and purchased there.

Exhibitions: RA, 1838 (513).

The group represents from left to right: Walter Prideaux (1806–89), a lawyer and poet; John Hollins (1798–1855), the artist; Sir William Milbourne James (1807–81), another lawyer and later lord justice; Robert Hollond (1808–77), a lawyer and MP; Thomas Monck Mason (1803–89), the author of *Aeronautica;* and Charles Green (1785–1870), the famous balloonist. Prideaux and James were friends of Hollond (all three men were lawyers), and apparently interested in ballooning, hence their inclusion in the group. The picture shows the three men who actually made the journey on the right, discussing their route with the aid of a map. Also on the table is a fur cap with ear-pieces and a compass, while Green is wearing a cap and holding a telescope. Visible on a ledge behind is a lantern. On the left are Hollond's two friends and the artist, very much in the role of spectators. In the background on the left the Vauxhall balloon is visible, with various figures surrounding it.

 No record of Hollond's relations with Hollins survives (enquiries to the Hollond family have not so far yielded any documents or letters). However, the artist was evidently well-known to this aeronautical

group; he painted an independent portrait of Green in 1837, formerly in the collection of Hollond, and a portrait of Mrs Robert Hollond, exhibited *RA*, 1841 (184).

The NPG picture was engraved by J.H.Robinson, published H.Graves, 1843 (example in NPG, plate 1034). The engraving shows several details much more clearly than the painting which has suffered from bitumen and restoration. The head of Hollond is particularly badly affected, having lost most of the modelling in the features. The picture has also darkened, and parts of it have been over-painted, most obviously the sky.

Apart from Green, none of the other sitters is represented in the NPG by individual portraits. Their names are listed in the main body of the catalogue, which is arranged alphabetically, and referred to this entry for the group.

Description: Mainly fresh complexions, brown eyes and brown hair. Three figures on right dressed in black stocks, white shirts and black or brown coats; the figure of Mason, second from right, also in a black cloak; the figure of Green on the extreme right in a brown cap holding a telescope. The three figures on the left also in dark stocks, white shirts and dark coats; the figure of Prideaux on the left in a grey overcoat, wearing white gloves and holding a yellow handkerchief(?) to his breast, carrying a stick. Table in foreground covered with heavy orange-brown cloth, with a mainly black and red patterned border. On the table is a cap with ear-pieces, a metal compass, and a large map (no details visible). The background behind the three seated figures is very dark brown, with a pillar faintly visible on the right, and a lantern in the centre. On the left is a grey balustrade, with behind a view of Vauxhall Gardens (fresh green), the crimson and white striped balloon and a blue sky.

THE ANTI-SLAVERY SOCIETY CONVENTION, 1840

The convention of the British and Foreign Anti-Slavery Society was held in London in June 1840. The aims of the Society were the universal abolition of slavery and the slave trade, and the protection of emancipated negroes in the British Colonies. The convention considered and discussed a number of issues: the treatment of slaves in America, and the internal slave trade in the southern states; the condition of emancipated labourers in British Colonies; different forms of slavery throughout the world; the conduct of various religious bodies in the United States; and the condition of coloured people who had fled to Canada. At the opening session, it was decided to exclude female delegates; this led to the withdrawal of a number of American delegates, like W. Lloyd Garrison, who watched proceedings from the gallery. The first meeting at Freemasons' Hall on 12 June 1840 was presided over by the aged Thomas Clarkson, one of the founders of the anti-slavery movement in England. The convention continued its sittings until 24 June, when it concluded with a meeting at Exeter Hall presided over by the Duke of Sussex. Amongst the more distinguished people attending the convention were Daniel O'Connell, Joseph Sturge, Wendell Phillips, Sir Thomas Buxton, Stephen Lushington, Amelia Opie, Lady Byron, Thomas Binney, Sir John Jeremie, Samuel Gurney and Sir John Bowring.

599 Oil on canvas, 117 × 151 inches (297·2 × 383·6 cm), by BENJAMIN ROBERT HAYDON, 1840–1. PLATES 1035–1039

Signed and dated (on one of the steps, bottom left): B.R.HAYDON./1841.

Collections: Commissioned by the British and Foreign Anti-Slavery Society, 1840, and presented by them, 1880.

Exhibitions: Egyptian Hall, Piccadilly, 1841.

Literature: 'Description of Haydon's Picture of the Great Meeting of Delegates Held at the Freemasons' Tavern, June 1840, for the Abolition of Slavery and the Slave Trade Throughout the World',

1841; *Life of Benjamin Robert Haydon . . . from his Autobiography and Journals*, edited Tom Taylor, (1853) III, 154–76; J.Elmes, *Thomas Clarkson: a Monograph* (1854), pp296–313; H.Richard, *Memoirs of Joseph Sturge* (1864), pp216–19; G.Paston, *B.R.Haydon and his Friends* (1905), pp237–9, 242; *A Quaker Journal: Being the Diary and Reminiscences of William Lucas of Hitchin (1804–1861)*, edited G.E.Bryant and G.P.Baker (1934), I, 201–2, 231 and 241; E.George, *The Life and Death of Benjamin Robert Haydon* (1948), pp241–2; *The Diary of Benjamin Robert Haydon*, edited W.B.Pope (Cambridge, Mass, 1960–3), I,210n; IV, 640–64; V, 3–53, 259–60, and 296; for MS references see text below.

In his pamphlet on the picture, Haydon wrote ('Description of Haydon's Picture', 1841, pp7–8): '*Of all the meetings for benevolent purposes which were ever held in London, none ever exceeded in interest or object that which met at the Great Room, Freemasons' Tavern, in June 1840, headed by the venerable Clarkson, and composed of delegates from various parts of the world, in order to consult on the most effectual method of abolishing the curse of Slavery from those countries which, in spite of the noble example set them by England, still maintained it in all its atrocity and horror. The day before the meeting a deputation of gentlemen waited on me, to ask if I thought such an assemblage, with such a leader, might not be a subject fit for an historical picture? As it was necessary for me to be present before I decided, they invited me to attend the next day; and I candidly acknowledge I did so, rather unwilling to be drawn from my painting-room, and expecting nothing more than the usual routine of a public meeting – votes of thanks, and such like things. On entering the meeting at the time appointed, I saw at once I was in the midst of no common assembly. The venerable and benevolent heads which surrounded me, soon convinced me that materials existed of character and expression in the members present, provided any one moment of pictorial interest (on a fact) should occur. I immediately prepared for a sketch, and drew slightly with a pen on the back of my ticket the general characteristics of room and meeting*'.

Haydon wrote in his Diary under 12 June 1840 (*Diary*, IV, 640): '*Exceedingly excited, exhausted. I attended the great Convention of the Anti-slavery Society at Freemasons' Hall. Clarkson was there, and last Wednesday a Deputation called on me from the Committee, saying they wished a Sketch of the Scene. The meeting was very affecting . . . I returned after making various Sketches, and put in an all one*'. The exact reasons why Haydon was selected for the commission are not known (he said himself that it was the result of no connection or influence), though his advanced political opinions and deep religious sympathies would have recommended him to the largely Quaker Anti-Slavery Society. His only previously commissioned group portrait was the 'Reform Banquet, 1832' (collection of Lady Mary Howick, Howick).

Haydon decided to represent in his picture the concluding moments of Clarkson's speech, which had made a powerful impression on the assembly (a copy of the speech is in the British Museum, Add MS, 41267A, f178–9): '*The women wept – the men shook off their tears, unable to prevent their flowing; for myself, I was so affected and so astonished, that it was many minutes before I recovered, sufficiently to perceive the moment of interest I had longed for had come to pass*' ('Description of Haydon's Picture', 1841, p10). Clarkson is shown in the centre finishing his speech: '*Behind, beneath, and about him, are the oldest and dearest friends of the cause – whilst a liberated slave, now a delegate, is looking up to Clarkson with deep interest, and the hand of a friend is resting with affection on his arm, in fellowship and protection; this is the point of interest in the picture, and illustrative of the object in painting it – the African sitting by the intellectual European, in equality and intelligence, whilst the patriarch of the cause points to heaven as to whom he must be grateful* ('Description of Haydon's Picture,' 1841, p10).

William Lucas, who had noticed Haydon sketching the scene in Freemasons' Hall, doubted his '*having stability and perseverance enough to finish*' (*A Quaker Journal*, I, 202). Haydon, however, threw himself into the task with his accustomed enthusiasm and frenzy, having been assured by the Society that he would not suffer any loss for the sketch (*Diary*, IV, 641); he eventually received £525 (see *Diary*, V, 260). He drew Clarkson on 13 June and again on 15 June 1840: '*Breakfasted with Clarkson, and made another & a more aged Sketch, though a friend said of the other, "It had an indignant humanity"*' (*Diary*,

IV, 641). From 16–20 June, Haydon sketched continuously in the convention, remarking on the latter date that he had done fifty-two sketches of heads in five days. The following day, he wrote, '*This Convention has affected me deeply – too many heads, too remarkable diversity*' (*Diary*, IV, 642). Haydon began work on the picture itself on 24 June, the last day of the convention, remarking excitedly that he hoped it would '*advance the great cause of Abolition*' (*Diary*, IV, 642).

The vicissitudes of the picture are graphically described in Haydon's diary, and in his letters to the Clarksons. At times elated and at times depressed, he continued with his work almost uninterruptedly for nearly a year. His comments on his sitters are, by turns, laudatory, ironical, and contemptuous. He was quick to detect signs of insincerity and vanity in his subjects, and he poured scorn on their weaknesses. Early on, he had decided to place the negro delegate, Henry Beckford, from Jamaica, in the foreground of the picture, as a potent symbol of emancipation. Those members of the convention who objected to Beckford's prominent position were themselves relegated to the back rows.

Although the picture carries little conviction as a work of art, or as a statement about the Anti-Slavery movement, it was conceived and executed in a state of impassioned idealism. Haydon wrote characteristically to Mary Clarkson on 26 June 1840 (British Museum, Add MS, 41267A, f205–06): '*My heart & soul is in the Work . . . Never was a subject more worthy . . . It is now half in . . . & the Canvas will be all covered by tomorrow—You look simple & sweet & so does your Boy, even in the rough state – and your venerable Father is in his own attitude & position*'. On the following day, he wrote in his *Diary* (IV, 643): '*My sketches & the great Picture is sublime.*'

On 29 June 1840 he drew the American Lucretia Mott, whom he considered to have '*infidel notions, & resolved at once (narrow-minded or not) not to give her the prominent place I intended first. I will reserve that for a beautiful believer in the Divinity of Christ*' (*Diary*, IV, 644). On 30 June, Lloyd Garrison sat (he does not appear in the finished group), and on 3 July Lady Byron, who deeply impressed Haydon. Throughout July, he worked hard, drawing heads and transcribing them on to the canvas. In a letter to Clarkson of 8 July 1840 (British Museum, Add MS, 41267A, f214–15), he wrote: '*I am hard at work. The picture is all composed & rubbed in & Sturge, the negro, Scoble, Seakam, & Thompson done – I shall have 150 Portraits – I determined to place the negro (Beckford) on a level with the abolitionist – & have done so, and it tells the story at once – you seen addressing him . . . It will make a glorious Picture – depend on it and it will affect the people as to the vast effect of* Commemorative Art'.

The progress of the picture can be followed in Haydon's diary in detail. On 14 July, he wrote characteristically (*Diary*, IV, 647): '*Birney said Negro children equal Whites till seven, when, perceiving the degradation of their Parents, they felt degraded & cowed! Dreadful! Birney had discharged all his own Slaves. These Delegates are extraordinary Men in head, feature, & principle*'. And again on 18 July (*Diary*, IV, 648): '*Hard at work. Put in Prescod, the best painted head yet – capital tone. This picture will be to me a glorious study. I have done six heads this week. God be praised*'. Mrs Clarkson and her son sat again on 24 July, and on 29 July Haydon '*Sketched the head & advanced Clarkson*' (*Diary*, IV, 650); he had already borrowed Clarkson's clothes to paint from (see his letter of 19 July 1840 to Clarkson, British Museum, Add MS, 41267A, f222). Amelia Opie, whom Haydon thought '*a delightful Creature*' (*Diary*, IV, 651), sat on 31 July and on 1 and 3 August. On 8 August, he wrote (*Diary*, IV, 652): '*Worked hard – completed 10 heads this week. I think the neck of the Picture is broken. I began 24 of June. 32 heads are done – 7 days over for rubbing in & getting the Picture in order.*' Buxton sat on 15 August, '[his] *head is a singular expression of tenacity of purpose, and irresolution, yet he keeps to his object, in spite of his own conscious weakness of self will*' (*Diary*, IV, 661); Haydon's study of Buxton is in the NPG (3782).

Haydon's long bouts of work were productive. On 22 August, he noted (*Diary*, IV, 663): '*Nothing astonishes me so much as my rapidity with this Picture. It is truly the result of all my previous fagging – for years*'. He had moments of depression and lethargy, becoming, as he wrote (*Diary*, V, 4), '*faint & sick of "the human face divine"*', but his sense of purpose and dedication rarely wavered. One day he would work '*lazily, and the next gloriously hard*', but '*Certainly for 3 months I have not been Idle a week*' (*Diary*, V, 6). On 3 October, he worked on the background colour, '*& splashed in a negative tint, which*

did exactly & *which was delightful*' (*Diary*, v, 7). By 20 October, he had finished half the architectural background, and by the end of this month he remarked that the picture was three-fourths done. He continued to have sittings for the heads, drawing Sir Eardley Wilmot on 13 and 15 October, R.R. Madden on 6 November, and Dr Lushington on 11 and 16 November. Around this time, the Society who had commissioned the group, decided to increase the number of people represented: '*Their bringing me 31 heads more, after arranging 103, is rather a joke, but if they like, they shall have heads all over, like a peacock's tail*' (*Diary*, v, 15).

In December 1840 and January 1841, Haydon spent several days lecturing in the provinces, and was able to devote little time to his picture. By the end of January, however, he was once again hard at work, writing on 26 January 1841 (*Diary*, v, 29): '*Yesterday I rubbed out the Curtain & improved the whole effect. An Architect said today it did not look like a Picture, but like the thing itself*'. Daniel O'Connell sat on 9 February, '*a keen, lynx look, and great good nature, but cunning & trick[y]*' (*Diary*, v, 31). On 13 February, Haydon felt very dizzy, '*from painting 8 hours on the Floor*' (*Diary*, v, 33). For the rest of the month, and throughout March, he worked energetically. On 9 March, he added the drapery on the right of the picture: '*Adapted the improvement with great Effect*' (*Diary*, v, 37). By 12 March he had painted in one hundred and twenty heads: '*I am bringing this work rapidly to a conclusion*' (*Diary*, v, 37). He wrote to Clarkson on 19 March 1841 (British Museum, Add MS, 41267A, f232–3): '*The Picture is drawing rapidly to a close; such is the anxiety to be in it that abolitionists have come I verily believe from all the quarters of the Globe. . . . I trust in God, it will have a moral influence on the sacred cause, and by exciting attention contribute however humbly to keep up the desire among other more effectual stimulants the imperishable desire for the ultimate extinction of the greatest curse ever afflicted on creatures gifted with life & sensibility*'. The 'rush to be in' the picture, and the envy which it aroused, disgusted Haydon. On 26 March 1841, he drew Samuel Fox, and Professor Adams and Dr Murch on the following day. On 29 March, he improved the background, and wrote in his *Diary* on 31 March (v, 41): '*Last day of the Month in which I have, thank God, brought my Picture to a conclusion except toning & one head, which I go to Bristol to do tommorrow – Joseph Reynolds. For all thy mercies, O God, during its progress, accept my deep gratitude. Amen*'. On 6 April, Haydon visited Clarkson at Playford Hall, and drew him again on the 8th. He put in Reynolds, and '*finished & improved Clarkson*' (*Diary*, v, 48) on 12 April. Twelve days later he wrote (*Diary*, v, 48): '*I have now completed really my last head this day. The Picture is, in fact, except toning done*'. Three days later Haydon inscribed the names of Wilberforce, Sharpe and Toussaint on the curtain in the picture, but was forced to remove them by the Secretary of the British and Foreign Anti-Slavery Society (for his letter, and Haydon's comments, see *Diary*, v, 49 and n). On 30 April 1841 the picture was completely finished, and it was varnished on 4 and 5 May, and a few alterations to the tone of the background made on the following day.

The exhibition of the picture at the Egyptian Gallery opened on 13 May 1841, with an accompanying catalogue. The private view was '*crowded by nobility, gentry, clergy, delegates in drab . . . ladies of rank, male and female friends*' (Elmes, p 305). The exhibition was noticed in the press, although not in the *Times* or the leading art journals; the *Advertiser* wrote a favourable review, while the *Post* called it '*a great abortion in historical art*' (see *Diary*, v, 50n). Haydon himself felt that '*The Picture as an Exhibition has failed entirely*' (*Diary*, v, 50), and he was upset by the critical response to it: '*The Criticism of this Picture has been absurd. Because it looks like mere Nature, the Criticks think the* Art *has been overlooked; whereas, there is as much, or more Art, in this artless look than in many Compositions of more profundity*' (*Diary*, v, 53). In a later note, written in 1843, Haydon voiced a more cynical view: '*I have painted two such works* [as Hayter's 'House of Commons, 1833', NPG 54] – *the Quakers & the Whigs, but if I ever paint a third, I'll compose it as if I was composing an ancient Subject & fit on modern heads on principles of Art, not bend principles of art to modern Vanity. The Quaker Picture was so much a dozen; after the Composition was settled, I used to get notes from Joseph Sturge, "Friend Haydon, I would thank thee to put in the bearer (an old abolitionist)". There were at least 50 heads where no bodies could be squeezed, according to perspective. . . . I painted the picture for 525, & lost 248.16.8 by the exhibition of it*' (*Diary*, v, 259–60).

Among the abolitionists themselves, reactions to the picture were mixed. Mrs Clarkson wrote to her daughter (British Museum, Add MS, 41267A, f252): '*The Picture is the most wonderful thing I ever saw & far surpassed any thing that I could have imagined. . . . Nothing ever appeared to me so like enchantment*'. William Lucas voiced a more general opinion (*A Quaker Journal*, I, 241, 18 May 1841): '*Haydon's great picture of Anti-slavery Convention, a waggon load of heads, poor as a work of art but interesting from the number of portraits; these, though most may be recognized, are none of them faithful; they may all be said to be Haydonized. Clarkson not enough of the feeble old man*'. Concerning the likenesses Lucas had previously noted that: '*The best are those of T. Clarkson, W. Allen, F. Buxton, S. Gurney, Josiah Forster, Wm Forster, G. Stacey, J. Scoble, Stanton, Amelia Opie, Scales of Leeds*' (*A Quaker Journal*, I, 231, 26 December 1840). Lucas' criticism of the likenesses was echoed by Haydon himself (*Diary*, V, 16): '*My Portraits are never happy likenesses, yet they all come – they are strong, vigorous, natural likenesses. But they (my Sitters) seem ambitious to be able to say, "I too was an Arcadian, I too was one of his illustrious Victims".*' In the same vein, one of his sitters, Miss Patty Smith (not apparently included in the finished group), had written to Mrs Clarkson (British Museum, Add MS, 41267A, f209): '*His sketches are fine & he has given immense variety of character to the delegates but I doubt whether he is an adept in the peculiarity of likeness – Grandeur is his forte – Mr C looks like a Homer or a Belisarius – an affecting noble head, but not quite his Mr C's Eye. . . . He has made rather a magnificent sharp-nosed gaunt old lady of me very flattering certainly – picturesque & heroic*'.

In spite of Haydon's intense artistic ambitions, his picture of the 'Anti-Slavery Society Convention', like so many of his large paintings, does not live up to its promise. Even at a technical level, for instance in the arrangement of the space and the figures, it borders on the incompetent; the transition between the sea of faces in the foreground and the dim and distant background of the hall is crudely handled. The composition is monotonous and curiously implausible; Clarkson, with his upraised arm, is not a satisfactory point of focus for the crowded ranks of faces. The picture remains a 'waggon-load of heads', neither psychologically nor spatially related to one another, and apparently without bodies. Haydon was aware of this last defect, remarking that '*at last the picture threatened to become nothing but heads, without room for bodies*' (Elmes, p 306). Individually, some of the heads have a certain fierce and brooding power (they might be the work of a romantic German painter), but the overall conception is pedestrian. Haydon later wrote of Hayter's 'House of Commons' group (NPG 54), that '*The Time is fast coming when we shall get sick of these bastard "High Art Works"*' (*Diary*, V, 259), but his own picture belongs to the same genre, and reflects the same uneasy coalition of group portraiture and history painting.

Although Haydon clearly executed a vast number of studies for his picture (references to sittings will be found in his *Diary*), very few can now be located. A pen-and-ink study for the whole composition is in the British Museum (Add MS, 41267A, f216) (plate 1036), a drawing of Buxton is in the NPG (3782), and two groups of drawings of heads were owned by A. T. Playfair and E. Kersley, 1952; the latter were sold at Sotheby's (book sale), 11 March 1952 (lot 154). These studies of heads are noted with the names of the individual sitters listed below. The list, based on that in the 'Description of Haydon's Picture', 1841, is arranged alphabetically, with the dates of the sitters, if known, the places they represented in the convention and their numbers in the key in brackets. An asterisk beside the name of a sitter denotes that other portraits of him are included in this catalogue, which is arranged alphabetically with (except in the case of other groups) an accompanying iconography. Other sitters are briefly mentioned in the main body of the catalogue, and referred to this section. The following people are represented:

Adam, Professor. Delegate from Massachusetts, USA (129).

Adey, Rev Edward. Delegate from Leighton Buzzard (101).

Alexander, George William (1802–90). Treasurer of the British and Foreign Anti-Slavery Society (7).
 Pencil study, 1841: Sotheby's, 11 March 1952 (lot 154).

Allen, Richard (1787–1873). Delegate from the Hibernian Anti-Slavery Society (75).
 Pencil study: A. T. Playfair, 1952.

Allen, Stafford (1806–89). Member of the committee of the British and Foreign Anti-Slavery Society (30A).

Allen, William (1770–1843). Member of the committee of the British and Foreign Anti-Slavery Society (2).

Baines, Edward (later Sir Edward) (1800–90). Delegate from Leeds (22A).

Baldwin, Edward. Delegate from the Hibernian Anti-Slavery Society (76).

Bannister, Saxe (1790–1877). Delegate from the Aborigines Protection Society (122).

Barrett, Edward. An emancipated slave; delegate from the Western Baptist Union, Jamaica (83).
 Pencil study: A. T. Playfair, 1952.

Barrett, Richard. Delegate from Croydon (92A).

Bass, Isaac (1782–1855). Delegate from Brighton (116).
 Pencil study: Sotheby's, 11 March 1952 (lot 154).

Beaumont, Abraham (1782–1848). Of Stamford Hill (24).

Beaumont, John (1788–1862). Member of the committee of the British and Foreign Anti-Slavery Society (12).

Beaumont, Mrs John (1790–1853). Of London (96).

Beaumont, William (1790–1869). Delegate from Newcastle-on-Tyne (28).

Beckford, Henry. An emancipated slave; delegate from the Western Baptist Union, Jamaica (36).

Bennett, George. Member of the committee of the British and Foreign Anti-Slavery Society; delegate from the Congregational Union of England and Wales (124).

Bevan, Rev William. One of the secretaries of the convention; member of the committee of the British and Foreign Anti-Slavery Society; delegate from Liverpool (40).

*Binney, Rev Thomas (1798–1874). Delegate from the Associated Churches and Ministers in the Isle of Wight (82).

Birney, James Gillespie (1792–1857). One of the vice-presidents of the convention; delegate from the American and New York Anti-Slavery Societies (11).
 Pencil study, 1840: Sotheby's, 11 March 1952 (lot 154).

Birt, Rev John. Delegate from Manchester (99).
 Pencil study: A. T. Playfair, 1952.

Blackhouse, Jonathan. Delegate from Darlington (21).

Blair, W. T. One of the vice-presidents of the convention; delegate from Bath (25).

Boultbee, William. Delegate from Birmingham (113).

Bowly, Samuel (1802–84). Delegate from Gloucester (20).
 Pencil study: Sotheby's, 11 March 1952 (lot 154).

*Bowring, John (later Sir John) (1792–1872). Delegate from Exeter (55).
 Pencil study: Sotheby's, 11 March 1952 (lot 154).

Bradburn, George. Delegate from the Massachusetts Anti-Slavery Society (13).

Brock, Rev William (1807–75). Delegate from Norfolk and Norwich (77).

Bulley, Thomas. Delegate from Liverpool (106).

Burnet, Rev John. Delegate from the Congregational Union of England and Wales (39).
 Pencil study: A. T. Playfair, 1952.

*Buxton, Sir Thomas Fowell (1786–1845). Member of the committee of the British and Foreign Anti-Slavery Society (14). Pencil study: NPG 3782 (this is catalogued elsewhere under Buxton).

Byron, Lady (1792–1860). (50).

Cadbury, Rev Tapper (1768–1860). Delegate from Birmingham (102).

Carlile, Rev James (1784–1854). Delegate for Bradford, Wiltshire (81).

Clare, Peter (1781–1851). Member of the committee of the British and Foreign Anti-Slavery Society; delegate from Manchester (57).

Clarkson, Thomas (1760–1846). President of the convention (1). Two pencil studies, 1840 and 1841: Sotheby's, 11 March 1952 (lot 154).

Clarkson, Master Thomas. Grandson of the president of the convention (10).

Clarkson, Mrs Mary. Widow of the late T. Clarkson, junior, and daughter-in-law of the president of the convention (9).

Colver, Rev Nathaniel. Delegate from the American Baptist and Massachusetts Anti-Slavery Societies (64).
 Pencil study, 1840: Sotheby's, 11 March 1952 (lot 154).

Conder, Josiah (1789–1855). Member of the committee of the British and Foreign Anti-Slavery Society (73).

Cooper, Joseph (1800–81). Member of the committee of the British and Foreign Anti-Slavery Society (56).

Cox, Rev Francis Augustus (1783–1853). Delegate from the Congregation, Hare Street, Hackney (22).

Crewdson, Isaac (1780–1844). Delegate from Manchester (108).
 Pencil study: A. T. Playfair, 1952.

Crewdson, William Dillworth. Honorary member of the committee of the British and Foreign Anti-Slavery Society; delegate from Kendal (32).
 Pencil study: A. T. Playfair, 1952.

Cropper, John, junior. Honorary member of the committee of the British and Foreign Anti-Slavery Society; delegate from Liverpool (33).

Dawes, William. Delegate from the Ohio Anti-Slavery Society (19).
 Pencil study: A. T. Playfair, 1952.

Dean, Professor James. Delegate from Vermont, USA (74).

Eaton, Joseph (1793–1858). Delegate from Bristol (65).
 Pencil study: Sotheby's, 11 March 1952 (lot 154).

Ellis, John (1789–1862). Delegate from Leicester (88).

Fairbank, William (1771–1846). Delegate from Sheffield (111).

Forster, Josiah (1782–1870). Member of the committee of the British and Foreign Anti-Slavery Society (5).

Forster, Robert (1792–1873). Member of the committee of the British and Foreign Anti-Slavery Society (46).

Forster, William (1784–1854). Delegate from Norfolk and Norwich (6).

Fox, Samuel (1781–1868). Delegate from Nottingham (20A).

Galusha, Rev Eton. Delegate from the American Baptist Anti-Slavery Society (80).
 Pencil study: A. T. Playfair, 1952.

Godwin, Rev B. Delegate from the Baptist Church, Oxford (69).

Greville, Robert Kaye (1794–1866). One of the vice-presidents of the convention; delegate from Edinburgh (18).

Grosvenor, Rev Cyrus Pitt. Delegate from the National and American and Foreign Anti-Slavery Societies (79).
 Pencil study: A. T. Playfair, 1952.

Gurney, Samuel (1786–1856). Member of the committee of the British and Foreign Anti-Slavery Society (3).
 Pencil study: Sotheby's, 11 March 1952 (lot 154).

Head, George Head. Delegate from Carlisle (47).
 Pencil study, 1840: A. T. Playfair, 1952.

Hinton, Rev John Howard (1791–1873). Member of the committee of the British and Foreign Anti-Slavery Society (84).
 Pencil study: A. T. Playfair, 1952.

Hodgson, Isaac (1783–1847). Delegate from Leicester (105).

Isambert, M. M. Secretary of the French Society for the Abolition of Slavery (29).

James, Rev John Angell (1785–1859). Delegate from Birmingham, and for Jamaica (85).

James, Rev William. Delegate from Bridgwater (119).

Jeremie, Sir John (1795–1841). Governor-general of Sierra Leone; honorary member of the committee of the British and Foreign Anti-Slavery Society (61).
 Pencil study, 1840: A. T. Playfair, 1952.

Johnson, Rev J. H. Delegate from Devizes (58).

Kay, William. Delegate from Liverpool (107).

Keep, Rev John. Delegate from the Ohio Anti-Slavery Society (66).
 Pencil study: Sotheby's, 11 March 1952 (lot 154).

Ketley, Rev Joseph. Honorary member of the British and Foreign Anti-Slavery Society; delegate from Demerara (41).

Knibb, Rev William (1803–45). Delegate from the Western Baptist Union, Jamaica (38).

Knight, Miss Ann (1792–1860). Of Chelmsford (95).
 Two pencil studies: Sotheby's, 11 March 1952 (lot 154).

Leatham, William (1783–1842). Delegate from Wakefield (30).

Lecesne, L. C. Member of the committee of the British and Foreign Anti-Slavery Society (23).

Lester, Rev C. Edwards. Delegate from the Bleeker Street Church, USA (54).

L'Instant, M. Delegate from Haiti (45).

Lucas, Samuel. Delegate from Croydon (23A).

*Lushington, Dr Stephen (1782–1873). Member of the committee of the British and Foreign Anti-Slavery Society (15).

McDonnell, Rev T.M. Delegate from Birmingham (97).

*Madden, Dr Richard Robert (1798–1886). Delegate from the Hibernian Anti-Slavery Society (86).

Marriage, Joseph, junior (1807–84). Delegate from Chelmsford (27).

Miller, Colonel Jonathan. Delegate from Vermont, USA (63).

Moorsom, Captain (later vice-admiral) Constantine Richard (1792–1861). Delegate from Birmingham (67).

Morgan, Rev Thomas. Delegate from Birmingham, and for the Pembrokeshire Association (87).

Morgan, William. One of the secretaries of the convention; member of the committee of the British and Foreign Anti-Slavery Society; delegate from Birmingham (35).

Morrison, Rev John. Delegate from the Durham County Association of Congregational Churches (72).

Mott, James. Delegate from Pennsylvania, USA (92).

Mott, Mrs Lucretia (1793–1880). Of the USA (127).

Murch, Dr. Delegate from the Baptist Union (131).

Norton, Hon John T. Delegate from Connecticut, USA (93).

*O'Connell, Daniel (1775–1847). Delegate from the Hibernian and Glasgow Anti-Slavery Societies (17).
 Pencil study, 1841: A.T.Playfair, 1952.

Opie, Mrs Amelia (1769–1853). Of Norwich (49).
 Pencil study, possibly representing her: Sotheby's, 11 March 1952 (lot 154).

Pease, Joseph, senior (1772–1846). Delegate from Darlington (26).

Pease, Miss Elizabeth. Of Darlington (94).

Peek, Richard. Member of the committee of the British and Foreign Anti-Slavery Society; delegate from Kingsbridge, Devon (60A).

Phillips, Wendell (1811–84). One of the secretaries of the convention; delegate from Massachusetts, USA (52).

Pinches, Thomas. Delegate from Birmingham (103).
 Pencil study: Sotheby's, 11 March 1952 (lot 154).

Post, Jacob. (1774–1855). Member of the committee of the British and Foreign Anti-Slavery Society (51).

Prescod, Samuel J. Delegate from Bridge Town, Barbados (43).

Price, Dr Thomas. Member of the committee of the British and Foreign Anti-Slavery Society (115).

Prince, Dr G.K. Delegate from Chesterfield (71).

Rathbone, Richard. Delegate from Liverpool (100).

Rawson, Mrs. Of Sheffield (48).

Reynolds, Joseph. (1769–1859). Delegate from Bristol (114).
 Pencil study: A.T.Playfair, 1952.

Sams, Joseph (1784–1860). Delegate from Barnard Castle (98).

Scales, Rev Thomas. One of the secretaries of the convention; member of the committee of the British and Foreign Anti-Slavery Society; delegate from Leeds (34).

Scoble, John. One of the secretaries of the convention; honorary member of the committee of the British and Foreign Anti-Slavery Society; delegate from Newark (37).

Smeal, William (1792–1877). Delegate from Glasgow and Paisley (109).

Smith, Edward. Delegate from Sheffield (104).
 Pencil study: A.T.Playfair, 1952.

Soul, Joseph. Of Islington (126).

Stacey, George (1787–1857). Member of the committee of the British and Foreign Anti-Slavery Society (4).

Stanton, Henry B. One of the secretaries of the convention; delegate from the American and New York Anti-Slavery Societies (44).

Steane, Rev Edward. Delegate from the Baptist Union (118).

Steer, John (1780–1856). Delegate from Derby (91).

Sterry, Henry (1803–69). Member of the committee of the British and Foreign Anti-Slavery Society (78).

Sterry, Richard (1785–1865). Delegate from Croydon (70).

Stovel, Rev Charles. Delegate from the Baptist Union (60).

Stuart, Captain Charles. Delegate from Jamaica (62).

Sturge, John. Delegate from Birmingham (59).

Sturge, Joseph (1793–1859). One of the vice-presidents of the convention; honorary member of the committee of the British and Foreign Anti-Slavery Society; delegate from Birmingham and Jamaica (31).

Swan, Rev Thomas. Delegate from Birmingham (117).

Tatum, William (1783–1862). Delegate from Rochester and Chatham (121).

Taylor, Rev Henry. Delegate from Woodbridge (89).

Taylor, William. Member of the committee of the British and Foreign Anti-Slavery Society (68).

Thompson, George (1804–78). Delegate from the Edinburgh and Glasgow Anti-Slavery Societies (42).

Tredgold, J. Harfield. Secretary of the British and Foreign Anti-Slavery Society (8).

Tredgold, Mrs. Of London (130).

Tuckett, Henry. Member of the committee of the British and Foreign Anti-Slavery Society (53).

Turnbull, David. British consul at Havana; member of the committee of the British and Foreign Anti-Slavery Society (90).

Webb, Richard D. Delegate from the Hibernian Anti-Slavery Society (120).

Wheeler, Samuel (1776–1858). Delegate from Rochester (112).
 Pencil study: Sotheby's, 11 March 1952 (lot 154).

Whitehorne, James. Delegate from Bristol, and for Jamaica (123).

Wilmot, Sir John Eardley Eardley, Bart (1783–1847). Hon corresponding member of the British and Foreign Anti-Slavery Society (16).

Wilson, William. Delegate from Nottingham (125).

Woodwark, Rev John. Member of the committee of the British and Foreign Anti-Slavery Society; delegate from the Congregational Union of England and Wales (110).

Description: A full inspection of the picture was not possible, because of its fixed position and enormous size. The painting is predominantly dark in tone; the high-lighted heads stand out from the generally black costumes and prevailing gloom; two gilt chandeliers in the centre and on the right; red curtain top right, with a red and gilt cord to the left of it; dark grey and brown architecture in the background; red gallery below, with white high-lights on the background figures; large grey pillar at left, with a full-length portrait of a man just to the left of it; Clarkson is shown standing in front of a wooden armchair covered in red, resting one hand on a table, with a white cloth, and on it a black ink-stand and quill and red sealing-wax, a rolled white document or newspaper, and two brown leather volumes, the top one entitled on the spine, 'EAST INDIES/1837', and the other, 'CLARKSON/ON THE/SLAVE TRADE'; greyish-brown wooden or stone steps (three) on the left, covered with a red carpet; lightish brown wooden floor in foreground, with two unidentified brown leather-bound volumes lying on it; the backs of several wooden chairs are visible above.

SAMUEL ROGERS, MRS NORTON (LADY STIRLING-MAXWELL) AND MRS PHIPPS, *c* 1845

Oil on canvas, $24\frac{1}{2} \times 29\frac{3}{8}$ inches (62·2 × 74·6 cm), by FRANK STONE, *c* 1845. PLATES 1040, 863

Collections: Henry Bohn, sold Christie's, 28 March 1885 (lot 1581), bought Lord Houghton; presented by his son, the 2nd Marquess of Crewe, 1921.

Exhibitions: Charles Dickens, Victoria and Albert Museum, 1970 (P19).

Literature: Connoisseur, LXII (1922), 174, reproduced 175.

The picture represents Mrs Phipps on the left, Samuel Rogers in the centre and Caroline Norton (later Lady Stirling-Maxwell) on the right. Its early history is unknown. The fact that it remained unfinished, and that it was painted at a time when Stone had largely given up portraiture, suggests that it was a spontaneous and informal sketch, rather than a commissioned work. The attribution to Stone rests on tradition, but is very credible, and accords well with his style. The date is based on costume. A small oil sketch of Rogers by Stone (15 × 12 inches (38·1 × 30·5 cm)), very close in pose and features to the NPG portrait, is in the collection of William Marshall, sold from the Burdett-Coutts Collection, Christie's, 4 May 1922 (lot 240). Stone is known to have been friendly with Rogers (they were probably introduced by Dickens), while Caroline Norton was an old friend of the poet. Mrs Phipps had married Caroline Norton's brother-in-law, the Hon Charles Francis Norton, in 1831. Following his death in 1835, she married the Hon Edmund Phipps, son of the 1st Earl of Mulgrave, in 1838. Other portraits of Caroline Norton in the NPG are included in the main body of this catalogue under her second married name, Stirling-Maxwell. Portraits of Samuel Rogers in the NPG will be catalogued in the forthcoming Catalogue of Portraits, 1790–1830.

Description: Mrs Phipps on the left, fresh complexion, dark eyes and brown hair, dressed in black with white lace sleeves and neck. Rogers, sallow complexion, dark eyes, grey hair, dressed in a white shirt, dark stock and dark brown coat. Mrs Norton, fresh complexion, dark eyes, black hair, dressed in white with a blue bow at her bosom. Background colours red and brown.

THE FINE ARTS COMMISSIONERS, 1846

The Fine Arts Commission was appointed in November 1841 to consider the decoration of the newly rebuilt Houses of Parliament, with a view to 'promoting and encouraging the Fine Arts' in England. The Palace of Westminster had been burnt down in a spectacular fire in 1834, and had forced on the state a large measure of public patronage of the arts. In 1835 a Royal Commission had chosen Charles Barry as the architect of the new Palace, after a widely advertised competition, and by 1840 his building was far advanced enough to consider the question of suitable decoration. With the growth of interest in history painting, stimulated by the successes of the French and German schools, the time seemed ripe for an ambitious series of murals celebrating the nation's achievements. A select committee of 1841, called together to consider the whole issue, listened to a number of expert witnesses, and discussed a variety of questions, for instance, the most suitable technique for mural painting, the most appropriate subjects, and the best method of selecting artists. They recommended that a commission should be set up to deal with the whole question of decoration for the new building. Peel, the prime minister of the day, appointed Prince Albert as the president of the Commission (it was a suitably safe and unpolitical field of activity for the young and inexperienced Prince), and Charles Eastlake, probably the most knowledgeable art historian of his time, as secretary. The Commission included a number of figures who had already sat on the Committee, or had been called as witnesses: Sir Robert Peel; Sir Robert Inglis, a Tory MP and a vice-president of the Society of Antiquaries; Lord Francis Egerton, the great

collector; Benjamin Hawes, an MP, on whose motion the Select Committee of 1841 had been set up; Thomas Wyse, a traveller, scholar and educational reformer; Henry Gally Knight, a traveller and author of several architectural books; and George Vivian, who had been on the Commission of 1835 which selected Barry as the architect. The Commission included a number of statesmen and politicians: the Marquess of Lansdowne; the Duke of Sutherland; Viscount Morpeth (later Earl of Carlisle); Viscount Melbourne; Sir James Graham; the Earl of Aberdeen; Viscount Canning (later Earl Canning); Viscount Palmerston; Lord John Russell; Lord Lyndhurst; Charles Shaw-Lefevre (later Viscount Eversley); and the Earl of Lincoln (later Duke of Newcastle). Two military men were included, Lord Colborne and Lord Willoughby De Eresby; the financier, Lord Ashburton; the historians, Thomas Macaulay, Viscount Mahon (later Earl Stanhope), and Henry Hallam; the poet, Samuel Rogers; and the architect, Charles Barry.

The whole history of the Commission – the competitions it organized, the artists and subjects it selected, the frescoes and statues that were actually completed – is extremely complicated, and was attended with endless problems and controversies, not least the enormous volume of comment in the public press. It is discussed in great detail in T. S. R. Boase's excellent article, 'The Decoration of the New Palace of Westminster, 1841–1863', *Journal of the Warburg and Courtauld Institutes*, XVII (1954), 319–58, on which this short description is largely based. If, in the final analysis, the attempt to create a form of high art, in keeping with the spirit of the new Victorian Age, was, almost inevitably, a failure, and no more than an interesting incident in the history of English art, it was the most notable example of state patronage in England since the Middle Ages.

342 Oil on canvas, 74 × 145 inches (188 × 372·8 cm), by JOHN PARTRIDGE, *c* 1846–53. PLATE 1043

Collections: The artist, presented by him, 1872.

Literature: 'Mr Partridge's Picture, Representing a Meeting of the Royal Commission of the Fine Arts' (printed pamphlet, NPG archives); R. L. Ormond, 'John Partridge and the Fine Arts Commissioners', *Burlingon Magazine*, CIX (1967), 397–402.

This picture is now a complete ruin through the effects of bitumen, and is only preserved as an interesting relic. It is discussed in detail in the *Burlington Magazine* article referred to above. Partridge, who was portrait painter extraordinary to the Queen, and a friend of the Prince Consort, was probably encouraged by the latter to undertake the group picture of the Commissioners, though he never received an official commission[1]; the artist presumably hoped that the picture would re-establish his reputation after his row with the Royal Academy.[2]

Partridge's picture represents the Commission as it was constituted in 1846, and includes twenty-eight figures. Prince Albert executed a drawing for him to show the position of members at a particular meeting (NPG 343b below), but Partridge did not follow this seating plan, and his portrait is inevitably a more generalized statement. He chose an idealized setting for the picture, grouping a number of famous paintings and sculptures by English artists around the room: '*The two-fold object of the Picture is to commemorate the extension of Government Patronage to the Fine Arts, in the decoration of the New Houses of Parliament, and to present an assemblage of the eminent men appointed to carry this purpose into effect. The locale of the Meeting is Gwydir House* [Whitehall]; *and (with a view to illustrate the previous state of Art in England, as well as to relieve the monotonous effect of an unfurnished room, and a mass of*

[1] This is borne out by two letters written by Macaulay. In the first, to an unidentified correspondent (30 May 1849, collection of Dr A. N. L. Munby, Cambridge), he writes: '*One of the pictures for which I am sitting contains numerous figures, and will, when it is finished, be the property of His Royal Highness Prince Albert*'. In the second to J. E. Denison (25 April 1853, collection of Colonel W. M. E. Denison, on loan to the University of Nottingham), he writes: '*I am sitting to another artist for a group which Prince Albert has ordered*'. That this

was NPG 342 is proved by an entry in Macaulay's 'Journal' (26 April 1853, Trinity College, Cambridge): '*lost the morning in sitting to Partridge*'. I am most grateful to Thomas Pinney of Pomona College, California, for pointing out these references. They are not included in the *Burlington Magazine* article.

[2] See Partridge's pamphlet, 'On the Constitution and Management of the Royal Academy' [1864], in which he airs his grievances.

sombre unpicturesque costume) an imaginary collection of the works of our principal deceased Artists, has been arranged on the walls, and throughout the apartment' (pamphlet, p 1). A list of the works of art depicted is given in the *Burlington Magazine*.

Partridge appears to have begun making studies for the picture as early as 1844 or 1845, and Macaulay's letter of 1853 (see footnote) makes it clear that the group was still unfinished in that year. A complete list of studies, together with various manuscript datings and letters from sitters, is given in the *Burlington Magazine*. The four studies in the NPG of Aberdeen, Macaulay, Melbourne and Palmerston are catalogued individually under each sitter's name. An asterisk indicates that there are other portraits of the person in the NPG, either included in the main body of this catalogue, which is arranged alphabetically, or to be catalogued in subsequent volumes. Related sketches for NPG 342 are catalogued below. No description of the big picture is possible in its present condition. The people represented in the group are as follows (the list is alphabetically arranged):

*1 Aberdeen, George Hamilton Gordon, 4th Earl of (1784–1860).

*2 Albert, Francis Charles Augustus Emmanuel, Prince Consort (1819–61).

*3 Ashburton, Alexander Baring, 1st Baron (1774–1848).

*4 Barry, Sir Charles (1795–1860).

*5 Canning, Charles John Canning, Earl (1812–62).

*6 Carlisle, George William Frederick Howard, 7th Earl of (1802–64) (at the time of this picture he was Lord Morpeth).

7 Colborne, Nicholas William Ridley-Colborne, 1st Baron (1779–1854).

*8 Eastlake, Sir Charles Lock (1793–1865).

*9 Eversley, Charles Shaw-Lefevre, Viscount (1794–1888) (at the time of this picture he was still a commoner).

*10 Graham, Sir James Robert George, Bart (1792–1861).

*11 Hallam, Henry (1777–1859).

12 Hawes, Sir Benjamin (1797–1862).

*13 Inglis, Sir Robert Harry, Bart (1786–1855).

14 Knight, Henry Gally (1786–1846).

*15 Lansdowne, Sir Henry Petty-Fitzmaurice, 3rd Marquess of (1780–1863).

*16 Lyndhurst, John Singleton Copley, the younger, Baron (1772–1863).

*17 Macaulay, Thomas Babington Macaulay, 1st Baron (1800–59).

*18 Melbourne, William Lamb, 2nd Viscount (1779–1848).

*19 Newcastle, Henry Pelham Fiennes Pelham-Clinton, 5th Duke of (1811–64) (at the time of this picture he was the Earl of Lincoln).

*20 Palmerston, Henry John Temple, 3rd Viscount (1784–1865).

*21 Peel, Sir Robert, Bart (1788–1850).

*22 Rogers, Samuel (1763–1855).

*23 Russell, Lord John, 1st Earl (1792–1878).

*24 Stanhope, Philip Henry, 5th Earl (1805–75) (at the time of this picture he was Lord Mahon).

*25 Sutherland, George Granville Sutherland-Leveson-Gower, 2nd Duke of (1786–1861).

26 Vivian, George (1798–1873).

27 Willoughby de Eresby, Peter Robert Drummond Willoughby, 22nd Baron (1782–1865).

28 Wyse, Sir Thomas (1791–1862).

343a Oil on paper, stuck on canvas, 18¾ × 33⅞ inches (47·6 × 86 cm), by JOHN PARTRIDGE, *c* 1846. PLATE 1044

Collections: Presented by the artist, 1872.

Literature: Burlington Magazine, CIX (1967), 397–404, reproduced figure 17.

This is a preliminary oil study for NPG 342 above. Since the original picture is almost invisible now, the study is particularly important. Three of the sitters are omitted in the study (apparently Hawes, Vivian and Knight), but it shows the same general disposition of the figures as the big picture. Some of the works of art are different, and others have been rearranged; Fuseli's *Hamlet and the Ghost* is shown instead of his *Lazar House*, and Bacon's *Narcissus* replaces his *Flora*. There are other slight differences in the furnishings and architecture of the room. The exact date of the study is not known.

Description: The figures are mainly in dark suits, with white shirts, and some with coloured waistcoats. The seats and arms of the chairs are covered in red material. The table is covered with green baize (?). The carpet is red with a gold pattern. The walls are dark red with a gold cornice and gold architraves above the mahogany (?) doors, and a light-greyish green ceiling above. The multi-coloured paintings are generally subdued in effect. The statues, bust and architectural model are off-white. The general effect is relatively sombre, but the colours have probably darkened.

343b Pencil on brown, discoloured paper, 4¾ × 7⅝ inches (12·1 × 19·4 cm), by PRINCE ALBERT, *c* 1846.
PLATE 1041

Inscribed in pencil above the sketchily drawn figures are the names of those represented.

Collections: Presented by the artist's wife, Mrs Partridge, 1872.

Literature: Burlington Magazine, CIX (1967), 398.

This was executed by Prince Albert to show Partridge the disposition of the Fine Arts Commissioners at a particular meeting. Included are Lord Morpeth, Thomas Wyse, Charles Shaw-Lefevre, Sir Robert Peel, Lord John Russell, Thomas Macaulay, Lord Mahon, Sir Charles Eastlake, Lord Colborne, Prince Albert, Sir James Graham, the Duke of Sutherland, George Vivian, Lord Ashburton, Lord Lyndhurst, Sir Robert Inglis, Lord Lincoln, Samuel Rogers, the Marquess of Lansdowne, Henry Hallam, Lord Melbourne, Lord Aberdeen, Henry Gally Knight, Lord Palmerston, and two figures whose names are cut off. Prince Albert's drawing has suffered from exposure to light, and is only visible in an infra-red photograph.

343C Key to NPG 342. Pen and ink wash on paper, $18\frac{3}{8} \times 40\frac{3}{8}$ inches (46·6 × 102·5 cm), by JOHN PARTRIDGE. PLATE 1042

Inscribed at the top in ink: KEY TO THE PICTURE OF/THE MEETING OF THE FINE ARTS COMMISSION. 1846.

Inscribed below are the names of all those represented.

Collections: Presented with NPG 342 by the artist, 1872.

Literature: Burlington Magazine, CIX (1967), reproduced facing 398, figure 18.

THE ARCTIC COUNCIL, 1851

This group represents the officials, naval officers and explorers most active in the search for Sir John Franklin (1786–1847). An expedition, led by Franklin, was sent out by the Admiralty in May 1845 to try to penetrate a North-West Passage from the Atlantic to the Pacific Ocean. It consisted of two ships, HMS EREBUS and HMS TERROR. The ships were last seen on 26 July 1845 by a whaling ship from Aberdeen between Melville Sound and Lancaster Sound in Baffin's Bay.

In 1847 anxiety began to be felt about the fate of the expedition, as no news of it had been received, and the Admiralty, advised by the people represented in Pearce's picture, decided to organize a search. In 1848 three expeditions were sent out: one under Sir James Clark Ross and Captain Edward Bird; a second overland expedition under Sir John Richardson and Dr John Rae; and a third to Behring's Straits under Captain Henry Kellett and Captain Thomas Moore. No trace of Franklin or his party was found. More expeditions were organized in 1850, during which Captain Ommaney discovered traces of Franklin's first wintering station at Beechey Island. Although other expeditions were sent from England, both by the Admiralty and by Lady Franklin, it was not until 1854 that Dr Rae heard from the Eskimos of Boothia Felix that a party of about forty men had been seen off the coast of King William's Island, on their way to the Great Fish River, where they had all perished of starvation. Rae obtained relics of the ill-fated party from the Eskimos, and received the government reward of £10,000 for this discovery.

The Admiralty sent one more expedition to search for the remains of Franklin and his party, but it failed to reach King William's Island. Lady Franklin, however, was not satisfied that her husband was dead, and in 1857 she dispatched, at her own expense, the 'Fox' under Captain McClintock. This reached King William's Island, and discovered the last remains of Franklin and his men, together with a number of relics and a written record which established their fate.

1208 Oil on canvas, $46\frac{1}{4} \times 72\frac{1}{8}$ inches (117·5 × 183·3 cm), by STEPHEN PEARCE, 1851. PLATE 1045

Signed and dated (bottom left): STEPHEN PEARCE. 1851.

Collections: Commissioned by Colonel John Barrow, and bequeathed by him, 1899.

Exhibitions: H. Graves & Co, Pall Mall, 1851; *R A*, 1853 (249); *Royal Naval Exhibition*, Chelsea, 1891 (61).

Literature: Morning Herald, 7 July 1851, 7 April 1853; *Sunday Times*, 20 July 1851; *The Sun*, 24 July 1851; *Morning Chronicle*, 8 July 1851, 19 July 1853; *Art Journal* (1853), p 145; *Britannia*, 7 May 1853, 22 October 1853; *ILN*, XXII (1853), 379; pamphlet produced by Graves & Co (copy in NPG library); S. Pearce, *Memories of the Past* (1903), pp 52–9.

This portrait does not depict an actual meeting, nor an official body, despite its full title, 'The Arctic Council Discussing a Plan of Search for Sir John Franklin'. It represents ten of the distinguished sailors and explorers on whom the Admiralty called for advice, when fears for Franklin's safety were first expressed in 1847. However, they did not constitute an official body, nor did they collectively organize the early search expeditions, though the reports which they submitted led directly to the expeditions organized by Ross and Richardson in 1848.[1] The Admiralty continued to rely on the advice of these experts, which apparently was tendered individually. Barrow, who was one of the secretaries at the Admiralty and directly concerned in the search for Franklin, decided to commission a group portrait to commemorate the various search efforts; he chose Stephen Pearce as the artist, an old friend (see Pearce's *Memories of the Past*, pp 17–18). The resulting group is a postscript to what had already been achieved, rather than a contemporaneous view of the various explorers at work. It shows them in a generalized interior, and represents from left to right:

1 Sir George Back (1796–1887); in the full-dress uniform of a naval captain.
2 Sir William Parry (1790–1855); in the full-dress uniform of a naval captain.
3 Edward Joseph Bird (1799–1881); in the full-dress uniform of a naval captain.
4 Sir James Clark Ross (1800–62).
5 Sir Francis Beaufort (1774–1857).
6 John Barrow (1808–98); the donor of the portrait.
7 Sir Edward Sabine (1788–1883); in the full-dress uniform of a colonel of the Royal Artillery.
8 William Baillie Hamilton (1803–81).
9 Sir John Richardson (1787–1865); in the full-dress uniform of a naval staff surgeon with the CB.
10 Frederick Beechey (1796–1856); in the full-dress uniform of a naval captain, with the Naval General Service Medal.

In the background are represented portraits of Sir John Franklin (possibly the painting by Pearce, after a drawing by Negelen, in the Scott Polar Research Institute, Cambridge), Captain James FitzJames, Franklin's second-in-command (artist and location unknown), and Sir John Barrow (painting by J. Lucas, of which several versions exist). On the table is a large map of the Arctic region, and various other charts, a dispatch bag inscribed 'Admiralty', two letters of sympathy to Lady Franklin from the two Americans responsible for the American expedition in search of Franklin, Lieutenant Edwin de Haven (the leader of the expedition) and Henry Grinnell, and another map entitled 'Arctic America'.

Pearce executed studies of eight of the sitters for 'The Arctic Council', Barrow, Sabine, Hamilton, Richardson, Beechey, Parry, Ross and Beaufort, which are also in the NPG (NPG 905, 907, 908, 909, 911, 912, 913 and 918). These were purchased from Colonel Barrow by Lady Franklin, and were bequeathed by her niece in 1892; they are fully catalogued under the individual names in the main body of the catalogue, which is arranged alphabetically, with accompanying biographical descriptions, and iconographies; they are discussed collectively, with the other portraits of Arctic explorers (over forty in all) owned by Lady Franklin and Colonel Barrow, in *Collections:* 'Arctic Explorers' by S. Pearce, p 562. The studies for 'The Arctic Council' show the sitters in the same poses as in the finished picture, though not always in identical costume, but they are finished portraits in an autonomous setting, rather than rough sketches. In a memorandum of *c* 1899 (NPG archives) Pearce lists seven of the eight studies as painted in 1850; the exception is Barrow painted in 1851, though the study of Hamilton also probably belongs to that year. Pearce wrote (*Memories of the Past*, pp 52–3): '*I found that some of the distinguished officers were unable to sit to me at my studio in London, and as my canvas was too large to take to the houses of Sir Edward Parry and Sir John Richardson at Haslar Hospital, there was only one plan to adopt*

[1] See Sir J. Richardson, *Arctic Searching Expedition* (1851), I, 10–31; Rev E. Parry, *Memoirs of Rear-Admiral Sir W. Edward Parry* (1857), pp 326–7; and Rev J. McIlraith, *Life of Sir John Richardson* (1868), pp 187–92.

– viz. to go to them, taking small canvases. This I did, and a most interesting and pleasant time I passed at Haslar.' Back and Bird, for whom no studies exist, were presumably painted direct on to the large canvas. Pearce made use of some of his studies (which are mainly on board, not on canvas) for further commissions.

The group was finished by July 1851, and was sent round to Buckingham Palace to be inspected by Queen Victoria and Prince Albert. It was then exhibited with Graves & Co, before touring the country. It was engraved by J. Scott, published Graves, 1853 (example in NPG), the engraving dedicated to Lady Franklin. At the *RA* the painting was accompanied by a descriptive key, a historical sketch of the various expeditions which had searched for the North-West Passage, and biographical memoirs of the men represented prepared by W.R.O'Byrne. The picture was generally praised, and Pearce himself regarded it as one of his best works (see for instance his letter to Scharf of 16 December 1871, NPG archives).

Description: Sir G. Back (1) has a fresh complexion, brown eyes and hair and side-whiskers; he is dressed in a black stock, white shirt, dark waistcoat, a dark blue naval uniform with gold-braided epaulettes and buttons, and holds a white chart. E.J. Bird (3) has a fresh complexion, blue eyes, brown hair and greying side-whiskers, and is also dressed in a black stock, white shirt, and dark blue naval uniform with gold buttons and epaulettes. Personal descriptions of other individual figures will be found with the studies of them in the main body of the catalogue, which is arranged alphabetically. On the left of the picture is a chair with a brown leather seat, above it brownish-yellow shutters, and to the right a red-figured curtain. The table is covered with a green cloth, a red leather dispatch box, a large map coloured pale blue and pink, other white papers, a black inkstand with a silver handle, white quills, white stamp (?), and red and blue glass ink-wells. On the right is a red leather chair. The general background colour is greyish-brown of various shades. The pictures in the background are in gilt frames, and are predominantly brown, black and grey in colour, except for the red curtain behind Barrow on the right.

THE COALITION MINISTRY, 1854

The coalition ministry, under the leadership of the Earl of Aberdeen, came to power in 1852, following the short-lived tory administration under the Earl of Derby. It included the leading whig and Peelite statesmen of the period. The outbreak of the Crimean war in March 1854 found the army woefully unprepared, and the early set-backs and the controversies over the conduct of operations further undermined an already weak and divided cabinet. In January 1855, Aberdeen resigned, to be succeeded by Palmerston, who brought the war to a successful conclusion in 1856.

1125 Pencil, pen and ink and wash on paper, with touches of Chinese white, $17\frac{1}{2} \times 27$ inches ($44\cdot3 \times 68\cdot7$ cm), by SIR JOHN GILBERT, 1855. PLATE 1046

Signed and dated (bottom left): John Gilbert /1855. *Inscribed on the mount in pencil are copies (?) of the autographs of the sitters, as they appear on the engraving. Also on the back is a label relating to the 1897 exhibition.*

Collections: Commissioned by William Walker, the engraver, and purchased from him, 1898.

Exhibitions: Victorian Era Exhibition, 1897, 'Historical Section' (442), lent by Walker.

This grisaille drawing was specially executed for the engraving of the same subject by W. Walker (the vendor), published by him, 1857 (example in NPG, plate 1047). Both drawing and engraving are almost identical in size and general arrangement. There are several differences between the two, however, in the poses, features and costumes of the sitters, and in the accessories. Gilbert's likenesses, for which he does not appear to have received sittings, were altered and strengthened by Mrs Elizabeth Walker prior to the engraving, and his mannered and expressive draughtsmanship smoothed away.

NPG 1125 shows Aberdeen's cabinet deciding upon the expedition to the Crimea in the early months of 1854. Palmerston, on the right, is seen pointing at the town of Balaklava on a map of the region held open by the Duke of Newcastle. Gladstone, on the left, is holding a letter on his knee, and Lord Granville in the background is absorbed in reading a newspaper. These attempts to introduce drama and life into the composition are not successful, and the picture retains all the features of a rather stiff and self-conscious group photograph. Engravings of the successive cabinets of the day became popular from the mid-19th century onwards, and that of Aberdeen's is one of the earliest. Gilbert, a pioneer of pictorial journalism, later helped to prepare the design for Scott's engraving of Derby's third cabinet, after a painting by H. Gales, published Graves, 1870 (example in NPG).

The following list of people represented in NPG 1125 is arranged alphabetically. The office of each sitter is noted after his name. An asterisk denotes that other portraits of the sitter are included in this catalogue, which is arranged alphabetically, with (except in the case of other groups) an accompanying iconography:

*Aberdeen, George Hamilton Gordon, 4th Earl of (1784–1860). Prime minister.

Argyll, George Douglas Campbell, 8th Duke of (1823–1900). Lord privy seal.

Clarendon, George William Frederick Villiers, 4th Earl of (1800–70). Foreign secretary.

*Cranworth, Robert Monsey Rolfe, Baron (1790–1868). Lord chancellor.

*Gladstone, William Ewart (1809–98). Chancellor of the exchequer.

*Graham, Sir James Robert George, Bart (1792–1861). First lord of the admiralty.

Granville, Granville George Leveson-Gower, 2nd Earl of (1815–91). President of the council.

Grey, Sir George, Bart (1799–1882). Secretary for the colonies.

*Halifax, Charles Wood, 1st Viscount (1800–85). President of the board of control for India.

*Herbert of Lea, Sidney Herbert, 1st Baron (1810–61). Secretary at war.

*Lansdowne, Henry Petty-Fitzmaurice, 3rd Marquess of (1780–1863). No office.

*Molesworth, Sir William, Bart (1810–55). Commissioner of works.

*Newcastle, Henry Pelham Fiennes Pelham-Clinton, 5th Duke of (1811–64). Minister for war.

*Palmerston, Henry John Temple, 3rd Viscount (1784–1865). Home secretary.

*Russell, Lord John Russell, 1st Earl (1792–1878). No office.

Collections

DRAWINGS OF PROMINENT PEOPLE, 1823–49

2515 (1–104) By WILLIAM BROCKEDON

Collections: By descent to Brockedon's daughter, Elizabeth, wife of J.H.Baxendale; bequeathed to the National Gallery by their son, J.W.Baxendale, with a life interest to his son, Colonel J.F.N.Baxendale and male heirs; placed on loan at the NPG by Colonel Baxendale, 1931; on his death in 1958, without male issue, officially transferred to the National Gallery; on permanent loan from the National Gallery since 1958.

The 104 drawings in this collection have been mounted in two leather-bound volumes, and arranged in roughly chronological order. Almost all of them are accompanied by an autograph letter from the sitter, mounted on the opposite page to the drawing. In most cases the letters do not relate to the drawings or their execution, though a few are concerned with appointments for that purpose. It is clear that Brockedon intended the volumes to be a record of his famous contemporaries, many of whom happened to be his friends, and that all the drawings were done specially for the volumes, and letters carefully preserved for the same purpose. They were to form an inheritance for his son, Phillip, as a letter from Henry Hopley White (see no. 58) to Brockedon makes clear (25 January 1832):

I fear that you will think I have forgotten you and yours, and that my silence and delay are symptoms that I do not well appreciate your flattering request that I would give you an opportunity of sketching my Phiz to be deposited in the Album you call little Phillip's book of his father's friends. I need not tell you how lawyers are wedded to their books and papers and you must pardon my apparent indifference on the score of professional imprisonment. If preeminence for Talent or acquirements in Science constituted the only title for admission among the distinguished individuals with whose portraits my own, through your kind proposal, is destined to be associated, I should prudently hide my diminished head, warned by the fable of the bird and its borrowed plumage, but as kindly sympathies are also to impart a sentiment to Phillip's book, perhaps, among all your friends who may be registered there, there will not be one with whose early acquaintance, more than mine, you can associate the occasion of some of the brightest years of your life.

Brockedon's drawings are a tribute to the range of his friendships and interests, for though he did include some comparative strangers, most of his subjects were well-known to him. They were also well-known to the world, no less than seventy-nine of them being included in the *Dictionary of National Biography*, without considering the dozen or so distinguished foreigners. The strong scientific and geographical bias evident in Brockedon's choice of sitters is explained by his own career as an inventor and author. Brockedon was a competent draughtsman, and his drawings constitute a unique visual record of the period (in some cases Brockedon's drawing is the only recorded likeness). His achievement recalls that of G.F.Watts, who, with the same disinterested passion, recorded his great contemporaries in a long series of portraits, many of which are in the National Portrait Gallery.

All the drawings are listed below. An asterisk denotes those sitters with full entries and iconographies in the main body of this catalogue, which is arranged alphabetically. Foreigners (strictly speaking outside the NPG's terms of reference), denoted below by an 'F', and unimportant English sitters, are briefly listed in the main text and referred to this section. Other sitters will receive full entries in the appropriate forthcoming catalogues.

VOLUME I

1 BELZONI, Giovanni Baptista (1778–1823). Italian actor, engineer, and traveller.
Dated 'May 1823'. Letter dated 3 May 1821. This drawing will be catalogued in the forthcoming Catalogue of Portraits, 1790–1830.

F2 CANOVA, Antonio (1757–1822). Italian sculptor and painter.
Undated letter in French. This drawing is probably not from life, but after the portrait by Sir Thomas Lawrence.

F3 DENON, Dominique Vivant, Baron (1747–1825). French painter, archaeologist and traveller.
Dated 'Decʳ. 1824'. Undated letter in French.

4 PHILLIPS, Molesworth (1755–1832). Soldier, accompanied Captain Cook on his last voyage.
Dated 'March 1825'. Letter dated 5 April 1826. This drawing will be catalogued in the forthcoming Catalogue of Portraits, 1790–1830.

5 NORTHCOTE, James (1746–1831). Painter.
Dated 'June 1825'. Letter dated 5 July 1824. This drawing will

be catalogued in the forthcoming Catalogue of Portraits, 1790–1830.

F6 IRVING, Washington (1783–1859). American biographer and novelist.
Dated 'Dec^r. 1. 1824'. Letter dated 17 December 1829.

F7 PERKINS, Jacob (1766–1849). American inventor.
Dated 'Dec^r. 27 1825'. Undated letter.

*8 WYON, William (1795–1851).

*9 AIKIN, Arthur (1773–1854).

10 WOLLASTON, William Hyde (1766–1828). Scientist.
Letter dated 19 April. This drawing will be catalogued in the forthcoming Catalogue of Portraits, 1790–1830.

11 SHIELD, William (1748–1829). Composer.
Dated '27.5.26.' Letter dated 11 December 1827. This drawing will be catalogued in the forthcoming Catalogue of Portraits, 1790–1830.

*12 PROUT, Samuel (1783–1852).

*13 MARTIN, John (1789–1854).

14 KITCHENER, William (1775?–1827). Writer on science and music.
Printed invitation dated 12 May 1826. This drawing will be catalogued in the forthcoming Catalogue of Portraits, 1790–1830.

*15 BIDDER, George (1806–78).

*16 EASTLAKE, Sir Charles (1793–1865).

17 PERING, Richard (1767–1858). Inventor.
Dated '10 – 6. 29'. Undated letter.

*18 WIFFEN, Jeremiah Holmes (1792–1836).

F19 ALDINI, Giovanni (1762–1834). Italian experimental philosopher, and author.
Dated '5.3.30'. Undated letter.

*20 BURNES, Sir Alexander (1805–41).

21 LAWRENCE, Sir Thomas (1769–1830). Painter.
Undated letter. This drawing will be catalogued in the forthcoming Catalogue of Portraits, 1790–1830.

*22 SMITH, Charles Hamilton (1776–1859).

*23 PROCTER, Bryan Waller (1787–1874).

*24 FARADAY, Michael (1791–1867).

*25 POOLE, John (1786?–1872).

*26 RICHARDSON, Robert (1779–1847).

27 HOARE, Prince (1755–1834). Painter and dramatist.
Dated '15 7 31'. Letter dated 29 June. This drawing will be catalogued in the forthcoming Catalogue of Portraits, 1790–1830.

28 BRUNEL, Sir Marc (1769–1849). Engineer.
Dated '18.8.8'. Letter dated 22 May 1834. This drawing will be catalogued in the forthcoming Catalogue of Portraits, 1790–1830.

29 GODWIN, William (1756–1836). Philosopher.
Dated '2.6.32'. Letter dated 4 September 1832. This drawing will be catalogued in the forthcoming Catalogue of Portraits, 1790–1830.

30 SCOTT, Sir Walter (1771–1832). Novelist and poet.
Letter dated 12 February 1830. This drawing will be catalogued in the forthcoming Catalogue of Portraits, 1790–1830.

*31 CROLY, George (1780–1860).

32 FLAXMAN, John (1755–1826). Sculptor.
Letter dated 14 December 1824. This drawing will be catalogued in the forthcoming Catalogue of Portraits, 1790–1830.

*33 BABBAGE, Charles (1792–1871).

34 SMITH, John Thomas (1766–1833). Draughtsman and antiquary.
Dated '2.6.32'. Letter dated 5 April 1829. This drawing will be catalogued in the forthcoming Catalogue of Portraits, 1790–1830.

35 FROUDE, Robert H. (1771?–1859). Divine, father of J.A., R.H., and W. Froude.
Dated '3.4.32'. Letter dated 4 March 1809.

*36 ARUNDELL, Francis Vyvyan Jago (1780–1846).

*37 GALT, John (1779–1839).

F38 HUMBOLDT, Friedrich Heinrich Alexander, Baron (1769–1859). German naturalist.
Letter in French dated 7 February 1841.

*39 CUNNINGHAM, Allan (1784–1842).

*40 STANFIELD, Clarkson (1793–1867).

41 HOGG, James (1770–1835). Poet.
Dated '10.3.32'. Letter dated 7 March 1832. This drawing will be catalogued in the forthcoming Catalogue of Portraits, 1790–1830.

42 CARR, Sir John (1772–1832). Traveller.
Dated '1832'. Letter postmarked 16 April 1832. This drawing will be catalogued in the forthcoming Catalogue of Portraits, 1790–1830.

*43 PRIOR, Sir James (1790?–1869).

*44 BRITTON, John (1771–1857).

*45 LATROBE, Charles Joseph (1801–75).

*46 BACK, Sir George (1796–1878).

*47 LANDER, Richard Lemon (1804–34).

*48 FRASER, James Baillie (1783–1856).

F49 FORTIA D'URBAN, Agricole, Marquis de (1756–1843). French antiquary and patron of letters.
Dated '13.10.33'. Inscribed 'le mquis[sic] de fortia d'urban a voulu exprimer ici sa reconnaissance pour son aimable et habile peintre'. Two letters in French, dated 14 March 1831, and 16 July 1834.

F50 TURPIN DE CRISSÉ, Launcelot Théodore, Count (1781–1852). French painter.
Dated '15.10.33'. Letter dated 6 May 1830.

VOLUME II

*51 WATTS, Alaric Alexander (1797–1864).

52 FOULIS. . . .
Dated 'Ap^l 24 – 1825'. Letter dated 25 April 1825.

*53 PAPWORTH, John Buonarotti (1775–1847).

54 FULLER, John (1776–1834). Traveller and author.
Dated '6.5.30'. Undated letter.

*55 DYER, Joseph Chessborough (1780–1871).

*56 BOWRING, Sir John (1792–1872).

F57 LAFAYETTE, Marie Joseph, Marquis de (1757–1834). French general and statesman.
Letter dated 15 March 1831.

58 WHITE, Henry Hopley (1790–1876). Lawyer.
Dated '17.4.32'. Letter dated 25 January 1832.

*59 TURNER, Charles (1774–1857).

*60 MACFARLANE, Charles (d 1858).

F61 GUICCIOLI, Countess Teresa (1801–73). Byron's mistress.
Dated '4.1.3'. Undated letter.

*62 MEYRICK, Sir Samuel (1783–1848).

63 BAUER, Franz Andreas (1758–1840). Botanist.
Dated '25.4.34'. Letter dated 22 October 1834.

*64 LANDER, John (1807–39).

F65 FEUILLET DE COUCHE, F. (probably Baron Felix, 1798–1887). Master of ceremonies to Napoleon III.
Dated '17.5.34'. Letter dated 3 March 1834.

66 DALTON, John (1766–1844). Scientist.
Inscribed 'Sketched during his visit in May 1834 to London'. Letter dated 20 May 1839. This drawing will be catalogued in the forthcoming Catalogue of Portraits, 1790–1830.

67 TELFORD, Thomas (1757–1834). Engineer.
Dated '11.6.34'. Letter dated 22 August 1832. This drawing will be catalogued in the forthcoming Catalogue of Portraits, 1790–1830.

*68 ALLEN, William (1793–1864).

*69 HOLMAN, James (1786–1857).

70 PHILLIPS, Thomas (1770–1845). Painter.
Dated '11.7.34'. Letter dated 17 April. This drawing will be catalogued in the forthcoming Catalogue of Portraits, 1790–1830.

*71 BRAY, Anne (1790–1883).

*72 CRAMER, John Anthony (1793–1848).

*73 THOMASON, Sir Edward (1769–1849).

*74 STODDART, Charles (1806–42).

F75 CAVOUR, Camille, Count (1810–61). Italian statesman.
Dated '9.6.35'. Letter dated 16 April 1832.

76 SOANE, Sir John (1753–1837). Architect.
Dated '22-7-35'. Undated letter. This drawing will be catalogued in the forthcoming Catalogue of Portraits, 1790–1830.

F77 BARRAS.... Prior of the monastery on the Great St. Bernard Pass.
Dated 'Sept 6th 1835'. Letter of 17 August 1834, and two other autographs.

F78 DE LUC.... (probably Jean André, 1763–1847). Swiss geologist, and meteorologist and a member of the Royal Society; his brother, G. A. De Luc, was also a geologist.
Dated '29.9.35'.

*79 ROGET, Dr Peter Mark (1779–1869).

80 HOLDSWORTH, Arthur Howe (1780–1860). Last governor of Dartmouth. Dated '22.2.37'. Letter dated 4 April 1832.

*81 FRANKLIN, Sir John (1786–1847).

*82 COLBY, Thomas Frederick (1784–1852).

83 MURRAY, John (1778–1843). Publisher.
Dated '11.9.37'. Letter dated 26 November 1839. This drawing will be catalogued in the forthcoming Catalogue of Portraits, 1790–1830.

*84 WHEATSTONE, Sir Charles (1802–75).

*85 SMYTH, William Henry (1788–1865).

*86 WILKINSON, Sir John Gardner (1797–1875).

*87 BUCKLAND, William (1784–1856).

88 GILBERT, Davies (1767–1839). Scientist.
Dated '12.2.38'. This drawing will be catalogued in the forthcoming Catalogue of Portraits, 1790–1830.

F89 RASSAM, Christian Anthony (d 1872). Nestorian Christian, accompanied various British expeditions in the Middle East; British vice-consul at Mosul, 1839–72.
Dated '14.2.38'. Letter dated 1838.

*90 BEAUFORT, Sir Francis (1774–1857).

*91 SCHOMBURGK, Sir Robert Hermann (1804–65).

F92 CURSETJEE, Manockjee (1808–87). Parsee merchant, judge and sheriff of Bombay.
Dated '1.8.41'. Letter dated 18 July 1844.

93 CAMPBELL, Thomas (1777–1844). Poet.
Dated '21.4.42'. Letter dated 19 April 1842. This drawing will be catalogued in the forthcoming Catalogue of Portraits, 1790–1830.

*94 DE LA BECHE, Sir Henry Thomas (1796–1855).

95 WESTMACOTT, Sir Richard (1775–1856).
Dated '18.6.44'. Undated letter. This drawing will be catalogued in the forthcoming Catalogue of Portraits, 1790–1830.

*96 GIBSON, John (1790–1866).

*97 FELLOWS, Sir Charles (1799–1860).

*98 OWEN, Sir Richard (1804–92).

*99 ROSS, Sir James Clark (1800–62).

*100 BROWN, Robert (1773–1858).

*101 HOOK, Theodore Edward (1788–1841).

102 BERNAYS, Dr Albert James (1823–92). Chemist.
This drawing will be catalogued in the forthcoming Catalogue of Portraits, 1860–90.

103 LAYARD, Sir Austen Henry (1817–94). Archaeologist.
Undated letter. This drawing will be catalogued in the forthcoming Catalogue of Portraits, 1860–90.

104 ENDERLEY, Charles (1797–1876). South Sea whaler.
Dated '8.3.49'. Letter dated 19 July 1848.

ARTISTS, 1825

3944 By JOHN PARTRIDGE

Collections: Purchased from the artist's collateral descendant, Mrs Ursula Richmond, 1955.

Literature: NPG Annual Report, 1955–6, (1956), p 9.

Partridge's drawings of artists are included in a sketchbook, which belonged to his wife. It is inscribed at the front: 'Clementina S. Partridge/Rome 1825'. It includes contributions from other artists besides Partridge, and provides an interesting view of the artistic milieu in Rome of which he was a part (see *Burlington Magazine*, CIX (1967), 397). The size of the sketchbook is approximately $7\frac{1}{4} \times 9\frac{1}{2}$ inches (18·4 × 24·1 cm), and it is watermarked 'J Whatman/1823'. The contents of the sketchbook are briefly noted in the following list. Those drawings of artists which have an asterisk are catalogued in the main body of the catalogue, which is arranged alphabetically, with accompanying iconographies. One or two have been removed from the sketchbook and are now separately mounted:

1 Inscription by Clementina Partridge.

2 Wash drawing of St Peter's, Rome, attributed to Sir Charles Eastlake.

3 Drawing of an Italian woman by Joseph Severn; signed and dated, 1825. Another version of this drawing, of 1824, entitled 'Portrait-study of a Lady of Cenzano', is reproduced W. Sharp, *The Life and Letters of Joseph Severn* (1892), p 145.

*4 Drawing of the younger Richard Westmacott by Partridge.

5 Drawing of a statue of a young girl in classical robes, holding a bird, attributed to the younger Richard Westmacott. Westmacott exhibited a 'Girl with a Bird', *RA*, 1827 (1089), his first contribution.

6 Water-colour of a Neapolitan fisher-boy, with a view of Mount Etna behind, attributed to Thomas Uwins.

7 Wash drawing of a Neapolitan girl possibly by Partridge. Dated 'Naples 1825'.

8 Wash drawing of a Neapolitan scene possibly by Partridge. Dated 'Naples 1825'.

9 Drawing of an unknown man by Partridge. Signed and dated 'October 1825'.

10 Wash drawing of a Neapolitan scene possibly by Partridge.

11 Drawing of an unknown man in Vandyck costume by Partridge.

12 Drawing of a river scene with figures attributed to Partridge.

13 Humorous drawing of a painter being saved from falling off a church into the clutches of the devil by a statue of the Madonna, by an unknown artist.

*14 Drawing of Thomas Uwins by Partridge.

15 Blank, inscribed 'Severn'.

16 Drawing of a girl in classical costume playing the lyre, with a boy playing a pipe, attributed to Joseph Severn. See inscription on previous page.

17 Water-colour of an Italian fisher-boy attributed to Mrs Westmacott. Signed 'RW'. Inscribed in pencil on the reverse 'Mrs Westmacott'.

*18 Drawing, possibly of Joseph Severn, by Partridge.

19 Drawing of an unknown man by Partridge (it has been suggested that this drawing might also represent Severn, but it seems unlikely).

*20 Drawing, probably of Joseph Severn, by Partridge.

21 Drawing of classical ruins at Selimonte attributed to Partridge. Inscribed 'Selimonte'.

*22 Drawing of Sir Charles Eastlake by Partridge.

23-4 Blank.

25 Wash drawing of a seated Neapolitan mother and child, possibly by Partridge.

26 Drawing of an unknown man by Partridge.

27-8 Blank.

29 Blank, inscribed 'Dyce'.

*30 Drawing of William Dyce by Partridge.

31 Drawing of a putto pursuing a butterfly by John Gibson. Signed.

*32 Drawing of John Gibson by Partridge.

33-4 Blank.

35 Drawing of rustic archway with figures attributed to Partridge.

36-8 Blank.

39 Verso. Drawing of a seated man, attributed to Partridge.

40-54 Blank.

DRAWINGS OF MEN ABOUT TOWN, 1832–48

4026 (1–61) By COUNT ALFRED D'ORSAY

Collections: Gore House Sale, Phillips, 7–26 May 1849 (lot 1263), bought in; purchased by Sir Thomas Phillipps, through T. & W. Boone of New Bond Street, under-bidders at the sale; Phillipps Sale, Sotheby's, 13 February 1950 (lots 215 and 216).

Literature: 'The D'Orsay Gallery', *Ainsworth's Magazine*, VII (1845), 226–30; R. R. Madden, *The Literary Life and Correspondence of the Countess of Blessington* (1855), 3 vols; Michael Sadleir, *Blessington – D'Orsay: A Masquerade* (1933); Sotheby's book catalogue, 13 February 1950, pp 19–20; Willard Connely, *Count D'Orsay: the Dandy of Dandies* (1952); *NPG Annual Report: 1957–8* (1959), pp 7–12.

These drawings once formed part of a larger collection, which was sold by D'Orsay at the Gore House Sale; the only recorded catalogue of this sale is in the Wallace Collection. Three additional portraits of Lady Chesterfield, Mrs George Anson, and an unidentified lady were sold there as a separate item. Lot 1263 contained 263 portrait drawings, in two large portfolios. The drawings appear as no. 13526 in the catalogue of Sir Thomas Phillipps' library, but only 221 are listed as opposed to the 263 in the auction catalogue (possibly an error of printing or enumeration). Although Phillipps opened his library to scholars, D'Orsay's drawings effectively disappeared from view till 1897, when his daughter, Mrs Fenwick, lent seventeen of them to the Diamond Jubilee Exhibition at 105 Piccadilly. They then disappeared again, till the sale of part of the Phillipps' Library at Sotheby's, 13 February 1950 (lots 209–216). Lots 209, 210, 211, 214, 215A, and 215B, comprising eight drawings, were bought by Messrs Maggs; lots 212, 213, 215, 215C, and 216, comprising two hundred and forty-nine drawings, were bought by Messrs Colnaghi. The sixty-one drawings in the NPG are the residue of those handled by Messrs Colnaghi, from whom they were purchased in 1957. Two drawings, of Isaac D'Israeli and Charles Greville (NPG 3772 and 3773), were purchased earlier from Colnaghi's in 1950, from the same source.

Most of the portrait drawings which D'Orsay executed were intended for his own collection – a visual diary of his friends and contemporaries. This is the reason why so many of them were

autographed by his sitters. During periods of financial strain, D'Orsay undoubtedly tried to turn his artistic talents to financial advantage, but, beyond keeping himself in gloves, he does not seem to have been very successful. His earliest portrait drawings were of Byron, executed at Genoa in May 1823. During the 1830s and 1840s, D'Orsay's portraits provide a fascinating survey of the fashionable world of London, and are evidence of the extraordinary diversity and brilliance of his and Lady Blessington's circle. As *Ainsworth's Magazine* commented (VII, 226):

Since the period when Count D'Orsay became the observed of all observers in this great metropolis, dating, as well as our recollection serves us, from the year 1832, his artistical ability has not been suffered to lie dormant. He has successively enriched the gallery that bears his name with the portraits of the fair, the noble, the learned, and the highly-gifted; the statesman, the poet, the wit, the beauty, the philosopher, shine like stars in the firmament of his creation.

Connely (pp 565–74) lists 297 known D'Orsay drawings, including the 257 sold at Sotheby's, but his list is certainly not complete, and it is not always entirely accurate.

All D'Orsay's portrait drawings show the sitter in profile (they are mostly half-length, without accessories of any kind), and they tend to be very repetitive – a clear indication of his amateur talent. However, it must be remembered that these drawings do not represent the whole of D'Orsay's artistic endeavour. His statues and busts (see for instance his self-portrait bust, on loan to the NPG), and his oil portraits (see that of the Duke of Wellington, NPG 405) show considerable expertise, even allowing for professional assistance. The technique in the drawings is comparatively simple. The head is tightly drawn in pencil, often with touches of red on the lips, cheek and forehead, while the hair and costume are executed more freely in black chalk and stump. The paper is usually white, but is occasionally tinted. Almost all the drawings are signed and dated, and several are inscribed with the name of the place where they were executed, and the sitter's autograph. As a chronological sequence, they provide valuable biographical information about D'Orsay's activities.

As early as 1832, D'Orsay employed Richard Lane to lithograph his drawings of prominent people singly. They were published and sold for 5/- each by John Mitchell of Bond Street. In 1841, D'Orsay conceived the idea of selling folios of Lane's lithographs. Madden (II, 466–7) lists 137 lithographs which appeared in the folios, as well as advertising them on behalf of Mitchell, but as no folio has survived in its original form, the details of its presentation are unknown. The NPG and the British Museum both have large collections of the lithographs (one album in the NPG from the collection of Edmund Gosse, containing 68 lithographs, is inscribed with the name of Lady Blessington's niece, Margaret Power, and the date 1842; it was probably put together by D'Orsay himself).

Taken with Madden's list, and another collection of lithographs in the possession of A. Rodgers, Newcastle-on-Tyne, in 1949, it is clear that Lane executed at least 150 lithographs after D'Orsay's drawings, and probably several more. In many cases the lithographs are more decisive and successful than the original drawings. Many of the lithographs are listed in Lane's MS account books (NPG archives). The close relationship between Lane and D'Orsay is proved by the existence of letters between them, several of which are quoted by Madden (II, 468–71); there are also a few in the archives of the NPG (Lane MS notebooks and letters). D'Orsay writes, for instance, on 15 November 1845 (Lane letters, I, 83): '*The lithographes are perfection the Miss Powers are enchanted.*' He writes on another occasion (Lane letters, II, 116): '*I have received three proofs. Stop the printing of Miss Power, as you can improve two different points, that Landseer advises*'. After D'Orsay's death, Lane wrote to Madden (II, 468–9):

As a patron, his kind consideration for my interest, and prompt fulfilment of every engagement, never failed me for the more than twenty years of my association with him In the sketches of the celebrities of Lady Blessington's salons, which he brought to me, (amounting to some hundred and fifty or more), there was generally an appropriate expression and character, that I found difficult to retain in the process of

elaboration; and although I may have improved upon them in the qualities for which I am trained, I often found that the final touches of his own hand alone made the work satisfactory.

Mitchell was Lane's chief publisher, not only for the D'Orsay lithographs, but for his other work. Letters between Lane and Mitchell (Lane letters, NPG archives) reveal that they were friendly and close associates. Before the rediscovery of D'Orsay's original drawings, the lithographs were the only source for a study of D'Orsay's work. *Ainsworth's Magazine*, Madden, and Sadleir (who wrote, p345: '*Where are the hundreds of originals of D'Orsay's drawings of his friends?*'), all relied on lithographs.

The sixty-three D'Orsay drawings in the NPG (including the two drawings of D'Israeli and Greville, NPG 3772 and 3773, bought separately) are listed below. Those marked with an asterisk appear in the main body of the catalogue, which is arranged alphabetically, with a full catalogue entry for each drawing, biographical descriptions and iconographies. Those sitters who will be dealt with in forthcoming catalogues, and unimportant sitters, are briefly noted in the main text, and are referred to this section. Beyond the date of the drawing, and the fact that it has been lithographed by Lane, there is no further catalogue description:

1 ALLEN, Joshua William, 6th Viscount (1781–1845). Soldier.
Dated '25 mars/1838.' Lithograph by Lane (example in NPG).

2 ALLEN, Joshua William, 6th Viscount.
Similar drawing (unfinished) to the one above, but in reverse.

*3 BARNARD, Sir Andrew Francis (1773–1855).

4 BARRINGTON, George William, 7th Viscount (1824–86). Man of affairs.
Dated 'July 1847.' Lithograph by Lane (example in NPG).

*5 BEAUFORT, Henry Somerset, 7th Duke of (1792–1853).

6 BESSBOROUGH, John Ponsonby, 5th Earl of (1809–80). Man of affairs.
Dated '1834/London.' Lithograph by Lane (example in NPG).

7 BUSHE, John.
Dated '1st April 1847.' Lithograph by Lane, listed by Madden, II, 467 (see above).

8 BYNG, Hon Frederick (*d*1871). Son of 5th Viscount Torrington, member of foreign office.
Dated '1840.' Lithograph by Lane, listed by Madden, II, 466 (see above).

9 BYNG, Hon Frederick.
Dated '15 avril 1847/Gore House.'

10 CAMPBELL, Thomas (1777–1844). Poet.
Dated '1er Aout/1832.' This drawing will be catalogued in the forthcoming Catalogue of Portraits, 1790–1830.

11 CANTERBURY, Charles Manners-Sutton, 1st Viscount (1780–1845). Politician.
Dated '1833.' Lithograph by Lane (example in NPG). This drawing will be catalogued in the forthcoming Catalogue of Portraits, 1790–1830.

12 CHARLEVILLE, Charles Bury, 2nd Earl of (1801–51). Man of affairs.
Dated '21 Novb 1844.'

*13 CHORLEY, Henry Fothergill (1808–72).

14 CLANRICARDE, Ulick de Burgh, 1st Marquess of (1802–74). Statesman.
Dated '21. June 1847.' Lithograph by Lane, listed by Madden, II, 467 (see above).

*15 COTTON, Sir Willoughby (1783–1860).

16 COWPER, Hon Charles Spencer (1816–79). Son of 5th Earl Cowper.
Dated '26 Oct. 1845.' Lithograph by Lane (example in NPG).

17 CRAVEN, William, 2nd Earl of (1809–66). Lord Lieutenant of Warwickshire.
Dated '17. July/1843.'

18 CRAVEN, Keppel (1779–1851). Traveller.
Dated '10 Aout/1832.' This drawing will be catalogued in forthcoming Catalogue of Portraits, 1790–1830.

19 CALABRELLA, Mrs Thomas Jenkins, Baroness de. Wife of Lady Blessington's first protector.
Dated 'July 1843.' Lithograph by Lane, listed by Madden, II, 467 (see above).

D'ISRAELI, Isaac (1766–1848): NPG 3772.
This drawing will be catalogued in the forthcoming Catalogue of Portraits, 1790–1830.

*20 DUNCOMBE, Thomas Slingsby (1796–1861).

21 EDWARDES either William, Lord Kensington (1801–72), or one of his brothers, George (1802–79), Richard (1807–66), Charles (1813–81), or Thomas (1819–96). Dated '1838'. Inscribed 'Edwards [*sic*] –/Lord Kensington's son'.

22 FAIRLIE, John. Married Edmund Power's granddaughter, Louisa Purves. Dated '1840'.

23 FITZCLARENCE, Lord Frederick (1799–1855). Illegitimate son of William IV.
Dated '8 Juillet 1846'.

24 FORESTER, George, 3rd Baron (1807–86). General and politician.
Dated '24 April/1844'.

25 FORESTER, Charles Robert Weld (1811–52). Son of 1st Baron Forester, and brother of George, 3rd Baron (see above), soldier. Dated 'May 1840'. Lithograph by Lane (example in NPG).

26 HOLLAND, Henry Fox, 4th Baron (1802–59). Diplomat. Drawn at Naples.

27 GARDNER, Alan Legge, 3rd Baron (1810–83). Held various court appointments.
Dated '11 August 1841'.

*28 WILKINSON, Sir John Gardner (1797–1875).

29 GOODRICKE, Sir Henry James (*d*1833). Hunting squire.
Dated '1833 – Melton.' Lithograph by Lane (example in NPG).

30 GORE, Robert (1810–54). Brother of 4th Earl of Arran, naval captain, politician and diplomat.
Dated '1 Mars 1844.'

31 GORE, Robert (1810–54).
Almost identical with the drawing above.

* GREVILLE, Charles (1794–1864): NPG 3773.

*32 GRIEVE, William (1800–44), or Thomas (1799–1882).

33 HASTINGS, George, 2nd Marquess of (1808–44).
Dated 'July 1841.' Lithograph by Lane (example in NPG).

34 HERBERT, George (1812–38). Grandson of 1st Earl of Carnarvon, soldier.
Dated '1834.' Lithograph by Lane, dated '1837' (example in NPG).

35 HUGHES, Seymour Ball. Son of Edward Ball Hughes (see below).

Dated 'Gore House 5th Jany. 1848.' Autograph 'Sey Ball Hughes.' Lithograph by Lane listed by Madden, II, 467. This drawing clearly shows a different and younger man than no. 36.

*36 HUGHES, Edward Ball (d1863).

*37 JESSE, John Heneage (1815–74).

38 JOCELYN, Robert, Viscount (1816–54). Soldier and politician.
Dated 'May 1839.' Lithograph by Lane (example in NPG).

39 KNIGHTLEY, Rainald, 1st Baron (1819–95). Politician.
Dated '3 July 1845.' Lithograph by Lane (example in NPG).

40 LYSTER, John (d1840). Soldier.
Dated '1834.' Lithograph by Lane (example in NPG).

*41 MADDEN, Richard Robert (1798–1886).

42 MUNDY, Godfrey Charles (d1860). Soldier, author of *Pen and Pencil Sketches in India* (1832).
Dated '24. April 1844.'

43 PAGET, Sir Arthur (1771–1840). Diplomat.
Dated '1840.' This drawing will be catalogued in the forthcoming Catalogue of Portraits, 1790–1830.

44 PHIPPS, Hon Edmund (1760–1837). Son of 1st Baron Mulgrave, general.
Dated '10 Aout/1832.' Lithograph by Lane (example in British Museum).

*45 PHIPPS, Hon Edmund (1808–57).

46 POWELL, John Allan. Solicitor, law-agent for Lord Blessington.
Dated '10 Aout/1832.'

47 POWERSCOURT, Richard Wingfield, 6th Viscount (1815–44).
Dated 'July 1841.' Lithograph by Lane, in reverse (example in NPG).

*48 PROCTER, Bryan Waller (1787–1874).

49 PURVES, John Home. Lady Blessington's nephew, soldier.

Dated '5 Mars/1838.' Lithograph by Lane (example in NPG).

*50 ROMER, Isabella Frances (d1852).

51 SPALDING, Jack. Ex-lancer, gambler at Crockford's.
Dated '3 Jy. 1843.' Lithograph by Lane (example in NPG).

52 STANDISH, Charles (1790–1863). Politician, and sportsman.
Dated '7 Novb/1837./Ranton Abbey.' Lithograph by Lane (example in NPG).

53 STANHOPE, Hon Lincoln (1781–1840). Son of 3rd Earl of Harrington, soldier.
Dated '1836 –/London.' Lithograph by Lane (example in NPG).

54 SUSSEX, Augustus, Duke of (1773–1843). Son of George III.
Dated '25 April/1843.' From the cast taken by William Behnes on 23 April. This drawing will be catalogued in the forthcoming Catalogue of Portraits, 1790–1830.

55 TALBOT, Christopher Rice Mansel (1803–90). Politician. Dated '1834'.

56 TANKERVILLE, Charles, Lord Ossulston, 6th Earl of (1810–99). Man of affairs.
Dated '28 July/1842.' Lithograph by Lane (example in British Museum).

57 TATTERSALL, Richard II (1786–1859). Horse auctioneer.
Dated '1841 –/London.'

58 VILLIERS, Hon Augustus (1810–47). Son of 5th Earl of Jersey, soldier.
Dated '15 Decb 1841.' Lithograph by Lane (example in British Museum).

*59 WESTMACOTT, Richard (1799–1872).

60 WINCHILSEA, George, 11th Earl of (1815–87).
Dated '24 Mai 1840 –.' Lithograph by Lane (example in NPG).

61 WOMBWELL, Sir George, Bart (1792–1855).
Dated 'avril 1841.' Lithograph by Lane (example in NPG).

THE CLERK FAMILY, SIR ROBERT PEEL, SAMUEL ROGERS AND OTHERS, 1833–57

2772 By JEMIMA WEDDERBURN

Collections: The Clerk Family; by descent to Miss Clerk, and presented by her, 1935.

Jemima Wedderburn, later Mrs Hugh Blackburn of Glasgow, was a niece of Sir George Clerk, Bart, of Penicuik (title still current). Her mother, Isabella Clerk, married James Wedderburn (1782–1822), solicitor-general for Scotland, in 1813. Jemima Wedderburn's album is mainly composed of sketches of the Clerk family, at home and on expeditions, sketches of animals (mostly dogs and horses), and illustrations by her (again mainly of animals) to various periodicals and books. All the items (approximately 150, of which 90 are drawings and water-colours) have been stuck into the album, which numbers over seventy pages. They are a delightful record of family life in the mid-nineteenth century, executed in a naive but charming style. The chief items of interest are the water-colours of Peel, Kean and Rogers (pp 28 and 33); the first two have been included in the main body of the catalogue, which is arranged alphabetically; the water-colour of Rogers will be included in the forthcoming Catalogue of Portraits, 1790–1830.

SKETCHES OF ARTISTS, 1836

4230-3 By JOHN PARTRIDGE

These four oil sketches of J. J. Chalon (NPG 4230), Thomas Uwins (NPG 4231), C. R. Leslie (NPG 4232), and Robert Bone (NPG 4233), are discussed in detail in the individual entries for these four sitters in this catalogue. They are all studies for Partridge's group portrait of the 'Sketching Society, 1836'.

DRAWINGS OF ARTISTS, *c* 1845

1456 (1–27) By CHARLES HUTTON LEAR

Collections: The artist; bequeathed to John Elliot, and presented by him, 1907.

Literature: Extracts from Lear's letters and diary, communicated by the donor (NPG archives); R. L. Ormond, 'Victorian Student's Secret Portraits', *Country Life*, CXLI (1967), 288–9.

Lear (1818–1903) studied at Sass' drawing school and later at the RA schools; he exhibited various subject pictures at the RA and British Institution, 1842–52, and then in the words of his executor, '*fell into ill-health & gave up his profession except as a pastime*'. Fortunately he had large private means. His drawings were mainly done surreptitiously in the Royal Academy schools between 1845–6: '*Being "very like the originals" if they succeed in amusing you for a few brief moments I shall be satisfied. They were done in fits of idleness on the corners of my Academy drawings in the life school so that they are though slight, yet still interesting as taken from "nature".*' Lear wrote this in a letter to his father, to whom he sent the drawings for interest and amusement. He wrote later: '*The heads do rise slowly but do not think I am negligent. Whenever I have an opportunity, & these do not occur every day, I take advantage of it, as the enclosed will assure you Don't close the frame, for I shall from time to time send you others, which you can replace others with, for some of them, if I recollect, are so very slight as almost to amount to nothing.*' In another letter to his mother, he wrote: '*I never imagined, when I sent him the sketches of heads, that my Father would think them worthy of a frame. I am delighted to find they are so amusing to him & you all. Enclosed he will find one or two more.*' Most of the drawings are of prominent Royal Academicians, many of whom were official visitors to the life school during 1845 and 1846, like Etty, Baily, Leslie, Maclise and Mulready. Only two, Linnell and J. C. Hook, are of fellow-students. Those drawings marked with an asterisk are included in the main body of the catalogue, which is arranged alphabetically, accompanied by biographical descriptions and iconographies. Those sitters who fall outside the limits of this catalogue, and unimportant sitters, are briefly mentioned in the main text, and are referred here. Besides the date of the drawing, there is no further catalogue description. Two drawings by Lear of the 1st Baron Brougham and Vaux of 1857, which will be discussed in the forthcoming Catalogue of Portraits, 1790–1830, were also presented by John Elliot.

*1 BAILY, Edward Hodges (1788–1867).

*2 COOPER, Abraham (1787–1868).

*3 CRISTALL, Joshua (1767–1847).

*4 DODGSON, George Haydock (1811–80).

*5 EGG, Augustus Leopold (1816–63).

*6 ETTY, William (1787–1849).

*7 ETTY, William.

*8 ETTY, William.

*9 HART, Solomon Alexander (1806–81).

*10 HERBERT, John Rogers (1810–90).

*11 HILTON, William (1786–1839).

*12 UWINS, Thomas (1782–1857).

*13 HOOK, James Clarke (1819–1907).

*14 JONES, George (1786–1869).

*15 LESLIE, Charles Robert (1794–1859).

16 LINNELL. One of the sons of the painter, John Linnell. Inscribed 'Linnell/Nov 45'.

17 LINNELL. One of the sons of the painter, John Linnell. Inscribed 'young Linnell'. Not apparently the same sitter as no. 16 above. Linnell had three sons who were painters, John junior, James Charles and William.

18 LONG, William (fl 1821–55). Painter. Inscribed 'Long'. Copy of an undated letter from Lear to his family, mentioning this drawing (NPG archives).

*19 MACLISE, Daniel (1806–70).

*20 MACLISE, Daniel.

*21 MORRIS, Ebenezer Butler (fl 1833–63). Painter; and WYON, William (1795–1851). This drawing is fully catalogued under Wyon, but not under Morris, in the main body of the catalogue.

*22 MULREADY, William (1786–1863).

*23 PICKERSGILL, Henry William (1782–1875).

*24 SASS, Henry (1788–1844).

25 TURNER, James Mallord William (1775–1851). Painter. This drawing will be catalogued in the forthcoming Catalogue of Portraits, 1790–1830. A copy of an extract from Lear's diary,

dated 3 May 1847, relating to Turner, is in the archives of the NPG, communicated by the donor.

26 WEST, Benjamin (1738–1820). Painter. This drawing will be catalogued in the forthcoming Catalogue of Portraits, 1790–1830.

27 WESTMACOTT, Sir Richard (1775–1856). Sculptor. This drawing will be catalogued in the forthcoming Catalogue of Portraits, 1790–1830.

DRAWINGS, *c*1845

4216–18 By GEORGE HARLOW WHITE

Collections: The artist; E. E. Leggatt, presented by him, 1910.

These three drawings of Samuel Drummond, Edward Taylor and Thomas Uwins come from a sketchbook belonging to the artist. That of Drummond was executed in the Royal Academy, where White was a student (admitted 1836), in 1842, and the same is probably true of the drawing of Uwins. The drawing of Taylor dates from 1845. All three drawings are included in the main body of the catalogue, which is arranged alphabetically. Although they entered the collection in 1910, the drawings were not registered as acquisitions but remained with the autograph letters presented by Mr Leggatt at the same time, which had also belonged to the artist. Presented with them was a silhouette (NPG 4219), called G. H. Harlow by himself. It is inscribed 'George Harlow/by Grandfather. G. H. W[hite].' White was the nephew of G. H. Harlow, the artist, who was an only child. If the silhouette was by Harlow's father, who died before the birth of his son, it must have been of a brother or another relative. It appears to date from the late 18th century.

ARCTIC EXPLORERS, 1850–86

The sitters represented in this collection were almost all involved, at one time or another, in the search for Sir John Franklin. It was to commemorate their efforts that Lady Franklin commissioned her series. Pearce's group portrait, 'The Arctic Council, 1851', is discussed under groups above.

905–924, 1209–1227 By STEPHEN PEARCE

Collections: NPG 905–24. Commissioned or purchased by Lady Franklin, and bequeathed by her niece, Miss Sophia Cracroft, in accordance with the wishes of her aunt, 1892.

NPG 1209–24. Commissioned or purchased by Colonel John Barrow, and bequeathed by him, 1899.

In 1850, Barrow commissioned Pearce to paint the 'Arctic Council' (NPG 1208). The studies for this were acquired by Lady Franklin. Both she and Barrow gave Pearce further commissions for individual portraits of Arctic explorers. Apart from four large three-quarter length paintings of McClintock, McClure, Nares and Penny, the remaining thirty-five portraits are all small half-lengths (approximately $15\frac{1}{4} \times 12\frac{3}{4}$ inches ($38 \cdot 7 \times 32 \cdot 5$ cm)), usually on canvas, but occasionally on millboard. All the portraits are catalogued individually under the names of their sitters in the main body of this catalogue, which is arranged alphabetically, with accompanying biographical descriptions and iconographies.

The following list is arranged in roughly chronological order. The first eight portraits are studies for Pearce's group of 'The Arctic Council, 1851' (NPG 1208; see *Groups*, p 548):

905 BARROW, John (1808–98).

907 SABINE, Sir Edward (1788–1883).

908 HAMILTON, William Alexander Baillie (1803–81).

909 RICHARDSON, Sir John (1787–1865).

911 BEECHEY, Frederick William (1796–1856).

912 PARRY, Sir William Edward (1790–1855).

913 ROSS, Sir James Clark (1800–62).

918 BEAUFORT, Sir Francis (1774–1857).

1227 BELLOT, Joseph René (1826–52).

1223 INGLEFIELD, Sir Edward Augustus (1820–94).

921	Replica of NPG 1223.	1224	OSBORN, Sherard (1822–75).
1209	PENNY, William (1809–92).	916	Replica of NPG 1224.
1213	RAE, John (1813–93).	1217	BELCHER, Sir Edward (1799–1877).
1225	KENNEDY, William (1813–90).	1218	AUSTIN, Sir Horatio Thomas (1801–65).
917	Replica of NPG 1225.	910	HOBSON, William Robert (1831–80).
1220	STEWART, Alexander (1830–72).	1211	McCLINTOCK, Sir Francis Leopold (1819–1907).
1221	COLLINSON, Sir Richard (1811–83).	922	WALKER, David (1837–1917).
914	Replica of NPG 1221.	1214	MAGUIRE, Rochfort (d 1867).
1210	McCLURE, Sir Robert John le Mesurier (1807–73).	1215	MOORE, Thomas Edward Laws (1819–72).
1222	KELLETT, Sir Henry (1806–75).	1219	OMMANEY, Sir Erasmus (1814–1904).
915	Replica of NPG 1222.	923	RICHARDS, Sir George Henry (1820–96).
1216	McCORMICK, Robert (1800–90).	920	YOUNG, Sir Allen William (1827–1915).
1226	McCLINTOCK, Sir Francis Leopold (1819–1907).	1212	NARES, Sir George Strong (1831–1915).
919	Replica of NPG 1226.	924	SMITH, Benjamin Leigh (1828–1913).
906	MURCHISON, Sir Roderick Impey (1792–1871).		

SKETCHES OF THE PUSEY FAMILY AND THEIR FRIENDS, c1856

4541 By MISS CLARA PUSEY

Collections: Peter Eaton; Theodore Hoffman, purchased from him, 1967.

This collection consists of over fifty drawings and water-colours, stuck down on both sides of thirteen sheets of mostly blue paper (some of the sheets are water-marked '1897'). Apart from two drawings (see no. 13 verso below), they are all the work of Clara Pusey. She, her brother Sidney, and her sister Edith, resided with their uncle, Dr Edward Pusey (1800–82), one of the leaders of the Oxford Movement, after the death of their father, Philip Pusey, in 1855 (their mother, Lady Emily Pusey, had died in 1854). Clara remained in Pusey's household at Christ Church until her marriage to Captain Frank Fletcher in 1862.

The drawings are amateurish, but they reveal a charming picture of social and family life in Oxford in the mid-19th century. Several, if not all of them, were sent to Clara's cousin, Alice Herbert,[1] as part of an apparently regular correspondence, or running commentary, on events in Oxford (see nos. 4, 6, 9, 10, 11, below). Some of the drawings are inscribed 'Christ Church Express', and those that are dated are all of 1856. Apart from the drawings, there are also a few accompanying descriptions of the people whom Clara drew, which are well-observed and witty. Below most of the drawings are later type-written labels identifying the figures; these were presumably added when the drawings were stuck down on the blue sheets of paper, possibly by Clara Pusey or Alice Herbert, or, at any event, by someone familiar with their significance.

The earlier provenance of the collection is not known. Given below is a brief description of the individual sheets. Some of these bear old numbers (there were once apparently several more in the set), which are given in brackets after the NPG enumeration. Drawings of Dr Edward Pusey, Bishop Samuel Wilberforce, Dr Henry Mansel and Dr Richard Cotton are asterisked; they are included in the main body of the catalogue, which is arranged alphabetically, with accompanying biographical descriptions and iconographies:

[1] Alice Herbert (born 1834) was the daughter of Clara Pusey's great-uncle, Lord Algernon Herbert. The latter was the son of the 1st Earl of Carnarvon (Clara's mother, Lady Emily, was the daughter of the 2nd Earl), and had married Marianne Lempriere; hence the frequent appearance of Lemprieres in the drawings. The other Herberts represented were the children of Henry, 3rd Earl of Carnarvon, and of his brother Lord Edward Herbert. The Herveys were the Rev Lord Charles Hervey and his family, one of whom Sidney Pusey (Clara's brother) later married. I am most grateful to the Rev Peter Cobb of Pusey House, Oxford, for his help in identifying the families, and establishing their relationships.

1 *verso*. Water-colour of an archery scene, with Miss Griffinhoofe, Charles Pusey, J.C.Herbert and Charlotte Markby. Two separate pen-and-ink drawings of Mrs Frere handling a bow.

recto. Pen-and-ink drawing of two separate archery scenes; the first with William Markby, Mrs Wale, the Hon Blanche and the Hon Charlotte Osborne; the second with Mrs Frere and the Rev Alfred Peel. Pen-and-wash drawing of an unidentified man with a bow (possibly Alexander Pym).

2 (11) *verso*. Pen-and-ink drawing of an archery scene, executed (according to type-written note) at Duxford on 22 August 1856, with Clara Pusey, Markbys, Herberts and others.

recto. Pen-and-ink drawing of an archery scene, similar to the one above, and executed at the same time.

3 (15) *verso*. Pen-and-ink drawing of an archery scene, with Clara Pusey, George Slade, Alexander Pym (?) and Robert Herbert. Pen-and-ink drawing of Robert Herbert reading. Two separate pen-and-ink drawings of the Rev G.Green and the Rev Lamprill. Pen-and-ink drawing of two unidentified heads. Pen-and-ink drawing of Alice Herbert.

recto. Pen-and-ink drawing of an archery scene, with the Rev Alfred Peel, Rev Sutton and Miss Herbert. Pen-and-ink drawing of the Rev W.Sparrow Simpson playing the piano, inscribed in ink 'Excelsior'. Pen-and-ink drawing of Mrs Wilkes seated in a chair.

4 *verso*. Pen-and-ink drawing of a breakfast at All Souls; signed (bottom left), 'Clara Pusey del.'; inscribed (along top), 'Breakfast at All Souls. 18ᵗʰ Feb. 1856', and (bottom right), '6ᵈ sold'; included are Herberts, Puseys, Lemprieres and others.

recto. *Pen-and-ink drawing of the Pusey household at breakfast, and on the reverse a companion drawing of the Herberts at breakfast; they were sent by Clara Pusey to her friend Alice Herbert as an amusing comment on the friendship between themselves and their families; the first is inscribed in ink 'No 1 Christ Church express', and in pencil (lower left), '13th September 1856/dearest Alice/one or more members of the first above party is al/ways very much gladdened in the shades/of Oxford by one or more members of the [continued over-page along the bottom of the second drawing] 2nd above party sending tidings of the whole party or any portion of [the ?]/same whenever any member of the same feels that way inclined [one or two words cut off by edge of drawing being stuck down]/by no means if one or more members feel sufficiently occupied by [one or two words cut off] & agreable toils and pleasures of Tchleton[?]'.

5 *verso*. Pen-and-ink drawing of two boating scenes, with Herveys, Herberts and Pyms. Pen-and-ink drawing of various people in coaches and carts.

recto. Pen-and-ink drawing of a riding scene, with Herveys, Herberts and Lemprieres.

6 *verso*. Three small pen-and-ink drawings of various figures, one apparently of Clara Pusey asleep, inscribed in ink (top right), 'a good night/your aff. cousin/Clara Pusey'.

recto. Blank.

7 (3) *verso*. Pen-and-ink drawing of a boating scene, with Clara Pusey, Lemprieres and Herberts. Pen-and-ink drawing of Hodgson, the gardener, and his dog Galba. Pen-and-ink drawing of Hodgson and three children.

recto. Pen-and-ink drawing of a boating party, similar to the above. *Two pen-and-ink drawings of Dr Pusey preaching.

8 (9) *verso*. Water-colour of an evening musical scene at the house of the Herberts.

recto. Pen-and-ink drawing of an archery scene, with Greens, Herberts, Herveys, etc.

9 (19) *verso*. *Pen-and-ink drawing of a lunch or dinner scene at the house of Henry Mansel, and on the reverse a pen-and-ink drawing of Dr Cotton, provost of Worcester College, receiving the Duke of Nemours; both were sent by Clara Pusey to Alice Herbert, and are inscribed 'The Christ Church Express No 2' (the first also 'Tuesday'); the first is inscribed in pencil (lower

right), 'My dearest Alice/only want of time has prevented my shewing you the order in wh we sat at Mr Glass who [continued over page, along the bottom of the second drawing] Marcel [inscription here covered by the typewritten names]/his Royal highness [inscription covered] the Prince-Duke de Nemours at Worcester.'

recto. *Pen-and-ink drawing of figures coming out of the Cathedral at Christ Church; inscribed in ink (top left), 'The Cadogan Express', (bottom right), 'coming out of Cathedral', and (bottom left), 'Dearest Alice/How can I thank you & Jamie [inscription here cut off]'. The only identifiable figures are Bishop Samuel Wilberforce, and Dr Edward Pusey.

10 (23) *verso*. Four pen-and-ink drawings, with accompanying descriptions, evidently cut out from a larger illustrated manuscript describing an Oxford dinner-party; presumably sent by Clara Pusey to Alice Herbert. 1. Drawing of 'Mrs Arthur', 'very/elegant looking she kept up a perpetual/laughter at the Miss Gough & Mr Burt/her end of the table'. 2. Drawing of 'Miss Butler', 'Lady B. remarked/men's taste when they exercise it is nearly always/the best. Miss Butler said it would be a very/great nuisance & if she married/she wouldn't let her husband have/anything to do with her dress'. 3. Drawing of 'Mr Arthur', 'I went/in last with a Mr Arthur Miss Gough's cousin/& next Miss Tervil about the middle of/the table. He began to me "You're/a niece of Dawhter Pusey?" "Yes"/I said "do you know him?" "O. – Ay'm/connected with – sarm rhelaytions –/of – his The Bouveries!!!" "O are you?" "Do you know Admiral Bouverie"/(I write it so to give you a faint impression of the/thick impassiveness of his speech) "No" I said'. 4. Drawing of 'Miss Gough', 'Miss Gough/being a safe distance from Lady/B dilated on the beauties of the/ "London season – that great beauty/I met the other day Lady Georgiana/Lygon" now Lady Raglan – she said/her eyes & hands just like her Father/ "Perfectly Orien–/tal! I don't/know what you/may think but I consider/her Perfectly Oriental!"'

recto. Pen-and-ink drawing of various figures, inscribed (along top): 'A scene in Company'.

11 (2) *verso*. Pen-and-ink drawing of a park scene, inscribed in ink (along bottom), 'Stanford Hall View from my window. The Christ Church Express/no iv'. Pen-and-ink drawing of a man's head, inscribed in ink (along the top) 'Some Irish Lord's brother', and (below), 'Mr Butler'. A second similar drawing, inscribed in ink (top), 'Roman Catholic', and (below), 'Mr Tervil'. A third similar drawing, inscribed in ink (below), 'Mr Puchin', with the following description, 'Mr Puchin a large Leicestershire/landowner who is very devoted to/Music & has a Gregorian/Choir which he pays for himself'. A fourth similar drawing, inscribed in ink (below), 'Mr Gough', with the following description, 'I did not hear much of Mr/G's conversation with Lady B/except "Good GGracious Heavens/been all over the world &/not been to Scotland! Good/Gracious me! Don't know what you've lost!/What mons'r [sic] loss!"' Pen-and-ink drawing of a bathing scene, inscribed in ink (bottom left), '. . . . [illegible] bathing'.

recto. *Water-colour sketch of Bishop Wilberforce preaching, presumably in the Cathedral at Christ Church. Pen-and-ink drawing of a card-playing scene.

12 (7) *verso*. Pen-and-ink drawing of a lunch or dinner party, with Herberts, Puseys, etc.

recto. Pen-and-ink drawing of a man in medieval costume looking up at a lady by a window, inscribed in ink (lower left), 'Hopeless Gregory'. A second drawing of the same couple in ordinary costume, inscribed in ink (top right), 'Lady Alice/and /Hopeless Gregory'. Separate drawings of Alexander Pym, the Rev W.Sparrow Simpson, Alice Herbert and Philip Frere, and an unidentified lady practising archery.

13 (5) *verso*. Two separate pen-and-ink drawings of Parker Hammond reciting by the Rev Alfred Peel. Below one is a quotation from the piece that Hammond is evidently declaiming.

recto. Pen-and-ink drawing of an indoor sketching party, with Herberts, Herveys, Okes, etc. Pasted over the right-hand side of the drawing is another drawing of Mr Heavyside, apparently on horseback.

DRAWINGS OF ROYAL ACADEMICIANS, c 1858

2473-9 By CHARLES BELL BIRCH

Collections: The artist, presented by his nephew, George von Pirch, 1930.

These drawings, all executed in pencil, were done at the Royal Academy schools, where Birch was a student from 1852. Three of them are dated 1858 and 1859, which is probably the period when the others were executed. All these drawings are included in the main body of the catalogue, which is arranged alphabetically, with accompanying biographical descriptions and iconographies:

2473 MULREADY, William (1786–1863).

2474 LONG, Edwin Longsden (1829–91). Dated 1858.

2475 SCOTT, Sir George Gilbert (1811–78). Dated 1859.

2476 MACLISE, Daniel (1806–70), and HART, Solomon Alexander (1806–81).

2477 EASTLAKE, Sir Charles Lock (1793–1865), LESLIE, George Dunlop (1835–1921), and WOOD, John (1825–91).

2478 EASTLAKE, Sir Charles Lock. Dated 1859.

2479 HART, Solomon Alexander. This was previously identified as Eastlake; the features, however, agree much better with Hart (see NPG 2476 above).

DRAWINGS OF ARTISTS, c 1862

3182 (1–19) By CHARLES WEST COPE

Collections: The artist; his sale, Christie's, 22 June 1894 (probably lot 27), bought J.P.Heseltine; purchased from Sotheby's, 24 May 1944 (lot 19).

Literature: R.L.Ormond, 'Art Students through a Teacher's Eyes', *Country Life*, CXLIII (1968), 1348–9.

These drawings are mounted in an album, inscribed, 'Sketches of Royal Academicians/ by C.W.Cope. R.A./from his sale J.P.H.' Lot 27 of the artist's sale contained 33 drawings of academicians' heads, and is probably the one which Heseltine purchased. The latter was himself an artist, and a friend of Cope; they were both members of the Etching Club. He mounted the drawings in the leather-bound album, which is inscribed, 'In Memoriam'. Most of the drawings are of individual artists, and general views of the Royal Academy schools; Cope was an official visitor at the school of painting and the life school from 1861 to 1866, and most of the sketches were executed there between these dates. They are mainly in pencil or pen-and-ink, vivid and spontaneous sketches of artists at work. In 1865, Cope etched a view of the life school (example in British Museum), but none of the drawings appear to be studies for this. Those drawings marked with an asterisk have been included in the main body of the catalogue, which is arranged alphabetically, with accompanying biographical descriptions and iconographies. The other drawings, except for those of Ward (to be catalogued in another volume) and White, and the two which include Pickering (nos. 15 and 16), have no identifiable figures. Neither Pickering nor White are important enough to be fully catalogued; they are briefly mentioned in the main text, and are then referred to this section.

*1 COOPER, Abraham (1787–1868).

*2 HORSLEY, John Callcott (1817–1903).

*3 HART, Solomon Alexander (1806–81), and *COUSINS, Samuel (1801–87).

*4 LESLIE, Charles Robert (1794–1859).

*5 MULREADY, William (1786–1863), and LESLIE, Charles Robert (1794–1859).

*6 HAYTER, Sir George (1792–1871), and WITHERINGTON, William Frederick (1785–1865).

*7 ROBERTS, David (1796–1864).

*8 ROTHWELL, Richard (1800–68).

*9 PICKERSGILL, Henry William (1782–1875), and WITHERINGTON, William Frederick (1785–1865).

10 WARD, Edward Matthew (1816–79).
Inscribed (top right), 'Ward'. This drawing will be fully catalogued in the forthcoming Catalogue of Portraits, 1860–90.

11 WHITE, Edward. Connoisseur, and friend of Charles Lamb.
Inscribed, 'White reading Boccacio/at Florence'.

*12 EASTLAKE, Sir Charles (1793–1865).

13 Two unidentified heads, one full face, the other in profile of the same sitter.

14 General view of the life school at the Royal Academy, with students at work.
Inscribed, 'Life School Nov 1862'.

15 General view of the life school, with students at work.
Inscribed, 'R.A. Dec –/1862'. Inscribed below the nearest figure 'Pickering'. Ferdinand Pickering (1811–*c* 1882) was a life student, who continued to attend the Schools. He was a figure of fun to his fellow students.

16 PICKERING, Ferdinand (1811–*c*1882). History painter.
Inscribed, 'Pickering/RA – /Painting School CWC [in monogram] 1867/Etc [?]'.

17 View of the students at work in the Royal Academy schools.
Inscribed, 'RA. Oct 26 1855'.

18 View of a sculptor working from a male model in the life school of the Royal Academy.
Inscribed, 'The model resting – RA'.

*19 COOPER, Abraham (1787–1868).

Appendix

MACAULAY *Thomas Babington Macaulay, 1st Baron (1800–59)*

For other portraits of Macaulay in the NPG, see pp 287–90 of this catalogue.

4882 Oil on canvas, 25 × 30 inches (63.5 × 76.3 cm), by EDWARD MATTHEW WARD, 1853. PLATE 570

Inscription on the back of the canvas in brown colour, recorded by Scharf (see below), 1879 (now covered by relining): Rt Hon^ble T B Macaulay/in his study No I Albany/Picadilly [*sic*]/painted from life/ E M Ward/June 1853

The frame is the original one supplied by Criswick & Dolman (label recorded by Scharf), inscribed on the front in the centre: THE R.T HON. T. B. MACAULAY IN HIS STUDY./E. M. WARD, R.A. *and on either side, in a later inscription:* BOROUGH OF STRETFORD PURCHASED 1934.

On the back of the frame is a label for Thomas Agnew & Sons. The original canvas was supplied by Roberson's (recorded by Scharf).

Provenance: E. M. Ward Sale, Christie's, 29 March 1879 (lot 82), bought Agnew; Richard Hurst, his sale, Christie's, 25 April 1899 (lot 125), bought Agnew; presented to the Whitworth Art Gallery, Manchester, through R. D. Darbishire, 1899; purchased from the Whitworth by the Borough of Stretford, 12 June 1934, and sold by them, Henry Spencer & Sons, Retford 14 May 1971 (lot 222); Bonham's, 1 July 1971 (lot 98), bought Abbott & Holder; purchased from Patrick Corbett, 1972.

Exhibitions: SKM, 1868 (538); *Royal Jubilee Exhibition*, Manchester, 1887 (788); *VE*, 1892 (330).

Literature: Macaulay's 'Journal' (Trinity College, Cambridge), VI, 73–4, 76[1]; George Scharf, 'SSB' (NPG archives), XCIX, 22, under 1879.

Macaulay noted in his 'Journal' for 18 May 1853: '*Ward came at eleven. I had a long sitting. I am tired to death of these sittings. He did not go till three, and would not have gone then if I had not sent him away*'. On 25 May he wrote again: '*He sate all day in the room*[illegible: poisoning?] *it with the smell of paint. At one I went out—came back at four and found him still there. He has made me uglier than a Daguerreotype. However he is a clever fellow.*' In a note on the picture when it was exhibited in 1868, Scharf wrote that it was '*very much Macaulay's attitude*' ('SSB', LXXX, 78a). In his copy of Ward's sale catalogue, he called the portrait '*excellent*', and wrote that it was '*The Room as I knew it*'. In his biography of Macaulay, G. O. Trevelyan wrote of his chambers in the Albany (II, 97–8), that they '*were comfortably, though not very brightly, furnished. The ornaments were few but choice:- half a dozen fine Italian engravings from his favourite great masters; a handsome French clock, provided with a singularly melodious set of chimes, the gift of his friend and publisher, Mr Thomas Longman; and the well-known bronze statuettes of Voltaire and Rousseau . . . which had been presented to him by Lady Holland as a remembrance of her husband*'. The illustration in the plate volume is taken from the 1868 SKM negative; the present block was made before the portrait entered the collection, when its location was still unknown. Comparison with the 1868 photograph reveals some insensitive restorations in the lower right hand part of the picture, expecially on the carpet under the desk. The portrait of Macaulay is one of at least seven pictures of writers in their studies executed by Ward in the 1850s. The others include Thackeray (1854, destroyed), Bulwer Lytton (1851, Knebworth, plate 562), Stanhope (1854, Hughenden Manor), Dickens (untraced), Hallam (1858, untraced), and Forster (Victoria and Albert Museum). Apart from the portrait of Forster, all the others appeared in the artist's sale. They were evidently painted as a companion series which Ward may have hoped to exhibit together, with a view to selling and engraving them as a group. Portraits of literary figures were popular at the time, and Ward's pictures combine portraiture with a genre representation of the writer in his setting.

Description: Healthy complexion, brownish grey eyes, grey hair. Dressed in a white shirt, black stock, medium greyish waistcoat and trousers, dark grey coat and black shoes, holding a pair of library spectacles. Seated in a dark brown, polished leather armchair. Brown wooden pillar table beside him

[1] I am grateful to Thomas Pinney for references to the 'Journal'.

with red and green leather-bound books, the former either a copy of the Post Office Directory or Burke. Dark brown leather desk chair at right, a wicker waste-paper basket, and a wooden desk with a single drawer covered with a folding, wooden writing-case, bound in brass, books and papers. Bookcase behind with assorted books on the shelves, surmounted by a clock. View of greyish houses, brownish-red chimney pots and blue sky through window behind. Red curtain on the left of the window, and beyond another bookcase. Door behind Macaulay, and above a framed picture or design(?). Framed print to the left of the door, with white and red reflections in the glass, and a bookcase below. Further to the left a white marble fireplace with a large mirror above, and a glass ornament, a fan, and a black statuette of Voltaire on the mantelpiece. Below a coal fire in the grate, and a brass fender with two fire-irons resting on it. Red runner carpet in front of fireplace, on top of a paler red patterned carpet covering most of the floor. A grey drugget carpet covers the area below the desk, desk chair and pillar table.

STIRLING-MAXWELL *Caroline, Lady, and her sister, the Duchess of Somerset, now tentatively identified as Alexina and Catherine Lindsay*

3791 This picture is catalogued on p 432. Just before this catalogue went to press, the portrait was cleaned, and the signature of Andrew Geddes, the Scottish portraitist, was uncovered. There is no record that Geddes ever painted Lady Stirling-Maxwell and her sister, and the identity of the sitters has now been called into question. The doubts raised by the discovery of the signature are reinforced by the evidence of costume. On this evidence, the portrait must date from after 1835, when both Lady Stirling-Maxwell and her sister were married; such portraits of sisters were rarely painted after marriage.

Geddes is recorded as having painted two double portraits of sisters[1]. The first represents Lady Mary and Lady Gwendaline Talbot, daughters of the 16th Earl of Shrewsbury, who became, respectively, Princess Doria Pamphili Landi and Princess Borghese. The portrait was painted in Rome around 1829, and there is a compositional drawing for it and a study of the head of Lady Gwendaline in the National Gallery of Scotland. Neither study ties with the NPG portrait, and, in any case, the evidence of costume mitigates against a date as early as 1829. The second recorded portrait is of Alexina Nisbet and Catherine Hepburne Lindsay, daughters of the Hon Charles Lindsay, who was the second son of the 6th Earl of Balcarres and the 23rd Earl of Crawford. This portrait was painted in 1838, when Catherine was sixteen (b 1822), and Alexina slightly older. It is difficult to be certain of the ages of the two sitters in the NPG portrait, but 1838 would agree excellently with their costume. The present Earl of Crawford has confirmed that no portrait of Alexina and Catherine Lindsay by Geddes is in his possession or that of his immediate family. The NPG portrait has, therefore, been tentatively identified as the Lindsay daughters, although it cannot be substantiated until more evidence comes to light.

[1] See 'Memoir of the Late Andrew Geddes' by Adela Geddes, 1844 (Victoria and Albert Museum Library, Box 195C), and *The Etchings of David Wilkie and Andrew Geddes* by David Laing, 1875.

Indexes

INDEX OF OWNERS AND COLLECTIONS

This does not include references to sales, or engravings. Most engravings mentioned in the catalogue are in the NPG or the British Museum.

INDEX OF ARTISTS

This does not include engravers, etchers and lithographers, or photographers, for which see separate indices.

INDEX OF ENGRAVERS, ETCHERS AND LITHOGRAPHERS

INDEX OF PHOTOGRAPHERS